Focal Encyclopedia of
Photography

Focal Encyclopedia of Photography

Digital Imaging, Theory and Applications, History, and Science

Fourth Edition

MICHAEL R. PERES
Editor-in-Chief

AMSTERDAM • BOSTON • HEIDELBERG • LONDON
NEW YORK • OXFORD • PARIS • SAN DIEGO
SAN FRANCISCO • SINGAPORE • SYDNEY • TOKYO

Focal Press is an imprint of Elsevier

Acquisitions Editor: Diane Heppner
Publishing Services Manager: George Morrison
Project Manager: Paul Gottehrer
Associate Acquisitions Editor: Cara Anderson
Assistant Editor: Doug Shults
Marketing Manager: Christine Veroulis Degon
Cover Design: Heidi Ziskind
Interior Design: Shawn Girsberger

Focal Press is an imprint of Elsevier
30 Corporate Drive, Suite 400, Burlington, MA 01803, USA
Linacre House, Jordan Hill, Oxford OX2 8DP, UK

 Recognizing the importance of preserving what has been written, Elsevier prints its
books on acid-free paper whenever possible.

Library of Congress Cataloging-in-Publication Data
Application submitted

British Library Cataloguing-in-Publication Data
A catalogue record for this book is available from the British Library.

ISBN 13: 978-0-240-80740-9
ISBN 10: 0-240-80740-5

ISBN 13: 978-0-240-80975-5 (CD-ROM)
ISBN 10: 0-240-80975-0 (CD-ROM)

For information on all Focal Press publications
visit our website at www.books.elsevier.com

07 08 09 10 11 5 4 3 2 1

Printed in China

Working together to grow
libraries in developing countries

www.elsevier.com | www.bookaid.org | www.sabre.org

ELSEVIER BOOK AID International Sabre Foundation

Contents

Contributors

Peter Adelstein, Ph.D.
Senior Research Associate
Image Permanence Institute
Rochester Institute of Technology
Rochester, New York, USA

Greg Barnett
Operations Manager
College of Imaging Arts and Sciences
Rochester Institute of Technology
Rochester, New York, USA

Wolfgang Bengel, DDS
Imaging Consultant and Private Dentist
Bensheim, Germany

Lynne Bentley-Kemp, Ph.D.
Head of Photography
Florida Keys Community College
Key West, Florida, USA

Hartmut Blaue
Ilford Imaging Switzerland GmbH
Marly, Switzerland

Jonas Brane
Scientific and Technical Photography
 Photographer
Mölle, Sweden

David Brittain
AHRC Research Fellow
Manchester Metropolitan University
Manchester, London, United Kingdom

Owen Butler
Associate Professor
School of Photographic Arts and Sciences
Rochester Institute of Technology
Rochester, New York, USA

Daniel Burge
Research Scientist
Image Permanence Institute
Rochester Institute of Technology
Rochester, New York, USA

Christopher Burnett
Director
Visual Studies Workshop
Rochester, New York, USA
http://vsw.org

Roger L. Carter
webmaster
www.digitalcamhistory.com
Xenia, Ohio, USA

Guenther Cartwright
Associate Professor
Photojournalism
School of Photographic Arts and Sciences
Rochester Institute of Technology
Rochester, New York, USA

Bruce Checefsky
Director
Reinberger Galleries
The Cleveland Institute of Art
Cleveland, Ohio, USA

Eric H. Cheng
Underwater Photographer
Oakland, California, USA

Nathan Claxton
National High Magnetic Field Laboratory
Florida State University
Tallahassee, Florida, USA

A. D. Coleman
Independent Photography Critic, Historian,
 and Curator
Staten Island, New York, USA
http://photocritic.com

Anthony H. Cooper, Ph. D.
District Geologist Yorkshire and
 The Humber
Karst Geohazard Specialist
British Geological Survey
Keyworth, Nottingham, United Kingdom

Andrew Davidhazy
Professor
Imaging and Photographic Technology
School of Photographic Arts and Sciences
Rochester Institute of Technology
Rochester, New York, USA
www.rit.edu/~andpph

Michael W. Davidson
National High Magnetic Field Laboratory
Florida State University
Tallahassee, Florida, USA

Denis Defibaugh
Associate Professor
Advertising Photography
School of Photographic Arts and Sciences
Rochester Institute of Technology
Rochester, New York, USA

Dennis di Cicco
Senior Editor
Sky Publishing Corp.
Cambridge, Massachusetts, USA

William W. DuBois
Professor and Chair
Photographic Arts
School of Photographic Arts and Sciences
Rochester Institute of Technology
Rochester, New York, USA

Peter Eastaway, Hon. FAIPP, FAIPP
Magazine Publisher and Professional
 Photographer
Collaroy Beach, New South Wales, Australia

Margaret P. Evans
Associate Professor
Communication/Journalism Department
Shippensburg University
Shippensburg, Pennsylvania, USA

John Fergus-Jean
Associate Professor
Media Studies
Columbus College of Art and Design
Columbus, Ohio, USA

Andy Finney
Invisible Imaging Expert
Atchison Topeka and Santa Fe Limited
Godalming, Surrey, United Kingdom

John (Craig) Freeman
Associate Professor
Emerson College
Boston, Massachusetts, USA

Franziska S. Frey, Ph.D.
McGhee Distinguished Professor
School of Print Media
Rochester Institute of Technology
Rochester, New York, USA

x Contributors

Peter W. W. Fuller
Consultant in Instrumentation and
 Imaging Science
Bromley, Kent, United Kingdom

Andrew Paul Gardner, BSc ABIPP
MIMI ARPS RMIP
Chief Photographer
UCL Ear Institute Photographic Unit
London, United Kingdom

Gretchen Garner
Photographic Author and Scholar
Columbus, Ohio, USA

Mike Gristwood
Formerly of ILFORD Imaging UK
Stockport, Cheshire, United Kingdom

Todd Gustavson
Curator
Technology Collection George Eastman
 House International Museum of
 Photography and Film
Rochester, New York, USA

David C. Hart, Ph.D.
Assistant Professor
Cleveland Institute of Art
Cleveland, Ohio, USA

Paul Harcourt-Davis
Professional Photographer and Author
Sugano, Orvieto, Italy

Barry Haynes
Photographic Author
Gibsons, British Columbia, Canada
www.barryhaynes.com

Robert Hirsch
Light Research
Buffalo, New York USA
www.lightresearch.net

Alan Hodgson, Ph.D.
Consultant
Macclesfield, Cheshire, United Kingdom

Krystel R. Huxlin, Ph.D.
Assistant Professor
Ophthalmology
University of Rochester Eye Institute
Rochester, New York, USA

Sean Johnston, Ph. D.
Senior Lecturer
Science Studies
University of Glasgow Crichton Campus
Dumfries, Scotland, United Kingdom

Jon A. Kapecki
Imaging Consultant
Retired Senior Laboratory Head, Eastman
 Kodak Company
Rochester, New York, USA

Daile Kaplan
Vice-President and Director of Photographs
Swann Galleries, Inc.
New York, New York, USA

John Kaplan
Professor
College of Journalism and Communications
University of Florida
Gainesville, Florida, USA
www.johnkaplan.com

Terrance Kessler
Senior Research Engineer and Group Leader
Optics and Imaging Sciences
Laboratory for Laser Energetics
University of Rochester
Rochester, New York, USA

Ted Kinsman
Science Photographer and Image Consultant
Kinsman Physics Productions
Rochester, New York, USA

Michael Kriss, Ph.D.
Digital Imaging Consultant
Camas, Washington, USA

Ralph W. Lambrecht, M.E. ARPS
Independent Writer and Photographer
Way Beyond Monochrome
Leverkusen, Germany

Staffan Larsson
Director
Lennart Nilsson Image Center
Karolinska Institute
Stockholm, Sweden

Donald L. Light
Aerial Imaging Consultant
Airborne and Space Systems for
Mapping and Remote Sensing
Rochester, New York, USA

J. Tomas Lopez
Professor
Art and Art History
University of Miami
Coral Gables, Florida, USA

Paul E. Lowman Ph.D.
Geophysicist
Goddard Space Flight Center/NASA
Greenbelt, Maryland, USA

David Malin
Astronomer/Photographic Scientist
Anglo-Australian Observatory
Sydney, New South Wales, Australia
Adjunct Professor of Scientific Photography
RMIT University
Melbourne, Victoria, Australia

Doug Manchee
Associate Professor
School of Photographic Arts and Sciences
Rochester Institute of Technology
Rochester, New York, USA

Simon Margulies
Imaging and Media Lab
University of Basel
Basel Switzerland

Dougal G. McCulloch
Associate Professor
Microscopy and Microanalysis Facility
RMIT University
Melbourne, Victoria, Australia

Donald McRobbie, Ph.D.
Head
Radiological and MR Physics
Radiological Sciences Unit
Charing Cross Hospital
Fulham, London, United Kingdom

Larry S. Miller, Ph.D.
Professor
Criminal Justice and Criminology
East Tennessee State University
Johnson City, Tennessee, USA

Therese Mulligan, Ph.D.
Professor and Coordinator
School of Photographic Arts and Sciences
Rochester Institute of Technology
Rochester, New York, USA

Cliff Ogleby
Senior Lecturer
Department of Geomatics
Documentation
The University of Melbourne
Melbourne, Victoria, Australia

Joseph M. Ogrodnick
Srenior Photographic Specialist/Writer
New York State Agriculture Experiment
 Station
Cornell University
Geneva, New York, USA

Scott Olenych
National High Magnetic Field Laboratory
Florida State University
Tallahassee, Florida, USA

Mark Osterman
Process Historian
George Eastman House International
* Museum of Photography*
Rochester, New York, USA

Saul Ostrow
Associate Professor
Chair, Visual Arts and Technologies
Head of Painting
The Cleveland Institute of Art
Cleveland, Ohio, USA
Editor, Critical Voices in Art, Culture, and
* Theory*
Routledge, United Kingdom

Romano Padeste
SINAR AG
Feuerthalen, Switzerland

Michael Peres
Professor
Biomedical Photographic Communications
School of Photographic Arts and Sciences
Rochester Institute of Technology
Rochester, New York, USA

Phred Petersen
Scientific Photography
Department of Applied Physics
RMIT University
Melbourne, Victoria, Australia

Ernst Riolo
Ilford Imaging Switzerland GmbH
Marly, Switzerland

Grant B. Romer
Director of Conservation
George Eastman House International
Museum of Photography
Rochester, New York, USA

Bob Rose
President
VMI, Inc.
Technical Editor
Rangefinder Magazine
Woodcliff Lake, New Jersey, USA

Mitchell R. Rosen, Ph.D.
Assistant Professor
Munsell Color Science Laboratory
Chester F. Carlson Center for Imaging
* Science*
Rochester Institute of Technology
Rochester, New York, USA

Lukas Rosenthaler, Ph.D.
Imaging and Media Lab
University of Basel
Basel, Switzerland

Patti Russotti
Associate Professor
School of Print Media
College of Imaging Arts and Sciences
Rochester Institute of Technology
Rochester, New York, USA

Carl Salvaggio, Ph.D.
Associate Professor
Chester F. Carlson Center for Imaging
* Science*
Rochester Institute of Technology
Rochester, New York, USA

Gary Sampson, Ph.D.
Associate Professor
Liberal Arts
Associate Dean
Graduate Studies
The Cleveland Institute of Art
Cleveland, Ohio, USA

Matthias Schellenberg, Ph.D.
(Ing. Chem. ETHZ), Retired
Ilford Imaging Switzerland GmbH
Marly, Switzerland

Henry Schleichkorn
Owner
Custom Medical Stock Photography
Chicago, Illinois, USA
www.cmsp.com

Millard Schisler
School of Print Media
Rochester Institute of Technology
Rochester, New York, USA

Matt Schlitz, BA (Hons), GDBA, MA
Consultant Archaeologist
Biosis Research Pty, Limited
Port Melbourne, Victoria, Australia

Nicholas M. Short, Ph.D., Retired
NASA Scientist
Bloomsburg, Pennsylvania, USA

John Sidoriak
Independent Photography and Multimedia
Contractor
Director of Operations
Fisher-Cal Industries, Inc.
Magnolia, Delaware, USA

Christye P. Sisson, CRA, MS
Associate Professor
Biomedical Photographic Communications
School of Photographic Arts and Sciences
Rochester Institute of Technology
Rochester, New York, USA

Gale Spring
Associate Professor and Program Leader
Scientific Photography
Department of Applied Physics
RMIT University
Melbourne, Victoria, Australia

Leslie Stroebel, Ph.D.
Professor Emeritus
Rochester Institute of Technology
Rochester, New York, USA

Nancy M. Stuart, Ph.D.
Executive Vice President and Provost
The Cleveland Institute of Art
Cleveland, Ohio, USA

Sabine Süsstrunk, Ph.D.
Professor
School of Computer and Communication
* Sciences*
Ecole Polytechnique Fédérale de Lausanne
Lausanne, Switzerland

Masahiro Takatsuka, Ph.D.
Director
Visualization and HPC Lab
The University of Sydney
Sydney, New South Wales, Australia

Jon Tarrant, MA Cantab
Freelance Technical Journalist
Former Editor of British Journal of
* Photography*
Teaching Faculty of Physics
Jersey College for Girls
Jersey, Channel Islands, United Kingdom

Jean-Pierre Van de Capelle, Ph.D.
Xerox Corporation
Webster, New York, USA

Garie Waltzer
Photographer and Consultant
Photography Program Coordinator (Retired)
Cuyahoga Community College
Cleveland, Ohio, USA

Chuck Westfall
Director/Media and Customer Relationship
Camera Marketing Group
Canon U.S.A., Inc.
Lake Success, New York, USA

Ken White
Associate Professor
Fine Art Photography
School of Photographic Arts and Sciences
Rochester Institute of Technology
Rochester , New York, USA

Scott Williams, Ph.D.
Associate Professor
Imaging Chemistry
School of Print Media
Rochester Institute of Technology
Rochester, New York, USA

Dietmar Wüeller
Dietmar Wüeller Image Engineering
Frechen, Germany

David R. Wyble
Munsell Color Science Laboratory
Rochester Institute of Technology
Rochester, New York, USA

Hiroshi Yano
Executive Director
Japan Camera Industry Institute
Tokyo, Japan

Richard Zakia, Ph. D.
Professor Emeritus
School of Photographic Arts and Sciences
Rochester Institute of Technology
Rochester, New York, USA

Milan Zahorcak
Independent Collector
Tualatin, Oregon, USA

The following individuals prepared entries for the 1969 edition of the *Focal Encyclopedia of Photography Desk Edition* or the *Focal Encyclopedia of Photography, 3rd Edition,* which have been reproduced in this Edition.

Mary Street Alinder
Michael Bruno
Arthur Chevalier
George Cochran
R. Colson
Ira Current
John G. Delly
Joseph DeMaio
Michael Flecky
Kathleen C. Francis
Thomas Gorman
J.C. Gregory
Grant Haist

H. Harting
Terry Holman
Roger Horn
J. Gordon. Jarvis
Russell Kraus, Ph.D.
John Larish
Mike Leary
Howard LeVant
Warren L. Mauzy
Judy Natal
C.H. Oakden
Harry Roberts
M. von Rohr

Martin Scott
George Schaub
Paul Schranz
Thomas Shay
M.E. and K.R. Swan
Michael Teres
Hollis Todd
Allan Verch
Allen Vogel
Peter Walker
Howard Wallach
Richard Saul Wurman

Photographers and Image Contributors

Berenice Abbott
Miriam and Ira D. Wallach Division of Arts
New York Pubic Library
New York, New York, USA

Ansel Adams
Ansel Adams Publishing Rights Trust
Mill Valley, California, USA

Robert Adams
George Eastman House Collection
Rochester, New York, USA

Raymond K. Albright
George Eastman House Collection
Rochester, New York, USA

Thomas Annan
George Eastman House Collection
Rochester, New York, USA

Frederick Scott Archer
George Eastman House Collection
Rochester, New York, USA

Eugéne Atget
George Eastman House Collection
Rochester, New York, USA

Anna Atkins
Spencer Collection
New York Pubic Library
New York, New York, USA

Australian Key Centre for Microscopy and Microanalysis
The University of Sydney
Sydney, New South Wales, Australia

Édouard Baldus
George Eastman House Collection
Rochester, New York, USA

Thomas Barrow
George Eastman House Collection
Rochester, New York, USA

A. Bartlett
George Eastman House Collection
Rochester, New York, USA

Samuel A. Bemis
George Eastman House Collection
Rochester, New York, USA

Wolfgang Bengel, DDS
Imaging Consultant and Private Dentist
Bensheim, Germany

Barthelmy-Urbain Bianchi
George Eastman House Collection
Rochester, New York, USA

James Wallace Black
Prints and Photographs Collection
Boston Public Library
Boston, Massachusetts, USA

Abraham Bogardus
George Eastman House Collection
Rochester, New York, USA

Bradley University
Special Collections and Archives
Peoria, Illinois, USA

Mathew Brady
George Eastman House Collection
Rochester, New York, USA

Brady's National Portrait Gallery
George Eastman House Collection
Rochester, New York, USA

Adolphe Braun
George Eastman House Collection
Rochester, New York, USA

Frederick Brehm
Library of Congress
Prints and Photographs Division
Washington, D.C., USA

Anne W. Brigman
George Eastman House Collection
Rochester, New York, USA

Gordon P. Brown
Imaging Consultant
Rochester, New York, USA

Nancy Burson
George Eastman House Collection
Rochester, New York, USA

Owen Butler
Associate Professor
School of Photographic Arts and Sciences
Rochester Institute of Technology
Rochester, New York, USA

Henry Herschel Hay Cameron
George Eastman House Collection
Rochester, New York, USA

Julia Margaret Cameron
George Eastman House Collection
Rochester, New York, USA

Canon USA, Inc.
Lake Success, New York, USA

Lewis Carroll
George Eastman House Collection
Rochester, New York, USA

Eric H. Cheng
Underwater Photographer
Oakland, California, USA
http://echeng.com/photo/uw/

Charles Chevalier
George Eastman House Collection
Rochester, New York, USA

Carl Chiarenza
George Eastman House Collection
Rochester, New York, USA

Ch. Chusseau-Flaviens
George Eastman House Collection
Rochester, New York, USA

Walter Clark
George Eastman House Collection
Rochester, New York, USA

Antoine-Francois Jean Claudet
George Eastman House Collection
Rochester, New York, USA

Chuck Close
George Eastman House Collection
Rochester, New York, USA

Anthony H. Cooper, Ph.D.
District Geologist Yorkshire and
* The Humber*
Karst Geohazard Specialist
British Geological Survey
Keyworth, Nottingham, United Kingdom
Commerce Graphics, Ltd, Inc.
New York, New York, USA

Commerce Graphics, Ltd, Inc.
New York, New York, USA

Robert Cornelius
George Eastman House Collection
Rochester, New York, USA

Cromer's Amateur Daguerreotypist
George Eastman House Collection
Rochester, New York, USA

Edward S. Curtis
Edward S. Curtis Collection
Library of Congress
Prints and Photographs Division
Washington, D.C., USA

David Curtis
Photography Student
Rochester Institute of Technology
Rochester, New York, USA

Louis Jacques Mandé Daguerre
George Eastman House Collection
Rochester, New York, USA

Andrew Davidhazy
Professor
School of Photographic Arts and Sciences
Rochester Institute of Technology
Rochester, New York, USA

Bruce Davidson
Magnum Photos
George Eastman House Collection
Rochester, New York, USA

George Davison
George Eastman House Collection
Rochester, New York, USA

Michael Davidson
National High Magnetic Field Laboratory
Florida State University
Tallahassee, Florida, USA

F. Holland Day
George Eastman House Collection
Rochester, New York, USA

Dennis di Cicco
Senior Editor
Sky Publishing Corp.
Cambridge, Massachusetts, USA

DigitalGlobe (sic) QuickBird satellite
Satellite Imaging Corporation
Houston, Texas, USA

André-Adolphe-Eugène Disdéri
George Eastman House Collection
Rochester, New York, USA

William W. DuBois
Professor
School of Photographic Arts and Sciences
Rochester Institute of Technology
Rochester, New York, USA

Maxime du Camp
George Eastman House Collection
Rochester, New York, USA

Louis Ducos Du Hauron
George Eastman House Collection
Rochester, New York, USA

P. Dujardin and Léonard Berger
George Eastman House Collection
Rochester, New York, USA

Durst Image Technology U.S., LLC
Rochester, New York, USA

Peter Eastaway Hon. FAIPP, FAIPP
Magazine Publisher and Professional
 Photographer
Collaroy Beach, New South Wales,
Australia

George Eastman
George Eastman House Collections
Rochester, New York, USA

George Eastman House
George Eastman House International
 Museum of Photography and Film
Rochester, New York, USA

Peter Henry Emerson
George Eastman House Collection
Rochester, New York, USA

Elliot Erwitt
George Eastman House Collection
Rochester, New York, USA

Frederick H. Evans
George Eastman House Collection
Rochester, New York, USA

Walker Evans
George Eastman House Collection
Rochester, New York, USA

Eye of Science
Oliver Meckes and Nicole Ottawa
Reutlingen Germany
www.eyeofscience.com

Amy Faber
Student
Shippensburg University
West Chester, Pennsylvania, USA

Roger Fenton
George Eastman House Collection
Rochester, New York, USA

Andy Finney
Invisible Imaging Expert
Atchison Topeka and Santa Fe Limited
Godalming, Surrey, United Kingdom

Robert Fichter
George Eastman House Collection
Rochester, New York, USA

Mike Fisher
Custom Medical Stock Photo
Chicago, Illinois, USA

Brian J. Ford
Professor
Beyond Distance
University of Leicester
Leicester, United Kingdom

Jacob Forsell
Photographer
Stockholm, Sweden

Samuel M. Fox
George Eastman House Collection
Rochester, New York, USA

Abe Frajndlich
Visual Studies Workshop
Rochester, New York, USA

Felice Frankel
Massachusetts Institute of Technology
Cambridge, Massachusetts, USA

Clive Fraser
University of Melbourne
Melbourne, Victoria, Australia

C.D. Fredricks
George Eastman House Collection
Rochester, New York, USA

Lee Friedlander
George Eastman House Collection
Rochester, New York, USA

Francis Frith
George Eastman House Collection
Rochester, New York, USA

Adam Fuss
George Eastman House Collection
Rochester, New York, USA

Alexander Gardner
George Eastman House Collection
Rochester, New York, USA

Robert Gendler
Gendler Astro Imaging Galley
Hartford, Connecticut, USA
http://www.robgendlerastropics.com

GM Media Archive
General Motors
Detroit, Michigan, USA

Gernsheim Collection
Harry Ransom Humanities Research
 Center
The University of Texas at Austin
Austin, Texas, USA

Elias Goldensky
George Eastman House Collection
Rochester, New York, USA

Emmet Gowin
George Eastman House Collection
Rochester, New York, USA

Baron Jean-Baptiste-Louis Gros
George Eastman House Collection
Rochester, New York, USA

Armin Gruen
Swiss Federal Institute of Technology
Switzerland

Ernst Haas
George Eastman House Collection
Rochester, New York, USA

Philippe Halsman
George Eastman House Collection
Rochester, New York, USA

Franz Hanfstaengl
George Eastman House Collection
Rochester, New York, USA

Paul Harcourt-Davis
Professional Photographer and Author
Sugano, Orvieto, Italy

James Harrington
Saugus Photos Online
Massachusetts, USA

Barry Haynes
Independent Author and Photographer
Gibsons, British Columbia, Canada
www.barryhaynes.com

Robert Heinecken
George Eastman House Collection
Rochester, New York, USA

Alexander Hesler
Illinois State Historical Society
Chicago, Illinois, USA

David Octavius Hill and Robert
Adamson
George Eastman House Collection
Rochester, New York, USA

Lewis W. Hine
George Eastman House Collection
Rochester, New York, USA

Graciela Iturbide
George Eastman House Collection
Rochester, New York, USA

Frederic Ives
George Eastman House Collection
Rochester, New York, USA

William Henry Jackson
George Eastman House Collection
Rochester, New York, USA

Jewish Community Center
Rochester, New York, USA

Laura Adelaide Johnson
George Eastman House Collection
Rochester, New York, USA

J. Murray Jordan
George Eastman House Collection
Rochester, New York, USA

Kenneth Josephson
George Eastman House Collection
Rochester, New York, USA

John Kaplan
Professor
College of Journalism and Communications
University of Florida
Gainesville, Florida, USA
www.johnkaplan.com

Gertrude Käsebier
George Eastman House Collection
Rochester, New York, USA

Ted Kinsman
Science Photographer and Image
Consultant
Kinsman Physics Productions
Rochester, New York, USA

Mark Klett
George Eastman House Collection
Rochester, New York, USA

Eastman Kodak Company
Rochester, New York, USA
www.kodak.com

Les Krims
George Eastman House Collection
Rochester, New York, USA

Barbara Kruger and the
Mary Boone Gallery
New York City, New York, USA

Ralph W. Lambrecht, M.E. ARPS
Independent Writer and Photographer
Way Beyond Monochrome
Leverkusen, Germany

Dorthea Lange
Farm Security Administration
Office of War Information Photograph
 Collection
Library of Congress Prints and Photographs
 Division
Washington D.C., USA

W. and F. Langenheim
George Eastman House Collection
Rochester, New York, USA

Kevin Langton
Columbia University
New York, New York, USA

Staffan Larsson
Director, Lennart Nilsson Image Center
Karolinska Institute
Stockholm, Sweden

Gustave Le Gray
George Eastman House Collection
Rochester, New York, USA

Henri Le Sec
George Eastman House Collection
Rochester, New York, USA

Lawrence Livermore National
Laboratory
University of California
Livermore, California, USA

Life Magazine
New York, New York, USA

Gabriel Lippmann
George Eastman House Collection
Rochester, New York, USA

J. Tomas Lopez
Professor
Art and Art History
University of Miami
Coral Gables, Florida, USA

Danny Lyon
Edwynn Houk Gallery
George Eastman House Collection
Rochester, New York, USA

Joan Lyons
George Eastman House Collection
Rochester, New York, USA

Nathan Lyons
George Eastman House Collection
Rochester, New York, USA

David Malin
Astronomer/Photographic Scientist
Anglo-Australian Telescope
Sydney, New South Wales, Australia
RMIT University
Melbourne, Victoria, Australia

Keith Mancini
Forensic Photographer
Westchester County Forensic Laboratory
Westchester, New York, USA

Étienne Jules Marey
George Eastman House Collection
Rochester, New York, USA

Mary Ellen Mark
George Eastman House Collection
Rochester, New York, USA

Thomas L. McCartney
West Palm Beach, Florida, USA

Mark McCaughrean
European Southern Observatory—Chili
Garching, Germany

Susan Meisalas
Magnum Photos
George Eastman House Collection
Rochester, New York, USA

Joel Meyerowitz
George Eastman House Collection
Rochester, New York, USA

David Miller
Night Time Landscapes
http://www.davidmalin.com/miller/general/about_dmiller.html

Larry S. Miller, Ph.D.
Professor
Criminal Justice and Criminology
East Tennessee State University
Johnson City, Tennessee, USA

Richard Misrach
George Eastman House Collection
Rochester, New York, USA

Laszlo Moholy-Nagy
George Eastman House Collection
Rochester, New York, USA

Nickolas Muray
George Eastman House Collection
Rochester, New York, USA

Museum of Contemporary Photography
Columbia College Chicago
Chicago, Illinois, USA

Eadweard J. Muybridge
George Eastman House Collection
Rochester, New York, USA

Rebecca Myers
Student
Shippensburg University
Shippensburg, Pennsylvania, USA

Nadar
George Eastman House Collection
Rochester, New York, USA

Daisuke Nakamura
Student
Fine Art Photography
Rochester Institute of Technology
Rochester, New York, USA

National Aeronautics and Space Administration (NASA)
Apollo Program Photograph
Washington, D.C., USA

NASA and The Hubble Heritage Team (AURA/STScI)
Baltimore, Maryland, USA

NASA Goddard Space Flight Center
MODIS Team
Greenbelt, Maryland, USA

NASA Goddard Space Flight Center
C. Mayhew and R. Simmon
NOAA/ NGDC DMSP Digital Archive
Greenbelt, Maryland, USA

NASA/GSFC/METI/ERSDAC/JAROS and U.S./Japan ASTER Science Teams
Jesse Allen

NASA/JPL/NGA Assembled
California Institute of Technology
Pasadena, California, USA

NASA USGS EARTH RESOURCES OBSERVATIONS SYSTEMS Data Center DMSP

NASA Visible Earth/AVIRIS

NASA Wilkinson Microwave Anisotropy Probe Science Team

National Center for Supercomputing Applications (NCSA)
The Board of Trustees of the University of Illinois
Champaign, Illinois, USA

New Moon
Panoramic Images
Chicago, Illinois, USA

New York Botanical Gardens Herbarium
Bronx, New York, USA

Joseph Nicéphore Niépce
Gernsheim Collection
Harry Ransom Humanities Research Center
The University of Texas at Austin
Austin, Texas, USA

Lennart Nilsson
Karolinska Institute
Stockholm, Sweden

Joseph Ogrodnick
NYSAES
Cornell Extension
Geneva, New York, USA

Olympus America Corporation
Lake Success, New York, USA

Mark Osterman
The Scully and Osterman Studio
Rochester, New York, USA

Willie Osterman
Professor
School of Photographic Arts and Sciences
Rochester Institute of Technology
Rochester, New York, USA

Timothy H. O'Sullivan
George Eastman House Collection
Rochester, New York, USA

Pach Brothers
George Eastman House Collection
Rochester, New York, USA

Olivia Parker
George Eastman House Collection
Rochester, New York, USA

Gordon Parks
Farm Security Administration
Office of War Information Photograph
* Collection*
Library of Congress Prints and Photographs
* Division*
Washington, D.C., USA

Martin Parr
Magnum Photos
George Eastman House Collection
Rochester, New York, USA

Damian Peach
Views of the Solar System Gallery
http://www.damianpeach.com/

Michael Peres
Professor
Biomedical Photographic Communications
School of Photographic Arts and Sciences
Rochester Institute of Technology
Rochester, New York, USA

Phred Petersen
Scientific Photography
Department of Applied Physics
RMIT University
Melbourne, Victoria, Australia

Joe Petrella
Daily News L.P.
New York, New York, USA
www.dailynewspix.com

John Pfahl
George Eastman House Collection
Rochester, New York, USA

Michael Profitt
Shippensburg University Student
Kirkland, Washington, USA

Stephanie Prokop
Student
Shippensburg University
Hamilton Square, New Jersey, USA

Jill Rakowicz
Student
Shippensburg University
Gettysburg, Pennsylvania, USA

Oscar Rejlander
George Eastman House Collection
Rochester, New York, USA

Richter & Company
George Eastman House Collection
Rochester, New York, USA

H. Armstrong Roberts
Classic Stock
Philadelphia Pennsylvania, USA

James Robertson
George Eastman House Collection
Rochester, New York, USA

Henry Peach Robinson
George Eastman House Collection
Rochester, New York, USA

Lukas Rosenthaler, Ph.D.
Abt. für Bild und Medientechnologien
University of Basel
Basel Switzerland

RIT Big Shot
Rochester Institute of Technology
Rochester, New York, USA

**RIT Archives and Special
Collections**
Wallace Memorial Library
Rochester Institute of Technology
Rochester, New York, USA

Patti Russotti
Associate Professor
School of Print Media
College of Imaging Arts and Sciences
Rochester Institute of Technology
Rochester, New York, USA

Arthur Rothstein
Farm Security Administration
Office of War Information Photograph
* Collection*
Library of Congress Prints and Photographs
* Division*
Washington, D.C., USA

Jean Baptiste Sabatier-Blot
George Eastman House Collection
Rochester, New York, USA

Erich Salomon
George Eastman House Collection
Rochester, New York, USA

Lucas Samaras
Pace/MacGill Gallery
New York City, New York, USA

Howard Schatz
Schatz/Ornstein Studio
New York, New York, USA
http://www.howardschatz.com/

Henry Schleichkorn
Owner
Custom Medical Stock Photo
Chicago, Illinois, USA

Matt Schlitz, BA (Hons), GDBA, MA
Consultant Archaeologist
Biosis Research Pty, Limited
Port Melbourne, Victoria, Australia

Scully and Osterman Archives
Rochester, New York, USA

Sonia Landy Sheridan
George Eastman House Collection
Rochester, New York, USA

Southworth & Hawes
George Eastman House Collection
Rochester, New York, USA

Cindy Sherman
Metro Picture Gallery
New York, New York, USA

John Sidoriak
Independent photography and Multimedia
* Contractor*
Director of Operations
Fisher-Cal Industries, Inc.
Magnolia, Delaware, USA

SE-IR Corporation
Goleta, California, USA

Christye P. Sisson, CRA, MS
Associate Professor
Biomedical Photographic Communications
School of Photographic Arts and Sciences
Rochester Institute of Technology
Rochester, New York, USA

Göran Scharmer and Mats Lofdahl
Swedish Solar Telescope—LaPalma
The Institute for Solar Physics
Stockholm University
Stockholm, Sweden

John Shaw Smith
George Eastman House Collection
Rochester, New York, USA

Frederick Sommer
George Eastman House Collection
Rochester, New York, USA

**Frederick and Francis Sommer
Foundation**
Prescott, Arizona, USA

Gale Spring
Associate Professor and Program Leader
Scientific Photography
Department of Applied Physics
RMIT University
Melbourne, Victoria, Australia

Scott H. Spitzer
Assistant Project Manager
Base Multimedia Center
McGuire AFB, New Jersey, USA

Paul Strand
George Eastman House Collection
Rochester, New York, USA

J.C. Strauss
George Eastman House Collection
Rochester, New York, USA

Nancy M. Stuart, Ph.D.
Executive Vice President and Provost
The Cleveland Institute of Art
Cleveland, Ohio, USA

William Henry Fox Talbot
George Eastman House Collection
Rochester, New York, USA

Jon Tarrant, MA Cantab
Freelance Technical Journalist
Former editor of British Journal of
* Photography*
Teaching faculty of Physics at Jersey College
* for Girls*
Jersey, Channel Islands, United Kingdom

David Teplica, M.D., MFA
Fine Artist, Plastic and Reconstructive
* Surgeon*
Chicago, Illinois, USA

John Thomson
George Eastman House Collection
Rochester, New York, USA

Adrien Tournachon
George Eastman House Collection
Rochester, New York, USA

Jerry Uelsmann
George Eastman House Collection
Rochester, New York, USA

Doris Ulmann
George Eastman House Collection
Rochester, New York, USA

Chiedozie Ukachukwu
Student
Biomedical Photographic Communications
Rochester Institute of Technology
Rochester, New York, USA

Visual Studies Workshop
VSW Archive
Rochester, New York, USA

J. Ward
CSIRO and Scion
Australia

Weegee
International Center of Photography/
* Getty Images*
George Eastman House Collection
Rochester, New York, USA

Kelly L. West
Student
Biomedical Photographic Communications
Rochester Institute of Technology
Rochester, New York, USA

WETMAAP Program
www.wetmaap.org

Clarence H. White
George Eastman House Collection
Rochester, New York, USA

Susan Wilson
Ilford Photo
United Kingdom

Joel Peter Witkin
George Eastman House Collection
Rochester, New York, USA.

Alycia Yee
Student
Biomedical Photographic Communications
Rochester Institute of Technology
Rochester, New York, USA

Milan Zahorcak
Independent Collector
Tualatin, Oregon, USA

Zeiss MicroImaging
Thornwood, New York, USA

Charles C. Zoller
George Eastman House Collection
Rochester, New York, USA

About the Editors

EDITOR-IN-CHIEF

Michael Peres is the Chairman of the Biomedical Photographic Communications department at the Rochester Institute of Technology where he is also a Professor in the School of Photographic Arts and Sciences. Professor Peres teaches and specializes in photomicrography as well as biomedical photography. He began teaching at RIT in 1986 and has authored numerous publications, delivered more than 100 oral papers, and conducted more than 35 imaging-related workshops all over the United States as well as in Sweden, Tanzania, the Netherlands, Germany, and Australia. He has been a member of Bio-Communications Association since 1978 and is currently a member of the Ophthalmic Photographer's Society. Peres serves as the Chair of the Lennart Nilsson Award Nominating Committee, is one of the coordinators of the annual R.I.T Big Shot (www.rit.edu/bigshot) project and the R.I.T Images from Science project (http://images.rit.edu). In 2003, Peres was awarded RIT's Eisenhart award given annually for outstanding teaching. Michael holds a Master's Degree in Instructional Technology and Bachelors degrees in Biology and Biomedical Photographic Communications.

SECTION EDITORS

Mark Osterman is process historian for the Advanced Residency Program in Photograph Conservation at the George Eastman House International Museum of Photography and Film. Mark is a recognized expert in the technical evolution of photography and leads a series of demonstrations and workshops in his area of expertise worldwide. Osterman frequently demonstrates the pre-photographic techniques, the earliest photosensitive methods of Niépce and Daguerre through gelatin emulsion for papers and plates.

A graduate from the Kansas City Art Institute, Osterman has taught studio and darkroom photography for 20 years at the George School in Bucks County, Pennsylvania prior to coming to the George Eastman House.

With his wife France Scully Osterman, Scully and Osterman are widely recognized as the foremost experts in the collodion process in all its variants. Through their research, writings, workshops and exhibitions the Ostermans have been the single most important influence in the current revival of collodion in fine art photography.

Grant B. Romer is currently the Director of the Advanced Residency Program in Photograph Conservation at the George Eastman House International Museum of Photography and Film. He has been active as an educator and advocate for the conservation of photographs and a specialist in the history and practice of the nineteenth century photography, particularly the daguerreotype. He has lectured extensively world-wide as well as having held numerous fellowships and visiting professorships.

A graduate of the Pratt Institute and the Rochester Institute of Technology, Romer joined the staff of the International Museum of Photography and Film at George Eastman House in 1978 when he became its Conservator. He has also served as curator of numerous exhibitions, most notably the permanent historical survey gallery of the museum, and recently, "Young America—The Daguerreotypes of Southworth and Hawes."

Romer is recognized, internationally, for his broad understanding of photography and unique perspectives on the importance and nature of the medium.

Nancy M. Stuart is the Executive Vice President and Provost of The Cleveland Institute of Art. From 1984–2002 she held various faculty and administrative positions including Associate Professor of Photography, Associate and Acting Director of the School of Photographic Arts and Sciences, as well as the Associate Dean of the College of Imaging Arts and Sciences at Rochester Institute of Technology. She also served as Applied Photography Department Chair. She began teaching photography in 1975 at Lansing Community College.

As an artist, she has addressed various social issues through her work. Her most recent published project, *DES Stories: Faces and Voices of People Exposed to Diethylstibestrol* (VSW Press, 2001) explores the impact of accidental chemical exposure on the lives of forty individuals. One portrait from the book was chosen for the John Kobal Portrait Award Exhibit at the National Portrait Gallery in London.

Nancy completed her Ph.D. at the State University of New York at Buffalo in the Graduate School of Education. She lives with her husband David and two children, Sarah and Stuart, in Chagrin Falls, Ohio.

Franziska S. Frey is the McGhee Distinguished Professor in the School of Print Media at Rochester Institute of Technology. She currently teaches required courses and is involved in research projects in the Sloan Printing Industry Center at RIT and the Munsell Color Science Laboratory. Franziska is also a Faculty in the "Mellon Advanced Residency Program in Photograph Conservation" at the George Eastman House, International Museum of Photography. Franziska Frey received her Ph.D. degree in Natural Sciences (Concentration: Imaging Science) from the Swiss Federal Institute of Technology in Zurich, Switzerland in 1994. Before joining the faculty of the School of Print Media, she has worked as a research scientist at the Image Permanence Institute at RIT. Her work has primarily focused on establishing guidelines for viewing, scanning, quality control, and archiving digital images. Franziska publishes, consults, and teaches in the U.S. and around the world on various issues related to establishing digital image databases and digital libraries. She is also involved in several international standards

groups dealing with Technical Metadata and Digital Photography. Franziska is a VP on the board of the Society for Imaging Science and Technology (IS&T) and is actively involved in a number of the conferences IS&T is organizing.

J. Tomas Lopez is a Professor of Art and Art History as well as the Director of Photography/Digital Imaging at the University of Miami. Professor Lopez is nationally and internationally known for his large-scale digital prints ranging from underwater photography to politically charged flags. He has been showcased in over 100 group exhibitions and 25 solo exhibitions. His work is included in many permanent collections: The Smithsonian Institution, National Gallery of American Art, La Biblioteque Nationale de France (Paris), The International Museum of Photography, and many museums, public, and private collections. He has been with the University of Miami since 1994 where he lives and works with his wife Carol. Professor Lopez has been a recipient of the Florida Individual Artist Grants program, the Cintas Foundation Fellowship, and the NEA Award in the Visual Arts.

David Malin has actively been involved in scientific photography since 1960, initially using optical and electron microscopes and later X-ray diffraction techniques to study very small objects. In 1975, Malin moved from the United Kingdom to join the Anglo-Australian Observatory in Sydney, Australia as its photographic scientist, where he developed new ways of extracting information from images of bigger and more distant objects. Some of this work including the development of three-color astronomical imaging techniques and 'malinization,' which allowed images to be produced that were unequalled at the time when glass plates were the primary imaging material in astronomy. These novel image-enhancement techniques quickly led to the discovery of two new types of galaxies. Malin-Carter 'shell' galaxies have low contrast but large-scale features associated with otherwise normal galaxies, while in 1987 he discovered an extremely faint, uniquely massive 'proto-galaxy' which has since been named Malin-1. Malin's photographs have been widely published on the covers of hundreds of books and magazines, including *Life* and *National Geographic* and as a series of Australian postage stamps. They have also been appeared in international solo art exhibitions in Australia, Britain, China, France, Italy, India, and the U.S. David Malin is the recipient of numerous awards for his work including two Doctor of Science (Honoris Causa) degrees. He was awarded the Rodman Medal of the Royal Photographic Society in 1990 and was the recipient of the Lennart Nilsson Award in the year 2000. David is currently an adjunct professor of Scientific Photography at RMIT University as well as active in the publishing and licensing of astronomical images through his web site http://www.davidmalin.com/index.html.

Scott Williams teaches courses pertaining to the Imaging Material Sciences and Media Law. He received his B.S. in Biochemistry from Purdue University, and his Ph.D. in Physical Chemistry from Montana State University. Prior to joining the School of Print Media faculty, Dr. Williams had held academic appointments in the RIT School of Photographic Arts and Sciences, RIT Department of Chemistry, and the Department of Chemistry and Chemical Engineering at the South Dakota School of Mines and Technology. Dr. Williams actively conducts research in the area of ink and paper coating chemistry and formulation. He is the inventor of over 30 U.S. and International patents related to advanced photographic and digital imaging media.

Mission Statement

The Focal Encyclopedia of Photography, Fourth Edition, has been designed to be the definitive reference book for students, practitioners, and researchers of photography as well as digital imaging practitioners who work in business, industry, publishing, advertising, science, and the visual arts. This volume, a complete revision of the award-winning 1993 *Third Edition*, uses a completely new informational design sharing the ever-changing breadth of photographic topics with a special emphasis on digital imaging and contemporary issues. This *Encyclopedia* was created not to simply be another academic text, but rather to appeal to those with broad interests in photography seeking authoritative information about the myriad branches of photography and imaging and issues associated in this dynamic era when both film and digital technologies co-exist.

This *Encyclopedia* was produced by an international team of photographic and imaging experts with collaboration from the world-renown George Eastman House. The *Fourth Edition* contains comprehensive essays as well as numerous photographic reproductions sharing information where photography and imaging serve a primary role—ranging from the atomic to the cosmic.

The design of this book is intended to share a comprehensive selection of photographic topics in a single volume. The revision has been created to enable readers to have immediate and easy access to highly concise information written in a style that will be complimentary to the Internet.

Preface

Revising *The Focal Encyclopedia of Photography, Fourth Edition*

The first edition of *The Focal Encyclopedia of Photography* was published in 1956 at a time when innovations in silver halide technology, photographic tools, and practices were growing exponentially. Reading the Introduction to the *First Edition* published by Hungarian author Andor Kraszna-Krausz, the first chairman of the editorial board, I could not help but realize how similar that introduction was to mine except for the era. It is an achievement for this, or any book, to still be published 50 years after its initial printing. An average book in the United States may have a 10-year life expectancy. In the *First Edition's* introduction, it was written that "Photography is experiencing significant growth and the tools and practices are constantly evolving". Today, more than growth, photography is undergoing a huge transformation as a consequence of digital technology. Although some of the fundamental reasons why people take pictures have not changed during this period, the applications of photography are broader than ever as a consequence of its new tools. One significant difference between the first and fourth editions was the time it took to produce the books. The *First Edition* took nearly 10 years to complete, while this edition was finished in just more than 3 years.

co-mingle and users are firmly entrenched in both technologies. This edition was written in a narrative style to allow subjects to be explored from both the theoretical and an applications perspective. When the revision strategy was developed, it was decided subjects would be grouped thematically rather than alphabetically. The decision to allow subjects to be explored this way is less traditional for modern encyclopedias and it was my hope that this would lead to a photographic resource that is uniquely different in this era of electronic resources. The exploratory writing style was selected to enable users to see how a subject is widely defined and then be able use the ever-increasing resources found on the web in a complimentary manner. Additionally, readers will find glossary terms, which will be useful, nested with the essays rather than in the back of the book.

From the beginning of this project in December of 2003, the *Fourth Edition's* objective was to assemble a diverse team of international experts to serve as editors who would completely revise the awarding winning *Third Edition* in a new way. The revision's objective was to create a comprehensive research tool for practitioners and students of photography which would maintain a complete archive of core information required to practice silver halide photography as well as incorporating—in as complete of a way as possible—the ever-changing world of

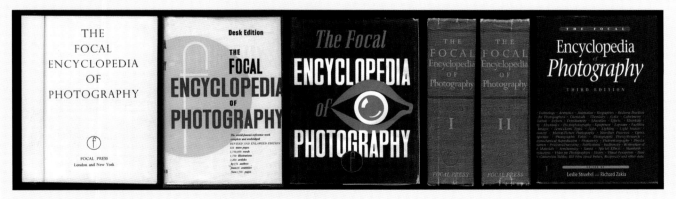

Various covers and title pages from the previous 50 years of editions.

This book has been designed to be a nontraditional encyclopedia. The content in this *Fourth Edition*—undertaken at a time when great changes are being experienced in all technologies associated with photography—has been limited only by the physical size of this edition. Its format should provide a concise and comprehensive resource sharing the breadth of photography at a time when both film and digital practices

digital photography. At the time of writing this Introduction, printed encyclopedias were fast becoming the dinosaurs of the book world and Web-based encyclopedias on the other hand were becoming the norm. To further complicate the revision, libraries at major universities were seriously exploring how to reinvent themselves as the communications industry continued to move itself online.

That being shared, one might ask why then was this book revised at a time when online or multimedia encyclopedias such as Wikepedia® provide volumes of information electronically? The reason for producing this revision was a simple one, to provide a legitimate alternative resource to the Web.

In 1993 when the *Third Edition* was released, the World Wide Web was principally an ASCII text-based environment and digital photography was a radical new approach for picture making and claimed few practitioners. Using digital photography was mostly experimental and unproven except in very specific applications in science and the military. In fact, most professional photographers thoroughly rejected using it because of its "poor quality" when compared to film at that time. However, some were curious and actively participated in its evolution. Since that time, the world of photography has undergone an extraordinary transformation from its chemical/physical beginnings, to digital technologies seemingly overnight. Digital photography technologies have, in less than 10 years, displaced silver halide materials as the primary technology used in photography. This transformation has resulted in more pictures and applications of photography—with its digital tools—than film technology was capable of producing. However, at this time most digital pictures do not get printed and reside hidden on hard drives. This transformation has led to significant changes in all aspects of photographic practice, tools, industries, and manufacturers.

The Focal Encyclopedia of Photography, Fourth Edition was produced to continue the legacy of first three editions. Six section editors were invited to review the vast amount of information found in the *Third Edition* and to each create 150 pages of new content for sections including the "History and Evolution of Photography," "Major Themes and Photographers of the 20th Century," "Photographic Companies and Applications," "Digital Photography," "Contemporary Issues," "Scientific Photography: Expanded Vision," "HumanVision," and "20th Century Materials and Process Essentials."

Our work was principally accomplished electronically and the analysis of the material was undertaken using the different perspectives from both the scientific and artistic applications of photography. The editor's diversity created a rich tapestry of content as a consequence of their networks. As a consequence of space limitations and the creation of new content, it was decided that this edition would not be able to include material covering audio or cinematography.

In 1888 when Kodak and George Eastman branded the expression "you push the button and we do the rest" for the Kodak marketing campaign of the time, little could the world have imagined the penetration photography would have into everyday life world-wide in the 21st century. In 2006, people were using photography in ways that were never before attempted in the film era. In this edition, many of these new applications are explored and compared to the many core principles found in photography. It is interesting to consider that while the reasons why people take pictures have stayed the same, the means and the dissemination paths people use have significantly changed. The prominence of images has only given

The editors of this book define photography as beginning when the recording of images "could-be-made-permanent."

Important dates Pre-Photographic[1]

1200s	▶ Simple glass lenses were introduced.
1472	▶ Leonardo da Vinci: Discovered the multi-colored nature of white light.
1676	▶ J.C. Sturm: Portable camera obscura with reflex mirror and focusing lens.
1704	▶ Sir Isaac Newton: Published *Opticks* in which he presented his discoveries in optics and elaborated on his corpuscular theory of light.
1725	▶ J.H. Schulze: Experiments on light sensitivity of silver salts; contact images (from stencils) on liquid mixtures of chalk and silver nitrate in a bottle; no fixing.
1758	▶ John Dolland: Invented the achromatic lens.
1777	▶ G.C. Lichtenberg: Developed electrostatic discharge patterns with dry powder.
1777	▶ C.W. Scheele: Blackening of silver chloride in the violet and the blue of the spectrum quicker than by other colors.
1800	▶ Sir John F.W. Herschel: Discovered infrared radiation.
1800	▶ T. Wedgwood and H. Davy: Contact copying of silhouettes, leaves, etc., on leather sensitized with silver nitrate; no fixing.
1801	▶ J.W. Ritter: Blackening of silver chloride by ultraviolet radiation.
1815–1820	▶ Sir David Brewster: Invented the optical system of the future parlor stereoscope.
1816	▶ J. Nicéphore Niépce: Camera photographs on paper sensitized with silver chloride; partially fixed.
1819	▶ Sir John F.W. Herschel: Discovery of thiosulfates and of the solution of silver halides by "hypo."
1822–1825	▶ J. Nicéphore Niépce: Copying of engravings on glass, zinc, and pewter sensitized with bitumen to further attempts at direct photography.

[1] Originally published in the Focal Encyclopedia of Photography — 3rd Edition Harry E. Roberts & J. Gordon Jarvis

photography a more personal and cultural importance. Fundamental in people from all societies at a basic level is the premise of having something photographed confers an importance on that event or person. No event in the developed world occurs without cameras being present. Cameras are found virtually everywhere in medicine, at birthday parties, on the moon, in art museums, in cellular telephones, and at natural disasters. The power of the image and the consequences of photography brings to bear are often overlooked at the time of the picture making during everyday events, yet the capturing of such routine events sometimes can be compelling evidence of events long gone.

Thomas Sutton is credited with having produced the first *Dictionary of Photography* in 1858, which was published by Sampson Low, Son and Company, London, England. Examining his book provided an interesting glimpse into the earliest times of photography's written history as shared through various essays describing the materials, processes, and equipment of the time. Since that book was published, numerous dictionaries and encyclopedias have been created for the purpose of communicating the relevant information of the time. Most reasonable encyclopedias have boasted of being the most comprehensive collection of photographic knowledge available at the time of their publication, and why not. It seems obvious that that should be an encyclopedia's goal. It certainly has been the core objective of this one.

One of the major challenges in creating the *Fourth Edition* was simply the continued explosion of the Internet and the rapid displacement of film photography by digital technologies during the book's production cycle. Writing and producing this edition in the time frame when there was constant change in the technology and applications of photography was never completely achieved. And while it is impossible to chronicle in real time this evolution using traditional printing technologies, synchronicity is coming to the photographic world. In the year 2003, more digital cameras were sold than film cameras and sensitized products were being "retired" by the invention and distribution of new technologies. New photographic "companies" such as Hewlett Packard, were targeting markets traditionally held by photographic industry giants such as Eastman Kodak. Companies that had withstood time in the film technology were closing their silver halide production lines, going out of business, or moving to digital products as quickly as possible. Concurrently, photographers and photographs were experiencing situations never before encountered in the film era such as invisible "digital" image piracy and other challenging issues that have caused the industry to be concerned for longevity and archiving.

Using topics and themes as a method for grouping essays rather than the traditional alphabetical approach of past editions was chosen after considering how the results of a Web search would be provided. This edition's strategy was also modeled after some of the successful photographic encyclopedias of the recent past produced by the Eastman Kodak Company and Time Life, Inc. One significant change in this book is the use of 4-color photographic reproductions wherever possible. Use of photographs in this edition has created a completeness that prior editions were unable to achieve. Images were supplied by authors, photographers, organizations, and from the Technology and Image Collections at the George Eastman House International Museum of Photography and Film.

With the roles and goals of photography, photographers as well as many other peripheral disciplines are becoming more blurred. It is hard to imagine what the new challenges and issues will be for the tools and practices of visual communication and photography in the near future. Prior editions of this book were more technical in their content selection while this edition is more exploratory and features an entire section exploring the dynamic future and its challenges for photography and photographers.

In a July 2005 issue of *Time* magazine, there was a 2-page spread publishing pictures made with cell phone cameras taken in the London subway immediately after terrorist bombings on July 7th, 2005. The making of, and immediate distribution of pictures during such a calamity would not have been possible with film. The sharing of such events almost synchronously with the event itself would also not have been possible. Do the publishing of those photographs made by everyday citizens have implications for the professional photojournalist? Digital technologies increase the distribution of pictures to numbers of viewers unparalleled and immeasurable.

Creating this book at this moment in time has created many new questions as a consequence of the pace of all the changes the industry and users wrestle with. When I use the digital tools that are re-defining photography today, I often wonder "whether the majority of my digital pictures made in this era will be readable tomorrow by my children or colleagues?" Will the images of this era survive the journey of time "when the equipment required to make, and see them, is changing at rates never before experienced in this medium". Although the complex technical problems surrounding this issue is explored in several essays in the digital and contemporary sections of this book, the future is still an unsettled place for photographers who are anxious about these changes and evolution. Therese Mulligan, Ph.D. suggests in her "that we might consider for a minute that this era in photography must have practical and cultural circumstances that were similar to the era when photography was first practiced in the 1830s. The new is often met with trepidation and this is the nature of change. However, how do digital technologies present opportunities and new possibilities for interpretation, communication, and art? Do they co-exist with photography and deepen its significance or is the converse the future?"

Michael Peres
Editor-in-Chief
January 2007

Acknowledgments

Writing this last entry to complete *The Focal Encyclopedia of Photography's* revision represents an odd thing, and in some ways feels similar to my college graduation when all the mixed emotions come out as a consequence of being so fully married to something at both a physical and emotional level for an intensely long period of time. A time when you can't wait for something to be over but you also don't want it to end.

As I write this conclusion to the project, I am reminded of the more than 1300+ e-mail files in my inbox archive, the countless word and image files, as well as the gigabytes of data created during the last 3 years but more importantly how naïve I was when I started the revision. This book in many ways represents the work of the worldwide photographic community, and because of the method in which the revision was undertaken, it has been suggested that this edition wrote and illustrated itself. In the late fall of 2003, when I invited the first editor and author, the content for the book's proposed 1200 pages existed only in my head as a concept.

From the beginning of this process, it was my objective to achieve the quality and successes of the first three editions, but to do so in a new and different way. A book like this required help from so many people. The revision represents the work of many talented people who live in nine different countries. It includes the cumulative knowledge and experience of many dedicated professionals, most of whom I do not know but were invited by the various section editors, whose vision shaped the contributor base.

Although I have never worked on a project this complicated, the journey has been one of great discovery and adventure. During the final months of producing this book, I was delighted to receive many excellent essays and images that will define this nontraditional *Encyclopedia* by its users in the future. My heart felt thanks goes out to all the authors and photographers for sharing their expertise and in the end, creating the wonderful and diverse content for this edition.

Words alone cannot begin to express my appreciation to Diane Heppner, the book's acquisition editor who started this journey for me by supporting my application for the editor-in-chief position. I am grateful for that support but more importantly, I am sincerely grateful for her advice, which she shared freely during the various phases of creating, producing and publishing this *Encyclopedia*. There were many weeks when problems were more plentiful than solutions and Diane's experience was invaluable to me in finding a way. Early on in the revision, Diane shared that my selection was easy for Focal Press because Dr. Richard Zakia and Dr. Leslie Stroebel, the editors for the 3rd Edition were supportive of my selection.

Both Drs. Zakia and Stroebel were faculty members at RIT when I started my teaching career in 1986. I sincerely appreciated their advice as I moved through the early phases of the revision. They, of all people, understood what I had in front of me. I was also fortunate to have the unanimous support of Professors Andrew Davidhazy and Bill DuBois, the administrative chairs in the School of Photographic Arts and Sciences (SPAS) who enthusiastically endorsed my involvement in this project from the beginning. The School of Photographic Arts and Sciences is a very special place where my students and colleagues are a source of inspiration, knowledge, and creativity, which is shared daily through their work and passion for photography.

The first step in revising this book was creating a revision strategy. Getting the proposal approved took more time than I imagined. With the approval to produce a "different" type of encyclopedia, the next phase required identifying and persuading six section editors to join the team. The book's revision proposal process took less time than finding my editors. Finding six people was very slow and difficult, but once the six editors were committed to the project, the results they produced were well worth the struggle. The expertise and networking accomplished by David Malin, Scott Williams, Ph.D., Professor Tom Lopez, Nancy Stuart, Ph.D., Franziska Frey, Ph.D., and Mark Osterman and Grant Romer was truly remarkable. Their personal knowledge and their invitations to authors reached deep into communities that only experts in their fields could access. Their dedication to the long process and staying with the project speaks for itself. If they did not believe in this project, it would not have been possible to produce this revision in this way. I would speculate more than 95% of this book was produced by taking full advantage of the digital technologies the *Encyclopedia* was trying to define. Using the Internet, e-mail, and FTP sites, our files and writing was shared taking full advantage of all the possible electronic tools available during the production of this Edition. This Edition epitomizes the power of the Internets' ability to communicate and distribute information amongst the group in a timely and almost synchronous way. This Edition represents what is possible when a group of dedicated and brilliant editors, authors, and photographers who are passionately involved with photography commit to a project, because it certainly was not for the money that they earned.

Early in the conceptual phase of this revision, I reached out to Mr. Tony Bannon, the Director of the George Eastman House about a possible collaboration with the Museum and its collections. The idea to explore the collaboration was quickly embraced and became very important to me knowing this revision would include some of the world's important photographs. The Museum's validation of the book came at a challenging time for me and pushed me to pursue other ideas. Once supported, the Museum's curator, Alison Nordström and Sean Corcoran, the assistant curator, as well as Todd Gustavson the curator of the technology collection, selected and delivered excellent suggestions to illustrate many of this edition's essays. Although

xxviii Acknowledgments

I do not know all the people by name, some of those who assisted in that process at the Museum were Joseph Struble, Shannon Perry, Rachel Topham, and Anne Maryanski.

Many others offered help and encouragement throughout the various stages of this production. Becky Simmons, Kari Horowicz, and Amelia Hugill-Fontanel, from the RIT Wallace Memorial Library, provided many helpful insights when I was at various stages of producing this book and needed to do more research. The RIT Special Collections at the library also provided a number of important pictures taken during RIT's 100-year history of teaching photography.

Cara Anderson, an associate acquisitions editor at Focal Press, was also very helpful and experienced in her managing of the revision's details in what seemed like constant chaos especially as we got into the thick of it in the summer of 2006. Cara's knowledge and constant reassurances as she finished the contracting as well as tying up all the loose ends made finishing far less stressful. I am still amazed at the number of details and steps required to publish a book. Her guidance provided timely responses to all the various questions from the editors and contributors while keeping things moving during the intensity of the final months.

Paul Gottehrer, the book's production editor and his staff worked tirelessly for only a "short" few months massaging the raw material, which was submitted in so many various stages of completion and formats into this remarkable edition, to which I am so grateful. Paul's patience with my frequent phone calls trying to make this perfect was well matched to his attention to detail and skills.

As the volume of essays and photographs began arriving, some gaps in the revision's content were discovered, which allowed me to include some essays from prior editions during the last few weeks of this Edition's content creation. This process of including material from previous editions speaks to the book's rich 50-year history as a photographic treasure and resource. The authors whose excellent work that has been included, have greatly enriched this edition and I am grateful to be able to perpetuate their work in this volume.

I would also like to recognize the Rochester Institute of Technology for sponsoring a professional leave in the fall of 2005. The leave provided me the time to develop my ideas and ponder a strategy that I could use to achieve my vision. I would be remiss not to thank so many of my current and former colleagues in SPAS, Russ Kraus, Therese Mulligan, Richard Norman, Owen Butler, Willie Osterman, Donna Sterlace, and so many others who listened to me share my challenges and offered suggestions along the way.

There were many others that offered encouragement and I wish I had enough pages to list all of my collaborators that helped prepare me for this challenge. My parents, who more than 25 years ago supported me pursuing a second University degree in photography probably unknowingly exposed me to this opportunity. In the end though, the love and support of my wife Laurie and my children Jonathan and Leah, made this revision possible. Their understanding of my passion for new adventures gave me the confidence to take on this challenge for which I am forever grateful. Their love was never more evident when I was in the final stages of trying to finish on time at a time when there did not seem to be enough time.

Michael Peres

Introduction

THERESE MULLIGAN, PH.D.

After Photography: Some Thoughts

People are constantly exposed to significant daily changes in the development of digital technologies via the objects, networks, data, and the resultant images it produces. These technologies also support and distribute images very rapidly, which quickly advances us into the future. As I write this Introduction, my e-mail system "dings" to alert me to a new arrival, the incessant beeping of my PDA urges me to keep an appointment, and my niece hollers through the study door for help with downloading pictures to her iPod. To be sure, a cultural paradigm shift has accompanied our ever-embracing digital world, suspending us in a seemingly perpetual state of the "new." The future is a mouse click away. To listen at the doorways of academia, along the corridors of civic and corporate institutions, or the pathways of interconnectivity on the Internet, unabashed zeal is mixed with dire apprehension at the transformation of our world. Such attitudes, whether enthusiastic or apocryphal, are predominantly symbolic, an outward recognition of the significance of transformation, its inextricable relationship to culture and inevitable consequence for history. Arguably, no segment of culture has grappled more with the significance of this world-view transformation than photographers and people interested in visual culture.

What is in a Name?

Encyclopedias are necessarily concerned with what is in a name and definitions. All-inclusive in nature, they are a modern romantic ideal of accumulated human knowledge, positing the past, pronouncing the present, and forwarding the future. They take forms, both old and new, from the print format of a book to an online resource such as Wikipedia, a growing digital archive of data and images edited by its users and accessible in many languages. Photography has proved to be a fitting encyclopedic subject in either format. Publicly introduced in 1839, the photograph introduced the first universal system of communication that had the capacity to create a collection of all things familiar and unknown, from the microscopic to the celestial, the mundane to the rare. It transcribed the world and reproduced it in countless numbers. It expanded upon and enriched the encyclopedic ambitions of its time, conditioned by the investigations of the eighteenth century's Age of Enlightenment. The ability to record, inventory, and name; gave photography and those who used it, unprecedented influence in shaping human knowledge and experience. Marked by innovation, photography proved to be a revolutionary medium of cultural and representational change. By virtue of its diverse character, it helped instigate and maintain a burgeoning modern visual culture, with all its benefits and hazards.

Digital imaging is the next evolutionary step in providing for and advancing today's postmodern visual culture. With a world-view marked by new technologies, consumerism, and the media, its influence is simultaneously local and global, a further democratization of knowledge mediating contemporary human experience. Digital imaging claims for itself the sites of societal activity long recognized as those once sustained by photography. Building upon this groundwork, it draws other media into its expansive sphere, uniting the still, the filmic, and the televisual into the wide-ranging whole of hypermedia. The emergence of digital imaging and its accompanying technologies represents a reconfiguration of the appearance, use, distribution, and meaning of pictures, both still and moving, for newly conditioned audiences of interactive users.

The illiterate of the future will be ignorant of the camera and the pen alike.

—László Moholy-Nagy

This oft-quoted statement by Bauhaus teacher and theorist Moholy-Nagy, pronounced in his 1936 essay "From Pigment to Light," declares the superiority of the photographic medium as the future purveyor of visual communication.[1] It also provides an instructive caution concerning visual literacy that does not recognize the pervasive and persuasive power of a lens-based culture. Formulated as part of his pedagogical theories of New Photography and the larger Modernist movement of New Vision, this statement dramatized Moholy-Nagy's view of photography's influential role in visual culture, specifically with the rise of the popular picture press and its emergent genre of photojournalism, the advancement of commercial photography such as advertising, and the marshalling of photographic images for propaganda purposes. Fired with the revolutionary rhetoric of his day, Moholy-Nagy's proclamation still resounds 70 years later. Its call for visual literacy and acknowledgement of the societal implications of the "new" is very much a vital component for understanding the "now" of our post-photographic era:

There is no simple Now: every present is nonsynchronous, a mix of different times. Thus there is never a timely transition, say, between the modern and the postmodern, our consciousness of a period not only comes after the fact: it also comes in parallax.[2]

The impact of new digital imaging technologies upon older and existing technologies such as the still and moving image can be seen in dynamic play in the social sites of the domestic, the civic arena, leisure and entertainment, and the visual arts, to name a significant few. These social sites have not only given

[1] Moholy-Nagy, L., "From Pigment to Light," *Telehor*, 1,2, 1936; translated and reprinted in Lyons, *Photographers on Photography*, 80.
[2] Foster, H., "Postmodernism in Parallax," *October* 63 (1993) 5–6.

shape to image technologies old and new, but reciprocally are shaped by their practices and products. For example, family snapshots once fixed on the supportive matrix of paper and album page are now carried on digital media, enabling wider access and dissemination in the form of computer upload to a shared webpage, downloaded to a printer, or sent via e-mail attachment to another hard drive. Consequently, the use of the domestic family picture has changed, although its photographic underpinnings and appearance are largely unaffected. In the civic arena, new technologies have prompted a radical update of information acquisition. Once the realm of the photographic, digital technologies now enable government and corporate entities to cast a wider, local and global net over personal and public information as a means to survey, classify, regulate, and control. Within the cultural constitution of mass media and consumerism, digital imaging is profoundly re-envisioning sites of leisure and entertainment as they negotiate with existent, traditional forms of the still and moving image in a new environment replete with new audiences/consumers, exhibition/virtual venues, practices/interactivity, and products. Today's oscillating mixture of digital imaging and photography presents a refreshing, innovative cultural perspective to look through the expressive engagement of these mediums, as well as to look at it as appearance, function and meaning are reinterpreted in reaction to a changing visual culture. And what of digital imaging technologies in the visual arts, a primary concern of an encyclopedic endeavor such as this publication, as it instructively encapsulates the future practice and aesthetic of photography and its practitioners?

As an exuberant exponent of digital imagery, William Mitchell in *The Reconfigured Eye* (1994) provides an early critical reading of the differences of the photographic and the post-photographic:

The tools of traditional photography were well-suited to Strand's and Weston's high-modernist intentions—their quest for a kind of objective truth assured by a quasi-scientific procedure and closed, finished perfection. But (as the culturally attuned will be quick to recognize) we can construe the tools of digital imaging as more felicitously adapted to the diverse projects of our postmodern era. ...a medium that privileges fragmentation, indeterminacy, and heterogeneity and that emphasizes process or performance rather than the finished art object will be seen by many as no bad thing. ...[We will see] the emergence of digital imaging as a welcome opportunity to expose the aporias in photography's construction of the visual world, to deconstruct the very ideas of photographic objectivity and closure, and to resist what has become an increasingly sclerotic pictorial tradition.[3]

In this interpretation, Mitchell elucidates a well-versed, reductive narrative of the competing forces of Modernist and postmodernist intentionality. Importantly, however, was his introduction of digital imaging as a means to assuage Modernist photographic tropes of "objective truth," "closure," and a fossilized picture-making tradition in fine art photography. In digital imaging, he found practices more in step with the present day,

distinct from their analog antecedents and leading to a more particularized postmodern aesthetic experience. In his book, Mitchell enumerated the fundamental distinctions of the analog and digital in terms of enlargement of information data, reproducibility, and manipulation. While the continuous tonal and spatial variations of a photograph can be enlarged to reveal greater detail and thus more information, this is not true for a digital image. Processes of enlargement in a digital image will display its limited resolution, disclosing less and less information until what appears is the image's discrete grid of pixels. Due to these same discrete and precise components, digital images can be exactly reproduced without degradation of image information: an original and copy are indistinguishable. For a photograph, the original and copy will always bear subtle differences because fine tonal variations in an analog image cannot be precisely replicated. Finally, and in Mitchell's view the most important distinction between the analog and the digital, are the processes of manipulation or alterability of an image: "Computational tools for transforming, combining, altering, and analyzing images are essential to the digital artist as brushes and pigments are to a painter, and an understanding of them is the foundation of the craft of digital imaging."[4] For Mitchell, alterability promises a new creative freedom that releases image making from its Modernist past, in which manipulation of the photographic image was antithetic to the medium's supposed nature of faithful, objective description, at least the approach practiced by late modernists such as Edward Weston, Paul Strand, and others of their generation such as Ansel Adams. Despite Mitchell's supposition, however, the alterability of the photographic image has long been part of the medium's legacy as practitioners recognized its inextricable ties to visual culture as mass communication and newly minted art form.

Concurrent with the publication entitled *The Reconfigured Eye*, many photographers who were well-schooled in Modernist traditions in academia but had experimented with or thrown off these traditions for a generation or more, were drawn to the broader prospect of digital imaging and its postmodern cultural currents. These photographers, including Robert Heinecken, Joyce Neimanas, Nancy Burson, John Pfahl, Thomas Barrow, and Pedro Meyer, to name an influential few, understood well that photography was an inherently malleable medium, a combination of fact and fiction, easily manipulated in the camera or darkroom to fit a particular end. They reacted against the notion of the photograph as an isolated, auratic object of observation and reverence, as proscribed by late Modernist photographers, preferring to revel in the medium's photomechanical past and present with its mediating connections to visual and popular culture. These photographers were among the first generation that, in the 1970s, took up reproduction or electronic technologies, such as xerography and television, or subject matter born of mass media. Their attentiveness to the "new" was on one hand a way to continue extending the boundaries of traditional photographic practices, while on the other hand an attempt to integrate wider cultural issues and themes into art

[3]Mitchell, W., *The Reconfigured Eye*, Cambridge, MA: MIT Press, 1994, 8.

[4]Mitchell, W., *The Reconfigured Eye*, Cambridge, MA: MIT Press, 1994, 7.

West's First Station, Lake Windermere, England. Permutations on the Picturesque. Photograph by © John Pfahl 1995–1997. Image courtesy of the George Eastman House collection, Rochester, New York, USA on loan from Bonnie Gordon.

photography. They investigated processes which have become standards of digital practice today, ranging from the appropriation of imagery from mass media to the seamless montage of found or invented pictures, from reworking pre-existing photographs and negatives to experimenting with computer manipulations of pictorial form and perspective to play with concepts of photography's ties to originality, reality, and truthfulness, a particular postmodern orientation.

An example of this experimental approach is John Pfahl's *Permutations of the Picturesque* (1997), a cycle of IRIS printed images detailing the photographer's pilgrimage to oft-pictured vistas in painting and photography. Many of the vistas Pfahl recorded hold fascination as sites of nineteenth-century discovery, such as Lake Como where Henry Fox Talbot, drawing the landscape with a *camera lucida*, first conceptualized fixing an image through mechanical and scientific means; or "Thomas West's First Station on Lake Windermere...the late eighteenth

century equivalent of [Weston's] Point Lobos."[5] This cycle celebrates variation and transformation, the very definition of permutation, as the Romantic beauty of each pictured landscape is computer manipulated, beginning with negative scanning, and then image and color adjustment in order to eliminate errant particulars of the landscape or sky for a more "authentic" perspective closely aligned to the past. The resultant images have the appearance of a period watercolor and are "watermarked" with a row of enlarged pixels that measures the height or width of each image. In this work, the photographic and post-photographic are wonderfully intertwined in an insightful interpretation of traditions, technologies, and histories.

The work of Pfahl and his generation, many of whom are included in this publication, sought to reveal the process of their

[5]Pfahl, J., *Permutations of the Picturesque*, Syracuse: Light Work, 1997, 1.

medium, and thus divine its mediating power in early post-modern visual culture. Due to their place in history, straddling late Modernist and postmodernist traditions, these photographers had a unique vantage point from which to examine the ways in which earlier and new visual media mediate one another, at once celebrating, challenging, and refashioning their convergent cultural and aesthetic uses and world views.

This approach is a touchstone for today's professional and student practitioners, the principle audience of this encyclopedia, as digital imaging and its technologies of capture, processing, and output move center stage in the creation, use, and distribution of images. With its intertwining photographic and post-photographic values and attitudes, some in our digital age will continue to seek new hybrid approaches in visual media while others have made the complete conversion and silver halide materials have been completely eliminated for their practices.

Continual change will influence the values, application, and the tools used in defining photography. Virtual or immaterial artistic expression will gain in currency. The Internet will provide new avenues of display and access far beyond the physical museum and gallery walls and its audiences, by establishing interactive interfaces, which will discard spectatorship for a more intimate participation and collaboration with the image maker in the shaping and defining of aesthetic, informational, and cultural meaning of photography.

GLOSSARY TERMS

Hypermedia—is a term used to denote the intertwining of multiple medias, including audio, video, photography, plain text, and non-linear hyperlinks, to create a generally non-linear medium of information. The World Wide Web is an example of hypermedia-oriented realm.

Interactive—in computer science, interactive refers to software that responds to input from human contributors. Familiar interactive software programs include word processing and image applications.

IRIS—is a term for a print made on printers manufactured by IRIS Graphics of Bedford, Massachusetts. IRIS Graphics is a leading supplier of the ink-jet printers used in the graphic arts industry. IRIS images debuted as a fine arts reproduction medium in the late 90s. Previously, IRIS printers had been used solely in the graphics arts field for proofing and commercial design projects. IRIS prints have more recently been called Giclee prints, which is a French word meaning "to spray forcefully." Properly made IRIS prints are beautiful and superior to other ink jet prints in both image permanence and tonal quality.

Modernism—defines an artistic and cultural movement. Modernism emerged in the 1890s as a reaction to the academic and historicist traditions of the nineteenth century. In photography, modernism took many forms, including documentary photography, photojournalism, and commercial photography. It was during this period that many notable photographers, including Alfred Stieglitz and Edward Weston, sought to elevate photography to a fine art, equal to traditional art forms, including painting and the graphic arts. Importantly, photography was viewed as a predominant visual medium, in step with the cultural and technological concepts of modernity. By the mid-twentieth century, Modernism itself was challenged, especially in regard to its institutions, and usurped by Postmodernism, a term used to distinguish the evolving phase and concepts of late modernity in the last quarter of the twentieth century and the early twenty-first century.

Photomechanical—describes a combination of photography and printmaking techniques. Photomechanical processes allow for the distribution of photographic reproductions in print formats.

Post-photographic—distinguishes photography's diminishing central role in visual culture since the emergence of digital imaging technologies in the mid-1980s. It characterizes technological and media transformations that have radically changed the historic function of the photographic image in contemporary society.

Visual culture—is characterized by the introduction and development of new visual media and their associated images, which have had a pervasive and persuasive impact on modern and contemporary culture and life. It encompasses all manner of appearances, products, and functions that support and promote a visual orientation to understanding and knowledge of the world. The introduction of photography and film in the nineteenth-century is cited as primary forces in establishing modern visual culture. In the twentieth-century, television and digital media, i.e., the Worldwide Web, are further developments in determining and expanding contemporary visual culture.

Wikipedia—is a free Internet encyclopedia, which allows anyone to contribute and and edit entries. The English version was started in 2001 and as of September 2005 was working on 750,986 articles. Wikipedia is a multilingual, Web-based project written collaboratively by volunteers and operated by the non-profit Wikimedia Foundation based in St. Petersburg, Florida. There are about 100 active editions in English, German, French, Japanese, Italian, Polish, Swedish, Dutch, Portuguese, and Spanish. Wikipedia began as a complement to the expert-written Nupedia on January 15, 2001. The site attempts to remain neutral and accurate, however due to its open nature, vandalism and inaccuracy are a constant problem. The status of Wikipedia as a reference work has been controversial. It has been praised for its free distribution, editing, and diverse range of coverage; it has been criticized for systemic bias, preference of consensus to credentials, and a perceived lack of accountability and authority when compared with traditional encyclopedias.
http://en.wikipedia.org/wiki/Main_Page

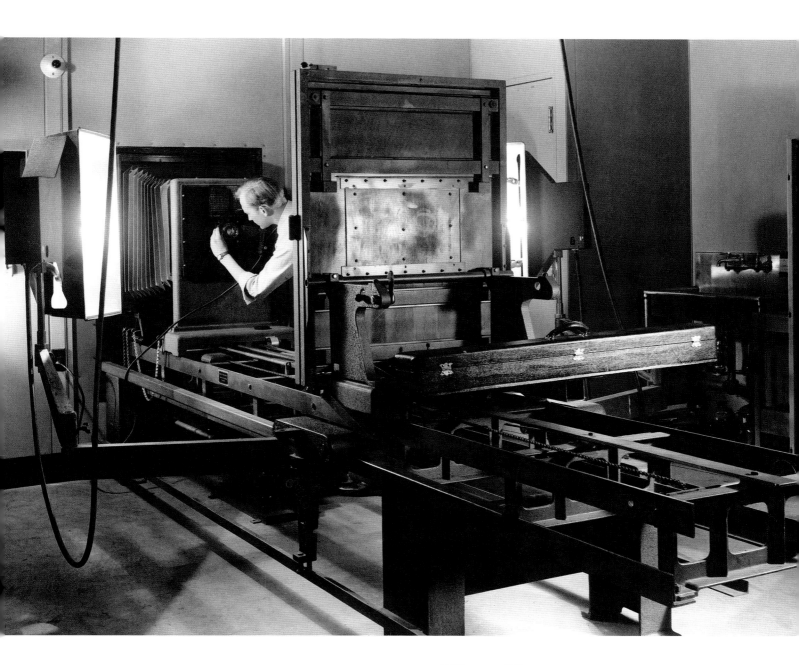

Timelines

Advances in Photographic Technology

UPDATED FROM THE *FOCAL ENCYCLOPEDIA OF PHOTOGRAPHY, 3RD EDITION* **BY MICHAEL PERES 1990–2005.**

ORIGINALLY WRITTEN BY HARRY ROBERTS AND J. GORDON. JARVIS 1826–1990

1826	▶ Niépce, J. Nicéphore: First photograph from nature on pewter sensitized with bitumen (exposure 8 hours). Bellows for photographic camera; iris diaphragm.
1827	▶ Niépce, J. Nicéphore: First prints from etched heliographic plates.
1833	▶ Florence, H.: Worked with paper sensitized with silver salts and coined the word photography in Brazil, but his achievements were not widely recognized until 1973.
1835	▶ Talbot, W. H. Fox: "Photogenic drawings," copied on paper sensitized with silver chloride; fixed with potassium iodide or by prolonged washing in salt water. Also tiny camera photographs.
1835–1837	▶ Daguerre, L. J. M.: Daguerreotype (direct photography on silvered copper plates with a silver iodide surface); development of the latent image by mercury vapor, 1837, fixing with salt solution.
1838	▶ Morse, S. F. B.: Demonstrated his telegraph system.
1839	▶ Bayard, H.: Direct positive photographs on paper (silver chloride paper blackened by light, then impregnated with potassium iodide and exposed in the camera). ▶ Daguerre, L. J. M.: Publication of working instructions for the daguerreotype by the French Government. ▶ Experimental photographic portraits in France and U.S. ▶ Herschel, Sir John F. W.: Generally credited with the first use of the word "photography" (see 1833). Independent invention of a photographic process in glass. ▶ Ponton, M.: Light sensitivity of a paper impregnated with potassium bichromate – the basis of many printing processes. ▶ Reade, J. B.: Photomicrographs in the solar microscope on paper sensitized with silver nitrate and gallic acid (by printing out or by development with gallic acid); fixing with thiosulfate.

FIGURE 1 Photo by Julia Margaret Cameron of Sir J. F. W. Herschel (BART) 1867. Albumen print [GEH 1981:1129:0004]. (Image courtesy of George Eastman House Collection.)

1839–1841	▶ Donné, A.; Berres, Joseph; Grove, W. R.; Fizeau, H. L.: Transformation of daguerreo-types into etched printing plates.
1840	▶ Draper, J. W.: First successful daguerreotype portrait. ▶ Fizeau, H. L.: Gold toning of daguerreotypes. ▶ Goddard, J. F.: Use of bromine for the acceleration of daguerreotype plates. ▶ Petzval, J.: Portrait lens (first application of calculation for the investigation of a lens type). ▶ Soleil, J. B. F.: Actinometer for exposure time determination. ▶ St. Victor, N. de and R. Hunt: Thermography. ▶ Talbot, W. H. F.: Calotype, developed-out negative, printed-out positive. ▶ Wolcott, A.: Patents for mirror camera in U.S. ▶ Wolcott, A.: Opened world's first photographic portrait studio in New York.
1841	▶ Beard, R.: Opened first photographic portrait studio in Europe. ▶ Claudet, A.: Red light for dark room. ▶ Talbot, W. H. Fox: Calotype process (negatives on silver iodide paper impregnated with silver nitrate and gallic acid; development of the latent image by gallic acid, positive prints from these paper negatives).
1842	▶ Herschel, Sir John F. W.: Ferro-prussiate paper and other processes using iron salts.
1843	▶ Claudet, A. F. J.: Use of painted backgrounds for portraiture.
1844	▶ Fizeau, H. L. and Foucault, L.: Discovery of reciprocity failure on daguerreotypes; photographic photometry. ▶ Hunt, R.: Ferrous oxalate process, ferrous sulfate development. ▶ Talbot, W. H. Fox: Published part I of the Pencil of Nature, the first photographically illustrated book.

1845	► Martens, F. von: Panoramic camera for daguerreotypes.
1846	► Zeiss, C: Receives business certificate to open Zeiss Optical Manufacturing, Jena Germany.
1847	► Blanquart-Evrard, L. D.: Modification of calotype process. ► Mathieu, P. E.: Gold toning of positive prints on paper. ► Niépce de St. Victor, C. F. A.: Negatives on glass by the albumen process. ► Niepce De St. Victor, C. F. A.: Albumen glass plates.
1848	► Becquerel, E.: Attempts at color photography (heliochromy) on silver plates that were incompletely chlorinated. ► Niépce, A.: Albumen process.
1849	► Brewster, Sir David: Lenticular stereoscope prototype. Introduced in 1851. Suggests binocular camera, prototype 1853.
1850	► Blanquart-Evrard, L. D.: Albumen paper for positive prints. ► Humphrey, S. D.: Publication of the first photographic journal: The Daguerreian Journal, New York. ► Le Gray, G.: Waxed paper process.
1851	► Archer, F. S. and Fry, P. W.: Ambrotypes (negative collodion-on-glass photos with black background giving positive effect). ► Archer, F. S.: Wet collodion process. ► Blanquart-Evrard, L. D.: Prints by development. ► Claudet, A. and Duboscq, J.: Animated photographs (in Zoetrope and Phenakistoscope) suggested. ► Dodero: Portraits on visiting cards, popularized by Disdéri. ► Regnault, V.: Use of pyrogallol as developer (physical development). ► Talbot, W. H. Fox: Photograph of an object in rapid movement by using an electric spark.

FIGURE 2 Early example of negative through a light box. (Image courtesy of the George Eastman House Collection.)

1852	► Laussedat, A.: Photography applied to surveying. ► Lemercier, Lerebours, Barreswil, and Davanne: Photolithography with halftones on grained stone sensitized with bitumen. ► Martin, A. A.: Positive-looking images by the wet collodion process on a blackened metal support (ferrotypes). ► Talbot, W. H. Fox: Insolubilization of bichromated gelatin by light; first experiments with halftone heliogravure.
1852–1853	► Delves, J., Highley, S,.and Shadbolt, G.: Photomicrographs by the wet collodion process.
1853	► Dancer, J. B.: Prototype of stereo-camera with two lenses. ► Dancer, J. B.: Microphotographs by the wet collodion process. ► Gaudin, M. A. A.: Use of potassium cyanide as fixing agent for silver images; experiments with gelatin as carrier for silver images. ► Martin, A. A.: Tintype process (wet collodion).
1854	► Brébisson, A. de: Salted paper with starch, for positive prints. ► Cutting, J. Ambrose: Patented ambrotype process. ► Melhuish, A. J. and Spencer, J. B.: Roll-holders for sensitive paper negatives. ► Nègre, C.: Photo engravings giving halftone with bitumen-coated steel plate.
1855	► Lafon de Camarsac, P. M.: Photographs on enamel and porcelain (burnt-in). ► Maxwell, J. C., isolation of primary colors. ► Nièpce de St. Victor, C. F. A.: Heliogravure with bitumen on steel. ► Poitevin, A. L.: Photolithography on stone sensitized with bichromated gelatin, glue, albumen, or gum – principle of collotype; first attempts to obtain carbon prints. ► Relandin: Roller-blind shutter mounted on the lens. ► Taupenot, J. M.: Negatives on collodio-albumen dry plates prepared in advance and requiring only a complementary sensitization.
1856	► Martin, A. A.: Dry tintype process. ► Norris, R. Hill: Collodion dry plates preserved with gum arabic or gelatin put on the market. ► Pretsch, P.: Photogalvanography (halftone intaglio copper printing plates by galvanoplastic molding from bichromated gelatin reliefs).
1857	► Grubb, T.: Aplanat lens. ► Woodward, J. J.: Solar enlarger.
1858	► Anthony, H.: Ammonia-fumed albumen paper. ► Tournachon, G. F. ("Nadar"): Photography from the air in a free-floating balloon.

1859 ▸ Asser, E. J. and James, Sir H.: Photozincography.
▸ Bunsen, R. and Roscoe, H. E.: Use of magnesium to provide artificial light.

1860 ▸ Collodion dry plate.
▸ Joubert, F.: "Phototype" (collotype).
▸ Willème, F.: Photosculpture.

1861 ▸ England, W.: Focal plane shutter.
▸ Fargier, A.: Halftone pigment images on bichromated gelatin with transparent support, exposed from the back.
▸ Maxwell, J. Clerk: Three-color separation, and color synthesis by multiple projection.
▸ Russell, C.: Dry collodion plates preserved with tannin.

1862 ▸ Ducos du Hauron, L.: Beam splitter camera for color images.
▸ Leahy, T. and Russell, C.: Alkaline developer (pyrogallol-ammonia) for chemical development; reversal by dissolving the first negative and development of the remaining silver salt.

1864 ▸ Bolton, W. B. and Sayce, B. J.: First workable collodion emulsion.
▸ Ducos du Hauron, L.: Patent for an apparatus for animated photography (camera and projector) made by J. Duboscq.
▸ Swan, Sir Joseph W.: First successful carbon process (with double transfer).
▸ Woodbury, W. B.: Multiplication of carbon prints by molding (Woodbury type).

1865 ▸ Simpson, G. Wharton: Positive collodio-chloride emulsion for printing-out papers, made by J. B. Obernetter (1868).
▸ White, W.: Magnesium flash powder.
▸ Woodbury-type photomechanical printing process.

1866 ▸ Sanchez, M. and Laurent, J.: Baryta coating of photographic papers.
▸ Steinheil, A.: Aplanat lens (rectilinear).

1867 ▸ Cook, H.: Opera-glass camera and plate change-box for dry collodion plates.

1868 ▸ Albert, J.: Perfected collotype (use of glass plates as supports).
▸ Cros, C.: Principle of three-color separation and synthesis.
▸ Ducos du Hauron, L.: Three-color photography and the various methods of achieving it; subtractive color synthesis.
▸ Harrison, W. H.: Experiments with positive silver bromide gelatin emulsion for chemical development.
▸ Photolithography/collotype

1869 ▸ Ost, A.: Citric acid stabilization of printing-out papers.

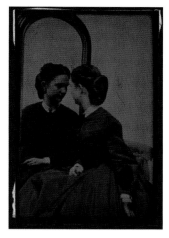

FIGURE 3 Unidentified Maker. Portrait of a Woman Looking into Mirror ca. 1870. Tintype with applied color [GEH 1978:0829:0013]. (Image courtesy of the George Eastman House Collection.)

1870 ▸ Dagron, P. R. P.: Use of miniature photographs for the pigeon post during the Siege of Paris.

1871 ▸ Liverpool Dry Plate Co., gelatin coated silver bromide printing paper.
▸ Maddox, R. L.: First gelatin dry plates. Extremely slow. Improved by J. Burgess (1873), R. Kennett (1874), and C. Bennett (1878).

1872 ▸ Gillot, C.: Line blocks on zinc, using the etching technique of F. Gillot (1850).

1873 ▸ Mawdsley, P.: Gelatin bromide paper for negatives and positives.
▸ Vogel, H.: Dye sensitization for the green (basis of orthochromatic plates).
▸ Willis, W.: Platinum paper for development (sold commercially in 1878 after various improvements).

1873–1874 ▸ Johnston, J. and King, J.: Silver bromide gelatin emulsion (negative) prepared with excess bromide and washed before coating.

1874 ▸ Janssen, P. J.: Photographic revolver for the chronophotographic study of the Venus transit.

1875 ▸ Warnerke, L.: Stripping-film paper on reels in a roll-holder for 100 exposures.

1876 ▸ The Liverpool Dry Plate Co. began manufacture of R. Kennett's gelatin dry plates.

1877 ▸ Carey-Lea, M.: Ferrous oxalate developer.

1877–1885 ▸ Muybridge, E.: Study of the movement of animals by instantaneous photography and chronophotography.

1878	▶ Gelatin silver bromide glass dry plate. ▶ Monckhoven, D. C. E. van: Preparation of silver bromide gelatin emulsions in the presence of ammonia. ▶ Swan, J. W. and Bennett, C.: Increase in the speed of silver bromide gelatin emulsions by ripening in a neutral medium. ▶ Wratten, F. C. L.: "Noodling" of silver bromide gelatin emulsions before washing.
1879	▶ Kliç, K.: Photogravure on copper by transfer of a carbon print after graining with resin. ▶ Swan, J. W. and Eastman, G.: Machine for coating plates.
1880	▶ Abney, Sir W. de W.: Use of hydroquinone as developer. ▶ Eder, J. and Toth, :Pyrocatechin developer.
1881	▶ Cros, C.: Dyeing of gelatin by imbibition (hydrotypy). ▶ Eder, J. M. and Pizzighelli, G.: Silver chloride gelatin emulsion (positive) for chemical development. ▶ Horgan, S.: Halftone photomechanical reproduction process. ▶ Pumphrey, A.: Magazine camera (for gelatin sheet film).
1882	▶ Attout, P. A. and Clayton, J.: Commercial manufacture of orthochromatic silver bromide gelatin plates. ▶ Abney, Sir W. de W.: Silver chloride gelatin emulsion for printing-out papers manufactured commercially in 1886 by Liesegang. ▶ Berkeley, H. B.: Use of sodium sulfite in developers. ▶ Meisenbach, G.: Commercial production of halftone blocks (line screen turned at 90° in the middle of the exposure).
1882–1896	▶ Marey, E. J.: Chronophotography on fixed plates and on movable films (photographs in rapid succession at equal time intervals).
1883	▶ Eder, J.: Developing-out chlorobromide paper. ▶ Farmer, H. E.: Single-bath reducer (with ferricyanide and thiosulfate).
1884	▶ Eastman, G.: Roll-film system and machine coated printing paper. ▶ Kayser, H.: Plate-changing magazine. ▶ Nipkow, P.: First described the essential elements of a viable TV system. ▶ Vogel-Obernetter, :Orthochromatic dry plate.
1885	▶ Urie, J., sen. and jun.: Patent for automatic positive printing machine.
1886	▶ Abney, W. de W. and Liesegang, P. E.: Aristotype gelatin silver chloride paper. ▶ Ives, F. E.: Halftone blocks with crossed screen and square diaphragm. ▶ Urie, J., sen. and jun.: Patent for continuous positive print processing machine.
1887	▶ Bausch, E.: Central shutter with blades forming, also an iris diaphragm. ▶ Goodwin, H.: Patent (granted only in 1898) for the manufacture of celluloid roll film coated with silver bromide gelatin emulsion. ▶ Hertz, H.: The father of wireless communication; demonstrated the radiation of electromagnetic waves. ▶ Pizzighelli, G.: Platinum paper for printing-out.
1888	▶ Andresen, M; p-Phenylenediamine developer. ▶ Anschutz, O.: Patented focal plane shutter with 1/1000 of a second exposure time. ▶ Carbutt, J.: Silver bromide gelatin coated celluloid sheet film. ▶ Eastman Kodak Co.: Introduction of the first "Kodak" roll-film camera. ▶ Hurter, F. and Driffield, V.: Patented actinograph, a slide-rule type exposure calculator.
1888–1889	▶ Andresen, M.: Use of p-phenylenediamine and Eikonogen as developers.
1889	▶ Eastman nitrocellulose roll-film base. ▶ Edison, T. A.: Use of flexible Eastman film for Kinetoscope pictures. ▶ Enjalbert, T. E.: Portrait automaton for ferrotypes. ▶ Lainer, A.: Stabilization of fixers with bisulfites. ▶ Namias, R.: Acid permanganate reducer. ▶ Rudoloph, P.: First anastigmat lens (Protar) introduced by Zeiss. ▶ Shawcross, H.; Vandyke brown print process.
1890	▶ Bonnet, G.: Bichromated glue process for block-making (so-called "enamel" process). ▶ Gelatin silver chloride gas light paper. ▶ Hurter, F. and Driffield, V. C.: Scientific investigation of emulsion characteristics; creation of photographic photometry and sensitometry. ▶ Platinum chloride paper.
1891	▶ Andresen, M.: Use of p-aminophenol as developer. ▶ Bogisch, A.: Use of metol, glycine, and diaminophenol as developers. ▶ Edison, T. A.: Kinetoscope giving the illusion of movement by viewing images representing phases of a short scene. ▶ Ives, F.: Kromskop "one-shot" three-color separation camera. ▶ Ducos du Hauron, L.: Anaglyphs, 3D photographs using red-green discrimination for separation. ▶ Lippmann, G.: Color photography by the interference method. ▶ Turner, S. N.: Daylight-loading film rolls (Kodak).

FIGURE 4 Photo by Gabriel Lippmann. Garden at Versailles 1900. Direct color (interference process) Lippmann plate [GEH 1981:3016:0001]. (Image courtesy of George Eastman House Collection.)

1892	▶ Ives, F. E.: One-shot color camera.
1893	▶ Baekeland, :Velox silver chloride ammonia gaslight paper. ▶ von Hoegh, E.: First double anastigmat lens (Dagor) introduced by Goerz. ▶ Schumann, V.: Emulsions with negligible gelatin content, sensitive for the extreme ultraviolet. ▶ Taylor, H. D.: Anastigmatic objectives with three uncemented lenses (Cooke lens).
1894	▶ Ives, F. E.: Patents photochromoscope, later called "Kromskop," viewer for seeing single or stereoscopic photographs in color (invented 1892). ▶ Joly, J.: Line screen additive color images. ▶ Rouillé-Ladevéze, A.: Gum-bichromate prints for pictorial photography.
1895	▶ Kliç, K.: Intaglio screen photogravure and rotogravure introduced (invented 1890). ▶ Liesegang, R. E. J.: Silver bleached away, dye image remains. ▶ Lumière, A. and L.: Cinematograph. ▶ Roentgen, W. C.: Discovery of X-rays and of radiography.
1896	▶ Liesegang, R. E. J.: Lenticular screen color process. ▶ Méliès, G.: Directing of films; cinematographic effects and illusions.
1897	▶ Braun, K. F.: Invented the cathode ray tube (CRT).

1898	▶ Acres, B.: First narrow-gauge cine film (17.5 mm., Birtac camera).
1899	▶ Manly, T.: Ozotype carbon.
1900	▶ Lumière, A. and L.: "Photorama" for the taking and the projection of panoramic pictures of 360°.
1900–1905	▶ Von Bronk, O.: Described electrolytic electrophotography with a photoconductor.
1901	▶ Eichengrün, A.: Safety films from cellulose acetate. ▶ Gaumont, L.: Synchronization of a cinematograph with a phonograph. ▶ Marconi, M. G.: Made the first transatlantic wireless transmission. ▶ Pulfrich, C.: Stereocomparator for the accurate exploitation of stereo pairs in terrestrial photogrammetry.
1902	▶ Deckel, Fr.: Compound shutter. ▶ Deville, E.: Principles of an apparatus for stereophotogrammetric restitution. ▶ Eastman Kodak Company: Gelatin backing on films to prevent curl (commercially introduced); daylight development tank. ▶ Lüppo-Cramer, H.: Metol-hydroquinone developer. ▶ Rudolph, P.: Tessar anastigmat lens introduced by Zeiss. ▶ Traube, A.: Ethyl Red used as color sensitizer; this was the first sensitizer of the isocyanine series.
1903	▶ Agfa: Panchromatic film.
1904	▶ Fleming, J. A.: Invented the diode vacuum tube rectifier and detector. ▶ Goerz, C.: Pneumatic lens shutter using one set of overlapping blades for the shutter and the iris diaphragm. ▶ Johnston, W.: Patented panoramic camera design that was later labeled cirkut camera. ▶ König, E. and Homolka, B.: Ortho and panchromatic sensitizers (Orthochrome, Pinachrome, Pinacyanol). ▶ Korn, A. and Glatzel, B.: Phototelegraphy. ▶ Rawlins, G. E.: Fatty ink processes (oil prints) applied to artistic photography.
1905	▶ Brehm, F.: Patented first cirkut camera to be commercially manufactured. ▶ Schinzel, K.: Dye destruction.

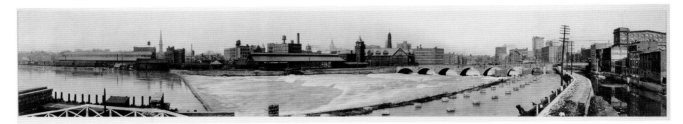

FIGURE 5 A view of Rochester and Genesee River south of Broad Street by Frederick W. Brehm, ca. 1910 [GEH 1976:0152:0002]. (Image courtesy of George Eastman House Collection.)

1906	▶ Courtet, E. (pseudonym Cohl): Animated films. ▶ DeForest, L.: Invented the triode vacuum tube amplifier. ▶ Finlaycolor additive screen plate. ▶ Wratten and Wainwright Ltd.: First commercial panchromatic plates.
1907	▶ Goldschmidt, R. B.: Photographic reduction of documents for library use. ▶ Homolka, B.: Color development with leuco dyes. ▶ Lumière, A. and L.: Autochrome plate for color photography introduced. ▶ Smith, C. A., and Urban, C.: Kinemacolor, first commercial additive two-color cine process. ▶ Welbourne Piper, C., and Wall, E. J.: Bromoil process.
1908	▶ Belin, E.: Phototelegraphy on telephone lines. ▶ Clerc, L. P.: Theory of the photogravure screen. ▶ Keller-Dorian, A.: Patent for lenticular color process for cinematography.
1910	▶ Dufay, L.: Regular screen process of additive color photography. ▶ Goldberg, E.: Molded neutral gray wedges for sensitometry.

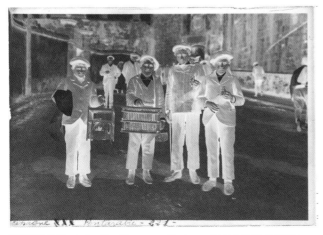

FIGURE 6 Photo by Ch. Chusseau-Flaviens, Espagne Fontarabie, ca. 1908. Negative, gelatin on glass [GEH1975:0111:3757]. (Image courtesy of George Eastman House Collection.)

1911	▶ Lauste, E. A.: First experiments in talking films.
1912	▶ Armstrong, E. H.: Developed the electronic oscillator. ▶ Deckel, Fr.: Compur shutter introduced. ▶ Fischer, R.: Multi-contrast paper. ▶ Fischer, R. and Siegrist, H.: Color development based on formation of indamine and indophenol dyes (later employed in three-color photography). ▶ Gaumont, L.: Three-color cinematography by simultaneous additive synthesis.
1914	▶ Eastman Kodak Co.: First Kodachrome process (two-color subtractive).
1915	▶ Technicolor dye imbibition motion picture film. ▶ Kodachrome, subtractive 2-color process, black-and-white separation negatives.
1916	▶ Agfa: Color dyed vanish screen plate film.
1919	▶ Adams, E. Q., and Haller, H. L.: Discovery of cryptocyanine, the first practical sensitizer for infrared. ▶ Autotype Co.: Carbro print process.
1920	▶ Lüppo-Cramer, H.: Desensitization. ▶ Pope, Sir W. J., Mills, W. H., and Hamer, Miss F. M.: Constitution of the color sensitizers of the cyanine group.
1921	▶ Belin, E.: Transmission of pictures by wireless. ▶ Bocage, A.: Radiographic tomography of living objects. ▶ Duclaux, J. and Jeantet, P.: Sensitization for the far ultraviolet by putting a fluorescent layer on the emulsion.
1923	▶ Eastman Kodak Co.: Reversal processing of 16 mm film, leading to widespread amateur cinematography. ▶ Koegel, G.: Diazo prints developed with ammonia vapor. ▶ König, W.: Preparation of di- and tri-carbocyanines, sensitizers for the extreme red and the near-infrared.

1924 ▸ Barnack, O.: Leica camera using 35 mm film, manufactured by Leitz.
▸ Sheppard, S. E. and Punnett, R. F.: Discovery and identification of active impurities in gelatin, which led to the preparation of very rapid emulsions.
▸ Zworykin, V. R.: Invented the Iconoscope TV camera tube.

1925 ▸ Dye imbibition.
▸ Séguin, A. and L.: Practical use of a condenser discharge in a rare gas for the photography of very rapid movements.

1932 ▸ Agfa: Lenticulated film.
▸ Technicolor Corp.: First full-length color motion picture films produced using the imbibition color transfer process.
▸ Western Electric Instrument Corp.: Weston Universal 617 photoelectric exposure meter.

1935 ▸ Birr, E. J. (Agfa): Triazaindolizines (azaindene) emulsion stabilizers.
▸ Brooker, L. G. S. and Keyes, G. H.: Preparation of tetra- and pentacarbocyanines.
▸ Heisenberg, E.: Emulsion for direct positives and prints, without inversion of a provisional negative.
▸ Laporte, M.: Electronic flash with white light.
▸ Mannes, L. D. and Godowsky, L. (Kodak): Subtractive three-color separation with superimposed emulsion layers, the color couplers added to the developers, and color separation obtained by controlled differential dye bleaching (early Kodachrome process).
▸ Merocyanine spectral sensitizers discovered independently by J. D. Kendall (Ilford) and L. G. S. Brooker (Kodak).
▸ Selenyi, P.: Described dry powder development of charge patterns formed on an insulating layer.

FIGURE 7 Photograph of Charles Lindberg and plane May 20–21, 1927, transmitted gelatin silver print. The Bartlane system was the first machine to translate photographs into a digital code in the early 1920s. It could also transfer a photo from New York to London in about three hours. (Image courtesy of George Eastman House Collection.)

1927 ▸ Beginning of universal use of sound films.

1928 ▸ Arens, H. and Eggert, J.: Density surfaces for various types of emulsion.
▸ Commercial microfilming on 16 mm film in rotary camera.
▸ Eastman Kodak Co.: Lenticular additive color amateur motion picture film. First Kodacolor film.
▸ Franke, P. and Heidecke, R.: Rolleiflex twin-lens reflex camera introduced.
▸ Hamer, Miss F. M.: Polymethine sensitizers derived from benzothiazoles with alkyl substitution on the middle carbon.

1929 ▸ Jacobsohn, K.: Hypersensitization with ammonia and ammoniacal silver chloride.
▸ Ostermeir, J.: Flashbulb – combustion of aluminum wire or foil in oxygen in a sealed bulb.

1930 ▸ Three-color carbro print process.

1931 ▸ Schmidt, B.: Catadioptric lens with large aperture.

FIGURE 8 Image of 1935 Kodachrome cine box from 1935. (Image courtesy of the George Eastman House Collections.)

1936 ▸ Agfacolor: Neu, tripack coupler incorporated.
▸ Kine: Exakta 35 mm single lens reflex camera.
▸ Koslowski, R.: Discovers gold sensitization of silver halide emulsions, but discovery is kept a trade secret by Agfa until 1945.
▸ Land, E. H.: Stereoscopic projection with two projectors equipped with polarizing filters; viewers used polarizing spectacles.
▸ Strong, J.: Reflection-diminishing coatings with insoluble fluorides on lens surfaces.
▸ Wilmanns, G., Kumetat, K., Frohlich, A., and Schneider, W. (Agfa): Fat-tail couplers incorporated in the emulsion layers of color films. Used in Agfacolor films.

| 1937 | ▶ Mees, C. E. K. (Kodak): Supersensitization using the combination of two sensitizing dyes giving higher sensitivity than the sum of their individual effects. |

| 1938 | ▶ Carlson, C. F.: Invented electrostatic electro-photography, later called xerography.
▶ Kodak: Super 620 camera with automatic photocell exposure control.
▶ Mannes, L. D., Godowsky, L., and Wilder, L. (Kodak): Improved Kodachrome process based on selective re-exposure.
▶ Mott, N. F., and Gurney, R. W.: Theory of latent image formation.
▶ Trivelli, A. P. H., and Smith, W. F. (Kodak): Independently discover gold sensitization of silver halide emulsions. |

| 1938–1939 | ▶ Staehle, H. C. (Kodak): Cardboard mount for 35 mm color slides. |

| 1939 | ▶ Agfacolor: Negative-positive color printing process.
▶ Dumont: First commercial TV sets.
▶ Edgerton, H. E.: Improvement in electronic flash lamps.
▶ James, T. H.: Investigations of the kinetics of development.
▶ Jones, L. A.: Experimental basis of the stan-dardization of the sensitometry of negative emulsions.
▶ Leermakers, J. A., Yackel, E. C., and Hewitson, E. H. (Kodak): Improved gold sensitization using silver halide emulsions made with inert gelatin and sensitized with thiosulfate, thiocyanate, and a water-soluble gold salt.
▶ Rott, A. and Weyde, E.: Diffusion-transfer copying systems. |

| 1940 | ▶ Ardenne, M. von: Investigation of the struc-ture of developed images with an electron microscope.
▶ Ilford: Multigrade variable contrast paper.
▶ Weisberger, A. (Kodak): Low allergenic alky sulfonamidoalkyl substituted phenylenedi-amine color developers. |

| 1941 | ▶ High-resolution plates permitting 750x enlargement.
▶ Nietz, A. and Russell, F. (Kodak): Thiocyanate ripened silver halide emulsions. |

| 1942 | ▶ Atanasoff, J. V. and Berry, C.: Built the first electronic digital computer.
▶ Carroll, B. H. and Allen, C. F. H. (Kodak): Quaternary ammonium salt development accelerators used to increase sensitivity.
▶ Gaspar, B.: Oxonol filter and backing dyes.
▶ Kendall, J. D.: Patent on Phenidone, a new developing agent (1-phenyl-3-pyrazolidone).
▶ Rott, A. (Gevaert): Reversal images produced by the silver salt diffusion image transfer process. Also discovered independently by E. Weyde at Agfa. Evolved into document copy-ing and instant photography.
▶ Silver halide-sensitized zinc plates for rapid photolithography. |

| 1943 | ▶ Jelley, E. E. and Vittum, P. W. (Kodak): Oil-in-water dispersions of non-diffusing couplers. Process currently used in most incorporated-coupler color materials. |

| 1944 | ▶ Gaspar, B.: Color separation by sensitivity differential. System used in most color print materials.
▶ Stauffer, R. E., Smith, W. F., and Trivelli, A. P. H. (Kodak): High contrast images produced by the hydrazine effect. |

| 1945 | ▶ Multicontrast photographic papers with the contrast depending on the color of the expos-ing light. |

| 1946 | ▶ Back, F. (Zoomar Corp.): Designed zoom lens for 16 mm motion-picture cameras.
▶ Ektachrome reversal sheet film, user pro-cessed.
▶ Blackner, L. L., Brown, F. M., and Kunz, C. J.: Rapid processing and projection of images 15 seconds after taking.
▶ Evans, R. M.: Introduced the photofinishing concept that the total light reflected from each print should integrate approximately to a neutral hue.
▶ Ilford, Kodak: Improved nuclear track materi-als for recording nuclear particles. |

| 1946–1950 | ▶ Kodak/Time-Life: Scanner for halftone sepa-ration negatives. |

| 1946 | ▶ Kodak Dye Transfer print process. |

| 1947 | ▶ Blake, R. K., Stanton, W. A., and Schulze, F. (DuPont): Polyethylene glycols used as development modifiers to increase sensitivity and contrast.
▶ Gabor, D.: The theory of holography, which became feasible after the introduction of lasers in 1960.
▶ Magnetic recording begins to replace pho-tographic sound recording in motion picture films. |

1948
- ▶ Bardeen, J., Brattain, W., and Shockley, W.: Transistors, making miniature photocells and microelectronic circuits possible.
- ▶ Battelle Memorial Institute introduced the amorphous selenium photoconductor (Bixby, W. E.), corona charging (Walkup, L. E.), two-component dry xerographic development (Walkup, L. E. and Wise, E. N.), and electro-static toner transfer to plain paper (Schaffert, R. M.).
- ▶ Land, E. H.: Polaroid black and white peel-apart diffusion-transfer material.

1949
- ▶ General introduction of safety cellulose ester film base for 35 mm motion picture films.
- ▶ Zeiss Contax S 35 mm single lens reflex camera with pentaprism for eye-level viewing.

1950
- ▶ Fallesen, G. E. (Kodak): Internal-image emul-sion reversal process.
- ▶ Haloid-Xerox flat plate xerographic camera for plain-paper copies and lithographic print-ing plates.
- ▶ Hanson, W. T. (Kodak): Colored couplers used for integral masking.
- ▶ Kendall, W. B., and Hill, G. (Kodak): Autopositive materials, based on Herschel reversal, comprising fogged silver chloride emulsions containing a desensitizer.
- ▶ Norwood, D.: Incident-light exposure meter with a hemispherical light diffuser.
- ▶ RCA (Forgue, S. V., Goodrich, R. R., and Weimer, P. K.): Introduced the Vidicon TV camera tube.
- ▶ Russell, H. D., Yackel, E. C., and Bruce, J. S.: Principles of stabilization processing.
- ▶ Sprague, R. H. (Kodak): Sulfo-substituted cyanine dyes.

1951
- ▶ Hanson, W. T., and Groet, N. H. (Kodak): Incorporated coupler color negative film hav-ing an improved sensitivity graininess ratio, produced by double-coated emulsion layers having the same spectral sensitivities but different overall sensitivities, with the more sensitive emulsion containing a low concen-tration of coupler. Used in Eastman Color Negative Motion-Picture Film.
- ▶ Ives, C. E. (Kodak): Improved internal-image reversal process using hydrazine fogging agents.
- ▶ Brooker, L. G. S., and Keyes, G. H. (Kodak): Solubilized merocyanine dyes.
- ▶ Davey, E. P., and Knott, E. B. (Kodak): Halide conversion internal-image emulsions.

1952
- ▶ Lowe, W. G., Jones, J. E., and Roberts, H. E. (Kodak): Sulfur plus gold plus reduction sensitization.
- ▶ Yutzy, H. C. and Yackel, E. C.: Colloid image transfer process used in the Kodak Verifax document copying process.

1953
- ▶ Haloid-Xerox Copyflo xerographic microfilm enlarger.
- ▶ Miller, C. E. and Clark, B. L.: Thermal imaging system of the type used in the 3M Thermofax document copying process.
- ▶ NTSC standard for color TV was announced.

1954
- ▶ Minsk, L. M.: Photosensitive polyvinylcin-namate polymers used in photoengraving, lithography, and in the preparation of printed circuits. (Kodak Photo Resist).
- ▶ Univac: 1103 digital computer with magnetic-core memory.
- ▶ Young, C. J. and Grieg, H. G., (RCA): Demonstrated the Electrofax xerographic document copying process; expendable spectrally sensitized zinc oxide photoconduc-tor and magnetic brush development.

1955
- ▶ Carroll, B. H. and Spence, J. (Kodak): Use of acid substituted cyanine dyes to reduce unsensitizing of incorporated coupler emul-sions.
- ▶ Haloid-Xerox: Xeroradiography with aerosol development.
- ▶ DuPont: Poly(ethyleneterephthalate) film sup-ports.
- ▶ Riester, O. H. (Agfa): Alkane sultone synthesis of sulfoalkyl substituted cyanine dyes.
- ▶ Schouwenaars, M. A. (Gevaert): Reduction gold-fogged silver halide direct-positive emul-sions.
- ▶ Yule, J. A. C., and Maurer, R. E. (Kodak Autoscreen Film): Prescreened lith films.

1955–1956
- ▶ Logetronics enlarger/printer with optical feedback.
- ▶ Heseltine, D. W. (Kodak): Neopentylene infra-red spectral sensitizers.
- ▶ Metcalfe, K. A. and Wright, R.D.: Described high-resolution xerographic development with toner particles dispersed in an insulating car-rier liquid.
- ▶ Polyethylene resin-coated paper supports (RC papers).
- ▶ Russell, T. A. (Kodak): Simultaneous multi-layer coating.

1957
- ▶ Ginzberg, C. P. (Ampex): Developed the mag-netic tape video recorder.

1958
- ▶ Agfa: Planographic printing plates prepared using the silver salt diffusion transfer pro-cess.

1959	▶ Kilby, J. (Texas Instruments) and Noyce, R.N.: Invented the integrated circuit chip. ▶ Russell, H. D. and Kunz, C. J. (Kodak): Roller transport processing of radiographic films. ▶ 3M: Filmac 100 Reader-Printer: Zinc-oxide-photoconductor-coated foil and electrolytic development. ▶ Voigtlander: Optical compensation zoom lens for 35 mm single lens reflex camera. ▶ Xerox: 914 plain-paper xerographic document copier; radiant-heat toner fusing. ▶ Haloid, Xerox: Xerography – Introduction of the xerographic document copying system.
1960	▶ Maiman, T.: Introduction of lasers, making holography possible.
1960–1965	▶ Philips: Audio cassette magnetic tape recorder.
1961	▶ Apeco: Document copier with zinc oxide paper and magnetic brush xerographic development. ▶ Hunt, H. D. (DuPont): Internal-image direct print emulsions containing a stannous salt halogen acceptor. ▶ Luckey, G. W. and Hoppe, J. C. (Kodak): Very high speed film using an image intensification system comprising a fogged internal-image silverchlorobromide emulsion blended with a surface-sensitized silver bromoiodide emulsion. ▶ Rogers, H. G. (Polaroid): Dye-developer color image-transfer process. Process used in Polacolor films.
1962	▶ Dann, J. R. and Chechak, J. J. (Kodak): Thiopolymer sensitizers for silver halide emulsions. ▶ IBM: Introduced magnetic disk computer program and data storage. ▶ SCM: Model 33 document copier with zinc oxide paper and liquid xerographic development. ▶ Williams, J. and Cossar, B. C. (Kodak): Thioether ripened silver halide emulsions.
1962–1963	▶ Bruning: Copytron 1000 microfilm enlarger with zinc oxide paper and magnetic brush xerographic development; precursor of the Model 2000 copier and the TCS lithographic plate maker.
1964	▶ Sorensen, D. and Shepard, J. (3M Corp.): Photothermographic system using silver halide, the silver salt of an organic acid, and a reducing agent.
1966	▶ Barnes, J. C., and Rees, W.: 90-second processing of radiographic films using a hardening developer. Kodak XOMAT system.
1966	▶ McBride, C. E. (Kodak): High-speed thioether ripened direct-print emulsions processed by photodevelopment. ▶ Weyerts, W. J. and Salminen, W. M. (Kodak): Improved dye-developer color image transfer process using quaternary salts that form methylene bases. System used in Polacolor films.
1967	▶ Dunn, J. S. (Kodak): Selenium plus gold sensitized silver halide emulsions. ▶ Gotze, A. and Riester, O. (Agfa): Fogged direct-positive emulsions containing phenylindole electron-accepting sensitizing dyes. ▶ Porter, H. D., James, T. H., and Lowe, W. G. (Kodak): Covered grain (core/shell) internal-image emulsions. ▶ Xerox: 2400 xerographic copier with hot-roller toner fusing. ▶ Xerox: 6500 xerographic color document copier.
1968	▶ Bahnmuller, W.: Mechanism of iridium sensitization. ▶ Berriman, R. W. (Kodak): Iridium doped reduction-gold fogged internal-image photobleach direct-positive silver halide emulsions. ▶ Kitze, T. J. (Kodak): Incorporated developer papers containing a hardener precursor designed for rapid stabilization processing.
1968–1973	▶ Phototypesetters for the graphic arts introduced by Mergenthaler, Compugraphic, and others.
1968–1978	▶ Scanners for graphic arts halftone separations introduced by Hell, Crossfield, and others.
1969	▶ Barr, C. R., Thirtle, J. R., and Vittum, P. W. (Kodak): Couplers that release developer inhibitors that improve graininess, DIR couplers. Used in Kodacolor II-type materials. ▶ Bell Labs (Boyle, W. S. and Smith, G. E.): Invented the charge-coupled device (CCD) photocell array. ▶ Brooker, L. G. S. and Van Lare, E. (Kodak): Imidazoquinoxaline electron-accepting spectral sensitizers. ▶ Morgan, D. and Shely, B. (3M Corp.): Improved photothermographic materials using silver halide, the silver salt of an organic acid, and a reducing agent in which the silver halide is formed in situ by reacting halide ions with the silver salt of the organic acid.
1970	▶ IBM: Xerographic copier with an organic photoconductor. ▶ Illingsworth, B. I. (Kodak): Reduction-gold fogged monodispersed photobleach direct-positive silver halide emulsions.
1971	▶ 3M: Xerographic copier using monocomponent developer.

1972
- ► James, T. H., Babcock, T. A., and Lewis, W. C. (Kodak): Hydrogen sensitization.
- ► Kodak: 110-film format and camera.
- ► Kodak: Three-solution rapid process for color papers. System used for processing Ektacolor papers.
- ► Land, E. H. (Polaroid): SX-70 camera and integral color image transfer system.
- ► Philips: Videodisc with laser and photodiode readout; precursor of the compact disk (CD).
- ► Schwan, J. A. and Graham, J. L. (Kodak): Spectrally sensitized color films designed to be exposed under several types of illumination. Universal sensitization.

1973
- ► Evans, F. J. (Kodak): High speed internal-image core/shell silver-halide emulsions for use in the internal-image reversal process.

1975
- ► Fleckenstein, L. J. and Figueras, J. (Kodak): Immobile sulfonamidophenol dye-release compounds of the type used in Kodak Instant Print Film.
- ► IBM: Model 3800 xerographic computer; scanning HeNe laser exposure.
- ► Kodak: Ektaprint 100 xerographic document copier; belt-form aggregate-type organic photoconductor (Light, W. L. and Dulmage, W. J.), flash exposure, recirculating document feeder, and conductive magnetic brush development.

1977
- ► Kodak: Ektavolt organic photoconducting films.

1978
- ► Polaroid: Sonar ultrasound range-finding system.

1979
- ► Canon: Sure Shot camera with infrared range-finding system.

1980
- ► Nippon: Sheet Glass introduced with Selfoc gradient-index optics array.

1981
- ► Sony: Electronic still camera and thermal dye sublimation printing process.

1982
- ► Kodak: Disk film format and camera.

1983
- ► Canon: Digital electronics copier with document scanner and xerographic printer.
- ► Canon: LBP-CX xerographic computer printer with semiconductor laser.
- ► Canon: Personal xerographic copier with photoconductor, charger wires, and developer in a replaceable cartridge.
- ► Improved high-contrast emulsions containing arylacylhydrazide derivatives. Used in graphic arts films such as Kodak Ultratec Film.

1984
- ► Abbott, T. I. and Jones, C. G.: Improved radiographic films containing high-aspect ratio spectrally sensitized silver halide grains. Used in Kodak T-Mat Radiographic films.
- ► Bando, S., Shibahara, Y., and Ishimaru, S. (Fuji): Improved high-speed octahedral silver-bromoiodide double-structured grains having a silver-bromide core and a silver-bromoiodide shell.
- ► Epson and Casio: Xerographic computer printers using liquid crystal (LCD) arrays with gradient-index optics.
- ► Kofron, J. T., Booms, R. E., Jones, C. G., Haefner, J. A., Wilgus, H. S., and Evans, F. J. (Kodak): Incorporated coupler color-negative films with improved speed/graininess characteristics resulting from the use of high-aspect-ratio tabular grain spectrally sensitized silver halide emulsions. Used in Kodacolor negative films such as Kodacolor VR 1000 Film introduced in 1983.
- ► Solberg, J. C., Piggin, R. H., and Wilgus, H. S. (Kodak): Improved high-speed tabular grain silver-bromoiodide emulsions with the iodide concentrated in discrete areas.

1986
- ► Kodak: Ektaprint 1392 computer xerographic printer with light-emitting diodes (LEDs) and gradient-index optics.
- ► Kodak: Signature color-proofing system for the graphic arts; organic photoconducting film and liquid xerographic developers.
- ► Fuji: Quicksnap, the first "disposable" camera is released. The name is quickly changed from "disposable" to "single use" – for environmental reasons. A similar product by Kodak was introduced within months of this release.

1987
- ► Fuji: Relocates its headquarters to Elmsford, New York.
- ► Canon: EOS 650, the first EOS camera in a product line still offered is released.

1988
- ► Fuji: Heat-developable color-image-transfer photographic materials containing heat-decomposable alkali precursors and sulfonamidophenol dye-release compounds.
- ► Konica: Color photothermographic image-transfer process using a color developer precursor and immobile couplers that form diffusible dyes.
- ► Fuji: Fujifilm introduces the world's first one-time-use 35 mm camera with a flash.

1989
- ► Fuji: REALA color negative films are introduced.

1990
- ► Fuji: Velvia a 17-layer slide film that used E-6 processing is released.

- ► Kodak: Kodak Ektacolor RA-4 rapid-access process for processing color papers.

1993	► Kodak: Cameo 35 mm Camera Line, Ektachrome Lumiere Films, and an underwater version of Ektachrome film are released.
1994	► Fuji: Fujifilm introduces the Thermo-Autochrome Color Print System – a print development technology that used heat in place of chemicals. ► Kodak: Kodak Royal Gold Film line is released: ► Polaroid: Microcam is released.
1995	► Canon: World's first single lens reflex camera zoom lens with image stabilization is released. ► Leica: 70~180/f2.8 Vario Apo-Elmarit Zoom lens technology is released, which is described to be the first zoom lens to match or outperform the finest fixed focal length lenses.
1996	► Agfa, Kodak, Fuji, Nikon, Canon, and others: The Advanced Photo System format is introduced featuring drop-in film cartridge loading mid-roll change enabling the film to be removed before being completely exposed as well as three different picture formats – classic, group, and panoramic. ► Kodak: Advantix brand line and its related products are introduced. ► Nikon: F-5 is introduced.
1998	► Cosina of Japan: "Snap-Shot" Skopar f4/25 mm lens using Leica thread-mount is released and is the first to bear the Voigtländer name in 16 years. ► Kodak: Kodalith, an industry standard, is discontinued. ► Fuji: Tiara, the world's smallest Advanced Photo System (APS) camera is released. ► Kodak: Portra Color Negative Films and Supra III Color Paper is released
1999	► Hasselblad–Fuji: X-Pan camera is released. Hasselblad of Sweden, and Fuji in Japan, sharing a technology agreement since the late 1990s, released the X-Pan to be sold by Fuji in Japan and Hasselblad everywhere else. ► Polaroid: I Zone camera released.
2000	► Agfa: Advanced film technology is patented boosting photographic film sensitivity up to 10 times. Published in the journal Nature, researchers say they have captured every particle of available light on film by employing a chemical called formate. ► Fuji: Nexia 800, the first 800 speed APS film is released.
2001	► Polaroid: Polaroid files Chapter 11 on Friday, October 12.

2002	► Kodak: Announced the discontinuance of Kodachrome 25, originally released as Kodachrome II in 1961. Kodachrome 200 was also eliminated at this time as well. ► Kodak Kodalith Film 6556 discontinued.
2003	► Konica/Minolta: Merged in January.
2004	► Hasselblad is acquired by Shriro Sweden of the Shiro Group who also purchased Imacon on 8/12/2004 forming a merger between Hasselblad and Imacon. ► Kodak discontinues production of the Carousel Ektagraphic Slide Projector manufacturing and service. ► Kodak announces that it will stop selling its APS and reloadable 35 mm film cameras in the United States, Canada, and Western Europe. ► Kodak: Technical Pan Film discontinued. ► Nikon: F6 SLR released.
2005	► Kyocera: Contax brand camera operations were terminated. ► Agfa Photo: Filed for insolvency. ► Ilford: Enters reorganization. ► Kyocera: Company will cease production of film and digital cameras. ► Kodak: Discontinues production of all black and white photographic printing papers. ► Leica: Digital-Modul-R the world's first hybrid 35 mm format camera used for both film and digital photography.
2006	► Kyocera: Konica/Minolta cease production of digital cameras & devices.

ADDITIONAL INFORMATION

http://www.canon.com/camera-museum/index.html
http://www.dpreview.com/
http://www.kodak.com/global/en/professional/support/data-banks/filmDatabankBW.jhtml
http://www.nwmangum.com/Kodak/Rochester.html#
http://www.photoxels.com/history_canon.html
http://www.reference.com

Advancement of Digital Photography and Related Technologies Timetable

ROGER L. CARTER
www.digitalcamhistory.com

Photography's Earliest Years

1826 ► Niepce, Joseph: Produced the oldest known photograph, a reproduction of a 17th century Dutch engraving showing a man leading a horse. The photograph was sold at Sotheby's in Paris on March 21, 2002, to the French National Library for $443,000 (£330,000).

1839 ► First production cameras: Daguerreotype cameras of 1839 produced by Giroux in Paris. They weighed 120 pounds each and cost 400 Francs (about $50).

1843 ► Bain, Alexander: Bain, a Scotsman, patented a design for a mechanical device, which used a stylus attached to an electromagnetic pendulum to send typed words over a telegraph line. The first commercial fax service was opened between Paris and Lyon, France, in 1865. Popularity of facsimile machines increased significantly in 1906 and thereafter when they were employed for transmitting newspaper photos.

1880s ► Bell, Alexander Graham: Bell proposed an optical system for transmitting telephone signals without wires.

1884 ► Nipkow, Paul: Nipkow, a German inventor, developed and patented the world's first electromechanical television system with no method of amplifying the very weak signals (produced by a selenium cell) needed to build a workable receiver. Nipkow used a rotating disk to send pictures over a wire in 1884. This early idea of "cable television" was abandoned as impractical since the receiving screen couldn't be any bigger than one square inch.

1895 ► Amstutz Electro-Artrograph: The cover story of a *Scientific American* issue described the Amstutz Electro-Artrograph which could scan photographs and transmit them over wire.

1908 ► Swinton, A.A. Campbell: The first proposal for a workable system of electronic photography was put forward in 1908 by a Scotsman, Alan Archibald Campbell Swinton, and published in a journal called Nature—an idea for a device using an electric pickup tube for recording images. The camera described was completely electronic, producing images without any mechanical assistance apart from focusing.

1920 ► Bartholomew, Harry G. and McFarlane, Maynard D.: The Bartlane facsimile system was one of the first applications of digital images with digitized newspaper pictures being sent by submarine cable between London and New York. Introduction of the Bartlane cable picture transmission system reduced the time required to transport a picture across the Atlantic from more than a week to less than 3 hours. It utilized a punched tape like the original Wall Street ticker tape.

1924 ► RCA transmitted the first radiophotograph, a precursor to the facsimile machine, across the Atlantic Ocean.

1928 ► Baird, John Logie: The first videodisc, the Phonodisc, was developed by Scottish inventor John Logie Baird. It was a 250 mm; 78 rpm record similar to the discs being produced for sound recording at that time.

1938 ► Carlson, Chester F.: Xerography invented by Carlson. While others sought chemical or photographic solutions to instant copying problems, Carlson turned to electrostatics and on October 22 produced the first-ever xerographic image.

1957 ► Kirsch, Russell A. (National Bureau of Standards): Kirsch scanned the first-ever photograph into a computer, an image of his baby son. Kirsch and his colleagues, working at the NBS in the mid-1950s, constructed a simple mechanical drum scanner and used it to trace variations of intensity over the surfaces of photographs.

► Dye sublimation process is produced. A printer that produces continuous-tone images giving the appearance of those made from photographic film. Used cyan, yellow, and magenta ribbons containing an equivalent panel of dye for each image to be printed.

1959 ► Noyce, Bob (Fairchild Semiconductor): Noyce printed an entire electronic circuit on a single microchip of silicon using a photographic process. This breakthrough enabled the computer revolution to begin.

1963 ► Gregg, D. (Stanford University): Gregg created a crude forerunner to digital photography. His videodisk camera could photograph and store images for several minutes. Although they were transient, videodisk images foreshadowed emerging technology.

1964 ▶ In July 1964, NASA, at the Jet Propulsion Lab in Pasadena, California, received the first-ever electronic camera photos of Mars from video cameras on board the Mariner 4 (IV) spacecraft.

1967 ▶ Shugart, Alan (IBM): The first floppy disk drive (FDD) used an 8-inch disk (later called a "diskette" as it became smaller), which evolved into the 5.25-inch disk that was used on the first IBM Personal Computer in August of 1981.

1968 ▶ Stupp, Edward H., Cath, Pieter G., and Szilagyi, Zsolt: First solid-state imager patent. U.S. patent #3,540,011, filed September 6, 1968, granted November 10, 1970.

1969 ▶ Boyle, Willard and Smith, George: Boyle and Smith originated the basic design for the charge-coupled device (CCD).

1970 ▶ Bell Labs researchers: constructed the world's first solid-state video camera using a CCD as the imaging device.

1972 ▶ Adcock, Willis A. (Texas Instruments): received the first U.S. patent of a filmless electronic camera. A completely electronic system for recording and subsequently displaying still images.

1973 ▶ Fairchild Imaging: successfully developed and produced the first commercial charge-coupled device (CCD) in 1973 with a size of 100 × 100 pixels.

1974 ▶ Amelio, Gil: conceived a fabrication process that allowed CCDs to be produced on a conventional wafer fabrication line.
▶ A 100 × 100 pixel Fairchild CCD and an 8-inch telescope produced the first astronomical CCD image, a photo of the moon.

1975 ▶ Kurzweil, Ray: Kurzweil Computer Products created the first CCD flatbed scanner, the Kurzweil Reading Machine in support of individuals who are blind.
▶ Sasson, Steve (Kodak): the world's first known operational electronic CCD still image camera. The camera used the newly developed Fairchild black and white 100 × 100 pixel CCD as an image sensor
▶ Siemens: the first laser printer to the public in 1975 with the ND2 laser printer.

1976 ▶ The first commercial CCD camera, the Fairchild MV-101 with 100 × 100 pixel resolution, was used to perform Procter & Gamble product inspections.

1977 ▶ Canon: Thermal inkjet technology was called bubble-jet. Hewlett Packard independently discovered a similar method which it named thermal-inkjet which is now the preferred name for the technology.

1978 ▶ Epson: Piezoelectric inkjet technology. A piezoelectric-inkjet print head uses the electrically controlled movement of a piezoelectric crystal to eject small ink drops from an ink chamber.

1979 ▶ Modern videodisc: A collaboration of Philips and Sony, sound and images were digitally recorded and imprinted as micro-pits on a disk. A laser then optically scanned the information and converted it into pictures and sound for home television.
▶ RCA: 320 × 512-pixel liquid nitrogen-cooled CCD system began operation on a 1-meter telescope at Kitt Peak National Observatory. Observations quickly demonstrated its superiority over photographic plates.

1980 ▶ Sony: the world's first commercial color video camera that utilized a completely solid-state image sensor, a charge-coupled device (CCD). It was also the smallest camera on the market, weighing only 2.8 pounds.

The Age of Electronic Still Photography Begins

1981 ▶ Sony: unveiled a prototype of the first consumer still video camera, the Mavica (Magnetic Video Camera), on August 25, which recorded images on 2-inch floppy disks and played them back on a television set or video monitor.
▶ Hitachi: VK-C1000, the first consumer video camera with integrated solid-state image pickup device (MOS—metal oxide semiconductor) rather than an image pickup tube.
▶ University of Calgary Canada ASI Science Team: constructed and operated a functioning digital camera, the All-Sky camera, using the first commercially available CCD, the Fairchild 100 × 100 pixel CCD of 1973. The All-Sky Camera produced digital data rather than analog data while photographing auroras thus making it the first documented use of a digital camera.

1982 ▶ Iomega: 10MB Bernoulli drive is released.
▶ Sony: CDP-101 was the world's first consumer compact disk player.
▶ First thermal wax printer released.

1983
- ► Pentax: Nexa, a black-and-white still video camera prototype demonstrated.
- ► Syquest: 44MB removable drive is released, used primarily by the graphic arts community for electronic pre-press work.

1984
- ► Byrd, Debbie: posted the first message concerning electronic cameras on the World Wide Web on October 27th, using the net. atro newsgroup.
- ► Canon: conducted a trial professional color still video camera, the RC-701 and an analog transmitter at the Los Angeles Olympics. The images were transmitted back to Japan via phone lines in less than 30 minutes and were printed in the Yomiuri newspaper in July.
- ► Copal CV-1 prototype electronic camera: 2/3-inch CCD is released.
- ► Hewlett-Packard: LaserJet whose technology was the same as used by a Xerox photocopier. Price: $3495.
- ► Hewlett-Packard: ThinkJet named by combining Thermal and INKJET, ThinkJet was the industry's first mass-marketed, personal inkjet printer. It printed at 96 dpi, required special paper, and was limited to black ink. Price: $495
- ► First disposable inkjet cartridge is released.
- ► Hitachi: prototype still video camera with a 2/3-inch metal oxide semiconductor (MOS) image sensor and horizontal resolution of 300 TV lines.
- ► Panasonic: prototype still video camera 500 × 600 pixel CCD.
- ► Siemens: Twin Printing Systems combined two printers and allowed duplex and two-color printing of continuous forms in a single operation. The ND3 Twin Printing System was the world's first laser printer with additional colors.

1985
- ► Fuji: ES-1 still video single lens reflex (SLR) camera: 2/3-inch, 640 × 480 pixel CCD is released.
- ► Konica: SVC-20 and SVC-40 prototype still video cameras: 2/3-inch, 300,000 pixel CCDs.
- ► Pixar: introduces the first digital imaging processor.

1986
- ► Canon: first to market a still video electronic camera, the professional model RC-701 (RC = Real-time Camera).
- ► Hitachi: Dye Diffusion Thermal Transfer (D2T2.) VY 50A printer used a process using a set of ribbons coated with a dye that is transferred to a receiver material by the application of heat and pressure from a stylus at discrete points.

- ► Kodak: 1.4 million pixel CCD.
- ► Digi-View by NewTek is built to run on the Amiga platform and has the first video digitizer to function with a computer.
- ► Nikon: SVC (Still Video Camera) prototype electronic camera was built using a 2/3-inch CCD of 300 000 pixels. The body of the SVC was designed similar to that of the Nikon F801 film camera
- ► Sony: Mavica A7AF still video camera recorded images onto 2-inch floppy disks. Images were registered by a 2/3-inch charge coupled device (CCD) of 380,000 pixels.

1987
- ► Canon: RC-760 still video camera used a 600,000 pixel CCD. *USA Today* began covering special events with the Canon RC-760 camera.
- ► Casio: VS-101 marketed MOS (metal oxide semiconductor) still video camera. It had a 280,000 pixel CCD and recorded images onto a 2-inch floppy disk
- ► Hewlett-Packard: First color inkjet printer called Paintjet with CYMK—cyan, yellow, and magenta on one cartridge and a separate cartridge for black. Price: $1395.
- ► Kodak: entered the still video market with its Still Video System for recording, storing, manipulating, transmitting, and printing electronic still video images.
- ► Kodak: Sucy, Pete J. electronic camera using digital audiotape for recording images, which was never manufactured.
- ► Kodak: prototype still video camera capable of 25 full frame images or 50 field images using a still video floppy disk.
- ► Konica: KC-400 still video camera with ½-inch, 300,000 pixel CCD.
- ► Minolta: SB-70S and SB-90S still video camera systems used interchangeable digital backs for the Minolta Maxxum 7000 and 9000 35mm film cameras.
- ► Olympus: V-100 still video camera, part of a modular system that used V-200 or V-300 playback processor.

1988
- ► More than six new additional still video camera models were released—Fuji, Konica, Nikon, Panasonic, and Pentax.
- ► Canon: RC-470, part of the Canon Professional Still Video Imaging Kit that included a 2-inch video floppy drive and SV Scan image editing software.
- ► Canon: RC-250 XapShot (Ion in Europe, Q-PIC in Japan) Hi-band still video camera with ½-inch, 200,000 pixel CCD.
- ► Chinon: CP9-AF still video back.

▶ Fuji: DS-1P, world's first fully digital consumer camera and the first to record images on removable flash card media. Images were digitally recorded directly to memory card developed jointly with Toshiba.

▶ Hewlett-Packard: inkjet printer becomes a consumer item with release of the DeskJet inkjet printer. Price $995.

▶ Joint Photographic Experts Group (JPEG) adopts standards for image compression. JPEG is a compression file format developed so that it would be practical to transmit images electronically over the Internet.

▶ Macintosh: PhotoMac is first image manipulation program available for the Macintosh computer.

▶ Personal Computer Memory Card International Association (PCMCIA): an international standards body founded to establish standards for integrated circuit cards and to promote interchangeability among mobile computers.

▶ Polaroid: 8801 HiRES still video camera and companion printer. The system consisted of a camera, a control unit and a printer using Polaroid type 53 or 55 film for hard copy. This system was unique in that is recorded still images on VHS videotape. It was used at the Democratic National Convention in 1988

▶ Sony: Mavica MVC-C1 Personal Camera and MVC-A10 Sound Mavica.

1989 ▶ Canon: CLC 500 Color Copier with digital electronics.

▶ Fuji: DS-X still digital memory card camera 2/3-inch with a 400,000 pixel CCD.

▶ Kodak: 4-million pixel CCD array.

▶ Letraset: Color Studio 1.0, first professional image manipulation program for Macintosh computers.

▶ Sanyo: SVC-05 prototype electronic still camera 390,000 pixel CCD.

▶ Sony: DIH 2000 Digital Image Handler captured single frame images from any video source, motion or still video cameras, transmitting them over standard phone lines. The DIH 2000 and a Sony still video camera, the ProMavica MVC-5000, were used during the Persian Gulf War by the U.S. Army to transmit photos to the Army Media Services Branch in Washington, D.C. It was also the first to transmit almost instantaneous still color images over phone lines using the Sony DIH2000 Digital Image Handler and used by the CNN crew in China to transmit the Tienemen Square protest images.

▶ Toshiba: IMC-100 still digital memory card camera 2/3-inch with a 400,000 pixel CCD

1990 ▶ More than six additional still video camera models were released—Chinon, Dycam, Olympus, Pentax, Toshiba, and Yashica.

▶ Adobe: Photoshop 1.0 the second image manipulation program available for Macintosh computers.

▶ Dycam: Model 1 / Logitech Fotoman black and white digicams were the first completely digital consumer cameras sold in the United States.

▶ Hubble Space Telescope: The Hubble's workhorse instrument is the Wide Field and Planetary Camera (WFPC2). Four postage stamp-sized charge-coupled devices (CCDs) collect information from stars and galaxies to make photographs.

▶ Kodak: DCS-100 SLR digital camera used a Nikon F3 body shown at Photokina in 1990 and marketed in 1991.

▶ Kodak: Photo CD System converted film negatives or slides into digital images and burned to a Compact Disc in 5 resolutions; 35mm Rapid Film Scanner CCD array

▶ Northrop Corporation adopted the Sony Electronic Photography System eliminating the use of 1.2 million gallons of water for processing photos as well as the electrical energy required to heat the water to 90 degrees.

▶ Olympus: IC Card Camera prototype still video camera with solid-state storage.

▶ Samsung: SNAC (Samsung New Age Camera) hi-band still video camera with a 300,000-pixel MOS (metal oxide semiconductor) image sensor.

▶ Sony: CVP-G500 still video image capture device and printer combined into one unit.

▶ Sony: Hyper HAD (Hole Accumulated Diode) sensor, a light-focusing micro lens positioned over each pixel gathers, concentrates, and focuses incoming light toward the photo sensor's active imaging area

1991 ▶ More than twelve new additional still video camera models as well as partnerships were released by Bauer/Canon, Fuji, Konica, and Olympus.

▶ Crossfield: Celsis-130 and -160 professional studio digital cameras.

▶ Hasselblad DB 4000 professional model digital studio camera with Leaf digital back attached to Hasselblad film camera.

▶ Kodak: XL 7700 Digital thermal dye-sublimation transfer printer.

▶ Polaroid "G" Camera: Color version of the 1988 Polaroid HiRes black and white camera.

▶ Ricoh: professional studio camera system consisting of a film camera front and a digital back.

▶ Solid Ink Printers: Laser-class printers that use solid wax inks that are melted into a liquid before being used. Instead of jetting the ink onto the paper directly as inkjet printers do, solid ink printers jet the ink onto a drum

▶ Sony: SEPS-1000 (Sony Electronic Photography System) digital studio camera with three CCDs of 2478 × 1108 pixels each.

▶ Sony: MiniDiscs a disk-based digital medium for recording and distributing consumer audio that was intended to be near CD in quality.

▶ Sony: MVR-100 consumer still video player/recorder with RGB Sync output for direct connection to computers that had image capture boards.

▶ Tamron: FotoVix converted negatives or slides into video output for viewing on a TV monitor or recording to tape.

1992 ▶ More than six new additional still video camera models were released by Canon, Ricoh, and Sony.

▶ Iomega: a 250MB tape drive.

▶ The National Center for Supercomputing Applications released Mosaic, the first browser enabling users to view photographs over the Internet.

▶ Kodak: DCS 200 portable SLR digital camera built using a Nikon N8008S with built-in hard drive for image recording with 1280 × 1024 pixel CCD.

FIGURE 1

1993 ▶ More than six new additional still video camera models were released by Fuji, Olympus, Sony, and Toshiba

▶ Canon: prototype EOS SLR 1.3MP CCD.

▶ Da Vinci amateur camera: Built-in thermal copier which printed on thermal paper. Sold in the U.S. by American Airlines.

▶ Dycam: Model 4 24-bit color or black and white gray scale camera with a 495 × 366 pixel CCD. Gator modular digital camera developed as a joint effort between Dycam, IBM, and the University of Florida Research Foundation.

▶ Sony: Data MiniDisc used for storing computer data

▶ Stardot: WinCam.One tethered camera which connected directly to serial port eliminating the need for video capture cards and camcorders. 640 × 480 pixel CCD.

1994 ▶ Apple: QuickTake 100 first mass-market color digital camera for under $1000. 640 × 480 pixel CCD.

▶ AP/Kodak: NC2000 and NC2000E Associated Press digital SLR cameras for photojournalists:

▶ SanDisk: Compact Flash memory card introduced in October as first memory card available on the market capable of holding up to 24 MB.

▶ Durst: Lambda 130 released as the first large-format output device for the direct exposure of digital images and text data by means of laser on all types of photographic RA-4 papers.

▶ Epson: First full-color inkjet printer, MJ-700V2C provided a full 16 million colors as well as 720 × 720 dots per inch. Price: $3000.

▶ Fuji: Thermo autochrome printer Fotojoy NC-1 using specialized paper with three heat-sensitive pigment layers (cyan, magenta, and yellow) in the paper. Each layer is sensitive to a different temperature. The printer selectively heats areas of the paper with ultraviolet energy one color at a time activating and fixing the pigments

▶ Nilimaa, Stina of the Umeå Institute of Design, University of Umeå, Stockholm, Sweden: A Hasselblad digital camera design degree project by Nilimaa (1995 graduate) in collaboration with Hasselblad Electronic Photography.

▶ Iomega: a 100 MB ZIP drive.

▶ Olympus: Deltis VC-1100 world's first digital camera with built-in transmission capabilities. Photojournalists and other photographers could connect a modem to the VC-1100 and upload digital photos over cellular and analog phone lines

▶ SmartMedia memory card: The key difference between a SmartMedia card and a Compact Flash card is that the controller chip is in the camera rather than in the SmartMedia card.

1995

- ▶ More than 35 new digital camera models were released by Apple, Canon. Canon/ Kodak Chinon, Dycam. Fuji, Kodak, Logitech, Minolta, Olympus, Ricoh, Ritz, Snappy, Samsung, and Toshiba
- ▶ Agfa: StudioCam professional digital studio camera with a 4500 × 3648 pixel CCD.
- ▶ Casio: QV-10 first consumer digital camera with a pivoting lens and the first with a Liquid Crystal Display (LCD).
- ▶ Casio: LT-70 household videophone.
- ▶ Apple: Apple Color Laser Writer and QMS Magicolor, both at 600 dpi, provided photo quality prints with a $7000 price range. 496 × 365 pixel CCD.
- ▶ Dycam: Agricultural Digital Camera (ADC) portable digital camera specifically tailored for multi-band photography in the visible red and near infrared.
- ▶ Kodak: Dye sublimation printers provided the best quality image output for the price (starting around $5000), however, media costs ran several dollars per page (11 × 17) compared to 50 cents per page for inkjet or thermal wax printers.
- ▶ Fuji: ATOMM technology helps create 100MB Zip™ disk format – far exceeding the current limit of 21MB. (Zip is a trademark of Iomega Corporation)
- ▶ Inkjet dye-sublimation transfer printing. Desktop computers and inexpensive inkjet printing of sublimation transfers are used for the mass customization market such as clip-boards, mouse pads, and coffee mugs, but the process works on synthetic substrates only.
- ▶ eBay: (Nasdaq: EBAY) is formed in September.
- ▶ Iomega: JAZ drive, 1GB
- ▶ Kodak: DCS 460 based on the Nikon N90S, with a CCD chip of 6 million pixels (2036 × 3060 pixels).
- ▶ Kodak: introduced its Internet website www. kodak.com.
- ▶ Minolta: RD-175 (Agfa ActionCam): A profes-sional/prosumer SLR digicam based on the Minolta Maxxum 500si body with three 380,000-pixel CCDs, each with a size of 1528 × 1146 pixels.
- ▶ Ricoh: RDC-1 first digital camera to offer both still image and moving image/sound record-ing and reproduction. 768 × 480 pixel CCD
- ▶ Play Snappy video still capture device: The Snappy and similar devices have the capabil-ity of capturing still images from various ana-log or digital moving image sources.
- ▶ Toshiba: ProShot PDR-100 first compact digi-tal still camera equipped with a modem and communications software allowing users to transmit recorded digital images via standard telephone lines without any additional exter-nal equipment. 1/3-inch 640 × 80 pixel CCD

1996

- ▶ More than 67 new digital camera models were released Agfa, Apple, Canon, Casio, Chinon, Compro, Epson, Fuji, Epix, Kodak, Konica, Kyocera, Minolta, Momitsu, Olympus, Panasonic, Polaroid, Ricoh, Samsung, Sanyo, Sega, Sharp, Sierra, and Sony.
- ▶ Dicomed: BigShot 4000 professional digital studio camera back that was the first not only to exceed the 35mm frame size, but also to exceed the 5.6 × 5.6 cm size of a Hasselblad back
- ▶ Hitachi: MP-EG1, MP-EG1A, and MP-EG10 world's first digital cameras which could output moving pictures to a personal com-puter in the MPEG format. ¼-inch with a 352 × 240 CCD for video and 704 × 408 (still) pixels CCD.
- ▶ JVC: TK-F7300U and KY-F55 professional still video cameras designed for medical and industrial use. Single 1/3-inch with a 4416 × 3456 pixel CCD.
- ▶ NASA and the Jet Propulsion Laboratory began America's return to Mars after a 20-year absence by launching the Mars Global Surveyor (MGS) spacecraft. Most of the data from the MGS was generated by a dual-mode camera called the Mars Orbiter Camera (MOC).
- ▶ Nikon: Coolpix 100 first camera with remov-able PC card slot camera insert. 1/3-inch, 512 × 480 pixel CCD
- ▶ Obsidian Imaging: IC-100 designed to pre-vent image tampering by creating an image signature within the camera when the photo was taken. The camera software was able to compare any subsequent copy of the image with the original and detect alterations.
- ▶ Pentax: EI-C90 unusual first digicam, the EI-C90 could be separated into two sections so that the section containing the camera could be carried alone if desired while the section containing the LCD could be left at home with a 768 × 560 pixel CCD.
- ▶ Pixera: Professional tethered (non-portable) digicam. Images were stored on the PC hard drive. 1/3-inch, 1280 × 1024 pixel CCD.
- ▶ Sony: Picture MD, prototype of the Sony MiniDisc camera. Designed to use the Sony Data MiniDisc developed in 1993.

1997

- ▶ More than 156 new digital camera models were released Agfa, Altima, Aztech, Canon, Casio, Claxon, Epson, Fuji, Hewlett Packard, Intel, Kinon, Kocom, Kodak, Konica, Kyocera, LG, Liton, Minolta, Mustek, NEC, Olympus, Panasonic, Phillips, Plus, Polaroid, Pretec, Relisys, Ricoh, Sampo, Samsung, Sanyo, Sega, Sharp, Sony, Sound Vision, Spot, Toshiba Trust, UMAX, Viewcom, Vivitar, Xerox, and Yashica.
- ▶ Iomega JAZ drive 2GB, 40MB click drive.

- ► Leica: S1 Prototype studio scanner camera.
- ► Plasmon: DW260 magneto optical drive
- ► Sony: introduces Read-Write (RW) Compact Disks
- ► Sound Vision: SVmini (Vivitar Vivicam 3000, UMAX MDX-8000) first digital still camera on the market to use a CMOS sensor instead of a charge-coupled device (CCD). 1000 × 800 pixel CMOS image sensor;

1998
- ► More than 160 new digital camera models were released Agfa, Ansco, AOL, Canon, Casio, Claxon, Epson, Fuji, Hewlett Packard, Intel, Jenoptik, JVC, Kinon, KBGear, Kodak, Konica, Kyocera, Largon ,LG, Leica, Liton, Minton, Minolta, Mustek, Nikon, NMC, Olympus, Pentacon, Panasonic, Phillips, Plus, Polaroid, Premier, Pretec, Relisys, Ricoh, Rollei, Samsung, Sanyo, Seagull, Sharp, Sony, SVision, and Toshiba.
- ► Google, Inc: Incorporated in Menlo Park, California.
- ► Iomega: 250MB ZIP drive.
- ► Kenwood: VC-H1 combined an image-scan converter, CCD camera and LCD monitor into a single battery-operated unit. It could be connected to an amateur radio transceiver to send and receive color images over the air. Detachable ¼-inch, 270,000 pixel CCD camera.
- ► Retired Senator and former astronaut John Glenn used a Kodak DCS 460 digital camera during his space shuttle trip in 1998. Eastman Kodak Company donated the camera to the Smithsonian's National Air and Space Museum, Washington, D.C.
- ► America Online and Kodak announced "You've Got Pictures!," a service where AOL members could have their processed pictures delivered online.
- ► Nintendo: Game Boy Camera and Pocket Printer—128 × 128 pixel black-and-white CMOS sensor. The first company to integrate an ICIS (Intelligent CMOS Image Sensor) chip into a commercial product was Nintendo in 1998 with their Game Boy Camera. The camera plugged into the Nintendo Game Boy as a game cartridge and allowed users to acquire images and edit them for viewing or output then onto the Pocket Printer.
- ► Sony: MemoryStick; in the fall Memory Card standard is released.
- ► Spheron: VR PanoCam DPC-10 designed to take panoramic photos directly rather than by stitching individual still photos in a PC with a 2500 × 10,000 pixel CCD.

1999 and Forward
- ► In 1999 there was a veritable explosion of digital photography and products. Manufacturers in Taiwan, Korea, China, Japan, and elsewhere began to produce large numbers of digital cameras, especially at low price that were sold under a wide variety of names. Often, a single camera would be sold under a dozen or more brand names. For this reason it was not practical or possible to obtain information concerning many digital photography products. Items listed from 1999 and thereafter are limited to major brands or those camera or innovations that were unusual or considered to be of significant general interest.
- ► C3D Fluorescent Multi-layer Card (FMC) and Disk (FMD): Public demonstration of C3D's three-dimensional optical storage technology.
- ► Fuji: Super CCD New honeycomb-shaped CCD image sensor.
- ► IBM: Microdrive CompactFlash+ (or CF Type II) format. Original capacity up to 340 MB.
- ► JPEG 2000: The International Standards Organization's JPEG2000 committee finalized specifications for the JPEG 2000 algorithm (ISO 15444).
- ► PrintRoom.com begins on-line photo finishing and sharing services.
- ► Sanyo/Olympus/Hitachi Rewritable magneto-optical disc: 730 MB capacity.
- ► Secure Digital memory card to be jointly developed by Matsushita, SanDisk, and Toshiba.

2000
- ► Castlewood: ORB drive 2.2 GB
- ► Samsung: camera cell telephone. Samsung integrates a digital camera into a mobile phone that can take up to 20 pictures of 640 × 480 pixels (350,000 pixel CCD, 1 MB internal storage).

2001
- ► Agfa: announces intention to withdraw from the digital camera market.
- ► Buffalo (Japan): announces the "AirStation" wireless Compact Flash Type II card.
- ► Durst Technologies: develops the high performance inkjet printer Rho 160 for industrial large-format digital printing for photo laboratories, silk-screening, and the publishing industry and the Theta 50 which is a fully digital lab based on laser exposure technology guarantees the highest quality in specialized photo finishing laboratories
- ► Google launches a search engine for images.
- ► Konica: e-mini M Camera plus MP3 player with a 640 × 480 pixel CMOS image sensor.
- ► PCMCIA, an international standards body and trade association for the modular peripheral industry, announces the release of CardBay(tm), the fourth-generation standard for PC Card technology.

- Polaroid Corporation files for bankruptcy protection.
- Princeton (Japan): announces the first physically write protectable CompactFlash memory. Available as a Type I flash card in a variety of capacities.
- Sharp: one CompactFlash type I Bluetooth card and two other Bluetooth modules, which can be used internally within a device.
- Sony: "InfoStick" module which provides a Bluetooth communications module for compatible hardware. Large-scale Active Matrix Organic Electro Luminescence (OEL) display driven by thin film transistors (TFT);
- Viking Components: announces the addition of MultiMedia Cards (flash storage cards about half the size of SmartMedia) to their product range.

2002
- Foveon: announces an image sensor called the X3, the first sensor capable of capturing full color for every pixel in its array by measuring different colors at different depths within the silicon.
- Fujifilm: announces xD Picture Card flash storage media. The xD Picture Card was developed in conjunction with Olympus as a replacement for the SmartMedia format.
- Leica: Digilux 1 2240 × 1680 pixel CCD. Optical viewfinder.
- Olympus and Kodak announce the Four Thirds System (4/3 System) designed to be a new standard for digital SLR cameras.

2003
- Iomega: announces development of a 1.5 GB Digital Capture Technology (DCT) platform aimed at OEM manufacturers.
- Konica, the world's third-largest photo film-maker, and Minolta, a leading maker of SLR cameras, announce agreement to merge.
- Kodak: EasyShare Printer Dock 6000. Direct dye sublimation 4 × 6 inch printer combined with camera dock (image downloader). Price $199.
- The PCMCIA technology association announces the NEWCARD format. This format makes use of PC Card, PCI Express, and USB 2.0 technologies.
- Ritz Camera announces "Single-Use" digital camera.
- SanDisk announces a combined WiFi (wireless fidelity) and flash memory CompactFlash and Secure Digital cards.

2004
- Casio has announced the development of a lens for compact cameras which is made of a transparent ceramic material rather than glass.
- Matsushita announces the development of its next-generation image sensor ν(nu)MAICOVICON.

- Philips Research demonstrates a variable-focus lens system with no mechanical moving parts. Philips' FluidFocus system mimics the action of the human eye using a fluid lens that alters its focal length by changing its shape.
- MMCmicro multimedia card: Samsung announces a multimedia card for camera phones that is one-third the size of RS-MMC (reduced size multimedia cards). The MMCmicro was designed as a response to the decreasing size of mobile phone cameras.
- Toshiba announces a methanol fuel cell weighing 8.5 g (0.3 oz) which can produce 100 mW of power.

2005
- Agfa Photo files for insolvency.
- Hewlett-Packard discontinues camera sales in Asia.
- Kodak announces that the DCS Pro SLR/n and DCS Pro SLR/c digital SLRs have been discontinued and will no longer be manufactured.
- Kodak earns more money from its digital products than its film products for the first time in the 3rd business quarter of the year.
- Konica Minolta and Sony announce an agreement to jointly develop digital SLR cameras.
- Kyocera announces that the company will cease production of film and digital cameras.
- Kyocera announces that Contax brand camera operations will be terminated.
- SanDisk announces an SD card which has a hinged portion that when flipped over allows the card to become a USB 2.0 Flash Drive.
- Scientists at Canada's Université Laval develop a lens five times thinner than paper which can zoom without using mechanical parts. The lens is created by adding a small quantity of photosensitive material to a liquid crystal cell.
- Wacom Europe has announces the first pen tablet to incorporate wireless technology.

Concluding Thoughts

The last entry was made September 2005 so that the manuscript could be moved through the production cycle on time. Recording of significant milestones in any technology's advance wis a never complete. For more information go to the following web sites:

http://www.dchis.com (DigiCamHistory.Com)
http://www.dpreview.com (Digital Photography Review)
http://www.digitalkamera.de/Kameras/Schnellzugriff-de.htm (digitalkamera.de)
http://www.imaging-resource.com/ (Imaging Resource)
http://www.steves-digicams.com/ (Steve's Digicams)

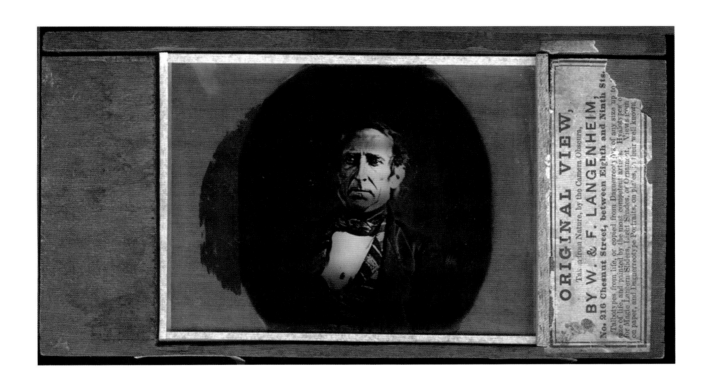

HISTORY AND EVOLUTION OF PHOTOGRAPHY

MARK OSTERMAN
George Eastman House International Museum
 of Photography and Film

GRANT B. ROMER
George Eastman House International Museum
 of Photography and Film

Contemporary Thoughts on the History of Photography

GRANT B. ROMER

George Eastman House and International Museum of Photography and Film

All photographers work today with historical perspective. They know that the technology they use has an origin in the distant past. They know photography has progressed and transformed over time, and they believe the current system of photography must be superior to that of the past. They are sure they will witness further progress in photography. These are the lessons of history understood by all, and none need inquire any further in order to photograph.

Yet photography has a very rich and complex history, which has hidden within it the answers to the fundamentally difficult questions: "What is photography?" and "What is a photograph?" All true photographers should be able to answer these questions for themselves and for others. To do so, they must make deep inquiry into the history of photography.

Recognition of the importance of history to the understanding of photography is evidenced in the title and content of the very first manual of photography published in 1839, *The History and Description of the Process of the Daguerreotype and Diorama.* Most of the early inventors of photographic processes gave account of the origin of their discoveries not just to establish priority but also to assist comprehension of the value and applications of the technology. When the entire world was childlike in understanding the full potential of photography, this was a necessity.

Many histories of photography have since been written for many different reasons. Each historian, according to his or her interest and national bias, placed certain details large in the foreground, diminished others, and represented most by a few slight touches. By 1939, the hundredth anniversary of photography, a much-simplified chronological story had been told, more or less fixed and repeated ever since. In essence it goes as follows: Photography emerged in the first quarter of the 19th century in Western Europe out of the exploration of the properties and effects of light, the progress of optics and chemistry, and the desire to make accurate and reproducible pictorial records of visual experience.

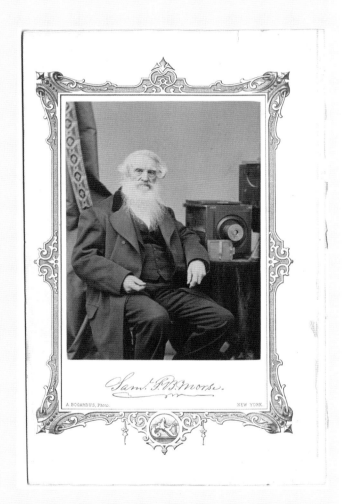

FIG. 1 A representative period portrait of inventor Samuel F. B. Morse, ca. 1890, by Abraham Bogardus. Albumen print. Courtesy of the George Eastman House Collection, Rochester, New York.

Part page photograph: Photograph of John Taylor made by W. and F. Langenheim, ca. 1846. Transparency, albumen on glass (Hyalotype). Image courtesy of the George Eastman House Collection, Rochester, New York.

The first processes were relatively limited and were rapidly improved by the efforts of many through better lenses, camera design, and chemical innovation. One process yielded commercial dominance to an easier and better one until gelatin emulsion technology brought a new era of photography in the 1880s, which was to continue into the 21st century. The photography industry subsequently grew. More people became enabled to make more photographs. Cameras were freed from the tripod. Color and motion picture photography became possible. The applications of photography steadily multiplied and increasingly benefited society. "Masters" of the medium, in every era, created photographs that transformed how we see and what we know.

The developments of the last decade now make it necessary to deconstruct and reassemble that history of photography to include the origins, progress, and transformation of electronic imaging as well as that of other recording, reproduction, and information technologies. For instance, Becquerel's observation of the photovoltaic effect in 1839 must be placed along with Daguerre and Talbot's discovery of principle of the latent image as a primal moment in the history of photography. Every purchase of a digital camera adds to the historical importance of the discovery of the conversion of light into electricity.

With the convergence of imaging and information technology, it is now quite legitimate to trace the history of photography within many contexts other than that of the progress of optics and chemistry. Photography is now seen as a part, not the all, of imaging technology. The very definitions of *photography* and *photograph* are in transition along with the technology and industry of photography. Thus the history of photography must also change as silver is replaced by silicon. A new generation of photographers will soon know nothing directly of the thrill and mystery of the development of the latent image, which has long been the initiatory experience and bond among serious photographers. The digital revolution, like all revolutions, is in the process of disrupting and destroying an old order. The history of the chemical era of photography may become less interesting if it is not properly linked to the electronic era by a new inquiry.

History teaches that photography is a mutable and ever-changing technology. How it changes is not as interesting as why it changes. By what criteria is any method of photography judged superior to another at any given time, and who are the significant judges? Who decides what form of photography serves in the present? The future historians of photography would do well to address these questions. Perhaps the most interesting and important question for all is, "What do we want photography to be?"

The Technical Evolution of Photography in the 19th Century

MARK OSTERMAN
George Eastman House and International Museum of
 Photography

Concept and First Attempts

Whereas the observation of numerous light-sensitive substances and the formative evolution of the camera obscura predate 1800, the invention of photography, as we know it, was essentially a 19th-century phenomenon. Who actually invented photography has been disputed from the very beginning, though the task would have been easier had there been a universally accepted definition of *photograph*.

Taken literally, the Greek words *photos* and *graphos* together mean "light drawing." Even today the term *photography* is being manipulated to fit digital imaging, but in its most elegant form, a photograph may best be described as a reasonably stable image made by the effect of light on a chemical substance. Light is energy in the form of the visible spectrum. If light or some other invisible wavelength of energy is not used to make the final picture by chemical means, it cannot, by this definition, be a photograph.

The stability of an image made by light is also important. Without stability, the term *photograph* could apply to the most fragile and fugitive examples of images such as frost shadows of buildings on a sunny November morning. The word *photography* was not the product of just one man. Its introduction was a logical choice by those with knowledge of Greek who contemplated the concept. The term may have been first used by Antoine Hercules Romuald Florence in 1833. Florence was living in Brazil, working in relative isolation, and had no apparent influence on the European scientific community. Sir John Herschel (Figure 30), in England, also used the terms *photography* and *photograph* in 1839, but his contacts were many. Because of this Herschel has traditionally been credited with the use of the terms by those seeking words to describe both the process and product.

Some of the first images to be recorded with light-sensitive materials were made by Thomas Wedgwood, son of Josiah Wedgwood, the well-known potter. His associate, the scientist Sir Humphrey Davy, published the results and observations in the *Journal of the Royal Institution* in 1802. Wedgwood and Davy made images on paper and white leather coated with silver nitrate. They laid leaves and paintings on glass upon the sensitive materials and exposed them to sunlight, which darkened the silver. In an attempt to keep the image, they washed the exposed materials without success. They found that combining the silver solution with sodium chloride produced the more sensitive whitish paste of silver chloride. Even with this improvement, Wedgwood felt the process was too slow to make images in a camera, and though they did make the first photographic enlargements of microscopic specimens by projecting the images using a solar microscope, they had no way to preserve the image once it was formed.

Many of the observations of Wedgwood and Davy were actually ideas already covered years earlier by Johann Heinrich Schulze (1725), Carl Wilhelm Scheele (1777), and Jean Senebier (1782), though without the same sense of purpose. Schulze discovered the sensitivity of silver nitrate to light rather than to heat. Scheele, in addition, observed and published that ammonia would dissolve unexposed silver chloride, the means to permanently fix silver chloride images. It is still difficult to understand why Scheele's published observation escaped Davy. The experiments of Wedgwood and Davy are important because their work combined photochemical technology with the sole intent to make images with light. Few doubt that success would have come to Wedgwood had he applied ammonia to his images, but he died a few years after publishing his findings. Davy did not continue the research.

Joseph Nicephore Niépce

Several years later Joseph Nicephore Niépce (Figure 110), living in the village of Saint-Loup-de-Varennes near the town Chalon-sur-Saône in France, began his own experiments using paper sensitized with silver chloride. Some time around 1816, Niépce made printed-out negative images on paper by using a camera obscura and partially fixed them with nitric acid. Not satisfied with the process, he moved on to another light-sensitive material, asphaltum.

Niépce had been involved with etching and lithography and was looking for a means to make etched plates without having to depend on skilled handwork. It is probable that he and others would have noticed that the asphalt etching ground was harder to remove with solvents when printing plates were exposed to the sun. He coated lithographic stones and plates of copper, pewter, zinc, and glass with asphaltum dissolved in oil of lavender. When the asphalt dried, the plates were covered with an object and exposed to light. The unexposed areas were then dissolved with a solvent such as Dippel's oil, lavender oil, or turpentine while the hardened exposed areas remained intact, creating a negative image. Why Niépce did not use his asphalt images on glass as negatives to make positive prints on silver chloride paper remains a mystery to photographic historians and scholars.

Niépce eventually placed waxed engravings in contact with these sensitive plates. After the unexposed areas were removed with a solvent, the plate negative image of the engraving was visible. The plate was then etched with acid and subsequently used as a conventional etching plate for printing in a press. Niépce called these plates heliographs, from the Greek words *helios* and *graphos*, meaning "sun drawing." The process eventually became the conceptual cornerstone of the photoengraving industry.

Of all the heliographic plates made by Niépce, the only known surviving example made in a camera has become an icon of photographic history. In 1826 Niépce prepared a heliograph with a thinner asphalt coating upon polished pewter. This plate was exposed in a camera facing out the window of

his estate, known as Le Gras (Figures 38–40). The "View from the Window at Le Gras," now in the Gernsheim collection at the Harry Ransom Center in Austin, Texas, probably took two days of exposure to record the outline of the horizon and the most primitive architectural elements of several buildings outside and below the window. Niépce's image is both negative and positive depending on how it is illuminated, and it is permanent.

Louis Jacques Mandé Daguerre

It was 1826 when Louis Jacques Mandé Daguerre contacted Niépce though the firm of Vincent and Charles Chevalier (Figure 26), opticians in Paris from whom they were both purchasing lenses for their experiments. Daguerre, inventor of the popular Diorama in Paris, was also seeking a means to secure images by light in a camera. At the time of their meeting, Niépce was discouraged because of an unsuccessful trip to London where he had tried to generate interest in his heliograph process. Daguerre had nothing more to offer than some experiments with phosphorescent powder and a technique called *dessin fumee*—drawings made with smoke (Figure 41). Nevertheless, Niépce entered into partnership with Daguerre in 1829 for the purpose of working toward a common goal. It is assumed that he felt that Daguerre's energy and popular success would be of some benefit.

By the early 1830s, both Daguerre and Niépce observed that light would darken polished silver that had been previously exposed to iodine fumes. Niépce used that same technique to darken the exposed portions of heliographs made on polished silver plates. Niépce and Daguerre had also developed the physautotype, a variant of the heliograph that used rosin instead of asphalt on silver plates. The process was equally slow, but the images were superior to the heliograph, looking more like the daguerreotype that was soon to be invented. It is assumed that around this time Daguerre came upon the process that would make him famous. His experiments began by exposing silver plates fumed with iodine in the back of a camera obscura. Given sufficient exposure, a fully formed violet-colored negative image against a yellow ground was made on the plate within the camera. These images were beautiful, capable of infinite detail, but not permanent.

Daguerreotype

In 1833 Niépce died, leaving his heliograph process unpublished and his son Isadore to assume partnership with Daguerre. Two years after Niépce's death, Daguerre discovered that the silver iodide plate required only a fraction of the exposure time and that an invisible, or latent, image that could be revealed by exposing the plate to mercury fumes. Instead of requiring an exposure of hours, the new process required only minutes, and the image could be stabilized by treating it in a bath of sodium chloride.

The resulting image, called a daguerreotype, was both positive and negative depending on the lighting and angle in which it was viewed. The image was established by a delicate,

frosty white color in the highlights and black in the polished silver shadows, provided the plate was tilted toward a darkened room. By the time he demonstrated the daguerreotype process to Francois Arago, the director of the Paris Observatory, Daguerre had a completely practical photographic system that included fixing the image permanently with sodium thiosulfate, a process that was discovered by Sir John Herschel in 1819. Sodium thiosulfate was known at this time as hyposulfite of soda or as hypo. In 1839 the French government awarded Daguerre and Isidore Niépce a pension for the technology of the daguerreotype and offered the discovery to the world.

Every daguerreotype was unique. The final image was the very same plate that was in the camera during exposure. The latent image and use of silver combined with iodine (silver iodide) that were introduced by Daguerre became the basis of every major camera process of the 19th century until the introduction of gelatin bromide emulsions used in the manufacture of dry plates and developing-out papers.

Photography on Paper

William Henry Fox Talbot (Figure 36), an English scholar in the area of hieroglyphics, began his own experiments with silver chloride in 1834. Talbot, however, came to understand how the percentages of silver nitrate to sodium chloride affected sensitivity. Nevertheless, images made in the camera could take hours. Why he did not use hypo to fix his images remains a mystery since he was in communication with Herschel. Hypo was an expensive chemical, and it is possible that Talbot sought another compound for the sake of economy.

His observations, however, led him to discover a way of making the unexposed areas of his images less sensitive. Talbot treated his images in a strong solution of sodium chloride and a dilute potassium iodide or potassium bromide, which resulted in the colors brown, orange, yellow, red, green, and lilac, depending on the chemical and degree of exposure. This process did not actually remove the unexposed silver chloride, so these images were simply considered "stabilized." Provided the image was not exposed to strong light, it could be preserved for years or even used to make a positive image by contact printing in the sun on a second piece of sensitized paper.

The process for both the stabilized negative and the subsequent positive print was called photogenic drawing. Like all silver chloride papers, the exposures required for a fully formed print were minutes for a contact image of a leaf printed in the sun and up to several hours for a negative made within a camera, depending on the size of the negative. Typically the procedure of using the original negative to make a positive print often darkened the former so much that it was useless for printing a second time. By 1839 Talbot's positive photogenic drawings were colorful, soft in focus, and still relatively sensitive. Compared to the speed, permanence, and infinitesimal resolution attainable by the daguerreotype, the photogenic drawing was very primitive, very slow, and impossible to exhibit in daylight without a visible change. Sir John Herschel is said to have remarked to Arago after seeing a daguerreotype

in May of 1839, "This is a miracle. Talbot's [photogenic] draw-ings are childish compared with these."

1839 — The Race for Acknowledgment

Talbot was caught off guard when Daguerre's work was announced by Arago to the Academy of Sciences in Paris on January 7, 1839. Aware but not knowing the details of Daguerre's technique, Talbot rushed to publish his own photo-genic drawing process in a report titled, "Some Account of the Art of Photogenic Drawing." The report was read to the Royal Society on January 31 and subsequently published in the English journal *The Athenaeum* on February 9. Talbot's account made a strong point of the utility of his process but contained no specific formulas or details of the actual tech-nique of making photogenic drawings.

Daguerre and Isidore Niépce had accepted a government pension in exchange for the details of both the daguerreo-type and heliograph processes. On August 19, 1839, Arago explained the daguerreotype process in detail to a joint meeting of the Academy of Science and the Academy of Fine Arts at the Palace of the Institute in Paris. A daguerreotype camera and complete set of processing equipment was manu-factured by Giroux, Daguerre's brother-in-law, and offered for sale at this time. Daguerre also produced a manual, which was the first of its kind and remains one of the most compre-hensive photographic treatises ever written. Within its pages are historical accounts, complete formulas, descriptions of Niépce's heliograph process with variations, and Daguerre's latent image process, and line illustrations of all the equipment needed to make a daguerreotype.

Bayard, Ponton, and Herschel

Hippolyte Bayard, an official at the Ministry of Finance in Paris, invented a direct positive process on paper in 1839. His process was based on the light bleaching of exposed silver chloride paper with a solution of potassium iodide. The prints were then permanently fixed with hypo. Bayard sought the attention of the French government to claim the inven-tion of photography. His direct positive process was perma-nent but very slow and was rejected in favor of Daguerre's. In 1840 Bayard submitted his process a second time and was rejected again. In response he produced a self-portrait as a drowned man and sent it to the Academy accompanied with prose expressing his disappointment. Had this image been of a leaf or piece of lace, like so many of Talbot's photogenic draw-ings, Bayard and his process would probably never have been remembered with such pathos. In comparison, Bayard's direct positive self-portrait was technically superior to what Talbot was making at the same time.

In 1839 Mungo Ponton, in Scotland, observed that paper soaked in a saturated solution of potassium bichromate was sensitive to light. The delicate printed-out image was washed in water and had reasonable permanence. The process was not strong enough for a positive print and not fast enough for camera images, but Ponton's work led Talbot to discover

the hardening effects of gelatin treated with chromium compounds. This characteristic of dichromated colloids became the basis of both carbon and gum printing and several photomechanical printing processes.

In the same year, Sir John Herschel made hypo-fixed silver carbonate negatives on paper. He also produced the first silver halide image on glass by precipitating silver chloride onto the surface of a plate and printing out a visible image within a camera. The process was similar and as slow as the photogenic drawing, however in this case the image was permanently fixed with hypo. When this glass negative was backed with dark cloth, it could be seen as a positive image. Herschel, who could have invented photography, seems to have been satisfied with helping others to do so. He held back on publicizing his processes as a courtesy to Talbot.

Improvements to Daguerre's and Talbot's Processes
The improved daguerreotype

Daguerre's original process of 1839 was too slow to be used comfortably for portraiture. Exposures were typically no less than 20 minutes. Because of the slow lens and optics of the time, the early daguerreotype process was limited to still-life and landscape imagery. Two improvements that were to change all this were the introduction of bromine fumes in the sensi-tizing step of the process and the formulation of a faster lens.

In 1840 several experimenters working independently discovered that different combinations of chlorine, bromine, and iodine fumes could be used to produce daguerreotype plates that were many times more sensitive than plates that were simply iodized. Because of these experimenters' research, daguerreotypists eventually settled on fuming their plates with iodine, then bromine, and once again with iodine. The bromine fuming procedure eventually became standard prac-tice throughout the daguerreotype era, allowing daguerreo-typists to make exposures measured in seconds.

The design of a faster lens, formulated in 1840 by Max Petzval, also allowed for shorter exposures. In combina-tion with the more sensitive plate, this faster lens ushered in the first practical application of the daguerreotype process for portraiture. The Petzval lens was designed specifically for portraiture and became the basis for all portrait and projec-tion lenses for the next 70 years. By the early 1840s, commer-cial daguerreotype portraits were being made in studios under a skylight (Figure 45).

Another important improvement in 1840 was gold toning, introduced by Hippolyte Fizeau. A solution of *sel d'or*, made by adding gold chloride to hypo, was applied to the fixed plate. The process became known as gilding. Gilding extended the range of tones and made the fragile image highlight less susceptible to abrasion.

The calotype

Talbot's photogenic drawing process, as introduced, was also impractical for portraiture even when improved lenses became

available. In 1841, however, Talbot changed his formula to use silver iodide, which was more sensitive than silver chloride. It was the very same silver halide as used by Daguerre, though applied to paper. The iodized paper was sensitized with a solution of silver nitrate, acetic acid, and a small amount of gallic acid.

This new paper was exposed damp and required only a fraction of the time needed to print a visible image with the photogenic drawing process. It bore either a feeble or no visible image when removed from the camera. The latent image was developed to its final form in a solution of gallic acid and then stabilized in potassium bromide or permanently fixed in sodium thiosulfate. The new process was called the calotype, from the Greek *kalos,* meaning "beautiful." Despite the use of silver iodide, the calotype process usually required at least a minute of exposure in full sunlight using a portrait lens.

Calotype negatives could be retouched with graphite or inks to prevent transmission of light or could be made translucent locally with wax or oil. Talbot made positive prints from these as he did with photogenic drawings, by printing them in the sun onto plain silver chloride paper. Even after Talbot adopted the use of hypo for fixing his negatives, he occasionally stabilized these prints in salt or iodide solutions, presumably because he preferred the final image colors. Eventually Talbot and other calotypists chose to permanently fix their positive images in hypo, resulting in an image of colors ranging from deep orange to cool brown. These were called salt (or salted) paper prints (Figures 51 and 52). Another improvement was made by not adding the gallic acid in the sensitizing step of the process.

Those wishing to use the patented calotype process were required to pay Talbot for the privilege. This license was expensive, and the commercial potential of the calotype process was not particularly attractive to the average working person. The calotype seemed to appeal to the educated upper classes that had an appreciation for the arts, scientific curiosity, and plenty of leisure time. Variants of preparing calotype paper began to emerge as more people used the process. An early improvement to the process omitted the gallic acid in the sensitizer, allowing the paper to be used hours after preparation without browning spontaneously.

In 1844 Talbot published the first installment of a book titled *Pencil of Nature,* which was illustrated with salt prints from calotype negatives. The publication was sold by subscription, and subsequent issues were sent to the subscriber as they were produced. Because of technical difficulties, *Part II* was not sent until seven months after the first. *Part VI* was not available until 1846. The venture was not successful, but it offered a vision of what might be possible in the future. If there was ever a commercial use for the calotype, it was to be for the illustration of written material and particularly for documentation of architecture. Although not technically conducive to portraiture, particularly in a studio, the calotype process was used on occasion for this purpose.

The most ambitious and celebrated uses of the calotype process for portraits were made by the team of David Octavius Hill and Robert Adamson (Figure 50) as reference images for a painting that Hill was planning of the General Assembly of the Free Church of Scotland. The portraits for this project give a fair idea of the quantity of light required for an exposure. In many examples the subjects face sunlight as if it were a strong wind. Hill and Adamson produced several bodies of work from 1843 to 1847, including genre portraits and architectural views. Their work stands alone as the most comprehensive use of calotypy for portraiture.

Although the calotype process was licensed by Talbot to Frederick and William Langenheim of Philadelphia, the calotype would never become popular in the United States. Shortly after the process was perfected by the Langenheims, the daguerreotype was well established and not to be toppled until the invention of collodion photography in 1851.

Calotypes were made by a small number of photographers in the 1840s and early 1850s (Figures 58 and 60), the most famous examples being documentary images of architecture by French and English photographers. In 1851 Maxime du Camp produced major albums of views from Egypt, Palestine, and Syria, which were documented by the calotype process in 1849 (Figure 62). Documentary work by Edouard Baldus and Henri le Secq (Figure 59) were also made with an improved variant of the calotype called the waxed-paper process, introduced by Gustave Le Gray in 1851.

The waxed-paper process evolved because French papers were not ideally suited for calotype as they were sized with starch rather than gelatin. Le Gray saturated the paper with hot beeswax prior to treating with iodine and sensitizing with silver. The development was identical to the calotype. Waxing the paper prior to iodizing resulted in better resolution, and the process could be done with the paper completely dry, making it perfect for the traveler.

The Business of Photography

By the late 1840s, the daguerreotype process was being used commercially in every industrialized nation of the world. Although the total number of calotypes made in the 19th century might be counted in the thousands, this was still less than the yearly production of daguerreotypes in most major cities in the United States in the 1850s. The business of the daguerreotype was profitable for many daguerreotypists, the plate manufacturers, and the frame and case makers.

The American daguerreotypists in particular produced superior portraits (Figure 69). A technique perfected in America called galvanizing involved giving the silver plate an additional coating of electroplated silver. Galvanizing contributed to greater sensitivity, which was important for portraits, and it provided a better polish, resulting in a wider range of tonality. The works of Thomas Easterly and of the celebrated team of Albert Southworth and Josiah Hawes (Figure 56) remain as both technical and artistic masterworks. The daguerreotype was well established in the early 1850s as a commercial and artistic success, though it also had drawbacks. The images were generally small, laterally reversed direct positives that required copying or a second sitting if an additional image was desired.

Although not impossible, landscape work was a technical commitment and not commercially profitable considering the effort required to make a single plate. When properly illuminated, daguerreotypes were (and still are) awe inspiring; however, they were seldom viewed at the best advantage. This failure resulted in a confusion of negative and positive images juxtaposed with the reflection of the viewer.

Negatives on Glass

In 1847 a new negative process, producing the niépceotype, was published in France by Abel Niépce de Saint Victor (Figure 33). After initial experiments with starch, Niépce de Saint Victor came upon the use of egg albumen as a binder for silver iodide on glass plates. Variants of the same albumen process were simultaneously invented by John Whipple, in Boston, and the Langenheim brothers, in Philadelphia. Development of these dry plates was identical to the calotype, but they required much more time. Exposures too were much longer than those required for the calotype, but the results were worth the effort. Even by today's standards, the resolution of these plates was nearly grainless. The Langenheims took advantage of this characteristic and in 1848 invented the hyalotype (Figures 53 and 54). This was a positive transparency on glass that was contact-printed from albumen negatives.

The Niépceotype process was never to be used for studio portraiture, but for landscape and architectural subjects it was technically without equal even after the collodion process was invented. It was, however, still a tedious process, and after 1851 the only reasonable applications of the albumen process were for when a dry process was advantageous or for the production of lantern slides and stereo transparencies where resolution was important.

A major essay made during the latter part of the Crimean War in the mid-1850s was documented with large albumen plates by James Robertson (Figure 71), and Felice Beato. After the war Robertson and Beato made images in the Middle East, continuing a series started before the war, and in war-torn India. The pictures of the Siege of Lucknow and the Kashmir Gate at Delhi feature the first true glimpses of the horrors of war.

The Wet Plate Process

In 1848 Frederick Scott Archer (Figures 25 and 57), an English sculptor and amateur calotypist, experimented with collodion as a binder for silver halides as a means to improve the calotype. The term *collodion,* from the Greek word meaning "to stick," was used to describe a colorless fluid made by dissolving nitrated cotton in ether and alcohol. When poured onto glass, collodion dried to a thin, clear plastic film. In their calotype manuals of 1850, both Robert Bingham, in England, and Gustave Le Gray (Figure 67), in France, published the possible benefits of using collodion, but the first complete working formula of the wet collodion process was published by Archer in 1851 in *The Chemist.*

Archer's formula began with coating a glass plate with iodized collodion. The collodion film was then sensitized, while still wet, by placing the plate in a solution of silver nitrate. After exposure in a camera, the latent image was developed with either gallic or pyrogallic acid. The image was then fixed with hypo and washed. The fragile collodion film retained the alcohol and ether solvents throughout sensitizing, exposure, and processing, which is why it was known as the wet plate process.

Contested unsuccessfully by Talbot as an infringement on his calotype process, Archer's wet plate technique came at a time when the calotype, the waxed-paper, the daguerreotype, and the albumen processes were all being used. Originally the process was conceived by Archer to include coating the fixed image with a rubber solution and stripping the film from the glass plate. The thin rubber-coated collodion film was then to be transferred onto a secondary paper support for printing. The stripping and transfer method was quickly abandoned as unnecessary, though it eventually became an important technique used in the graphic arts industry until the 1960s.

Exposure times were reduced by half with the wet plate technique, making portraiture in the studio possible when ferrous sulfate was used for development. Although more sensitive than the calotype, the wet collodion negative process as generally practiced in the studio was not faster than the daguerreotype of the 1850s.

Collodion negatives were used to make salted paper prints, originally called crystalotypes by Whipple (Figure 63), but were perfectly matched to the albumen printing process introduced by Louis Deserie Blanquart-Evrard in 1850. The synergy of the collodion negative (Figure 91) and albumen print was to become the basis of the most commercially successful and universally practiced photographic process in the 19th century until it was eventually replaced by the gelatin emulsion plate in the 1880s.

By 1855 the collodion process had eclipsed the daguerreotype for commercial portraiture and was quickly being adopted by the amateur as well. The great photographic journals such as the *Photographic News, The British Journal of Photography, La Lumiere, Humphrey's Journal*, and the *Photographic and Fine Art Journal* were all introduced in the early 1850s. Such publications fueled the steady advancement of photography and were the "chat rooms" of the era, featuring well-documented research by chemists, empirical discoveries by the working class, and petty arguments between strong personalities.

The Art of Photography

From the 1860s onward, the photographic journals occasionally touched on the subject of art and photography, though like many art forms, there was little consensus. Photographic societies and photo-exchange clubs were formed in many cities, and exhibitions based on the salon style were held and judged. It is customary to mention in histories of photography the celebrated artists of the wet plate process such as Julia Margaret Cameron (Figures 30 and 84), Oscar Gustave Rejlander (Figure 84), and Gaspar Felix Tournachon, also known as Nadar. At the time, however, much of their work was not generally recognized by the public or the greater photographic community.

Critics also failed to take photography seriously as an art form, an attitude that continued for many years to come.

Cameron's genius was not recognized until late in the century when the pictorialists were deconstructing the convention of photography. Nadar on the other hand came to own a very successful Parisian Photo Gallery. His operators posed the subjects, processed the plates, and delivered the prints, producing commercial portraiture that was technically enviable though generally without the soul of his own early work.

The great landscapes documented with collodion such as those of Gustave Le Gray (Figure 67), Francis Frith (Figure 75), Leopoldo and Giuseppe Alinari, and John Thomson (Figure 90) were pictorial achievements by any standards and were made under very difficult conditions. The wet plate process was challenging enough in a studio, but to pour plates within a portable darkroom was an enormous task made more taxing when the plates were large. In Western America, Carleton Watkins, Eadweard Muybridge, William Henry Jackson (Figure 94), and Timothy O'Sullivan (Figure 88) also produced work under equally difficult conditions. In most cases the works of these landscape photographers were the first recorded images of a region. The final product, however, was most often seen by the general public not as an albumen print but as a wood engraving from the print.

Heavily retouched solar enlargements printed on salted and albumen paper were offered by progressive photographers in larger towns and cities throughout the 1860s and 1870s, but at great expense. The process of enlarging did not become commonplace until the acceptance of silver bromide developing papers, beginning in the late 1880s.

The most common connection of the public with photography in the 1860s was the commercial albumen print in the form of the small *carte de visite* (Figure 78) (calling card) portrait or a stereograph — two albumen prints on a card designed to be seen in three dimensions with a special viewer. By the late 1860s, the larger cabinet card photograph was also introduced. Cabinet cards (Figure 96) and *cartes de visite* ushered in an industry of mounts and album manufacturing. Larger framed prints were available at the portrait studios, but the two smaller portrait formats were the bread and butter of the working photographer until the end of the century. Stereographs remained popular until after the turn of the century and were usually a specialty item made by landscape photographers and sold by subscription or in stores.

Collodion Variants and the Positive Processes

The mid-1850s proved to be a fertile era for both new processes and variants of the collodion process. Soon after its introduction, collodion was used for stereo transparencies, microphotographic transparencies, and lantern slides. Direct collodion positives, called alabasterines by Archer, were originally made by bleaching an underexposed plate with bichloride of mercury. When ferrous sulfate was adopted as the developer and cyanide as the fixer for collodion positives, the plates were more sensitive and the positive images did not require

bleaching. Exposures of these plates in the studio were faster than exposures for the daguerreotype. The plates were also a cheaper and easier-to-view alternative. These plates were generally known as collodion positives, verreotypes, daguerreotypes without reflection, or daguerreotypes on glass. Though the actual image-making technique was usually the same, there were many variants, and those who introduced them were quick to apply a new name to each type.

A patent was awarded to James Anson Cutting in 1854 for a method of sealing these positive images on glass with balsam, using the same technique as that used for covering a microscope slide. Cutting called his variant of the collodion positive process *ambrotype*, from the Greek word meaning "imperishable." Cutting eventually changed his middle name to Ambrose to commemorate the process. Though the name *ambrotype* was specific to Cutting's patented sealing technique, the word quickly evolved to be the generic term for all such images (Figure 70).

Direct positive collodion images on japanned iron plates were invented simultaneously by photographers working in England, France, and the United States. In 1853 Adolphe Alexandre Martin first published the process in France. Hamilton Smith, in the United States, and William Kloen, in England, both patented the process in 1856. Smith, who called his plates melainotypes, sold the rights to Peter Neff, who manufactured them. Victor Griswold, a competitor, also manufactured japanned plates, calling them ferrotypes, a name that would eventually be adopted by the general public along with the less-formal "tintype" (Figures 99 and 103).

It is important to understand that those who made commercial ambrotype or ferrotype images were not considered photographers. Although the term *photography* is often applied indiscriminately to any photosensitive process used in the mid-19th century, it is technically specific to the making of negatives used to produce prints. Those whose work cannot be strictly classified as photography were known as daguerreotypists, ambrotypists, and ferrotypists or tintypists.

Positive collodion transfers onto patent leather (Figure 68), oilcloth, and painted paper were called pannotypes and were also born in this era, along with the milk-glass positive (Figure 86), printed from a negative onto a sheet of white glass. But neither of these would approach the popularity of the tintype, which eventually replaced the ambrotype in the 1860s and continued to be made in various sizes throughout the 19th century.

Collodion Variants and the Negative Processes

In an attempt to make the collodion process possible without erecting a darkroom on location, some amateurs began experimenting with making preserved or dry collodion plates in the 1850s. Humectant-based processes relying on oxymel, a medical compound of honey and acetic acid, and various syrups to keep the sensitive plate damp were very successful. These plates, however, were up to five times slower than the conventional wet plate. The dry tannin and Taupenot plates were also very slow. These techniques, although an interesting footnote in the evolution of the collodion process, were

never sensitive enough to be useful for anything but landscape work and were seldom used. Most landscape photographers preferred to see the plate develop on site should they need to make a second exposure.

In the late 1870s, collodion emulsions were being used by curious amateurs. Based on the technique that used initial silver chloride emulsions for collodion printing-out papers, collodion emulsions were made by mixing halide and silver together in the collodion rather than sensitizing an iodized plate in a separate silver bath. Although the collodion emulsion process for negatives did not come into general use, it was the basis for the gelatin emulsion process and the production of collodion chloride printing-out papers used well into the next century.

Concerns of Permanency

The correct processing of paper prints from collodion negatives was not fully understood during the 1840s and early 1850s, and the consequence of fading prompted committees in both England and France to investigate the problem and search for alternatives. Despite the gold-toning procedure applied to all albumen prints, most of these prints were prone to fading. This was usually caused by incomplete fixing or washing.

From this climate of questioning came the carbon printing process introduced by Alphonse Louis Poitevin and the developed-out salt printing processes of Thomas Sutton and Louis Deserie Blanquart-Evrard. The cool tones of developed-out salt prints were not embraced by photographers or the public, though the process was much more stable than any other printed-out technique. The process eventually found its niche with the technique of solar enlarging, which was introduced in the late 1850s. The typical printed-out solar enlargement from a collodion negative required more than an hour of exposure. Exposures on developed-out salted papers were counted in minutes.

The carbon process, based on the light sensitivity of pigmented gelatin treated with potassium bichromate, did not achieve its technical potential until the single-transfer variant patented by Sir Joseph Wilson Swan was universally adopted in 1864. Despite the superiority of the carbon process to albumen prints in both tonality and permanence, they were tedious to make, particularly for a single print. Carbon prints were better suited to making large runs of a single image but not for the typical studio portrait (Figure 89). Photographers preferred to make albumen prints over carbon prints until albumen printing was replaced with the collodio-chloride and gelatin-chloride aristotype printing-out papers late in the century. Carbon and gum prints based on the same principle continued to be available but in very limited numbers.

In 1873 one of the most beautiful printing processes of the 19th century was patented by William Willis (Figure 97), of London. Although platinum had been used on occasion for toning prints, Willis's process, perfected by 1879, was based on a faint image, formed with iron compounds, that was developed to completion into a pure platinum deposit. The Platinotype

Company, established in 1879, produced sensitized platinum papers that were favored by a growing movement of artists using photography. The matte finish and neutral tones of the platinum print were ideally suited to the soft masses of tonality favored by the pictorialist and fashionable portrait galleries late in the century.

The cyanotype, a process invented by Herschel in 1841, was reasonably permanent, but the image was blue and not particularly suited to most imagery. With the exception of documenting botanical samples by contact and occasional printing from calotype or collodion negatives, the cyanotype process was not popular until the end of the century (Figure 106), when amateurs used it as an easy and economical way to proof their gelatin negatives.

Gelatin Emulsions and the Modern Era

It may seem out of place to call the last quarter of the 19th century the modern era of photography. However, the introduction and eventual acceptance of gelatin emulsion plates, papers, and flexible films in this period became a technology that was not challenged until digital imaging appeared at the end of the 20th century. Looking back from a 21st-century perspective, we might more appropriately call the late 1800s the last era of photography.

The complicated evolution of research, development, and manufacturing of silver gelatin photographic materials in the latter quarter of the 19th century is filled with simultaneous invention, lawsuits, and countersuits. Chronicling the history is beyond the scope of this essay, but what follows presents the essential progression.

The invention of emulsion plates was primarily English and began with collodion emulsions of the 1850s. In 1865 G. Wharton Simpson made printed images on paper coated with a collodion chloride emulsion. Soon after this, leptographic paper coated with a collodion chloride emulsion was manufactured by Laurent and Jose Martinez-Sanchez in Madrid. An innovation introduced specifically for collodion emulsions was the use of a baryta coating applied to the paper support as a smooth, white barrier layer. Leptographic paper was made until 1870 with limited success, but baryta papers reappeared several years later and were eventually used throughout the 20th century for all photographic papers.

In England W. B. Bolton and B. J. Sayce introduced a collodion emulsion for negative plates in 1864 that was based on bromides rather than iodides. These were nearly as sensitive as wet collodion plates and were processed with an alkaline developer. The use of bromides and of alkaline development was to become the key to making fast plates with gelatin emulsions. Collodion emulsion plates remained the territory of advanced amateurs for the next 20 years.

Based on the earlier experimental work of W. H. Harrison, Dr. Richard Leach Maddox added silver nitrate to a warm gelatin solution bearing some cadmium bromide and then coated some glass plates with the emulsion. After exposing the plates in the camera, Maddox developed them with pyrogallic

acid and some silver. The process used with these plates was slower than the wet collodion process but was the first serious attempt at making a gelatin emulsion. Maddox's silver bromide gelatin emulsion process was published in the *British Journal of Photography* in 1871.

Additional experiments in the early 1870s were continued by John Burgess, who used pyro developer in an alkaline state. The problem with the Burgess emulsion was that although it contained the necessary silver bromide, it was also affected adversely with potassium nitrate, a by-product of the technique. Removing the unwanted compound was first accomplished by J. Johnson, who allowed his gelatin emulsion to dry into thin sheets called pellicles. He then cut them into small pieces and washed them in cool water. After washing, the sensitive gelatin was dried in darkness and packaged. These pellicles could be stored and rehydrated for coating at a later time. Richard Kennett patented a similar product of washed sensitive pellicles in 1873 and was selling both the pellicle and the precoated gelatin plates by 1876. The English market for gelatin plates was growing steadily but did not fully topple collodion technology until the mid-1880s.

Gelatin emulsion plates were a hard sell to professional photographers who were used to getting excellent results with the wet collodion process. The early gelatin plates were met with limited interest and limited commercial success. The discovery that changed everything was observed when the gelatin pellicle was rehydrated and the emulsion was melted. The longer the emulsion was heated, the more sensitive it became. The cause, called ripening, was first identified by Sir Joseph Wilson Swan in 1877 and was a trade secret until revealed in 1878 by Charles Bennett, who also observed the phenomenon. Bennett continued his experiments by keeping the emulsion hot for days.

A year later George Mansfield suggested ripening the emulsion at a higher temperature over a period of minutes, a method generally adopted by all those who continued research in this area. By 1879 gelatin emulsions were ripened by heat and then allowed to set to a firm jelly. The emulsion was squeezed through a mesh to produce noodles that were washed in cool water to remove the unwanted nitrate. The washed noodles were then drained and remelted with some additional gelatin and applied, while hot, onto glass plates by hand under dim, red light. Coated plates were then placed on marble leveling tables until the gelatin set to a stiff jelly, at which point they were taken to a dark drying room and packed in boxes. This was the way all commercial plates were made until the development of automated equipment in the mid-1880s.

Gelatin plates, also called dry plates, were being manufactured by hand on a much larger scale by 1880. Interest and acceptance by both amateur and professional was much slower in the United States than in England and the rest of Europe. The English photographic journals at this time were beginning to include more articles on the gelatin process than collodion, and these, in turn, were being reprinted in the American journals. Some American professionals began using the new plates with mixed results, and they published their findings.

In 1880 the Photographers Association of America appointed a committee to investigate the new technology of gelatin plates. The quality of commercial plates varied considerably, but the plates had great potential in skilled hands. Many of the problems photographers had with these plates were due to increased sensitivity. Fogging, more often than not, was caused by overexposure in the camera or poor darkroom conditions that had little effect on the slower collodion plates.

As interest grew, more plate manufacturers appeared on the American horizon, and more professionals began taking the risk of changing their systems from wet to dry. The prices of plates were decreasing, and interest was growing. At the same time, all of the manufacturers of cameras and associated equipment were targeting a new generation of amateurs who could make images at any time without the skills that were previously necessary.

Gelatin plates could be relied upon at any time and developed later at a more convenient location. When plate-coating machines became a reality, the price of plates was reduced enough for the commercial photographer to adopt plates for their work as well. It can be assumed that most commercial photographers in America were using gelatin plates for both exterior and studio portraiture by 1885.

The popular developers for these early plates were alkaline solutions of pyrogallic acid or ferrous oxalate. Within a few years, hydroquinone was also used, followed by metol and a combination of the two chemicals, commonly called MQ developer. Developing powders were available in boxes of premeasured glass tubes.

Flexible Films

The concept of flexible film dates back to the calotype and Archer's initial idea of stripping collodion film from glass plates. Attempts to market paper roll film and sheets of celluloid-based film on a large scale did not succeed until the products were introduced by the Eastman Dry Plate Company in the mid-1880s. This stripping film was made by applying a standard silver bromide gelatin emulsion on a paper support previously coated with a thin layer of soluble gelatin. The machine that produced stripping film was also used to manufacture silver bromide developing-out paper for printing. Marketed as American Film, rolls of paper-support stripping film were designed to be used in a special holder that could be fitted to the back of any size of camera. The film, the machine that was used to coat the paper, and the system to transport the film in the camera were all patented at the same time.

The exposed film was cut into separate sheets in the darkroom with the aid of indexing notches and was processed as usual. The washed film was then squeegeed onto a sheet of glass coated with a wet collodion film and was allowed to set for about 15 minutes. The plate was then placed in hot water that softened the soluble layer of gelatin, which allowed the

paper support to be removed. The plate could then be dried and used like any other gelatin glass negative, or the film could be stripped from the glass by applying a second layer of clear gelatin, followed by a second layer of collodion, and then cut from the plate with a sharp knife.

American Film was supplied in the first Kodak introduced in 1888. The Kodak was a small detective camera that spawned several generations of hand-held box cameras used by millions of amateur photographers. While not a commercial success, American Film bought enough time for the Eastman Dry Plate and Film Company to introduce Eastman Transparent Film in rolls and sheets of clear, flexible nitrocellulose in 1889.

Sensitometry

The concept of measuring the actinic effect of light or the sensitivity of photosensitive materials dates to the earliest days of photography, but the first reliable sensitometer was invented by Russian-born Leon Warnerke in 1880. With this tool a reliable rating number could be applied to an emulsion calculated against the average sensitivity of a collodion plate. Some companies in the 1880s used the Warnerke rating system while others simply addressed the matter by stating that a specific plate was fast, slow, or extra quick.

A unified standard for emulsion speeds did not come until much later, and even then there were different scales requiring conversion tables. Two major innovations that came from sensitometry were the evolution of the instantaneous lens shutter and an attempt to set a numerical standard to the apertures placed in lenses. Two systems of aperture standards evolved during the dry plate period: the f-numbering system and the US (Uniform System) introduced by the Royal Photographic Society. The US featured the numbers 1, 2, 4, 8, 16, 32, 64, and 128. The f-system as introduced used 4, 5.6, 8, 11.3, 16, 22.6, 32, and 45.2. The only rating that was common to both systems was 16.

Glimpses of Color

Throughout the 1880s gelatin-emulsion makers were engaged with increasing the sensitivity of their product. Though the speed of gelatin emulsions was gradually increased, the emulsions were still mostly sensitive only to the ultraviolet, violet, and blue wavelengths, a defect they shared with all of the previous photographic processes of the 19th century.

Increasing the spectral sensitivity of photographic materials was important for many reasons but essential to the evolution of color photography. Color daguerreotypes — invented by Levi Hill in the 1850s — and a similar product, the heliochrome, first exhibited in 1877 by Niépce de St. Victor, stood alone and were not influential in the evolution of modern color photography. However, in 1861 James Clerk-Maxwell made a celebrated demonstration of additive color synthesis, generating interest in finding a way to extend sensitivity of collodion plates for full-color photography. Thomas Sutton made three negatives of a colorful ribbon through red, blue, and green filters for Maxwell's demonstration. These separation negatives were used to make lantern slides that were projected from three magic lanterns through the same filters. The virtual image on the screen was convincing enough for the era.

In 1869 Ducos Du Hauron patented a procedure in France that relied on red, blue, and green additive dots applied to a sensitized plate. However, this type of additive screen process was not a reality until John Joly introduced the first commercially successful additive ruled plates in the mid-1890s. Du Hauron did, however, suggest the subtractive-color process with which he made assembly prints from yellow, cyan, and magenta carbon tissues exposed from additive color-separation negatives as early as 1877 (Figure 93). The subtractive-assembly concept evolved to be the basis for how all color photographs are made.

Adolph Braun, Hermann Wilhelm Vogel, and Frederic Ives (Figure 104) conducted promising experiments in the 1870s using dye-sensitizing emulsions with eosin and chlorophyll. Braun, Vogel, and Ives were sensitizing collodion bromide emulsions at the time. These so-called orthochromatic emulsions were still highly sensitive to the blue areas of the spectrum but also to green and some yellow.

By the 1890s other dye sensitizers helped to extend the range of gelatin emulsions to deep orange. Such plates were known as isochromatic. True panchromatic plates that were sensitive to the entire visible spectrum were not available until 1906, and even after they became available, few photographers embraced the technology. The fact was that panchromatic plates were seen as a disadvantage by photographers accustomed to developing negatives by inspection under safe light. The important experiments with isochromatic emulsions, however, were a great help to those in the printing industry and individuals interested in making color-assembly prints from separation negatives or experimental additive color plates.

Floodgate to the 20th Century

By the end of the century, more individuals, both amateur and professional, owned cameras than in the daguerreotype and wet plate eras combined. There was no need to go to a professional studio photographer anymore, even though studios could generally achieve better results. The photofinishing business was evolving to accommodate the amateur market, and manufacturers were introducing photographic equipment and materials at a dizzying rate. Enlargements on silver-bromide paper were being made by projection, using gas or electrically illuminated magic lanterns.

The photographic image, itself a copy of nature, was being reproduced in magazines and books by several different ink processes, making anything that was originally the product of a camera known as "a picture." In the 1890s photographs were common and available in a wide range of sizes on a variety of photographic papers, including platinum-toned collodio-chloride and gelatin-chloride printing-out papers, developed-out silver-bromide paper, silver chloride gaslight papers, cyanotypes, carbon and gum prints, and, if money was no object, pure platinum prints.

The influence of the impressionists, members of an artistic movement who rethought the role of painting in a world of

photography, in turn released a 50-year grip on photographic convention. This allowed the pictorialist movement to redefine what a photograph needed to be. Photography, long appreciated for how it could copy nature in infinite resolution, was being used in a way that was, in a word, antiphotographic. The romantic photographic departures of P. H. Emerson in the 1880s had paved the way for the likes of Clarence White, Gertrude Kasebier, and F. Holland Day in the next decade. As a result, the pictorialists' soft imagery and romantic approach to photography influenced a new direction in commercial portraiture that remained popular for 30 years after the turn of the century. ◉

Introduction to Photographic Equipment, Processes, and Definitions of the 19th Century

MARK OSTERMAN

George Eastman House and International Museum of Photography

This edition of the *Focal Encyclopedia of Photography* has been written at a time when the industrial production of silver halide materials is rapidly declining as a result of digital photographic technologies and practices. At this same time, the movement to preserve the technology of handmade processes from the 19th century is becoming stronger. The greatest challenge for future photohistorians will not be the understanding of photographic processes of the 1800s but rather the photographic industry of the 20th century that is being dismantled at this time.

The concept of photography was conceived two centuries and many technologies ago. Since 1802, when Wedgwood first made images with silver on paper and leather, every generation of photographer has seen the natural progression of technological changes, followed by their obsolescence. Deciding what information to preserve and publish from previous technologies is a difficult task when space is limited, and the decision will certainly create unavoidable disappointment for some readers. Limits, of course, are necessary within constraints of a physical book. We have made choices to anticipate what will be useful, instructive, and possibly influential. Unlike most references on the technological history of photography, including the previous edition of the *Focal Encyclopedia*, much of the information written for this new edition comes from observation of historic texts and experience with nineteenth century photographic processes.

Many of the following entries have been the topic of extensive research by scholars and practitioners over the years. Additional information for any of the subjects can be found in other publications and on the Internet. Unlike the printed

FIG. 2 A skylight studio including portrait cameras, cloth background, posing chair and table, head stand, and diffuser. The Scully and Osterman Studio, Rochester, New York.

page, anyone can post information on the Internet with implied authority and with much less effort. Primary research should always be considered as the best way to gain insight in the history and practices of photography.

The following pages contain entries written by this editor, Mark Osterman, and entries that were published in this encyclopedia's Revised Desk Edition (1969) or Third Edition (1993) by the following authors: Ira Current, John Fergus-Jean, Michael Flecky, Roger Hailstone, Grant Haist, Mike Leary, Judy Natal, Michael Teres, Paul Schranz, Martin Scott, Leslie Stroebel, Sabine Süusstrunk, Hollis Todd, Howard Wallach, and Richard Zakia.

Photographic Equipment, Processes, and Definitions of the 19th Century
A
Abrading medium

An abrasive powder often made of emory used to reduce the density of a gelatin-emulsion negative. The powder is gently rubbed onto the surface of the emulsion to gradually remove the

silver-bearing gelatin. This action results in a loss of density. This process was not applied to collodion negatives where the image-bearing silver did not occur throughout the entire binder layer.

Absorption

The process in which energy that is incident on a substance is converted to another form of energy that remains in the substance. All substances absorb some radiation that falls on or passes through them. Absorbed light energy may be transformed into light of another color and then emitted. The amount of absorption that occurs in a given situation depends on the wavelength of the incident radiation. Selective absorption is largely responsible for natural colors since most natural light contains at least some of all of the wavelengths of light, whereas strong colors contain predominantly only a limited range of wavelengths. Before the use of filters in cameras, the absorption effect was most important in the darkroom. Most 19th-century sensitive materials were simply blue sensitive. Darkroom illumination was filtered to absorb blue light by layers of yellow or orange-red cloth, brown paper, or red or amber glass.

Accelerator

A chemical used to increase the speed of photosensitive materials. Daguerreotypists used bromine and chlorine as accelerators. In the collodion process, bromides brought the sensitivity of the plates to the green bands of the spectrum. Ammonia was used to increase the sensitivity of salted and albumen papers and, later, gelatin-based silver bromide emulsions.

Acetylene

Discovered around 1845, acetylene is an explosive gas used for illumination in magic lanterns and early horizontal enlargers. The gas was produced by allowing water to drip on dry calcium carbide in a special generator. A tube conveyed the gas to one or more burners, providing a very intense flame powerful enough for projection.

Acid fixing bath

A fixing bath made with sodium thiosulfate and citric or tartaric acid was popular for silver gelatin bromide plates and papers. Its primary use was to remove yellowing from the emulsion and to stop the action of an alkaline developer.

Acetic acid, $C_2H_4O_2$

Colorless liquid prepared by the distillation of wood or the oxidation of dilute ethyl alcohol. Acetic acid has a very pungent smell, and the vapors are flammable. When obtained in full strength (99 percent), it congeals as an ice-like solid at 16.7°C. For this reason the term *glacial* is also used to describe this acid. It is soluble in water, alcohol, ether, chloroform, and gelatin.

Acetic acid was used as a restrainer for the physical development of calotypes, Niépceotypes, and collodion plates. Photographers also used it to retard non-image reduction of these processes by adding it to the silver nitrate solution. Acetic acid is used as a stop bath and as a solvent for gelatin.

Acids

Hydrogen compounds that test low on the pH scale. Acids may be liquids, gasses, or solids—organic or inorganic. Acids were used frequently in 19th-century photographic processes, and they are addressed in this encyclopedia under specific entries.

Actinic

A very common 19th-century term referring to the photographic quality of light, specifically ultraviolet, violet, and blue light. Nonactinic light and colors (such as green, yellow, orange, brown, and red) have little effect on blue-sensitive materials. Processes requiring actinic light were daguerreotypes, calotypes, albumen-on-glass negatives, collodion plates, early gelatin-based silver bromide plates, and silver chloride silver printing-out. Dichromated colloids, platinum, and cyanotype processes also relied on actinic-light exposures.

Actinic focus

The plane of focus established by the blue, violet, and ultraviolet rays of the spectrum. Simple uncorrected lenses cannot focus all the rays of light on the same plane. This was not a problem until photography was introduced. Blue-sensitive materials that are used to record images taken with such lenses produce images out of focus because the visible image used to focus the camera is made from the nonactinic red and yellow rays that fall on a different plane than the actinic blue and violet rays.

Actinometer

The actinometer was a form of light-measuring device. It measured the actinic power of light by comparing the ongoing exposure of blue-sensitive photographic paper to a set of standards. These devices were most valuable when making prints by the carbon or gum methods, where visual progress of the print during exposure was impossible. The actinometer typically included a box containing a strip of sensitized silver chloride printing-out paper that was pulled into a window where it would be exposed to light.

A reference panel bearing the color of exposed silver chloride paper was positioned next to the window. Every time the sensitive paper printed out to the same degree as the standard, the photographer took note and pulled a new section of sensitive paper into position. By this method timing was always consistent and was based on the actual effect of light rather than on time.

Additive color

See Color Photography.

Adhesives

Paper photographs were mounted on a wide variety of papers and card stocks by using many different adhesives. Most of these mountants were made with natural gums, animal glues, or starches. Natural rubber was also used by first dissolving the raw material in a solvent such as benzene or benzine. The

most popular adhesive for mounting cabinet cards, *cartes de visite*, and large albumen prints was wheat-starch paste, which was applied to a dampened print.

Aerial perspective

The effect of distance in 19th-century landscape photographs created when the background becomes progressively lighter in tonality. This was usually an involuntary but serendipitous aesthetic caused by blue-sensitive plates recording hazy atmosphere as a light color.

Agar-agar

A vegetable gelatin made from seaweed that is found on the shores of the Red Sea. It was used occasionally as a substitute for bovine gelatin in photographic work, specifically in the sizing of hand-coated sensitive papers and in dichromated pigment processes.

Air bells

Small bubbles trapped in or on the binder of photographic plates and papers. In albumen printing these can occur when the photographer floats the paper on the albumen or the silver solution. These are usually removed by touching them with a small brush or toothpick. When organic restrainers, such as gelatin or sugar, are used to develop collodion plates, air bells prevent development unless they are brushed away soon after forming. For gelatin plates, a preliminary wash in water with some agitation usually prevents the formation of air bells.

Air brush

A pneumatic device that sprays a controlled mist of liquid pigments or dyes. The first commercially available air brush was introduced by Liberty Walkup in 1885. It was immediately adopted for the use in overpainting and retouching photographic enlargements, first on printing-out papers exposed by solar enlargement and later on developed-out bromide papers. *See also* Crayon Enlargement, Solar Enlarger.

Alabasterine process

When Frederick Scott Archer introduced the wet plate collodion process in 1851, he noticed that underexposed negatives displayed against a black background appeared as positive images. Archer coined the name *alabasterine* for plates bleached with bichloride of mercury, a chemical treatment that left the image highlights much brighter and made the positive effect easier to see. *See also* Ambrotype.

Albertype

The first practical photomechanical collotype process, introduced by Josef Albert. A glass plate is coated with dichromated gelatin and exposed from the glass side. After washing and drying, the gelatin is coated with a second layer of dichromated gelatin. When dry, the gelatin is exposed in contact with a negative. Conventional printing is done in a press by inking the emulsion after it is dampened with water.

Album

A book designed to display paper photographs and/or ferrotypes. Early albums were either made by the photographer or purchased as blank books from a bookbinder. Paper prints of all types were glued onto pages by the corners (a technique called tipping) or around the edges (a technique called perimeter mounting) or by applying paste or glue to the entire back of the print (a technique called mounting overall).

Albums with slip-in mounts were first available for *carte de visite* prints and ferrotypes of the same size in the late 1850s. When the cabinet-card format became popular in the early 1870s, albums were made to accommodate both formats, including combinations of both sizes in the same album. The smallest albums manufactured were designed to display miniature gem tintypes. The variety of designs applied to albums is seemingly unlimited, with some including elaborate coverings and decorations, display stands, and even mechanical music boxes. The heavy slip-in style of album remained popular until after the turn of the century.

Albumen

A transparent fluid with a slight yellow tint made from animal or vegetable proteins. Carbon, hydrogen, oxygen, and sulfur are commonly found in albumen, which is collected from the whites of eggs or from blood serum. For photographic use, albumen from fresh hens' eggs was the traditional source. Albumen is coagulated by heat, alcohol (not anhydrous alcohol), and metallic salts such as silver nitrate.

Albumen in photography

The use of albumen as a binder for silver halide emulsions dates back to the earliest era of photography. William Henry Fox Talbot began experiments with albumen for both paper and glass in 1840, although without much success. By the middle of the 1840s, the Langenheim brothers, of Philadelphia; John Whipple, of Boston; and Niépce de St. Victor (nephew of Néciphore Niépce) all produced a workable negative-on-glass process. Niépce de St. Victor has been acknowledged as the official inventor because he was the first to publish the niépceotype process in 1847.

All of these processes used glass plates coated with albumen binder (which bore an iodide) and then sensitized in a bath of silver nitrate. The plates could be exposed wet or dry and were physically developed in gallic or pyrogallic acid and fixed with hypo in the same fashion as in the calotype process. The salted paper printing-out process was used to make positive prints from the finished negative.

The Langenheims may have missed their chance for recognition in the invention of glass negatives, but they took the next logical step. In 1848 they contact-printed their negatives on a second prepared plate to produce the first positive transparencies. They used their hyalotype process to make lantern slides for projection and stereo transparencies.

Whipple also contributed to the evolution of the process by increasing the sensitivity of the plates by adding honey to the

albumen. He called both his albumen negatives and the subsequent salted paper prints "crystalotypes," referring in both cases to the clear glass support of the negative.

The Niépceotype was nearly made obsolete soon after it was introduced when in 1851 Frederick Scott Archer published the wet collodion process. Archer's was a more sensitive process, and despite the necessity of precoating the plates and developing them immediately after exposure, the process was soon to become the dominant imaging system for the next 25 years.

Even after the general acceptance of collodion, some photographers continued to use albumen negatives, presumably because they were produced by a dry process. James Robertson is notable for having recorded some of the most thought-provoking images of the Crimean War on massive albumen plates.

When photographers began to create preserved and dry variants of the wet collodion process in the 1850s, albumen was one of many coatings applied to the collodion film. In the Taupenot process, a glass plate was coated with iodized collodion and then iodized albumen. Once the coatings dried, the plate was sensitized in a silver bath and allowed to dry once more. Such plates required less exposure than in a typical albumen-negative process but more than in the wet collodion process.

Albumen continued to be used into the 1860s for making lantern slides and stereo transparencies because the process was capable of much higher resolution than those made with collodion. The difference in quality was lost on the general public, and collodion became the more common process until it was replaced by the process used for silver gelatin plates.

Albumen on paper
In 1850 Louis-Désiré Blanquart-Evrard published the albumen printing process. It was closely related to salt printing, a printing-out process invented by Talbot that required alternate coatings of dilute sodium chloride and silver nitrate for sensitizing. The prepared paper was used for contact printing in the sun to produce a visible image and was then fixed permanently with sodium thiosulfate. Blanquart-Evrard added albumen to the chloride solution (in a 1:1 ratio) to prevent the image from forming too deeply in the paper fibers and to impart a slight gloss to the finished print. Paper was floated on the salted albumen and allowed to dry. When needed, the albumenized paper was then floated on a bath of silver nitrate to make it sensitive. When dry, the paper was contact-printed in the usual way. Early albumen prints were toned with gold chloride that was added to the hypo bath; this process was also known as *sel d'or* toning. Once the albumen printing process became common, salted paper prints came to be known by many as "plain" prints.

By the 1860s it was common for albumen paper makers to use pure albumen, resulting in a higher gloss. A separate gold toning bath was also used before fixing. With the introduction of the burnisher in the mid-1870s, albumen prints were routinely waxed and burnished to an even higher gloss. By the

1880s printers could purchase papers with multiple coatings of albumen and special calendaring which resulted in a more glossy surface.

There were attempts to introduce a developed-out albumen paper, specifically for solar enlargements, but the processes were never exploited. Presensitized albumen papers were also available in the last quarter of the 19th century but were not as popular as those sensitized by the photographer. Matte albumen papers, made by adding starch or other matting agents to the albumen, were used in Europe as late as the 1930s.

Albumen for other photographic purposes
Albumen was used as an effective subbing layer for collodion negatives to prevent peeling when plates were developed with pyrogallic acid. For this purpose it was applied to the plate after being diluted as much as 1:40 and was allowed to air-dry on a rack. Albumen subbing was also applied (only along the edges of the plate) for the same purpose.

Some photographers in the 1840s and 1850s applied albumen to the surface of salted paper prints to enhance the shadow areas and protect the image from atmospheric contamination. This practice ceased after the albumen printing process was introduced. Opalotypes (also known as opaltypes or milk glass positives) opalotypes were made with many different processes, including a printed-out albumen chloride method. Lippmann color plates were first made with a panchromatic silver bromide albumen emulsion. The albumen binder was eventually replaced with gelatin.

Dichromated albumen was used well into the 1940s in the graphic arts industry as a photosensitive resist to make etched zinc printing plates. *See also* Whirler.

Alcohol

A class of organic compounds, containing an -OH group, whose liquid members are often used to hold chemicals of low solubility in a water solution. Ethyl alcohol (CH_3CH_2OH, molecular weight 46.05) is also called ethanol, grain alcohol, or alcohol. This clear, colorless, flammable liquid of characteristic odor can cause human disorientation if imbibed in sufficient quantity. The absolute grade is almost 100 percent ethyl alcohol, but many industrial grades are denatured (made unfit for human consumption).

Methyl alcohol (CH_3OH, molecular weight 32.03, also called methanol or wood alcohol) is a clear, colorless liquid that is volatile, flammable, and highly poisonous if ingested. It mixes with water, ether, and other alcohols. Methyl alcohol is used in small quantity with ethyl alcohol to make that alcohol unfit for drinking, thus avoiding governmental taxation. Methyl, ethyl, and other alcohols, such as isopropyl and benzyl, are useful in the preparation of photographic emulsions and in concentrated developers—where they increase solubility and activity—as well as for drying or cleaning photographic materials.

Alkali

The direct opposite of acid, reading higher than 8 on the pH scale. An alkaline solution turns red litmus paper blue and is capable of neutralizing acids. Alkaline development was introduced by Major Russell in 1862 but was not universally adopted until the advent of silver bromide gelatin emulsions.

Allegorical photography

Photography in which the image becomes a visual reference for some well-known idea or theme drawn from religion or mythology. For example, a photograph of a woman leaning forward and admiring herself in a mirror can remind one of the Narcissus myth.

Two of the early pioneers in allegorical photography using composite images were Oscar Gustave Rejlander (1813–1875) and Henry Peach Robinson (1830–1901). Two of Rejlander's important composite photographs are "Two Ways of Life" (1857) and "Hard Times" (1860). Loosely based on Raphael's fresco *School of Athens*, Rejlander's photograph "Two Ways of Life" represents an allegory of the choice one must make between good and evil, between work and idleness. The allegorical theme is similar to that used in emblematic literature that warns against idleness and praises work. Rejlander's composite photograph was intended to compete with paintings entered in art exhibitions. The composite print was made from some 30 separate negatives posed by a number of models, both clothed and unclothed. Although one of the five versions of the work was purchased by Queen Victoria, critics termed it unsuccessful as allegory. Reflecting the narrowness of that time period, they reasoned that a work of art should not depend on mechanical means.

Retlander's photograph "Hard Times" is a social commentary as relevant today as it was in 1860 (Figure 80). The photograph shows a forlorn unemployed father, carpenter tools by his side, sitting by his wife and child, who are asleep in their bed. Being unemployed and unable to provide for loved ones has a contemporary ring, as do most allegories.

Robinson's composite photograph "Fading Away" shows a young, sick girl lying half upright in front of a partially draped window with what appears to be her mother and grandmother by her side in quiet contemplation. In the photograph, a man, presumably her father or husband, stands with his back to her in a hopeless position, looking out the window. To his right is a stand with some flowers in a vase. One of the flowers is drooped, and a few petals have fallen and lie on the top of the stand. It is interesting to compare this photograph by Robinson to a 1992 advertisement in which a large color photograph shows a young man lying in bed, dying of AIDS. His father is by his side, sharing the sadness and trying to comfort his son while the mother and sister in remorse are off to one side. The photograph was not posed, and it represented a real situation. The family gave permission to use this very personal photograph to help the fight against AIDS. Nevertheless, the resulting ad received considerable criticism from those who felt that the use of such a photograph in a commercial advertisement was inappropriate.

In the 19th century there were critics who denounced the use of photography to convey allegory and moral messages, yet these themes continued to be addressed, particularly by the pictorialist photographers. In one of Camille Silvy's photographs, "Mrs. John Leslie as Truth" (1861), the central and only figure is a model dressed in a large white gown that graces the floor. She holds a white flower in her hand as she looks heavenward with glassy eyes and an angelic expression. Behind her, and covering most of the background, are contrasting dark clouds.

Alum, potassium, $KAl(SO_4)_2*12H_2O$

Also known as aluminum potassium sulfate, this is a white crystal that is soluble in water. It is made by roasting alunite in a furnace and then harvesting the product by crystallization. Alum was used to harden gelatin emulsions by introduction, by bathing the exposed plates prior to development, or by use in the fixing bath. Mixed with citric or other acids, it was also used as a clearing bath to remove developer stains in negatives.

Aluminum chloride, $AlCl_3$

A yellowish-white crystalline or granular powder made by passing chlorine gas over alumina in a heated state and collecting the product by sublimation. Aluminum chloride was occasionally used in gold and platinum toning baths.

Amateur

A person who engages in photography simply for pleasure. Many of the most important advances in the technology of photography were discovered or perfected by amateurs who had the curiosity, the means, and the time to seek an answer that professionals could not or would not pursue.

Amber

A fossil resin from an extinct variety of pine tree found primarily in the Baltic States. Amber is found as a brittle yellow, amber, or reddish-brown translucent substance that is soluble in ether and chloroform. When the dissolved resin is mixed with alcohol, it makes a varnish used for collodion images.

Ambrotype

A direct-positive wet collodion image on glass made in a camera, specifically produced through a method of sealing the picture with balsam and a second cover glass. Marcus Aurelius Root first suggested the term *ambrotype* (from the Greek word *ambrotos*, meaning "imperishable") presumably because the images were hermetically sealed.

James Anson Cutting, of Boston, first published the term *ambrotype* in his English patent of 1854 for an *Improved Process of Taking Photographic Pictures upon Glass*. In his patent, Cutting suggested a method of treating the nitrocellulose used in making the collodion, the addition of camphor, and the sealing of the finished image with balsam and a cover

glass in the fashion used to produce a microscope slide. An eccentric, Cutting also changed his middle name to Ambrose around the same time, essentially naming himself after his invention rather than the other way around. Positive collodion images made in the camera have been a common by-product of underexposing wet plate color negatives ever since the very introduction of the process by Archer in 1851. The developed silver of collodion plates is a light brown rather than black observed in gelatin emulsions because of the minute particle size. The deepest shadows are clear glass. When underexposed plates are backed with something black, the positive image is formed with dull brown highlights and black shadows. Archer bleached the plates with mercuric chloride to whiten the brown highlights and called the plates "alabasterines."

By the mid-1850s photographers switched from using pyrogallic acid to develop collodion plates to using iron sulfate, and many adopted potassium cyanide as a fixing agent. The new processing left silver deposits in the image that were a light grey to creamy tan color. As a result, the positive effect was even more pronounced with these chemical improvements and made the bleaching step unnecessary. Once the process was understood and perfected, it was quickly adopted as a popular studio portrait technique, replacing the daguerreotype in both style and presentation. The public liked ambrotypes because the exposures were slightly faster and they were easier to view than the highly reflective daguerreotype image, which was made on a polished silver plate.

Like collodion negatives, collodion positives were usually varnished with a protective coating. Many positives, however, were left unprotected because the varnish darkened the final image; the lighter highlight was often preferred. As with the daguerreotype, a case or frame offered collodion positives adequate protection from abrasion and atmosphere. In time, unvarnished images often developed tarnish patterns like those found on daguerreotypes.

Prior to the Cutting patent, such images were known simply as *collodion positives*. Other descriptive names included *verreotypes (images on glass), daguerreotypes on glass,* and *daguerreotypes without reflection.* Whereas by definition a true ambrotype would be made by the Cutting technique, the word quickly became a generic term for all collodion direct positives on glass that were made in the camera.

Amidol, $C_6H_3(NH_2)_2OH*2H_2O$

A trade name for diamidophenol, a developing agent for silver bromide gelatin emulsions that was introduced by Dr. Anderson in 1892. Amidol made negatives grayish black, with very little fog. It was favored over other alkaline developers because it could facilitate faster exposures.

Ammonia, NH_3

A substance obtained by the dry distillation of animal or vegetable matter that contains nitrogen. A common source was the hooves and horns of animals, inspiring the name *spirits of hartshorn.* Urine was also a source for ammonia; it was in this

form that Hercules Florence fixed his images before the introduction of sodium thiosulfate.

Ammonium bicarbonate, NH_4HCO_3

White crystals made by carbonate salts acting upon ammonium hydroxide followed by crystallization. Also known as *hartshorn* and *rock ammonia,* ammonium bicarbonate is soluble in water but decomposes when heated. It was used in place of ammonia when making ammonia-ripened gelatin emulsions.

Ammonium bromide, NH_4Br

Colorless crystals made by hydrobromic acid acting upon ammonium hydroxide followed by crystallization. Soluble in ether, alcohol, and water, ammonium bromide was used as a halide in collodion formulas and as a restrainer in alkaline developers.

Ammonium chloride, NH_4Cl

White crystals made by ammonia salts acting upon hydrochloric acid followed by crystallization. Ammonium chloride is also known as *sal ammoniac.* Soluble in water and alcohol, ammonium chloride was used as a halide in many processes, including the salted paper, albumen paper, albumen opaltype, and gelatin emulsion processes.

Ammonium dichromate, $(NH_4)_2Cr_2O_7$

Yellow needles made by chromic acid acting on ammonium hydroxide. The product is produced by crystallization. Ammonium dichromate was used interchangeably with potassium dichromate for sensitizing gelatin, albumen, gums, and other colloids that were used for pigment processes. Ammonium dichromate is more sensitive than the potassium alternative.

Ammonium iodide, NH_4I

White crystals made by the action of ammonium hydroxide on hydroiodic acid followed by crystallization. Soluble in water and alcohol, ammonium iodide was used as a halide in collodion formulas, particularly in situations where it was needed for use immediately. Ammonium iodide decomposes quickly when mixed with plain collodion, releasing iodine.

Ammonium nitrate, NH_4NO_2

Colorless crystals made by the action of ammonium hydroxide on nitric acid. Soluble in water, alcohol, and alkalies, ammonium nitrate is explosive and was used as a substitute for potassium nitrate in making flashlight mixtures.

Ammonium thiocyanate, NH_4CNS

Colorless deliquescent crystals made by boiling an aqueous solution of ammonium cyanide with sulfur or polysulfides. It must be kept in a well-sealed container. The principal use for ammonium thiocyanate was in gold-toning formulas, but it was also used in a 5 percent solution to dissolve gelatin in overexposed carbon prints.

Amphitype

One of the many curious and interesting printing processes invented by Sir John Herschel. It depends on the light sensitivity of ferric, mercuric, and lead salts, and it gives a rich, vigorous print that can be viewed from both sides of the paper or as a transparency. A sheet of paper is prepared with a solution (either ferric-tartrate or ferro-citrate of protoxide, or peroxide of mercury) and then with a saturated solution of ammonia-citrate of iron. Exposed in a camera for a time ranging from a half hour to six hours, a negative is produced on the paper. The negative gradually fades in the dark but may be restored as a black positive by immersion in a solution of nitrate of mercury.

Amyl acetate, $C_7H_{14}O_2$

A colorless liquid made by adding sulfuric acid to a mixture of amyl alcohol and acetic acid with subsequent recovery by distillation. It is slightly soluble in water but insoluble in alcohol. Amyl acetate was used as one of the solvents in making celluloid film and as fuel for the Alteneck lamp, adopted as the standard light in sensitometry by the International Congress of Photography in 1889.

Analglyph

A stereoscopic method introduced by Ducos Du Hauron. Two photographic plates exposed from different viewpoints were used to print both records on each other by using two colors of ink, typically red and blue. The two records do not register exactly, but when they are viewed with glasses bearing filters of the same two colors, a single 3D image is seen. This technique was also applied to transparencies for projection.

Anhydrous

A term indicating that a substance is free of water. In photographic work it distinguishes a chemical sold as a powder from a crystal in hydrated form. When making solutions, photographers needed to take note whether the anhydrous form of a chemical was called for, since this chemical could be more active than the hydrous counterpart.

Aniline, C_6H_7N

A thin, colorless oil prepared by reducing benzene with iron filings in the presence of hydrochloric or acetic acid and then separating the aniline formed by distillation. It is slightly soluble in water but dissolves easily in alcohol, ether, and benzene. Aniline is the base for many dyes used to increase the sensitivity of emulsions.

Aniline dyes

Solutions used to increase the spectral sensitivity of both collodion and gelatin plates. Some of the most common dyes were eosine blue, eosine yellow, erythrosine, and cyanine.

Ansco

An early manufacturer of photographic materials in the United States. In later years, until 1981, it was the only domestic manufacturer to compete with Kodak in offering a full line of photographic materials and equipment.

In 1842, three years after L. J. M. Daguerre published his process for producing an image by the action of light, Edward Anthony, a civil engineer living in New York City, became a supplier of chemicals, cameras, and equipment for carrying out the process. In 1852 Edward's brother Henry T. Anthony became a partner in the firm. In 1853 the brothers conducted the world's first photo contest.

A historical memorial plaque at 308 Broadway, New York City, was dedicated in 1942 with the following inscription: "Here Edward Anthony 100 years ago opened the first photographic supply house in the United States."

A division of the Scoville Manufacturing Company of Waterbury, Connecticut, made brass plates that, when silvered, were used in making daguerreotypes. After the Civil War, the company moved to New York City, where it purchased the American Optical Company, which also supplied photographic materials.

When, in the 1850s, the wet collodion process brought on the demise of daguerreotypes, the Anthonys adapted by introducing a new line of supplies. In 1860 Anthony products were used to make the first aerial photograph, one showing Boston Harbor. They supplied materials to photographer Mathew Brady and other photographers during the Civil War.

The Anthonys also supplied materials and equipment to W. H. Jackson for his pictures of Yellowstone Park (during the Hayden Survey) in 1871, Grand Teton National Park in 1872, the Colorado Rockies in 1874, and Mesa Verde in 1875.

In 1880 the Anthonys offered a Defiance Dry Plate of their own manufacture, and in 1882 they took on the entire output of Eastman plates for distribution. In 1901 a merger formed the Anthony & Scoville Company, which included numerous other manufacturers. One of these was the Monarch Paper Company, which owned a factory in Binghamton, NY for the production of roll film and cameras. In 1902 the company name was changed to Ansco.

In the mid-1880s Reverend Hannibal Goodwin, of Newark, New Jersey, was experimenting with nitrocellulose to find a flexible material that could be wound in a roll for picture taking — as a replacement for the heavy glass plates then in use. His experiments were successful, and on May 2, 1887, he applied for a patent. Eleven years later, in 1898, he was granted U.S. Patent number 610,861. Twelve broad claims offered protection for Goodwin's work. With this potential, Goodwin formed the Goodwin Camera and Film Company, whose main asset was the patent.

Appreciating the value of the protection offered by the Goodwin patent and the potential of the product described by it, the Anthony & Scoville Company bought the Goodwin Camera and Film Company and proceeded to market flexible film. When the company's name was changed to Ansco, roll film was marketed under the name Ansco Speedex. Developing-out papers were marketed under the names Noko and Cyko. The Eastman Company also marketed flexible film for which patent applications were pending.

In 1902 Ansco sued Eastman for infringement of the Goodwin patent. This litigation dragged through the courts until 1914, when Eastman offered a settlement for $5 million, which the plaintiff gladly accepted. Part of the proceeds were used to pay a large dividend to unhappy stockholders who had received no dividends for several years, and the rest were used to build a nitration plant at nearby Afton, New York, to make film-grade nitrocellulose, a main ingredient in flexible-film base. Ansco was severely affected by the shortage of nitrocellulose during the First World War. The newly built Afton plant was never used because by the time it was completed, the war was winding down, and film-grade nitrocellulose for civilian use was on the open market at a lower cost.

In 1928 the company, then known as Ansco Photo Products, merged with the German company Agfa Products, Inc., under the name of Agfa Ansco Corporation. This merger brought in European scientists, along with European scientific developments. Ansco produced the first American-made miniature camera, called the Memo, which was part of a family of miniature camera products that included a transparency printer, a paper print printer, and the Memo projector.

In 1941, during the Second World War, the company was taken over by the Alien Property Custodian. The manufacture of the first American dye-coupler film, Ansco Color, was begun for military use. The name Agfa was dropped in 1943. The Ansco Autoset became the first camera used in space by astronaut John Glenn. In 1961 Super Anscochrome film was used to make the first color photographs of the earth. The Anscochrome family of films made user processing a reality.

Beginning in the 1960s, GAF's (General Analine & Film) expansion efforts spread the company's assets too thin, and in 1981 the company sold off its photographic operations, along with others, cutting income in half. The company had earlier stopped using the Ansco name, and in 1978 the trademark was sold to W. Haking Enterprises Limited, a Hong Kong company.

Antiseptic

A substance used to prevent the tendency of purification in gelatins and starches. Antiseptics such as oil of cloves, wintergreen, and cinnamon were used in starch-based pastes for mounting photographic prints. The most common antiseptics for gelatin emulsions were alcohol, thymol, and formalin.

Anthotype

A process suggested by Sir John Herschel that used the colored extracts and tinctures of flowers and vegetables to sensitize paper. Objects such as leaves, lace, and other thin materials were placed in contact with the sensitized paper and exposed to sunlight. Anthotypes were not fixed or stabilized, making them impossible to display except in night albums, for evening viewing.

Antihalation

A state of reduction or removal of halation. In the collodion process, photographers placed red paper or cloth behind negative plates in the holder. Doing so made light reflect from the back of the plate to cast a nonactinic color, preventing reexposure of the plate. In gelatin plate work, the backs of plates were coated with a red, orange, or yellow pigment in a water-soluble gum base. *See also* Aurin.

Aqua fortis

An archaic name for weak nitric acid. *See also* Nitric Acid.

Aqua regia

An archaic name for the combination of one part nitric and three parts hydrochloric acid. Regia is the Latin word for King. It was called this because nitrohydrochloric acid could dissolve gold, known as the king of metals. Aqua regia was used to dissolve gold for the preparation of gold chloride.

Aqua vitae

An archaic name for alcohols, literally meaning "water of life."

Argentometer

A device for measuring the strength of silver baths used by photographers. The argentometer was essentially a standard hydrometer calibrated to measure the grains of silver in a silver nitrate solution. Such readings were accurate only when the silver bath was new in the case of collodion work. Like all hydrometers, the argentometer also measured the specific gravity of alcohol, and a silver bath used for the wet collodion process would contain alcohol left after dipping plates into the solution. Overworked baths were usually retired by pouring the solution into a large glass jar resting on a sunny windowsill. This allowed alcohol and ether to evaporate so that more-accurate readings could be taken. *See also* Hydrometer.

Aristotype

The product name for a collodion-chloride printing-out paper made by the Aristotype Company of Jamestown, New York. The name was also applied to gelatin chloride printing-out paper. The term *aristotype* was first introduced by Emil Obernetter in the 1880s.

Arrowroot

A refined starch made from several different plants that have tuberous roots, including potatoes. It is a fine, white powder that is soluble in water. Arrowroot was used for sizing

hand-coated sensitive papers or used as a light binder to carry various halides.

Artigue process

A modification of the carbon process that was named after its inventor, Frederic Artigue, in 1878 but reintroduced after improvements and modifications by his son Victor in 1893. The paper produced by this process, which was commercially available, was coated with a very fine black pigment (or two other monochrome colors) and suspended in a solution of a colloid substance.

Before printing, the paper had to be sensitized in a solution of potassium dichromate. Once dry, it was contact-printed to a negative. An essential feature of the process was the method of development. The manufacturer supplied very fine sawdust with the paper. The sawdust was mixed with water to a thick consistency. The print was soaked in tepid water, and then the sawdust-water mixture was poured over the print repeatedly to remove unexposed and unhardened pigment.

The prints produced by this process are characterized by a delicate, velvety matte surface, full tonal graduation, and rich black shadows with full detail. The introduction of the gum bichromate process lessened demand for the artique print process, but gum-bichromate images did not surpass the delicate quality and richness of images produced by the artique process.

Asphalt

Also known as asphaltum, bitumen, bitumen of Judea, and Jew's pitch, asphalt is a brown-black product of decomposed vegetable substances. It is soluble in alcohol, ether, chloroform, and most oils. Asphalt is somewhat sensitive to light. Nicéphore Niépce used asphalt dissolved in oil of lavender for his heliograph process to produce acid-etched copper and pewter plates, iodine-fumed silver plates, and the celebrated 1826 camera image "View from the Window at Le Gras."

Atomic weight

The standard measurement of different elements. In photography atomic weight is useful information when substituting one halide for another. For example, using the same measured quantity of ammonium iodide as potassium iodide in a formula would result in greater iodide content.

Aurin, $C_{19}H_{14}O_3$

A red coloring medium made from phenol or carbolic acid. It is soluble in alcohol and ether but insoluble in water. When fabrics were steeped in this solution, the color was nonactinic and therefore safe for darkrooms, windows, and doorways. Aurin was also mixed with water-soluble gums and brushed on the backs of collodion and silver bromide gelatin plates as an antihalation layer.

Avoirdupois

Literally translated from the French, *avoirdupois* means "goods of weight." This system of measuring by grains was used in Great Britain and America for everything except precious metals, gems, and medicines. *See also* Weights and Measures.

B
Baby holder

A device to secure infants for portraiture. Baby holders usually featured an adjustable clamp that held the child at the torso. Before the introduction of baby holders in the 1880s, the mother would typically hold the child on her lap or from behind. To isolate the subject, mothers were usually draped with dark cloth, or their image was removed from the negative by scraping or retouching. In this type of arrangement, the mothers' hands often remained visible where they held the child around the waist. Special chairs were also produced to photograph infants, featuring an opening in the back for the mother to hold the child.

Background

Typically the most distant area of the image, or, in a closer composition, the space behind the subject. The term was most often used in the 19th century to describe a pictorial device placed behind the subject in a portrait studio. In the earliest days of photography, portraits were taken outdoors using woolen blankets and similar household linens as backgrounds.

Plain backgrounds remained popular throughout the 19th century and were made from wool blankets or canvases painted with distemper. The cloth was usually stretched over and tacked onto a light wooden frame to produce a ground that had no wrinkles to catch the light.

Daguerreotypists preferred a medium-dark ground. This made the subject stand out and present a more dimensional effect. A technique peculiar to daguerreotypists was to have an assistant move the background during the exposure so that the resulting tone would be based on tonality rather than substance.

In the collodion era, light blue or grey backgrounds were routinely used for ambrotypes and tintypes. Both the blue and the medium-dark grounds were used by photographers making prints from negatives; many felt that proper lighting was always more stylish than a painted scenic ground. The best photographers manipulated their background and skylights to produce a gradation of tones, allowing the light areas of the subject's face to play against the darker portions of the ground.

A variant of the plain ground was the graduated ground. This type of ground was painted in tones from light to dark to mimic the effect of more-difficult lighting. These were available as standard grounds or were mounted on a large disc for bust portraits. The disc grounds could be rotated to manipulate the orientation of the tones.

Painted scenic backgrounds
Trompe l'oeil was used in studio photography to create scenic backgrounds. In some cases these were very believable,

although more often than not, the backgrounds were a formulaic attempt at art and a poor substitute for creative lighting and posing. Early scenic grounds for daguerreotypes often showed a horizon painted in soft focus to give the impression of distance between the subject and the landscape.

The more typical examples of backgrounds were less convincing, with compressed perspective that featured everything in focus. Such background products are still being made today. Specialty grounds for military portraiture commonly included camp scenes, maritime vistas, and ramparts fitted with waving flags. Nineteenth-century scenic grounds were often painted in monochromatic tones of warm grey or rose.

Curved backgrounds

During the collodion era, a special type of plain background was introduced to manipulate the light. The alcove background was a massive chamber built in the shape of a standing cylinder cut in half. By placing the subject in front of this chamber and adjusting the studio skylights, the photographer could illuminate one side of the subject's face, juxtaposing it against the shadowed curve of the ground, and could illuminate the ground behind the darkened side of the subject's face.

A variant of the curved background was the cone background. Cone backgrounds were usually headgrounds — smaller grounds for shooting the head and shoulders of the subject. The cone or hemispherical ground was often made of painted papier-mâché and mounted on a moveable stand.

Atmospheric backgrounds

Some studio photographers used the distance of a chamber to establish background tonality. The most famous of these were the daguerreotypists Southworth and Hawes, of Boston. In their system the photographer took advantage of a corner featuring one bright wall turning to a progressively less-illuminated chamber to give a ground with both light and dark tonality.

Backing

Ambrotypes made on clear glass required backing with something dark to make the positive effect visible. Backing materials included dark cloth, japanned iron, and painted paper or by painting a black medium directly on the plate.

Backing paints were made with either carbon black or asphaltum as the colorant. When asphalt was used, the colorant and binder were the same, requiring only a solvent turpentine Canada balsam and sometimes a drying agent such as chloroform. Ambrotypes backed with asphalt varnishes appeared reddish brown when lit from behind. Carbon black could be added to asphalt varnishes to create a more neutral black color. Many ambrotypists, however, simply put carbon into the gum-based spirit varnish they used for collodion plates.

Ambrotype backings were applied to either the collodion side or the glass side of the plate. When the plate was viewed from the collodion side, the image was reversed. When the collodion side was turned down, the image appeared correct. Occasionally the painted backing was applied directly to the collodion side. Images backed by using this technique are often found today with both the backing and the image-bearing collodion layer in poor condition. *See also* Antihalation.

Bain marie

A heated water bath. This was essentially a double boiler made by putting one tray of water into another. The advantage of this system was that the upper tray could never boil despite the temperature of the heated tray below. This system was particularly useful for development of albumen plates and for the carbon printing process.

Balance

A device for measuring the relative weight of materials based on a known set of standards. The typical balance used by 19th-century photographers was very simple and was known from antiquity. Such instruments featured a long beam with a fulcrum in the center, onto which was fitted a needle. The balance was supported from the center of the frame bearing the fulcrum. Two trays were suspended from opposite ends of the beam by wires, chains, or string. A compound could be measured by placing a standard ounce, gram, or grain weight in one tray and carefully adding the material to the other. When the needle settled upright, the correct amount by weight was reached.

Balsams

Sticky exudations from some trees and plants. These adhesives begin as liquids but harden into solids as the liquid evaporates. Canada balsam, also known as Canada turpentine, is soluble in benzol. Before the advent of modern optical adhesives, it was routinely used to cement lens elements. Both the Cutting and the Skaife methods of sealing collodion positives used the same technology as used in mounting microscope slides with Canada balsam. Balsams were also used in asphalt varnishes and applied to albumen and salted paper prints to render them translucent for chrystoleums and ivorytypes.

Baryta paper

Paper coated with barium sulfate ($BaSO_4$), barium chloride ($BaCl_2$), or baryta [$Ba(OH)_2$]. It is also know as *porcelain paper* or *clay-coated paper*. Baryta papers were made by coating paper with the three aforementioned powders mixed in gelatin and then running it through heavy rollers to produce a smooth, white surface. The resulting layer was first featured for the manufacture of collodion and gelatin aristotype papers and later became the standard for silver bromide developing-out and gaslight papers. Baryta-coated papers continued to be manufactured throughout the 20th century.

Base

A metal oxide that reacts with an acid to form a salt.

Bas-relief

A term often used to describe the raised portions of an image. Bas-relief is most commonly seen in dichromated colloid processes such as carbon or gum printing, particularly before

the prints dry completely. Relief can also be seen in negatives if a tanning developer is used or the image is intensified or redeveloped.

Bath

A term often applied to any solution used in photography, including processing and washing chemicals; however, the term is most frequently associated with the silver nitrate solution. In printing, the silver solution was always placed in a horizontal bath or tray. In the albumen-plate and collodion processes, both horizontal and vertical vessels were used. The vertical tanks were also called baths.

Vertical baths were made from a variety of materials, including wood, rubber, ceramic, and glass. A dipper was used to lower plates into the silver solution. The advantage of vertical baths was that they could be made with a sealed lid, making them easier to transport and prepare for use. They were also less prone to contamination by airborne dust, although the limited surface area did little to allow the evaporation of the ether and alcohol introduced by every plate dipped into the solution.

Beer

Among many other humectants, stale beer was used to preserve collodion plates in a moist state. The plate was coated with collodion and sensitized in the silver bath as in the wet plate processes, but the excess silver solution was then washed off with water, and beer was poured on the sensitive surface. After draining on a rack, the plate could be kept sensitive for days in a light, tight box.

Preserved plates were much less sensitive than the more common wet plates, making them useful only for landscape work. Exposed plates were typically developed with a solution of pyrogallic acid, with acetic or citric acid and a few drops of silver solution to replace the silver that was washed off during the preparation of the plate.

Beeswax

The natural wax produced by bees to store honey in the hive. Beeswax was heated and combined with solvents and oils to produce a paste for coating prints. Such coatings improved the tones of salted paper prints and other processes without the necessity of binders. The coatings also provided an atmospheric barrier.

Bellows

A telescopic chamber between the front and back elements of a camera. The bellows is made with accordion pleats of paper, leather, rubberized cloth, or regular cloth. It allows a variable range of separation from the camera to the lens. Use of the bellows was an improvement over the sliding-box system of adjusting focus; it provided improvements in both flexibility and weight. Originally introduced as a square tube, it was also made to taper toward the lens. The Kinnear camera was one of the first tapered-bellows field cameras.

Benzene, C_6H_6

Also known as *benzol, benzole, coal tar naphtha,* and *phenyl hydride,* benzene is a clear, colorless, flammable liquid made by passing coke gas through oil, which is then distilled to produce benzene and toluol. The benzene is separated from the toluol by fractional distillation. Benzene is soluble in alcohol, ether, chloroform, and glacial acetic acid, but it is insoluble in water. Benzene was used as a solvent for many photographic operations in the 19th century. In the collodion process, benzene was used to dissolve rubber to both subcoat and supercoat negatives. It was also used as a solvent for Canada balsam in the Cutting method of sealing ambrotypes and cementing lens elements. Benzene was also used as a solvent for wax, gums, resins, and amber and in particular for retouching varnishes applied to silver bromide gelatin negatives.

Barium sulfate, $BaSO_4$

A heavy, white powder made by treating barium salts with sulfuric acid. Barium sulfate was used as a preliminary coating for raw photographic papers to produce a smooth, white surface and to act as a barrier to prevent reactions between the paper and subsequent coatings of gelatin or collodion emulsions. Barium sulfate was also added directly to emulsions to produce a matte finish. It is also known as *barite, synthetic barite, blanc fix, baryta white,* and *mountain snow.*

Bichromate disease

A condition characterized by a violent irritation that is caused when bichromates enter a scratch or abrasion in the skin. Rubber gloves would have been the best prevention for bichromate disease, but precautions such as this were little used in the 19th century unless a chronic condition was established. Potassium and ammonium dichromate are now known carcinogens.

Bicolored

A bicolored print or negative in the 19th century was considered a mistake — usually the result of inconsistent processing or toning. Bicoloring could be caused by the condition of the toning bath, the density of the silver image, or the solubility of the binder of a particular process. In the gum-over-platinum process, however, bicoloring was an aesthetic choice. Today we refer to black-and-white prints featuring two or more hues as *split toned.*

Binder

A substance that suspends the image-bearing chemicals in photosensitive materials. The most common binders for silver halides were albumen, collodion, and gelatin. In the bichromate processes, gums, gelatins, albumen, and other water-soluble colloids were used as binders.

Bitumen of judea

See Asphaltum.

Black cloth

Also known as a focusing cloth, black cloth was used to cover the head of the photographer and back of the camera to exclude extraneous light in order to facilitate viewing the projected image on the ground glass. Some photographers temporarily attached their black cloth to the camera by using snaps or drawstrings to prevent the cloth from being blown in the wind. Other modifications included sewing small weights to the lower edges for the same purpose.

Black mirror

A thick plate of black glass or onyx that is highly polished to a smooth, reflective surface. Also known as a *Claude Lorraine glass* and well known to artists, such viewing devices were used to observe landscapes in monotone so that the photographer could visualize the effect of light and shadows without the distraction of colors.

Black spots

Nonimage specks usually caused by airborne dust in the darkroom. Black spots on hand-coated prints came from either metallic particles in the raw paper or pinholes in the actual negative that allowed light to expose the sensitive paper. Black spots in negative materials had many causes but were most typically attributable to foreign matter in the air or water. Black spots resembling a celestial comet (with one or more tails) were common on collodion plates. *See also* Comets.

Black varnish

Dark backing for ambrotypes. *See also* Backing.

Blacking

Dead matte coloring applied to the interior of cameras and lenses to reduce or eliminate reflections that would otherwise fog the plate or film during exposure. Blacking was typically a paint or varnish made with lampblack or a preparation formulated to darken wood or brass by chemical reaction.

Blanchard's brush

Coating tool made by cutting a strip of glass to about 1.5×6 inches and covering one end with two or three layers of flannel secured with either string or a rubber band. The advantage of this brush was that the flannel could be removed and the glass thoroughly cleaned to avoid chemical contamination. Blanchard's brush was particularly suited to the preparation and development of calotype negatives and any of the hand-coated printing papers.

Bleaching

The first step in intensifying a negative or sulfide-toning a silver bromide print was to bleach the metallic silver image. Bleaching could be done with mercuric chloride, potassium bromide, and potassium ferricyanide or with potassium bromide and copper sulfate. Once the silver image was bleached and washed, the print or plate was placed either in a second chemical to create a new silver compound or in dyes that turned the image a new color. Bleaching was also done to produce positive images on silver bromide gelatin plates and to further whiten the highlights of collodion positives.

Blister

When gelatin or albumen binders expand and detach from the support material, the result is called a blister. This problem in albumen printing was more common but not limited to processing double-coated papers. Blisters were usually the result of overwashing or indelicate handling, although they could occur at any time because of the nature of a hand-coated material. In the case of plates coated with gelatin emulsions, blistering was a common problem because of the great expansion of gelatin in cold water. An alum bath prior to development or fixing was the typical cure for blistering and frilling. *See also* Frilling.

Blocking out

When areas of the negative were not wanted in the final print, they were blocked out, or "stopped out." This retouching treatment was very common for calotypes, albumen plates, collodion plates, and silver bromide gelatin negatives. Such negatives, being equally sensitive to blue and white, would rarely record distinct clouds, leaving large areas to feature the chemical and procedural mishaps of the photographer. Instead of printing such unsightly artifacts, photographers simply removed them by blocking them out.

There were several methods to block out or mask a sky in negatives. Paper negatives were treated with various black, blue, and red inks. Glass negatives could be blocked out with delicately cut black, brown, red, orange, or yellow paper, usually applied to the glass side of the plate. Pigments of these same colors in a gum binder, called opaque, were also painted on both the collodion or the glass side, depending on the effect required. Blocking on the glass side resulted in a softer mask than when applied to the image side, because the glass thickness prevented actual contact with the printing paper.

Negatives of machinery and other commercial objects were frequently isolated from their surroundings by stopping out the background completely. By the last quarter of the 19th century, the medium of choice for blocking out was made from either graphite or iron oxide in a gum binder and was sold as water soluble opaque.

Blotting paper

There were many uses for absorbent paper in the darkroom. It was important that such paper be manufactured with chemically clean linters and without sizing. Often called *bibulous paper* in the old manuals, blotting paper was used in great quantities to produce calotype and wax-paper negatives and to dry prints. Blotting paper of unknown quality could be made safe by treating it with boiling water that contained sodium carbonate and then washing it thoroughly.

Blue glass

The use of blue glass to glaze studio skylights had little to do with its actinic quality; it was preferred for the comfort of the sitter, particularly when direct sunlight was used to illuminate the subject in the early days of the daguerreotype. Blue glass did not produce shorter exposure times, as many assumed it would.

Blue sensitive

All of the silver halide processes of the 19th century were only ultraviolet sensitive, violet sensitive, and blue sensitive until the adoption of dye sensitizers for collodion and gelatin emulsions. When plates of extended sensitivity were available at the end of the century, the blue-sensitive materials became known as *ordinary* or *color blind*. It is important to note that all gelatin emulsions start out as ordinary or blue sensitive until treated with dyes to increase sensitivity past the blue-green wavelengths of the spectrum.

Blue toner

Silver bromide prints could be toned a rich blue in a bath of potassium ferricyanide and ferric ammonium sulfate. Examples of blue-toned prints from the 19th century are rare and seem to have been produced for novelty. The technique was also used on transparency materials to produce the blue layer for experimental three-color assembly processes.

Blurring

When subject movement is faster than the exposure, the resulting image shows a proportional loss of focus. Head rests and posing tables were introduced into 19th-century studio to help subjects remain motionless during exposures. The blurring of running water and trees in the wind was common in landscape images until faster plates were introduced in the latter part of the century. Blurring should not be confused with poor focusing of the camera or distinct double imagery that is caused by shifting of the negative in the printing frame.

Boiling

Silver bromide gelatin emulsions were originally heated to increase particle size and, as a result, sensitivity. Charles Bennett was the first to discover the effect in 1878. The term *boiling* refers to heating the water surrounding the emulsion kettle to the boiling point. An alternative to boiling emulsions was to increase speed by introducing ammonia to the melt.

Bone gelatin

Photographic emulsions of the 19th century were made from gelatins obtained from one of two sources: animal bones or hides and skins. Both porcine (pig) and bovine (cattle) gelatins were used for plates, films, and paper.

Book camera

When silver bromide gelatin plates were sensitive enough to allow hand-held exposures, numerous novelty detective cameras were designed for candid photography. The book camera, as the name suggests, was designed to resemble a bundle of books held together by a leather strap.

Bon ton

By the mid-1860s tintypes were being sold in paper mats as a less expensive and more easily mailed alternative to the more elaborate wood and thermoplastic cases available at the time. Multi-lens cameras were built with a special back mask and a sliding plate holder, allowing either four exposures on a 5×7 inch plate or eight exposures on an 8×10 inch plate. After the plates were exposed, processed, and varnished, the individual images were cut with tin snips. Tintypes made in this size were known as bon tons, possibly referring to the French term *bon temps*, meaning "good times." The four lens sets were also known as *bon ton tubes*. Tintypes in sizes smaller than the bon ton were usually called *gems*.

Borax, $Na_2B_4O_7*10H_2O$

A natural, colorless salt crystal found in some lake beds. It is soluble in water and glycerin but not in alcohol. When mixed with water, it produces a slight alkaline reaction. Its use in photography was principally as a pH modifier in gold toning baths, but it was also used as a restrainer in pyrogallic acid developers and as an accelerator in hydroquinone developers.

Boric acid, H_3BO_3

A substance made by adding hydrochloric acid to a strong, hot solution of borax and water. When cooled, this mixture forms colorless crystals of boric acid. These require washing and recrystallization. Boric acid was occasionally used as an antiseptic and in combined toning and fixing baths.

Bottles

Throughout the 19th century, glass bottles were used to hold various substances. Acids were kept in bottles with ground glass stoppers. Because these stoppers were prone to sticking, many photographers applied grease to the bearing surfaces to make an air-tight seal that was easy to open. When it was necessary to keep stoppers from working loose, a strong cotton string was wrapped around the neck of the bottle and tied to the top of the stopper.

Solutions that were sensitive to light were stored in amber or brown bottles. A bottle with a larger opening was used for dry chemicals to allow the introduction of a small spatula. Collodion-pouring bottles used in the wet plate process were patterned after apothecary syrup bottles. These featured a central spout, from which the collodion was poured, and a larger domed cap with a ground glass seal to prevent evaporation of the ether and alcohol. These were commonly called *cometless* pouring bottles. The cap never came in contact with the collodion, thus preventing particles of dry collodion from falling onto the coated plate, which could cause small comets in the final image. *See also* Comet.

The favorite vessel for pouring collodion or gelatin emulsions was a recycled Rhine wine bottle. This had a long, gradually tapered neck that was particularly useful when bubbles were a problem.

Demijohns were bottles protected from shock by a woven cover of straw, wicker, twine, or twisted paper. They were typically used for storing or shipping larger quantities of solutions.

Boudoir

The boudoir print was a mounted portrait photograph introduced in the last quarter of the 19th century. Similar in style to the cabinet card, the boudoir mount measured 5-1/4 × 8-1/4.

Boxes

An endless variety of boxes was used for as many purposes in 19th-century photography. The camera was referred to as a box. Boxes were used to sensitize, develop, and store daguerreotype plates. Before the introduction of accordion bellows, boxes fitted within boxes were used to adjust the focus of cameras.

In the collodion process, boxes held the glass silver bath, carried the chemicals, and served as portable developing stations. Slotted plate boxes held clean glass plates, presensitized plates, and varnished negatives for dead storage. Zinc-lined plate boxes were used to hold developed and washed (but unfixed) collodion negatives that were preserved with glycerine until their processing could be completed.

Silver bromide and silver chloride gelatin plates were sold in light-tight cardboard boxes that were often also used to store the finished negatives. Lantern slides were usually stored in long wooden slotted boxes that were indexed to make finding the images easier.

Wood boxes were usually made with two different types of corner joints: dovetail joints and finger (or box) joints. Early boxes were fitted with hand-cut dovetail joints, so called because the ends of the tapered joints resemble their namesake. The machine age offered an easier alternative to hand-cut dovetails in the form of finger joints. These are easily identified by the numerous parallel machine-cut joints along the corners.

Bristol board

Used for the mounting of prints, primarily *cartes de visite*, bristol board was a smooth, thin card stock made by laminating several layers of very thin rag paper. These boards were available in different grades, designated by the number of plies; *cartes* usually contained six plies. The multiple layers were important to counteract the tendency of albumen prints to warp the mount when applied with starch paste, as was the custom in the latter half of the 19th century. Boards of such quality are not available today.

Bromide

One of the halide compounds used in photography to produce a silver halide. Bromine fumes were used in the daguerreotype process to produce silver bromide, an accelerator allowing faster exposures. For all of the other 19th-century processes, bromide compounds made with potassium, cadmium, and ammonium were the most common form. In calotypy the dominant halide was an iodide with bromides acting as both an accelerator and a restrainer, depending on the quantity. Bromides were added to iodized collodion to extend spectral sensitivity to the blue-green range. When silver bromide gelatin emulsions were introduced in the 1870s, bromides were the dominant halide and were also used as a restrainer in alkaline developers.

Bromide paper

Silver bromide gelatin emulsions were used to coat a wide variety of papers near the end of the 19th century. Bromide papers are developed out.

Bromine, Br

One of the four halogens used in silver halide photography, bromine is a nonmetallic element that was discovered in 1811. The earliest use of bromine for photography was in the elemental form to fume daguerreotype plates alternately with iodine. Bromine was an important accelerator, allowing the daguerreotype process to be used for portraiture. Bromine was used to make a number of salts used for photography throughout the 19th century, the most common being ammonium bromide, cadmium bromide, and potassium bromide. *See also* Bromide.

Bronze

A term referring to a color shift that resulted from overexposure of silver chloride printing-out papers such as salted paper, albumen, collodio-chloride, and gelatin chloride. A properly printed negative would display a very small amount of this effect in the deepest shadows when pulled from the printing frame. Negatives with very high contrast produced prints that bronzed very easily because the thin areas of the negative would print completely before the areas of greater density.

Brown print process

Also called the Vandyke process (after the Flemish painter Anthony Van Dyck, because of the similarity of the brown tones in his paintings to those produced by this process), the brown print process was devised in 1889 by H. Shawcross for plan copying. A negative sepia image was made from a positive master. Later the process was applied to pictorial photography and the printing of images on fabric. The sensitizing solution consists of ferric ammonium citrate, tartaric acid, and silver nitrate. Exposure is by contact in sunlight or artificial light, and development is in running water with potassium dichromate added when required to enhance contrast. Fixing is in a weak solution of plain sodium thiosulfate.

Brush development

A development technique that dates to the era of the calotype. Talbot used a brush to apply gallic acid restrained with acetic acid to his paper negatives. Brush development was devised to use as little developer as possible. For artistic effect, brush development with a camel-hair mop brush was also used later in the century in the platinum process to concentrate development to specific areas. Brush development was also used in silver bromide printing when a slow-working developer was used.

Buckle's brush

A brush made by pulling cotton wadding through a glass tube by using a loop of cotton thread. The two ends of wadding were not pulled completely through the tube but were left exposed. Like Blanchard's brush, the advantage of the Buckle's brush was that it was easy to clean and to replace.

Buff

Used by daguerreotypists to apply the final polish to their silver plates. Buffs were usually made by initially applying layers of flannel cloth or cotton wadding to the flat surface of a long wooden paddle. A cover of cotton velvet, chamois leather, or buckskin was then stretched over the padding and tacked down along the edges of the paddle. The daguerreotypist polished the plate with two buffs. One buff was dusted with either rouge or carbon black just before passing it repeatedly over the plate. The second buff was used without these fine abrasives.

Bulb exposure

When lens shutters were introduced in the 1880s, one way of tripping the mechanism was by squeezing a rubber bulb that was connected, by a long rubber tube, to a small piston. One option for exposure was a duration, called instantaneous. The other exposure was keeping the shutter open as long as the bulb was compressed and was therefore known as a "bulb" exposure.

Burnisher

A finishing tool for applying a smooth, glossy finish to mounted prints. By the 1870s all *cartes de visite* and cabinet-card prints were burnished, as were many of the larger print sizes. When originally introduced, the burnisher featured a hand-cranked, textured roller that pulled the print over a smooth, heated bar. Eventually this design gave way to a rotary burnisher that featured two rollers: one smooth and heated and the other textured. In this configuration, the rollers rotated at different speeds, simultaneously compressing and rubbing the surface of the print. To get the best results, prints were rubbed with a lubricant before they were sent through the rollers. Burnished photographs remained popular until around the First World War.

Burnt-in photography

Also known as *ceramic photography,* this produced permanent vitrified images on enamel or ceramic supports. This practice was most commonly used for oval portrait vignettes on porcelain applied to tombstones. The process was also used for novelty jewelry and commemorative ceramic vases.

C

Cabinet photograph

Introduced in the early 1860s, the cabinet-card format featured a 4 × 5-1/2 inch print on a 4-1/4 × 6-1/2 inch mount. It was used primarily for studio portraiture, although views can occasionally be found. Prints mounted in this format were made on albumen paper, collodion-chloride printing-out paper, developed-out silver bromide gelatin paper, and gelatin chloride printing-out paper. Along with the *carte de visite,* cabinet cards were very popular until the end of the century, often sharing space in the family album.

Cadmium, Cd

A soft bluish metal, cadmium is extremely toxic, particularly in the compounds used for photography. It is found in zinc ores and in the mineral greenockite (CdS).

Cadmium iodide, CdI_2

Made by the action of hydriodic acid on cadmium oxide and crystallization. The colorless, flaky crystals are soluble in water, alcohol, and ether. This halide was a common iodizer for collodion formulas, particularly for negatives.

Cadmium bromide, $CdBr_2 4H_2O$

Made by heating cadmium to redness in bromine vapor. The yellowish crystalline powder is soluble in water and alcohol and is slightly soluble in ether. The crystals are deliquescent and must be kept in a well-stoppered bottle. Like its iodide counterpart, cadmium bromide was used in collodion in conjunction with an iodide of either ammonium or potassium.

Cadmium chloride, $CdCl_2 * \frac{5}{2} H_2O$

Made by the action of hydrochloric acid on cadmium and crystallization. The small white crystals are soluble in alcohol and water. Cadmium chloride was used to make collodion-chloride printing-out emulsions, also known as *leptographic* or *aristotype* papers.

Calcium bromide, $CaBr_2$

Made by the action of hydrobromic acid on calcium oxide and crystallization. The white granular crystals are soluble in water. Calcium bromide was used in making collodion emulsions, particularly for dye-sensitized plates.

Calcium carbonate, $CaCO_3$

Made by adding soluble carbonate to a calcium salt solution. The white powder or crystals are soluble in acid but not in water. Calcium carbonate was used to neutralize gold toning baths and as a fine abrasive added to water and alcohol for cleaning glass plates before they were coated with photographic binders.

Calcium chloride, $CaCl_2 * 6H_2O$

Obtained as a by-product in the manufacture of potassium chlorate. The white crystals, soluble in water and alcohol, are deliquescent and must be kept in a well-stoppered bottle. Calcium chloride was used in iodized collodion formulas and in collodion emulsions. It was also an important desiccating substance used in tin calcium tubes designed to store presensitized platinum papers.

Calotype

The first permanent negative process on paper, the calotype (also known as the *Talbotype*) was patented by William Henry Fox Talbot in 1841. The root of the word *calotype* comes from the Greek and means "beautiful." The calotype process was much faster than the photogenic drawing process that preceded it. It was a latent-image process based on the sensitivity of silver iodide. Paper was first coated with a solution of silver nitrate followed by a solution of potassium iodide. The potassium nitrate and excess iodides formed during the preceding step were washed from the paper. After drying, the iodized paper was coated again with silver nitrate, acetic acid, and gallic acid (called gallo-nitrate of silver) and then exposed in a camera while still damp.

The exposed paper was developed with a mixture of gallic acid, acetic acid, and drops of silver nitrate as needed to promote physical development. When development was complete, the paper was washed and fixed with sodium thiosulfate and then washed again to remove the residual fixer.

The calotype negative was permanent, displayed a pleasant range of tonality when made by skilled hands, and could be used to contact-print an unlimited number of salted paper prints. For this reason, the calotype process has often been regarded as the forerunner of modern negative/positive photography. Although the calotype was never to reach the popularity or commercial success of the daguerreotype, there is no doubt that the invention of glass negatives was a direct result of its influence. Glass negatives made by the wet collodion process quickly eclipsed both the daguerreotype and the calotype methods by the mid-1850s. *See also* Photogenic Drawing.

Camera

The viewing of an inverted image through a pinhole in a large room was recorded as far back as the 5th century in China. In the 16th century, Aristotle used this principle to view solar eclipses. However, it was not until the Renaissance that the concept really began to be worked on in earnest. Scientists and inventors such as Leonardo da Vinci and Girolamo Cardano began making references to the phenomenon of image projection in what then was known as the camera obscura. During the 16th century, great improvements over the original design were made, which not only improved the camera obscura but also extended its applications. A problem had existed concerning the dim image that the small hole projected. It was common knowledge that if the size of the hole was increased, the sharpness of the image would decrease. With this principle in mind, Cardano fitted a biconvex lens to the camera obscura in 1550, and Daniel Barbaro added a diaphragm that would improve the depth of the field in 1568. In 1676 Johann Strum inserted a 45 degree reflex mirror that allowed the image to be projected to the top of the box onto a sheet of oiled paper — and onto a ground glass in later versions. The significance was that the camera obscura could now be used from the outside, and thus it could be greatly reduced in size. The focusing lens became a complex arrangement of separate glass elements in a brass housing that corrected for various aberrations.

Cameras of the 19th century

All images on the following pages are courtesy of the Technology Collection, George Eastman House International Museum of Photography and Film, Rochester, New York. Comprising more than 16,000 objects, the George Eastman House technology collection is one of the world's largest collections of photographic and cinematographic equipment. It contains 19th- and 20th-century objects of photographic technology, including cameras, processing equipment, motion-picture devices, and a broad range of early historical accessories. Many of the objects are unique, representing distinguished historical ownership and significant scientific achievement.

This collection is the most comprehensive held by any institution in North America and is equaled in overall quality by only three other holdings worldwide. From devices that predate the formal invention of photography in 1839 to the most modern state-of-the-art instruments used by both amateurs and professionals, the collection offers visitors an unparalleled opportunity to examine and learn about photographic technology.

FIG. 3 Collapsible camera obscura, ca. 1800.

FIG. 4 Samuel Bemis daguerreotype outfit. Clockwise from lower left: camera, mercury chamber, iodizing box, plate box, ca. 1839.

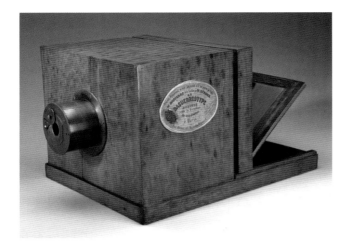

FIG. 5 Giroux daguerreotype camera, ca. 1839.

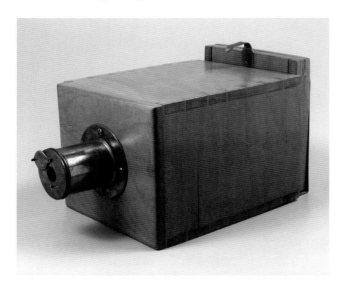

FIG. 6 Talbot design calotype camera of 1840 (replica).

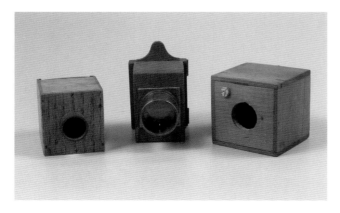

FIG. 7 Talbot design mouse trap cameras (replicas).

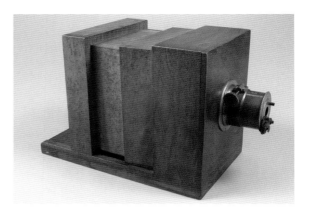

FIG. 8 Sliding box camera with single achromatic landscape lens, ca. 1841.

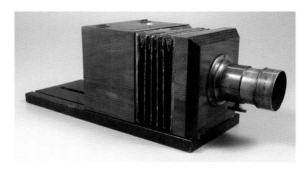

FIG. 9 W. & W.H. Lewis daguerreotype camera, ca. 1852.

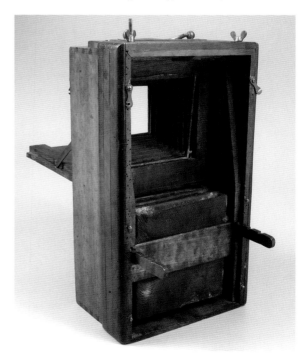

FIG. 10 Albites patent laboratory camera, ca. 1860.

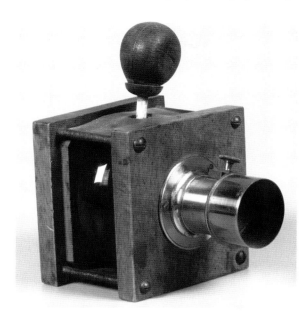

FIG. 11 Dubroni laboratory camera, ca. 1860.

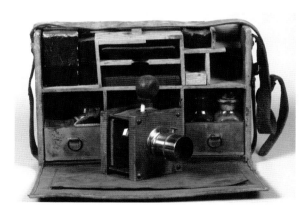

FIG. 12 Dubroni outfit, ca. 1860.

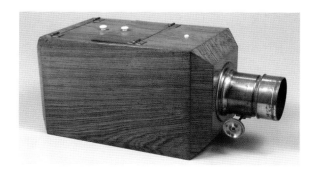

FIG. 13 American chamford box daguerreotype camera, ca. 1864.

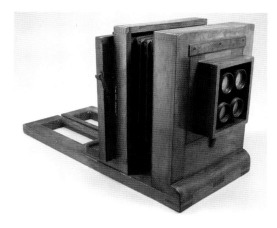

FIG. 14 John Stock bon ton ferrotype camera, ca. 1870.

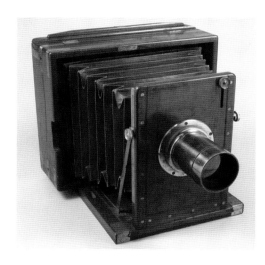

FIG. 15 W. Rausch folding camera, ca. 1870.

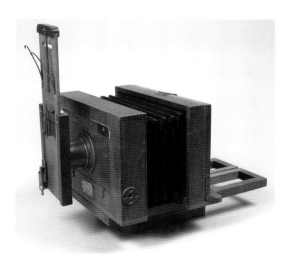

FIG. 16 Drop shutter, ca. 1880.

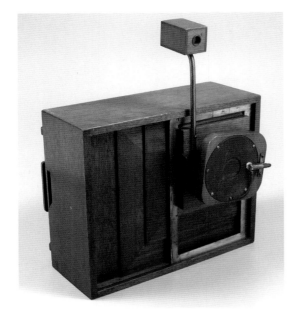

FIG. 17 Simon Wing "new gem" multiplying camera, ca. 1881.

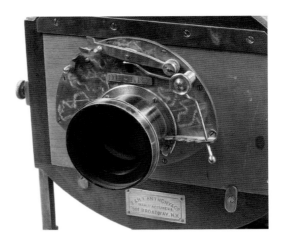

FIG. 20 Prosch duplex shutter, ca. 1844.

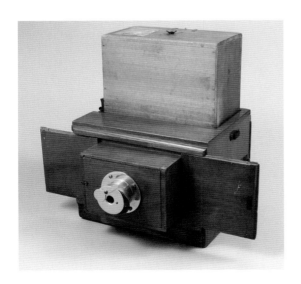

FIG. 18 Blair tourograph magazine camera, ca. 1882.

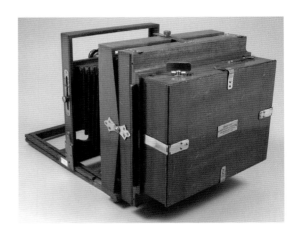

FIG. 21 Eastman-Walker roll holder, ca. 1885.

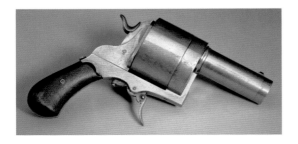

FIG. 19 PhotoRevolver Oe Proche, Paris, France, ca. 1882.

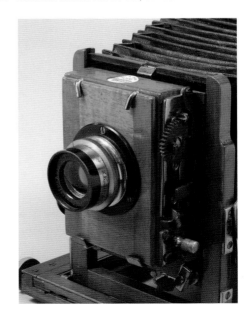

FIG. 22 Thornton-Pickard cloth shutter, ca. 1886.

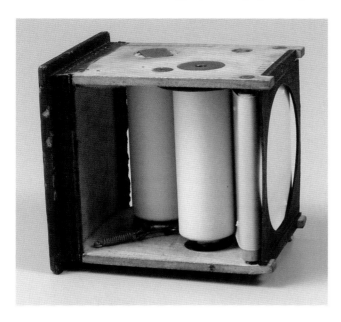

FIG. 23 Eastman American flim in Kodak roll holder, ca. 1888.

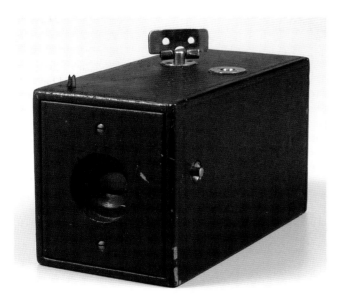

FIG. 24 Kodak camera, ca. 1888.

The portability of the new camera obscura greatly interested architectural and landscape artists, who carried the tool to various locations to do preliminary traced sketches for paintings. In 1807 William Hyde Wollaston added more portability to realistic sketching with the camera lucida, a prism-and-stand device that projected an image of a scene downward, where the image could be sketched more easily. A realistic perspective recording was a much-sought aesthetic—and a fundamental reason for photography's later popularity.

It is interesting to note that by the 17th century, the box, lens, reflex mirror, and ground glass had all been introduced. It would take another two centuries before the chemistry of the photographic process would become sophisticated enough to be applied to the camera apparatus.

Photographic Cameras

All photographic cameras were and continue to have the same basic elements: a box with an aperture on one end that may or may not be fitted with a lens and a focal point on the opposite end, where the projected image is visible. The very first cameras for photographic use were no different from the common camera obscura available for a hundred years before photography was invented. Very primitive results were produced when using these boxes fitted with simple biconvex lenses. The poor quality was due partly to the lengthy exposures required to print out a visible image but also to the fact that the materials were sensitive only to ultraviolet, violet, and blue light. Simple lenses did not focus parallel rays of light on the same plane—a defect called *spherical aberration,* which resulted in the loss of focus on the outer edges of the image. Nor did the lenses focus all the colors of the spectrum on the same plane—a defect called *chromatic aberration.* The most visible colors to the human eye are in the yellow range, so even if the image was focused properly, the final product would be out of focus on materials that were sensitive only to violet and blue light.

The First Cameras

Thomas Wedgwood, Nicéphore Niépce, William Henry Fox Talbot, and Louis Daguerre all made their very first images using simple uncorrected lenses, often taken from a solar microscope. The early experimenters quickly realized that lens design was critical for better results, and they looked to opticians for the achromatic lens used by telescope makers. While not always fully achromatic, these lenses were superior to the simple biconvex lens and were capable of remarkably good focus when stopped down.

The earliest photographic cameras known to exist are those used by Nicéphore Niépce, on display at the Muse Niépce in Chalon-sur-Sônne. The most notable example features a sliding box within a box for focusing (an innovation from camera obscuras that predates photography) and an unusual lens board that allowed the biconvex achromatic lens to be removed by sliding half of the board upward. Niépce gave one of his cameras to Daguerre when they became partners, but this was probably lost in the fire that destroyed Daguerre's studio in 1839.

Talbot's Early Cameras

Cameras used by Talbot before he introduced the more sensitive calotype process in 1841 were wooden boxes of various

sizes fitted with a simple lens set in a brass tube. The lens tube was either fixed or sliding, allowing the focus to be adjusted by pushing or pulling the friction-fitted tube from the front of the box. Camera boxes with adjustable focus included a second peephole on the front of the camera so that the projected image could be seen on the sensitized photogenic paper for a moment to allow focusing. Once the image was focused, the peephole was plugged for the duration of the exposure. Many of these cameras still exist, the most endearing being those Talbot's wife called "mouse traps" because of their small size.

The first production camera

The first publication to feature both descriptions and illustrations of photographic equipment was Daguerre's 1839 manual. A masterwork whose comprehensiveness has never been equaled, Daguerre's manual included scale drawings of the camera, plate holder, focusing glass, and reflex viewing mirror. Although the equipment was available for purchase, the manual also featured all of the processing equipment in drawings detailed enough for a skilled cabinetmaker to produce any one of them to order.

Daguerre's camera was an adaptation of Niépce's, featuring the sliding-box system for focusing. The sensitive plate was brought to the camera in a holder with a hinged double door, which opened into the camera when the operator pushed curved brass levers from the outside. The 6-1/2 × 8-1/2 inch plates were temporarily tacked to a removable wood plate in the back of the holder. The camera featured a brass mounted single-achromatic lens (made by Charles Chevalier) that was fitted to the box (built by Alphonse Giroux [Figure 5]). The basic design — with the exception of the unusual system of exposing the plate to the interior of the camera — was used by camera makers well into the late 1850s for all of the processes common in that era, including daguerreotype, calotype (also called the waxed paper process), albumen, and collodion-on-glass methods.

Wolcott's mirror camera

The world's first studio system also included the most unusual camera. Alexander Wolcott patented a lensless camera on May 8, 1840, that was based on designs adopted by the scientific community for celestial telescopes. By replacing the lens with a highly polished concave mirror of speculum metal, Wolcott was able to create a faster camera suitable for portraiture. The mirror also solved the problem of chromatic aberration because light wasn't required to pass through glass. Wolcott's camera was used by Richard Beard in the world's first commercial portrait studio at the Royal Polytechnic Institution in London.

Despite its optical advantages, the Wolcott camera never realized commercial success. This was probably because of the small image-size limitations of the heavy mirror, which seemed grossly disproportionate in diameter and weight. The camera did not feature a separate plate holder, making it necessary to load the camera in the darkroom or under a covering in the studio.

Sliding-box cameras

The sliding-box camera was the most common instrument of the 1840s and 1850s. In that period, the box design was common to all photographic processes, and the portrait and landscape lenses were made to suit their respective purposes. It was the plate holder that differed from process to process. Holders, also called shields, were available for either plates or paper. Some holders designed for calotypy were hinged like a book, with a central septum to hold two pieces of sensitized paper. Other holders required the paper to be either affixed to or placed between two sheets of glass.

Sliding-box cameras were usually made with two boxes, but some featured multiple telescoping boxes (Figure 8). They were made in a variety of sizes for studio portraiture, with single or multiple lenses, but also for landscape and stereo work. The sliding-box design continued to be used for some purposes well into the dry plate era.

The addition of bellows

The use of an accordion-type bellows to lengthen photographic cameras was commercially introduced by the W. and W. H. Lewis Company of New York (Figure 9). The company initially sold chamfered box daguerreotype cameras with two different plate positions: one for portraits and views, the other for copy work. This design was abandoned for an inner sliding box. In 1851, the company introduced a camera cut in half, featuring leather bellows between the front and rear sections of the box. This innovation allowed almost unlimited flexibility of focusing on objects near and far. The Lewis design influenced camera makers in the United States and Europe, and bellows-type cameras would eventually replace the sliding-box style by the middle of the 1860s.

An important variation of the bellows-type camera was the introduction of the tapered bellows (Figure 15), by Scottish photographer C. G. H. Kinnear in 1857. The tapered design allowed the folds of the bellows to collapse upon themselves in a way that required a fraction of the space needed for the so-called square bellows. The Kinnear design was adopted by camera makers who produced equipment suited for landscape work. Weight limitations were always a consideration there because of the inherent difficulties of working in the field. Tapered and square bellows were used throughout the 19th century and are still in use today.

Early improvements

By the early 1850s, other improvements were made that evolved to become standard features on many cameras by the third quarter of the 19th century. The lens board was designed to be raised and lowered, making it possible to include more or less sky in the picture without tilting the camera box, which would cause distortion. The back of the camera was also made to tilt forward and backward to manipulate the focal plane and to correct for the keystone effect, where for example, a building looks narrower at the top than at the bottom. Plate holders for cameras of the 1850s through the 1870s were

generally designed to hold one plate loaded from the back, with the dark slides being withdrawn from either the top or right side of the holder when the operator was standing at the back of the camera.

The earliest cameras were built on a rigid frame, called the bed. The bed extended beyond the rear of the camera far enough for the back holding the focusing glass to allow focusing the closest subject. This rear extension of the bed became know as a *tailboard*.

When photographers in the 1860s sought cameras specifically for landscape work, clever builders cut the tailboard so that the rear extension could be folded. By the 1870s most cameras were manufactured for the studio, with rigid tailboards or with folding (or even detachable) tailboards for landscape work.

Laboratory cameras

Less known were the laboratory cameras of the wet plate era. The first of such cameras to be manufactured and offered for sale was designed in 1853 by the inventor of the collodion process, Frederick Scott Archer. A glass plate was coated with iodized collodion in the daylight as usual, but then the collodionized plate was placed into the camera to be sensitized with silver nitrate solution and to be exposed. The exposed plate was then developed in the camera and washed with water, allowing it to be removed from the camera for subsequent fixing. Some of these cameras featured separate dipping tanks for the silver, developer, and water wash; the operator relied on a system of levers or pulleys to manipulate the plate from the outside (Figure 10).

The Dubroni

The first commercially successful and most common laboratory camera was the Dubroni, introduced by the inventor G. J. Bourdin in 1864 (Figures 11 and 12). Unlike other designs, Bourdin's camera was made with a ceramic or blown-glass chamber held between the front and rear sections of a wood camera. The chamber had a small opening in the top for introducing processing solutions, a hole in the front to allow the projected image to pass from the lens to the back, and a larger opening with a ground edge in the back, onto which the collodionized plate was placed.

Once the plate was in place, the back was closed and silver solution was poured into the camera using a small funnel. The camera was tilted back so that the silver solution came in contact with the collodion surface of the plate. The camera was then turned upright, and the silver solution was drawn out by a suction pipette. The exposure was made, and the subsequent development and water wash were performed by the same means as that used for the silver solution. Many Dubroni cameras in several sizes were sold in the wet plate era, although very few images made from them exist in collections.

Multiple-lens and Multiplying Cameras

Cameras bearing more than one lens were originally introduced for the purpose of stereo photography in the mid 1850s.

John Dancer, an English optician, patented and sold the first successful double-lens sliding-box stereo camera in 1856. Before this, stereo images were made either with two cameras side by side or with a single camera carefully moved from one side to the other between exposures. A design variation of the single-lens stereo camera was the sliding or multiplying back, which was to become a very important camera movement for studio portraiture.

When the need for photographs in quantity was spawned by the introduction of the *carte de visite* in the late 1850s, camera makers increased efficiency by applying more lenses to the camera box. By attaching four lenses to the front of the camera and a sliding back to the rear, it was possible to make eight *carte*-size negatives on an 8×10 inch plate. More often than not, however, most *carte de visite* negatives were single plates made with smaller and less expensive single-lens studio cameras.

The four-lens design with or without the sliding back found its true calling with the ferrotype camera (Figure 14). Often confused with the much rarer four-lens *carte de visite* camera, ferrotype cameras were manufactured specifically for making ferrotypes, popularly known as tintypes. The most common format was four images made on a 5×7 inch plate. Called *bon tons* in the trade, the individual tintypes were cut from the plate and inserted into paper window mats. If the four-lens bon ton set was replaced with a standard portrait lens, several other sizes of images could be made, depending on various back masks that were available. Multiple-lens sets with nine or more tubes were manufactured throughout the last quarter of the 19th century, with popularity fading after the First World War.

By using different back masks, the tintypist could make either four or eight images on a 5×7 inch plate by using four lenses. If the camera was fitted with a sliding back, 8 to 16 images could be made on an 8×10 inch plate with one movement of the back. A variation of the sliding back for multiple exposures was the sliding front, patented by Simon Wing in 1862. Wing's multiplying camera allowed a single lens to be moved both up or down and side to side between exposures to make 15 exposures on a 5×7 inch plate (Figure 17). When made on tintype plates, these images became known as *gems*. Other variants of the Wing camera also had multiple lenses and sliding backs. *See also* Multiplying Camera.

Exposure control

Throughout the daguerreotype, calotype, and wet collodion eras, exposures were slow enough to forego the need for a lens shutter. Photographers made exposures simply by standing to the side of the camera and uncapping the lens. In the days before adequate lens hoods, the photographer often used the withdrawn dark slide to shield the lens from strong light. The earliest shutters were patterned after their namesake, a design featuring one or two doors that were opened by hand or pneumatic tube. Speed was not the issue for these shutters; they simply facilitated the uncapping of the lens.

In the 1860s some photographers boasted that they could make instantaneous exposures with wet plates. These were

almost always made on plates with high bromide content using smaller cameras. A fast lens of a short focal length and a well-lit subject out-of-doors made these instantaneous exposures possible. But the term *instantaneous* was not very specific. The earliest-manufactured shutters for instantaneous exposures resembled a guillotine (Figure 16). Known as *drop shutters,* or simply *drops*, these were made by cutting a hole in a long, thin piece of wood and allowing it to drop into a second wooden track with a hole that was attached to the front of the lens. Gravity was the initial power for drop shutters; the introduction of more-sensitive gelatin plates in the mid-1880s allowed for faster exposures, and rubber bands were applied to the mechanism.

Mechanical shutter designs evolved as the sensitivity of gelatin plates increased throughout the last quarter of the 19th century. Most of these designs used a system of one or more thin blades of hard rubber that opened and closed by a lever, cord, or pneumatic bulb. Like the popular Prosch Duplex shutter (Figure 20), these early examples included both an instantaneous and a timed setting. The earliest Kodak camera, introduced in 1888, used a spring-loaded rotating barrel shutter that was cocked by pulling a string at the top of the camera and was released by depressing a button.

By the early 1890s, an iris-diaphragm shutter design had been adopted that was particularly suited for photography outside the studio. The iris-diaphragm shutter was based on a series of thin blades pivoting from an outer ring and converging on a central aperture. This design, which can be seen on one of Niépce's cameras in the Muse Niépce, continued to be used well into the 20th century.

The last improvement in exposure control in the 19th century was the slit shutter (Figure 22). This system used a long cloth panel fitted with an open slit and wound between rollers set in front or behind the lens. The focal-plane slit shutter was placed just in front of the sensitive plate or film. When the spring-loaded system was tripped, the length of cloth traveled from one roller to the other, moving the open slit past the film and making the exposure. Once again, this design had many variants and was used by camera makers throughout the next century.

Magazine and detective cameras

The wet collodion process made candid photography virtually impossible, although Skaife's pistolgraph came close to reaching the technology. The tiny brass camera was fitted onto its own small wooden storage box by means of a ball-and-socket joint. Relatively fast exposures were made possible by a small lever-action barn-door-type shutter.

When thoughts turned to producing dry plates, the collodion process was the first practical method. By the mid-1850s, amateurs were experimenting with wet collodion plates prepared as usual and then kept moist or allowed to dry completely by applying one of many treatments. By the late 1870s, collodion emulsions were being coated on glass. Dry collodion plates were generally 3 to 10 times slower than the wet plate process, but plates could be made weeks prior to

shooting, doing away with the necessity of a darkroom in the field. These dry processes were particularly suited to a special magazine system for loading and retrieving plates. The plate magazine was usually a separate slotted box that attached to the camera. Plates were transferred from box to camera, and vice versa, by indexed knobs, buttons, or levers.

The magazine camera was not a commercial success until after the general adoption of gelatin plates (over the collodion process) in the late 1880s. In particular, the magazine system was used on many so-called detective cameras. These hand-held cameras were introduced when the general public had become accustomed to seeing larger cameras mounted on tripods.

Flexible film cameras

While the concept and application of flexible transparent films dates back to Archer in 1851, the first true roll-film holder was introduced by Leon Wernerke around 1875. His film was designed to be stripped from a temporary paper support, a technique later improved by George Eastman when he introduced American Film. Wernerke's product was not a commercial success. Professor E. Stebbing, a Parisian camera maker, produced his so-called Automatic Camera in 1884 to accommodate glass plates and flexible negatives on paper or gelatin-based film transported between rollers. Once again, this camera design met with limited success.

George Eastman and William Walker, a Rochester camera maker, produced the Eastman-Walker roll holder around the same time (Figure 21). This system used Eastman's American Film: a silver bromide gelatin emulsion layer on a soluble layer of plain gelatin that was applied to a flexible paper support. Although the holder could be made to fit existing view cameras, real success wasn't realized until the introduction of the hand-held Kodak detective camera in 1888 (Figures 23 and 24). The Kodak was arguably one of the most influential cameras for the next century, allowing amateurs to make photographs easily and spawning several generations of hand-held box cameras manufactured by a host of companies. By the end of the 19th century, flexible films were made by applying silver bromide gelatin emulsions to a transparent cellulose-nitrate base; however, the professional photographers and many advanced amateurs still shot on glass plates.

Camera stands

Large cameras used in commercial portrait studios required a stand that could be moved easily across the floor and adjusted without removing the camera. The camera stand was a substantial piece of studio equipment that was available with either three- or four-legged supports, which usually stood on roller casters. It was essential that the stand be designed to allow raising, lowering, and tilting the camera. Typically the camera rested on a flat wooden bed secured only by weight. There was no need to attach the camera to the bed.

Some four-legged stands, particularly for larger cameras, were fitted with counterweights and pulleys or springs to facilitate raising and lowering the camera. The tripod's adjustments

were made by turning a crank, which raised or lowered the system. Another less popular design was the lever stand, whereby the height of the camera was adjusted by using notched wooden levers. When silver bromide gelatin dry plates were adopted, manufacturers began to offer a wood rack attached to the side of the stand that held loaded plate holders at the ready.

Pinhole cameras

The pinhole camera uses a small hole (made by a needle) in a thin opaque material instead of using a lens to relay an image to the focal plane. The pinhole forms an image by allowing only a single narrow beam of light from each point on an object to reach the opposite surface. Light rays traveling through this pinhole continue in a straight line and form an inverted image on the opposite side of the box, where a piece of photosensitive emulsion is placed to record the image. The pinhole itself should be circular with clean edges, and the opaque material should be thin enough to prevent objectionable vignetting. Image size depends on the distance from the pinhole to the opposite side. The f-number of a pinhole is calculated by dividing the pinhole-to-film distance by the diameter of the pinhole; for example, 5 inches divided by 1/50 inch equals f/250. Pinhole images are not critically sharp, but the sharpness appears uniform from within a few inches of the camera to infinity. The relatively long exposure times required prevent the pinhole camera from recording moving objects without blur.

Canada balsam

See Balsam.

Carbon, C

Carbon can be found in three basic forms: charcoal, graphite, and diamond. All three forms were used in 19th-century photographic studios. Carbon black, made from the gleanings of lampblack, was used as a colorant for dichromated colloid printing processes such as gum printing and carbon transfer. Graphite powder and pencils were used for retouching paper and glass negatives. Graphite powder was also mixed with gums and used as a blocking-out medium. Diamonds were hand set into brass, then fitted onto wood handles and used to cut glass until the introduction of the steel-wheel-type cutters late in the century.

Carbon process

The fading of prints made by the processes available in the 1840s encouraged a search for a method of making permanent positive prints in pigment. In the 1850s, a variety of techniques were proposed by A. L. Poitevin, J. Pouncy, and A. Fargier. They relied on the hardening of potassium bichromate when it is exposed to light to make carbon pigment suspended in gelatin or gum insoluble in water after exposure. In the mid-1860s, Sir J. W. Swan introduced a process that used ready-made carbon tissue and transfer sheets manufactured by his firm, Mawson and Swan.

Swan's tissue consisted of finely powdered carbon in gelatin, spread on paper. The photographer sensitized the tissue with potassium bichromate, dried it, and made an exposure by contact. The degree of exposure determined the depth to which the gelatin hardened, with the gelatin closest to the exposing light becoming hardest. The tissue was then attached to a temporary paper support and soaked to remove the paper backing and the soluble parts of the gelatin — those that had not received a sensitizing exposure. This transfer was necessary to facilitate the removal of the gelatin from the area adjacent to the backing paper. A laterally reversed image was now left on the temporary paper support — unless the exposure had been made from a laterally reversed negative — and the image was transferred to a final support to produce a positive relief image in carbon pigment. Greater exposure through thin areas of the negative produced a greater thickness of carbon in the final print.

The Swan patents were purchased in 1868 by the Autotype Company of England, which introduced improvements to the original process and supplied 50 or more different tissues in 30 colors. Variations on the gum bichromate-based carbon process included Victor Artigue's artigueotype, shown in 1892; Walter Woodbury's woodburytype of 1864; the photomezzotint patented by Swan in 1865, which, like the Woodburytype, produced multiple carbon relief images from a master gelatin relief image; and Thomas Manly's ozotype of 1899 and ozobrome of 1905 (the latter was called *carbro* in an improved version by Autotype in 1919).

Carbon tissue

The paper prepared for printing in the carbon process. It consists of paper coated with a pigmented gelatin. The color of the pigment used determines the color of the print. Carbon tissue is prepared in two forms. In the first form, the potassium dichromate (which is the light sensitizer) is combined with the pigmented gelatin. In the second form, the tissue requires sensitizing by immersion in a bath of potassium dichromate before it can be used. There are photomechanical reproduction processes that also can use carbon tissue. An example of this is the photogravure process, which uses the carbon tissue as a photoresist that is transferred onto a copper plate and etched through the exposed gelatin relief image.

Carte de visite

A photographic visiting card, often a full-length portrait. The *carte de visite* was introduced in 1851 by Dodero, a photographer working in Marseilles. The *carte* was popularized by André-Adolphe-Eugéne Disdéri, of Paris, in 1854, after he patented a method of producing as many as 10 (but usually 8) images on a single wet-collodion plate. Most photographers, however, could not afford this multi-lens camera and made individual images on a single quarter plate. The image size was 3-1/2 × 2-1/2 mounted on a 4 × 3 inch visiting card. Disdéri produced thousands of *cartes de visite* each month. His studio

was patronized by wealthy and powerful people, including Napoleon III. The popularity of the *carte* peaked in the 1870s, when *cartes* of celebrities were sold by the hundreds of thousands to the public. They were produced until the end of the 19th century.

Celluloid

Nitrated cellulose, when combined with a plasticizer such as camphor or butyl phthalate, can be coated on a smooth surface to form thin, tough, and transparent films suitable as a flexible base for photographic emulsions. Nitrocellulose was the first practical film base but is highly flammable, sometimes catching fire spontaneously. This film base had better dimensional stability and less water absorption than the less flammable cellulose triacetate safety films. Celluloid for flexible film stock was originally made by pouring a viscous solution of cellulose on the smooth surface of a glass casting table. Improvements in manufacturing replaced the table with a large rotating casting wheel. When the solvents evaporated during the wheel's rotation, the ribbon of celluloid was pulled through a series of rollers and wound on a core at the end of the factory.

Cellulose nitrate

The product of treating cellulose, usually clean cotton, in fuming nitric and sulfuric acids. Cellulose nitrate was introduced by German chemist Christian Fredrich Schonbien in 1846. Nitrated cotton is increasingly flammable, depending on the level of nitration based on the strength of the acids and duration of the treatment. The highest level of nitration, achieved in gun cotton, was used to make smokeless gun powders and to fill exploding projectiles. Cellulose nitrate treated to the 14 percent level of nitration was dissolved in equal parts of alcohol and ether to make collodion. This product was also called *cellulose nitrate solution* or *dope*. Cellulose nitrate was known by many names; among them were *nitrocellulose, soluble cotton, nitrated cotton, positive and negative cotton,* and *pyroxylin. See also* Collodion.

Ceramic process

A process by which photographs are permanently vitrified onto ceramic or enamel surfaces. The end product was used for jewelry, ceramic objects, commercial decorative novelties, and permanent portraits applied to tombstones. Several methods were invented in the mid-19th century by as many individuals. The substitution processes introduced by Du Motay involved making a collodion transparency on glass from a negative. The image was toned with gold, platinum, or another metal and then transferred onto the final ceramic or enamel support. When fired, the collodion binder burned off, leaving the metal image fused to the vitrified support.

The other methods were based on the bichromated colloid work of Poitevin. A carbon-transfer print made from a tissue bearing finely powdered glass could be applied to the final support and fired. A variation based on the dusting-on process relied on coating the final support with bichromated sugar. After exposure in contact with a negative, the sugar was selectively hardened where exposed to light, allowing fine powdered glass to stick preferentially.

Chilling table

When hot gelatin emulsions were hand applied to glass plates, a chilling table was required to set the gelatin to a stiff jelly before the plate was placed vertically in a drying box. The tables were usually long, leveled slabs of polished marble. They did not require chilling with ice as long as the ambient temperature was not very high. Chilling tables were used by both amateurs and commercial platemakers before the introduction of automated plate-coating machinery in the mid-1880s.

Chloride paper

The use of silver chloride paper dates back to the experiments of Thomas Wedgwood in 1802. H. Florence used chloride printing-out paper as did N. Niépce. William H. F. Talbot also used this paper for photogenic drawing. Silver chloride with an excess of silver was used with albumen, gelatin, and collodion binders. Gaslight papers were developing out a silver-chloride paper, but they were made with an excess of chloride rather than silver. These contact printing papers could be exposed using a common house-hold gaslight. The emulsion was not sensitive enough for enlarging.

Chlorophyll

The natural substance that gives plants green coloring. It is neutral and soluble in alcohol and ether but not in water. Although the concept was known by others, Frederic Ives introduced chlorophyll as a dye sensitizer for collodion bromide plates in 1879.

Chlorine, Cl

A greenish yellow, poisonous gas, chlorine is one of the halogens used in silver halide photography. In its elemental form, chlorine was used in the daguerreotype process as an accelerator. *See also the various chlorides listed under their compound names, such as* Ammonium Chloride.

Chromatype

A variant of photography on paper, using chromium salts. Robert Hunt, who coined the name, announced his process in 1843. The paper was prepared with a solution of sulfate of copper and potassium bichromate. It produced direct positive photogenic drawings but was not sensitive enough for use in the camera.

Chrysotype

Sir John Herschel sensitized a sheet of paper with ferric ammonium citrate, contact-printed it, and developed the image in a weak solution of gold chloride. The ferrous salts created by exposure to light in turn reduced the gold, which

precipitated out as a purple deposit over the image in proportion to the original exposure. Also called *chriotype*.

Citric acid, $C_6H_8O_7$

An organic acid obtained from lemon or lime. The colorless crystals of this acid are soluble in water and alcohol but less so in ether. It was used as a chemical restrainer particularly in developers for the collodion process and in silver nitrate solutions used for sensitizing salted and albumen papers.

Cloud negative

It was very difficult to produce landscape negatives — with proper exposure of the ground and sky at the same time — when using blue-sensitive plates. A light-blue sky and white clouds would produce the same density on the negative, preventing the clouds from being recorded at all. Worse, a cloudless sky emphasize the indelicate handling of the plates and of applications of collodion, silver, and developer. More often than not, muddy skies were simply painted out with opaque on the negative, leaving a perfectly white sky in the finished print.

To produce clouds in the finished print, special sky negatives were made by underexposing plates of dramatic skies, particularly skies that were pink or red. These negatives were used to print-in the sky in prints made with negatives where the original sky had been painted out.

Cloud shutters and stops

Photographers understood that if the sky was exposed much less than the landscape when making a negative, there was a chance that clouds might be recorded, provided that the sky was tinged with pink. Special cloud shutters and stops were designed to allow less light to expose the lower area of the plate producing better exposure of the sky.

Coating machine

The first commercially successful coating machines were designed in the early 1880s for coating collodion and gelatin emulsions on rolls of paper support. These were soon followed by machines that coated glass plates with silver bromide gelatin emulsions and finally with gelatin emulsions, onto a flexible nitrate-based film support.

Collodion process

Plain collodion

A clear solution of cellulose nitrate in ether and alcohol. The discovery that nitrated cotton would dissolve into equal parts if these two solvents were present, was made by several experimenters around 1847. Louis Menard, of France, and John Parker Maynard, a medical student in Boston, are credited independently with the invention of collodion. The root of *collodion* is taken from the Greek word meaning "to stick." The liquid is not actually sticky to the touch; however, a thin, clear film of collodion adheres firmly to many materials once the solvents

have evaporated. It was originally introduced as an adhesive to consolidate cloth medical dressings but was quickly identified as a perfect substance for bearing light-sensitive silver halides. When describing the assay of collodion, the percentage of cellulose nitrate is usually stated first, followed by the ether content by percentage. Since there is no other constituent besides alcohol and ether, the latter is seldom mentioned.

Wet collodion process

The first person to suggest the use of collodion for photography was probably Robert Bingham, in his 1850 book *Photogenic Manipulation*. Gustave Le Gray published the first formula for iodized collodion in his photographic method on paper and glass in 1850; however, his formula was only theoretical at best. Frederick Scott Archer introduced the process with tested and working formulas in the 1851 issue of *The Chemist*. Archer sought to improve the process for making paper negatives by attempting to coat paper with collodion-bearing silver iodide. When coating paper with the solution appeared to be problematic, Archer turned to sheets of glass as a temporary support for exposure and processing, subsequently transferring the thin film that bore the finished image onto the paper. The glass was then reused. Eventually, Archer decided that each image should remain on its own glass support.

The process as introduced was simple enough. A 2 percent solution of collodion, bearing a very small percentage of potassium iodide, was poured over a plate of glass, leaving a thin, clear film containing the halide. The plate was then placed in a solution of silver nitrate. When removed from the silver, the collodion film contained a translucent yellow compound of light-sensitive silver iodide. The plate was exposed still wet and then developed by inspection under red light, using acid-restrained pyrogallic acid. The developer was then washed off with water and brought into sunlight, where it was fixed in sodium thiosulfate to remove the unexposed silver iodide. Once the plate was washed and dried, it was coated with a protective varnish. The mechanics of this process remained essentially the same throughout the collodion era.

Improvements to and variations of the process

The early collodion negatives had a medium-brown image color. When underexposed plates were placed against a black ground, the brown-silver image appeared as a dull positive. Archer bleached these underexposed images with bichloride of mercury to lighten the color of the silver highlights and make the positive effect easier to view. He called these *alabasterine positives*. Bleaching was also the first step to intensifying underdeveloped negatives. Once bleached, the image could be toned with one of several chemicals to a darker or warmer color that was more suited to the printing-out papers used at that time.

Wet-collodion was primarily an iodide process, but the addition of lesser amounts of bromides contributed to greater sensitivity in the blue-green hues, giving the impression of a general gain in sensitivity. Halides of cadmium, potassium, and ammonium were all used throughout the collodion era.

When photographers began using ferrous sulfate developer rather than pyrogallic acid, exposure times were reduced, making studio portraiture easier. By the end of the 1850s, all studio photographers were using ferrous sulfate. By this time potassium cyanide was also being used as the fixing agent. The combination of iron development and cyanide fixing produced a light yellowish brown image that made the additional step of bleaching unnecessary for collodion positives. The color of the image by transmitted light was also a warm brown color that contributed to spectral density when making negatives. Throughout the collodion era, both hypo and cyanide were used for fixing positives and negatives.

Collodion positives

Positive images made by the collodion process fall under two categories: those made in the camera (direct positives) and secondary images made with negatives. Both of these could also be transferred onto another support. These process variants were firmly established by the late 1850s. The camera images included collodion positives on glass (known as *ambrotypes*), positives made on japanned iron (introduced as *melainotypes*), and direct collodion positives that were transferred onto a secondary support. *See also* Pannotype.

In the 19th century, collodion on glass positives made in camera were called *alabasterines, collodion positives on glass, daguerreotypes on glass, daguerreotypes without reflection, verreotypes,* and *ambrotypes.* These were made on either clear glass requiring a dark backing or on dark glass, often called *ruby glass,* although it was not always red. Images made on metal were introduced as *melainotypes.* Another manufacturer called these *ferrotypes.* Before long the general public called all of the iron-plate collodion positives *tintypes.*

Collodion positives made with a negative were images viewed by reflected light or by transmitted light. Positives made for transmission were lantern slides, stereo transparencies, and novelty microphotographs mounted on microscope slides or miniature Stanhope lenses. The positives were made by lighting a negative from behind and photographing it with a second collodion plate on clear glass. Positives viewed by reflected light were made the same way, but the new support was usually translucent white milk glass. These were called *milk glass positives, opaltypes,* or *opalotypes.*

The wet collodion process was used for commercial portrait and landscape photography until it was replaced by the silver bromide gelatin dry plate in the mid-1880s. It continued to be used by some tintypists until the turn of the century, long after gelatin emulsion tintype plates were introduced. The graphic arts industry used wet plates until the mid-20th century for the production of halftone-screened negatives. These were often stripped from the original glass support and applied to a multiple negative for exposure onto zinc plates for printing.

Collodion without the darkroom

By the mid-1850s many amateurs were thinking of ways to make collodion negatives in the field without carrying a darkroom with them to sensitize and process their plates. A wide variety of humectant coatings—including beer, honey, and syrups—were applied to the sensitized plate in an effort to keep the coating from drying. Preserved plates could also be made perfectly dry with albumen or substances high in tannic acid. Preserved collodion plates were typically several times slower than wet plates, making them useless in the studio but excellent for views and time exposures in dimly lit buildings.

Collodion emulsions

In the 1870s collodion emulsion plates were being used by a very active group of amateurs. Based on the earlier work of Gaudin and Laurent a few years earlier, these were made with collodion that included a mixture of iodides, bromides, and silver nitrate. Once again the plates were too slow for anything but landscape work, but they were more convenient in the field and led the way for the commercial introduction of collodio-chloride printing-out papers and eventually silver bromide gelatin emulsions. Collodio-bromide emulsions sensitized with dyes were also used for three-color processes until the First World War.

Collodion papers

Marc Gaudin first suggested collodion papers in 1853, and then again eight years later. Gaudin called his collodion emulsion *photogen.* Variants of the collodion-paper process, based on the selection of halides, were theorized, but no actual product was sold to the public. In 1865 G. Wharton Simpson made prints on printing-out papers coated with collodio-chloride emulsions. Shortly after Wharton's experiments, Jean Laurent and Jose Martinez-Sanchez, in Madrid, began producing leptographic paper, a collodio-chloride printing-out paper. Leptographic paper was available on baryta-coated stock and met with some success until the Franco-Prussian War in 1870.

Other attempts to commercialize collodion paper failed until the mid-1880s, when coating machines were introduced to make the paper on a larger scale. J. B. Obernetter, one of the manufacturers in Germany, was the first to coin the name *aristotype,* later used by the Aristotype Company of Jamestown, New York. The Aristotype Company produced large quantities of collodio-chloride aristotype printing-out paper with both glossy and matte surfaces. Collodion papers were popular in the United States until the First World War. The German companies, however, continued to market their product until the late 1930s.

Collodion bottle

When a common cork-stopped bottle was used to pour collodion onto a plate, small particles of dried collodion would often fall on the plate, causing comets. Apothecary bottles, originally designed for dispensing syrups, were found to be the perfect solution to the comet problem. These bottles featured a domed lid with a ground glass seal that covered but did not touch the smaller pouring spout. These became known as *cometless pouring bottles.*

Collodion enamels

Enameling was a method to cast a very glossy surface on prints. A plain, flexible collodion containing a small amount of castor oil was first applied to a sheet of glass that was dusted with French chalk. The collodionized plate and print were then placed in a bath of gelatin and drawn out together, with the image facing the collodion coating. The print was then carefully pressed against the glass with a squeegee and set aside to dry. The print was subsequently removed from the glass support by lifting one corner with a thin knife.

Color photography

The history of color photography involved three major developments. The first was the reproduction of the spectral distributions of light observed in the original scene. The second was the synthesis of colors in pictures by means of additive mixtures of separate red, green, and blue beams of light. The third was the use of cyan, magenta, and yellow colorants in a single beam of white light—the so-called subtractive systems. The first development had the earliest beginning, and the third development is of by far the greatest current interest, but there is considerable overlap in the timelines of the three developments.

Spectral color photography

Reproducing the same spectral distributions of light in the picture as in the original was an early goal in color photography. As early as 1810, Johann Seebeck and others knew that if a spectrum were allowed to fall on moist silver chloride paper, some of its colors were recorded; however, the images soon faded, leaving no permanent record.

An explanation of this result was given by Wilhelm Zenker in 1868. He reasoned that when light was incident on the layer of silver chloride, it passed through the light-sensitive material and was then reflected back by the white paper. This caused standing waves. At the nodes the forward and backward beams canceled each other, but at the antinodes the beams supplemented each other. At these points the light intensity became sufficient to cause photochemical decomposition of the silver chloride. Hence, through the depth of the layer, there were formed laminae of silver whose distances apart were half the wavelength of the incident light. The laminae served as interference gratings for any subsequent light incident upon them, and these gratings resulted in the wave pattern of the original being reproduced.

Lippmann method

In 1890 Otto Werner pointed out that it should be possible to replace the silver chloride layer with a fine-grain photographic emulsion. Gabriel Lippmann did this in 1891, using a layer of mercury in contact with the emulsion to provide the backward-traveling beam of light. He also obtained permanent images by fixing them with hypo.

Many color photographs were produced by the Lippmann method in the following decade, and examples can be seen today in photographic museums (Figure 113), testifying to the excellent permanence that was achieved. That the colors were indeed formed by interference was demonstrated by cutting cross sections through the film and examining them under a microscope. In areas exposed by saturated light, distinct laminae were always present, but in areas exposed by white light, the image was always more diffuse in depth. Where laminae were present, they were typically between four and eight in number.

Although quite elegant, the Lippmann method did not survive as a successful process for several reasons. First, to resolve the laminae, which were separated by only half the wavelength of the exposing light, it was necessary to use extremely fine-grained photographic emulsions, and these are of very low speed. Consequently, exposures of at least several minutes were necessary even in bright sunlight. Second, the use of mercury in the camera was a hazard both to the emulsion and to the photographer, and it made the camera unwieldy. Third, because the picture had to be viewed by reflected light, it could not be easily projected, and it was too dark and its angle of view too restricted to be considered a reflection print.

Microdispersion method

An alternative method of reproducing the spectral distributions of the colors in the original scene is to disperse them through a prism. In this microdispersion method, the light from the lens in the camera is imaged on a coarse grating that has about 300 slits per inch (12 per mm), separated by rather wider opaque interstices. The light that passes through the slits is then dispersed by a prism that has a narrow angle, of only 2 or 3 degrees. A lens then forms images of the slits on a suitable photographic material, but because of the prism, the light from each slit is spread out into a small spectrum. In this way recordings are made of the spectral composition of the light from each point along each slit. The photographic material is processed to yield a positive and is repositioned in exactly the same place in the camera as when it was exposed, and white light is then passed back through the apparatus. Of the light that emanates from any point on the processed material, only that of the same wavelength as made the exposure at that point is able to retrace its path through the apparatus and emerge at the other end; all other light is blocked by the opaque interstices of the grating. In this way the spectral composition of the reproduction is the same as that of the original at each point in the picture. This method was developed by F. W. Lanchester in 1895.

The microdispersion method was not successful for various reasons. First, very fine-grain photographic material was necessary to record the small spectra; hence, as with the Lippmann method, long exposures were required even in strong lighting. Second, the grating reduced the resolution of the picture. Third, the photographic material had to be precisely registered in exactly the same position after processing. Fourth, the necessity for the prism and lens system, required to form the spectra, resulted in a very unwieldy camera.

Additive color photography

The idea that the perception of full color had a triple nature gradually became established in the 18th century, and by 1807 Thomas Young had correctly ascribed this to the light-sensitive properties of the eye. James Clerk Maxwell decided to use a photographic demonstration to illustrate the trichromacy of color vision at the Royal Institution in London in 1861. The experimental work was done by Thomas Sutton, a prominent photographer of that time.

The subject matter of Maxwell's demonstration was a tartan ribbon. Three collodion negatives were taken of the ribbon: one through a red filter, one through a green filter, and one through a blue filter (a fourth was also taken through a yellow filter but was not used in the demonstration). A collodion positive transparency was made from the picture taken through the red filter, and it was then projected through a red filter onto a white screen. Similarly, positives from the negatives taken through the green and blue filters were projected through green and blue filters, respectively. The three projected images were positioned in register, and the result was the first trichromatic color photograph. Although the quality of the picture obtained was apparently not very good, the principle demonstrated was basic to all modern forms of color reproduction, whether in photography, television, or printing.

One of the strange things about Maxwell's demonstration is that it was done at a time when the photographic materials available were sensitive only to blue light. This apparent anomaly remained unexplained for a hundred years. In 1961 Ralph M. Evans reconstructed Maxwell's experiment and found that his green filter transmitted just enough blue-green light to make an exposure possible and that the red filter transmitted ultraviolet radiation, to which the photographic material was also sensitive. The three negatives were therefore exposed not to red, green, and blue light, but to blue-green and blue light and to ultraviolet radiation. The use of blue-green instead of green would not have vitiated the demonstration entirely, but the use of ultraviolet instead of red would at first seem to be disastrous. Evans drew attention to the fact that many red fabrics also reflect light in the ultraviolet, so that, by using a tartan bow as the subject, a color reproduction was produced that was evidently sufficiently realistic to serve as a demonstration of the trichromacy of vision, which was Maxwell's objective.

Sensitizing dyes

Proper color photography requires photographic materials that are sensitive to the greenish and reddish parts of the spectrum, in addition to the bluish part to which they naturally respond. Sensitivity to parts of the spectrum in addition to blue is obtained by the use of sensitizing dyes. Hermann Wilhelm Vogel discovered sensitizing dyes for green light in 1873 and for orange light in 1884; the extension of the sensitivity to red light was achieved in the early years of the 20th century. Frederic Ives also promoted the use of chlorophyll as a dye sensitizer for orange light, commencing in 1879. *See also* Dye Sensitization.

One-shot cameras

Maxwell's method, involving three successive exposures through different filters and projection from three projectors in register, was inconvenient, and much ingenuity was used to find better ways of carrying out additive trichromatic color photography. Many different workers were involved, among whom Louis Ducos du Hauron and Frederic E. Ives were particularly prominent.

One way of simplifying the exposing step was to use a one-shot camera. In this device, light passed through the lens and was divided into three beams by semireflecting mirrors and was focused onto three different pieces of photographic material—a red filter being used in one beam, a green filter in the second, and a blue filter in the third. Similar devices, such as the Ives Kromskop, were also made for viewing the three positive images by superimposing virtual images seen in semireflecting mirrors.

Tricolor additive mosaic processes

Another method was to cover the photographic material with a fine mosaic of small areas of red, green, and blue filters. Red, green, and blue records were then made on neighboring areas of the same piece of photographic material, which was processed to a positive and viewed at a sufficient distance for the red, green, and blue light from the small areas to blend together just as effectively as in triple projection. The success of this method depends on the fact that the eye has only a limited resolution, determined by the optical properties of its lens system and by the finite size of the cones in the retina. The first commercially successful plates using the tricolor additive processes was the Joly plate, consisting of alternating red, blue, and green lines ruled on a piece of glass that was placed in contact with a dye-sensitized silver bromide gelatin dry plate.

Subtractive color photography

The history of subtractive reproductions extends to before the invention of photography. For example, in 1722 Jakob Christoffel LeBlon was using a form of three color printing. The main credit for introducing the idea of subtractive color photography, however, goes to Louis Ducos du Hauron, who described it in some detail in 1868. The principle, which du Hauron clearly grasped, is to modulate the reddish, greenish, and bluish thirds of the spectrum in a beam of white light by varying the amounts of a cyan (red-absorbing) dye, a magenta (green-absorbing) dye, and a yellow (blue-absorbing) dye. du Hauron's subtractive color process featured carefully registered assemblies of three separate dyed bichromated gelatin transfer images on thin, transparent supports of either gelatin or celluloid.

Colored photographs

Not to be confused with color photography, colored photographs have the pigments applied by hand. The technique was borrowed from the tradition of ivory miniatures, made

for hundreds of years before the invention of photography. Daguerreotypes, ambrotypes, and ferrotypes were routinely colored by adding finely ground pigments to the cheeks of a human subject. Paper prints were also colored with inks, water colors, gouache, and pastels throughout the 19th century.

Comet

One of the many defects of the wet plate process, comets are dots of various sizes bearing one or more tapered tails. They are always caused by particles falling upon the plate either before or after pouring the collodion. The particles cause turbulence when the plate is dipped into or covered with processing solutions. Comets with one tail are usually formed in the silver bath whereas those with more tails are the result of development activities. Comets appear in ambrotypes, ferrotypes, lantern slides, negatives, and prints made from collodion negatives.

Condenser

A large lens designed to collect and condense light. In 19th-century photography, the condenser was an important element in solar enlargers that were used to print enlarged images.

Contact printing

A process in which a photosensitive material is placed in intimate contact with a negative or with a physical object. The technique dates back to the earliest experiments requiring extended exposures. Niépce contact-printed waxed engravings on asphalt-coated plates for his heliograph process. The technique was not limited to printing-out papers although it is most often associated with them.

Contact printing frame

The earliest contact-printing frames were simply a sheet of glass laid on a plank of wood. The addition of a wooden frame and removable pressure back kept the two elements in better contact and prevented extraneous light from exposing the paper from the sides and back.

Copper, Cu

A malleable pinkish metal used in the daguerreotype process. Thin copper plates were coated with pure silver by either electroplating or applying a separate plate of silver on the copper and compressing the two plates between steel rollers.

Copper chloride, $CuCl_2*2H_2O$

Also known as *cupric chloride*, this substance was made by treating copper carbonate with hydrochloric acid. The greenish blue crystals are soluble in water, alcohol, and ether. This halide was added to printing-out and silver bromide emulsions for increased contrast.

Copper bromide, $CuBr_2$

Also known as *cupric bromide*, this substance was made by double decomposition when mixing aqueous solutions of copper sulfate and potassium bromide. This greenish blue solution was used as the bleaching step for intensifying collodion and gelatin negatives.

Copper sulfate, $CuSO_4*5H_2O$

Also known as *blue vitriol*, this substance was made by the action of sulfuric acid on elemental copper. The bright-blue crystals are soluble in water and alcohol. Mixed with ammonia, copper sulfate was used in liquid filters. The most common application for copper sulfate was combining it with potassium bromide for making copper bromide bleach for intensification and toning. Some photographers used copper sulfate as a restrainer in ferrous sulfate developers that were used in the collodion process.

Copying

Photography is the act of copying from nature. It was natural for photographers to make copies of photographic images. In the case of direct in-camera processes such as the daguerreotype, ambrotype, and ferrotype, copying was the only way to make a second example without having the subject sit for successive exposures. The earliest American chamfered-box daguerreotype camera featured a special position for the plate holder that was specifically for copy work.

Copying negatives was very common, commencing with the wet plate collodion era. Negatives of important people for the mass production of *carte* photographs were routinely copied. The original negative was lit from behind and rephotographed with a second plate, resulting in a positive transparency — also known as an interpositive. The interpositive was then rephotographed as before to make the final copy negative. Using this system the photographer could also make the final negative much larger than the original, allowing the enlarged negative to be used for contact printing. This was an alternative to solar enlarging, a process that was impractical in regions where sunlight was not always available.

Cotton gun

See Cellulose Nitrate.

Crape markings

One of the many defects of the wet plate process, crape markings are caused by evaporation of the solvents or water in the collodion. These usually appear as wavy, chamberized parallel lines in the direction of the corner where the excess collodion was poured from the plate. Crape markings appear in ambrotypes, ferrotypes, lantern slides, negatives, and prints from collodion negatives.

Crayon enlargement

Solar enlargers were used to make a lightly printed-out or developed-out image on salted paper. The exposure for a printed out image could take as long as 2–3 hours. The image would act as a guide for subsequent retouching with ink, watercolor, gauche, charcoal, crayon, pastels, or airbrushes. Crayon enlargements were often, but not exclusively, made from copy negatives taken from cabinet-card originals.

Crown glass

A term used to describe the type of glass used in lenses with low dispersion that have an Abbe number higher than 50 and a refractive index greater than 1.6, or an Abbe number higher than 55 and a refractive index below 1.6. Types of crown glass include fluor crowns (70–59 and 1.465–1.525) and barium crowns (63–51 and 1.552–1.657). Crown glass is one of the earliest glasses found that is hard and weather resistant. In combination with flint glass, it could be used to form an achromatic lens.

Crystalotype

Boston daguerreotypist John Whipple invented an albumen-on-glass negative process independent from those published by Niépce de St. Victor or the Langenheim brothers. Whipple used the term *crystalotype* to refer to these albumen plates as well as to the salted paper prints made from his glass negatives. Many of Whipple's prints were stamped with the term *crystalotype* on the paper mount. When Whipple eventually switched to the collodion process to make his negatives, he continued for a short time to call the prints crystalotypes, a reference to the glass negative support.

Crystoleum

An early color process made by combining a black-and-white transparency and a hand-colored image that gave the appearance of direct painting on glass. A photographic print (usually albumen) on very thin paper was glued face down on the inside of a curved glass with wax and resin. The paper was then reduced by sandpapering until it was almost removed. The print was rubbed with oil, wax, or varnish to make it translucent. Colors were placed on the back of the print and adhered to a white sheet of paper. The process produced a finely colored photograph without the appearance of paint on its surface or any loss of photographic detail because of the paint. This process was based on a technique, called mezzotint painting, that was used in the 18th century to hand-color engravings.

Cutting patents

James Ambrose Cutting, a Boston photographer and inventor, was granted three patents for improvements in photography in the mid-1850s. The first patent regarded the addition of camphor to the collodion, a modification that was never influential. The second patent was issued for the technique of hermetically sealing collodion positives with Canada balsam and a second sheet of glass after the fashion of microscope slides. The English version of this patent included the first publication of the word *ambrotype*. Photographers using Cutting's ambrotype sealing method were required to buy a license for the privilege, although the technique was very controversial in both effectiveness and originality.

The third patent was issued for the addition of potassium bromide in iodized collodion. Here too, Cutting should never have been granted letters of patent. Bromine had been used in the daguerreotype process since 1840, and bromide compounds had already been used by many photographers for calotypes and albumen-on-glass plates and in collodion. Bitter lawsuits were filed throughout the 1850s regarding the second and third patents, but Cutting usually won. When the 14-year term of patent finally expired, the photographic community rallied, preventing the Cutting patents from being reissued.

Cyanide

See Potassium Cyanide.

Cyanotype

Invented by Sir John Herschel and presented to the Royal Society of London in a 1842 paper titled "On the Action of the Rays of the Solar Spectrum on Vegetable Colours and on Some New Photographic Processes." From the Greek word meaning "dark blue impression," cyanotype is a simple process based on combining ferric ammonium citrate with potassium ferricyanide, resulting in an image that combines ferrous ferricyanide and ferric ferrocyanide. Each chemical is mixed separately with water to form two working solutions, which in turn are mixed in equal parts to form a light-sensitive solution that is then coated on a paper or cloth support. The sensitized material is dried in the dark and then contact-printed by exposure to ultraviolet radiation through either a negative (to make a print) or direct contact with an object (to make a photogram). It is then washed in a bath of running water to permanently fix the image and develop its characteristic cyan-blue color. The image is embedded in the fibers of the paper or cloth and accounts for its matte print surface. A very dilute solution of hydrogen peroxide can be added to the wash water to intensify the blue coloration. The process was used in 1843 to illustrate the three volumes of the book *British Algae: Cyanotype Impressions*, by Anna Atkins. This is considered to be the earliest example of a book illustrated by a purely photographic process. The process was little used after this until the 1880s. The cyanotype process is also called the blue print or Prussian-blue process.

Cylinder glass

A glass sheet made by first blowing a long cylinder from a scaffold and then opening the bottom of the cylinder and making a single slit from bottom to top, allowing the thin glass walls to be opened and laid on a heated metal table to form a flat sheet. This was also called broad sheet glass. *See also* Glass.

D
Daguerreotype

A direct-positive photographic image made on silver-coated copper plates. The process for making the image was made public by Louis Jacques Mandé Daguerre in 1839. The process described in the following paragraphs is as it was first introduced by Daguerre.

A silver-plated copper plate was carefully cleaned on the silver side by sifting fine pumice through a cloth bag onto the surface and rubbing this with a piece of tufted cotton that

was moistened with sweet oil (olive oil). The residual oil was removed by dusting the plate again with pumice and rubbing it with a clean piece of dry cotton. This process was repeated several times. The plate was then placed on a wire rack, and heat was applied from below with an alcohol lamp. A white residue that was formed from heating was removed by wiping the plate with a piece of cotton moistened with dilute nitric acid, and the plate was lightly polished several times with pumice and dry cotton to a highly reflective mirrorlike finish. The polished plate was then tacked, with the silver side exposed, onto a thin board.

In a room lit by candle or yellow light, the board bearing the polished plate was placed plate-side down in the top of a wood sensitizing box that contained a small dish with crystals of elemental iodine. The iodine fumes created a thin golden-yellow film of light-sensitive silver iodide on the surface of the plate, which was then set into the back of a plate holder and taken to the camera for the exposure.

After exposure, the holder was brought to the processing room. The board bearing the exposed plate was removed and placed at a 45 degree angle in the top of a wooden developing box. This box was fitted with a small metal dish in the bottom that contained about two pounds of elemental mercury. The latent image was made visible by heating the bottom of the box from below with an alcohol lamp to produce mercury fumes. These fumes created a frosty-white disturbance in the silver where the plate had been exposed to light. The deepest shadows of the image remained highly reflective.

The developed plate was then brought to the light and bathed in a solution of saltwater or sodium thiosulfate to remove the unexposed silver iodide. The choice of sodium thiosulfate quickly became the standard fixing solution for daguerreotypes and all other silver halide processes. A final washing in clean water, followed by careful drying to prevent spots, completed the process. The fragile image was made essentially of two forms of silver: textured areas that scattered light and smooth areas that reflected light. Because metallic silver is highly susceptible to tarnishing, all daguerreotypes required careful framing to keep out sulfurous air and physical contact that might abrade the image.

The original process was not sensitive enough to allow for studio portraiture. In 1840 John Goddard and others suggested the use of chlorine and bromine fumes, in addition to iodine, in the sensitizing step. Many variations followed, but the use of iodine and bromine seems to have been the most common. The plates were first fumed with iodine, then bromine and back over the iodine. This procedure made the plates much more sensitive.

Another innovation introduced by Hippolyte Fizeau in the same year was the gilding process. Gold chloride was added to sodium thiosulfate to make a solution known as *sel d'or*. The fixed plate was leveled on a stand, the *sel d'or* was poured onto the surface, and the plate was heated from below. Gilding, the first method of photographic toning, improved the tonality and contrast of the daguerreotype and also made the image more resistant to abrasions.

Once the use of bromine and gilding was adopted, the daguerreotype process remained essentially the same throughout the daguerreotype era. Improvements in the technique of polishing plates were a source of pride but also fiercely proprietary, for in the polish lay the quality of the black areas of the daguerreotype. Long polishing buffs covered with velvet or buckskin were used with fine abrasives such as rouge and lampblack. Polishing was made more effective by the American technique of galvanizing a thin coat of pure silver to a polished plate by the method of electroplating. The galvanized the plates were then buffed again before being sensitized.

Darkroom

The photographic darkroom of the 19th century was never really very dark. It was once suggested that if you couldn't read a newspaper in your darkroom, it was too dark. Plates and papers were very slow and only sensitive to ultraviolet, violet, and blue light, allowing the photographer to handle them in warm yellow, amber, orange, or red light.

The size of a darkroom was relative to the most common size of plate produced by a studio. The average small-town studio rarely made plates larger than 6-1/2×8-1/2 inches. In the daguerreotype and wet plate era, all exposures in the studio were made with natural daylight, and all processing was typically done at the time of the sitting. For this reason darkroom safelights were seldom needed, because a red-glazed window in the darkroom provided more than enough filtered light. It was important to keep daylight, no matter how feeble, from the darkroom, and typically the skylight room was within steps of the darkroom door. Some photographers glazed the darkroom door with the same filter material as the work area. Filters were made from stained glass, layers of colored paper, or dyed cloth. Common brown butcher paper was frequently used in the early days.

The daguerreotype darkroom did not actually require a sink, although it was handy for the latter steps of the process. The wet plate process, however, was particularly messy, and a sink and running water were sought whenever possible. Darkroom sinks were usually made by fitting a thin sheet of zinc into a wooden frame. Tar and oilcloth were also used to line wood sinks. Running water was often gravity-fed by attaching a spigot and hose to the bottom of a wood barrel or fabricated metal cistern. Keeping the water cistern full was one of the jobs of the apprentice. A dry area set away from the sink was also important for loading and unloading plates.

Storage space in the darkroom was not needed before the advent of gelatin plates because light-sensitive materials were made as needed for every exposure. A small shelf to hold just enough processing chemicals for immediate work was better than many racks and open cabinets, which quickly accumulated dust. Keeping the darkroom clean was essential for good work; airborne dust could shut down processing for a day or two. Because of this, darkroom floors were always mopped rather than swept, and counters were usually cleaned with a damp cloth.

Fumes emitted from the processing chemicals in both the daguerreotype and collodion processes were occasionally irritating and often harmful. A well-built 19th-century darkroom was not complete without some type of ventilation, although many went without. More often than not, when a darkroom ventilator was installed, it took the form of a wooden box fitted with a light baffle that was mounted on the wall or ceiling.

The silver chloride printing-out processes were so insensitive that they could be conducted in relatively strong artificial light. The printing darkroom therefore required only an adequate space away from natural daylight. A source of fresh water and a large sink were necessities for processing prints. Dry areas for loading and unloading printing frames were also important. Drying and finishing prints were done in another area.

When silver bromide gelatin dry plates were universally adopted by the mid-1880s, the darkroom changed to a form that remained for more than a hundred years. No longer was it necessary to process plates while the customer waited. Because dry negatives and developing-out papers could be processed in the evening hours, there was a need for safe darkroom illumination by artificial light. The darkroom safelight was usually a sheet-metal oil lamp fitted with either a red or amber glass globe or a flat glass filter. Less expensive versions were supplied with a simple candle instead of an oil lamp. Flame-illuminated safelights were available in catalogs long after the turn of the century, until the incandescent electric light replaced them.

Dark tent, portable darkroom tent

The wet collodion process required preparation and processing of the plate at the time of exposure. A dark tent, or portable darkroom tent, was a common appliance for the traveling or landscape photographer. Dark tents were often made by the photographer but could also be purchased in a wide range of sizes and styles. Typically these tents were made with a light wood frame covered with two layers of cotton cloth, one black the other a nonactinic color such as orange, amber, or red. The photographic journals of the period frequently featured articles illustrating ingenious homemade dark tents.

Variants of the portable darkroom tent include those into which only the upper body is placed in the darkened work area. These should not be confused with developing boxes, which were designed so that only the arms of the photographer are inserted into the box, and the activity is viewed through a red window from the outside.

Decantation

The transfer of liquid from one container to another without disturbing the lower levels or sediment. Small amounts of liquid in large vessels can simply be poured off into a new container. A siphon, however, is a better choice when most of the contents must be decanted without including precipitates at the bottom of the bottle.

Developers, development

The mechanism by which the invisible or latent image formed on silver halide by exposure to light is made visible as a solid deposit of metallic silver. This action is also called reduction. In the daguerreotype process, silver iodide is reduced to a deposit of fine metallic silver by exposure to mercury fumes. The calotype, waxed paper, albumen-on-glass, and wet and dry collodion variants were all silver iodide processes relying on reduction by physical development and an acid reducing agent such as gallic acid, pyrogallic acid, or ferrous sulfate. Physical, or "acid," development depends on an excess of free silver nitrate to mix with the reducing agent to form the visible image on and in the film. Physical developers therefore must have silver added or must rely on extra silver present on the plate, as in the wet collodion process. These developers are also restrained with either an acid or an organic substance, such as gelatin or sugar, to prevent spontaneous nonimage reduction, also known as fog.

Chemical, or "alkaline," development was adopted when silver bromide collodion and gelatin bromide plates were displacing the wet collodion method. Pyrogallic acid, ferrous oxalate, hydroquinone, and metol were the early reducing agents used for chemical development. Unlike physical development, chemical development did not require excess silver nitrate. Ammonia was added to the developer to increase the chemical activity; to balance this effect, potassium bromide was often added as a restrainer. One of the characteristics of chemically developed plates was a cool black image, the result of a larger silver particle caused by filamentary growth during development.

The science of development

There are many types of development, but all rely on the detection of a small nucleus of silver by the developing agent. The agent transfers electrons to this silver nucleus. The electron-rich nucleus incorporates silver ions, causing additional silver metal atoms to form, thereby enlarging the nucleus. One way to classify development is by the source of these silver ions. If they are obtained from the silver halide grains in the coating, the process is called chemical development. If they are obtained from a silver salt dissolved in the developer solution, the process is called physical development. The latter can take place either while the silver halide grains are present (in a process known as prefixation physical development) or after they have been removed (in a process known as postfixation physical development). The silver solution transfer process is based on the principles of physical development.

Chemical development

Reducing agents in commercial developers are usually drawn from three classes of aromatic organic compounds: polyphenols, aminophenols, and polyamines. In typical developer formulations, these reducing agents will, given enough time, reduce all the silver halide grains to silver metal, whether they have been exposed or not. What makes discrimination

between exposed and unexposed grains possible is the presence of the latent image. This center provides a lower-energy pathway for transfer of electrons from the developing agent to the grain; i.e., the latent image catalyzes the development process. Thus, the development of exposed grains occurs at a much faster rate than the development of unexposed grains and, by proper choice of development time, good discrimination between image and fog is achieved.

Developer formulations usually are aqueous-based and include components other than the developing agent. The more reducing forms of the developing agents are the ionized versions, where one or more protons have been removed from the molecule. Thus, high pH (typically 9 to 12) is a characteristic of developer formulations. The pH level is maintained by using buffering agents, such as metaborate/tetraborate, carbonate/bicarbonate, or phosphate/monohydrogen phosphate. The developing agents also can be oxidized, so sulfite salts are usually included as a preservative as well as a scavenger for oxidized developer, which could retard development. A third common ingredient of developer formulations is bromide ion. This tends to slow the development reaction, but it does so more for the unexposed than the exposed grain and thus decreases fog.

It is often convenient to view the development reaction as an electrochemical cell composed of two half-cells. In one half-cell, the silver ions are being reduced to silver metal, and in the other half-cell, reduced developer is being converted to its oxidized form. An electrochemical potential can be calculated for each half-cell: the overall potential for the cell is the difference of the two half-cell potentials. If the potential is zero, the system is at equilibrium. If it is positive, silver is reduced; if it is negative, silver is oxidized. The latter condition is due to oxidized developer buildup. This can be prevented by incorporating an oxidized developer scavenger, such as sulfite, into the solution.

The majority of commercial non-color developing solutions actually contain two developing agents. It has been found that when two agents are present in the right proportion, a synergistic effect often occurs. The exact mechanism of this effect is not easily discerned, but it does appear to be some sort of regeneration effect. One of the agents transfers an electron to the growing silver nuclei and is in turn oxidized. This oxidized form then interacts with the reduced form of the second agent and is converted back to the reduced form, ready for another electron transfer to the growing silver nuclei. The oxidized second agent is presumably removed in a sulfite reaction.

Commercial developers are almost exclusively capable of detecting only surface latent images. If the latent image forms more than a few atomic layers below the surface, it will go undetected. This is usually not a problem since commercial emulsions are ordinarily made and sensitized so that the latent image is formed at or very near the surface. In cases where the latent image, either unintentionally or by design, is formed at a location that is unreachable by the developer, the developer formulation must be modified to include a silver halide solvent or recrystallization reagent. These compounds allow the slow dissolution of the silver halide or the disruption of the surface with inward-pointing channels that allow the developer access to internal latent-image centers. The optimization of internal latent-image detection involves optimizing the level of these reagents. In favorable cases the efficiency of internal latent-image detection can be as high as that for surface latent images.

Physical development

In physical development, the dissolved silver salt is slowly reduced to form a supersaturated silver solution. The presence of the latent-image nuclei causes the silver to be deposited from solution; the nuclei virtually become silver plated. In time the physical developer will plate silver at random onto the walls of the development chamber and over the surface of the emulsion coating. Thus, physical developers are inherently unstable and must be mixed just before use.

Chemical development includes, to some extent, physical development. Even though no silver salt is intentionally added to the developer formulation in physical development, there are components in the typical developer formulation that can act as silver halide solvents, most notable among these components is sulfite because it is present in such large quantities. These solvents can transport silver ions to the site of development, whereupon they are reduced to silver. The silver ions may originate elsewhere on the developing grain or form adjacent grains in the coating. This phenomenon is present to some extent in all developers and is known as *solution physical development.* The extent of solution physical development depends on the region of the characteristic curve under examination. In the toe (shadows), many grains are undevelopable, and they serve as a source for silver ions to take part in solution physical development. In the shoulder (highlights), most grains are developing, and the supply of silver ions for solution physical development is low.

Diamond
The most common tool used for cutting glass plates in the 19th century was a diamond chip set into a brass housing that was fitted onto a rosewood handle. The diamond was used to score the glass, which caused a fracture that allowed the plate to be broken with some accuracy. A diamond glasscutter often included a steel breaking tool affixed to the brass housing. This tool was used for nibbling off small bits of glass that did not follow the scored area.

Diffusion screen, diffuser
A studio apparatus used for portraiture. A piece of thin, white translucent cloth was stretched over a wood or thick wire frame on the end of a pole. The pole was mounted to a sturdy stand or held by an assistant. Diffusers were helpful when certain areas of the subject required less light, such as the top of a bald head or the hands.

Dipper

When albumen and collodion plates were sensitized, they were lowered into a tray or tank of silver nitrate solution. The earliest technique for sensitizing used a tray. For tray sensitizing, a silver hook was used to lower one end of the plate, coated-side down, into the solution. Most collodion plates were sensitized in a vertical silver bath that required a dipper to hold the bottom of the plate. These dippers were made from a variety of materials, including ceramic, glass, hard rubber, wood, or silver wire.

Direct positive

When the early experimenters made their first images, they were seeking a direct positive image right from the camera. Some processes resulted in both a positive and a negative image, depending on how the plate was lighted and viewed, as was the case with Niépce's heliograph on pewter. The daguerreotype also produced this unique phenomenon.

Talbot's photogenic drawing and calotype methods were strictly negative processes used to make secondary positive prints, or "proofs." In 1839 Hippolyte Bayard used a form of Talbot's salt printing process to make silver chloride paper that bleached when it was exposed to light. Bayard exposed salted paper completely until dark brown, soaked it in a dilute solution of potassium iodide, and placed it in a camera on a piece of slate or between two sheets of glass. As long as the paper was damp with potassium iodide, sunlight would bleach the dark brown paper. The positive print was then fixed in hypo, washed, and dried. Talbot's own version of this process was called the *leucotype*.

The albumen-on-glass process, introduced by Niépce de St. Victor in 1847, was capable of making both negatives and positives as in the better-known collodion process. In both processes, the developed silver's particle size was so small that it appeared as light color. If the plates were slightly underexposed, the image would appear as a positive when the fixed plate was placed on a black ground. The ambrotype and ferrotype, based on this technology, were both direct collodion positives, the only difference being the support material used.

Silver-bromide gelatin dry tintypes were introduced in the 1880s. These too were direct positive plates relying on a special alkaline developer containing some hypo and free silver. Many street photographers used this direct positive system in special cameras designed to allow the exposed plate to fall into a tank below. These cameras were also used to expose and develop direct positive postcard prints.

Direct positive by reversal was a process applied to films and papers that yielded a positive image of the subject, following reversal processing. Typically the major processing steps included image exposure (forming negative latent image), first developer (forming visible negative image), bleach (destroying visible negative image), general nonimage exposure (fogging remaining silver halide), second developer (forming visible positive image), fix, wash.

Documentary photography

From its inception in 1839, photography was heralded as the epitome of realistic representation, in large part because of its unique ability to show things in literal, objective, and commonly understood visual terms. The medium's unsurpassed power of realistic representation rested on its precision, clarity, sharpness, impartiality, truth to nature, and compelling believability. Photography thus provided evidence of places and events in an accurate and truthful way, the cornerstone of factual documentary reporting.

Although it may be said that any photograph is documentary because it shows what actually occurs in front of the camera, the documentary genre in photography is more specifically based on the premise that the photograph is a transcription of reality that contains fact, evidence, and truth. Documentary photography therefore is expected to alter events as little as possible from reality, i.e., to show what would have occurred or existed had the photographer not been present and to provide viewers with substantially the same experience as in the original event.

The basic form of pictorial documentary representation involves an emphatically unmanipulated approach that underscores the undisputed priority of subject over style. To this end documentary photographers use a wide variety of personal techniques that eschew transparent artistic and pictorial conventions and yet allow the photographer to remain as unobtrusive and candid as possible. Traditional ways of working include clear and direct framing of the subject, an overriding but not obtrusive narrative approach, freedom from pictorial distortion and bias, a clear and impartial display of fact that appeals to the denotative aspects of the medium, use of multiple station points in observation, and use of the snapshot aesthetic.

Historically, documentary photography is a rich and diverse genre that has great popular appeal. From its inception in 1839, documentary photography has helped satisfy curiosity of the unknown by bringing impartial and accurate images of faraway places and events to the viewer. In the process, documentary photography has also created important records that provide tangible evidence supported by great visual detail, cast the compelling impression of truth, allow viewers to occupy the position of the photographer, serve as an impartial and faithful witness to life's events, and freeze an instant of time so that places and events may be later studied and restudied.

Pioneers of early documentary photography include French photographer Maxime du Camp, with his published views of the ancient Near East that were done in 1849 and 1850; the British photographer Roger Fenton with his popular and publicly sold images of the last phases of the Crimean War in 1855; the American Mathew Brady, who in 1861 through 1865 organized nearly 20 photographers to produce more than 10,000 negatives of the American Civil War; and after the Civil War, photographers such as Carleton Watkins, Timothy O'Sullivan, and William Henry Jackson, who used the unwieldy wet plate process to document the unexplored Western territories of the United States.

Social-documentary photography
Social-documentary photography uses an approach and style similar to that of pure documentary photography. However, the social document goes further than the simple recording of events and phenomena by highlighting their impact on the human condition. It is for this reason that the social-documentary photographer often uses the persuasive power of the medium to influence viewer awareness and understanding and to elicit positive social change.

Social-documentary photography also has a rich history. It has been used by such notable individuals and groups as Thomas Annan, in the published album *The Old Closes and Streets of Glasgow* (1868), documenting the squalid conditions and dehumanizing effects of the slums in Glasgow, Scotland; John Thomson, in *Street Life in London* (1877), which revealed the daily lives of London's street merchants and working lower class; Jacob Riis, in books such as *The Children of the Poor* (1898) and *How the Other Half Lives* (1890), showing the sordid living conditions of America's urban poor; Lewis Hine in his powerful pictorial critique of the destitution endured by laboring classes and immigrants in early 20th-century America.

Double transfer

A term used in the carbon process to describe the method of working when the reversed print given by the ordinary single-transfer method is inadmissible. The print is transferred first to a temporary support. The print is then transferred to a paper, which is to be its final support. The necessity for this second transfer gives the method the title of "double transfer." *See also* Carbon Process, Single Transfer.

Drachm

The drachm, pronounced DRAM, was a unit in the English system of weights and measures. The term is also spelled "dram."

Drop shutter

The earliest design for instantaneous exposures. It was usually constructed as a wooden track with a thin piece of wood, into which a hole was bored, which was dropped in front of the lens by use of gravity. The lever that released the drop was tripped either by hand or by a pneumatic hose-and-piston combination. When faster exposures were needed, a rubber band was attached to the slide and the track.

Drop, dropping

The 19th-century term for *drop* was *minim*. Drops and minims are supposed to be synonymous, but such is not the case. A minim is one-sixtieth part of a dram, but a drop may measure more than a minim or less, as shown by the following list, which gives the average number of drops that make up one drachm: water, 71; nitric acid, 96; hydrochloric acid, 70; sulfuric acid, 100; ether, 290; alcohol, 130; turpentine, 220; castor oil, 157; olive oil, 168.

Drops also vary according to the way they are dropped and the receptacle from which they are dropped, but happily in most photographic operations, extreme accuracy in the size of a drop does not matter. The easiest way to dispense a single drop was by pipette, and special calibrated flasks were made for multiple drops. Dropping bottles were also designed for dispensing drops. There were various patterns. In one, a pipette or dropping tube is set into the stopper. Another variant allows the drops to pass to a suitable lip in the neck when the preparer turns the stopper, in which a slot is cut. When the bottle is not in use, a second turn of the stopper blocks the liquid from the lip.

Dry plates

When gelatin finally replaced collodion as a binder for silver halides in the 1880s, most commercial photographers were familiar with wet collodion technology. They called the new technology dry plate photography to differentiate the two processes. The common assumption by most writers on the technical evolution of photography is that *dry plate* refers only to these silver bromide gelatin emulsion plates. The term *gelatin dry plate* is actually redundant since there were no gelatin wet plates; nevertheless the term is usually associated with gelatin emulsion plates.

The introduction of the gelatin dry plate marked a new era in photography. There is some difference of opinion as to who was the actual inventor—Burgess, Maddox, Kennett, Wratten, and others were all working at the same time in practically the same direction. It was, however, on September 8, 1871, when Dr. Maddox published an account of his experiments that the first hint was given. On July 18, 1873, J. Burgess, of Peckham, England advertised ready-made emulsion, with which photographers could coat glass to make their own dry plates; Kennett followed suit and on November 20 of the same year took out a patent for "pellicle," with which photographers could make their own plates.

Improvements followed rapidly, Bolton, Sayce, Wratten, Mawdsley, Berkeley, Abney, Bennett, and others doing much to bring the dry plate to perfection and to make it an article of commerce. As far as can be ascertained, the first ready-made dry plates were advertised in April 1878 by Wratten and Wainwright and the Liverpool Dry-Plate Company (Peter Mawdsley), the plates by the latter being called "Bennett" plates. It was not until 1880 that gelatin dry plates became popular. There were, however, other dry plate processes in the 19th century. The albumen-on-glass negative and positive processes could be exposed either wet or dry. The collodion process was also practiced in several dry variants. There were also collodion emulsion dry plates introduced in the 1880s and dye-sensitized variants that were used after the turn of the century for process work.

Dye sensitizer

When blue-sensitive photographic materials are modified to respond to green, yellow, orange, or red light, the method used is called spectral or dye sensitization. The first practical

work in this area was by H. W. Vogel in 1873. Vogel, applying earlier theories suggested by J. Waterhouse, proved that collodion plates could be made sensitive to yellow and greenish yellow wavelengths by tinting them with selected coal tar dyes, including corallin, aldehyde green, eosin, and cyanin.

In 1875 Abney theorized that the dyes combined with the silver to produce colored organic salts of silver that were sensitive to light. He also stated that the dyes themselves were reduced by light producing a nucleus onto which metallic silver would be deposited. Additional research by Amory, Abney, Eder, Ives, and others contributed to the techniques used for the commercial production of orthochromatic (green-sensitive) and isochromatic (orange-sensitive) silver bromide gelatin plates. By using more than one dye sensitizer, it was eventually possible to produce panchromatic (full spectral sensitivity) gelatin plates just after the turn of the century.

The use of negative materials with complete spectral sensitivity was not met with great acceptance in the beginning, because the plates required loading and processing in total darkness. Many continued to use orthochromatic plates that were developed by inspection for much of their work. Panchromatic or color-specific emulsions were essential when color separations were required.

Dusting-on process

A printing process that uses a support coated with a layer of gum arabic and a hygroscopic substance like honey, glucose, or sugar that was sensitized with a bichromate. A coating of this nature becomes sticky with moisture that it absorbs from the atmosphere, but if light reaches any part of it, that part loses its stickiness. This is the effect that makes the imaging process possible. The sensitized surface is exposed to light under a positive transparency. It is then left in the air, away from light, to acquire a particular degree of stickiness.

The surface is brushed lightly with a selected color of powdered pigment. Where the positive image has masked the surface, it remains sticky and holds the pigment. In this way the printer is able to build up a positive image that can be sprayed with fixative. This process has been used particularly for printing photographic images on glass or ceramic objects by replacing the pigment with a powder that can subsequently be burned in or vitrified.

E

Edging

Dilute albumen, gelatin, or rubber solutions were occasionally applied to the edge of glass plates to prevent peeling of collodion or gelatin binders. The edging was applied by brush or a small sponge, and the treated plates were allowed to dry on a rack. Edging was less time-consuming than overall subbing, which required the entire surface of the plate to be coated.

Emery

A very hard material made of alumina, silica, and iron that was reduced to a fine powder. Wet plate photographers sometimes used a stick coated with emery to take the sharp edge from a glass plate before it was coated. In retouching, fine emery was used to roughen the varnished surface of collodion negatives so that graphite pencils could be used to apply density. In gelatin plate retouching, emery was used to reduce density of the negative by abrading metallic silver in the emulsion.

Emulsification

In photographic work an emulsion typically consists of a mixture of water-soluble silver nitrate combined with a soluble halide in a viscous solution of collodion, albumen, or gelatin. If the silver and halides are mixed in plain solvents, the silver halide precipitates out of the solution and falls to the bottom. When the viscosity of the binder is increased, the light-sensitive halides form more slowly and stay in a suspended form. Technically speaking, photographic emulsions are regarded by most chemists as suspensions, but the term *emulsion* has become accepted throughout the industry and by photographers.

Early photographic emulsions
The first practical emulsions were made with a collodion binder and silver chloride. Plates prepared with collodio-iodide emulsions were used by a small number of amateur landscape photographers as a dry alternative to the wet plate process. Collodio-chloride emulsions were coated onto lantern slide plates, white glass for making opaltypes, and baryta-coated printing-out papers. The first plates to be dye sensitized for increased spectral sensitivity were collodio-bromide emulsion plates. Even after the turn of the century, when gelatin plates had replaced the collodion process, color separation negatives were made on panchromatic collodion emulsion plates. *See* Collodion.

Silver bromide emulsions with albumen as the binder were used by Lippmann for the first examples of color interference plates. Called *Lippmann emulsions*, these plates were notable for their fine grain and high resolution. Emulsion technology, however, was most exploited when gelatin was used for the binder. Chlorides, bromides, and iodides in various combinations were mixed with silver nitrate in gelatin to produce a wide range of photosensitive coatings that were applied to as many supports. Gelatin emulsions were more complex chemically and represented a much larger industry than those made with collodion as a binder.

Gelatin emulsions
An understanding of 20th-century gelatin emulsions relies on theories and techniques introduced in the 19th century. Historically, the precipitation of silver halides to prepare a photographic emulsion has been a secret operation practiced in near darkness, figuratively and literally.

Enameling

A process for creating vitrified photographic images on enameled metal plates or forming images in enamel on uncoated plates. Invented in the 1860s, enameling involved removing a collodion positive from its glass support and transferring the positive to an enameled surface. When fired, the silver fused

to the enamel while the collodion burned away. Later developments included preparing a carbon print with enamel oxides instead of pigments in the emulsion that was transferred to the plate for firing.

The enameline process, an early halftone engraving process invented in the late 1800s, used a copper plate—coated with bichromated gelatin or glue—that was exposed under a halftone negative. In development, the unexposed emulsion was washed away, and the resulting positive image was fired over a gas flame and etched in acid to enhance the image relief and contrast.

The term *enameling* is also related to the casting of a glossy barrier layer on photographic prints. A glass plate is lightly waxed, and a coating of thick, flexible plain collodion is poured on the surface in the same fashion as used for collodionizing a photographic plate. The plate is then placed in a warm solution of gelatin, with the collodion side facing up. The print is placed in the warm gelatin solution, image side down, and allowed to soak. In a few minutes, the print and glass plate are pulled from the solution, lightly squeegeed together, and then set aside to dry. When the print is dry, a sharp blade is used to cut around the edge of the print, permitting removal by carefully peeling from one corner. The cast collodion surface produces a high gloss on the surface of the print.

Encaustic paste

Early in the 1840s, it was discovered that a coating of wax or varnish applied to the surface of salt prints produced a richer depth of tone and helped to prevent exposure to sulfurous air (which caused fading). Encaustic pastes made of beeswax or paraffin mixed with an essential oil or other solvent were used throughout the 19th century and were particularly useful as lubricants when mounted prints were polished with rotary burnishers.

Energiatype

Also known as the *ferrotype process*, the energiatype process was invented by Robert Hunt in 1851. Paper was coated with a solution of gum arabic, sodium chloride, and succinic acid. When dry, the paper was sensitized with silver nitrate solution and dried in the dark. The sensitized paper was exposed in the camera, developed with a ferrous sulfate and gum solution, and then fixed with ammonia.

Enlarging

The production of photographic enlargements dates back to the early experiments of Thomas Wedgwood. By using a solar microscope, Wedgwood projected enlargements of microscopic specimens onto paper sensitized with silver chloride. Similar experiments were made by Daguerre and Talbot, who used solar microscopes to project images onto sensitized paper and plates.

Projection enlarging was first practical when the negative-on-glass was invented by Niépce de St. Victor. The Langenheim brothers of Philadelphia invented the first photographic transparencies on glass, called *hyalotypes*. The technical evolution of projecting photographic positives and negatives is closely tied, and improvements happened simultaneously throughout the 19th century.

Nearly all of the photographs that survive from the 19th century were contact-printed from negatives of the same size. By the late 1850s, photographic solar enlargers, patterned after the solar microscope, were available to project the image from a small negative onto printing-out paper. (*See* Solar Enlarger, Crayon Enlargements.) Developed-out salted paper prints were also made using the solar enlarger because the exposure times were a fraction of those required for the printing-out technique. When silver bromide developing-out paper became commercially available in the 1880s, there was no need for solar illumination for exposure. Magic lantern-type horizontal enlargers were used from the 1880s to around the end of the First World War for projection printing with artificial light. These enlargers were first illuminated by gas and later by incandescent light.

Another method of making enlarged images was to rephotograph a positive image with a larger camera to make a larger daguerreotype, ambrotype, tintype, or negative. Rephotographing, or copying, was frequently done when making framed whole-plate or 8×10 inch tintype portraits, most of which were copied from smaller tintypes and *cartes de visite*. These images are often heavily overpainted, not only on the subject but on the background as well so that the edges of the original image can be hidden. Larger copy negatives taken from the original were used with a wide variety of printing variants.

Where solar enlargement was difficult because of climatic conditions or was simply too expensive, most photographers were able to rephotograph a negative lit from behind to produce an interpositive on glass. This simple technique could be done with a long box and a single camera by placing the negative to be photographed on one end of the box and a camera on the other end. The negative end of the box was tilted up to a cloudless sky for even illumination. Two cameras could also be used. The lens board was removed from the camera that would bear the negative in the rear, and the second camera was pointed into the first. Special enlarging cameras were also built that resembled the mechanics of the two-camera system. Enlarging cameras were built with two sets of bellows and the lens board in-between. Fittings on both ends were designed to receive either a plate holder with the sensitive plate or the negative plate to be rephotographed.

The interpositive did not need to be larger than the original negative. To make the printing negative, the interpositive was lit from behind and rephotographed with a larger camera to produce the final enlarged negative for printing. This system of making duplicate negatives was also used routinely for making copy negatives of particularly valuable originals that were used for commercial printing.

Eosin, $C_{20}H_8O_5Br_4$

A generic name for a class of sensitizing dyes known as the phthalein group, starting with fluorescein. It is usually purchased as a red powder and is soluble in water, alcohol, and

ether. When minute amounts of eosin are added to emulsions or used in solution to treat ordinary collodion or gelatin plates, the sensitivity of the plates can be increased to the green and yellow-green wavelengths of the spectrum.

Erythrosine, $C_6H_4(COC_6HI_2ONa)_2O$

Also known as blue eosin, erythrosine is a bluish red powder soluble in water, alcohol, and ether. It was used as a dye sensitizer for the yellow-green and yellow wavelengths for both collodion and gelatin emulsions.

Ether, $C_2H_5OC_2H_5$

A clear, colorless, extremely flammable liquid with an pleasant odor. Ether, also know as *sulfuric ether* and *ethyl oxide*, is made by the action of sulfuric acid on ethyl alcohol followed by distillation. It is soluble in water and alcohol. Ether should be kept in a well-stoppered container in a cool place. Open bottles should be kept away from flames or sparking electrical equipment. The primary use of ether for photography was in combination with ethyl alcohol as a solvent of cellulose nitrate for making collodion. Ether was also used to wash bitumen (asphalt) to increase sensitivity.

Ethyl alcohol, C_2H_5OH

A clear, colorless, volatile liquid with a pleasant, vinous odor. Ethyl alcohol, also called grain alcohol, is made by the fermentation of sugars extracted from starch. It is soluble in water, ether, and methyl alcohol. Ethyl alcohol is not to be confused with methyl alcohol, which is made by the distillation of wood.

There were several uses for ethyl alcohol in 19th-century photography. It was combined with ethyl ether and used as a solvent for cellulose nitrate for making collodion. Spirit-based varnishes applied to photographic plates were made by dissolving various gums or shellac in ethyl alcohol. Spirit lamps filled with ethyl alcohol were frequently used for heating liquids and photographic plates prior to varnishing. Ethyl alcohol was also added to gelatin emulsions as both a preservative and a surfactant.

Evaporating dish

A wide porcelain or enameled dish with a small pouring spout on one end. Evaporating dishes were used in the preparation of various photographic chemicals such as silver nitrate, where crystals are formed and then washed to remove unwanted acid. On a smaller scale, wet plate photographers frequently used large evaporating dishes to remove the alcohol and ether from overworked silver nitrate solutions. These could be used at room temperature or placed on a stove to accelerate the effect. Special heated and vented evaporation dishes were used in graphic arts darkrooms, when the collodion process was used.

Exchange club

Usually a select group formed within a larger photographic club. The photographers involved agreed to make enough prints from their favorite negative to distribute to the entire group. Accompanying the print would be all its technical information, including the title, date, time of day, lighting conditions, lens, aperture, exposure, type of negative, and printing method used.

Exposure

The basis of both latent and visible image formation, exposure is the action of radiant energy on a photosensitive material. An understanding of the effect of exposure was absolutely essential in making photographic images. Exposure when using a camera was based on the following:

1. The amount and color of ambient light.
2. The color of the object being photographed.
3. The speed of the lens and opening selected.
4. The duration of exposure made through the lens.
5. The sensitivity of the photographic plate or paper.

The earliest photographic images were typically made with silver chloride on paper. The effect of exposure to sunlight on the sensitive paper was easily seen, and observations could be made. When these printing-out materials were placed in a camera obscura, the effect did not appear until the paper was removed from the camera. This technique for printing by observation was used with many printing-out papers. Daguerre's first silver iodide plates were exposed this way. In this primitive system, an initial exposure time was noted, and future plates and papers were exposed based on earlier experiences.

Latent image photography was invented by Nicéphore Niépce. Exposures of asphalt and rosins on various supports did not result in strong visible images, and the photographer had to evaluate after revealing the image with solvents. Daguerre's final process also required development. Talbot's calotype process set the standard for development of plates and films, relying on silver halides for latent-image formation.

An understanding of exposure has always been very difficult for fledgling photographers, requiring them to make repeated attempts and thoughtful observations of the final images for future success. Learning to understand the effects of exposure is facilitated by an understanding of latent-image development. The two concepts are so intimately linked that it is almost impossible to gain useful skills studying either one alone.

Exposure meter

In the days before mass production of gelatin emulsion plates, exposure meters were rarely used. Photographers usually exposed a test plate in the beginning of the day and later evaluated the results based on observation of the shadow areas of the subject. There were many attempts to make exposure meters in the 19th century, but from batch to batch and day to day, results might be very different, making the meter worthless. Experienced photographers generally gained a sense of the relative sensitivity of their medium and worked without meters. Exposure meters gained popularity late in the 19th

century, when gelatin plates were introduced with numeric standards that were based on sensitometry. Around this same time, standards were also being established in marking the apertures of lenses.

Photographers shooting landscapes often kept an exposure notebook, jotting down the time of day, quality of light, lens and aperture combination, and exposure time. These notes enabled them make an educated guess for future shooting in similar situations. The time of year was also noted because the quality of actinic light varied from season to season. Exposure tables based on certain subjects with specific lighting conditions were commercially available by the last quarter of the 19th century and continue to be published on the inside of film packages as of this writing.

The closest thing to an exposure meter in the 19th century was the actinometer, which was most useful when exposing sensitive materials where a change was difficult to view. Among these materials were positives printed on glass supports, such as opaltypes, and latent-image negative materials and printing processes that required ultraviolet light but did not display much or any visual change as in carbon or platinum papers. Actinometers used a strip of sensitized paper pulled from a small box. An opening in the lid of the box allowed light to expose a small portion of paper. When the sensitive paper turned to the same color as a painted reference patch or tinted glass window next to the opening, a new piece was pulled into position to repeat the process. Based on a previous test, the photographer could keep track of how many sequences were needed to properly expose the plate or paper.

F

Fading

The deterioration of photographs has always been a topic of great importance. The making of a photographic image was perfected long before the process for preserving a photographic image. The first printed-out images were damaged not by fading but by exposure to light, which continued reducing the silver, creating a darker picture. Both Daguerre and Talbot originally used common sodium chloride to make their respective processes less sensitive to light. Similarly, both eventually followed Herschel's research and used sodium thiosulfate to remove the unexposed silver halides and fix their images permanently.

The daguerreotype, being made on a metallic support and having no binder, fared much better in regard to fading than the calotype and salt print. Daguerreotypes were more prone to physical damage caused by abrasion and were darkened by tarnishing, the result of airborne contaminants. For these reasons daguerreotypes have always been presented in carefully sealed packages designed to keep out curious customers and the harmful atmosphere.

Like the daguerreotype, collodion-based imagery was also very susceptible to abrasion and tarnishing when exposed to sulfurous air. For this reason all collodion negatives were coated with a protective varnish. Cased ambrotypes and tintypes, however, were either varnished or not, based on the whims of the photographer. The varnishing of collodion positives always

made them darker; many people, however, chose to present them "bright." The cheaper collodion tintypes presented in paper envelopes were routinely varnished for protection from abrasion and the atmosphere.

Other hard images made with silver halides include albumen-on-glass negatives and positives and gelatin emulsion plates. Images made with the albumen-on-glass process were noticeably resistant to abrasion and did not require varnishing, although many examples can be found with a protective coating. Early gelatin emulsion negatives were often varnished, but this seems to have been a carryover from the finishing of collodion plates. The surface was not as fragile as the collodion negative, and eventually mastic varnishes were applied to gelatin plates only locally as a means to create a matte surface for retouching. Gelatin tintypes, introduced in the 1880s, were typically not varnished or well processed, which probably accounts for the generally poor condition of these images today.

Salted paper prints were highly susceptible to deterioration for several reasons. The quality of the paper support was just the beginning. Poor fixing caused by weak or exhausted fixing baths and incomplete washing of the sodium thiosulfate were common causes of fading. Unlike the case with developed-out calotype negatives, printing-out produced very fine particles of photolytic silver that were more susceptible to deterioration. Airborne contaminants, particularly sulfurous fumes, broke down metallic silver, resulting in a lighter color. Fading of the original image color to something warmer and lighter was the result.

Fading of albumen prints in the early 1850s was acknowledged and studied by committees in both England and France. The invention of the carbon process by Poitevin, and Sutton's enthusiastic call for developed-out salt prints, were direct results of dissatisfaction with the albumen and salted paper processes.

When printed-out gelatin chloride papers were introduced in the 1880s, the problem was not solved. These prints faded more easily than the photographs that preceded them, probably because few photographers understood the need for extended washing of gelatin emulsion binders compared to albumen or salted papers. Interestingly, collodio-chloride bromide printing-out papers did not have the same problem, probably because of the collodion binder. Gelatin developing-out papers commercially available in the last quarter of the 19th century suffered from the same causes of fading as the gelatin printing-out papers, although all things being equal, the images were made from a more robust filamentary silver particle.

Farmer's reducer

Howard Farmer invented a chemical compound in 1883 that would reduce and even completely remove the metallic silver from photographic plates and papers. Farmer's reducer was a compound made by combining sodium thiosulfate and potassium ferricyanide. This product should not be confused with reduction, which was a term used to describe the transition of a silver halide back to a metallic state.

Ferric ammonium citrate, Fe(NH$_4$)$_3$(C$_6$H$_5$O$_7$)$_2$

A mixture of neutral ammonium ferric citrate, acid ammonium ferric citrate, and ferric citrate. These greenish yellow powdery flakes of variable size are soluble in water (1:4) and are slightly sensitive to light. Ferric ammonium citrate was used with potassium ferricyanide to sensitize cyanotype paper and for blue toning print and lantern slides.

Ferric ammonium oxalate, Fe$_2$(C$_2$O$_4$)$_3$3(NH$_4$)$_2$ C$_2$O$_4$ 8H$_2$O

Also called *iron oxalate*, ferric ammonium oxylate was made by dissolving ferric hydrate in ammonium oxalate solution and then evaporating it to crystal form. Exposure to light reduces this to *ferric* ammonium oxalate. It was used with potassium ferricyanide for cyanotype printing and as a cold developer in the printing-out platinum process.

Ferric cupric process

An iron salt process that results in a range of red and purple tones. In 1864 J. B. Obernetter published his results with this iron process. It is based on the light sensitivity of a mixture of ferrous and copper chlorides, which results in cuprous chloride being formed upon exposure to ultraviolet radiation. It was also known as *cuprotypes*.

Ferric gallic process

An iron salt process that produces a direct-positive image of black lines on a white ground. This has been used as a substitute for the blueprint process. The paper is coated with a gelatin or gum arabic solution of ferric chloride and ferric sulfate and then developed in water if the print has been dusted with gallic or tannic acid, or developed without dusting in an acid solution. Gallic acid produces purple-black lines; tannic acid produces brown lines.

Ferric oxalate, Fe$_2$(C$_2$O$_4$)$_3$

The most light sensitive of all the iron salts, these greenish scales are soluble in water. Ferric oxalate was used as a sensitizer in both the platinum and kallitype processes.

Ferrotyping

Not generally practiced until after the turn of the 19th century, ferrotyping was a method of making very glossy gelatin prints by casting. The wet, swollen gelatin emulsion of a print was squeegeed against the smooth surface of japanned iron plates that were used to make tintypes (also known as *ferrotypes*). When the gelatin print dried, it would fall from the plate and would bear a glossy surface. A similar method of making albumen prints glossy was called *enameling* in the 19th century. *See also* Enameling.

Ferrotype process

The first suggested use of thin, iron plates as a support for positive collodion images was in 1855 by French photographer A. A. Martin, although his work had little influence. In the same year, the "ferrograph" experiments were conducted by Hamilton Smith of Gambier, Ohio. In 1856, Smith patented the process of the iron plate. A year later the process was patented by Smith. Also in that same year, the process was patented in England by William Kloen and Daniel Jones. The process was identical to making a collodion positive on glass, except that the support material was iron. Smith assigned his patent to William and Peter Neff, who manufactured the iron material and called their product *melainotype* plates, a reference to the black color of the baked-on asphaltum coating, also called Japan black.

A competitor, Victor Griswold, manufactured similar japanned plates for collodion positives, calling them *ferrotype* plates in reference to the iron support. The term *melainotypes* never really caught on, but *ferrotype*, *ferrotypists*, and *ferrotyper* were often used during the 19th century. More often than not, however, the public preferred the less formal *tintype*, implying the cheap, tinny feeling of the material.

Ferrotype plates were less expensive than sheets of glass at the time, particularly the dark-stained "ruby" glass used in making the highest-quality collodion positives, which were eventually called ambrotypes. The metal plates were also not easily broken, allowing them to be carried without worry and sent through the mail, a capacity that led to them occasionally being called *lettertypes*. Both of these factors contributed to the commercial success of the product. Early melainotypes and ferrotypes were presented in the same style of protective cases used for daguerreotypes and ambrotypes. By the 1860s, they were being offered in paper mats.

Although ferrotypes/tintypes could be made in any size, the most typical tintype format from the late 1860s to the turn of the century was made using a four-lens camera that produced four images on a 5×7 inch plate. Called *bon tons*, the individual images were cut from the plate, positioned in the mat opening, and either glued from the back using a piece of gummed paper backing or later slipped loose into the sleeve of a paper mat. *See also* Bon ton.

By the late 1880s, a dry gelatin emulsion tintype plate was introduced. This was precoated and ready to use right from the package. Gelatin tintypes were developed in a special developer/fixer solution. Special laboratory cameras designed for street photography were available by the turn of the century. To make an image, the operator put his or her hand through a gloved opening in the back of the camera to take the plate out of the package and place it into the focal plane of the camera. After exposure, the plate was dropped through a slit in the bottom of the camera into a tank of developer/fixer and was processed for about a minute. Once the plate was fixed, the tank was turned so that the plate could be removed from the solution from outside the camera and placed in a bucket of water to remove the excess chemical solutions. Silver bromide emulsions on double-weight postcard material were also used in these cameras, as well as a paper "tintype" made on black, glazed card stock.

Ferrous ammonium sulfate, Fe(NH$_4$)$_2$(SO$_4$)$_2$*6H$_2$O

Pale blue-green crystals made by ferrous and ammonium sulfate. Soluble in water, ferrous ammonium sulfate was a more

stable alternative to ferrous sulfate and was used as a developer in the wet collodion process.

Ferrous nitrate, $Fe(NO_3)_2 * 18H_2O$

Greenish white crystals made by dissolving iron wire in nitric acid or by mixing ferrous sulfate with barium nitrate. Ferrous nitrate is soluble in water (1:6) and dilute alcohol. It was used as a developer in the collodion positive processes, giving a whiter color to the reduced silver.

Ferrous oxalate, $FeC_2O_4 * 2H_2O$

Ferrous oxalate was made by mixing potassium oxalate with ferrous sulfate. It is nearly insoluble in water, but solubility increases with alkalinity. In 1877 ferrous oxalate was introduced as an alkaline developer by both M. C. Lea, in America, and Wm. Willis, in England. Ferrous oxalate was one of the first developers for silver bromide gelatin plates and remained popular until the introduction of hydroquinone and metol.

Ferrous sulfate, $FeSO_4 * 7H_2O$

Ferrous sulfate was made by treating iron wire or filings with sulfuric acid, followed by evaporation to its crystal form. In the purest form, ferrous sulfate was sold as bright green crystals that dissolved easily in water with little or no residue. Poorer grades contain a large amount of inactive solids that precipitate when mixed with water. Tightly stoppered ferrous sulfate has a long shelf life, but it oxidizes when exposed to air.

Ferrous sulfate, also known as *iron sulfate*, *green vitriol*, *copperas*, and *protosulfate of iron* was the most popular reducing agent in physical developers used for the wet collodion process. It was always used in combination with either an acid or an organic restrainer to prevent spontaneous reduction of nonimage silver. Ferrous sulfate was also combined with potassium oxalate to make ferrous oxalate.

Festoon

One of the advances in the evolution of gelatin emulsion coating, festoons were long, continuous loops of coated paper that hung from poles gathered by machinery. Festoons allowed the gelatin coating to dry, using less room space. Eastman's American Film coating machine made the first large-scale use of festooning.

Film

A thin coating on a secondary support is often referred to as a film; as in the case of collodion, albumen, or gelatin binders on glass. *Film* is often a better term to use than *emulsion* because many of the early processes, such as those for wet collodion and albumen plates and papers, were not made as an emulsion with the halides and silver mixed before coating. The more common use of the term signifies the actual support, suggesting a thin, flexible material.

Film support

Frederick Scott Archer was probably the first to create a transparent, flexible photographic film. Archer's original concept was to make collodion images on glass and then transfer them onto a paper support. The image-bearing collodion layer was allowed to dry before stripping and transfer. One variant of the technique was to coat the collodion surface with a solution of gutta-percha (a natural rubber dissolved in benzol) and to allow this to dry. The plate was then placed in a water bath containing some nitric acid, which would shrink the film. When removed from the water, the collodion-rubber film could be peeled from the plate.

Archer's method of stripping and transferring film was little used in the collodion era. There were a few landscape photographers in the 1850s who used the technique, and it was central to the seldom-used pannotype process. Stripping and transferring of film found its niche in the graphic arts industry, where the procedure was used well into the 1960s.

Thin sheets of mica, coated with wet collodion, were being used as early as the 1850s to make collodion positives and negatives. This very light, transparent material was used not for reasons of flexibility but because it was lighter than glass and because the final image could be trimmed to make photographic jewelry.

In the mid-1860s, an Englishman named Alexander Parkes invented a tough, flexible material based on the addition of oils to collodion. His product, Parkesine, was introduced in 1864 but was not a commercial success. Daniel Spill received an English patent in 1875 for a similar product made by adding camphor to collodion. Spill's product was called *xylonite*. The British Xylonite Company produced the product as a flexible window material. Around the same time in Albany, New York, John and Isaiah Hyatt used a similar formula combined with heat to make a variety of useful objects normally manufactured with elephant ivory, such as billiard balls. They formed the Celluloid Manufacturing Company in the early 1870s, which evolved to become the largest maker of synthetic materials in America by the end of the century.

Flexible transparent film supports coated with light-sensitive emulsions evolved through the work of several experimenters in the 1880s. In Philadelphia, John Carbutt offered the first commercial celluloid sheet films in 1884. Other gelatin dry plate manufacturers soon introduced their own sheet films, but they were never a popular product in the 19th century.

It was understood that clear celluloid films could possibly be made thin and flexible enough to be transported between rollers in the back of a camera, but the task was difficult. The sheet films of the early 1880s were not flexible enough, and long ribbons of the material were difficult to make and to coat with emulsions. Several strong personalities set to work simultaneously on solving the problem. Interestingly, it was a paper support coated with gelatin emulsion that was first mass-produced as a flexible film.

Developed-out paper negatives had been introduced by Talbot back in 1840, and there were early attempts to use rolls of this sensitized paper in cameras, although without success. When emulsion technology was blossoming in the late 1870s, William Henry Jackson attempted to use rolls of sensitive

paper for landscape work in the American Southwest, an experiment that ended in complete failure. It was George Eastman, a gelatin emulsion plate maker in Rochester, New York, who introduced a system that actually worked.

In 1884 George Eastman patented a machine that applied warm gelatin solutions to long rolls of paper. Through a system of festooning, the gelatin coating dried evenly on the surface. Eastman also patented American Film, made by coating paper with a primary layer of soluble gelatin. After this layer dried, the paper was coated again with a silver bromide gelatin emulsion that was hardened with alum. The film was cut to fit wooden spools that were designed to be used in a special holder designed by William H. Walker, who shared the patents relating to the paper film, the roll holder, and the system of manufacture.

The Eastman-Walker roll film back could be customized to fit most plate cameras in use at the time. An inventor in Wisconsin named David Houston informed Eastman's attorney in 1885 that the Eastman-Walker roll holder infringed on his design. Houston had patented a similar roll holder in 1881 that featured a way of indexing exposures by perforating the edge of the film. Eastman originally licensed Houston's idea so that he could manufacture the Eastman-Walker holder by the spring of 1885. Unfortunately, however, American Film was not yet ready, and in order to get the product into the marketplace, the Eastman Dry Plate Company issued a silver bromide paper film that was designed to be printed through the paper support. The processed negatives were oiled to make them translucent, but the paper fibers of the support were visible in the final prints, a giant leap backward to the days of Talbot. The public was not impressed at the time. After the turn of the century, when the pictorialism movement was at its zenith, fine art photographers went back to using paper negatives for the soft, mealy characteristics imparted to the final images.

American film

American Film was exposed normally and then, with the turn of a knob, was transported from one side of the camera to the other to bring the unexposed film into position for the next exposure. The film was taken into the darkroom and cut to the individual exposures marked by perforations on the edges. The individual sheets were developed, fixed, and washed. After the initial wash, the films were squeegeed, emulsion side down, onto glass plates that were coated with hardened gelatin. Hot water was then poured over the paper backing to soften the soluble gelatin layer, and the paper support was removed. At this point the glass negative could be used like any other, or the emulsion side could be coated with a second sheet of hardened gelatin and removed from the glass as a thin pellicle. American transfer film was issued with the first Kodak cameras in 1888, but they were eventually replaced with nitrocellulose films. Rather than pay a license to David Houston for the indexing roller used in the Kodak camera, Eastman purchased the patent outright in 1889 for $5000.

Nitrocellulose roll films

Celluloid had been used for sheet films in the early 1880s, but the first commercially successful production of nitrocellulose-based supports for roll film was George Eastman. The technical and legal evolution of flexible nitrocellulose film was difficult. In 1887 Reverend Hannibal Goodwin, a Protestant Episcopalian minister from Newark, New Jersey, filed for a patent regarding a "sensitive pellicle better adapted for photographic purposes." Goodwin had devised a method of casting sheets of film by pouring liquid nitrocellulose on a long glass table. When the volatile solvents evaporated, the resulting tough, thin, transparent film could be stripped from the glass. The key to the technique was in the solvents that were used.

Eastman and one of his chemists, Henry Reichenbach, were working on a similar system at the time Goodwin applied for his patent. From the time Goodwin originally filed in 1887 to 1889, he revised his patent application several times. Both the Goodwin and the Eastman-Reichenbach patents were refused because of interference. Eastman did not file again, but Reichenbach revised his formula enough to secure his patent, ushering in the flexible-film industry. The Eastman Kodak Company commenced making nitrocellulose-based flexible film in 1889 under the Reichenbach patent and supplied the film with the Kodak camera. Various sizes of film were soon issued for other cameras as well. Goodwin was eventually awarded a patent in 1898 after revising his formula several times. He died two years later, the result of a fatal street car accident.

Filter (chemical)

Many chemical solutions in photography require filtering. Although special fine filtering papers manufactured for chemists were available, most photographers in the 19th century simply compressed cotton wadding into the neck of a funnel for the purpose. Glass filtering funnels were made with special internal ridges to support filter papers and to allow more flow of liquids along the sides of the paper.

Filter (optical)

The first practical use of filters in photography was to make the sitter more comfortable while being photographed in direct sunlight. Richard Beard created liquid filters filled with a solution of blue copper sulfate. Colored glass filters were also used to experiment with the sensitivity of photographic materials and to filter out actinic light in darkrooms. Though the concept of placing a small colored glass filter was known early in the 1840s, there was very little need for the modification until the advent of color separation negatives. Maxwell's additive color demonstration was accomplished by both exposing and projecting through liquid-filled filters.

Fixer

Photographic materials that have been printed-out or developed to create a visible image are susceptible to continued reduction of silver unless the unexposed silver halides are

completely removed. This clearing process is called fixing. Without fixing, all silver-based photographic materials would eventually darken. The first recorded attempts to fix a photographic image were by Hercules Florence in 1833. According to his journals, Florence kept his printed-out silver chloride images on paper from fading by treating them in a solution of urine, ammonia being the active ingredient. His research, conducted in Brazil, went unnoticed.

The important observation that unexposed silver chloride was soluble in ammonia had been made by Carl Wilhelm Scheele of Sweden and published in 1777. History would have identified Thomas Wedgwood and Humphry Davy as the inventors of permanent photography had the two referred to Scheele's research and fixed their silver chloride-based imagery. Talbot and Daguerre initially used sodium chloride to stabilize their images, a process that doesn't actually remove the unwanted halides but simply makes them less sensitive to light.

Sir John Herschel, the first photochemist, discovered thiosulfates in 1819 and observed that they could be used to dissolve all silver salts. Herschel suggested to both Daguerre and Talbot that sodium thiosulfate was a better alternative to the chlorides for fixing photographic images. At that time sodium thiosulfate was mistakenly called hyposulfite of sodium. Over time the oversight was corrected, but the shortened name of "hypo" has remained to the present day.

Hypo, Na_2S_2O $5H_2O$

Hypo was used for fixing all silver-based photosensitive materials throughout the 19th century, although the strength of the solution varied by the process and the photographer. The chemistry of fixation was not generally understood, and many early photographers fixed their images by inspection, often preferring exhausted solutions for the resulting color of the print. *See also* Sodium Thiosulfate, Fading.

When gelatin plates displaced the wet collodion process, many photographers were accustomed to the short washing times of wet plates. Many were not prepared for the extended fixing and washing that was required for gelatin emulsions. As a result, many plates and prints were ruined because of insufficient fixing and washing. By the 1890s both commercial and amateur photographers came to realize how to properly process their materials.

Cyanide

When the collodion process was invented by Archer in 1851, hypo was used to fix collodion negatives. Shortly thereafter, many photographers adopted the use of potassium cyanide because it required less washing and produced clearer minimum density areas. The use of cyanide also resulted in a lighter colored metallic image particle, which was particularly useful for making direct collodion positives. (*See also* Ambrotype, Ferrotype, Melainotype.) Both cyanide and hypo were used for fixing collodion negatives throughout the collodion era, and each photographer had his or her own defendable reasons for preferring a given fixer.

Cyanide is a deadly poison that when ingested causes almost certain death. Minor cuts or abrasions on the hands usually fester and worsen when exposed to cyanide solutions. Combining cyanide with acids produces the cyanide gas used in gas chambers.

Stabilization

Stabilization, originally introduced by Talbot, is a process where residual silver halides are converted into more stable complexes that are not subsequently washed out of the emulsion but are left in the final image. Stabilization is commonly used today in rapid-processing systems and in products for which image permanence is not a major issue. Stabilization allows one to forgo the final wash, one of the longest steps in processing, especially with fiber-based printing papers. The material must be dried directly after the stabilization bath.

Certain thiosulfates, thiocyanates, thiourea, and allied compounds are used for stabilization baths. However, the image stability is never as good as after proper fixation and washing. When a stabilized image deteriorates, one of two reactions can occur. The highlights can turn yellow and then brown, or the image silver can be bleached away. Either result may dominate, depending on the circumstances (type of compound used, illumination, temperature, and humidity). If a stabilized image is refixed in a normal fixing bath, it can be made permanent.

Fixing gelatin-based materials

Only a small amount of the silver salts in the emulsion layer of a photographic film or paper is needed to produce the silver of the developed image. The unused, unwanted silver halide of the emulsion layer will darken upon exposure to light if it isn't removed in a short time, obscuring the silver image. The process of removing the undesirable silver halides from the photographic material is called *fixation*; the solution that dissolves the silver halides is the *fixing bath*, or more simply, the *fixer*.

The chloride, bromide, and iodide salts of silver are almost insoluble in water and thus cannot be washed from the emulsion layer. A considerable number of compounds, however, adsorb to the crystal surface of the silver halides and react with silver ions to form water soluble compounds, which then diffuse with an equal number of halide ions into the solution. The silver crystals are etched away, leaving a metallic silver image in the otherwise transparent emulsion layer. The developed image has been "fixed," that is, protected from continuing change by the removal of the unwanted silver salts.

Many compounds in solution possess the ability to etch the crystal surface of the silver halides. Certain developer constituents actually begin the etching process during the development treatment. Silver halide solvents in developers include ammonia or ammonium salts; potassium or sodium thiocyanate; sodium sulfite; sodium thiosulfate; and chloride, bromide, or iodide ions. Any of these silver halide-solubilizing compounds, as well as nitrogen (amine) or sulfur (mercapto)

organic compounds, might be used in separate baths to complete the removal of the unused silver salts.

In practice, however, the choice is quite limited. Ammonia and sodium sulfite solubilize silver chloride but are slow to attack silver bromide. Potassium cyanide easily dissolves all the silver salts, even silver sulfide, but is highly poisonous. Even this did not stop cyanide from being used as a fixing bath for the early high-iodide wet plate or ambrotype processes. Organic fixing agents are costly and often toxic. When chemical activity, solubility, stability, toxicity, and cost are all considered, today's universal choices have been sodium thiosulfate ($Na_2S_2O_3$) and ammonium thiosulfate [$(NH_4)_2S_2O_3$].

The thiosulfate ion dissolves the insoluble silver halide crystal by combining at the surface with a silver ion, forming a complex ion. A second thiosulfate is thought to be necessary before the complex silver ion can be carried into the solution. The reactions of thiosulfate fixation may be written as shown in the following table. Note that a bromide ion (Br^-) is also released with each silver ion solubilized. Eventually an excess of bromide ions in the fixing solution will effectively compete with the thiosulfate for the silver ions. At this point the fixing bath is said to be exhausted.

AgBr (Solid) + $S_2O_3^{2-}$ (Solution)
→ $[AgS_2O_3]^-$ (Adsorbed complex of low solubility and low stability) + Br^- (From solid into solution)

$(AgS_2O_3)^-$ (Adsorption complex) + $S_2O_3^{2-}$ (Solution)
→ $[Ag(S_2O_3)_2]^{3-}$ (Leaving crystal's surface and passing into solution)

$[Ag(S_2O_3)_2]^{3-}$ (Solution) + $S_2O_3^{2-}$ (Solution)
→ $[Ag(S_2O_3)_3]^{5-}$ (Solution)

Fixing baths are not simple water solutions of the thiosulfate salts. Because developing solutions are alkaline, the fixing solutions need to be acid to inhibit further image formation. The presence of a gelatin-hardening compound in the fixing bath is desirable, but hardening agents, such as the alums, are effective only in moderate acidity. These factors dictate that the fixing solution be acidic, but such a need greatly complicates the composition of the bath.

Because thiosulfate ions are unstable in low pH solutions, the solution must be maintained so that the solution does not become highly acidic. Alum, usually potassium alum, requires a narrow range of acidity, usually that given by a buffered acetic acid solution. Sodium sulfite is needed as a preservative as well as an inhibitor of the precipitation of sulfur from the thiosulfate ions in the fixing bath. Boric acid is added to acid fixers as an antisludging agent and helps the buffering of the solution.

Flash photography

The use of pyrotechnics to illuminate subjects for photographic exposure dates to the mid-19th century. The first practical substance to be used was magnesium. Thin ribbons of the metal were laid in a dish or affixed to a vertical tin tray and lit by matches. The metal burned as a brilliant white light and left behind a thin ash and white smoke. By the early 1870s, special lamps were manufactured to dispense magnesium ribbon; the most fascinating variant of this idea included a clockwork motor that fed the ribbon through a hole in the center of a polished reflector. Magnesium ribbon dispensers continued to be popular until after the turn of the century.

By the 1880s a special flashlight or flashlamp for burning magnesium powder had been introduced. When a match was set upon a small pile of magnesium powder, only the outer areas exposed to the air would burn completely. Magnesium powder flashlights were designed so that an alcohol lamp would be lit first, establishing the means of ignition. The magnesium powder was loaded in a chamber with a hinged lid. When the exposure was to be made, a pneumatic bulb was squeezed and magnesium was blown from the chamber past the open flame. In this way fine powder had ample oxygen to effect complete ignition. Obviously this was a dangerous system, and a new illuminant was introduced late in the century to make flash photography easier.

Flash powder

Flash powder did not require the blow-through style of alcohol flashlamp; in fact it was actually dangerous to use the older-style lamp with the new illuminant. In its most basic form, flash powder was made from a combination of powdered magnesium and potassium chlorate, although there were many variants formulated by photographers in the same secretive way fireworks are designed. Certain additives to the basic mixture, such as ammonio-chloride of copper, would create a cool-blue color that was more actinic.

Flash powder could be poured on any surface in any amount and lit with a match or spark. The most popular apparatus for flash powder was a metal tray on a handle that was fitted with a spring-loaded rotating friction wheel that rubbed against a flint like those used in a cigarette lighter. Depressing a lever or button released the wheel to produce a shower of sparks that ignited the powder. To make the exposure, the photographer would uncover the lens by removing the cap or would trip the shutter with one hand and then set off the flash with the other hand. The shutter speed B (or bulb) was specifically suited for this type of exposure. As long as the pneumatic bulb was depressed, the shutter remained open; once the bulb was released, the shutter would close. Flash powder continued to be used for interiors, banquets, and night exposures until the invention of vacuum flashbulbs long after the turn of the century.

Flour paste

Ordinary household wheat flour was used as a mountant for affixing albumen and salted paper prints to card stock and album pages. The paste was made by mixing wheat starch with cold water until it was the consistency of thick cream. This was cooked and stirred in a double boiler until further thickened, and then it was poured into a glass or crockery jar to

cool. Additives such as alcohol or oil of cloves were added to the warm mixture to prevent spoiling.

Pastes were applied to the back of prints in a thin, even coat using a stiff brush. When the paste was applied to albumen paper, the albumen side had to be dampened slightly to prevent curling. The pasted print was then positioned on the mount, covered with a piece of absorbent paper, and rolled with a brayer from one end to the other, forcing air bells and excess paste to the far end. The cover paper was then removed, and the mount that bore the print was wiped lightly with a damp cloth to remove any superfluous paste. Mounted prints were then pressed or burnished.

Focusing glass

The focusing glass is a variant of translucent tracing paper, placed on the glass focal plane of a camera obscura for the purposes of viewing the image. Talbot's earliest cameras were fitted with peepholes in the front to view the projected image on sparingly sensitive photogenic papers. The focusing glass for cameras was frosted by either mechanical or chemical means. Fine abrasives in a liquid medium were rubbed over the glass with a second smaller piece of glass, or acids could be used to etch the surface.

Fog

A fine film of nonimage silver on photographic materials is often referred to as *fog*. Fog can be seen in daguerreotypes, calotype negatives, albumen glass negatives, collodion glass negatives and positives, gelatin glass and film negatives, and all types of prints on paper. In calotype negatives, fog was often called "browning." There are many causes of fog; the most common are overexposure, light leaks in the camera, plate holder or darkroom, and an overactive developer.

Plates processed by physical development are also prone to veiling, a type of fog that is superficial and wipes off, leaving a normal image. Veiling is usually caused by microscopic organic material that is reduced to silver during development.

Frilling

Frilling is a crinklelike defect caused when a gelatin emulsion layer expands and separates from the support at the edges. It is generally caused by high temperatures in processing, sudden changes in temperature during processing, excessive processing times, rinses or washes in excessively soft water, or extremes in pH (such as when switching from a highly alkaline developer to a strongly acid stop bath or fixer). The problem occurs less frequently when rinses and washes are carried out with hard water.

Early silver bromide gelatin plates often frilled when processed. To prevent frilling, photographers placed the negative plate, emulsion side up, in an alum bath before development and/or fixing.

Fuming

A technique dating to the era of the great photographic experimenters. Niépce, Daguerre, Talbot, Hunt, and others used fumes to either sensitize or reveal a latent image. The daguerreotype process in particular is essentially a hands-off method based on fuming. Once the laborious cleaning and polishing of the silver plate is completed, the essence of the process is accomplished by fumes. (*See* Daguerreotype.) Albumen glass plates were also fumed with iodine before being sensitizing in a solution of silver nitrate.

The second-most-common process that used fuming in the 19th century was the albumen printing process. By the late collodion era, a change of style suggested that portraits should have a more delicate range of tones. Collodion negatives in the 1870s were being made with less density and being finished with more-elaborate pencil retouching. Because these negatives had lower printing density, photographers usually fumed their albumen paper with ammonia, which resulted in a stronger print without the need for deep printing.

Fuming albumen paper was done in a large wooden box with a tight lid and a false bottom that was perforated with small holes. A small dish of liquid ammonia was placed under the false bottom, and the fumes were evenly diffused by the holes. Paper was affixed to wood rods and lowered into the box. It was important to fume the paper in a different room than the darkroom because ammonia fumes caused fogging in other sensitive materials.

G
Gallic acid, $C_7H_6O_5$

White silky crystals formed by cooling a solution made by boiling gall nuts. The crystals are soluble in 20 parts cold water and 3 parts boiling water. Gallic acid usually contains a large quantity of tannic acid and it was this substance, which Reverend Reade assumed was an active ingredient for sensitizing silver chloride paper in 1839. Talbot used gallic acid restrained with acetic acid for both the sensitizing and development of the silver iodide calotype negative. When added to the silver solution the new compound was called gallo-nitrate of silver. Eventually Talbot and others dropped the gallic acid for the sensitizing step, but it remained as the standard developing agent mixed with silver nitrate and acetic acid for both the calotype and waxed paper negative process.

Gallic acid was largely replaced by pyrogallic acid, made by super heating gallic acid crystals, though it was used by some to physically develop-out lightly printed silver chloride or silver whey prints in the 1850s.

Gaslight paper

Silver chloride gelatin emulsion papers with an excess of silver are generally called printing-out papers. In the late 1890s The Nepera Chemical Company introduced an unusual silver chloride gelatin emulsion paper without the excess silver called Velox. The popular terms for Velox and its eventual imitators were gaslight or contact developing-out paper. Emulsions for gaslight printing were primarily chloride but they could also contain some bromides.

Gaslight papers were so called because they could be handled in a darkroom with a single dim gaslight a few feet

away without fogging the sensitive emulsion. When placed in a printing frame, the paper was in contact with a negative and was exposed by holding the frame close to the gaslight, which was adjusted to a proper intensity. Development with an alkaline developer was performed under a dim gaslight as well. Gaslight papers could also be exposed with weak daylight or magnesium ribbon.

Gelatin

Gelatin is a naturally occurring protein having many uses in photography, most importantly as a binding medium for photosensitive compounds and other emulsion ingredients. It is extracted from animal hides, bones, and connective tissues by various processes that influence its properties. Different types of gelatin are used for different purposes. It is insoluble in cold water, but will absorb about 10 percent of its weight in water. (This is mainly what must be driven off in drying films after processing.) Hot solutions of gelatin will set to a rigid gel when chilled, a property useful in photographic emulsion manufacture. Gelatin is not a definite chemical compound, and a given sample may contain molecules of various molecular weights, ranging from about 20,000 to more than 100,000, and of various amino acid compositions.

An important property of gelatin is its protective colloid action toward silver halide crystals during emulsion preparation. (A photographic *emulsion* is not an emulsion in the modern usage of physical chemists, but rather, a suspension. The term, however, is too well established to displace.) The gelatin present during the precipitation reaction of silver nitrate with potassium halide influences the rate and nature of crystal growth of the resulting silver halide. In the absence of gelatin the silver halide is precipitated as crystals too large for photographic purposes.

Sometimes the best type of gelatin for precipitation does not have the ideal properties for coating or for some desired property in the finished film. In such cases the first gelatin can be removed by *isoing*; that is, adjusting the pH of the emulsion to the isoelectric point of the gelatin, the pH at which it loses its colloidal protective power. The crystals precipitate and the gelatin solution is drawn off and discarded. The crystals are then resuspended in a solution of the desired gelatin.

A property of gelatin directly connected with the actual photographic process is its role as a halogen receptor. During exposure, the action of light on a silver halide leads to the formation of atoms of silver and of the halogen. If the very reactive halogen is not immediately trapped by another substance, it may then recombine with a newly formed silver molecule, thus nullifying the effect of the light. Gelatin is such a substance, although other halogen receptors are also added to emulsions.

One of the earliest materials used as a binder for silver halide was collodion, or cellulose nitrate, on which the *wet collodion process* was based in 1851. In 1871, however, gelatin was found to be a good binding medium, and had the advantage over collodion that emulsions made with it were much more sensitive, and were also sensitive when dry. Not all gelatins gave equally sensitive emulsions, and the "good" photographic gelatins were found to contain a few parts per million of certain sulfur compounds. The addition of such compounds, for example, allyl thiourea, to "poor" photographic gelatins enabled good emulsions to be made.

Aside from the silver halide process, gelatin itself plays a major role in many imaging processes where its physical properties are somehow changed by the action of light. On exposure it can combine with heavy metal ions to form insoluble products. Some photomechanical processes are based on this light-induced hardening of gelatin. For example, the action of light on gelatin containing potassium dichromate (formerly called bichromate) forms an insoluble compound. Washing with warm water removes the unexposed areas, leaving a relief image. Gelatin is also hardened by other agents including formaldehyde and the oxidation products of some developers, such as pyrogallol. *See also* Pigment Process, Gum Print, Carbon Print.

Ghost image

When exposures are extended and there is subject movement the result is usually a ghost image. The earliest known example of a transparent subject is Daguerre's plate showing a lone bootblack polishing the shoe of a ghostly customer on the corner of a busy Parisian boulevard. Similar examples were recorded on a regular basis throughout the 19th century on every type of camera image. In the 1860s W. H. Mumler perfected the art of spirit photography. His images usually featured an average commercial studio portrait with translucent heads floating above or standing behind the subject.

The term *ghost* was also applied to non-image silver reduction on negatives and direct positives. These cloudy white areas in the picture could take the form of any shape and were usually caused by chemical reactions, organic matter in the chemicals, or light leak in the camera or plate holder. A hazy white circle of reduced silver in the center of a photographic plate was occasionally called a ghost. These were caused by light entering the lens at a certain angle particularly when using early landscape lenses using the globe design.

Gilding

In 1840, H. Fizeau invented a technique to tone daguerreotypes using a solution of gold chloride and sodium thiosulfate in a process called gilding. Gilding a daguerreotype improved the contrast and tonality of the image but also made the fragile surface less susceptible to abrasion. By the mid-1840s all conscientious daguerreotypists gilded their plates.

Glass

In its pure form, glass is a transparent, hard-wearing, essentially inert, strong but brittle, and biologically inactive material that can be formed with very smooth and impervious surfaces. These properties can be modified or changed with the addition of other compounds or heat treatment. The basic ingredients

are amorphous silicon dioxide (SiO_2), soda (sodium carbonate Na_2CO_3), or potash, the equivalent potassium compound to lower the melting point, and lime (calcium oxide, CaO) to restore insolubility. The resulting glass contains about 70 percent silica and is called a soda-lime glass. Soda-lime glasses account for about 90 percent of manufactured glass.

There are a wide variety of glasses used in photography, the most common are sheet window glass (such as lites for glazing a studio skylight), plate glass, crown glass, flint glass, and optical glass. Window, or broad sheet glass, and crown glass were the two most common processes for making glass for windows up until the 19th century. When making cylinder glass, wide sheets of glass were made by blowing molten glass into an elongated balloon shape using a blowpipe or puntil. Then, while the glass was still hot, the ends were cut off and the resulting cylinder was split with shears and flattened on an iron plate. The quality of this was poor, with many imperfections and limited size. Crown glass was produced by blowing molten glass into a "crown" or hollow globe. An opening was then made in the globe. By rotating the blow pipe, the glass opened into a flat disc shape by centrifugal force, up to 5 or 6 feet in diameter. The glass was then cut to the size required. Because of the manufacturing process, the best and thinnest glass is in a band at the edge of the disk, with the glass becoming thicker and more distorted toward the center. The center of the disc bearing the thick area where the puntil was attached for blowing was either melted again or sold for inexpensive windows.

Plate glass developed out of the manufacture of broad sheet glass and the need for higher quality glass. The ingredients varied with manufacturer, but they all had special care taken in regard to purity. Early plate glass was made from broad sheet glass by laboriously hand grinding and polishing both surfaces. The technique later developed into a process whereby molten glass was poured onto a flat table and an iron cylinder was rolled over it to the thickness required. The plate was then placed in an annealing oven. After the glass was annealed it was ground with sand and water on both sides and given a final polish with powdered emery. Plate glass was of a sufficient quality and size for mirrors and photographic purposes. Patent plate glass was lighter and produced from cylinder glass that had been polished via the same method as plate glass.

Optical glass was made from a combination of flint glass and crown glass to produce achromatic lenses. This was possible because of their compensating optical properties. Traditionally, flint glasses contain around 4–60 percent lead oxide.

Colored glass or stained glass was produced in a number of ways. Tin or zinc oxides were used to produce white opaque glass, such as those used in opalotypes. Metals could be added to the chemistry to produce vibrant colors — gold or copper to produce red or manganese to produce amethyst ruby glasses, both used in the direct positive collodion processes. Colored glass could also be made by flashing (the application of a thin veneer of colored glass) or by coating a sheet of clear glass with collodion or gelatin containing dye colorants.

Glass positive

The first glass positives were most likely made by Nicephore Niépce using the heliograph process. These would have been both positive and negative depending on the lighting and viewing angle. In 1839 Sir John Herschel produced an image on glass sensitized with silver chloride that would have had a similar effect. The first experiments of the albumen on glass process by Whipple, the Langenheims, and Niépce de St. Victor produced direct positives on glass when the plates were underexposed and overdeveloped. The first glass positive transparencies made from negatives and strong enough to project in a magic lantern were made by the Langenheim brothers in 1849. The brothers made copy negatives of daguerreotypes using the albumen on glass processes then rephotographed them onto a second plate. They called their plates "hyalotypes."

Two years later when Frederick Scott Archer introduced the wet collodion process he observed that underexposed negatives looked faintly positive when backed with something dark. To accentuate the effect Archer bleached the silver image to make highlights brighter and called them alabasterines. Unlike the hyalotype, which was made for projection, Archer's positives were viewed by reflected light. Improvements to the collodion process soon made the bleaching step unnecessary. Early collodion direct positives on glass were known as daguerreotypes on glass, daguerreotypes without reflection, and verreotypes. The Cutting patent introduced a novel way of sealing the final image and also coined the word ambrotype, which became the generic term for all direct positives made on glass by the wet-collodion method. *See* Collodion.

The wet plate, preserved collodion plate, and a collodion emulsion process was also used to make collodion positives on glass derived from a negative. By rephotographing a negative lit from behind, the photographer could make lantern slides on clear glass or milk glass positives also known as opalotypes or opaltypes if photographed on translucent white glass. Milk glass positives and lantern slides were also made using the developed-out and printed-out albumen processes, the carbon transfer process, and developed-out and printed-out gelatin emulsions.

Glue

The common glue of the 19th century was made from poor quality animal gelatin and for this reason it was often called hide glue. It was purchased as either dry sheets, flaked, or ground up into small grains. To make glue it was first necessary to soak the dry product until it absorbed as much water as possible. Excess water was then poured off and the swollen gelatin placed in a double-boiler-type glue pot and placed on a stove. Fish gelatin, also known as isinglass, was also used to make glue. Gelatin glues were always applied hot using a brush. Mucilage glues were made with gum arabic, gum tragacanth, and dextrin. These glues were used cold.

Hot hide glues were used when assembling frames, image cases, cameras, and all photographic equipment made of wood throughout the 19th century. Both hot and cold glues were also used to mount photographs. It was discovered that

glues discolor over time staining the image, making them a poor choice for application to the entire back of the print. Because of this, starch pastes were used for overall mounting. The superior strength of glues as compared to starch pastes accounts for their continued use when the adhesive was only to be applied on the corners (tipping) or the edges (perimeter mounting) of prints.

Glycerin, $C_3H_5(OH)_3$

Glycerin is a colorless, viscous liquid obtained by distilling fats. It is soluble in water and alcohol and very hygroscopic. Glycerin was used as a humectant in photographic processes. Developed and washed collodion plates made in the field were preserved in trays of glycerin until a more convenient location for fixing could be found. It was added to both collodion and gelatin emulsions for flexibility and to improve the porosity of the films during processing. Glycerin was added to the pigmented gelatin to keep carbon tissues from drying brittle. It was also used in developers to slow down the chemical actions by increasing viscosity of the fluids.

Gold, Au

The most familiar of the noble metals, elemental gold was used to make gold chloride $AuCl_3$ also known as auric chloride, terchloride, or perchloride of gold. Gold chloride was made by dissolving pure gold in aqua regia, a mixture of nitric and hydrochloric acids. The product was typically sold in sealed glass capsules containing 1 g by weight. The golden yellow or brown crystals are very soluble in water.

Gold toning

Gold chloride was mixed with a solution of sodium thiosulfate to make the gilding solution used in the daguerreotype process. *See* Daguerreotype. Gold toning of paper prints did not become a standard procedure until the middle of the 19th century. In 1850 Blanquart-Evrard introduced the albumen printing process. Untoned albumen prints were a yellowish brown color. By toning prints in sel d'or, a solution similar to that used in gilding daguerreotypes, the image color shifted to a cooler hue that was more pleasing. *See* Albumen Printing.

By the end of the 1850s gold toning the prints was a separate step done before the hypo fixing bath with a solution of gold chloride mixed with a pH modifier such as borax or bicarbonate of soda. Gold toners were used with all other silver-based photographic materials throughout the 19th century for the purposes of modifying image color and/or increased permanence.

Graduate

Glass vessels for measuring the volume of liquids were typically etched or engraved with marks on the side. These measuring glasses were made in a variety of sizes and styles, the most accurate was the graduated cylinder. Vintage examples can be found with markings for minims, drachms, ounces, and cubic centimeters (the same volume as milliliters).

Graphite

Graphite is a black mineral also known as black lead. It is mixed with clay to make leads used in pencils. Graphite was one of the first mediums applied to photographic negatives dating back to the calotype. It could be applied either as a powder and rubbed onto the surface of the negative or in pencil form for more delicate re-touching. Collodion negatives required abrasion of the protective varnish prior to applying pencil re-touching to the surface of the film. Gelatin plates, on the other hand, required the application of a mastic varnish that dried with a texture for the "tooth" necessary to accept pencil re-touching.

Gum arabic

Gum is a natural product that exudes from the *Acasia senegal* tree found in West Africa. The raw gum is harvested as small irregular tears that are insoluble in alcohol, ether, and oils, but very soluble in water. Gum arabic solutions were popular adhesives and the basis for the gum bichromate printing process.

Gum bichromate process

The gum bichromate process (also known as gum dichromate process) is one of the techniques based on the selective solubility of bichromated colloid resulting from the action of light. The gum bichromate process, also described as the photo-aquatint process, was first demonstrated in 1894 by A. Rouillé-Ladevèze in Paris and London. The process enjoyed immense popularity among pictorial photographers and was adopted as the process of choice in the fine art photography movement between 1890 and 1900.

The gum bichromate technique is valued for the high degree of artistic control in the printmaking process. A print is made by brushing a sensitizing solution of gum arabic, pigment (usually in the form of watercolor pigment), and potassium bichromate onto a sheet of heavily sized paper. Upon drying, it is exposed to ultraviolet radiation in direct contact with a negative the desired size of the final image.

After exposure, the print is placed in a tray of water, and the gum solution that was not exposed to light and therefore has remained soluble is slowly dissolved and washed away. The process lends itself to a great deal of hand alteration and manipulation by brushing selected areas of the surface of the print to dissolve greater amounts of the pigmented gum, thereby controlling the density of the deposits of pigment.

Once dry, the print can either be recoated with the same color gum solution, for a richer print, or other color gum solutions can be built up layer upon layer with careful registration of the negative image to alter, deepen, or enrich the print overall or in selective areas. It was not uncommon to combine the gum process with other processes such as the platinum process. The gum process does not contain silver, and the image is permanent.

Gun cotton

When cotton cellulose was subjected to the highest level of nitration it was called gun cotton. The term has been used indiscriminately to describe any sample of cellulose nitrate, a discovery by Christian Fredrich Schonbien in 1846. It is typical to find collodion formulas in 19th century texts that include gun cotton as the soluble solid, although it was actually the lesser nitration of cellulose that was used.

Gutta percha

A hard plastic material made from the dried milky exudation of a species of tropical trees, *Gutta percha*, was formed into a wide variety of manufactured goods in the 19th century. Some chemical bottles, trays, silver baths, and plate dippers were made from this material in the early collodion era, although it was prone to softening in the heat. Vulcanized rubber eventually replaced *Gutta percha* for these products.

H

Halation

Halation occurs when light exposes the surface of a clear support, such as glass or nitrocellulose coated, with light-sensitive film making it is possible for the same light to reflect off the back of the support and re-expose the film. This second instantaneous exposure usually occurs when photographing the source of light in a scene and the second exposure often results in a halo effect giving the name to the phenomenon.

When blue sensitive materials were used, such as collodion or ordinary gelatin plates, the halo effect could be controlled by using a backing in the sensitive plates with something red or orange to absorb the energy once it had passed through the emulsion. Collodion plates were backed with red paper or cloth to prevent halation. Gelatin anti-halation plates were coated with a non-actinic red or orange paint made with a gum binder. The water-soluble coating would dissolve during the pre-wash or development.

Half-plate

Half-plate sizes of daguerreotype plates were based on a standard set by Daguerre. The "whole plate," also known as a "full plate," measured 6 1/2 × 8 1/2 inches. The term *half-plate* implies that it is half of a whole plate, though in the case of the American half-plate, the dimensions are 4 1/4″ × 5 1/2 inches. In Europe the half-plate was either 6 1/4 × 5 1/2 inches, a true half-plate, or 6 1/4 × 1/4, known as a "double quarter" plate.

Halogen

The term *halogen*, from the Greek meaning *salt producer*, was given to chlorine, bromine, iodine, fluorine, and astatine based on their property to form haloid salts when combined with elemental metals. All silver-based photography relies on a light-sensitive combination of silver and a halogen.

Head rest/head stand

One of the most important appliances in the 19th century portrait studio was the head rest, also called a head stand or immobilizer. These were used to help sitters hold still during long exposures. The typical head rest was made with an adjustable vertical rod set into a heavy cast iron base. A second horizontal rod with two spoon-shaped rests pivoted at the top. The photographer first posed the subject and then brought the rest from behind and adjusted the two spoons to contact the base of the sitter's head.

Heliochrome

The heliochrome was a direct positive full color process made on silver plates invented in 1853 by Niépce de St. Victor. The technique was based on earlier theories established by Becquerel regarding the reproduction of colors on silver chloride. Niépce de St. Victor exhibited his experimental images but they were not stable and faded quickly. The process was not well-practiced by others at the time.

Heliograph

Heliography, sun writing, is the name given to the asphalt system of imaging invented by Joseph-Nicéphore Niépce in 1822. Interested in the new lithographic printing process, Niépce was seeking a simplified way to print multiple impressions from a single master. He knew that bitumen of Judea asphaltum used as a resist in engraving, hardened after exposure to light. He coated a variety of materials and contact printed engravings on paper that he had oiled to enhance its translucency. After washing in several different solvents, the asphalt that was in contact with the inked lines of the engraving was washed away exposing the support below.

Niépce used glass, zinc, copper, lithographic stone, pewter, and silver-surfaced copper plates. In 1826, he succeeded in making what is now generally accepted to be the first permanent, camera-made image. He took one of his plates and placed it in a camera that he pointed out a second story window of his estate, Le Gras, near Chalon-sur-Saône in central France. The plate required at least one day exposure to record an image. After removing the unexposed areas of the asphaltum with a solvent, a direct positive image was visible against the polished background of the plate.

Hillotype

Levi Hill, a former Baptist minister living in the Catskill Mountains in New York State, announced in 1851 that he had invented a direct positive color photographic process on silver plates. The announcement of Hill's process was celebrated by Samuel Morse and other prominent daguerreotypists of the time, although there was much speculation by others that his claims were unfounded. Hill's announcement was premature as he did not have his difficult process perfected enough to produce reliable results. The general public held from having their portraits taken with the old process as they waited for the improved daguerreotype to become available, but Hill was unable to establish a working method and the secret died with him a few years later.

Humectant

A substance used to keep another substance wet is called a humectant. Some photographic materials were more sensitive when exposed wet or damp making the use of a humectant very important. In the wet collodion process humectants such as honey, beer, glycerin, sugared preserves, and syrups were poured upon the plate to keep the alcohol-swollen nitrocellulose layer from drying out. Humectants were also important additives for gelatin emulsions and for keeping pigmented gelatin carbon tissues flexible.

Hyalotype

Hyalotype is the first photographic positive transparency and was invented in 1848 by the Langenheim brothers of Philadelphia. The plates, both negative and positive, were made with the albumen on glass process. *See* Albumen Processes, Glass Positives.

Hydrochloric acid, HCl

Hydrochloric acid is found naturally in the gases of volcanoes and is commercially produced by adding common salt to warm sulfuric acid. It is very soluble in water and in dilute form is available as muriatic acid, or known in the 19th century as spirits of salts. Hydrochloric acid was used as a cleaning solution for removing ferric oxalate developers from platinum and bromide prints.

Hydrometer

The hydrometer is a device used to measure the specific gravity of liquids. These were available throughout the 19th century as a tall sealed glass tube with a weighted spherical or cylindrical chamber on the bottom. When lowered into a larger glass cylinder containing the liquid to be measured, the hydrometer comes to rest at a level based on the weight of the instrument and the density of the liquid. The shaft of the hydrometer is usually marked with one or more scales based on standards previously established. The typical hydrometer is calibrated to read zero when placed in distilled water at 58°F. Each degree below this point (that rises as the density increases) represents 1 percent of sodium chloride. Hydrometers were also manufactured and calibrated for specific ranges.

Photographers in the 19th century mixed their chemicals by either percent solutions, parts, or by specific gravity. The hydrometer, known as an argentometer, was often used for measuring the strength of silver baths for albumen and salt printing and the wet plate collodion process. *See* Argentometer.

Hydroquinone, $C_6H_4(OH)_2$

Hydroquinone is a dirty white crystal that is a by-product of reducing agents on quinine. It is soluble in water, alcohol, ether, and glycerin. Captain Abney was the first to suggest this as an alkaline developer though it was not initially accepted until gelatin plates were firmly established and the high price of hydroquinone reduced late in the century. It evolved to be one of the most useful developers for silver gelatin emulsion plates, films, and papers for the next 100 years.

Hypo

Hypo is a familiar term for sodium thiosulfate salts or the fixing baths made with these compounds. The term is derived from the early but incorrect name, hyposulfite of soda, given to sodium thiosulfate. *See* Fixing.

I

Image

The optical term image refers to a visible representation of an object made by pencils of light reflected from or around that object. A visible projected image is formed in a camera by this light which passes though an aperture (or lens) and falls upon the focal plane; the back of the camera, a focusing glass, or image-recording material. Making images was not as difficult as it seems. The invention of photography, however, was fundamentally about recording and preserving a reproduction of the visible image.

The earliest photographic records of images were made on materials that created a visible negative picture as they were exposed in a process called printing-out. These photographic records of light images, though not permanent, were also called images. Printed-out images became the foundation of many printing processes used today. The turning point in photography was an understanding of the invisible latent image.

Nicephore Niépce made the first latent image photographs in 1822 using the heliograph process. When plates coated with asphalt were exposed to light, the coating became less soluble in several different solvents. The unexposed areas were then dissolved and removed by the solvent. The first permanent silver halide-based latent images were made in 1835 by L. J. M. Daguerre using the daguerreotype process. The calotype, invented by W. H. F. Talbot was the first silver halide latent image negative process, followed several years later by the albumen on glass and wet collodion processes. Silver bromide gelatin emulsions introduced in the 1870s set the standard for latent-image silver-based photography for the next century and a quarter.

Imperial

A 19th century photographic mount format measuring between 6-7/8 × 10 and 7-7/8 × 9 inches.

Indian red

Re-touching mediums were applied to the sky areas of calotype, albumen, collodion, and gelatin negatives. Indian red was a water color made by mixing finely ground earth pigments with a binder such as gum arabic.

Instantaneous exposure

Success in capturing movement with photography progressed with the evolution of photosensitive material and optics. The first photographs made of instantaneous events were made by W. H. F. Talbot. He made exposures that were illuminated with an electric spark. To capture movement in natural lighting was more difficult. The term was widely used in the 1860s when some photographers were making exposures of brightly lit

city streets using stereo cameras. The process involved using a newly made collodion, a neutral silver bath, strong developer, and lenses with a short focal length. The exposure was made by removing and then replacing the lens caps as quickly as possible. A thin foundation negative was intensified to bring it up to the density required for printing.

When faster silver bromide gelatin plates were introduced, mechanical shutters soon followed. The first instantaneous mechanical shutters were drop style and based on gravity. The term *instantaneous* continued to be used until more sophisticated shutters were introduced late in the century that featured exposure times measured by fractions of a second. *See* Exposure Control.

Intense negative

Learning how to evaluate the quality of a negative was essential in knowing how to make one suitable for printing. An intense or hard negative was generally one that was underexposed and overdeveloped. The more common term would be high contrast. A soft negative, on the other hand, would be one that was overexposed and developed too little. Experienced photographers understood that the key to understanding the effects of exposure versus development was by observing the degree of information visible in the shadow areas of the subject in the negative.

Intensification

When negatives lacked the density needed to produce strong images with printing-out papers they were frequently given a post-development treatment called intensification. Intensification techniques included the addition of new metallic silver density to the silver of a previously developed negative, adding another metal to the silver, converting the silver image into another compound, or toning the image silver to a color to which printing-out papers were insensitive such as certain shades of yellow, brown, orange, or red.

There were two basic techniques used in the 19th century for intensifying a silver-based image—toning or redevelopment. Toning was usually done by first bleaching the metallic image with mercuric chloride, potassium bromide and potassium ferricyanide, or potassium bromide and copper sulfate. After a quick water rinse the bleached image could be intensified in a variety of solutions including silver nitrate which added new silver. When intensified in sodium sulfide the solution converted the silver image to a new compound; a brown deposit of silver sulfide. The sulfides were lovingly called "stink" for the smell of rotten eggs that accompanied their use. Gold chloride was also used to tone negatives and glass positives with or without the bleaching step.

Bleached silver images could be dyed a different color, but this method was seldom used until the turn of the century when experimenters were looking for ways to exploit the positive subtractive color processes.

Redevelopment by definition was intensification that relied on a reducing agent. Collodion plates were physically redeveloped by treating the fixed and washed plate with a solution of tincture of iodine. This treatment converted the metallic silver image into silver iodide solution. The iodine solution was washed off and the plate exposed to light, after which it was developed with either pyro and citric acid or ferrous sulfate and acetic acid. In both cases some free silver solution was added from time to time to feed the physical development.

Interiors

The earliest known photographic interiors were made by L. J. M. Daguerre and W. H. F. Talbot. Both men made still life images near sunlit windows with their respective processes. Their choice of subject for these early images was understandable when one considers that they were using methods that required extended exposures and that experimentation near the point of preparation and processing is the most efficient.

The daguerreotype process as practiced after 1840 was more sensitive to light than the calotype process, though neither were used to a great extent for interior work with the exception of commercial daguerreotype portraiture done in a skylight studio.

The wet collodion negative process was slightly less sensitive than the daguerreotype and also had the disadvantage of requiring the plate to remain wet prior to development. This was not a problem when using a portrait lens in a well-lit skylight studio, but shooting the interiors of a public building was a different matter. Interiors required wide-angle lenses and smaller stops to render architectural details and appointments in focus, an approach that resulted in long exposures. Plates could retain moisture for 15 to 25 minutes if the relative humidity was high and the temperature not too high.

On occasion, the dry or preserved collodion process was used for interiors because they could be exposed for many hours with no detrimental results. The only limitations were the insensitivity of the plates to certain colors and the predictable appearance of halation when windows or other sources of light were included in the composition. In the mid-1860s photographers began experimenting with artificial light for interior photography. The majority of the actinic artificial light in this era was produced by the burning of thin ribbons of magnesium.

When the silver bromide gelatin plate eventually replaced the wet plate process in the 1880s, interiors were much easier to photograph with natural light. Great strides had also been made with artificial light photography. By the end of the century professional and amateur photographers were equipped with the means to record interiors by both artificial and natural light. The difficulties with halation were eventually reduced by adding a water-soluble antihalation backing to the glass side of the plates. *See* Halation.

Iodine, I

This flaky grayish purple non-metallic element is extracted from sea brines. Iodine is an essential element in living organisms. It is slightly soluble in water but freely dissolves in solutions of potassium iodide, alcohol, ether, and chloroform. Iodides are a compound containing iodine. The invention of

latent image silver halide photography was established by the use of silver iodide by L. J. M. Daguerre, and iodides remained the dominant imaging halide until the acceptance of silver bromide gelatin emulsion processes in the 1880s.

Iodine solutions were also used to render metallic silver sensitive to light in the physical redevelopment process and mixed with potassium cyanide to reduce the density of, or completely remove, metallic silver. Elemental iodine was discovered by Courtois in 1812.

Iron, Fe

One of the earliest known metals, iron is a transition element found alone, in ores and oxides. It is an essential element in living organisms. Ores are smelted to produce pig iron. Further processing results in cast and wrought iron and eventually steel. Iron is very reactive and rusts (oxidizes) by exposure to moist air. It forms ionic salts and several complexes used in photography. Iron-based compounds may be referred to using either the words iron or ferrous in 19th century photographic manuals. *See* Ferric and Ferrous.

Iron salt process

Photographic processes utilizing the action of light on ferric salts are reduced to the corresponding ferrous salts. The latter act is intermediary in forming a visible image. Thus it can be converted into Prussian blue (blueprint process) or used to reduce silver salts in the emulsion to silver (kallitype and other iron-silver processes) or to reduce palladium or platinum salts (palladiotype and platinotype). In the Pellet process, a variation of the blueprint process, the *un*exposed iron salts are converted into Prussian blue, rather than the exposed salts, to form the image. Yet another type of iron salt process is based on insoluble colored compounds formed by ferric salts with gallic or tannic acid (ferro-gallic and ferro-tannic processes).

Isochromatic photography

To extend the sensitivity of collodion plates to the green colors of the spectrum H. W. Vogel treated them with red dyes. The plates were exposed in the camera with a yellow filter over the lens to hold back the blue wavelengths. Although still not sensitive to orange and red, these plates produce a negative with a more normal range of tones. Soon after, Waterhouse suggested other dyes extending the spectral sensitivity to orange. The term *isochromatic* from the Greek words *isos*, meaning equal and *chroma*, meaning color, was eventually replaced with orthochromatic, neither of which are accurate. It was not until after the turn of the century when true panchromatic plates were commercially available. *See* Orthochromatic.

Ivorytype

A positive photographic print resembling a hand-painted ivory miniature, ivorytypes were first produced in the mid-1850s. As the term suggests, some of these images were made on thin sheets of actual ivory or artificial ivory made of pigmented and hardened gelatin. There were several variants of the process all of which were made using a negative. A positive collodion transparency could be toned with gold to a darker color and transferred onto the ivory support. The image could be deeply toned after being transferred. Then the collodion binder was removed leaving a delicate image of stained gold.

The American ivorytype, invented by Frederick Wenderoth in 1855, was made by lightly coloring a salted paper print. This print was then waxed, varnished, or glued image side up to the back of a sheet of clear glass using a combination of Canada balsam and beeswax. This treatment rendered the lighter areas of the picture translucent. A second sheet of plain white paper onto which was carefully painted patches of bright colors corresponding with the subject was then placed behind the photograph. These colors would show through the translucent areas of the photograph in a way that softened their intensity. A variant of the backing paper was a lightly printed duplicate of the original photograph that provided a guide for the coloring.

J

Japan varnish, Japanning

Tinsmiths of the 19th century occasionally finished their hand-crafted products with a baked-on coating of asphaltum. The glossy black finish, which resembled Japanese lacquerware, was very popular and was applied to a wide variety of domestic objects. The most typical formula for Japan varnish was solvent, asphaltum, and Canada balsam.

Japanned black-plate iron was the support material for melainotypes and ferrotypes, popularly known as tintypes. The plates were not made by the ferrotypist but commercially manufactured in standard cased sizes or in large sheets to be cut to size as needed.

Joly plate

In 1894 John Joly of Dublin, Ireland, patented and then commercially introduced the first additive color process applied to linear screen plates (Figure 107). Joly ruled extremely fine alternating lines of red, green, and blue dyed gelatin onto thin glass plates. The plates were placed with the ruled lines in contact with the gelatin side of a nearly panchromatic silver bromide plate. When exposed in the camera with the ruled side facing the lens, the dyed lines selectively absorbed some colors and allowed others to pass and expose the emulsion. When processed in conventional developer the result was a negative image made up of black, gray, and clear lines.

The negative was then contact printed onto a second silver bromide plate to produce a positive lined image bearing black, gray, and clear lines. When the positive lined plate was placed back in contact with the dyed additive lined plate, areas that were clear on the silver image allowed the proper color to be viewed and areas masked with black silver prevented unwanted colors to be seen. This resulted in a full color lined image.

Joly's product was not a great commercial success, but it ushered in a fruitful era of experimentation in early color photography. The subsequent introduction of all other additive color plates such as the autochrome and dufay was possible due to the principles established by Joly. Although all of the additive plate processes were obsolete by the time

Kodachrome was introduced in the mid-1930s, Joly's additive color process is the basis of the technology used in television and computer screens.

K

Kallitype

This iron-based printing process was invented by Dr. W. J. Nichol in 1899. Paper was coated with a combination of a ferric oxalate, oxalic acid, and silver nitrate. When exposed under a negative a visible image of ferrous oxalate and silver oxide was formed. This image was developed in one of many developers usually containing Rochelle salt, borax, and either sodium tungstate or potassium bichromate. Development reduced the silver oxalate to metallic silver and rendered the iron salt soluble in the subsequent fixing bath. The finished kallitype print could also be subjected to countless after treatments to reduce or gain density or modify image tone. This process never gained the popularity of the platinum, albumen, or salted paper print.

Kaolin

A natural white porcelain clay made from the decomposition of granite. Kaolin, also known as china clay or white bole, was mixed with water and alcohol and used to clean glass prior to coating in the wet collodion and emulsion processes. When silver nitrate was used to sensitize albumenized paper organic matter would combine with the silver and eventually turn the solution red. There were two ways of clearing the silver bath of this red color — sunning or kaolin. When daylight was weak, kaolin was the only other option. The silver solution was poured into a tall glass container and a spoonful of kaolin added with agitation. As the kaolin settled overnight it would precipitate the organic matter from solution. *See* Sunning the Bath.

Kits

Many 19th century camera plate holders were designed to accommodate smaller plates by the means of a thin wooden reducing frame called a kit. Kits were made in standard cased sizes and were made to nest into each other as a set. For the wet collodion process kits usually featured glass or ceramic corners if made in America or silver wires when manufactured in England. French kits often had wood corners.

19th century gelatin plate holders can also be found with reducing kits. When flexible film sheets were introduced special sheet film adapters were made so that standard plate holders could be used.

Knife

There were two specific uses for a sharp knife for photography — trimming prints and etching negatives. Prints were usually trimmed using a thick piece of glass as a trimming guide. The best knife for trimming prints was a used straight razor for shaving, though a carefully sharpened pen knife was also used.

Knives used for etching negatives resembled surgical scalpels. Etching as a form of negative re-touching evolved with developed-out gelatin emulsions. Wet plates had most of the fine image silver on, and just under, the surface of a very thin and fragile collodion binder. Gelatin emulsions, on the other hand, were thicker and relied on large filamentary image silver occurring throughout the binder. Because of this, one could actually shave away image density of the dried gelatin emulsion using a sharp tool or powdered abrasives. *See* Emery.

Kodak, the

This 6-1/2 × 3-1/4 × 3-3/4 inch detective camera was introduced in 1888 by the Eastman Dry Plate Company. It was equipped with a unique barrel shutter and sold for $25 and came from the factory loaded with enough American film to expose one hundred images. The entire camera was sent back to the factory for negative and print processing and was sent back to the owner with new film installed and the finished prints. *See* Eastman Kodak Company.

Kromscop

This was invented by Frederick Ives in 1894 and used for the viewing of additive color images. In 1888 Ives first demonstrated triple lantern projection of three-separation positive transparencies through red, green, and blue filters to produce a full color virtual image. The basic process and projection was almost identical to what Maxwell had done in 1861, the main difference was that Ives was able to make better separation negatives because he treated his plates with dye sensitizers. Ives was also perfecting a camera that could make all three exposures at the same time.

The triple lantern apparatus for projecting additive color was very expensive and cumbersome, prompting Ives to design a smaller apparatus he called the Kromscop. A similar device for making and viewing three color separations had already been patented by Ducos du Hauron in 1874 and Antoine Hippolyte Cros in 1889. Instruments of this type became known as chromoscopes.

The Kromscop was manufactured in both mono and stereo variants but the system was the same. A set of three separation positives on glass, called kromograms, were bound together along the ends with black cloth tape so that they could be laid upon three different panels of the Kromscop in registration. Each panel had its own color filter of red, blue, or green and an internal system of mirrors to enable the viewer to see all three separate images simultaneously through a small eyepiece. The Kromscop was not a commercial success from a consumer standpoint though a good many were sold to colleges and universities for the purpose of demonstrating the physics of additive color synthesis.

L

Lantern slide

The lantern slide predates photography by many decades but the concept was the same. Transparencies were produced on sheets of glass and projected from a magic lantern onto a wall or cloth screen. Pre-photographic lantern slides were either

completely hand-painted or received a transfer lithograph and hand-tinted. The first photographic lantern slide was invented by Fredrick and William Langenheim in 1848 using their hyalotype albumen on glass process. The production of lantern slides closely followed the technical evolution of photography and examples can be found using the albumen, wet and dry collodion variants, and gelatin emulsion processes. Many slides were hand-tinted with transparent colored dyes to give the impression of full color photography. Lantern slides evolved to be made in two standard sizes. English slides were usually 3-1/4 × 3-1/4 inches while American and European slides were 4 × 3-1/4 inches.

By the end of the century lantern slides were commercially made by the thousands for cultural, educational, and religious programs. Some advanced amateurs also made lantern slides from their own negatives. Because amateurs were not encumbered by the requirement to produce a large numbers of slides, they often took great care in the craft and hand-tinting of their slides.

Lavender oil

Also known as oil of spike, this fragrant essential oil is made from the leaves and stems of the *Lavendula spica*. Lavender oil was used by Nicephore Niépce to dilute asphaltum in the heliograph process. The unexposed asphalt was also dissolved in a solution of white petroleum and lavender oil. In the physautotype process, a collaboration between Niépce and Daguerre, lavender oil was reduced by heat, added to alcohol, and poured upon silver plates. The resulting white frosty bloom was sensitive to light.

Most of the 19th century varnishes used to protect the fragile collodion surface of wet plate negatives and positives were made with lavender oil. The oil was added to prevent the gum varnish from drying too quickly, a condition that could crack the image bearing layer.

Lead, Pb

Lead is a soft blue-gray metal found in ores and separated by heat. Sheets of lead were used to line wooden sinks in darkrooms because it was easy to manipulate and resistant to acids. Lead compounds, all of which are poisonous, were also used in photographic solutions.

Lead acetate, $Pb(CH_3COO)_2 * 3H_2O$

Lead acetate, also known as sugar of lead, is a white crystal made by the action of acetic acid on litharge. It is soluble in water and alcohol. Lead acetate was used in gold toning baths to modify the pH.

Lead chromate, $PbCrO_4$

Lead chromate is a yellow crystal made by the action of sodium chromate and lead nitrate. It is insoluble in water but dissolves in acids. Its primary photographic use in the 19th century was for an orange fabric dye used for darkroom curtains and windows.

Lead nitrate, $Pb(NO_3)_2$

Lead nitrate is a white crystal soluble in both water and alcohol. It was made by the action of nitric acid on elemental lead. Lead intensifiers were based on the use of lead nitrate for bleaching silver images prior to toning with a sulfide.

Leptographic paper

The first commercial collodion-chloride printing-out papers were introduced in 1870 by Jean Laurent and Jose Martinez-Sanchez in Madrid. They poured collodion emulsions onto baryta-coated papers and called the product leptographic paper. *See* Collodion.

Leveling

To make something level required the tool of the same name. Levels were usually fitted with a small glass tube closed on both ends containing some alcohol. This is why they were called spirit levels. When the object adjusted was level a bubble in the glass tube moved to a pre-marked position. Leveling was used in three different processes in the 19th century.

Calotype negatives were occasionally sensitized and developed on a leveling stand made by leveling a thick piece of glass. The negatives were developed with the image side down in a very small amount of solution. The reason for this was to prevent the gallic acid developer from oxidizing during development. Early texts suggest developing collodion negatives on a leveling stand and blowing on the developing solution to encourage even distribution.

When gelatin plates were coated by hand a leveling slab was an indispensable tool. Gelatin emulsions were applied hot to a warmed glass plate using a technique similar to coating a collodion plate. Unlike collodion, which relies on ether and alcohol to evaporate, gelatin emulsions must be chilled to set firmly into a jelly-like state. The common leveling slab was a sheet of perfectly flat polished marble placed on a wood board with three or four adjustable legs. Immediately after coating the plate with hot emulsion, it was placed on the cool marble surface. The emulsion would usually set firm enough to place upright on a drying rack in a few minutes.

Light trap

Because photographic manipulations in the 19th century were performed by non-actinic or safelight, there were occasions when special gates or traps were necessary to prevent unwanted exposure from white light. The photographic plate holder required a light trap to allow pulling the dark slide from the holder without exposing the sensitive plate. These were usually spring-loaded flaps of wood hinged on one side in the gate of the holder. When the slide was pushed into the gate the flap made intimate contact with the slide. When the slide was removed, the flap snapped shut across the opening into a groove on the other side of the gate.

Light traps were also used when ventilating the darkroom to allow air to pass in or out of the darkroom without exposing the interior of the room to daylight. *See* Darkroom, Ventilation.

Lighting

In the early years of photography, daylight was the only light intense enough to provide feasible exposure time with the slow sensitized materials then available. Photographers had no other choice. If they wanted to make a picture, the sun was all they had.

Some enterprising photographers went to great lengths to build their studios with glass walls and ceilings to let as much light into their studios as possible, and subjects who sat for their portraits were often held still for the long exposures required by the complex arrangements of props and supports.

Photography by artificial light was possible but impractical because of the less sensitive emulsions. Although photographers experimented with artificial light almost from the birth of photography, widespread application came with later improvements in materials. The most significant such advance was the evolution of highly light-sensitive, gelatin-based emulsions during the 1880s. Ongoing improvements in the resolution of film in the 20th century have made progressively smaller film sizes practical. Because smaller images have an acceptable depth of field at wider apertures, photography is possible with less light.

The first artificial light

Artificial lighting appeared on the scene during the 1840s when the carbon arc light was used to make daguerreotypes. The first known portrait with such a light source was made in Russia in 1857.

During the same period experiments were also tried in which lime was heated by a hydrogen flame to produce a bright light. However, this technique proved more useful for making enlargements and illuminating magic lanterns than for taking pictures.

Magnesium flames and flashes

The 1860s saw the introduction of burning magnesium wires and ribbons as artificial light sources. In one form or another they continued to be used until the 1930s.

The first use of powdered magnesium as a light source occurred in 1886. When ignited, it produced a bright flash. Flash powder was used with a number of different firing devices. Among the most common were troughs that were filled with flash powder and then fired by a sparking device similar to that used in cigarette lighters. Flash powder was also used in fuse-ignited *bombs* and in cartridges fired from pistols made specially for the purpose. Flash powder produced adequate illumination, but it clouded the air with smoke and it was a fire hazard. *See* Magnesium, Flash Powder.

Linked ring

The "Linked Ring" was the managing body of the London Photographic Salon and consequently became known as that. Their first exhibition took place in 1893 at the Dudley Gallery in London.

Lippmann emulsion

This is a silver bromide emulsion of surpassingly fine grain and extreme contrast formulated by Gabriel Lippmann for use in the color process that bears his name. The process at once simple and elegant in concept, but very difficult in practice. The size of the photosensitive crystals is so small that there is virtually no scattering of light. Resolving powers beyond 5000 line-pairs per millimeter are estimated. Emulsions of this type have also found use in some forms of holography and special scientific application.

Lippmann process

French physicist Gabriel Lippmann devised a system for color photography in 1891 that relied on wavelength interference, rather than dyes or pigments. His panchromatic glass plate was coated with an almost clear emulsion of very small silver halide crystals.

In the camera, the plate faced away from the lens, in contact with a nearly perfect mirror of liquid mercury. Light passed through the plate and was reflected by the mercury. Phase difference caused the reflected rays to interfere with light coming through the plate.

Varying degrees of cancellation and reinforcement occurred, producing a latent image of the interference pattern on the plate. After development, the faint but natural color image was viewed by placing the plate against a mirror and shining a light through it. Examined at a carefully determined angle, only the original wavelengths could pass through the interference pattern. The process has proven to be too difficult for any application beyond the scientific investigation for which it was originally conceived.

Lithium, Li

Lithium is a soft, silvery metal, that is extracted from spodumene, petalite, and mica lepidolite. It reacts with oxygen and water and with the addition of heat, nitrogen, and hydrogen. The photographic uses of lithium are for compounds used as halogens.

Lithium bromide, LiBr

Lithium bromide is a white crystal soluble in water, alcohol, and ether. It is made by the action of hydrobromic acid on lithium hydroxide. It was used in the making of collodion dry plate emulsions due to its solubility in alcohol and ether.

Lithium chloride, LiCl

Lithium chloride is a colorless crystal soluble in water, alcohol, and ether. It is made by the action of hydrochloric acid on lithium hydroxide. It was used in making collodion-chloride printing-out emulsions and for increasing contrast in gelatin-chloride printing-out emulsions.

Litmus paper

When knowing the acid content of a solution was important litmus paper was used as a better and safer indicator than taste. Blue litmus paper was made by treating an unsized

paper with a solution of tincture of litmus. The blue dye was made as a product of fermenting *Roccella tintoria*, a species of lichen, with potash. The blue color would turn red when the paper was in contact with an acid solution. It would return to the blue color when in contact with an alkaline solution. The speed in which the changes took place gave photographers a sense of the relative strength of solutions.

Lubricant

A lubricant was usually applied to the surface of a mounted print before feeding it into the burnisher. Burnishing lubricants were usually made from bees wax, paraffin or castile soap softened with turpentine, whale oil, or an aromatic essential oil such as oil of lavender. *See* Burnishing.

M
Magazine camera

These small hand-held cameras are usually associated with the gelatin plate era, although they may originate from the changing boxes introduced with dry collodion plates. Magazine cameras typically featured a series of slots that held the plates in a vertical orientation for exposure and then dropped to a horizontal orientation for storage once exposed. A common complaint when using this system was the necessity of using a darkroom to free a stuck plate, which would prevent successive exposures.

Magic lantern

The magic lantern was essentially a camera obscura with an internal light source used for projection. The magic lantern predates photography. Glass transparencies for magic lantern projection were originally hand-painted. When lithography was invented lithographed plates with hand-coloring were introduced. Photographic lantern slides were invented by the Langenheim brothers in 1848. The Petzval design portrait lens evolved to become the standard projection lens for 19th century magic lanterns making them difficult to tell apart from those with short focal lengths used on cameras.

Magnesium, Mg

Magnesium is a white-colored malleable metal found in limestone. It can also be produced by the decomposition of magnesium chloride and potassium. Pure magnesium was usually available as a powder or formed into long thin ribbons. It was used in the 19th century for the purpose of removing free silver from used fixing baths and producing artificial actinic light for making camera exposures or for printing. Magnesium was first used to create light by Charles Waldack for photographing in the interior of Mammoth Cave in Kentucky in 1866. These exposures were made with magnesium ribbons. Magnesium powder evolved as an illuminate because the exposure was shorter.

Ribbons burned at a rate of about one inch per second, whereas a sizable quantity of magnesium powder could be made to burn completely in a second or two. Magnesium required oxygen for complete combustion. This was no problem when using ribbon. Magnesium powder on the other hand could not be laid in a pile and lit because only the outer layer exposed to oxygen would burn completely.

Magnesium flashlights were designed to blow powdered magnesium through a pre-lit alcohol lamp; a very dangerous method. Eventually an oxidizer was added to magnesium powder to allow full combustion allowing small troughs of powder to be lit by a spring-loaded sparking wheel.

Mammoth plate

Mammoth plate was a format used in 19th century photography though the exact size is variable. Most texts suggest that any plate larger than 10×12 could be considered a mammoth plate. The term is most commonly applied to the 20×24 inch wet collodion negatives made by photographers of the American West, though such sizes were also produced in commercial studios of the larger cities.

Mask

Masks were used in the back of multiplying cameras to allow two images to be made on one plate without overlapping. Standard masks were made of painted wood and came in sizes to make two images on a specific size plate. Multiple lens boards came with a set of septums — thin wood or sheet metal dividers and back masks.

Masking negative

When skies in blue-sensitive negative processes displayed chemical artifacts or were deficient in density the re-toucher would cover them with a thin coat of opaque or by applying a paper mask. When re-touching medium was not available masks were cut from yellow, brown, or white paper that was colored black and applied to the glass side of the negative with glue.

Mastic

Mastic is a yellowish resin obtained from the *Pistacia lentiscus* tree. Mastic is insoluble in water but dissolves in alcohol, ether, chloroform, turpentine, and benzole. It was used for making varnishes, in particular a special matt varnish applied locally to gelatin emulsion negatives. Mastic re-touching varnish dried with a slight matt texture that was particularly suited to receiving pencil re-touching.

Mat

A decorative spacer that prevents a framed image from touching the cover glass is called a mat. These were also called passé-partout, a French term referring to the window opening that allows the image behind the mat to be seen from the front.

All daguerreotypes, ambrotypes, and ferrotypes were first covered with a matt before placing them into frames or protective cases. The earliest daguerreotype mats were made of thin paper. Eventually stamped metal mats of copper or

brass became the standard for cased images. Framed prints were usually matted with paper, heavier card stock, or pasteboard. The cheap ferrotypes called bon tons were placed in a special paper mat with an integral folding paper cover.

Matt surface

The aesthetics of a photographic print is usually based on the lighting and focus of the image and the surface of the actual printing medium. The earliest photographic prints made in the late 1830s were printed from negatives onto plain silver chloride printing-out paper, known simply as salted paper. These prints had a matt surface that allowed the visible paper fibers to scatter light. When the dilute albumen process was introduced in 1850 by Blanquart-Evrard, the surface was only slightly smoother than the salted paper print.

By the end of the 1850s, papers were coated with pure albumen and mounted prints were pressed to make the surface even smoother. The photographic print burnisher was invented in the 1870s. Burnishing quickly became a standard finishing procedure expected by the public. Eventually all albumen prints were waxed and burnished to a glossy finish, an aesthetic that was also applied to commercial portraits printed onto baryta coated papers with collodion-chloride and gelatin-chloride emulsions.

When the pictorialists began to adopt the platinum process in the last quarter of the century there was a new appreciation for matt finish prints. The original salted paper process was also dusted off and made new by adding different starches to the chloride solution for different effects. Late in the century manufacturers introduced platinum-toned matt collodion papers for commercial portraiture.

McDonough's process

In 1892 Chicago photographer James William McDonough patented an additive color transparency process based on a tri-color screen made by sifting evenly distributed particles of shellac dyed red, green, and blue onto glass plates. The additive screen was then coated with a panchromatic emulsion and exposed in the camera with the screen facing the lens so that the colors would absorb or transmit light upon the sensitive surface.

The exposed plate was then reversal developed to produce a full color positive transparency. McDonough did not produce any product at the time but the concept of this type of additive color screen was used with great success when introduced as the autochrome by the Lumière brothers in 1904.

In 1893 and 1834, McDonough and John Joly of Dublin, Ireland, came upon the same idea of making linear screen plates by ruling fine red, green, and blue lines of dye onto plates coated with gelatin. The plates were exposed in contact with a separate panchromatic negative plate. The exposed plate was developed and contact printed onto another plate to produce a positive ruled image, which was then placed in contact with another tri-color ruled screen so that the viewer could see the full color positive transparency. McDonough's linear screen plates were not commercially introduced until

1896 after a similar process by John Joly in England was already in production. *See* Joly Plate.

Measles

"The measles" were blotchy dark markings easily seen through the paper. It was a common ailment of both the salted paper and albumen printing processes and often was the result of improper fixing or an overworked fixing bath. Another form of measles was caused by insufficient time in the sensitizing bath.

Melainotype

In 1856 Hamilton Smith of Gambier, Ohio, patented a direct positive collodion process on Japanned iron plates. He called both the process and the plate melainotype, a reference to the black color of the asphalt Japan coating. *See* Ferrograph, Ferrotype, Tintype.

Melt

A batch of gelatin emulsion was often call "the melt." This could also be specified as a first melt, when the bromide and silver are added to the gelatin and ripened by heat or the second melt after the emulsion was noodled and washed.

Mercury, Hg

Mercury is a very heavy liquid with a silver color. The most common source of mercury is the ore of sulfide cinnabar. The fumes from elemental mercury were the primary developer used in making the latent image on a daguerreotype visible. *See* Daguerreotype.

Mercuric chloride, $HgCl_2$

Mercuric chloride, also known as bichloride of mercury, is a white crystal soluble in water, alcohol, ether, pyridine, and acetic acid. It was made by subliming common sodium chloride and mercuric sulfate together. Mercuric chloride was a very popular bleaching agent during both the collodion and gelatin era. Plates bleached with mercuric chloride were then typically toned with dilute hypo, silver nitrate, or a sulfide.

Methylated spirit, CH_3OH

Methylated spirit is alcohol made by the distillation of wood. This clear, colorless liquid burns without a visible flame and is miscible in water. It is used for denaturing ethyl alcohol and cleaning the residue of collodion and alcohol-based varnishes. It is a much cheaper alternative to ethyl alcohol for alcohol lamps. A visible flame can be produced by the addition of a small amount of sodium chloride.

Metol, C_7H_9NO

Metol was the trade name given to *N*-methyl-*p*-aminophenol. A white powder soluble in water, Metol came to be a very useful developing agent for both silver bromide and silver chloride gelatin emulsions. Metol was also combined with hydroquinone to produce so-called MQ developers.

Mica

This silicate mineral is found as muscovite, biotite, or lepidolite. It has a layered structure that can be carefully delaminated to produce extremely thin flexible transparent films, although limited in size. Mica was used in the 19th century for lamp chimneys and windows in ovens. Some amateurs in the 1850s made collodion negatives on sheets of mica. Commercial portrait photographers made small positive collodion images on mica for mounting into jewelry.

Microphotography

Not to be confused with photomicrography (photographing minute objects), microphotographs were miniature novelty images mounted on either microscope slides or cut from the original plate and face mounted onto a miniature viewing lens.

Microphotographs

Microphotographs were invented in 1851 by English microscope maker and photographer John B. Dancer. The technique was to rephotograph a collodion negative lit from behind using a microscope converted to a camera and a microscope slide coated with collodion. After processing the positive transparency that resulted was roughly a 3-mm square. The image was protected by a second slip of thinner glass glued to the surface of the slide with a drop of Canada balsam. Dancer's microphotographs included reproductions of engravings, paintings, and photographs of personalities including the Queen and Royal family and text. Microphotograph slides, however, required an expensive microscope for viewing, which make them beyond the reach of the average person.

Around 1857 French photographer M. Prudent Rene Patrice Dagron discovered a method of attaching positive microphotographic transparencies onto the end of a viewing lens, which made an expensive microscope unnecessary. He introduced the photographic toys at the 1859 International Exhibition in Paris. The mounted images were called Stanhopes, a reference to the original inventor of the lens design, the Third Earl of Stanhope. Stanhope images were inserted into a wide variety of bone, ivory, wood, and metal novelties. The most common Stanhope to be found today is typically a cross made of gold or silver metal featuring a microphotograph of the Lord's Prayer.

Dagron was also responsible for the first important use of microfilm. During the Franco-Prussian War (1870–1871) Paris was under siege. Dagron photographed entire pages of Parisian newspapers in miniature, removed the collodion film from the glass support, and rolled them into a tight tube. The film tubes were inserted into short quills and secured to the wings of carrier pigeons. When received outside of Paris, the films were reattached to glass plates and projected by magic lantern to be transcribed and eventually set in type.

Milk glass

White translucent glass used as a base material for a positive images was usually called milk glass. It was basic silica soda glass made white by the addition of various oxides. Milk glass plates were coated with nearly every variant of the albumen, collodion, and gelatin printing processes for the production of milk glass positives; also known as opalotypes or opaltypes. The carbon transfer process was also used to a limited extent. Milk glass positives were often hand-tinted and always displayed in frames or cases similar or identical to those used to house daguerreotypes, ambrotypes, and early ferrotypes. Very large framed examples made by the gelatin developing-out process were produced near the end and turn of the 19th century. *See* Glass, Opaltypes.

Minim

See Drop.

Mirror

In the most basic form a mirror is a polished and reflective object capable of forming an image. Typically mirrors were made by either polishing metal or by coating glass with a deposit of metallic silver. L. J. M. Daguerre's production camera made by Giroux in 1839 featured a glass reversing mirror set at a 45 degree angle to the focusing glass for correcting the inverted image. Front surface mirrors were also fitted onto the front of the lens for lateral correction of the projected image upon the daguerreotype plate. This same technique was used years later when laterally corrected ferrotypes were needed when shop owners preferred their names read correctly on the finished product.

Concave mirrors were capable of reflecting visible images upon a secondary surface. Alexander S. Wolcott patented a mirror camera in 1840 that featured a heavy concave specular metal mirror of the type used in telescopes. The mirror was faster than any lens, though the relative size needed to project a focused image was disproportionate to the final product. *See* Camera.

Mount (photographic)

The secondary material upon which a photographic print was affixed was called a mount. The earliest mounts were thin papers of the same type upon which the images were made. Prints were glued onto these mounts by the upper two or all four corners in a technique called tipping. They were also perimeter mounted by applying glue only to the back edges of the print. Finally, many prints were pasted onto mounts by applying starch paste to the entire back of the print. When cartes de visite were introduced in the late 1850s albumen prints were pasted onto thin mounts of Bristol board.

By the 1860s mounts made by laminating many thin layers of paper were available. The number of laminations for cartes was usually no less than four, but this increased steadily throughout the century for cartes, cabinet cards, and large mounts.

Mounting

The most common technique for the commercial mounting of albumen, gelatin-chloride, or collodion prints was to apply

starch paste on the back of the print with a stiff brush. When mounting albumen prints it was important to first mist the front of the print with water to prevent curling. Once the paste was applied, the print was positioned onto the front of the mount, which had previously been marked by pencil or pin pricks. The print was then covered with a blotter and a roller was applied from the center outward in both directions to ensure contact and push any air bubbles to the edge of the print. The blotter was then removed and any excess paste removed with a damp cloth. The mounted print was then placed between blotters and left to dry under a weighted board or in a press.

If a smoother surface was required the mounted print was burnished. Burnishing was done when the print was not quite completely dry. The addition of wax lubricants made burning more effective. *See* Burnishing, Lubrication.

MQ developer

The combination of Metol and hydroquinone in a developer was often called MQ. It was a very popular alkaline developer for gelatin emulsions introduced in the late 19th century and used throughout the 20th century for photographic plates, films, and papers.

Mucilage

See Glue.

Multiplying camera

A camera with features that allow for more than one image on a single plate by moving the plate or lens is a form of multiplying camera. Though not generally considered, the first of this type was the single lens stereo camera. Successive exposures of the same subject could be made by slightly moving the position of the camera in between exposures before making the next exposure. Daguerreotypist and photographer Albert S. Southworth of Boston patented a sliding plate holder in 1855 that when combined with using four lenses produced eight exposures on an 8 × 10 plate. *See* Camera.

In 1862 Simon Wing patented the most innovative multiplying system using a series of plates that allowed a single lens to be moved both vertically and laterally. Wing also introduced a multiple lens camera in 1863 with a moving back that could produce thirty-two 1 × 1-3/8 inch images on a ferrotype plate. These small ferrotypes were known as gems. By using more and smaller lenses and a multiplying back, Wing created additional camera systems to make over sixty smaller images on ferrotype plates.

The most common multiplying cameras of the 19th century were those equipped with a sliding back and an indexing system. A single lens could be used with back masks to make two successive vertical exposures on a horizontal 5 × 7 plate or two 5 × 7 vertical exposures on a horizontal 8 × 10 inch plate. By installing the four lens set and a special divided septum and back mask, the photographer could make four images on a 5 × 7 plate or with one shift of the back, eight exposures on an 8 × 10 plate. Additional lens boards with smaller four lens sets or boards with more lenses and appropriate back masks could also be purchased.

N
Negative

A term first attributed to Sir John Herschel, negative refers to the visible image that is reversed in tonality from the actual subject, which it represents. The first negatives were made using sensitized paper were made by T. Wedgwood and H. Davy. Nicephore Niépce made the first negatives on glass using the heliograph process but evidently never applied the technique to the second step of printing onto sensitive papers. The physautotype process, a collaboration of L. J. M. Daguerre and Niépce was both negative and positive. Daguerre's first printed out images made on iodized silver were negatives. When Daguerre perfected the latent image daguerreotype process it was both negative and positive. H. Florence, Reade, W. H. F. Talbot, and a decade later Gustave le Gray produced negatives on paper.

Herschel made the first silver halide negatives on glass in 1839, followed several years later by Niépce de St. Victor who invented the albumen on glass negative process in 1847. The wet collodion technique was published in 1851 by F. S. Archer as a negative process followed by Maddox and others who established the silver bromide gelatin emulsion negative that evolved into the most successful process in photographic history.

Negative envelope

A paper storage folder for negatives, negative envelopes were introduced in the collodion era and were used well into the 21st century in different forms. They continue to be available with either a plain opening or a folding flap. Nineteenth and early twentieth examples can be found with preprinted lines labeled for including technical information about each negative.

Negative holder

The term *negative holder* can mean the frame used to hold negatives in an enlarger or the enclosure used to bring the sensitive film or plate to and from the camera. *See* Plate Holder.

Negative number

Commercial photographers and organized amateurs kept track of their negatives by assigning a number to individual plates or film negatives. The typical technique used during the collodion era was to actually scratch the number into the fragile collodion film with a sharp stylus prior to applying the varnish. It is common to find cartes de visite with the negative number inscribed on the back in pencil for future print orders.

Negative varnish

All collodion negatives were varnished to protect the fragile surface from being scratched or tarnished by exposure to sulfurous air. Albumen and gelatin plates were not so easily damaged and did not require this protection although examples

can be found with a varnish coating. Most negative varnishes were made with a gum soluble in alcohol combined with an essential oil to retard drying. The typical negative varnish was made with either shellac or gum sandarac dissolved in alcohol with the addition of lavender oil. Water-soluble gum varnishes such as gum arabic were also used, although they were not as effective and less popular.

Niépce process

Nicephore Niépce was best known for the heliograph process. This process was started by first coating a copper plate with a mixture of asphaltum dissolved in oil of lavender. The plates were brushed in overlapping lines and then leveled and heated to distribute and harden the coating. All but one of the plates that existed were exposed to light after being covered with an engraving that was oiled to allow light to pass though the paper more easily. The areas of the plate exposed to light hardened the asphalt leaving the unexposed layers soluble in either Dippol's oil or a mixture of lavender oil and turpentine.

Once the soluble layers of asphaltum were dissolved the plate was rinsed with water and set to dry. The result was a plate with open areas exposing the metal below and an asphalt resist. The dry plate was then prepared for acid etching. After the bare areas of the plate were etched, the remainder of the asphalt was removed with pure white petroleum. The etched and cleaned plate was then inked and used in a press to make an inked print on paper. Niépce used the heliograph process on a variety of materials including glass, stone, copper, zinc, and pewter.

The most of famous of Niépce's heliographs is also the only known example made by exposure in a camera. The view from the workroom window in his country estate called Gras in St. Loupe de Varennes is the first permanent photograph made in a camera. Known today as "View from the Window at Le Gras" the plate was made in 1826. In this example the image was made on a polished pewter plate using a much thinner coating of asphalt. Like the physautotype and daguerreotype that soon came after, this plate relied on the reflective polished surface to establish the darkest parts of the picture. The asphalt highlights were established by a dull coating that scattered light. This allowed the asphalt deposits to read lighter than the reflective metallic areas when viewed at just the right angle.

According to Niépce's essay published in Daguerre's 1839 manual, he also made heliographs on silver-plated copper sheets. In this variant the exposed silver areas of the processed plate were subsequently fumed with iodine and exposed to light making them darken to a deep blue black color. The asphalt resist was then dissolved away leaving a white silver background with a positive image established in darkened silver iodide. No examples of these images have been discovered.

Niepceotype

The first practical process of producing a glass negative was invented in 1847 by Niépce de St. Victor who was the nephew of Nicephore Niépce. His technique was to add potassium iodide to a solution of egg albumen. Glass plates were coated with this halide solution and then placed in a separate sensitizing bath of silver nitrate and acetic acid. The sensitized plates were exposed in the camera and then developed in a hot solution of gallic acid to which was added some silver nitrate to promote the physical development. Development of these plates could take up to an hour or two. In a variant of the process, plates could also be coated with plain albumen and exposed to iodine fumes to introduce the halide prior to sensitizing. Niepceotypes could be exposed either wet or dry with the dry plates requiring more exposure.

Despite its very high resolution, the process was quickly eclipsed in 1851 by the wet collodion process which was much more sensitive and did not require the lengthy development with hot solutions.

Night photography

While night photography by extended exposure was possible throughout the 19th century it was not generally practiced. Records of the moon by telescope were first made in the 1840s by the daguerreotype process. Images of city streets lit by gas light could have been made by both the daguerreotype and wet collodion methods but examples are quite rare. When the gelatin plate was commercially introduced in the 1880s there were more attempts, but it was not until the advent of electric street lights at the end of the century when photographers began to document subjects by evening light.

Ninth plate

The ninth plate measuring approximately $2 \times 2\text{-}1/2$ inches was the second most popular cased image format for daguerreotypes, ambrotypes, melainotypes, and ferrotypes. These were a cheaper alternative to the slightly larger sixth plate.

Nitrate film

The first transparent flexible films were made with cellulose nitrate. The earliest commercial sheets of this material were cut from a solid block of celluloid. Roll films were originally cast by pouring a solution of nitrated cellulose and camphor dissolved in volatile solvents onto a long glass table. When the solvents evaporated a thin clear flexible plastic could be peeled from the glass. Improvements in manufacture evolved to include pouring the liquid cellulose nitrate onto the polished surface of a very large revolving casting wheel. This early base material was known simply as nitrate film. It was eventually phased out of commercial production in the middle of the 20th century because of its extreme flammability.

Nitric acid, HNO_3

This heavy, clear or slightly yellowish fluid is very poisonous and causes severe burns on contact with the skin. It was made by the distillation of an alkali-metal nitrate combined with sulfuric acid. The combination of nitric and sulfuric acids was used to convert plain cotton to cellulose nitrate. Nitric acid was used in the wet plate process as an additive to ferrous

sulfate developers to promote a whiter image color for ambrotypes and ferrotypes. It was also added to lower the pH of the silver bath for collodion plates. Adding acid to the silver bath made collodion plates less sensitive to light, which had the beneficial effect of reducing the occurrence non-image fog.

Nitro-cellulose
See Cellulose Nitrate.

Non-silver process
It is necessary to examine the early history of photography to understand how the evolving technology that brought the photograph into existence blazed a trail of immense exploration and experimentation using non-silver processes. There were literally hundreds of processes invented between 1839 and 1885. Each practitioner of photography was required to learn how to manipulate chemicals and chemical apparatus, and the photographic journals of the day were filled with descriptions of new techniques and improvements developed by energetic amateurs.

The development of non-silver photographic processes is the very history of photography itself. The birth of photography is marked in history books by Daguerre's dramatic announcement in 1839 of his invention of the daguerreotype. However, the earliest camera photograph was created in 1826 in France by Joseph-Nicéphore Niépce. "View from the Window at Le Gras" was the first permanent photograph based on his experiments that started in 1822. It was made of a layer of bitumen of Judea, a type of asphalt that becomes insoluble when exposed to light, thinned with oil of lavender, then coated on a polished pewter plate. *See* Niépce Process.

Cliche-verre, literally meaning "drawing on glass," is a cameraless process invented by three English engravers shortly after William Henry Fox Talbot introduced his negative-positive process in 1839. Materials such as varnish, asphalt, and carbon from the smoke of candle were applied to make a sheet of glass opaque. Once dry, an etching needle was used to draw, paint, or scratch away an image through the applied surface. This was then used as a *negative* to make numerous impressions that were contact-printed onto light-sensitive materials.

In the 1850s, Adalbert Cuvelier updated the process by incorporating the recent photographic discovery of the collodion glass plate process with cliche-verre. Artists from the French Barbizon school, particularly Jean-Baptiste Corbot, used this process as a means to produce quick and inexpensive editions of monoprints. Although this marked the heyday of cliche-verre, such notable later artists as Man Ray, Brassai, Max Ernst, Picasso, Paul Klee, Fredrick Sommer, Henry Holmes Smith, and Joel-Peter Witkin revived interest in the process in the 1960s. The number of ways that cliche-verre can be used in conjunction with other processes in limitless.

Iron salt process
What preceded Niépce's early experiments in France was an era of exploration of light-sensitive materials that is unprecedented throughout the history of photography. Many different metallic salts were investigated in regard to their light-sensitive properties. None, however, yielded as many successful possibilities as the ferric salts. When combined with other chemicals and exposed to strong ultraviolet radiation these salts produce a reaction in three primary ways. The first is when there is a light-hardening effect of ferric salts on a colloidal compound. The second is the ability of ferric salts to react chemically with certain metallic compounds to form images of metallic precipitate. The third relies on the reaction of iron salts with chemical compounds to form a colored by-product that creates an image. Some of these processes, now obsolete and anticipated, were important stepping stones to the processes that followed. Catalysotype, chromatype, chrysotype, amphitype, anthotype, energiatype, and fluorotype were just some of the processes developed in the 1840s that did not survive. However, the one process that has survived from this period of time, leaving a rich body of work behind, is the cyanotype process.

Sir John Herschel—a famous English scientist, astronomer, inventor, and friend of William Henry Fox Talbot—made numerous achievements and contributions to the field of photography and photochemistry including the discovery of a method of permanently *fixing* an image by the use of sodium thiosulfate (hyposulfite of soda) in 1819. He is also credited with coining the terms *photography* and *negative* and *positive* for the image made in the camera and the print resulting from it, in reversed tonalities.

In 1842, in a paper to the Royal Society of London titled "On the Action of the Rays of the Solar Spectrum on Vegetable Colors and on Some New Photographic Processes," Herschel described for the first time the discovery of the printing process that used the sensitivity of iron salts to light. He also invented the chrysotype process, which depended on the exposure of ferric salts to light and the development of the ferro-image with gold and silver solutions.

The cyanotype process, from the Greek meaning *dark blue impression*, also known as the blueprint of the ferroprussiate process, is an exceedingly simple process based on the reactions of two chemical compounds, ferric ammonium citrate and potassium ferricyanide. The resulting image is a combination of ferrous ferricyanide and ferric ferrocyanide (Figure 106). The two compounds are each separately mixed with water to form two solutions that in turn are mixed in equal parts to form the light-sensitive solution that is then coated on paper or cloth. The support is dried in the dark and is contact-printed by exposure to light through either a negative, to make a print, or an object, to make a photogram. It is then simply washed in a bath of running water to permanently *fix* the image and develop its characteristic *cyan* blue color and matt print surface. Out of the many photo discoveries Sir John Herschel made, the cyanotype process became the most commercially successful.

The major user of the cyanotype process during Herschel's lifetime was one of the earliest woman photographers known, Anna Atkins. Her remarkable *British Algae—Cyanotype*

Impressions was the first book to use photography for scientific illustration. Predating William Henry Fox Talbot's *The Pencil of Nature*, the first of her three volumes was published in 1843. These volumes combined scientific accuracy with the cyanotype process to document Atkins' extensive research on her vast seaweed collection using actual specimens. The cyanotype process was particularly suited due to its low cost, permanence, simplicity of process, and freedom from any patent restrictions. However, its unchangeable blue image color, particularly suitable for illustrations of seaweed, kept the cyanotype from entering the mainstream of photographic practice.

The cyanotype process became popular again at the turn of the century but was used mostly by amateur photographers. Family album quilts, using cyanotype on satin, are but one unique example of the work produced at this time. It was also at this time that architects, shipbuilders, and draftsmen, began to use commercially prepared cyanotype paper to generate fast, inexpensive copies of line drawings and architectural renderings.

Another process, patented in 1878, with very similar qualities to the cyanotype process, and occasionally referred to as the positive cyanotype, is the Pellet process. This more obscure process produced a positive image from an original positive (the reverse of the cyanotype). It used gum arabic as a colloidal body to suspend the sensitizer consisting of ferric ammonium citrate and ferric chloride. The exposed material was developed in a bath of potassium ferrocyanide, which produced the characteristic blue of the print. This process eliminated the additional step of making a negative from a film positive to achieve a positive-reading print.

Herschel's idea, to precipitate precious metals by exposing ferric salts on those parts of the image where ferro-salts form, was dramatically improved when platinum salts were introduced to this process. Herschel gave an account of the reductive action of light on a salt of platinum at a meeting of the British Association of Oxford.

In 1844 Robert Hunt published his own experiments with platinum in his book *Researches on Light*. But not until Englishman William Willis, on June 5, 1873, patented his new photographic printing process that was based on the use of combining ferric oxalate with platinum salts was the platinum process of printing perfected. Willis, realizing the instability of silver images, set out to develop a more permanent alternative called the platinotype and billed the process as "Perfection in the Photomechanical Process." The exquisite quality of the image, matt surface, neutral black tone, and the extraordinary permanence of the image ensured wide acceptability of the process.

Monochromatic pigment processes

Between 1860 and 1910, there was an explosion of photographic printing processes that were invented to produce photographic images in pigment rather than silver or other metals. Some of these processes never died out altogether and are still a viable form of image making today. These processes are still taught, and prints utilizing them are supported and encouraged through the art market and within the gallery/museum structure. They were created for several reasons that addressed specific needs:

1. In early photographic processes, silver images were not completely stable. Images in pigment, however, are very stable and permanent. They are not susceptible to the fading and discoloration that have plagued the development of the silver processes.
2. The pigment processes particularly, through the various steps, allowed and encouraged at times dramatic alteration and manipulation of the image. At this time photography was trying to emerge as a fine art so that imitations of paintings, etchings, drawings, pastels, and other fine art mediums were in vogue. This went, sometimes, so far as to completely conceal the photographic origins of the image.
3. Pigment process materials were much less costly and therefore commercially more viable than other metal-imaging materials, like platinum and gold, that could equal the pigment processes permanence.
4. The pigment processes offered some of the first feasible color processes, because pigments, watercolors usually, were offered in a wide variety of colors ranging anywhere from the more neutral colors of the lamp blacks to the sepias and warm reddish browns to the realization of a polychrome image. It was also a way to introduce color without the artistic skill and control necessary to apply the paint.

Almost all the pigment processes utilize one of two basic methods of working. The first is where pigment is literally part of the emulsion of the print material. The process of exposure fixes or hardens the pigmented gelatin in direct proportion to the negative, and development washes away any of the unexposed pigment, which results in a positive image. The carbon and gum bichromate processes work in this way. The other method relies on exposure to make an unpigmented emulsion or surface receptive so that it will retain pigment either dusted on it or transferred by pressure to it, or attached by either a chemical reaction or an electrostatic charge. An example of this is the bromoil process introduced after the turn of the century.

Color techniques

Predating the invention of photography, in 1807 Thomas Young revealed that our perception of color is based on only three basic colors—red, green, and blue. These he called the *additive* primaries because when added together in varying amounts they can produce all the other colors found in the real world. In 1839 Daguerre announced his astounding invention—the daguerreotype—to the world in Paris. Even before the photographic process was perfected, attempts to incorporate and reproduce color photographically were made. In 1859 and again in 1861 in London, James Clerk Maxwell gave a three-color photographic slide presentation in which he projected images from positive glass transparencies that he prepared by exposing collodion plates through a red, a green,

and a blue filter, which when superimposed in register on the screen produced what appeared to be fairly realistic color pictures.

The second system of color is called the *subtractive* system of color, which relies on using colorants that are complementary in color to the additive primaries; namely cyan, magenta, and yellow. Color separations were made by exposing three separate negatives of the subject, one through a red filter, one through a green filter, and one through a blue filter. The red-filter negative produces a cyan printer, the green-filter negative a magenta printer, and the blue-filter negative a yellow printer.

The carbon process was a monochromatic process, invented in 1855 by Alphonse Poitevin, which used the photosensitive qualities of potassium bichromate to sensitize gelatin. This process became popular and practical in the late 1890s using carbon black as the pigment of choice for the print, hence the name of the process. The logical development of this process was to substitute cyan, magenta, and yellow colorants for the black pigment, to make three separation negatives, and produce three pigmented gelatin positives which, when transferred in register, yielded a full-color photographic carbon print.

O

Oil coloring

Although uncommon, plain and albumen prints were occasionally re-touched with oil colors. Large framed ferrotypes, usually copies of other ferrotypes, cartes de visite or cabinet card images, were routinely painted with oil colors often in the most outrageous manner. When made as a copy the over-painting also served as a means to extend the background of the final image and make it look less cramped. By the end of the century oil colors were used to color gelatin developing-out papers by rubbing the colors onto the surface of the print with cotton balls, a technique that softened the effect.

Olive oil

Olive oil was also called sweet oil. It was used to make engraved prints translucent for more effective contact printing in the heliograph process. It was also used as a lubricant vehicle with finely ground abrasives such as rottenstone and tripoli for polishing daguerreotype plates.

Opalotype

This is a positive photographic image made from a negative upon a light-sensitive coating on opal glass. Opal glass, also called a milk glass, was a white translucent glass made by the addition of oxides to basic silica soda glass. Flashed opal glass had the translucent white layer on top of a sheet of clear glass. Sheets of opal glass were also used as a diffuser when rephotographing negatives by transmitted light. The terms *opaltype*, *opalotype*, and *milk glass positive* are synonymous. *See* Milk Glass Positive.

Opaque

An opaque substance is a substance though which light does not pass. Opaque was a water-soluble solution of red, yellow, or black pigment applied to negatives to prevent the transmission of light. It was typically made with gum arabic colored with black graphite, red or yellow iron oxides, or red cochineal.

Ordinary emulsion

When all basic silver halide photographic emulsions are first made they are only sensitive to ultraviolet, violet, and blue light. These are called ordinary emulsions. To make ordinary emulsions sensitive to more colors of the visible spectrum, sensitizing dyes are either added to the emulsion or the ordinary coated plates bathed in the dyes. *See* Orthochromatic, Isochromatic.

Orthochromatic

The range of spectral sensitivity was increased in ordinary photosensitive materials with the addition of certain dyes. The first of these dyes was red which extended the sensitivity of the plates to green. When sensitized to include the yellow orange region the plates were often referred to as orthochromatic from the Greek words *ortho* meaning right or true and *chroma* meaning color. These were first known as isochromatic plates. It was not until after the turn of the century when true panchromatic plates were commercially available. *See* Isochromatic Photography.

Overdevelopment/overexposure

It is impractical to mention one concept without the other knowing the difference between overexposure and overdevelopment is essential to the success of all photographers. Prior to the advent of panchromatic photographic plates after the turn of the century, all photographic operations could be performed under red safelight. Observations of the plate as it was developed helped the photographer to understand the effect of both exposure and development so they could correct the problem immediately or when making exposures in the future. One of the major complaints when the spectral sensitivity was expanded to capture red in photographic materials was the inability to develop by inspection.

The effects of overexposure were easily observed during the first moments of developing the plate. If the highlights and shadow areas of the image came up quickly without steady progression, the plate was overexposed. Overexposed plates developed by inspection were usually stopped before the developer could produce anymore image density. The result was a foggy plate with a great deal of detail in the highlights but deficient density in the shadows. If the development was stopped in time, the photographer could redevelop the plate after fixing to either change the silver to a non-actinic color for spectral density or add additional metallic silver. *See* Intensification.

Underexposed plates, on the other hand, were routinely overdeveloped. When the developer was applied to an underexposed plate only the highlights, such as the sky, would be visible for the first moments of development. With insufficient exposure, there was no energy in the shadow areas and extending development only produced density in the highlights

of the image. The result was a plate with excessive contrast, clear shadow areas, and great density in the highlights.

Oxalic acid, $H_2C_2O_4$

Oxalic acid is made by the action of nitric acid on sugars, starch, or cellulose. This highly poisonous colorless crystal is soluble in water, alcohol, and ether. It was used to make ferric oxalate, as a preservative for pyrogallic acid developers, as a sensitizer for platinum papers, and to reduce the density of cyanotype prints.

Oxgall

Also known as oxbile, this bile fluid extracted from an ox is soluble in water and alcohol. Oxgall was applied to the surface of albumen prints prior to the application of watercolors to improve adhesion.

Oxymel process

Oxymel was a 19th century pharmaceutical made by adding dilute acetic acid to honey. It was also used in the mid-1850s as a pre-exposure humectant type preservative of wet collodion plates. The plate was coated and sensitized in the usual way and then washed with tap water to remove the excess silver nitrate. After draining, the plate was coated with the oxymel solution and drained on a rack in the dark. The sensitive collodion surface remained damp for weeks allowing the plate to be exposed at a later time. Exposures were at least five times longer than those of conventional wet plates. After exposure the plate was developed with a solution of pyrogallic acid with some silver nitrate added to supply that which was washed off in the preparation of the plate.

Ozotype

This method of pigment printing was invented by Thomas Manly in 1899 and later replaced by the ozobrome process. It was a form of carbon printing. A sheet with bichromated gelatin was contact exposed to a negative. It was then placed in contact with a pigmented carbon tissue soaked in a dilute solution of acetic acid and hydroquinone and squeegeed together. A chemical reaction took place that hardened the carbon emulsion in direct proportion to the degree of exposure. The sheets were separated and the unexposed and therefore unhardened pigment was washed away, which left the hardened areas to form the image.

P
Palladium, Pd

Palladium is a soft white metal found in copper and nickel ores. The chloride compound of this element was used after the turn of the century for printing and also in combination with platinum for printing.

Panoramic

The desire to make panoramic images of wide vistas was first satisfied by exposing a series of daguerreotype plates by pivoting the camera from a single point. By the collodion era special panoramic cameras were introduced so that the entire subject could be captured on one plate. The Sutton camera featured a water-filled, wide-angle lens that required curved plates to maintain the proper focus. Curved plates required a special silver bath and plate holder. Other panoramic cameras were designed to only expose a vertical slit upon a flat plate that moved past the slit during the exposure. This technique was improved upon when flexible film was invented and became the standard system, with some variants, throughout the next century.

Pannotype

These direct positive collodion images were made on glass and transferred onto a secondary support material by placing the glass plate bearing the image in an acidified water bath that caused the collodion film to shrink. The secondary support was then placed in the water and the two were taken out of the bath with the image in contact with the surface of the secondary support. The back of the support was then pressed against the glass with a squeegee and the plate. The back of the plate was then gently heated until the image and support fell from the glass. Often called pannotypes, from the Latin word *pannos* meaning cloth, these images were transferred onto black oil cloth, patent leather, and black enameled paper.

Paper

Special papers were manufactured for photographic purposes as early as the 1840s. The calotype process required an even-grained woven type cotton paper with good wet strength to withstand the chemical processing. English papers of the period were usually sized with gelatin, an advantage when making calotypes. The French papers, however, were usually sized with starches, a disadvantage when making calotypes, but excellent for the waxed paper process. The papers manufactured by Rives and Saxe became the standard papers used for albumen, collodion, and gelatin coatings in the 19th century. Blotting or bibulous paper was thick and unsized for the purpose of absorbing fluids. Blotters were used extensively for the preparation of paper negatives and drying photographic prints.

Paper negative

The earliest negative processes capable of producing a secondary positive print was made on paper support. Nearly everyone associated with the 19th century invention of photography began with sensitized paper and produced a negative; including Wedgwood and Davy, Florence, Niépce, Daguerre, Herschel, Reade, and Talbot. Early paper negatives were made for use in photogenic drawing and calotype and waxed paper processes. At the time the softness imparted to the final image was not a desired aesthetic, but near the end of the century when the pictorialists sought a softer look for their images they used the same factory-made paper. Paper negatives made using commercially available papers were used by art photographers well into the 20th century. The first roll film used in the Eastman-Walker roll holder of 1885 was

silver bromide gelatin emulsion paper made translucent after processing by the application of oil.

Passé-partout

This is a French term generally applied to a window mat. Specifically the passé-partout mount included a deep mat and a reverse painted cover glass often decorated with a gold pin line around the opening. These were very common in Europe for the mounting of daguerreotypes and collodion positive images.

Paste

Photograph mounting pastes were made by mixing various starches with cool water to the consistency of thick cream, followed by cooking in a double boiler. When cool the paste was applied to the back of prints with a stiff brush. Occasionally additives such as oil of cloves or wintergreen were included to prevent spoiling.

Pastel portrait

Also called a crayon enlargement, the pastel portrait was a photographic enlargement heavily colored with pastels. The basic method was invented in the late 1850s and continued until well after the turn of the 19th century. The earliest examples were printed-out solar enlargements, followed by developed-out salt prints and eventually silver bromide gelatin prints. *See* Crayon Enlargement, Solar Enlarger.

Patent plate

The most expensive glass used for photographic purposes was called patent plate. It was made by pouring molten glass upon a flat table and rolling it to the required thickness. After annealing the plate was ground flat on both sides and polished.

Pellet process

See Non-Silver Processes.

Pencil

The lead pencil was the most common negative re-touching tool of the 19th century. Pencil implies a wooden outer covering with a graphite core, although special holders for separate leads were also used. Pencil also referred to a very thin brush. *See* Graphite.

Photo-finishing

This is a term referring to that which happens between processing the negative and handing the customer the finished image. The techniques of finishing photographic prints in the 19th century included trimming, pasting, waxing, rolling or burnishing, and presentation.

Photogene

The first emulsions were theorized in 1853 by Marc Gaudin. He suggested the addition of various halides and silver nitrate to collodion. There is no reference that suggests that he produced photogene commercially. *See* Collodion.

Photogenic drawings

When W. H. F. Talbot began experimenting with silver chloride papers in the mid-1830s his first images were no more advanced than those made by T. Wedgwood in 1802. Talbot's first contribution to the evolution of negative/positive photography was alternate applications of silver nitrate and sodium chloride solutions to the paper. More important was the stabilization of silver chloride images with a strong solution of sodium chloride, potassium iodide, or potassium bromide.

Stabilization did not actually remove the unexposed silver halides, but made them much less sensitive to light. Extended exposure to light eventually turned the highlights of chloride stabilized prints blue and iodide prints yellow. By making the negatives less sensitive to light Talbot was able to superimpose them with a second sheet of sensitive paper, expose them to sunlight, and made a positive image that was also stabilized. Both negatives and positives were called photogenic drawings when stabilized.

The photogenic drawing negative was superseded by Talbot's calotype process patented in 1841. Talbot continued to make stabilized photogenic drawing prints from calotype negatives despite their questionable permanence. It is assumed that he did this because the colors of the prints were more attractive than hypo fixed salted paper prints which were shades of brown.

Photoglyptie

This is the French term for Woodburytype. *See* Photomechanical Processes.

Photogram

Photographic images made by the placing of an object in intimate contact onto a photosensitive material are generally called photograms. The earliest experiments conducted prior to the invention of photography were made by this technique and all of the inventive contributors made them with their respective processes.

Photographer

While all of the 19th century processes made with a camera fall under the general category of photographic, often the person performing the activity was called a more specific term. This was often the case with the direct positive processes so that if you made daguerreotypes you were a daguerreotypist or daguerreotyper. If you made ambrotypes you were an ambrotypist. The ferrotypist could also be called a ferrotyper, tintypist, or tintyper. There were no set rules except when it came to making negatives. If you made negatives of any sort you were a photographer and if a woman, a photographist. The process specific term of calotypist was used on occasion, but photographer became synonymous with making negatives for the purpose of producing positive prints. One title that did

accompany nearly all the commercially successful processes was that of the operator, implying the person who actually manipulated the camera.

Photographic gun

When the silver bromide gelatin plate became commercially available a variety of novelty detective cameras were introduced. One of the most peculiar was the gun camera. These were slightly larger than a conventional hand gun and no doubt created more attention than setting up a camera on a tripod when attempting to make candid images. (*See* Figure 19.)

Photographic journal

There was no more important technical resource than the photographic journals in the 19th century. In the late 1830s and early 1840s news of technical advancements in photography were only available through the scientific publications such as *The Athenaeum* in England, the *Compte Rendue* in France, and the *Journal of the Franklin Institute* of Philadelphia, Pennsylvania. The first true photographic journals appeared around 1850 and continued throughout the 19th century. Some of the most important journals were the following:

> *La Lumiere*
> *The Photographic News*
> *The Philadelphia Photographer*
> *The British Journal of Photography*
> *The American Journal of Photography*
> *The Photographic and Fine Art Journal*
> *Humphrey's Journal*
> *The Daguerrean Journal*

Publishers often reprinted articles from other journals and it is possible to see the identical text in *La Lumiere*, *The Photographic News*, and *The Philadelphia Photographer* in successive issues. Articles were written by the publisher, selected experts, and contributors. There were also question and answer sections listed under correspondence. These proved to be a very useful format even though in many cases only the answers were printed leaving the reader to ponder the question. From a research standpoint, the photographic journals offer the most accurate information of what was done and how it was accomplished at any given time during the 19th century.

Photography

While the topic of much debate at the time of this writing, the conventional definition of photography refers strictly to the Greek words *photos* meaning light and *graphos* meaning to write. The word was first used by Hercules Florence while working in isolation in Brazil. Sir John Herschel is credited with coining the word in England a few years later and it is probably from his reference that the term was dissimilated throughout Europe and America. While the term *photography* has been generally applied to almost every means of photosensitive process or product, in the mid-19th century it evolved as

specific to the making of negatives for the purpose of creating a secondary positive print. *See* Photographer.

Photomechanical process

Though not the emphasis of this encyclopedia some mention of photomechanical processes is appropriate. Any photographic process that produces a matrix from which a final image is produced without the necessity of light might be called a photomechanical process. This is usually associated with images made by various conventional ink printing methods. The asphalt heliographs made in 1822 by N. Niépce for the purpose of etching plates for ink printing were the first examples of a photomechanical process. W. H. F. Talbot's photoglyphic engraving process was done by acid etching using steel plates with a resist made by exposure to dichromated gelatin.

The most popular photomechanical process of the mid-19th century was the Woodburytype patented by Walter Woodbury in 1866. Woodbury created a relief image in dichromated gelatin from a negative. The gelatin relief was then used to create a lead mold in relief. This mold was set into a heavy press and a small quantity of pigment was applied to the center. A piece of paper was inserted in the press and pressure applied until the excess pigmented gelatin oozed from the edges. When the press was opened the fully formed image was complete; the dark areas formed by the thickest deposits of gelatin, gradually lightening where the mold had less relief.

Photogravure

This was first introduced in 1879 by Karl Klic, a Viennese photographer printmaker. This process, based on the earlier work of Niépce and Talbot, also relied on acid etching through a relief. A copper plate was first coated with an even layer of rosin dust and heated to fuse the particles to the metal. A negative carbon print was then transferred onto the surface of the plate and when dry the plate was acid etched. The resists were removed prior to printing with ink in a conventional etching press. Photogravure processes were used extensively after the turn of the century.

Photometer

See Actinometer.

Physautotype

This is a direct positive photographic process based on the sensitivity of resins. Physautotype, from the Greek word meaning image that makes itself, was a collaborative technique of Niépce and Daguerre. It was described in great detail in Daguerre's 1839 manual. It is considered by some scholars that the published, but now lost, image of a table setting by Niépce was made with the physautotype process. No actual examples of this process exist today.

A physautotype was prepared by pouring an alcoholic solution of reduced colophony or lavender oil upon a polished silver plate. When the solvent dried, the residue bloomed to a

powdery white veil. The plate was exposed to daylight in intimate contact with an object for several minutes or in a camera for many hours. The exposed plate was then developed by the fumes of turpentine, which made the unexposed areas turn clear allowing the polished metal to be seen. The final image was nearly identical to the daguerreotype and viewed in the same way.

Physical development
See Development.

Pictorialism

The term *pictorialism* was used generally by photographers in the late 19th and early 20th centuries to describe an artistic approach to the making of photographs as well as to define a number of specific groups organized to promote art photographers and their work.

The question of artistic intent in photography had been discussed widely in Europe, particularly in England, beginning as early as the 1850s. Speaking on behalf of the artistic purposes of photography were critics and journalists such as Lady Elizabeth Eastlake, Oscar Rejlander, and Peter Henry Emerson. In 1869, Henry Peach Robinson published his *Pictorial Effect in Photography*, giving weight to the notion of photography as a self-conscious art form and popularizing the critical concept of pictorialism.

Pictorialism served historically as a reaction against the flood of unexceptional and easy photographs enabled by the technical advances of the 1880s. Convenient innovations such as the dry plate hand-held camera, and flexible roll film, as well as improved camera design and optical sharpness, made camera work available to a larger group of amateurs whose primary concern was the graphic recording of information. Without attention to or regard for notions of aesthetic merit, the work of amateur photographers was seen by some to be artless and hopelessly devoid of personal sensibility.

Contemptuous of the literal representation of subjects and scientific and commercial applications of the medium, groups of photographers spontaneously organized under the banner of pictorialism to promote expressive feeling in their pictures by application of the principles, styles, and subject matter of the *high art* tradition. They turned away from what had been the primary photographic concern for accuracy in portraiture, architecture, and landscape to a concern for the picturesque — idealized and personalized views that showed conscious and careful attention to pictorial composition, broad delineation and tonality, symbolic and allegorical allusion, and signs of the careful hand of the artist.

Much the same as the academic painters and printmakers they emulated, pictorialists favored the classification of subject matter in such categories as landscape, portraiture, still life, genre, and allegorical scenarios. In seeking to connect with the high art tradition of the 19th century, pictorialists sought to give pedestrian photography a look of aesthetic respectability, to elevate the photograph to the status of rare and collectible

art object, and to include amateur photographers in the dedicated service of art for its own sake.

Not only subject matter, but also manner of execution was important in the pictorialist salon. Pictorial photographers took great pains to attempt to see a picture where an ordinary person would not and to invest that image with spiritual significance. There followed the challenge to execute the making of the photograph in such a way that the creative intentions of the maker were unmistakable. In striving to create unique art objects and to suppress the mechanical and reproducible origins of the photograph, pictorialists resorted to non-standard and inventive processes that relied on handwork and manipulation. Much as painters or watercolorists, photographers used techniques that lent a unique signature to their work and obscured the literal photographic information of the image. Photographic detail was suppressed by the use of a variety of textured and hand-made papers on which the photographic original might be rubbed, erased, or otherwise worked by hand. Hand-applied emulsions of gum bichromate and pigment such as platinum, palladium, and iron sales, and multiple applications of toners and dyes not only were capable of exploiting the exquisite tonal range prized by pictorialists, but also gave each photograph standing as a unique and singular artifact. Pictorialist prints are frequently characterized by their fine observance of the quality of light — attention to atmospheric effects of haze and fog and rain made possible by printing-out carefully exposed negatives in direct sunlight. The striking effects of light were also exaggerated or distorted by the use of soft-focus lenses specifically designed to imitate the diffuse effect of impressionistic paintings and watercolors.

Although pictorialism was a widely dispersed movement, it was most carefully followed in England and the United States. The development of a clear pictorialist tradition may have its roots as early as 1887 in the organization of amateur camera clubs in the eastern United States, devoted to the international presentation of artistic photographs in an annual series of joint exhibitions that continued until 1894. These popular camera club salons, with their broad base of amateur membership, attempted to elucidate the notion of artistic feeling in subject matter and developed canons of practice based on the teachings of the fine art academy. More important, they mounted well-attended juried exhibitions that traveled to city art museums and galleries and were influential in promoting a popular understanding of the pictorialist aesthetic.

In 1891 a group of English pictorial photographers took on the name The Brotherhood of the Linked Ring and seceded from The Photographic Society of London to dedicate themselves to photography in the service of aesthetic pleasure. They initiated the first London Salon of Photography in 1894. In 1902, Alfred Stieglitz formed a group called The Photo-Secession following his involvement with the New York Camera Club. Exhibitions at the Little Galleries of the Photo-Secession in New York as well as critical articles and gravure reproductions in the periodical *Camera Work* became the focal point for the pictorialist movement and modern art until 1917, when the effects of war devastated the dialog of the artistic community worldwide.

In the 1920s, pictorialism gave way to a new aesthetic of sharp optical rendering and realistic objectivity exemplified in the work of photographers like Edward Weston and the Group f/64 in California. As late as the 1930s, pictorialist theory was still argued in journal debates by William Mortenson, but the structure of the camera club salons and the pictorialist movement had become a thing of the past. Nevertheless, interest in pictorialism continues today among contemporary fine art photographers, particularly evidenced in the interest for reviving vintage processes such as the platinotype, cyanotype, and gum print to render stylized and singular art images of the picturesque.

Pigeon post
See Microphotograph.

Pigment process
Finely ground pigments were added to dichromated colloids to establish the final image color in both the carbon and gum processes. The first pigment used was carbon black. By the end of the century carbon tissues were available in different colors. Those using the gum printing process coated their own papers and used either raw pigments or commercially made watercolors. *See* Carbon, Gum Bichromate Processes.

Pinhole camera
While the concept of the pinhole camera predates the invention of photography by hundreds of years its application was not really exploited until the advent of gelatin plates. The soft imagery admired by the pictorialists at the end of the century brought the pinhole into use.

Plain paper
With the invention of the albumen printing process by Blanquart-Evrard in 1850 came a new term to describe the salted paper print. Prior to albumen printing these were called silver chloride or salt prints, but since the albumen process also relied on sodium or ammonium chloride as the halide the only real difference was the albumen binder. As a result paper coated with only chlorides dissolved in water prior to sensitizing with silver were known as plain or ordinary. The process was often referred to as printed in the "ordinary way."

Plate
Many photographic processes in the 19th century were made on plates of either metal or glass. These materials include pewter, copper, silver plated or clad copper, glass of various types, and Japanned iron. Vitrified photographs were made on ceramic or enameled copper plates.

Plate box
A plate box is a wood or metal box to keep cleaned or sensitized plates ready for exposure in the camera. It was also a box to keep exposed plates prior to processing or as safe storage of processed plates. Plate boxes usually featured vertical slots on either side of the interior to allow the plates to be held upright without touching other plates.

When silver bromide gelatin plates were introduced in the 1880s they were sold in pasteboard boxes. Gelatin plates were usually packaged in sets of two with the emulsion facing outward. These sets had paper spacing strips placed over the ends to prevent contact with the emulsion of the next set. The group of sets was then wrapped in black paper and placed in the bottom of the box. The box had two lids to prevent accidental light exposure. Other dry plate variants such as autochromes were sold in similar boxes.

Plate holder
Any of the camera processes using a sensitized plate required a means to bring the plate to the camera and back to the darkroom after exposure. The plate holder, or shield, was a thin wooden box designed to hold the plate at exactly the same distance from the lens as the focusing glass on the camera. The plate was exposed to the interior of the camera by a dark slide that was withdrawn prior to uncapping the lens and replaced after exposure to permit removal from the back of the camera. Plate holders designed for daguerreotype and collodion work were designed to hold only one plate and loaded from the back.

When more than one piece of sensitive material could be prepared for exposure, such as the calotype and wax paper processes or the gelatin emulsion plate, holders designed to hold two plates or paper could be used. These double holders were made in a wide variety of styles. Early examples were made from wood and opened like a book with a hinged septum of metal that prevented one side from exposing the other. The dark slides were not removable. Throughout the latter part of the century various designs evolved, although by 1900 a type featuring a rigid septum and two removable dark slides came to be a standard throughout the 20th century.

Plate rack
Wooden plate racks were designed with grooves to hold glass plates for a variety of photographic operations.

Plate sizes
Throughout the 19th century there were many different plate sizes, particularly before the introduction of the commercially manufactured gelatin emulsion plate. Daguerreotype plates were purchased in standard sizes. In the collodion era, the photographers themselves cut their own glass plates and so slight variations within a standardized format were also common. If there was any commonality in format it was with most of the cased image sizes used for daguerreotypes, ambrotypes, ferrotypes, milk glass positives, and pannotypes. These were based on the whole plate of Daguerre, though even here there are variants in size depending on the country of origin; for example, the American half plate was usually 4-1/4 × 5-1/2 inches compared to the English counterpart that measured either 6-1/4 × 4-3/4 inches, a true half plate, or 6-1/4 × 4-1/4 inches known as a "double quarter" plate.

Negative sizes varied considerably. The single carte de visite negative was usually made on a quarter plate, although with a sliding back these were also made as two or three exposures on

a longer plate. The full plate or whole plate was a common landscape format. It was also an important portrait negative size as a single image or exposed horizontally for two images on a plate. The 8 × 10 plate was used for portraits and was best known for making two 5 × 8 portrait negatives on a horizontal plate.

The 5 × 7 negative did not really become popular until the advent of gelatin emulsion plates, although it was a very common format for making bon ton ferrotypes. The bon ton was essentially four vertical images on a 5 × 7 iron ferrotype plate. After varnishing the individual ferrotypes were cut from the plate using tin snips and placed in paper mounts. By changing the lens arrangement and back masks both larger and smaller ferrotypes could be made.

Stereo negatives in the collodion and early gelatin era were usually made on 5 × 8 inch plates, although stereo cameras could also be used with a single lens to make a single image on the plate. Many of the landscape images mounted as cartes de visite were made from half of a 5 × 8 inch stereo negative. Plates larger than 8 × 10 inches were used both in the studio and in the field. These larger sizes include the following formats measured in inches, many of which were called mammoth plates depending on the maker of the plate holder: 10 × 12 inches, 11 × 14 inches, 14 × 17 inches, 17 × 20 inches, 18 × 22 inches, and 20 × 24 inches. A variety of other negative formats were used in England and the continent.

Gelatin plates of the late 1880s included in inches — 3-1/4 × 4-1/4, 4 × 5, 4-1/4 × 6-1/2, 5 × 7, 5 × 8, 6-1/2 × 8-1/2, and 8 × 10 and the larger sizes listed above. Even after the introduction of gelatin plates the international standardization of plate/film sizes did not happen until the middle of the 20th century when the 4 × 5, 5 × 7, and 8 × 10 evolved to become the most common glass plate formats.

Plate vice

When daguerreotype plates and glass plates were cleaned and polished they were held in a plate vice. Early examples for the daguerreotype held the plate by two or four corners. Later types required the corners to be clipped and the edges bent to fit into a special block that was then held in a wooden vise. The same type of vice was used for small glass plates.

Platinum, Pt

Platinum is a white noble metal that looks very much like metallic silver found in copper ore. The name platinum comes from the Spanish word *plata*, meaning silver. Platinum compounds were used in the platinum printing process and for toning silver images.

Platinum process

By 1832 Sir John Herschel knew that some platinum salts were sensitive to light. Robert Hunt discussed the effect in 1844, but it was not until 1880 that a platinum-based printing material was marketed. William Willis took a patent on his process in 1873 and formed the Willis Platinotype Company in 1879. Three years later, the formulas were made public and enthusiasts could coat their own paper. The process was embraced by a large group of fine art photographers including Pictorialists and Photo-Secessionists for the delicacy of its tones, its permanence, and its print surfaces, which suggest that the image is part of the paper.

The platinotype is a ferric process. Fine-textured rag paper is sensitized with ferric oxalate, potassium chloroplatinite, oxalic acid, and, perhaps, potassium chlorate. The mixture is brushed on and dried. During contact printing with sunlight or a UV source, the image prints-out partially, creating a self-masking effect. Early production of shadow density retards the rate at which low print values darken, allowing highlights to receive more exposure than is possible in a purely developing-out process and facilitating the printing of negatives that have long tonal scales. Full development of the image is performed in potassium oxalate. Clearing and fixing are in dilute hydrochloric acid, followed by washing and drying.

Pneumatic holder

Holding glass plates from underneath while coating the surface with collodion occasionally caused thin spots in the film due to the heat of the fingertips. This was a particular problem in cool studios and made more apparent when shooting against an even colored background where such spots would read as dark areas in the print. To prevent these thin spots various plate holders were sold throughout the collodion era. The most common design was essentially a rubber suction cup called a pneumatic holder.

Pneumatic shutter

In the last quarter of the 19th century shutters were introduced with pistons that opened or tripped the mechanism. A pneumatic release was a rubber bulb connected to the shutter by a length of rubber tubing, which was depressed to introduce pressure to the piston. This could be used to trip the shutter release. Because the tubing could be any length, this system was often used for self-portraiture or when photographing children off guard. Pneumatic shutters were eventually superseded by spring-loaded mechanisms, but the pneumatic release fitted with a piston was used well into the 20th century for any type of shutter. *See* Shutter.

Porcelain paper

The first photographic papers with a subcoating of white clay or baryta mixed with gelatin were called porcelain papers. After the coating dried these papers were fed through heavy polished metal rollers that gave a finish that resembled vitrified china. Porcelain papers were coated with collodion-chloride emulsions to make leptographic paper.

Portrait photography

The technical and financial progress of photography in the 19th century was fueled by the commercial success of portrait photographers. Portraits were very difficult to make until the daguerreotype process was perfected and the portrait lens

invented by 1841. The first successful daguerreotype portrait is said to be of Dorothy Catherine Draper, taken by her brother Dr. John W. Draper in 1840. The first commercial potrait studio was established in New York City by Alexander W. Olcott in 1840. The first commercial portrait studio was established in New York city by Alexander W. Olcott in 1840. By the middle of the 1840s daguerreotype portrait studios began to appear in the cities of every industrialized nation. By the middle of the century portrait studios could be found in the smallest towns.

Portraits made with such slow processes required a special approach and some specialized equipment. The average portrait lens of the 1840s and 1850s was around f4 by today's standards. By the 1860s the collodion process hovered around ASA 1 when everything was working properly. Collodion positives required less exposure than daguerreotypes, but the negative process was actually slower in most cases. Studios were glazed with large skylights exposed to north light if possible. The subject was made comfortable and advised to look natural but also reminded not to move during the exposure.

To aide the customer heavy cast iron head rests were placed behind and adjusted to make contact with the back of the head. Posing tables offered another point of support. The subject was asked to focus on a specific object or an adjustable "eye rest" and told they could blink as many times as they needed during the exposure. The experience was traumatic for some and may account for the forced expressions seen in many examples of the era.

Early gelatin emulsions were slightly faster than the wet collodion process but the commercial portrait approach changed very little. The pictorialists of the 1890s influenced some of the more sophisticated portrait galleries and the hard looking images of the previous decades gave way to a softer aesthetic in both focus and posing. The gradual increase of sensitivity of the plates was also a major contribution. By the turn of the century gelatin plates and films were so much faster and easier to process that many amateurs were making their own photographic portraits at home by both artificial and window light.

Poisons

Poisonous substances have always been a peril to the health and even the life of humans. Photographic processing, like daily living, involves hazards. Some photographic chemicals are poisonous to all; other chemicals may be injurious only to susceptible persons. Safe handling of acids, bases, and heavy metal salts involves only careful laboratory practices, but special care is needed for substances that are poisonous gases or are liquids or solids that emit gases, fumes, or vapors. Identification and knowledge of specific poisons is necessary. The following substances are of a dangerous nature.

The element mercury occurs in nature as a pure metal and as natural compounds, such as cinnabar. The liquid metal, called *quicksilver*, describes how it looks and acts, especially if spilled on a hard surface. Even at room temperature, the liquid metal gives off vapor into the atmosphere. Mercury poisoning is insidious; the effect of minute amounts may take months to show up, usually as damage to the human brain and kidneys.

Continued exposure causes insanity, unconsciousness, paralysis, and death. "Mad as a hatter" is an old saying that refers to hat makers who had been poisoned by the mercury in felt used to make hats.

Mercuric chloride and mercuric bromide (corrosive sublimate) have been widely used in intensificating solutions for the silver image, as the insoluble mercuric salt reinforces the image. Mercury vapor has been used to increase the sensitivity of film materials (hypersensitization). Mercury occurs in batteries, thermometers, dyes and inks, fluorescent lights, plastics, and many other materials encountered in photography.

Avoid the chemical use of mercury metal or its compounds. If mercury metal is spilled, call a poison control center for details. Do not discard in landfills. A person with mercury poisoning should be treated immediately by a physician. If mercury is ingested, giving egg whites may help. The compound BAL (2,3-dimercapto-1-propanol) is the antidote for mercury poisoning.

Cyanide is a white granular powder or pieces having a faint odor of almonds that dissolves in water to produce a very alkaline solution (around pH 11). On exposure to humid air, cyanide solid reacts with carbon dioxide, liberating a gas. Both the solid and the solution may give off hydrogen cyanide, a colorless gas that is intensely poisonous. Exposure to hydrogen cyanide at 150 parts per million in air for 30 minutes to 1 hour has been reported to endanger human life. The average fatal dose of the solid is said to be 50–60 mg.

A solution of potassium cyanide is an excellent solvent for silver salts of low solubility, such as for the removal of silver sulfide stains. Cyanide was the preferred fixing agent for the silver iodide of the early wet plate process. It is used as an ingredient (as sodium cyanide) in the blackening solution for silver image mercury intensifiers.

Do not use cyanides if possible. Do not add acids or acidic solutions, metallic salts, or oxidizing compounds to solid cyanide or its solutions, even during disposal, as the poisonous hydrogen cyanide gas may be liberated. Sodium nitrite or sodium thiosulfate have been used as antidotes.

Poisonous gases

Special attention should be given to substances that may exist in gaseous form. Solids and liquids containing such gases are often unstable, easily releasing the gases, fumes, or vapors. Some of these potential poisons are discussed below.

Ammonia, ammonium hydroxide, and ammonium salts

Ammonia is a colorless and pungent gas that can irritate and burn. Do not mix ammonia with chlorine bleach. If taken internally, give lemon juice or diluted vinegar.

Formaldehyde and formalin (37 percent in water)

A colorless, irritating gas that attacks the eyes, skin, and respiratory system and can cause coma and death. If swallowed, induce vomiting with a glass of water containing 1 tablespoon of ipecac syrup.

Acid gases
Hydrogen bromide, hydrogen iodide and iodine, hydrogen chloride, hydrogen sulfide, and nitric acid are either poisonous gases or water solutions that give off irritating and corrosive fumes that are dangerous to the skin or eyes or if inhaled or swallowed. Hydrofluoric acid is especially insidious as it does not burn when contacting the skin, only becoming painful after some hours. Glacial acetic acid, a liquid with a pungent odor, can cause severe burns.

Organic solvents
Acetone, amyl acetate, benzene and xylene, carbon tetrachloride, ether, methyl, and ethyl alcohol, various amines, and other solvents are often volatile, flammable, and poisonous. Avoid their use if possible, but they may be needed for their unique solubilizing properties for photographic chemicals. Carbon tetrachloride and other chlorinated solvents may be carcinogenic. Methyl alcohol is flammable and a poison; ethyl alcohol causes human impairment and inebriation. Benzene and xylene are flammable liquids that have acute and chronic poisoning effects. The volatile organic amines are often flammable.

Handling poisons
Avoiding the use of poisonous substances is to be preferred. If such substances must be handled, protection against contact with the skin or eyes, breathing gases or vapors, or ingestion is necessary.

Positive

A positive is a photographic image that presents the subject in reasonably correct tones. This is a relative term when considering the spectral insensitivity of almost all 19th century photosensitive materials.

Post-mortem photography

The desire to make a visual record of the deceased dates back to the daguerreotype and continues to the present day. When infant mortality and death by accident or disease was commonplace, the post-mortem portrait was often the only photographic record a family had of loved ones. Great skill was needed to give the impression that the deceased was in repose.

Potassium, K

Some of the most common compounds in 19th century photography were made with this silvery metallic element discovered by Sir Humphrey Davy in 1807. There is not enough room in this work to list all of these compounds, but the following represent a reasonable sampling.

Potassium bichromate, $K_2CR_2O_7$

Also known as potassium dichromate, this bright orange crystal was made by the acidification of potassium chromate. It is toxic and an oxidant and is soluble in water but not in alcohol. In 1839 Mungo Ponton sensitized paper with a solution of potassium bichromate to print-out images in the sun.

The most important use of potassium bichromate was used to make colloids sensitive to light for a variety of processes such as the photoglyphic engraving process, the carbon process, the gum bichromate process, and in the preparation of the gelatin relief used to make lead molds for the Woodburytype.

Potassium bromide, KBr

This white crystal was made by the action of bromine on hot potassium hydroxide solution. It is soluble in water but much less so in alcohol. Potassium bromide was used as a secondary halide in combination with an iodide in the paper negative processes, the albumen on glass process, and the wet collodion processes. When silver bromide gelatin emulsion was invented, potassium bromide was the primary halide. It was also used in combination with either bichloride of mercury, copper sulfate, or potassium ferricyanide in photographic bleaches and as a restrainer in alkaline developers used for gelatin plates and developing-out papers.

Potassium cyanide, KCN

Potassium cyanide is a white granular salt made by the absorption of hydrogen cyanide in potassium hydroxide. It is soluble in both water and alcohol and a lethal poison. If mixed with acids it produces highly toxic hydrogen cyanide gas. This was the preferred fixing chemical for collodion positives because it contained no sulfides to darken the highlight silver. As a fixing agent cyanide was particularly effective. After dissolving the unexposed silver halides cyanide would also remove non-image fog producing very clean shadow areas. Prolonged fixing would eventually remove image silver. Tincture of iodine was added to dilute solutions of potassium cyanide and used to remove unwanted non-image silver in photographic materials and to remove silver stains.

Potassium chloroplatinate, K_2PtCl_4

Potassium chloroplatinate is a red colored crystal that is soluble in water but less soluble in alcohol. Potassium chloroplatinate is produced by a complicated treatment of the reducing of platinum chloride with sulfurous gas and adding potassium chloride. It was used primarily in the platinum printing process, but also for toning silver prints.

Potassium iodide, KI

Potassium iodide is a white crystal, granule or powder made by the reaction of iodine with hot potassium hydroxide solution followed by crystallization. It is very soluble in water, alcohol, and acetone. Potassium iodide was first used as the primary halide in Talbot's calotype process, then in the albumen on glass process followed by the wet collodion process. It was also used as a secondary halide in silver bromide gelatin emulsions.

Potassium ferricyanide, $K_3Fe(CN)_6$

Also known as *red prussiate of potash*, this deep red crystal was made by passing chlorine gas through a solution of potassium ferrocyanide. The crystals are soluble in water but less so in alcohol. Potassium ferricyanide was used with ferric

ammonium citrate to sensitize paper for the cyanotype process and mixed with hypo to make Farmer's reducer which was used to reduce the density of silver-based images.

Potassium ferrocyanide, $K_4Fe(CN)_6*3H_2O$

Potassium ferrocyanide is a yellow crystal also known as *yellow prussiate of potash*. It was made by stirring hot potassium carbonate with wool or horn clippings with an iron rod. It is soluble in water 1:4 but not in alcohol. Potassium ferrocyanide was used as a developer for some iron processes and as an additive for alkaline pyro developers.

Potassium nitrate, KNO_3

This natural substance is the product of the decomposition of lime and urine. The white granules or powder are soluble in water 1:3 but insoluble in alcohol. Potassium nitrate, also called *saltpeter* or *nitre*, was combined with sulfuric acid to nitrate cotton for the manufacture of collodion. It was also used with magnesium to make flash powder and added to ferrous sulfate developers to produced cool white tones in collodion positives.

Potassium oxalate, $K_2C_2O_4*H_2O$

Potassium oxalate is a white crystal or powder made by neutralizing oxalic acid with potassium carbonate. It is soluble in water 1:3 but not in alcohol. Potassium oxalate was used as an early developer for gelatin plates but is best known as the developer for platinum prints.

Printing frame

When negatives were contact printed onto printing-out papers the printing frame was a requisite. The printing frame was a sheet of glass set into a wood frame backed with a flat board held in place under tension. Early examples used for calotype negatives usually have a thicker plate of glass than those used for glass plate negatives. Progress was evaluated by removing the entire board. Registration was maintained by gluing two corners of the negative to the printing paper. Nearly all printing frames, however, feature a hinged or "split back" so that progress on half the print could be checked without having the negative and print fall out of register.

Print

The photographic print implies a positive image on paper made from a negative. These were also called proofs, a term borrowed from the engraving, etching, letterpress, and lithographic arts.

Printing-out, POP

Most of the photographic printing processes of the 19th century relied on printing-out technology. All of the printing-out papers produced a fully formed visible image by exposure of the paper to sunlight while in contact with a negative in a printing frame. The printing-out papers formed visible images by the reduction of silver chloride, with an excess of silver, to photolytic metallic silver. Once the image was printed, the excess silver was removed by washing the print in a very dilute sodium chloride solution. The print could then be toned in gold chloride, fixed in hypo, and washed. Salt prints made before 1850 were seldom if ever toned. All albumen prints, however, were toned with gold. Although the acronym POP was originally coined by the Ilford Company in 1891 for their brand of gelatin chloride papers, it has become a term applied to all printing-out papers.

Promenade

Promenade is a photographic print and mounting format introduced late in the 19th century. The promenade card was produced in some size variants but a typical example would feature a mount that measured 8-1/4 × 4 inches with the actual print cut somewhat smaller. A petite version called the promenade midget measured around 3-1/8 × 1-5/8 inches. The promenade formats were never as commercially successful as the carte de visite or cabinet card.

Pyrogallic acid, $C_6H_3(OH)_3$

The white powdery crystal was made by the superheating of gallic acid. Pyrogallic acid, popularly known as pyro, is one of the earliest developers and its use has spanned three centuries. It was first used in an acid state to physically develop wet collodion negatives. When silver bromide gelatin plates were adopted pyro was used again but in an alkaline state for chemical development. It was used throughout the 20th century and often chosen for the peculiar yellow stain it imparted to gelatin negatives.

Pyroxylin

Pyroxylin is one of the many synonyms for nitrated cotton. *See* Cellulose Nitrate.

Q
Quarter plate

A photographic size loosely based on the whole plate introduced by Daguerre. The quarter plate usually measured around 3-1/8 × 4-1/8 inches and was a popular size for cased images such as the daguerreotype, ambrotype, ferrotype, and opalotype. It was also the most popular plate size for wet collodion negatives taken for the purpose of making cartes de visite prints.

QS

The letters QS mean "quantity sufficient" and appear in formulas from many of the 19th century photographic method books and journals. It also means as needed. On occasion not all of the constituents of a formula are required right away such as the alcohol surfactant in ferrous sulfate developer used in the collodion process. Alcohol was added to the developer (as needed, QS) if the fluid did not flow easily across the collodion film, the result of an overworked silver bath.

R

Redevelopment

When negatives contained all the necessary visual information but lacked sufficient density for printing this defect could be corrected by a second development before or after fixing. Fixed and washed plates were usually made sensitive again by a treatment with tincture of iodine and exposed to light prior to redevelopment. Acidic solutions of pyrogallic acid or ferrous sulfate were used to develop collodion plates. The physical development was made possible by the addition of some excess silver nitrate.

Reducing/reduction

These terms are often confused with two different concepts and must be used in context for a full understanding. Reducing usually implies the removal of the metallic silver image, such as with chemical reducing with Farmer's reducer or shaving away the density of a gelatin plate with a knife or abrasive. Reduction is a scientific term used in photography to describe the action of a silver halide such as silver iodide converting back to a solid metallic state. A more accurate term for a developer used in photography is reducing agent. When a photographic plate displays some fog in the clear areas, it could be accurately referred to as non-image reduction.

Reflecting screen

One of the most important pieces of apparatus in the 19th century skylight studio was the reflecting screen used to add light where needed on the subject. Screens were made by stretching a piece of cloth over a wood frame and then painting it white. Screens could also be made by painting or covering thin wood frames with metal foil. In both cases reflecting screens were usually fitted to a set of casters to allow easy manipulation in the studio.

Relievo

In an effort to make the ambrotype "life like" this technique was applied to give the collodion image some relief. The portrait was taken against a dark background on clear glass but instead of backing the entire image with black varnish the backing was carefully applied to the subject only. The other option was to scrape away the background of the primary image so that there was clear glass. A piece of white card stock was then placed behind the image so that a shadow that would fall upon the backing and give the impression of physicality. Other backing options were using a second sheet of glass coated with collodion, exposed completely and developed, or a second ambrotype of a landscape or interior image.

Rembrandt lighting

This style of lighting the subject is loosely inspired by the paintings of the artist Rembrandt. The subject was lit from behind and the face positioned to reveal just enough detail in the shadows by the use of a reflecting screen. This style of lighting was introduced in the 1860s with much ridicule from the general public. Rembrandt lighting was revisited late in the century and remained a popular lighting option in the more sophisticated portrait studios for the next twenty years.

Repeating back

The most important element of a multiplying camera, the repeating back, allowed the plate holder to move from side to side so that the subject could be photographed more than once on the same plate. *See* Camera, Multiplying.

Restrainer

Chemical or physical restrainers were added to developer to retard the reduction of silver during development. Developers were required to be active enough to bring out the image, but controlled so that non-image reduction was held to a minimum. In the paper negative, albumen negative, and collodion processes the typical developer restrainer was acetic acid. Organic restrainers such as sugars and gelatin were also very effective restrainers for physical development as they functioned by increasing the viscosity of the developer. Potassium bromide was the most common restrainer for alkaline development of gelatin plates.

Re-touching

Photographic re-touching was used to correct the results of incomplete spectral sensitivity and poor technical manipulation or "improve" the general appearance of the subject. Coloring is related to re-touching but was solely an aesthetic application.

Calotypes were routinely re-touched with inks, watercolor, and graphite, particularly in the skies. Although rare, daguerreotypes could be re-touched with pigments that closely matched the image highlight color to soften wrinkles. Collodion landscape negatives usually show evidence of sky re-touching with water-soluble opaque or thin sheets of brown, yellow, black, or white paper colored black glued to the glass side of the plate. On occasion, tissue paper was glued to the glass side of the negative so that the photographer could add graphite, by pencil or powder, locally to restrain transmission of light.

The art of photographic re-touching, however, was fully realized with the collodion portrait negative. The generally non-actinic colors of human skin resulted in thin areas of the negative. Freckles, blemishes, wrinkles, and generally dark or reddish skin would appear many shades darker in the finished print. Nearly every 19th century portrait negative shows some sign of re-touching applied to coax the final image to appear normal.

Collodion negatives were first prepared by roughening the surface of the smooth varnish with an abrasive such as calcium carbonate or emery. They were then placed on the ground glass frame of a special wooden re-touching desk. This was usually made with a mirror on the bottom to reflect window light through the negative from below. A thin paneled wood shade was attached to the top of the desk to exclude extraneous light. Lead pencils were applied to the surface of

the roughened varnish in a series of many small lines and dots. These re-touching marks are very noticeable when looking at the faces of the subjects on cabinet card photographs.

Adding density to gelatin plates with graphite was identical to that of collodion plates with the exception that a matt drying varnish was applied to the emulsion to provide the proper tooth. One technique that evolved with the gelatin plate was etching. While not possible on a fragile collodion plate, density could actually be reduced gradually from gelatin plates by controlled scraping with a sharp scalpel or with abrasive powders.

Re-touching of prints was effected with a wide range of media throughout the 19th century. Watercolor, ink, graphite, charcoal, pastels, and by the mid-1880s airbrush, were all applied to a wide range of photographic prints. The crayon enlargement, made from the late 1850s to the end of the century, was particularly susceptible to the indelicate attacks by well-meaning but heavy-handed re-touchers.

Revolving back
There were three ways to change the vertical to horizontal orientation of the format in 19th century cameras: within the plate holder, by the orientation of the camera box, or by rotating or revolving the back of the camera. The revolving back improvement was introduced during the gelatin plate era.

Revolving background
In the 1870s special circular headgrounds, backgrounds made specifically for single portraits, were introduced that were painted with a gradient and could be rotated. Revolving backgrounds were not made to spin during the exposure as might be assumed. The dark colored portions of the ground could then be positioned to juxtapose with the side of the face that was lit and vice versa.

Ripening
There were certain solutions used in 19th century photography that required some settling or ripening time before they could be used to the best advantage. In the collodion process, both the salted collodion and the silver nitrate bath worked best when ripened. Some gold toning baths required ripening. Ripening by heat and time was the most common technique to increase grain size and therefore sensitivity when making gelatin bromide emulsions.

Rocking dish
Although not particularly popular in the 19th century, the rocking dish was introduced for the prolonged development of gelatin plates. One of the biggest problems in the processing of these early gelatin plates was frilling of the gelatin emulsion which was made worse by excessive agitation.

Roll holder
The detachable box that acted as a flexible film transport system in the Eastman-Walker patent was called a roll holder. *See* Film.

Roller squeegee
Also known as a brayer, the roller squeegee was used for smoothing photographic prints onto the mount after the starch paste was applied. These were usually made with an iron frame, a wooden handle, and a rubber-covered roller.

Rolling press
Before the introduction of the burnisher in the 1870s, most mounted albumen plain prints were finished by running the prints through a roller press. The roller press was similar to a heavy etching press, but mounted prints did not require the expensive felts used for etching. If a gloss was required the print could also be placed in contact with a sheet of polished metal when rolled.

Rottenstone
Also known as tripoli, rottenstone is a mineral ground to a fine abrasive powder. It was used for cleaning and polishing daguerreotype plates; glass plates prior to coating albumen, collodion, or gelatin; and for cleaning laboratory glassware.

Rouge
A very fine abrasive made from red iron oxide. Rouge or carbon black were the finest abrasives used to polish daguerreotype plates prior to fuming. This final polishing medium was usually applied by first dusting small amounts onto a cloth or leather covered buff.

Rubber cement
Unlike water-based adhesives, rubber cement, made by dissolving natural rubber in benzol, did not cockle the mounted photograph. Hailed as a miracle adhesive in the mid-19th century, natural rubber adhesives were ineffective and also discolored the print.

Ruby glass
Ruby glass was the name of the dark stained glass used for making high end direct positive collodion images, generically called ambrotypes. The name implies that the glass color was red, though most examples are actually a deep wine color. When referred to as a support for ambrotypes, the term *ruby glass* was also loosely applied to several other dark colors such as deep blue, violet, and even an amber brown.

Ruby light
A reference to the red glass filter often used, a ruby light is another term for safelight or darkroom light. Ruby lights were also fitted with amber-colored glass.

S
Safe edge
When making a carbon print it was necessary to create a so-called safe edge around the perimeter of the negative so

the edge of the print would not frill or be damaged during the transfer process. The safe edge was usually a paper mask or opaque medium applied to the collodion or emulsion side of the negative.

Safelight

A darkroom safelight was seldom used until the advent of the gelatin plate. Early examples were adapted from conventional oil lamps. Most daguerreotype and collodion era darkrooms were so placed to take advantage of an outside window or a window looking into the skylight studio and were covered with non-actinic paper, fabric or glass.

When gelatin plates became popular in the 1880s many photographers, both professional and amateur, chose to develop their plates in the evening. Processing after sunset required some type of artificial safelight. By the mid-1880s the photographic supply catalogs offered several different designs illuminated by candle, oil, gas, and even direct current electricity. The most famous of these safelights was John Carbutt's Multum in Parvo Dry Plate Lantern, which featured ruby, amber, and diffused opal light for negative evaluation.

Salt

The popular name for sodium chloride salt was the first halide used in combination with silver. Every early experimenter in photosensitive materials used salt at some point. W. H. F. Talbot discovered that when too high a proportion of salt was used in relationship with silver the paper became less sensitive establishing the means to stabilize salted paper prints. Dilute salt water was also used to remove excess silver from exposed silver chloride printing-out paper.

The word salt can refer to silver nitrate crystals or a halide salt such as chloride, bromide, or iodide. When iodide was added to collodion it was known as iodized or salted collodion. Salted paper print refers to a plain silver chloride print without any albumen, collodion, or gelatin binder fixed in sodium thiosulfate.

Saltpetre

See Potassium Nitrate.

Sandarac

Several natural gums were used to make photographic varnishes. Gum sandarac, also known as gum juniper, is a yellowish resinous tear harvested from the bark of the *Callitris quadrivalvis* tree. It was used as incense but also dissolves easily in strong alcohol making it ideal for photographic purposes. Sandarac varnish was always made with an essential oil such as lavender oil to retard drying.

Sel d'or, $Au_2S_2O_3$

The first gold toning solutions called sel d'or or gold hyposulfite were made by combining the gold chloride with sodium thiosulfate. Sel d'or was first suggested by Hippolyte Fizeau for gilding daguerreotype plates. It was later used for toning salted paper and albumen prints although was eventually phased out by the late 1850s in preference to a separate gold toning bath prior to fixing.

Self-masking

Printing-out papers such as salted paper, albumen, collodio-chloride, and gelatin chloride rely on an effect called self-masking. Thin areas of the negative allow daylight to print out visible photolytic silver directly on the surface of the paper. This initial reduction of silver halide back to metallic silver acts as a mask holding back the light and retarding further printing out in those areas.

Self-portrait

Also known as an auto-portrait, the self-portrait was a common subject when learning photography. The photosensitive materials in the 19th century were slow enough that the photographer could easily uncap the lens and sit for an exposure without the aid of an assistant. Self-portraits were often made when testing a new lens or formula when there was no subject to press into service.

Self-toning paper

At the end of the 19th century some commercial collodion and gelatin printing-out papers were made available with the toner in the emulsion. Although they rarely achieved the tonality of a traditional gold toned print, they were a cooler brown color that would have been possible without toning altogether.

Sensitometry

Sensitometry is the complex process of determining and quantifying the response of photographic materials to light (and other radiation) and processing. Begun in the late 19th century by Vero Driffield and Ferdinand Hurter, the initial aim was to develop test methods that would enable comparison of different films with respect to their sensitivity as expressed by emulsion speed values.

Sensitizer

Many natural substances are sensitive to light or energy and most do not require a separate sensitizer. In the silver processes of the 19th century the sensitizer was silver nitrate when combined with either organic matter or a halide. Chromium salts such as ammonium or potassium bichromate were used to sensitize colloids in the gum and carbon processes.

Shellac

Shellac is made from a substance known as lacca or lac, which is obtained from trees when infested by the insect *coccus* (*Tachardia*) *lacca* that exudes this resinous substance over its entire body. Shellac is made with lac combined with colophony. It is soluble in alcohol and was used as a finish for many wood objects by brushing or French polish. Shellac was also used to make photographic varnishes.

Shutter

The very first camera shutter looked very much like its namesake. The plate holder on the Giroux camera of 1839 had two hinged wood panels that opened into the interior of the camera like barn doors. The process was so slow that this system worked well enough. As the sensitivity of photographic materials was improved it was more effective to remove the lens cap for the duration of the exposure.

Shutters were introduced late in the collodion era. These were usually a flap or door type shutter resembling the ones used by Giroux in 1839 or the drop shutter. Flap shutters could be purchased with either one or two doors and like the lens cap were used primarily for time exposures. The flap shutter could be operated by controlling a lever or a pneumatic piston, which was connected to a rubber bulb with rubber tubing. The drop shutter featured a tall thin panel of wood, metal, or hard rubber with a hole that fell through a second grooved frame attached to the end of the lens. By definition the drop was designed for instantaneous exposures, though some were fitted for time exposures as well. The drop was the first shutter used for gelatin plates and as the sensitivity of the plate increased throughout the 1880s the shutter speed was eventually made faster by the addition of a spring or rubber band.

By the mid-1880s leaf type shutters were introduced. These typically featured one, two, or more thin sheets of metal or hard rubber that slid across an opening in a metal framework. The release of these plates was controlled with a spring or a piston that was actuated by a rubber bulb. The exposure times on most of these shutters were either instantaneous, time, or bulb. The difference between bulb and time was that time required the bulb to be depressed once for opening and a second time for closing. The bulb setting meant that the shutter was open as long as the bulb was depressed. The Eclipse Shutter patented by Cyrus Prosch in 1885 was a leaf type shutter that featured variable exposures by adjusting a spring on a notched bar. Durations of from 1/2 second to 1/200 were possible.

Fairly accurate instantaneous exposures of less than a second were realized when the iris diaphragm shutter was introduced by Dallmeyer in the late 1880s. This featured a design that dated back to one of Niépce's cameras. The iris diaphragm was set between the front and back elements of the lens and worked like the iris of an eye. The iris was made with many thin leaves of metal or hard rubber that opened and closed at exposures of time, bulb, and fractions of a second. Shutters of this type usually featured a second set iris diaphragm for controlling the aperture.

By the end of the century various leaf and diaphragm type shutters were used for fast work though the lens cap was still the preferred exposure control for slow landscape and architecture negatives.

Silver, Ag

This malleable white metal is found as argentite (Ag_2S) and horn silver (AgCl) or in lead and copper ore. Copper plates coated with a thin layer of elemental silver and fumed with iodine were used by Niépce and Daguerre. Aside from the heliograph and physautotype, silver halide compounds were the basis of all photographic processes used in the camera and most of the printing processes during the 19th century.

Silver bath/silver solution

The silver bath was any solution of silver nitrate mixed with water. The term was applied to sensitizing solutions used in the paper negative, albumen on glass, collodion, and any of the hand-coated silver printing processes. The vessel holding the silver solution for sensitizing paltes and papers was also called the silver bath. The earliest form of silver bath was a tray or dish. These were used for the paper negative and albumen on glass processes. By the collodion era most photographers preferred a vertical tank made from ceramic, hard rubber, wood, or glass, which was also called a glass bath. The glass type vertical baths were always encased in a wooden box with a lid and some means to tilt the bath back at an angle.

Silver bromide, AgBr

A yellowish powder made by the combination of any soluble bromide with silver nitrate. Silver bromide could also be formed by exposing metallic silver to the fumes of bromine as in the daguerreotype process. It is soluble in sodium thiosulfate, potassium bromide, and potassium cyanide solutions. Silver bromides were *secondary* halides for the paper negative processes, albumen negative process, and wet or preserved collodion processes. Silver bromides were the *primary* halides for the silver bromide collodion emulsion negative and the silver bromide gelatin emulsion processes. Silver bromide is the most photosensitive silver halide.

Silver chloride, AgCl

Found in nature as *horn silver*, this white powder is made by the combination of a soluble chloride and silver nitrate. Silver bromide could also be formed by exposing metallic silver to the fumes of bromine as in the daguerreotype process. It is soluble in sodium thiosulfate, potassium bromide solutions, and strong ammonia. This silver halide was the first to be observed to darken spontaneously by exposure to light. Silver chloride formed the basis of the photogenic drawing, salted paper print, albumen print, collodion-chloride POP, gelatin chloride POP, and gaslight paper.

Silver halide

One of the least understood and pivotal concepts of photography is knowing the difference between a halogen and a halide. The photographic halogens are the elements chlorine, bromine, and iodine from the periodic table. Halides are a combination of one of these halogens with an elemental metal like potassium, cadmium, ammonium, or sodium; for example, when iodine is combined with potassium it is called *potassium iodide*. The halides are chlorides, bromides, and iodides. A *silver* halide can be made by combining either a halogen or a halide with elemental silver or silver nitrate.

Aside from the daguerreotype plate that was sensitized by the fumes of halogens (elemental iodine, chlorine and bromine), all of the other silver-based photosensitive materials made in the 19th century were made by combining water-soluble halides with silver nitrate.

Silver iodide, AgI

Silver iodide is a yellow powder formed by the combination of a soluble iodide combined with silver nitrate. Silver iodide could also be formed by exposing metallic silver to the fumes of bromine as in the daguerreotype process. This was the primary halide used for all of the 19th century camera processes until the introduction of the silver bromide gelatin plate. With the exception of the daguerreotype, all silver iodide processes relied on physical development using a reducing agent such as gallic acid, pyrogallic acid, or ferrous sulfate, an acid restrainer, and excess silver.

Silver nitrate, $AgNO_3$

The basis of nearly all photographic silver halides with the exception of the daguerreotype process, silver nitrate is a heavy white crystal made by dissolving elemental silver in nitric acid followed by evaporation. It is soluble in water, ether, and glycerin. Silver nitrate is not sensitive to light, but when combined with an organic material, a halogen, or a halide it will reduce back to a metallic state when exposed to light.

Silver stains

Silver stains are an occupational hazard for anyone who sensitizes their own photographic materials. Whenever silver nitrate makes contact with organic matter it darkens when exposed to light. With the exception of the daguerreotypist, the hands and clothing of 19th century photographers were frequently stained black, giving rise to some calling photography the black art. Some 19th century photographic journals suggested removing stains by wetting the hands and rubbing them with chips of potassium cyanide. This is not recommended by this author.

Silver sulfide, Ag_2S

Silver sulfide is a brownish back powder formed by the combination of an alkaline sulfide with silver. It is a very stable compound made when toning silver-based images in sulfides. It is soluble in sulfuric and nitric acids but insoluble in water and alcohol.

Simpsontype process

George Wharton Simpson, editor of the British publication *The Photographic News*, introduced a collodion-chloride printing-out emulsion formula in 1864. The emulsion could be poured onto porcelain paper, opal glass, or clear glass. This was essentially the same collodion-chloride emulsion used to make leptographic and aristotype papers.

Single transfer

To preserve the continuous gradation possible by the carbon process it was necessary to either expose the carbon tissue from the support side or transfer the exposed side of the tissue to another support. In 1860 Fargier obtained a French patent for a technique used to remove the exposed dichromated gelatin from the primary support by coating it with a film of collodion. The soluble gelatin was then washed away and the image transferred to a secondary support. This technique never become popular. The term single transfer is most associated with English photographer Joseph Wilson Swan who, a few years later, invented the technique of transferring the image by squeegeeing the exposed and washed carbon tissue onto a wet second paper support coated with hardened gelatin. The tissue and secondary support package was then placed in hot water to dissolve soluble gelatin. This allowed the tissue to be removed for the remainder of the processing. The single transfer did leave the image reversed, a defect that was corrected by a second transfer.

Siphon

The siphon was a useful device used for transferring fluid from one vessel to another without disturbing sediment. It was also used to drain large vessels like silver nitrate baths that were difficult to handle otherwise. In the most elementary form the siphon was simply a length of hose. One end was placed into the fluid being drained and slight suction was applied to the other end until fluid traveled into the hose after which it was placed into a receiving vessel set at a lower level than the first.

Sixth plate

The sixth plate measuring approximately 2-5/8 \times 3-1/4 inches was the most popular cased image format for daguerreotypes, ambrotypes, melainotypes, ferrotypes, and pannotypes. It was small enough to carry in the pocket and when opened fit easily in the hand.

Sky negative

Special negatives for the purpose of combination printing in skies were made on days when the white clouds were strong and the sky was pink. The pink color was not actinic, which allowed the difference of the clouds and the sky to be recorded on blue-sensitive plates.

Skylight

A large glass window or series of glass windows so positioned to illuminate an interior from above. The individual glass panes were called lites. Rather than using wooden frames throughout the individual sheets were usually glazed into vertical supports with the lower lites slightly overlapping the next higher lite, thus allowing water to drain when it rained. Photographic studies were often built with both sky and side lights. Roller blinds were used to control the amount and direction of light falling on the subject.

Slip-in mount

Bon ton size tintypes were originally offered in a paper window mount that required the tintypist to glue a second piece of paper over the back of the plate and the mat to keep the image in place. The slip-in mount required no glue to mount the plate. It was made from two pieces of paper; the first was the window mat with a folding cover, the second piece was perimeter glued

behind the mat along three edges. The opening faced the fold between the mat and the cover. Tintypes sold in slip-in mounts usually had the two corners on one side clipped to allow them to slide into the mount more easily.

Sodium, Na

This soft silvery metal occurring as chlorine in seawater was first isolated as an element by Humphry Davy in 1807. Sodium is one of the essential elements required by living organisms and it is highly reactive oxidizing in air and reacting with water. Sodium chloride was the first halide to be combined with silver for photographic purposes. Many of the sodium compounds were also used in gold toning baths. Some of them are included here.

Sodium acetate, $NaC_2H_3O_2*3H_2O$

This colorless crystal, also known as sodium ethanoate or acetate of soda, was made by the reaction of acetic acid with sodium carbonate. It is soluble in water but less so in alcohol. Sodium acetate was used as a pH modifier for toning baths.

Sodium carbonate, $Na_2CO_3*10H_2O$

Also known as washing soda or carbonate of soda, sodium carbonate is a white crystal or powder made by converting salt into sodium sulfate, which was followed by roasting with limestone and coal. It is soluble in water and glycerin but not alcohol. Sodium carbonate was used as a pH modifier in toning baths and as the primary alkali in developers used for gelatin emulsions.

Sodium chloride, NaCl

Commonly known as table salt, sodium chloride is found as the mineral halite and in brines and seawater. Sodium chloride is soluble in water but less so in alcohol. It was the first halide to be combined with silver nitrate and was also used by L. J. M. Daguerre and W. H. F. Talbot as a stabilizer before fixing with hypo was adopted.

Sodium citrate, $Na_3C_6H_5O_7*2H_2O$

Also known as citrate of soda, the white crystals or granular powder was obtained by neutralizing citric acid with sodium carbonate. It is soluble in water but less so in alcohol. Sodium citrate was used as a preservative in albumen papers.

Sodium sulfite (sulfite), $Na_2SO_3*7H_2O$ (in crystal form)

These white crystals were prepared by passing sulfurous gas over moist sodium carbonate. Sodium sulfite is soluble in water but less so in alcohol. It was used as a preservative for alkaline developers and as a hypo clearing agent in photographic printing.

Sodium sulfide, Na_2S

These yellow flakes were made by fusing sodium carbonate with sulfur. Soluble in water but less so in alcohol, sodium sulfide was lovingly called "stink" by those who used it for toning prints or intensifying negatives because of its sulfurous smell.

Sodium thiosulfate (thiosulfate), $Na_2S_2O_3*5H_2O$

Known simply as "hypo," an abbreviated form of the incorrect form hyposulfite, this white crystal was made by boiling calcium thiosulfate with sodium sulfate. It is soluble in water and oil of turpentine but not in alcohol. The property of sodium thiosulfate to dissolve silver halides was discovered in 1819 by Sir John Herschel and was probably first used to fix photographic images by L. J. M. Daguerre. After Daguerre published its use in his 1839 manual W. H. F. Talbot finally used it to fix calotype negatives and silver chloride prints, although he continued to stabilize them with potassium iodide and sodium chloride presumably for the variety of colors possible. Sodium thiosulfate was the primary fixing agent throughout the 19th century and is still used today.

Solar enlarger

Equally known as the solar camera, this apparatus introduced in the late 1850s was simply an enlarged version of a solar microscope invented in the 18th century. Both instruments were fitted with an adjustable mirror, a condensing lens, a stage, and a projecting lens. Both the solar microscope and the solar camera were made to be attached to a window so that the adjustable mirror was on the exterior to reflect the rays of the sun through the condenser. The amplified light then passed through the specimen or negative in the stage and out the projection lens onto a screen or easel holding sensitized paper. The main difference between the two besides the size was that the solar enlarger was made for the projection of negatives upon photosensitive paper. Because of this a lens corrected for chromatic aberration was needed.

The solar camera, patented by Woodward in 1859, was a large box designed to fit in a window and project into a darkened room. It featured a tilting and pivoting mirror manipulated within the interior of the room. The negative image was projected onto printing-out paper affixed to board on an easel. Due to the rotation of the earth, the mirror required adjustments roughly every two minutes to keep the light centered on the convex condenser. Depending on the degree of enlargement the exposure required to make a fully formed image on silver chloride printing-out papers could take as much as two to three hours. Developed-out salted paper technology cut exposure times to minutes, but the technique was not often used.

Solar cameras were also made as freestanding devices. These did not need the reflecting mirror because the condensing lens could be directed toward the sun. Unlike the interior types the outdoor solar cameras required an enclosed projection chamber and a paper holder so that prepared paper could be safely brought from the darkroom to the camera and back. A small window allowed the operator to check the progress of printed-out images. This type was usually rolled out onto a flat rooftop on sunny days. Regardless of the type of solar enlarger the adjustments required to print out an image meant constant attention or the sun's rays would focus on the wooden interior of the camera causing a fire. A clockwork

device called a heliostat was available, which maintained the proper angle of a reflection mirror throughout the day. This device was very expensive. Solar enlarging was rarely done in the 19th century except by the largest urban studios or by specialty enlarging houses.

A later version of the solar enlarger used for developed-out silver bromide gelatin emulsion papers was manufactured in the early 1890s. These four-sided tapering boxes featured an upper removable holder for the negative and a lower removable holder for the enlarging paper with an enlarging lens situated in-between. The enlarger was positioned in the studio under a north skylight to receive the even light of a cloudless sky. The dark slide of the paper holder was removed exposing the paper to the interior of the camera. The exposure could then be made by removing the dark slide from the negative holder for the predetermined amount of time. Horizontal magic lantern style enlargers were introduced for developing-out papers around the same time and became the more popular alternative.

Specific gravity

Specific gravity is defined as the weight of a volume of a substance as compared to the weight of an equal volume of water. The metric system is designed to make the calculation of specific gravity simple in that the weight of water (at standard temperature and pressure) is defined to be 1 kg/l or 1 g/ml (cubic centimeter). The specific gravity of a liquid (and hence in many cases the concentration of a dissolved substance) can be measured using a hydrometer.

Spectral sensitization (also optical sensitization)

A chemical treatment that increases the response of silver halide crystals of a photographic emulsion to wavelengths of light longer than the natural sensitivity. Spectral sensitization is accomplished by organic dyes that absorb to the surface of the silver halide crystals. The dye becomes excited by the absorption of light energy and transfers the energy to the crystal, forming a latent image. The chloride, bromide, or iodide salts of silver are sensitive to light but respond only to violet, blue, and ultraviolet radiation. These wavelengths of radiation have sufficient energy to eject a photoelectron from the halide ion of the silver salts of the photographic emulsion layer. Green, yellow, orange, and red light have less energy, so silver salts have almost no response to these colors of light. Photographic films and papers made with pristine silver halides are color blind to most of the visual spectrum.

A chance observation by Hermann Vogel in 1873 provided the clue for increasing the limited spectral response. While testing dry collodion plates, which the manufacturer had secretly treated with a yellow dye to reduce halation, Vogel noted that the plates were green sensitive. After some clever detective work, Vogel established that the yellow dye was responsible for the extended spectral sensitivity. This major advance was rejected by some of the noted photographic

authorities who were unable to sensitize the gelatin dry plates, which contained less iodide than the collodion plates.

The first spectral sensitizer for green light was eosin, a dye discovered by J. Waterhouse in 1875, but the related dye, erythrosin, was the first used commercially. Such dyed photographic materials were said to be orthochromatic (*ortho-*, meaning correct); that is, sensitive to ultraviolet, violet, blue, and green light but still insensitive to red light. In 1884 Vogel found that a blue dye, cyanine, was a weak sensitizer for red light, but there would be many human lifetimes of work and devotion before suitable dye sensitizers would make practical panchromatic sensitization (*pan-*, meaning all) possible for all colors.

Spike oil
See Lavender Oil.

Spirit photography

Spirit photography can be considered as an early form of photomontage, where two or more images are superimposed to form a third image that is a composite. It consisted of photographs made by double exposing an image so that one of the images in the composite was thin and ghost-like, often an image of the spirit of a deceased loved one.

This movement began as early as 1861 by a Boston photographer named William Mumler and lasted for a number of years. Mumler claimed that while he was taking a picture of himself in a chair, an unexpected second image appeared on the developed photographic plate. The image was of a little girl apparently sitting in his lap. He identified her as a young relative who had died some 12 years earlier. This created considerable interest with the townspeople, and he continued to perform similar feats on a number of occasions, claiming that the extra figures in the photographs were actually images of spirit forms present in his studio. These forms were not visible to the human eye but were visible to the photographic plates in his camera. For a while this amazing phenomenon was accepted until suspicion arose when it was discovered that the spirit images were all of living people. Mumler was accused of photographic fraud and died in poverty in 1884. His photographs showed evidence of having been produced by double exposure.

Mumler was often imitated by other photographers who were often professionals from the United States and Britain. Almost without exception, these self-styled spirit photographers were convicted of fraud, and in many instances they even confessed to trickery and deception.

Stanhope

In 1859 M. Prudent Rene Patrice Dagron introduced this novelty microphotograph at the International Exhibition in Paris. The 3-mm collodion microphotographs were produced with a multi-lens camera onto a sheet of very thin glass. Individual images were cut from the glass with a diamond and glued to the end of a miniature lens. The lens design was

invented a half century earlier by Charles, the Third Earl of Stanhope, the name of whom was adopted for both the lens and subsequently the photographic toy. Stanhopes were made throughout the 19th century in a wide variety of objects and styles. *See* Microphotograph.

Stereo photography

The simulation of three-dimensional effects by making two photographs of the same subject from slightly different positions that represent the separation of the eyes, and presenting the images so that each eye sees the appropriate image, but with the images superimposed is stereo photography.

Stereo photographic images were first made with the daguerreotype process using a single camera to make two separate images. In the collodion era stereo cameras with two lenses were used to make wet plate negatives in the hundreds of thousands for the production of stereo transparencies on glass, stereographs, on albumen paper, and stereo tissues. Of the three variants the stereograph was the most popular probably because it was less expensive. Stereographs continued to be immensely popular throughout the 19th century and were made by the prevailing printing processes of each era.

Stereo transparencies were the gold standard of stereo imagery having an effect and depth of tone unequaled by any other format. These were first produced by the Langenheim brothers using the albumen on glass process and were available hand-tinted with transparent dyes. Like the stereograph they were made throughout the 19th century and were produced by the wet collodion and eventually the gelatin emulsion process.

Stereo tissues were a French specialty available in the mid-19th century. These novelty cards were mounted stereo albumen prints on skeletal pasteboard mounts that allowed the viewing of the images by either reflected or transmitted light. A second piece of translucent paper positioned behind each print was painted with bright colors that were only visible when viewed with illumination placed behind the card. Additional touches such as coloring on the surface of the prints and pinpricks that allowed points of white light to give the impression of street lights made the effect more dramatic.

Stereoscope

Stereographs were viewed with a stereoscope. These viewers were manufactured in both hand-held and table top styles throughout the 19th century. The table top variants offered from the 1850s to the 1880s were usually made with a pair of continuous cloth or chain loupes fitted with metal frames to hold a large number of images. A knob on the side of the viewer turned the internal mechanism so that individual cards or transparencies could be viewed.

Strontium, Sr

This soft, yellowish, metallic element was isolated by Sir Humphry Davy in 1808. It was found in the minerals strontianite and celestine. The strontium halides were used in the making of collodion emulsions.

Strontium bromide, $SrBr_2*6H_2O$

Strontium bromide are colorless crystals made by neutralizing hydrobromic acid with strontium hydrate. The crystals are soluble in water but less so in alcohol. Strontium bromide was occasionally used to increase contrast in collodion emulsions.

Strontium chloride, $SrCl_2*6H_2O$

Strontium chloride are white needles made by fusing calcium chloride with sodium carbonate. It is soluble in water and alcohol. Strontium chloride was a popular halide for making collodion-chloride printing-out emulsions.

Strontium iodide, SrI_2*6H_2O

Strontium iodide is a yellowish granular powder made by treating strontium carbonate with hydriodic acid. It is soluble in water, alcohol, and ether. Strontium iodide was occasionally used to increase contrast in collodion emulsions.

Studio

The earliest photographic studios were actually outside to take advantage of the strong natural sunlight. Even by the mid-1840s some daguerreotypists made portraits with subjects sitting on open balconies accessorized to appear indoors. When a large window was available daguerreotypists moved indoors and lit their subjects by sidelight and reflector. Skylights were always preferred, particularly when lit by north light, which gave an even illumination throughout the day.

By the collodion era the skylight studio was well established. Most city studios were situated on the top floor of a commercial building. These walk-up studios were usually accessible from the street through a modest door that opened up to a small stairway. Examples of the photographer's work were often displayed outside the entrance and the name of the establishment mounted on a signboard connected between the front of the building and the edge of the sidewalk or on the building itself. Studios in small towns were occasionally free-standing buildings built on ground level.

The complete studio included a reception area with examples of the photographer's work on the walls and displays of various mounting and framing options. There would also be a small dressing room with a mirror to adjust one's hair or clothing. From the reception room would be the entrance to the skylight room. This would be the largest room in the studio featuring a simple skylight, a large sidelight, a sidelight and skylight combination, or a single slant skylight that ran from the floor to the ceiling. Special roller curtains adjusted by long cords running through pulleys would be fitted to the skylight to adjust the illumination. The length of the studio would dictate the maximum numbers of subjects that could be photographed and the size of the negative that could be made. Re-touching was usually performed at a small desk set under the skylight or the brightest area.

Studio apparatus in the skylight room would include the portrait camera on a rolling studio stand, a large carpet, at least one background, several head rests, posing tables,

posing chairs, diffusers, and reflectors (Figure 2). The dark-room was often built into one of the corners of the skylight room. It usually featured a wooden sink lined with pitch, zinc, or lead and a safe window overlooking the skylight room or the outside. Water was supplied by cistern, water barrel, or plumbed when possible. Darkroom ventilation, though rarely addressed, was usually by a vertical shaft built with a light trap.

There was usually a small room with shelves for negative storage. A room with southern exposure and a large window was perfect for making prints by the printing-out processes. This type of studio and darkroom design remained the same throughout the later part of the 19th century, improved slightly by an occasional gas or electric light and better plumbing.

Subbing

Before coating glass for the wet collodion or gelatin emul-sion process a thin subbing solution was occasionally applied to create a better surface for adhesion. Albumen diluted as much as 1:40 was used as a subbing layer for collodion plates. Subbing was critical if plates were to be subjected to lengthy after processing or development with pyrogallic acid, which had a tendency to contract the collodion film causing peeling.

Gelatin plates were also subbed with albumen, dilute gelatin, or dilute collodion. The American paper roll film patented by Eastman and Walker relied on a sub layer of soluble gelatin before the sensitive silver bromide emulsion was applied. After processing the emulsion was transferred to a subbed glass plate and the soluble sub layer was dissolved to remove the paper support.

Subtractive color process

The various color assembly processes rely on subtractive color synthesis. The transparent subtractive colors of magenta, yellow, and cyan blue can be layered or assembled in pairs or by themselves to produce any color of the spectrum on materials viewed by reflective or transmitted light. *See* Color Photography.

Sulfuric acid, H_2SO_4

Also called oil of vitriol, this colorless oily liquid was made by roasting pyrites or sulfur in a lead furnace. Sulfuric acid was mixed with either nitric acid or potassium nitrate to treat cotton in the making of nitro cellulose. The nitro cellulose was then dissolved in ether and alcohol for making collodion.

Sulfur toning

See Toning.

Surfactant

Surfactants (surface-active agents or wetting agents) lower the surface tension of a liquid by reducing the cohesive forces that hold together the molecules of the liquid. These agents act in the interface between a liquid and a solid or between two liquids. Surfactants are important in the coating of photographic emulsions as well as in the solutions for their

processing. The 19th century term for surfactant was spreader. The most common spreader was alcohol and it was used as needed in developer for the wet collodion process and in gelatin emulsion making.

T
Talbotype process

When W. H. F. Talbot introduced the calotype in 1841 some felt the process should bear his name similar to the Daguerre-otype. Patent Talbotype paper was manufactured for the purpose of making paper negatives and Talbot did include a stamp on his prints bearing the word Talbotype, but the process was better known as simply the calotype. *See* Calotype.

Tailboard

When the bed upon which the camera box is connected extends from the back of the camera it was called the tailboard. Depending on the intended use of the camera the tailboard could be rigid, as was the case with most studio portrait cameras or folding, as applied to cameras meant to be taken into the field.

Tannic acid, $C_{76}H_{52}O_{46}$

Tannic acid is a powder extracted from gall nuts that is soluble in water but less so in alcohol. Tannic acid was used by Major Russell in the mid-1850s for the tannin process of preparing dry collodion plates. The collodion plate was coated and sensitized as usual but the excess silver was then washed completely from the surface. A solution of tannic acid was then poured on and off the plate and the collodion film allowed to dry completely in the dark. The tannin plate could be preserved for months prior to exposure. The exposed plate was developed in pyrogallic acid, citric acid, and silver nitrate to replace that which was washed off during the initial preparation. The exposures required for tannin plates were as much as five times longer than wet collo-dion plates, which made them suitable only for landscape work.

Taupenot's process

A dry collodion-albumen process introduced in 1855 by Dr. J. M. Taupenot. The collodion plate was prepared as in the tannin process above, but the washed plate was then coated with albumen and dried. The dry plate was then dipped into an acidified silver solution and washed and dried again. Devel-opment was identical as with the tannin plate.

Temperature

Temperature is a measure of the energy or heat present in a substance that considers primarily the molecular motion occurring in the substance. (*See* Absolute Temperature.) Temperature should be distinguished from energy or heat in that a given amount of energy input to two different substances will not necessarily raise the temperatures of the substances by the same amount. For example, a thermometer may read 20°C for a body of water and the surrounding air, but the water will feel much colder due to its greater ability to absorb heat from the body. The water and the air, however, will not exchange energy since they are the same temperature.

Tent

Tents were used by photographers to sensitize plates, transfer sensitized plates into plate holders, or process exposed plates. With the wet collodion process sensitizing, transfer into the plate holder and development was done on location using a tent or developing box. The term tent was used specifically to describe a chamber allowing at least the upper body of the photographer in safelight conditions. Naturally these could also be large walk-in tents. Safelight illumination was supplied by natural sunlight filtered through a yellow-orange, yellow-brown, or red filter. The developing box in contrast to the darkroom tent referred to a portable laboratory where only the hands were inserted into the processing chamber and manipulations viewed from the outside looking in through a safelight window. *See* Dark Room, Dark Tent.

Thermometer

The thermometer was an essential tool when developing daguerreotype plates. Mercury type glass thermometers were usually built into the developing box so that the daguerreotypist could maintain the chosen temperature of the mercury fumes. Although, the ambient temperature was a critical factor when using wet collodion plates, the actual temperature of the processing chemicals was seldom taken since sensitizing and development were by inspection and not by time. Ordinary and isochromatic gelatin plates were also developed by inspection. Thermometers came into use again when panchromatic plates, available after the turn of the century, could only be developed by time and temperature.

Tintype

Although first introduced in the 1850s as the ferrograph then the melainotype and finally the ferrotype, the popular slang term tintype quickly became the popular name for these direct positive collodion images on Japanned iron plates. Ironically there was seldom any tin used in making the iron support upon which the image was made. The reference seems to have been based on the cheap, tinny feel of the thin iron plates. Multiple images on a plate were frequently cut out from the sheet by the tintypist with snips. *See* Ferrotype.

Tinting

A more delicate form of coloring, tinting suggests the use of transparent or lightly applied colors. Daguerreotypes, ambrotypes, and ferrotypes were all tinted by dusting finely ground pigments onto the surface of the images with small brushes. Occasionally finely ground rosin was mixed with these pigments to improve adhesion, a benefit activated by gently breathing on the surface of the tinted area. Salted paper prints were tinted with inks and watercolor. Both watercolors and thinned oil colors were applied to albumen prints. Adhesion of watercolors to the albumen surface was improved by rubbing the surface with a solution of ox gall. Lantern slides and stereo transparencies were tinted with water-soluble dyes.

Toning

The daguerreotype was toned or gilded with a mixture of gold chloride and sodium thiosulfate called sel d'or. Toning improved the contrast of the fragile image and made it less prone to abrasion. Printed-out photographs made by the salt, albumen, collodion-chloride, and gelatin-chloride processes had an orange-brown image color due to the fine particles of photolytic silver. Developed-out photographs on the other hand had a cooler color based on a larger silver particle, the result of filamentary growth during development. Toning was applied to both types of prints for permanence but also to cool the warm tones of printed-out images and warm the cool tones of the developed-out prints. Gold chloride was the most common toning agent in the 19th century, although platinum, mercury, and sulfides were also used. Toning was also used to change the image color of negatives to provide spectral density.

Tracing paper

Tracing paper is thin paper treated with benzene or turpentine to make the cellulose fibers translucent. Re-touchers occasionally glued translucent tracing paper to the back of the glass negatives along the edges for the purpose restraining light during printing or increasing the density of large areas by applying graphite. The re-touching was made with pencils and powdered graphite.

Transfers

The transfer of a photographic image was introduced by Frederic Scott Archer as an integral part of the collodion process which was invented as an improvement to the calotype method. The image was made on a plate of glass but then transferred onto a sheet of paper for printing. In truth, the process as invented by Archer in 1851 made keeping an image on the plate somewhat difficult. Eventually Archer realized that a glass plate for each image was a better system because the glass support was perfectly clear and relatively flat. Some European expedition photographers in the mid-19th century transferred collodion images to paper supports as a means to reduce the weight of the materials, but the technique never became popular. The collodion transfer process would eventually be a common technique for graphic arts photography after the turn of the century. There were other transfer techniques used in the mid-19th century, the most common being the pannotype. *See* Pannotype.

Transparency

Typically a positive transparency or diapositive, these were positive photographic images on clear glass meant for viewing by transmitted light. Most positive transparencies from the 19th century were made from a negative by either intimate or near contact or by rephotographing the negative illuminated from behind. As an end product transparencies were made as lantern slides and stereo viewing and mounted in thin frames for hanging in the window. The first photographic transparencies were invented by the Langenheim brothers in 1848 using the hyalotype method. (*See* Glass Positives.) Interpositives were also positive transparencies made from a negative specifically

for the purpose of rephotographing a second generation for the production of duplicate or enlarged negatives.

Trimmer

Photographic prints were carefully trimmed before mounting on card stock. The most common tools for trimming were either a sharp penknife or a second-hand straight razor. These trimmers were used with a thick glass outside guide placed on the surface of the print to allow visualization of the image being trimmed. The Robinson Photograph Trimmer featured a special revolving rotary cutting disc in an iron handle. The internal cutting guide was a plate of steel with the shape cut out in the center. This guide was placed on the print and the rotary knife followed the internal edges while cutting the image to the proper size and shape. Substantial made die cut trimmers were also manufactured for cartes de visite, cabinet card, and stereo formats. These were heavy iron lever-operated trimmers designed for production work.

Tripod

From the Greek meaning three legs, the tripod was an essential tool when using slow photosensitive materials. Tripods were almost always made of wood and early versions were not adjustable featuring single shafts or legs resembling crutches. Improved designs from the middle of the 19th century featured retractable or folding legs, although these were not common until the dry plate era.

Attachment of the camera to the tripod was originally by laying the camera body onto a flat top with raised moldings around the perimeter. Eventually camera makers installed a threaded nut on the bottom of cameras to allow attachment by a single bolt, a system still in use today. The tripod is associated with outdoor work but could also be used indoors, although three- or four-legged examples used in the studio were typically called camera stands.

Tripoli

Tripoli is a fine abrasive for polishing and cleaning. *See* Rottenstone.

U

Ultraviolet rays

These are the rays that vibrate beyond our sense of vision on the high end of the spectrum between 10 and 400 nm. While they are invisible to our eyes ultraviolet rays have a strong effect on photosensitive materials. Unfortunately the glass in camera lenses, gelatin binders, and films absorb all but the longest ultraviolet rays.

Umbrella tent

Amateur photographers in the 1850s discovered that a large wooden umbrella frame made an ideal field darkroom when covered with layers of black and orange red cotton cloth. The safelight was often made by removing a square of the outer black cloth to allow two or three layers of the red cloth to filter out the actinic light.

Underexposure/underdevelopment

Like the effects of overexposure and overdevelopment, underexposure and underdevelopment should be discussed at the same time. Throughout the 19th century nearly all photographic manipulations could be performed by inspection under safelight conditions. This luxury allowed the photographer to see the effects of overexposure and follow the duration of development.

Underexposure

When photosensitive materials have not been given enough energy through exposure they are said to be underexposed. Underexposure was easily identified during the development under safelight. The image would come up slowly and only the highlights of the subject would be visible. The medium and dark shadow areas would not contain any of the visual information of the actual subject being photographed. Underexposed plates were routinely overdeveloped in a desperate attempt to retrieve information in the shadow areas. The result of overdeveloping an underexposed plate was usually high contrast caused by too much density in the highlights and clear areas in the shadows.

Underdevelopment

Underdevelopment was usually a defect of choice. Because development was carried on by safelight the photographer had complete control of this function. The effect of underdevelopment was a thin deposit of reduced silver lacking in density. Plates were usually underdeveloped when the exposure was too long in the camera. When the developer was applied during processing the highlight and shadow information of an image would flash up immediately. When plates were overexposed the photographer usually stopped development as soon as possible, an action that resulted in thin density and foggy plates with detail information in both the highlights and shadow areas. If the development was stopped in time, the photographer could redevelop the plate after fixing to either change the silver to a non-actinic color for spectral density or add additional metallic silver. *See* Intensification.

Uniform standard (US) system

This is a system of stop numbers proposed in 1881 by the Royal Photographic Society. Based on f/4 as the unit, a stop requiring 2× the exposure was marked 2; three times the exposure, 3; half the exposure, 1/2 and so on. The idea never was popular and was last used in the 1930s. Some enlarging lenses, however, were marked with numbers to indicate relative exposures which referred to the maximum aperture taken as 1, giving the series 1, 2, 4, 8, and 16.

Uranium, U

Uranium is a white radioactive metallic element found in pitch-blende ore, also known as uraninite. Uranyl chloride and uranyl nitrate are two uranium compounds used in photography.

Uranyl chloride, UO_2Cl_2

This element is a greenish yellow poisonous flake that was prepared by dissolving uranic oxide in hydrochloric acid. It is soluble in water and alcohol. Uranyl chloride was occasionally used as a halide for printing-out paper and added to chloride emulsions to increase contrast.

Uranyl nitrate, $UO_2(NO_3)_2*6H_2O$

This element is a yellow poisonous crystal made by dissolving uranic oxide in nitric acid. It is soluble in water, alcohol, and ether. First suggested by C. J. Burnett in 1855, a uranyl nitrate printing process was patented by Niépce de St. Victor in 1858. The paper was floated on a uranyl nitrate solution and dried in the dark. The paper was exposed under a negative in the sun until a faint image appeared. The image was developed to completion by floating the paper on a solution of silver nitrate or gold chloride followed by washing. A process patented in 1864 by Jacob Wothly called for adding uranyl nitrate and silver to collodion, which was then applied to paper. The Wothlytype was a printing-out process.

Uranyl nitrate was used in printing-out emulsions and with potassium ferricyanide for toning prints and intensifying negatives. It was also used with silver nitrate for making uranium/silver gaslight papers.

Union case

One of the first large-scale commercial uses of thermoplastic was the Union Case introduced in the mid-1850s. These were manufactured for the protection and display of daguerreotypes, ambrotypes, and melainotypes. The term refers to the union of two materials; fine sawdust, pigment and shellac. This paste was pressed in iron molds under pressure and heat to produce a wide variety of products including frames and cases for the photographic trade.

V

Varnish

The asphalt solution used by Nicéphore Niépce has often been referred to as a varnish, though the most common use of the term in photography is the gum-based coatings used to protect photographic plates and prints. Varnishes made by dissolving gums in strong alcohol were first used to protect daguerreotypes. Paper prints were varnished to protect them from the atmosphere and to improve the tonality. Varnishes made with gum arabic, gum sandarac, and shellac were used.

In the collodion process a protective varnish was a requisite. The collodion surface was very fragile and prone to both abrasion and deterioration by exposure to the atmosphere. Unless there was a compelling reason to the contrary, all collodion negatives were varnished. Collodion positives on glass and early ferrotypes were always cased or framed and for this reason they can be found unvarnished because the photographer decided to leave the image a brighter color. When ferrotypes were offered in paper mounts they were susceptible to abrasion so they were varnished. Collodion images were usually varnished with sandarac and shellac varnishes though on occasion, water-based gum varnishes were applied to collodion negatives.

Gelatin emulsion negatives did not require varnishing, but early examples were often varnished until the practice was seen as unnecessary. The exception to this was when pencil re-touching was required, and for this a special mastic varnish was applied that would dry with a matt texture. *See* Re-touching.

Glass plate negatives of both the collodion and gelatin processes can also be found with a light yellow varnish applied to the glass side of the plate for the purpose of absorbing blue light when printing. This would retard the printing and help to increase contrast in the final print.

Ventilation

The daguerreotype, paper negative, and collodion processes required either dangerous or noxious chemicals for processing. Those who did these processes were well aware that some ventilation was preferable to none at all, although very few darkrooms were equipped to deal with the problem. There were two styles of ventilators, both of which were usually made on site by the photographer. The most common was a series of holes drilled on the bottom of a door or an outside wall covered with a wooden light trap. The other style was a wooden shaft with holes on each end resembling a child's periscope. The shaft-type ventilator was mounted in the ceiling of the darkroom and was exposed to the outside roof. A secondary door or wall vent allowed air to circulate within the room.

Victoria card

The Victoria card was a 19th century photographic print format. The print measured 3 × 4-1/4 inches and was pasted upon a 3-1/2 × 5 inch mount.

Vignette

One of the most popular printing techniques of the 19th century, the vignette was a style of image that featured gradual fading of the subject on the outer edges until it matched the background. There were both dark and light vignettes. Dark vignettes were made by photographing a subject against a dark background or in a darkened hall. The softening of the subject from the shoulders down was done by placing a serrated vignetting mask inside the camera which cast a soft shadow on the negative, ambrotype, or ferrotype. Light vignettes were more popular and they were made by photographing the subject against a white background. A white serrated vignetting mask was set in front of the lens to soften the subject from the shoulders down. A more common approach was to use a vignetter during the printing process. Vignetting masks were made of pasteboard with an oval hole positioned over the negative and tacked over the printing frame. These were usually made by the photographer for specific negatives. The printing frame was moved continually during the printing process so that the shadow cast by the vignetter was softened. The vignetter could also be made with a ring of tufted cotton

along the inside edge to make the process easier. Commercially made vignetting papers could also be purchased as stiff paper sheets with thin tracing paper stretched over an oval opening. The tracing paper had a black or gold gradation printed on the surface that had the maximum density along the opening in the pasteboard gradually lightening toward the center.

Virtual image

All images viewed on a focusing glass or projected on a screen are virtual images. The most memorable of the 19th century were projected additive full-color images demonstrated by J. C. Maxwell in 1861 and later by Frederic Ives. These could only be viewed by superimposing three separate red, blue, and green images upon a screen using three magic lanterns. The final result was a full-color virtual image. Du Hauron and Cros invented hand-held virtual color viewers that were called chromoscopes. The Ives variant of this instrument was called the Kromskop.

W
Washed emulsion

When an emulsion was made by combining, for example, potassium bromide with silver nitrate, there were two compounds that were produced by double decomposition; silver bromide and potassium nitrate. Silver bromide is the light-sensitive silver halide required for the photosensitive emulsion. Potassium nitrate, however, is not required and is even detrimental. Luckily potassium nitrate is soluble in water and silver bromide is not. A washed emulsion is an emulsion that has been washed of this unwanted compound. Collodion emulsions were poured into water in a steady stream. The plastic-like nitrocellulose was then filtered from the water and allowed to dry as a sensitive pellicle, which was then dissolved in ether and alcohol. Gelatin emulsions were washed by first chilling the emulsion to a consistency of a stiff jelly and then squeezing it through a cloth mesh like those used for hooking rugs. The extruded "noodles" were then washed in several changes of cool water, drained, and melted again as a washed emulsion.

Washing

Critical to the permanence of photographic materials, thorough fixing and washing away the fixing agent was not very well understood in the early years of photography. Finding a reliable source of clean water was also difficult, particularly in large cities. More often than not, poor washing was the result of the having to carry water to a studio without plumbing. The continued use of contaminated water was a major cause of fading prints.

Waterhouse stop

The waterhouse stop was an early form of aperture adjustment consisting of fixed stops in a range of sizes, cut in flat plates so that they could be inserted in a suitable slot machined in the lens mount. The stops were numbered arbitrarily, if at all and had no direct relation to the relative aperture. John Waterhouse

of Halifax invented the system in 1858. It became obsolete when the iris diaphragm calibrated in numbers was invented.

Wave theory

The wave theory explains the behavior of light as a wave. Wave theory was first proposed by Christian Huygens and was developed considerably by others such as Thomas Young and Fresnel. James Clerk-Maxwell elaborated on wave theory by proposing that the waves involved were electric and magnetic field waves, hence the electromagnetic wave theory. Wave theory breaks down under some circumstances where the quantum behavior of electromagnetic radiation is significant. It is used extensively in optics and electromagnetic engineering, where quantum aspects typically do not need to be considered.

Wax

Beeswax was mixed with solvents and essential oils to make encaustic pastes applied to photographic prints. The most common of these was the combination of beeswax and oil of lavender. Prints were waxed as early as the 1840s and the practice continued throughout the 19th century. Waxing prints improved the depth of tone particularly in the shadow areas and created a barrier from airborne contamination, one of the major causes of fading. Wax was also applied as a lubricant prior to burnishing prints.

Wax was also applied to calotype negatives. Waxing negatives made the paper translucent to allow better transmission of light for printing. The wax paper process introduced by Gustave le Gray called for waxing paper prior to the iodizing step. *See* Wax Paper Process.

Waxed paper process

The most serious shortcoming of W. H. Fox Talbot's calotype was its lack of sharpness and grainy appearance, especially when compared to the daguerreotype. Efforts to improve the calotype in the 1840s concentrated on waxing or oiling the processed negatives to enhance their translucency.

In 1851, Gustave le Gray waxed the paper base of the negative before it was iodized, sealing the surface of the paper to a glass-like smoothness. He used starch, and later albumen, to help the light-sensitive salts adhere. The prints produced by these negatives had exceptional detail and tonal range, essentially equal to the wet collodion plate. Additionally, waxed paper negatives could be prepared up to two weeks in advance, whereas calotype negatives had to be made the day before. Dry albumen glass plates had low sensitivity to light, particularly when compared to wet collodion plates. Latent images on waxed paper negatives kept for several days; calotypes had to be developed the same day. On the other hand, waxed paper negative development took as much as three hours. Some photographers who traveled favored the waxed paper process well into the wet collodion era.

Wet collodion process

See Collodion Process.

Whey process

The whey process was a non-halide silver-based developing-out printing process championed by Sutton in the mid-1850s. It evolved as an alternative to printing-out for the purpose of making more permanent prints. Milk whey was made by boiling whole milk and adding rennet or acetic acid to coagulate the solid curds. The fluid strained from the curds was called whey. Paper was either brushed or soaked in whey and then dried. The dried whey paper was then soaked in silver nitrate solution and dried. The sensitive paper was contact printed with a negative in the sun for only a few seconds. The faintest of images was visible after exposure. Development of the latent image was done with an acid solution of gallic acid or pyrogallic acid followed by a water wash, fixing with hypo, and a final wash. The image was cooler in color than the printed-out alternative and was nearly as strong on the back of the paper as the front. This process was also used for solar enlarging because it did not require the extended exposures of the printing-out papers.

Whirler

The whirler was a tool designed to hold and rotate glass plates for the application of albumen for the albumen negative processes. Albumen did not flow easily across a glass surface unless the surface tension was broken with water. The plate was first secured to the end of the whirler by means of a dollop of sealing wax, a suction cup, or a clamp. The surface of the glass was then steamed using a kettle and the albumen poured onto the plate. Immediately after coating the plate with albumen the whirler was turned to spin the plate, which forced the albumen to the outer edges by inertia.

Whitened camera

The whitened camera was a technique for softening harsh contrast in portraiture. The interior of the camera was either painted white or lined with white paper that would reflect onto the sensitive plate during exposure. The Boston daguerreotypists A. Southworth and J. Hawes used this technique to produce masterworks of daguerrean portraiture. Similar effects could be had by pre-exposing the plate to white paper before making the exposure of the subject.

Whole plate

This size (6-1/2 × 8-1/2 inch) was based on the largest plate made by L. J. M. Daguerre. The whole plate dimension was used throughout the 19th century for daguerreotypes, collodion negatives, ambrotypes, tintypes, milk glass positives, and gelatin negatives. This format was phased out by the first world war.

Willis' process

See Platinum Processes, Non-Silver Processes.

Wing camera

Simon Wing patented a system of making successive multiple exposures on a single plate in 1862. Wing's camera featured a special front that allowed moving a single lens both up and down and side to side between exposures. There were several variants of Wing cameras including some that also had sliding backs and multiple lenses. One of the more popular styles made 15 tintypes on a 5 × 7 inch plate. These small tintypes were called "Gems" and were popular enough to have special miniature albums manufactured for their display.

Window lighting

The term implies exposure by a window in a domestic setting rather than by the more evolved side or skylight of a commercial studio. Window lighting was the very first form of interior illumination for photography. Because the light usually came from only one side a reflecting screen was used to fill the dark side of the subject. Simple window lighting became associated with amateur photography throughout the 19th century but was occasionally imitated by studio photographers attempting to create a more natural domestic setting.

Woodburytype

A Woodburytype was a photomechanical printing process invented by Walter Woodbury in 1866. Though not strictly a photograph, the Woodburytype was cast of pigmented gelatin from a lead mold made by the application of pressure on a gelatin relief image produced by the action of light. The final image is often confused with a carbon print because they are made of the same materials, pigment and gelatin. *See* Photomechanical.

Wothlytype

A collodion emulsion printing-out process using uranium nitrate and silver nitrate invented in 1864 by Jacob Wothly. *See* Uranium Nitrate.

Y

Yellow glass

The blue-sensitive photographic processes of the 19th century were processed in darkrooms, illuminated by amber, orange, or red light. Of these colors amber yellow was the most popular because it was easier on the eyes of the photographer. Finding stained glass of the correct color to absorb the unwanted blue light was not always easy. For this reason red glass, which was a stronger filter of blue light, was often chosen when the correct hue of yellow could not be found.

Young theory

Thomas Young visualized a triangular outline for representing pure spectral colors—with red, green, and blue at the apexes and white in the center—in place of the circular arrangement suggested by Newton. Mixtures of red and green, green and blue, and red and blue were placed on the straight lines connecting the pairs of colors. This suggested that the visual system required only three types of colors sensors, a concept stated more

explicitly by Helmholtz in the Young–Helmholtz theory. In this theory there are three different sensors in the retina, each of which is sensitive to a different primary color of light, specifically red, green, and blue. Physiological evidence in favor of this hypothesis involves the discovery that such sensors do exist.

Z
Zinc, Zn
This bluish white metallic element is found in sphalerite ore that is roasted to give an oxide that is reduced with carbon to make zinc vapor, which is condensed. Elemental zinc foil was occasionally used to decolorize old collodion rich in iodine. The zinc halides were used primarily in collodion emulsions.

Zinc bromide, ZnBr$_2$
Zinc bromide is a white crystalline powder prepared by dissolving zinc carbonate in hydrobromic acid. Zinc chloride ($ZnCl_2$) is a white granular crystal made by the action of hydrochloric acid on zinc. Zinc iodide (ZnI2) is a white powder made by dissolving zinc in ionic acid. All of the zinc halides are soluble in water, alcohol, and ether. They were all used as halides for the collodion emulsion processes. ◉

Introduction to the Biographies of Selected Innovators of Photographic Technology

GRANT B. ROMER
George Eastman House International Museum of Photography and Film

The marvelous nature of the tools, technology, and imagery of photography drives us to wonder after the individuals responsible for their creation. Something in photography appeals to the individualist. Every photographer is, in a way, a pioneer. Whatever initial instruction they receive, some aspects of photography can only be learned through highly personal and private experimentation. All photographers have certain primal experiences of discovery that provoke a sense of real contact with the pioneers of photography and give an understanding of the impetus for invention and innovation in photography.

The photographic technology of our day is the composite achievement of thousands of individuals working in many different disciplines over centuries. However, single individuals made contributions that had profound impact upon all of photography. It is easiest to discern such "heroes" of photography in its earlier history. Many historians have attempted to select the most important names from the host of amateurs and professionals who contributed significantly to photography in its first hundred years. All attempts have failed to be fair to every interest.

An interesting exercise for anyone deeply involved in photography would be to arbitrarily fix a number, say fifty, and make a list of the important contributors to photography. By what criteria can a balanced selection be made from the host of scientists, inventors, designers, mechanics, manufacturers, industrialists, photographers, historians, curators, collectors, critics, and publishers who have shaped photography? Within each category, fifty names could be listed without exhausting the possibilities for inclusion.

A perusal and comparison of the index of any history of photography will reveal the common occurrence of the names of Niépce, Daguerre, and Talbot. Much energy has been misdirected in the past to establishing which individual was the inventor of photography. There can be no common agreement on that issue. But everyone agrees that knowing the lives and works of these three pioneers is an indispensable part of understanding the history of photography. Beyond these three, however, much less agreement can be found. The selection that has been made for this edition is based upon what agreement is found in the most influential histories of photography in English. It excludes photographers who made purely pictorial achievements in favor of individuals that made important technical contributions that influenced the progress of photography in its formative era, since this publication primarily serves technical inquiry.

Josef Maria Eder's *History of Photography* is the best source to consult for basic biographical information on photography's great innovators. Eder's history, first published in English in 1945 and, regrettably, now out of print, is unparalleled in scope and scholarship. Those more concerned with aesthetics and socio-cultural contributions will find in the classic histories of photography by Taft, Gernsheim, and Newhall, the biographies of the great "masters" of the art. Monographs for each of these individuals abound. Any number of valid histories could be written using an entirely different set of names than is found in all of the above works; so rich is the story and population of photography. The biographies included in this publication can only represent how individual achievements have contributed to the great technology that truly changed the culture of the world.

Biographies of Selected Innovators of Photographic Technology from the 19th Century
Editor's Note: The following entries were originally published in the *Focal Encyclopedia of Photography*, Revised Desk Edition, 1969 or the 3rd Edition, 1993. The biographies were written by: Mary Street Alinder; Arthur Chevalier; R. Colson; H. Harting; J. C. Gregory; C. H. Oakden; M. von Rohr; and M. E. and K. R. Swan.

Abney, Sir William (1843–1920)
Sir William Abney was an English chemist, writer, and educator. He discovered hydroquinone as a developing agent (1880). Invented gelatin chloride printing-out paper (POP) in 1882. Developed infrared-sensitive emulsion to help chart the solar spectrum. Served as president of the Royal Photographic Society of Great Britain for five years, the first photographic authority to assume that position.

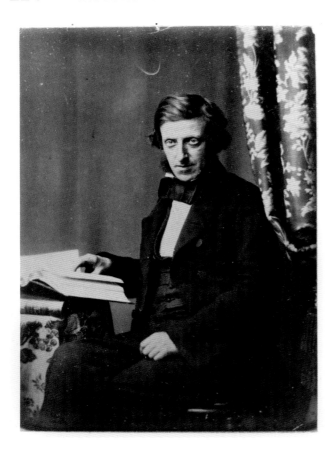

FIG. 25 Frederick Scott Archer, ca. 1849, albumen print from original negative printed later. (Courtesy of the George Eastman House Collection, Rochester, New York.)

Archer, Frederick Scott (1813–1857)

Frederick Scott Archer was an English inventor and sculptor. Archer published the first working formula of the wet collodion process. He presented his discovery as a free gift to the world (March 1851). Archer's collodion wet plate process superseded both the daguerreotype and calotype and was the primary process used by photographers for 30 years. He authored the *Manual of the Collodion Photographic Process* (1852), and invented the collodion positive on glass, and also introduced the stripping of collodion films, later used in much photomechanical work. However, since Archer had not patented the collodion process, he died unheralded and impoverished.

Bayard, Hippolyte (1801–1887)

Hippolyte Bayard was a French photographer and inventor. In early 1839, spurred on by reports of Daguerre's achievement of positive images, but with little additional information, Bayard produced the first positive images directly in the camera. His

independent discovery, almost simultaneous to the very dissimilar processes of Daguerre and Talbot, yielded unique paper photographs. Bayard intentionally created his photographs as art, often expressive in content. Thirty of his prints were the first publicly exhibited photographs on June 24, 1839, in Paris, hung amid work by Rembrandt and Canaletto. Bayard did not reveal the directions for his process until 1840 only to find a public already infatuated with the daguerreotype which was made public in August 1839. Bayard's discovery was ignored. He was a founding member of the Société Héliographique (1851), and from 1866 to 1881 was the Honorary Secretary of the Société Franç Laise de Photographie.

FURTHER READING

Jammes, A. and Janis, E. P. (1983). *The Art of the French Calotype*. Princeton: Princeton University Press.

Becquerel, Alexandre-Edmond (1820–1891)

Alexandre-Edmond Becquerel was a French physicist who discovered in 1839 the photogalvanic effect, upon which a century later the first photoelectric light meters were based. He demonstrated in 1840 that an underexposed daguerreotype plate could be intensified by diffused supplementary exposure under red glass (the Becquerel effect). Becquerel was acknowledged as a founding father of color photography. He achieved natural color images on daguerreotype plates in 1848, although after years of experimentation he was never able to make them permanent.

Bennett, Charles Harper (1840–1927)

Charles Bennett was an English amateur photographer. In 1878 he published his method for increasing the photographic sensitivity of gelatin emulsions by prolonged heating at a temperature of 90°F.

Bertsch, Adolph (Dates Unknown)

Adolph Bertsch was a French microscopist and photographer. He introduced in 1860, the chamber noire automatique, a 4-inch-square metal box with frame viewfinder, spirit level, and fixed focus (automatic) lens of 3-inch focal length. The 2-1/4 inch square negative could be enlarged 10× in diameter with Bertsch's megascope or solar enlarger. This was the forerunner of the modern system of a small camera producing negatives for enlargement at a period when enlarging was seldom practiced.

Blanquart-Evrard, Louis-Désiré (1802–1872)

Louis-Désiré Blanquart-Evrard was a French photographic publisher, inventor, and photographer. He invented albumen paper in 1850 and pioneered the archival processing of photographs. He founded one of the first photographic printing and publishing firms in 1851 at Lille. Blanquart-Evrard's technique of developing-out prints instead of the slow business of printing them out speeded up the mass production of prints for sale, and enabled the publication of a large number of books and albums illustrated with original photographs. Photographs

became commonly available during the 1850s largely due to his efforts.

Bogisch, A. (1857–1924)

A. Bogish was a German chemist who worked at the Hauff factory at Feuerbach near Stuttgart. In 1893 he discovered the new developers Metol, amidol, glycin, and ortol used to process gelatin emulsions.

Brewster, Sir David (1781–1868)

Sir David Brewster was a Scottish scientist and educator who studied optics, lenses, and polarized light. He invented the kaleidoscope in 1816. Brewster was appointed principal of the United Colleges of St. Salvator and St. Leonard, St. Andrews in 1838. He was a friend and advisor to Talbot, conducting an intense correspondence during the crucial years of Talbot's development of his photographic process (1839–1843). Unhampered by Talbot's English patent restrictions, Brewster shared his knowledge of the Talbotype (calotype) with his countrymen where it enjoyed early and great popularity. He introduced D. O. Hill to R. Adamson (1843). Brewster's discoveries allowed for the first practical stereoscope in 1851.

Carey-Lea, Matthew (1823–1897)

Matthew Carey-Lea was an American chemist who carried out many photo-chemical researches; advised the use of green glass for safelights in darkrooms and for the better preservation of sight. He introduced the mordant dye pictures in 1865, and investigated the latent image and the development process, especially ferrous oxalate developers from 1877 to 1880. Carey-Lea was a prolific contributor to photographic journals on both sides of the Atlantic and wrote a well-known *Manual of Photography*.

Chevalier, Charles Louis (1804–1859)

Charles Louis Chevalier was a French optician and camera obscura manufacturer. He made an apparatus for Niècpe and gave his address to Daguerre for whom he was also working. In 1839 he made lenses for the Daguerre-Giroux cameras. In 1840, he introduced the Photographe, a portable daguerreotype camera. He produced photomicrographs as early as March 1840. Chevalier was one of the earliest French photographic writers and dealers. There was a biography written about him by Arthur Chevalier (Paris 1862).

Claudet, Antoine Francois Jean (1797–1867)

Antoine Francois Jean Claudet was a French daguerreotypist and scientist. In 1827, he resided in London as a glass importer and was one of the first and last to practice the daguerreotype process. He established a supply house for daguerreotype materials in partnership with G. Houghton. Claudet was also an early professional photographer (he established the second photographic studio in London in 1841) and introduced painted backgrounds. Published in 1841, he proposed the acceleration process for the daguerreotype. He introduced red

FIG. 26 Self-portrait of Charles Chevalier (right), Daguerre's lens maker with physicists Charles Wheatstone, ca. 1843–1844. (Courtesy of the George Eastman House Collection, Rochester, New York.)

light into the darkroom and was one of the foremost photographic scientists of the early period. In 1851 he suggested the use of a series of photographs for the synthesis of motion in the Phenakistiscope.

Cros, Charles (1842–1888)

Charles Cros was a French doctor, poet, philologist, and painter. In 1881 he discovered the dye imbibition process and was a notable pioneer in the theory and practice of three-color photography (1869).

Daguerre, Louis-Jacques-Mandé (1787–1851)

Louis-Jacques-Mandé was the French inventor of the daguerreotype, the first commonly used photographic process. He also successfully designed theatrical sets and invented the diorama (1822). In 1829, he became partners with Niépce, who had been attempting for many years to permanently capture the image obtained in the camera obscura. Niépce died in 1833 and Daguerre continued the project based on Niépce's work. In 1831, Daguerre had found that iodized silver-coated copper plates were light sensitive. His decisive discovery in 1835 was that those plates, after exposure in a camera obscura, developed a direct positive image when subjected to the fumes of mercury. In 1837, Daguerre was able to fix the image with a salt solution, and in 1839, he applied Herschel's suggestion to use a solution of hyposulfite of soda (sodium thiosulfate). Dubbed "hypo," it is still used today. The first official report of the daguerreotype was made by the French physicist Arago on January 7, 1839, to the French Academy of Sciences. The process was bought by the French government and was given "free to the world" on August 19, 1839, but had been patented in England and the United States five days earlier. The coming

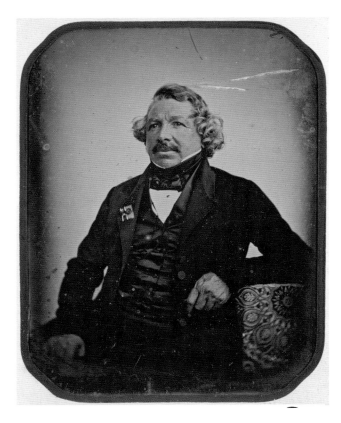

FIG. 27 Louis Jacques-Mandé Daguerre, 1844, Jean Baptiste Sabatier-Blot 1/3 Plate Daguerreotype. (Courtesy of the George Eastman House Collection, Rochester, New York.)

of the daguerreotype aroused keen interest worldwide and remained popular until the mid-1850s. It suffered from three grave defects—it produced only one, non-reproducible original; the image, though exquisitely detailed, was difficult to view due to its highly mirrored surface; and mercury fumes are highly toxic.

FURTHER READING
Buerger, J. E. (1989). *French Daguerreotypes*. Chicago and London: University of Chicago Press.
Gernsheim, H. and Gernsheim, A. (1956). *L. J. M. Daguerre*. Cleveland and New York: World Publishing.
Newhall, B. (1967). *Latent Image*. New York: Doubleday.

Dallmeyer, John Henry (1830–1883)
John Henry Dallmeyer was an optician and lens manufacturer in London connected by employment and later by marriage to the Ross family. He produced portrait lenses based on Petzval's design. In 1866 he patented the rectilinear lens which was very similar to Steinheil's aplanat.

Dancer, John Benjamin (1812–1887)
John Benjamin Dancer was an English optician and microscopist in Liverpool and later in Manchester. He made the first photomicrograph in England by the daguerreotype process in 1840 and was the first to make micrographs (by the collodion process) on microscopic slides. Dancer made the prototype of the binocular camera proposed by Sir David Brewster, which did not go into production until 1856.

Davy, Sir Humphry (1778–1829)
Sir Humphry Davy was an English chemist. Around 1802 his experimentations with Thomas Wedgewood led to the production of silhouettes and contact copies of leaves, etc., on white paper or leather moistened with silver nitrate and chloride solution, and under the microscope, but could not fix them. He discovered the electric arc light in 1813.

Draper, John William (1811–1882)
John William Draper was an American professor of chemistry and a great investigator in the field of scientific photography. He was a pioneer daguerreotypist associated with Samuel F. B. Morse. Draper discovered of the law of photochemical absorption, since known as the Draper-Grotthuss Law. He was probably also the first observer of the retrogression of the latent image in daguerreotypes. In 1840, he published the first paper on portrait photography and probably took the first successful ones. He produced the first daguerreotype photographs of the moon and of the spectrum (1840).

FURTHER READING
Scientific Memoirs (1878).

Driffield, Vero Charles (1847–1915)
Vero Charles Driffield was an English chemist who, with Ferdinand Hurter, originated the study of sensitometry. In 1890 they charted the H&D curve that traces the relationship between exposure and photographic density, determining the speed, or sensitivity, of the emulsion and enabling the computation of correct exposure times.

Ducos Du Hauron, Louis (1837–1920)
Louis Ducos Du Hauron was a French scientist and pioneer of color photography. In *Les Couleurs en Photographie* (1869) he described a three-color photographic process and formulated the principles of the additive and most of the subtractive methods of color reproduction. His research provided much of the foundation of color theory.

Eastman, George (1854–1932)
George Eastman was an American photographic inventor and manufacturer. His first products were gelatin dry plates for which he introduced machine coating in 1879. He invented the first roll film in 1884 using paper negatives and, in 1888, roll film on a transparent base, which is still the universal standard until the end of the 20th century. Eastman introduced

FIG. 28 Self-Portrait deformation, ca. 1888. Photography by Louis Ducos Du Hauron albumen print. (Courtesy of the George Eastman House Collection, Rochester, New York.)

FIG. 29 George Eastman, 1890. Photograph by French photographer Nadar (1820–1910), albumen print. (Courtesy of the George Eastman House Collection, Rochester, New York.)

the "Kodak" in 1888 along with the first roll-film camera. The incredibly popular Kodak box camera encouraged millions of hobbyists worldwide to become photographers. The camera's advertising slogan, "You press the button, we do the rest," proved true to great success. As a direct consequence, the Eastman Kodak Company in Rochester, New York, provided a dramatic, almost fantastic example of growth and development in industry, and it has founded and supported a unique chain of research laboratories. Eastman's commercial manufacture of roll film provided the basic material for cinematography. Eastman introduced 16 mm reversal film for amateur filmmaking (and the necessary camera and projector) in 1923 and developed various color photography processes to commercial application. Eastman died by his own hand—"My work is done—why wait?"

FURTHER READING
Collins, D. (1990). *The Story of Kodak.* New York: Abrams.

Eder, Josef Maria (1855–1944)
Josef Maria Eder was an Austrian photochemist, teacher, and photographic historian. He made outstanding contributions to photography, photographic chemistry, and photomechanical work so numerous that only a few highlights can be listed. In 1879 his thesis on *The Chemical Action of Colored Light* was published. In 1880 Eder became professor of chemistry at the Royal Technical School in Vienna. With Pizzighelli, he introduced gelatin-silver chloride paper in 1881. In 1884 he produced his encyclopedic *Handbook of Photography* on the science and technique of photography, which remained in print through many editions for 50 years. He was appointed director of Vienna's highly regarded Graphic Arts Institute in 1889, a position he held for 34 years. Finally, among other books, there is his respected *History of Photography*, the last edition (German) of which appeared in 1932.

Fizeau, Hippolyte Louis (1819–1896)
Hippolyte Louis Fizeau was the French physicist who invented gold toning of daguerreotypes in 1840. He also invented a very successful process of etching daguerreotypes for mechanical printing in 1841. With Foucault in 1844 Fizeau studied the action of various light sources and of the spectrum on daguerreotype plates and found reciprocity law failures. He took the first pictures of the sun on daguerreotype (1845) with Foucault.

Foucault, Jean Bernard Léon (1819–1868)
Jean Bernard Léon Foucault was a French physicist who was one of the foremost photographic scientists in the first quarter century of photography. With Donne he constructed (1844) a projection microscope, and in 1849 (with Duboscq) an electric arc lamp. With Fizeau in 1844 he studied the effect of light on daguerreotype plates, and produced the first daguerreotype photograph of the sun in 1845. His collected works were edited by Gabriel and Bertrand (Paris 1878).

Fraunhofer, Joseph Von (1787–1826)

Joseph Von Fraunhofer was a German optician who, after an early struggle, became an assistant and later partner in important optical works. In 1814 he discovered a method of calculating a spherically and chromatically corrected objective. He also invented a machine for polishing large and mathematically accurate spherical surfaces. Between 1814 and 1817 he determined accurately the dark lines in the solar spectrum, since known by his name. He was the first to study diffraction with a grating and was responsible for producing high-quality optical glass.

Gaudin, Marc Antoine Augustine (1804–1880)

Marc Antoine Augustine Gaudin was a French photographer, optician, and scientist. He improved the daguerreotype process, and achieved the first instantaneous exposure in 1841. He also investigated the Becquerel effect (1841) and studied nitrated cellulose (1847) and silver halide collodion emulsions (1853, 1861). In 1853 Gaudin proposed potassium cyanide as fixing agent and gelatin and other substances as image binders. He described a collodion emulsion for negatives in 1861.

Goddard, John Frederick (1795–1866)

John Frederick Goddard was a Science Lecturer in London, England. He was employed by Beard and Wolcott to speed up the daguerreotype process by chemical means. Goddard published his successful application of bromine as an accelerating sensitizer on December 12, 1840. This shortened the exposure from about 15 minutes to approximately 2 minutes, thus constituting a major improvement in the daguerreotype process.

Herschel, Sir John Frederick William (1792–1871)

Sir John Frederick William Herschel was an English astronomer and pioneer photographic chemist. In 1819 he discovered thiosulfates and that their properties included the ability to completely dissolve silver salts. Upon learning in 1839 that both Talbot and Daguerre claimed to have discovered photography, he independently invented a silver chloride negative process on glass (1839). Herschel generously suggested to both men, and others, that they use sodium thiosulfate or "hypo," as a photographic fixing agent. This proved to be important, since hypo more effectively eliminated unexposed silver salts than the common table salt then used. Though widely credited with coining the word *photography*, that was actually done by the Frenchman Hercules Florence in Brazil in 1834. He introduced the terms *negative* and *positive* as well as *emulsion* and *snapshot*. Herschel investigated the photochemical action of the solar spectrum, and discovered the different spectral sensitivities of the silver halides, chloride and bromide, and silver nitrate. He also described the light sensitivity of the citrates and tartrates of iron and of the double iron-ammonium citrates. He discovered the Herschel effect, the name given to the fading caused by infrared radiation falling on an exposed image, which has been the starting point for much

FIG. 30 Sir J. F. W. Herschel (Bart), 1867. Photography by Julia Margaret Cameron, albumen print. (Courtesy of the George Eastman House Collection, Rochester, New York.)

modern research on the nature of the photographic latent image. Herschel invented the cyanotype, the first blueprint in 1842 and suggested microfilm documentation.

FURTHER READING

Newhall, B. (1967). *Latent Image*. (*Letters 1842–1879*). New York: Doubleday.
Hunt, Robert 1807–1887.

Hurter, Ferdinand (1844–1898)

Ferdinand Hurter was a Swiss chemist who worked in an English chemical factory and was a colleague of V. C. Driffield. These two scientists and amateur photographers established the first reliable approach to accurate sensitometry, including the H&D curve, now known as the D-log H-curve. They published a full description of their apparatus and methods in 1890, and they were granted the Progress Medal by the Royal Photographic Society in 1898.

Ives, Frederic Eugene (1856–1937)

Frederic Eugene Ives was an American photographic inventor. Among his 70 U.S. patents are many concerning improvements in the halftone printing process, the most important

FIG. 31 Portrait of Frederic E. Ives, ca. 1915. Photograph by Elias Goldensky, gelatin silver print. (Courtesy of the George Eastman House Collection, Rochester, New York.)

was the cross-line screen introduced in 1886. Also a pioneer in color photography, he invented a series of cameras, beginning in 1892, that produced a color image via three transparencies viewed all together with the assistance of a special viewer or projector. He performed basic research in the field of subtractive color during the 1920s that was essential to the development of Kodachrome film in 1935.

Lippmann, Gabriel (1845–1921)
Gabriel Lippmann was a French physicist and professor at the Sorbonne. In 1891 he originated the interference method of direct color photography that produced the first excellent and fixable color photographs, but the process was difficult to carry out and is now only practiced as a technical curiosity. Lippmann received the Nobel Prize in physics in 1908 for this invention. In 1908 he suggested lenticular film should be used for additive color photography and for the production of stereoscopic images.

Lumiére, Auguste (1862–1954) **and**
Lumiére, Louis (1864–1948)
Auguste and Louis Lumiére were French scientists, filmmakers, and photographic manufacturers. Their father, Antoine,

founded a photographic dry plate factory in Lyon in 1882. The two brothers continued the manufacture of dry plates and expanded to the production of roll films and printing papers in 1887. Together and separately, they carried out and published important scientific and technical work on a variety of photographic subjects. In 1904 they invented the first widely used color process, the autochrome. In 1895 they publicly demonstrated their cinematographe motion picture camera and projector, which used perforated, celluloid 35 mm film; the design continues to be used in nearly all modern filmmaking apparatus. They were acknowledged in that same year for making the first movie to be publicly exhibited.

FURTHER READING
Rosenblum, N. (1984). *A World History of Photography*. New York: Abbeville Press.

Maddox, Richard Leach (1816–1902)
Richard Leach Maddox was an English physician, inventor, and photographer. In 1871 he described the first workable dry plate process that unshackled photographers from their darkrooms. Maddox coated silver-bromide gelatin emulsion on glass plates that, with improvements by others such as the replacement of glass by celluloid in 1883, laid the foundation of the future film industry. He made his ideas public "to point the way," without patenting this revolutionary process and spent his last years in straitened circumstances.

Maxwell, James Clerk (1831–1879)
James Clerk Maxwell was a Scottish physicist who established that light was an electromagnetic wave. He was the author of valuable investigations on color perception. In 1855 Maxwell began making some of the earliest color photographs. He formally demonstrated the fundamental basis of projected additive three-color photography in 1861.

Monckhoven, Desire Charles Emanuel Van
(1834–1882)
Desire Charles Emanuel Van Monckhoven was a Belgian chemist and photographer who became one of the foremost photographic scientists of the 19th century. Working in Vienna from 1867 to 1870 he built a famous studio for the photographer Rabending where life-size solar enlargements were made. In 1878, he perfected the preparation of silver bromide gelatin emulsion in the presence of ammonia. In 1879, he improved the manufacture of dry plates and sold emulsion to dry plate factories. Later, in Belgium, he established a factory for pigment papers. He also worked on spectral analysis and astronomy and improved the solar enlarger to which he added artificial illumination. He wrote papers on photographic chemistry and optics.

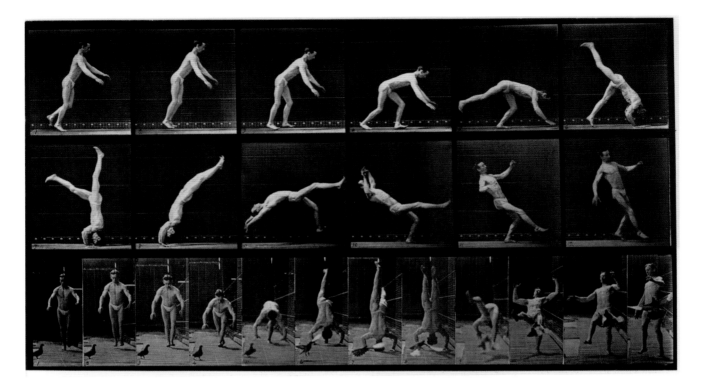

FIG. 32 Head-spring, a flying pigeon interfering. Animal Locomotion, Philadelphia, 1887. Photograph by Eadweard J. Muybridge, collotype print. (Courtesy of the George Eastman House Collection, Rochester, New York.)

Muybridge, Eadweard James (1830–1904)

Eadweard James Muybridge was an English photographer who journeyed to the United States in early 1850s. He gained fame with spectacular photographs of Yosemite from his trips in 1867 and in 1872, when he used 20 × 24 inch collodion mammoth glass plates to great effect. He was hired in 1872 by Leland Stanford to prove with photographs that at some time a galloping horse has all four feet off the ground. Muybridge successfully captured this circumstance in 1877 by assembling a string of cameras that made consecutive exposures at regular intervals. In 1879, he synthesized motion with his Zoogyroscope, using drawings from serial photographs, producing the first animated movie. He published eleven volumes in 1887 containing 780 plates of the first serial photographs of humans and animals in motion. His work greatly influenced painters and stimulated other investigators in photographic analysis, synthesis of motion, and early cinematography.

FURTHER READING

Mosely, A. V. (ed.) (1972). *Eadweard Muybridge—The Stanford Years, 1872–1882*. Stanford: Stanford University Press.

Naef, W. J. and Wood, J. N. (1975). *Era of Exploration*. Buffalo and New York: Albright-Knox Art Gallery and Metropolitan Museum of Art.

Niépce de St. Victor, Claude Felix Abel (1805–1870)

Niépce St. Victor was a French cavalry officer who invented the albumen-on-glass process in 1847. He modified the heliograph (bitumen process) of his uncle Nicéphore Niépce into a heliogravure photomechanical printing process on bitumen-coated steel plates, which gave good halftone prints (1855). Following Edmond Becquerel's ideas, Niépce de St. Victor succeeded by in taking natural light color photographs (called heliochromy) on silver plates by the interference method (about 1860), but the colors were not stable.

Niépce, Joseph Nicéphore (1765–1833)

Niépce, Joseph Nicéphore (1765–1833) French inventor of photography, which he called *heliography*. In 1816, using a camera obscura, obtained negatives by the action of light on paper sensitized with silver chloride, but could not fix them. By 1822, he succeeded in making permanent images by coating glass, stone, or metal plates with asphaltum. After exposing it for many hours by direct contact with oiled engravings, they were washed with solvents to reveal the shadow portions that had not been hardened by light thus obtaining the first permanent photographic image. The earliest surviving photograph from nature, taken in a camera, dates probably from 1826 and is now in the Gernsheim Collection at the

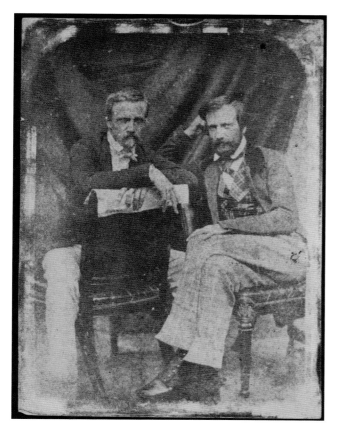

FIG. 33 Portrait of Claude-Felix-Abel Niépce de St. Victor (left) and unidentified man, possibly Alexandre-Edmond Becquerel, ca. 1855. Unidentified French photographer salted print. (Courtesy of the George Eastman House Collection, Rochester, New York.)

FIG. 34 Joseph Nicéphore Niépce ca. 1840. P. Dujardin and Léonard Berger, photogravure. (Courtesy of the George Eastman House Collection, Rochester, New York.)

University of Texas, Austin. Niépce was the first to use an iris diaphragm and bellows in his cameras. In 1829, substituting silvered metal plates for pewter, he found he could darken shadows (bare silver) by iodine fumes. He described that in detail in his supplement to the partnership agreement that he concluded with Daguerre in 1829, and doubtless contributed to Daguerre's discovery of the light sensitivity of iodized silver plates in 1831. Niépce died in 1833, leaving the completion of his work to Daguerre.

FURTHER READING

Buerger, Janet E. (1989). *French Daguerreotypes*. Chicago and London: University of Chicago Press.
Gernsheim, Helmut (1982). *The Origins of Photography*. London and New York: Thames & Hudson.
Jay, Paul (1988). *Niépce, Genesis of an Invention*. Chalon-sur-Saone, France: Society des Amis du Musee Nicephore Niépce.
Newhall, Beaumont (1967). *Latent Image*. New York: Doubleday.
Marignier, J. L. (1999). *Niépce, L'invention De La Photography*, Paris, Editions Berlin.

Obernetter, Johann Baptist (1840–1887)

Johann Baptist Obernetter was a German photographer and photographic manufacturer. In 1868 he introduced commercially the collodion silver chloride of G. W. Simpson under the name of Aristotypie. He also invented (ca. 1886) a photogravure process on copper plates called Lichtkupferdruck. Obernetter introduced (ca. 1870) a collotype process similar to Josef Albert. In the 1880s his firm made good orthochromatic dry plates.

Ostwald, Wilhelm (1853–1932)

Wilhelm Ostwald was a German professor of physical chemistry at Leipzig University for 20 years and established his independent laboratory nearby in 1907. He received the Nobel Prize for chemistry in 1909. Between 1892 and 1900, Ostwald proposed theories on the chemical development of the latent image and on the ripening and growth of the grains in an emulsion. In 1914, he introduced a new theory of color and published his *Color Atlas*. In this publication he described the Ostwald System of color tabulation that added varying proportions of black and white to pure hues.

Petzval, Josef Max (1807–1891)
Josef Max Petzval was a Hungarian mathematician who, in 1840, invented the first purposely designed photographic lens, which reduced exposure time by 90 percent. This allowed the rapid development of the daguerreotype's use for portraiture. Manufactured by Voigtländer and later copied by others, the Petzval lens marked a great advance from previous lenses and was widely used for half a century.

Poitevin, Alphonse Louis (1819–1882)
Alphonse Louis Poitevin was a French engineer, chemist, and photographic inventor. He investigated galvanography (1847), engraving of daguerreotype, photography with iron salts, photolithography, photo-ceramics, and the reaction of chromates with organic substances (e.g., glue). In 1855 he laid the foundations of both collotype and pigment printing (carbon and gum printing) and also produced direct photolithographs in halftone on grained stone coated with bichromated albumen.

FIG. 35 Portrait of Alphonse Louis Poitevin ca. 1865. Photographer unknown. Carbon Print. (Courtesy of the George Eastman House Collection, Rochester, New York.)

Ponton, Mungo (1801–1880)
Mungo Ponton was a Scottish photographic inventor and the secretary of the National Bank of Scotland. In 1839, while experimenting with making photogenic drawings with silver chromates, he discovered that paper impregnated with potassium bichromate was sensitive to light. This was of fundamental importance for most photomechanical processes. Ponton used this photographic paper to record thermometer readings in 1845.

Reade, Rev. Joseph Bancroft (1810–1870)
Joseph Bancroft Reade was an English clergyman, microscopist, astronomer, and pioneer in photography. Early in 1839 he made photomicrographs in the solar microscope on silver chloride paper, which was moistened with an infusion of gall nuts (e.g., gallic acid) thereby using tannin as an accelerator. He was the first to use hypo as a fixing salt for photography (1839). He made camera photographs in 1839.

Regnault, Henry Victor (1810–1878)
Henry Victor Regnault was a French scientist and professor at the Collège de France. He was the President of the Sociètè Francaise de Photographie from 1855 to 1868. He proposed (simultaneously with Liebig) pyrogallic acid as a developer in 1851. He also worked on the carbon process and described in 1856 an actinometer using silver chloride paper.

Sabattier, Aramand (1834–1910)
Aramand Sabattier was a French doctor and scientist. In 1862 he described the "pseudo-solarization reversal," a negative image on a wet collodion plate changed to a positive when daylight fell on the plate during development. This Sabattier effect was exploited for making a positive of a reversal, a second exposure, and development after the first exposure and developing.

Scheele, Carl Wilhelm (1742–1786)
Carl Wilhelm Scheele was a Swedish chemist who built on Johann Schultze's discovery of the light sensitivity of silver compounds. In 1777 Scheele determined that the silver in silver chloride would turn black when exposed to light and that the unexposed silver chloride could be washed away with ammonia. He also found that silver chloride blackened more quickly in the violet end of the spectrum than in other colors and deduced the existence of the unseen radiation band that we call ultraviolet rays. Among his many other significant discoveries, he is credited with first identifying elemental oxygen, before Joseph Priestly.

Schulze, Johann Heinrich (1687–1744)
Johann Heinrich Schulze was a German chemist who, in 1725, made the landmark discovery that light darkens silver nitrate, which proved that heat did not have this effect. Photography was eventually built upon Schulze's discovery.

Seebeck, Johann Thomas (1770–1831)

Johann Thomas Seebeck was a German physicist who, in 1810, investigated the photochromy of silver chloride; when this was exposed to white light and then to the spectrum colors, the spectrum reproduced itself on the silver chloride in its own natural colors. This interference process was one of the few direct processes of photography in natural color, but it took 80 years and the work of many inventors before a practical process of giving a permanent image was evolved by Gabriel Lippmann.

Simpson, George Warton (1825–1880)

George Warton Simpson was a English photographer and editor of the *Photographic News* and the *Year Book of Photography* (1860–1880). He did valuable work on development (1861); collodion silver emulsions for printing-out papers (1864–1865), which formed the basis for the manufacture of Celloidin paper by Obernetter (1868); on the "photochromy" of collodion silver chloride papers (1866); and on Swan's pigment print (carbon) process.

Steinheil, Carl August Von (1801–1870) **and Steinheil, Hugo Adolph** (1832–1893)

Carl August Von Steinheil was a German astronomer and professor of physics and mathematics at Munich University. Shortly after learning of Talbot's calotype process in early 1839, then Daguerre's process in August 1839, he produced the first calotypes and daguerreotypes in Germany by using cameras he designed. In December 1839, he made the first miniature camera, which produced pictures that had to be viewed through a magnifying glass. In 1855 Steinheil founded the Munich optical company that still bears his name and that was purchased by his son, Hugo, in 1866. The younger Steinheil was a noted designer and manufacturer of fine photographic lenses.

Sutton, Thomas (1819–1875)

Thomas Sutton was an English photographer, inventor, editor, and publisher. Encouraged by Prince Albert and partnered by Blanquart-Evrard, he established a photographic printing works in Jersey (1855). He founded and edited the periodical, *Photographic Notes* (1856–1867). He invented a fluid globe lens in 1859, which he used in his panoramic camera in 1861. Sutton patented the first reflex camera in 1861 and published the first *Dictionary of Photography* in English in 1858.

Swan, Sir Joseph Wilson (1828–1914)

Sir Joseph Wilson Swan was an English inventor, chemist, and photographic manufacturer. He perfected the carbon process for printing photographs in permanent pigment in 1864 (introduced in 1866) and applied it to a mechanical form of carbon printing from an electrotyped copper mold-photomezzotint in 1865. He discovered the ripening process by heat in gelatin emulsion in 1887 when his firm, Mawson & Swan in Newcastle, began producing commercial gelatin plates. He patented the first automatic plate coating machine

in Britain in 1879. At the same time, he started the manufacturing of gelatin bromide paper. He greatly advanced halftone printing with lined screen turned halfway through the exposure in 1879. Swan took out over 60 patents; his best known invention was the carbon filament electric light bulb in 1881.

Talbot, William Henry Fox (1800–1877)

William Henry Fox Talbot was an English inventor of photography. He originated the negative-positive process that enabled the production of multiple prints from one negative, which continues to be the basis for photography as it is practiced today. Frustrated while drawing with the aid of the camera lucida, in 1834 he experimented with the fixing of images by chemical means. He investigated the action of light on paper treated with silver salts, making successful photograms, which he called photogenic drawings, of such subjects as lace and leaves. In 1835, using a small, homemade camera, he produced a 1-inch square negative image of a latticed window in his home, Lacock Abbey, but did not make a positive print from a negative until 1839.

A scholar of many pursuits, Talbot left his experiments in photography, only to return when told of Daguerre's invention in January 1939. Disturbed that he would not receive due

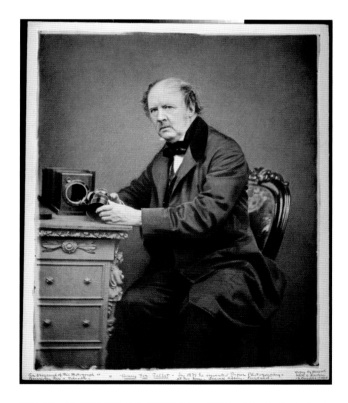

FIG. 36 Portrait of Talbot, 1948 (from 1865 original). Photograph by William Henry Fox Talbot, carbon print. (Courtesy of the George Eastman House Collection, Rochester, New York.)

credit, Talbot's process was described to the Royal Society in London on January 31, 1839.

He greatly increased the stability of his prints in 1839 by using Herschel's suggested fixer, sodium thiosulfate. Exposure times for Talbot's photogenic drawings were extremely long, but were dramatically shortened with his improved calotype process (also called Talbotype) in 1840, which he patented in 1841. The calotype relied on paper treated with silver iodide and washed with gallic acid and silver nitrate. When exposed in a camera, the paper produced an unseen, latent image that could then be successfully developed in the same solution of gallic acid and silver nitrate outside the camera.

Talbot began the first printing company for the mass production of photographs in 1843, and published his own book *The Pencil of Nature* in 1844, the first book illustrated with photographs. In 1852, he patented a photoengraving process, and in 1858 he patented an improved process that produced fairly good halftone reproductions.

FURTHER READING

Jammes, A. (1973). *William H. Fox Talbot—Inventor of the Negative-Positive Process.* New York: Collier.

Newhall, B. (1967). *Latent Image—The Discovery of Photography.* Garden City, NY: Doubleday.

Talbot, W. H. F. (1969, 1989). *The Pencil of Nature.* Facsimiles, New York: Da Capa Press and New York: H. P. Kraus.

Vogel, Hermann Wilhelm (1834–1898)

Hermann Wilhelm Vogel was a German chemist and teacher who became the first professor of photography at the Institute of Technology, Berlin, in 1864. He founded several photographic societies and an important periodical, *Photographische Mitteilungen* also in 1864. His *Handbook of Photography*, first published in 1867, was one of the most important textbooks of the late 19th century. In 1837 Vogel discovered that the selective addition of dyes to collodion plates increased their sensitivity to include the green portion of the spectrum. Along with Johann Obernetter he invented the orthochromatic gelatin silver dry plate in 1884, which was sensitive to all colors except deep orange and red. An influential teacher, his students included Alfred Stieglitz in 1881.

Voigtländer, Peter Wilhelm Friedrich (1812–1878)

Peter Voigtländer was an Austrian optical manufacturer who, in 1849, established a new branch of the family firm originally founded in 1756 in Vienna at Brusnwick. From 1841 his firm manufactured the famous portrait and landscape lens calculated by Petzval in 1840. Also in 1841, he produced the first metal daguerreotype camera.

Warnerke, Leon (Vladislav Malakhovskii) (1837–1900)

Leon Warnerke was a Russian civil engineer. In 1870 he established a private photographic laboratory in London. He lived in both London and St. Petersburg and established a photographic factory in Russia. He invented the Warnerke sensitometer, which was the first serviceable device for measuring

speed (1880). He used this device during investigations on the silver bromide collodion stripping paper. He manufactured silver chloride gelatin papers starting in 1889. He was awarded the Progress Medal of the Royal Photographic Society in 1882.

Wedgwood, Thomas (1771–1805)

Thomas Wedgwood was an English scientist. Son of the famous potter, Josiah Wedgwood, he produced images made by the direct action of light (photograms, e.g., silhouettes and botanical specimens) on paper or leather moistened with silver nitrate solution and silver chloride. In 1802 he published, with Sir Humphry Davy, an account of a method for copying paintings upon glass and of making profiles by the agency of light upon nitrate of silver. But he and Davy were not able to fix their images, which could only be viewed for a few minutes by candlelight.

FURTHER READING

Gernsheim, H. (1982). *The Origins of Photography.* New York: Thames & Hudson.

Wheatstone, Sir Charles (1802–1875)

Sir Charles Wheatstone was an English scientist who invented the stereoscope. He experimented with this device from 1832 to 1838, publishing his results in 1838. Wheatstone invented the concertina (1829).

Willis, William (1841–1923)

William Willis was an English engineer, bank employee, and photographer. He patented the Platinotype process in 1873 and founded the Platinotype Company, which manufactured platinum development papers from 1878 onward. He later worked out the Satista (silver-platinum) and the Pallidiotype papers. He was awarded the Progress Medal of the Royal Photographic Society in 1881.

Wolcott, Alexander (1804–1844)

Alexander Wolcott was an American instrument maker and daguerreotypist. He designed and patented a camera without a lens in which the light entered to be reflected by a concave mirror onto the plate (that was turned away from the subject). On October 7, 1839, he probably took the first successful portrait ever made. In March 1840 he opened the world's first portrait studio in New York.

Woodbury, Walter Bentley (1834–1885)

Walter Woodbury was an English professional photographer. In 1864 he invented the Woodbury process for printing with pigmented gelatin from lead molds obtained from chromated gelatin reliefs. The process was widely used as it produced prints with halftones and high definition and without any grain or screen. It was superseded in the late 1880s by the collotype process and other processes whose prints did not need trimming and mounting. He invented the stannotype in 1879. Woodbury also worked on balloon photography, on rotary printing, and on stereo projection. He received the Progress Medal of the Royal Photographic Society in 1883 for his stannotype process, a simplified variant of the Woodburytype.

Wratten, Frederick Charles Luther (1840–1926)

Frederick Wratten was an English inventor and manufacturer. In 1878 he founded one of the earliest photographic supply businesses, Wratten and Wainwright, which produced and sold collodion glass plates and gelatin dry plates. He invented, in 1878, the "noodling" of silver-bromide gelatin emulsions before washing. With the assistance of Mees, he produced the first panchromatic plates in England in 1906 and became a famous manufacturer of photographic filters. Eastman Kodak purchased the company in 1912 as a condition of hiring Mees.

FURTHER READING

Mees, E. C. K. (1961). *From Dry Plates to Ektachrome Film.* New York: Ziff-Davis.

Zeiss, Carl (1816–1888)

Carl Zeiss was a German lens manufacturer who founded the Zeiss optical firm in 1846. With collaborators Ernst Abbe and Otto Schott, he devised the manufacture of Jena glass, the finest optical quality glass. Zeiss became famous for its excellently designed microscopes, binoculars, optical instruments, and cameras. Zeiss photographic lenses became the standard in the field. Chief lens designer, Paul Rudolph, produced the first anastigmat (1890) and the still-popular Tessar (1902). ◉

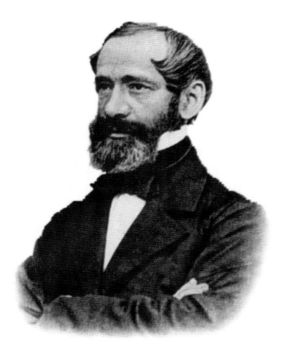

FIG. 37 Portrait of Carl Zeiss, ca. mid-1800s. (Courtesy of Carl Zeiss MicroImaging, Thornwood, New York.)

Selected Photographs from the 19th Century

MARK OSTERMAN
George Eastman House and International Museum of Photography and Film

Joseph Nicéphore Niépce has been credited with creating the first photograph, titled "View from the Window at Le Gras." It was taken in 1826 in Saint-Loup-de-Varennes, France. This picture, a heliograph on pewter, was made using a camera obscura. After an exposure of at least 8 hours, the camera obscura created a single, one-of-a-kind image. Reproduced here are three versions of that image. The first version was made at the Kodak Research Laboratory in Harrow, England. The rephotographing process produced a gelatin silver print in March 1952. The second version was created by Helmut Gernsheim and the Kodak Research Laboratory in Harrow, England. The second version, a gelatin silver print with applied watercolor reproduction was created March 20–21, 1952. It is interesting to note that Gernsheim, a well-know photographic collector, historian, and author had written several essays and consulted this encyclopedia's first edition before creating the print. The most recent version of Niépce's piece, produced in June 2002, was completed by the Harry Ransom Center and J. Paul Getty Museum.

The images on the following pages were selected by the editor to represent the pictorial evolution of the photograph and to include pictures that have not been published before. They have been arranged chronologically, starting at 1830 and concluding at the turn of the century. All images, except where

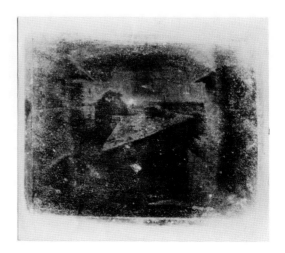

FIG. 38 First version of "View from the Window at Le Gras," made at the Kodak Research Laboratory in Harrow, England, 1952. Gelatin silver print, 20.3 × 25.4 cm. (Reproduced with permission of the Gernsheim Collection, Harry Ransom Humanities Research Center, University of Texas at Austin.)

noted, are courtesy of the Image Collection at the George Eastman House International Museum of Photography and Film in Rochester, New York.

The photography collection at the George Eastman House International Museum includes more than 400,000 photographs

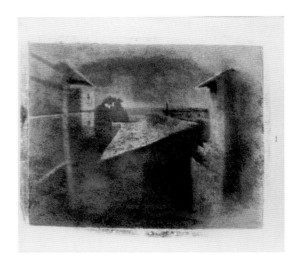

FIG. 39 Second version of "View from the Window at Le Gras," made by Helmut Gernsheim at the Kodak Research Laboratory in Harrow, England. March 20–21, 1952. Gelatin silver print and watercolor, 20.3 × 25.4 cm. (Reproduced with permission of the Gernsheim Collection, Harry Ransom Humanities Research Center, University of Texas at Austin.)

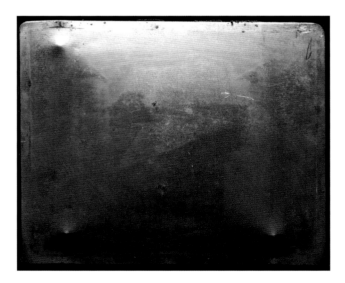

FIG. 40 Digital print reproduction of "View from the Window at Le Gras," made by Harry Ransom Center and J. Paul Getty Museum, June 2002. Color digital print reproduction, 20.3 × 25.4 cm. (Reproduced with permission of the Gernsheim Collection, Harry Ransom Humanities Research Center, University of Texas at Austin.)

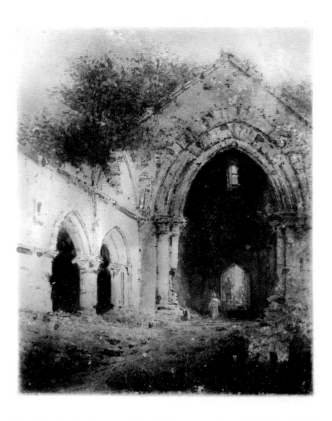

FIG. 41 Louis Jacques Mandé Daguerre, French (1787–1851). "Gothic Ruins," ca. 1830. Dessin fumée, 7.7 × 6 cm. Gift of Eastman Kodak Company, Gabriel Cromer collection.

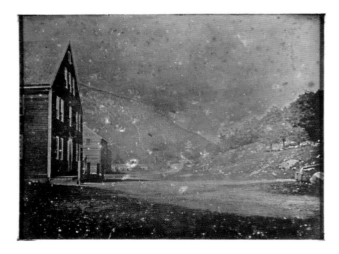

FIG. 42 Samuel A. Bemis, American (ca. 1793–1881). "Abel Crawford's Inn at the Notch of the White Hills, White Mountains, New Hampshire," ca. 1840. Daguerreotype, 16.5 × 21.6 cm, full plate. Gift of Eastman Kodak Company.

and negatives dating from the invention of photography to the present day. The collection embraces numerous landmark processes, rare objects, and monuments of art history that trace the evolution of photography as a technology, as a means of scientific and historical documentation, and as one of the most potent and accessible means of personal expression in the modern era. More than 14,000 photographers are represented in the collection, including virtually all the major figures in the history of the medium. The collection includes original vintage works produced by nearly every process and printing medium employed. (For more information, go to http://www.eastmanhouse.org.)

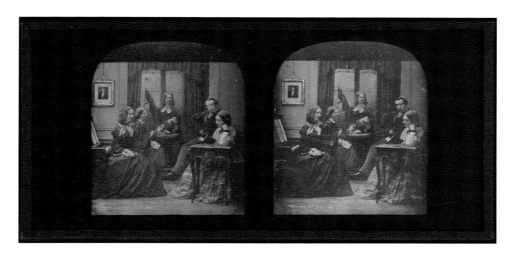

FIG. 43 Antoine-Francois Jean Claudet, English (1797–1867). "Portrait of Claudet Family," ca. 1855. Stereo daguerreotype with applied color. Gift by exchange of Mrs. Norman Gilchrist.

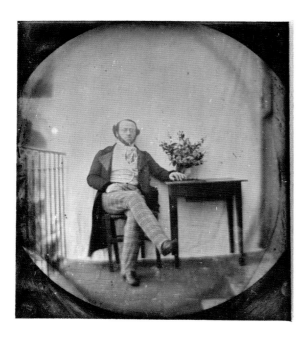

FIG. 44 Unidentified photographer. "Portrait of a Man at a Table," taken with a gaudin camera, 1840. Daguerreotype, 8.2 × 7.4 cm (1/6 plate). Gift of Eastman Kodak Company, Gabriel Cromer collection.

FIG. 45 Louis Jacques Mandé Daguerre, French (1787–1851). "Portrait of an Artist," ca. 1843. Daguerreotype, quarter plate, 9.1 × 6.9 cm (visible) on 15.6 × 13.0 cm plate. Gift of Eastman Kodak Company, Gabriel Cromer collection.

FIG. 46 Robert Cornelius. "Self-Portrait with Laboratory Instruments," 1843. Daguerreotype. Gift of 3M Company, ex-collection Louis Walton Sipley.

FIG. 48 Cromer's Amateur, French. "Still Life, Bouquet of Flowers," ca. 1845. Daguerreotype, 8.2 × 7.0 cm, 1/6 plate. Gift of Eastman Kodak Company, Gabriel Cromer collection.

FIG. 47 Unidentified photographer. "Chestnut Street, Philadelphia," ca. 1844. Daguerreotype, 8.2 × 7.0 cm, 1/6 plate.

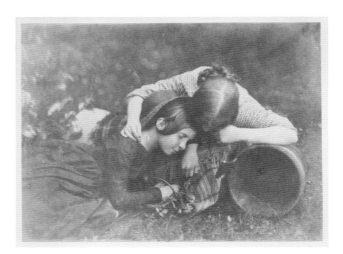

FIG. 49 Hill and Adamson, Scottish. "The Gowan," ca. 1845. Portrait of Mary and Margaret McCandlish. Salted paper print, 15.3 × 20.4 cm.

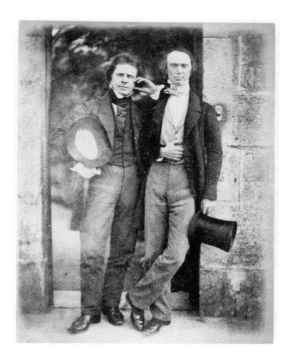

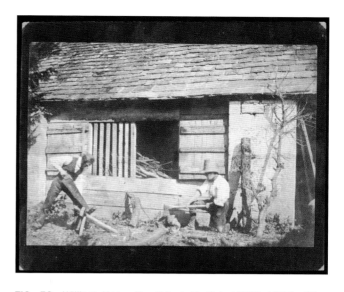

FIG. 52 William Henry Fox Talbot, English (1800–1877). "The Woodcutters," ca. 1845. Salted paper print, 15.2 × 21.2cm. Gift of Alden Scott Boyer.

FIG. 50 Hill and Adamson, Scottish. "D. O. Hill and W. B. Johnstone," ca. 1845. Salted paper print, 18.8 × 14.5cm. Gift of Alden Scott Boyer.

FIG. 51 William Henry Fox Talbot, English (1800–1877). "Lace," ca. 1845. Salted paper print, 23.0 × 18.8cm (irregular). Gift of Dr. Walter Clark.

FIG. 53 W. and F. Langenheim, American. "Anna Langenheim Voightlander," 1848. Hyalotype transparency from albumen negative; image: 13.3 × 10cm; frame: 17.6 × 14.5cm. Gift of 3M Company, ex-collection Louis Walton Sipley.

FIG. 54 W. and F. Langenheim, American. "Portrait of Anna Langenheim Voightlander," 1848. Albumen negative, 18.9 × 14.4 cm. Gift of 3M Company, ex-collection Louis Walton Sipley.

FIG. 56 Southworth and Hawes, American (active ca. 1845–1861). "Unidentified Bride," ca. 1850. Daguerreotype, whole plate, 21.5 × 16.5 cm. Gift of Alden Scott Boyer.

FIG. 55 Baron Jean-Baptiste Louis Gros, French (1793–1870). "Monument de Lysicrates, Vulgairement Appelé Lanterne de Demosthenes; Athenes," May, 1850. Daguerreotype, half plate, 10.8 × 14.7 cm (visible). Gift of Eastman Kodak Company, Gabriel Cromer collection.

FIG. 57 Frederick Scott Archer, "Kenilworth Castle," 1851. Sel d'or–toned albumen print from whole-plate wet collodion negative. Scully & Osterman Archive, Rochester, New York.

FIG. 58 Unidentified photographer. "Chevet de l'Eglise de Saint-Pierre de Caen," ca. 1850–1855. Calotype negative, 20.5 × 26.8 cm. Gift of Eastman Kodak Company, Vincennes, via the French Society of Photography, ex-collection Henri Fontan.

FIG. 59 Henri Le Sec, Chartes. "Portal with Wood Supports," 1851. Cyanotype from paper negative, 32.2 × 21.5 cm.

A

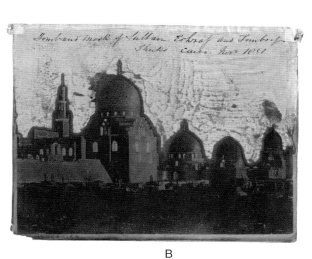

B

FIG. 60 John Shaw Smith, Irish (1811–1873). (A) "Tomb and Mosque of Sultan Eshraf," November 1851. Calotype negative, 16.8 × 22.0 cm (irregular). (B) Reverse, showing selective waxing on lower areas. Gift of Alden Scott Boyer.

FIG. 61 Adolphe Braun, French (1812–1877). "Still Life of Flowers," ca. 1854–1856. Albumen print, 43.8 × 46.5 cm. Gift of Eastman Kodak Company, Gabriel Cromer collection.

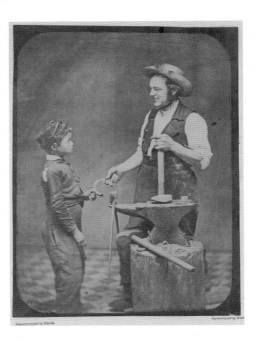

FIG. 63 Hesler. "Driving a Bargin," 1854. Crystalotype print by John A. Whipple from original daguerreotype. Reproduced from *Photographic and Fine Art Journal*.

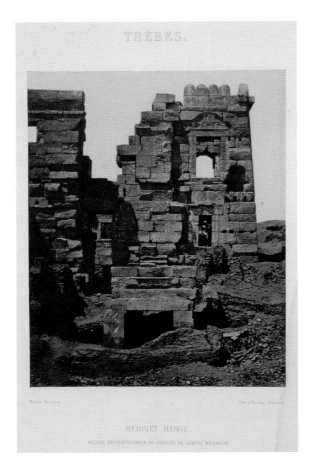

FIG. 62 Maxime du Camp. "Façade Septentrionale du Gynecee de Ramses Meiamoun," 1854. Developed-out salted paper print from a paper negative from *Egypt and Syrie*.

FIG. 64 Édouard Baldus, French (1813–1889). "Pavillon de Rohan, Louvre, Paris," ca. 1855. Salted paper print, 44 × 34.5 cm. Gift of Eastman Kodak Company, Gabriel Cromer collection.

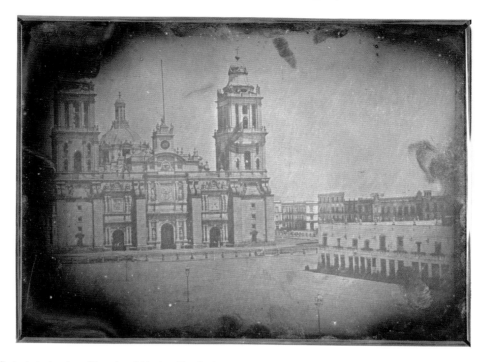

FIG. 65 Unidentified photographer. "Facade of Mexico City Cathedral and 'El Parian,'" ca. 1840. (The two-story structure to the right was the enclosed marketplace known as the Parian. It was torn down on June 24, 1843.) Daguerreotype, 16.4 × 21.5cm, full plate. Gift of Eastman Kodak Company, Gabriel Cromer collection.

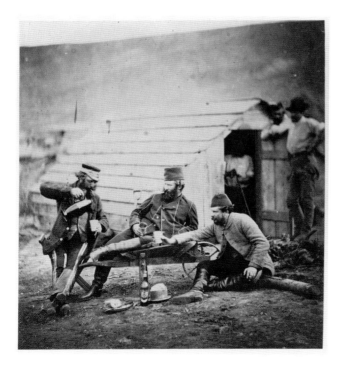

FIG. 67 Gustave Le Gray, French (1820–1884). "Mediterranean Sea with Mount Agde," ca. 1855. Albumen print from collodion negative, 31.9 × 40.7cm. Gift of Eastman Kodak Company, Gabriel Cromer collection.

FIG. 66 Roger Fenton, English (1819–1869). "Hardships in the Camp," 1855. Salted paper print, 18.3 × 16.6cm. Gift of Alden Scott Boyer.

FIG. 68 Unidentified photographer. "Unidentified Woman, Head and Shoulders Portrait," ca. 1855. Pannotype (collodion on leather), image: 6.5 × 5.5 cm. Gift of Reverend H. Hathaway.

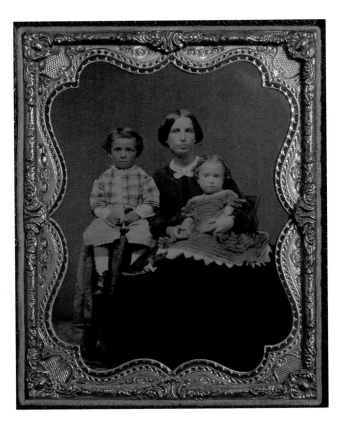

FIG. 70 Unidentified photographer. "Woman Seated, Holding Young Girl on Lap; Young Boy Seated on Posing Table beside Them," ca. 1855. Ambrotype; image: 10.5 × 13.9 cm, 1/2 plate. Gift of Eastman Kodak Company.

FIG. 69 Unidentified photographer. "Two Men Eating Watermelon," ca. 1855. Daguerreotype with applied color, 5.8 × 4.5 cm., 1/9 plate. Museum purchase, ex-collection Zelda P. Mackay.

FIG. 71 James Robertson, British (1813–1888). "The Barracks Battery," 1855. Salted paper print, 23.8 × 30.2 cm. Gift of Eastman Kodak Company, Gabriel Cromer collection.

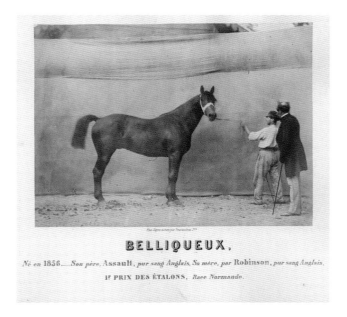

FIG. 72 Adrien Tournachon, French (1825–1903). "Ratter-Filly," ca. 1855. Salted paper print; image: 16.8 × 23 cm; mount: 31 × 47 cm. Gift of Eastman Kodak Company, Gabriel Cromer collection.

FIG. 74 Unidentified photographer. "Seated Man," ca. 1855. Collodion positive on slate, 10.5 × 8 cm.

FIG. 73 Nadar et Cie. "The Marquis du Iau D'Allemans," ca. 1855. Vitrified photograph on enamel, 9 × 7.3 cm.

FIG. 75 Francis Frith, English (1822–1898). "The Great Pillars and Smaller Temple," ca. 1863. Albumen print, 23.4 × 16.3 cm. Gift of Alden Scott Boyer.

FIG. 76 Unidentified photographer. "Portrait of a Woman, Portrait of a Man (Husband and Wife?),"
in double case, ca. 1857. Daguerreotype with applied color, 5.0 × 3.7 cm (each); 1/9 plate. Museum
purchase, ex-collection Zelda P. Mackay.

FIG. 77 Henry Peach Robinson, English (1830–1901). "She Never
Told Her Love," ca. 1858. Albumen print, 18.6 × 24.3 cm.

FIG. 78 Mathew B. Brady, American (1823–1896). "Prof. Dunn,
Reading Book and Posed with Stoppered Bottles and Beaker,"
ca. 1860. Albumen Carte de viste print, 8.5 × 5.7 cm (image),
10.1 × 6 cm (mount). Gift of Graflex Corp.

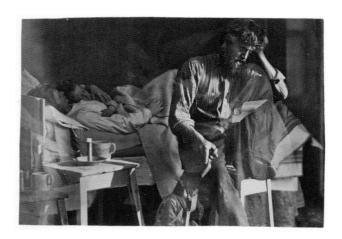

FIG. 80 Oscar Rejlander, English (1813–1875). "Hard Times," ca. 1860. Albumen print, 13.9 × 19.9 cm.

FIG. 79 Franz Hanfstaengl, German (1804–1877). "Portrait of Count Johann von. Yrsch (1797–1862)," ca. 1860. Albumen print or treated salted paper print, 22.0 × 16.8 cm.

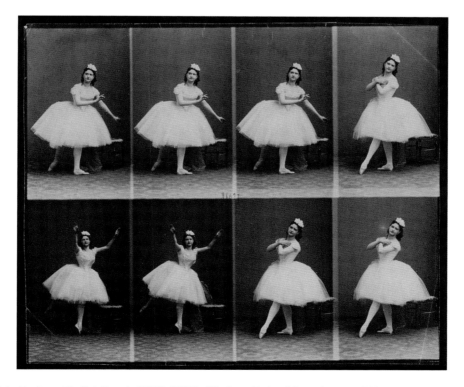

FIG. 81 André-Adolphe-Eugèene Disdèri, French (1819–1889). "Madame Petipa," June–August 1862. Albumen print (uncut *carte-de-visite* sheet); image: 20.1 × 24 cm. Gift of Eastman Kodak Company, Gabriel Cromer Collection.

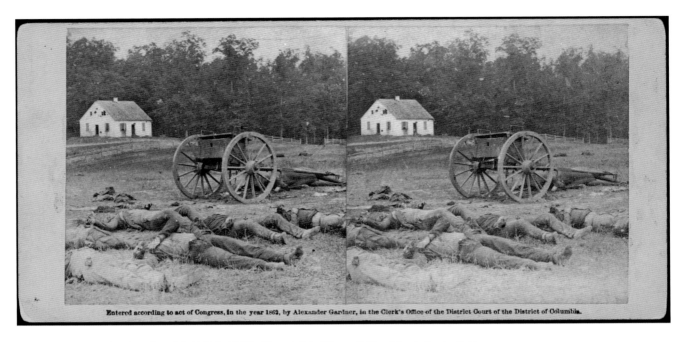

FIG. 82 Alexander Gardner, Scottish (1821–1882). "Completely Silenced! (Dead Confederate Soldiers at Antietam)," 1862. Albumen print stereograph, 7.6 × 15.0 cm, ensemble. Gift of 3M Company, ex-collection Louis Walton Sipley.

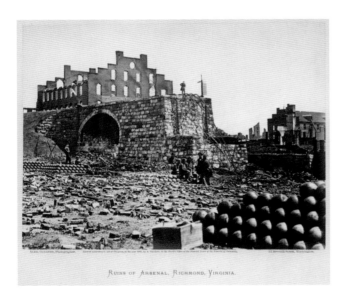

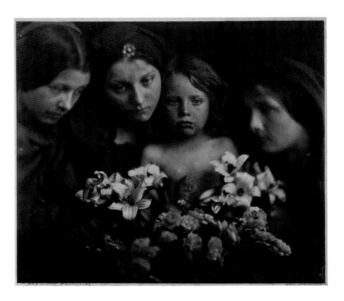

FIG. 83 Alexander Gardner, Scottish (1821–1882). "Ruins of Arsenal, Richmond, Virginia." April, 1863. Albumen print, 17.4 × 22.5 cm. Gift of Alden Scott Boyer.

FIG. 84 Julia Margaret Cameron, English (1815–1879). "Wist Ye Not That Your Father and I Sought Thee Sorrowing?" 1865. Albumen print, 25.2 × 28.8 cm. Gift of Eastman Kodak Company, Gabriel Cromer collection.

A

B

FIG. 85 Unidentified photographer, American. (A) "Unidentified Man, Seated"; (B) "Unidentified Man, Seated, Wearing Coat, Vest, Hat; Holding Chain of Pocket Watch," ca. 1865. Tintype, 8.5 × 7.5 cm (each image), 1/6 plate. Gift of Donald Weber.

FIG. 87 Unidentified photographer. "Mr. Sutherland, Mr. W. Cochrane, Mr. Balfour, Mr. Machonachie, Mrs. B. Cochrane, Mr. W. Machonachie, Lady M. Hervey, Mr. Powlett, Mr. J. Cochrane, Lady Dunlo, Miss H. Farquharson," 1867. Albumen print photomontage with watercolor embellishment, 28.9 × 23.1 cm. Constance Sackville West album, London.

FIG. 86 Unidentified photographer. "Unidentified Man," ca. 1860. Albumen positive on white glass plate, 11 × 8.4 cm.

FIG. 88 Timothy H. O'Sullivan, American (1840–1882). "Pyramid Lake, Nevada," April, 1868. Albumen print, 19.8 × 27.0 cm. Gift of Harvard University.

FIG. 90 John Thomson, Scottish (1837–1921). "Wah Lum Chu, Canton," ca. 1868. Albumen print, 23.0 × 27.9 cm. Gift of Alden Scott Boyer.

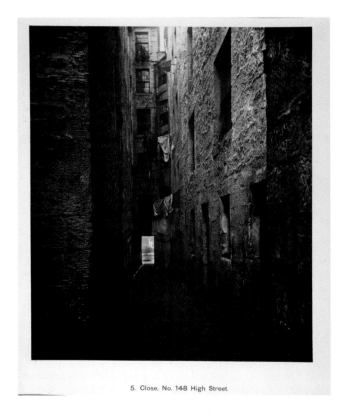

5. Close, No. 148 High Street.

FIG. 89 Thomas Annan, Scottish (1829–1887). "Close, No. 148, High Street," 1868–1877. Carbon print, 27.3 × 23 cm.

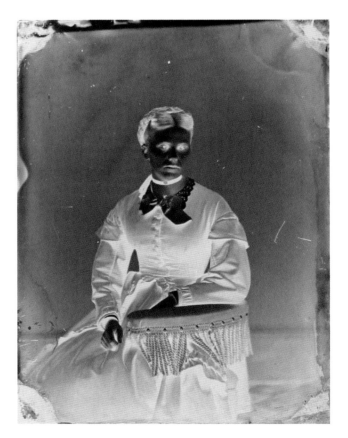

FIG. 91 Unknown photographer. "Studio Portrait of Woman," ca. 1870. Quarter-plate wet collodion negative. Scully & Osterman Archive, Rochester, New York.

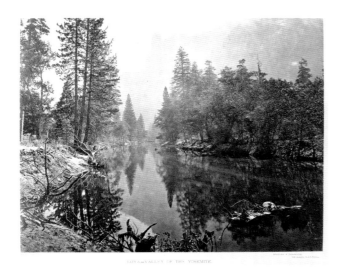

FIG. 92 Eadweard J. Muybridge, English (1830–1904). "Loya— Valley of the Yosemite. (The Sentinel, 3,043 Feet High)," ca. 1868. Albumen print, 42.3 × 53 cm. Gift of Virginia Adams.

FIG. 94 William Henry Jackson, American (1843–1942). "Hot Spring," 1871–1872. Albumen print, 10.4 × 18.4 cm.

FIG. 93 Louis Ducos du Hauron, French (1837–1920). "Still Life with Rooster," ca. 1869–1879. Transparency, three-color carbon, 20.5 × 22.2 cm.

FIG. 95 Lewis Carroll (Rev. Charles Ludwidge Dogson), English (1832–1898). "Xie Kitchin as 'a Chinaman,'" 1873. Gum platinum print. Print ca. 1915, by Alvin Langdon Coburn. Gift of Alvin Langdon Coburn.

FIG. 98 Samuel M. Fox. "An Old Saw Mill," ca. 1880. Albumen print from (dry) collodion emulsion negative, 16.5 × 21 cm. From a Philadelphia Exchange Club album, ca. 1880.

FIG. 96 Richter and Company. "Unidentified Child at Fence," ca. 1880. Albumen print, cabinet card; image: 14.6 × 10.1 cm; mount: 16.2 × 10.5 cm.

FIG. 97 Pach Bros./William Willis, Jr. "Group of Four Military Cadets Under a Tent Opening," ca. 1865. First platinum print made in America (1877) by William Willis, Jr. From ca. 1865 negative, made by Pach Bros. Studio. Image 18.1 × 23.7 cm., mount 20.4 × 25.5 cm.

FIG. 99 Unknown photographer, page from a gem album with ferrotypes; each image is 2 × 1.5 cm; each page is 8.5 × 8.1 cm. Personal album.

FIG. 100 Peter Henry Emerson, English (1856–1936). "The Clay-Mill," ca. 1886, Photogravure print (ca. 1888), 20.1 × 29 cm. Gift of Alden Scott Boyer.

FIG. 101 Raymond K. Albright, American (d. 1954). "Ascending Vesuvius, Naples," ca. 1888. Albumen print, 6.8 cm (diameter). Gift of Mrs. Raymond Albright.

FIG. 102 George Davison, English (1854–1930). "The Homestead in the Marsh," ca. 1890. Platinum print, 22.5 × 18.0 cm. Gift of 3M Company, ex-collection, Louis Walton Sipley.

FIG. 103 Unknown photographer. "Group of Three Men and Three Women," ca. 1890. Tintype, 9.3 × 6.3 cm.

FIG. 105 Laura Adelaide Johnson. "Man Playing Banjo for a Woman," ca. 1892. Platinum print, 19 × 12.1 cm. Family album.

FIG. 104 Frederic Ives. Transparency set for additive color projection, ca. 1890. Silver bromide gelatin emulsion plates, each image is 5.5 cm in diameter; object is 7.5 × 23 cm.

FIG. 106 Unidentified photographer. "Varnishing Day, Wassonier Salon," 1892. Cyanotype, 11.5 × 19 cm.

FIG. 107 Unidentified photographer, "Collection of Stuffed and Mounted Birds," ca. 1895. Color plate screen, Joly (natural color) process, 10.2 × 8.2 cm.

FIG. 108 Gertrude Käsebier, American (1852–1934). "Adoration," ca. 1897. Brown platinum print. Gift of Hermine Turner.

FIG. 109 Clarence H. White, American (1871–1925). "The Readers," 1897. Platinum print, 19.4 × 10.7 cm.

FIG. 110 F. Holland Day, American (1864–1933). "Into Thy Hands I Commend My Spirit," from *The Seven Last Words,* 1898. Platinum print, 20.2 × 15.1 cm.

FIG. 111 Dr. J. Murray Jordan. "Mar Saba," from *Travel Views of the Holy Land, etc.,* ca. 1900. Platinum print, 13.5 × 18.5 cm. Personal album.

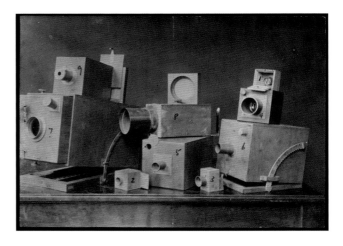

FIG. 112 A. Bartlett. "Display of Talbot's Cameras," ca. 1900–1907. Gelatin silver print, 10.3 × 14.6 cm. Gift of the Eastman Kodak Patent Museum.

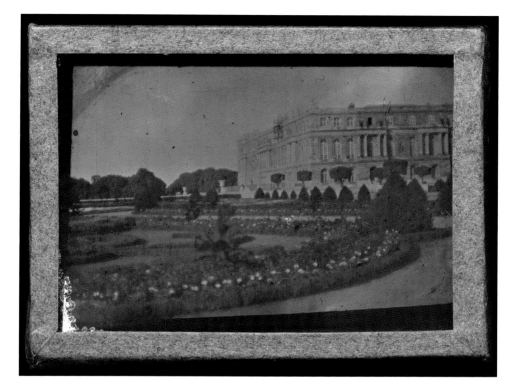

FIG. 113 Gabriel Lippmann, French (1845–1921). "Garden at Versailles," 1900. Direct color (interference process); Lippmann plate. Gift of Eastman Kodak Company.

Cameras of the 19th century

All images on the following pages are courtesy of the Technology Collection, George Eastman House International Museum of Photography and Film, Rochester, New York. Comprising more than 16,000 objects, the George Eastman House technology collection is one of the world's largest collections of photographic and cinematographic equipment. It contains 19th- and 20th-century objects of photographic technology, including cameras, processing equipment, motion-picture devices, and a broad range of early historical accessories. Many of the objects are unique, representing distinguished historical ownership and significant scientific achievement.

This collection is the most comprehensive held by any institution in North America and is equaled in overall quality by only three other holdings worldwide. From devices that predate the formal invention of photography in 1839 to the most modern state-of-the-art instruments used by both amateurs and professionals, the collection offers visitors an unparalleled opportunity to examine and learn about photographic technology.

Evolution of the Photographic Lens in the 19th Century

MILAN ZAHORCAK
Private Collector

Working constraints in lens design

From the very beginning, lens makers were constrained by the properties of light and its behaviors in glass, the availability of suitable glass, and the practicalities and limitations of the manufacturing process.

The physical properties of glass cause it to bend or refract light as it passes through a lens, but in the process, it will also separate or diffract light into its component colors. A perfect photographic lens would bring all light, of all colors, from all portions of the lens into focus on a flat plane without distortion.

Aberrations are problems of focus caused by the inability of a lens to bring light from all portions of a lens into focus at the same point, or the inability to bring light of all colors to focus at the same point. Distortions are a problem of geometry

caused by the inability of a lens to reproduce the exact shape of the subject even though the image may be in focus.

Various types of optical glass have different physical properties. Two or more types of glass may be used in combination to help offset, or compensate for each other's deficiencies. Until the mid-1880s, lens makers had only two types of glass suitable for use in photographic lenses. Given the glass available, designers could not fully correct for all the aberrations.

Until very recently, practical considerations limited the shape of the surfaces that could be produced in the manufacturing process. All surfaces were either flat or curved. But, if the surface was curved, then manufacturing limitations required that it be spherical in design. In other words, the radius of curvature must be exactly the same at all points of the surface. Another surface could be flat, or could have some other radius of curvature, but all curved surfaces had to be spherical in nature.

Until the early 1890s, the necessity of spherical surfaces, together with the narrow constraints of the available glass, combined to produce a set of problems for the lens maker that could only be dealt with through compromise. Even in the best of designs, there was some residual aberration or distortion that was less controlled than would be desired.

In the late 1880s, new types of glass with a wider range of properties became available. Lens makers quickly introduced new designs that brought all forms of aberration into much better control and the modern era of photographic lenses began.

Early adaptations and designs

It is generally held that photography was "born" in September 1839 when Daguerre (France) released his process for capturing images through the action of light on a sensitive emulsion. While his work may have resulted in the first somewhat practical photographic process, experimentation had gone on for decades prior to 1839. Pinhole imagery and contact printing had been practiced for many years, and long before Daguerre's process was perfected, it was already understood by all of the pioneers in photography that some sort of lens would be required in order to record an image properly. As it turns out, Daguerre got the credit for his breakthrough process, but the optics he used for the invention preceded him by decades.

Long before Daguerre, opticians had worked out the basic optical principles for various lenses and truly fine optical instruments, such as telescopes, had been in production for almost a century. John Dolland (England) is usually given credit for inventing the "achromatic doublet" (Figure 115) in 1754. This lens was composed of a converging crown glass element cemented to a diverging flint glass element and was used as the objective in most telescopes of the time. It would also prove to be the best starting point for almost all photographic lenses 85 years later.

To be fair, the first truly useful photographic lens was the single element meniscus lens invented by William Wollaston (England) around 1812. Prior to Daguerre, the Wollaston lens (Figure 116) was used in camera obscuras to project an image that could be viewed, or perhaps traced, by the user. Since it was already used in a near-photographic process, the single element meniscus was the obvious choice for first use in a true camera, and very early experimental images were probably recorded using this type of lens.

For photographic purposes, the meniscus lens, used at about f/16 with the convex side toward the subject, produced a relatively wide and fairly flat field of view, but not without significant and immediately apparent flaws. This single element lens suffered from many inherent limitations and its aberrations cannot be adequately controlled. Consequently, within days of its first photographic use, the meniscus design gave way to the achromatic doublet as a far better choice of lens.

The landscape lens

In September 1839, Daguerre's camera used an achromatic doublet, a modified telescope-type objective made by Chevalier (France). In the next few weeks, Chevalier and another French maker, Lerebours et Secretin, had experimented with the optical design and stop position, and by the end of 1839, Chevalier had introduced a far better achromatic lens.

Chevalier's redesign was slightly meniscus overall with the convex side toward the subject and an f/15 stop well forward of the lens. Given the constraints of the glass available, it was about as good as this type of lens could get. Although not quite distortion-free and with a few spherical and chromatic aberrations showing, it still performed quite well for a fairly simple and inexpensive lens. As the basic form of the achromatic doublet had been around for almost 85 years, there were few legal niceties to be observed, and Chevalier's design was quickly copied by lens makers everywhere. In later years, these lenses were marketed as the "French landscape lens" (Figure 118) thus avoiding giving credit to any particular maker while still alluding to its design.

As the name implies, the landscape lens was generally used outdoors. At first, that was not necessarily the intended use, but given the speed of the Daguerreian process and the early working aperture of about f/16, it could hardly be used for anything else. By the end of 1840, there were other lenses more suitable for portraiture and indoor use, and the lens was quickly relegated to scenic or architectural work and was universally referred to as a view, or landscape lens. Though somewhat outdated even by the 1880s, the design remained in common use through the early 1900s.

There were few attempts to improve upon the "French" design. However, in 1857, Thomas Grubb (Scotland) modified the design, reversing the crown and flint elements, and adjusting the curves. He called his lens an "Aplanat" (Figure 119) and claimed that it was better corrected for certain aberrations. It performed well, although whether better than the French lens is debatable. The lens did prove to be fairly popular in some circles, and was copied by other makers as well. It was offered as an alternative to the French design, and of course, it quickly became known as the "English landscape lens."

The last really serious attempts to improve upon either of the established designs were made by John Dallmeyer (England). In 1864, he introduced the "Rapid Landscape" lens

(Figure 120). This 3-element f/11 design was still meniscus in overall shape, perhaps a bit better corrected, and was about one stop faster than earlier landscape designs. Dallmeyer liked this lens, and he listed it for many years. In 1880, he released a long focus version of the lens, the "Rapid Landscape — Long Focus." And finally, in 1888, he released the Rectilinear Landscape (Figure 121), also a three-element design, but a radical departure from the norm with an air-spaced rear element. All of his lenses were very good for what they did, but the older French and English landscapes were entrenched with their followers and by the 1880s, other more generalized designs had come on the market. Interest in new types of landscape lenses had waned.

By the early 1890s, the usefulness of any sort of landscape lens had run its course. Many other lenses, both optically superior and faster were available. And while landscape lenses were still sold, they were generally found as the stock lenses on less expensive cameras, mostly for the amateur market.

The portrait lens

Within weeks of Daguerre's announcement in 1839, and even as the landscape lens was being perfected, pressure was already building for a much faster lens. The potential for photographic portraiture was immediately apparent, but neither the low sensitivity of the Daguerreotype process, nor the small apertures of the available lenses lent themselves to this use.

Chevalier recognized the "need for speed" immediately, and began to experiment with combinations of elements that were already at hand. In a largely trial-and-error process, he combined two cemented achromats, back-to-back, which produced a much faster lens (about one stop) with an almost acceptable image. In 1840, he introduced the "Photographe a Verres Combines" lens (Lens 7) with a working aperture of about f/6. It was roughly three times faster than his landscape lens, and could reduce exposure times from 15 minutes down to about 3 minutes as a direct consequence of its improved transmission. Chevalier produced the lens for some time, but it was never really perfected and was quickly succeeded by a far better design.

At about the same time as Chevalier began to produce the "Photographe," Joseph Petzval (Austria), a professor of mathematics, undertook a project to design a very fast lens. His eventual design was the first lens to properly compute on paper before going into production. It may be that he first worked out the math of an existing achromatic design and them reformulated it properly to correct for the known problems. Regardless, the first Petzval portrait lens (Figure 123) was built in mid-1840. It used a cemented achromat in front and an air-spaced achromat in the rear. The result was a very fast f/3.6 lens that produced a very good central image with exposure times in the one-minute range. The lens was not without flaws, but the qualities of the image that it produced were so distinctive and well-appreciated that it defined expectations for photographic portraiture for the next six decades.

The design was given to Voigtländer, then in Austria, and the first lenses were produced, but Petzval received little in the way of compensation or royalties. His lens was protected only by an Austrian patent, and the design was quickly copied and produced, essentially unchanged, by many makers for decades to come, even through the early 1900s.

Given the types of glass available at the time, little could be done to improve on the Petzval design, but there were some interesting variations over the years. One of the more successful attempts was the Jamin (France) "Cone Centralisateur" lens (Figure 124) introduced in 1855. This was designed as a combination portrait and landscape lens. When fully assembled it was essentially a Petzval-type portrait lens. However, it could be taken apart and rearranged so that the front cell could be reversed, mounted by itself on the flange, and used as a landscape lens. As with all successful designs, it was soon copied by a number of other European makers.

In 1866, John Dallmeyer (England) patented the first significant change to the design of the traditional portrait lens by reversing the position of the elements in the air-spaced rear cell. It is debatable whether his "Patent Portrait" lens (Figure 125) actually produced a superior image, but Dallmeyer was a superb craftsman and his lenses were acknowledged to be of the highest quality available and with far less lens-to-lens variation than most other makers.

In 1878, Voigtländer, perhaps while considering the Dallmeyer portrait variation, thought to reformulate the design using cemented pairs in both the front and rear. The new design (Figure 126) was quite good, but the older traditional designs were deeply entrenched, and many other designs were already on the market. The lens sold fairly well, but had little long-term impact on the field.

The last significant portrait lenses were introduced by Steinheil (Germany), perhaps in response to the Voigtländer product. The "Group Antiplanet" in 1879 (Figure 127) and the "Portrait Antiplanet" in 1881 (Figure 128) were both somewhat radical designs, using much thicker elements with far greater curvatures. These rather late designs attempted to correct some long lingering aberrations by approaching the traditional design issues in a more aggressive manner, employing off-setting corrections and compensations. The lenses were very innovative and well-thought out, but late to the game. The group lens was used on a number of high-end cameras at the time, but was not significantly better than some far more common and far less expensive lenses already available.

Experimentation and alternatives

The traditional landscape achromat and Petzval-type portrait lens completely dominated the field for many years. However, starting in the late 1850s, other lenses began to appear, and the next two decades saw the introduction of many additional lens types.

The term "lens evolution" brings to mind an orderly process with a succession of logical improvements to earlier designs. However, that most definitely was not how lenses evolved in the 1800s. Even after basic lens design was understood and the ever-persistent aberrations had been clearly defined, most lens designers still chose experimentation on the equipment rather than sit down with log tables and slide rules. Lens evolution was largely a hands-on, trial-and-error process.

Occasionally, some new construction, or improbable experiment, yielded promising results and there would be a flurry of

similar activity as various makers attempted to capitalize on the new design, perhaps even to improve upon it, while trying to work around patent restrictions. There were relatively few gifted designers, but their influence was widespread.

Oddly enough, the first truly distinctive design to appear on the market in many years was another 1840 design by Joseph Petzval. The Orthoskop (Figure 129) was an f/8.7 wide field landscape lens, a variation on the portrait design which had not been brought to market. Having never received proper compensation for his portrait lens, Petzval brought his second design to market in 1856. However, as with his famous portrait lens, Petzval had little in the way of patent protection and within a year Voigtländer in Germany and CC Harrison in the United States were producing their own versions of the lens. The Orthoskop got good reviews, but was more expensive, yet not significantly better than the achromat. Interest in it quickly waned.

The next significant lens appeared in 1859 when Ross (England) developed the incredible Sutton panoramic water-filled "ball" lens (Figure 130). Although it worked reasonably well considering its limitations, this astonishing lens was for all practical purposes a technological dead end. Still, it was the first truly wide-angle lens and had a conceptually simple two-element design. While this type of lens was far too complex and difficult to produce, the application of complete symmetry meant that certain aberrations were easily controlled. Though the Ross/Sutton lens was not practical, it was something lens makers began to think about.

In 1860, Harrison & Schnitzer (United States) patented their justifiably famous "Globe" lens (Figure 131). The Globe is composed of two symmetrical pairs whose outer surfaces, if continued, would form a sphere. The Globe threw a very wide and remarkably flat field, but at f/30 was very slow. As might be expected, the Globe found use as an outdoor view lens, but perhaps surprisingly, it could also be used for process and reproduction work as well.

The Globe lens proved to be a very successful design and large numbers were made through about 1870, both by Harrison in the United States and by several licensed makers in Europe. Both Gasc & Charconett (France) and Ross (England) produced licensed versions of the Globe. It also spawned a number of copies, and it influenced lens design for years to come as makers scrambled to offer a competing product or to work around the patent restrictions. For example, Hermagis (France) produced their own "improved" version of the Globe. Interestingly, several U.S. companies such as Richard Walzl (Baltimore) imported Globe copies from Gasc & Charconnet (and perhaps Hermagis) and put their own names on the lenses. Essentially, they competed against Harrison's Globe while using the Harrison design.

Lenses of the 19th Century

All reproductions published here are courtesy of the personal collection of Milan Zahorcak, Tualatin, Oregon.

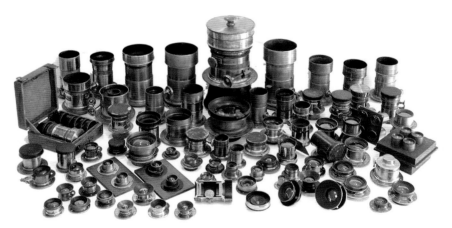

FIG. 114 Lenses of the 19th century.

FIG. 115 An achromat doublet lens.

FIG. 116 A meniscus lens.

FIG. 117 A modified telescope objective.

FIG. 120 A Dallmeyer Rapid Landscape lens.

FIG. 118 A French Landscape lens.

FIG. 121 A Dallmeyer Rectilinear Landscape lens.

FIG. 119 A Grubb Aplanat Landscape lens.

FIG. 122 A Chevalier Photographe a Verres Combines lens.

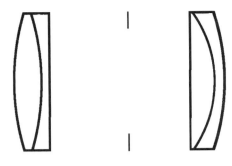

FIG. 126 The design of the Voigtländer portrait lens.

FIG. 123 A section Petzval-type portrait lens.

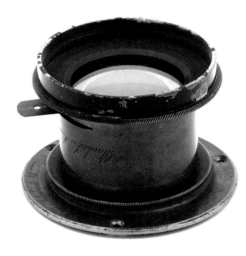

FIG. 124 A small Jamin Cone Centralisateur lens.

FIG. 127 A Steinheil Group Antiplanet lens.

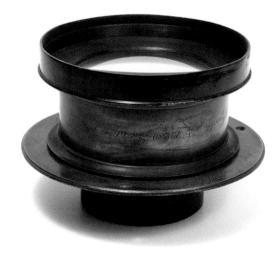

FIG. 125 A Dallmeyer Patent Portrait lens.

FIG. 128 A Steinheil Portrait Antiplanet lens.

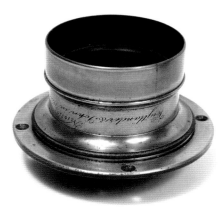

FIG. 129 A Petzval Orthoskop lens designed in 1840.

FIG. 132 A small Pantoskop lens.

FIG. 130 A Sutton panoramic lens by Ross.

FIG. 133 A Fitz View lens.

FIG. 131 The Harrison & Schnitzer Globe lens.

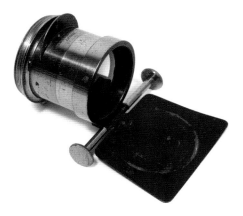

FIG. 134 A Ross Achromatic Doublet Large Angle.

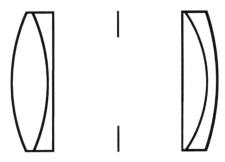

FIG. 135 Early portrait lens experiment.

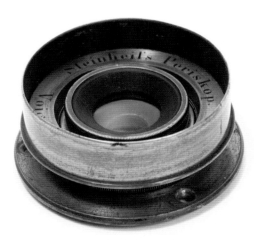

FIG. 136 A Steinheil Periskop lens by Voigtländer.

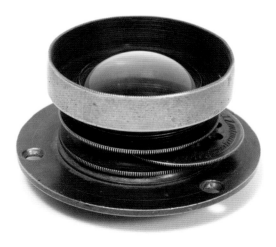

FIG. 137 A Zentmayer 2–3 combination lens.

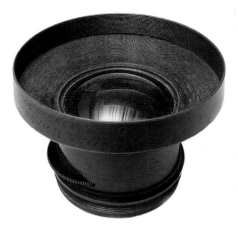

FIG. 138 A Schnitzer Hemispherical lens.

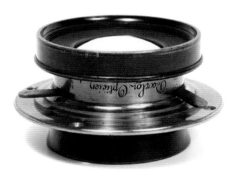

FIG. 139 A Darlot 3-lever Wide-Angle Hemispheric lens.

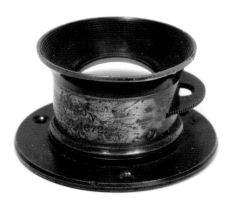

FIG. 140 A Morrison Wide-Angle View lens.

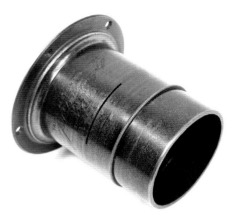

FIG. 141 A Dallmeyer Triple Achromat lens.

FIG. 144 A Steinheil Aplanat lens.

FIG. 142 A Dallmeyer Wide-Angle Rectilinear lens.

FIG. 145 An Alvan G. Clark lens by Bausch & Lomb.

FIG. 143 A Dallmeyer Rapid Rectilinear lens.

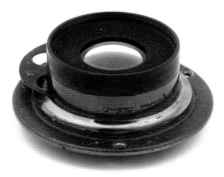

FIG. 146 A Ross Concentric lens.

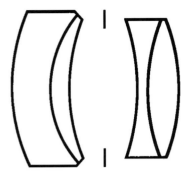

FIG. 147 A Zeiss Anastigmat lens diagram.

FIG. 148 A TTH-Cooke Triplet lens diagram.

Initially, the Globe was such an innovative design that it had little in the way of competition, but in time, a few makers offered their own takes on the concept. In 1865, Busch (Germany) introduced the Pantoskop (Figure 132), a very similar design but with more pronounced curvature that was if anything a better lens than the Globe. It remained popular until simpler and less expensive designs came along several years later.

In 1866, Julia Fitz, the widow of Henry Fitz (Harrison's mentor), briefly produced a very similar lens called the Fitz View (Figure 133). The Fitz estate maintained that the Globe was a Fitz design, but could not establish proof. Consequently, the Fitz lens had to work around the Harrison patent, and while the design compromises resulted in a lens that was easier to produce, it was not as well corrected. It was not very good, and was only on the market for a matter of months.

The success of the Globe design also encouraged, and perhaps forced, other makers to bring out competing products. Later wide-angle designs departed from the Globe concept entirely, some with an inspired new design, others attempting to cut costs, but many to avoid potential infringement issues.

The Ross Doublet (Figure 134) was an interesting lens. By the mid-1860s, Ross (England) had been involved with the (by then) defunct Sutton panoramic lens (1859), and was producing the Globe lens under license from Harrison. Ross wanted to offer a wide-angle of its own. In the Ross archives was a very early, but unsuccessful lens that Thomas Ross (the founder) had designed in 1841, the Ross/Collen lens (Figure 135). The Collen lens was originally meant to be a fast portrait lens, but at the time, was difficult to produce and could not compete with the traditional Petzval lens. Very few were made. In 1864, Andrew Ross (the son) modified the design to produce the Ross doublet, it was much less radical in nature than the Globe, probably easier to produce, and yielded very good results. The doublet received good reviews and was quite successful.

Other challengers to the Globe took a different approach. In 1865, Steinheil (Germany) introduced the two-element Periskop (Figure 136), a symmetrical arrangement of two simple meniscus lenses. Symmetry took care of some problems, but it suffered from the usual aberrations. Still, it

produced a flat field, and was usable within certain tight constraints. It was offered for many years, but because of its inherent limitations, never became very popular.

In 1866, Zentmayer (United States) produced an amazing two-element design that was much more spherical in nature, but used a carefully sequenced asymmetrical pair of differing focal length elements. Many of his lens barrels could accept three or even four different sized cells that were used two at a time. This allowed the user to change the focal length of the lens simply by swapping cells. Although a very controversial design at the time, the combination lens (Figure 137) performed remarkably well and was something of a local success on the East Coast of the United States.

With the lasting popularity of the Globe design, and the resulting demand, several makers began to look for less difficult designs to produce so that they could offer a less expensive lens to the public. Harrison died in 1864 and his partner in the Globe patent, John Schnitzer, left the company to form his own. In 1867, Schnitzer produced the hemispherical lens (Figure 138). As the name implies, the lens was half of a sphere, employing a Globe-like pair on one end, and a simple single-element meniscus lens at the other.

This cost-cutting idea was quickly picked up by other makers, notably Darlot (France) who produced their very distinctive lever-operated Wide-Angle Hemispheric lens (Figure 139). Their design initially used a Globe-like cell paired with a two-element achromat and produced very good results. However, soon after their original version was introduced, an even simpler, better, and less expensive design, the Rapid Rectilinear, appeared on the market. Within a few years, Darlot quietly modified the Wide-Angle hemispheric, replacing the hemispherical design with the new rectilinear design, but never changed the name, still playing on the lore of the sphere.

Finally in 1872, Richard Morrison (United States), who had been the shop manager for both Harrison, and then later for Schnitzer, formed his own company, and released a line of lenses, including the wide-angle view (Figure 140) that also built upon the hemispherical approach.

Harrison was the first truly successful American lens maker, and it is remarkable to consider how many lenses were

inspired either directly as a result of his Globe design or indirectly by the competitive pressures that the Globe's popularity brought to bear on other makers.

Thus far this essay has chronicled the evolution of the landscape and portrait lens; the two designs dating back to the first days of photography. It has also evaluated some of the most significant designs through the 1870s. It is, however, important to pause for moment and regress in time to discuss the most significant design of the 1860s.

The 1860s saw huge growth in the number and types of lenses available. At the beginning of that decade the industry was dominated by the traditional portrait and landscape lenses that had been designed 20 years earlier. By the end of the decade, another design had appeared that would take over the stage for the next 20 years and remain popular well into the early 1900s. The all-purpose Rapid Rectilinear lens first appeared in 1866, but within about 10 years, it had become the lens of choice for many photographers, and had essentially displaced almost all other designs — except for the deeply entrenched portrait and landscape lenses that had clearly defined and marked out their territories long ago.

Design limits

In 1860, John Dallmeyer (England), who had been associated with Ross until the year before, formed his own company. From the beginning, Dallmeyer produced very high quality products. In 1861, he designed the Triple Achromat (Figure 141), a general purpose lens which, not surprisingly, was an arrangement of three achromatic doublets. The Triple Achromat came on the market in 1862, which proved to be very well corrected and received very good reviews. It was, however, fairly expensive and difficult to produce. It worked at about f/10 which made it a bit slow for indoor portraiture, although emulsion speeds had increased, which helped produce shorter exposures. Outdoors, it did not have quite the field of a landscape lens, and was far more expensive, but the results were impressive. It proved to be a popular design as photographers could now pack just one lens. The Triple Achromat helped establish the Dallmeyer name, and the company grew.

In 1864, he released the Rapid Landscape lens (discussed earlier), and in 1866, Dallmeyer had one of the best design years ever. In quick succession he released his Patent Portrait lens (discussed earlier), and another design, the Wide-Angle Rectilinear (Figure 142). This wide-angle lens was probably his response to the popularity of the Harrison Globe (1860), and the recently released Ross doublet (1864).

Market pressures may have rushed the release of the Wide-Angle Rectilinear before it was optimized. The lens is an unsymmetrical arrangement of two achromats surrounding a central stop, but the design of each cell appears be very similar to that used by Grubb in his 1857 Aplanat (discussed earlier). It is puzzling that Dallmeyer did not use symmetrically arranged identical pairs from the beginning, but it did not take him long to make that change.

In a matter of weeks, he released his third design of 1866, the Rapid Rectilinear. At first, the Rapid Rectilinear (Figure 143)

was an all-purpose lens of moderate focal length, working at about f/8. Because of limitations in the types of glass that were available, the lens was a bit tricky to produce. However, once the compromises were worked out, the self-canceling effect of symmetry on the basic types of aberrations made it a superb lens. In time, a number of very successful variations were produced, including several excellent wide-angle designs.

Remarkably, at almost exactly the same moment that the Rapid Rectilinear came onto the market, an almost identical lens, the Steinheil Aplanat (Figure 144), was released in Germany. Controversy immediately ensued. Each company claimed priority and original work, and each accused the other of somehow stealing their design. Eventually, it was determined that both companies had independently and almost simultaneously come up with nearly identical designs, although Steinheil probably was first by a matter of weeks. In Europe, this discussion probably would have featured Steinheil with a note about Dallmeyer, but in England and the United States the discussion featured Dallmeyer. The coincidence is still amazing.

Whatever the case, the Aplanat and Rapid Rectilinear quickly superseded most other types of lenses, and all of the exciting lens developments in the 1860s would simply come to play second fiddle to this design. Some designs were discontinued, some were adapted, many simply lingered with their own devoted following. But the Rapid Rectilinear design dominated as no other lens had and was eventually adopted and produced in absolutely huge numbers by every maker on the scene.

The last of the pre-anastigmat lenses worth discussing is the double-Gauss design used by Alvan G. Clark in his lenses. In 1817, a mathematician named Gauss proposed using two air-spaced single meniscus elements as a telescope objective, but the idea went nowhere. In 1888, Clark revisited the design, putting two Gauss-type objectives back to back about a stop, hence the name double-Gauss (Figure 145). He marketed a number of variations of this design with only limited success. A few years later, a number of other makers, using newer types of glass, were more successful. However, the real success of double-Gauss lens came decades later with many very fast modern lenses using variations on this design.

Breakthrough in glass technology

At this point, the introduction of the more important lens designs from the early 1800s though the mid-1880s has been written about. To review the important inventions, in the early 1880s, the traditional landscape and portrait lenses were still popular and common. The Rapid Rectilinear lens was proving to be an eminently successful and adaptable design and its use and variations, especially the wide-angle designs, were spreading quickly. Other designs were also available, but not nearly as popular.

Also, by this time, photography was entering the dry plate era. Large numbers of amateurs were coming into the market, cameras were growing smaller, lighter, and more convenient, and news traveled further and faster than ever before.

Also at by this time, lenses had progressed just about as far as creative designs could take them since they were constructed with only two types of glass. By the mid-1870s, existing lenses could only be tweaked and optimized, but no real breakthroughs in lens design could occur until more types of glass with a wider selection of optical properties became available. Fortunately that happened in the mid-1880s.

In 1880, Ernst Abbe, a physicist working for Carl Zeiss (Germany), got together with German glassmaker Otto Schott, and the two of them founded the Schott Glassworks in Jena, Germany. Within a few years they had developed a huge number of entirely new types of glass, with an amazing array, which varied widely and had useful properties. By the late 1880s, these new types of glass were becoming more generally available, and more important, their properties were becoming more generally known to designers. New lens designs quickly followed.

Prior to this, even the best of lenses had traces of some pesky residual aberrations. The basic aberrations and distortion were fairly well-controlled, but several higher order problems remained; astigmatism was the most difficult lingering issue.

The first modern lenses

In 1889, using one of the newly developed types of glass, Ross (England) produced the Concentric lens (Figure 146). Perhaps because the symmetrical design of the Rapid Rectilinear lens was so successful, the concentric lens was also designed as a simple symmetrical lens, but using a pair of achromats made from the new glass. This design could not take full advantage of the potential of the glass, and it had certain limitations; the worst was a very slow f/20 working aperture. However, the image was superb, and all signs of astigmatism had been eliminated. The lens was well-received and remained on the market for years. Many consider it the first true anastigmatic lens.

Still, f/20 was painfully slow, and after decades of using much faster lenses, many photographers thought this a high price to pay for a better corrected lens.

A year later, in 1890, Paul Rudolph of Zeiss designed an entirely new lens. It was asymmetrical and comprised of two dissimilar doublets surrounding a stop, but it took full advantage of the properties of the newer glass. He also recognized that his new design could be scaled and modified to suit a variety of uses and this one design was incorporated into a wide range of types, ranging from an f/4.5 portrait lens to an f/18 extremely wide-angle lens.

He called his lens the "Anastigmat," later changed to "Protar" (Figure 147) and for all practical purposes, the modern era of lens design had arrived. The numbers and types of lenses that followed from all manufacturers simply exploded. Within a very short span of time, a bewildering array of new lenses, sporting dramatically new and creative names were competing for market attention.

There were dozens of important new designs in the last few years of the 19th century, but only one other lens will be covered here because of its impact on future designs.

In 1893, H. Dennis Taylor, while working for Cooke (England), designed a simple looking, but theoretically very complex air-spaced triplet lens consisting of three separate single elements made from several types of the newly available glasses. Taylor intensely worked on the mathematics of his design for some time before having test samples made, then made several design changes to improve upon the actual performance. The lens design proved to be quite fussy and difficult to manufacture, but once refined was a very good lens. Taylor named the lens after his employer, and the Cooke Triplet (Figure 148) in various forms, remains in production to this day, one of the longest lasting of all designs.

Lens evolution time line

Figure #	Date	Maker	Lens	Type	f/stop
149	1754	Dolland	Achromatic doublet	Telescope objective	—
150	1812	Wollaston	Meniscus	Landscape	f/11
151	1839	Chevalier	Achromat	Modified telescope objective	—
152	1839	Chevalier	Achromat	French landscape	f/15
—	1839	Chevalier	Photographe a Verres Combines	Portrait	f/6
154	1840	Petzval	Portrait	Portrait	f/3.6
153	1840	Petzval	Landscape	Reintroduced 1856 Orthoskop	f/8.7
155	1842	Ross/Collen	Portrait	Portrait variation	—
—	1855	Jamin	Cone centralisateur	Combined portrait and landscape	f/4
156	1856	Petzval	Orthoskop	1840 landscape design	f/8.7
157	1857	Grubb	Aplanat	Landscape	f/16
158	1859	Ross/Sutton	Panoramic	WA	f/30
159	1860	Harrison	Globe	WA	f/30

Lens evolution time line (*continued*)

Figure #	Date	Maker	Lens	Type	f/stop
160	1861	Dallmeyer	Triple achromat	General	f/10
161	1864	Dallmeyer	Rapid landscape	Landscape	f/11
162	1864	Ross	Doublet	General, 3 types	f/9, 15, 19
163	1865	Busch	Pantoskop	WA	f/25
164	1865	Steinheil	Periskop	WA	f/15
165	1866	Dallmeyer	Patent portrait	Portrait	f/4
166	1866	Dallmeyer	WA rectilinear	WA	f/8
167	1866	Dallmeyer	RR	General RR	f/8
167	1866	Steinheil	Aplanat	General RR	f/8
168	1866	Fitz	View	WA	f/30
169	1866	Zentmayer	Combination	WA	f/22
170	1867	Schnitzer	Hemispherical	WA	f/11
—	1870	Darlot	WA hemispheric	WA hemi, then RR	f/16
—	1872	Morrison	WA view	Various types	f/8
171	1878	Voigtländer	Portrait	Portrait	f/4
172	1879	Steinheil	Group antiplanat	Portrait	f/6.2
—	1880	Schott and Abbe	Glass works	Founded Schott Glass Works	—
173	1881	Steinheil	Portrait antiplanat	Portrait	f/4
—	1885	Schott and Abbe	New glass	Various new types of glass	—
174	1888	Clark	Double-Gauss designs	Various types	f/8, 12, 35
175	1888	Dallmeyer	Rectilinear landscape	Landscape	f/11
176	1889	Ross	Concentric	Regarded as first anastigmat	f/20
177	1890	Zeiss	Anastigmat	WA	f/4.5–18
178	1893	Taylor	TTH-Cooke triplet	General	f/4.5

WA—wide-angle; RR—rapid rectilinear

Lens element and internal configurations 1754–1893

FIG. 149 Maker—Dolland, 1754 achromatic doublet telescope objective.

FIG. 150 Maker—Wollaston, 1812 meniscus landscape lens.

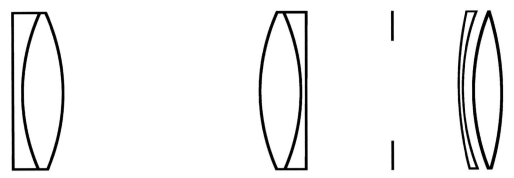

FIG. 151 Maker: Chevalier, 1839 achromat modified telescope objective.

FIG. 154 Maker—Petzval, 1840 portrait lens.

FIG. 152 Maker—Chevalier, 1839 achromat French landscape lens.

FIG. 155 Maker—Ross/Collen, 1842 portrait variation lens.

FIG. 153 Maker—Chevalier, 1839 Photographe a Verres Combines lens.

FIG. 156 Maker—Petzval, 1856 Orthoskop 1840 landscape design.

FIG. 157 Maker—Grubb Aplanat Landscape.

FIG. 160 Maker—Dallmeyer, 1861 Triple Achromat general purpose lens.

FIG. 158 Maker—Ross/Sutton 1859 panoramic wide-angle.

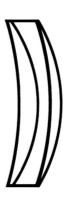

FIG. 161 Maker—Dallmeyer, 1864 Rapid Landscape.

FIG. 159 Maker—Harrison Globe wide-angle.

FIG. 162 Maker—Ross, 1864 Doublet general, three types.

FIG. 163 Maker—Busch, 1865 Pantoskop wide-angle.

FIG. 166 Maker—Dallmeyer, 1866 Rectilinear Wide-Angle.

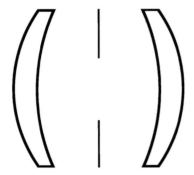

FIG. 164 Maker—Steinheil, 1865 Periskop wide-angle.

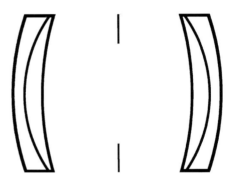

FIG. 167 Maker—Dallmeyer, 1866 Rapid Rectilinear general lens.

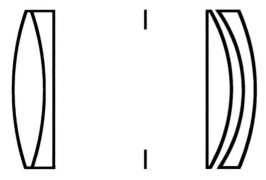

FIG. 165 Maker—Dallmeyer, 1866 Patent Portrait lens.

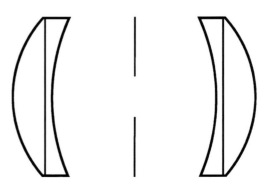

FIG. 168 Maker—Fitz 1866 view wide-angle.

FIG. 169 Maker—Zentmayer, 1866 combination wide-angle.

FIG. 172 Maker—Steinheil, 1879 Group Antiplanat portrait.

FIG. 170 Maker—Schnitzer, 1867 Hemispherical wide-angle.

FIG. 173 Maker—Steinheil, 1881 Portrait Antiplanat portrait.

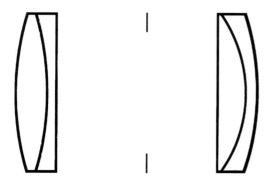

FIG. 171 Maker—Voigtländer, 1878 portrait lens.

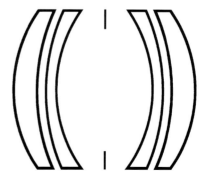

FIG. 174 Maker—Clark, 1888 double-Gauss design, various types.

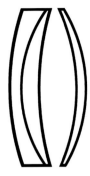

FIG. 175 Maker—Dallmeyer, 1888 Rectilinear Landscape.

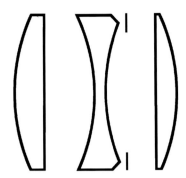

FIG. 178 Maker—Taylor, 1893 TTH-Cooke Triplet general.

FIG. 176 Maker—Ross, 1889 Concentric, regarded as first anastigmat.

FIG. 177 Maker—Zeiss 1890 Anastigmat wide-angle.

GLOSSARY OF TERMS

Aberration—In a lens, any problem introduced to and usually seen at the focused image when projected onto a flat field, perpendicular to the central axis of the lens is called an aberration. In theory, there are seven types of aberrations, but in general terms, the most basic are those of focus, color, curvature, and distortion.

1. **Spherical aberration** is the inability to bring peripheral and central light "rays" to a common focus.
2. **Chromatic aberration** is the inability to focus all colors to a common focus.
3. **Curvature** is the inability to bring an image to focus on a flat field. There are several forms of curvature problems, but the most difficult to control is astigmatism.
4. **Distortion** is the inability of a lens focus straight lines as straight lines. It happens when the magnification at the edge of the lens is not the same as at the center.

Achromatic—A lens that has been corrected to bring at least two different colors to focus at the same point. Usually requires that the lens be made of at least two different types of glass with differing optical properties. No lens made of just one type of glass can be achromatic. One of the biggest problems in early lens design was that the human eye primarily uses yellow light to focus, but early emulsions were only sensitive to blue. An image that appeared to be in focus to the photographer would produce a blurred photograph if the lens was not color-corrected.

Air-spaced—Two or more elements used in combination that are not cemented together, which are not touching each other, and have a space between them.

Anastigmat—A lens that has been corrected for astigmatism.

Aperture—The opening or the size of the opening, through which light passes in a lens. Often deliberately made much smaller than the diameter of any of the glass elements, mostly to limit the amount of light which passes through the lens, or to control the direction from which light is allowed to enter.

Astigmatism — An aberration caused by the inability of a lens to bring light entering at an angle to the lens at the same focus as light coming from straight ahead.

Asymmetrical — A lens design in which the arrangement of elements, their number, thicknesses, surfaces, or glass properties are not the same on either side of a central point.

Cell — In general terms, many lenses are composed of several elements, often arranged in one or more set groups. These groups of elements are often held together in a housing of some sort to maintain spacing. This grouping of bound together elements is referred to as a cell. Many lenses have front and rear cells.

Cemented Elements — Two or more elements of a lens may be cemented together with some form of adhesive. Naturally, the internal surfaces that are joined together must have exactly matching shapes.

Chromatic Colors — Describes light-revealing colors as compared to achromatic colors such as gray, white, and black.

Chromatic Aberration — Light is composed of many colors. Chromatic aberration is the inability of a lens to bring all the colors from a point of light to focus at a common point. Blue light will come to focus closer to the lens, red light further away.

Combination Lens — A lens that has more than one application. Usually a design where some physical component can be added or removed to give the resulting lens a different quality. Typically, these changes would result in a different focal length or angle of view.

Concave — A surface which curves inward toward a central point.

Concentric — Curved lines or surfaces that have a common center, and consequently, are parallel to each other.

Converge — In lenses, for example, to bring parallel light "rays" closer together (although not necessarily to focus as this could be only part of the optical design).

Convex — A surface which curves outward, away from a central point.

Crown Glass — One of two types of early glass available to lens makers, the other was "Flint" glass. Crown glass is harder than Flint glass, but cannot bend light (refract) as much, nor separate the colors (diffract) as well. However, when used together with Flint glass, the different properties of each can be used to compensate and correct for the problems encountered by the other. Early color-corrected achromatic lenses used elements made of Crown and Flint glass.

Diffract — The spreading out of energy when forced to interact with an opaque obstruction.

Distortion — A lens aberration that causes straight lines in the subject to appear as curved lines in the photograph. May also cause the same sized objects in a scene to appear as different sizes in the photograph. Typically seen when comparing similar areas in the center of a photograph to those at the edges or corners.

Diverge — In lenses, for example, to spread parallel light "rays" further apart (although not necessarily resulting in the image being out of focus as this could be only part of the optical design).

Doublet — An old and confusing term with multiple meanings. It may be a lens with just two elements, or more common, a lens with two groups of elements, or sometimes a lens component that had two elements used together, perhaps even cemented together.

Element — A single piece of glass of some shape. However, the term has many generic uses, and is often used to describe some portion of a lens, such as the "front element" (the outer visible surface).

Flat Field — In photography, a lens is usually designed to project a focused image onto a flat plane, either for focusing, or to record an image as a photograph. It turns out to be quite difficult to design a lens that throws a truly flat image.

Flint Glass — One of two types of early glass available to lens makers, the other being "Crown" glass. Flint glass is softer than Crown glass, but can bend light (refract) further, and separate the colors (diffract) better. When used together with Crown glass, the different properties of each can be used to compensate and correct for the problems encountered by the other. Early color-corrected achromatic lenses used elements of made of Crown and Flint glass.

Gauss-Type Lens — An optical design that uses two single air-spaced meniscus elements in a single group. Lenses that used this design usually used two of these groups symmetrically arranged about a stop. These would also be known as "double-Gauss" lenses.

Hemispherical — Not truly half of a sphere. Hemispherical lenses used two groups of elements, one group had a very pronounced bubble-like spherical shape, while the other group was much less curved. However, the term was used very loosely by several manufacturers, and there is no specific or proper definition.

Landscape Lens — A term applied to many early achromatic lenses that contained only a single cemented pair of elements at the back of the barrel. Because of its poor light-gathering ability and various distortions, these lenses were very slow and could only be used outdoors. But they were inexpensive, and outdoors they did very well with scenery and landscapes. Early on they became generically and universally known as view, or landscape lenses.

Lens — Almost a generic term with many meanings. Can refer to a single element, or a group of elements, or an entire optical arrangement of elements or groups of elements that form a single physical lens as found on a camera.

Meniscus — A shape that has one concave and one convex surface. In general, the term refers only to the shape. A meniscus element is a single piece of glass with one side concave and the other side convex, but a cemented pair could also have this shape, and it says nothing about the shape of the internal cemented surface.

Pinhole Photography — A form of photography that uses just a tiny hole to admit light, and uses no lens of any sort.

Portrait Lens — A term applied to the very earliest forms of mathematically computed lenses. At first, it referred to

the specific design as computed by Joseph Petzval in 1840. This was a very fast, four-element lens with a cemented achromat in front, and an air-spaced pair in back, to be used for indoor portraiture. This design was universally accepted for many years as the only design suitable for portraiture, and all lenses using this design or any close variant became known as portrait lenses.

Rectilinear, Rectilinear Lens — Applied to lenses that were capable of rendering straight lines straight both without curvature and without distortion. Often described in ads as "distortionless lenses" to avoid legal complications regarding the use of the term Rectilinear as a trade name.

Refract—The ability of glass to bend light passing through it.

Spherical—A loose term, often used out of context. Technically, and until only very recently, all curved surfaces found on all lens elements ever produced were spherical in nature. This was a manufacturing necessity, and a constraint. There simply was no practical method to produce any other shape in quantity. It is far from the optimal shape for focusing light. In more generic use, however, it came to refer to lens elements, surfaces, or designs that had a very pronounced, bubble-like appearance.

Spherical Aberration—Light radiates out from a point and is gathered in by all portions of the front of a lens. Spherical aberration results from the use of spherical surfaces in the design of lenses and causes the blurring of a point. A simple spherical surface cannot bring all the light gathered from any given point source back to a common point.

Symmetrical—A lens design in which the arrangement of elements, their number, thicknesses, surface shapes, and properties are the same on either side of a central point.

Wide Angle—A very loose term. A lens that renders a scene with the same perspective and "look" as the human eye would have about a 47° field of view. Wide-angle lenses take in a much wider angle. The perspective is the same, but the scene appears as if seen from a greater distance.

MAJOR THEMES AND PHOTOGRAPHERS OF THE 20TH CENTURY

NANCY M. STUART, PH.D., EDITOR
The Cleveland Institute of Art

Photography in the 20th Century

NANCY M. STUART PH.D.
The Cleveland Institute of Art

Photography by its very definition is a physical and chemical process that requires the fixing of radiant energy using a photo-sensitive surface typically with a mechanical or electronic camera. Much can and has been written about the science and technology of this process, but it is the impact of its images on our society that has visually defined our culture and forever changed the way people have communicated following its invention.

Few disciplines other than photography would have the distinction of functioning as a commercial product, an applied science, and a studio art. The complexity of editing this volume is further exacerbated by the possible approaches to organizing a volume on this particular century: a chronological historical survey, an alphabetical compendium of significant practitioners, or an analysis of popular theoretical and critical themes. The outline that was selected grew almost organically out of the author invitation process and their individual interests or areas of scholarship. Because the science and technology of the medium is so aptly investigated in the other sections, I chose to review the trends that differentiated this century from the 19th and, likely from the one we are currently living in. Additionally, it was necessary, due to space limitations, to focus primarily on the factors in North America while recognizing that this view is limited because photography itself is a universal practice, if not language.

This volume is categorized by photography's practice (art, society, and commerce), programs (museums, education, and associations), publishing (magazines, books, and theories), and practitioners (image-makers) that have all operated in significant ways during the 20th century.

The first section has been organized to take a broad view of photography's influence on culture. The critic Saul Ostrow writes about photography as a creative medium and its impact on art practice. Independent scholar and author Gretchen Garner took on the effect that photography has had on amateur picture making, advertising, and journalism. Bruce Checefsky, artist and gallery director, began with an investigation of fashion photography that naturally grew into the photography's common objective of "desire" in pornography and fashion genres.

The second section evaluates related programs that grew out of photography's practice. Educator and artist Dr. Lynne Bentley Kemp studied the act of collecting on the discipline of photography through the museums, galleries, and corporate and individual collections that expanded during this era. Chris Burnett, Director of the Visual Studies Workshop, assessed the educational practice of photographic workshops while I reviewed the emergence of photographic programs at the college level and the resulting professionalization of the discipline through the formation of professional associations and journals.

The third section explores the publishing activities in relation to photography. British author David Brittain's essay explores the photographer's press during the influential decade of the 60s. Dr. Gary Sampson reviews the cultural discourse evidenced through photography's published histories, theories, and criticism.

Section four is prefaced by Dr. David Hart's essay on African American photographers and their involvement in the medium since its inception. The chapter then provides an alphabetical listing of over 250 short biographies of some of last century's most influential practitioners by authors and photographers Robert Hirsch, Ken White, and Garie Waltzer. The selection concentrates on image-makers rather than related influential individuals such as authors, curators, editors, educators, or inventors. Determining which photographers were included was left up to the discretion of each author with the guideline of selecting those key individuals who in effect represent a larger group of practice or ideas. The biographies indicate what a given photographer accomplished and why it is considered of importance. Additionally, at least one significant publication from each photographer was listed for further reading. The decision to include such a minor inclusion of people's work was influenced by the limitations of the book's size.

Each author worked independently and each essay stands on its own merit. Naturally, each topic had the potential of overlapping another, but rather than reading as redundant it reflects the reality of interwoven influences and the richness of a practice that is intertwined throughout 20th century society. ◉

Part page caption: "Young Photographers, Greece 1987," © Professor Willie Osterman.

Photography, Fine Art Photography, and the Visual Arts: 1900–2001

SAUL OSTROW
The Cleveland Institute of Art

Photography, Fine Art Photography, and the Visual Arts: 1900–2001

This essay represents the relationships between photography, fine art photography, and the visual arts as they developed in the United States between 1900 and 2001. Though photography had come to be acknowledged as a legitimate form of artistic pursuit by the early part of the 20th century, it was considered a minor one. This was regardless of the fact that photography's introduction had had a significant impact on our perception and our visual culture. Instead, this evaluation was premised on the fact that photography as a medium had no historical precedent, and if any parallel was to be drawn it would be with that of printmaking, whose conventions of editioning it would eventually adopt. From the point of view of the "Academy," "art" was fixed in concept and form, because it reflected values that were eternal. While this position allowed for the emergence of new styles, which were historically contingent on one another, it did not readily allow for new forms and media. Consequently, abstract art or the material experimentation of the early avant-garde would become integrated into art's history after much critical debate and adjustment. By contrast, for most of the 20th century, photography would exist in a world of parallel institutions, circumscribed by their own history.

In relation to art, photography did not gain a significant position until the 1960s when conceptual artists such as Mel Bochner, Robert Morris, Hans Haacke, Doug Huebler, Dan Graham, Bruce Nauman, Dennis Oppenhiem, Robert Smithson, Gordon Matta-Clark, Michael Asher, et al., were developing non-media-specific, post-studio practices appropriated photography. The effect of this conceptual turn resulted in an end to the hierarchy so cherished by traditionalists, which set photography and film into a category of its own. Today art rather than being media specific constitutes a definitive economy of concepts given representation by those media that best serve them.

During the first half of the 20th century, photography's lack of an historical connection with traditional art making gave rise to a constellation of issues that informed the debate concerning its status. Therefore, while artists and photographers could equally represent their work as the products of their personal struggle to express their individual (subjective) vision, photography during the late 19th and early 20th centuries also represented a challenge to the conventions underpinning the traditional Western arts. This stemmed from the fact that photography was the product of a chemical process that captured and fixed the light reflected off an object into an image of that object, and seemingly required only minimal skills. Photography, consequently, was judged to be no more than a means to mechanically reproduce appearances and as such was most suitable for scientific and documentary (evidentiary) use rather than creative ends.

During this period as photographers explored the mechanics of their new media to determine its capabilities beyond mere transcription, painters were grappling with its effects on their own practices. Since the middle of the 19th century, painters used photography as an optical aid the way previous generations had used the camera obscura and other such devices. While photography's very ability to reproduce appearances more accurately, more realistically, and more objectively served the artist, these qualities also threatened painting's supremacy in the same manner that digital imaging does today. To counter photography's effect and to sustain painting's relevancy in the modern world, painters set about extricating themselves from the limitation imposed upon them by traditional approaches to representation. They did this by initially accentuating color and abandoning perspective to emphasize the literal flatness of the canvas and painterly process. These were all qualities that were beyond the photographic process, which produced mostly black and white images of the external world.

The emerging influence of photography can be found in Edouard Manet's use of a shallow, layered space and flattened color, while his mixture of paint handling and differing degrees of finish announces photography's limitations. Meanwhile, painters such as Claude Monet, and later George Seurat, applied the latest knowledge of optics and light to painting to challenge photography's claim on science by placing dabs or dots of primary and complementary colors in close proximity to one another so that they would blend in the eye of the viewer. In this manner, they could claim painting to be more scientific and superior to photography. The effect of photography can also be found in the manner that Edgar Degas uses the framing edge to cut through a figure. This notion of the picture as a fragment of a continuum that extended beyond the framing edge challenged the classical conception of the painting as a self-contained whole has its origins in photography.

Subsequently, post-impressionist painters such as Utrillo abandoned direct observation altogether and painted his views of Paris' suburbs, from photographs, which offered him ready-made views and compositions that he executed with heavy strokes. Yet, the effect of new medium on the visual arts actually was more profound then as a source of new imagery, optical effects, or even as a means of reproduction. Photography is a contributing factor in the causal chain of cultural, political, and technological events that resulted in emergence of an avant-garde that in the name of "modernity" rejected not only traditional representations, but also the very conventions of art.

The successive schools of impressionism, post-impressionism, cubism, futurism, etc., incrementally moved art to seek new models in the primitive and the industrial. This resulted in artists committed to pictorial issues, as well as focusing materially on the industrial and scientific perspectives

that were altering "everyday life." This questioning of the traditional forms of artistic production not only made it possible to stylistically give expression to the iconography of modern life, but it also led to the inclusion of actual bits and pieces of the real world.

Cutting up bits of colored paper and magazines, photographs, old prints, wallpaper, and other materials; lining teacups with fur; or having sculptures and paintings industrially fabricated obviously does not require the same types of technical skills that a naturalistic rendering of an apple glistening with condensation does. This move toward using the real as a means of expression became the foundation for the most important innovation of 20th-century art — the development of collage by Max Ernst, Pablo Picasso, and George Braque. Collage led to the development of photomontages by the Dadaists, Russian Constructivists, and the Bauhaus, which was informed by an ideological vision of an art that could be integrated into and transform everyday life as common things, rather than specialized forms. In this manner, photography significantly contributes to the modernist conception of art in terms of how and what can be represented, by challenging its historical means.

Against the backdrop of modernism's emergent practices, the photographer, gallerist, and progressive thinker, Alfred Stieglitz became a tireless advocate for photography as an aesthetic medium. Stieglitz was a talented "amateur" at a time when the world of fine art photography was made up of amateur photography societies and clubs. Professional photographers were those who maintained portrait studios, produced landscape, created documentary photographs or sentimental scenes for commercial consumption. Consequently, Stieglitz set about to establish the criteria by which photography could be practiced as an art form. He envisioned photography as a pictorial art, premised on the unadulterated image of what the photographer observed through the camera lens, rather than as something to be subjected to manipulation. As such, he opposed the practice of many fine art photographers who altered the photographic image by hand or chemically to make them painterly. Photography and painting in Stieglitz' view were distinctive art forms and each must follow their own course. Due to the new practices of abstraction, Stieglitz came to predict that photography would not be able to continue to follow painting. Yet, this was not true. While staying true to a purist camera approach, Paul Outerbridge, Jr., Edward Weston, Charles Scheeler, Edward Steichen, Imogen Cunningham, and Paul Strand created pictorial strategies that turned real-world things, such as barn siding, the patterns formed by leaves, or the simple geometry of industrial forms into abstract or semi-abstract images.

Just as painters continued to abandon the conventional point of view associated with traditional perspective, photographers began to explore the use of disconcerting viewpoints, taking photographs from above, from below, and at oblique angles to their subject. This produced distortions, deformations, and foreshortening, which called attention both to the optic system of the camera — which is not at all eye-like — and to the

photographic image as something potentially unnatural. The sources of many of these effects were aerial photography and scientific studies of motion. The resulting disorientation, along with an emphasis on tonality, pattern, and shape, forestalled the conventional associations with objectivity and narrative, which had become photography's mainstay. It was by these means that photographers liberated themselves from the idea that the photograph was an unbiased image of the objective world. Photographers who had grown bored with conventional photographs used these means to create new visual experiences by creating unexpected visual effects.

As early as 1913 Alvin Langdon Coburn, a member of the Photo-Secession, used a pinhole camera to produce nearly abstract images. Exploiting photography's divided nature, these images presented the world from unexpected perspectives and orientations. Their downward views and distorted perspectives turned streets, squares, and buildings into abstract patterns, which he likened to cubist painting. These photographs took advantage of the fact that when a camera is not held level the building seems to be falling over because the parallelogram of the façade becomes a trapezoid. Although this effect is quite accurate in terms of academic perspective, photography manuals advised amateurs that if the world was to be accurately photographed it was to be photographed head on. Nevertheless, by the 1920s, this new perspective of angled shots and extreme close-ups had become synonymous with modernism and expressionism, which offered the photographer a vast array of compositional possibilities.

Extreme composition, light patterns, and obtuse perspectives and viewpoints were used by the Russian Constructivists and Bauhaus photographers as a way to reinvigorate documentary photography. These effects, all of which could be done in the camera, were used to create an image world that celebrated engineering, mass production, commerce, and fashion. Antithetical to the residual naturalism of these photographers were photographers who, in the first half of the 20th century, scorned the world of appearances by producing images whose artificiality and strangeness were apparent. From the perspective of those who were engaged in such experimentation, both the darkroom and the optical effects produced a truthfulness that was equal if not superior to that of the unadulterated photographic image. In this, they sought to be true to their medium.

Alvin Langdon Coburn also produced a portfolio of abstract photographs in 1917. He called these Vortographs and they were produced by constructing a kaleidoscope-like device consisting of three mirrors clamped together, through which he photographed still-life-like arrangements of crystal and wood. These produced prismatic images without any recognizable reference to the objects photographed. Coburn eventually abandoned this line of inquiry, though other photographers would take up various other approaches to making abstract images. By 1918 Christian Schad, a member of the Zurich Dadaist group, was making camera-less photographs using a technique borrowed from the founder of photography, H. Fox Talbot. By these means Schad produced images that closely

resembled cubist collages by laying cut out pieces of paper and flat objects onto light-sensitive paper.

By 1921, painters Man Ray and Maholy-Nagy were exploring similar territory to that of Schad. The main difference between their work and his was that these artists/photographers made their camera-less photographs by placing three-dimensional objects, rather than cut up paper on light-sensitive paper. These objects produced complex images, which consisted of cast shadows and textures in the case of transparent or translucent objects. Although their processes were similar, their goals and imagery were significantly different. The Maholy-Nagy aesthetic was related to that of the Russian Constructivists. He considered his works an exercise in "light modulation" and was concerned with producing architectonic compositions rather than images of the objects he employed. The resulting images he called "photograms," while Man Ray, who was associated with both Dadaists and Surrealists, on the other hand, chose objects such as a pistol, a spinning gyroscope, and an electric fan because these would cast evocative shadows and provoke associations to produce his "Rayographs."

In the same time period photographers and artists also began to experiment with a number of chemical effects. The best known is solarization or Sabattier in which a photograph that has been developed, but not fixed, is exposed to light and then continues to be developed. The image shows a reversal of tones and wherever there is a sharp edge and its contours are rimmed in black. Photographers also experimented with different ways of developing photographs such as subjecting the prints to rapid temperature changes, which produces an over all web-like texture. Many other effects mimicked X-ray exposures, astronomical photography, and photomicrography.

This process of transforming art into all manners of idiosyncratic things by the avant-garde artists and photographers of the 1910s and 1920s coincides with and is supported by the developing technologies of mass reproduction that were making traditional skills redundant. Walter Benjamin, the German philosopher and critic, in his 1937 essay "Art in the Age of Its Mechanical Reproducibility" describes how the advent of photography and the eventual making of moving pictures revealed how "aura had become a fetter on art's conceptual and political development." For Benjamin the mass production and distribution of images and texts held out the potential of ushering in a progressive political culture that held the promise of producing a democratic culture in which everyone would be a potential producer. Consequently, beyond the development of camera-less photography, the creation of photomontage and collage by artists such as Hannah Hoch, John Heartfield, and Georg Grosz, which is paralleled in the Soviet Union by Alexander Rodchenko and Gustav Klutsis, represents both the influence of cubism and the growing importance that mechanical reproduction played in the circulation of photographic images.

Mass culture supplied both photographers and artists with new sources of imagery as well as new types of visual experiences. Modern life was increasingly fractured along the lines of the public and private as well as the increased tempo of industrial society. Photomontage and photo collage, with their mixing of typography and photographic images, gives expression to these conditions while extending photography beyond what had become fine art photography's limitations and conventions. Though thought of as revolutionary, these innovations were premised on the tricks of the trade of the late 19th century work of commercial photographers, which included double-exposure, timed exposures, and darkroom techniques such as masking, burning, and dodging. The significant difference between the early manipulation of images and those of the 20th century avant-garde photographers and artists is that the latter emphasizes its fracture making it apparent that the photographic image is always a construct.

Coinciding with the formal drive to de-skill and re-orientate art, another vision of art as an expression of irrationality, the libinal and the abject was developing out of Dada's anti-art and anti-aesthetic. Surrealists sought to give representation to the irrationality of our inner world and the power of imagination, unlike the Dadaist who wanted to expose the madness of the world around us. To this end, the surrealist, while embracing all that was new, also sought to subvert art's traditional forms. Consequently, in the case of photography, there is a connection between surrealism and the documentary tradition. For the surrealist, the truth of photography was its ability to create an illusionary image of the unconsciousness that circumscribes our reality. As such, the French photographer Atget bridges the ideal of photography as an objective record of what is seen, and the surrealist fascination with the strangeness of the chance occurrences of everyday life.

Atget pioneered the cleansing of photography of all acts of aesthetization meant to make photography look like art. Today his views of Paris, due to the patina of time, look poetic. They can also be viewed in the context of the ability of the photograph to defamiliarize its object. Atget used the part to represent the whole to reorder the familiar genres of landscape and the candid photograph. His pictures are full of the common things that are forever present and therefore tend to be overlooked or forgotten. By the standards of the day, these pictures would have been considered empty in that they are eerily unpopulated. A similar move toward objectification appears in the work of August Sander who, rather than making portraits, photographed types. This distanced view of the strangeness of chance occurrences of everyday life and representing people as objects bridges the ideal of the photograph as an objective record of what is seen with that of the psychology of the photographer inversely.

Hans Bellmer used photography in his Poupee Project to create strangely disturbing images that are disquietingly hallucinatory invoking trauma and mutilation. Bellmer sometimes took straight photographs of dolls; at other times he would exploit multiple exposures and super impositions of his poupees posed in familiar space. For these photographs, Bellmer created dolls that consisted of differing combinations of female parts, symmetrical pairs of legs joined at the hips, or at times nothing more than provocative bulges and swells. Other photographers

such as Raoul Urbac explored the photographic process itself by submitting the photographic negative to heat to produce what he came to call Brulages. The deformed liquefied image on the negative constituted an attack on form, difference, and identity. Other states of formlessness were the result of the blurring of genres, for instance, when Man Ray photographs a female torso in such a manner as to produce an image in which her arms and chest can be read as a bull's head (Minataur, 1934). Likewise, a photo-work by Salvador Dali executed in collaboration with Brassai also crosses categorical boundaries invoking the found montage of bulletin boards where images of everyday life are juxtaposed, implying a narrative.

While the results of this intense period of experimentation and exploration of the photographic medium with its emphasis on process, phenomena, materiality, and mechanical reproduction became an important part of art's discourse, its most immediate and long-lasting effects were on the experimental films of artists such as Hans Richter, Viking Eggling, and Leopold Souvage who was interested in synathesia. In the 1950s and early 1960s, in the wake of abstract expressionism, Jonas Mekas, Stan Brakhage, Joyce Weiland, and Paul Sharits among others began to again explore film as an expressive medium. Their films construct abstract narratives by means of rhythmic editing, montaging of found footage, hand-drawn animation, and non-traditional processing. With the emergence of video in the 1970s, this analytic manipulation of the medium was employed by such artists as Joan Jonas, Keith Sonnier, and Frank Gillette and continues to be the basis for the video works of artists such as Bill Viola, Stan Douglas, Douglas Gordon, and Tacita Dean. Conversely, photo collage, with its political associations, came to be tamed by graphic designers and continues to play a significant role through the works of painter Robert Rauschenberg. Most notably this tradition within the context of post-modernism is exploited by Barbara Kruger and the Starn Twins who turned the history of experimental photography into a series of devices meant to self-reflexively expose themselves.

As we move into the 21st century, the discourse between critical culture and mass culture, the mechanical and the interpretive, the commercial and the creative continue to circumscribe photography's relation to the visual arts. This continues to be predominantly expressed through its relationship with its other: painting. Photography's influence on both abstract and figurative painting actually intensified during the last decade of the 20th century as both began to be imperiled by digital technologies. During the 1980s and 1990s painters such as Eric Fischl, David Salle, Troy Brauntuch, Jack Goldstien, Elizabeth Peyton, Richard Philips, and Luc Tuymanns made paintings that used photographs as their source, while photographers such as Hanno Otten, Penny Umbrico, and Thomas Shrutte explored photography's relationship to abstract painting. Their work is a critical extension of Pop Art and Photo-Realism, which flourished in the late 1960s and 1970s. Andy Warhol's work is an exemplary model. Unlike Rauschenberg or Rosenquist, Warhol's work explicitly acknowledges the sheer repetitiveness of the image world of photography

and reproduction. Warhol's work is not only a depiction of the spectacle of mass culture, but his adaptation of the grid and his hands-off processes wed high art to popular culture by merging abstract painting in the form of ground to the photographic image as figure. The relation between photo silk screen images and its painted ground announces the interdependency of their alterity.

There are also insightful connotations in Warhol's work, as to the nature of photography and its relation to painting. This lies in the most obvious aspect of Warhol's work in that if the order of ground and photographic image were reversed, the painted ground would obliterate the silk-screened image. To paint over the silk screen the way that Rauschenberg does would unhinge the visual equilibrium that this "natural" ordering makes explicit, which is that the photograph as a picture of something or someone is always already transparent. So we can either see the transparency of "representation" and the opacity of the painting (the ground) or their unity that produces a synthesis in which each element loses part of its identity while acquiring some part of its others. By these means, Warhol establishes the economy of the real (color and process) and the mimetic (image and temporality) by privileging neither. Warhol's use of photo silk screen comes to play a similar role to Picasso's use of collage in the progressive discarding of painting's tradition-laden baggage, while preserving its form.

On the heels of Pop Art, painters used photographs as subject matter to create an inclusive and discursive formalism, one in which issues of composition, opticality, and process would compliment rather than subjugate the image's contents. By these means, they set about recording the changing state of representation as it goes from observation to reproduction to replication. In doing this, these painters absorbed photography's simulacra back into painting. They did this by exploiting the knowledge that within the image world art had already come to exist as something most viewers believed could be known through reproduction. This condition was the central theme of Andrea Malraux's book *Museum Without Walls*. Consequently, the movement referred to alternately as Photo-Realism, or Sharp Focus Realism embraced and subverted the course of reproduction by turning the seamless information of photographs into the fractured information painting. This can be seen in Richard Estes and Ben Shonziet's paintings of urban street scenes and store windows, which when reproduced look as if they were color photographs. Another example of this use of the photographic look in painting would be Chuck Close's large-scale black and white airbrush mug shot-like portraits of friends from the 1970s and 1980s. Though the subject appears casual, Close works from photographs done by a studio photographer.

Another artist who has investigated the relationship between photography and painting, within the context of both Pop Art (as a source of imagery) and post-modernism (focusing on the look of the photographic image) is the German artist Gerhard Richter, who works both in figurative and abstract styles. The reference to photography, in Richter's case is indexed

particularly to the idea of the focal plane and the photographic blur. He uses this effect not only in his figural works but also in his abstract paintings. The irony underlying this practice is that unlike photography, painting can never be out of focus, nor is their subject ever in motion, especially when the painting is an abstract one. With such practices painters not only explore how photography orders our perceptions but also our expectations. While many painters continue to work from photographs, others such as Gwen Thomas, Fabian Marcaccio, and Frank Stella either print digital images onto canvas, or incorporate them into their paintings where they are reworked to produce a hybrid form comparable to collage.

While artists in the 20th century were adapting to photography (and motion-picture) influences, photographers who aspired to develop photography into a creative medium used painting as their model. They appropriated art's traditional subjects, photographing tableaux vivants that mimicked neoclassical paintings, pastorals, and picturesque scenes replete with peasants. It is common for new forms during the period of their gestation to imitate (mimic) the traditional forms, which they will either eventually replace or significantly transform. Out of this process, given its tendency to be both commercial and more often then not kitschy, two counter-trends arose that would come to define fine art photography — one was interpretative and expressive, and its predominant aesthetic models were that of impressionism. This tendency is best represented by the works of Mary Devons. The other counter-trend, the documentary tradition, grew out early use of photography to record the world of people places and event. Photographers such as William H. Rau were committed to the idea that though the photograph is authored, it should in the main constitute an unmodified document of what is portrayed.

Given these formative practices and despite the periods of intense experimentation in which the aesthetic, structural, and conceptual concerns of artists and photographers often coincided, fine art photographer's concerns have remained decidedly different than those of the Modern artist. In part, this is because beyond the legitimating debates concerning the role of the photographer's authorial role, the respective truthfulness of the photograph, and aesthetic issues, photography's broad-based popularity and accessibility had to be addressed both in theory and practice. In the pursuit of freeing themselves from being viewed as mechanical and scientific fine art photographers had to also overcome the fact that social and cultural location diminished its acceptability as an artistic medium. Its novel verity pleased the newly emergent middle classes, which embraced photography both as enthusiasts as well as consumers.

With the development of commercially produced film, processing, and mass produced cameras, amateur photographers came to dominate the field producing souvenir photographs of all types of events and occasions. Amateur photo clubs and societies became the mainstay of photography in the absence of any other institutional support and sprang up everywhere. The middle classes economically secure enough to have cultural aspirations having one's self photographed (from birth to death) first professionally and then as a constant stream of snapshots remains the fashion. The fact that anyone could take photographs without much skill or effort further diminished its acceptability as an art form (at least until the 1970s).

Creating a critical base for fine art photography

The photograph is never unique since (in most cases) it is made from a negative. It is therefore always a copy and always reproducible. Viewing a photograph in reproduction does not degrade it to the degree that a painting is degraded when viewed in reproduction. In other words, "mechanical reproduction had brought an end to the work of art's 'aura'". Yet, in the case of photography its aura has been institutionally established by fetishizing the vintage print (in which it is hoped the photographer had either authored that print or at least supervised its production). For the collector such editioning guarantees that there are a limited number of copies in existence and returns to an anonymous image the aura of authorship. Those photographers who make camera-less photographs or work with the intention of making unique works such as Lucas Samaras, Robert Mapplethorpe, and William Wegman, who had worked extensively with Polaroids, are of course the exception.

Given this complexity of issues, Alfred Stieglitz, at the beginning of the 20th century, worked tirelessly to differentiate the practice of art photography from the mixed bag of amateur and distinctly commercial interests. The photography community of the time viewed Stieglitz' circle as elitists because of the high critical standards and strict views that they held concerning the practice of photography as art. Rather than being interested in capturing a picturesque moment, or creating one in the darkroom, these photographers were committed to expressing a depth of emotion that was dependent on temperament and aesthetics while reinforcing the generally accepted view that veracity was photography's quintessential characteristic. To achieve these goals, Stieglitz asserted that fine art photographers not only needed critical criteria but they also needed to establish their own institutions based upon them.

The struggle to create an institutional base for art photography began with Stieglitz' founding in 1902 of the journal *Camera Works* and launching the organization Photo-Secession. This organization, due to its select membership of influential photographers, became the primary legitimizing institution for fine art photography. In 1905 with the opening of his gallery 291, Stieglitz further advanced photography's claim to being art by exhibiting photographers along with avant-garde American and European artists. Between 1908 and 1911 the photographer, Edward Steichen, and Stieglitz organized exhibitions that included Matisse, Picasso, Cézanne, Rodin, and Brancusi. Yet, despite this impressive record, when it came to the Armory Show of 1917 organized by the Association of American Painters and Sculptures, Stieglitz was little more than a consultant. Yet, the Armory Show permanently changed American culture, unleashing a new vision that wed

science, revolution, and new artistic forms (including photography) together.

The triumph of the process of institutionalization and differentiation set into motion by Stieglitz culminated in 1929 when the Museum of Modern Art opened with a photography department that acknowledged both fine art photography as well as vernacular images as an important facet of Modernist practice. Ironically, in the 1960s such photography departments were finding it necessary to discriminate between fine art photographers and artists who were using photography as a medium. This confluence of art and photography in the 1960s reflected both the influence of mass media and reproduction in producing our image world, as well as Modernism's own conflicted nature, which in the wake of Abstract Expressionism coalesced into a formalist aesthetic. Based on a reductive vision of art, formalism took as its premise the belief that art's specificity lay in the essential qualities of its traditional forms.

Spurred by the failure of the formalist vision to sustain art's ability to challenge its audience, it seemed that art's inevitable fate was that it would become a form of decoration, a product of taste, a novelty, or a commodity. In the face of such a dire prediction, there was a renewed interest in Dadaism and in particular the conceptual and media experiments of Marcel Duchamp. In the mid-1950s, the composer John Cage, while teaching at Black Mountain College and then in his seminal course in composition at the New School, disseminated Marcel Duchamp's ideas to artists such as Robert Rauschenberg, Alan Kaprow, and Jasper Johns as well as those who would form the core of both Pop Art and the Fluxus movement. In keeping with Warhol and Rauschenberg's use of photo silk screen, John Baldarsari and Bob Wade began to make "paintings" that consisted of half-tone photographs printed on canvases that had been prepared with liquid light (a paint-on, light-sensitive photo emulsion). In these cases, the photo imagery was handled either as a found object or as a staged event. For instance, Pop artist Ed Ruscha began to produce books of photographs to document such mundane events as the destruction of a Royal typewriter being dropped from a speeding car or documenting all of the buildings on Sunset Strip. In those cases where the artist took the photographs, their amateurishness can be understood as part of the ongoing process of de-skilling art.

The rash of experimentation that characterized the 1950s and early 1960s came to focus on the hope of establishing a conceptual specificity that went beyond formalist issues and began to play with the idea that art's object-hood was expendable. These artists envisioned the work of art as little more than a document that corresponded to the artists' intentions. In this, they considered that they were furthering the modernist program of challenging the conventions of art by exposing that art is an information system that functioned within an institutional framework. At its most extreme, conceptual art was immaterial in the sense that its only object was the limited means by which to communicate an idea or event. From this perspective, all modes of representation and presentation from those of spoken and written language

to the creation of large-scale objects and systems became available.

Within the context of conceptual art, stripped of aesthetic aspiration and disciplinary limitations, photography had now become an art medium. As such, Douglas Huebler, Mel Bochner, and Joseph Kosuth, along with Dan Graham, Walter DeMaria, and Victor Burgin, produced works using a wide array of photo-derived reproduction processes such as Xerox, and photo-stats, as well as photography per se. Others like the minimalist Robert Smithson were producing photo-essays with titles such as The Monuments of Passaic, and Mirror Travel in the Yucatan, which were published in the art magazine *ArtForum.* Sol Lewitt, another artist identified with minimalism, also produced photographic books (catalogs) of his systemic sculptures based on the grid as well as ones in which the images of things were ordered categorically. Likewise, by presenting their photographs as artworks, artists such as Wallace Berman, Dan Graham, and Douglas Huebler jumbled the categorical, practical, and aesthetic goals that it had taken photographers so long to sort out.

Performance artists such as Vito Acconci, Gilbert and George, and Carolee Schneemann presented photographs often taken by others in the course of their performance as a means to communicate what being there might have been like. These photographs in form and content run the gamut from the snapshot to what might be considered a theatrical still depicting significant moments. Other artists such as William Wegman, Mac Adams, and Bill Beckley created tableaus and performances in their studios that were essentially meant to be photographed. These works related to the staged photographs of the 19th century. Others used the photograph to document such temporal or inaccessible works as earthworks (Robert Smithson and Michael Heizer), walks in the English countryside (Richard Long and Hamish Fulton), or to create an image that would function as record of a temporal events (Bruce Nauman, Joseph Beuys, Klaus Rinke, etc.).

Likewise, the German artists Hilla and Bernd Becher at the intersection of conceptual art and minimalism produced photographic studies that consisted of multiple examples or views of such industrial structures as water towers, conveyor belts, and factories. The Bechers exhibited these as either sets of the same type of structures or multiple views of a single structure. Their black and white images with their banal objectivity shared an aesthetic with such photographers as Louis Baltz, Robert Adams, Joe Deal, and Nicholas Nixon among others. What was common to this latter group's work was that they explored with a dispassionate eye the desolate, disfigured, and forgotten places nearly ruined by natural detritus and human intervention that made up the new American landscape. These photographers, similar to the minimalist and conceptual artists, were trying to define both the role of objectivity and aesthetics in contemporary art.

What held these diverse practices together were conceptual and aesthetic congruities rather than stylistic or thematic consistencies. These differing practices formed a definitive economy of practices that corresponded to the formal aspects

of the media used to realize them. Consequently, the use of non-traditional materials and processes, and forms such as ready-mades, text, photography, film, and video came to be added to the canon of both art making and art photography. This brought an end to the hierarchy of both forms and subjects that were cherished by traditionalist and formalist, alike. From the point of view of fine art "photographers," beyond the fact that art sold for more than photographs, the worst aspect of this trend was that these artists had adopted the amateur aesthetic of pointing and clicking; in other words, they were presenting snapshots as artworks. Equally reprehensible was the alternative that in other cases artists did not take their own photographs, but were hiring professional (commercial) photographers to produce their images for them.

Critically, the purist stance, which was the standard well into the 1970s (and beyond) was based on the general belief that fine art photographs depict what we would have seen if we had been there ourselves looking through the camera's lens. In this they continue to adhere to the veracity of the photographic image. This mythology was introduced to qualitatively rather than quantitatively differentiate the subtle ways fine art photographers manipulated their images from the ways in which commercial photographers constructed their images. Early fine art photographer's commitment to create evocative images that were more truthful than mere transcriptions of the world required that they produce photographic images that appeared natural, which is not quite the same thing as unadulterated. Consequently, fine art photographers could assert that their photographs conserved the veracity of photography while reaching beyond the merely documentary to produce something aesthetic.

A parallel approach to this idea of preserving the veracity of photography emerges from the formalist aesthetic and structuralist investigations of the 1970s. Both photographers and artists set to work exposing what is veiled by the conventions of the photograph and the practices and contexts these engage. Likewise the methodology of Canadian artist and filmmaker Michael Snow and the British conceptual artist Victor Burgin was to turn the means that were used to create photography's illusion of naturalness inward to expose the deeper structural and conceptual implications that stem from the fact that even the most common photograph was an artifice.

Snow's paintings and sculptures during this period included the production of photographs, short films, and film installations that explored the subject of a medium's ability to represent itself and its limitations. Burgin rather than making works that were about himself in the sense of process, instead sought to expose the hidden semiotics of photography and the codes and practices that make it a vehicle of ideology by indexing them to context. Comparable to Burgin's stance would be the work of Mary Kelly who would come to address in psychoanalytic terms what photography represses and Martha Rosler's composites (photocollages) meant to make explicit the politics of photographic representation.

Such themes are also taken up by photographers Zeke Berman, Thomas Barrow, and John Pfahl whose works

exploited the distortions produced by the camera, and the qualities of the negative, processing, and print. Their intent was to challenge the assumptions and conventions that circumscribed fine art photography motivated by questions of the relevance of the imposed limitations of the tradition that defined their work as art. Acknowledging the fact that while a photograph is a record of what has been seen, they also refer to what had been excluded in the very process of its making. Others like Robert Cummings tackled the presumption that the photograph represents an isolated a moment in a continuum. Cumming's photographs of studio setups demonstrates how cropping masks the truth of an image by exposing how the photograph is just one frame in an endless sequence of other frames. His pairing of photographs exposes how what the photographer chooses to exclude or include creates a fiction in the guise of truth—each image is no more truthful then the other—and that the photograph creates its own truth.

Robert Frick took our expectations of what may take place before or after a given moment as his subject. He presents repeat images of his subject from differing distances, angles, and lighting in a grid format allowing the viewer to go from detail to whole. The resulting experience (that is both cinematic and minimalist in form) forces upon the viewer an awareness of how the framing of an image is an act of inclusion and exclusion and that our knowledge of a given situation is always a composite of multiple experiences. Other photographers, such as Eve Sonneman and Jan Groover, who straddled the art/photography divide also challenged the belief that a photographer's choice questions the notion of the photograph as representing the most significant or opportune moment within a given continuum by presenting what appeared to be sequential images. For instance, Sonneman would present similar sequences of images in both color and black and white in this way and in doing so she tested the sense of reality that photographs induced.

If photographers were interested in visually exposing how all photographs in one manner or another are fictions, Duane Michals and Frencesca Woodman used anecdote and narrative captions rather than titles to establish context for their images. Michals' work consists of narrative sequences of photographs accompanied by short handwritten text similar to storyboards. Woodman, on the other hand, includes short self-reflective texts. Such approaches extend photography beyond what had become fine art photography's limitations and conventions by suggesting other models of what might constitute the veracity of the image. This conceptual approach addressed the possibility that photography is capable of documenting something more than the external world while also corresponding to the renewed interest of contemporary artists in narrative and anecdote.

Openly using the photograph as an element in the construction of narratives has its roots in the history of staged photography, which developed in the days before the advent of moving pictures. This was also reflected in the experimental works of the surrealist photographers. The effect of these traditions is found in the allegorical photography of Clarence

John McLaughlin, Ralph Meatyard, and Jerry Uelsmann. These created-for-the-camera or made-in-the darkroom visions form the bridge for the staged tableaux of the photographer Les Krims and the staged, manipulated images of the artist Lucas Samaras in the 1960s that form the segue into what photography critic A. D. Coleman identifies as the directorial mode of the 1980s.

Though often identified with post-modernism, such contemporary artist/photographers as David Levinthal, Gregory Crewdson, Jeff Wall, Sandy Skoglund, Joel Peter Witkin, Laurie Simmons, and Cindy Sherman, respectively, exploited differing aspects of both photographic and cinematic traditions to naturalize what are obviously staged situations. This work is based on the theory that every photograph is the intersection of two complimentary precepts. These artists and photographers have self-consciously appropriated the conventions of photography's catalog of genres and exploit photography's ability to induce in us a state of suspended disbelief premised on our continued belief that photography in some manner is the shadow of the real. Mary Kelly, Carrie Mae Weems, Felix Gonzalez-Torres, Shimon Attie, and Krzysztof Wodiczko in the form of installations, or site-specific projections consequently, exploit the lack of a clear-cut division between photography as a means of commentary and reportage (the evidentiary) as a document and an artifice.

Also emerging in the mid-1980s, artists such as Sherri Levine, Richard Prince, and Barbara Kruger who were also identified with post-modernism, extended the critical practices of Pop and Conceptual Art by making explicit the sociopolitical opacity of the photographic medium and its reproduction. Levine does this by photographing reproductions of the work of historically important photographers such as Walker Evans, Rodchenko, and Edward Weston. Upon cursory inspection, the viewer cannot discern her copies from the original. In doing so, she questions the authenticity of the fetishization of the vintage photograph in the sense that her reproductions of reproductions seemingly offer the same pictorial information and aesthetic experience. Likewise, Prince whose early photographic works consist of re-photographing images from advertisements and biker magazines, and Kruger, who works with appropriated photographic images, address how the implicit associations of a photographic image can be made explicit by textually and aesthetically contextualizing it.

The practices ushered in during the late 1980s meant to analyze modernism's essentialist myth of originality, authorship, and purity corresponded not only to the values of mass culture, but also the changing terms and conditions of cultural production and its media. Central to this was the degree to which advertising and mass media had immersed us in a world of simulated representations and reproductions created by new technologies that increasingly could simulate most other media. For the photographers this meant that due to digital imaging technologies the photograph was an aesthetic effect. Seemingly under such conditions, what had driven photography's discourse for more than a century—its capacity to compel (or challenge) us to believe that its referent is real

and therefore capable of invoking the past—had come to an end. Yet under these conditions photography and its doppelganger, the photographic effect (of digital imaging), continues to be ordered by the look of photography's historical development and practices, as well as a self-conscious reference to its construct as a simulacrum. The distinction here is that digital imaging, though different in process, is indistinguishable in appearance beyond that of scale and on occasion material choice (paper, canvas, lamination, and inks).

The work of "photographer/artists" Andreas Gursky, Thomas Ruff, and Thomas Struthe is located at the intersection of those discourses concerned with the effect wrought by the technologies of mass production, reproduction, and replication and the historical imagery and practices that inform our conception of what photography is. Within their appropriation of the wide range of photographic genres and their ethos, these artist/photographers investigate the relation between three categories of media image—documentary (objective), aesthetic (expressive), and the collaged (constructed). Given the scale and clarity of digital photography, by extension their work also reopens the question of photography's relation to painting. In this digital imaging has a relationship to chemical photography that is similar to photography's relation to painting in its early days. As such, the evidence of the digital's effect on our consciousness may be observed in the changing relationship between painting, photography, and film as each succumbs to, resists, or is annexed into the experiences and aesthetics engaged by digital's media sphere. Consequently, just as modernism (which was stimulated by the advent of photography and the age of mechanical reproduction) is brought to its end, the differentiation between visual art and photography now exists only as an index of differing perspectives and contexts. ◉

Photography and Society in the 20th Century

GRETCHEN GARNER
Independent photographic author and scholar

Introduction

It would be hard to imagine a technology that had more impact on 20th century life than photography: the automobile, the airplane, nuclear power, all of these were higher profile than photography, yet in day-to-day terms, photography was truly the most pervasive. Here the effect that photography has had on 20th century society will be discussed in four distinct areas: amateur photography (making everyone a photographer), advertising photography (creating desire in the public), journalistic/editorial photography (informing and entertaining the public), and documentary photography (recording the lives of real groups of people).

Background

To imagine a social world before photography, we would have to think of a world without picture IDs; without portraits of ordinary people (or schoolchildren); one without pictures as souvenirs of travel; one without celebrity pictures; one without advertising photographs; one without X-rays or views of outer space; a world without views of foreign and exotic peoples; one without pictures of sports, wars, and disasters; and one in which the great masses of people had no way to visually document the important events of their lives.

Such a world is unimaginable to us now, and we have photography to thank for all these things: visual souvenirs, portraits of common folk as well as the famous, advertising pictures that have created desire in the public and educated them about all the products the new consumer culture has on offer, medical diagnostic tools, incredible views of exotic places and even of outer space, pictures of the world's news, and most important, pictures of the events and intimate moments of one's own life.

The technology of photography is part chemical, part optical, and dates from 1839. Soon after its simultaneous invention by William Henry Fox Talbot in England and Louis Jacques Mandé Daguerre in France, photography was used to document foreign places of interest such as India, the Holy Land, and the American West. It was also used for portraits with photographs taken of kings, statesman, and theater or literary personalities.

During the 19th century, however, cameras were mainly in the hands of professionals or self-educated entrepreneurs who tried photography as a trade. Interestingly, photography has never required professional licensing or guild membership (with the exception of Talbot's unsuccessful attempt to sell licenses early after his invention). In the mainstream, any tinker or businessman could buy the equipment, obtain the directions, and proceed. This openness of the medium made photographic practice rather free from the traditions that had grown up around painting or the various printmaking arts.

When pre-coated dry plates were introduced in 1878, the tedious and messy coating of glass plates in the darkroom (or dark tent, for photographers in the field) was eliminated, and when pre-coated photographic papers were made available, printing of photographs became much easier and more predictable. From this point on, photography could be practiced by hobbyists or amateurs (literally, lovers of the medium). Perhaps predictably, since most who had the leisure for such an advanced hobby were educated and sophisticated, they wanted to make photographs that looked like Art.

Amateur Photography

Thus, aspiring to art, the late 19th to early 20th century amateurs were interested in aping the artistic formulae they had learned from Whistler and the Tonalist painters of the time. To do this, soft-focus lenses, matte papers, and elaborate mounting and framing techniques were employed by the so-called Pictorialist photographers. Sometimes unusual emulsions would be hand-coated onto the printing papers, and often drawing or other handwork was introduced onto the images,

either onto the negative or onto the print itself as if to say: This is not a mechanical art.

These Pictorialist amateurs formed themselves into societies and clubs. Clubs were formed in many European countries as well as the United States, and exchanges between their members were common. Magazines, such as *American Amateur Photographer*, kept the network of amateurs connected and provided technical information and news, as well as criticism. Many of the clubs sponsored journals, such as the New York Camera Club's *Camera Notes* (edited by Alfred Stieglitz until the membership grew dissatisfied with him, whereupon he started his own publication, *Camera Work*, 1903–1917). In the clubs, annual and even monthly salon competitions were held, and these salons and clubs continued into the mid-20th century, eclipsed only when academic programs in fine art photography replaced them for the most part.

The Kodak

Meanwhile, late in the 19th century, a sense that amateur photography could be marketed to the masses was building. The first entrepreneur to be enormously successful at this challenge was George Eastman. Eastman's company, the Eastman Dry Plate and Film Company, had been in business since 1884 in Rochester, New York. His breakthrough product was the Kodak camera of 1888 (no special meaning to the invented word, Eastman just liked the letter K). The Kodak was a plain box camera with a reel of paper-backed emulsion. The lens was a wide-angle affair, the shutter simplicity itself, and the printed pictures were circular. The pictures were lively snapshots (a new word in the vocabulary). Kodak's now-notorious advertising slogan was "You press the button, we do the rest." This was an appeal to the masses, not to sophisticated amateurs.

The camera was purchased for $25 with a 100-exposure reel, and when the photos had all been taken, the whole thing was returned to the factory for development of the pictures and reloading of the camera for a modest fee. In its second year, 1889, the Kodak carried its emulsion on a transparent nitrocellulose support, introducing film to photography and eliminating the need for the delicate stripping of the emulsion from the original paper base. A variety of slightly more complex folding Kodaks (cameras with bellows that allowed more precise focusing) were added to the amateur lineup of equipment by Eastman. The folders, as they were called, were popular into the 1940s.

George Eastman realized early on that there was no existing need for his cameras. He had to create a need. Therefore, he invested heavily in advertising from the beginning. One of Eastman's prescient views was that women must be targeted, because women were the most likely recorders of family events and of their children's lives. From the early, rather saucy Kodak Girl to the mothers tenderly recording their offspring, women were seen as the largest potential amateur market for Kodak products—both cameras and films—and were pictured constantly in Kodak advertisements.

One of Kodak's most notable advertising campaigns was the series of Colorama pictures—enormous back-lit color transparencies, 18 × 60 feet—that hung high at the end of

FIG. 1 This 1926 Kodak advertisement from *Good Housekeeping* magazine shared a family-centered photography theme, which turned out to be a huge phenomenon and the rock-solid base of the Eastman Kodak's success. Early on, the Eastman Kodak Company emphasized the importance of family snapshots in their advertising and often the photographer pictured was a woman. (Image reproduced with permission of the Eastman Kodak Company, Rochester, New York.)

The new miniature cameras

In 1924 the Ermanox camera was put on the market in Europe. This radical new instrument was very small, and it could be hidden in a vest for surreptitious shooting or held at eye level for quick framing and shooting. The Ermanox had a maximum f/2 lens (meaning a lens opening one-half of its focal length, quite a wide aperture), and could thus photograph in low-light situations. All this was almost revolutionary, but unfortunately, for its future, the Ermanox did not handle roll film. The truly revolutionary camera came along a year later in 1925 when the Leica was invented by Oscar Barnack. The Leica had the diminutive size of the Ermanox and a wide aperture on its excellent Leitz lenses, but, more important, used a length of 35 mm motion picture film. This allowed the sequential shooting of up to 36 exposures, instead of the single image taken in the Ermanox. The impact on professional, as well as amateur, photography was profound. Henri Cartier-Bresson was the most notable early practitioner with the Leica, but thousands of others—professionals and serious amateurs—soon followed.

Closely following the Leica came the Rolleiflex (1928), another German machine and also what was then called a miniature camera, although its negatives were 6 × 6 cm, and the camera was a twin-lens reflex held at waist level (now we call this a medium-format camera). Many imitations of both types of cameras ensued, several made by Kodak, and then the mix was enriched by the Japanese single lens reflex (SLR) cameras that came on the market in the 1950s (the pioneering Nikon was first marketed in 1948). These cameras also took 35 mm roll film, but the viewing and focusing mechanism, instead of a rangefinder, was a mirror/pentaprism that was more easily mastered for focusing by most amateur photographers. The Japanese SLRs were also more competitive in the amateur marketplace (many Korean War vets had also come home with these cameras).

Continuously, photography was made more accessible to the amateur. Even those who could not buy the Leica, the Rolleiflex, or the Nikon were able to buy knock-offs made by Kodak or other manufacturers like Ansco. At the same time, film was improving for amateurs. For example, Verichrome film, a wider-latitude black and white film, was introduced by Eastman Kodak in 1931, and in 1935 the still-unequaled Kodachrome color transparency film was introduced. It was followed in 1942 by Kodacolor film (color negative film, making color prints). These materials were used by professionals, but also were accessible to amateurs.

Polaroid

In 1947 Edwin Land introduced his instant Polaroid camera system. Its film/paper pack, as soon as the exposure was made, was pulled through rollers that released the chemicals that would develop the print. In a matter of seconds, the 4 × 5 print could be peeled from its negative, fixed with a saturated pad provided with the film pack, and enjoyed. Land invited many professionals to test his system, thus assuring a professional acceptance of Polaroid, but he also marketed the camera

Grand Central Station in New York. The Colorama campaign extended from 1950 to 1990 and concluded when the station was renovated. The depictions featured family (or couple) activities, with the amateur photographer the focus of attention—either with a snapshot camera, like the Instamatic, first marketed in 1963, or with an 8 mm movie camera. The Kodak scenes were always ones of middle-class happiness and social activity, with the exception of a few dramatic NASA photographs such as Colorama #284, *Earthrise from the Moon*, 1967.

In Europe no marketer reached the populace with Eastman's success, yet the most important technical camera advances in the early decades of the century would happen there. These were more sophisticated cameras than the simple Kodak, adopted mostly by professionals and advanced amateurs.

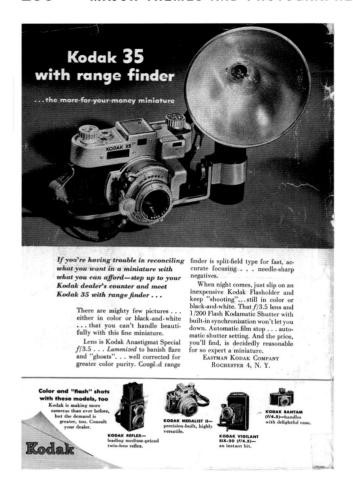

FIG. 2 In this ad from 1947, Kodak appealed to the serious amateur who might like a Leica or Rolleiflex but also wanted a less expensive camera. Kodak also marketed its folding cameras in this ad. Later they would abandon serious camera manufacture as the American market became flooded with Japanese cameras, but recently has been very active with its highly acclaimed digital cameras for the amateur market. (Image reproduced with permission of the Eastman Kodak Company, Rochester, New York.)

FIG. 3 When Kodak introduced its Kodachrome film in 1935, it began using well-known photographers. In this example from 1947, Ansel Adams, who was not credited in the ad, was asked to test the film. The color negative Kodacolor was introduced to the market in 1942, the same year Agfa (Germany) and Sakura (Japan) introduced their color negative films. (Image reproduced with permission of the Eastman Kodak Company, Rochester, New York.)

to amateurs. In 1963, color Polaroid material was introduced, and in 1973 the SX-70, the camera that had the most impact on amateur photographers, was put on the market. This oddly shaped little camera spit out square color images that developed right before the eyes, and it became a popular sensation. Although its technical problems (color balance and color stability) were formidable, the SX-70 was adopted by many.

As it had done with many other technical advances, Kodak came out with its own version of this camera, but this time Polaroid struck back in 1976 with a lawsuit against Kodak, suing for copyright infringement of their instant cameras. In 1985 Polaroid won their case against Kodak, and in 1991 Kodak paid Polaroid hundreds of millions. Such a big win

did not save Polaroid, however, because the instantaneous possibilities of digital photography would make Polaroid's niche of instant imagery obsolete. In 2001 Polaroid filed for Chapter 11 bankruptcy protection, and the company's heyday seemed to be over. Ansco, an earlier competitor of Kodak, had also won a multimillion dollar suit against the Yellow Giant, as Kodak has been called, in 1914. Kodak was able to absorb these challenges, and although it has had its ups and downs, Kodak now survives in better condition than the now-defunct Ansco or the hobbled Polaroid companies. Kodak, after abandoning the serious camera market when the

Japanese had gained dominance, has now re-entered this arena with its digital cameras even as its film and paper markets diminish.

Photography without film
Digital, or film-less, photography has now gained dominance over film photography, especially in the amateur market. In 1981 Sony pioneered the genre with its Mavica camera, but without the supporting environment of Photoshop (first marketed in 1989), computers in every home, and high-quality digital printers, it took many years for digital photography to really catch on. In 2003, however, digital camera sales surpassed film cameras, according to the Photo Marketing Association. Many photo labs who have not accommodated the digital world have succumbed to this new regime. Kodak announced in 2005 that it would cease production of its black and white printing papers, further sealing the fate of darkroom photography. Meanwhile, the new giants in photographic printing, like Epson and Hewlett-Packard, are thriving in this new world.

Amateur photography for the masses can be seen as a positive, democratic social phenomenon—making everyone a visual recorder of his own life—but likewise it is a successful, capitalist business phenomenon. Without the lure of fortunes to be made from millions of customers, it is unlikely that the businesses that have made such an impact would have entered the field.

Advertising Photography
Even as Kodak was using advertising to create a market for its cameras, films, and papers, the advertising industry itself turned increasingly to photography during the 20th century. Newspapers as well as the great number of popular magazines (especially in the pre-TV era) were the carriers of most of this print advertising.

The purpose of advertising was and is to create a desire for the new consumer products available to the public (sometimes advertisers call this education), and then, of course, to sell the products. Although drawings and painted illustrations were featured predominantly in ads during the early part of the century, gradually photography took over, and by the end of the 20th century virtually all visual advertising was photographic. Today, in the 21st century, digital photography has introduced the kinds of fantastic effects impossible in straight photography, further enriching the possibilities of advertising photography.

While half-tone reproductions of photographs had been possible since the 1880s, and magazines and newspapers regularly used them in their editorial pages, before World War I advertisers seldom did. The great shift happened in the 1920s and 1930s. By the mid-1930s photographs at least equaled hand-drawn illustrations in print advertising, and have only gained greater dominance since then.

Before WWI advertisements were generally reliant on copy to sell their products, which were often quite lengthy texts by modern standards. But after the war, a new attitude took hold. Some hopeful idealists saw advertising clients as modern society's new art patrons, the new Medicis, as it were, and felt there was no reason why the very best artistic talent should not be used in advertising. The advertising agencies hired art directors to manage this visual side of the work, and in 1920, The New York Art Directors' Club was founded to encourage advertising art by holding exhibitions and lectures.

European modernism/American realism
In Europe, which had been most disrupted by WWI, new artistic styles like Cubism, photomontage, and even photograms were translated to successful effect in photographic advertisements and posters. In America advertising photographers generally practiced a more realistic style, albeit often with dramatic lighting and extreme close-ups. Edward Steichen was the most prominent example of these new advertising artist-photographers.

In the first decade of the century, Steichen had been a famous Pictorialist photographer, partner, and talent scout for art photography impresario Alfred Stieglitz. But after the War (in which he served as an aerial photographer), Steichen changed directions. When he returned to the United States in 1923 he began a career not only as a successful fashion and portrait photographer for *Vogue* and *Vanity Fair*, but he opened his own commercial studio to produce advertising photographs as well. Stieglitz disdained his new direction, maintaining that artistic and commercial work were irreconcilable, but Steichen made a great success of both. The two men never reconciled. Later, of course, Steichen served again as a military photographer in World War II, and then in 1947 became the Director of Photography at the Museum of Modern Art in New York, where his most famous exhibition was the vastly popular The Family of Man in 1955.

Other prominent early advertising photographers in the United States (whose work is now held by art museums) include Paul Outerbridge, Gordon Coster, John F. Collins, Alfred Cheney Johnston, Victor Keppler, Lejaren à Hiller, Nickolas Muray, Anton Bruehl, and Grancel Fitz.

The question whether the new patrons of art, the advertising clients, actually did encourage true Art is one that cannot be answered in the affirmative unless the pictures are removed from their intended purpose and somewhat cynically understood. Although Steichen may have created a fresh and striking image of cross-lighted Camel cigarettes and Fitz a wonderful view of sophisticates observing a new Chevrolet, the overriding ethos of the pictures was to sell the cigarettes and the cars.

And for that, no amount of glamorizing or fantasy was too much; in other words, these pictures did not partake of the highest modernist photographic value, truth. The people seem always content and upper class (there is never any sign of the Depression), and nondescript products are rendered as stunning, abstract, modernist designs or else not rendered at all, as in the case of the Chevrolet ad, where class atmosphere was the only thing pictured.

This truth about advertising photography—that it does not necessarily describe the truth—is understood now by one

FIG. 4 Photograph by Grancel Fitz for a General Motors Company ad made in 1933 for a campaign produced by Campbell Ewald Company. (Image courtesy of GM Media Archive.)

and all (including savvy consumers), yet commercial photography has continued to attract talent, and enormous amounts of money continually change hands in this field. After mid-century, any number of artistic giants gained prominence in advertising (Irving Penn, Richard Avedon, Bert Stern, Henry Wolf, and Hiro, among others) as advertising gave a kind of stylistic license to photographic exploration. Especially as large photographs came to dominate advertisements late in the century, the sheer impact of the photographs demonstrate the creativity alive within advertising.

How well has photographic advertising worked? There is no truly objective answer to this question, but suffice it to say that increased desire for and consumption of goods bears tribute to the effectiveness of vivid and alluring advertising photography. Corporations with a product to sell, and brands looking for image identity, have continued to use photography to sell themselves to the public, continuing to believe in the 1930 ad copy by the Photographers' Association of America, headlined: "SELL MORE … with photographs."

Journalistic/Editorial Photography

As advertising photography has opened a Pandora's box of desires for the products consumers can buy, so has editorial photography opened the treasure chest of information the public can know and know in a visual, not just verbal, sense.

People love pictures. Text without pictures is boring to the mass audience. Drawings and engravings had been used in newspapers and magazines for as long as the technology had allowed, and in 1880 that technology expanded to include half-tone reproductions of photographs (the mechanical rendering of continuous tone photographs into larger and smaller dots of ink on the page).

Photographs soon became a staple of the daily paper. The development of the wirephoto, scanned photographs beamed across telegraph and telephone wires, also sped up the worldwide dissemination of news pictures. The Associated Press pioneered its AP Wirephoto, sending pictures to its member networks beginning on January 1, 1935. In terms of quality, rotogravure sections (higher quality printing devoted solely to pictures) were a feature of Sunday papers up until the introduction of the Sunday supplement magazines, mostly in color, that are familiar today.

In the last quarter of the century most newspapers made the transition to color printing for photographs on their news pages, led by the successful and colorful *USA Today*. Even the staid *The New York Times* made the transition to front page color in the 1990s. *The Wall Street Journal* remains the only holdout among the major papers.

The magazines

As important as newspapers were, the greatest mass vehicles for photographs in the 20th century were actually the picture magazines. With higher quality printing and coated paper, and less need for daily, topical news, the magazines had the liberty to present more features and greater variety in their coverage. And in a world before television, the weekly magazines were literally readers' windows on the world, eagerly devoured and subtly creating a common visual culture.

Magazines were a staple of early 20th century culture, as Berenice Abbott's 1935 photograph of a newsstand demonstrates, but covers and major illustrations were usually drawn or painted. Fashion and celebrity photographs, to be sure, were already being published in magazines like *Vogue* and *Vanity Fair*, but when *Life* came on the scene on November 23, 1936, America had its first completely photographic general interest magazine.

Life and the picture magazines

America did not lead the way, however, with picture magazines. The pioneer had been the *Illustrated London News*, and in the 1920s, the European picture magazines, particularly the *Berliner Illustrirte Zeitung* (*BIZ*), and in France, *Vu*, took the lead. So when publisher Henry Luce and his favorite photographer, Margaret Bourke-White, went on a European pilgrimage, they were looking for already existing models for the yet-to-be-born *Life*.

The prospectus for *Life* spelled out the challenge, and especially the visual emphasis, the new magazine would have:

To see life; to see the world; to eyewitness great events; to watch the faces of the poor and the gestures of the proud; to see strange

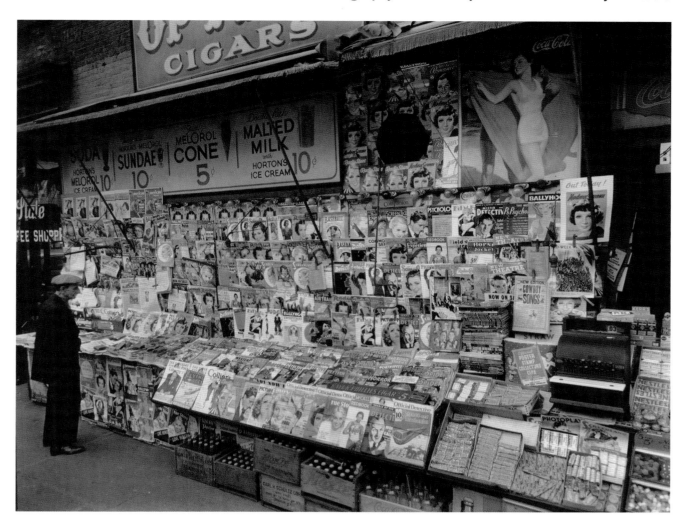

FIG. 5 In 1935, when Berenice Abbott photographed this newsstand in Manhattan as part of her documentary, *Changing New York*, all of the covers on the magazines were painted illustrations. Today they would all be photographs. (Photograph credit from the Photography Collection, Miriam and Ira D. Wallach Division of Arts, Prints and Photographs, The New York Pubic Library, Astor, Lenox, and Tilden Foundations.)

things — machines, armies, multitudes, shadows in the jungle and on the moon; to see man's work — his paintings, towers and discoveries; to see things thousands of miles away, things hidden behind walls and within rooms, things dangerous to come to; the women that men love and many children; to see and to take pleasure in seeing; to see and be amazed; to see and be instructed.

To see, above all, was the mission of *Life*. At its initial newsstand price of 10 cents, it was irresistible. The magazine encouraged many superb photojournalists, such as W. Eugene Smith, especially in the development of photo-essays, whole stories that would be told visually, in contrast to the single images for which most newspaper photographers were known.

When *Life* was released on November 23, 1936, it began a hugely popular run that did not pause until 1972, when the impact of television (including lost advertising revenue for the magazine, as well as diminished interest in a weekly news magazine) caused *Life*'s demise. Although it has had monthly, annual, and semi-annual format revivals since then, *Life* has never regained the central position in American culture that it had between 1936 and 1972. Another picture magazine that met a similar fate was *Look*, also closing down in 1972.

In the era of television, beginning mid-century, the general interest magazines like *Life* and *Look* lost their grip on the imagination of the public. But since then, magazines that appeal to special interests, particular lifestyles, and celebrity

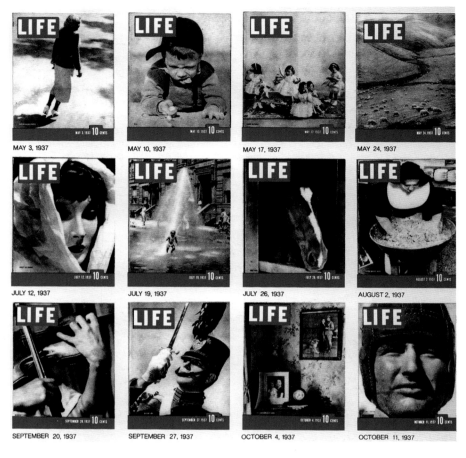

MAY 3, 1937 MAY 10, 1937 MAY 17, 1937 MAY 24, 1937

JULY 12, 1937 JULY 19, 1937 JULY 26, 1937 AUGUST 2, 1937

SEPTEMBER 20, 1937 SEPTEMBER 27, 1937 OCTOBER 4, 1937 OCTOBER 11, 1937

FIG. 6 When *Life* magazine came on the scene in November 1936, bold photographic covers were its style. *Life*'s dedication to using photographs extended from the covers into the entire contents of the magazines shared in a series of magazine covers from the publication's first year. (Reproduced with permission of *Life* magazine, New York.)

culture have continued strong in the market, all of them featuring photography (now exclusively in color) in their pages. Today's magazine giants include the fashion magazines like *Vogue*, the lifestyle magazines like *Martha Stewart Living*, and the celebrity magazines like *People*. Any number of more specialized publications fit niche readerships: men, women, hobbyists, and enthusiasts of all kinds.

War coverage

The news in the 20th century was as visual as it was textual. Every 20th century war—from World Wars I and II, the Korean War, the Vietnam War, to Desert Storm, and many smaller, often guerilla, wars in between—was covered photographically. Some well-known journalists such as W. Eugene Smith, David Douglas Duncan, Larry Burrows, and Susan Meiselas, for example, have become best known for their war photography. *Life* magazine came on the scene in late 1936 with World War II on the not-too-distant horizon. *Life*'s

coverage of that war in both the European and Asian theaters was thorough, and many of the visual icons we all remember from WWII were first published there. Excellent war coverage was a strong element of *Life*'s success.

The kind of hopeful early idealism that held that if people could just see the devastation of war, they would stop it (W. Eugene Smith, for one, hoped his photographs would have this effect). Sadly this has not been realized. The thrill of violence in picture form continues as a staple, and it seems to titillate as much as it horrifies the public. Nevertheless, censorship of war pictures is currently a strategy of the U.S. government and its coalition forces fighting in the present Iraq conflict. In this war initial policies forbade press pictures of draped coffins, so that readers at home would not think of the inevitable—death—in relation to this war. Such was the government's thinking, but it seems that the public has become well aware of the price of death that American soldiers are paying, as numbers of casualties and deaths have risen and

support for the war has declined. In another effort to control journalists and photographers in the current Iraq conflict, the policy of embedding them within defined military companies has limited their freedom to look for their own news.

Also, no end of trouble has ensued from the outrageous amateur images that a few American soldiers made of their torture of prisoners in the Abu Ghraib prison in Iraq. The scandals that erupted when the pictures became public have borne witness to the continuing power of photographs, whether professional or amateur.

Other news and technologies

Sports events and celebrities, natural disasters, great artists, entertainers, fashion, and food were also made visible to the daily reader of the paper or the weekly reader of the news magazines in the 20th century. Many photojournalists in the first half of the century continued to use their Speed Graphics when photographing news or celebrity features, but gradually the 35 mm camera became standard equipment after mid-century, and photographers armed themselves also with repeatable electronic flash units instead of the one-use flashbulbs that earlier had been standard.

The electronic flash was invented by Professor Harold Edgerton at MIT in 1931, but it took some years for the handy, small units that fit onto a camera hot shoe to become common. These automatic units (with a sensor that could shut off the brief flash when the right amount of light was received by the subject) were pioneered by companies like Vivitar in the late 1970s with its Vivitar 283 and the development of its Thyristor light-measuring circuitry.

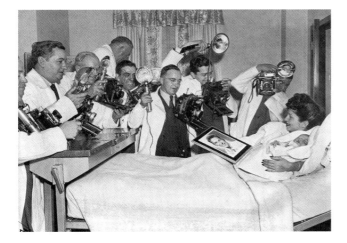

FIG. 7 Photograph by Joe Petrella for the *New York Daily News*, January 12, 1944, shows Mrs. Frank Sinatra and her newborn son Frank, Jr. surrounded by photographers in the hospital. Note all the photographers are using Speed Graphic cameras and flashbulbs. Frank, Sr. is present only in the framed photograph on her lap. (Reproduced with permission of the *New York Daily News*.)

Today, most photojournalists have quit their film cameras in favor of digital cameras gaining added speed from sending their pictures back to editors via the Internet, with no delays for film shipment, film development, or printing. Because their cameras record everything in color (but that color can be transformed to black and white with the click of a computer button), color is generally used in magazines and on the front pages of newspapers, while black and white may be used inside. Color, it is thought, is more appealing to the public, with an added level of realism.

National Geographic

The continual success of fashion and celebrity magazines throughout the 20th century has been noted already, and another, in a class by itself, was the monthly *National Geographic*. This magazine showed pictures of far-away locales and cultures that were exotic to the readers, and brought them to life in vivid, beautifully printed color photographs. Less dependent on topical stories than the weekly *Life*, it positioned itself as an educational journal of geography, and its subscribers as members of the National Geographic Society. This, and the increasingly lavish color printing of its photographs, has ensured its viability.

The *National Geographic* had printed photographs since 1895, and was an early pioneer of color, reproducing more than 1500 autochromes (an early type of color transparency) between 1921 and 1930. In 1936, when Kodachrome film became available, it became the standard film for the eventually all-color magazine.

National Geographic has continued to evolve in the kinds of stories it presents, as the exotic world seems to have been thoroughly explored. More stories today are about explorations of science, weather, and medicine, but the coverage is always strongly photographic, and the magazine continues to be hugely popular.

Printed photographs thus have played an enormous role in educating and informing the 20th century public, as well as entertaining them.

Documentary Photography

There is a final branch of photography directly related to popular social life, and that is documentary photography. Documentary projects generally focus on social reality and human life, informed by the strong feelings of the photographer. They are photographs with a point of view, focusing not just on events, but on the daily texture of life of their subjects. Many reformist projects in the earlier years of the 20th century were documents of disadvantaged social groups in dire straits, poverty, and cultural alienation. But projects toward the end of the century have tended to be more personal to the photographers, sometimes documenting the photographer's own social group and concerns.

Reformist photography

While documentary projects have not always appealed to a mass audience, they have played an important role in

changing perceptions and sometimes even in influencing legislation. Lewis Hine said about his photographic efforts that he wanted to show both what should be appreciated but also what should be changed. And indeed, his documentary coverage of child labor in the first decade of the century was effective evidence used in the development of child labor laws in the United States. And his later documentary coverage of workers constructing the Empire State Building (1930–1931) turned these little-known men into 20th century heroes. Hine followed Jacob Riis, who similarly tried to reveal the deplorable living conditions in the tenements of New York in his book, *How the Other Half Lives* (1890).

Roy Stryker, director of the Historical Section of the Farm Security Administration (FSA) during the Depression, organized a federally subsidized documentary project (1935–1943) of a scope never seen before, or since. Stryker was proud to state that the FSA project introduced Americans to America. His large staff of photographers were sent around the country to record the plight of Americans suffering from the Depression, and the pictures were distributed to many papers and magazines, including *Life*. There, in the magazine pages, mostly middle-class readers were brought face to face with the kind of hardships suffered by less visible and less privileged Americans. While the reformist purpose of the photographs was less evident than their overwhelming appeal to human sympathy, the project as a whole was a public relations effort of an agency of President Franklin Roosevelt's government, an effort to popularize his agricultural reforms. Dorothea Lange, Walker Evans, Ben Shahn, Russell Lee, and Arthur Rothstein were a few of the important photographers employed by the FSA. These photographs are now in the Library of Congress, and many have entered the iconic imaginations of Americans.

Other impressive 20th century documentary projects include Edward S. Curtis' massive documentation of the North American Indian, which was published in 20 volumes between 1907 and 1930, and in Germany a rather similar project by August Sander, conceived after World War I, which he called "People of the Twentieth Century," that he intended to publish in a series of 45 portfolios. Because of Nazi persecution much of Sander's work was destroyed, but some of his pictures had been in circulation and a large compendium, titled *August Sander: Citizens of the Twentieth Century*, was published in

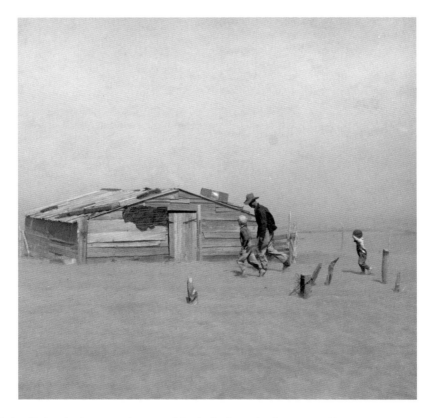

FIG. 8 Photograph by Arthur Rothstein. Farmer and sons walking in the face of a dust storm. Cimarron County, Oklahoma, 1936. Farm Security Administration—Office of War Information Photograph Collection. Library of Congress Prints and Photographs Division, Washington, D.C. [reproduction number LC-DIG-ppmsc-00241].

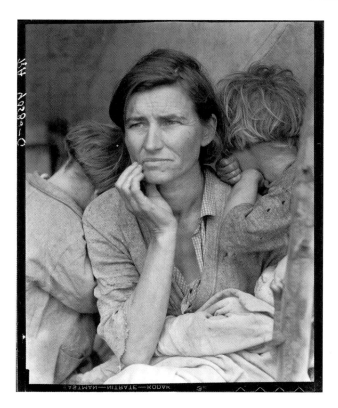

FIG. 9 Photograph by Dorothea Lange. Migrant Mother. A photograph from the Farm Security Administration Collection, made in February or March of 1936 in Nipomo, California. (Courtesy of Library of Congress, Prints & Photographs Division, FSA/OWI Collection. Reproduction number LC-USF34-9058-C.)

1986. Sander photographed with an almost clinical neutrality. He believed the physiognomy of his subjects, posed very simply, would tell the story.

Sander's work has influenced many documentarists whose work is similarly evasive or neutral in terms of viewpoint; for example, Bruce Davidson's *East 100th Street* (1970), rather affect-less pictures of the so-called "most crowded block" in New York. Yet other strong documentarists have continued in the sympathetic, reformist mode: Sebastião Salgado in his mammoth study *Workers: An Archaeology of the Industrial Age* (1997); Eugene Richards in *Cocaine True, Cocaine Blue* (1994); Mary Ellen Mark in her *Streetwise* (1988), and Donna Ferrato in *Living With the Enemy* (1991). However, tendency toward more neutral viewpoints (as in Davidson) or more personal subjects has been the late-century trend.

The Family of Man

In mid-century, in the midst of the Cold War, Edward Steichen conceived and developed a hugely popular exhibition at New York's Museum of Modern Art called The Family of Man.

The show was visited by thousands in New York in 1955 and by millions more at its many tour sites around the world (the international tour was sponsored by the U.S. Information Agency).

Steichen wanted to create an exhibition about the similarity of human culture all over the world, and to do so he solicited photographs worldwide, which he edited down to certain themes he had pre-determined. Most of the 500+ prints that ended up in the show were pictures in the documentary tradition. Unfortunately for the individual visions of the participating photographers, their own viewpoints were diminished in Steichen's grand scheme, based on his editorial vision and selection of single images. Nevertheless, most viewers seemed to appreciate Steichen's vision of the one-ness of mankind, and documentary photography (even though this was not a documentary project per se) was showcased in a very public, international forum. The Family of Man catalog is still in print and popular, 50 years after the exhibition.

Personal documentary

After mid-century, and after the uneasy critical reception of The Family of Man (despite its popular success), much documentary style photography turned in a more personal direction, and has been less appreciated (or even accessible) by the general public. The first notable project in this direction was Swiss photographer Robert Frank's *The Americans* (published in France in 1958 and in the United States in 1959). Not really a sympathetic portrait of Americans, not even a credible survey of American life, the book was a personal, melancholy (if not downright negative) view of Frank's adopted land. Critical reception was mixed, but in hindsight one can see the importance Frank's book had in turning documentary away from reformist or celebratory modes.

Several photographers began exploring their own social groups late in the century. For example, Bill Owens, in his *Suburbia* (1973) documented the very place where he lived with his young family, in suburban California, and British photographer Tony Ray-Jones offered a light-hearted spoof of his fellow countrymen at play, in *A Day Off* (1974). Larry Clark documented the drug culture he inhabited in *Tulsa* (1971). More recent examples of the genre include Larry Sultan's *Pictures from Home* (1992), Sally Mann's *Immediate Family* (1992), and even Nan Goldin's *The Ballad of Sexual Dependency* (1986).

Later, even more personal documentaries have given up, one might say, any kind of connection with a wide public, so they don't need to be mentioned here. Such pictures are generally exhibited in art galleries and published by specialized art publishers and don't reach a broad magazine or newspaper audience. And the general trend, toward the personal instead of the public and has made documentary less engaging to the general public. However, in its glory days in the first half of the 20th century documentary played a socially significant role in the culture by introducing its viewers to fellow humans whose lives they would have never glimpsed otherwise.

FURTHER READING

Bendavid-Val, L. (1994). *National Geographic: The Photographs*. Washington, DC: The National Geographic Society.

Bezner, L. C. (1999). *Photography and Politics in America: From the New Deal Into the Cold War*. Baltimore: Johns Hopkins University Press.

Capa, C. (ed.) (1968). *The Concerned Photographer*. New York: Grossman.

Fulton, M. (1988). *The Eyes of Time: Photojournalism in America*. Boston: NY Graphic Society/Little Brown.

Garner, G. (2003). *Disappearing Witness: Change in 20th Century American Photography*. Baltimore: Johns Hopkins University Press.

Hall-Duncan, N. (1979). *The History of Fashion Photography*. New York: Alpine Books/International Museum of Photography.

Hurley, F. J. (1972). *Portrait of a Decade: Roy Stryker and the Development of Documentary Photography in the Thirties*. New York: DaCapo Press.

Kunhardt, P. B., Jr. (ed.) (1986). *LIFE: The First Fifty Years, 1936–1986*. Boston, Toronto: Little Brown.

Meltzer, M. and Bernard, C. (1974). *The Eye of Conscience: Photographers and Social Change*. Chicago: Follett.

Sobieszek, R. (1988). *The Art of Persuasion: A History of Advertising Photography*. New York: Harry N. Abrams. ◉

Photography and Desire: Fashion, Glamour, and Pornography

BRUCE CHECEFSKY
The Cleveland Institute of Art

The invention of photography in the 1830s brought voyeurism to the masses. It made public what was previously only imagined and secret.

The great early erotic–pornographic photographers proved that high shock value and intense sensuality compelled the reader to pay attention, willingly or otherwise. Nineteenth century fashion photographers learned this lesson quickly. Desire has always been the common objective of pornography and fashion photography.

Many 19th century photographers who shot nudes chose to remain anonymous, so it is virtually impossible to attribute their work. Among the few who are documented are William (Guglielmo) Plüschow (1852–1930), Ernst Heinrich Landrock (1878–1966), Rudolf Franz Lehner (1878–1948), Vincenzo Galdi (active 1880–1910), Louis-Amédée Mante (1826–1913), Léopold-Emile Reutlinger (1863–1937), Wilhelm von Gloeden (1856–1931), Paul Nada (1856–1939), Gaudenzio Guglielmo Marconi (1841–1885), and Stanislaus Julian Walery (1863–1935).

Pornography undermines the power dynamics between male and female, photographer and subject. It reinforces crude, restrictive sex-role stereotypes and standards of beauty. Despite its adverse social implications, the pornography industry in the United States earns revenues of more than $10 billion annually, with up to $2 billion spent on porn Web sites. Pornography ranges from profound explorations of desire to highly stereotyped sexual explicitness, and from soft-core images of attractive models to graphic depictions of kinky sex acts.

Glamour photography, on the other hand, generally stops short of showing explicit sex; it is intended to be erotic. Mainstream erotic–pornographic imagery is as polished as fashion photographs from publishers Condé Nast or the Hearst Corporation.

Fashion Photography Pioneers

Fashion photography started in the 1850s when couturier Charles Worth began using live, moving models to show his clothes. While the half-tone process for printing photographs revolutionized print culture, the invention of the sewing machine made possible the mass production of clothing. By 1900, the number of national magazines carrying apparel ads grew tenfold.

Commercial photographers proliferated at the turn of the century and learned to adapt to the needs of potential clients. Some concentrated on fashion photography, furniture, or food, while others concentrated on automobiles or heavy machinery. Their styles were influenced by the fledgling movie industry and companies such as the Jesse Lasky Feature Play Company, which designed detailed, convincing sets for film versions of Broadway hits. Photographers readily adapted the realistic style to their clients' products.

The new approach to editorial photography in magazines was met by an increasingly sophisticated use of photography in advertisements. For some couturiers, this style conveyed too much information; they were concerned about keeping exclusive rights to their designs, so they did not trust fashion photographers immediately.

The first illustrated fashion magazine, *Vogue*, was launched in 1892, but fashion photography did not replace illustrations until Condé Nast hired Baron Adolphe de Meyer in 1913 and Edward Jean Steichen during the 1920s to take experimental pictures. De Meyer (1868–1946) is best known for his effective use of backlighting and the soft-focus lens. Though static, the pose was often natural, and the picture was arranged using a strong pattern of vertical elements, which gave a sense of authority and formality.

Edward Steichen (1879–1973) was born in Luxembourg, moved to the United States in 1881, and first photographed fashion models in 1911 for the magazine *Art and Decoration*. His use of very simple props was modernist, but his elegant arrangement of forms was classical in its order. Steichen did not have a studio of his own, and he wrote that his first fashion photographs were made in a Condé Nast apartment:

For the first sitting, we had a good-looking young woman wearing a handsome and rather elaborate gown covered down

the front with rich embroidery. I had never made photographs with artificial light, but there was the Condé Nast electrician with a battery of about a dozen klieg arcs, wanting to know where he should put the lights. I said 'Just wait,' and went to work with the model in the natural daylight of the room.... Not knowing what to do I asked for a couple of bed sheets. No one at a photographic fashion sitting had ever asked for bed sheets, but Carmel Snoa, fashion editor of Vogue *at that time, had a policy that a photographer should have whatever he required, no questions asked. When the sheets came in, I lined up the chairs in front of the electrician's lights and over them draped a four-ply thickness of sheets, so that when he turned on the lights, they didn't interfere with my model. The electrician was satisfied. I heard him say to one of the editors 'That guy really knows his stuff.' Applied to electric lights, this statement was as far from the truth as anything imaginable ..."*

Steichen realized that adding artificial light to natural light was his greatest ally in getting variety into fashion pictures, transforming advertising photography from straightforward pictures of a product to more natural, sensuous depictions. This innovation made Steichen the most highly paid photographer of the 1930s.

Like Steichen, Anton Bruehl, Nikolas Muray, George Hoyningen-Huene, Horst P. Horst, and Cecil Beaton successfully manufactured consumer desire in the face of the great economic uncertainty of the 1930s.

Born a baron in St. Petersburg in 1900, Hoyningen-Huene left his country soon after the Bolshevik Revolution, traveling in a rarified circle that included Coco Chanel, Greta Garbo, Salvador Dali, Jean Cocteau, Cecil Beaton, Marlene Dietrich, and Kurt Weill. He began his career as a fashion draftsman publishing his drawings in *Harper's Bazaar* and *Fairchild's Magazine*. By 1925, he was the chief photographer for French *Vogue*. In 1935, he moved to New York and began working almost exclusively for *Harper's Bazaar*. His photographs, best known for their sensuous formality and sophisticated use of lighting, were void of deceit; they presented the model not the photographer.

Cecil Beaton recognized at the start of his career that print and other mass media had the power to make reputations. In 1929, he contracted with Condé Nast to photograph the new stars of cinema. His charm gave him access to celebrities; his romantic vision of royalty was increasingly in demand.

Beaton juxtaposed elegant and common objects to convey a comical sense of play. The images were shocking to *Vogue* editors, who were used to Steichen's formal, straightforward images. Beaton's fashion photography was influenced by his set design work in theater; in 1958 he won an Oscar for his costume design in *Gigi*, and in 1964 for costume design and art direction/set direction in *My Fair Lady*.

Beaton was working for British *Vogue* in 1930 when he received a visit by Hoyningen-Huene and Horst P. Horst, who had met that year and traveled to England together that winter. The next year, Horst began his association with *Vogue*, publishing his first photograph in that November's French edition.

Best known for his photographs of women and fashion, Horst also is recognized for his photographs of interior architecture. His work often reflects an interest in Surrealism. Most of his figurative work displays his regard for the ancient Greek ideal of physical beauty.

Horst carefully arranged the lighting and studio props before each shoot. He used lighting to pick out the subject; he frequently used four spotlights, often with one pointing down from the ceiling. Few of his photos contain background shadows. While most of his work is in black and white, much of his color photography uses monochromatic settings to set off a colorful fashion. A 1942 portrait of Marlene Dietrich is considered his most famous work.

Male nudes began to appear during the 1930s in the work of Herbert List, who made homoerotic photographs. By 1936, his pointed anti-Nazi opinions and homosexual friends forced his exile from Germany to London. He settled in Paris, where he worked as a fashion photographer for *Vogue, LIFE, The Studio, Photographie, Arts et Métiers Graphiques,* and *Harper's Bazaar*.

List's photographs featured young, healthy male bodies in strong sunlight, a significant contrast to the high-society fashion images of women from the same period. There is a feeling of voyeurism in work such as Amour II, taken on the beach at Hammamet, Tunisia, in 1934. His images are explicit without showing anything that would stir controversy. During the 1980s, Bruce Weber and Robert Mapplethorpe would follow List's path, pushing the boundaries of decency while raising important issues of homosexuality and society.

World War II

The development of hand held cameras, faster film (the 1/1000 Leica), the Rolleiflex, and color film during the 1930s elevated fashion photography from ad illustration to fine art. The easy portability of the new cameras meant fashion photographers were less bound to the studio.

Fashion photography was considered frivolous during World War II, however. The fashion industry in France effectively closed because it lacked materials, models, and safe locations. Photographers still working in London often had to shoot during air raids to meet production deadlines. Studio photography, with its props and setups, became too costly. The French *Vogue* studio closed its doors in 1940 as Hitler entered Paris, and many photographers, including Horst and Man Ray, immigrated to New York. There they found a new type of fashion photography in the youthful exuberance of American culture. Back in Europe, material restrictions changed fashion photography from decadent aristocratic images to straightforward, no-nonsense magazine work. For Lee Miller in wartime Paris and Beaton in war-torn London, fashion photography recorded important historical and social events. Miller, a *Vogue* war correspondent, produced photographs that were compassionate but unsentimental, even while she was under combat on the front. While men either were drafted or fled Europe, women like Miller pictured models in the latest version of a gas mask or military-influenced utilitarian clothing. Magazine

publishers viewed the resulting photographs as intriguing staging grounds for a new type of fashion photography that concentrated on the interests of women.

In New York, commercial photography continued unaffected by the war, and Louise Dahl-Wolf did her first fashion work for *Harper's Bazaar* in 1936. She had trained at the California School of Design with noted colorist Rudolph Schaefer and had honed a flawless instinct for the psychological effect of luminosity. She had an eye for subtle change in tone, line, and color. A pioneer in large format photography, Dahl-Wolf brought high resolution and exact color to fashion photography with the new 8 × 10 Kodachrome sheet film. She influenced fashion photography for decades by depicting women as feminine rather than as objects of desire.

In 1943, the FSA disbanded, sending many talented documentary photographers looking for work elsewhere. Gordon Parks attempted to find a position with a fashion magazine, but the Hearst Organization, publisher of *Harper's Bazaar*, would not hire a black man. Edward Steichen was so impressed with his work that he introduced Parks to Alexander Liberman, director of *Vogue*. Liberman, in turn, put Parks in touch with the senior editor of *Glamour*, and by the end of 1944 his photographs appeared in both magazines. Parks joined *Life* as a photojournalist in 1948, shooting a distinguished documentary series for Standard Oil on life in America. His work during the Civil Rights movement remains among the most compelling images of the 1960s.

Post-war Growth

The post-war increase in production of consumer goods shifted attention to mass-market, ready-to-wear clothing. Russian-born Alexey Brodovitch helped *define the new market* with unposed photographs and pioneering use of angular, Russian Constructivist influenced space, transcending the traditions of the fashion magazine.

Brodovitch was art director of *Harper's Bazaar* from 1934 to 1958. He replaced the narrow vertical layout with a compositional structure using single rectangles spread over several pages. His experiments with white space and different type styles challenged photographers.

"Astonish me," he often said to them. "When you look into the camera, if you see an image you have ever before, don't click the shutter." Among his students were photographers Irving Penn, Richard Avedon, and Art Cane as well as art directors Bob Cato, Otto Storch, and Henry Wolf.

Lillian Bassman, born in New York City, was a painter with the Works Progress Administration in the 1930s when Brodovitch discovered her. From the 1940s through the 1960s, she brought a new aesthetic to fashion photography with her dreamy, moody abstract images. Bassman experimented in the darkroom, blurring and bleaching areas of the photograph for dramatic effect. Her personal project from the 1970s, Men, is a series of large cibachrome prints of musclemen in which she distorted her subjects into monsters and heroes.

Alex Liberman lived through the revolution in Russia and war in Europe, moving first to London, where he attended school, then to Paris, where he studied painting with Andre Lhote and worked briefly at the photographic newsweekly *Vu*. In 1941, he moved to New York, where a prize he had won for magazine design at the 1937 Exposition Universelle in Paris earned him a foot in the door at *Vogue*. Liberman was named art director in 1943. In 1962 he became editorial director of all Condé Nast publications, a position he held until 1994.

A painter, sculptor, photographer, and graphic designer, Liberman crossed the imaginary boundary between the commercial and art worlds, much like Brodovitch. Liberman commissioned artists Joseph Cornell, Salvador Dali, Marc Chagall, Marcel Duchamp, Robert Rauschenberg, and Jasper Johns to work on projects for the magazine. An often difficult and demanding editor, his tenacity for change in the fashion magazine culture influenced a younger generation of photographers, including Diane Arbus, Bruce Davidson, Robert Frank, Robert Klein, and Lisette Model.

For photographer Irving Penn, the aim of fashion photography was the truthful depiction of a sociological subject, stripped of props, beautifully composed, where women were sensitive and intelligent. Penn enrolled in a four-year course at the Philadelphia Museum School of Art, where Alexey Brodovitch taught advertising design. Three years after Penn graduated, Brodovitch hired him as his assistant. In 1943, Penn took up photography professionally when a still life photograph he arranged—consisting of a leather bag, scarf, and gloves; several differently colored fruits; and a topaz—was published on the cover of *Vogue*.

Influenced by the simplicity and natural light of painters Giorgio di Chrico and Goya, Penn quickly developed an expressive formal vocabulary. He dispensed with the naturalism, spontaneity, and the theatrical lighting so much a part of the previous generation's technique. He often posed his subjects in a blank white space, removing all references to their surroundings, keeping them emotionally detached. His elegant femininity was imitated in the work of Henry Clark, John Rawlings, and John French.

The 1960s as Reaction to the 1950s

Fashion photography at the start of the 1960s was revolutionary and futuristic. Photographers wielded considerable authority over magazine designers as experimental fashion rose to the forefront of design. Third-wave feminism, anti-war demonstrations, and Pop Art shook fashion photography out of its romantic retrospection. Photographers exposed the body with blatant sexuality; the playful and sometimes perverse eroticism between body and clothes promoted sexual liberation.

Bob Richardson emerged as one of the most influential fashion photographers during the 1960s. His work for *Vogue* anticipated the strategies of 1990s fashion photography by borrowing camera angles and lighting from experimental film directors like Antonioni and Goddard.

While Richardson's highly original images caused anxiety among editors at *Harper's Bazaar*, Richard Avedon quickly became recognized for his genius as a photographic dramatist. Avedon presented the model as pretty, but not glamorous.

Gone were the goddesses of the 1930s and 1940s; Avedon's early work was spontaneous, improvised, and accidental. His photographs of models were real, and his subjects were full of life and vitality. Avedon depicted women as astute and resourceful.

Influenced by novelist Marcel Proust, Avedon sought insight into societal behavior. He viewed individuals as isolated, and throughout his career he would remove his subjects from their surroundings and place them in a neutral studio environment.

By the late 1950s, Avedon worked only in the stark white space of his studio. He believed the studio would "isolate people from their environment … they become in a sense symbolic of themselves." He developed his signature style: models set against a plain white background, often airborne, illuminated by the harsh light of the strobe.

Avedon's great achievement as a fashion photographer was to become a barometer of the times, reflecting back to the viewer—sometimes brutally—the realities of social conditions. To refocus his fashion interest, Avedon photographed mental patients in the East Louisiana State Hospital in 1963. He continued to photograph while traveling through the South, and in 1964 he published a collection of photographs of white racists and civil rights workers in *Nothing Personal*, with text by James Baldwin.

Around the same time, Avedon began using Twiggy, a 16-year-old model from London. Twiggy shot to fame in the 1960s as the boyish rage of the London fashion scene. Her skinny, boyish look was a radical reversal from the voluptuous female of the 1940s and 1950s. In the late 1960s *Newsweek* described her as "four straight limbs in search of a body," but her sex appeal captivated readers during the decade of the miniskirt and the birth control pill, a time when women asserted themselves as never before.

William Klein, by contrast, encouraged his models to act rather than pose. He photographed them on the street without regard for the background.

In 1954, Klein had returned to New York after six years in Paris when Alex Liberman unexpectedly hired him to photograph New York City for *Vogue*. Klein approached the city as an ethnographer. His snapshot-style aesthetic was crude, aggressive, and vulgar; his prints were grainy, blurred, bleached, or repainted. He experimented with wide-angle and long-focus lenses, long exposures combined with a flash, and multiple exposures.

The editors of *Vogue* were shocked by Klein's view of the city. Consequently, he wasn't able to find an American publisher for his book *New York, New York* (1956). In France, however, where the book was eventually published, he was a resounding success and won the Prix Nada.

Although not usually associated with fashion photography, Diane Arbus was hired by *Harper's Bazaar* in 1962 to photograph children's fashions. Her photographs made little distinction between fashion and the personal. She made three extensive series of remarkable photographs for the *The New York Times* in 1967, 1968, and 1970. The photographs show clumsy, outcast, and dejected children, making them the most disturbing fashion images ever published.

David Bailey, the prototype photographer–hero of the 1960s, was a young London-based member of the "Terrible Three," which also included Terrence Donovan and Brian Duffy. Bailey's fashion photographs were stark, streetwise, and spontaneous beyond anything done before. His images were sexually charged by his notorious personal and professional relationships. Michelangelo Antonioni's film *Blow Up* exploited Bailey's rapid-fire shooting, where the camera-as-penis was the only thing between the viewer and the female subject.

In New York, art director-turned-photographer Bert Stern rose and fell in the fashion photography hierarchy. Stern reversed the outer-directed approach of George Hoyningen-Huene; Stern's photographs were about himself, not the model or the apparel. Pop culture defined Stern, and accordingly his contributions to fashion photography are best represented by his experiments with silk screening and offset printing. In 1971, Stern's lavish lifestyle, million-dollar studio, and thousand dollar fees caused his empire to collapse.

Post-war Porn

The 1960s marked a turning point in sexually explicit photography. Fashion magazines explored the sexual and social codes in clothing and gesture; style, elegance, and social status gave way to overtly sexual narratives.

By the late 1960s, however, nudity in fashion magazines had lost its shock value; it had become common. Meanwhile, American pornography, still comparatively conventional in the 1960s, evolved from *Playboy* and *Modern Man*—photographs of nude or semi-nude women, their genitals and pubic hair hidden—to the more explicit *Penthouse*.

In the 1970s, Helmut Newton and Guy Bourdin crossed boundaries with a style of fashion photography that was sexually aggressive and violent.

Berlin-born Newton fled Germany for Singapore in December 1938; a month after Nazi-led attacks on Jewish communities threatened his life. The experience had a profound effect on his photographs. He created an erotically charged world full of sexual predators and sexual prey. His unique mixture of sex and theater became his signature style. Newton's images for American *Vogue's* "Story of Ohh," featuring a man, two women, and a dog, are considered uncompromising in their depiction of open, forceful lust. The piece caused a scandal when it first appeared. The title refers to the French pornographic novel *The Story of O* by Pauline Reage (a pen name for Anne Desclos), in which the masochistic heroine is a fashion photographer.

Newton's fascination with photographing nude women led him to *Playboy*, where in the mid-1970s he photographed Debra Winger and Grace Jones. His edgy, erotic images changed not only fashion photography, but also fashion itself. He became a household name and the most copied fashion photographer of the 20th century. Newton later moved away from graphic violence to exploiting the relationship between sex and power: lovemaking without love.

Bourdin, however, increased the graphic display of horror. In a 1975 shoe advertisement for Charles Jourdan, Bourdin fabricated a car crash scene where a woman had been thrown from the car and killed. Her body had been removed from the scene, but a white chalk outline of her outstretched arms and legs remained. Bourdin strategically placed a red Jourdan shoe amid the wreckage.

The public response was outrage. Bourdin claimed to have taken his cue from another famous fashion photographer, Cecil Beaton. Beaton describes the scene forty years earlier: "… it would be gorgeous … to take the (same woman in a suit) in a motor accident, with gore all over everything and bits of car here and there." (From "I am Gorged with Glamour Photography," *Popular Photography*, April 1938.)

Some critics consider Bourdin's soft-porn images sexually liberating. In his lingerie photographs, Bourdin's subjects are lit softly and naturalistically. The clothing is sexualized; women stand next to a bed with their legs open. His concept of women as vulnerable is reinforced by his use of shadows to create a sense of mystery and threat. His images are painstakingly constructed. Clues are scattered throughout the image, but he puts the burden of interpretation on the viewer.

Despite Bourdin's use of violence as spectacle, he has created some of the most compelling images ever published in fashion magazines. Some of his 1970s photographs would raise issues of censorship even today.

Chris von Wangenheim avoided Bourdin's overt sexual violence. His photographs were published in the men's magazines *Playboy* and *Oui* in addition to fashion magazines. His fashion images from the 1970s, however, involve voyeurism and sadomasochism taking him closer to Bourdin's psychosexual images.

Post-1960s Fashion

The Vietnam War brought fashion down to earth. By the early 1970s clothes were more realistic and wearable and were depicted by women photographers like Eve Arnold, Deborah Tuberville, and Sarah Moon.

The style of French photographer Moon was grainy, out of focus, and mysterious. Subculture photographers revered her "moments of awakening" images. Moon was the first to photograph a bare-breasted young woman for the Italian tire company Pirelli's popular cheesecake calendar.

Questioning the very basis of fashion photography, fashion-editor-turned-photographer Deborah Tuberville once asked hairdresser and makeup artist Jean Paul Troili to make the models ugly rather than beautiful. Images from Tuberville's *Public Bath House* series from 1975 convey mystery and suggestion, but she was criticized for evoking a concentration camp.

During the early 1980s—the "Me" Decade—Ronald Regan won the presidency with a conservative agenda, AIDS appeared, and the freewheeling disco days ended. Women's fashion reflected responsibility and restraint as newfound wealth gave birth to a Nouvelle Society.

By the late 1980s, however, supermodels emerged as icons of perfection and material success. Waif-like model Kate Moss

became a symbol of 1980s excess. The female body depicted in mass media became increasingly thin; *Playboy* centerfolds' bust and hip measurements increased while their waist measurements decreased significantly. At the same time, innovative fashion images spoke more about attitude than clothes. Images of prostitution, lesbianism, and transvestitism appeared in many fashion magazines.

Fashion photographer Herb Ritts became known for glamour photography, his black and white portraits of male and female nudes reflecting an interest in classical Greek sculpture. He first gained national attention with portraits of his friend Richard Gere, and often worked with *Harper's Bazaar*, *Rolling Stone*, *Vanity Fair*, and *Vogue*.

Newton and Bourdin continued to exert significant influence on young photographers. They made some of their best work during the 1980s.

1960s Fashion Precipitating 1980s Porn

Erotica and pornography looked more like fashion photography and pushed the boundary of high shock value further than before. Nude men, homoerotic images, and powerful, aggressive women challenged the conventions of erotic imagery.

The 1980s saw art photographers turn to fashion photography for inspiration. California photographer Jock Sturges best represents their use of erotica, which he claimed was unintentional.

Sturges introduced images of children and young people, some in full frontal nudity. In 1990, the FBI and the San Francisco Police Department raided his studio and they seized Sturges' camera and film negatives. The following year, a grand jury declined to indict him on charges of child pornography on constitutional free speech ground. The controversy over his pictures continues today. Sturges' books *Radiant Identities* (1994) and *The Last Days of Summer* (1991) have been banned in many public libraries throughout the country, but his photography career has flourished, with sold-out exhibitions in major cities like New York and Los Angeles.

Sally Mann also was accused of child pornography for *Immediate Family*, a series of portraits of her son and two daughters taken at home and in the nearby foothills of Virginia's Blue Ridge Mountains. Mann's photos are disturbing in their honesty and emotional intensity.

In David Hamilton's book, *The Age of Innocence* (1995), teenage girls, nude from the waste up, are posed boudoir style and photographed in color through a soft-focus filter.

Suze Randall garnered attention in the 1980s while working for top adult magazines like *Penthouse* and *Playboy*. Working as a fashion model in the early 1970s, she became known for erotic photographs of her fellow model friends. Her breakthrough came when she spotted the pinup model Lillian Müller and photographed her for *Playboy* in 1975. Müller became Playmate of the Year in 1976.

Late-century Fashion

In the 1980s fashion photography lacked any clear direction, except in the work of Bruce Weber.

Europeans had grown tired of hard-core fashion pornography, and the erotic images of the 1970s had faded. In America, the 80s was the decade of kitsch and conspicuous consumption. Mediocrity was met with approval and acquisitiveness by the Nouvelle Society.

Weber became known for his Calvin Klein advertisements, which introduced the blatant male sexual object into the artistic canon of fashion. The male nude flourished in fashion photography, and as a result of Weber's work, the Adonis-like "New Man" emerged with a focus on the body, not the clothing. The photography was not unique except for the gender, but it pushed Puritanism and homophobia to their limits. It was overly erotic, said some critics, but Weber's homoerotic fashion photographs remain masterful examples of gender-specific images. Weber successfully sold male-on-male sex. The decade of uninhibited self-indulgence ended with fashion photographers setting up scenes: mini-docudramas that were culled from the archives of avant-garde cinema and were meant to intimidate. Photographers began to appropriate images from pop culture for psychological manipulation. Magazines like *Tank*, *W*, and *Harper's Bazzar* used this style of fashion photography to sell lifestyles, not products.

Artists and photographers crossed over to advertising throughout the 20th century with great success. Man Ray, Fredrick Kiesler, Herbert List, Edward Steichen, Irving Penn, and Andy Warhol all contributed significantly to fashion photography. In the 1980s, it became increasingly common for mainstream fashion magazines to hire artists and art photographers.

Nan Goldin, more than any photographer of the decade, epitomized this trend. She launched a style of fashion photography that was grittier than those of Helmut Newton or Deborah Tuberville. In 1985, *The Village Voice* commissioned Goldin to produce images for its first advertising insert, *View*. The resulting series "Masculine/Feminine," consists of pictures of Goldin's women friends dressed in men's underwear and lingerie. These images, taken in a Russian bathhouse on New York's Lower East Side, are highly personal snapshots, deliberately unglamorous and raw.

More 1980s Porn

Pornography became less glamorous as well in that amateur pornography grew steadily, capturing a significant portion of the non-commercial photography market. The videocassette recorder brought snapshot pornography within reach of anyone. It led to pro-am pornography; professionally produced pornography involving amateur or first-time performers. These pieces often started with a host introducing the new actor, then a minimum of dialog, followed by scenes in which the amateur is prompted on camera to perform various sex acts, including masturbation, oral sex, intercourse, and lesbian or gay sex. Married and same-sex couples were encouraged to experiment for the camera.

Soon, personal computers refined the process. Color monitors with improved screen resolution, greater graphics capabilities, and modems created a boom in adult movies and personal Web site pornography. Couples shot home movies and photographs and distributed them among friends. Baby Boomers, once the force behind the sexual revolution of the 1960s and 1970s, also fueled this industry.

Gay pornography, although evident in the 1950s in *Physique Pictorial* and *After Dark*, hit the newsstands in the late 1970s. It gained wide circulation in both the straight and gay communities during the 1980s.

Robert Mapplethorpe's politically explosive 1989 retrospective at New York's Whitney Museum was seen by tens of thousands of viewers in Cincinnati, Boston, and Berkeley. His highly stylized and eroticized imagery disturbed some critics and politicians. In 1990, Cincinnati Art Center director Dennis Barrie was tried on obscenity charges for refusing to remove homoerotic images from Mapplethorpe's exhibit. The controversy dominated the news, and although Barrie was later acquitted, the trial added momentum to the religious right movement. It led to Congress's revocation of grants from the National Endowment programming for individual artists.

1990s Porn

Pro-am sex photography became an underground culture in the 1990s with a highly personalized style appealing to various sexual subcultures. By then, pornography was challenging societal boundaries as it featured sexual penetration, homosexuality, group sex, and fetishes.

Certain photographers became prominent with this culture. Michele Serchuk and Paul Dahlquist used a variety of soft-focus techniques to emphasize body form, while Michael Rosen's studio portraits involved sadomasochism, erotic piercing, gender play, and what he calls "non-standard penetration." Barbara Nitke used her friends to create beautiful, intimate images between consenting adults. Vlastimil Kula's photographs explored sexual territory in which sex, taboo, love, passion, and rebellion are the key themes. Roy Stuart's pictures were a fascinating look into explicit forbidden voyeurism. Ray Horsch, Will Roge, and Ron Raffaelli used various ways of altering their photographs, including computer manipulation, long exposure, and grainy infrared film. Sexual subculture is emphasized over technique in the work of Vivienne Maricevic (outlawed peep and lap dancing shows), Barbara Alper (sex clubs), Mark I. Chester (radical gay sex), and Mariette Pathy Allen (transsexuals and cross-dressers).

With the 1990s, the work of Nick Knight, Richard Kern, and Mark Borthwick brought grunge and *street* fashion to avant-garde fashion magazines such as *Dutch, Purple, The Face, Big, Spoon*, and *Visionaire*. Borthwick broke through the conventions of fashion photography with highly designed performances set against the backdrop of architecture. Kern, best known as an underground filmmaker, turned to still-frame photography. Like his films, Kern's fashion images explored the psychosexual drama of porn and punk. Knight, on the other hand, likes to refer to social issues like breast cancer awareness in his pictures.

The anti-fashion model Cindy Sherman focused the camera on herself for *Harper's Bazaar* in 1993. Her series *Fashion* explored voyeurism, femininity, and costume in the fashion

industry using closely cropped photographs to emphasize voyeuristic impression. The bleak vulgarity of fashion photographs of the 1960s and 1970s by Guy Bourdin, Helmut Newton, Bob Richardson, James Moore, and Jerry Schatzberg reappeared in the 1990s in the youthful alienation images of Collier Schorr and Glen Luchford. Schorr's pictures of shirtless young men confuse gender in their sexual ambiguity. Her work is often about androgyny and identity, and boyish masculinity. Luchford collaborated with artist Jenny Savile in 1995 to produce a series of compelling photographs that capture the full tonality of flesh. Savile, a well-known figurative painter, underwent reconstructive surgery and wanted to express the violence and pain associated with the operation. Luchford photographed her body pressed against glass, producing grotesque images of distorted flesh. It was fashion collaboration unlike any seen before. Digital imagery and computer manipulation in David La Chapelle's work recalled surrealist photography, suppressing and blurring the visible facts. La Chapelle remains interested in an artificial, constructed and staged reality. His photographs express mixed feelings and unease about our world. Corinne Day, a self-taught photographer, was shunned by *Vogue* magazine for her unflattering images of supermodel Kate Moss. Day ignored the magazine and spent the last decade photographing her friends in confrontational, unconventional, and highly personal portraits, with drugs, sex, and abandonment as dominant themes. Day's most successful work revolves around her close friends Tara and Yank, and her own diagnosis, surgery, and recovery from a brain tumor in 1996. Steven Meisel embraced a sphere of elite in his fashion photographs, confronting us with excessive wealth unknown by most people. Meisel worked against the tide of youth culture seen in fashion photographs of Jurgen Teller and Wolfgang Tillmans.

Jurgen Teller, who does not consider himself an art or fashion photographer, has a casual and blunt documentary style. Teller is interested in the depth of a photograph rather than its surface. Wolgang Tillmans, one of the most influential photographers to emerge during the 1990s, produces raw images of traditional subjects like portraiture, landscape, and still life meticulously arranged in classical compositions. His focus on the everyday resembles sociological and ethnographical inquiries. Both Teller and Tillmans have found success in the art world.

The interchange of ideas between the fashion and art worlds influenced Larry Sultan, who gained national attention as a photographer for his series of portraits of his parents in *Pictures from Home*. In his most recent book, *The Valley*, Sultan examines the complexity of domestic life invaded by the porn industry by focusing on porn's mechanics: set, actors, and equipment. The images are reminiscent of 1930s photographers Horst P. Horst and Cecil Beaton. Today, pictures by Horst, Beaton, and Sultan are displayed and sold in art galleries or auctioned for a dollar amount unimaginable just a few decades ago.

Other fine art photographers, including Philip-Lorca di Corcia, Tina Barney, Larry Sultan, and Ellen von Unwerth effectively worked both fashion and art. They paved the way for a new generation of photographers who again are reinventing fashion photography, including Paolo Roversi, best known for his romantic fashion images and portraits using 8 × 10 Polaroids; Mario Testino known for his highly polished, exotically colored scenes of aristocrats; and German-born Peter Lindbergh, influenced by his childhood background in the West German town of Duisburg near the Rhine River where one side of the river was flanked by green grass and tress, and stark industrial landscape on the other. Lindberg uses this contradiction to create dark, contrasting images of models set against decaying post-industrial architecture.

Current Work
Today's catalysts include photographer and filmmaker Craig McDean, renowned for his striking fashion imagery and portraiture. In 1999, McDean published *I Love Fast Cars*, a series dedicated to the world of drag racing. He has also directed commercials for Versus fragrance and Calvin Klein's Contradiction.

Alexei Hay draws on photojournalism and Hollywood inspired backdrops. Like Philip-Lorcia di Corcia, Hay moves effortlessly between magazine and gallery work. Hay sympathizes with his models, never concealing their personal identity. He challenges the stereotypical fashion image by using bearded and two-headed models and prosthetics.

Others who have made recent statements in fashion photography include Steven Klein, who stands out among his peers in his view of the hypersexualized male; self-taught photographer Mario Sorrenti, who rose to fame in the early 1990s with his candid black and white images of his daily life and his launching the career of supermodel Kate Moss; Richard Burbridge, whose close-up portraits are brutally confrontational; and Ruven Afanador Torero, whose work is heavily influenced by his native Colombian culture.

Commercial pornography is still directed toward a male audience and generally emphasizes sexual arousal and desirability. In recent years, however, pornography for women has become more common in magazines and on commercial Web sites. The poses and facial expressions follow a pattern similar to that of male pornography, and the results presumably are the same.

Despite its prevalence, sexual photography, pro-am photography and film, and pornography remain highly controversial. Sex is a private pleasure in Western culture, and witnessing other people performing it challenges society's boundaries. Sex today is more obsessive than the liberating 1960s and our visual culture is increasingly crowded with images of it.

Fashion photography and art have merged to form a new hybrid of fash-art photography. The influence of pornography on both forms is undisputable. Fashion trends construct gender identities that reflect our sexual fantasies. Fetish subcultures and an attraction to fashion's dark side have provided designers and photographers with a rich source of material for decades.

Ours is a sex-fearing culture, and as long as boundaries are drawn between what is "normal" and what is "subversive," fashion photography will survive, prosper, and challenge us.

Photography Programs in the 20th Century Museums, Galleries, and Collections

LYNNE BENTLEY-KEMP, PH.D.
Florida Keys Community College

Photography has benefited greatly from the vitality and intellectual curiosity of its practitioners and its audience since its inception in 1839. The history of photography has been recorded and preserved by collectors, artists, scholars, bon vivants, and adventurers worldwide. Collections of photography span the vastness of the medium itself. Photography has been embraced as an art form, document, scientific record, and means of remembrance. It has expanded our universe and given us a language that, like all languages, adapts and evolves with culture.

The act of collecting is as old as civilization. Human beings have collected walking sticks, shells, mineral specimens, toys, and objects of aesthetic interest throughout history. Curators, the people who manage and exhibit collections, have preserved many of the most valued objects in museums so that they could be appreciated by generations to come. Collecting as a personal passion has become more widespread in the 20th century, primarily due to the "broadened conceptualization of things that are collectible."

Photography has been attractive to collectors due to a multitude of factors, some personal, some universal. At first it engaged the curiosity of the viewer, with its seemingly magical capture of an image on a surface. Later photographs became collectible due to perceived meaning, subject matter, or maker. Beginning in the 1970s photography has grown as an art form and its acceptance by significant cultural institutions has contributed to photography's cultural and artistic status. Museums, galleries, and academic institutions have been major factors in the explosion of photography and have played an important role in creating the enormous demand for the medium.

"Museums make their unique contribution to the public by collecting, preserving, and interpreting the things of this world. Historically, they have owned and used all manner of human artifacts to advance knowledge and nourish the human spirit." This statement is part of the American Association of Museums Code of Ethics and presents the role of the museum as one that connects the public to material culture at large. Galleries tend to be more specific as to the type of art that is exhibited and sold to collectors. The function of a gallery tends to be more economic than historic. Therefore, a gallery's primary responsibility lies in marketing the work of artists. Both museums and galleries present the medium to the public and act as gatekeepers by signifying what objects possess cultural value and are worthy of exhibiting and collecting.

Looking at the many ways in which photography has affected the world it is no wonder that throughout the 20th century museums that house photographs and galleries that exhibit the state of the art, and collections of photographic materials have grown complex and become varied in scope and size. Artistic boundaries have blurred to an amazing degree and following major technological and aesthetic changes the photographic arts have evolved as a key element in multimedia, installation and performance art.

Art photography came of age in the 20th century and museum professionals and gallery directors have fostered its development into a mature art form. It is not surprising that the growth of photography has occurred predominantly within wealthier nations that have enjoyed relatively stable political climates. England, France, Germany, Japan, and the United States house many of the most important collections and support a substantial percentage of exhibition spaces. The industrialization of these countries in the early 1900s played a prominent role in the rise of photography and was largely responsible for the birth of the Modernist movement in art. Modernism became a catalyst for the acceptance of photography as an art form, but it was not until the late 1960s that photography was truly established as an art worthy of exhibition to the serious art collector and connoisseur.

During the Modern era photography was strongly influenced by avant-garde painting, sculpture, and architecture. The images of serious photographers were brought into the canon through the work of forward-thinking curators, collectors, and gallerists. By 1914 New York City had become the center of Modernist art and the toehold that Europe had on the art world shifted to major cities in the United States.

Alfred Steiglitz was a quintessential New Yorker and his contributions as a photographer, curator, collector, and critic did much to establish photography as a modern art form. Stieglitz' active promotion of the art created a platform from which serious photographers could display their virtuosity. Stieglitz' publication *Camera Work*, his galleries, and his association with the avant-garde community gave Stieglitz the fuel for his iconoclastic support of a modern aesthetic movement in photography. Steiglitz believed that photography was most certainly a fine art and that the artists he supported (i.e., Paul Strand, Charles Sheeler, and Morton Schamberg) represented "the expressive potential of photography."

Stieglitz' influence spans a pivotal era of photographic history beginning with his 291 Gallery in early 1900, the Photo-Secession Gallery with Edward Steichen, and An American Place, which endured until his death in 1946. He influenced a progression of New York galleries beginning with Julien Levy's gallery in 1930.

The galleries that exhibited photography reflected the passion of people who were singularly suited for the task. Alfred Stieglitz, Julien Levy, Helen Gee, Lee Witkin, and Harry Lunn were all seminal figures in the commercial marketing of photography as art. These people believed in the medium and had the prescience to exhibit and recognize many that would go on to become established as masters of photography.

The Julien Levy Collection, now housed in the Philadelphia Museum of Art (PMA), is made up of nearly 2000 images that Levy collected during the 1930s and 1940s. Levy was the most influential proponent of photography in New York from 1931 to 1948 exhibiting the work of Eugene Atget, Ann Brigman, Imogen Cunningham, Charles Sheeler, Man Ray, and Lee Miller to name just a few of the 130 artists represented in the PMA collection.

Although the market for photography did not come to fruition until the 1970s, Helen Gee's Limelight Gallery in New York in 1954 and Carl Siembab's gallery in Boston in 1961 managed to present a varied and vital presentation of the medium showing the work of Minor White, David Vestal, Wynn Bullock, Arnold Newman, Elliot Porter, Ruth Bernhard, Roy DeCarava, Nathan Lyons, Carl Chiarenza, Aaron Siskind,

FIG. 10 The White Fence, Port Kent, New York, 1916. Photogravure print. Photograph by Paul Strand. (Courtesy of George Eastman House Collection, Rochester, New York.)

FIG. 12 Peace Warrior (Samurai) 492, 2003. Gelatin silver print. Carl Chiarenza. (Courtesy of George Eastman House Collection, Rochester, New York.)

FIG. 11 The Bubble, 1907. Photogravure print. Photograph by Anne Brigman. (Courtesy of George Eastman House Collection, Rochester, New York.)

and many others who would go on to make an impact in the world of art photography.

Lee Witkin entered on the gallery scene in New York in the 1970s. The Witkin Gallery was a presence in the world of photography for many years exhibiting the work of most of the important photographers of the time. The Witkin Gallery became one of the most successful commercial galleries of photography and ushered in the era of marketing photographs as legitimate fine art investments. When Witkin died in 1984, Harry Lunn, a fine art dealer in Washington, DC, took over as a pre-eminent collector and supporter of photography as a fine art. In 1970, when Lunn discovered Adams' "Moonrise, Hernandez, N.M.," he began a campaign to move photography into the realm of fine art collecting. His first show of Adams in early 1971 drew the attention of the press and the public. His ability to market and publicize was legendary and he was one of the first to produce a catalog of photographs for sale.

With this interest in the photograph as a cultural artifact, museums and galleries were legitimizing its potency. John Szarkowski, Director Emeritus of the Museum of Modern Art's Department of Photography has stated, "the role of the photography collection is to present and make visible the prime examples on which we will form our understanding of the influence of photography on modern sensibilities." Szarkowski is one of the most influential curators and critics of the twentieth century. As director of MoMA's Department of Photography for 29 years, Szarkowski held firm to the belief that the curator was a critical liaison between the artists and the public. Photography's influence upon society was as seductive as it was ubiquitous. Photography became one of the most pervasive methods in recording the grand and subtle changes in society over the course of time. Forward-thinking people like Szarkowski, Beaumont Newhall, Sam Wagstaff, and so many others recognized this fact and kept photography in a prominent place on the public agenda.

The artist's camera recorded the reverberations of many of these changes throughout 19th and 20th century society. A select group of Modernists brought the art of photography into the forefront of the fine arts, but all photographers throughout the history of the medium are responsible for creating a visual time line for society. Collectors and curators have preserved and signified an artistic, commercial, and documentary tradition that allows us all to participate as witnesses to history-making events.

The acute cultural observations of Alexander Rodchenko, Man Ray, Eugène Atget, August Sander, Dorothea Lange, and the architect of the decisive moment, Henri Cartier Bresson, helped establish photography as an integral part of western culture.

College and university programs in photography helped to establish the perception that photography was a vital part of the art scene and created an educated audience in the post-war world, an audience that expanded exponentially in the 1970s and 1980s. The audience, in turn, helped to encourage the growth of museums and galleries devoted to photography.

FIG. 13 Avenue de l'Observatoire 1926. Silver printing out paper print. Photograph by Eugéne Atget. (Courtesy of George Eastman House Collection, Rochester, New York.)

An active art scene in America has embraced documentary and commercial imagery as serious artistic work. This popular attention to method and craft further developed the perception of photography as a legitimate art form. Richard Avedon and Irving Penn created iconic images that have moved from the pages of fashion magazines to the walls of museums and galleries. WeeGee (Arthur Fellig), Diane Arbus, and Larry Clark redefined the meaning of documentary photography with their piercing gaze at ordinary lives. Robert Rauschenberg and Andy Warhol blurred the boundaries between photography and painting when they began exhibiting photographs on a very large scale with their silk screens on canvas. Works on this scale are commonplace today and occupy an important place in galleries and museums. In the Post-Modern era Andreas Gursky, Tina Barney, Robert and Shana Parke Harrison, Gregory Crewdson, Thomas Struth, and Adam Fuss all challenge modern artistic convention with the size of their works as they observe and construct the absurdity and drama of everyday life.

A glance at the art market today would demonstrate an active interest on the part of serious collectors for this work. As a result of this serious interest images have become investments as well as functioning as works of art and documents. The market for photographs has developed into a mainstream investment practice in the world of celebrities and the mega-rich. Now significant collections are routinely bought and sold through art auction houses such as Sotheby's, Christie's, Phillips de Pury & Company, and Swann Galleries. The first auction by Swann Galleries took place in 1952 and the first photographs that went on sale sold at "ridiculously low prices." The market for photographs did not find a niche until 1970 when Parke-Bernet sold photographs from the Sidney

FIG. 14 Murder Victim in Hell's Kitchen, ca. 1940. Gelatin silver print. Photograph by Weegee. (Courtesy of George Eastman House Collection, Rochester, New York.)

FIG. 15 The George Eastman House International Museum of Photography and Film, Rochester, New York.

Strober collection for a grand total of $70,000. The market went through quite a few ups and downs through the 1970s and 1980s, but continued to gain strength in the 1990s. Rick Wester, a fine art photography graduate of Rochester Institute of Technology, was an important catalyst in bringing the market for photography into prominence. He began his career at Light Gallery in New York and went on to become senior vice president and international department head of photographs for Christie's. He is presently the photography director at Phillips, de Pury & Company. During his tenure at Christie's he oversaw the heyday of photography auctions. In the fall of 1993 Wester auctioned a portrait of Georgia O'Keeffe by Alfred Steiglitz for the then unheard of price of $398,500.

Private collectors have been the lifeblood of the photography market and photographic collections are bought and sold for a variety of reasons. Wester likes to use the example of the three "Ds" as the motivation for the sale a collection. Death, divorce, and de-accessioning (when a museum decides to sell off works so that they may invest in other projects or collections) precipitate many changes in ownership. The reasons for buying photographs can be more esoteric. Sam Wagstaff, a curator of contemporary art for many years, amassed an

impressive private collection of photographs in the late 1970s. "He saw collecting as a visual and intellectual pleasure, the happy indulgence of one's prejudices." Some collectors gravitate toward rarity, others for intellectual, sentimental, or aesthetic reasons.

Along with prominent private collectors like Wagstaff, the corporate world turned to collecting photography in the 1960s and 1970s. Hallmark, Polaroid, Chase Manhattan Bank, Seagram's, and the Gilman Paper Company have all made a huge impact on the formal collection of fine art photography. In time many of these collections have been absorbed into the archives of museums. Chairman of the Gilman Paper Company, Howard Gilman, with the aid of master curator, Pierre Apraxine, assembled one of the finest private collections in the world and as an example of corporate philanthropy gave the collection to the Metropolitan Museum of Art in 2005. In 2006 many important images from the collection were sold, which allowed it to expand in other areas. The movement of collections through the hands of private collectors and public museums is ever changing and not without sentimental attachments.

Close ties to their hometown could be the primary reason that the Hallmark Collection has been handed over to the Nelson-Atkins Museum of Art in Kansas City. The gift of this multi-million dollar collection is a gesture that adds tremendously to the cultural life of Kansas City and to the perception that Hallmark's corporate leadership has strong attachments to the city.

Indisputably, one of the most important public collections is housed in the International Museum of Photography (IMP) at the George Eastman House (GEH). Beaumont Newhall can claim the credit for setting the standard for the Eastman House archives. Newhall assumed directorship of the museum in September of 1958 and maintained that position until 1971. He had been the first curator of photography

and assistant director at GEH in 1948. He left his post as the first curator of photography at the Museum of Modern Art (1940) to set up a museum and archive of photography at the George Eastman House. He was extremely influential in the growth and development of the museum and a pivotal figure in a scholarly investigation of photography. One milestone in Newhall's career was his text, *The History of Photography from 1839 to the Present*, first published as a catalog accompanying an exhibit at the Museum of Modern Art in 1937.

The collection at IMP/GEH is made up of more than 400,000 photographs and negatives. While other collections may have more objects, the IMP has the most comprehensive selection of masterworks in still photography and film.

The depth of the IMP/GEH collection makes it one of the most popular sources for loans and collection sharing. The International Center of Photography (ICP) is an example of this kind of collaboration. IMP/GEH and ICP are collection sharing by using the same database system, creating a virtual collection of over 500,000 photographs. The ICP was the brainchild of Cornell Capa, a photographer for *LIFE* magazine and member of the photographic agency Magnum. The collection he has assembled contains over 50,000 images. Capa opened ICP in 1974 as a center for the promotion of documentary photography, or to use Capa's term, "concerned photography." The combination of the two collections is a synchronistic event that enhances the status of both institutions in disseminating and broadening the knowledge of visual culture.

The second largest collection in the United States is housed at the Center for Creative Photography (CCP) at the University of Arizona. Significant images from the 19th and 20th century make up more than 60,000 photographs housed at CCP. The photographs and personal archives represent more than 2000 photographers at an impressive facility on the Tucson campus. Centers like ICP and CCP focus on specific collections of photography in great depth and take on a scholarly role hosting exhibitions, workshops, and seminars devoted to the advancement and analysis of photography and photographers.

In New York City the Museum of Modern Art houses its own substantial collection of 19th and 20th century works. It began collecting photographs in 1930 and the photography department, under the direction of Edward Steichen, was established in 1940 with Beaumont Newhall as the curator of photographs. Presently MoMA's holdings of more than 25,000 works constitute an important collection of photographs that reflects the substance and scholarship of its leadership. The Museum of Modern Art owes a huge debt to John Szarkowski for the breadth and depth of its involvement in the world of photography. For almost 30 years Szarkowski was the force behind an illustrious list of exhibitions, publications, and scholarly reviews of the medium. Szarkowski not only wanted to expose the public to important images, but made a great effort in getting the museum-going public to think differently about photography. His method for looking at photographs expounded on five qualities that all photographs had in common: the thing itself, the framing of the image, the details within the image, the moment in time that was forever

captured, and the vantage point from which the photograph was made. This approach to photography raised photography to new levels of sophistication and emphasized Szarkowski's coda that "a good photograph is an experience; it enlivens truths, but does not prove them."

Alfred Stieglitz would have agreed that the great photograph is an experience, an experience that had to be shared on a grand scale. To this end Stieglitz was instrumental in establishing the photographic collection at the Metropolitan Museum of Art. The collection was formed in 1928 with a gift of his own photographs. Steiglitz augmented the collection in 1933 with a gift of Photo-Secessionist works. Throughout the 20th century photographers like Steiglitz, Steichen, Ansel Adams, Minor White, and more recently Nathan Lyons and Carl Chiarenza, have made significant contributions in critical areas of photographic history, theory, criticism, and archives establishment. The practitioners have always had a great deal to do with the advancement of their chosen art form and contemporary society owes them a great deal for their efforts. Everything these visionaries created, wrote about, and researched has prepared us for the next stage, the digital revolution.

The 21st century has brought huge advances in the sharing and archiving of visual information. Digital technology has become commonplace in the photographic realm, both in the creation of images and in the cataloging of historic and contemporary photographic production. Alliances between museums, galleries, and private and public collections have contributed to the accessibility of vast amounts of photographic information. Databases have helped to expand the sharing of images regionally and worldwide. In the 21st century it is rare to find a gallery, museum, or collector that does not utilize digital technology in the cataloging and archiving of collections regardless of size. Connoisseurs and scholars are able to access the Internet to peruse holdings from a wide variety of sources. The Library of Congress, the George Eastman House, the Center for Creative Photography, and the Museum of Modern Art are representative of only a very few of the many major institutions that present their collections in an easily accessible format on the Internet. Many of these sites are well worth looking at in terms of the skillful use of technology to engage an audience and the large numbers of photographs that are available to anyone with access to the Internet.

The use of the Internet to display collections of all kinds is commonplace and ever expanding. In keeping with a historian's sense of stewardship, enlightened archivists are preserving diverse storehouses of cultural artifacts that can be accessed by anyone with an interest in learning more about a particular aspect of photography. The late Peter Palmquist, historian and founder of the Women in Photography International Archive, created and maintained an archive of significant images made by women as a passion and his life work. Pam Mendelsohn continues to foster his legacy, dedicating the archive to maintaining the visibility of women photographers from the past and the present. The WIPI Internet site constitutes a vital source of support for contemporary women artists and acts as a virtual gallery space. Specialists like Palmquist and

Mendelsohn now have the ability to popularize their passions and add to an impressive storehouse of knowledge in the field by accessing and utilizing cyberspace. Entering the keywords "photography galleries" or "photography collections" on an Internet search engine will bring up thousands of sites representing brick and mortar exhibition spaces as well as the purely virtual.

Digital technology has profoundly affected the efficacy of photographic art practice and the publishing of photographic books. The digital camera has further democratized the art of photography by giving amateurs and professionals a tool that allows anyone to send a photograph anywhere, anytime. Many of these practitioners have created their own personal galleries online. The photograph as an art object has come out of the darkroom, with rich, long-lasting prints that are generated from a computer printer. It is evident from the changes that have already occurred throughout the medium that the evolution of photography has gained momentum from the digital age and has made a major contribution to the information revolution that is currently underway. Museums and galleries have risen to the challenge of new technology and added to this revolution by embracing the relevant digital applications. This reaction on the part of the institutions serving photography will continue to uphold the value of the photographic image as an artifact and as a universal means of communication far into the future. ◉

Photographic Higher Education in the United States

NANCY M. STUART, PH.D.
The Cleveland Institute of Art

That crazy feeling in America when the sun is hot on the streets and music comes out of the jukebox or from a nearby funeral, that is what Robert Frank has captured in tremendous photographs taken as he traveled on the road around practically forty-eight states in an old used car (on Guggenheim Fellowship) and with agility, mystery, genius, sadness, and strange secrecy of a shadow photographed scenes that have never been seen before on film.

Jack Kerouac, Introduction to *The Americans*
So began the introduction to Robert Frank's book first published in this country in 1959 heralding the beginning of photography's "golden age." Photography critic and curator, Jonathan Green stated "almost every major pictorial style and iconographical concern that will dominate American straight photography in the late sixties and throughout the seventies can be traced back to one or more of the eighty-two photographs in *The Americans*." Kerouac, whose book *On the Road* was published in 1957, wrote the introduction to Frank's book

thereby, according to Green, linking photography to the "beat" generation and freeing the discipline from political or visual constraints as part of the anti-establishment movement.

Edward Steichen's Family of Man exhibit at the Museum of Modern Art in New York City four years earlier brought photography into the general public's consciousness, but Frank's book helped launch a revolution among young, politically disenfranchised, liberal thinkers throughout the country by showing a less than glamorous America. Photography, if considered an art at all, was considered a radical art at the time. Therefore, student demand for photography programs and workshops grew steadily in the sixties and the seventies in part to answer their demand for relevance in higher education. By 1980 there were photography and history of photography programs at universities in every state. One member of the board at the George Eastman House described photography's popularity on college campuses by saying, "they are wearing cameras like jewelry."

Enrollments were expanding at universities in all programs due to the perceived social and economic necessity of higher education combined with the "baby boom" after World War II. However, the interest in photography was impacted by the confluence of additional factors, including an expanding market for art and the formation of The Society for Photographic Education in 1963. In addition, the mechanics of photography became democratized with the introduction of Kodak's Instamatic camera designed by Frank A. Zagara of Kodak in 1963. Because the camera was easy to load with a 126 film cartridge, the photographer was ready to shoot for a $15.95 investment. Many students of photography in the 1960s and 1970s experienced making pictures for the first time through a Kodak Instamatic camera when they were younger. Between 1963 and 1970 over 50 million Instamatic cameras were produced. Photography came to be seen as both a common visual language and a revolutionary art.

Few disciplines have the distinction of functioning as a commercial product, an applied science, and a studio art discipline. As a result, Kodak's 1960 *Survey of Photographic Instruction* reported that photography courses were found in science departments, journalism departments, art departments, and architecture schools. "The tendency for photography to become increasingly important in the non-photo courses is also growing. It is more and more frequently recognized by science, medicine, art, and other departments that photography is a tool without which the graduate is not really adequately prepared."

The 1964 report *Photography Instruction in Higher Education* by Dr. C. William Horrell, Associate Professor of Photography at Southern Illinois University, indicated a total of 25 degree programs in photography graduating a total of 143 students per year. It also documents that photography was taught in 28 different departments or academic areas and covered 57 different approaches or types of photography courses. He felt that this was a reflection of the broad application of photography to many different disciplines and its relative newness as a college subject. The highest frequency of

departmental location in the 310 schools surveyed was journalism with 99 schools (31%) reporting photography instruction within their journalism department. Art was second with 47 of the schools (15%) and audio-visual education was third with 38 schools (12%). Of the 310 schools surveyed only 22 reported (7%) having a department of photography. The remaining 104 schools reported photography offerings in departmental locations as wide ranging as Physics (20), Science (7), Police and Correctional Science (3), Engineering (2), and Liberal Arts (1).

The overwhelming impact, however, was the addition of photography majors within the university's fine art departments. Keith Davis notes the rapid change in the departmental location of the nation's college level photography courses:

In 1964, such courses were twice as likely to be found in departments of journalism as in departments of fine art. The number of fine art photography courses doubled between 1964 and 1968, and doubled again between 1968 and 1971. By contrast, the number of photography courses taught in journalism programs declined in these years. While this overall expansion of photographic education was clearly a positive sign, the shift from vocational training to self-expression prompted some to question the purpose of these new programs.

The proliferation of photography programs at the college level occurred during the later third of the 20th century. The annual Higher Education Arts Data Services (HEADS report) published by the National Association of Schools of Art and Design (NASAD) lists 109 colleges with photographic BFA degree programs in 2004–2005. According to the report there are 5118 students majoring in photography at the undergraduate level and 645 students at the graduate (MFA) level. This data would not include the equally numerous students enrolled in community college programs, proprietary (for profit) vocational institutions, or non-degree granting programs and workshops.

National Influence on Photographic Education

Some photographers who learned their skills in this era actually attribute the medium's popularity to Michelangelo Antonioni's 1966 film entitled *Blow Up*. The movie chronicles a hip young professional photographer's attempt to solve a murder mystery detected through the repeated enlargement of one of his photographs. Though undeniably influential to young males in the 1960s, the movie is just one of many examples of the medium's appeal to popular culture. Other influences came from the popular press and the expanding number of galleries featuring photographic exhibits.

Though it may seem contradictory to photography's popularity, it was also a time when classic picture magazines like *LIFE* and *Look* were being supplanted by television images as a source of news. What the demise of these magazines in the early 1970s caused, however, was a release for photography from its role as objective witness. Just few years later, a surprising surge in new magazine production including

Smithsonian, *Quest*, and *Geo* featured photography as beautifully crafted still images. The rising cost of television advertising prompted many firms to return to print-based mediums, but the loss of the image's utilitarian function allowed photographic illustrations to be appreciated for their artistic merit.

An expanding art market for photographic prints was in part a function of the establishment of the National Endowment for the Arts (NEA) in 1965. Bruce Davidson received the first photography grant in 1968 for his work *East 100th Street*, a documentary project focused on a New York City neighborhood. At the same time, the Guggenheim Fellowships in photography were awarded at an increased pace of 181 fellowships during the 19 years between 1966 and 1985, up from 39 fellowships awarded during the prior 19 years.

Time-Life issued their successful *Library of Photography* venture in 1972. Seventeen beautifully printed volumes were published about the history and art of photography. They were considered collector's items by serious amateur photographers including those bound for college studies in photography. In the same decade major magazines including *Newsweek*, *Esquire*, and *Rolling Stone* did cover stories devoted to photography. Photography was modern, artistic, and hip. Galleries were showing photographs at an increasing rate, particularly in New York City where in 1968 no less than 24 photographic exhibits were on view during a one-month period. An article reproduced in the journal *Image* in 1971 reports on a visit to Lee Witkin's Gallery in New York City where sales of photographs were "booming even with price tags from fifty to one hundred and fifty dollars per print!"

Cultural critic, Susan Sontag published a series of essays on photography in the *New York Review of Books* starting in 1973. The series was critical of the medium but served to legitimize photography as a subject worthy of consideration. The essays were later revised and published as a book, *On Photography*, in 1977. In this book Sontag examines aesthetic and moral problems raised by the authority of the photographed image in everyday life. The book considers the relation of photography to art, to conscience, and to knowledge.

The literary world applauded the book and Davis considered its publication a landmark event in the cultural history of photography. "Sontag changed the way the medium was perceived in at least two important ways: she confirmed its intellectual worth and expanded its critical audience."

While photography was welcomed into the art world, academia was showing an interdisciplinary interest in it. In 1975, Wellesley College sponsored a series of lectures around the theme Photography Within the Humanities featuring lectures by Susan Sontag, John Szarkowski, Robert Frank, W. Eugene Smith, Irving Penn, and Paul S. Taylor. Author Keith Davis states "many academic disciplines — including art history, American Studies, English, anthropology, and philosophy — suddenly took an interest in the photographic image."

Another factor increasing enrollment in colleges across the nation is that the "photography boom" was preceded by the Baby Boom. Returning WWII veterans fathered a population explosion that resulted in 76 million births necessitating major

expansion of housing, schools, and services nationwide. At the same time the Servicemen's Re-Adjustment Act (GI Bill) was financing the college education of returning military personnel increasing the perception of the necessity of a college education. The expectation of a college education placed on the Baby Boom generation combined with the possibility of studying something as "fun" and current as photography caused enrollments to soar in the new photographic departments.

The confluence of the amplified demographics of college-aged individuals, the critical and cultural acceptance of photography as an art form, and the increased expectation for the attainment of higher education combined to escalate the enrollment in photography departments across the country.

Early College Level Programs in Photography

With the advent of any new technology and its requisite new tools, inventors themselves tend to provide the first instructions. Soon after the announcement of the daguerreotype process to the French Academy of Sciences in 1839, L. J. Mandé Daguerre published detailed instructions for each camera he sold. Forty-five days after the first public demonstration of Daguerre's invention, formal instruction in picture making was offered at the Stuyvesant Institute of New York City. By 1856, the University of London was offering a course in photographic chemistry. Shortly following were courses in Berlin, Dresden, and Munich all introduced between 1863 and 1888. The speed at which the news traveled and courses were formed was indicative of the great interest in this new process.

The California College of Photography at Palo Alto, California, in the early 1900s was one of the earliest schools in the United States dedicated to training professional photographers. On the east coast, Clarence H. White began teaching photography at Teacher's College at Columbia University in New York City in 1906. In 1914 he opened the Clarence H. White School of Photography, and taught at both schools concurrently. White was associated with the Photo-Secession movement endorsing a revolt against the pseudo-impressionistic in photography on the grounds that photography must depend on its own unique capabilities rather than following the lead of painting.

Walter Gropius founded The Bauhaus in Weimer, Germany, in 1919. The program promoted the concepts of experiential learning, sound craft skills, and breaking down barriers between "fine art" and craft. Though not a photographic school, the students were encouraged to use photography in design, applied technology, and experimentation. Regular courses in photography were started in 1929. Laszlo Moholy-Nagy, a Hungarian painter, photographer, and graphic designer taught a foundation course starting in 1923 and, later, founded the New Bauhaus in Chicago after activities at the Bauhaus in Germany aroused the suspicions of reactionary political forces that brought about its closing in 1933. Moholy-Nagy was the first photographer to become a principle motivating force behind an American institution of higher learning believing that, "the illiterate of the future will be the person ignorant of the use of the camera as well as the pen." Lacking financial support from the founding organization, The New

FIG. 16 A view of Professor Charles Savage's class at the RIT School of Photographic Arts & Sciences downtown studios ca. 1940–1950s. (Image courtesy of the RIT Special Collections Wallace Memorial Library, Rochester Institute of Technology, Rochester, New York.)

Bauhaus closed in 1938 but was opened again in another location in 1939 as the Chicago School of Design. Its final name change came in 1944 as the Institute of Design at the Illinois Institute of Technology. It has produced numerous graduates, many who became photography professors in the expanding programs across the county.

Henry Holmes Smith was hired to teach the first photography course at the New Bauhaus in 1937. Later, Smith taught the first History of Photography course for a fine art department at Indiana University at Bloomington in 1947. He started a small graduate program in 1952 that influenced the future of photographic education through graduates like Jack Welpott, Jerry Uelsmann, Betty Hahn, Robert Fichter, and Van Deren Coke, who became important photographic artists and teachers themselves. For all his success, however, Smith felt that the administration did not hold photography in high esteem, causing problems in program development. Smith was a one-man department until Reginald Heron was hired in 1970.

Not far away, at Ohio University, a camera club's enthusiasm was so contagious that a course in photography was added to the curriculum of the College of Fine Arts. Ohio University was the first university to offer both a bachelor's and masters' degree in photography inaugurated in 1943 and 1946, respectively. This program was also the first to combine photography with other disciplines such as art history and design.

The San Francisco School of Fine Arts had courses conducted by Ansel Adams, Minor White, and others since 1945. Though not a degree granting school, the influence of the courses was significant. In addition, painters Clyfford Still

FIG. 17 C. B. Neblette, ca. 1940. (Image courtesy of the RIT Special Collections Wallace Memorial Library, Rochester Institute of Technology, Rochester, New York.)

and Mark Rothko taught there during the same era. The school was "aided by the mature students just out of the armed forces and the support of the G.I. Bill, there was undeniably a most stimulating assembly of teachers and students at this West Coast school during the decade after the end of World War II," according to Van Deren Coke's article.

Rochester Institute of Technology (then the Rochester Athenaeum and Mechanics Institute; RAMI) offered evening courses in photography as early as 1902. Eastman Kodak Company's Director of Training and Personnel, Mr. Earl Billings, founded the School of Photography at RAMI as a two-year work-study program in 1930. The first class consisted of twenty-four students. The first two teachers, Frederick F. Brehm and C. B. Neblette were reassigned from Eastman Kodak to the school on a part-time basis. The program changed in 1936 due to high enrollment numbers (30–40 per class) and the industry's inability to immediately absorb all the graduates. As a response, a three-year program was introduced with the first year being full time and the second two years being work-study. A student could opt for two full time years, eliminating the work experience.

By 1959 there were 400 students in the School of Photography earning a bachelor of science degree. A bachelor of fine arts degree was added in 1960 and a master of fine arts degree was first offered in 1969. By 1979 over 1000 students were enrolled in the school's comprehensive selection of photographic programs.

The Society for Photographic Education

In the interest of formalizing their educational commitment, a few dedicated educators led by Nathan Lyons organized an Invitational Teaching Conference at the George Eastman House in November of 1962. During the three-day event it was unanimously decided to establish a permanent organization. Twenty-seven men participated including Beaumont Newhall, Minor White, John Szarkowski, Aaron Siskind, Clarence H. White, Jr., Henry Holmes Smith, and Jerry Uelsmann. Attendees represented institutions from locations as diverse as Ohio University, University of Minnesota, Kalamazoo Institute of Art, Rennsselaer Polytechnic Institute, Philadelphia Museum College of Art, the University of Iowa, and the University of Florida. Only two attendees came from organizations other than a college or university: Museum of Modern Art and Eastman Kodak Company.

In the proposal for an association, presented by Henry Holmes Smith, the following goals were articulated: the organization would be built around the group assembled as its first members, they would collect and disseminate current teaching practices and principals of photography, act as an advisory group for school administrators interested in establishing photographic courses at any level, assist all organizations attempting to collect examples of photography, provide information as to current curriculum practices in schools that teach photography, help teachers advance their own skills, serve as a clearing house for teaching positions, establish a voice for teachers in relationship with the photographic industry, issue appropriate publications, and undertake cooperative efforts with other photographic groups. The original members were focused on their individual challenges in the classroom, and there is no mention of promoting scholarship within the discipline. The founders also did not seek to limit membership by setting standards or issuing licenses. Photographic education as proposed, was broadly located from primary to secondary institutions as well as post-secondary institutions though no attendees of the first meeting taught below the university level.

One of the attendees of the teaching conference was Professor Charlie Arnold from RIT. He recalled teaching in the early 1960s when the Society for Photographic Education (SPE) was in its infancy and articulates one reason it may have been needed.

SPE happened when everybody was up in arms to throw everything out the window and do everything different. The students wanted courses and they didn't want grades given. They wanted to choose any one of fifteen different courses. They wanted courses about unbelievable things. I mean, it was just mayhem but it was interesting mayhem.

FIG. 18 A 1972 photograph made on the new RIT campus with 70 new enlargers and some of the 800+ students who were enrolled at the time. (Image courtesy of the RIT Special Collections Wallace Memorial Library, Rochester Institute of Technology, Rochester, New York.)

Arnold and Ralph Hattersley had just introduced a BFA in photography at RIT. "Doing everything different" would be an alternative to the applied science program already established.

Topics discussed during the weekend conference included: Photography and General Education, The Needs of the People — Photo Instruction — Who Wants to Learn and Why?, The Place for Photography in the University Curriculum, Creative Photography for Advanced Students, A Function of the Teacher As Critic in the Arts, and Interrelationship of Image and Technique. The subjects reflected the particular perspective of each panel's chair and reflected the diversity of questions surfacing in the new programs of photography.

Keith Davis refers to this first conference in his photographic history *An American Century of Photography* and states that the motivation for the conference was based on expanding the audience for serious photography.

The desire to expand the audience for serious work dominated the talks at the 1962 conference. Everyone agreed that the medium suffered a woeful lack of informed criticism and was viewed superficially by most art museums and members of the public. To this end, a deeper understanding of visual literacy — accompanied by a refinement of critical terminology and methodology — was deemed essential. How was the photographic image related to the science and psychology of perception? How were the meanings of photographs derived from a larger context of social thought and cultural value? Such complex issues dominated thinking in the field, but resisted definitive analysis.

The first annual meeting of SPE was held in Chicago in 1963.

The organization had an important impact on the working lives of photographers who, in increasing numbers, were beginning to use the medium as an expressive form. With the growing number of photography programs at the college level, for the first time photographers had an option to doing commercial work to make a living. Additionally, the academic calendar afforded many burgeoning artists the time needed to pursue creative work. Nathan Lyons spoke of the significance of this particular development:

... there seemed to be a need to get the teaching of photography into college curriculum so that the same advantages that art programs have would be there for photographers. It would open up job possibilities and I think people underestimated the significance of getting the SPE started and helping to grow the educational field so that photographers didn't have to work commercially to do their own work. And, that, I think was an incredibly significant development for the field in the 60s.

Today, with over 1800 members, SPE's stated mission reads in contrast to its earlier goals:

The Society of Photographic Education is a non-profit membership organization that provides a forum for the discussion of photography and related media as a means of creative expression and cultural insight. Through its interdisciplinary programs, services and publication, the Society seeks to promote a broader understanding of the medium in all its forms, and to foster the development of its practice, teaching, scholarship and criticism.

Photographic education continues to transform itself through digital technology. The lines between traditional disciplines are blurring as new programs emerge in time-based mediums including multimedia production, film and video, animation, and Web design. New fields are forming as specialized skills are needed in information technology and communication design. Photographic imaging continues to play a primary role in all forms of new media. The tools are changing but the talent of *seeing* can still be enhanced through education and training.

FURTHER READING

Arnason, H. H. and Prather, M. F. (1998). *History of Modern Art*, Fourth Edition. Upper Saddle River, NJ: Prentice Hall and Harry N. Abrams, Inc., p. 356.

Arnold, C. (2002). *Interview with Author*. Rochester, NY, February 15.

Bossen, H. (1983). *Henry Holmes Smith: Man of Light, Studies in Photography,* No. 1. Ann Arbor, MI: UMI Research Press, p. 128.

Coke, V. D. (1960). The art of college teaching. *The College Art Journal* XIX, No. 4, p. 333.

Coke, V. D. (1960). The art of college teaching. *The College Art Journal* XIX, No. 4, p. 334.

Davis, F. K. (1999). *An American Century of Photography: From Dry-Plate to Digital*, Second Edition. Kansas City, MO: Hallmark Cards, p. 314.

Davis, F. K. (1999). *An American Century of Photography: From Dry-Plate to Digital*, Second Edition. Kansas City, MO: Hallmark Cards, p. 390.

Davis, F. K. (1999). *An American Century of Photography: From Dry-Plate to Digital*, Second Edition. Kansas City, MO: Hallmark Cards, p. 389.

Davis, F. K. (1999). *An American Century of Photography: From Dry-Plate to Digital*, Second Edition. Kansas City, MO: Hallmark Cards, p. 393.

Davis, F. K. (1999). *An American Century of Photography: From Dry-Plate to Digital*, Second Edition. Kansas City, MO: Hallmark Cards, p. 399.

Eastman Kodak Company (1960). *A Survey of Photographic Instruction, Second Edition a Resume of Instruction in American Colleges, Universities, Technical Institutions and Schools of Photography*. Rochester, NY: Eastman Kodak.

Gantz, C. (2001). *100 Years of Design: A Chronology 1895–1995* [proposed book; cited July 22, 2003]. Available from www.idsa.org.

Gaskins, W. G. (1971). Photography and photographic education in the USA. *Image* **14**, No. 5–6.

Gaskins, W. G. (1971). Photography and photographic education in the USA. *Image* **9**.

Green, J. (1984). *American Photography: A Critical History 1945 to the Present.* New York: Harry N. Abrams, p. 92.

Green, J. (1984). *American Photography: A Critical History 1945 to the Present.* New York: Harry N. Abrams, p. 145.

Horrell, C. W. (1964). *Photography Instruction in Higher Education.* Philadelphia: American Society of Magazine Photographers, p. 1.

Horrell, C. W. (1964). *Photography Instruction in Higher Education.* Philadelphia: American Society of Magazine Photographers, p. 2.

Invitational Teaching Conference at the George Eastman House (1962). Paper presented at the Invitational Teaching Conference at the George Eastman House. Rochester, NY, p. 2.

Lokuta, D. (1975). *History of Photography Instruction.* Columbus, OH: Ohio State University.

Lyons, N. (2003). *Interview with Author.* Rochester, NY: June 13.

Shoemaker, William Soule. (1980). "History of Spas," RIT Archives and Special Collections, Rochester, NY, p. 2–3.

Society for Photographic Education (2001). *SPE Resource Guide and Membership Directory.* Oxford, OH: The Society for Photographic Education.

Sontag, S. (1973). *On Photography.* New York: Farrar, Straus and Giroux, jacket notes.

Stroebel, L. and Zakia, R. D. (eds.) (1996). *Encyclopedia of Photography.* Boston: Focal Press, p. 565.

Traub, C. (ed.) (1982). Photographic Education Comes of Age. In *The New Vision: Forty Years of Photography at the Institute of Design.* New York: Aperture, p. 27.

Photographic Workshops: A Changing Educational Practice

CHRISTOPHER BURNETT
Visual Studies Workshop

Photography can be learned in a weekend.

It can take a lifetime to learn photography.

For decades, workshops have spanned these poles of photographic education and all levels of engagement in between. The versatility of workshops accompanies a range of educational needs and options according to which the format adjusts and adapts itself. A workshop can mean anything from an afternoon encounter of a group of camera buffs to the committed

union of dedicated artists lasting a few months. The numbers involved may vary from a few to a baker's dozen. The settings could be a photographer's living room, an ordinary classroom or darkroom, or the great outdoors within a national park or a tropical resort. The idea that a workshop idea encompasses so many experiences, and yet names such a distinctive means of learning and teaching, indicates that we have encountered a cultural practice.

Workshops, in the sense commonly used today, emerged as an educational practice in 1930s America with the progressive education movement set in motion before World War I. Cultural practices are not invented but emerge in the wake of social discussions, efforts, explorations, conflicts, negotiations, and the eventual formation of institutional programs. The labels arise from and help consolidate the customs. An early deliberate use of the term "workshop" as a special educational variety appeared in the summer of 1937 when teachers from public and private high schools gathered on the campus of Sarah Lawrence University. The principles that the group applied to themselves called for a kind of "recess" for teachers: there would be no grades, no credits, no required class attendance, and written examinations. Yet, even with an informal atmosphere, each teacher/student was strictly responsible to come to the workshop with a definite project in mind. The sessions unfolded around the interactions of the group as members helped each other with their projects. Other requirements were that they report to their school officials back home and document their results for the future. By the early 1950s, this "unshackled" way of learning had branched out to so many lines of endeavor that educator Earl Kelly considered it necessary to bring the workshop idea back to its original basis. He did so by defining workshops according to these essential components: (1) a planning session where all are involved at the beginning, (2) work sessions with considerable time for all to work together on their individual problems, and (3) a summarizing and evaluating session at the close. The combination of individual responsibility with group dynamics; the intensity of involvement with open, responsive forums; and improvisation tempered by accountability are the classic hallmarks of workshop practice.

The particular potency of the workshop model for photography comes out of this tradition of experimentation and its various combinations of educational values. Workshops have figured as a primary vehicle of photographic education because they combine progressive high-mindedness with a workable pragmatism, freedom combined with purpose; intensity with ongoing involvement on many levels of commitment. Perhaps it would be not too fanciful to say that these features are in accordance with the very status of photography itself as a cultural practice.

Origins of the Workshop

Photography would find a particular affinity with workshops as an informal, unshackled way of learning because the medium was never quite shackled from the start. From the time of its invention, the instruction of photography ran in side currents apart from the mainstream of 19th century art education. Photography was only slowly and reluctantly adopted by the academies, schools, and universities of Europe and the Americas. More common were impromptu forms of training demonstrations and ad hoc apprenticeships through which painters-turned-photographers and aspiring tradesmen learned their photographic techniques and practices. Shortly after the announcement of the Daguerreotype process by the French Academy of Science, François Gouraud came to America and exhibited Daguerre's pictures along with public demonstrations about the invention in New York, Boston, and Providence. He also took a small number of pupils to learn photography including Samuel F. B. Morse in New York and Edward Everett Hale, Albert Sands Southworth, and Josiah Johnson Hawes. These initial "demonstrations" were not workshops in the modern sense, but they shared similar aspects in their brevity, small numbers, and impromptu quality. They also held in common the workshop sense that the practical know-how of photography could be eagerly acquired and "passed on" to other receptive practitioners who would further develop and relay knowledge of the craft.

Along with these ad hoc meetings and relays, official institutions established more formal conduits for learning photography. The Royal Photographic Society played an important educational role from its founding in 1853. Camera clubs, such as the Camera Club of New York since 1884, provided organized contexts for meetings that provided a sense of community as well as education. Out of these institutions grew dedicated schools such as the Clarence H. White School of Photography (1914–1942). Despite these developments, the place of photography in colleges and universities was as sporadic as it was scattered. Photography popped up haphazardly in any number of departments depending on the particular leanings of certain disciplines and their faculty. For example, the medium gained an early foothold within Sociology at Harvard University. To this day, the Kansas State University Geology Department still hosts the darkrooms where photographic practice first took hold on campus. One might have to be a sociologist or geologist to learn photography in these academic settings. Apart from the hodgepodge of these campus offerings and the insular nature of camera clubs and photography schools, serious photographers and artists would seek alternative forms of education.

The founding of the Bauhaus in Weimar, Germany, in 1919 would provide more consistent and purposeful paradigms of photographic education. Though the school was built around teaching architecture and the disciplines of painting, sculpture, textiles, graphic design, and others, photography was central to its curriculum. A full treatment of Bauhaus pedagogy and its importance to photography lies outside the scope of this essay, but I should note the central tension at the school between art and industry and visual concepts and practicality. The Bauhaus workshop became a significant site for playing out these tensions. This usage of the term workshop goes back to the Arts and Craft movement in England and Charles R. Ashbee's

founding of the Guild and School of Handicraft in London's East End, in which training took place, not in the studio or atelier, but in workshops. At the Bauhaus, production operated alongside education as areas of practical training as well as embedded cottage industries. The textile workshop, for example, sold its wares to the public. Significant to the divided union of formal education and practical production was the pairing of the "Master of Form" with the "Master of the Workshop." This division and subsequent coupling of roles augured the later union of artistic vision and practice in the modern photographic workshop as it took root in the United States along with other pedagogical influences of the Bauhaus.

The Modern Workshop
Beginnings of modernist workshop: late 1930s to early 1950s

The first glimmerings of this modern workshop was in the newly reorganized Photo League of 1936 with the work and teaching of Sid Grossman and Aaron Siskind. Though they did not apply the term, their classes of advanced students in the production of documentary photo-series called Feature Group Projects had many of the earmarks of modern workshops influenced by both the Bauhaus and progressive social movements. These classes were occurring at the same time as the progressive education workshops for teachers on campuses. The Photo League classes had the critical feature of the individual project plan around which group interaction flexibly organized itself. Significantly, the pedagogy expounded by Siskind in the June–July 1940 issue of *Photo Notes* emphasized his progressive view of education as a laboratory. This work laid the foundation for his teaching credo emphasizing commitment and regular practical production. As Carl Chiarenza put it, "It is what inspired his formation of the so-called 'student independent' projects: work produced by students on their own initiative away from school. He taught by example, by being a working, committed artist." Siskind brought about the workshop ideal of practice and set it in motion.

Another very influential educational setting, Black Mountain College in North Carolina, had already activated the wheels of progressive education in the arts. Founded in 1933 by John Andrew Rice, Black Mountain College made a living laboratory of the movement's central tenets that education involved situation, self-defined problems and projects, cooperation, and a flexible curriculum fused with experience (as John Dewey understood it). At Black Mountain College the process of growth and change was more important than the assimilation of a body of information in a classroom. Teachers were guides, not dispensers of a syllabus and grades. As for art, the community understood it as a generative force in life that stood at the center of the curriculum.

Photography eventually worked itself into the fabric of Black Mountain College in the 1940s and its Summer Institute hosted groundbreaking events in photographic education along the lines of workshop practice. Beaumont Newhall spent three summers there teaching and finishing his *History of Photography* in 1948. In the summer of 1951, photography erupted into full bloom with successful seminars organized by Hazel-Frieda Larson, with Arthur Siegal, Harry Callahan, and Aaron Siskind from the Institute of Design in Chicago. Photography was treated as a modern art form at Black Mountain College as opposed to an ordinary documentary or commercial medium. These seminal photographic educators interwove teaching with the development of their own work. Even as temporary summer visitors, they enjoined the college's way of thinking that education was a lifetime commitment and was never complete.

Even earlier, in 1940, Ansel Adams had begun his annual one-week workshop of landscape photography in Yosemite National Park. Though occurring across the gap of a continent and within a very different educational milieu, it shared many similar motives with Black Mountain College in using flexible, intensive educational meetings to combine high-minded vision with straight photographic practice. Between the Photo League feature group production units, the Black Mountain College photographic seminars, and Adams' Yosemite Workshop, the stage was set for the modern photographic workshop to bloom.

The Aperture "School": late 1950s to the early 1960s

A special issue of *Aperture* in 1961 expressed this bloom with lucid accounts of the seminal workshops of Minor White, Ruth Bernhard, Ansel Adams, Nathan Lyons, and Henry Holmes Smith. White, editor of the journal, introduced the issue with an overview of workshop at that opportune moment in history. White noted that the word workshop had been used loosely in the field of photography due mostly to the "healthy independence and lamentable isolation" of workshop leaders. Despite this, he found two broad classifications of workshops: the "blitz" and the "intermittent." The former takes advantage of the "effect of concentration [and fatigue] … as short as a weekend or as long as a fortnight." The latter are held evenings and/or weekends on a weekly schedule. In either kind, these workshops are a "personal matter" subject to individual variation. Each practitioner represents a type: Bernhard "represents those who eat sparingly in order to live fully in their own world of the camera"; Adams the nationally known photographer; Lyons, assistant director of George Eastman House, who supported his photography by work in an allied field; and Smith who performs in both classroom and workshop photography. White claimed that despite these variations, their workshops held in common the "indignations of the leader." For them, workshops were a form of protest against schools, training, advertising, propaganda, magazines, pictorialism, and all those, who were, in White's words, "deadset in promotion of visual blindness." Against this, the workshop leaders offered some form of "seeing" or "vision." Furthermore, their protest and promulgation of "seeing" was not meant to be esoteric, but "plain." Their workshops were "makeshift" and unornamented, but offered an educational experience beyond description that each of these pioneers in photographic education would nevertheless go on to describe.

FIG. 19 Minor White was a major contributor at workshops across the country, shown in this photo taken in 1976 by Abe Frajndlich. (Image courtesy of the Visual Studies Workshop, Rochester, New York.)

Bernhard emphasized the importance of a free exchange of ideas and work among all participants. As a "workshop leader," she did not consider herself so much a teacher, but, rather, a catalyst. Her workshops, purposely designed with "no system" incorporated a range of topics and disciplines such as philosophy, poetry, and music. White surveyed the several workshops he held across the country at places such as Portland, Oregon; Idyllwild, California; Denver, Colorado; and Rochester, New York. Though the workshops differed in format, they held in common the infusion of White's quasi-religious and therapeutic ambitions. Bound in prosaic worlds of "not seeing," the object was to free the individual to see and acquire, in the process, an "intensified consciousness." Clearly more grounded, Adams was concerned that he do nothing through habit or authority to destroy the informal character so necessary to the independent spirit of his annual Yosemite workshop. Nevertheless, he espoused a number of principles he hoped would lead to greater powers of visualization and creative excitement. For Lyons, the excitement was found in the tension between knowing and seeing. Projects or assignments were used simply as points of departure to encounter "the unfamiliar view" that tested boundaries and generated significant expression. Lyons' workshops were successful if they showed signs of challenging established visual and cognitive surroundings. Finally, Henry Holmes Smith used his article to announce his Conference and Workshop on Photography Instruction at Indiana University planned for the summer of 1962. Like the journal *Aperture* itself, the conference would aim to direct attention to problems of photographic education "on the highest level." Smith referred, along with the other educators, the implicit view that workshops held the key for enlightened considerations of photographic education in general. The workshop had become

a concentrated vehicle of meta-education: learning how to teach; learning how to learn.

This meta-disciplinary or discursive function of the workshop reappears a few years later in *Aperture* with White's telling editorial "Transactional Photography." Here, the workshop becomes as integral to creative photography as the camera and as necessary to the broad process of "camerawork" as the vision behind it. As an educational apparatus, the workshop is not a means to an end but a destination itself where the photographer completes a process of visualization set in motion by the camera and darkroom. The workshop in effect took the place of the gallery and augmented display with the photographer's presence and the opportunity for the "transaction" with others. Tellingly, White grappled with the presence of language in this eminently visual process. He encouraged other means of communication in the workshop mix: gestures, "sketching responses," "inarticulate animal sounds, or eloquent silence." White ultimately struggled editorially with his own reliance on words, which could only hint at "the rarefied air of transaction photography."

The burden of language was not White's alone but shared by the other workshop leaders. Language's tricky relationship to the exalted status of sight figures as a paradoxical crease in their modernist discourse on workshops. Lyons saw pictures functioning linguistically in a sense (visual objects could serve as nouns or adverbs), but restricted conversational speech as a tool to be used only with "extreme caution." Their belief that projects should speak for themselves was caught up in a split orality that, on one hand, relied on the presence of speech and, yet, disavowed the mediation of words and the tongue in a bid for the directness of the eye and transcendent visual signs. The disturbance of language as mediation points to other contradictions in their formation of the workshop that is shot through with idealism and yet grounded in practice. White titled the issue "The Workshop Idea in Photography," and yet "practice" would stand out as much as "idea" — it was the ultimate value that they courted. These practical idealists wished to climb down from their high horse, and yet they would become the lofty maestros of workshops as a retreat for romantic visionaries. Out of this mixed soil of idealism and pragmatism, contradictory language and vision, the modern workshop would not only bloom but boom.

The modern workshop comes of age: late 1960s to the early 1980s

The special issue of *Aperture* closed with announcements of workshops by these forward-looking practitioners, and along with other offerings at the time (surveyed in two special issues of *Popular Photography* in 1961), they would herald the scores of workshops established in the late 1960s and early 1970s. Photographic education itself was taking off and finding more secure footings within art schools, colleges, and universities, and yet, as demonstrated by the Indiana Conference in 1962, workshops were not just a sideshow but often held center stage as models of value and educational practice. The burgeoning interest in photography as an art form coupled with a

FIG. 20 The poster that was used to promote the Apeiron Workshops of the early 1970s. In the group is the former director of the apeiron, Peter Schlessinger. (Image courtesy of the Visual Studies Workshop, Rochester, New York.)

population of Baby Boomers signaled that workshops were ready to rock 'n' roll.

Most influential workshops on photographic education—many disbanded, some still in operation—grew out the "makeshift" efforts of the *Aperture* visionaries. Adams' Yosemite Workshop eventually became part of the Friends of Photography program (1967–2001). Lyons founded the Visual Studies Workshop (1969–present). White moved to the Massachusetts Institute of Technology and continued his workshop activity, until his death in 1976, at many locales such as the Hotchkiss Workshop in Creative Photography in Connecticut (1970).

These more institutionalized workshops influenced another generation to spawn their own workshop enterprises. Peter Schlessinger founded Apeiron Workshops (1971–1981) in upstate New York implicitly under the influence of White. Carl Chiarenza, Warren Hill, and Don Perrin started the Imageworks Center and School in Boston (1971–1973). The Center of the Eye was founded by Cherie Hiser in Aspen Colorado (1969) and later connected to the Aspen Center for Contemporary Art and Anderson Ranch Arts Center in Snowmass, Colorado. Fred Picker operated his Zone VI workshops in Putney, Vermont (1970–2002) in much the same spirit and aesthetic as Adams' annual Yosemite Workshop. Magazine photographer, David Lyman, started Maine Photographic Workshops (1973–present) in Rockport, Maine, with a keen business model attracting clientele as diverse as artists, journalists, and amateurs of many professions who desired to mix photographic study with a vacation.

Important workshops popped up on the international stage based on the American model. In 1969 Lucian Clegue set up Rencontres d'Arles, an arts festival in the south of France including photography workshops. Earlier in Mexico, El Taller de Gráfica Popular (Popular Graphics Arts Workshop) involved photographers such as Lola Álvarez Bravo and Mariana Yampolsky. And, Paul Hill opened the Photographers' Place in Derbyshire, England, in 1976.

Back in the United States, many other institutions offering workshops included: The School at The International Center of Photography, New York; the Center of Photography at Woodstock, New York, the Penland School of Crafts, Penland, North Carolina; the Art Institute of Boston; Lightworks at Film in the Cities, St. Paul, Minnesota; Silvermine Guild Arts Center, New Canaan, Connecticut; Santa Fe Photographic Workshops; Summer Museum School, School of the Museum of Fine Arts, Boston and Ghost Ranch, New Mexico.

Some short-lived but influential workshops are Roy DeCarava's Kamoinge Workshop (1963); the Photo-Film Workshop at the Public Theater (1969); Real Great Society's Media Workshop; and Woodstock, New York (1970).

By the early eighties, the number and range of workshops had risen to the point where A. D. Coleman would survey them as "the workshop circuit." And if the term workshop seemed loose to White in 1961, it was even more so for Coleman writing in 1982: "The time space it encompasses apparently runs anywhere for half a day to two weeks; the

FIG. 21 A photograph made during a workshop at VSW. (Image courtesy of the Visual Studies Workshop, Rochester, New York.)

number of participants can range from 5 to 20 or more, and the nature of the encounter can be almost anything." But it wasn't the vagueness of the practice that bothered Coleman so much as the posturing. Authentic master–apprentice relationships and informal synergies of participants had fallen to opportunities for "workshop junkies and dabblers" to pad their resumes with the names of luminaries. In 1982 Apeiron Workshops closed its doors, and Coleman quotes Schlessinger, "I think something called workshops became big business in the mid-1970s and mostly garbage shortly thereafter. Any gathering in the presence of a star photographer was suddenly a 'workshop.'" Coleman does acknowledge the continuing value of workshops, but his article seems to mark a turning point and the end of an era for the modernist workshop.

How much the workshop environment has changed since then becomes even more pronounced with the publication in 1999 of Mark Goodman's book, *A Kind of History*. His photographs and narrative poignantly describe the experience of Apeiron Workshops and nearby Millerton, New York. His "perpetual" residency for years in the 1970s goes well beyond White's categories of "blitz" and "intermittent" to total immersion in a kind of visual subculture. But more than a "workshop junkie," Goodman carried with him the innate sensibilities of an anthropologist and committed photographer who could use his workshop experience to reveal the multi-dimensional life of a small town over years of involvement. His attachments to photography and the people of Millerton amount to a tale of two cultures involving the tension of proximity and distance and mixed allegiances as he moved back and forth between Millerton and Apeiron at Silver Mountain. His work reflects back on Apeiron and the capacity of workshops to form, complete, and project an extended body of work beyond the internal "transactions" of an artists' enclave. He embraced the several levels of workshop involvement from short-term intensity, intermittent study, to persistent residency. He

demonstrated the purpose of workshops to integrate learning and life growth.

Current Trends and Future Directions

With further proliferation, the "circuit" of workshops that existed in 1982 has grown into an "intercircuit" of workshops in a manner similar perhaps to networks aggregating themselves to become an Internet. Not only are there myriad workshops to choose from, but many types, formats, aesthetics, styles, genres, and payment plans. Certainly the field has become commodified, but more telling, the workshop has become globalized, often figuring as gateways to other worlds, landscapes, and global cultures. The combination of recreation and travel with workshops is not new, but it has been amplified to a level that distinguishes our current period.

Like planning for a trip, there are a number of published guides to cope with the number of options and arrive at a decision point. In the early 1990s, there were guides in print such as Jeff Cason's *The Photo Gallery & Workshop Handbook* (1991) and ShawGuides' *The Guide to Photography Workshops & Schools* (1994). The former lists over 200 workshops, seminars, and photo-tours arranged by category and by geographic index. The ShawGuide lists over 400 workshops and tours. But these listings are small compared to the current online edition that, according to the banner headline, is "A Free, Online Directory from ShawGuides with 536 Sponsors of 2655 Upcoming Photography, Film & New Media Workshops Worldwide!" The Guide to Photography, Film & New Media Workshops is one tab among other related zones such as Art & Craft Workshops, Career Cooking & Wine Schools, Cultural Travel, Golf Schools & Camps, Writers Conferences & Workshops, and Language Vacations. A few of the leading workshops on the home page include the Venice School of Photography, Exposure36 Photography, American Photo/Popular Photography Mentor Series, Sand Diego Photo Safari, Horizon Photography

Workshops, White Mountain Photography Workshops, and Branson Reynold Photographic Adventures. Like many travel opportunities in global culture, the global workshop offers an educational encounter and an ephemeral sense of place in a placeless world. Here the classic, modernist workshop's commitment to participation and presence has become taunted by an ironic play of distance and proximity.

How the workshop in photography will adapt to future developments in technology and media is an open question. It is unclear if distance education systems will ever be a suitable vehicle for workshops in the classic sense. The gangly figure of a "distance education workshop" is almost a tautology in terms given that presence, not absence, defines the internal logic of workshops. Face-to-face communication and situated expression drives workshops whether it is in the "authentic" terms of modernism or the "simulated" experiences of postmodernism. Interestingly, back in the early 1960s, White held out the possibility of distance workshops with an experiment he conducted by exchanging photographs and audio-taped commentary through the mail. But, for White, the recorded voice supplied the necessary signifier of presence, and even with that reassurance, he never sustained the experiment. Apparently, new media communications will frame the continuing possibilities of the workshop as content, but they can never fully reproduce the workshop form.

The possibilities of new media as the subject-matter of workshops are equally questionable. Short courses and educational training classes for new media gravitate toward the "demo," or demonstrations of technical procedures, tours of the software package's interface, and the organization of a series of tasks. For example, digital photography is taught in terms of the delineation of "work flow" or the relationship of the activities in a project from start to finish. Demos as staged events require preplanning and are contrary to the classic manner of workshops that incorporate planning only as an

FIG. 22 Photograph made at the Ansel Adams Photo Eye workshop held at the Rochester Institute of Technology in spring 1990. (Professor Willie Osterman, Rochester Institute of Technology, Rochester, New York.)

immediate prelude to work sessions and group interaction. Even so, perhaps workshops can overcome these barriers and introduce more depth and two-way dialog into the process of learning and thinking about new media and digital photography. Perhaps with the use of computer technology becoming increasingly second nature, the time is right for workshops to engage the emerging media of our time in a more unshackled, progressive fashion. Workshops have proved to be an adaptable and robust educational vehicle and will continue to do so as long as individuals are ready to turn a passing encounter with photography into a life-long passion.

FURTHER READING

Cason, J. (ed.) (1991). *The Photo Gallery & Workshop Handbook*. New York: Images Press.

Chiarenza, C. (1988). *Chiarenza: Landscapes of the Mind*. Boston: D. R. Godine.

Coleman, A. D. (1982). Light readings. *Lens' on Campus*, **38**, p. 40.

Duberman, M. B. (1972). *Black Mountain: An Exploration in Community*. New York: Dutton.

Gernsheim, H. and Gernsheim, A. (1955). *The History of Photography*. England: Oxford University Press.

Goodman, M. (1999). *A Kind of History: Millerton, New York 1971–1991*. San Francisco: Marker Books.

Kao, D. M. and Meyer, C. A. (eds.) (1994). *Aaron Siskind: Toward a Personal Vision, 1935–1955*. Chestnut Hill, MA: Boston College Museum of Art.

Kelley Earl, C. (1951). *The Workshop Way of Learning*. New York: Harper, p. 137.

Scholastic principles applied to themselves by 150 teachers. *The New York Times*, August 1, p. 77.

ShawGuides (ed.) (1994). *The Guide to Photography Workshops & Schools*. New York: ShawGuides.

White, M. (1961). The workshop idea in photography. *Aperture* **9**, No. 4, pp. 143–144.

White, M. (1964). Editorial [transactional photography]. *Aperture* **11**, No. 3, p. 90.

Wick, R. K. (2000). *Teaching at the Bauhaus*. Ostfildern-Ruit: Hatje Cantz, Germany. ◉

Magazines: The Photographers' Press in the United States and Great Britain During the Transition Decade of the 1960s

DAVID BRITTAIN
Manchester Metropolitan University

In a seminal essay called "Mirrors and Windows," John Szarkowski argues that there was a "sudden decline" in the fortunes and prestige of mass market pictorials such as *Life*, in the late 1950s. In former times, magazines had supported great photographers from Beaton to Bourke-White. But in response to the pressures of competing for advertisers, jobbing "amateurs" entered the profession, replacing the great talents. Szarkowski, a renowned curator, notes that the most ambitious photographers of the counter-culture viewed this new situation as an opportunity to pursue their artistic destiny elsewhere. The decline of the pictorials, then, instigated a transition during which the identity of the American photographer shifted from artisan to artist.

As is universally acknowledged, one of the models for the new American photographer (and an inspiration to young photographers, internationally) was the individualistic Robert Frank. The U. S. publication, in 1959, of his book *The Americans*, might be said to represent the start of the trajectory that ended with photographers being elevated to a new social status. Not only did *The Americans* set a high standard artistically, it also sent the signal that artistic control was possible, but only outside the constraints of the mass media and commercial photography. The sixties was a decade of transition in American photography. The milestones would include the founding of the Society of Photographic Education (SPE) in 1962, by such key figures as Minor White, Aaron Siskind, and Nathan Lyons; the 1962 publication of Marshall McLuhan's book *The Gutenberg Galaxy*; The Photographer's Eye curated by John Szarkowski at MoMA, New York in 1964; the publication in 1964 of *The Painter and the Photograph* by Van Deren Coke; the release of Antonioni's iconic film, *Blow Up* in 1966; and not forgetting the other MoMA exhibition, New Documents in 1967. The exhibition launched three talents—Lee Friedlander, Garry Winogrand, and Diane Arbus,—who would come to personify the poet-photographer of the post-*Life* era.

By the middle of the decade some of the conditions were in place to support independent photographic practice: an expansion of the provision for photography in higher education, offering some employment prospects, two major museums with dedicated departments and acquisition budgets, and the beginnings of a publishing culture for photographers' books. But much else would be needed if young photographers were to survive outside of the commercial systems. Photography as art was still in search of a scholarly discourse and the market for original prints was in its infancy. This meant that the sixties was a decade of promise and disappointment for photographers.

Szarkowski's main claim that magazines were in decline, and were no longer recognizing or attracting independently minded photographers, may have been true of big titles such as *Life*, but publishers and photographers alike were adapting and finding new audiences. Even as photography was beginning to become more widely exhibited and reviewed, reputations were still being made in glossy magazines such as the new color supplements in Britain and youth magazines such as *Nova* in England and *Twen* in Germany that were commissioning the most innovative photographers. A regular contributor was Diane Arbus, one of the sensations of the 1967 New Documents exhibition.

Before photography galleries became commonplace, the news kiosk was the photo gallery of its day. Many new photographers emerged out of the media because magazines were central to the economy and identity of photographic culture, and this is reflected in the fact that some of the first art exhibitions and publications originated with magazine assignments. Photographers still admired the old-style *Life*, not least because the magazine made the profession seem respectable. In Britain photographers cherished a similar fondness for *Picture Post* (closed in 1957) in which Bill Brandt and others came to prominence during the war years, marking a "golden age." In the 1960s magazines — but also catalogs and annuals — were still very important for the interchange of issues, ideas, and images among young photographers, providing them with a cast of indomitable role models. Readers and editors alike scanned pages for the best images, often removing them for future reference and memorized the bylines of the photographers they admired. Long before most learned of Walter Benjamin's notion of the reproduction as a popular art gallery, the illustrated press made photographers feel connected, even as they were scattered. In an address to the readers of *Camera Arts*, in 1980, the celebrated editor Jim Hughes sums up the impact of the magazines on his generation of photographers. "Via the medium of the printed page and in the quiet of my own room, I was moved by the eloquence of Edward Weston, Dorothea Lange, Paul Strand, W. Eugene Smith, Lisette Model, Ansel Adams … and so many others … I began to comprehend that there was art in life."

The decline of *Life* (whether as a result of TV or not) coincided with an expansion of the alternative press in major cities across America, Europe, and Australasia. This global network of small magazines catered to specialist literary, cultural, and political audiences and included a number of titles produced by art photographers. The best known and most established is *Aperture*. Like *Aperture*, many of the magazines that comprised the photographers' press possessed names evocative of the technology of photography such as *Image*, *Halide*, *Camera*, *Photography*, and so on. And it was in the pages of these titles that some of these best young photographers of the 1960s were first introduced to their peers as authors, as opposed to jobbing illustrators.

As the interface between image-makers, audiences, and taste-shapers, photographers' magazines participated in a climate in which art photography became institutionalized during the 1960s and 1970s. Yet the titles were so marginal they hardly comprised a network; nor have they been well chronicled by histories of photography. More accurately, they belong to the social history of photography as collaborative projects.

There is no agreement about what to call such a publication: terms include portfolio or folio magazine, art photography magazine, and photographers' magazine. Database evidence suggests that the decade of the seventies saw the biggest expansion in small photographic magazines. The sharp statistical blip coincides with the expansion of photography courses in higher education, in the United States especially, and might reflect

evidence of publishers targeting new academic markets. Less is known about the scene in the 1960s, which (in the United States at least) was a golden age for the photographers' press. A survey in a 1978 issue of the trade magazine, *Printletter*, reveals that about ten "art photography magazines" survived from the 1960s from Italy, Japan, the United States, the UK, Switzerland, the Netherlands, and Germany. It is not known how many folded or did not respond to the survey, or indeed how many worthy of the name were still in print, but were excluded because they were classified as something else. Most of those listed were, in fact, commercial operations. While many of these contained informed commentary about photography, they were run for the benefit of publishers, rather than photographers who regarded them with some suspicion.

For the purposes of this essay, let's assume the photographers' press of the 1960s is distinguished by a few titles (perhaps as few as 20 in English) that were edited, for love not money, by photographers and their supporters. It would be foolhardy to hazard any general observations because so many variations existed within the type: in ownership, editorial philosophy, geographical spread (whether regional or national), frequency, and quality. To complicate matters, a title also tends to change radically with each new editor or new owner. *Aperture* is typical in some ways but untypical in others. The first issue announced itself with a cover picture of a sign-post indicating dozens of destinations that symbolized the adventure ahead. Like many magazines it was founded (in 1952) in a flush of idealism at a meeting of friends. The difference is that these included the most influential figures of the day, such as Ansel Adams, Beaumont and Nancy Newhall, Barbara Morgan, and Dorothea Lange, who were all part of Stieglitz' circle. They were keen to launch a magazine fashioned on *Camera Work*. Stieglitz' lavish periodical "fought" for the art of photography (1903–1917) with firebrand conviction, intelligence, taste, and high production values. While it was common knowledge that *Camera Work* only survived because Stieglitz subsidized it, this was no deterrent when it came to launching *Aperture*. As a result of chronic underfunding the quarterly scraped by, once saving money on repro with a text-only issue, eventually becoming bankrupt in 1977 before being rescued. *Aperture* was also unusual because it was under the control of one editor for the first half of its existence (Minor White died in 1976). It was suspected that White got to exert such enormous control over the editorial in a contra deal for donating his time. Most titles are not as well known as *Aperture* nor so long-lived. Much has been written about *Aperture* as the ultimate modernist organ. I believe that this reputation was attributable partly to a combination of tasteful presentation and impeccable production standards. By floating reproductions inside generous white margins, the design evoked an original black and white print set in a matte; it seemed to demand that the reader take a step out of the noisy modern world into contemplation. The photographs tended to be "timeless" and "universal" subjects taken in recognizable genres (still life, nude, landscape, and so on).

More by example, than anything, Minor White established an agenda that was adopted and improvised upon by most of

the editors that came along in the 1960s. First, that the mission of the photographers' press was to complete the daunting task begun with *Camera Work*: to win academic respectability for the art of photography, improved social status for art photographers, and to cultivate a sophisticated audience to support their cultural activities. Secondly, that excellence must be a high priority. By far the most important of these was the pedagogic insistence that photographer/readers must be active in the realization of these objectives. Aperture's campaign to get photographers to convert indifferent audiences into "visually literate" ones began in the 1950s, and was inspired by Henry Holmes Smith.

It has always been a matter of speculation what, if any, influence small photography magazines have on the direction of the events they mirror. Compared with the circulation figures of *Life*, the average photographers' magazine addressed a ridiculously small audience (measured in the low thousands or lower) and this tended to be restricted within the country of origin. Yet its loyal and passionate audiences were the ones that serious photographers wanted to reach and their contributors included the most influential figures of their day such as Szarkowski who was a regular contributor to *Contemporary Photographer* and then later to *Creative Camera*.

I want to speculate upon the successes and failures of two key titles of the photography scene in the 1960s. *Contemporary Photographer* was published between 1960 and 1969 in New York and Boston and was *Aperture*'s rival for a while. *Contemporary Photographer* was more pluralistic than *Aperture* and is interesting because it tried to encompass all styles of art photography during the 1960s. The last two editors were Lee Lockwood and Carl Chiarenza. *Creative Camera* may be one of the first of the photographers' magazines to appear outside America. Because of its monthly frequency, the magazine could be (and was) even more eclectic in its tastes. *Creative Camera* was founded in London in 1968 by a photographer called Colin Osman. But its editor, Bill Jay, began commenting on the English scene a year earlier at the helm of *Creative Camera Owner*, *Creative Camera*'s predecessor. In many ways *Creative Camera* looks like a British version of *Contemporary Photographer*. The logo is similar and Jay's crusading tone is identical to Lockwood's. With its iconic silver cover, *Creative Camera* was thinner than the quarterlies and more disposable looking.

The editors of these magazines saw it as their mission to rally their readers round the cause of "good photography" through the cultural isolation of the 1960s. Editorials testify that this was an era that was full of false dawns on both sides of the Atlantic. The photographers who subscribed to *Contemporary Photographer* and *Creative Camera* experienced contrasting cultural situations but thought of themselves, for a short while, as a community — united perhaps by their frustrations and marginalization. These magazines helped to focus that sense of community, acting as a mirror to enable this community to see an image of itself. *Contemporary Photographer*'s perspective was limited to developments on the East Coast of the United States where Lockwood and Chiarenza were based. It did not cover Europe. By contrast, *Creative*

Camera focused on Europe and the United States. Europe had its émigré photographers and its classic pictorials as well as a great heritage of avant-garde photomontage. Readers were probably more excited about reports from America where exciting trends were being set. American contributors included John Szarkowski and Peter Bunnell of MoMA and Robert Frank had a column for a while. For Jay, America represented an encouraging model for the future shape of what in Britain was called "creative photography."

Editors were good at informing their communities of readers about what had to change and why and were, I would argue, very effective at motivating them to participate in change, or at least to feel they were involved in change. To compensate for their comparatively small audience numbers, the photographers' magazines had one advantage: that was an intimacy between editors and readers that helped them work together to try to change things. The intimacy of the small magazine, then as now, is in contrast to the "editorial distance" of the daily newspaper. Editors and readers were the same people and used the same language. The editors of *Lightwork* addressed their readers as equals when they apologized for offering to pay $10 for each photo they printed: "That's shamefully little but it's the best we can do ..." Small magazines make effective catalysts because readers and editors share the same values, if not the same opinions. Editorials, some almost confessional, promoted a sense of community and common ownership. A leader in *The Boston Review of Photography* January 1968 refers to the magazine as "your magazine" and as a "workshop for the entire photographic community." The inaugural issue of the newsletter, *Minority Photographers Inc.*, answers the rhetorical question, Who are we? "... photographers who have joined together in a mutual effort to overcome discrimination in the exhibition of their work ..."

The bond between readers and their titles was strengthened in the knowledge that the magazines were produced by photographers for photographers. At its inception, *Creative Camera* instigated "postal circles," urging keen photographers to form social networks of up to 15 people. Each put one print each into a box and circulated it, offering and receiving constructive criticism as it went. In ways like this the magazines acted as catalysts and their editors became well-known activists within their communities. A magazine came to stand for something that was rare or missing in the commercially driven mainstream such as a commitment "to provoke rather than to inform" (*Contemporary Photographer*) or to "quality" over "quantity." Readers were prepared to lend support because editors and the contributors were all in some way committed to photography and prepared to forfeit financial gain to prove it. Boston Review's editor writes, "... letters from readers constitute my salary as Editor, I consider myself well paid." The editors of the Toronto-based *Impressions* announced, "The only ideological bias of the magazines is against commercialism ..." In contrast to the mainstream magazines, the photographers' press carried no advertising. Big business prospered by selling photographers essential materials, but refused to support these magazines. Some editors bemoaned

their enforced marginal status but others celebrated it. An editorial in *Contemporary Photographer*, "The Uses of a Small Magazine" announces that "owing allegiance to neither advertiser not to mass readership…" a small magazine can remain, "serious and non-commercial."

Editors devoted themselves to mapping the transition years, highlighting new developments that would interest and possibly hearten discouraged readers. *Contemporary Photographer* sounded upbeat about the New York scene in the early 1960s: "Photography as a fine art is only now crossing the threshold of its potentiality … but its future promises even greater things." The fortunes of independent photography in Britain did not look up until the 1970s. But things were changing in the late 1960s. When Jay could not report good news from home he referred readers to encouraging trends in New York or Rochester, home of the George Eastman House.

By highlighting the lack of many crucial things for the health of photography — great pictures, great photographers, mature critical writing and so on — the magazines put the onus on readers to supply these missing essentials. *Contemporary Photographer* appealed to "serious photographers" for photographs and manuscripts but mostly for dialog in the form of comments on the contents of past issues. Their failure in attracting critical and other texts may explain why these magazines may now seem so improvised and parochial.

Editors recognized that the single most important missing element was a sophisticated audience for photography and made this one of their favorite topics. Lee Lockwood once quoted Walt Whitman, "To have great poets, there must be great audiences too." Without an audience there could be no "print-buying public," Lockwood notes.

Contributors to *Creative Camera* and *Contemporary Photographer* urged photographers to start a dialog with the public. Young photographers were regularly applauded for trying, the more opportunistic the better. Lockwood reported favorably on an initiative by three young photographers who exhibited at the New York School for Social Research in 1962. Each produced and marketed a small portfolio comprising ten photographs. Each was signed and numbered and cost $25.00. Lockwood supposed that this innovation might have implications for other "serious cameramen" who would prefer to avoid soul-destroying commercial work. In a time of "shrinking markets for photojournalism … the small, personal portfolio such as described above may one day be one way out of the dilemma."

Bill Jay endorsed such enterprise too, but he had his eye on the eventual prize of state subsidy from the Arts Council of Great Britain. If this body already distributed funding to the fine and performing arts, then why not to photography? In one 1969 issue Jay reported the encouraging news that an Arts Council committee had been set up to "discuss the place of photography in future art gallery programmes." "It's a big step forward," he conceded. But then he cautioned that no one with "vision and passion" about photography was represented on the committee. Jay was the master at stirring up passions. "The fate of photography in this country is at stake," he concluded.

All magazines need role models, and the photographers' press needed people that would willingly inspire readers and give them hope during this testing decade. The past was a great source of colorful, crusading characters, and editors and photographers alike rummaged through the back catalogs of photography for material. As a result *Contemporary Photographer* published the first monograph of the photographs of Charles Sheeler. The English photographer Tony Ray-Jones tells readers of *Creative Camera* that the 1930s photojournalist, Bill Brandt, was a major influence and Diane Arbus is said to admire August Sander, a German portraitist of the pre-war era. Of course the thriving media scene produced its own cast of young, up-to-date role models, which inspired young photographers, often luring them into the media with its promises of globe-trotting adventures. Lee Lockwood and Bill Jay were both active in the commercial media and knew many of the photographers and the realities of the magazine world. These included upcoming talents such as Don McCullin, Phillip Griffith-Jones, and Bruce Davidson. The decline of *Life* coincided with the rise of art directors, such as Willy Fleckhaus at *Twen* and Michael Rand at the *Sunday Times* magazine, who were presented to readers as allies of photography.

Mainstream magazines traded money for images. By contrast the photographers' press traded images for cultural capital and access to appreciative, well-connected audiences. While *Contemporary Photographer* and *Creative Camera* took full advantage of what the mainstream could offer in terms of resources and talent, their editors were selective about the kind of image-makers they published. It is noticeable that the personality of the photographer was as important to these editors as were the images. These young, glamorous image-makers were enlisted to help reinforce some of the values of the community such as independence, altruism, tenacity, and self-sufficiency.

Editors and readers valued photographers that did not "sell out," who kept their integrity. Both Robert Frank and W. Eugene Smith were regularly covered in the photographers' press as men of integrity. It was not just editors who invoked the personality of talented photographers. In the essay "Mirrors and Windows" John Szarkowski observes that Smith "came to be regarded as a patron saint among magazine photographers, not only because of the excellence of his work, but because he quit *Life* magazine in protest not once but twice …" Smith's name was routinely invoked in the context of articles that carped at the press for interfering with pictures. In one such piece, in which Bill Jay challenges young photographers to change "the commercial world," Smith is described as a "constant source of inspiration to young photographers."

Frank was known to consider magazine work to be a sell out. He reinforced his contempt for magazine photographers in an unprecedented series of Letters from New York that were published in *Creative Camera* throughout 1969, which must have been awe-inspiring for young readers. In Frank's world view the line between art and commerce was clearly drawn. In one letter he describes meeting a well-known *Life* photographer at a Bill Brandt exhibition, who tells Frank that

he "doesn't buy" Brandt. "Of course Mili and *Life* and 500 other editors wouldn't buy it either … you have to be an artist to do that kind of stuff."

Lee Lockwood's notion of the ideal young photographer is profiled in an issue of *Contemporary Photographer* along with a sketch of the daunting tasks awaiting him. The young photographer must articulate a "personal vision" of the world, Lockwood states. This would involve following the "pure" path that avoids "non-commercial photography" and salaried photojournalism. Because these were pioneering days, new photographers needed to act as activists too because outlets for their photography were scarce. Audiences would need to be awakened from "visual lethargy" induced by a media that has abandoned its commitment to hard-hitting, truth-telling photo-essays and dumbed down.

One can only speculate about the effect of this kind of rhetoric on young photographers. Lockwood's last issue as editor contains the thoughts of one ambitious young photographer who was trying to measure up to these impossibly high standards, both morally and artistically. If the values Lockwood articulated in his editorials can be said to reflect those of the photographic community, then Charles Harbutt embodied many of them. He was young, a Magnum member, therefore independent of big media and more likely to be motivated by something higher than the quest for financial reward. Harbutt has evolved an experimental type of picture essay, and so has pushed his medium toward a "personal vision" that is transcendent of the limitations of the press. His mentor was no less a person than Smith. Furthermore, Harbutt was altruistic; he was giving something back to the community in the shape of a new concept. Harbutt's essay, "The Multi-Level Picture Story" (which would be reprinted in *Creative Camera* two years later) was written in the spirit of a colleague sharing advice with his peers. By contrast with Frank, who seems sure of his place, Harbutt emerges as a man in transition, caught between the moral imperatives of photojournalism past, with its stress on intuitiveness and reverence for the mass audience, and yet burning to take creative control of his work, to create a "personal vision."

The article focuses on an 8-page picture sequence titled, The Blind Boys. The multi-level picture story attempts to bridge a gap between the "simple picture story" and something transcendent that can "tell 'stories' on deeper levels." Most of the article is taken up with describing how each of the "six levels" might be interpreted to complement the whole. Toward the conclusion Harbutt admits to a personal "quandary" which seems to be between heart/intuition and head/intellect. If the essence of photography is "life as it is lived" then the multi-level picture story has failed, because the intuitive rapport between image-maker and subject has been submerged by the complexity of the design.

Harbutt believes his pictures "do not have real existence unless they are published." Journalism is "socially useful and making photographs is more than valid …" For Smith, staying with *Life* was a sell out, but Harbutt is torn. He enjoys the editorial process but agrees that caption writers and designers can interfere with or contradict the photographers' message. "This is a particular problem in the contemporary magazine field …" admits Harbutt, and that is why "the 'multi-level picture story' is a rarity in photojournalism." Finally he renounces the experiment. Which route will he follow: the heart or the head? Will be stay the artisan or become the artist? "I have not resolved the problem as yet," he concludes. Harbutt was fortunate to be offered this platform for his views and we are lucky to have them on record. The photographers' magazines give us access to the human face behind the official rhetoric.

Traditionally, small magazines have been the mouthpieces for art movements because they are well suited to the role of catalyst. The editors of the photographers' press understood this when they appointed themselves in charge of bringing their photographer readers through transition. There is evidence that they were resourceful at selling the dream of a bright future for non-commercial photography. They harnessed the resources of their communities and ruthlessly exploited the glamour and myths of the mass media, as well as its shortfalls. One of their biggest assets was the voice of the grassroots art photographer. Editors such as Jay and Lockwood spoke with the voice of their readers and they often succeeded in transforming their frustrations and aspirations into actions; for instance, getting together with others to stage exhibitions or lobby an authority. This voice — fatalistic and alternating between carrot- and stick-wielding — became the voice of the art photography establishment. It is detectable in the rhetoric of photography's greatest proselytizers from Stieglitz to Ansel Adams and including John Szarkowski, who were all photographers first and foremost.

A more ambivalent asset was a strong, moral role model. Based on an amalgam of Robert Frank and W. Eugene Smith, this complex "black and white" photographer appeared in countless guises and was courted by editors because he testified to the existence of a path outside "commercialism." While many young photographers were doubtless inspired by qualities such as independence, focus, and moral courage, these were also difficult to emulate and could be divisive, as photography historian Ian Jeffrey has observed. He once speculated that many young photographers of the period may have simply given up, fearful of being unable to make the sacrifices demanded. Harbutt's essay is valuable because not only does it give a human dimension to the high ideals expressed in editorials such as Lockwood's, but it illustrates, quite movingly, this dilemma. By taking the pure path, into books and exhibitions, a photographer might exchange a mass audience for an elitist audience but trade a cherished social role for the loneliness of the poet.

The magazines promoted an "us and them" mentality, but that is a function of any small magazine. But they also championed a very restrictive range of artistic identities. Even though Harbutt had the skills of an editor and designer, he seemed unwilling or unable to imagine himself transcending the role of picture-taker/artisan. By contrast, outside the narrow world of photography, artistic identities were in flux as boundaries were

perceived to be melting between high and low cultures, artist-as-author, and author-as-consumer. This was the view of Susan Sontag in her influential 1965 essay, "Against Interpretation."

One of the key roles of the photographers' magazine was as a benchmark of high standards and best practice. But there was mystery and some anxiety surrounding the criteria that editors (and curators) used to elevate average photographers to great ones. How much was it to do with personality or how one earned a living? This uncertainty was satirized in an article in the Californian artists' magazine, *The Dumb Ox*, in an exchange between two editors. "Most people have very bizarre opinions about things but are socialized into suppressing those views," James Hugunin observes. "Like how many people would have the guts to say that Jack Welpott's most recent photographs belong in a camera club salon and not in an art museum? Well, even I don't have that much guts!"

While *Aperture* and *Creative Camera* both continued to publish into the 21st century (albeit after a succession of identity changes since the 1960s) many of their rivals closed. *Contemporary Photographer* folded in 1969 but not before producing one final issue that neatly symbolizes the end point of the trajectory begun in the late 1950s. The editor, Carl Chiarenza, made a special point of inviting women writers to contribute to this predominantly male domain. More pertinently, the Boston art historian Samuel Edgerton takes photography a significant step out of the ghetto toward the cultural mainstream. Edgerton suggests that the "specialism" of photography as an art was not derived from its technical and chemical processes (as argued by formalists), but rather that it was encountered in reproductions. Acknowledging McLuhan ("the medium is the message"), and with a nod to Walter Benjamin, Edgerton notes that museums confer status on photography, but the ideal context is "the medium of its original appearance"; i.e., printed matter. In challenging norms, this final edition of *Contemporary Photographer* (appearing a year after Aspen published Barthes' essay, "The Death of the Author") anticipates the pluralism of the 1970s.

The photographers' magazines delivered their audiences to the altered cultural climate of the 1970s, but did not die; new ones adapted to changing situations. But many of the values that the magazines of the 1960s represented—photography as an autonomous art, the photographer as author, and the original print as the marquee of genius—were soon eclipsed, first in the United States, then in Britain and then later further afield. As the critique of photographic modernism gathered momentum, from various "counter-hegemonic" cultural sites, the distinctive voice of the grassroots art photographer lost its prominence within discourse. By the mid-1980s the photographers' press contained a diversity of titles that attested to the broadening of photographic discourse. Talk of a homogenous community of art photographers gave way to talk of multiple communities, each representing a competing yet complementary philosophy or practice.

Arguably, one of the most valuable things about the photographers' press of the 1960s is that it represents an alternative photographic history, a kind of folk history, that takes its authority from the voices of photographers and their supporters.

FURTHER READING
Batchen, G. (1999). After Postmodernism. *Art Monthly Australia* No. 124, 22–25.
Benjamin, W. (1969). The work of art in the age of mechanical reproduction. In *Illuminations* (Ardent, H., ed.), New York: Schocken Books.
Bourdieu, P. (1990). *Photography: A Middle-Brow Art.* Cambridge: Polity Press.
Brittain, D. (ed.) (2000). *Creative Camera: 30 Years of Writing.* Manchester: Manchester University Press.
Coleman, A. D. (1979). Minor White: Octave of prayer (I), Minor White: Octave of prayer (II). In *Light Readings: A Photography Critic's Writings 1978–78* (Coleman, A. D., ed.), pp. 140–150. New York: Oxford University Press.
Coleman, A. D. (2000). Toward critical mass: Writing and publishing in the Boston area, 1955–1985. In *Photography in Boston: 1955–85* (Rosenfield, L. R. and Nagler, G., eds.), pp. 118–135. Cambridge, MA: MIT Press.
Craven, R. H. (2002). *History of Aperture. Photography Fast Forward: Aperture at 50.* London: Thames & Hudson, pp. 8–197.
Duncombe, S. (1997). *Notes from the Underground: Zines and the Politics of Alternative Culture.* London: Verso.
Evans, J. (ed.) (1997). *The Camerawork Essays: Context and Meaning in Photography.* London: Rivers Oram Press.
Finnegan, C. (2003). *Picturing Poverty: Print Culture and FSA Photographs.* Washington and London: Smithsonian Books.
French, B. (ed.) (1999). *Photo Files: An Australian Photography Reader.* Sydney: Power Publications and Australian Centre for Photography.
Sellers, S. (1997). How long has this been going on? *Harper's Bazaar*, Funny Face, and the construction of the modernist woman. In *Looking Closer: Critical Writings on Graphic Design* (Bierut M., Drenttel, W., Heller S., and Holland D. K., eds.), pp. 119–130. New York: Allworth Press.
Stein, S. (1990). The graphic ordering of desire: Modernization of a middle-class women's magazine, 1914–1939. In *The Contest of Meaning, 2nd edition* (Bolton, R., ed.), pp. 145–161. Cambridge MA: MIT Press.
Taylor, J. (1986). Ten.8 Quarterly Magazine. In *Photographic Practices: Towards a Different Image* (Bezencenet S. and Corrigan P., eds.), pp. 95–99. London: Comedia. ◉

Histories, Theories, Criticism

GARY SAMPSON, PH.D.
The Cleveland Institute of Art

The story of photography's past is usually characterized now in terms of histories, and no serious student or scholar of the medium would assume that one single account could pass as

an exhaustive reference for such a pervasive phenomenon in modern culture. Neither would one consider without suspicion the argument that a single line of thinking about the meaning of photographic images might somehow comprise the essential properties of their form and significance. The modernist rhetoric of essential meanings and overarching narratives, so crucial for the historical and critical interpretation of the past two centuries until the 1960s, has given way to a more varied cultural discourse, which has fostered contemporary awareness of formerly undisclosed social functions and meanings of visual culture, photography included. This essay will thus first highlight select events, movements, written accounts, and compilations of work, especially with respect to the emergence of a modernist historical and theoretical casting of 20th century photographic image production and reception. It will then take up developments in the later part of the century that led to the expansion in the literature of photography to include a broader regard for its social and theoretical meanings. This essay will not concern itself with the impact of photography on artists who worked in other media (see Photography, Fine Art Photography and the Visual Arts, 1900–2001). With the exception of some concluding remarks, it also will not engage the complications of digital image-making, such as the further challenge to photography's believability or whether the digital really constitutes "photography" as conventionally conceived by the modernist position.

As a point of entry into the discussion, the reader may find it useful to briefly reflect on the three categories considered in this essay, their interrelationship as well as their distinctiveness. In taking a historical view, one also assumes, whether explicitly stated or not, a theoretical one, in which one can discern a particular way of thinking; for instance, about events, individuals, innovations, institutions, forms of production, which provides a framework for understanding an aspect of the past over a period of time. Any thinking in retrospect is hence theoretical, although it need not be the immediate concern of the writer to call attention to this. This should be distinguished from the kind of writing that foregrounds theory as a chief concern either in grasping the causes and effects pertinent to the meaning of the past, or proposes a new theory for getting at the significance of things as they are in the present. Further, when historians or theorists make judgments about something, whether implicitly or explicitly, they are being critical. When, however, the writer presumes to make judgments that are backed up by argument (not necessarily rational), and puts it out in the public arena, one can call this criticism. As a fairly recent profession that emerged in the 18th century, being a critic entailed making judgments about cultural activities in a way that could ideally assist the public in attaining a discerning eye and an intelligent regard for things presumably worthy of attention on the basis of noble sentiment and witty observation, universally understood ideas, and formal values.

While one could surely split hairs over these basic distinctions of history, theory, and criticism, they are immediately appropriate to thinking that occurred concerning photography early in the 20th century. By this time a considerable body of material already existed that had laid the groundwork for further response from an historical as well as a theoretical point of view. When closely studied, such sources reveal a history of thinking about the medium in terms of practical application and subject categories for the professional and serious amateur, technical advancements and advice, and more philosophically disposed issues regarding the nature of photography — whether, for instance, a mechanical device like the camera could turn out anything like a conventional work of art. George Eastman's roll film camera, known as the "Kodak," and related developments in the late 1880s and 1890s had made it relatively easy for anyone to "snap" pictures, a popularization of photography that annoyed a number of elite practitioners who would rather think of themselves as artists than shutterbugs.

In the United States one of the arch proponents of the photograph as art was Alfred Stieglitz, who broke from the club set to form the Photo-Secession, thus implying there was something special about what he and his affiliates were doing with the camera. Stieglitz was adamant about distinguishing between work of a commercial nature, popular amateur uses of the camera, and pictures by serious photographers who aspired to artistry by endowing the photographic image with expressive qualities. Critically speaking, photographs might then be judged in accordance with similar stylistic and formal criteria that had previously been reserved for painting and the graphic arts. Stieglitz set about supporting an aesthetic lineage for art photography by calling attention to exemplars of the medium including pioneers D. O. Hill and Julia Margaret Cameron in the Photo-Secession's journal *Camera Work*. He thus began a tradition of the "canon," an authoritative selection of artists deemed important enough to consider in any serious history. The brilliance of Stieglitz is that he was able to construct a history, together with an institutional apparatus consisting of a gallery, a journal, and a network of artists and writers. This made a forceful case to establish photography as art.

Secessionists and their allies in pictorial photography had counterparts in Europe, including England, Germany, and France. Together they formed an "international" movement that was essential to the furtherance of critical discourse premised on simulating or applying artistic effects. Writers like Sadakichi Hartmann and Charles Caffin were among the critical voices that took the cause in intriguing directions greatly infused with the aestheticism and japonisme that had endowed western European art with a stylish verve, seductive atmospheric effect, and restrained decadence late in the previous century. Precision of detail was too close to documentary work, to the applied, contrary to the artful manipulations employed by the majority of pictorialists in their portraits, genre scenes, nudes, and landscapes. This fusion of art and photography would be the catalyst for a profusion of popular and sentimentalized pictures that continued to prevail in regional photo clubs well into the 20th century.

Out of the earlier specialized network of artist photographers and their supporters, however, came a resistance to any direct tampering with the negative and print surfaces for

aesthetic ends. A respect for what was considered the inherent properties of the medium — maximum depth of field, high resolution, maintaining the integrity of the initial exposure — gave rise to a modernist rhetoric in the next wave of critical material on photography. Proponents of this attitude included Hartmann and Stieglitz himself, who renounced pictorialist devices for the direct or "straight" approach, as it would come to be known to future generations. Paul Strand would come to embody for Stieglitz the new direction, as witnessed in 1916 at the final photography show of the latter's Manhattan gallery "291" (originally the Little Galleries of the Photo-Secession). By the 1920s, Strand, Stieglitz, Charles Sheeler, Edward Weston, Imogen Cunningham, and the young Ansel Adams, among others, would contribute to a critical and theoretical engagement with their craft, which activated subsequent generations of writers, scholars, and practitioners in either supportive or critical response. That the reductionist forms and tropes of early modern abstraction were influential in this regard is witnessed in Strand's corresponding attention to the close-up and the machine. Similarly, Weston would write of "the thing itself" in his daybook entry of March 10, 1924, paralleling what John Tenant said of Stieglitz in 1921; that his work focuses on "the subject itself, in its own substance or personality…without disguise or attempt at interpretation." The new modernist criticism, so much a collective project of the artists themselves, was further supported by writers and reviewers of the radical journals of the period, such as *The Little Review*, *The Dial*, *Broom*, and *The New Republic*. The short-lived Group f.64, formed in 1932 to champion the straight approach on the west coast, included Adams, Cunningham, Weston, Willard Van Dyke, and others. Adams, best known for his extremes of delicate grace and epic grandeur in his photography of the wilderness, was particularly emphatic in a series of writings and books about the proper use of photography. He theorized about the notion of "pre-visualization" while strategizing a fool-proof method for obtaining consistently superior exposures called the zone system.

In Europe and the fledgling Soviet Russia, where modernist experimentation had achieved new force following WWI, the "new photography" (as it was often referred to by its proponents) was closely associated with a "new vision" in which radical art and social action would conspire to lead the masses into the future. The Russian Constructivists El Lissitsky and Alexander Rodchenko found new strategies in both the straight radical view and the montage practices that also informed the European vanguard of the 1920s. In Germany, Bauhaus designer Laszlo Moholy-Nagy's *Painting, Photography, Film* (1925) demonstrated how innovative uses of the medium might transform one's view of the world; in a prophetic utterance quoted by his contemporary, the cultural theorist Walter Benjamin, Moholy-Nagy declared, "The illiterates of the future will be the people who know nothing of photography rather than those who are ignorant of the art of writing." Though it explored all varieties of photography and recent productions in film, a similar visionary impulse was at the heart of the 1929 international exhibition in Stuttgart, Film und Photo (or simply

Fifo), which was sponsored by the Deutscher Werkbund, the German industry and design collaborative. The show was a significant testimony to the industrial world's embrace of photography in general; a recognition of the camera's potential for expression and for its applied use as an extended way of seeing and knowing the world. Both sides of the Atlantic were also represented, as Edward Weston and Edward Steichen, Stieglitz' photographer friend and associate, assembled an American section. From an historical perspective, written support for the serious implications of the work on display came not from the catalog, but from other publications of the period. These include Werner Gräff's foreword to *Es kommt der neue Fotograf!* (*Here Comes the New Photography*, 1929), and *Foto-Auge* (*Photo-Eye*), in which Franz Roh offers intelligent commentary on the classes of photography previously explored by Moholy-Nagy and further demonstrated by the photographer's section of Fifo. In contrast to the diverse techniques encouraged by Roh, Moholy-Nagy, and the Russians, the direct approach represented by the American contingent was only one of numerous possibilities for modern innovation, paralleling especially The New Objectivity, exemplified in close-ups of plants by Karl Blossfeldt (*Urformen der Kunst/Art Forms in Nature*, 1929) and the patterns of industrial and natural forms in Albert Renger-Patzsch's pictures (*Die Welt ist schön/The World is Beautiful*, 1928).

The rhetoric of modernism, having fully emerged in the 1920s and early 1930s, infused the use of the medium in documentary and photojournalistic enterprise with a revelatory sensibility related to Surrealism. Advances in hand-held cameras like the 35 mm Leica and the advent of magazines like *Münchner Illustrierte Presse* and the French *Vu*, whose popular appeal depended on the picture story, encouraged a special kind of awareness of the social landscape. Books of photographs appeared of both cosmopolitan and provincial subjects, culturally savvy and formally sophisticated. Paris *Vu*, for instance, ran pictorials by the Hungarian André Kertész, and his compatriot Brassaï produced in *Paris de nuit* (1933) a haunting impression of the city's cafes, its denizens, and boulevards at night. In 1952 Henri Cartier-Bresson, whose prolific career ran well into the century, articulated his personal theory of photography in *The Decisive Moment*. Here he called for an almost preternatural sense of convergence at the time of exposure, which for him resulted in pictures of spirited formal and social piquancy. Undoubtedly inflected by André Breton's Surrealist notions of the uncanny and marvelous, such photographers incorporated a special awareness of the extraordinary power of the medium to convey the odd spectacle of life. Surrealism offered alternative avenues for expressive photography; Breton and his cohorts had already grasped the aspect of "making strange" the environs of Paris at work in the documentary imagery of Eugène Atget, who became adopted as a precursor of the movement before his death in 1927. The critical reception of Atget's pictures indicates an awareness of photography's potential — seen also in Kertész, Brassaï, and Cartier-Bresson — to provide a politically subversive strike against the appropriation of the medium for

extremist propaganda, in which a battle was waged for the attention of the masses (Hitler himself had well understood the utility of photography and film in this regard). In his 1931 essay "A Short History of Photography" (published in *Literarische Welt*), Walter Benjamin noted with respect to Atget's "voiceless" and seemingly "empty" pictures of the city that "These are the sort of effects with which Surrealist photography established a healthy alienation between environment and man, opening the field for politically educated sight, in the face of which all intimacies fall in favor of the illumination of details." Though not to be truly appreciated in the United States until the political foment of the 1960s, Benjamin's writings were nonetheless prescient with respect to the understanding of photography as integral to the development of modern culture, affording insights that few had made thus far.

With the proliferation of pictures in reproduction during the Interwar period, Benjamin had also recognized the crucial importance of the caption to anchor meaning for the reader. The coupling of words and pictures for both informing and entertaining reached a climax in the photo-essay, which in America was the chief form of reportage for magazines like *Life* and *Look*, whose circulation began in 1936 and 1937, respectively. A documentary ethos was soon to be articulated, exemplified in bold black and white images, varied scale, and the succinct texts of the essay. As later studies of the photo-essay have demonstrated — for instance, the question of authenticity of Robert Capa's treatment of the Spanish Civil War or of shifting contexts for W. Eugene Smith's 1951 Spanish Village pictorial in *Life* — the persuasiveness of a narrative depended not only on these variables, but on the political ideological persuasions of the popular media in which they appeared. Art editors, who must work with the explicit aims of their publishers in mind, and not necessarily on behalf of the photographers' own wishes, understood that they had the power to shape conditions of representation that in turn would have a pronounced impact on public reception, and hence issues of public debate of sometimes major political importance. The photography journals in America tended to support populist sentiments that at once both reiterated and departed from the high modernist aesthetics related to the New Photography and the straight approach of the 1920s and 1930s. Elizabeth McCausland's "criteria," which appeared in the *U.S. Camera Annual* for 1940, included the terms "honesty," "truthfulness," "a popular art," "historical value," and "propaganda."

Distinctive theoretical differences between photography and art are often not easily discerned, complicated by photography's multiple applications, structural properties, and cultural reception. In the March 1946 issue of *The Nation* the American critic Clement Greenberg published a review of the work of Edward Weston, titled "The Camera's Glass Eye." Greenberg wrote in his review that the appropriate province of photography was the "literary," which correlated with his modernist narrative of the inherent characteristics appropriate to any given medium. Weston was a case of a photographer who had gone inappropriately in search of a formalist aesthetic more suitable for contemporary painters. By way of contrast, the work of Walker Evans was singled out as "modern art photography at its best." Evans came into the limelight as the first photographer to have a solo exhibition at the Museum of Modern Art in New York (or simply "MoMA"), which occurred in 1938 — a critical gesture in itself from the principal American museum dedicated to modern art. The photographer exercised control over the sequencing of the images in the accompanying publication, *American Photographs*. Captions were limited to lists of generic titles and place names, allowing the images, some of which dated back to the late 1920s, to convey the passing of an earlier age in America, and the impact of industrialism and the automobile especially on the built environment. (Evans had briefly been one of Roy Stryker's photographers for the Farm Security Administration (FSA), a New Deal program that sought to create a visual account of the wretchedness of the rural poor and other visible signs of the impact of the great Depression.) Evans actually had more in common with Weston than Greenberg's criticism would allow. Weston, who tended to disavow theoretical explanations of photography including his own, published several volumes of his work during his lifetime (see, e.g., *California and the West*, with Charis Wilson Weston, 1940). These were the product of "mass production seeing," according to him, relating to the rapidity with which photographs could be made, and to other forms of modern technology that symbolized speed. "Authentic photography," he declared, "in no way imitates nor supplants paintings: but has its own approach and technical tradition." Weston repeatedly claimed intrinsic properties for the medium, and thus was actually posing a similar modernist argument for photography as Greenberg had for painting. Greenberg, however, would appear to have missed the point of Weston's strong sense of form, as witnessed, for instance, in his landscapes and close-ups of vegetables, shells, and nudes. For both Weston and Evans, photographs, whether leaning toward a modernist emphasis on form or a narrative approach, underscored the free expression of ideas through "recording the objective, the physical fact of things."

From its inception in the late 1920s, the mission of MoMA was to inform the public concerning the art and design of the modern age. The selection of certain cultural objects as modern led to its embrace of photography, and in 1937 its first major show was organized by Beaumont Newhall. Trained as an art historian, Newhall brought a significant intellectual framework for comprehending photography as a narrative that paralleled the history of modern culture. Newhall's exhibition became a central force in shaping the public's understanding of the medium's past. The exhibition catalog, revised in 1938 as *Photography, A Short Critical History*, formed the basis of Newhall's *History of Photography*, which told the story in terms of technological developments and practitioners whose photographs were particularly compelling for aesthetic merit and the revelation of events. Twentieth century scholarship owes an enormous debt to him, as well as to his wife Nancy Newhall, for bringing to the foreground numerous photographers whose bodies of work adhered to high standards of practice and stylistic presence. Newhall's specific contribution

in the form of exhibition and the subsequent expansion of the catalog into the book (with editions in 1949, 1969, and 1982) marked another major turning point following the Film and Photo show. Important for its evaluation of genres of images and the articulation of aesthetic lineages like the straight approach and a documentary style, Newhall's treatment of the photograph as an expressive object tended to overshadow his attention to photography as a social formation responsive to seminal events and world-changing circumstances. It further legitimated the importance of photography through the art museum, but lacked the theoretical specificity found in the literature associated with the German exhibition and critics such as Benjamin. Social history specific to photography in America was explored by Robert Taft in *Photography and the American Scene*, which came out in 1938. Unusual for its treatment of the history of the medium from a nationalist perspective, Taft's book focused only on the 19th century.

The immediate post-war period saw an increase in attention to making photography even more intelligible to the public while continuing the historical and critical emphasis on the object, the photographer as artist, and the overall potential to enlarge one's awareness of the world. Thus, by 1955 Helmut and Alison Gernsheim had brought their sensibility as serious collectors to their own historical account, *The History of Photography from the Earliest Use of the Camera Obscura in the Eleventh Century up to 1914*, which was dedicated to Beaumont Newhall. This volume, subsequently revised and enlarged to two volumes (1969, with a third edition in 1982), clearly demonstrated the Gernsheims' interests by using their extraordinary collection of 19th century photographs. It also underscored the importance of collectors and curators, with all their idiosyncrasies, in bringing to light topics germane to photography, culture, and society that were worth careful scholarly consideration. The release of the Gernsheims' history coincided with Edward Steichen's Family of Man exhibition at MoMA, which comprised the work of numerous operators who were selected not for espousing any one individual position, but instead for projecting a collective optimistic vision of a world brought together by common aspects of humanity. This was understood by some of the more critically astute writers of the period. The French structuralist Roland Barthes, who would become an influential theorist of photographic meaning a few years hence, noted the exhibition's imperialist overtones. Steichen's production, which included a widely distributed catalog, also suggested to later commentators that his was a mission as much as anything else to use the photograph as an ambassador of goodwill in the face of Cold War fears. In retrospect, Family of Man has taken on additional meaning because it puts into high relief several lines of photographic discourse that contributed more specifically to historical and critical assumptions about how the medium could operate as an agent of spiritual rumination and speculation on the one hand, and of photographic wit and socially caustic commentary on the other.

Minor White is generally credited for establishing a path of philosophical inquiry into photography paralleling the subjective experiments and existential evocations in the visual arts and literature of the late 1940s and 1950s (one thinks here of the Beat generation of poets as well as the New York School of Abstract Expressionism). The thrust of White's concerns together with a number of other American photographers, including Aaron Siskind, Harry Callahan, Frederick Sommers, Walter Chappell, and Henry Holmes Smith, represented a counter-phalanx to the mass appeal of the medium. The writings and photographs of these artists formed a collective body of esoteric, quasi-mystical material that ventured from the popular, tending again—as Stieglitz and company earlier in the century—toward a romantic enchantment with the photographic image as having the potential for expression equivalent to art. The ideas can best be seen in the essays and images published in the journal *Aperture*, edited by White himself beginning in 1952. It was White too who responded to a call for a method of explicating a photograph that could succinctly be conveyed to the uninitiated. He promoted the reading of images beyond the superficial recognition of its subject to see the possibility of the image as a source of revelation, and finally as a bridge to expression through words. Such a platform encouraged experimentation related to finding startling juxtapositions and features of abstract beauty in the environment, which could then act as poetic metaphor.

If White and *Aperture* represented an essentially modernist reaction to popular conceptions of photography, another occurrence pressed the case for photography's importance as a catalyst for reflection on the repressed social realities underlying American cultural values and institutions of the 1950s. The Swiss-born Robert Frank had made an automobile trip across America with a grant from the Guggenheim Foundation in 1954 and 1955. As a result, in 1959 he published *The Americans* (first produced in France as *Les Américains* in 1958), something of a 1950s reprisal of Evans' *American Photographs*. The popular response to Frank's penetrating experience on the road was anything but positive; his was a vision few would have called beautiful or appropriate for upholding the myth of a heroic and unified world led by America—highway diners, roadside accidents, racially divided buses, movie premiers, patriotic displays, black funerals, and working class ennui. This off the cuff record from a European perspective would soon be joined by the imagery of Bruce Davidson, Danny Lyon, Diane Arbus, and others. Their probing of the subcultures of American society had a hip insider edge that came to comprise a newer, darkly cast mode of urban photography. Such work would come to be characterized as part of the "social landscape," a term used in conjunction with several shows of the mid-1960s, including the 1966 exhibition curated by Nathan Lyons at the George Eastman House in Rochester, Toward a Social Landscape. Street photography had a long tradition extending back to the mid-19th century, but Frank's strategies of skewed framing and variable focus led to new approaches in the 1960s in which fortuitous alignments, instantaneity, and a perceptive scavenging for quirky human behaviors challenged the metaphorical assumptions posited by White and his associates. Garry Winogrand and Lee Friedlander, both of whom

acknowledged the significance of Frank's road trip, developed ambiguities of form and subject that would seem to defy any specific reading. Winogrand's best known statement, "I photograph to find out what the world looks like photographed," provides a glimpse into his theoretically subversive posturing.

John Szarkowski, Edward Steichen's successor as director of the Photography Department at MoMA, championed both Winogrand and Friedlander. He articulated a concise theory of photography in terms of identifiable aspects of production and outcome related to practitioners of all subjects and backgrounds, while still celebrating the canon of previously established photographers and critically distinguishing new artists on the basis of a set of formal principles. These were set down as five key elements in *The Photographer's Eye*, his companion volume to the MoMA's show of 1966: "the thing itself," "the detail," "the frame," "time," and "vantage point,"—all of which acknowledged the selective process of the photographer in taking from the "actual" world and making a "picture." For the fourth element, time, Szarkowski revealingly called attention to Cartier-Bresson's concept of the decisive moment by stating "decisive, not because of the exterior event (the bat meeting the ball) but because in that moment the flux of changing forms and patterns was sensed to have achieved balance and clarity and order—because the image became, for an instant, a *picture*." This had the ring of Greenberg's earlier notions of the appropriate characteristics for each medium, but Szarkowski clearly saw form as equally important to a photograph as it might be for a painting, where the critic had more narrowly gauged a successful photograph in terms of how well it functioned as part of a larger narrative construct. Moreover, Szarkowski seemed to close the door on White's romanticized vision of photographs as symbolic images, which could be translated into verbal equivalents that would make legible hidden meanings. Szarkowski's initial theoretical clarity, with its emphasis on the autonomy of the picture, was later complicated by the curator himself, most notably in his exhibition and book of the same title, *Mirrors and Windows: American Photography Since 1960* (1978), which actually acknowledges White's notion of the photograph as a mirror.

Theories of the photograph as social artifact manifested themselves increasingly in the 1970s following critical responses to the urban landscape, cultural difference, civil unrest, racial and sexual oppression, politics, and war. Accelerated interest in the medium may also be credited to wider recognition of photographs as a relatively untapped source of collecting, connoisseurship, and scholarship, and the related expansion of museum collections and art and art history programs at colleges and universities now convinced of photography's importance. And the critics would look to photography as a fertile ground for examining issues of modern culture. Susan Sontag's commentary on photography, best seen in *On Photography* (1977), a collection of essays that first appeared in *The New York Review of Books*, came to represent a newer intellectual stance with regard to the potential of images to take on multiple meanings beyond any specific intent of the photographer. One can never actually acquire

knowledge from photographs in themselves, but "are inexhaustible invitations to deduction, speculation, and fantasy." Neither metaphysically esoteric nor predicated on the subjective vision of the artist photographer, Sontag's affecting criticism, which drew from her wide knowledge of literature and art, stimulated thinking about the medium as a collective social experience. This awareness stood in contradistinction to prior theories that reduced the meaning of photographs to an easily graspable set of inherent characteristics related to technique and the indexical properties of the analog image, which downplayed the differentiations of historical, emotional, and social reception adhering to the subject. Greater attention to the theory and criticism of photography also became apparent in art journals such as *Artforum* and *October*, which by the mid-1970s were challenging the modernist rhetoric of the work of art as an autonomous form and increasing awareness of the potential of photographic images to expand the philosophical investigation of meaning in art. It is not the intent of this essay to explore this avenue (see Photography, Fine Art Photography and the Visual Arts, 1900–2001), but it is important to acknowledge how this recognition of the photograph's structural peculiarities—its direct indexical and iconic relationship to the phenomenal world—served to expand the scope and depth of inquiry related to the nature of the medium. Paralleling and infusing the art world discussion with a new critical rigor from outside this rather insular circle, the semiotic and social theorist Roland Barthes called the photograph "a message without a code," while looking at the *polysemic* function of images in advertising and journalism, instruments of persuasion in the political, racialist, and economic ferment of late modern society. Barthes' analysis was readily adopted by those who found too self-reflexive the photography-as-art idea witnessed earlier in the thinking of Stieglitz and White. A seminal instance of the challenge is found in Alan Sekula's essay "On the Invention of Photographic Meaning," published in the January issue of *Artforum* in 1974, in which the photographer and author took a semiotic approach to question the former pat assumptions made concerning art photography.

The seventies also saw new histories and specialized studies such as Gisèle Freund's groundbreaking *Photography and Society*, first published in French in 1974, and Tim Gidal's important introduction to the early picture story, *Modern Photojournalism: Origin and Evolution, 1910–1933*, published in English translation in 1973. Reassessments of specific episodes of photography's past, exhibitions and studies of important collections, and compilations of writings by photographers and their contemporaries continued to enlarge the public discussion. Alfred Stieglitz' contribution was re-examined in light of his extraordinary collection of photographs of others (see, e.g., *Camera Work: A Critical Anthology*, 1973, edited by Jonathan Green, and The Metropolitan Museum of Art's *The Collection of Alfred Stieglitz: Fifty Pioneers of Modern Photography*, 1978, edited by Weston Naef). The writings of Sadakichi Hartmann, Stieglitz' contemporary who was full of insights about photography as a fine art, filled a volume in *The Valiant Knights of Daguerre* (1978). Peninah R. Petruck's

two-volume *The Camera Viewed: Writings on Twentieth-Century Photography* was published in 1979 and a year later Alan Trachtenberg's *Classic Essays on Photography* appeared. In 1981, Vicki Goldberg's *Photography in Print: Writings from 1816 to the Present* was published. The importance of making this material available in such "readers" should not be underestimated as a means of stimulating dialog, scholarship, and innovative responses among photographers and students of photography. In addition to earlier influential figures in American and European circles, they also served to disseminate the critical ideas of more recent writers such as Barthes, Sekula, Sontag, and John Berger, whose widely read *The Look of Things* (1974) and *About Looking* (1980) emphasized the importance of photographs as a facet of visual culture.

Following the arc of this concentrated attention to the medium, new historical surveys entered both the academic arena and the public mainstream. Naomi Rosenblum's *A World History of Photography* appeared in 1984, and *A History of Photography: Social and Cultural Perspectives* by Jean-Claude Lemagny and André Rouillé was published in 1987 (originally published in French as *Histoire de la photographie*, 1986). Challenges to orthodox views of the photograph as an aesthetic object continued as the academic climate shifted within the discipline of art history itself toward interdisciplinary activity and theories of the post-modern. The development of cultural studies, literary theory, feminist theory, Marxist-informed social history and theory, cultural anthropology, and post-colonial studies contributed to nuanced perspectives on how photographic images had an important function in the cultural and social formation of attitudes and ideologies in the modern world. John Tagg examined photographic agency in legal and political contexts in *The Burden of Representation* (1988), and Rosenblum wrote a *History of Woman Photographers* (1994). Christopher Pinney and Elizabeth Edwards brought semiotics, anthropology, and photography together in their analyses of images of non-Western peoples in, respectively, *Anthropology and Photography, 1860–1920* (1992), and *Camera Indica: The Social Life of Indian Photographs* (1997); Richard Bolton edited *The Contest of Meaning: Critical Histories of Photography* (1989), an influential assemblage of essays whose authors utilized the new methodologies to examine photography and issues of identity, sexuality, and documentation. The sesquicentennial of photography's public introduction (i.e., its 150th anniversary) in 1989 led to a flurry of reassessments, such as Szarkowski's *Photography Until Now* at MoMA. Szarkowski's overview, long awaited but now somewhat passé in treatment, only served to underscore how far the scholarship and thinking about photography had come.

Perhaps the passage of the modern age of photography has fostered an even greater zeal to recognize the international scope and culturally diverse uses of the medium (see, e.g., *A New History of Photography*, edited by Michel Frizot, 1998 and Mary Warner Marien, *Photography: A Cultural History*, 2002). Among the telling indications that the community of critics and scholars in the field have not arrived at a comprehensive theory of photography, however, is reflected in papers associated with symposia and conferences: questions of whether photography has anything that approaches a consistent theory are evident in such publications as *Photography: A Crisis of History* (2002). Spanish photographer and historian Joan Fontcubara asked a number of colleagues from a wide variety of institutions a set of questions related to former histories and their shortcomings, wondering if there was indeed any possibility of a consistent theory of photography. Complicating the situation further has been the ascendancy of digital photography and related computer applications. This strategic development has enabled the hybridization of photographs outside the technical parameters of conventional processes, thus precipitating further discussion of cultural perceptions of photography and its meaning. This is seen to be far more elusive than once was believed, so that former modernist assertions about the nature of the medium seem almost naïve. Analog photography seems destined to become a facet of practice that will become ever more arcane as the years pass, but digital photography promises to make the phenomenon all the more acutely intriguing for subsequent generations of thinkers and practitioners.

FURTHER READING

Barthes, R. (1972). The great Family of Man. *Mythologies.* Trans. by Annette Lavers. New York: Hill and Wang.

Barthes, R. (1985). The photographic message. *The Responsibility of Forms: Critical Essays on Music, Art, and Representation.* Trans. by Richard Howard. New York: Hill and Wang.

Benjamin, W. (1978). New things about plants. In *Germany: The New Photography, 1927–33* (Mellor, D., ed.). London: Arts Council of Great Britain.

Benjamin, W. (1980). A short history of photography. In *Classic Essays on Photography* (Trachtenberg, A., ed.), pp. 199–216. New Haven: Leete's Island Books.

Bunnell, P. C. (ed.) (1980). *A Photographic Vision: Pictorial Photography, 1889–1923.* Salt Lake City: Peregrine Smith.

Green, J. (1984). *American Photography: A Critical History, 1945 to the Present.* New York: Abrams.

Green, J. (ed.) (1973). *Camera Work: A Critical Anthology.* New York: Aperture.

Greenberg, C. (1986). *The Collected Essays and Criticism. Vol. 2: Arrogant Purpose, 1945–1949* (O'Brian, J., ed.). Chicago and London: University of Chicago Press.

Marien, M. W. (2002). *Photography: A Cultural History.* New York: Harry N. Abrams.

Mellor, D. (ed.) (1978). *Germany: The New Photography, 1927–33.* London: Arts Council of Great Britain.

Sontag, S. (1977). *On Photography.* New York: Farrar, Strauss and Giroux.

Szarkowski, J. (1966). *The Photographer's Eye.* New York: The Museum of Modern Art.

Tenant, J. (1921). The Stieglitz exhibition. *The Photo-Miniature* **16**, 135–139.

Wells, L. (ed.) (2000). *Photography: A Critical Introduction, 2nd edition.* London and New York: Routledge.

Westerbeck, C. and Meyerowitz, J. (1994). *Bystander: A History of Street Photography.* Boston: Little, Brown and Company.

Weston, E. (1931). Statement. *Experimental Cinema* No. 3, 13–15.

Weston, E. (1973). *The Daybooks of Edward Weston. Vol. 1, Mexico.* New York: Aperture.

Willumson, G. (1992). *W. Eugene Smith and the Photographic Essay.* Cambridge and New York: Cambridge University Press.

Winogrand, G. (1977). Public Relations. New York: Museum of Modern Art. ◉

African Americans as Photographers and Photographic Subjects

DAVID C. HART, PH.D.
Cleveland Institute of Art

Stereotypes, Racial Uplift, and the Democratic Medium

By the end of the 19th century, African Americans in the United States had considerable experience with and access to the medium of photography allowing them, as image-makers and as subjects, a degree of control over their representations. The body of images that have come down to us by, and of, African American photographers over the course of the 20th century reveals that they were not singularly obsessed with racism. This photographic imagery can generally be said to reflect the interior lives, communities, and aspirations of African Americans, a testament to the very humanity that racism in American society denied.

Any discussion of African American photography necessarily engages the scholarship of Deborah Willis, an art historian and photographer whose numerous books constitute a significant contribution to the literature in the field. Willis has shown that the history of African American photographers in the United States begins at the time photography made its debut in the United States as the careers of two of its most successful practitioners reveal. Among the first daguerreotypists in the United States was Jules Lion (1810–1866) who learned the daguerreotype process in France in 1839 and operated a successful lithography and daguerreotype studio in New Orleans. In 1847 James Presley Ball (1825–1905) opened his Great Daguerrean Gallery of the West in Cincinnati, the largest such studio in the region, and later operated studios in Minnesota and Helena, Montana. Typical of Ball's output were portraits of prominent members of his community with dignified, erect poses before painted backdrops, conventions borrowed from earlier grand manner portraiture and romantic painting. Although formally and technically similar to the work of their European American counterparts, portraits of and by African Americans at the turn of the century have significance beyond merely "documenting" businesses or middle-class

membership. Such images countered the gross caricatures of African Americans as sambos, mammies, and pickaninnies prevalent in American print media throughout the 19th century.

Grounded in white supremacist fantasies and fears, stereotypic images of African Americans were inextricably linked to a larger social and political context after the Civil War, which saw the retreat from the efforts to grant African Americans the rights of citizenship. By the turn of the century Reconstruction had been abandoned and the Fourteenth and Fifteenth Amendments to the constitution granting former slaves full citizenship rights were undermined by the growth in racial segregation in the form of Jim Crow laws (upheld by the United States Supreme Court in 1898), mob violence by the Ku Klux Klan, and a system of tenant farming in the south that was, in effect, economic slavery. This led the historian, novelist, and political activist, W. E. B. DuBois, to declare in *The Souls of Black Folk* (1903), that racial division would be the problem of the new century, a sobering statement in an era of positivist rhetoric. DuBois' most powerful metaphor, however, captured the psychic conflict resulting from racial division that African Americans possessed. African Americans were born with two warring identities, a double-consciousness, he argued, forming their world view. One was American, through which its darker citizens were viewed with contempt, the other Negro.

Old and New Negroes

In the wake of virulent mob violence and widespread white supremacist ideologies at the dawn of the 20th century, African Americans began an effort to redefine themselves through a discourse forming another dichotomy; that between an old Negro and a new Negro. Key to this effort was the cultivation of an educated black leadership who would not simply serve as an example of social and economic betterment but who would "reconstruct" and re-conceptualize themselves by turning their backs on the legacy and associations of an old Negro as dependent and deserving of pity and replacing it with a self-sufficient, confident, and creative new Negro.

One solution was education, and photography figured prominently in it. Many elites, both African- and European-American, felt that the task of the assimilation of vast numbers of poor and uneducated African Americans, many in the South, clearly fell on African Americans themselves. Historically black institutions such as Hampton University in Virginia and Tuskegee University in Alabama had been established to educate African Americans in skilled trades thereby "uplifting" them from the poverty and ignorance in which they were left after the Civil War. This was a goal and philosophy of Hampton graduate and Tuskegee founder Booker T. Washington. In keeping with Washington's emphasis on trades-based education as a vehicle for social and economic betterment, in 1916 Tuskegee hired photographer Cornelius Marion Battey (1873–1927) to head its Photography Division in order to teach photography as an employable profession. Battey produced work that established his reputation as an accomplished portrait photographer and educator in the North, which would

later win awards in the United States and Europe, an example of the viability of photography as a profession as well as photography's aesthetic potential.

The benefits of education and the results of assimilation by African Americans were depicted in photographic form in the Exhibit of American Negroes organized by DuBois and mounted in 1900 in the Negro Pavilion at the Exposition Universelle in Paris. It consisted of hundreds of photographs of middle-class African Americans such as business owners, institutions of higher education, and their students. The photographs were accompanied by books, objects, and demographic statistics, with which DuBois sought to document, as a social scientist, a narrative of social uplift, the face of stereotypes, and re-position of African Americans in the national march toward progress only 35 years after emancipation. The Negro Pavilion also included images by Frances Benjamin Johnston (1864–1952), a white photographer who was commissioned to take a series of over 150 photographs at Hampton, some of which contrasted poor rural African Americans with educated middle-class Hampton students and graduates. The Negro Pavilion's photographs reflected a philosophy that appeared in a book published that same year by Washington and others titled *A New Negro for a New Century*, whose accounts and portraits of African Americans who had struggled against the odds to both advance themselves and thereby contribute to society were intended to shift the image of African Americans in the new century toward a new Negro and away from the gross stereotypes, black-face minstrelsy, and pseudoscience which were now relegated to the province of the old Negro.

The idea of representing a self-constructed, self-sufficient, and self-assured Negro that was distinct from, and contrasted with, an older, debased Negro was therefore not entirely new when Alain Locke published the *New Negro: An Interpretation* (1925), a highly influential anthology of artistic, literary, historical, sociological, and political essays. Locke, a professor of Philosophy at Howard University, called for a race-based aesthetic that looked to Africa for inspiration just as the Western tradition was grounded in the legacy of classical antiquity. Locke also characterized the Great Migration, the movement of thousands of African Americans from the south to northern cities (making New York's Harlem the nation's largest African American neighborhood), as a sign of modernism. The largely literary flowering of art production by and patronage of African Americans in the 1920s known as the Harlem Renaissance or New Negro movement was a phenomenon that actually took place in several cities such as New York, Chicago, and Washington, DC. Unprecedented artistic patronage flowed from individuals and organizations of both races such as the National Association for the Advancement of Colored People (NAACP), founded in 1909, whose magazine *Crisis* was edited by DuBois and which published the work of black photographers; the Harmon Foundation, which granted awards and funded exhibitions of African American artists; and white critic, writer, and photographer Carl Van Vechten (1880–1964). James Latimer Allen (1907–1977) was one of the few photographers to win a Harmon Foundation prize. Allen did

not often engage African-inspired subject matter or modernist abstraction. Instead, he employed a soft-focus pictorialism as, for example, in a portrait of the New Negro movement's most celebrated poet, Langston Hughes.

James Van Der Zee (1886–1983), a largely self-taught studio photographer unfamiliar with Locke's ideas, owned one of Harlem's most prominent studios and was also employed as photographer for pan-Africanist Marcus Garvey's United Negro Improvement Association (UNIA). Like other African American commercial photographers such as Addison Scurlock (1883–1964) in Washington, DC; Richard S. Roberts (1881–1936) of Columbia, South Carolina; and Prentice Herman Polk (1898–1984) in Tuskegee, Alabama; Van Der Zee photographed his community's leaders, intelligentsia, and middle class. Regardless of their familiarity with Locke's ideas, many of the portraits by these photographers constituted a type of modernism, not necessarily dependent on formal abstraction, but rather associated with the intellectual and creative achievement, social engagement, upward mobility, and urban sophistication of African Americans.

Van Der Zee actively worked to manipulate an image through careful composition, use of multiple negatives, retouching, dramatic lighting, and skillfully painted backdrops and props. An example is *Wedding Day* (1926), a photograph of a couple made in Van Der Zee's Harlem studio. It is tempting to compare this multi-layered image to a photomontage created in the 1920s and 1930s. Van Der Zee was not familiar with either the avant-garde photographic practices in Europe nor the modernist straight photography created closer to home by Alfred Stieglitz (1864–1942) and Paul Strand (1890–1976). Van Der Zee's skillful manipulation of his photographs reflects instead the efforts of the photographer and his clients to represent their urban and modern aspirations. The painted backdrop of a fireplace and a superimposed image of a girl (who plays with a newly available black doll) all speak to the couple's dreams of a middle-class status, a domestic family life, and black pride; ideas in keeping with the New Negro movement.

The popularity of the New Negro in art and commercial portrait photography lasted for the first four decades of the 20th century as another type of old Negro emerged. Derived from a construct of the southern African American "folk" culture populated by humble, unassuming people whose way of life had remained unchanged, these images could be found in the photography of white photographers such as the pictorialist Rudolph Eickemeyer (1862–1932) and some images of "old" Negroes in Frances Benjamin Johnston's Hampton photographs. Prentice H. Polk's portrayals of poor and working class southern African Americans differed from these images of the folk old Negro in some crucial respects. Polk's portraits from his *Old Character Series* such as *The Boss* (1932) evinces material lack in terms of sartorial appointment, but this unidentified woman's confident pose, direct gaze, and serious expression exude the same dignity and self-confidence as the photographer's wealthier sitters. Regardless of whether depictions of rural blacks were characterized as something outmoded, and to be abandoned in favor of the new and modern; or whether

viewed nostalgically as a vanishing relic of American history; the taste for the folk would give way to the lure of the immediacy, claims to documentary truth, and hope of progressive social action in the era of Roosevelt's New Deal.

Documentary Photography in Black and White

The liberal sensibilities of Roy Stryker (1893–1976), head of the Historical division of the Resettlement Administration (later the Farm Securities Administration or FSA) during the Roosevelt administration led a bevy of socially conscious photographers including Dorothea Lange (1895–1965), Ben Shahn (1898–1969), Walker Evans (1903–1975), Marion Post Wolcott (1910–1990) and others to depict the plight of poor rural workers including unprecedented numbers of images of African Americans. Although tenant farming in the rural south and the squalid conditions of urban slums affected African Americans disproportionately during the Great Depression, it was Dorothea Lange's *Migrant Mother* (1936) that would emerge as the iconic face of rural poverty. The FSAs only

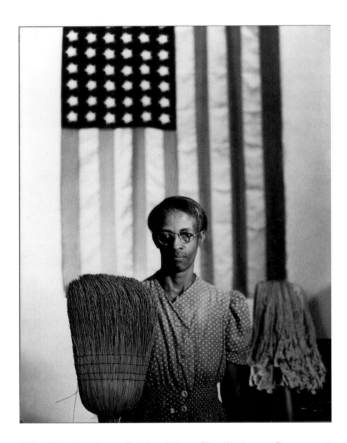

FIG. 23 American Gothic, Mrs. Ella Watson, Government Charwoman, by Gordon Parks, Farm Security Administration—Office of War Information Photograph Collection. Library of Congress Prints and Photographs Division Washington, D.C. [reproduction # C-DIG-fsa-8b14845 DLC].

black photographer, however, Gordon Parks (1912–2006), on the suggestion of Stryker, created his best known photograph of Ella Watson, who worked for the federal government for twenty-five years as a cleaning woman.

In an ironic take on Grant Wood's *American Gothic*, Watson stands, with mop and broom in front of the American flag prompting the viewer to ask why this woman should suffer, by virtue of her race and class, the denial of civil rights and poverty in the land of wealth and freedom. Parks later went on to a successful career for *Life* where he published photo-essays on such racially charged issues as gang violence in Harlem and segregation in the South and then as a film director.

Aesthetics and Politics

Roy DeCarava (b. 1919), who also worked for *Life*, credited Parks' success as having opened doors to other African American photographers. DeCarava's 1955 collaboration with Langston Hughes resulted in the publication of *The Sweet Flypaper of Life* in which the photographer's images of real people were coupled with the writer's fictional narrative. This nuanced glimpse into Harlem from "within" by two artists who knew it very well was an early precursor to street photography. Dissatisfied with the ideological bend of 1930s documentary photography, DeCarava's work became increasingly modernist formally by combining reductive and abstracting qualities with the qualities inherent to the medium, such as the "decisive" photographic moment that characterized the work of French photographer Henri Cartier-Bresson (1908–2004).

In 1955 African American photojournalist Earnest C. Withers (b. 1922) self-published the *Complete Story of Till Murder Case*, an account of the brutal murder of African American teenager Emmett Till in Mississippi by two white men for having spoken to a white woman. These images also appeared in *Jet*, a photo and news weekly by Johnson Publications marketed to African Americans nationally. Like Gordon Parks' socially conscious photojournalism in *Life* the following year on segregation in the South, Withers' work provoked greater public consciousness of the horrors of racism as the Civil Rights movement gained strength.

Canadian theorist Marshall McLuhan's claim that what was important about any medium was the degree to which it changed social relations was played out in the 1960s as television, radio, and photographs, especially those in magazines, brought visceral evidence of the violent tumult of the Civil Rights Era. Perhaps the best known of the photographers who documented the moments of the Civil Rights Era of the 1960s was photojournalist Moneta J. Sleet, Jr. (1926–1996) whose images of civil rights marches, boycotts, and meetings were viewed by the readership of *Ebony* magazine. His photograph of Coretta Scott King and her daughter at the funeral of slain civil rights leader Martin Luther King, Jr. received the Pulitzer Prize in photography, the first such award given to a black photographer. As the integrationist ideals of the Civil Rights movement represented by Martin Luther King, Jr. gave way to more confrontational approaches to confront racism, images of Malcolm X by photographers such as Robert L. Haggins

along with books such as *The Autobiography of Malcolm X*, co-authored by Alex Haley, were consumed by large numbers of Americans interested in understanding his legacy, even as many condemned and often misunderstood Malcolm.

The 1980s and 1990s witnessed a revival of interest in Malcolm X as evidenced by the neonationalist lyrics of rap music, an array of commercial products such as baseball caps sporting an "X", and Spike Lee's 1992 film *Malcolm X*. T-shirts and books, both new and reprinted, made significant use of the slain leader's photographic image. This cultural phenomenon occurred in quite different circumstances than those of the 1960s. As British cultural theorist Stuart Hall observed, by the 1980s the "age of innocence" had passed in which fixed notions of black identity generated within the black community that employed sexism, homophobia, or binary oppositions of "good" versus "bad" public images could go unchallenged. It was a nuanced and diverse approach to African American identity that informed cultural critic Michael Eric Dyson's 1995 book that analyzed the image of Malcolm X in American culture, *Making Malcolm: The Myth and Meaning of Malcolm X*. Designer David Tran followed suit with a dust jacket for the book whose aged, creased, and unattributed photograph of its subject spoke to the cultural construction of Malcolm's legacy and the contested terrain on which it was played out.

Negotiating African American Cultural Identities

The de-colonization of Africa beginning with Ghana in 1956 and followed in rapid succession by other West African nations in the 1960s coincided with a growing consciousness in the United States among African Americans of the need for, and achievement of, civil rights, and black identity as part of an African Diaspora. For many people, Africa did not represent a foreign land to which contemporary African Americans had no cultural connection, but an ancestral home and legacy. Renewed interest in the 1970s with African cultural influences still present in the United States and the controversy over the displacement of residents of the South Carolina Sea Islands where these cultural practices were still evident served as the impetus for Jeanne Moutoussamy-Ashe's (b. 1951) photographic essay documenting the people of Daufuskie Island, South Carolina, in 1982. With a forward by Alex Haley, whose book *Roots* popularized the historical legacy of the African Diaspora, Moutoussamy-Ashe's project was informed by a fear — dismissed by contemporary scholars — that these enclaves of Africanisms needed to be captured in photographic form before they vanished forever. Although this fear was similar to the sense of nostalgia and loss that motivated white photographer Doris Ulmann's (1882–1934) photographs of African Americans in the same region some 50 years earlier in *Roll Jordan Roll*, Moutoussamy-Ashe's collection of photographs, taken together, allow for a sense of the transformation and change that characterize all cultures over time. For example, the man in his boat on the cover of the book illustrated the residents' need to travel to the mainland and thus undermined the sense of physical and cultural isolation upon

which the concept of a vanishing culture in earlier photographs of life on the islands depended. It is this approach that would, in a deeper and more complex way, characterize the meanings of Africanisms and our relationship with them in the work of Chester Higgins (b. 1946) and Carrie Mae Weems (b. 1953) in the 1990s. Weems, who has degrees in both fine arts and folklore, combined in her mixed media works objects, photographs, and text that speak to the material culture, oral histories, and the cultural memories associated with places such as the sea islands that have long held interest for the students of African American history and culture. Far from treating the sea islands as a rare site from which to trace "authentic" African cultural "roots" or as a cultural museum to be preserved, Weems' works, as Lisa Gail Collins has observed, conveyed the dynamic nature of cultural exchange over time and how any exploration of the past is necessarily viewed through the lens of the present.

By the 1980s the lessons learned from the Civil Rights Era, the women's movement, and post-colonial and post-modern theory were employed by artists questioning national, gender, class, and racial identities including African American artists who worked in photography. An example is the public debate in the mainstream media, and among politicians, artists, and intellectuals concerning the development and meaning of hip-hop music and culture in the 1980s. The people who listened to and dressed like the performers of this music, whose hard-hitting lyrics "rapped" about the drugs, violence, and other realities of life in poor, inner city neighborhoods were often conflated in public discourses with the very subject matter of these lyrics. The result was that both the music and those who listened to it were seen as threats, especially if they were African American or Latino. It is in this context that we understand the photographs of Coreen Simpson (b. 1942) who depicted the urban youths of New York's hip-hop culture. Works in her *B-Boy* series, by lending dignity to their subjects, countered a widespread vilification of these youths and their distinctive forms of dress and music. Dawoud Bey (b. 1953) likewise questions identity in the large format Polaroid that he created. The multi-paneled individual and group portraits, taken from slightly different positions that sometimes fragment the subjects, evoked the dynamic processes of becoming who we are like the unfolding narrative of a triptych, comic strip, or film.

The work of several photographers in the 1980s including Robert Mapplethorpe (1946–1989) and Lyle Ashton Harris (b. 1965) reveal how the intersections of racial, gender, and sexual identities are a contested terrain. Mapplethorpe, a gay, white photographer, intended his photographs of nude African American men in his *Black Book* (1986) to highlight their beauty by referring to the artistic conventions, some associated with the sculpture of classical antiquity, that have long equated idealized beauty with whiteness. Kobena Mercer, drawing in part on feminist analyses of pornography and Laura Mulvey's analysis of how women are filmed, made the most thoughtful critique of Mapplethorpe's work regarding race by arguing that these photographs were also exercises in racial fetishization,

ugly re-inscriptions of the black body as hypersexual and as an erotic object offered up for the delectation of a mastering white gaze.

African American photographer Lyle Ashton Harris' self- and group portraits treat black, gay, male, and national identities as complex and intersecting categories. In *Miss Girl*, 1987–1988, from his *America's Series*, Harris presents himself in a contrived, campy pose, and the drag of whiteface, women's makeup, a wig, and the Styrofoam hat commonly worn at political conventions. The artifice of these disjunctive contrivances can be read as an indicator of how personal identities are socially constructed categories, but also how to desire is an inherent part of the photographic process.

In the 1980s and 1990s several African American women artists including Pat Ward Williams (b. 1948), Carrie Mae Weems, and Lorna Simpson (b. 1960) combined text with photographic images in ways that questioned both image and language as signifying systems and by extension other categories such as gender, race, history, and the politics of media and other institutions. Such work was informed by post-colonial, African American, feminist and post-structuralist theory that was profoundly influential on a wide range of artists working in a variety of media in the 1980s. The use of image and text in art in the 1980s by African American artists often simultaneously questioned the ability of any text — and by extension an image — to convey fixed, universally understood meanings while at the same time uncovering the ways that language and images can be used as tools of oppression. Precedents for artists who combined images and text necessarily drew on a number of artists both black and white. The conceptual art of John Baldessari (b. 1931) and Joseph Kosuth (b. 1945) in the 1960s and 1970s provoked and confounded our notions of how systems of signification function with works that juxtaposed images and text in works such as Kosuth's *One and Three Chairs* (1965). Conceptual artist Adrian Piper's (b. 1948), *Mythic Being* series in the 1970s included several works where the artist often posed as a black male. The images of these performances served as the basis for posters with text that confrontationally addressed issues of race, class, and gender and social attitudes about these categories.

The work of Lorna Simpson juxtaposes images and text to reveal how both function, in the post-structuralist sense, as slippery signifiers at several levels, especially as they relate to the experiences of black women. Like much of her work from the 1980s, *Three Seated Figures* (1989) is a multiple image of a black woman's torso dressed in a loose fitting shift with the head cropped, accompanied by a series of individual words or short phrases on labels. Artist Barbara Kruger combined the image-text vocabulary of advertising to confront the viewer's assumptions about desire and the degree to which even the act of looking, the gaze, is invested with the power politics that place women and men on different rungs of the social ladder. Simpson's works also interrupt the power of the viewers gaze, but also evoke the histories and legacies of racism as they are intertwined with gender. By fragmenting and covering the body Simpson denies the gaze, the means by which racial fears

and fantasies are played out. By being open-ended, the text is similarly disruptive of clear or simple interpretation, juxtaposing the individual, subjective experience of women and the supposedly objective systems by which facts are determined, thus calling into question the validity of each. Vacillating between image and text, the work asks us to contemplate notions of the personal and the universal and the means by which photographs and language convey meanings.

The work of African American photographers in the 1980s and 1990s reveals broader lessons about how we conceptualize African American photography in the 20th century. What is fundamentally important is not so much the race of the photographer or the search for an authentic and singular expression of blackness. Ultimately such designations guarantee nothing in terms of artistic expression; rather understanding African American cultural products necessarily means the simultaneous recognition of the variety and diversity of African American expression on the one hand and the commonalities in African American communities, culture, and practices, what Powell calls "the dark center," on the other. Whether a simple portrait in one's Sunday best, a visual testament of social conditions or protest, or a multi-layered and multimedia critique of systems of communication and cultural categories, African American photography in the 20th century faces us with the challenges of the human condition.

FURTHER READING
Collins, L. G. (2002). *The Art of History: African American Women Artists Engage the Past.* New Brunswick, NJ and London: Rutgers University Press.
Gates, H. L. (1990). The face and voice of blackness. In *Facing History: the Black Image in American Art, 1710–1940* (McElroy, G., ed.). Washington: The Corcoran Gallery of Art.
Jones, K., Golden, T., and Iles, C. (eds.) (2002). *Lorna Simpson.* London and New York: Phaidon Press Limited.
Lewis, D. L. and Willis, D. (2003). *A Small Nation of People: W. E. B. DuBois and the African American Portraits of Progress.* New York: Amistad.
Mercer, K. (1994). *Welcome to the Jungle: New Positions in Black Cultural Studies.* New York and London: Routledge.
Natanson, N. (1992). *The Black Image in the New Deal: the Politics of FSA Photography.* Knoxville: The University of Tennessee Press.
Patton, S. F. (1998). *African-American Art.* Oxford and New York: Oxford University Press.
Powell, R. J. (2002). *Black Art: A Cultural History* (2nd edition.). London: Thames & Hudson, Ltd.
Willis, D. (1985). *Reflections in Black: A History of Black Photographers 1840 to the Present.* New York and London: W.W. Norton & Company, Inc.
Willis-Braithwaite, D. (1993). *VanDerZee, Photographer: 1886–1983.* New York: Harry N. Abrams in association with The National Portrait Gallery, Smithsonian Institution. ◎

Biographies of Selected Photographers From the 20th Century

Editor's note: The following pages include an alphabetical listing sharing over 250 short biographies of some of last century's most influential photographers. These entries were compiled by authors and photographers Robert Hirsch, Ken White, and Garie Waltzer. This selection concentrates on image-makers rather than related influential individuals such as authors, curators, editors, educators, or inventors. Determining which photographers were included was left up to the discretion of each author with the guideline of selecting those key individuals who in effect represent a larger group of practice or ideas. The biographies indicate what a given photographer accomplished and why it is considered of importance. Additionally, at least one significant publication from each photographer was referenced. The decision to include such a small reference of people's work was influenced by the limitations of the book's size and the sheer numbers of some of the photographer's publications.

A–K
ROBERT HIRSCH
Independent Scholar and Writer

L–P
KEN WHITE
Rochester Institute of Technology

R–Z
GARIE WALTZER
Photographer and Consultant

ABBOTT, BERENICE (1898–1991) American
Man Ray's Paris assistant. She met Atget just before his death in 1927, subsequently rescuing and promoting his photographs. Opened a New York studio in 1929 and used an 8 × 10 inch camera to create a photographic record of the city that fused Atget's unadorned realism with the playfulness and humor of her Parisian modernist experience. Stylistically, she worked from many viewpoints often cropping her prints to manifest the chaotic and complex relationship of beauty and decay within an urban environment.

Publications
Abbott, B. (1939). *Changing New York*. New York: E. P. Dutton.

ADAMS, ANSEL (1902–1984) American
Through his writings, environmental activism, and photographs, Adams's images are seen as the quintessential pictorial expression of the American Western landscape, a site of inspiration and redemptive power to be preserved. Adams' visual power came from an awareness of light's changing nature and its movement within the landscape. With the help of Fred

FIG. 24 Horse in Lincoln, Square, 1930. Gelatin silver print. Berenice Abbott Commerce Graphics, Ltd, Inc. (Courtesy of George Eastman House Collection, Rochester, New York.)

Archer (1888–1963), he developed the Zone System in the late 1930s, adopting the science of sensitometry to a system of tonal visualization of the image. Adams compared the negative to a musical score and the print to its performance. Images like Moonrise, Hernandez, New Mexico (1941) utilized the straight photographic precepts of Group/64 not to simply document, but to convey a transcendental sense of optimism about the vanishing pristine space of the American West. His book, *Born Free and Equal* (1944), testifies to the World War II internment of Japanese Americans. By the 1960s, the accessibility of Adams' images, the respect for his technical brilliance, and the ability of his work to command higher prices helped photography reach a broader range of venues.

Publications
Adams, A. (1985). *An Autobiography*. Boston: Little, Brown.
Szarkowski, J. (2001). *Adams at 100*. Boston: Bulfinch Press.

ADAMS, (EDDIE) EDWARD T. (1934–2004) American
Over a 45-year career in photojournalism, during which he covered 13 wars and was regularly published worldwide, Adams was renowned for his Pulitzer Prize winning photograph of a South Vietnamese general firing a bullet into a suspected Vietcong prisoner's head that took on mythical proportions in the public's memory. With his hands tied behind his back, the victim's contorted face at the instant of death transformed the event and became a symbol summarizing the bitter Vietnam legacy.

Publications
Image: Eddie Adams. Saigon, 1968. (General Loan executing prisoner).

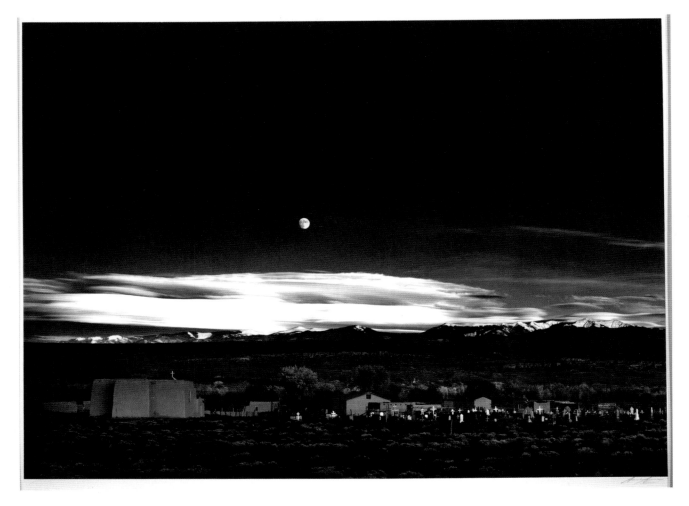

FIG. 25 Moonrise, Hernandez, New Mexico 1941. Gelatin silver print. Ansel Adams Publishing Rights Trust. (Courtesy of George Eastman House Collection, Rochester, New York.)

ADAMS, ROBERT (1937) American

Adams' "New West" photographs express the diverse interaction between culture and nature. His minimal landscapes acknowledge that the beauty, grace, and order of the open American West has been obscured by the confusing commercial disorder of freeways, road signs, strip malls, and tract and trailer homes. This New Topographics outlook refers to the human-altered landscape characteristic of photographers who sought a contemporary landscape aesthetic dealing with those living in it without the romantic notions of the picturesque or the sublime.

Publications

Adams, R. (1974). *The New West: Landscape Along the Colorado Front Range*. The Colorado Associated University Press.

ARBUS, DIANE NEMEROV (1923–1971) American

In her teens, Arbus worked in fashion photography with husband Allan Arbus, eventually being hired by *Harper's Bazaar*. Studying with Lisette Model (1955–1957) produced a profound shift in her work. Arbus pioneered a confrontational street style that relied on frontal light and often a flash to sharply depict people who seemed willing to reveal their hidden selves for the camera. Accused of appealing to peoples' voyeuristic nature, Arbus believed that "a photograph is a secret about a secret. The more it tells you the less you know." Her curiosity led her to unblinkingly photograph people at the margins of society making images not of them as individuals but as archetypes of human circumstance. Controversy followed Arbus as she broke down public personas by pushing the boundaries of what was permissible and heroically visualizing her subjects. Arbus' final series of retardates, whose being and

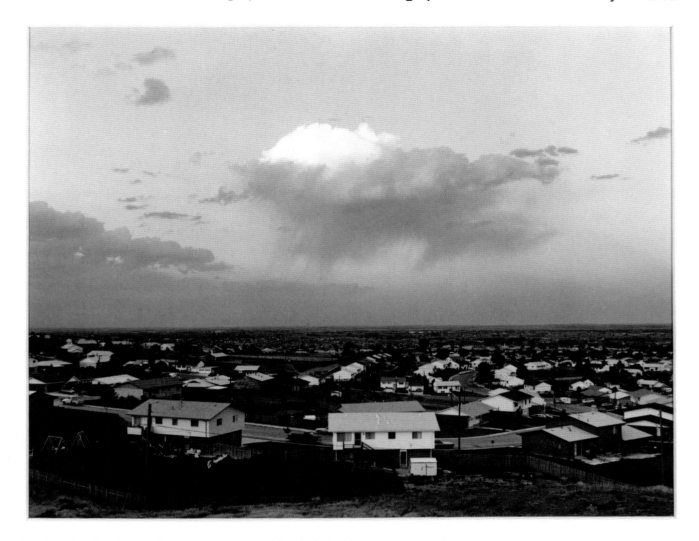

FIG. 26 Tract housing, North Glenn and Thornton, Colorado 197. Gelatin silver print. Robert Adams. (Courtesy of George Eastman House Collection, Rochester, New York.)

identity take us to an edge of human experience, created a sensation by challenging the definition of self and confronting viewers with the "secret" fact that nobody is "normal."

Publications

Bosworth, P. (1984). *Diane Arbus: A Biography*. New York: Knopf.

Phillips, S. S. et al. (2003). *Diane Arbus Revelations*. New York: Random House.v

ATGET, JEAN-EUGÈNE-AUGUSTE (1857–1927) French

From 1897 until his death, Atget created a massive methodical photographic survey of over 10,000 images of the old quarters of Paris and its surrounding parks with an outmoded wooden view-camera, often using a wide-angle lens that did not match the camera format. Atget scratched out a living selling contact prints to artists, made from his glass plate negatives on printing-out paper and toned with gold chloride. Atget's empirical observations of a pre-modern Paris are as much about the psychological nature of time as they are an extended architectural study. The surrealists saw Atget as a primitive in touch with his unconscious self: his storefront pictures of mannequins, window reflections, and odd juxtapositions of objects could distort time, space, and scale so that they appeared to have emerged from a dream. The value of his work was recognized only after his death when his glass plates and prints were rescued and promoted by Berenice Abbott.

Publications

Szarkowski, J. and Hambourg, M. M. (1981, 1982, 1983, 1985). *The Work of Atget*, 4 Vols. New York: Museum of Modern Art.

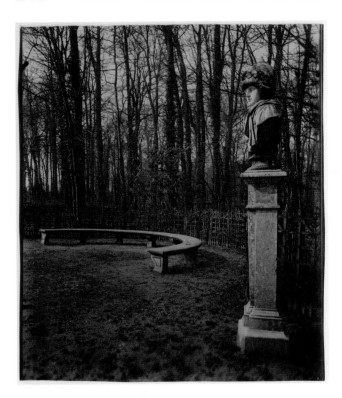

FIG. 27 Versailles—Bosquet de l'arc de triomphe. Eugène Atget 1904. Albumen print. (Courtesy of George Eastman House Collection, Rochester, New York.)

AVEDON, RICHARD (1923–2004) American
Closely working with his mentor, Brodovitch, at *Harper's Bazaar* (1945–1965), Avedon became a dominant practitioner of fashion photography. He opened the Richard Avedon Studio in New York City in 1946 and was a staff photographer for *Vogue* (1966–1990), and *The New Yorker* (1992–2004). His large format studio portraits isolated people from their environment by placing them in a white seamless void. Avedon's style embraced the minute details of the terrain of the human face and not the idealization of the sitter, reading more like topographic maps than traditional portraits.

Publications
Hambourg, M. M. (2002). *Richard Avedon Portraits.* New York: Harry N. Abrams.

BALDESSARI, JOHN (1931) American
Baldessari breaks down photography's boundaries by playfully commingling mediums to court ambiguity and the dualities of chaos and order and to free himself from the classic artistic expectation of organizing the world and giving it a defined, narrative structure. Baldessari appropriates images from popular culture, especially Hollywood film stills, taking the

existential position that the act of making choices along with their accompanying chance occurrences is what makes life and art authentic.

Publications
Baldessari, J. (2005). *John Baldessari: Life's Balance; Works 84-04.* Köln: Verlag Der Buchhandlung Walther Konig.

BALTZ, LEWIS (1945) American
Baltz's New Topographics approach is emblemized in The New Industrial Parks near Irvine California (1974), a detached, minimalist social critique of the desolate sites of the contemporary urban/suburban landscape. Utilizing formalism to order and repossess a bland, mundane subject, his sophisticated, unemotional, conceptually based distancing strategy symbolically communicates an ever-present, dehumanized, placeless corporate warehouse sense of place that was rolling over California's then still-agrarian terrain.

Publications
Rian, J. (2001). *Lewis Baltz.* New York: Phaidon Press.

BARROW, THOMAS (1938) American
Barrow worked with numerous experimental processes that pried the photograph away as an automatic witness. In his Cancellation series (1974–1978), Barrow slashed an "X" onto the negative to point out that regardless of how much empirical data is knowable, reality remains a makeshift combination of belief, ignorance, and knowledge. Barrow also agitated the flat surface of the fine photographic print by adding caulk, spray paint, and staples. His multi-layered actions signal his dissatisfaction with the straight print and the machine-like, spiritual detachment of the photographic process and provided a challenging model dealing with the complexity and the difficultly of deciphering any image. For Barrow photographic data is a jumping-off spot, as the immaculate print is discarded in the conviction that artistic response lies beyond the pictorial vision of the lens.

Publications
McCarthy Gauss, K. (1986). *Inventories and Transformations: The Photographs of Thomas Barrow.* Albuquerque: University of New Mexico Press.

BECHER, BERND (1931) and **HILLA** (1934) German
Collaborating since the late 1950s to document industrial structures like blast furnaces, grain elevators, and water towers as archetypes. Their dispassionate photographs are organized into a series based on functional typologies and arranged into grids or rows. This reinforces the comparative sculptural properties of their subjects, which they refer to as "anonymous sculptures" and allows for an empirical cataloging of forms by function for the purpose of creating a new grammar so people can understand and compare different structures. They have been highly influential teachers and their students include Andreas Gursky, Thomas Ruff, and Thomas Struth.

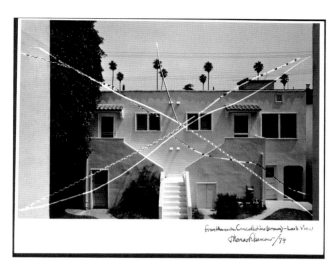

FIG. 28 From the series Cancellations (Brown). Lew's View, 1974. Toned gelatin silver print. Thomas Barrow. (Courtesy of George Eastman House Collection, Rochester, New York.)

Publications

Becher, B. and Hilla (2002). *Industrial Landscapes.* Cambridge, MA: MIT Press.

Becher, B. and Hilla (2004). *Typologies of Industrial Buildings.* Cambridge, MA: MIT Press.

BELLMER, HANS (1902–1975) German

Influenced by surrealism, Bellmer used sexually taboo imagery to symbolize and protest Nazi German society of the 1930s. Bellmer fabricated a life-size doll of a pubescent girl to make ambiguously erotic and jarring tableaus. Published as an artists' book, Bellmer's hand-colored photographs contrasted Nazism's mythic, utopian celebration of youth with the reality that it fostered abuse, decay, and death.

BELLOCQ, E. J. (JOHN ERNST JOSEPH) (1873–1949) American

A New Orleans commercial photographer whose visual explorations of the forbidden world of prostitutes have inspired films, novels, and poems. After his death most of his work was destroyed, but his whole plate glass negatives of the Storyville red light district were later found and acquired and printed by Lee Friedlander. These surviving plates convey a relaxed sense of complicity between the male gaze and the female sitter while examining the shroud of languor and suppressed desire in a manner not possible before photography.

Publications

Szarkowski, J. (ed.) (1912). *E. J. Bellocq: Storyville Portraits: Photographs from the New Orleans Red-Light District,* circa 1912. New York: Museum of Modern Art, 1970.

BERNHARD, RUTH (1905) American

In 1930, learned photography and became a successful advertising photographer in New York. Met Edward Weston (1935) and moved to California, opening a portrait studio. Known for her superbly controlled studio compositions, sensually cast in glowing light and shade of young, nude female bodies, personifying classical, sculptural ideals of beauty. Taught thousands of students through workshops worldwide.

Publications

Mitchell, M. and Bernhard, R. (1986). *The Eternal Body.* Carmel: Photography West Graphics.

BLOSSFELDT, KARL (1865–1932) German

For over 30 years, Blossfeldt produced thousands of sharp-focus, black and white, close-up details of plant forms, frontally or from above, against neutral white or gray backgrounds, to reveal the elementary structures of the natural world and their relation to artistic form. By isolating and enlarging discrete portions of a subject — the characteristics, details, patterns, and textures that would otherwise go unobserved by human vision or conventional photography — Blossfeldt made the imperceptible perceptible. His book *Urformen der Kunst* (*Archetypes of Art,* 1928), became a landmark of the Neue Sachlichkeit (New Objectivity).

Publications

Blossfeldt, K. (1998). *Natural Art Forms: 120 Classic Photographs.* Mineola, NY: Dover.

BOUGHTON, ALICE (1865–1943) American

Trained in Gertrude Käsebier's studio. Highly regarded portraitist known for her illustrative and romantic images, often celebrating the beauty of young women. Member of Photo-Secession. Exhibited at 291 and published in *Camera Work* (1909). She wrote that good portrait photographers must have tact, social instinct, and infinite patience. Her book, *Photographing the Famous* (1928), included portraits of notables such as Maxim Gorky, Henry James, and William Butler Yeats.

BOURKE-WHITE, MARGARET (1904–1971) American

Studied photography with Clarence White. First staff photographer for *Fortune* (1929), specializing in factories and machines. One of the original four staff photographers for *LIFE* (1933), where she produced the cover for its first 1936 issue, the Fort Peck Dam, Montana. Her photographs were included in Erskine Caldwell's You Have Seen Their Faces (1937), a gritty document of the Depression in the South. First official World War II woman military photographer, providing coverage from the German attack into Russia (1941) to the liberation of Buchenwald (1945). Continued working for *LIFE* into the 1950s, documenting the world from India during and after Gandhi to the mines of South Africa.

Publications

Callahan, S. (1998). *Margaret Bourke-White: Photographer*. Boston: Bulfinch.

Goldberg, V. (1987). *Margaret Bourke-White*. Reading, MA: Addison-Wesley.

BRAGAGLIA, ANTON GIULIO (1890–1960) and ARTURO (1893–1962) Italian

Influenced by futurism, the Bragaglia brothers made photographs of moving figures that blurred the intermediate phases of the motion by having their subjects move while the camera lens remained open. Their blurry depictions connected the science of positivism with transcendental idealism, suggesting that beyond the visible lay a recordable dynamic of continuous movement at play. Anton's theoretical manifesto, Futurist Photodynamism (1911), claimed to free photography from brutal realism and instantaneity through movementalism — recording "the dynamic sensation of movement and its scientifically true shape, even in dematerialization."

BRANDT, BILL (HERMANN WILHELM BRANDT) (1904–1983) British

Influenced by the surrealists and became Man Ray's assistant (1929). Freelanced for *Lilliput* and *Harper's Bazaar*. During the Depression Brandt re-created scenarios he had witnessed of upper- and working-class people that showed the divisions of English social class. These docudramas, published in *The English at Home* (1936), *A Night in London* (1938), and *Camera in London* (1948), were expressionistic interpretations rather than reportage. In the 1950s Brandt used a pinhole camera to exaggerate perspective to create formal, high-contrast, often grainy, black and white prints of statuesque female nudes, reminiscent of El Greco, and eerily atmospheric landscapes possessing an ambiance of a troubled dream to poetically explore the anxiety of the new atomic era.

Publications

Delany, P. (2004). *Bill Brandt: A Life*. Stanford, CA: Stanford University Press.

Jay, B. (1999). *Brandt*. New York: Harry N. Abrams.

BRASSAÏ (GYULA HALÀSZ) (1899–1984) French

Motivated by Kertész and influenced by the surrealists, Brassaï contrived stylized tableaus of risqué Paris night life that revealed the subconscious "social fantastic," a place of the erotic and dangerous that lay outside of mainstream society. Dubbed "The Eye of Paris," Brassaï subjects re-enacted their concealed activities for his camera and flash, delivering a theatrical version of a candid moment that demystified and humanized the people from the world of night.

Publications

Paris at Night. (1976). *Paris: Arts et Metiers Graphiques, 1933; The Secret Paris of the 30s*. New York: Pantheon.

BRAVO, ALVAREZ MANUAL (1902–2002) Mexican

Coming from a family of artists, Bravo was encouraged in the late 1920s by Tina Modotti and Edward Weston to pursue photography. After meeting André Breton in 1938, he used surrealism to combine fantasy and Mexican societal customs. In enigmatic tableaux that often expressed anguish and irony, Bravo psychologically explored the interaction of Catholicism, peasant life, death, sexuality, and dreams. Bravo worked as a cinematographer (1943–1959) and was co-founder (1959) and director of El Fondo Editorial de la Plastica Mexicana, publishers of fine arts books.

Publications

Kismaric, S. (1997). *Manuel Alvarez Bravo*. New York: Museum of Modern Art.

La Buena Fama Durmiendo, 1939 (GEH).

BRIGMAN, ANNE (1869–1950) American

Actress, photographer, and champion of woman's rights, who separated from her husband to "work out my destiny." Brigman received acclaim and notoriety for her innovative interpretations of the female figure in nature, often inhabiting the landscape with her own nude body. Brigman's interpretation of the landscape removed the female body from the gaze of a clothed man in the confines of his studio. She was one of the 21 women of the 105 members of the Photo-Secession. Her work appeared in three issues of *Camera Work*. She was elected to the British Linked Ring Society, and published a book of her poems and photographs (*Songs of a Pagan*, 1950).

Publications

Ehrens, S. (1995). *Anne Brigman. A Poetic Vision: The Photographs of Anne Brigman*. Santa Barbara: Santa Barbara Museum of Art.

BRODOVITCH, ALEXEY (1898–1971) American

Pioneer of 20th century graphic design and highly influential art director of *Harper's Bazaar* (1934–1958), who devised a new compositional structure for the printed page that envisioned layouts as single rectangles that spread over two pages. He experimented with type, illustrations, white space, bleed photographs, and montage to expand and control the visual pacing of time. As a designer, teacher, and employer, Brodovitch affected the photographic styles of Lisette Model, Irving Penn, Richard Avedon, Louise Dahl-Wolfe (1895–1989), Hiro, and Robert Frank. Influenced business people who saw his trendsetting ideas in *Harper's Bazaar* and imitated them.

Publications

Purcell, K. W. (2002). *Alexey Brodovitch*. New York: Phaidon Press.

BUBLEY, ESTER (1921–1998) American

Pioneer woman photojournalist, mentored by Roy Stryker on his ongoing document of American life, which he started

at the FSA, moved to the Office of War Information, and continued after the war by Standard Oil of New Jersey. In a male-dominated arena, Bubley rose to the top through her ability to document the rapidly changing interaction of modern industry/technology with the lives of everyday people.

Publications
Yochelson, B. et al. (2005). *Esther Bubley on Assignment.* New York: Aperture.

BULLOCK, WYNN (1902–1975) American
Steichen selected Bullock's psychologically based work as the opening piece to his humanistic exhibition, The Family of Man (1955), because he believed Bullock's visual language united the natural environment with the abstract symbolism of the inner world in an accessible way. Although highly structured, the authority of Bullock's images lies in their ambiguous temperament and their capability to express his belief that reality is constructed through personal experience.

Publications
(1971). *Wynn Bullock.* San Francisco: Scrimshaw Press.

BURROWS, LARRY (HENRY FRANK LESLIE)
(1926–1971) British
Spent nine years covering the Vietnam War before being killed when his helicopter was shot down over Laos. Burrow's groundbreaking serial use of color for *Life* was part of the wave of appalling images that invaded America's living rooms (15 cover photographs). His brutal and poignant compositions plus his use of color, evoking a sense of Old Master paintings, bore witness to and became synonymous with a terrible war and the camera's ability to not only create a myth, but to show its exhaustion.

Publications
Halberstam, D. (2002). *Larry Burrows Vietnam.* New York: Alfred A. Knopf.

BURSON, NANCY (1948) American
Exploring perception and the interaction of art and science, Burson uses digital morphing technology to create images of people who never existed, such as composite person made up of Caucasian, Negroid, and Oriental features. Such images have no original physical body and exist only as pictures, showing the unreliability of images. Her work involving the unseen has enabled law enforcement officials to locate missing people; examined beauty, deformity, and gender; and allowed viewers to see themselves as a different race.

Publications
Burson, N. and Sand, M. L. (2002). *Seeing and Believing: The Art of Nancy Burson.* Santa Fe: Twin Palms Publishers.

FIG. 29 Untitled (89-22) 1989 computer-generated, digitized Polaroid Polacolor ER print. Nancy Burson. (Courtesy of George Eastman House Collection, Rochester, New York.)

CALLAHAN, HARRY (1912–1999) American
Influenced by Ansel Adams, with Arthur Siegel (1913–1978), and Aaron Siskind, developed and taught an influential, expressive photography program at Chicago's Institute of Design (1946–1961) and later at Rhode Island School of Design (1964–1977). Covering themes from his daily life, such as his wife and daughter, the city, and the landscape, Callahan intuitively infused his elegant photographs with a sophisticated sense of grace that was simultaneously distant and personal. His spare, abstract, black and white compositions reflect his Bauhaus training in design and form, but he also worked later in life exclusively in color. Callahan's appeal was because he was a doer and not a talker, concerned with what he called "the standard photographic problems," such as composition, contrast, focus, motion, and multiple exposures. "Because I love photography so much I was a successful teacher, although I never knew what or how to teach. It's the same with my photography. I just don't know why I take the pictures I do."

Publications
Greenough, S. (1996). *Harry Callahan.* Washington, DC: National Gallery of Art.
Szarkowski, J. (ed.) (1976). *Callahan.* Millerton, NY: Aperture.

FIG. 30 Harry Callahan. (Photograph by Nancy M. Stuart, April 2, 1992.)

CAPA, ROBERT (ANDRÉ FRIEDMANN) (1913–1954) Hungarian/American

Perceptive photographer who inspired humanist photojournalism later championed and known as "Concerned Photography." Photographed the Spanish Civil War, the Japanese invasion of China, World War II, Israeli independence, and the Indochina (Vietnam) War where he was killed by a landmine. Key co-founder with Cartier-Bresson of Magnum Photos (1947). Stated, "If your pictures aren't good enough, you're not close enough." A self-declared "gambler," Capa went in on the first wave of the 1944 D-Day invasion, only to have all but eight of his exposures ruined by a London darkroom assistant. Capa was so animated he often made exposures more rapidly than his camera's fastest shutter speed. These blurry and grainy images, such as the Death of the Loyalist Soldier (1936), give the sense that Capa could see events that occurred even too quickly for a camera to record.

Publications
Capa, R. (1947). *Slightly Out of Focus*. New York: Henry Holt.
Whelan, R. (2001). *Robert Capa: The Definitive Collection*. New York: Phaidon Press.

CAPONIGRO, PAUL (1932) American

A student of music and later of Minor White, Caponigro utilizes a large format view camera to celebrate Thoreau's "tonic of wildness." His gorgeous, high modernist landscapes (from New England's woodlands to Stonehenge), reflect an internal universe of beauty and mystery that examine the human relationship to nature to reveal "the landscape behind the landscape."

Publications
Caponigro, P. (1983). *The Wise Silence*. Boston: New York Graphic Society.

CARTIER-BRESSON, HENRI (1908–2004) French

A painter influenced by surrealism purchased a 35 mm Leica camera in 1931, which led him to photograph the world and develop a street photography style called the "Decisive Moment" — "the simultaneous recognition, in a fraction of a second, of the significance of an event as well as a precise organization of forms which gave that event its proper expression." This watchfulness for peak moments, when the formal spatial relationships of the subjects reveal their essential meaning, defined and shaped the modernist, small-camera aesthetic of intuitively anticipating when an element of life opens for an instant and defines itself. His full-frame aesthetic, a scene completely visualized at the time of exposure, separated the mental act of seeing from the physical craft of photography. His stripped-down photographic grammar shunned fine print axioms in favor of a direct application of materials and process, which was ideal for photographers who traveled and made their living by having their work reproduced in magazines and newspapers. Co-founder with R. Capa of the photographic cooperative Magnum (1947).

Publications
Arbaizar, P. et al. (2003). *Henri Cartier-Bresson: The Man, the Image and the World: A Retrospective*. New York: Thames & Hudson.

CHIARENZA, CARL (1935) American

Founding member of the Association of Heliographers, a nonprofit photography cooperative (1963–1965) with Walter Chappell, Paul Caponigro, Nicholas Dean, Paul Petricone, Marie Cosindas, and William Clift, who believed photography could transcend a subject and evolve emotional responses to it. Chiarenza went on to construct collages of scrap materials for the purpose of being photographed. His meditative symbols forge a connection between the mind and nature that elicit inner emotional states. This work, often related to the landscape, deconstructs formal media boundaries and permits photography to merge with graphic design, painting, and sculpture. Conceptually Chiarenza states photography is a process of transformation and its illusional qualities draw attention to the difference between a photograph and the reality it depicts, reminding viewers photographs are constructed images and not concrete realities. He is also a photo-historian noted for the critical biography, *Aaron Siskind: Pleasures and Terrors* (Little, Brown, Boston, 1982).

FIG. 31 Somerville 17, 1975. Gelatin silver print. Photograph by Carl Chiarenza. (Courtesy of George Eastman House Collection, Rochester, New York.)

Publications

Chiarenza, C. (1988). *Chiarenza: Landscapes of the Mind, Essays, Chronology, Bibliography, Etc.*, by E. Jussim, et al. Boston: David R. Godine.

Chiarenza, C. (2002). *Chiarenza: Evocations*, with poetry by Robert Koch. Tucson, AZ: Nazraeli Press.

Chiarenza, C. (2005). *The Peace Warriors of 2003*. Tucson, AZ: Nazraeli Press. With original print on the cover. Signed Edition of 500.

Chiarenza, C. (2005). *Solitudes*. Ottsville, PA: Lodima Press.

CLARK, LARRY (1943) American

Clark's tumultuous life is mirrored in his books, *Tulsa* (1971) and *Teenage Lust* (1983) plus movies such as *Kids* (1996). His photographs provide an insider's look into the male adolescent netherworld of drugs, guns, and sex without excuses or righteous statements. Clark dispenses with conventional artifice and interjects his own presence, voyeuristically steering viewers through a sexually charged but abjectly unromantic underside of youth culture. Indirectly the work explores how children from dysfunctional families construct their identity. The shocking and often unforgettable images candidly raise the issues of pornography and censorship and masculinity and teen violence.

CLOSE, CHUCK (1940) American

Close's mural size, hyper-real painted head portraits based on photographs that were gridded onto canvas, simultaneously replicate the authenticity of a photograph while undermining its objectivity. These works exemplify the overwhelming influence that photography's indexical qualities have had on the arts and our culture in terms of both the process of seeing the creative process.

Publications

Shorr, R. et al. (1998). *Chuck Close*. New York: Harry N. Abrams.

COBURN, ALVIN LANGDON (1882–1966) British

A member of the Linked Ring (1903) and the Photo-Secession, Coburn helped connect the European and American pictorial movements. His early work, influenced by Whistler, was soft-focus. Published *Men of Mark* in 1913, a significant volume of artists and writers portraits. In *The Octopus* (1912), he moved toward modernism by making pure form the content of the image through his use of aerial perspective, eliminating unwanted detail, and banishing the familiar, inviting viewers to celebrate formalistic beauty rather than the photographic impulse to identify and name subjects. In 1917 Coburn made abstract portrait photographs called "vortographs" by using a

FIG. 32 Working photograph for Phil, 1969. Gelatin silver print, ink, masking tape. Chuck Close. (Courtesy of George Eastman House Collection, Rochester, New York.)

mirrored prism in front of the lens to distort, flatten, multiply, and transform his subject into a two-dimensional form, thus articulating how a photograph could be both subjective and objective.

Publications
Weaver, M., Coburn, A. L. (1986). *Symbalist*, Millerton, NY: Aperture.
Coburn, A. L. (1966). *Alvin Langdon Coburn, Photographer, An Autobiography*. New York: Praeger.

COPLANS, JOHN (1920–2003) British
Coplans began photographing his aging when he was sixty-four. His formal, faceless close-ups of wrinkles, sags, and varicose veins are unrelenting and unsentimental reminders of diminishing capacity and mortality, visualizing unidealized conventions that a media-driven "youth culture" has repressed as too ugly to be seen. His looming, highly detailed images, in which the body becomes landscape, possess a sculptural quality and point out how the male body has been largely excluded from the modernist aesthetic.

Publications
Coplans, J. (2002). *A Body*. New York: PowerHouse Books.

CREWDSON, GREGORY (1962) American
Using elaborate Hollywood production methods, Crewdson's stages condensed cinematic stills that explore the tension between domesticity and nature in suburban life, often with a Freudian twist. As a teacher, Crewdson has propagated the use of staged ingredients, resembling museum dioramas, which combine documentary and fictional components with an implicit sense of voyeurism. This results in a photographer who no longer passively experiences and edits the world, but is an active participant who creates a world and then photographs it.

Publications
Berg, S. (ed.) (2005). *Gregory Crewdson: 1985–2005*. Germany: Hatje Cantz Publishers.

CUNNINGHAM, IMOGEN (1883–1976) American
Inspired to take up photography in 1901 after seeing the work of Gertrude Käsebier, she learned platinum printing from Edward S. Curtis, eventually opening a portrait studio in Seattle (1910). Her first work was romantic, soft-focus portraits and nudes. After moving to San Francisco in 1917, she adopted modernism. Cunningham's images came to reflect Group f/64's credo (of which she was a founder) that the "greatest aesthetic beauty, the fullest power of expression, the real worth of the medium lies in its pure form rather than in its superficial modifications." Her tightly rendered 1920s plant studies presents nature with machine precision or as sexual allusion, drawing sensual parallels to the female form that she explored through her long career. Although the picture is a faithful rendering of a plant, Cunningham's concern was not the subject itself, but what the subject could become under the photographer's control. She worked as a commercial photographer from the 1930s. Her last book, *After Ninety* (1979), was a sympathetic portrait collection of elderly people.

Publications
Dater, J. (1979). *Imogen Cunningham: A Portrait*. Boston: New York Graphic Society.
Lorenz, R. (1993). *Imogen Cunningham: Ideas Without End: A Life and Photographs*. San Francisco: Chronicle Books.

CURTIS, EDWARD SHERIFF (1868–1952) American
From 1900 to 1930, Curtis photographed about 80 Native American tribes of the Northwest, Southwest, and Great Plains, producing some 40,000 images, which resulted in The North American Indian (1907–1930). Curtis was not an objective documentarian. He suppressed evidence of assimilation and manipulated his images through romantic, soft-focus pictorial methods to create emotional and nostalgic views of the vanishing noble savage. Although criticized for treating native people as exotica, Curtis' fabricated images provide the only evidence of artifacts, costumes, ceremonies, dances, and games of many tribes' previous existence. Nobody wanted to look at the realism of reservation despair, but with the Native Americans' complicity, Curtis used his narrative skills to

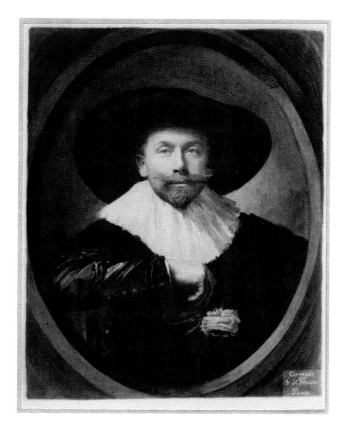

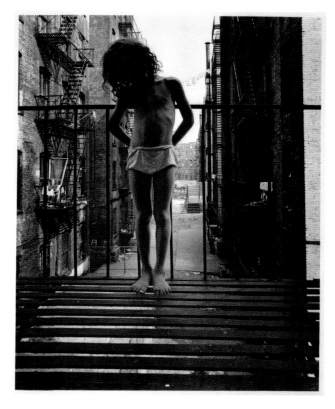

FIG. 33 J.C. Strauss Edward Curtis, Seattle. Self-Portrait by Van Dyck from untitled album. owned by Elias Goldensky featuring portraits of photographers in costumes after figures in the history of art in 1904. Retouched gelatin silver print. Manipulated portrait of the photographer Edward S. Curtis who is rendered in the Flemish baroque style of a Sir Anthony Van Dyke painting. (Image courtesy of George Eastman House Collection, Rochester, New York.)

FIG. 34 Child on Fire Escape, 1966. Gelatin silver print. Bruce Davidson, Magnum Photos. (Courtesy of George Eastman House Collection, Rochester, New York.)

recreate idealized symbols of a vanished time in the West and represent the timeless myth of the virtuous primitive.

Publications

Curtis, E. S. (1997). *The North American Indian: The Complete Portfolio*. New York: Köln: Taschen.

DAVIDSON, BRUCE (1933) American

A Magnum photographer since 1958, whose work exemplifies the personal style of "New Journalism," which contains authentic details about people and their circumstances yet presents a highly subjective view of the situation being covered. Davidson's early photo-essays about a circus midget, a New York City gang, and Spanish Harlem are indicative of his sympathetic representations of those who are not part of mainstream culture. His portraits reflect a direct, open approach of extended involvement and social conscience that

relies on gaining the trust of his subjects so they might reveal unguarded moments to his camera.

Publications

Davidson, B. (1970). *East 100th Street*. Cambridge, MA: Harvard University Press.

DE MEYER, BARON ADOLF (1868–1946) American

A pictorialist and member of the Linked Ring (1903). His photographs were exhibited by Stieglitz at 291. In 1911, the de Meyers promoted Diaghilev's Ballet Russe in their first London appearance and de Meyer made his famous photographs of Nijinsky. From 1914 to 1935 he lived in America where he became the top fashion photographer. Also known for his portraits of celebrities for *Vanity Fair*, *Vogue*, and *Harper's Bazaar*.

Publications

Brandau, R. (ed.) (1976). *De Meyer*. New York: Knopf.

DECARAVA, ROY (1919) American

Provided an insiders look into black Harlem life with a formal grace that blends social and personal identity. His understated

approach relies on examining the small impediments that define people's lives. His prints, whether of jazz musicians or tenement life, show the competing dynamism of darkness and light and the visible physical and invisible psychological forces that affect people. It contextualizes the racism that excluded most African Americans from the post-nuclear boom in the United States. First African American to receive a Guggenheim Fellowship (1952). Came into the public eye for *The Sweet Flypaper of Life* (1955), in collaboration with writer Langston Hughes. Opened A Photographer's Gallery in New York City (1955), an early effort to gain recognition for photography as an art. Ran the Kamoinge Workshop for young black photographers (1963–1966) and later taught at New York's Hunter College.

Publications

Alinder, J. (ed.) (1981). *Roy DeCarava, Photographs*. Carmel, CA: The Friends of Photography.

DEMACHY, ROBERT (1859–1936) French

The leading French pictorialist, member of the Linked Ring, exhibitor at Stieglitz' 291 gallery who championed the manipulated image with an outpouring of prints, lectures, and articles. Demachy's diverse subject matter often reverberated with the impressionistic style and always revealed the hand of their maker. Technically brilliant, especially in gum bichromate printing, Demachy was disdainful of the clarity of detail and the automatic trace of reality of the "straight," unmanipulated print and defended the painterly image arguing:

"A work of art must be a transcription, not a copy of nature ... there is not a particle of art in the most beautiful scene of nature. The art is man's alone, it is subjective not objective."

Publications

Jay, B. (1974). *Robert Demachy, 1859–1936*. New York: St. Martin's Press.

diCORCIA, PHILIP-LORCA (1953) American

Representing a quintessential post-modern outlook, diCorcia meticulously photographs choreographed mundane and ambiguous scenes from daily life. Instead of capturing a moment, diCorcia reconfigures it and then permanently casts it. His strategy combines the documentary tradition with the fictional methods of advertising and cinema to fashion ironic links between reality, fantasy, and desire. His quiet, mysterious, cinematic narratives utilize saturated colors to create a psychological intensity, built by juxtaposing the spontaneity of the snapshot aesthetic with the formalism of a staged composition and the drama between artificial and natural lighting.

Publications

diCorcia, P.-L. and Galassi, P. (1995). *Philip-Lorca diCorcia*. New York: Museum of Modern Art; distributed by Abrams.
diCorcia, P.-L. (2003). *A Storybook Life*. Santa Fe, NM: Twin Palms Publishers.

DISFARMER, MIKE (MIKE MEYERS)

(1884–1959) American

A self-taught eccentric, photographer who set up a portrait studio in the small farming town of Heber Springs, Arkansas, and was not recognized in his lifetime. He claimed he was not a Meyer, but blown into the Meyer family by a tornado as a baby, hence the name change to "not a farmer." His simultaneous familiarity and distance with this community enabled him to directly capture the essence of its people from 1939 until his death. By violating the etiquette of small town photographers, he allowed his subjects to simply be themselves before his camera. Favoring natural north light, simple backdrops, and a postcard format (3-1/2 × 5-1/2 inches), his portraits collectively present an utterly straightforward microcosm of anonymous rural people. When viewed outside of their original context, the images, resembling a naïve, mysterious, freewheeling blend of American Gothic, Arbus, Penn, and Sander, inadvertently pay tribute to a valuable service performed by small town photographers who documented daily life. A community member saved his glass negatives, leading to their belated public acclaim.

Publications

Scully, J. (2005). *Disfarmer, the Heber Springs Portraits 1939–1946*. New York: powerhouse Books.
Woodward, R. B. (2005). *Disfarmer: The Vintage Prints*. New York: powerHouse Books.

DOISNEAU, ROBERT (1912) French

Doisneau was a Parisian street photographer whose work from the 1930s to the 1980s can be seen as a humanistic visual social history of the city and its people. Doisneau called himself a "fisher" of pictures, a picture hunter who captured his observations of Parisian culture by immersing himself into the stream of life. Problems arose when Le Baiser de l'Hotel de Ville, 1950, a.k.a. The Kiss, was published in *Life* as an "unposed" icon of street photography and young love and it turned out to be reconstructions of scenes he had witnessed but had not been able to record. By accepting Doisneau's "unposed" picture his audience agreed to believe they were witnessing a scene from "real" life. Instead they were taken in by a docudrama. Doisneau's subjective-documentary approach breached the collective trust between the photographer and the audience, eroding public belief in the photograph's authenticity. It indicates seeing is not believing and that the age of the photograph being accepted as a non-fictional transcription of reality had to be rethought and seen instead as constructed fiction.

Publications

Doisneau, R. (1980). *Three Seconds from Eternity*. Boston: New York Graphic Society.

EDGERTON, HAROLD (1903–1990) American

A scientist who, in 1938, developed the electronic flash tube that emitted a brilliant light lasting less than one-millionth

of a second and was capable of being fired rapidly to obtain multiple-image stroboscopic effects. Electronic flash photography is based upon his discoveries. Using the stroboscope, he explored the field of high-speed photography, becoming the first to make stop-action photographs of events unperceivable to the human eye. The formal compositions of ordinary subjects, such as a bullet exploding an apple, aroused wonder and crossed the borders of art, entertainment, and science, making the invisible visible and thereby expanding our notion of reality.

Publications

Jussim, E. (1987). *Stopping Time, The Photographs of Harold Edgerton*. New York: Abrams.

EGGLESTON, WILLIAM (1939) American

His exhibition at the Museum of Modern Art in 1976, William Eggleston's Guide, featuring lush dye-transfer prints of the banal made in the American South ushered in the acceptance of color photography as a fine art. By means of a sophisticated snapshot aesthetic, Eggleston uses color to describe scenes in psychological dimensions that makes everyday events look unusual. Initially criticized for making vulgar images of insignificant subjects, such as a light bulb or the inside of an oven, he promoted the notion that anything could be photographed by democratically filling the dull existential void of American culture with color. The skewed angles of his "shotgun" pictures, not using the camera's viewfinder, helped to open the traditional "photographer's eye" in terms of how images are composed and what is acceptable subject matter. In turn, this sparked questions about the interpretation and response viewers have to images, and what the role of makers is in educating their audience.

Publications

Eggleston, W. (2003). *Los Alamos*. New York. Scalo.
Eggleston, W. (1976). *William Eggleston's Guide*. Cambridge, MA: MIT Press.

EISENSTAEDT, ALFRED (1898–1995) American

German-born, an early photojournalist who in 1929 began working for the Associated Press in Berlin using a Leica and natural light. Emigrated to the United States in 1935 where the next year he became one of the original four staff photographers for *Life*. Eisenstaedt's belief that his job was "to find and catch the storytelling moment," made him a consummate *LIFE* photographer; contributing more than 2000 photo-essays and 90 cover images in real-time, assignment-driven situations.

Publications

Eisenstaedt, A. (1990). *Eisenstaedt: Remembrances*. Boston: Bulfinch.
Eisenstaedt, A. (1980). *Witness to Our Time*, rev. ed. New York: Viking.

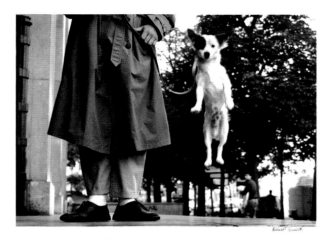

FIG. 35 Paris 1989. Feet and Legs of Man, Small Dog on Leash at his Side Jumping. Gelatin silver print. Elliot Erwitt. (Courtesy of George Eastman House Collection, Rochester, New York.)

ERWITT, ELLIOT (1928) American

A Magnum photographer known as the master of the "indecisive moment," black and white images of animals and people, usually dogs. Erwitt has an instinctual knack for capturing the significance of the insignificant — the irrational absurdities, coincidences, and incongruities of daily life often with Chaplinesque humor.

Publications

Sayle, M. et al. (2003). *Elliot Erwitt Snaps*. New York: Phaidon Press.

EVANS, FREDERICK HENRY (1853–1943) English

Best known for his delicately toned and unmanipulated platinum photographs of English and French cathedrals which were recognized for their atmospheric effects and handling of depth, height, and mass. Also took many fine portraits of his artistic and literary friends. Promoted by Stieglitz, who devoted an entire issue of *Camera Work* to Evans in 1903 as "the greatest exponent of architectural photography." A member of the Linked Ring and a purist who did not believe in retouching, Evans gave up photography when platinum paper became unaffordable after World War I.

Publications

Newhall, B. and Evans, F. H. (1973). Millerton, NY: Aperture.

EVANS, WALKER (1903–1975) American

The Godfather of large format American 20th century documentary photography, who was committed to straight, unadorned, black and white documentation. He established his

FIG. 36 Wells Cathedral: Stairway to Chapter House 1903. Gelatin silver print. Frederick H. Evans. (Courtesy of George Eastman House Collection, Rochester, New York.)

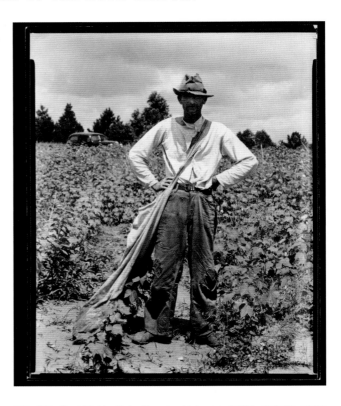

FIG. 37 Bud Fields Hale County, Alabama, 1936. Gelatin silver contact print. Walker Evans. (Courtesy of George Eastman House Collection, Rochester, New York.)

transparent, unheroic, clinical style as a photographer for the Farm Security Administration (1935–1938). His book *American Photographs* (1938) established the idea that looking at photographs in a book is fundamentally different than looking at photographs on the wall and that how the photographs were sequenced was critical in establishing meaning. It also revealed his affection for photographing signs (text), which often self-labeled the photograph. Evans' self-effacing approach with its edge of pessimism, made people believe in the power of the plain photograph. His second book with James Agee, *Let Us Now Praise Famous Men* (1941), was illustrated with Evans' unsentimental portraits of Alabama sharecroppers. His puritanical objectivity and economy of composition made the hardship of their situation self-evident yet preserved their dignity. From 1945 to 1965 he was a staff writer and photographer for *Fortune*.

Publications

Hambourg, M. M. et al. (2000). *Walker Evans*. Princeton: Princeton University Press.

Szarkowski, J. (1971). *Walker Evans*. New York: Museum of Modern Art.

FAURER, LOUIS (1916–2001) American

A photographer's photographer who expanded the small camera aesthetic to reflect the energy of New York and Philadelphia street life. Although Faurer worked as a fashion photographer for nearly thirty years and is not widely known by the public, his psychologically charged and socially aware inner-city images were a major influence in the post-war New York street-photography movement. Faurer's soulful black and white photographs, full of shadows and silhouettes, integrated the visual code of film noir with irony and juxtaposition to represent the instability of the rapidly shifting urban environment.

Publications

Wilkes Tucker, A. (2002). *Louis Faurer*. New York: Merrell.

FICHTER, ROBERT (1939) American

Fichter exemplifies a movement by a group of Rochester, New York, image-makers in the later 1960s that challenged accepted methods and philosophies of photographic presentation. This loose group included Tom Barrow, Betty Hahn, Bea Nettles, and Judy Harold-Steinhauser who also pushed the boundaries of conventional content as they often obtained critiques

FIG. 38 Geronimo (Apache Southwest) with Fold Mark. Gum biochromate print with oil and crayon. Robert Fichter. (Courtesy of George Eastman House Collection, Rochester, New York.)

of the media, the Vietnam War, and gender roles. Fichter, who studied with Jerry Uelsmann and Henry Holmes Smith, experimented with numerous alternative image-making methods including collage, cyanotype, plastic toy Diana camera, gum bichromate, hand-coloring, multiple exposure, Sabattier effect, and an old Verifax copy machine. This eclectic faction would have wide-ranging influence as they spread out and taught their alternative expressive approaches throughout the United States.

FLICK, ROBERT (1939) American
Flick's black-and-white gridded landscapes challenged 1970s presumptions about photographic process, space, and time. Now Flick uses a video camera to record entire Los Angeles streets, which he then presents as mosaic-like sequences that recreate the fragmented Southern California experience of viewing the world from the driver's seat. His visual development tracks both technological changes and the conceptual transition dealing with the discourse about interpretation, evaluation, and assessment of visual constructs that make up our notions of the landscape.

Publications
Flick, R. (2004). *Trajectories*. Steïdel: London.

FRAMPTON, HOLLIS (1936–1984) American
In his short film, *Nostalgia* (1971), Frampton transformed himself from a photographer into a filmmaker by upending the predictable narrative relationship between images and words by burning twelve still photographs and not having the narration match the photograph being depicted. This was part of a larger investigation in the early 1970s by many photographers, such as Lew Thomas (1932) and Jan Dibbets (1946), questioning the notion of a singular stable existence. Frampton is best known for the Vegetable Locomotion series (1975) he did with Marion Faller (1941) in which adjoining 35 mm frames with a gridded background were used to humorously explore real-time activity and pay homage to Eadweard Muybridge.

Publications

Moore, R. (2006). *Hollis Frampton: Nostalgia.* Cambridge: MIT Press.

FRANK, ROBERT (1924) American

The Americans (1958–1959), constructed from 800 rolls of 35 mm film of Frank's travels across the United States, became the seminal photographic publication for mid-twentieth century street photographers. Frank powered his book by arranging his images in sequences, which have completeness and make-up that no single image possesses. Part of the restless New York City Beat scene, the Swiss-born Jewish photographer had the astute ability of an outsider to critically examine booming post-WWII American culture and found a languor of alienation and loneliness. Open to possibilities, Frank was able to imagine photographs that nobody else had thought to make. Intuitively using a small Leica in available light situations as an extension of his body, he disregarded the photojournalistic standards of construction and content matter. Frank's stealthful, disjointed form; his use of blur, grain, and movement; and his off-kilter compositions, became the emotional, unpicturesque, and gestural carrier of what would be the new 35 mm message: The freedom to discover new content and formal methods of making photographs.

Publications

Frank, R. (1972). *The Lines of My Hand.* Tokyo: Yugensha.

Greenough, S. et al. (1994). *Robert Frank: Moving Out.* New York: Scalo Publishers.

FREUND, GISÈLE (1912–2000) German/French

Wrote the first Ph.D. thesis on photography. Known for her direct, naturalistic, tightly cropped portraits of France's literati (from 1938 often taken in color) and published reportage in *Life*, *Paris Match*, *Picture Post*, and *Vu* magazines. Her expanded Ph.D. thesis was later published as *Photography and Society*, which examined the history of photography in terms of the social forces that produced and molded it.

Publications

Freund, G. (1980). *Photography and Society.* Boston: David R. Godine Publisher.

FRIEDLANDER, LEE (1934) American

In a stream of conscious that has spanned four decades and two-dozen books, Friedlander constructs an interior world that was not apparent until it was formally organized through his camera. The discontinuous urban landscape is raw material for a hybrid, formalized, and personalized aesthetic that reshaped American street photography. With satirical humor, Friedlander orders fragmented chaos to characterize his place within society as the defining concept of what he called "the American social landscape and its conditions." The urban landscape becomes a stage for an investigation of the human presence within its enclosures, juxtapositions, and reflective and transparent surfaces that form overlapping realities within a single frame. His images within images approach involves

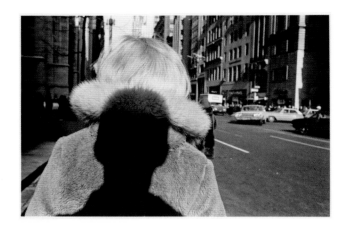

FIG. 39 New York City, 1966. Gelatin silver print. Lee Friedlander. (Courtesy of George Eastman House Collection, Rochester, New York.)

an often extremely complex piecing together, a reading of all the interconnected parts and signs to determine meaning. Favoring the ordinary subjects from televisions to trees, Friedlander works in series to do away with their hierarchical ordering, thus making objects, people, places, and time interchangeable. He forces viewers to search for a lone, human presence, often Friedlander's shadow (an assimilated Jew), which could be anyone's shadow, in a desolate landscape from which God has vanished.

Publications

Friedlander, L. (1970). *Self Portrait.* New York: Haywire Press.

Galassi, P. (2005). *Friedlander.* New York: Museum of Modern Art.

FUSS, ADAM (1961) British

In the gap between photography's metaphorical and representational capabilities, Fuss utilizes photograms, pinhole cameras, and daguerreotypes to mine the margins of what makes up a photographic image. Dealing with themes of life, death, and protracted time, Fuss transcends his organic subject matter, including animal entrails, flowers, plants, smoke, and water, and infuses them with a spiritual, post-modern amalgam comprised of the inner and outter worlds. Relying on the medium's basic components—the interplay of light and objects with light-sensitive material—Fuss' prolonged exposures produce unique images that both capture and transcend reality while evoking the unseeable.

Publications

Fuss, A. (2004). *Adam Fuss.* Santa Fe, NM: Arena Editions.

GIACOMELLI, MARIO (1925–2000) Italian

Giacomelli spent decades photographing the same piece of earth in his Italian village, from the same vantage point,

FIG. 40 Butterfly From "My Ghost" 1999. Daguerreotype. Adam Fuss. (Courtesy of George Eastman House Collection, Rochester, New York.)

throughout the year, usually altering the perspective by excluding the horizon line to deprive onlookers of any visual anchor. He foreshortened space by stacking up forms as if they were on a vertical plane. By 1960, Giacomelli's response to his sense that humans had overrun nature was to cut patterns into the landscape with a tractor. In 1970, he was photographing the plowed fields from the air, concentrating on details of texture and pattern. The sensation of violent upheaval can be seen in Giacomelli's audacious framing and image cropping along with his unconventional darkroom methods featuring grainy, high-contrast prints, which often had only three tones. In 1956, Giacomelli began a long-term project about old age that has been called bleak and pessimistic, but it accurately conveys the passionate sense of enclosing darkness that his elderly subjects were experiencing. This was followed by other series on butchered animals, gypsies, and war victims at Lourdes.

Publications
Crawford, A. (2006). *Mario Giacomelli*. New York: Phaidon Press.

GIBSON, RALPH (1939) American
In 1969 Gibson founded Lustrum Press, which during the 1970s published an unconventional collection of books. The Lustrum line included Robert Frank, Larry Clark, instructional books, and Gibson's dream-like trilogy of photo-novels *The Somnambulist* (1970), *Deja-Vu* (1973), and *Days at Sea* (1974). Gibson's grainy, tightly composed, high-contrast 35 mm work reflects the minimalist impulse to eliminate extraneous detail and get down to the essentials of producing a non-literal, but

visually complex, yet beautiful symbolic system, often sexually charged, enigmatic settings beyond the realm of empirical thinking.

Publications
Gibson, R. (1999). *Deus Ex Machina*. Köln: Taschen.

GILBERT AND GEORGE [GILBERT PROESCH (1943) and **GEORGE PASSMORE** (1942)] British
Former performance artists Gilbert and George (Gilbert Dolomites [1943] and George Totnes [1942]) who played on their sense of photographic time as they posed for hours as living sculpture, manipulated themselves as the content in their series of photographs presented in a grid formation. Photography became their vehicle for suspending movement and memorializing their daily lives and blurring the boundaries between art and life. Their graphic, colorful, monumental pieces, having much in common with sculpture, confront viewers with modern British social anxieties. Under the guise of respectable dandies, this duo uses an orderly, repetitive and accessible style to examine taboo subjects, especially homosexuality. Recently the artists have been making digital pictures.

Publications
Dutt, R. (2004). *Gilbert and George: Obsessions and Compulsions*. London: Philip Wilson Publishers.
Jonque, F. (2005). *Gilbert and George*. New York: Phaidon Press.

GILBRETH, FRANK B. (1868–1924) and **LILLIAN** (1878–1972) American
To make work sites more efficient the Gilbreths developed the "stereo chronocyclegraph" in which tiny lights were attached to a worker performing a visual indication of the physical action. This produced the stereographic pattern for each employee to imitate the "one best way to do work." Their stereo "motion economy" studies had a financial and social effect: they helped businesses, such as Kodak, make their employees more productive resulting in greater profitability. Social critics saw their photographs as a pre-Orwellian photographic methodology that coupled science to a de-humanizing process of industrial sameness. Their treatise Cheaper by the Dozen, which Hollywood has turned into film comedies, celebrated their principals of motion studies.

GILPIN, LAURA (1891–1979) American
Studied at the Clarence H. White School (1916–1917) and opened a portrait studio (1918). Known for her command of platinum printing, Gilpin devoted over 60 years to photographing the relationship of the people and the American Southwest landscape of New Mexico and Arizona, especially her Canyon de Chelly project (1968–1979). Her 35-year sympathetic documentation of the Navajos (1946–1968) is a peerless record of Native American life during a time of rapid change.

Publications

Gilpin, L. (1968). *The Enduring Navajo*. Austin, TX: University of Texas Press.

Sandweiss, M. A. (1986). *Laura Gilpin, An Enduring Grace*. Ft. Worth, TX: Amon Carter Museum.

GOLDEN, JUDITH (1934) American

Golden's work represents the burgeoning feminist expression of the 1970s movement that rejected modernism's values of ideal beauty. Her extended investigation of female personas and roles examines the ways photography can transform a subject. By humorously hand-manipulating the picture surface, Golden disregards traditional aesthetic values and emotional responses. Her approach was indicative of artists who used hand-work and appropriation to blur the distinction between the beautiful chemically produced image and one that was graphically generated. Golden assumes control over her public representation, creating tableaus that deconstructed underlying assumptions about photography and society upon which artists would build.

Publications

Featherstone, D. (ed.) (1988). *Cycles: A Decade of Photographs (Untitled 45)*. San Francisco: Friends of Photography.

GOLDIN, NAN (1953) American

Goldin's vérité-style slide and music diary, *The Ballad of Sexual Dependency* (published as a book in 1986), used 700–800 images and popular songs to spin a constantly evolving tale of abuse, drugs, and sex. Goldin's camera is part of her intimate relationships, recording her subjective internal feeling about what is going on between Goldin and her subjects. Her images are a post-modern morality tale that chronicles the heyday and collapse of a nihilistic lifestyle. Her work embodies the shift in photographic practice from the single flawless black and white print to casually composed collections of color snapshots that emphasize autobiography, sexuality, and outsider culture.

Publications

Goldin, N. et al. (1996). *I'll be Your Mirror*. New York: Scalo Publishers, 1996.

GOWIN, EMMET (1941) American

Gowin's early work incorporated the personal iconography of his life in the rural South while combining the "snapshot aesthetic" with a view camera, often featuring a circular motif. Concentrating on his immediate family and surroundings, Gowin made extended portraits of his subjects, especially his wife, in allegorical roles. His later work documents the dramatic clash between nature and culture. His weirdly beautiful aerial photographs of gashed and polluted landscapes in the service of agriculture, mining, and war walks a tightrope between the real and the surreal, black and white and color, the microscopic and the panoramic, seeking to re-establish a spiritual connectedness with the natural world.

FIG. 41 Edith, Danville, Virginia, 1971. Gelatin silver print. Emmet Gowin. (Courtesy of George Eastman House Collection, Rochester, New York.)

Publications

Bunnell, P. (1983). *Emmet Gowin: Photographs, 1966–1983*. Washington, DC: The Corcoran Gallery of Art.

Reynolds, J. et al. (2002). *Emmet Gowin: Changing the Earth*. New Haven: Yale University Press.

GROSSMAN, SID (1913–1955) American

With Sol Libsohn co-founder of the Photo League (1936–51) as a meeting place, gallery, and educational site. The Photo League promoted the sanctity of the straight image and the belief that photography needed to serve a sociopolitical purpose. Driving force that organized classes in documentary photography. He founded the Documentary Group and served on the board of directors. He was an editor, reviewer, and writer for Photo Notes, the league's newsletter. Advocate for art photography when few museums would show photography. His photography work involving labor union activity in 1940 sparked an FBI investigation. In 1947, Grossman and the league were blacklisted as a communist front, which lead to its demise.

Publications

Tucker, A. (2001). *This Was the Photo League*. Chicago: Stephen Daiter Gallery.

Group f/64 (1932–1935) American

Founded in Oakland, California, Group f/64 was a loose band of seven photographers—Edward Weston, Ansel Adams, Imogen Cunningham, Willard Van Dyke (1906–1986), Sonya Noskowiak (1900–1986), John Paul Edwards (1883–1968), and Henry Swift (1890–1960)—who promoted straight, modernistic photography. With their aesthetic stance based in

FIG. 42 New York Reflections, 1962. Dye transfer print. Ernst Haas. (Courtesy of George Eastman House Collection, Rochester, New York.)

precisionism, they named themselves after the smallest aperture on the camera lens, expressing their allegiance to the native principals of "pure photography"—sharply focused images printed on glossy gelatin silver papers without any signs of pictorial "hand-work" and mounted on white board. Favoring natural forms and found objects, they offered an alternative to Stieglitz' urban bias against the naturalistic West Coast artists and the California pictorialist style.

Publications
Alinder, M. S. et al. (1992). *Seeing Straight: The F.64 Revolution in Photography*. Seattle: University of Washington Press.

GURSKY, ANDREAS (1955) German

A student of Bernd and Hilla Becher, Gursky's premeditated Olympian sized spectacles of color and pattern present a computer-altered zeitgeist of industrial culture that appears more real than reality. His seductively colorful, super-formalistic, and hyper-detailed hybrid compositions show everything as they catalog the phenomena of globalization. So perfectly beautiful they could hang in a corporate boardroom, yet they evoke a sense of post-modern indifference and sublime that leads us to feel inconsequential.

Publications
Galassi, P. (ed). (2001). *Andreas Gursky*. New York: Museum of Modern Art.

HAAS, ERNST (1921–1986) Austrian

Joined Magnum (1949–1962), moving to the United States in 1951. At a time when color photography was a second-rate, commercial medium to black and white, Haas' 24-page Magic Images of New York (1953) was a groundbreaking innovation for *Life* that introduced the artistic and poetic possibilities of color photography into the public's viewing habits. Noted for his experiments with color in motion and slow shutter speeds, his was the first exhibition of color photography at the Museum of Modern Art (1962).

Publications
Haas, E. (1989). *Color Photography*. New York: Harry N. Abrams.
Hass, E. (1971). *The Creation*. New York: Viking.

HALSMAN, PHILIPPE (1906–1979) American

The publishing world's desire to promote and capitalize on the notion of fame can be seen in Halsman's incisive celebrity portraits that appeared on over 100 covers of *Life* as well as in magazines such as *Saturday Evening Post* and *Paris Match*. Halsman believed the portraitist's most important tools were conversation and psychology, not technique. Halsman utilized playful methods, like jumping in the air, to unmask his subjects and divulge their essence.

Publications
Halsman, P. (1959). *Jump Book*. New York: Simon & Schuster, 1959.

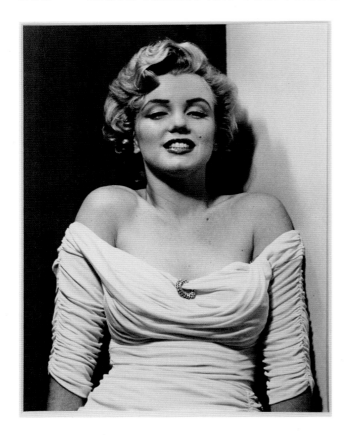

FIG. 43 Marilyn *LIFE* cover, 1952. Gelatin silver print ca. 1981 by Stephen Gersh under direction of Yvonne Halsman. Philippe Halsman. (Courtesy of George Eastman House Collection, Rochester, New York.)

FIG. 44 Mansmag October 1969. Lithographs (four-color) in the form of a pseudo magazine. Robert Heinecken. (Courtesy of George Eastman House Collection, Rochester, New York.)

Halsman Bello, J. et al. (1998). *Philippe Halsman: A Retrospective — Photographs From the Halsman Family Collection*. New York: Bulfinch.

HEARTFIELD, JOHN (JOHN HELMUT HERZFELD)

(1891–1968) German

A member of Berlin's Dada group and a pioneer of photomontage as a political method, Heartfield embodies the artist as activist. With cutting absurdity, he lambasted materialism, bourgeois pretensions, and the abuse of power in Germany in the late 1920s. During the 1930s he produced over 200 anti-Nazi and anti-conservative photomontages with captions. This combination, often featuring Nazi quotes, created ingenious visual puns that communicated a new message, which was the opposite of the original intent.

Publications

Heartfield, J. (1936). Hitler erzählt Märchen II. *AIZ*. March 5, p. 160.

Pachnicke, P. et al. (1993). *John Heartfield*. New York: Harry N. Abrams.

HEINECKEN, ROBERT (1931–2006) American

Leader of the American photographic avant-garde during the 1960s through the 1970s, extending the expressive possibilities of what we call photography by using collage, lithography, photocopies, artists' books, altered magazines, and three-dimensional objects. A "photographist" — a photographer who doesn't use a camera — Heinecken appropriated and manipulated images from the mass media to fabricate droll and often controversial images often concerned with the erotica, the female body, and violence.

Publications

Borger, I. et al. (1999). *Robert Heinecken, Photographist: A Thirty-Five Year Retrospective*. Chicago: Museum Of Contemporary Art.

Enyeart, J. (ed.) (1980). *Heinecken*. Carmel, CA: The Friends of Photography.

HILLER, LEJAREN à (1880–1969) American

Opened commercial photography to American print advertisers in 1913 by making less realistic and more fantastic

images by combining fine art aesthetics and pictorialist methods to create subjective tableaux using elaborate sets involving costumed actors. Hiller used combination printing, dramatic lighting, soft-focus, and heavy retouching to produce narrative theatrical scenes that gave his images a sense of emotion and dreamy desire that delighted advertisers. Best known for his humorous and slightly erotic ad campaign, now considered sexist, Surgery Through the Ages (1927 and 1933) done for Davis & Geck, Inc. who were makers of surgical sutures. For this project Hiller concocted a historic series of tableaux vivants consisting of over 200 great moments in medical history that appeared in medical journals and hung in hospitals and physician's offices throughout the country.

Publications

Brown, E. H. (2000) Rationalizing consumption: Lejaren à Hiller and the origins of American advertising photography, 1913–1924. *Enterprise & Society* **1** (Dec. 2000), 715–738.

HINE, LEWIS WICKES (1874–1940) American

Hine was a sociologist who took up photography in 1904 in the cause of social reform. He documented immigrants arriving at Ellis Island then followed them in their harsh new lives in the slums of America. In 1907, Hine photographed the Pittsburgh iron and steel workers revealing employment of children under grueling, dangerous conditions. As staff photographer to the National Child Labor Committee from 1911 to 1917, Hine's photographs exposed the negative consequences of a growing consumer society and contributed to the passing of child labor laws. In the 1920s, he embarked on "positive documentation" by making portraits of the working man. His landmark book about the construction of the Empire State Building, *Men at Work*, was published in 1932.

Publications

Gutman, J. M. (1967). *Lewis W. Hine and the American Social Conscience*. New York: Walker.

Trachtenberg, A. (1977). *America & Lewis Hine: Photographs, 1904–1940*. Millerton, NY: Aperture.

HÖCH, HANNAH (1889–1978) German

Höch's photomontages, which established the appropriation motif of big heads on little bodies, explored women's changing social identity through allegory, caricature, the grotesque, and irony. Mirroring her Dadaist attentiveness to alienation and estrangement, she took the familiar and made it unfamiliar, reflecting the shattering and rearranging of traditional women's roles, involving children, kitchen, and church. Höch's disruptive emotionally and sexually charged work played on tensions between anger/violence and pleasure/beauty to investigate issues of gender and bourgeois culture. Höch also made montages that fused Western and tribal imagery, thus dissolving the hierarchy that had defined their cultural relationship.

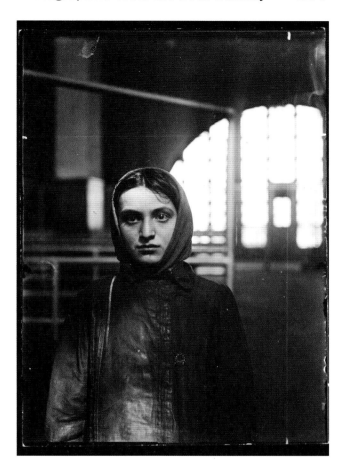

FIG. 45 Young Russian Jewess, Ellis Island, 1905. Gelatin silver print. Lewis W Hine. (Courtesy of George Eastman House Collection, Rochester, New York.)

Publications

Lavin, M. (1993). *Cut with the Kitchen Knife: The Weimar Photomontages of Hannah Höch*. New Haven: Yale University Press.

HOCKNEY, DAVID (1937) British

Hockney stated "photography is all right if you don't mind looking at the world from the point of view of a paralyzed Cyclops — for a split second." To overcome his dissatisfaction with photography's single-point perspective, he made numerous photographs of a scene from various vantage points and arranged the resulting prints into a cubist-like collage. His canvas-sized color visions bring together an expanded collection of components observed over time and fabricated into a grand, extended, constantly changing entirety. By interrupting space and displacing time, Hockney breaks the perspective of the Renaissance window, carrying his synthetic multifaceted representations of a subject beyond the edges of the frame, dissolving the photograph's traditional rectangle.

Publications
Weschler, L. (1984). *Cameraworks: David Hockney*. New York: Alfred A. Knopf.

HORST, HORST P. (HORST BORMANN) (1906–2000)
American

Horst's fashion career, spanning almost six decades with Condé Nast, began in 1931 as George Hoyningen-Huene's protégé. Best known for his classical images of fashion models and fashionable figures posed in dramatic, often Greek inspired settings, Horst established a pre-war savoir-faire style of sophisticated posing where elegance and manners counted. His dramatic mastery of studio lighting gave his subjects a timeless, statuesque quality, swathing them with a glowing patina of the glamorous ideal.

Publications
Pepper, T. (2001). *Horst Portraits: 60 Years of Style*. New York: Harry N. Abrams.

HOSOE, EIKOH (1933) Japanese

Hosoe merged desire and unseen memories to pioneer a grittily expressionistic form of Japanese photography. His high-contrast, graphic, black and white photographs portray a mysterious interior world of surreal dreams that is both sensual and disturbing. He gained recognition in 1963 with the publication of *Barakei* (*Ordeal by Roses*) in which an ornate world of aestheticism was constructed around the writer Yukio Mishima. By eliminating details Hosoe enhanced the black areas of his compositions to create complex and disorienting spatial compositions that challenged both accepted photographic practices and the nature of interpersonal relationships.

Publications
Holborn, M. *Eikoh Hosoe*. Millerton, NY: Aperture.

HOYNINGEN-HUENE, GEORGE (1900–1968) American

In the Paris of the 1920s and 1930s Hoyningen-Huene became the archetypal urbane sophisticate of fashion photographers. Working for *Vogue*, *Vanity Fair*, and *Harper's Bazaar* he made stylish location and studio portraits of artists, film stars, authors, models, and upper crust society. His celebrity studies, noted for their use of shadows, blended the artist and person to define glamour portraits. Influenced by Baron de Meyer, Man Ray, and Edward Steichen, Hoyningen-Huene was a master of lighting whose compositions commingled Hellenic and surrealistic motifs, which set a paradigm of classical elegance in a genre later expanded by Horst, Penn, and Avedon.

Publications
Ewing, W. A. (1998). *The Photographic Art of Hoyningen-Huene*. New York: Thames & Hudson.

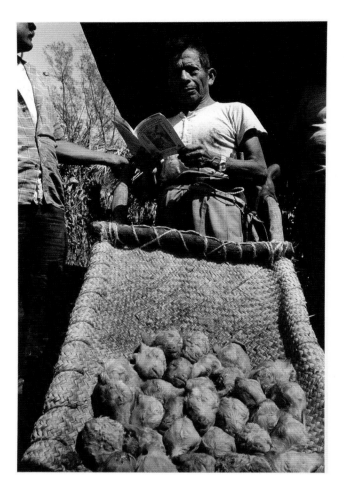

FIG. 46 En El Nombre Del Padre, Oaxaca, 1994. Gelatin silver print, 1994. Graciela Iturbide. (Courtesy of George Eastman House Collection, Rochester, New York.)

ITURBIDE, GRACIELA (1942) Mexican

Assistant to Manuel Alvarez Bravo. United her interests in anthropology and photography in a 1979 photo-essay on the matriarchal nature of Mexico's Zapotec Indian community. This became her working model: getting to know her subjects and then using her access to examine the lives of Mexico's indigenous peoples, their ceremonies and rituals, and the role of women. Her black and white images poetically document the interaction and tensions of urban and rural life, indigenous and modern culture, and social identity. Recent work centers on how people adapt to modernity and its effect on the landscape in other South American countries.

Publications
Medina, C. (2001). *Graciela Iturbide*. New York: Phaidon Press.

JONES GRIFFITHS, PHILIP (1936) British

Since the 1950s Jones Griffiths has photographed in 140 countries and covered conflicts in Vietnam, Northern Ireland, Africa, and other trouble spots. His Welsh background gave him a natural sympathy for the Davids over the imperial Goliaths of the world. Jones Griffiths' gruesome photographs, often of ordinary people, in *Vietnam Inc.* (1971), put a human face on the war. These disturbing images, which contrasted the extreme differences between the civilian and the military, helped arouse the ethical validity of the war in America. Jones Griffiths has a talent for making haunting images of incongruous situations, such as a half-black Vietnamese schoolgirl representing long-term human effects of the war.

Publications
Sayle, M. (1996). *Dark Odyssey*. New York: Aperture.

JOSEPHSON, KEN (1932) American

Josephson's conceptual approach that humorously alters perspective, scale, and point of view emphasizes the relationship between a photograph of a subject and the subject itself. His black and white photographs from late 1960s and 1970s, which include pictures within pictures, reveal "the process of creating pictures as ideas rather than as representations." In one series, Josephson holds a postcard of each scene into his photographic frame, playfully interjecting himself as a performer who is formally distorting reality while mocking the idea of photographic duplication, demonstrating the absurdity of attempting to re-occupy the same space. Josephson

reshapes the photograph to discover a new vantage point that disrupts Renaissance concepts of how the world is and what a picture is supposed to look like.

Publications
Wolf, S. et al. (1999). *Kenneth Josephson: A Retrospective*. Chicago: Art Institute of Chicago.

KARSH, YOUSUF (1908–2002) Canadian

Born in Armenia, he escaped the Turkish persecution, emigrating to Canada in 1924. Opened a portrait studio in Ottawa in 1932 where he established a reputation for photographing the powerful and famous of his era. His view-camera portraits were known for their clarity and dramatic lighting, emphasizing highlights, shadows, and rich textures. His 1941 *Life* cover of the imposing, wartime, bulldog-faced Winston Churchill infused the subject's personality with his public image to reveal what Karsh said was the sitter's "inner power."

Publications
Karsh, Y. (1996). *A Sixty-Year Retrospective*. Boston: Little, Brown.

KÄSEBIER, GERTRUDE (1852–1934) American

Opened a New York portrait studio (1897) where she created a reputation for her mother and child motifs that stressed tonality over formal compositional elements. Known as the leading woman pictorialist, she produced platinum, gum-bichromate, bromoil, and silver prints, and encouraged

FIG. 47 Chicago, 1961. Gelatin silver print. Kenneth Josephson. (Courtesy of George Eastman House Collection, Rochester, New York.)

women to take up photographic careers. Founding member of the Photo-Secession in 1902. Stieglitz promoted her highly romantic work, reproducing it in *Camera Work*. Eventually, she broke contact with Stieglitz over the issue of "straight" photography, forming the Pictorial Photographers of America in 1916 with Coburn and C. White.

Publications

Caffin, C. H. (1901, 1972). *Photography as a Fine Art*. New York: Doubleday.

Michaels, B. L. (1992). *Gertrude Käsebier, The Photographer and Her Photographs*. New York: Harry N. Abrams.

KEÏTA, SEYDOU (1923–1998) Malian

Through his commercial portraits that chronicle the shift of the colonial and post-colonial urban West African experience by blending Western technology with an African aesthetic and viewpoint, the self-taught Keita became the official photographer of Mali from 1962 to 1977. To make his customers look their best, Keïta used backdrops and props, such as bicycles, musical instruments, radios telephones, plus traditional and European clothing to pose his subjects to achieve their desired look. Dating from 1949, Keita's oeuvre of over 200,000 images depicts African modernization and brought Western attention to his work and indigenous African photography overall.

Publications

Magnin, A. (ed.) (1997). *Seydou Keïta*. New York: Scalo Publishers.

KEPES, GYÖRGY (1906–2001) American

A close associate of Moholy-Nagy, who became the head of the light department at Chicago's New Bauhaus, proclaimed he was not a photographer but an artist "committed to working with light." An avid experimenter who explored clichés-verre and photograms, Kepes juxtaposed fragmented light spaces with structured rhythmic patterns of geometric shapes to create visual opposition. This use of opposites and natural forms in a dream-like field of geometric shapes, was a metaphor of alternating natural and technological realities. As an influential educator he investigated the effect of visual language on human consciousness, chiefly how the design elements of line and form are perceived and how new types of perspective can bring about more vibrant visual representations. Founding Director of the Center for Advanced Visual Studies at MIT (1967), which explores confluences of art and technology.

Publications

Kepes, G. et al. (1995). *Language of Vision: Fundamentals of Bauhaus Design* (reprint). Mineola, NY: Dover Publications.

KERTÉSZ, ANDRÉ (1894–1985) American

By the late 1910s, Kertész was demonstrating the visual language of modernism with asymmetrical compositions, close-ups, distortions, reflections, and unusual points of view.

He came to use a Leica to geometrically order the unexpected moments of everyday life with a life-affirming sensibility that favored a play between pattern and deep space. He made his living as a European photojournalist before immigrating to the United States. Kertész' joyous "Leica spirit," the new small camera mentality, combined the formal design elements of De Stijl with a natural intuition to extract poetic "rest-stops" from the flow of time that alter expectations about common occurrences and objects. His spontaneous vision revealed a sweet, lyrical truth, celebrating the splendor of life and the pleasure of sight. Inspired Brassaï, Henri Cartier-Bresson, and Robert Capa.

Publications

Greenough, S. (2005). *André Kertész*. Princeton: Princeton University Press.

KLEIN, WILLIAM (1928) American

Klein, an ex-patriot American fashion photographer, filmmaker, designer, and painter has made Paris his home. He enlarged the syntax of photography by courting accident, blur, contrast, distortion, cockeyed framing, graininess, and movement. Rebelled against the 1950s notions of the decisive moment, which included not intervening into a scene, making good compositions, and producing normal looking prints. His images are not those of a detached observer but those of a provocateur. Klein referred to his *Life is Good for You in New*

FIG. 48 William Klein. Photograph by Nancy M. Stuart. Fall 1990.

York—William Klein Trance Witness Revels (1956) as "a crash course in what was not to be done in photography." His other photographic books of cities—*Rome* (1958–1959), *Moscow*, and *Tokyo* (both 1964)—are catalogs of irreverent "mistakes," revolving around aggression. The dynamic and unconventional framing and printing techniques present cities as théâtre noir, emphasizing a sense of anarchy, chaos, and dread of urban life that most people wished to ignore.

Publications
Heilpern, J. (1980). *William Klein: Photographs*. New York: Aperture.

KLETT, MARK (1952) American
As a member of the Rephotographic Survey Project (1977–1979), Klett helped precisely re-photograph 122 19th century western survey sites, pointing out how 19th century photographers saw the landscape and the unfolding interaction of human development and natural transformations over time. The pairing of old and new images showed how photography can display and measure time, establishing a dualistic meaning of time and space, putting viewers into a time machine that permits them to glance between then and now. This became central to Klett's work as in the Third View project, in which the locations from the first project were re-photographed again in the 1990s. Klett's photographic mapping of the past and the present illustrates the dynamic interaction of culture and geological forces, reflecting loss, and the encroachment of civilization on the wilderness.

Publications
Klett, M. et al. (2004). *Third Views, Second Sights: A Rephotographic Survey of the American West*. Albuquerque: University of New Mexico Press.
Klett, M. et al. (1984). *Second View: The Rephotographic Survey Project*. Albuquerque: University of New Mexico Press.

KOUDELKA, JOSEF (1938) Czech/French
Koudelka's graphic black and white images deal with those on the fringes of society. His formalized theatrical organization of reality looks at the daily community rituals of gypsies and exiles. His images of the invasion of Prague dramatically synthesized the terror and freedom of being isolated. His panoramic views search for a reprieve within a derelict landscape, where our own bleak despair has ruined nature's pleasures. Koudelka's prints utilize deep, dark black tones to continually portray the mental and physical conundrums and world-weariness of being a refugee.

Publications
Koudelka, J. (1999). *Chaos*. New York: Phaidon Press.

KRIMS, LES (1943) American
In the early 1970s Krim's provocative, self-published, boxed folios on dwarfs, deer hunters, murder scenes of nude young women, and his topless mother making chicken soup offended Main Street while encouraging young photographers to visualize their inner fictions and explore forbidden subjects. These images were printed on a graphic arts paper to deliver dramatically grainy, high-contrast, brown-toned effects that challenged the conventions of the fine print aesthetic. Detractors did not find the work humorous and heavily criticized it as condescending, mocking, and misogynistic.

FIG. 49 Petroglyphs in the Cave of Life, Petrified Forest National Monument, Arizona, May 31, 1982. Gelatin silver print. Mark Klett. (Courtesy of George Eastman House Collection, Rochester, New York.)

FIG. 50 Human Being as a Piece of Sculpture Fiction, 1970. Gelatin silver print, Kodalith. Les Krims. (Courtesy of George Eastman House Collection, Rochester, New York.)

Publications
Krims, L. (1972). *Making Chicken Soup*. Buffalo, NY: Humpy Press.

KRUGER, BARBARA (1945) American
Kruger spent ten years working as a graphic designer for various women's magazines that extolled beauty, fashion, and heterosexual relationships before producing photomontages, resembling billboards, with text that questioned capitalism's relationship to patriarchal oppression and the role consumption plays within this political and social structure. Turning the tables on the seductive strategies of advertising, Kruger reuses anonymous commercial, studio-type images to deconstruct cultural representations of consumerism, the

FIG. 51 Untitled ("You are a Captive Audience"), 1992. Photo silkscreen print. Barbara Kruger and the Mary Boone Gallery, New York City. (Courtesy of George Eastman House Collection, Rochester, New York.)

power of the media, and stereotypes of women to show how images and words manipulate and obscure meaning. Her red or white banners of text stamped on black and white photographs pound viewers with curt phases, such as "Your Body is a Battleground" or "I Shop Therefore I Am," deliver unsettling jolts to male demonstrations of financial, physical, and sexual power.

Publications
Kruger, B. (1999). *Barbara Kruger*. Cambridge: The MIT Press.

KRULL, GERMAINE (1897–1985) German
Often overlooked because of the diversity of her practice and the loss of her early work during the wars, Krull was an innovative, prolific, and versatile photographer whose advertising, architectural, fashion, industrial, montage, ironic female nudes, and reportage images were intertwined with her intense political and professional beliefs. Spanning nine decades and four continents, Krull broadly and expressively overlapped commercial and avant-garde approaches as she photographed in response to the situations and cultures she traveled through. Her Metall series (1927) sharply emphasized the abstract forms of industry and introduced German New Objectivity (Neue Sachlichkeit) photography to France.

Publications
Sichel, K. (1999). *Germaine Krull: Photographer of Modernity*. Cambridge: The MIT Press.

KÜHN, HEINRICH (1866–1944) German
Along with Hugo Henneberg (1863–1918) and Hans Watzek (1848–1903) formed the "Trifolium" of the Vienna Kamera-Club (1896–1903). Using the gum process, they exhibited under the collective known as Kleeblat (Cloverleaf) and were a driving force of the Austro-German secession/pictorialist movement. An amateur since 1879 and a member of the Linked Ring, Kühn made multi-layered landscapes and portraits in gum and, later, oil-pigment printing. His characteristic style featured bold, emblematic compositions on textured paper, printed in appealing brown or blue hues. His approach, to at times photograph from above eye-level, broke with the passé habits of professional portraitists and began a progressive photographic movement in Germany that reflected the concerns of similar pictorial groups that sprang up worldwide.

Publications
Kühn, H. (1988). *Heinrich Kühn: Photographien*. Munich: Residenz.

LANGE, DOROTHEA (1895–1965) American
Studied photography with Arnold Genthe (1915) and then Clarence White at Columbia University (1917–1918). Opened a portrait studio in San Francisco (1919–1934). In 1932, as the Great Depression deepened, Lange felt she must take her

camera out of her studio into the streets where she recorded labor strikes, demonstrations, and unemployment lines. A woman of great commitment, Lange dedicated her photography to revealing "the human condition" and social reform. Employed by the Farm Security Administration (FSA) from 1935 to 1942, she established her reputation as one of America's most gifted documentary photographers. She photographed all over the United States, producing a rich portrait of a poor America (publishing *An American Exodus* with husband, Paul Taylor, in 1939). Best known for her gripping images of migrant workers, including the iconic, *Migrant Mother* (1936) (see Figure 9), Lange continued to work for Federal agencies during WWII. In 1941 she was the first woman ever to be awarded a Guggenheim Fellowship. She closely advised Edward Steichen on the Family of Man exhibit at The Museum of Modern Art (MoMA) in 1955. During her later years, though slowed by illness, she traveled, taught, and worked freelance for several publications including *Life*, with photo-essays on the Mormons with Ansel Adams and later, Irish country women. Originally published in the *Focal Encyclopedia of Photography, 3rd edition* by Mary Alinder. Updated by E. Ken White.

Publications

Borhan, P. (2002). *Dorothea Lange: The Heart and Mind of a Photographer*. New York: Bulfinch Press.

Coles, R. and Heyman, T. (1982). *Dorothea Lange: Photographs of a Lifetime*. New York: Aperture.

Lange, D.(1939, 1999). *An American Exodus: A Record of Human Erosion*. With P. Taylor. New York: 1939 [new edition, Paris: Jean Michel Place 1999].

Meltzer, M. (1978). *Dorothea Lange: A Photographer's Life*. New York: Aperture.

LARTIGUE, JACQUES-HENRI (1894–1989) French photographer and painter

Raised in a wealthy French family, Lartigue was given a camera by his father at age six. Though his life as a photographer and a painter spanned most of the 20th century, he is most fondly remembered for his charming childhood and adolescent photographs, most of which were unknown outside his family circle until showcased in 1963 by John Szarkowski, curator at the Museum of Modern Art (MoMA). Living a privileged life, he candidly recorded the astounding events as the century turned (the first motorcars and airplanes) and the everyday quirks of life—his cousin skipping downstairs, seeming to float in the absence of gravity, and a family friend plunging backwards into a lake. Lartigue's uncanny perceptions and the capture of motion by the newer "snapshot" cameras has preserved a vernacular record of the end of France's belle époque and the advent of mechanized transportation. Images by Lartigue also recorded European fashions on the street and in societal circumstances, and one of his favorite personal themes—women. Despite his reputation now, during most of Lartigue's mature life he was known in art circles for his

paintings. Originally published in the *Focal Encyclopedia of Photography, 3rd edition* by Mary Alinder. Updated by E. Ken White.

Publications

Lartigue, J. H. (2003). *Jacques Henri Lartigue: A Life's Diary*. Paris: Centre Pompidou.

Lartigue, J. H. (1998). *Jacques Henri Lartigue, Photographer*. New York: Bulfinch Press.

Lartigue, J. H. (1970). *Diary of a Century*. Edited by R. Avedon. New York: Viking Press.

Lartigue, J. H. (1966). *Boyhood Photos of J. H. Lartigue, the Family Album of a Gilded Age*. Switzerland: Ami Guichard.

LAUGHLIN, CLARENCE JOHN (1905–1985) American

Self-taught photographer who spent most of his life in New Orleans, Louisiana, amid a personal library of over 32,000 volumes about fantasy. Laughlin is best known for his haunting images of Victorian-era architecture and surreal, ghost-like multiple exposures. His freelance photography began in 1934 and he also worked for the U.S. Army Corps of Engineers before serving in the U.S. military during WWII. After the war he was self-employed (1946–1967) selling views and details of architecture, giving lectures, and illustrating magazine articles. Influenced by Atget, Man Ray, and the French symbolist poets, Laughlin produced twenty-three themed groups of images such as Poems of the Interior World (begun in 1940). Most of his photographs were accompanied by voluminous writings and captions which often filled the reverse side of many prints. His black and white camera work is best represented by disquieting scenes of deserted architectural splendor (or ruins) and more self-conscious efforts to populate these spaces with veiled figures and spiritual ghosts. Admirers of his work may find an abundant intellect also revealed in his poetry and prose.

Publications

Brady, P. and Lawrence, J. H. (eds.) (1997). *Haunter of Ruins: The Photography of Clarence John Laughlin*. Boston: Bulfinch Press.

Davis, K. with Barrett, N. and Lawrence, J. (1990). *Clarence John Laughlin: Visionary Photographer*. Kansas City, MO: Hallmark Cards.

Laughlin, C. J. (1988). *Ghosts Along the Mississippi*. New York: Random House [New rev. ed.].

LEE, RUSSELL (1903–1986) American

Lee began his study of photography in 1935, ten years after earning a degree from Lehigh University (Pennsylvania) in chemical engineering. Photography, he thought, would aid his ability as a painter studying in San Francisco and at the Woodstock art colony (New York) in the early 1930s. His career took an abrupt shift when he was invited by Roy Stryker to join the government's Historical Section of the Farm Security Administration (FSA). Lee worked from 1936 to 1943 as

a prolific photographer in the FSA combining his keen sense of documentary with an engineer's precise mastery of lighting (especially flash photography). Stryker called him a "taxonomist with a camera." Besides making more FSA negatives than any other photographer, Lee was one of the first to utilize new color photography materials in his recording of people and events in Pie Town, New Mexico. After leaving the FSA, Lee continued to work for various government agencies until 1947 when he was hired by Standard Oil of New Jersey. His industrial images were printed in *Fortune* and in *The New York Times*. A second career spanned the years 1956–1973 while Lee was on the teaching faculty of the University of Missouri, and later at the University of Texas at Austin. Despite an education in engineering, Lee's images and teachings never underplayed the role of photography as an objective witness to call attention to the pride and prejudice that characterized society in the mid-1900s.

Publications

Hurley, J. (1978). *Russell Lee: Photographer*. Dobbs Ferry, NY: Morgan & Morgan.

LEIBOVITZ, ANNIE (1949) American

Born in Connecticut, educated at the San Francisco Art Institute (BFA, 1971), Leibovitz ascended to the very apex of contemporary portrait photography at the beginning of the 21st century. Her most respected work is of celebrity and literati personalities often seen in spectacular display in the pages of *Vanity Fair* as cover shots or lavish fold-out group portraits and portfolios. She is also the artist of many notable photo-essays and advertising campaigns, especially the celebrity icons photographed for the American Express media ads (1987). Her first involvement with photography came in Japan when her father was stationed there with the U.S. military. After studying painting in college, Leibovitz' first break came when she was retained as chief photographer for a start-up West Coast publication called *Rolling Stone* (1973). Perhaps her most memorable image is the nude John Lennon with the clothed Yoko Ono—an image made the same day Lennon was murdered in New York City (1980). By 1983, Leibovitz was hired by Condé Nast to be the primary talent to photograph for *Vanity Fair*. Most of Leibovitz' work (color and black and white) exhibits her talent for incorporating environment, props, or an idiosyncratic gesture to resonate with her subjects' persona or "public trademark." Leibovitz' extraordinary range of subjects has spanned from portraits of athletes at Atlanta's Olympic Games to a more recent book collaboration with Susan Sontag, *Women* (1999).

Publications

Leibovitz, A. (1984). *Annie Leibovitz: Photographs*. Introduction by T. Wolfe. New York: Pantheon/Rolling Stone.
Leibovitz, A. (1992). *Photographs, Annie Leibovitz*. With I. Sischy. New York: Harper Collins.

FIG. 52 Annie Leibovitz. Photograph by Nancy M. Stuart. September 26, 1991.

Leibovitz, A. (1999). *Women*. Introduction by S. Sontag. New York: Random House.

LEVINE, SHERRIE (1947) American

Levine earned her MFA degree in photo/printmaking at the University of Wisconsin in 1974. She became a lightning rod for charged criticism in the early 1980s after she was thrust into the forefront of the new post-modernist vanguard by an influential essay by Douglas Crimp in October called "The Photographic Activity of Post Modernism" (Winter 1980). She was nominated by Crimp to represent the art gesture of "appropriation" whereby an artist uses (transforms, recontextualizes, adds text to) existing art or photographs to make a commentary or create "critical discourse." Levine had made photographic copies of well-known images by Edward Weston, Eliot Porter, and Walker Evans (all made from existing book reproductions) and exhibited the copies, uncropped and only altered by the act of photographic reproduction with titles like "After Edward Weston (by Sherrie Levine)." Levine's intention was to offer her art that questioned originality, the patriarchal system of art "masters," and the fundamental nature of any art that utilized a photographic process to inscribe creativity and aesthetic value onto an art object (as Walter Benjamin had outlined in the 1930s). The debate, carried on in art journals and in universities for the next two decades, influenced a new generation of artists and critics for whom "the gesture" (often informed by Marxist and Feminist theories) superseded the modernist "object."

LEVINTHAL, DAVID (1949) American
Raised in California (art degree, Stanford 1970) Levinthal later earned an MFA at Yale where cartoonist, Garry Trudeau, was a classmate and early collaborator on the book, *Hitler Moves East* (1977), which featured Trudeau's text and Levinthal's table top photographs of toy soldiers in a mock-documentary style that was a precursor for the emerging post-modernist movement in photography. The use of toys, dolls, and scale models in the studio to produce faux documents that offer variable comment upon history and culture was a trademark of Levinthal's many themes and book publications in the 1980s and 1990s. Levinthal's progression of themes has evolved from sly parody of the Western cowboy to more barbed visual pronouncements about T&A pin-ups, bondage, the Holocaust, pornography, and racism. Each theme, usually displayed in saturated colors, has been an exegesis of spectator voyeurism. Using ambiguous space and thin slices of selected focus, Levinthal offers viewers an artificial body or dramatic pose that transforms cultural stereotypes into visual codes that viewers recognize as reminiscent of past memory — perpetuated in modern society by toymakers and tchotchke vendors. Levinthal's most intense work (*Desire, Mein Kampf, Blackface, XXX*) has raised controversy when critics can't agree on the propriety of an artist who trumps history with seductive images that are interpretations of society's coercion, lust, and depravity.

Publications
Levinthal, D. (2001). *David Levinthal: Modern Romance.* Essay by E. Parry. Los Angeles: St. Ann's Press.
Levinthal, D. (1997). *David Levinthal: Work from 1975–1996.* New York: ICP.
Levinthal, D. (1993). *Desire.* Essay by A. Grundberg. San Francisco: Friends of Photography.

LEVITT, HELEN (1949) American
By the time she turned sixteen, Levitt decided to become a professional photographer having learned darkroom practice from her job assisting a Bronx portrait photographer. Influenced by Walker Evans, with whom she studied (1938–1939), and by the work of Cartier-Bresson, Levitt purchased a Leica camera (with a right angle finder) to be a surreptitious photographer of street life. Her most notable work captures the parade of human comedy and mini-drama on the streets of New York, especially children at play. She was given her first solo exhibition at The Museum of Modern Art (MoMA) by the Newhalls in 1946. She had work published in *Fortune, Harper's Bazaar, Time*, and *PM Weekly*. James Agee became an admirer of her work and collaborated on two films and a book with Levitt. She is also known for her pioneer work using still color transparencies beginning in the late 1950s after more than a decade as a film maker. With the exception of images made in Mexico (1941), Levitt's photographs provide a candid, apolitical, look at the ebb and flow of life in her beloved New York — sidewalks, vacant lots, tenement stoops inhabited by children who paid no attention to the dark clad woman with the quiet, but omniscient little camera. She taught at Pratt Institute in the mid-1970s.

Publications
Levitt, H. (1965, 1981). *A Way of Seeing: Photographs of New York.* With J. Agee. New York: Viking Press (reprinted in 1981).
Phillips, S. and Hambourg, M. (1991). *Helen Levitt.* San Francisco: San Francisco Museum.

LINK, O. WINSTON (1914–2001) American
Born in Brooklyn, Link pursued an education at nearby Polytechnic Institute in civil engineering. He worked at several technical and industrial research jobs at Columbia University before deciding to teach himself photography, opening a commercial studio in New York in 1942. After WWII Link did mostly industrial photography. In the mid-1950s one of his assignments took him through West Virginia where he photographed rail lines and locomotives of the Norfolk & Western Railroad. His fascination with the prowess and photogenic character of the steam locomotive prompted him to seek special permission from the rail company executives to have extensive access to the railroad equipment and personnel. With this agreement he began to stage elaborate night exposures of the steam locomotives in settings that showed the juxtaposition of the railway to the rural villages and lifestyle of 1950s America. Using massive reflectors and banks of flashbulbs, Link made large-format exposures (2400 negatives) of the night landscape, people, and locomotives as the engines belched white steam on cue. Several well-known pictures from this series feature municipal swimming pools, drive-in movie theaters and the like as citizens of the nearby towns pose candidly to create a surreal blend of organic life with the gleaming black locomotives. These photographs only gained popularity after they were featured in an article in *American Photographer* in 1982, followed by an impressive monograph of Link's work in 1987.

Publications
Link, O. W. (1995). *The Last Steam Railroad in America: From Tidewater to Whitetop.* With T. Garver. New York: Harry N. Abrams.
Link, O. W. (1987). *Steam, Steel & Stars: America's Last Steam Railroad.* With T. Hensley. New York: Harry N. Abrams.

LIST, HERBERT (1907–1975) German
As a young student and protégé in his father's coffee import business, List traveled widely to the Americas before being encouraged as a photographer by Andreas Feininger in the United States. Returning to Europe in the early 1930s, he was influenced by Pittura Metafisica and the Surrealists (moved to Paris in 1936). His black and white images prior to WWII are divided between portraits of leading European artists and enigmatic scenes, with simple compositional elements, that are usually bathed in Mediterranean sunlight. The latter group derived more influence from the painting style of de Chirico

than from the contemporary photographs by Man Ray or Max Ernst. Some of List's most important images were made in Greece, outdoors, unlike many other surrealists who primarily used studios, interiors, and night settings. List had images published in *Verve*, *Harper's Bazaar*, and *Life*, dedicating his work to photojournalism in Munich after WWII (extensively contributing to *Du* between 1945–1960). He made no photographs after 1960 preferring to collect Old Master and Italian drawings.

Publications
List, H. (1993). *Hellas.* Munich: Schirmer/Mosel.
List, H. (1983). *I Grandi Fotograf.* Milan: Gruppo Editoriale Fabbri.
List, H. (1976, 1980). *Herbert List — Photographien 1930–1970.* Munich 1976 [reprinted by London: Rizzoli 1980].
List, H. (1953). *Licht über Hellas.* Munich: Verlag.

LYNES, GEORGE PLATT (1907–1955) American

A self-taught photographer, Lynes' first business was as owner of a small publishing firm. He began making portraits in the mid-1920s and was fortunate to be able to travel to Europe where he earned early support for his photography from Gertrude Stein. In 1923 he opened a studio in New York. Alexey Brodovitch, art director for *Harper's Bazaar*, hired Lynes for some early fashion assignments. Lynes utilized an ample studio for large-format work often collaborating with the painter, Pavel Tchelitchev, who helped design and construct backgrounds. Commercial and fashion images by Lynes later appeared in *Vogue* and *Town & Country*. Artistically, he is best known for his homoerotic male nudes and his mythology studies produced in the studio with dramatic lighting of muscular limbs and torsos. During the 1930s and 1940s Lynes made images for Lincoln Kirstein's American Ballet Company (Kirstein, a prep school classmate of Lynes). The photographer also enjoyed the patronage of Alfred C. Kinsey in the 1950s but, unfortunately, this alliance came too late to preserve some of Lynes' personal work, since the artist himself destroyed many negatives and prints that he feared would reveal his fascination with male sexuality.

Publications
Crump, J. (1993). *George Platt Lynes, Photographs from the Kinsey Institute.* Boston: Bulfinch Press.
Kirstein, L. (1960). *George Platt Lynes Portraits 1931–1952.* Chicago: Art Institute of Chicago.
Woody, J. (1981). *George Platt Lynes: Photographs, 1931–1955.* Pasadena, CA: Twelvetrees Press.

LYON, DANNY (1942) American photographer and filmmaker

Lyon, a New York native, studied history at the University of Chicago (BA, 1963) and became involved in the growing Civil Rights movement. He was self-taught as a photographer and his first images document this social struggle. It was a pattern to be repeated throughout his career — to actively live with

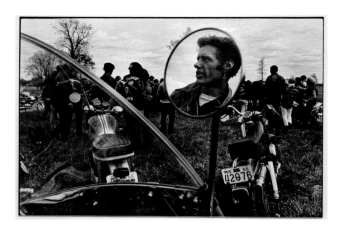

FIG. 53 CAL, Elkhorn, Wisconsin, ca. 1965–1966. Gelatin silver print. Danny Lyon. (Courtesy of George Eastman House Collection, Rochester, New York.)

subgroups or participate with segments of society he would document. He became a member of a Chicago motorcycle gang, The Outlaws, before producing the book, *The Bike Riders* in 1968. Later he spent time with construction workers, stock car racers, prison inmates, and peoples of the Third World to make his books and films. *Conversations with the Dead* (1971) was published with images, interviews, and writings of Texas prison inmates with whom he was allowed to visit intimately for a few months. Later work by this Jewish Caucasian has been especially empathetic with the plight of Latinos and Native Americans (he has lived in New Mexico since the early 1970s). Beginning in 1980 he has produced several autobiographical works (*Knave of Hearts*, 1999) and, among his films, *Little Boy* (1977) is a characteristic gem. Lyon remains a deeply committed artist/humanitarian who has expanded the public's awareness of individuals at the fringes of late 20th century society.

Publications
Lyon, D. (1981). *Pictures From the New World.* Millerton, NY: Aperture.
Lyon, D. (1969, 1980). *The Destruction of Lower Manhattan.* New York: Macmillan [reprinted by London: Rizzoli: 1980].
Lyon, D. (1980). *The Paper Negative.* Bernalillo, NM: Bleak Beauty.

LYONS, NATHAN (1930) and JOAN (1937)

Both American
This dynamic pair, married in 1958, have lived most of their lives in Rochester, New York, and are both associated with the Visual Studies Workshop, (VSW) founded by Nathan Lyons in 1969 after working for a decade at the George Eastman House. Both received college degrees from Alfred State University (SUNY) in 1957. Nathan is a true renaissance man in photography — artist, author, curator, historian, educator, archivist,

activist, mentor. He is best known as an image-maker for a lifelong trilogy of publications that are sequenced images of the urban landscape. Starting with *Notations in Passing* (1974), the work is densely referential to American culture, symbols, and clichés. For some critics, the work could be labeled as "street photography" or as "equivalents," but the intellect that knits the image sequences together surpasses these insufficient comparisons. In addition to tireless work for the medium (editing/writing for *Image* and *Aperture*), Nathan Lyons founded Afterimage in 1972, was a founding member and the first Chairperson of the Society for Photographic Education (1963), and has the international respect of almost every person in the realm of photography.

Joan Lyons shares her husband's passion for photography, publishing, and education. She founded the VSW Press in the 1970s and teaches at VSW. Her artwork is generated—and modified—by various image systems (xerography, print-making, non-silver processes), and her expressive ideas usually result in artist books whose themes are often self, family relationships, and women's issues.

Publications

Lyons, N. (2003). *After 9/11*. New Haven, CT: Yale University Press.

Lyons, N. (1999). *Riding 1st Class on the Titanic—Photographs by Nathan Lyons*. Andover, MA: Addison Gallery of Art.

Lyons, J. (1981). *Seed Word Book*. Rochester, NY: Visual Studies Workshop.

Lyons, J. (1977). *Abby Rogers to her Grand-daughter*. With text by A. Rogers. Rochester, NY: Visual Studies Workshop.

Lyons, J. (1973). *Wonder Woman*. With J. McGrath. Rochester, NY: Visual Studies Workshop.

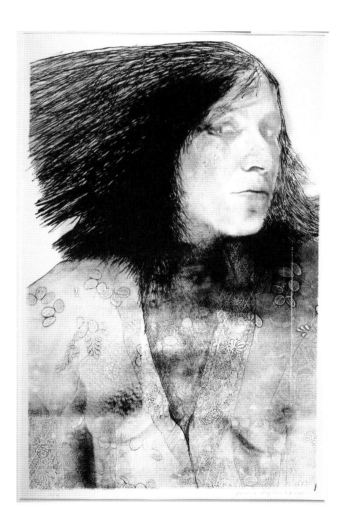

FIG. 54 Untitled (woman with hair) 1974. Offset lithograph from Haloid Xerox masters. Joan Lyons. (Courtesy of George Eastman House Collection, Rochester, New York.)

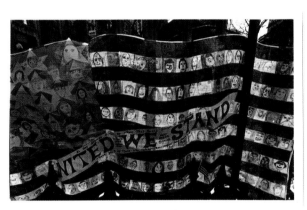

FIG. 55 Paper construction of American Flag with children's drawings of faces and detail of a poster with expressions of sympathy. Nathan Lyons. *After 9/11* photographs by N. Lyons with a poem by Marvin Bell 2002. (Courtesy of George Eastman House Collection, Rochester, New York.)

MAN, FELIX (HANS BAUMANN) (1893–1985)
German and British

As a student, Man studied art history at Freiburg University and had made his first photographs at age ten. Drafted into the German army during WWI, he made documentary photographs of the Western Front with a Vest Pocket Kodak (negatives later destroyed in WWII bombing). After 1919 he resumed art studies in Munich and Berlin, and worked as a layout artist/photographer for the news agency Dephot (Deutscher Photodienst). He published over one hundred photo-essays in *Munchner Illustrierte Presse* (MIP) and *Berliner Illustrierte Zeitung* (BIZ) from 1929–1932. He used the Ermanox and Leica cameras for spontaneous reportage. His most remarkable published work was *A Day with Mussolini* (1931, *MIP*) made with the small camera and available light which lent an air of authenticity to the scenes. Mussolini did not notice at the time that Man was making candid, "unofficial" images of Il Duce using the Ermanox. The photographs were segments of reality taken from the flow of actual events, not staged or posed. In 1934, due to rising Nazi prominence, Man moved to London where he spent the rest of his career (naturalized British citizen, 1948). With Stephan Lorant he founded *Weekly Illustrated* in 1934 and later worked for the *Daily Mirror* (pictures credited to his moniker, "Lensman"), and the new *Picture Post* (1938–1945). In England, Man's subjects were non-studio portraits, location fashion, country life, and color studies. He also contributed to *Harper's Bazaar* and *Life* in the 1950s until he retired to study the history of lithographic art.

Publications
Man, F. (1948). *Man With Camera: Photographs from Seven Decades*. New York: Schocken.

MANN, SALLY (1951) American

Mann has lived her life in a small town in the Shenandoah Valley in Virginia (except for years at Bennington College, Vermont). She earned an MA (1975) in writing from Hollins College, although her considerable talent seems to be in recognizing and shaping intricate visual statements. Her work could be deemed "traditional" in its execution with an 8 × 10 view camera from which she makes exquisite black and white prints sometimes using wet plate collodion negatives. She is best known for a series of work that documents her own family, especially the lives of her three children (images of husband, Larry, have yet to be included in much of her public work). *Immediate Family* was published in 1992 (concurrent exhibition) and instigated intense controversy over the explicit frankness and intimacy revealed in some photographs of the children in various states of nudity. The debate about the propriety of showing adolescent sexuality or loss of innocence is, perhaps, not one to be won or lost on the photographic evidence, but waged by those with a variance in their interpretations of those images. Her work is often compared to that of Emmet Gowin (also originally from Virginia), however, Mann's children seem to animate her strongest work from the 1980s and 1990s—the unvarnished passage from childhood to young adult. Mann has previously photographed girls at the age of twelve and is working on landscape images of Virginia, Georgia, and other locations (Civil War battlefields). Her talent as a writer/artist is elegantly demonstrated in her most recent publications. In *Deep South* (2005) the images are more ethereal and mystical as she allows the hand-applied collodion more autonomy in its marriage with light.

Publications
Mann. S. (2005). *Deep South*. Boston: Bulfinch Press.
Mann, S. (2003). *What Remains*. New York: Bulfinch Press.
Mann, S. (1994). *Still Time*. New York: Aperture.
Mann, S. (1988). *At Twelve: Portraits of Young Women*. New York: Aperture.
Mann, S. (1938). *Second Sight*. Boston: David R. Godine.

MAPPLETHORPE, ROBERT (1946–1989) American

Mapplethorpe achieved saturated recognition for his elegant photographic still life, portraits, and nudes, before dying tragically of AIDS. Born in New York to a Catholic family, he studied at Pratt Institute (drawing, sculpture) before becoming a photographic artist (he had considered a career as a musician). His interest in camera images was piqued by access to closed collections maintained by John McKendry (curator at Metropolitan Museum of Art) and Sam Wagstaff. He started taking Polaroid images and was influenced by Warhol's art. Early portraits were of Lisa Lyon and Patti Smith. Mapplethorpe's work was presented in a relatively modernist, aestheticized style and his best known photographs featured nudes of black males and images with overt homoerotic subjects. The Corcoran Gallery canceled a solo exhibit, The Perfect Moment, by Mapplethorpe in 1989 due to pressure from groups voicing opposition to depictions of homosexual eroticism and the fact that the artist had received some funding from the National Endowment for the Arts. The show was put on in Cincinnati in 1990 and this resulted in litigation over obscenity charges (subsequently, charges against the show sponsors resulted in an acquittal). The death of the artist from AIDS just before this brought about a clamorous collision between art, reality, morality, and legal issues. At the same time, the "culture wars" between liberal and conservative viewpoints flared up in many arenas. As an indirect consequence of Mapplethorpe's photographs, public funding for the arts suffered drastic curtailment in the 1990s but the art world, for the most part, became more steadfast as a defender of freedom of expression.

Publications
Danto, A. C. (1996). *Playing With the Edge: The Photographic Achievement of Robert Mapplethorpe*. Berkeley, CA: University of California Press.
Mapplethorpe, R. (1999). *Pictures: Robert Mapplethorpe*. Edited by D. Levas. New York: Arena Editions.
Mapplethorpe, R. (1983). *Lady: Lisa Lyon*. New York: St. Martins.

Mapplethorpe, R. (1980). *Robert Mapplethorpe: Black Males*. Text by Edmund White. Amsterdam: Galeria Jurka.

Marshall, R., Howard, R. and Sischy, I. (1988). *Robert Mapplethorpe*. New York: Whitney Museum of Art.

Morrisroe, P. (1995). *Mapplethorpe*. New York: Papermac 1995.

MARK, MARY ELLEN (1940) American

Mark is among an elite group of photographers known around the world for her incisive style of documentary work that is both engaging and sensitive. Her subjects often seem exotic or unusual but Mark cultivates an intimate quality in the pictures that renders familiarity without diminishing the very human circumstances of the people in front of her camera. Before earning an MA (1965) in photojournalism at the University of Pennsylvania, Mark had bought her first Leica and had already traveled on a Fulbright grant to Turkey and later, India. By 1969 she had assignments doing production stills for films like Satyricon with Fellini. Her work has been published in *Look*, *Life*, *Time*, *New York Times Magazine*, *Vogue*, and *Vanity Fair*, only to name a few among a hundred periodicals. She was a member of Magnum from 1977 to 1981. High-quality book publications have been a major goal of Mark's involvement with defined subcultures in society for almost three decades. Featured among these are teenage drug users in Seattle, women in a mental hospital, prostitutes in India, Mother Teresa, circus performers, and more recently, sets of identical twins (using Polaroid 20 × 24). A characteristic of Mark's considerable talent is her ability to form a trusting relationship with her subjects to provide viewers with a compassionate, first-person encounter — almost as if Mark is a surrogate for the general public who would never otherwise have such privileged access to these vital human dramas. The emotions and intellects that Mark has affected with her photographic oeuvre is truly one of the outstanding contributions to the history of the medium.

Publications

Fulton, M. (1991). *Mary Ellen Mark: 25 Years*. Boston: Bulfinch Press.

Hagen, C. (2001). *Mary Ellen Mark*. London: Phaidon Press.

Mark, M. E. (2003). *Twins*. New York: Aperture.

Mark, M. E. (1993). *Indian Circus*. San Francisco: Chronicle Books.

Mark, M. E. (1988, 1991). *Streetwise*. Philadelphia: University of Pennsylvania Press [reprinted by Aperture, 1991].

Mark, M. E. (1981). *Falkland Road: Prostitutes of Bombay*. New York: Knopf.

Mark, M. E. *Ward 81*. Text by K. Jacobs. New York: Simon & Schuster.

McBEAN, ANGUS (1904–1990) Welsh

Born in South Wales, McBean studied architecture before settling for a banking clerk's job. By 1925 family circumstances forced him to move to London where he worked for a prominent antiques dealer for seven years (sales and restoration).

FIG. 56 Tiny Seattle, 1983. Gelatin silver print. Mary Ellen Mark. (Courtesy of George Eastman House Collection, Rochester, New York.)

He learned photography from Hugh Cecil and began constructing and photographing masks. This series of events lead to McBean's eventual talent as one of the world's leading theatrical photographers. He is best known for his work constructing elaborate studio sets, mask making, costuming, manipulation techniques — all to produce personality and stage production images that have a very surreal look — almost like photographic versions of a Salvador Dali landscape. He photographed stage versions of McBeth sixteen times in four decades. Noted celebrity subjects include Audrey Hepburn, Paul Scofield, Lawrence Olivier, and Vivian Leigh (the later photographed by McBean dozens of times over thirty years). Many of McBean's photographs are stark illusions and startling depictions of lifelike heads and torsos, pieces of classical architecture, emerging from a sandy wasteland. Later in his career he photographed the Beatles for 1963 and 1970 album covers, and did color fashions for *Vogue* in the

mid-1980s. His annual Christmas card creations, sent to friends since 1936, have become a valuable auction item. In 1968 Harvard University purchased all of his theater negatives — 48,000 images weighing four and a half tons.

Publications

McBean, A. (1982). *Angus McBean*. Text by A. Woodhouse. Foreword by [Lord] Snowdon. London: Quartet Books.

MCCULLIN, DON (1935) British

McCullin studied painting for two years before joining the Royal Air Force in 1954 where he became a photo assistant for aerial reconnaissance. By 1959 he began reportage with his camera and had pictures of a London youth gang published in *The Observer*. He won acclaim for 1961 images of the building of the Berlin Wall. As a conscientious believer in the power of photography to effect change, McCullin decided to try to curtail war and brutality by documenting conflict to reveal the true horror of violence. He covered the war in Cyprus in 1964 and later the Vietnam War (graphic images of the Tet offensive of 1968). He has been on the front lines of wars and human disasters (famine, genocide) around the world — Congo, Israel, Biafra, Cambodia, Lebanon, Pakistan, Northern Ireland, and India. For a time he was a member of Magnum. Book publications include *The Destruction Business* (1971) also published in the United States as *Is Anyone Taking Any Notice?* (1973). After many years on staff with *The Sunday Times* he went back to freelance assignments in 1985. In the early 1990s he had gone into seclusion in England, trying to force himself to make more lyrical "art" photographs of still life and landscape, often utilizing antique photo processes. Self-assessment of this activity as a non-fulfilling pursuit brought him back to the forefront of social activism. Since 2000 he has worked in Africa for the Christian Aid Society and has been active in AIDS awareness campaigns.

Publications

McCullin, D. (2005). *Don McCullin in Africa*. London: Jonathan Cape.

McCullin, D. (2001). *Don McCullin*. London: Jonathan Cape.

McCullin, D. (1992). *Unreasonable Behaviour*. New York: Knopf.

McCullin, D. (1980). *Don McCullin: Hearts of Darkness*. Introduction by J. LeCarré. London: Random House.

MEATYARD, RALPLH EUGENE (1925–1972) American

Born in Illinois, Meatyard attended Williams College on the Navy V-12 program. He became a licensed optician in 1949 after working for Dow Optical in Chicago. Moved to Lexington, Kentucky, for an optician job, became interested in photography, and sought out Van Deren Coke as a teacher/mentor; bought twin lens reflex in 1950. He also studied with Minor White but thought of himself as a "primitive" photographer. Meatyard's photographic work is primarily square, black

and white images of children and anonymous figures wearing Halloween masks in rural fields, abandoned structures, or barns. He often experimented with movement of one or more human subjects producing enigmatic blurred features. The work creates macabre overtones with doll images and nightmare juxtapositions of innocence (children) and potential danger. Many critics have attributed visual elements in Meatyard's photographs to metaphors for death and decay. He was influenced by literary sources and his final theme, before an untimely death, was *The Family Album* of Lucybelle Crater (published posthumously in 1974). Characters and scenes in this series are taken somewhat literally from a Gertrude Stein story of a Southern lady. Meatyard's work appeared in print in the early 1970s just as university art programs in the United States began to experience a growing trend in creative photography; this, and the appeal of a psychological dimension, may explain the longevity of this man's influence.

Publications

Coke, V. D. (1976). *Ralph Eugene Meatyard: A Retrospective*. Normal, IL: Center for Visual Arts, Illinois State University.

Meatyard, R. E. (2004). *Ralph Eugene Meatyard*. Essay by G. Davenport. New York: ICP.

Tannenbaum, B. (1991). *Ralph Eugene Meatyard: An American Visionary*. Akron: OH: Akron Art Museum.

MEISELAS, SUSAN (1948) American

Meiselas has a BA degree (1970) in anthropology from Sarah Lawrence College and an MA in education from Harvard where she took her first photography course in 1971. She consulted with Polaroid Corporation on strategies for visual education in the nation's classrooms. Her earliest documentary book, *Carnival Strippers* (1976), is distinguished by her method of obtaining many of the images — she disguised herself as a man to gain entry to strip shows with her concealed camera. As a gatherer of "fact," she also made behind-the-scene images and sound recordings of women strippers she interviewed. Much of her career has been marked by involvement with the cultures and conflicts in Central America, particularly Nicaragua. Due to her tenacity and resourcefulness, she produced (and later published) an incredible record of civil war in Nicaragua (1978–1979) after determining that she needed to put herself in jeopardy in order to make the most compelling photographs. When she arrived alone in Managua she had little equipment, no press credentials, and could barely speak Spanish. She later documented civil strife in El Salvador, risking her life in areas where the government had banned all journalists. Her color photography documenting civil unrest is not so much a recording of "war" as it is a multi-layered view of a people's struggle to define and preserve their culture, religion, and methods of government. Meiselas has been a member of Magnum since 1976 and has had work published in *Time*, *Life*, *The New York Times*, *GEO*, and *Paris Match* among many other titles. She recently has documented events and peoples in Kurdistan and New Guinea.

FIG. 57 Awaiting Counterattack by the Guard, Matagalpa, 1978. Color print, chromogenic development (Ektacolor) process printed 1985. National Origin: Nicaragua. Susan Meiselas, Magnum Photos. (Courtesy of George Eastman House Collection, Rochester, New York.)

Publications

Meiselas, S. (2001). *Pandora's Box*. London and New York: Trebruk.

Meiselas, S. (1981). *Nicaragua From June 1978–July 1979*. New York: Pantheon.

Meiselas, S. (1997). *Kurdistan: In the Shadow of History*. New York: Random House.

METZGER, RAY (1931) American

Metzger received his MS degree from the Illinois Institute of Technology in 1959 where he studied with Harry Callahan and Aaron Siskind. Prior to that he graduated from Beloit College and had begun photographing at the age of fourteen. His innovative contribution to creative photography in the 1960s was making large composites of still images. Assemblages of 50 or more prints measured 4 × 5 feet; the photographs, usually of banal urban scenes, would have slight alterations between them but from a distance the mosaic became a pattern of shapes. The rows and columns formed a synthesis that might resemble sheet music or an industrial form like a manifold or metallic grid. In fact, Metzger had written in his journals that as a young artist he worked with kinetic sculptures influenced by music and flux — percussion patterns that manifest themselves in his abstract compositions. The photographs are fragments linked by juxtaposition in a cumulative regimen that could be inspected one image (photographic print) at a time and, at least in theory, they form a cinematic chronology without the need for actors or any implied drama. Another theme of Metzger's (Sand Creatures, 1979) was photographs made at Atlantic City of random sunbathers sprawled out on the beach (taken from a slight aerial position). The contrast patterns of shadow and highlight, bathing suit and flesh, created a similar rhythm of formal design, but not as syncopated

as the mosaic murals. A later series, Pictus Interruptus, included out-of-focus objects held up in front of the camera lens partially obscuring the scene. Recent images by Metzger have come from the organic landscape. Metzger has taught at the Philadelphia College of Art for four decades.

Publications

Tucker, A. W. (1984). *Unknown Territory: Photographs by Ray Metzger*. Houston: New York: Aperture.

Turner, E. H. (2000). *Ray K. Metzger: Landscapes*. New York: Aperture.

MEYEROWITZ, JOEL (1938) American

Meyerowitz enjoys a reputation as one of the most successful photographers to begin using large-format color materials in the 1970s when black and white was the palette of serious artists. Born in New York, Meyerowitz earned a degree in medical illustration and painting from Ohio State in 1959 and eventually took a job as an advertising art director. As part of his art directing job one day he had to accompany Robert Frank on a location shoot. Meyerowitz says his life changed completely after that (1963). He began using color slide film and then black and white film to make "street photographs" (other influences were Cartier-Bresson and Winogrand). His rapid assimilation of many photographic techniques led him to purchase an 8 × 10 Deardorff that was exactly as old as he was. His first award-winning book, *Cape Light* (1978), included photographs that captured the essence of light and the nuance of color at the cape where sky meets water and sand seen through misty hues (at f/90 and 1/2 second). Meyerowitz' other work includes lyrical views of St. Louis near the Arch, redheads at the cape, flowers, and work from Tuscany. Meyerowitz lives in lower Manhattan; on 9/11/2001 he was away from the city. When he was able to return to Manhattan, he took it upon himself to be the photographer for posterity's views of Ground Zero and the long progress of recovery and renewal. His story of how he got exclusive access to the site of the former World Trade Center buildings should accompany his poignantly bittersweet photo-essay. The U.S. State Department has already circulated dozens of his complete exhibitions on this subject to tour the world. Meyerowitz has also co-edited a ponderous book on the history of street photography.

Publications

Meyerowitz, J. (2003). *Tuscany: Inside the Light*. Text by M. Barrett. Boston: Bulfinch Press.

Meyerowitz, J. (1996). *At The Water's Edge*. Boston: Bulfinch Press.

Meyerowitz, J. (1990). *Redheads*. New York: Rizzoli.

Meyerowitz, J. (1983). *Wild Flowers*. Boston: New Graphic Society.

Meyerowitz, J. (1980). *St. Louis and the Arch*. Boston: Bulfinch Press.

Westerbeck, C. (2005). *Joel Meyerowitz*. New York: Phaidon Press.

FIG. 58 Couple holding hands, ca. 1964–1966. Gelatin silver print. Joel Meyerowitz. (Courtesy of George Eastman House Collection, Rochester, New York.)

MICHALS, DUANE (1932) American

As a child, Michals, born near Pittsburgh, liked to draw and to look at picture books in the local library. He went to the University of Denver to study art (BA, 1953) and soon was employed as a paste-up artist (*Look* magazine) and art director. He borrowed a camera to take on a trip to the USSR in 1958 and returned with a desire to change his career to photography. He was self-taught in darkroom rudiments and by 1966 began work on sequences of tableaux scenes that have become his signature contribution to creative photography. Strongly influenced by artists Magritte and Balthus, Michals uses simple interiors, a few actors (often himself), sparse props, and a psychological precept to create a dream-like sequence told in the space of three to ten images. Since the mid-1970s, handwritten text endorses the surreal drama to validate memories and aspects of our own dreams or premonitions about the mystery of relationships, metaphysics, or the afterlife. One of Michals' most popular sequences is "Things Are Queer" (1973)—a visual illusion of scale and presumed chronology which is turned inside-out in ten short steps. Much of Michals' work uses mirror reflections, double-exposure, blur, and the simple construct of suggestion to move the viewer through a paradoxical interpretation about the artist's favorite themes—sex, mortality, and spirituality. Parallel success as a commercial photographer has brought Michals a highly lucrative career in published portraiture and fashion (*Vogue, Mademoiselle, Esquire, The New York Times*). With a bare economy of production, no digital manipulation, and a potent respect for the human imagination, Michals remains one of the most influential artists for current generations of photographers.

Publications
Livingstone, M. (1997). *The Essential Duane Michals*. Boston: Thames & Hudson.

Michals, D. (1990). *Duane Michals: Now Becoming Then*. Essay by M. Kozloff. Altadena, CA: Twin Palms Publishing.
Michals, D. (1988). *Album: The Portraits of Duane Michals: 1958–1988*. Pasadena, CA: Twelvetrees.
Michals, D. (1986). *The Nature of Desire*. Pasadena, CA: Twelvetrees.
Michals, D. (1976). *Real Dreams: Photostories by Duane Michals*. Danbury, NH: Matrix Publishers.
Michals, D. (1970). *Sequences*. New York: Doubleday.

MILLER, LEE (1907–1977) American photographer and model

Born ("Elizabeth") in Poughkeepsie, New York, Miller drew much inspiration from her father, an avid photographer and inventor. After modeling for Steichen and Horst, she moved to Paris and became a model and assistant (and lover) to Man Ray (1929–1932) where she learned the technical craft and became an accomplished photographer of the avant-garde circle. She opened her own New York studio in 1932 and was successful in advertising, fashion, and portraits, eventually working solely for *Vogue*. Married an Egyptian, Aziz Bey, and moved to Cairo (1934), but that relationship dissolved and she moved to England and married (1947) the author and prominent art collector, Roland Penrose. During WWII she served as a U.S. Army war correspondent. After some documentary work for *Vogue* about the war's effects on England, she boldly got herself transported just behind the Allied lines near the Normandy beaches. Miller was one of the first to enter and photograph the German concentration camps of Buchenwald and Dachau. Later she lived in Hitler's Munich apartment and was photographed bathing in Hitler's bathtub (photo by partner, D. Scherman). After 1945 her life was enriched by the comings and goings of the art elite at the Penrose estate in East Sussex. Miller accumulated over 1000 negatives of Picasso over 20 years. Her career, documented in several biographies, was fast paced and certainly, through a combination of myth and truth, one of the most fascinating in 20th century photography.

Publications
Burke, C. (2005). *Lee Miller: A Life*. New York: Knopf.
Calvocoressi, R. (2002). *Portraits from a Life: Lee Miller*. New York: Thames & Hudson.
Livingston, J. (1989). *Lee Miller, Photographer*. New York: Thames & Hudson.
Penrose, A. (1992). *Lee Miller's War: Photographer and Correspondent with the Allies in Europe 1944–1945*. Edited by A. Penrose. Boston: Bulfinch Press.
Penrose, A. (1985). *Lives of Lee Miller*. New York: Holt, Rinehart & Winston [biography].

MISRACH, RICHARD (1949) American

Native of California, Misrach earned a BA in psychology from University of California-Berkeley (1971) and was self-taught in photography. His early work was of street people who lived near the Berkeley campus, but by the early 1980s, he shifted

his focus to the Southwest deserts lying beyond the Pacific coastal range. Night flash exposures of cactus were prominent in their toned, aesthetic appeal, but Misrach's mature work has evolved into a series of "cantos" (more than 20), which address complex issues of environment, pollution, and the notion of "beauty." The 18th century philosopher, Burke, could have written his essay on "The Beautiful and the Sublime" by seeing only Misrach's photographs. His landscape studies are sensory, precise records of the past, present, and future of American deserts littered with the remnants of human toil and discard — atomic craters, animal carcasses, tourist detritus, huts, bomb casings, toxic waste, and other archaeological debris. The cantos are given numbers and brief descriptions: Canto XVII: The Skies (The Flood, The Fire, The Pit). There is mixed optimism and apprehension in his oeuvre; amid the crystal atmosphere of a clichéd paradise we see the Space Shuttle, a distant freight train, and sun-gilded mountains. Misrach continues to explore and distill his experiences watching the desert, pointing out clues, sounding the alarm. His seductive perfection (with the camera and in his control over award-winning printed books) has an undertone of our mortal fear — toxic contamination, infection, destruction by fire or submersion in a catastrophic flood (if the bombs don't kill us first). Recently he has expanded his sentry territory to areas around the Mississippi River in Louisiana (prior to Katrina).

Publications

Misrach, R. (2000). *The Sky Book*. Santa Fe, NM: Arena Editions.

Misrach, R. (1992). *Violent Legacies; Three Cantos*. New York: Aperture.

Misrach, R. (1990). *Bravo 20: The Bombing of the American West*. Baltimore: Johns Hopkins University Press.

FIG. 59 Desert Fire #42, 1982. Color print, chromogenic development (Ektacolor) process. Richard Misrach. (Courtesy of George Eastman House Collection Rochester, New York.)

Misrach, R. (1987). *Desert Cantos*. Albuquerque, NM: University of New Mexico Press.

Misrach, R. (1979). *A Photographic Book*. San Francisco: Grapestake Gallery.

Tucker, A. W. (1996). *Crimes and Splendors: The Desert Cantos of Richard Misrach*. Boston: Bulfinch Press.

MODEL, LISETTE (1906–1983) American
photographer and educator

Born to affluence in Austria, Model studied music and voice, had private tutors and learned photography as a practical skill (introduced to the medium by her sister, Olga). Moved to Paris (1922–1937); first significant photographs were of tourists at the French Riviera in Nice. Emigrated to New York (1937) where her camera work was encouraged by Brodovitch and Beaumont Newhall, garnering her commercial assignments as well as exhibition venues. She sought out the support of the Photo League and became an active member (investigated by the FBI in 1954 for leftist leanings). She is primarily known for her black and white candid street portraits, unsuspecting subjects captured in a revealing pose and attitude, sometimes in a slightly offset or askew frame. In America, her favorite subjects were people at Coney Island and the Lower East Side. Many images have a slightly "grotesque" aspect partly due to Model's selection of bodies and physiognomy and partly to cropping and high-contrast lighting. Freelance assignments were published in *Look*, *Harper's Bazaar*, *PM Weekly*, and *Ladies Home Journal*. Her considerable influence extended through the university as she taught photography at New School for Social Research, New York, from 1950 until her death. Prominent students included Robert Frank, Diane Arbus, and Larry Fink.

Publications

Model, L. (1979). *Lisette Model*. Millerton, NY: Aperture.

Thomas, A. (1990). *Lisette Model*. Ottawa: National Gallery of Canada.

MOHOLY-NAGY, LASZLO (1895–1946) Hungarian
photographer, filmmaker, teacher, painter

Moholy-Nagy was one of the 20th century's most influential creative intellects and theoreticians. He set new goals for all of the visual arts, promoting photography not as a picture-making medium, but as a method of experimentation for learning. He was a professor from 1923 to 1928 at the Bauhaus, the highly influential German school of art and design founded in 1919 by Walter Gropius. Moholy-Nagy had started his adult life studying law. After being wounded and held as a POW during WWI, the revolutionary art movement, MA, in Hungary got his attention. He then absorbed energy from the new Dadaist and Constructivist art he witnessed when he moved to Berlin. By 1922 he was making photograms and photomontage ("fotoplastik") with his artist-wife, Lucia Schultz Moholy (she gets half credit for these innovations as well as doing the darkroom work). When he was hired at the Bauhaus, Moholy-Nagy was in charge of the foundation year. He made all students make

photograms and "light space modulators" which they had to photograph in variable lighting. "Light" was the magic catalyst in art he preached. His own work also included photographs made from unusual angles, negative images, and films. One of several books he wrote endorsed Neue Sehen (New Vision)—*Malerei, Fotografie, Film (Painting, Photography, Film)* published in 1925. He fled Germany when the Nazis took control and eventually came to Chicago where he was appointed Director of the New Bauhaus in 1937. A year later he created the Institute of Design in Chicago and taught there until his death.

Publications

Haus, A. (1980). *Moholy-Nagy: Photographs and Photograms.* New York: Pantheon.

High, E. M. (1985). *Moholy-Nagy: Photography and Film in Weimar Germany.* Wellesley, MA: Wellesley College Museum.

Kostelanetz, R. (1970). *Moholy-Nagy.* New York: Da Capo Press.

FIG. 60 Sailing, 1928. Gelatin silver print. Laszlo Moholy-Nagy. (Courtesy of George Eastman House Collection, Rochester, New York.)

Moholy-Nagy, L. (1995). *In Focus: Laszlo Moholy-Nagy Photographs from the J. Paul Getty Museum.* Edited by K. Ware. Los Angeles: J. Paul Getty Museum.

Passuth, K. (1985). *Moholy-Nagy.* New York: Thomas & Hudson.

MORGAN, BARBARA BROOKS (1900–1992)

American photographer and painter

Born in Kansas, Morgan studied art at UCLA and taught there from 1925 to 1930. She had decided at age four to become an artist. When she married photographer Willard Morgan they moved to New York and she continued her abstract painting until the birth of two sons. Having met Edward Weston in 1925, Morgan already knew that photography could be a potent art form, and with encouragement from her husband, she began making photographs. With a camera she could explore the rhythms of nature that she had learned about from her father as a little girl (that all things are made of moving, dancing atoms). Her most famous work soon followed; the dance movement photographs of Martha Graham. Morgan had said that dance was a "combustion" of energy and she felt challenged to capture this on film. Letter to the World—Kick (1940) is her triumph (Graham interpreting the life of Emily Dickinson). For ten years until 1945, Morgan documented the genesis of modern dance in America, dramatically capturing for posterity the graceful and athletic movements of Graham, Merce Cunningham, Charles Weidman, and Josè Limòn. Morgan was also a pioneer in her use of photomontage and moving light abstraction. Portraits and nature subjects also were found in her portfolio. She was a founding member of the Photo League (1937) and of the influential quarterly, *Aperture* (1952). She was co-owner, with her husband, of the photographic publishing house Morgan & Morgan, Scarsdale/Dobbs Ferry, New York (1935–1972).

Publications

Carter, C. (1988). *Barbara Morgan: Prints, Drawings, Watercolors & Photographs.* Dobbs Ferry, NY: Morgan & Morgan.

Morgan, B. (1980). *Barbara Morgan: Photomontage.* Dobbs Ferry, NY: Morgan & Morgan.

Morgan, B. (1972). *Barbara Morgan.* Dobbs Ferry, NY: Morgan & Morgan.

Morgan, B. (1964). *Barbara Morgan: Monograph. Aperture* issue #11.

Morgan, B. (1951). *Summer's Children: A Photographic Circle of Life at Camp.* Dobbs Ferry, NY: Morgan & Morgan.

Morgan, B. (1941, 1980). *Martha Graham: Sixteen Dances in Photographs.* Dobbs Ferry, NY: Morgan & Morgan [reprinted 1980].

MORIMURA, YASUMASA (1951) Japanese

Morimura has risen to fame as an artist featured in the 1988 Venice Biennale. Since 1990 his self-portraits combine complex tableaux and computer manipulation to allow him to occupy

the space of the main subjects in re-created famous paintings by Van Gogh, Manet, Rembrandt, Goya, Kahlo, and others. He has a BA degree in painting (1978) from Kyoto City University of Arts. As a child growing up in Osaka, Morimura states he learned about art history in school by seeing reproductions of famous Western masterpieces (oriental art was not emphasized). By using reproductions of famous Western paintings, changing gender roles (commonplace in traditional Japanese kabuki theatre), and restaging the painted scenes, Morimura is considered by some to be in tune with the post-modern critique of stereotypes, patrimony, and media saturation. Others find a complex yin/yang duality or racial re-identity in the substitution of previously painted subjects with an Asian face and a slim male physique. Still others find unabashed humor and delight at the props and costumes that the artist has constructed for the photograph. In assuming various roles for his camera, Morimura undergoes extensive transformation with make-up and clay augmentation to his face and body. His self-conscious display is a literal performance that goes beyond Duchamp's creation of "Rose Selavy" as the latter's alter ego. Morimura's most recent work is assembled from many studio stills (he plays all the parts in multi-figure compositions). Comparisons to the work of Cindy Sherman are frequent. Besides Western art history themes, Morimura has also made photographs of himself transformed into feminine idols (Monroe, Bardot, Minnelli). It is unusual to find vetted photographic art that is humorous, sardonic, entertaining, and perplexingly intricate all at the same time.

Publications

Morimura, Y. (2003). *Daughter of Art History: Photographs by Yasumasa Morimura*. Introduction by D. Kuspit. New York: Aperture.

MORTENSEN, WILLIAM (1897–1965) American
photographer, teacher, and author
Mortensen, born in Utah, lived in Southern California and became the outspoken leader of the pictorialist movement in the United States during the 1930s. His photography consisted of Hollywood film stills, portraits of noted actors/actresses, and his personal art, and aggressively manipulated images of mythological, historical, and literary characters. He carried on an intense debate in camera periodicals (1930s) with Ansel Adams over contentious principles of Pictorialism vs. "straight" photography (the latter personified by Group f/64). As an unjust consequence for his stubborn defense of more romantic theories for photography, Mortensen was essentially ostracized from most authoritative canons of photographic history—especially those authored by Adams' good friends, Beaumont and Nancy Newhall. Renewed interest and respect for Mortensen, his work and writings, has been courageously led by the critic A. D. Coleman (see his essay and others in *William Mortensen: A Revival*, 1998). Mortensen perfected his metal-chrome process (bromoil derived) and pattern screen methods for modifying photographic prints, as well

as publishing many books on abrasive-tone monoprints and technical hints on lighting, models, costumes, and darkroom modifications. His portrait subjects include Fay Wray, Jeanne Crain Lon Chaney, Clara Bow, John Barrymore, Jean Harlow, and George Dunham (his collaborator and favorite model). In 1932 he founded the William Mortensen School of Photography, Laguna Beach, California, and one of his students was Rock Hudson. Many contemporary critics and scholars point out the example of Mortensen's portrait style as a validated antecedent when considering the acclaimed praise and popularity of the manipulated images of Cindy Sherman and Yasumasa Morimura.

Publications

Mortensen, W. (1936, 1973). *Monsters and Madonnas.* San Francisco: Camera Craft Publishing [reprinted 1973].
Mortensen, W. (1937). *The Command to Look: A Formula for Picture Success.* San Francisco: Camera Craft Publishing.
Mortensen, W. (1937). *The Model: A Book on the Problems of Posing.* San Francisco: Camera Craft Publishing.

NACHTWEY, JAMES (1948) American
The title of Nachtwey's recent book, *Inferno* (1999), symbolizes not only the super-heated, destructive nature of the Hellish world events he has documented, it also asks his viewers for a pronouncement of guilt against the sins of sinister forces that destroy humanity and thrive outside the moral boundaries of common decency. In a way, Nachtwey's own career as a universally celebrated photojournalist has "caught fire" and has propelled his imagery into the forefront of the world's news and print media. Born in Syracuse, New York, educated at Dartmouth, Nachtwey learned the rudiments of newspaper photography in Albuquerque, New Mexico. He quickly rose to the top of documentary talents with membership in Black Starr (1981), Magnum (1986–2000), and more recently with Agency VII. He is on staff with *Time* magazine. He has traveled the world wherever hot spots are ignited by war, revolution, genocide, or mass famine—Belfast, Afghanistan, El Salvador, Bosnia, Rwanda, Sudan, Somalia, and Romania. He is the recipient of four Robert Capa gold medals, the Leica Medal, and the W. Eugene Smith award. His cumulative work is unquestioningly the ultimate visual summary of the worst unspeakable acts occurring in the last two decades. His dedication, not unlike many genuine photojournalists, puts him so close to the action he needs to use wide-angle lenses on his cameras. *Inferno* contains a brutal look at the savagery of the slaughter of Tutsis by the Hutus—pictures that Nachtwey hopes he will never have to replicate in another time and place. His desire is to compel world consciousness to undertake social and political action to prevent these kinds of horrors.

Publications

Nachtwey, J. (1999). *Inferno.* London: Phaidon Press.
Nachtwey, J. (1989). *Deeds of War.* New York: Random House.

NETTLES, BEA (1946) American

Nettles spent the first twenty years of her life in Florida—a fact that has motivated and influenced much of her personal art and self-published books, although the true inspiration for her has been her family and experiences as a daughter, wife, and mother. Nettles got her degree (BFA, 1968) at the University of Florida, working with Robert Fichter and Uelsmann (but majoring in painting/printmaking). Her MFA degree from the University of Illinois, Champaign-Urbana (where she has taught since 1984), was more photographic with mixed media. She has said her work is about "themes of loss and hope" (Tucker, *The Woman's Eye*, 1973). Many titles of books and series also reveal a sense of humor and we might assume that hope wins out in the end. For almost four decades she has used snapshots, plastic camera images, alternative processes, the physicality of mirrors, plastic, thread, and fabric to construct art objects. Nettles' work was selected by Peter Bunnell to be in an influential exhibit at the Museum of Modern Art (MoMA), Photography Into Sculpture in 1970. When she began teaching in Rochester, New York, in the 1970s, she produced many modest books (privately published by Inky Press). The first of these was *Events in the Water* (1973). In most of her work, usually accompanied by suggestive titles, Nettles has made use of family snapshots, self-portraits, and references to the stages of the life cycle to create metaphors and designate archetypal vehicles for her view of what really matters. Her reputation in the field is generally acknowledged to be equally important as an educator at Rochester Institute of Technology (1976–1984) and at the University of Illinois. She has also published a technical "recipe" book on alternative photographic processes.

Publications

Nettles, B. (1997). *Memory Loss: Bea Nettles*. Urbana, IL: Inky Press.

Nettles, B. (1990). *Life's Lessons: A Mother's Journal*. Norfolk, VA: Prairie Books Art Center.

Nettles, B. (1979). *Flamingo In The Dark: Images by Bea Nettles*. Rochester, NY: Inky Press.

Nettles, B. (1977). *Breaking the Rules: A Photo Media Cookbook*. Rochester, NY: Inky Press.

NEWMAN, ARNOLD (1918–2006) American

Born in New York, Newman might have become a painter but for the fact that his family's finances from several oceanside hotels evaporated in 1938 while he was studying art at the University of Miami. As compensation for disrupted academic study, Newman accepted work with a family friend who ran a chain of cheap, mass production portrait studios (Perskie's in Philadelphia area department stores). For about a year, Newman makes 49 cent portraits, toils in the darkroom but becomes encouraged by his vision for meaningful photographs. By 1940 Newman adopts the camera as his artist's tool and makes portraits (especially artists), abstractions, and social documentation. In 1946 he is in New York and begins freelance assignments for *Harper's Bazaar* and *Life*. His most famous image is a 1946 portrait of Igor Stravinsky in the extreme lower left corner of a graphic space dominated by the silhouette lid of his piano—ironically, rejected for publication by Brodovitch for *Harper's Bazaar*. During the next half century, Newman's portraits established the high water mark for "environmental portraiture." The highest echelon of these groups—artists, presidents, corporate leaders, musicians, authors—have been the subjects of Newman compositions (most in black and white) that place the personality in a dynamic equilibrium with that person's tools, creations, symbols, or work space. Max Ernst sits in a high-back, ornate throne next to a kachina, his head wrapped in surreal curls of smoke; Mondrian is amid a geometric grid of his canvases and an easel. Shooting 24 covers for *Life*, Newman's work has also appeared in *Fortune, Look, Holiday, Esquire, Town and Country*, and *The New Yorker*. A recent monograph, *Arnold Newman* (Taschen, 2000), is a comprehensive survey of Newman's photographic oeuvre with biographical essays, a chronology, and extensive bibliography.

Publications

Fern, A. M. (1992). *Arnold Newman's Americans*. Boston: Bulfinch Press.

Newman, A. (1986). *Arnold Newman: Five Decades*. San Diego: Harcourt Brace Jovanovich.

FIG. 61 Arnold Newman. Photograph by Nancy M. Stuart, 1996.

Newman, A. (1979). *The Great British*. London: Weidenfeld & Nicolson.

Newman, A. (1974). *One Mind's Eye, The Portraits and Other Photographs of Arnold Newman*. Boston: David R. Godine.

NEWTON, HELMUT (1920–2004) Australian

Born (H. Neustaedter) in Berlin, Newton bought a box camera when he was twelve; schoolwork was replaced by photography of many girlfriends and he was expelled from two schools. Self-taught in some aspects, he apprenticed with Yva (Else Simon), a fashion/portrait photographer until Newman's parents insisted he leave Germany as the Nazi menace grew. He wound up in Singapore then became an Australian citizen (served 1940–1945 in the Australian military). He married June Brunell (a.k.a. Alice Springs) in 1948. His career took off when he returned to Europe in the late 1950s. He was on staff at *Vogue* for many years as his daring fashion work became more charged with erotic tension and voyeurism. His work was seen in *Elle, Stern, Playboy, Nova*, and *Queen*. His fashion images are noted for their depiction of somewhat aloof, domineering models that exude an aggressive power. His sets were not studios; Newman preferred fin-de-siecle hotel staircases, luxury apartments, lavish estates, and castles as backdrops for dramatic scenes that were fraught with jet set accessories and suppressed desire. His work, never understated, drew sharp criticism from a growing cadre of critics — both male and female — that denounced the images as abusive and degrading to women, promoting S & M behavior, and nothing more than soft porn. Many Newton books were published that showcased images that had not appeared in the American media — photographs that broadly hinted at lesbianism, bondage, and fetish attraction. He died in an automobile accident in Hollywood in 2004.

Publications

Newton, H. (2002). *Helmut Newton: Autobiography*. New York: Nan A. Talese.

Newton. H. (2000). *Sumo*. Cologne: Taschen.

Newton. H. (1981). *Big Nudes*. Text by K. Lagerfeld. Paris: Xavier Moreau Inc.

Newton, H. (1978). *Sleepless Nights*. Munich: Schiermer/Mosel/Verlag GmbH.

Newton, H. (1976). *White Women*. London: Quartet Books.

NILSSON, LENNART (1922) Swedish

Known worldwide as a pioneer biomedical photographer, Nilsson was the first to photograph the growth of a live fetus inside the womb. Born near Stockholm, he never formally studied science or medicine, but by age five had a collection of local flora and fauna. He got a camera when he was 12 and became a press photographer in the 1940s. Some early images of workers resemble the documentary style of Farm Security Administration (FSA) photographers in the United States. He completed an in-depth photo-essay about the Salvation Army in Sweden. His work shifted to close-up magnifications; ants became the subject of his first book in 1959. In 1965 he published *A Child is Born*, which showcased his work photographing the growth of the human embryo inside the mother's womb using special lenses with fiber-optic lights. One notable image of a human fetus was featured on the cover of *LIFE* April 30, 1965 — the issue sold out — eight million copies in four days. He continued on staff at *Life* for seven years doing picture stories on polar bears and Ingmar Bergman, among others. His other remarkable accomplishments are images of the body (inside the beating heart during surgery, first photograph of an image registered on the human retina). More recently he has used scanning electron microscopes to photograph the fertilization of a human ovum by a single sperm and the first images of the isolated HIV virus. Although he never received proper credit in books on the history of photography, he has been honored to have his embryo images sent out into the universe aboard NASA's Voyager I and II spacecrafts.

Publications

Nilsson, L. (2002). *Lennart Nilsson: Images of His Life*. Jacob Forsell, ed., Stockholm: Bokförlaget Max Ström.

Nilsson, L. (1987). *The Body Victorious: The Illustrated Story of our Immune System*. New York: Delacorte Press.

Nilsson, L. (1966, 1971). *A Child is Born: The Drama of Life Before Birth*. New York: Delacorte Press (reprint 1971).

NIXON, NICHOLAS (1947) American

Born in Detroit, Nixon received his BA in American literature (University of Michigan) and his MFA in 1974 (University of New Mexico). His early photography was of architecture and

FIG. 62 Lennart Nilsson, 2003. Jacob Forsell, Stockholm, Sweden.

city views; he was one of the artists featured in the important 1975 exhibition, New Topographics, at the George Eastman House. Since then his photography has been almost exclusively of people, most made with an 8 × 10 view camera (Pictures of People, 1988). A concern for social issues was underwritten by his volunteer work for VISTA in St. Louis before he started graduate school. Nixon's choice of image groupings, often measured out in one year assignments, has included children and adults shown in the semi-public space of the "front porch," his wife, Bebe and her three sisters (The Brown Sisters, 1999), school pupils, and people with AIDS. His carefully controlled photograph situations, which still allow a surprising degree of spontaneity from subjects, is generated by the photographer's immense respect for his subjects and a keen intuition for visual density and detail. His AIDS documentation (exhibition at the Museum of Modern Art and book with text by Bebe Nixon, 1991) created public discord and controversy; in no way due to the photographer's lack of sensitivity, talent, or ethical standards. Most recently, Nixon has been photographing couples posed in intimate contexts, and people out and about in the Boston Public Gardens. Another recent project has been the documentation of his son's sixth grade class in the unfolding events of a typical year in public school.

Publications

Nixon, N. (1983). *Nicholas Nixon: Photographs from One Year.* Carmel, CA: Friends of Photography Bookstore.

Nixon, N. (1991). *People With AIDS: Photographs by Nicholas Nixon.* Text by B. Nixon. Boston: David R. Godine.

Nixon. N. (1998). *School: Photographs from Three Schools.* Essay by R. Coles. New York: Bulfinch Press/Little, Brown.

OUTERBRIDGE, PAUL, JR. (1896–1958) American

Trained in sculpture, illustration, and theater design, Outerbridge quickly switched allegiance to photography after service in the Canadian Royal Air Corps and a job photographing airplane parts in Oregon. In 1921 he enrolled in the Clarence White School in New York. Within a few years he was teaching aesthetics and composition there. By 1924 he did commissions for *Vanity Fair, Harper's Bazaar,* and *Vogue.* While in Paris (1925–1929) as art director of *Paris Vogue,* he was embraced by the group of avant-garde artists that included Duchamp, Dali, Picabia, and Man Ray. He returned to the United States in 1929 and continued as a popular commercial photographer for his usual magazine clients now including *House Beautiful.* During the 1920s and 1930s his platinum prints were mostly done in the studio and were characterized by bold composition, a concern for volume, line, and abstraction that were, as he stated, "devoid of sentimental association." His technical skill was unrivaled in the unique production of tri-color carbro prints; this process and his philosophy were described in his book, *Photography In Color* (1940). Later in his life he moved to Laguna Beach, California, and traveled extensively. After WWII his more provocative 1930s color work with the female nude gradually became known. This work, held in his private

collection, revealed more Freudian preoccupations with sexual fetishism, decadence, and erotic surrealism.

Publications

Howe, G. (1980). *Paul Outerbridge, Jr., Photographs.* New York: Rizzoli (reprinted from a smaller 1976 exhibition catalog).

PARKER, OLIVIA (1941) American

Educated at Wellesley in art history (BA, 1963), Parker was self-taught as a photographer in 1970 after experimentation with painting. Most of her work has been close-ups (tombstone carvings), studio constructions, and arrangements using an assortment of objects, old engravings, and cast shadows. Making large-format contact prints from 4 × 5 through 8 × 10 negatives, one of Parker's particular stylistic traits has been a luscious split tone of cooler grays with eggplant purples (selenium toned gelatin silver prints). Compositions include floral subjects, fruit, and prisms, as well as old iron hardware and figurative elements such as small reproductions of classical busts. Objects and their arranged juxtapositions take on a new context of meaning that may hint at a multitude of intellectual interpretations. Her work offers up influences from Joseph Cornell and Frederick Sommer. Parker, in her artist statements, is quite forthcoming in listing her interests, yet she resists any direct suggestion of what her visual work may be about. A general theme for her photographs could be a mapping for understanding the unknown; a specific concern would be the emancipation of anima motrix — the spirit found inside special objects when they are aligned beneath the alchemist's illumination. One of her books, *Under the Looking Glass*

FIG. 63 Saturday, 1980. Split toned silver contact print. Olivia Parker. (Courtesy of George Eastman House Collection, Rochester, New York.)

(1983), features color images. She has also worked with the Polaroid 20 × 24 camera.

Publications
Parker, O. (1978). *Signs of Life*. Boston: David R. Godine.
Parker, O. (1987). *Weighing the Planets*. New York: New York Graphic Society.

PARKS, GORDON (1912–2006) American
photographer, author, musician, composer, poet, and film director
A self-taught photographer who purchased a used camera in 1937, Parks was one of the earliest internationally praised African American photographers; his career has gone beyond stellar. He grew up in poverty (moving to St. Paul, Minnesota, in 1928) as the youngest of fifteen siblings. He worked as a busboy, lumberjack, professional basketball player, and piano player, but got paid for his first photographs of fashion made in Chicago. Sent on a fellowship to the nation's capital, Parks was hired by Roy Stryker to photograph for the Farm Security Administration (FSA) in 1942. One of Parks' most noted images was made right inside the FSA government office of custodian Ella Watson (whose husband had been lynched) holding her mop and broom in front of a symbolic American flag (see Figure 23). Parks later traveled the world making pictures for Standard Oil of New Jersey (1943–1948). He ultimately became a mainstay staff photographer for *Life* (1948–1972), producing such major photographic essays

as "The Death of Malcolm X," "On the Death of Martin Luther King, Jr.," and the poignant story of a Brazilian child, "Flavio da Silva." He founded *Essence* magazine in 1970 and has photographed a range of personages from Gloria Vanderbilt and Ingmar Bergman to Muhammad Ali. He has also been successful as a mystery author and a Hollywood director (*The Learning Tree*, 1969; *Shaft*, 1971). Recently Parks has dedicated new energy as a post-octogenarian to still life and landscape photography in color and with digital technologies.

Publications
Parks, G. (1997). *Half Past Autumn: A Retrospective*. New York: Bulfinch Press.
Parks, G. (1990). *Voices in the Mirror, An Autobiography*. New York: Nan A. Talese.
Parks, G. (1948). *Camera Portraits: Technique and Principals of Documentary Portraiture*. New York: Franklin Watts.

PARR, MARTIN (1952) British
Parr has become the documentarian of Great Britain's middle class over the last three decades, working in black and white and color, publishing numerous books. Born in Upsum, England, he attended Manchester Polytechnic in the early 1970s. One of his first books was *Bad Weather* (1982), about the palpable curtain of mist, rain, and snow flurries that envelopes the British Isles; he purchased an underwater camera and flash attachment so he could defy the elements. Parr has

FIG. 64 Weymouth, 1999. Color print chromogenic development (Fujicolor) process. Martin Parr, Magnum Photos. (Courtesy of George Eastman House Collection, Rochester, New York.)

been associated with Magnum since 1994. His newer work, almost always in super-saturated colors, takes stock of the public and semi-private life of the English; characters not so stodgy that they won't tolerate his incessant picture snapping, not too removed from distant claims to royalty or a dukedom that they totally lose all pretense of having that stiff upper lip. In the sum of Parr's work we see an archive of things and people Aglaise — fish and chips stands, New Brighton beach bathers, Tupperware parties, Tudor style suburbia, the horse and hunt crowd, Piccadilly punks, and shoppers. Visually, his images often provide looming close-ups of hands, arms, or advert signage against a middle ground populated by a dense assortment of figures on holiday or shopping at Ikea. He uses fill-flash in daylight to throw a democratized illumination into all the important crevices of each scene. Writer Susan Kismaric has said that Parr's off-beat reportage is in harmony with many British authors, like Jonathan Swift, who portrayed society with a tinge of dry humor.

Publications
Parr, M. (2000). *Think of England*. London: Phaidon Press.
Parr, M. (1989). *The Cost of Living*. Manchester: Cornerhouse Publications.
Parr, M. (1986). *The Last Resort: Photographs of New Brighton*. Merseyside: Promenade.
Williams, V. (2002). *Martin Parr*. London: Phaidon Press.

PENN, IRVING (1917) American

Penn studied art and design with Brodovitch in the mid-1930s at the Philadelphia Museum of Art School. He spent a year in Mexico painting before moving to New York where he was hired by Alexander Liberman to assist with the graphics for covers of *Vogue* in 1943. Penn was so particular with the designs that he began photographing them himself. In his career he has done more than 130 *Vogue* covers. His photography during 1945 to 1960 — portraits, fashion, still life — is characterized by cool, formal composition with simple backgrounds. In most instances he prefers diffused natural light to studio strobes. He opened his own studio in 1953 and continues to have many corporate clients (Clinique). Though best known for his work in fashion and portraiture, Penn has developed a varied body of creative work including photographs of ethnic peoples isolated from their environment, whether in New Guinea, Morocco, or Peru, by positioning them against plain backdrops (*Worlds In A Small Room*, 1974). In some ways these exotic subjects become "fashion" models or conceptual still life forms seen against a neutral field. He also has made elegant platinum prints of what could generically be termed "trash" — cigarette butts from the gutter outside his studio, discarded paper wrappers, and a torn and soiled glove. In the 1970s he added images of large-size nudes, studies of flower stalks and blooms, and arrangements of bleached animal bones and skulls to his oeuvre. Penn is one of the most prolific and well-respected of all photographers who have ever looked through a viewfinder or on the ground glass. Numerous books about his photography have been published

but many viewers still see Penn's work every day, without credits, on glossy advertisement pages.

Publications
Greenough, S. (2005). *Irving Penn: Platinum Prints*. New Haven, CT: Yale University Press.
Penn, I. (1991). *Passage: A Work Record: Irving Penn*. New York: Knopf.
Penn, I. (2001). *Still Life: By Irving Penn*. Boston: Bulfinch Press.
Szarkowski, J. (1984). *Irving Penn*. New York:

PORTER, ELIOT FURNESS (1901–1990) American

Porter (brother of the painter Fairfield Porter) graduated from Harvard Medical School (1929) after earning a degree in chemical engineering. He was a professor of biochemistry until 1939. He began photographing in Maine at his family's summer home at the age of 13 using a Kodak box camera. Introduced to Ansel Adams in the early 1930s, Adams encouraged Porter to switch to a large-format camera for increased quality and control. Porter's devotion to photography slowly escalated and from 1938 to 1939 Stieglitz exhibited his photographs at An American Place, the last solo exhibition by any photographer there (except for Stieglitz himself). Most of his subject matter was wildlife, especially birds, and the natural landscape. At first he made black and white prints, but with his background in chemistry, Porter became an early practitioner of color photography using the dye transfer process; he made his own three color separation negatives and prints. In 1946 he moved to Santa Fe, New Mexico, where he spent most of his remaining life, although he traveled for months at a time. An admirer of Henry David Thoreau, Porter was an ardent conservationist and many of his books were published by the Sierra Club. Books he published documented species of North American birds while other titles were more about geographic "place" including the final natural history documents of the Glen Canyon on the Colorado River just before it was dammed and flooded by the U.S. Corps of Engineers. Other places showcased in print by Porter were Penobscot Country (Maine), Antarctica, the Galapagos, China, and Greece.

Publications
Porter, E. (1987). *Eliot Porter*. Boston: Little, Brown.
Porter, E. et al. (1968). *Galapagos: The Flow of Wildness*. San Francisco: Sierra Club.
Porter, E. (1963). *The Place No One Knew: Glen Canyon on the Colorado*. Edited by David Brower. San Francisco: Sierra Club.

RAUSCHENBERG, ROBERT (1925) American

Born in Texas, Rauschenberg burst onto the New York art scene in the 1950s with his unconventional "combines," three-dimensional assemblages that brought together images and objects in a profusion of non-traditional materials. Referred

to as Neo-Dada, his multimedia assemblages mixed eloquent passages of paint with transferred news photographs and photo silk screens as well as real objects in a spirit of Dada-like candor and spontaneity. The synergistic integration of highly charged photographic imagery with other media in his work raised new possibilities for photography, illuminating its multiple identities as fiction and fact, abstraction and allegory, enduring and ephemeral, and autobiographical and universal. His aesthetics were enormously influential in the cultural expression of the 20th century: While he blurred discipline-defining boundaries, his works resonate, as he hoped, in the "place between art and life."

Publications

Kotz, M. L. (1990). *Rauschenberg, Art and Life*. New York: Harry N. Abrams.

Rauschenberg, R. (1981). *Photographs/Robert Rauschenberg*. London: Thames & Hudson.

Rauschenberg, R. (1969). *Rauschenberg*. New York: Abrams.

RAY, MAN (EMMANUEL RUDNITSKY) (1890–1976) American

Noted for his "Rayographs," lens-less photograms exploring the pure use of light, his darkroom experiments with the Sabattier effect, and his innovative mixed media assemblages. A Dadaist provocateur, he became the only American member of the surrealist movement. From 1921 to 1939 he combined artistic endeavors with commercial practice, becoming a noted portraitist of Parisian intellectuals and artists, and establishing a reputation as a fashion photographer. The Nazi occupation forced his escape to Hollywood where he established himself as a controversial figure of the American avant-garde before returning to Paris in 1951.

Publications

Baldwin, N. (1988). *Man Ray, American Artist*. New York: Clarkson N. Potter.

Perl, J. (1997). *Man Ray*. New York: Aperture Foundation.

Ray, M. (1997). *Photographs, Paintings, Objects*. New York: Norton.

Ray, M. (1982). *Man Ray, Photographs*. New York: Thames & Hudson.

Ray, M. (1963). *Self Portrait*. Boston: Little, Brown.

Tashijian, D. (1996). *Man Ray: Paris~L.A.* Santa Monica, CA: Smart Art Press.

RENGER-PATZSCH, ALBERT (1897–1966) German

A proponent of photography's Neue Sachlichkeit (New Objectivity.) Renger-Patzsch's collection of 100 photographs of nature and industry, *Die Welt ist Schon* (*The World is Beautiful*) published in 1928, exemplifies the rationality, precision, and faithfulness to subject he characterized as inherent photographic qualities. A purist, Renger-Patzsch helped define photography in the late 1920s and 1930s as a unique, autonomous art form with realism at its essence. His precisely crafted images of natural and factory made objects eschewed subjective influences, and strove to reveal, with rational purity, the material world's order and beauty.

Publications

Kuspit, D. (1993). *Joy Before the Object*. Los Angeles: J. Paul Getty Museum.

Wilde, A., Wilde, J., and Weske, T. (1997). *Albert Renger-Patzsch: Photographer of Objectivity*. London: Thames & Hudson.

RICHARDS, EUGENE (1944) American

World-renowned social documentary photographer following in the tradition of W. Eugene Smith. Born in Dorchester, Massachusetts, he was an activist and social worker before becoming a noted magazine photographer, prolific member of Magnum, filmmaker, author, and dedicated teacher. Co-director of Many Voices, a media group dedicated to producing films and books on contemporary social issues such as aging, pediatric HIV/AIDS, poverty, and the mentally disabled. Richards works in a compassionate documentary style to produce intimate long-term narratives that educate and promote dialog while sustaining an unflinching look at the hard realities of our contemporary social landscape. Honored for his many books that reflect concern for social justice, his seminal work *Exploding Into Life*, chronicles his wife's struggle with breast cancer.

Publications

Lynch, D. (1986). *Richards, Eugene: Exploding Into Life*. New York: Aperture.

Richards, E. (2005). *Cocaine True, Cocaine Blue*. New York: Aperture.

Richards, E. (2002). *Stepping Through the Ashes*. New York: Aperture.

Richards, E. (2000). *Dorchester Days*. London: Phaidon.

RODCHENKO, ALEXANDER MIKHAILOVICH (1891–1956) Russian

A versatile and influential artist in post-revolutionary Russia, Rodchenko helped found the Constructivist movement. His early Constructivist ideas regarding the artists' role in a progressive Communist society influenced the aesthetics of his wide-ranging projects in various fields of design, photography, and filmmaking. He is known for his experimental photomontage work and innovative photographic composition energized by extreme oblique angles, unorthodox perspectives, and unexpected framing. While he rose to prominence in the cultural bureaucracy of early Bolshevism, his artistic idealism was not able to survive the brutal cultural climate of Stalinism and he spent the last two decades of his life in isolation and obscurity.

Publications

Elliott, D. (1979). *Alexander Rodchenko*. New York: Pantheon.

Noever, P. (ed.) (1991). *Aleksandr M. Rodchenko and Varvara F. Stepanova*. Munich: Prestel.

ROTHSTEIN, ARTHUR (1915–1985) American

Notable as the first member of a team of photographers chosen by Roy Stryker for the Farm Security Administration's (FSA) ambitious documentary project, Rothstein photographed poverty in Gee's Bend, Alabama, life in farm labor camps in California, the struggles of cattle ranchers in Montana, and the devastation of the Dust Bowl, creating iconic images of depression America that influenced public policy. His controversial photograph, Fleeing a Dust Storm, made in the Oklahoma panhandle, created a dialog about documentary practice when it was determined that aspects of the scene had been manipulated by the photographer for dramatic effect (see Figure 8). His dedication to the truth, and his ability to simultaneously picture the dramatic and the ordinary, propelled his photojournalistic career. He photographed for *Look* magazine, and became head of the photography departments for both *Look* and *Parade* magazines. He was a founding member of the American Society of Magazine Photographers, now American Society of Media Photographers (ASMP).

Publications

Rothstein, A. (1986). *Documentary Photography*. Boston: Focal Press.

Rothstein, A. (1984). *Arthur Rothstein's America in Photographs, 1930–1980*. New York: Dover.

RUSCHA, EDWARD (1937) American

Employing a wry taxonomical approach to the photographic documentation of West-Coast vernacular structures, Ruscha's work from the 1960s and 1970s embraces photography in the service of conceptual art. *Twenty-Six Gasoline Stations*, *Every Building on the Sunset Strip*, and *Thirty-Four Parking Lots in Los Angeles* are among his commercially produced and widely influential books. A painter, printmaker, and filmmaker, Ruscha combines Dadaist sensibilities, articulate painting style, and fascination with language into dreamily elusive wordscapes: a poetic blend of word and image that is both critique and celebration of contemporary culture.

Publications

Rauscha, E. (1966). *Every Building on the Sunset Strip*. Los Angeles: Edward Ruscha.

Ruscha, E. (2004). *Leave Any Information at the Signal: Writings, Interviews, Bits, Pages*. Edited by Alexander Schwartz. Cambridge, MA: MIT Press.

Ruscha, E. (1965). *Some Los Angeles Apartments*. Los Angeles: Anderson, Ritchie & Simon.

SALGADO, SEBASTIAO (1944) Brazilian

Educated as an economist, Salgado became a photojournalist in 1973, working for the Sygma, Gamma, Magnum Photos, and eventually founding his own agency, Amazonas Images in 1994. His long-term documentary projects, rendered with haunting chiaroscuro, capture the dignity and endurance of humanity against oppression, war, and famine. With a detailed panoramic grandeur, his essays on the inferno of Brazilian

FIG. 65 Sebastian Salgado. Photograph by Nancy M. Stuart, February 15, 1990.

gold-ore mines, the end of large-scale manual labor, and the plight of refugees and migrants across 21 countries, chronicle this century's brutalities. "The planet remains divided," Salgado explains. "The first world in a crisis of excess, the third world in a crisis of need."

Publications

Salgado, S. (2000). *Migrations*. New York: Aperture.

Salgado, S. (2000). *The Children: Refugees and Migrants*. New York: Aperture.

Salgado, S. (1997). *Terra: Struggle of the Landless*. New York: Aperture.

Salgado, S. (1993). *Workers, An Archaeology of the Industrial Age*. New York: Aperture.

Salgado, S. (1990). *An Uncertain Grace*. New York: Aperture.

Salgado, S. (1986). *Other Americas*. New York: Pantheon Books.

SALOMON, ERICH (1886–1944) German

Using available light and the new miniature cameras with fast lenses, first the Ermanox f.2 with glass plates and then the Leica Model A which used 35 mm motion picture stock, Salomon pioneered modern photojournalism. Beginning in the 1920s, he successfully captured unaware and unposed politicians, diplomats, business magnates, and royalty with his often hidden camera, a keen sense of timing and an uncanny ability to gain access to his subjects. The phrase "candid photography" was coined by a London art critic in 1929 in response to his work. His published work *Celebrated Contemporaries in Unguarded Moments*, exemplifies his remarkable talent for

FIG. 66 Summit Meeting in 1928. The architects of Franco-German Rapprochement, Aristide Briand and Dr. Gustav Stresemann, meet in the Hotel Splendide in Lugano with British Foreign Minister, Sir Austen Chamberlain. Left to right: Zaleski, Poland; Chamberlin; Briand; and Scialoia, Italy. Erich Salomon 1928. (Courtesy of George Eastman House Collection, Rochester, New York.)

capturing the revealing psychological moment. Interned by the Nazis and killed along with his wife and a son at Auschwitz concentration camp.

Publications

Salomon, E. (1978). *Erich Salomon*. Millerton, NY: Aperture.
Salomon, E. (1975). *Portrait of an Age*. New York: Collier Books.

SAMARAS, LUCAS (1936) American

Known as a sculptor, painter, and performance artist, Samaras explored the malleability of photography's descriptive powers in his complex psychological portraits and tableaux. In his series of AutoPolaroids and PhotoTransformations of the late 1960s and 1970s, Samaras focused on himself as subject, playing multiple roles as artist, subject, actor, director, audience, and critic. With theatricality and narcissistic abandon, he used the baroque and claustrophobic space of his apartment studio for his performance: Exaggerated gesture, garish lighting, and post-exposure photo manipulation characterize his probing meditation on identity. His work revels in the interplay of photographic materials and illusion, enhanced by manipulation of Polaroid's SX-70s wet photo dyes. He painted directly on the surface of images, splicing together panoramic tableaux and illuminating the simultaneously narrative, documentary, and imaginary character of the medium.

Publications

Lifson, B. and Samaras, L. (1987). *Samaras: The Photographs of Lucas Samaras*. New York: Aperture.
Prather, M. and Samaras, L. (2003). *Unrepentant Ego: The Self Portraits of Lucas Samaras*. New York: Harry N. Abrams.

FIG. 67 Self Portrait, November 16, 1973. Color print, internal dye diffusion (Polaroid SX-70) process. Lucas Samaras, Pace/MacGill Gallery, New York. (Courtesy of George Eastman House Collection, Rochester, New York.)

SANDER, AUGUST (1876–1964) German

Sander's portraits of the German people of the 1920s and 1930s made with uncompromising clarity and directness deeply influenced a century of portraiture and documentary work. In 1910, he began work on Menschen des 20 Jahrhunderts (Man of the 20th Century) which, never fully realized, was intended as a comprehensive typological portrait of German society. Eschewing the use of a traditional painted backdrop, he posed his subjects outdoors or in their own environments; his subjects represented every social strata and occupation, from formally posed industrialists to cooks in their kitchens. By organizing his full figure portraits of people into typologies, he hoped to create a total portrait of German society. The first volume of this project, *Antlitz der Zeit (Face of Our Time)*, was published in 1929, but Sander's work was banned and all existing books were seized and destroyed by the Nazis. Sander's studio was bombed during the war. After the war he continued to photograph mostly landscape and architectural studies.

Publications

Sander, A. (1999). *August Sander, 1876–1964*. London: Taschen.

FIG. 68 Sonia Through the Planet/Sonia Through Marilyn Goldstein, 1974. 3M color-in-color print. Sonia Landy Sheridan. (Courtesy of George Eastman House Collection, Rochester, New York.)

Sander, A. (1986). *August Sander: Citizens of the Twentieth Century: Portrait Photographs 1892–1952*. Edited by Gunther Sander. Cambridge, MA: MIT Press.
Sander, A. (1980). *August Sander, Photographs of an Epoch*. Millerton, NY: Aperture.

SCHAD, CHRISTIAN (1994–1982) German

While recognized as a painter and proponent of the Neue Sachlichkeit (New Objectivity) whose cold realist portraits reveal the hedonism and apathy in Weimar Germany, he is also acclaimed as the 20th century's earliest practitioner of experimental camera-less photography in the tradition of Talbot's "photogenic drawing." Using torn tickets, receipts, and other "trash," he created chance arrangements on photographic film called "Schadographs," so named by the Dada artist and leader Tristan Tzara. In the iconoclastic aura of experimentation that European Dada and Surrealism engendered, artists such as Lazlo Moholy-Nagy and Man Ray independently discovered the creative capabilities of the photogram, but Schad's experiments preceded theirs by several years and exemplified the Dada ethos of making art from junk.

Publications
Lloyd, J. and Peppiatt, M. (2003). *Christian Schad and the Neue Sachlichkeit*. New York: W.W. Norton & Co.

SHEELER, CHARLES (1883–1965) American

Known primarily as a Precisionist painter, Sheeler's photographic work was inspired by both the rural and industrial landscape, and was intimately connected, both ideologically and formally, to his painting. His exacting precisionist vision, eye for abstraction, and expressive use of form were central in his photographs, drawings, and paintings. His commercial photographic work for *Fortune*, *Vogue*, and *Vanity Fair* during the 1920s and 1930s gave him a platform to develop his

growing interest in architectural and industrial form. Beguiled by the ideology of American industrialism, he produced his most notable photographic series for Ford Motor Company in 1927 at the River Rouge Plant. "Our factories," wrote the artist, "are our substitute for religious expression."

Publications
Lucic, K. (1991). *Charles Sheeler and the Cult of the Machine*. London: Reaktion.
Lucic, K. (1997). *Charles Sheeler in Doylestown: American Modernism and the Pennsylvania Tradition*. Allentown, PA: Allentown Art Museum and University of Washington Press.
Stebbins, T. E., Jr. and Keyes, N., Jr. (1987). *Charles Sheeler: The Photographs*. Boston: Little, Brown.

SHERIDAN, SONIA LANDY (1925) American

Sheridan's pioneering work during the 1970s and 1980s focused on the use of contemporary communications technology in the practice of art. Working with early reprographic systems, she went on to experiment with an array of imaging tools that included video, computers, and sound, which explored the intersection of photography and binary code. Artist and educator, Sheridan created the Department of Generative Systems at the Art Institute of Chicago based on the notion that art, science, and technology are interrelated conceptual systems. Her work encouraged theoretical discourse essential to our understanding of photography's changing nature in a global communications environment.

SHERMAN, CINDY (1954) American

Sherman emerged as a key figure in the art world in the 1980s with her series Untitled Film Stills — black and white images that explore gender, identity, mythmaking and the media. She combines performance, masquerade, and photography's innate collusion with veracity to create film stills of herself as the solitary female heroine in an American drama; her fictional

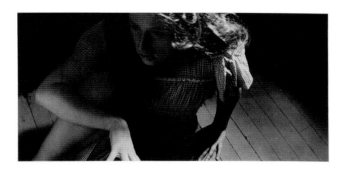

FIG. 69 Untitled #85, 1981. Chromogenic development print. Cindy Sherman and Metro Picture Gallery, New York. (Courtesy of George Eastman House Collection, Rochester, New York.)

identities were inspired by movies of the 1950s and 1960s. Sherman's chameleon-like capacity for self-transformation, her blurring of the real and unreal, and her use of saturated color materials and large scale audaciously explore her notion of human identity as a cultural construct.

Publications

Krauss, R. E. (1993). *Cindy Sherman, 1975–1993.* Essay by Norman Bryson. New York: Rizzoli.

Sherman, C. (2003). *Cindy Sherman: The Complete Untitled Film Stills.* New York: Museum of Modern Art; London: Distributed outside the United States and Canada by Thames & Hudson.

Smith, E. A. T. and Jones, A. (1997). *Cindy Sherman: Retrospective. Exhibition Catalogue.* Essay by Amanda Cruz. Museum of Contemporary Art, Los Angeles, and Museum of Contemporary Art, Chicago. New York: Thames & Hudson.

SISKIND, AARON (1903–1991) American

A member of the New York Photo League through the 1930s, Siskind's early projects such as Dead End: The Bowery and The Harlem Document are rich contributions to the social documentary tradition. In the 1940s he developed enduring connections with artists of the New York School and his work was transformed by a growing interest in abstraction: A visceral and metaphorical abstract expressionism evolved in his richly textured black and white images of found objects, graffiti, peeling posters, and other urban detritus. He became a renowned educator at Chicago's Institute of Design (1951–1971) and Rhode Island School of Design (1971–1976) and a founder of the Society for Photographic Education.

Publications

Chiarenza, C. (1982). *Aaron Siskind: Pleasures and Terrors.* Boston: Little, Brown.

Featherstone, D. (ed.) (1990). *Road Trip.* San Francisco: The Friends of Photography.

Siskind, A. (2003). *Aaron Siskind 100.* New York: powerHouse Books.

SMITH, W. EUGENE (1918–1978) American

Smith's extended photo-essays in *LIFE* magazine (1939–1955), Man of Mercy (on Albert Schweitzer), Country Doctor, Spanish Village, and Nurse Midwife helped define a new style of magazine photojournalism in America. Forming an ideology of social responsibility and humanism during his years as a WWII photographer in the Pacific, Smith returned from the war to produce picture stories for *Life* that resonate with depth, optimism, and belief in the human spirit. His moral and visual standards have had a lasting impact on today's photographers. "My principle concern is for honesty, above all honesty with myself …" He eventually left the constraints of magazine work to pursue personal projects of greater depth and scope (in Pittsburgh and New York), defining himself as an artist and producing prints of outstanding tonal richness and beauty. His final work, Minamata (1975), produced in collaboration with his second wife, is an essay in photographs and words of the tragic effect of mercury pollution on this small fishing village in Japan. He taught at New York's New School for Social Research, and served as president of the American Society of Magazine Photographers.

Publications

Hughes, J. W. (1989). *Eugene Smith, Shadow & Substance.* New York: McGraw-Hill.

Maddow, B. (1985). *Let Truth Be the Prejudice, W. Eugene Smith, His Life and Photographs.* Millerton, NY: Aperture.

Smith, W. E. and Smith, A. M. (1975). *Minamata.* New York: Alskog-Sensorium Book.

SOMMER, FREDERICK (1905–1999) American

Known for his black and white contact prints of exceptional tonal beauty and his probing philosophical approach, he explored a wide range of visual expressions that merged painting, drawing, music, and the photographic image. Influenced by Alfred Steiglitz and Edward Weston, he began making photographs in 1935. His idiosyncratic choices of still life objects steeped in putrescence have a formal elegance, their structure and associations laden with psychological depth. His photographs of cut paper constructions, assemblages and lensless images of smoke on glass are a fantastical counterpoint to his horizon-less depictions of the southwest landscape. Sommer worked in relative isolation in Arizona for more than fifty years, his prominence coming late in his career.

Publications

Conkelton, S. (ed.) (1995). *Frederick Sommer: Selected Texts and Bibliography.* New York: G. K. Hall.

Sommer, F. (1980). *Frederick Sommer at Seventy-Five.* Long Beach: The Art Museum and Galleries, California State University.

FIG. 70 Eight Young Roosters, 1938. Gelatin silver print. Photograph by Frederick Sommer, Frederick & Francis Sommer Foundation. (Courtesy of George Eastman House Collection, Rochester, New York.)

STEICHEN, EDWARD JEAN (1879–1973) American

A pivotal figure in the growth of creative photography in America, Steichen was one of the founders, with Steiglitz, of the Photo-Secession (1902) and The Little Galleries of the Photo-Secession (known as 291) in New York. Introducing the modernist work of Picasso, Matisse, Cezanne, and Rodin to America with debut exhibits at 291, he was also a frequent contributor to Stieglitz' *Camera Work* magazine. He produced images of rich tonal depth and romantic sensibility; his early pictorialist use of manipulated gum and pigment printing processes were abandoned for a more precise, pragmatic style. His stylized fashion and celebrity images of the 1920s, published frequently in *Vanity Fair* and *Vogue*, were notable for their simple, theatrical settings; dramatic lighting and architectonic backdrops; and had an aura of impersonal cosmopolitan elegance. Shaped by his entrepreneurial spirit and his infatuation with celebrity and prestige, Steichen's career flourished as Director of Photography for Condé Nast publications (1923–1938). His career, twice punctuated with army and navy combat photographic service during both world wars, eventually led to the museum world. One of his most celebrated achievements came as Director of the Photography Department, Museum of Modern Art, New York (1947–1962) with his marketing of large themed exhibitions of photography, including the hugely popular The Family of Man (1955).

Publications

Niven, P. (1997). *Steichen: A Biography*. New York: Clarkson Potter.

Smith, J. (1999). *Edward Steichen: The Early Years*. Princeton, N.J.: Princeton University Press and the Metropolitan Museum of Art.

Steichen, J. (ed.) (2000). *Steichen's Legacy: Photographs, 1895–1973*. New York: Alfred A. Knopf.

STEINER, RALPH (1899–1986) American

Known as a modernist photographer and filmmaker, Steiner was a founding member of the New York Film and Photo League. His sharp focus, carefully composed photographs portray quotidian America, their exquisite detail and textures presented with a modernist's eye for meaning in form. A successful career in magazine and advertising photography supported his passion for art photography and avant-garde film. In 1929 he produced his first film, H_2O. Steiner's artistry in documentary filmmaking led to his collaboration with photographer Paul Strand as cameraman on Pare Lorentz' documentary film, *The Plow that Broke the Plains*, and in 1938 with Willard Van Dyke, on *The City*, a critically acclaimed film about New York.

Publications

Steiner, R. (1978). *A Point of View*. Middletown, CT: Wesleyan University Press.

Steiner, R. (1985). *In Pursuit of Clouds: Images and Metaphors*. Albuquerque: University of New Mexico Press.

Steiner, R. (1986). *In Spite of Everything, Yes*. Albuquerque: Harwood Museum of Art, Dartmouth College, University of New Mexico Press.

STEINERT, OTTO (1915–1978) German

One of the most important post-war German photographers and founder of the Subjective Photography movement in post-war Germany, Steinert was also curator of the international exhibition Subjektive Fotografie in 1951, 1954, and 1958 in Saarbrücken. Steinert's view of photography as an expression of an individual's inner state advocated dialog with plastic qualities, graphic manipulations, and concern for form associated with experimental Bauhaus photography of the 1920s. From 1959 until his death he was an influential teacher at the Folkwang School in Essen.

Publications

Steinert, O. (1999). *Der Fotograf Otto Steinert/Herausgegeben von Ute Eskildsen, Museum Folkwang Essen*. Göttingen: Steidl.

Steinert, O. (1952). *Subjektive Fotografie; ein Bildband moderner europäischer Fotografie. A collection of modern European photography*. Bonn: Brüder Auer.

STIEGLITZ, ALFRED (1864–1946) American

The 20th century's greatest champion of photography as an art form. Editor of *Camera Notes*, the journal of the Camera Club of New York, Stieglitz soon became leader of the Pictorialist movement in New York, co-founder of the Photo-Secession in 1902, and editor and publisher of the masterful periodical *Camera Work* from 1903 to 1917. With Steichen's assistance, his Little Galleries of the Photo-Secession, later called 291, then

The Intimate Gallery (1925–1929), and An American Place (1929–1946) first showcased in America the new modern art from Europe by Picasso, Matisse, Braque, Cézanne, Brancusi, and Rodin and introduced American painters O'Keeffe, Marin, Hartley, and Dove. Exhibiting painting with photography, his gallery showed photographers Clarence White, Coburn, Strand, Steichen, Adams, and Porter. Abandoning the soft-focus aesthetic of Pictorialism by World War I, Stieglitz became a staunch advocate of straight photography, adopting less self-conscious methods to depict the fast-paced cacophony that defined modern life, and simplifying his compositions to clarify light and form. His highly regarded images using a hand-held camera of the streets of New York City, portraits of his wife, the painter Georgia O'Keeffe, and his "equivalents" series of cloud studies that were analogs for emotional experience, helped realize the profoundly metaphorical possibilities of the medium.

Publications

Greenough, S. and Hamilton, J. (1983). *Alfred Stieglitz: Photographs and Writings*. Washington, DC: National Gallery of Art.

Lowe, S. D. (1983). *Stieglitz: A Memoir/Biography*. New York: Farrar, Straus & Giroux.

Whelan, R. (1995). *Alfred Stieglitz: A Biography*. Boston: Little, Brown.

STRAND, PAUL (1890–1976) American

Strand believed in the redemptive power of art that is rooted in the reality of everyday life, and was an articulate advocate for a "pure" aesthetic in creative photography. Believing in the "absolute unqualified objectivity" of photography, Strand created tightly structured compositions printed in rich chiaroscuro, innovative for their authenticity and dynamism. His early subjects included street people of New York, nudes of his wife Rebecca, still lifes, landscapes of New Mexico, and experiments with abstraction and movement. By 1916 his work was championed by Steiglitz with solo exhibitions at 291 and publication in *Camera Work*'s final issues, devoted exclusively to his photographs. An active filmmaker through the 1920s and 1930s, Strand returned to his interest in portraiture by the mid-1940s when his primary goal was to reveal the essential character of his subject with its physical and psychological ties to the larger world. Motivated by his ideology and influenced by his experience in film, he created a series of cultural portraits, exploring both the portfolio and book form: Photographs of Mexico (1940), Time in New England (1950), Un Paese (1955), Tir a'Mhurain: Outer Hebrides (1968), Living Egypt (1969), and Ghana: An African Portrait (1976). He emigrated to France in 1950 in response to the growing oppression of McCarthyism.

Publications

Greenough, S. (1990). *Paul Strand, An American Vision*. Washington, DC: National Gallery of Art.

Stange, M. (ed.) (1991). *Paul Strand, Essays on His Life and Work*. Millerton, NY: Aperture.

Strand, P. (1976). *Paul Strand: Sixty Years of Photographs*. Millerton, NY: Aperture.

STRUTH, THOMAS (1954) German

Studied with Gerhard Richter and Bernd and Hilla Becher at the Kunstakademie in Dusseldorf, Germany, where a new generation of photographers emerged in the 1980s and were noted for the cool intellectual detachment and epic scale of their color photographic work. The conceptual underpinnings of Struth's training find form in psychological landscapes of contemporary urban malaise. With precise detail, saturated color, and grand scope, he pictures such public spaces as church and museum interiors with a contemplative detachment that can also be found in his earlier black and white images of city streets. He has exhibited internationally since the late 1980s, and has numerous monographs published of his work. He lives in Düsseldorf.

Publications

Struth, T. (1993). *Museum Photographs*, Munich: Schirmer/Mosel.

Struth, T., Lingwood, J., and Teitelbaum, M., eds. (1994). *Thomas Struth: Strangers and Friends: Photographs 1986–1992*, Cambridge, MA: The MIT Press.

Essay by Dieter Schwarz. (2001). *Thomas Struth: Dandelion Room*, NY.: DAP/Shirmer/Mosel.

Struth, T. (2001). *Still*, New York: The Monacelli Press.

Essays by Norman Bryson, Benjamin H.D. Buchloh, and Thomas Weski. (2001). *Thomas Struth: Portraits*, Munich: P Schirmer/Mosel.

Essays by Ingo Hartmann and Hans Rudolf Reust. (2002). *Thomas Struth: New Pictures from Paradise*, Munich: Schirmer/Mosel.

STRYKER, ROY EMERSON (1893–1975) American

Director of the most extensive documentary photography project undertaken by the U.S. Government, for the Farm Security Administration (FSA) (1935–1943). Selecting such photographers as Walker Evans, Dorothea Lange, Russell Lee, Arthur Rothstein, and Ben Shahn, the FSA under Stryker's leadership produced a massive document of 250,000 negatives, archived in the Library of Congress, that captured the broad face of rural America as it weathered the Great Depression.

Publications

Stryker, R. E. (1973). *In This Proud Land*. With Nancy Wood. New York: Galahad Books.

SUDEK, JOSEF (1896–1976) Czechoslovakian

Working in Prague all his life, Sudek devoted himself to creating a portrait of his city, with mystical panoramic views of its streets and buildings, poetic still life images taken from his studio window and atmospheric depictions of his garden. His magical orchestration of rich, dark tones and the ethereal luminescence of his highlights render Sudek's world in a spiritual

and dream-like tone, where light is substance. The difficulties in Sudek's life, the loss of his right arm during World War I and the hardships suffered during the Nazi and Soviet occupations of Prague, color his evocative and emotional work. Despite his handicap, he used large view cameras, including a 12 × 20 panoramic format that he wielded both horizontally and vertically, photographing without the help of an assistant. He compiled seven books of Prague photographs, working in the streets until old age and his physical limitations made it too difficult to haul his cameras around.

Publications
Bullaty, S. (1986). *Sudek*. New York: Clarkson N. Potter.
Farova, A. and Sudek, J. (1990). *Josef Sudek: Poet of Prague, A Photographer's Life*. Millerton, NY: Aperture Books.

SUGIMOTO, HIROSHI (1948) American, Japanese born
Sugimoto's extended-time images of the interiors of movie theaters, atmospheric seascapes, dioramas, and waxworks probe the wonders of perception, time, transience, and memory. He first came to public attention with his images of the interiors of movie theaters, their delicate details rendered by the movie's cumulative illumination; the shutter was timed for the duration of each movie. His series of seascapes that divide the frame horizontally into sky and sea render in exquisite tonalities, the endless variations of atmosphere, tone, and light. Like reverberating echoes, his images are mesmerizing, evocative, and enigmatic. With simultaneous simplicity and depth, they give substance to the passage of time. Born in Tokyo, Sugimoto left Japan to study at the Art Center College of Design in Los Angeles. In 1974 he moved to New York City and now lives in both New York and Tokyo.

Publications
Bashkoff, T. and Spector, N. (2000). *Sugimoto Portraits*. New York: Guggenheim Museum Publications.
Kellein, T. (1995). *Hiroshi Sugimoto: Time Exposed*. New York: Thames & Hudson.
Schneider, E. (ed.) (2002). *Hiroshi Sugimoto: Architecture of Time*. Cologne: W. König, New York: DAP (outside Europe).

SZARKOWSKI, JOHN THADDEUS (1925) American
Following Edward Steichen as the Director of the Department of Photography, Museum of Modern Art, New York, Szarkowski was instrumental in shaping America's view of photography: MoMA produced 160 photo exhibitions during his tenure (1962–1991), many directed by Szarkowski. His role as critic, educator, and curator found form in a stream of books and critical writings, many associated with his exhibitions at MoMA. With a keen eye and thoughtful pen, he was a significant force in the careers of numerous contemporary photographers, championing the work of young photographers such as Arbus, Friedlander, Eggleston, and Winogrand, and paying homage to 20th century masters Adams, Callahan,

Steiglitz, Penn, Kertesz, Atget, and more. Having achieved success as a photographer in his own right early in his career, he returned to photographic practice after his retirement from MoMA and in 2005 mounted his first retrospective.

Publications
Phillips, S. S. (2005). *John Szarkowski: Photographs*. New York: Bulfinch Press.
Szarkowski, J. (1973). *Looking at Photographs: 100 Pictures from the Museum of Modern Art*. New York: Museum of Modern Art.
Szarkowski, J. (1978). *Mirrors and Windows: American Photography Since 1960*. New York: Museum of Modern Art; Boston: distributed by New York Graphic Society.
Szarkowski, J. (1989). *Photography Until Now*. New York: Museum of Modern Art.

TOMATSU, SHOMEI (1930) Japanese
Japan's premier post-war photographer, Tomatsu chronicles the complex cultural changes from Japan's traditional pre-war society through the ravages of World War II, American occupation, and its ambivalent struggle with Western influences. His historic documentation of the lives of atomic bomb survivors in Nagasaki is distinguished for its metaphorical depth and intimacy. Co-founder of the VIVO cooperative agency in 1959, he advocated a new social landscape of photography in Japan, influenced by the humanist subjectivity and surrealism of Europe and America. Initially black and white, characterized by graphic minimalism and dramatic composition, his later works embrace color. His portraits of bohemian nightlife in Tokyo's countercultural Shinjuku, his elegies to traditional life remaining in remote islands of Japan, and his ironic depictions of the collision of Western and Eastern cultures are powerful documents that simultaneously mourn and celebrate.

Publications
Jeffrey, I. (2001). *Shomei Tomatsu*. London: Phaidon.
Rubinfien, L., Phillips, S. S., and Dower, J. W. (2004). *Shomei, Tomatsu: Skin of the Nation*. Preface by Daido Moriyama. San Francisco: Museum of Modern Art in association with New Haven, CT: Yale University Press.
Tomatsu, S. (2000). *Tomatsu Shomei 1951–1960*. Tokyo, Japan: Sakinsha.
Tomatsu, S. (1998). *Visions of Japan, Tomatsu Shomei*. Korinsha Press, Distributed Art Publishers, New York.

UELSMANN, JERRY N. (1934) American
Creator of enigmatic, surreal images, Uelsmann was first known for his mastery of complex, multiple negative darkroom printing techniques and for his philosophy of post-visualization of the image. He creates composite images from his personal vocabulary of image fragments, with psychological association and metaphor at the heart of his work. In transitioning to digital production methods, he continues to create magically convincing paradoxes of time and space. An influential professor at the University of Florida, he is now retired.

FIG. 71 Hands with Round Object in Mountainscape, 1970. Gelatin silver print. Jerry Uelsmann. (Courtesy of George Eastman House Collection, Rochester, New York.)

Publications

Enyeart, J. L. (1982). *Jerry N. Uelsmann, Twenty-Five Years: A Retrospective.* Boston: Little, Brown.

Uelsmann, J. N. (2000). *Approaching the Shadow.* Tucson, AZ: Nazraeli Press.

Uelsmann, J. N. (2005). *Other Realities.* New York: Bulfinch Press.

ULMANN, DORIS (1882–1934) American

Studied with Clarence White. Her photographs provide a respectful portrait of the rural culture and craftspeople of the southern highlands of the Appalachian Mountains and the Gullahs of the Sea Islands of South Carolina. Bringing pictorialist techniques to documentary work, she used a view camera and made platinum prints based on her annual "folklore and photographic expeditions." Her images provide an important ethnographic and historical record.

Publications

Featherstone, D. (1985). *Doris Ulmann, American Portraits.* Albuquerque, NM: University of New Mexico Press.

Peterkin, J. and Ulmann, D. (1933). *Roll, Jordan, Roll.* New York: Robert O. Ballou.

Ulmann, D. (1974). *The Darkness and the Light: Photographs by Doris Ulmann.* Millerton, NY: Aperture.

VAN DER ZEE, JAMES (1886–1993)

Chronicler of the Harlem Renaissance. Self-taught, he opened his Guarantee Photo Studio on famed 125th street in Harlem in 1917 making artistic studio portraits that celebrate Harlem's emergent black middle class. He used ornate furniture, painted backdrops, and props to stage his portraits, posing each sitter

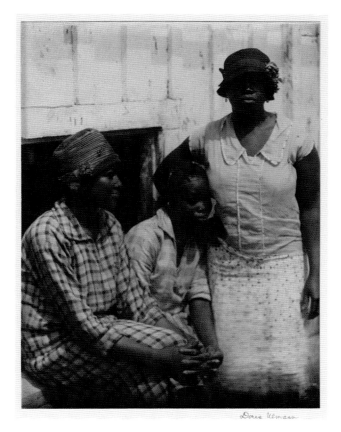

FIG. 72 Waiting for the Excursion Train, ca. 1930. Platinum print. Doris Ulmann. (Courtesy of George Eastman House Collection, Rochester, New York.)

"… in such a way that the picture would tell a story." His signature style often included retouching the final image with color and the use of photomontage. The official photographer to Marcus Garvey's United Negro Improvement Association, he photographed church functions, parades, and funerals, providing a valuable document of the vibrant life of African Americans in Harlem. After the war, Van Der Zee struggled to make a living and it was only in 1967, when The Metropolitan Museum of Art mounted the controversial exhibit Harlem on My Mind, that renewed interest in his work refueled his career.

Publications

Van Der Zee, J. (1968). *Harlem on My Mind: Cultural Capital of Black America, 1900–1968.* Edited by Allon Schoener. Preface by Thomas P. F. Hoving. Introduction by Candice Van Ellison. Metropolitan Museum of Art Exhibition. New York: Random House.

Van Der Zee, J. (1978). *The Harlem Book of the Dead: James Van Der Zee, Owen Dodson, Camille Billops.* Foreword by Toni Morrison. Dobbs Ferry, NY: Morgan & Morgan.

VISHNIAC, ROMAN (1897–1990) Russian-American
Produced a heroic photographic record of the final hours of
pre-holocaust Jewish life in Eastern Europe in the late 1930s.
At great personal risk, traveled through Lithuania, Poland,
Hungary, Czechoslovakia, and Latvia, compiling over 16,000
images (of which 2000 remain) of Jewish village life soon to be
eradicated by Hitler. His poetic images, bravely captured with
a hidden camera, are a most poignant reminder of photog-
raphy's gift of memory. He emigrated to the United States in
1940, where he pursued a remarkable career in the biological
sciences and was a renowned pioneer in photomicrography
and time-lapse cinematography.

Publications
Vishniac, R. (1969). *A Vanished World*. New York: Farrar,
 Straus & Giroux.

WARHOL, ANDY (WARHOLA, ANDREW)
(1928–1987) American
The most famous Pop artist of America, Warhol came onto the
art scene in the early 1960s with his Campbell's Soup Cans, a
campy image of a product he loved elevated to iconic status.
His affect-less images of mass-produced American prod-
ucts and his Pop Culture portraits used images appropriated
from mass media as their source; with stylish simplicity he
transformed photographic information, using garishly bright
silk-screened colors and flat painted forms to raise banality
to monumental status. Aiming for robot-like authorship,
Warhol's work was itself often mass-produced, with assis-
tants creating repetitive, multiple-image silk-screened pieces.
Moving fluidly from one medium to another, his prolific
output also included the publication of his magazine *Interview*
and over 60 films produced from 1963 to 1968.

Publications
McShine, K. (ed.) (1989). *Andy Warhol, A Retrospective*. New
 York: Museum of Modern Art.
Warhol, A. (1999). *About Face: Andy Warhol Portraits*. Essays
 by Baume, Nicholas, Crimp, Douglas, Meyer, and Richard.
 Hartford, CT: Wadsworth Atheneum and Pittsburgh: Andy
 Warhol Museum, Cambridge, MA: Distributed by MIT
 Press.
Warhol, A. (1989). *Andy Warhol, Photobooth Pictures*. New
 York: Robert Miller Gallery.
Warhol, A. (1988). *Andy Warhol: Death and Disasters*.
 Houston, TX: Menil Collection: Houston Fine Art Press.

WEEGEE (ARTHUR H. FELLIG) (1899–1968) American
Born in Lvov, Ukraine, Weegee was a photojournalist who rose
to celebrity status for his on-the-spot photos of daily news
events in New York City. Taking the name Weegee (Ouija)
from his ability to be at the scene within moments, he actually
had a police radio in his car and hook-in to police alarms near
his bed. He used on-camera flash with a 4 × 5 Speed Graphic
to photograph crime scenes, urban disasters, celebrities, and

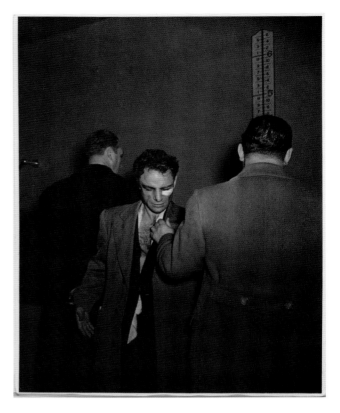

FIG. 73 Booked on Suspicion of Killing a Policeman, Anthony
Esposito, Accused Cop Killer, January 16, 1941. Gelatin silver
print. Weegee/International Center of Photography/Getty Images.
(Courtesy of George Eastman House Collection, Rochester,
New York.)

everyday street life, famous for his strategic, confrontational
approach and sardonic sensibilities. His first exhibit, Weegee:
Murder is My Business, opened at the Photo League in 1941,
and his first book, *Naked City*, was published in 1945 to be
followed by a series of books, museum exhibitions, and free-
lance projects.

Publications
Weegee (1975). *Naked City*. New York: Da Capo.
Weegee (1978, 1997). *Weegee*. Millerton, NY: Aperture.
Weegee (1975). *Weegee by Weegee: An Autobiography*. New
 York: Da Capo.

WEEMS, CARRIE MAE (1953) American
Weems is notable for her works that fuse words and image to
create psychologically and politically charged explorations of
identity and wrestle with complex issues of gender, race, age,
and ethnicity. Whether focusing on personal narrative or
larger cultural histories of the African American experience

and the issues of Diaspora, her works delve deeply into preju-dice, politics, history, folklore, and the human condition. She often groups images with words, using folkloric constructs of language and storytelling, or creates installation works with audio. Her notable series, Family Pictures and Stories, Colored People, Kitchen Table, Sea Islands, and Landed in Africa have been important contributions to our collective visual and social history.

Publications

Piche, T., Golden, T., Weems, C. M., and Everson Museum of Art. (2003). *Carrie Mae Weems: Recent Work*. George Braziller.

Willis, D., Zeidler, J., Weems, C. M., and Johnston, F. B. (2001). *Carrie Mae Weems: The Hampton Project*, Millerton, N.Y.: Aperture.

Kirsh, A., and Sterling, S. F. (1993). *Carrie Mae Weems*, The National Museum of Women in the Arts.

WESTON, EDWARD (1886–1958) American
Renouncing his early commitment to a soft-focus pictori-alism, Weston became one of the most influential advocates of straight photography in America. His images of the ARMCO Steelworks in Ohio, made in 1922, soon after meeting Steiglitz, Strand, and Sheeler, marked a radical shift toward a straight, unpretentious realism in photography. While in Mexico, where he lived for several years with photographer Tina Modotti (his assistant) and befriended artists of the Mexican Renais-sance, Rivera, Siqueiros, and Orozco, his aesthetic matured. Upon returning to California in 1927, he began his remarkable close-up photographs of shells and vegetables, including the famous Pepper, No. 30. His studio in Carmel was the site of his lifelong project to photograph the cypress trees, rocks, and beaches of Point Lobos. Working with an 8 × 10 view camera, he made silver and platinum contact prints with exquisite attention to light and form, photographing natural forms, the landscape, and nudes, including a series of his second wife, Charis Wilson. In 1932 he was a founding member of the Group f/64, along with Adams, Van Dyke, Cunningham, and Noskowiak who were proponents of straight photog-raphy. The first photographer to be awarded a Guggenheim Fellowship in 1937 and 1938, he produced *California and the West* (1940). Increasingly incapacitated by Parkinson's disease, Weston made his last photographs in 1948, and supervised the printing of his life's work by his sons, Brett and Cole.

Publications

Maddow, B. (1979). *Edward Weston: Fifty Years*. Millerton, NY: Aperture.

Newhall, B. (1986). *Supreme Instants: The Photography of Edward Weston*. Boston: New York Graphic Society.

Newhall, N. (ed.) (1990). *The Daybooks of Edward Weston, Two Volumes in One*. Millerton, NY: Aperture.

WHITE, CLARENCE HUDSON (1871–1925) American
A self-taught photographer of soft-focus images of family life in rural Ohio, White joined with Steiglitz in 1902 to help form the Photo-Secession. The first teacher of photography at Columbia University, New York in 1907, he founded the Clarence White School of Photography in 1914. An influential teacher, whose students included Bourke-White, Gilpin, Lange, Outerbridge, Steiner, and Ulmann, he became the first president of the Pictorial Photographers of America in 1916 in reaction against Stieglitz' shift to straight photography.

Publications

Bunnell, P. C. (1986). *Clarence H. White: The Reverence for Beauty*. Athens, OH: Ohio University Press.

White, M. P., Jr. (1979). *Clarence H. White*. Millerton, NY: Aperture.

WHITE, MINOR (1908–1976) American
Photographer, poet, and influential teacher. Drawing from Steiglitz' ideas of the photograph as an equivalent for human emotion, White's photographic philosophy emphasized the image as metaphor and as spiritual experience. He combined Eastern philosophy, meditation, Gestalt psychology, and the teachings of Gurdjieff as avenues to access creative expression, and focused on the meaningful interaction of images in series. His own exquisitely printed black and white images reflect his spiritual journey. In 1952 White helped found *Aperture* magazine, serving as its editor until 1975. He was a curator at George Eastman House in Rochester, New York, an influential teacher at Rochester Institute of Technology, San Francisco Art Institute, and Massachusetts Institute of Technology. A guru-like presence, many students lived with and studied under his mystical tutelage.

Publications

Bunnell, P. C. (1989). *Minor White, The Eye that Shapes*. Princeton, NJ: Art Museum, Princeton University; Boston in association with Bulfinch Press.

White, M. (1992). *Minor White: Rites & Passages*. Millerton, NY: Aperture [reissue edition].

White, M. (1982). *Mirrors, Messages, Manifestations: Minor White*. Millerton, NY: Aperture; distributed in the U.S. by Viking Penguin.

WINOGRAND, GARRY (1928–1984) American
Winogrand's new brand of documentary photography — raw, spontaneous, inclusive, and irreverent — helped define the 1960s. The controlled turbulence of his images, with their ironic juxtapositions, grainy energy, and complex content, reveal a voracious curiosity and obsession with photography. Influenced by the American photographs of Walker Evans and Robert Frank, Winogrand wandered the streets with his hand held 35 mm Leica, moving in fast and close to shoot wide-angle views of people and places with tilted framing. He was championed by Szarkowski, Director of the Department of Photography at the Museum of Modern Art in New York

and had his first major exhibition there in 1963. His books, including *The Animals* (1969), *Women Are Beautiful* (1975), *Public Relations* (1977), and *Stock Photographs: Fort Worth Fat Stock Show and Rodeo* (1980), only hint at his prolific output; at his untimely death from cancer he left thousands of undeveloped and unproofed rolls of film.

Publications

Friedlander, L. and Harris, A. (eds.) (2002). *Arrivals & Departures: The Airport Pictures of Garry Winogrand*. New York: Distributed Art Publishers.

Szarkowski, J. (1988). *Winogrand, Figments from the Real World*. New York: Museum of Modern Art.

Winogrand, G. (1999). *The Man in the Crowd: The Uneasy Streets of Garry Winogrand*. Introduction by Fran Lebowitz. Essay by Ben Lifson. San Francisco: Fraenkel Gallery and DAP.

WITKIN, JOEL PETER (1939) American

Witkin's dark, shocking tableaux portray beauty in the grotesque and give form to photography's power to confront taboos. Populated by deformed people, hermaphrodites, dwarfs, corpses, and body parts collected and combined to make psychologically charged, highly controversial images, Witkin's images "reflect the insanity of life." Drawing from the history of art and his personal spirituality, Witkin conjures a darkly mythological imagery, compelling and provoking us

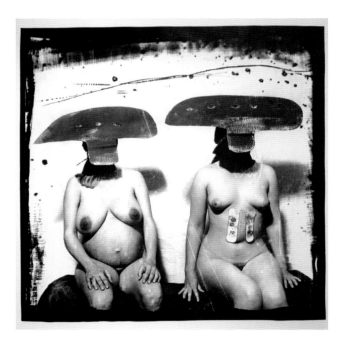

FIG. 74 I.D. Photograph from Purgatory: Two Women with Stomach Irritations, 1982. Gelatin silver print, toned. Joel Peter Witkin. (Courtesy of George Eastman House Collection, Rochester, New York.)

with his exquisitely beautiful grotesqueries. His black and white prints, toned, bleached, and containing scratches and scars made to the negative, are coated with wax overlays on the print's rich surface. Active as an exhibiting artist since the 1970s, Witkin lives in New Mexico.

Publications

Celant, G. (1995). *Witkin*. Zurich; New York: Scale, distributed in North America by DAP.

Witkin, J. P. (1998). *The Bone House*. Santa Fe, NM: Twin Palms Publishers.

WOLCOTT, MARION POST (1910–1990) American

A courageous social documentarian, Post Wolcott's short photographic career is highlighted by her three years photographing for the Farm Security Administration (FSA). Strand and Steiner, friends from the New York Photo League, introduced her to Roy Stryker, Director of the FSA's photography project who hired her to join the project from 1938 through 1941. Her growing social awareness was fueled by her encounters with race and class inequality in the pre-war rural South; with humor and pathos, her photographs often explore the politics of poverty.

Publications

Alinder, J. (ed.), Wolcott, M. P., and Stein, S. (1983). *Marion Post Wolcott: FSA Photographs*. San Francisco: Friends of Photography.

Hurley, F. J. (1989). *Marion Post Wolcott, A Photographic Journey*. Albuquerque, NM: University of New Mexico Press.

Wolcott, M. P. *Looking for Light*. New York: Random House. Out of print.

PHOTOGRAPHIC COMPANIES
AND APPLICATIONS

MICHAEL R. PERES, EDITOR
Rochester Institute of Technology

Photography's Dependence on Equipment

MICHAEL R. PERES AND GREG BARNETT
Rochester Institute of Technology

Taking pictures, whether at a basic or professional level, requires the use of equipment. In this era of technological transformation, taking pictures also requires the upgrading of equipment at frequent intervals. From the moment that there is a need for photography to be undertaken and concluding with the final image delivery, various pieces of equipment are required in each step of the photographic process. The word "equipment" is often used to describe a single entity, rather than taking into account the many individual types of equipment required at various stages in the picture-making process. A number of essays in this encyclopedia explore various photographic tools in all the eras such as cameras, lenses, light, and imaging software. However, in each essay the tool is considered separately rather than as part of a continuum of linked and related pieces. Cameras, for example, can make exposures, which do not result in usable photographic images. In each step in this process, influences occur that affect how the final image will be formed and how it may appear.

For photography to work, a chain of linked events must be completed in order, producing an image that communicates to the intended audience. The process may include both mechanical and electronic imaging tools as well as the physiological process of seeing an image or images and then interpreting what is seen. This process from start to finish is often referred to as the "chain image." Various locations exist in this sequence of events and most locations require equipment. The determination of what subject or scene should be photographed, evaluating the illumination requirements, measuring the light found in that environment—these steps and more, whether accomplished in a controlled or automatic way, must take place. The image-capturing phase requires a camera (or device that operates like a camera) that uses a functional lens with features such as an aperture. In each phase the equipment may influence the image's characteristics, such as its contrast, sharpness, and color. At each place in the chain, the decisions that are made influence the photographic result. These influences are often a function of the tools that are selected and used.

Subject/situation/scene + light/energy spectrum + reflection/transmission + camera + lens + image formation system + exposure + CCD characteristics + record system + storage system + file transferring + file saving + image processing influence + file saving + image system reading and display + image system archive I

Society plays a role in determining what photographic tools people may purchase and subsequently use. Improvements and breakthroughs in mechanics, optics, chemistry, and now electronics all have contributed to the rapid growth of photographic equipment and the processes of sharing images electronically. The most recent developments in technology have brought photography to highly sophisticated levels. In the world of digital technology, many people originally felt that equipment had become so advanced that it had a negative impact on the photographer's creativity, but one only has to watch teenagers with cell phone cameras and Apple Photo-Booth® software, for example, to know that this could not be further from the truth. A camera—or any image-making equipment — must be operated by a user. Users may or may not be trained photographers. The features found in many cameras now allow photography to be undertaken in almost any difficult lighting situation and produce acceptable results by untrained photographers. In the recent past, a film's color response was a major factor in the color quality, but now an image's white balance can be optimized in almost any environment.

Photographic equipment can be broken down into major groups: cameras, lenses, accessories, camera supports, lighting- and studio-related equipment, computers, scanners, imaging

Part page photograph: Street Photographer with large format camera in New York City and a photographer instructor with a Yashica Twin Lens reflex camera, ca. 1992. © Owen Butler, Rochester Institute of Technology. Rochester, New York.

software, and equipment for printing. Within each of these groups there may be further subdivisions.

Camera equipment can include the various types and formats of cameras, and lenses, including digital capture technologies. Camera supports refer to tripods, tripod heads, monopods, studio stands, dollies, and motion-compensation devices. Lighting equipment includes tungsten and studio lights, electronic flash for location and studio, reflectors and diffusers, and stands and booms. Darkroom and processing equipment, although rapidly vanishing, includes a wide array of items: sinks, processing tanks, thermometers, enlargers, safelights, driers, contact printers, and machine processors. Electronic imaging equipment, which is still a new and fluid category, represents the new technologies of photography, including computers, media, scanners, printers, software, and optical storage systems. The definitions of many of these devices are not so simple anymore.

Most people immediately think of a camera when the word "equipment" is used to describe photography. The earliest cameras were simple boxes with a simple lens; however, materials were not available at that time to record the visible images they produced. Development of light-sensitive plates in the mid-1800s led to the creation of what we would call a true photographic camera. Improvements in lens manufacturing and timing mechanisms for shutters provided early photographers with more control for recording images as camera technology advanced (see History cameras). With the advent of roll film, photography became available to the masses and multi-exposure cameras were available to anyone who could afford them. Improvements in film eventually created a demand for different sizes and formats. Over the years, many formats have come and gone. Those that have disappeared include the 110 mm, 126 mm, 626 mm, and disc formats. The era of the 35 mm film emulsion, the format most widely used, is clearly in the twilight of its usage. Medium and large formats, which were used extensively by professionals and advanced amateur-photographers, are still available, but digital photography continues to drive these markets as well. Medium-format cameras recently included 6 × 4.5, 6 × 6, 6 × 7, 6 × 9, 6 × 12, and 6 × 17 cm. Some of these may be discontinued by the time of this book's printing. The film size used in medium-format cameras was referred to as 120 or 220, depending on the length of the roll and the number of exposures. Large-format cameras use individual sheets of film or can easily accommodate direct digital backs. The film sizes most commonly used are 4 × 5, 5 × 7, 8 × 10, and 11 × 14, but as companies that make emulsions discontinue their product lines, brands and sizes are becoming more limited. Many large-format camera manufacturers are producing or distributing digital image capture components for their camera systems.

Recent advances in the design and consumption of digital cameras has been dramatic, to say the least. Photographers can choose from a wide selection of cameras in this era of manufacturing of new cameras, which has seen the release cycle change from a two-year period to fewer than three months.

2004 saw the first 6M DSLR camera priced under $1000, while a 10M camera for less than $1000 was offered in the summer of 2006. These cameras also allow for adding of data such as audio recordings or other important information to the image file. Practical features, such as wireless file sharing, that seemed so distant just a few years ago are now common. Shutters for these cameras and their film counterparts are available with either mechanical or electronically controlled timing. Modern optical engineering has produced lenses with a resolving power that sometimes exceeds what can normally be observed by the human eye. Combined with advanced multi-coating and low-dispersion glass, today's lenses offer outstanding performance. Certain lenses have been designed and manufactured specifically for digital technology to assure a direct path to the pixel.

Today's exposure meters, whether built-in to a camera or external, offer a high degree of accuracy and a number of exciting features. In the earliest times of photography's history, many failed attempts at determining exposures often led to poor image quality. Today, technology provides features that would astound early photographers. A typical professional meter will be able to measure incident, reflected, spot, flash, or combination readings almost concurrently. Meters talk to cameras and computers simultaneously. Many meters can store multiple readings, which allows averaging or zone system calculations as they are entered. Cameras with built-in meters offer the ability to take many readings, allowing the photographer to choose lens and shutter settings, which in turn leads to the automatic exposure control in challenging situations. Many of these in-camera meters also have selectable metering patterns. Within these camera advances, there are also built-in electronic flash capabilities that are also synchronized with the meter. Through-the-lens (TTL) metering, found in the latest camera technology on the market, is extremely accurate and produces image and exposure control that experienced photographers are always impressed by.

Good photography often requires the use of camera support equipment to create quality images, regardless of the type and format of camera. View cameras and other large-format cameras require some kind of support system because these cameras are heavy and cannot be characterized as hand-held. The basic goal of tripods has not changed much since their invention; however, lighter metal alloys and more ergonomic features characterize modern tripods. Most manufacturers carry various types and sizes of tripods that offer a choice of panning and tilting heads. These options allow the working photographer to use one base assembly with several different heads. Monopods are a lighter-weight alternative to tripods when stand-alone stability is not required. The type of photographic work undertaken will of course influence the type of materials, weight, features, and, ultimately, cost of such a piece of equipment.

The studio photographer needs a more substantial support system. Studio tripods are designed to meet this need. Typically, these stands have a heavy base, complete with retractable

wheels and a counter-balanced arm that can be adjusted with a minimum effort. Studio stands are capable of supporting heavy, large-format cameras without vibration or the possibility of tipping over. Camera dollies are mobile shooting platforms. They are primarily used for professional motion-picture and video camera requirements. For situations in which the camera is subjected to constant motion, such as aerial photography, gyro-stabilized mounts are available. Many of these devices use mounted gyroscopes coupled with stabilizing lenses to absorb vibration and sudden movements.

Photography often requires the use of artificial light. The earliest form of artificial light was created using flash powder. This explosive, gunpowder-like mixture was set off with a small triggering explosion just as the shutter was opened. While it did provide a burst of enough light to make an exposure, using too much often resulted in un-staged fires. In today's world, a wide array of tungsten and electronic flash equipment is available. Studio lights have remained fundamentally unchanged for many years. Mini-spotlights, focusable spots, spots with fresnel lenses, and diffused lights are all still widely used today. Small but powerful quartz lights are popular with photographers who specialize in location and architectural interiors. Diffusers or reflector panels are used to soften the hard light produced by these units. HMI lights and other new technologies have resulted in many interesting new products, including LED lights, which are finding applications in science. (See Lighting — Material & Process Essentials.)

Electronic flash has become the mainstay of many photographers. On-camera flash units are also widely used by photojournalists, wedding photographers, and amateur photographers. Most of the popular point-and-shoot cameras produced today are equipped with built-in flash units. In fact, the single-use camera, which became one of the most common cameras used in the 1990s, has a model with this feature built in. Some of the main advantages to using electronic flash over tungsten lights is the ability to stop action. Studio flash units offer a flexible output of light with a high degree of control and portability never before seen. Many systems allow for individual flash heads to be rationed at the power pack. Infrared remote control units and triggering are some of the features offered by sophisticated studio flash systems and are operable from the automobile electrical system with a proper adapter.

Many accessories are available for lighting equipment, including various types of stands, boom arms, clamps, diffusers, reflectors, and umbrellas. Some of these items bear unusual names such as cookie cutters, salad bowls, honeycombs, light panels, and gobos. They are all designed to aid in the placement of — or control over — lighting. Collapsible reflector panels made of fabric have become popular because of their light weight and portability. Plastic tubing, fiberglass wands, or spring steel bands are used in the reflectors for support. They are available in a variety of reflective surfaces and colors.

Darkroom and processing equipment has evolved significantly from the early days of developing daguerreotype plates over mercury vapors. Today's increased concern about handling dangerous chemicals has led directly to these improvements. Professional labs and home-darkroom enthusiasts alike have a wide array of equipment to choose from. In the 1990s, however, decreasing profitability for darkroom equipment manufacturing and sales has forced big changes in this industry. Most large-scale labs that processed film have switched over to small-automated machine processing. While smaller custom labs and home darkrooms still use many of the traditional tools, finding these labs and related chemicals is becoming difficult in some communities. Mail-order labs still can be located via the Internet, but the next decade will certainly see fewer of these vendors and their services. Most darkroom enlargers are collecting dust and only the true practicing artist seems determined to still use darkroom facilities. EBay has become the world's best resource for selling and buying darkroom equipment.

Electronic-imaging equipment is photography's modern technology. The initial debate as to whether electronic imaging will ultimately take over photography is no longer considered. The market has spoken. Needless to say, the new technologies will continue to alter the photographic equipment world. Central to electronic imaging is the personal computer, or PC. The Apple Macintosh system took the early lead as the premier imaging platform in the 1990s because of its graphic user interface and color display technology, but today, the Windows and UNIX machines command equal respect with Apple in these same industries. The fast pace of development work on these imaging systems has brought prices of digital equipment in all of its iterations down to a level that a typical professional photographer can afford.

Scanners are very common devices that allow users to digitize silver-based images into a computer imaging system. Transparencies, prints, or color and B &W negatives can be scanned and transformed into digital images that can be directly manipulated by software programs. High-quality scanners are able to resolve film images at original levels. The ability to maintain the original resolution, color, and density values of the image then becomes dependent on the hardware and software being used. Whole new services exist that offer scanning services at a variety of quality and cost levels. As the world continues to digitize images and other archives, such as those found in museums, the scanner has become a powerful tool.

Software packages for imaging offer an incredible number of features, allowing images to be manipulated in just about any fashion imaginable. Adobe PhotoShop®, which was released in February 1990 for the Macintosh, is the most well-known image-editing software on the market; its CS2 version (Version 9.0) was released in 2005. Color, density, and contrast can be altered or adjusted, and special effects such as image inversion can be executed in milliseconds. Sophisticated editing tools allow for cutting and pasting segments of images together and can be done so precisely it can't be detected. Other tools can take samples of colors or textures from one area of an image and reproduce them elsewhere. High-end

imaging software can produce color files that can be electronically transferred to prepress for reproduction in the printing process. Once an image has been manipulated, it can be printed out directly by the computer or sent to a film recorder or paper printer. Color inkjet printers — as well as other technologies, such as thermal — are available that can produce photographic quality prints, sometimes using RA-4 papers.

Image-storage technology and its related equipment is advancing rapidly forward. In 1992, the price of removable storage media was approximately $1USD per MB, while in 2006 that price had fallen to $ 0.01USD per MB. Change seems to be the only constant in the foreseeable future for the tools, manufacturers, and users of photography and its related supplies and equipment. Photography will always require equipment and related technology. Since 1993, when the 3rd Edition was published, significant changes have occurred in this field. One can only speculate what the next 15 years will bring. ◉

Profiles of Selected Photographic Film and Digital Companies

MICHAEL R. PERES
Rochester Institute of Technology

The use of silver halide photography en masse arguably began in the late 1800s, when the equipment and materials required to make pictures became more accessible and common. Film photography had its largest number of users at the end of the 20th century. Around the year 2000, digital photography began to seriously displace film as the primary technology used to make pictures. At the end of the 20th century, there were fewer than 20 companies world-wide that produced sensitized film and paper products, while according to a 2000 issue of PMA magazine, the estimated number of companies selling digital cameras and related models was more than 270. The proliferation of companies involved with digital technology is challenging to monitor because it is so dynamic, with changes almost monthly. Companies that produced film cameras now make digital-imaging equipment; companies that did not exist in 1993 dominate the market, while computer companies are making cameras.

The economics of photography as an industry is quite impressive, with a long list of companies, organizations, and people that generate an income from the practices, products, and services required by their customers. All persons involved with photography in any capacity will still find an "industry" that is in flux; however, the changes in 2006 are not as volatile as they once were. Companies that produce, distribute, and create photographic products and services in the largest definition are finding a constantly changing market enamored with cellular phone cameras and other "cool" products. It is a time when many pieces of electronic equipment are considered disposable. Photographic company icons such as Kodak are trying to operate in this new world, in which there has been a huge confluence of companies and distributors of photographic products and services. Many practitioners are generally at a loss to keep up with the constant changes and products as many in the industry constantly evolve their product lines. When today's consumer goes into a camera store, there is a large presence of electronic equipment, including computers, video cameras, and audio products; a few years earlier there would have only been silver halide equipment and products. That consumer will have the same experience in an electronics store.

The essays on the following pages profile some of the achievements of companies that have defined photographic materials and equipment, first in the silver halide era and now in the digital era of photography. The companies were selected because of their impact on silver halide and digital photography's equipment and materials. While companies such as Kodak, Ilford, Leica, and Zeiss are more than 100 years old, other companies were selected because of their name recognition in the field of new technologies. The following pages represent entries written by Michael Peres and Chuck Westfall, or are entries that were originally published in the *Focal Encyclopedia of Photography*, 3rd Edition (1993) by the following authors: Peter Walker, Thomas Shay, Warren L. Mauzy, Roger W. Horn, J. Samburg, and Allan Verch. Minor updating has been done by the editor and will be noted by the use of [] brackets.

Below is a selected list of companies that have made or are currently making products used in various applications of photography.

Adobe
Agfa
Altman
Apple
BASF
Belkin
Bogen
Broncolor
Bushnell
Calumet
Canon, Inc.
Casio Computer Co., Ltd.
Chinon Industrial, Inc.
Columbia Magnetic Products Co., Ltd.
Copal Co., Ltd.
Comet
Contax
Dai Nippon Printing Co., Ltd.
Dell
DuPont
Eastman Kodak Company
Efke
Elinchrome
Elmo Co., Ltd.
Epson, Inc. (Seiko Epson Co.)
Formatt
Forte
Fuji Photo Film Co., Ltd.
Gossen
Hasselblad
Heliopan
Hensel
Hewlett-Packard
Hitachi, Ltd.
Hoodman
Hoya
IBM
Ilford
Ikelite
Imacon
Iogear
Kaidan
Kasei Verbatim Corporation

Keystone Camera of Japan, Ltd.
Konica/Minolta Corporation
Kowa
Kyocera Corporation
LaCie
Leica
Lexar
Lumedyne
Macally
Mamiya Camera Co., Ltd.
Manfrotto
Matsushita Electric Industrial Co., Ltd.
Microtech
Mitsubishi Electric Corp
Mole-Richardson
Motorola, Inc.
NEC Corporation
Nikon Corporation
Nokia
Norman
Olympus Optical Co., Ltd.
Panasonic
Pentax (Asahi Optical Co., Ltd.)
Phase One
Philips International B.V.
Polaroid Corporation
Profoto
Quantum Instruments
Ricoh Company, Ltd.
Rollei, Inc.
Sailwind
Sachtler
Samsung Japan Electronics Co., Ltd.
Sankyo Seiki Manufacturing Co., Ltd.
SanDisk
Sanyo Electric Co., Ltd.
Schneider
Sea & Sea
Seagate
Seiko Co.
Sekonic
Sharp Corporation
Sigma
Sinar-Bron
Singh-Ray
Smartdisk
Strand Lighting
Sunpak
Sony Corporation
Svema
Tamron
TDK Corporation
Thompson-Japan K K Co.
3M Company/Sumitomo 3M, Ltd.
Tiffen
Toshiba Corporation

Victor Company of Japan, Ltd. (JVC)
Visatec
Wolverine
Zeiss

Adobe

Adobe Systems, Incorporated, was formed in 1982 and immediately changed how the world worked with graphics. The company's award-winning software and technologies had big influences on business, entertainment, and personal communication applications by introducing software that enabled graphics professionals and photographers to move from the "old tools" to the computer with a reasonably smooth transition. Adobe, headquartered in San Jose, California, has become in a short time one of the world's largest and most diversified software companies, with 2005 revenues of USD $1.996 billion (FYE Dec. 2, 2005). Adobe was founded by Chuck Geschke and John Warnock. Their vision of publishing and the graphic arts changed how people created electronic content and graphical information. The two met in the late 1970s while working at the world-renowned Xerox Palo Alto Research Center (PARC). In 1982, they founded Adobe Systems, Incorporated, focusing on the challenge of controlling how text and images observed on the computer screen could be controlled precisely so that the file could be reproduced beautifully and accurately in print.

In 1983, Adobe® PostScript® technology was launched, which revolutionized the desktop publishing industry by providing a radical new approach to printing text and images on paper. For the first time, a computer file could be printed exactly as it was displayed on the computer screen, maintaining all of its formatting, graphics, and fonts.

Building on the success of that software, Adobe expanded into desktop software applications in 1987 with Adobe Illustrator® and, in 1990, Adobe Photoshop® software, which both had a huge impact on the graphics and photographic fields. These unique applications redefined the control creators had on image quality as well as the complexity of the images that could be included. Adobe InDesign® software followed, which also changed the page-layout market, enabling household-name magazines, newspapers, and corporate brands to adopt modern, integrated publishing workflows.

Continuing to improve its software products for computing, Adobe released Adobe Acrobat® software and the Adobe Portable Document Format (PDF), which combined its expertise in desktop software with its roots in PostScript printing. Acrobat and PDF revolutionized information sharing by allowing people around the world to deliver digital documents exactly as intended across computing platforms and applications. Acrobat achieved quick success, and today the PDF file is the de facto standard for governments and businesses everywhere sharing documents across the Web, corporate intranets, and e-mail.

It is estimated that more than 90 percent of creative professionals use Adobe Photoshop or its smaller version, Elements. Adobe PDF documents make up nearly 10 percent of the content on the Web. Many of the world's PC manufacturers

ship their systems with PDF technology pre-installed. In 2005, Adobe acquired Macromedia, Inc., the developer of the powerful Flash software.

Today, the Adobe Engagement Platform, which is built around Adobe PDF and Flash technology, further enhances the work of people who create, manage and deliver visual information.

www.adobe.com

Agfa

Agfa is a photographic business that originated from a German company that produced chemicals and dyestuffs in the early 1900s. In the early 1920s, the manufacturing of photographic products became dominant and the acronym Agfa was adopted as the company's name. Agfa developed a grain-screen process in 1916 that enabled color transparencies to be produced. Agfa patented a triple-layer reversal color film in 1935 that went into production as Agfacolor New Reversal Film in 35-mm and 8-mm sizes in 1936. Four years later Agfa introduced a subtractive color negative film. Agfa Photo Imaging Systems, which was based in Ridgefield Park, New Jersey, operated within the Agfa Division of Miles, Inc. Agfa manufactured and distributed a sizable amount of its photographic films, processing equipment, paper, and chemicals to the minilab/retail, professional, wholesale, and consumer markets. Agfa was a leader in imaging technologies and was a complete full-system supplier to the photofinishing market. Agfa Division reported combined net sales of just under $1 billion in 1991 and employed nearly 4500 people in the United States, with facilities in more than 70 locations nationwide. Agfa manufactured some excellent black–and-white printing papers, including Agfa Brovira and Portriga rapid, which were favorites of many fine artists and print makers. In the early 1990s, Agfa was the largest it would be in the U.S. and world markets. As digital technology continued to capture film markets, film sales slowed at rates faster than many at Agfa had anticipated. Agfa experienced tremendous changes as a company and tried to adapt to the new marketplace. By the late 1990s, Agfa was having significant financial challenges phasing out the film technology business and development, as well as profitable distribution of digital products. In November 2004 the new AgfaPhoto group, headquartered in Leverkusen, Germany, took over all activities of the former Consumer Imaging division of the Agfa-Gevaert group. Products for end consumers — such as film — but especially the production and marketing of lab equipment, software, and consumer goods (particularly photo paper and chemicals) used for the professional development and production of photographic images were part of the AgfaPhotos' core business were closed. Agfa filed for insolvency procedures in June, 2005. AgfaPhoto North America (Ridgefield Park, NJ), the North American operating unit of AgfaPhoto, survived the insolvency filing of its parent company, AgfaPhoto GmbH in Germany. Their medical-products group is operating effectively in the digital radiography and healthcare industries.

FIG. 1 Rodinal was a fine-grain film developer that was popular for black-and-white photography.

Apple

Apple Computer, Inc., is an American computer company with annual sales in 2005 of USD $13.9 billion. Apple computer has its world headquarters in Cupertino, California. Apple became popular in the earliest phases of digital photography for a variety of reasons including its Apple Quick Take cameras. Apple continues to have a following because of the company's most well-known products: personal computers, the iPod portable music player, and the iTunes music software.

Apple has been a major player in the evolution of personal computing since its founding in 1976. The Apple II microcomputer, introduced in 1977, was immediately popular with some users. In 1983, Apple introduced the Lisa, the first commercial personal computer that used a graphical user interface, which was influenced in part by research done in Palo Alto by Xerox. In 1984, the Macintosh (commonly called the Mac) was

introduced, along with the first mouse used with a personal computer. Industry analysts suggest that Apple's success with the Macintosh computer influenced the graphical interfaces of other computer operating systems, such as the Commodore Amiga, Atari ST, and Microsoft Windows. In 1991, Apple introduced its line of PowerBook laptop computers. These laptops in particular established the modern design that has become signature for Apple machines. The early 1990s saw Apple's revenues fall in response to competition from Microsoft Windows and the comparatively inexpensive IBM PC-compatible computers that would eventually dominate the market. In the 2000s, Apple expanded their focus on software to include professional and pro-sumer (professional/consumer) video, music, and photo-production solutions, with an aim toward promoting their computers as a "digital hub" that connects all the pieces. It also introduced the very successful iPod, a portable digital music player that has become the most popular player on the market. Apple has created a following as a company that differentiates itself from others, reflected in its marketing slogan, "Think different." Apple has fostered a high level of brand devotion among some users.

Apple has its critics who are not supportive of the company corporate philosophy that all the hardware and software comes from within the company. For a long time, Apple's hardware was closed and proprietary, and Apple generally refused to adopt prevailing industry standards for hardware, instead creating and implementing their own. Apple largely reversed this trend starting in 2001, using UNIX language in its OS X and Intel processors in the newer Macs. An industry standard, the professional graphical arts and photographic communities use Macs almost exclusively. Apple continues to focus on its core professional markets and recently introduced Aperture, a new image-management and database tool for professional photographers.

www.apple.com

Canon

Canon's first business plan was to become the world's top camera manufacturer. The Hansa Canon, released in 1936, was the first 35 mm focal-plane shutter camera developed and manufactured in Japan. Since then, the company has continued to have a strong brand following among photographers ranging from amateurs to professionals by introducing cameras with innovations such as automatic exposure systems, autofocus lenses, optical image stabilization, and eye-controlled autofocus technologies.

Canon's expertise in optical technologies did not stop its advances in conventional film camera technologies. The company's digital cameras have earned a solid reputation, not only in the single lens reflex (SLR) market, but also among compact digital camera users. In addition, Canon's TV broadcasting lenses and medical equipment such as digital X-ray cameras are widely recognized for their high quality, enabling Canon to be a recognized leader in these markets worldwide.

FIG. 2 The Canon digital SLR. Courtesy of Canon, Inc.

Semiconductor production equipment is another important business in which Canon has applied its optical technologies. High-density chips made using this equipment are incorporated in Canon products as well as a wide array of information equipment on the market today.

Canon entered the business-machines industry in the 1960s and commercialized its first copying machines using original technologies in 1968. Later came laser beam printers (LBPs), bringing together all of the company's laser technology know-how. Canon went on to develop color LBPs and, more recently, network digital multi-function printers (MFPs). The result has been the evolution of the CLC series of color copying machines and the imageRUNNER (iR) series of MFPs.

Canon's digital imaging equipment also incorporates a variety of innovative technologies. Canon toners, inks, and paper products adopt the company's chemical technologies, while image-processing methods draw on proprietary software technologies. Control devices accurate to the nanometer level use Canon's original ultraprecision technologies. Proprietary production technologies, which allow Canon to market high-quality products at reasonable prices, are also a vital element in the company's technology mix.

Inkjet printers are the result of innovation arising from Canon's pursuit of technology advances. This groundbreaking technology has been perfected to the point that inkjet printers can output photo-quality images surpassing the quality of conventional photographs. Not satisfied with the results to date, Canon continues to push forward in its quest of technology to provide the ultimate in image quality.

In recent years, Canon has focused on developing and manufacturing key components for its products in-house, including optical elements, image sensors, and system LSI chips for digital imaging equipment, as well as developing software and algorithms. In this digital age, Canon's mission has evolved to pioneer information technologies that revolutionize the

workplace, work styles, and lifestyles, encompassing text, voice, and image data.

www.canon.com

DuPont

DuPont's participation in the photographic industry can be traced back to its work in the field of cellulose chemistry in the mid-nineteenth century. Cellulose nitrate, an extremely flammable material, was the key to diversification from the original Du Pont product—gunpowder. From it came lacquers, fabric coatings, rayon, and a clear, flexible film that proved suitable as a base on which to coat photographic emulsions. Motion picture film was chosen as the first application, and work began in 1912 to develop the film base. Finding a limited market for nitrocellulose solution, the company hired experts in 1915 to explore the manufacture of a photographic film base and light-sensitive emulsions to go on it. Plans to build an experimental plant for motion-picture film manufacture at Parlin, New Jersey, were announced in 1919, and the first sensitized DuPont photographic film was produced a year later. In 1924 a joint venture with Pathé Cinema Societé Anonyme de Paris was formed, providing an immediate outlet for DuPont's product. By 1931 DuPont acquired Pathé's interest and established the Photo Products department in Parlin. In 1927 Photo Products introduced a high-speed, fine-grain panchromatic film that won immediate endorsement among professional motion-picture cameramen as the highest quality fast film available. DuPont later won an Academy Award from the National Academy of Motion Picture Arts and Sciences for this product. Photo Products expanded rapidly into x-ray film with a unique blue base that enhanced the diagnostic clarity of radiographs (1932). It entered the graphic arts market (1935) with Photolith film, precursor of a broad range of films and printing plates that began the printing industry's change from letterpress to offset reproduction. By 1945 Photo Products reached $10 million in annual sales, half from x-ray film and screens. (The Patterson Screen Company, Towanda, Pennsylvania, was acquired in 1943.) In 1945 Du Pont acquired the Defender Photo Supply Company of Rochester, New York, a manufacturer of printing papers.

After the Second World War, research for an improved photographic film base commenced based on DuPont polyester technology. This led to the introduction of Cronar polyester film base in 1955 to replace the standard acetate base. Researchers at the Experimental Station demonstrated the application of photopolymerization for imaging in 1949 with the demonstration that a liquid polymer could be hardened into a plastic printing surface by ultraviolet exposure. This resulted in the introduction of Dycril photopolymer printing plates for the commercial printing market in 1957.

Throughout its rapid growth, Photo Products had concentrated on specific market areas and product lines in which DuPont's traditional technical skills and competence could make the greatest contribution. But the competition from companies supported by income from a growing amateur photographic market was a threat to Photo Products' offerings,

which were limited to the industrial market. In 1955 research expenditure was doubled and a fledgling amateur color film program was picked up from the corporate Chemical Department. A partnership with Bell and Howell to commercialize amateur color film was terminated unsuccessfully in 1965. In 1962 the acquisition of Adox Fotowerke in Neu Isenberg, Germany, was completed. Adox was a supplier of color and black-and-white photographic materials for the amateur and professional markets; over a period of years these products were replaced by graphic arts and x-ray films for the European market. From the increased research effort in the late 1950s came a steady stream of new products, including chromium dioxide magnetic material and Crolyn high-fidelity audio and video magnetic tapes (1967). From continuing advances in photopolymer technology came Riston, a dry film photopolymer resist film for printed-circuit manufacture (1968). DuPont then pioneered the development of photographic (phototooling) films specifically designed to expose these resists. By 1970 Photo Products sales reached $200 million, resuscitated by polyester-based graphic arts and x-ray films.

Around 1970 Photo Products added the Instrument Products Division, maker of analytical, process control, and medical instrumentation, and the Electrochemicals Products Division, maker of precious metals and glass powder for microcircuits. With the acquisition of Berg Electronics (connectors), the Ivan Sorvall Company (centrifuges) and the analytical operations of Bell and Howell in the early 1970s, Photo Products was becoming too broadly based in the marketplace, and the Biomedical Department was split off in 1978. Again in 1983 it split into Photosystems and Electronic Products and the Medical Products Departments.

Important contributions to the printing and publishing industry continued to result from photopolymer technology with Cromalin custom color proofing films in 1972, Cyrel flexographic plates in 1973, and Cromacheck peel-apart color proofing films in 1984. Rapid-access, film-processing chemistry for graphic arts was introduced in the early 1970s followed by Bright Light films in 1977 and X-Stat films in 1987. In 1986 Photosystems and Electronic Products split into Electronics and Imaging Systems Departments to better serve the needs of those rapidly expanding markets.

In the late 1980s, Imaging Systems began to organize its activities to address the growing impact of electronics on the printing and diagnostic-imaging businesses. The formation of a separate Electronic Imaging business division and joint ventures with Xerox (for digital proofing equipment) and Fuji (for electronic prepress) were announced. This was followed by the acquisition of Howson Algraphy (printing plates), Imagitex (monochrome electronic image scanners), Camex (newspaper electronic systems), and, together with Fuji, Crosfield (color electronic prepress systems). The development of photopolymer technology continued with new product and system developments to meet growing market needs in optical elements (Omnidex dry processing photopolymer holographic films in 1990) and stereolithography (SOMOS high performance liquids in 1991).

Today, DuPont Imaging Systems serves the needs of printing and publishing and the diagnostic imaging businesses but is not directly considered to be producing photographic products. Throughout 80 years of contribution to the photographic industry, DuPont has promoted healthy change by exploiting its core competencies through a continual release of innovative products and systems for the printing and diagnostic imaging markets. As silver halide technology disappeared from the applications end of the industry, DuPont developed more of a focus on graphic arts products, where it has become a leader with a significant range of products and software including: Sontara PC™ wipers, Cyrel digital imager Ink Jet ink sets Mounting Systems, Teflon graphics protection film, Teonex film, Tyvek envelopes, Digital Proofing Systems-sChromaCheck color proofing system, Cromalin b-Series ink jet proofer, CromaPro XP inkjet color proofing system, Dylux digital imposition proofing media, WaterProof thermal halftone proofing system, Solvent Platemaking Systems, Cyrel flexographic photopolymer digital and analog plates, Cyrel flexographic photopolymer sleeves, Cyrel solvent platemaking equipment, and Wide Format Digital Printing Systems. DuPont also creates electronic displays for devices such as cell phones, personal digital assistants, notebooks, and high definition TV. Holographic Optical Elements are components that produce brighter displays by managing light more efficiently. DuPont UNIAX — new to the company in 2000 — is a leader in electroluminescent polymers, a display technology that offers the prospect of a flexible, very thin display made entirely of plastic material.

www.dupont.com

Efke

Efke is the brand name of films, photographic papers, and chemicals produced by Fotokemika d.d., a company located in Samobor, Croatia. Efke films use emulsions with a very high silver content that produces a wide exposure latitude. The Efke 25, 50, and 100 products are made using the ADOX formulas that were first introduced in the 1950s. Unlike many modern black-and-white films, Efke products have been reported to be the most accurate to their published speeds and easier for beginners to use. Efke films are coated in one layer, unlike other films, which are coated in multiple layers. Efke also makes a line of chemistries used for black-and-white processing.

http://www.fotokemika.net/

Epson

Epson's parent company, Seiko Epson Corporation, had its origin in Suwa Seikosha, one of several manufacturing companies of The Seiko Group. The Seiko Group came out of the K. Hattori & Company, an import/export trading company of clocks and watches that was established in 1881. Their 100-year history began in watch-making and led to the invention of the world's first quartz watch, along with many other technology firsts. This long tradition of creating small, more precise products continues today, with the development of

other advanced capabilities for ultra-fine, high-precision processing used in inkjet printers and other electronic display devices.

The Seiko Epson Corporation was officially founded May 18, 1942 and manufactured men's watches as well as conducting research and recent development in the core technologies of CMOS integrated circuits and liquid crystal displays. Many of these components are integrated into their high-performance desktop, notebook, and hand-held computers and peripheral devices. In 1968, Suwa Seikosha developed the first commercially successful printer mechanism, the EP-101, incorporating technology that would later be found in the MX-80 printer.

Moving into the 21st century, Epson has developed a leading reputation for digital image innovation, specifically because of its printers. The company has sales offices throughout the United States and Canada with subsidiaries in Argentina, Brazil, Chile, Costa Rica, Mexico, and Venezuela.

Epson's U.S. History

In 1975, Epson America, Inc. was formed, with U.S. headquarters in Long Beach, California. It entered the U.S. market to supply original equipment manufacturer (OEM) components and peripherals to the computer and electronics market. Four years later, as the personal computer market grew, a need developed for a competitively priced desktop printer for home consumers. At that time, Epson introduced the MX-80. This successful and widely distributed printer became for many the de facto industry standard for serial impact dot matrix printers.

Epson continues to offer an extensive array of high-quality image-capture and image-output products, including color inkjet printers, scanners, LCD multimedia projectors, and monochrome dot matrix printers. Epson's products are designed for a variety of customer environments, including business, photography, government, audio visual, graphic arts, and the home. Epson's presence in the photographic output and printer market is hard to miss and has become a top choice among the best digital photographic printers.

Some notable Epson achievements:

- October, 1980: MX-80, a small, lightweight computer printer.
- July, 1982: HX-20, the world's first hand-held computer.
- December, 1982: TV Watch, the world's first television watch, with an active-matrix LCD.
- October, 1984: SQ-2000, the first commercial Epson inkjet printer.
- January, 1989: VPJ-7000, world's first compact, full-color liquid crystal video projector.
- 1990: TM-930, the PC-POS package printer that created a new market.
- March, 1993: Epson Stylus 800, the first inkjet printer equipped with Micro Piezo technology.
- May, 1994: Epson Stylus Color, the world's first 720 dpi color inkjet printer.
- April, 1997: Epson Stylus Photo, a six-color, photo inkjet printer.

- September, 1998: TM-H5000, Epson's first hybrid printer, featuring fast, quiet printing and copy functionality.
- November, 1999: ECM-A1192, low-power-consumption STN trans-reflective color LCD panel module that changed the mobile phone market.
- May, 2000: Epson Stylus Pro 9500, a large-format pigment-ink printer combining super photo quality with outstanding light fastness.

Since 2002, Epson has continually worked hard to create printers that professional and fine art photographers think of first, including the R1280, and the newer R1800, R2200, and R2400.

www.epson.com

Forte

The Forte Company opened for business in 1922, when the London-based Kodak company created a subsidiary for the production of black-and-white photographic paper in Vác, Hungary. Forte has manufactured a wide range of products focused on both the amateur and professional markets. Until fairly recently, Forte manufactured some 3 million square meters (sqm) of black-and-white photographic paper and nearly 1 million sqm of black-and-white photography film per year. Special products, such as x-ray diagnostic films and graphic arts materials, as well as a line of color film and paper, were also produced. At one time Forte produced 60 different black-and-white enlarging papers, which included a variable-constant brown-tone paper. Forte's black-and-white films are manufactured sheet, 35 mm, and roll formats in the speed range of 100–400 ISO. Forte also makes its own line of chemistries. The Forte brand name is well established in Europe and is distributed in more than 50 countries worldwide.

http://www.forte-photo.net/index.htm

Fujifilm

Fuji Photo Film Co., Ltd., headquartered in Tokyo, Japan, is a leading manufacturer and marketer of imaging and information products. Fuji Photo Film Co., Ltd., began operations in 1934 with the production of a professional 35-mm motion-picture film. In November 1936, Fuji brought its first amateur still film to market. The opening of the Ashigara Research Laboratory in 1939 paved the way for the introduction of Fuji's first color film in 1948. In 1954, Fuji established a magnetic tape research laboratory and in 1960 produced its first magnetic tape products. In 1963, the company introduced the first two-inch broadcast videotape to the domestic television industry.

In 1974, Fuji opened its first overseas manufacturing operation in Brazil. Initially built to produce photographic color paper, the plant manufactured photographic color film and processing chemicals as well. In 1984, Fuji opened a fully integrated production facility for photosensitized materials in the Netherlands and another facility in Kleve, Germany, to manufacture videotape and floppy disks. In 1989, the company opened a facility in Greenwood, South Carolina, to manufacture

presensitized plates, C-41 printing papers, and related products. In February 2006, Fuji announced that no more 35 mm color negative or paper emulsions would be manufactured at this facility as part of their continued transition to the digital age. The company also operated Fuji Hunt Photographic Chemicals factories in the United States, Canada, Belgium, and Singapore.

The company entered the North American market in 1955 and culminated a decade of growth with the establishment of its Fuji Photo Film U.S.A., Inc., subsidiary in 1965. Fuji has twice introduced the world's fastest color print still film: in 1976, a 400 ISO speed film; in 1984, a 1600 ISO speed film. The company also twice introduced the world's fastest color motion picture film: in 1978, an EI 250 speed film; in 1984, an EI 500 speed film. In 1987, Fuji introduced the world's first 35-mm one-time use camera, Fujicolor QuickSnap, and in 1988 introduced the QuickSnap Flash, the first 35 mm single-use camera with a built-in flash. Fujicolor Reala, advertised as the first film to reproduce colors as they are seen by the human eye, was introduced in 1989.

Fuji's technological advances in imaging products led to numerous citations and awards, including the 1982 Academy Award (the Oscar) and two Emmys for Technical Merit, one in 1982 for Fujicolor A-250 high-speed color negative motion picture film and one in 1990 for developments in metal particle tape technology. In 1991, Fuji received the Scientific and Engineering Award for its F-series of color negative motion picture films from the national Academy of Motion Picture Arts and Sciences.

Fuji has actively transitioned into digital photography with a wide range of digital products and services. Fuji FinePix cameras as well as the FinePix scanners and its Pictography printers are digital products that are found all over the world. The Fuji Frontier mini-lab is considered by many in the industry to be the gold standard of mini-labs. Fuji engineers developed and now integrate hexagonal pixels into their chips, allowing for more precise highlight-exposure control.

Fuji film products are still readily available in the United States as well as worldwide and include amateur and professional color photographic films, photographic papers, cameras, and mini-lab photofinishing equipment. Fujifilm has a variety of other products including their award-winning electronic imaging products; professional broadcast and consumer videotape; audiocassette tapes; electronic imaging storage media; professional motion-picture film; microfilm, microfilm camera/processors, reader/printers and chemicals; graphic arts film and chemistry; presensitized offset plates and chemistry; film and plate processors; color-proofing systems; and scanners, architectural, electronics, photogrammetry, and seismic recording reproduction applications; medical and industrial x-ray films and processors; and multiformat cameras and film-loaders.

www.fujifilm.com

Hasselblad

Hasselblad has been associated with photography almost since its inception. In 1841, the Hasselblad family established its

first trading company, F.W. Hasselblad & Co., in the port city of Gothenburg located in western Sweden. The location of Gothenburg, with its proximity to the European continent, was ideal for a fledgling international import-export firm. Right from the beginning, Hasselblad began importing supplies and products for the newly burgeoning field of photography, which was rapidly growing in the 19th century. Arvid Viktor Hasselblad, a son of the company's founder, established an independent photographic division within the company and the photographic department became a major part of F.W. Hasselblad & Co. While on his honeymoon, he met George Eastman and the two men formed a business partnership that would last for almost 80 years. In 1888, Hasselblad began importing Eastman's products as the sole Swedish distributor. The photographic division of the company grew rapidly and in 1908 formed Fotografiska AB, which was the exclusive Swedish distributor for what is now Eastman Kodak products. Developing labs and a nationwide network of retail outlets were established.

In 1937 Victor Hasselblad opened his own photographic company, Victor Foto, in central Gothenburg. The business was complete with its own processing laboratory. In the spring of 1940, the Swedish government approached the thirty-four-year old to ask if he could produce a camera identical to a recovered German spy camera. In April 1940, he built a camera workshop in a simple shed in an automobile workshop in central Gothenburg. At that time, he began reverse engineering the German camera and designing what would be the first Hasselblad camera, the HK 7.

In 1941 the new small business, originally named Ross Incorporated, moved into some new premises and began serial production of the handheld HK 7. The camera format was 7 × 9 cm using 80 mm film and had two interchangeable lenses, the first a Zeiss Biotessar and the second either a Meyer Tele-Megor or a Schneider Tele-Xenar.

Camera production for the military continued for a short time. All the while, Hasselblad viewed the production of military cameras as merely the first step towards the development of a civilian camera. Hasselblad always had sights on the consumer market to produce a top-quality, portable camera that would fit into a person's hands.

The new camera company worked to design and redesign camera prototypes while they produced the other cameras for the military. On October 6, 1948, Victor Hasselblad introduced the world to the first Hasselblad produced consumer camera, the Hasselblad 1600F. This model, a single-lens, mirror-reflex, 6 × 6 camera with interchangeable Kodak lenses, film magazines, and viewfinders, was unveiled at a press conference in New York City.

The first Hasselblads were technological marvels in many ways and beautiful to look at, but their technologically advanced interiors were very delicate. That new product led to other new products, including the 1000F. The new 1000F had many refined and improved features and a new lens series that now comprised six lenses. The American magazine *Modern Photography* field-tested the new Hasselblad 1000F and

reported spectacular results. In 1957 Hasselblad followed the success of the first cameras with a new revolutionary product, the Hasselblad 500C. This camera had lenses with central leaf shutters and flash sync on all shutter speeds. Then came the Hasselblad SWA in 1954, followed by the wide-angle Hasselblad SWC (1957), and the motor-operated Hasselblad 500 EL (1965). These cameras formed the base of the Hasselblad system for many years. The basic philosophy behind the system — modularity, versatility, and reliability — has guided the Hasselblad product line from the beginning. Hasselblad has become synonymous with the utmost in camera reliability and image quality.

A NASA astronaut took the first Hasselblad into space in 1962. This journey was the beginning of a long and mutually beneficial collaboration between Hasselblad and the world's largest space agency. In 1969, on Apollo 11, the first images of man on the moon and of earth from the moon were captured by Neil Armstrong and Edwin "Buzz" Aldrin, Jr., with a Hasselblad 500EL/70.

In 1966, Victor Hasselblad sold the distribution company and retailer network "Hasselblad Fotografiska AB" to Kodak, ending their long-term partnership, but not the friendships upon which it was based. In 1976, the Swedish investment company, Säfveån AB bought Victor Hasselblad AB.

In 1984 VHAB (Victor Hasselblad AB) was listed on the Stockholm Stock Exchange. In 1985 VHAB established the subsidiary, Hasselblad Electronic Imaging AB for the development, production, and marketing of digital imaging systems and systems for digital transmission of images.

Throughout the company's history, Hasselblad has carefully selected its suppliers and collaborative partners, forming long-term relationships with such renowned companies as Kodak and Zeiss. In 1998 another partnership — this time with Fuji Photo Film Ltd. — led to the introduction of the Hasselblad XPan camera. This unique system was developed and produced by Hasselblad in close cooperation with Fuji. The XPan utilized standard 35 mm film to produce medium-format panorama images and standard 35 mm shots on the same roll of film.

In 2002 Hasselblad launched another camera system, a 6 × 4.5 medium-format camera that incorporated the latest in technological developments including autofocus and very advanced electronics. Its design was inspired to couple with digital technology. A few months later, the Shriro Group — a long-standing Hasselblad distributor for the Asian Pacific region — acquired the majority shareholding of Victor Hasselblad AB. In line with the new facility and the new technologically advanced camera system, Hasselblad took another large step forward when Shriro acquired Imacon, the Danish direct digital back and scanner manufacturer.

www.hasselblad.com

HP Invent

Hewlett-Packard opened for business in 1939. It began as a small manufacturer of test-measurement instruments and

related equipment in Palo Alto, California. Like many high-tech innovators, Bill Hewlett and Dave Packard started HP in a garage, where they produced a precision audio oscillator, the Model 200A. Their first real innovation in the product was the use of a small night-light bulb as temperature gauge in the system. In 1939, the competitor's product was selling at $200; the 200A was priced at $54. Walt Disney soon became a major customer and Hewlett-Packard was off and running.

HP is thought by some in the industry to have produced the world's first personal computer, the Hewlett-Packard 9100A, in 1968. At the time, HP marketed it as a desktop calculator. HP continued through the 1970s and 1980s to be a technology innovator. Their product recognition was world-wide and included, the HP-35, a hand-held scientific electronic calculator (1972); the HP-41C, which was an alphanumeric and programmable hand-held calculator (1974); and the HP-28C, the first symbolic and graphing calculator. HP developed a reputation for building fairly priced, sturdy technology products.

HP first dabbled in photographic products with the Hewlett-Packard 196B oscilloscope camera in 1962. The Hewlett-Packard 196B had a Polaroid Land Camera back that produced finished photos in 10 seconds. In 1984 HP introduced its first laser and inkjet printers for the desktop. It also produced a line of scanners that could be turned into multi-functional pieces of equipment. HP has been a industry leader since 1990. In 1995, HP introduced its first home computer; in 1997 the HP PhotoSmart system became the first PC photography system designed for home users. It included a photo printer, a photo scanner, a digital camera, photo paper, and image-editing software. Users could scan photos, negatives, and slides into their PCs and then print them with the look and feel of real photos, suitable for albums or framing. The PhotoSmart digital camera featured a removable, reusable 4 MB compact flash card that captured up to 40 pictures.

In 2002 HP bought Compaq and Indigo, entering new computing and digital-image output markets. HP has expanded its 2006 products to include desktop and notebook PCs for home and office, black-and-white HP LaserJet printers (monochrome), color HP LaserJet printers, color inkjet printers, large-format printers/plotters, photo printers, mobile printers, multifunction and all-in-one print servers, digital publishing solutions, calculators, monitors, projectors, digital projectors, fax machines, copiers, and scanners. Today, HP carries nine models of digital cameras and thirteen models of photo printers, as well popular flat-panel monitors and televisions.

www.hp.com

Ilford

Ilford began as a simple company in 1879, when Alfred H. Harman began manufacturing glass dry plates for photographers in the basement of his home, in the small village of Ilford in Essex County, England. Mr. Harman chose to locate his enterprise there because of its nearness to London's market and because of its "clean, dust free environment." His original factory staff included two men and three boys, who sometimes,

when busy, were assisted by Mr. Harman's wife and housekeeper. The formation of his business, The Britannia Works, was one of the essential actions that took photography from amateur hands and set it securely on the way to becoming a significant, highly skilled, professional industry.

In 1886, after selling through a distributor for six years and expanding production to the point of building a special plate-manufacturing factory, the Britannia Works Company, Mr. Harman began selling his products, now called Ilford Dry Plates, directly to his customers. Ilford Dry Plates' popularity, gained through its performance in the marketplace, provided the foundation for the modern, international company that Ilford was to become. Alfred Harman's insistence on quality and innovation led him to hire a quality supervisor in 1889 and in the same year to publish the first edition of the *Ilford Manual of Photography*, together with other useful publications that promoted Ilford products.

In 1898, the company went public and in 1900 changed its name to Ilford Limited. Although Mr. Harman then discontinued active involvement in the day-to-day operations of Ilford Ltd., he maintained a consultant's activity and was a board member and a director until 1904, when ill health forced him to retire. By 1906 Ilford was a relatively small but successful company, employing about 300 workers. Alfred Harman died in 1913 at the age of 72.

Between 1906 and 1939, Ilford's expansion increased through the gradual acquisition of other old, established photographic companies. This consolidation included names well recognized in the photographic business world: Selo Limited, Imperial Dry Plate Co., Rajar Ltd., and the Thomas Illingsworth Company Ltd., to name a few. These and other companies lost their separate identities in 1930–1931 when they came under the Ilford name and organization.

Starting in 1946, a whole new program of expansion and reconstruction of war-damaged factories occurred. In the 1950s, Ilford and BX Plastics formed Bexford Ltd., which then produced all of the film base used in Ilford film products. Bexford later became a part of Imperial Chemical Industries (I.C.I.). Subsequently, through an exchange of technology with I.C.I., Ilford developed and introduced a line of color film products.

With time, I.C.I. accumulated all the outstanding shares of Ilford Ltd. stock and then sold 40 percent to CIBA, the Swiss dyestuffs and pharmaceutical company. CIBA and Ilford had independently developed color printing materials based on the silver dye-bleach process.

In 1970, CIBA merged with J. R. Geigy, another Swiss chemical company. Geigy and Ilford were not strangers. Since the 1950s, Geigy, with facilities in Manchester, England, had produced the dyes for Ilford's silver dye-bleach products and also manufactured Phenidone, the revolutionary new developing agent invented by Ilford chemists.

In 1972 Ciba-Geigy decided to operate Ilford as a part of its photographic group. Ilford Limited was declared not only a part of Ciba-Geigy's photographic division but also part of the newly formed Ilford Group, responsible for the worldwide

operation of the parent company's interests through its own factories and selling companies. The Ilford Group would also include Ciba-Geigy Photochemie AG at Fribourg, Marly, Switzerland, and Lumière SA at Lyon, France.

Between 1972 and 1989, many significant products were introduced. Cibachrome, a high-quality, direct-positive product line using silver dye-bleach technology was marketed. Cibachrome A was introduced to the amateur hobbyist market and became popular in the United States and Europe. In addition, new black-and-white products were marketed, including HP5 film and Galerie and Multigrade fiber-base papers. New production facilities were constructed in England, France, and Switzerland to supply the world market that the Ilford Group had developed.

In 1976, after 97 years of occupancy, Ilford left the original Essex site, the last glass plates having been coated there on November 11, 1975. Other sites at Brentwood and Basildon in the south of England were closed and sold. The U.K. production of film and paper was consolidated at the former Rajar Works in Mobberley, Cheshire, near Manchester in the north of England. This period was highlighted through the introduction of the Ilfospeed and Multigrade resin-coated paper product lines; the XP-1 400 chromogenic black-and-white film; Ilfospeed 2000, 2150, and 2240 paper processors; and the Multigrade 500 Enlarger Head exposure system. Ilford also entered the high-quality color-copy market with the introduction of the Cibacopy product line, which is based on silver dye-bleach technology.

In 1989 International Paper, an American company with international markets, purchased the Ilford Group from Ciba-Geigy. Ilford was part of the Imaging Products Division of International Paper, which comprises several formerly independent manufacturers of supplies for the printing, photographic, and graphic arts markets with worldwide sales of nearly $1 billion.

As the 1990s progressed, Ilford — like all silver halide photographic companies — was faced with a constantly changing market. Ilford, like Agfa, continued to struggle financially and, in September 2004, filed for insolvency. Ilford Imaging was comprised of two companies at the time: the monochrome film group in Mobberley, Manchester, England and the digital imaging group in Marly, Switzerland. The English group filed for reorganization while its Swiss counterpart was making a profit.

In 2004 Ilford celebrated 125 years of being at the forefront of imaging technology and manufacture of photo quality media. Ilford continues to be one of the world's leading manufacturers of inkjet media for desktop and wide-format applications and maintains a black-and-white core film and paper product line.

www.ilford.com

Kodak

In about 1877, George Eastman, a young bank clerk in Rochester, New York, began to plan a vacation in the Caribbean. A friend suggested that he take along a photographic outfit and record his travels. The "outfit," Eastman discovered, was really a cartload of equipment that included a light-tight tent, among many other items. Indeed, field photography required an individual who was part chemist, part tradesman, and part contortionist, for with wet plates there was preparation immediately before exposure and development immediately thereafter — wherever one might be.

Eastman decided there was something very inadequate about this system. Giving up his proposed trip, he began to study photography. At that juncture, a fascinating sequence of events began that led to the formation of the Eastman Kodak Company.

Before long, Eastman read about a new kind of photographic plate that had appeared in Europe and England. This was the dry plate — a plate that could be prepared and put aside for later use, thereby eliminating the necessity for tents and field-processing paraphernalia. The idea appealed to him. Working at night in his mother's kitchen, he began to experiment with the making of dry plates. He had no scientific training, but he was methodical, precise, and ingenious. Out of his experiments came a successful series of dry plates and, more important, an idea for a machine to make them uniformly and in quantity.

Because London was the center of the photographic and business world, Eastman went there in 1879 to obtain a patent on his plate-coating machine. An American patent on it was granted the following year.

In 1880, George Eastman rented a third-floor loft in Rochester and began to manufacture dry plates commercially. The success of this venture so impressed Henry A. Strong, a hardheaded businessman who roomed with the Eastmans, that Strong invested some money in the infant concern. On January 1, 1881, Eastman, together with Strong, formed a partnership called the Eastman Dry Plate Company.

In 1884, Eastman startled the trade with the announcement of film in rolls, with a roll holder adaptable to nearly every plate camera on the market. He dreamed of making photography available to everyone. With the No. 1 Kodak camera in 1888, he laid the foundation for fulfilling his goal.

The Kodak camera was a light, portable instrument that could be easily carried and hand-held during operation. It was priced at $25 and loaded with enough film for 100 exposures. After exposure, the camera and film were returned to Rochester, where the film was developed, prints were made, and new film was inserted — all for $10.

In 1884, the Eastman–Strong partnership had given way to a new firm — the Eastman Dry Plate and Film Company — with 14 shareowners. A successive concern — the Eastman Company — was formed in 1889.

The company has been called Eastman Kodak Company since 1892, when Eastman Kodak Company of New York was organized. In 1901, the present firm — Eastman Kodak Company of New Jersey — was formed under the laws of the State of New Jersey.

Eastman had four basic principles for the business: mass production at low cost, international distribution, extensive

advertising, and finding and meeting the needs of customers. Today, these principles are generally understood and accepted, but in 1880 they were novel. Eastman saw them as closely related, for mass production could not be justified without wide distribution, which in turn, needed the support of strong advertising. From the beginning, he imbued the company with the conviction that fulfilling customer needs and desires is the only road to corporate success.

To Eastman's basic principles of business, he added these policies: foster growth and development through continuing research; treat employees in a fair, self-respecting way; and reinvest profits to build and extend the business. The history of Eastman Kodak Company is, indeed, one of progress in development of these basic principles.

From the nineteenth century on, some great photographic discoveries occurred in Europe. Niépce and Daguerre in France, Talbot in England, and others laid the foundations for the techniques leading to present-day photography. By the time George Eastman launched his dry-plate business in 1880, European interest in photography was keen, but its practice was limited to professionals.

Eastman early recognized the potentialities of the world market. Only five years after the company was established in the United States, a sales office was opened in London. Within the next few years, particularly after the introduction of the Kodak camera and Eastman's simplified methods, picture-taking became popular with hundreds of thousands of amateurs.

By 1900, distribution outlets had been established in France, Germany, Italy, and other European countries. A Japanese outlet was under consideration, and construction of a factory in Canada was underway with the organization of Canadian Kodak Co., Ltd.

The Rochester Export Territory was established in the early 1900s for the distribution of Kodak materials to South America and the Far East. Service to Asia was broadened in 1907 when a small photographic-plate manufacturer in Australia joined Kodak to form Kodak (Australasia) Pty. Limited.

Kodak Pathé of France was added in 1927 as well as factories at Vincennes, Sevran, and Chalon-sur-Saone occupied with the manufacture of Kodak photographic products. The formation in Stuttgart, Germany, of Kodak A.G. also occurred in 1927.

These are highlights of the growth that contributed to the effective distribution in domestic and world markets. Today, Kodak products are marketed worldwide.

George Eastman's faith in the importance of advertising, both to the company and to the public, was unlimited. The very first Kodak products were advertised in leading papers and periodicals of the day — with ads written by Eastman himself. By 1889, the slogan "You Press the Button, We Do the Rest," coined by Eastman with the introduction of the No. 1 Kodak camera, was becoming well known. Later, with advertising managers and agencies carrying out Eastman's ideas, the Kodak banner appeared in magazines, newspapers, displays, and billboards. Space was rented at world expositions, and

the "Kodak Girl," — the style of her clothes and the camera she carried changing every year — smiled engagingly at photographers everywhere. In 1897, the word Kodak sparkled from an electric sign in London's Trafalgar Square — one of the first such signs to be used for advertising. By 1899, Eastman was spending three-quarters of a million dollars a year for advertising.

Today, the trademark Kodak, coined by George Eastman in 1888, is advertised in more than 50 countries. George Eastman invented the name Kodak; he explained: "I devised the name myself . . . The letter K had been a favorite with me — it seems a strong, incisive sort of letter . . . It became a question of trying out a great number of combinations of letters that made words starting and ending with K. The word Kodak is the result."

The distinctive Kodak yellow for packages of most company products is widely known throughout the world and is one of the company's most valued assets. The wide variety of photographic products that Kodak markets stems directly from productive research. After the introduction of the first Eastman photographic dry plate in 1880, each successive year brought the presentation of new Kodak products; photography and the company's business forged ahead.

The year 1889 saw the introduction of the first commercial roll film of transparent nitrocellulose support; this was the film that Thomas Edison used to make his first motion picture. In 1896, Kodak perfected the first positive motion-picture film, a great boon to the emerging motion-picture industry. In 1908, the company manufactured its first non-flammable film using safety cellulose-acetate base. With continued research, this improved base became the standard for a wide variety of film products. Gradually, it replaced the highly flammable cellulose-nitrate type.

In 1923, Kodak made amateur motion pictures practical with the production of 16 mm reversal film on safety base. Since 1928, experiments in the field of color photography have led to the continuous introduction of many new films and processes. The introduction of Kodachrome film in 1935 revitalized the world of photography. Further improvements in the first safety-base film enabled the company to switch the production of professional movie film wholly to safety base in 1951. More recently, Kodak films and equipment have found wide acceptance in the television industry, the data-processing field, and for missile and space projects.

In 1963 the company introduced Kodak Instamatic cameras and four cartridge-loading films designed to operate interchangeably. The cartridge-film pack eliminated the amateur snapshooter's perplexing problem — the difficulty of loading a roll of film. In 1965, the instant-load idea was applied to home movies. The company introduced Super 8 films in cartridges and a new family of Instamatic cameras. In the same year, the introduction of flashcubes further stimulated indoor picture-taking. Indoor color movies without movie lights became practical in 1971. The next year marked the introduction of the popular Kodak Pocket Instamatic cameras.

In 1975, Kodak announced the introduction of the Ektaprint copier/duplicator, a plain paper copier that combined easy operation with speed and outstanding quality.

Kodak has made its facilities for research and production available to the U.S. government during war and peacetime. Kodak designed and built a special camera-and-film system used by the National Aeronautics and Space Administration in the Lunar Orbiter program to determine favorable sites for moon landings by American astronauts. The brilliant flight of Apollo II and the historic pictures of man's first steps on the moon were recorded on Kodak film. A camera designed and built by Kodak specifically for the Apollo mission was used to take close-up photographs of the lunar surface — in stereo and color — for scientific study.

Other significant developments in Kodak history include:

- 1923: Kodak made amateur motion pictures practical with the introduction of 16mm reversal film on cellulose acetate (safety) base, the first 16mm Cine-Kodak Motion Picture Camera, and the Kodascope Projector.
- 1929: The company introduced its first motion-picture film designed especially for making the then-new sound motion pictures.
- 1932: The first 8mm amateur motion-picture film, cameras, and projectors were introduced. That same year, George Eastman died, leaving his entire residual estate to the University of Rochester. In 1949, his Rochester home was opened as an independent public museum — the International Museum of Photography at George Eastman House.
- 1935: Kodachrome film was introduced and became the first commercially successful amateur color film, initially in 16mm for motion pictures. 35mm slides and 8mm home movies followed in 1936.
- 1938: The first camera with built-in photoelectric exposure control was developed — the Super Kodak Six-20 Camera.
- 1942: Kodacolor Film for prints, the world's first true color negative film, was announced. Kodak's Rochester plants were awarded the Army-Navy "E" for high achievement in the production of equipment and films for the war effort.
- 1946: Kodak marketed Kodak Ektachrome Transparency Sheet film, the company's first color film that could be processed by the photographer with newly marketed chemical kits.
- 1948: Kodak announced a 35mm triacetate safety base film for the motion-picture industry to replace the flammable cellulose nitrate base — and the industry rewarded the company with an Oscar for it two years later.
- 1952: Kodak received an Oscar for the development of Eastman Color Negative and Color Print films, introduced in 1950.
- 1958: The Kodak Cavalcade Projector, the company's first fully automatic color slide projector, was introduced. The Kodak X-Omat Processor reduced the processing

time for x-ray films from one hour to six minutes. The company's first single-lens reflex camera, the Kodak Retina Reflex Camera, was manufactured by Kodak A.G. in Stuttgart, Germany. Kodak Polyester Textile Fiber, developed by Tennessee Eastman, was made available for use in clothing.

- 1960: Estar Base (a polyester film base) was introduced to give improved dimensional stability to Kodalith Graphic Arts Films. The Recordak Reliant 500 Microfilmer was introduced, capable of photographing up to 500 checks or 185 letters in one minute.
- 1961: The company introduced the first in its very successful line of Kodak Carousel Projectors, which featured a round tray holding 80 slides.
- 1962: The company's U.S. consolidated sales exceeded $1 billion for the first time and worldwide employment passed the 75,000 mark. John Glenn became the first American astronaut to orbit the earth, and Kodak film recorded his reactions to traveling through space at 17,400 miles per hour.
- 1963: The line of Kodak Instamatic Cameras was introduced, featuring easy-to-use cartridge-loading film, which eventually brought amateur photography to new heights of popularity — more than 50 million Instamatic Cameras were produced by 1970.
- 1973: The company unveiled sound home movies with the introduction of two Super 8 sound movie cameras and cartridge-loading Super 8 film, magnetically striped for sound recording. Sales surpassed $4 billion.
- 1981: Company sales surpassed the $10 billion mark.
- 1982: Kodak launched "disc photography" with a line of compact, "decision-free" cameras built around a rotating disc of film. Kodacolor VR 1000 Film was introduced, utilizing a new T-Grain Emulsion technology that represented a major breakthrough in silver-halide emulsions.
- 1990: The Kodak Photo CD system was announced as a consumer bridge between three very familiar — but formerly incompatible — systems: camera, computer, and television. Film images are transferred to a photo CD, allowing photographs to be viewed and manipulated on TV screens and computer monitors.

Like all silver halide manufacturers in the late 1990s, Kodak has had a very big transition to digital from film, In 1986, more than 56,000 people worked for Eastman Kodak Company in Rochester New York, home of Kodak's world headquarters. By January 2006, that number had fallen to 14,700 as the company continued its transition to digital. The transition to digital began slowly for Kodak in the 1990s, but by 2005 it had captured the largest portion of digital camera amateur U.S. market, a distinction that had been held by Sony for a number of years.

Kodak continues to be a world leader and innovator in the field of photography. Its name immediately creates an image of quality for the consumer, which is a consequence of the company's excellence for more than 100 years. Kodak has had

recent product successes in their patented EasyShare dock system for their consumer imaging cameras, digital radiography products and equipment, Encad and NexPress inkjet products, EasyShare Gallery (an online photo-finishing business), as well as a variety of document-imaging initiatives. In June 2005, Kodak announced it was ceasing production of all black-and-white printing papers, while concurrently introducing no fewer than 35 new digital products for health- and consumer-imaging products.

FURTHER READING

Eastman Kodak Company: A Brief History, October, 1983, Eastman Kodak Company

Journey Into Imagination: The Kodak Story, © 1988, Eastman Kodak Company

www.kodak.com.

Konica Minolta

Since the introduction of its first roll of black-and-white film in 1929, Konica produced and marketed products and services that were on the cutting edge of the silver-halide technologies of its time. A full line of products has been available from input through output including digital onsite mini-labs, inkjet photo papers, single-use cameras, color film, color paper, and film scanners up through 2006. In 2003, Konica acquired Minolta, a worldwide manufacturer of cameras, lenses, accessories, and photo copiers. Minolta started its business in 1928 and became known in the 1930s for making the Minolta Vest camera. In 2006, Konica Minolta announced that it would no longer make digital or film cameras.

Konica Minolta's Instrument Systems Division (ISD) still produces equipment that measures, matches, reproduces, and communicates color and light. It's about capturing texture, shape, and color of three-dimensional images. More than 70 percent of all the industrial light meters purchased in the world are Konica Minolta meters. Most major TV and computer manufacturers use Konica Minolta's Color Analyzers to adjust white balance. Konica Minolta Colorimeters can be found throughout the food chain, controlling the color from raw ingredients through food processing and production.

Konica Minolta built the world's first portable spectrophotometer and the first portable, three-dimensional, non-contact color digitizer. They also developed the first fingertip pulse oximeter and the first light meter to be used aboard a space craft (Apollo 8).

http://kmpi.konicaminolta.us/

Kyocera

Kyocera Corporation has its headquarters and parent company of the global Kyocera group in Kyoto, Japan. It is credited by several sources as having sold the first cell phone camera. Kyocera was founded in 1959 in Tokyo as a start-up venture by Dr. Kazuo Inamori and seven colleagues. They wanted to create a company dedicated to the successful manufacture and sale of innovative, high-quality products based on advanced materials and components. Kyocera has been very successful in achieving that goal and has Kyocera operations worldwide, including a large North American operating company. Kyocera has a diverse product base include ceramics, vacuum components, LCD panels, high-end business laser printers (and other office printers) as well as six digital cameras. Kyocera acquired the well-known Yashica Camera Company Ltd. in 1983, along with Yashica's prior licensing agreement with Carl Zeiss, and manufactured a line of high-quality film and digital cameras under the names Yashica and Contax, until Kyocera abandoned all film and digital camera production in 2005.

Kyocera today carries 33 different models of cell phones; 11 of these models have at least a 3-megapixel camera built in. Many sources suggested that Sharp's J-SH04 was the first camera phone. Sharp also claimed that on its Web site, naming the J-SH04 (released in 2000) as the industry's first mobile phone to feature an integrated 110,000-pixel CMOS image sensor for taking digital photos. But an article published in the July 18, 2005 issue of *Tech Watch* authored by J. Peddie, claimed that the first camera phone was the Kyocera Visual Phone VP-210, which was released in May of 1999 in Japan. Peddie recruited more than 2000 people to perform research for the article. Although the VP-210 was marketed as the first video-capable cell phone, it was also the first functional camera phone for digital still photos. The device weighed six ounces and had an integrated two-inch TFT display built in, capable of displaying 65K colors. It could also transmit two frames of video per second and was equipped to store 20 still images. In 1999, the VP-210 sold for 40,000 Yen or approximately US $335.

www.kyocera.com

Lucky Film

China Lucky Film Corporation was incorporated in 1958 and is now the largest national photosensitive materials and magnetic recording media manufacturer in China. China Lucky Film Corporation has its headquarters in Baoding, Hebei Province, which is 150 kilometers from Beijing. Lucky's businesses include: the No. 2 Film Factory, based in Nanyang; Lucky Research Institute of Photosensitive Chemistry, based in Shenyang; and Lucky Shanghai Paper Mill. China Lucky is committed to providing high-quality imaging and information products to its customers. These products include: photosensitive products, magnetic recording media, technical specialty films, and digital receiving products. Many technical innovations and advances have led to great improvement in quality of the products. Lucky color film and color paper have been awarded the top national prizes. In 1999, China Lucky attained certification of ISO9001.

http://www.luckyfilm.com/eng/index.html

Leica/Leitz

In his article "Leica: An Enviable History" (*Photo-Source*, July/August 1989), Michael Disney says, "Leica has occasionally

claimed in its advertising that the Leica was the first 35-mm still camera, much to the indignation of photographic historians and collectors. Although this claim is not literally true . . . it is in a sense justified. As a design the first Leica owed almost nothing to the predecessors. In contrast, almost every subsequent 35-mm camera has owed something to the Leica." His tribute to Leica concluded, "One can say without exaggeration that the history of the 35-mm camera as it has developed in this century would be inconceivable without the Leica, and whatever course it might otherwise have taken would probably have been very different."

Dr. Ernst Leitz II, who was responsible for the introduction of the Leica, was the son of the founder of Leitz/Wetzlar. Since its founding in 1849 the company's only concern has been the design and manufacture of precision optical equipment. This focus on optical precision is the base on which the Leica reputation has been built. Today Leitz manufactures instruments for scientific research, industry, and amateur and professional photography.

A brief chronological history of Leica's significant contributions to photographic technology includes the following:

In 1913, Barnack designed the first operational prototype of the Leica for 35 mm cine film. It had an all-metal housing, a collapsible lens, and a focal-plane shutter. A screwed-on lenscap, which was closed during shutter rewind, prevented fogging of the film. This camera is known as the original Leica.

The A-series model, introduced in 1923, was the first commercial Leica to be manufactured. Before its introduction, 31 prototypes were made by hand to test public reaction. The lens was a five-element, 50 mm anastigmat f/3.5 designed by Professor Max Berek. Its focal-plane shutter was self-capping with automatic compensation for acceleration. Film advance coupled with shutter retensioning and a frame counter prevented double exposures for the first time in photographic history. Although the handmade samples were greeted with considerable skepticism both inside and outside the organization, Dr. Ernst Leitz made the fateful decision to "build Barnack's camera." The Model A with a 50 mm Elmax (later Elmar) f/3.5 went into production in 1925, and before the year was out, 1,000 cameras were produced.

The year 1930 saw the introduction of the Model C, the first Leica with interchangeable lenses. Three screw-mounted Elmar lenses were available: 35 mm wide-angle, 50 mm f/3.5 normal focal length, and 135 mm f/4.5 long focal length. For focusing accuracy, a vertical longbase accessory rangefinder was part of the package.

Known as the Autofocal Leica, the Model II was introduced in 1932 and simultaneously established two significant firsts: It was the first camera with a built-in coupled rangefinder and the first camera with rangefinder coupling for a whole family of interchangeable lenses.

The new Leica III appeared in 1933 with speeds from 1 to 1/500 second. Slow speeds between 1 and 1/20 second were arranged on a front-mounted selector dial. Also in 1933, Leica introduced the first telephoto lens, the 200-mm Telyt f/4.5, for which the world's first accessory reflex housing was provided.

In 1934, a Reporter Leica was produced with spool-chambers holding approximately 33 feet of film. The new model took 250 exposures without reloading. Fewer than 1,000 Reporters were made in a number of small series between 1934 and 1942.

With the introduction of the Model IIIa in 1935, Leica's top speed jumped from 1/500 to 1/1000 second. For fast shooting with the IIIa, Leica also introduced a new baseplate trigger-advance unit. The new ultra-wide-angle 28 mm Hektor f/6.3 expanded the optical lineup to 12 lenses in nine focal lengths from 28 mm through 400 mm, giving angular fields of 6 to 76 degrees.

In the United States in 1935, Eastman Kodak introduced 35 mm Kodachrome film. Leica saluted the two co-inventors, Leopold D. Mannes and Leo Godowsky, Jr., by presenting them with Leica Nos. 150,000 and 175,000 respectively.

The first postwar camera design was the Model IIIf, introduced in 1950. Up until the introduction of the IIIf, Leica flash synchronization was by means of external devices, which either replaced the camera baseplate or made connection with its spinning shutter-speed selector dial. The new Model IIIf, however, provided full internal synchronization for all types of expendable flashbulbs as well as for the new electronic flash units that were beginning to gain popularity. Also introduced in 1950 was the 85 mm Summarex f/1.5, the fastest lens of its focal length to date.

In addition to being the world's first 35 mm camera to feature a built-in universal rangeviewfinder for four different lenses, the M3, introduced in 1954, scored another significant advance: Its illuminated lens viewfinder frames were automatically compensated for parallax over the full focusing range of each lens. Other advances included an automatically resetting frame-counter, an exclusive rapid-advance lever, and a quick-change bayonet lensmount of unusual precision and rigidity.

Between 1957 and 1967, Leica introduced many new lenses. Notable among these: 21 mm Super-Angulon f/4 ultra-wide-angle lens with a coverage of 92 degrees; f/2 Summicron lenses of 35 and 90 mm; and the ultra-fast Noctilux f/1.2, the world's first lens for 35 mm cameras using series-produced aspheric lens elements.

With the introduction of selective through-the-lens light measurement in 1968, the Leicaflex SL is the camera that brought Leica precision and the famous Leica feel to single-lens-reflex photography. A precision microprism central focusing field facilitates snap-in focusing for even short focal length lenses. The meter reads a central, circular area, equal to one-sixth the acceptance angle of whatever lens is attached to the camera. The area measured is sufficiently large to integrate typical scene brightness. However, it is selective enough to permit quick, accurate spot readings for difficult, high-contrast scenes. The meter needle, direction of diaphragm adjustment, and shutter speed are displayed in the viewfinder for easy reading without removing the eye from the camera. Inside the SL, the focal-plane shutter traverses the film aperture in approximately nine milliseconds, permitting flash synchronization up to 1/100 second and precise shutter speeds to 1/2000 second.

Introduced in 1971, the M5 combined Leica's half-century of development into a rangefinder with an accurate through-the-lens metering system.

Leica has continued to develop cameras into the twenty-first century:

- 1996
 - LEICA R8: completely newly developed SLR camera
 - LEICA M6 TTL with TTL flash exposure meter; Tri-Elmar-M 28–35–50 mm f/4: first Leica M lens with three focal lengths
- 1999
 - LEICA C1: Start of a new product design line in the compact camera segment
- 2000
 - LEICA 0-series: new edition of the small run of the LEICA 0-series produced in 1923/24
 - LEICA Digilux 4.3: Compact digital camera with triple zoom lens
- 2002
 - LEICA M7: Rangefinder system camera
 - LEICA R9: SLR camera
 - LEICA DIGILUX 1: Digital reportage camera with triple zoom lens and a large 2.5″ monitor
- 2003
 - LEICA MP: Purely mechanical rangefinder system camera
 - LEICA D-LUX: The new, elegant LEICA D-LUX digital camera
- 2004
 - LEICA DIGILUX 2: The "analog" digital camera
- 2005
 - Digital Modul R: Taking digital photos with LEICA R8 and R9
 - LEICA D-LUX 2: The compact digital for mega pictures

http://www.leica-camera.com/index_e.html

Nikon

In 1945, Nippon Kogaku K.K. considered the production of a small film camera. Until this time, Nippon Kogaku had only manufactured aerial cameras, as well as 2 m/3 m/5 m telescope cameras. The first cameras produced by Nippon Kogaku were popular with the Allied occupation troops, including American soldiers, leading to an increased demand. The company hastily began the production of more cameras. In April, 1946, the company decided to build a twin-lens reflex (TLR) camera (lens 80 mm f/3.5, using 120 format film, 6 cm × 6 cm format 12 frames) and an universal type small-size camera (using 35 mm (135 format) film, 24 mm × 32 mm format 40 frames.

The designs for the small-sized camera were to promote the advantages of the Leica" and "Contax" models. These models were considered the best models available at the time. The features were designed to be a 35 mm focal-plane shutter camera with a negative size of 24 mm × 32 mm format. The 3:4 proportion seemed to have better proportions than the "Leica" format (2:3), and it could also take 40 frames. From the beginning, the small-sized camera used the first name of "Nikorette," based on an abbreviation of Nippon Kogaku ("Nikko") and adding "ette" to indicate "small-size." The name was never fully embraced and Nikon soon became the formal company name.

The first prototype, the Nikon I Camera, was completed in November, 1947.

The following information is from the corporate history section of the Nikon Web site:

- 1917
 - Three of Japan's leading optical manufacturers merge to form a comprehensive, fully integrated optical company known as Nippon Kogaku K.K.
 - The company manufactured optical glass for glasses and other lenses.
- 1932
 - Nikkor adopted as brand name for camera lenses.
- 1945
 - With the end of World War II, production shifted to cameras, microscopes, binoculars, surveying instruments, measuring instruments and ophthalmic lenses.
- 1946
 - Pointal ophthalmic lenses marketed.
 - Nikon brand name adopted for small-sized cameras.
 - Tilting Level E and Transit G surveying instruments marketed.
- 1947
 - Nikon I small-sized camera marketed.
 - Model I profile projector marketed.
- 1950
 - *The New York Times* introduced superior features of Nikon cameras and Nikkor lenses.
- 1952
 - Nikkor Club established to promote photography culture.
- 1954
 - Model SM stereoscopic microscope marketed.
- 1957
 - Nikon SP small-sized camera marketed.
- 1959
 - Nikon F, Nikon's first SLR camera, marketed.
- 1963
 - NIKONOS all-weather camera marketed.
- 1966
 - Photoslit lamp microscope marketed.
- 1968
 - Rotary encoder RIE digital measuring instrument marketed.
 - Photo gallery Ginza Nikon Salon opened.
- 1970
 - Photo gallery Nikon House opened in New York City.
- 1971
 - Nikon F2 SLR camera marketed.
- 1974
 - 105 cm Schmidt-type telescope installed at Tokyo Astronomical Observatory.

- 1980
 - Nikon F3 SLR camera marketed.
 - Nikon 10 cm refractive equatorial telescope for astronomical observation marketed.
 - Nikon SLR cameras delivered to NASA for use on the space shuttle.
 - Development of dental root implant utilizing bioactive glass announced.
 - NSR-1010G Step-and-Repeat System (stepper) for VLSIs marketed.
- 1984
 - Successful development of magneto-optical disk-drive systems announced.
 - NT-1000 35 mm film direct telephoto transmitter marketed.
- 1986
 - TRISTATION three-dimensional coordinate measuring machine marketed.
 - Nikon F-501*1 autofocus SLR camera marketed.
 - Corporate name changed to Nikon Corporation.
 - Nikon F4 SLR camera marketed.
- 1992
 - NIKONOS RS, world's first underwater autofocus SLR camera, marketed.
- 1995
 - E2/E2S digital still cameras marketed (jointly developed with Fuji Photo Film Co., Ltd.).
- 1996
 - Nikon F5 top-of-the-line SLR camera marketed.
 - Nikon PRONEA 600i*2 Advanced Photo System SLR camera marketed.
- 1997
 - COOLPIX 100 digital camera marketed.
- 1999
 - Nikon D1 professional digital SLR camera marketed.
- 2004
 - Nikon D-70 marketed.

www.nikon.com

Olympus

Olympus, a company recognized worldwide, has produced an extensive line of excellent cameras and optical products for many years. Olympus opened its doors in 1919 under the name Takachiho Seisakusho with the goal of becoming a leader and innovator in the mass production of optical microscopes.

By 1921, the company had adopted Olympus as the brand name. In 1935, Olympus opened an optical research facility dedicated to making high-quality camera lenses. Olympus has evolved as rapidly as the technology has evolved and has developed products such as acoustic microscopes, ultrasonic endoscopes, reagent AIDS detection, digital voice recorders, and the Infinity Stylus — one of the best-selling 35 mm cameras in history. Today, 82 years later, Olympus is actively developing new technologies and products including its successful E-1 line of digital cameras. Its self-cleaning chip technology has received much praise for innovation.

http://www.olympusamerica.com

Polaroid

The Polaroid Corporation celebrated its 50th anniversary in 1987. The following abbreviated chronology of its history was supplied to the *Focal Encyclopedia of Photography*, 3rd Edition, in 1993:

1926 — Edwin H. Land leaves Harvard after his freshman year to pursue his own work on light polarization.

1928 — Land creates the first synthetic sheet polarizer.

1929 — Land files the patent for the first synthetic polarizer on April 26.

1932 — Edwin Land joins Harvard physics section leader George Wheelwright, II, establishes the Land-Wheelwright Laboratories to continue research and to manufacture polarizers.

1933 — Land-Wheelwright Laboratories is incorporated to manufacture polarizers and to continue research into applications of polarizers in sunglasses, photographic and microscopic filters, and automobile headlights. Land is issued the patent covering synthetic sheet polarizers formed of parallel-oriented submicroscopic crystals embedded in plastic film. The product is known as J-sheet.

1934 — Eastman Kodak signs a contract with Sheet Polarizer Co., Inc., to purchase light polarizers for the manufacture of photographic filters.

1935 — Land displays his invention to a representative of the American Optical Company. The American Optical Company signs a license agreement to use the polarizers for the manufacture of sunglasses. At the end of 1935, the first polarizer advertisement appears in a scientific journal, and Land receives the Hood Medal from the Royal Photographic Society. Land and Wheelwright develop the Polariscope, which is used to detect strains in transparent materials like glass and certain plastics.

1937 — On September 13, the Polaroid Corporation is organized under the laws of the state of Delaware.

1938 — Polaroid produces drafting table lamps, desk lamps, dermatology lamps, and polariscopes. Utilizing polarizing sheets, the company introduces variable-density windows. The first installation is made on the club car of a Union Pacific streamliner.

1939 — Curved lenses for prescription polarized sunglasses are developed using the glass/polarizer/glass laminates, making it possible to manufacture ground-and-polished prescription spectacles. Polaroid's stereoscopic motion picture, *In Tune with Tomorrow*, is shown at the New York World's Fair as part of the Chrysler exhibit. The first year's film is in black and white; the second year's is in color.

1940 — Polaroid announces Vectograph 3-D pictures. The Vectograph represents the fusion of the company's original technology, the polarizer, with photography. Among other applications, Vectographs will be used for aerial reconnaissance surveys during the Second World War.

Other products include optical goods, lighting equipment, three-dimensional picture viewers, polarized sheeting, variable-density day glasses, study lamps, three-dimensional motion pictures, and polarizers.

1941 — The ability to produce stereoscopic motion pictures is adapted for three-dimensional sound movies and optical bullets.

1942 — Most of Polaroid's products are for the war effort. With the invasion of Guadacanal, aerial vectographs are used extensively for military reconnaissance.

1944 — Land conceives of the one-step photographic system. Only after three years of intensive work will Land and a group of Polaroid scientists and engineers produce the complete photographic system.

1945 — A polarized, daylight driving visor is developed as a result of research into a polarizing system to eliminate glare from oncoming headlights.

1946 — Research continues on one-step photography: a new method of color motion picture processing (called Polacolor) and Vectography.

1947 — Land announces the one-step process for producing finished photographs within one minute.

1948 — The first Land camera, the Model 95, is sold in Boston at Jordan Marsh department store on November 26 for $89.50.

1949 — Photographic sales of the Polaroid Land camera Model 95 for the first year exceed $5 million. Land hires Ansel Adams as a consultant.

1950 — By 1950 more than 4000 dealers throughout the United States sell Polaroid cameras, film, and accessories. A contract from the Signal Corps results in the Tell-tale, a film badge that records radiation over a period of time. The resulting radiation record is developed in 60 seconds.

1951 — A print coater is added to black-and-white film. The print coater is a simple treatment for long-term image stability. The chemical components of the coater liquid neutralize any alkalinity and remove any residual processing reagent left on the sheet. The coater solution then dries to a hard coating that protects the print from atmospheric contaminants. Type 1001 Land film for radiography is introduced and becomes the first in a continuing series of Polaroid instant x-ray products. Type 1001 produces a 10 \times 12-inch x-ray print in 60 seconds. The Land Roll Film Back adapts professional cameras and various types of industrial and scientific instruments for use with Polaroid roll films.

1952 — Polaroid introduces the Model 110 land camera, called the Pathfinder. This camera is designed for professional use and is equipped with an f/l4.5 lens and provides shutter speeds to 1/400 of a second.

1953 — Polaroid begins to develop x-ray film for the civilian market.

1954 — The Model 100 debuts. It features special long-life roller bearings and a heavy-duty shutter. The camera is for use in business and industrial applications.

1955 — PolaPan 200 Land picture rolls are introduced to the public.

1956 — The one-millionth camera, a Model 95A, comes off the assembly line in September.

1957 — Polaroid markets several new cameras, and the Polaroid Transparency System is introduced.

1958 — One-step photography is extended to conventional studio and press cameras. The 50 Series of Land films (Types 52 and 53) and the 4 \times 5 film holder become almost indispensable proofing tools for the professional photographer.

1959 — Polaroid markets the Wink Light Model 250 and Model 252. Type 47 Land film, rated at 3000 ASA, becomes the fastest film available.

1960 — Polaroid introduces its first automatic exposure camera: Model 900 with Electronic Eye.

1961 — Polaroid releases two electric-eye cameras, the Model J66 and Model J33 in the $75 to $100 range. Type 55 P/N Land film is introduced. Polaroid continues to commission artists as consultants during the early 1960s.

1962 — The Polaroid MP-3 Land camera is introduced.

1963 — Polaroid debuts Polacolor. Products released this year include the CU-5 Closeup camera, type 510 Land film, featuring high-contrast reproduction for industrial applications and Type 413 Infrared L and film for use in laser research, military surveillance, and document analysis. The 5 millionth Polaroid Land camera, an Automatic 100, comes off the assembly line in Little Rock, Arkansas.

1965 — The inexpensive Polaroid Swinger is introduced.

1966 — CU-5 closeup framing kits are introduced to the industry. The ID-2 Land Identification System premieres. The ID-2 is the first in a series of self-contained identification systems using Polaroid instant photography. Among its applications, the system will be used for driver's license photos.

1967 — Five Electric-eye 200 Series cameras are introduced worldwide. Type 51 film is marketed for high-contrast reproduction of line art work. Speed of Type 1461 Land film is increased to 320 under daylight/electronic flash illumination, 125 under tungsten. Polaroid releases an Instant Halftone System for the MP-3 camera.

1968 — Polaroid introduces a number of additional new products: the M-10 camera, for low-level aerial reconnaissance pictures; the Special Events Land camera Model 228, for producing pictures on a high-volume, continuous basis; and a new Polaroid 4 \times 5 film holder (Model 545).

1969 — The Polaroid Model ED-10 Land Instrument camera is introduced for educational institutions and research labs. A special adapter enables it to fit over the eyepiece of a microscope to provide a simple method of making photomicrographs. The Polaroid 300 Series pack cameras are introduced. The top-of-the-line Model 360 Land camera represents the first incorporation of integrated circuits into a consumer product and includes an electronic flash.

1970 — Coaterless black-and-white film Type 20C for the Swinger camera goes on sale.

1971 — The ID-3 Land Identification System is introduced.

1972 — The revolutionary SX-70 system realizes Dr. Land's concept of absolute one-step photography: new concepts in camera and film interaction lead to the design of the first fully automatic, motorized folding single lens reflex camera that ejects self-developing, self-timing color prints.

1973 — The Clarence Kennedy Gallery is established. The gallery serves as a showcase for the work of emerging and professional photographers using Polaroid products. The MP-4 technical camera replaces the older MP-3.

1974 — Polaroid estimates that well over a billion instant prints will be made this year, about 65 percent of them being made in color.

1975 — Polaroid begins marketing Polacolor 2 film (Type 108). It is the first peel-apart color film that uses a color negative manufactured by Polaroid (Polaroid has made color negatives for integral X-70 film since its introduction in 1972).

1976 — The inexpensive Pronto! camera is introduced. The Pronto! uses SX-70 film and features a distance scale on the lens ring and an automatic electronic exposure setting.

1977 — The OneStep Land camera is introduced. Polaroid introduces the 20 × 24-inch camera; the prototype camera weighs 800 pounds. The camera produces color 20 × 24-inch photographs in 60 seconds. By the 1980s improvements to the camera reduce its weight to 200 pounds and add swings, tilts, and rising fronts.

1978 — Research into sonar technology, initiated in 1963, results in the Sonar Autofocus system for the SX-70 and Pronto! cameras. Polavision, a new instant color motion picture system, makes 2-1/2-minute films in self-developing cassettes. The system includes a camera, a self-developing film called Phototape, and a player.

1979 — Polaroid Type 611 video image recording film is introduced for use with medical diagnostic systems. Dr. Land demonstrates Time-Zero film. It is a brilliantly colored film for the SX-70 that produces an image visible in seconds and a developed print in 1-1/2 minutes.

1980 — The Polapulse P100 battery, first developed for SX-70 film, is introduced for commercial applications. New products include Polaroid Colorgraph film Type 891, the Polaprinter, and a new 4 × 5 professional pack film system.

1981 — The Polaroid Sun System brings the domain of automatic light mixing to amateur picture taking. Polaroid Colorgraph 8 × 10 Land film (Type 891) becomes the first instant color transparency film for overhead projection. Polaroid also releases a new 4 × 5 eight-exposure pack film system, which includes the Model 550 4 × 5 film holder, PolaPan Type 552 black-and-white film, and Polacolor 2 Type 558 color film.

1982 — Ultrasonic Ranging Systems are introduced. They are used in areas from instrumentation testing and hospital use to robotics. The company also introduces the SLR 680, a folding single-lens reflex camera using 600 ASA instant color film. The camera has a built-in strobe that uses sonar to precisely determine the distance to the subject.

1983 — The introduction of the 35 mm Autoprocess System makes Polaroid's instant photography products compatible with standard 35 mm cameras and equipment. Autoprocess produces rapid-access color or black-and-white transparencies without the use of a darkroom. Polaroid enters the computer and video industries. Supercolor video cassettes are premiered abroad with plans for national distribution in 1984. Polaroid introduces Palette, a low-cost computer image recorder that is supplied with Polaroid graphics software.

1984 — Technical improvements in existing cameras lead to the Sun 660 Autofocus and Sun 600 LMS. Both include integrated circuitry called SPARR (Strobe Preferred Automatic Rapid Recharge), which allows one to take pictures in rapid succession without recharging the strobe.

1985 — Recent developments result in the perfection of a continuous embossing process that makes low-cost, mass-produced holograms for commercial applications. The company announces the Polaform Process, a new custom service for the creation and mass production of embossed surface relief holograms, which can be viewed in ordinary light. The first conventional color transparency films, Polaroid Professional Chrome films, are distributed on a limited basis for commercial and industrial photographers.

1986 — The Spectra camera debuts at Jordan Marsh department store in Boston, thirty-eight years after the Polaroid Land camera Model 95 was introduced.

1987 — PolaBlue 35-mm instant slide film produces white-on-blue images from text, line art, graphs, and charts. A four-minute processing time in a Polaroid processor yields a high-quality presentation slide.

1989 — The Polaroid 600 series camera is restyled and called Impulse. A conventional, non-instant photographic film called OneFilm is introduced.

1990 — Polaroid expands its range of computer peripherals with photographic scanners and computer color image recorders for PCs and Macintosh environments including the Polaroid Palatte.

1991 — A new, high-definition Spectra film becomes available.

1992 — Introduction in Europe of a new format film and compact instant camera called Vision.

1993 — The Vision camera becomes available in North America. Introduction of a professional rugged camera called ProCam for use in high-volume photographic documentation of events occurring in difficult work areas such as construction sites and the MicroCam for microscopy are released. Polocolor Pro 100, a peel-apart high-definition color film, based on hybrid chemistry becomes available.

1994 — Sprint Scan 35 and ID4000 products are released.

1995 — Polaview 105 video projection is released.

1996 — PDC 2000, Polaroid's first digital camera is released.

1998 — Polaroid releases the Color Shot desktop digital color printer.

1999 — i-Zone camera is released; 400,000 digital cameras were sold as well as 9.7 million instant cameras.

2001 — P-500 Digital Printer is released.

2001 — Polaroid files for Chapter 11 petition.

2005 — Polaroid becomes part of the Petters Group Worldwide.

FURTHER READING
ACCESS Fifty Years by Richard Saul Wurman, ©1989 Access Press, Ltd.

www.polaroid.com

Sony

Sony Corporation, or Soni Kabushiki, is a Japanese company known worldwide for its electronic products and media businesses. Sony has its world headquarters in Tokyo, Japan, and was founded in 1945 in a radio-repair garage by Masaru Ibuka. Ibuka visited and collaborated with Bell Labs in the 1950s to learn more about transistors, and while many companies at the time were making transistor products, Ibuka targeted the communications industry rather than science and military applications. Transistor radios became popular in America in the 1960s with the evolution of rock and roll, and Sony radios were popular with that market.

Sony has been associated with high-quality electronic products since the 1960s. In March 2005 Sony reported to shareholders that it employed 151, 400 people and had $67 billion in sales. Throughout its history, Sony has continued to innovate with its product line, creating the Sony Trinitron television in 1968. They also invented the Betamax video technology used from 1975 to 1988 a direct competitor to VHS technology, which ultimately became the market's first choice for home video cameras and players.

Sony was very well-known in the video-technology industry and produced its first electronic still camera, the Sony Mavica, in 1981. The Mavica was an analog still video camera. Mavica cameras became known for recording images onto 3.5-inch floppy disks. This feature made them very popular among early adopters of digital photography since all computers at the time had disk drives compatible with this removable media. Sony manufactured many models of this successful camera line, which held the largest American market share through 2003. Starting with the floppy disk drive camera models, Sony produced the MVC-FD75, 73, 71, 78, 92, 83, 81, 85, 90, and 88 models. Sony also manufactured a CD camera—the MVC-CD200, 250, 300, 400, 500, and 1000 models. Sony has pioneered many digital photography innovations such as its Memory Stick technology. In June 2006, Sony produced its first DSLR camera, the Sony Alpha DSLR-A100, a 10-megapixel digital SLR. This was the first camera to come out of the Sony and Konica Minolta marriage, with many similarities to the Konica Minolta 5D.

www.sony.com

Svema

Svema is a Ukrainian company and a registered trademark of the Shostka chemical plant, located in Shostka, Sumy Oblast, Ukraine. Svema was a major film manufacturer in the former Soviet Union, but like many Soviet companies lost most of its film business to imported products during the late 1990s. Today Svema still makes black-and-white films and enlarging papers. Currently Svema is still manufacturing on a smaller scale.

3M

3M was founded in 1902 in Two Harbors, Minnesota. Five speculator/businessmen set out to mine a mineral deposit for grinding-wheel abrasives. But the deposits proved to be of little value, and the new Minnesota Mining and Manufacturing Co. quickly moved to nearby Duluth to focus on sandpaper products. In the early 1920s, 3M developed the world's first waterproof sandpaper, which reduced airborne dusts during automobile manufacturing.

A second major milestone occurred in 1925, when Richard G. Drew, a young lab assistant, invented masking tape—an innovative step toward diversification and the first of many Scotch brand® pressure-sensitive tapes. In the ensuing years, technical progress resulted in Scotch® Cellophane Tape for box sealing and, soon, hundreds of other practical uses.

In the early 1940s, 3M was diverted into defense materials for World War II, which was followed by new ventures, such as Scotchlite™ Reflective Sheeting for highway markings, magnetic sound-recording tape, filament adhesive tape, and the start of 3M's involvement in the graphic arts field with offset printing plates. In the 1950s, 3M introduced the Thermo-Fax™ copying process, Scotchgard™ Fabric Protector, videotape, Scotch-Brite™ Cleaning Pads, and several new electromechanical products.

Dry-silver microfilm was introduced in the 1960s, along with photographic products, carbonless papers, overhead projection systems, and a rapidly growing healthcare business of medical and dental products. Markets further expanded in the 1970s and 1980s into pharmaceuticals, radiology, and energy control. In 1980, 3M introduced Post-it® Notes, which created a whole new category in the marketplace and changed people's communication and organization behavior forever. In the 1990s, sales reached the $15 billion mark. 3M continued to develop an array of innovative products, including immune-response modifier pharmaceuticals; brightness-enhancement films for electronic displays; and flexible circuits used in inkjet printers, cell phones, and other electronic devices. In 2004, sales topped $20 billion for the first time, with innovative new products contributing significantly to growth. Recent innovations include Post-it® Super Sticky Notes, Scotch® Transparent Duct Tape, and optical films for LCD televisions.

http://www.3m.com/

Zeiss

Optical Instruments, founded by Carl Zeiss, opened for business as a German lens manufacturer in 1846. More than 150 years later, Zeiss is still considered a world leader in optics and lens manufacturing. Since 1905, six Nobel prizes have been earned by optical scientists employed by Zeiss. Products include a variety of camera lenses and precision instruments, including microscopes and other instruments that create magnified images. As imaging technology has evolved, Zeiss's product lines—like those of all manufacturers—reflected its markets. In 1941 M. Herzberger showed that complete color correction of a lens was possible, and in 1972 the Zeiss

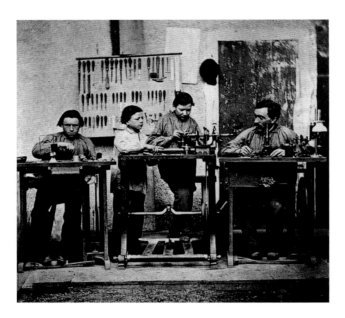

FIG. 3 The outdoor Zeiss lens grinding facility of their third workshop site, 1864. Image courtesy of Carl Zeiss, MicroImaging Inc., Thornwood, New York.

250-mm f/5.6 Superachromat lens was introduced, using four types of glass and fluorite in its design. Spectral correction is for 400–1000 nm without any focus correction required, so the lens is ideal for infrared photography. The Zeiss Luminar lenses are no longer considered by many experts to have produced the highest optical resolution of any lens ever made for magnification imaging applications, which was only limited by diffraction effects. Zeiss's current camera lens lines support ALPA Superior Swiss precision in medium format; ARRI and its cine productions; Contax, a joint Carl Zeiss and Kyocera company that was closed in 2005; Hasselblad, a very mature medium-format system; Rollei, a high-quality, automated, medium-format system; and Sony cameras.

http://www.zeiss.com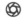

Overviews of Selected Applications of Photography

MICHAEL R. PERES
Rochester Institute of Technology

Many professional photographers start out as generalists; however, as their careers evolve, they are often recognized for a specific type of work. Photography as a field has become increasingly dependent on technology in the digital age where imaging equipment, software, and related products are necessary to make and deliver pictures as well as related services at a professional level. Staying current is quite a challenge—financially as well as educationally—for the most motivated professionals. Specialization by photographers is mostly a consequence of the markets and services professionals choose to offer. It is interesting to observe that as technology continues to change, the practitioners of traditional photographic services are displaced into photographic services that employ new technology. In some disciplines—such as film retouching—is a field almost nonexistent. Although new job titles are being created, there still exists a core group of professional photographers worldwide who make pictures. Their pictures, however, are distributed and viewed using a myriad of new methods, including cell phones.

The following list enumerates many recognized areas of photographic specialization. Some of these titles are supported by essays that can be found in this section, while other titles on this list may have essays that will be found in the History (h), Science (s), 20th Century Themes and Practitioners (20th), or the Contemporary Issues (c) sections of this book. While most of these fields have adopted digital technologies, the motivation to make pictures in these various disciplines remains mostly unchanged, and has stayed principally the same since the invention of photography.

On the following pages you will find essays written for this edition by invited contributors, this editor (Michael Peres), as well as entries that were originally published in the *Focal Encyclopedia of Photography*, 3rd Edition. Minor updating may have been done in these entries.

Abstract photography
Advertising photography
Aerial photography (s)
Allegorical photography (h)
Anthropological photography (s)
Archaeological photography (s)
Architectural photography
Astrophotography (s)
Audiovisual communications
Ballistics photography/videography (s)
Biological photography (s)
Botanical photography (s)
Candid photography
Catalog photography
Close-up photography (s)
Commercial photography
Communications photography
Corporate photography
Custom finishing
Dance photography
Decoration photography
Dental photography (s)
Documentary photography (h)
Erotic photography

Existing-light photography
Expressive photography
Fashion photography(20th century)
Fine-art photography (20th century)
Flash photography
Food photography
Forensic photography (s)
Freelance photography
Geological photography (s)
High-speed photography (s)
Historical photography
Holography (s)
Identification photography
Illustration photography
Image analysis
Imaging science
Industrial photography
Infrared photography (s)
Landscape photography
Magazine photography
Medical photography (s)
Microfilming
Military photography (s)
Multimedia
Nature photography (s)
Narrative, documentary and editorial
ORB photography
Ophthalmic photography (s)
Panoramic photography
Photofinishing
Photogrammetry (s)
Photographic education (20th century)
Photographic science
Photographic workshops (20th century)
Photoinstrumentation
Photointerpretation
Photojournalism (c)
Photomacrography (s)
Photometrology
Photomicrography (s)
Photomurals
Pictorial photography
Picture editing
Pornographic photography (20th century)
Portrait photography
Postcard photography
Professional photography
Radiography (s)
Remote sensing (s)
Repeat photography
Research photography
Reproduction photography
Restoration photography
School photography
Scientific photography
Snapshot photography

Space photography (s)
Spirit photography
Sports photography
Stereo photography
Stock photography
Still-life photography
Streak photography (s)
Surrealistic photography
Surveillance photography
Technical photography (s)
Theatrical photography
Travel photography
Underwater photography (s)
Wedding photography
Yearbook photography ◈

Applications of Advertising Photography

DENIS DEFIBAUGH
Rochester Institute of Technology

Introduction

Advertising photography describes the type of professional photography focusing on the creation of photographs to be used to publicly introduce, praise, or otherwise promote the sale of a product or services. Before the photomechanical reproduction process was invented, photographs had to be converted to line drawings by an artist to be reproduced in newspapers and other publications. This restricted their direct use in advertising since the viewing of the original photograph was limited to a small number of people. Even after the invention of practical color films for photography, reproducing color photographs using the photomechanical processes for mass distribution was complex. Thus, the demand for advertising photographs increased as the processes for reproducing the photographs in print improved and the cost of mass distribution decreased. Today, it is impossible to escape the bombardment of photographic reproductions used for advertising in newspapers, magazines, fliers, catalogs, posters, billboards, and Internet promotions.

The enormous demand for advertising photographs is being met by a large number of professional photographers around world. Advertising photographers range from a single-person studio to large multi-photographer organizations. Studios might specialize in one subject, such as automotive, fashion, food, still life, location, people, or illustrative photography. There are also generalist studios that accept virtually any type of assignment. (For discussions about studios, the studio essay in the Contemporary issues sections does a complete job of describing the various types of studios.) Advertising photographers are just one link in the chain of people and organizations involved in the production of print advertisements. Advertising photographers must initially produce photographs that

satisfy the client and/or advertising followed by those who are responsible for reproducing the photographs for mass distribution in print and on the Web.

Various paths are possible to becoming an advertising photographer, including formal education in a college or trade-school photography program, working in an advertising studio to obtain on-the-job training and, as is commonly done, obtaining a formal education in photography and then working for a limited period of time as an assistant to an established advertising photographer. ◎

Catalog Photography[1]

HOWARD LEVANT

One area of specialization in advertising photography is catalog photography. To anyone born during or before the Second World War, the idea of the mail-order catalog conjures up the image of the Sears Roebuck Catalog. Printed on thin paper (which often found its way into the family outhouse) and consisting of primitive renderings either drawn or photographed (or a combination of both), the mail-order catalog was home-delivered regularly, on a seasonal basis.

The purpose of the company's catalog and its unique style of illustration was to introduce a product to potential customers, usually in rural areas, and to share what the object that was being sold really looked like. The catalog itself relied heavily on the written word for the major part of its message. As was true of most early forms of advertising, catalogs were designed and produced by persons with a background and inclination for the written word.

Over the years, advertisers began to realize a much larger potential market for catalog sales existed. They recognized that customers who were not in rural locations might still enjoy the ease and luxury of shopping from home. Catalogs began appearing that tried to target urban consumers with specialized needs and interests. Many began to focus specifically on one type of merchandise, such as shoes, sporting goods, or tools, but continued to use the same style that was so successful in earlier publications. The industry soon realized that a new style of design and presentation was going to be necessary to reach these specialty markets.

Evaluating the style of the illustrations that existed up to that time is important. Early catalog illustrations were basically line drawings. Early advertising photography showed the approximate shape of an object and possibly highlighted some simple features. One can find examples in catalogs, magazines, and newspapers from the late 1890s up to the

Second World War. Their primary purpose was to represent merely what the merchandise looked like. Care was taken to show as much detail as possible. With the introduction of photomechanical reproduction of photographs, that style continued. The lighting in the photographs was kept to very low contrast ratios, affording maximum shadow and highlight detail.

As long as the general style of product photography for advertising stayed the same, these simplistic renderings were successful. However, with the availability, in 1936, of Kodachrome color film, magazine and billboard advertising became much more colorful and glamorous. A new style of commercial photography began to be used. This style, often referred to as illustrative photography, attempted to do more than show the customer what a product looked like. Advertisers began to try to create a mood that surrounded the product, thereby enticing the potential customer to buy it. In food photography, the expression, "don't photograph the steak, photograph the sizzle," exemplifies this type of illustration.

After considerable experimentation, the catalog industry now realizes that both the old, traditional rendering and the new, more sophisticated illustration have their place. Industrial catalogs need to do little more than provide a clear image of the object, supported by appropriate copy. General household or utilitarian products may be shown in a simple setting that suggests the environment in which it would be used. Less copy might be used in this case. High-priced luxury items may be shown using models, room sets, or expensive locations. The point is to make potential consumers relate to how the product could enhance their lifestyle. Many of the modern catalogs of this type—for example, the Sharper Image, Neiman-Marcus, Victoria's Secret, and LL Bean catalogs—have virtually become books filled with glamorous magazine-style advertisements.

Over the years an attitude has developed among professional photographers that catalog photography is what one does if no other work is available. This is hardly a realistic view. Some of the largest and most commercially successful photography studios in the United States are catalog houses. The advantages they offer to both new and experienced photographers are many and varied. They allow for the option of generalization or specialization. Some studios offer the opportunity of shooting one type of situation one day and something totally different the next. Others allow a photographer to develop a unique level of expertise by specializing in photographing furniture, cars, or some other genre of product.

Economically, catalog photography is a low unit cost/high volume business. Unlike general advertising, it is less affected by economic downturns and recessions. During advertising slowdowns, the volume of business seen by catalog and mail-order studios tends to hold up very well. Even though the Web has become a major medium for purchasing and viewing products, the catalog is still a strong vehicle to showcase product. In fact, many companies only publish their catalogs online. Catalog photography is a healthy, viable industry that offers opportunity and financial rewards for technical and creative photographers. ◎

[1]Originally published in the *Focal Encyclopedia of Photography*, 3rd Edition. Updated by D. Defibaugh.

Commercial Photography[1]

GEORGE COCHRAN

Commercial photography is the branch of professional photography concerned primarily with supplying the photographic needs of the advertising, communication, display, and sales sides of industry, as well as the art departments of media involved with industry. Commercial photographers typically make photographs of products for reproduction in catalogs, brochures, instruction manuals, press releases, and advertisements in newspapers, magazines, and other media. Because commercial photographs commonly serve as a substitute for the objects photographed, they are expected to appear realistic, and because they should create a favorable impression on the viewer, especially when used for advertising purposes, they are expected to make the objects appear attractive and desirable. Commercial photographers do not have the freedom that illustrative photographers have to glorify products and to create an exaggerated aura of prestige and desirability, but they can make maximum use of the basic controls such as choice of background and props, arrangement, lighting, viewpoint, choice of lens, and photographic craftsmanship to make an attractive but also realistic photograph.

Whereas some commercial photographers will accept a wide range of assignments, including photographing small manufactured products, automobiles, architectural interiors and exteriors, industrial locations and operations, food, and packaged materials, and making photographic copies of paintings and other images, other commercial photographers will specialize in a narrow area, such as making photographs only of furniture. Some large commercial photography studios will cover a range of assignments by using a number of photographers who specialize in different areas, such as glassware and polished metal or automobiles.

Commercial photographers generally prefer to work in a studio where they have control over lighting and the other elements involved in making photographs, but many will do both interior and exterior location work, including such assignments as making a sequence of photographs at a construction site for a progress report or for documentation purposes.

View cameras have been the camera of choice of commercial photographers because of the advantages of large-format film in recording detail and because of the control they offer over image shape and the angle of the plane of sharp focus with the tilt and swing adjustments. Although 8×10 and 4×5-inch format view cameras were considered to be the standard size in earlier years, subsequent improvements in digital technology have resulted in a strong movement to digital cameras. Currently new cameras are being designed and improved yearly. Models of digital SLR cameras that produce 17 million pixels and medium-format backs that produce 39 million pixels have improved the quality of digital photography to match or exceed conventional film. The fast pace of commercial photography is aided by the speed of producing digital images and instant approval of the image for reproduction. ◉

Food Photography[2]

ALLAN VOGEL

Today more than ever before, there is a constant need for photographs of food for promotional purposes. Much of this need is due to a wide interest in nutrition and health and the public's desire to explore the tastes of different cultures.

The food photographer's studio is designed with the kitchen as a main ingredient, and it can be as fully equipped as a professional chef's kitchen. Shooting food in the studio for an advertisement or a magazine editorial usually follows a certain pattern. Prop styling—the gathering of an assortment of dishes and table linens, silverware and glassware, and materials needed for backgrounds—is done a day or two before the actual shoot day. Although a number of photographers are accomplished chefs, most work with a home economist or food stylist, which leaves them free to concentrate on the photographic part of an assignment. Food shopping is done the day before or even the morning of the shoot to ensure that all food will be fresh and appealing. At times foods that are out of season may be flown in from other parts of the world.

Usually working from a layout, the photographer and art director or designer select the props, background, and setting for the photograph. Meanwhile the food stylist prepares a stand-in dish, which the photographer uses to refine the lighting and to determine proper exposure. Generally, electronic flash is used so that the heat from tungsten lights will not affect the food. Although more photographers are experimenting with using hot lights, electronic flash is still needed to freeze a pour at the high point of the action.

Appetite appeal is the primary reason to shoot food, and large-format cameras, 8×10-inch and 4×5-inch, allow for the texture and color to be rendered in great detail in reproductions and are still used frequently. Most food being photographed today is photographed using color transparency film. Because color provides an appetizing look, there is less black-and-white photography of food. Black-and-white work may occasionally be seen in newspapers, but these publications are also reproducing color. As with other types of commercial photography, digital cameras are becoming a part of food photography; however, only the highest-quality digital backs are being used in various studios to capture food images.

Teamwork and timing between the photographer and the food stylist is very important. Food must be photographed at

[1]Originally published in the *Focal Encyclopedia of Photography*, 3rd Edition. Updated by D. Defibaugh.

[2]Originally published in the *Focal Encyclopedia of Photography*, 3rd Edition. Updated by D. Defibaugh.

its peak after preparation to take advantage of its color and its "moment of serving" appearance. A timing sequence must be worked out so that the most perishable of the dishes reach the set as soon as possible after cooking. Just before the exposures are made, the photographer or stylist performs the last-minute touches that enhance the food's appearance, such as brushing certain items with a thin coating of vegetable oil to give them an attractive shine, spraying fresh vegetables and fruit with a mixture of glycerin and water to make them appear fresher and more appetizing, adding the little pools of gravy with a syringe, spooning on the sauce and dressings, or adding the important dessert toppings of powdered sugar or whipped cream or whatever is necessary to finish off the photograph and make it appear mouthwatering and desirable.

Photographing liquids presents other special problems. A can of soda must appear cold and perhaps frosty. A glass or mug of beer must have a full and appetizing collar of foam, and a bottle must pour smoothly without "burping" as it pours. To frost a can, a stylist may first spray it with a glycerin-water mixture, and then sprinkle it with salt, which will look like frost on the can. To achieve the same effect on a beer glass, it is first sprayed with a thin coat of clear lacquer so that the glycerin mixture will adhere to its surface. Room-temperature beer is used; the head is spooned on later and gently coaxed over the glass's rim. To make a bottle or can pour without gulping for air, a photographer or stylist drills a hole in or near the bottom. The can or bottle is then rigged on a stand, out of frame, and a small hose or funnel is used to allow the liquid to pour freely through. All of these techniques and methods take a great deal of patient practice before expertise can be achieved. ◎

Illustration Photography[3]

GEORGE COCHRAN

According to dictionary definitions of illustration, the term can be applied to all pictures, including drawings, paintings, and photographs. The terms illustration photography and photographic illustration, however, suggest a more limited meaning—namely, that photographs in this category are more than faithful images of objects. In addition to representing objects, such photographs are expected to communicate something less tangible to the viewer, such as a concept or a mood.

The field of photographic illustration can be subdivided based on the objective of the photographer in making a photograph or on how the photograph is to be used. A photograph made for the purpose of selling a product—by means of a magazine ad, for example—is identified as an advertising illustration. A photograph used to attract the reader's attention and provide a clue concerning the contents or to establish a mood for a magazine article or other publication is identified

as an editorial illustration. A photograph made for the purpose of communicating the photographer's opinions or emotions concerning a subject can be identified as an expressive illustration.

With respect to advertising illustrations, the photographer typically works closely with an advertising agency art director. The art director commonly provides the photographer with a layout, which may range from a rough sketch to a detailed drawing that the photographer is expected to place on the camera ground glass and conform to exactly. Some art directors like to be in the studio when the photograph is being made or to be provided with a proof print or a finished transparency or print before the set is dismantled. High-resolution electronic cameras and backs are now available that allow the image to be displayed on a computer monitor, which permits an art director to inspect the image and suggest changes when the image is captured. It is also possible to transmit images by email to another location such as an art director's office, where the image can be electronically retouched or modified and stored before being reproduced.

Photographers commonly become more involved in the planning and modification of layouts as they gain experience and the trust of the art director. Some photographers like to photograph a variation that incorporates their own ideas, after making a photograph that conforms to a specified layout, to be offered to the art director for consideration. Photographers who have gained a reputation of generating creative ideas may be given complete freedom to execute an assignment as they see fit.

Most advertising illustrations involve the efforts of other people in addition to an art director and photographer, possibly including the photographer's representative, a producer, prop manager, carpenter, set designer, location scout, hair and makeup stylist, studio manager, wardrobe supervisor, camera or digital assistant, and one or more models. Creating photographs on location and in the studio is necessary with all aspects of illustration photography. Most often photographers will use many lights to create and control the desired look for their locations or sets, although beautiful natural light is always a possible approach.

While advertising illustration may be the most lucrative type of illustration photography, there are many styles and forms of illustration to explore. Architecture, editorial, corporate/industrial, fashion, people/celebrity, travel, and lifestyle are areas of illustration in which photographers can build a career. ◎

[3]Originally published in the *Focal Encyclopedia of Photography*, 3rd Edition. Updated by D. Defibaugh.

Still-Life Photography

DENIS DEFIBAUGH
Rochester Institute of Technology

A still life is an arrangement of inanimate (or mostly inanimate) elements that express pictorial, narrative, or metaphorical

content. Photographic still-life studies evolve from the tradition of still-life paintings that originated as early as the 15th century. The most basic challenge of the still-life photographer is to create a composition of objects that are defined by light.

During the 17th century, the Dutch Masters produced exquisite still-life paintings. These opulent paintings contain lavish tableau arrangements of flowers, fruits, material treasures, and artifacts. The objects seem to be bathed in light that reveals texture, volume, space, and reality. Many photographers have followed the Dutch principles of the still life, both as an art form and for commercial applications.

The rudiments of a still-life photograph begin with the arrangement of light, shadow, form, and space. Natural or artificial light is used to define the subject's texture, surface, shape, and form. Directional sidelight is used to convey textual quality while emphasizing the line and shape inherent in the subject. By incorporating the shadow qualities of positive and negative space, the photographer is able to produce a more abstract composition. In contrast, soft, diffused light produces an almost shadowless light that reveals all the detail, tonality, and color of the subject.

The large-format camera is most commonly used for still-life photography. The large image size and the camera's movements that control perspective and depth of field allow exact rendering of shape and fine detail. Although still-life photographs have been created with every type and format of camera, the highest resolution and image quality are desirable.

Many still-life compositions are visual representations of objects that have been isolated from their environment. In this method the photographer is concerned with replicating the subject in its truest form. Some photographers use props to create an environment that will illustrate a story or provide a desired mood. These photographs have a natural, spontaneous quality. A still life can also be conceptual in nature. The conceptual still life may incorporate elements that represent such ideas as power, sexuality, mythology, or the classics. By alluding to an abstract idea or an emotion instead of the object's physical characteristics, the photographer transforms the literal quality of the object through symbolic associations.

While the message or style of a still life may vary infinitely, the photographer has the opportunity to work precisely to achieve an inspired lighting and composition. Whether a documented still life of personal objects, an abstract arrangement of ordinary elements, or an illustration of an exquisite product, the still life is an effective means of creative expression. ◉

Architectural Photography

WILLIAM W. DUBOIS
Rochester Institute of Technology

Architectural photography is dominated by photographs of entire buildings and exterior and interior sections of buildings, but the field includes close-up photographs of building details and even photographs of other structures such as bridges, towers, arches, sculptures, walls, and monuments. Most buildings are constructed for utilitarian purposes, but architecture is considered to be one of the fine arts, and photographs of buildings are made for both commercial and expressive purposes.

Buildings were popular subjects with early photographers, as were landscapes, and because buildings and their surroundings cannot be separated, many photographers developed expertise in both architectural and landscape photography. Photographs of historical structures and buildings having unique architectural styles in other countries held special fascination for the public, which previously had access only through drawings. An amateur photographer, Jean Baptiste Louis Gros, made the first daguerreotype images of the ancient Parthenon in Athens in 1840, only a year after the public announcement of the daguerreotype process. As described by Naomi Rosenblum in *A World History of Photography* (revised edition, Cross River, New York, 1984), "After returning to Paris, he was fascinated by his realization that, unlike hand-drawn pictures, camera images on close inspection yielded minute details of which the observer may not have been aware when the exposure was made."

Photographers soon realized that it was necessary to keep the camera level to prevent the vertical lines on buildings from converging in the photograph. Rising-falling fronts were added to cameras so that the image could be moved up or down on the ground glass without tilting the camera, with tilt and swing adjustments appearing on later models. Large-format view cameras have long been the preferred camera of architectural photographers, although the most popular sizes have decreased over the years from 8 × 10 and larger to 4 × 5, in response to increased quality of lenses and films. Even 35-mm cameras became architectural cameras with the introduction of the perspective-control (PC) lens, a wide-angle lens that can be shifted off-center to position the image without tilting the camera.

The basic task of architectural photographers is to represent three-dimensional architectural subjects realistically and attractively in two-dimensional photographs. Because of the nature of the subject, they are faced with special challenges.

Camera Placement

For exterior views of buildings, the camera is normally positioned to emphasize the front of the building while also showing one side of the building to reveal form. Ideally, the camera distance would be determined by the type of perspective desired—normal or strong—but in practice this is seldom possible because of obstructions that limit the camera distance and distracting objects that would appear in the foreground. As a result, the camera is placed in the best position available, and a lens is selected that provides the desired image from that angle of view. Thus, the photographer needs a choice of lenses covering a range of focal lengths, but all must have sufficient covering power to allow the view-camera movements to be used.

With interior views, the camera can seldom be placed far enough away from the area of interest for a normal focal-length lens to be used. Although the strong perspective that results from using short-focal-length, wide-angle lenses creates a false impression of distance and space, the effect is usually welcomed because it makes the area appear more spacious than it really is.

Lighting

Conventional lighting for exterior views consists of having the sun in a position that illuminates the front of the building while the visible side of the building is in the shade, a lighting effect that emphasizes the relief detail on the front surface of the building and the three-dimensional form of the building as a whole. Because the lighting changes constantly between sunrise and sunset, the photographer must anticipate when the desired lighting effect will occur. A hazy sun or mildly overcast sky is sometimes preferred for less contrast. Alternative lighting effects include night photographs of buildings having exterior lighting or that can be "painted" with multiple firings of electronic flash units and double exposures, one at dusk to record a sky tone and one after dark to record the building's night illumination.

FIG. 4 An unusual architectural photograph made in an elevator shaft. © William W. DuBois, Rochester Institute of Technology, Rochester, New York.

The task of lighting interior views is greatly complicated by the use of color films. Even where the existing lighting is satisfactory, it may be necessary to use color-correction filters on the camera lens, especially with transparency films. When it is necessary to combine existing room illumination with supplementary flash or tungsten lighting and/or a daylight scene visible through a window, the task becomes more difficult.

In cities, there is a large enough market for architectural photographs that professional photographers can specialize in this field. Architectural photographs find many different uses by individuals and organizations in diverse fields. At one extreme, a cover photograph for a national magazine might involve the combined efforts of a number of specialists in addition to those of the photographer, and many hours of preparation before the photograph is actually made. At a another extreme, a local real estate agent might make hand-held photographs with an instant-picture camera to show to potential clients. In between are all the architectural photographs made for documentation, information, advertising, and display, and for publication in newspapers, brochures, catalogs, magazines, and books.

Some architectural photographers develop distinctive styles, but it is important for professional architectural photographers to determine the needs of their clients and to make suitable photographs that meet those needs.

FURTHER READING

McGarth, Norman. *Photographing Buildings Inside and Out.* New York: Whitney Library of Design/Watson-Guptill, 1987.

Shulman, Julius. *The Photography of Architecture and Design.* New York: Whitney Library of Design/Watson-Guptill, 1977. ◉

Corporate Photography[4]

KATHLEEN FRANCIS

The pictures made for corporate photography are some of the most visible and important photographic communication pieces that can be produced by a company. Corporate photographs represent the company and its people and are used to create an image and identity for the organization to the public.

Companies place a high value on corporate photography and this type of work can generate sizable incomes for photographers who can find work with Fortune 500 companies such as Ford Motor Company, Pfizer, and Microsoft. Most corporate photography is similar to editorial photography and certainly has a location component. Photographers who work in this area must also have personal and business attitudes that, even if somewhat idiosyncratic, are consistent with the corporate officers with whom they work.

[4]Originally published in the *Focal Encyclopedia of Photography*, 3rd Edition. Updated by M. Peres.

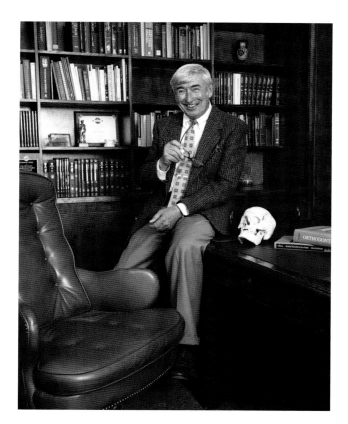

FIG. 5 An example of a corporate photograph. © Michael Peres.

Corporate photography assignments usually come from companies' public relations departments, their advertising agencies, or their graphic designers. Executives with titles such as advertising manager, public relations director, and director of communications—as well as those who report to them—authorize corporate photography assignments. These assignments may also come from advertising agency account executives and designers who have been assigned projects that require photographic illustrations for publications such as annual reports. Annual report photography is also a highly prized assignment This type of photography creates the visual image of a company's executives, facilities, workers, products, and so on. Depending on the style and length of the particular annual report, the photography may take a couple of days or several weeks to complete. Numerous subjects may need to be photographed, ranging from people to products, and industrial plants to customer applications.

Other corporate photography assignments might include photographing employees on and off the job for recruitment brochures; photographing a company's facilities and services for a capabilities brochure; or photographing just about anything related to the company, its employees, and its customers for internal and external publications. Corporate publications are distributed using traditional print methods and/or the Internet and may reach millions of viewers.

Corporate photography welcomes talented photographers who conduct business in a professional manner; however, making the right contacts to get such assignments is not a simple task. Meeting the various deadlines and delivering images that capture the philosophy of the company (or something better than was expected) are essential ingredients to success in corporate photography, as is an ability to work with all kinds of people. For this work to be considered successful, corporate pictures must create a positive impression that reflects well on the corporation.

A photographer interested in this type of work should locate someone within the corporation who assigns photography projects and make an appointment to show his or her portfolio. Ideally, the portfolio should be a powerful presentation of the photographer's best work, with every marginal picture edited out. Because corporate photographic needs are so diverse, a substantive portfolio may be appropriate. Newcomers to the field may offer a corporation some economy or flexibility they need to pursue a particular communications task. They also may offer the corporation access to special subject matter or certain techniques. One young photographer won a major assignment to photograph the alphabet for a large corporation because he had an extensive collection of old display type. ◉

Dance and Theater Photography[5]

KATHLEEN FRANCIS

Dance photography makes photographs of an art form that is defined by movements. Rather than simply stopping that movement, the best dance photographs somehow suggest movement through the position of the dancers' bodies, using purposeful and artistic blurs, or even multiple image techniques.

As with any kind of specialty photography, dance photography requires a photographer to know the terms, attitudes, and working methods of the subject—in this case, dancers and choreographers. With classical ballet and other known dance works, the best photographers familiarize themselves in advance with the particular dance that will be photographed. With any new production, conscientious photographers will attend rehearsals and choose the best moment to shoot, operating pre-focused cameras much like sports photographers anticipating the big play. Permission for when and where to photograph is always needed, and always before the photography begins.

Dance photographs that publicize a specific event most often feature sharp, easily understood images of moments from the performance; however, advertising and promotional photos take more liberties in an effort to suggest the scope and energy of the dance event. Artistic photographs, intended for

[5]Originally published in the *Focal Encyclopedia of Photography*, 3rd Edition. Updated by M. Peres.

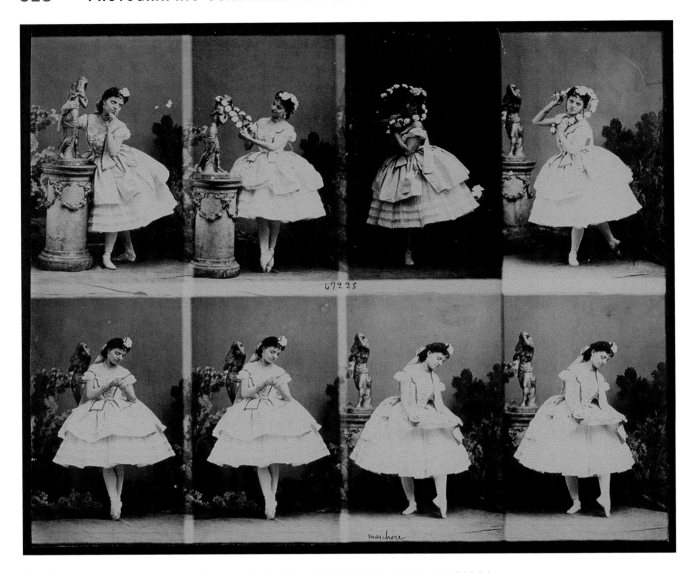

FIG. 6 An early example of dance photography. "Unidentified Ballerina," date unknown, André-Adolphe-Eugène Disdéri. Albumen print. George Eastman House Collection, Rochester, New York.

exhibition or for publication in books, offer subjective interpretation, a photographer's own response to the dance.

Clive Barnes wrote that, "we remember dance through its pictures." Some of the early dance pictures were paintings and lithographs. The first dance photographs were made of the Ballet of the Second Empire, the Royal Danish Ballet, and the ballets of Imperial Russia. Dance-world legends Isador Duncan and Vaslav Nijinsky dance through time in the images of Arnold Genthe and Baron Adolf de Meyer.

Technological improvements in cameras and film gave birth to the mid-air, stop-action dance photograph. Gjon Mili is believed to have been the first photographer to use strobe lights to photograph dance. Experiments with slower shutter

speeds suggested the possibilities of creative blur — when either the panning camera or the dancing subject moved during exposure.

Barbara Morgan, renowned photographer of Martha Graham, Merce Cunningham, and José Limón, among others, used her spiritual oneness with the dancers to capture the gesture, the vitality, the moment of triumph. Her photographs of American modern dance in the 1930s and 1940s, "strike the viewer with the impact of live experience" (*Dance Magazine*, August 1991).

Since the 1970s, Lois Greenfield has photographed what she calls "experimental" or modern dancers defying gravity with their leaps. Annie Leibovitz has transferred the physicality and

Theatrical Photography[6]

KATHLEEN FRANCIS

Theatrical photography seeks to capture the excitement and drama of the stage. Movies and performance art, as well as the individuality and charisma of the actors and actresses who bring such productions to life, are also featured elements of this type of photography.

Whether theatrical photographs are taken in the theater, the studio, or simply feature several of the key performers, they usually look like frozen moments of the production itself. Sharp and clear, they detail faces, costumes, sets, and situations as they actually might occur on stage or screen. Usually, however, these pictures are taken at a dress rehearsal or a photo call and are displayed in the theater lobby or sent as publicity work to newspapers and magazine editors.

Theatrical photographs destined for publicity, advertisements, and posters often take liberties with the facts of the actual production. Instead of documentation, they seek to convey the type and tone of the production — comedy, tragedy, classical, popular, or avant-garde, for example. They help to catch the eye of the casual observer and to cultivate interest in attending a performance.

Daguerreotypes of Jenny Lind (Mathew Brady, 1850) and Lola Montez (Southworth and Hawes, 1851) as well as albumen prints of Sarah Bernhardt (Nadar, circa 1860) established the importance of theatrical photographs taken of performers by portrait photographers. That tradition was extended by such well-known photographers as Nikolas Muray and Edward Steichen (*Vanity Fair*, 1920s), Richard Avedon (*Harper's Bazaar* and others, 1940s through the 1970s), and Annie Liebovitz (*Rolling Stone, Vanity Fair*, 1970s to present).

The distribution of glossy prints, which are distributed by every established and would-be performer to agents, news media, and fans, began in the 1850s. From the 1850s through the 1890s, a photographic calling card, the carte-de-visite, enjoyed broad popularity. Performers ordered these small prints mounted on cards approximately 2-1/2 × 4 inches for sale in theater lobbies. Photographers often gave free sittings and prints to well-known theatrical personalities in exchange for the right to sell their pictures from the studio.

Around the turn of the century, on-stage pictures began to call attention to specific productions. In the beginning, only operas, classical plays, and productions with major stars were photographed by prestigious photographers. When photographically illustrated programs emerged in the 1920s, however, the need for performance photographs as well as performer portraits grew. During that same decade, photographers began to document the set and lighting effects of major productions — a prelude to today's full coverage of all aspects of production.

In the motion-picture industry, still photographs not only document every aspect of production so that details can

FIG. 7 © Howard Schatz from *Passion & Line* (Graphis Press), originally published in *Dance Magazine*.

body consciousness of dance to her photographs of nondance celebrities as well as celebrated dancers such as Mikhail Baryshnikov. The directness of dance makes it easily accessible to the photographer willing to become the audience for studio setups and on-stage photo calls. Because it is a visual art, dance ordinarily does not need translation. An ability to feel the music and the dance and, somehow, to channel that feeling to the camera trigger finger, underlies the best dance photographs. Some photographers such as Edward Steichen and Cecil Beaton actually tried dancing to give them better insights into their dance photography.

Anna Pavlova is quoted in *Opportunities in the Dance* as saying, "For the dancer must feel so perfectly at ease, so far as technique is concerned, that when on stage she needs devote to it not a single thought, and may concentrate upon expression, upon the feelings which must give life to the dance she is performing" (Denis). Similar words apply to the photographer of the dancer.

Dance photography continues to be practiced. In fact, many fine art photographers are drawn to its grace and athleticism of its performers. Howard Schatz has earned a notable following for his work in this area. ⊚

[6]Originally published in the *Focal Encyclopedia of Photography*, 3rd Edition.

be matched when re-shooting, but they also help generate publicity with apparent, in-production action shots plus formal and informal portraits of the stars. In such disciplines as mime, deaf poetry, magic, circus, and performance art (where scripts either do not exist or do not adequately describe what happens), movie footage or, more recently, videotape captures the entire performance. Such disciplines, especially those with an essentially physical core, can be photographed directly as action happens.

Stage plays and movies, on the other hand, often draw their power from words and emotion. They require the still photographer to find a tableau or pose that sums up a theatrical moment visually. These pictures can then be taken right on the stage or the set with the actual performance lighting and, perhaps, direct or bounced electronic flash.

The photo call has become a tradition among stage actors, who must appear in costume and pose on the set of the production. The highly skilled photographer has only a limited time to take exciting photographs that will publicize the play.

FURTHER READING

Denis, Paul. *Opportunities in the Dance.* Lincolnwood, Ill.: VGM Career Horizons, 1985.

Greenfield, Lois. *Breaking Bounds.* New York: Chronicle, 1992.

Morgan, Barbara, and Martha Graham. *Sixteen Dances in Photographs.* New York: Duel, Sloan and Pearle, 1941.

Dance Magazine (back issues available.) ◉

Freelance Photography[7]

KATHLEEN FRANCIS

Freelance photography is defined as the work done by photographers or artists who run their own businesses rather than working for a company. Generally speaking, freelance photographers own their equipment and take photographs for many clients. If a freelance photographer works exclusively for one client or uses the client's equipment, that photographer may be deemed an employee of that organization and not a freelance photographer by U.S. tax laws.

Making a living as a freelance photographer is not easy. In fact, many of those willing to be called freelance photographers actually pay their bills by holding other part-time jobs, sometimes in other photo-oriented businesses (i.e., studios, camera stores, or newspapers) or even in unrelated fields.

The new freelance photographer might begin by assisting an established photographer with some client photography. At the same time, the person might build a portfolio by completing speculative assignments and, perhaps, shooting some pictures on the side for local publications and small businesses, weddings, or portraits.

Freelance photographers also emerge from the ranks of photographers employed by larger corporations, daily newspapers, and educational institutions. For photographers who retire early or simply want more freedom in their work, freelance photography holds genuine appeal. Doing work from the outside can often provide a needed income supplement as well as creative reward.

Freelance photographers may enjoy a long career but it is challenging to earn enough money to follow this path. The best freelancers will take a variety of assignments before becoming known for one specialty. The specialty gives a client a specific reason to call; the flexibility enables the photographer to say yes to a client challenge and, at the same time, to enhance the all-important portfolio.

Just about any publication that uses photographs are a possible outlet for freelance photography. So are businesses of virtually any size, along with their advertising and public-relations agencies.

One classic freelance market is the stock picture industry. For years, these picture agencies have accepted freelance photographers' images on consignment and then retained part of the fees they charge clients to use the pictures.

U.S. syndication agencies place feature stories, personality profiles, and news stories within the United States first. Then they resell the material in other countries. Freelance photographers whose work translates well to the world market eventually may be asked to cover a major story anywhere in the world.

For all freelance photography markets, photographers need to show a portfolio of their best work. Such a portfolio might consist of a Web site, a print portfolio, or both. Contents should include strong samples plus a photographic essay and some personal photography.

A freelance photographer, no matter how talented, must address the legal and business implications of self-employment in photography, including model releases and other required permissions—to shoot in a historic house, for example, or to borrow certain necessary props. A freelancer's legal responsibilities also include establishing ownership of photographs and usage rights before accepting assignments from new clients. Certain organizations that count freelance photographers among their members offer insurance for everything from a photographer's health to photographic equipment, props, and film. Such organizations also publish price guidelines for various types of freelance photography, although actual fees vary widely. ◉

Identification Photography[8]

KATHLEEN FRANCIS

Identification photography involves making inexpensive and quick portrait pictures of people for a passports, security

[7]Originally published in the *Focal Encyclopedia of Photography*, 3rd Edition.

[8]Originally published in the *Focal Encyclopedia of Photography*, 3rd Edition. Updated by M. Peres.

FIG. 8 An example of an ID photograph from a U.S. passport, ca. 1925. Image courtesy of Michael Peres.

passes, licenses, permits, or similar applications. The school ID, a driver's license, or company ID card are all uses of identification photography in this era of heightened worldwide security. Photography has become the preferred method of identification because a quick visual comparison is all that is required for verification upon entering or leaving facilities.

A French photographer, Louis Dodero, originated the idea of using photographs to establish identity or rights in 1851. A year later, Switzerland began to photograph all vagrants and beggars, and France started to circulate its first photographic "wanted" posters. In 1865, cartes-de-visite of John Wilkes Booth and his accomplices were glued onto the first U.S. "wanted" posters, prompted by the assassination of President Abraham Lincoln.

By 1860, both England and the United States made photographic records of those arrested and/or imprisoned. Alphonse M. Bertillon, appointed head of the Paris police ID section in 1882, devised the Bertillon system. The widely adopted system required three basic components: full and profile photographs; extended and precise written description; and body measurements, or anthropometry. In a famous 1903 case involving two nearly identical prisoners—Will West and William West—at the Federal Prison at Leavenworth, Kansas, fingerprints were found superior to body measurements for absolute identification.

Identification photographs were first used publicly in the United States by the Chicago & Milwaukee Railway Company for season ticket holders in 1861. Since then, countries, states, companies, universities, and just about any other large entity interested in confirming identity have turned to photography. In recent years, personal identification photography has proliferated throughout the world. While a person in the United States might need a photo ID to cash a check or to gain admission to a place where alcohol is served, a person in a Third World country might be required to show a photo ID simply to walk down a street or to drive along a country road.

A limited number of identification photographs are still made with a film camera, a medium telephoto lens, and color negative films, but digital technology has pretty much taken over this industry. Features of a successful photo identification system might include the ability to photograph a person and print metadata into the file, as well as the ability to photograph a special symbol over both areas of the photo; lamination to prevent alteration; and even additional heat sealing and a validation stamp to permit annual review.

Almost all new photo ID card systems use electronic imaging to generate photographs and other information by computer. A few Polaroid ID camera systems are still sold. The subject and other information are captured on a single piece of film and laminated in less than a minute. The photo ID can then be encoded with a magnetic stripe, a bar code, or other identifying data.

In this world where identity theft is a growing threat and security is a huge undertaking, retinal scans and DNA embedding are part of the future of this application of photography. 🔘

FIG. 9 An example of an industrial photograph taken in a welding shop. Image courtesy of Michael Peres.

Industrial Photography[9]

KATHLEEN FRANCIS

Industrial photography encompasses the broad range of photography in any organization dedicated to the commercial production and sale of goods and services. Although traditionally associated with manufacturing, industrial photography also applies to photographic work in non-manufacturing companies such as public utilities and mines.

The industrial photographer usually works directly for a specific company, whereas the freelance photographer will often supplement the work of the so-called in-house or in-plant photographer. The in-house photographer frequently has expertise in technical photographic areas necessary to photograph the company's operations, products, and services. Ideally, the photographer also may have studied engineering, design, chemistry, physics, or some other field related to the particular industry.

[9]Originally published in the *Focal Encyclopedia of Photography*, 3rd Edition.

The industrial photographer need to be aware of not only just about every facet of still photography, but also of the many roles that cinematography and videography may play in testing, documentation, advertising, or any other aspect of the job. With increasing interaction between computers and photographic images, industrial photographers must constantly learn enough about electronic imaging to keep their place in the company. Considering the breadth and depth of the field, the industrial photographer can never stop learning.

Career possibilities for industrial photographers include positions as a scientific or technical specialists, as general-purpose photographers, or as administrators of a photography department. In some companies, all photographic services are centralized. In others, individual departments support specialized photographic services such as identification photography (security) or public relations (publications). Cost and time factors influence such buying decisions for this type of photography. In an era of downsizing, the industrial photographic department, like every other department, needs to accomplish more work with a smaller staff. Industrial photographers need to be flexible specialists with an understanding of company direction and policies. They need to be able to schedule and manage the work of outside photographers as well as their own photography to meet the demands of the changing industrial environment.

The industrial photography department itself remains an unlikely candidate for outsourcing. In-house departments have advantages, including familiarity with the company and its products, easy and immediate access, security, economy, and fast turnaround. ◉

Landscape Photography[10]

DENIS DEFIBAUGH

Landscape photography creates photographic interpretations of the natural and man-made environment. Landscape photographs will be as varied as the land and photographers who make photographs of it. While landscape photography is generally recognized to require views of nature by itself, many landscape photographs will often include people, nudes, buildings, and other objects that lend interest to the idea and/or interests of the photographer.

Landscape photography began more or less at the time photography was invented. One of the first photographs taken by Louis Daguerre was made in 1839 of a Parisian view of the Seine and the Tuileries. One could argue that this was the beginning of urban landscape photography. The early exploratory photographers—Francis Frith, the Bisson

brothers, Timothy O'Sullivan, and William Henry Jackson—created pictures of places where Europeans had not been before. Jackson's photographs of Yellowstone were so compelling that they influenced Congress to create Yellowstone Park in 1872. These and many other photographers have helped to increase the public awareness of the beauty, wealth, and frailty of our environment.

The play of light on the landscape and the atmospheric conditions affecting that light are of great importance to the character of the photograph. It is always the challenge of the landscape photographer to capture this fleeting quality. The mood of the image is controlled by the direction, color, and quality of light and hence the challenge to the landscape photographer, since these conditions are constantly changing. The direction of light may come from the front, side, or back. The quality of light may be described as soft or hard and has significant influence on the resultant photographs. Hard light is usually strong and directional and creates contrast, texture, and mood. Overcast skies produce soft, non-directional light that is excellent for photographing delicate texture and soft shadow detail. This might be characterized as the soft light produced just before sunrise and shortly after sunset.

Many landscape photographers shoot during the morning or late afternoon when the sun is close to the horizon. This lighting creates long, dramatic shadows and produces a warm, red-orange color that adds interest to scenes that might otherwise appear monochromatic. In comparison, the cooler colors of the midday sun and sky introduce more blue light to the scene, especially in the shadows.

Any camera can be used for landscape photography. Photographers in the second half of the nineteenth century used cameras as large as 20 × 24 inches, while today most photographers use all formats and often digital cameras in particular. The larger size of large-format cameras still produces images that are excellent for recording the fine subject details and producing large prints. Large-format cameras have adjustments that provide control over the plane of sharp focus and image shape to obtain desired effects.

A camera with interchangeable lenses is desirable because of the option of using different focal length lenses to obtain images with different sizes and angles of view from a given location. The normal focal length lens renders perspective of the scene similar to that experienced by a person standing in the same location. Wide-angle lenses are used to accentuate space and distance between objects, emphasizing the foreground. The larger-angle of view of wide-angle lenses produces a broad panoramic view. Panoramic cameras that cover an even larger angle are sometimes used. The long focal length lens is used to bring distant objects closer and to eliminate unwanted areas of the composition. Its graphic compression of space has the opposite effect of the wide-angle lens.

Landscape photographers select the desired elusive qualities of light to define their subjects, and their vision isolates the select portion of the landscape to be recorded. Ansel Adams framed the grandeur and beauty of wilderness areas of the American West, Minor White explored the mystical realm

[10]Originally published in the *Focal Encyclopedia of Photography*, 3rd Edition. Updated by M. Peres.

FIG. 10 An example of a landscape photograph. Image courtesy of Michael Peres.

of nature, Edward Weston searched for truth and the essence of things in his natural surroundings, and Robert Adams revealed the intrusion of people into the landscape. ◍

Narrative, Documentary, and Editorial Photography

OWEN BUTLER
Rochester Institute of Technology

Truth has many viewpoints, all of which depend on the individual photographer. From its inception in 1839, photography itself was heralded as the epitome of realistic representation, in large part because of its unique ability to show things in literal, objective, and commonly understood visual terms. The medium's unsurpassed power of realistic representation rested on its precision, clarity, sharpness, impartiality, truth to nature, and compelling believability. Photography thus provided evidence of places and events in an accurate and truthful way, the cornerstone of factual documentary reporting.

One of the earliest subjects for photographers—many of whom were wealthy—was they could travel and carry a camera. Thus, much of the earliest photographic representations of what we call narrative, documentary, and editorial work (NDE) was personal work documenting the broader world and fell immediately prey to artistic biases of the photographer. None of this work was, however, a pure photographic document. A person's viewpoint and feelings always seeped through.

One might define NDE as the outcome of a project that is not bound by time nor driven by publication deadline. NDE

is often a time-consuming and expensive undertaking, both in dollars and human spirit. Therefore, it will often create outcomes that are unpredictable. An excellent example may be found in Eugene W. Smith's photographic essays of Albert Schweitzer, which were months late to his publisher because serious passion overtook deadline.

One outcome of the process of documentary photography is the creation of important visual records that provide tangible evidence of life. The extraordinary visual detail of photography shares compelling impressions of truth, allows viewers to occupy the position of the photographer, serves as an impartial and faithful witness to life's events, and freezes an instant of time in which places and events may be later studied and restudied.

Examples of early documentary photography include French photographer Maxime du Camp and his 1849–1850 work in the ancient Near East; British photographer Roger Fenton and his popular and publicly sold images of the last phases of the Crimean War in 1855; American Mathew Brady, who organized nearly 20 photographers to produce more than 10,000 negatives of the American Civil War between 1861 and 1865; and photographers such as Carleton Watkins, Timothy O'Sullivan, and William Henry Jackson, who used the unwieldy wet-plate process to document the unexplored Western territories following the American Civil War.

Narrative, documentary, and editorial photography has had a rich history. In 1868, Thomas Annan published *The Old Closes and Streets of Glasgow*, which documented the squalid conditions and dehumanizing effects of the slums in Glasgow, Scotland. In *Street Life in London* (1877), John Thomson captured the daily lives of London's street merchants and working class. American photographer Jacob Riis published books such as *The Children of the Poor* (1898) and *How the Other Half Lives* (1890), revealing the sordid living conditions of America's urban poor. Lewis Hine's photographs were a powerful pictorial critique of the destitution endured by laboring classes and immigrants in early twentieth-century America. The Farm Security Administration used photography in response to the social and economic devastation wrought by the American Depression in the 1930s. Through New York's Photo League (1930s to the 1950s), Aaron Siskind created *The Harlem Document* (1938–1940). Many photographers, such as W. Eugene Smith, David Seymour ("Chim"), and Robert Capa, published in mass-circulation picture magazines such as *LIFE* and *Look*, which were the main source of the documentary photography essay until the early 1970s. Werner Bischof, Dan Weiner, André Kertész, Leonard Freed, Donald McCullin, Gordon Parks, Marc Riboud, Ernst Haas, Bruce Davidson, Larry Burrows, Eddie Adams, Eugene Richards, Sebastião Salgado, and Milton Rogovin are only a few of the socially concerned practitioners of photography who are now considered twentieth-century icons.

Human tragedy and suffering has always been a prime subject for NDE. Some of the work of photographer Susan Meiselas focused on Nicaragua, where her political viewpoints were clearly evidenced. She has been working in this area of photography and was awarded a MacArthur fellowship (the "genius" grant) in 1992. Many NDE photographers find themselves taking sides on contentious issues, but that is not a core requirement of NDE. On the contrary, Jeff Wolin's book *Stone Country* shares an interesting story of how the stone used in many buildings in New York City was quarried. This book, with text by Scott Sanders, will serve as a historical reference for generations to come and is not plagued by tragedy, pain, and war.

DoubleTake magazine is a contemporary magazine that publishes pictorial essays featuring photographers who look closely at things they find in their worlds. Many of these photographers tackle the personal document: family, loved ones, and parenting, for example. The stories of their features are largely told through portraits. Many magazines also feature works-in-progress from photographers. For 15 years Jeff Mermelstein has photographed daily on the streets of New York where he lives. "I am not one who needs to travel to Afghanistan or Yugoslavia to make pictures, not that I would not want to do that, I just have not gotten bored with my home turf here in the city," he shares in the winter 1997 issue of *DoubleTake*.

Styles sometimes are easy to define, but often a photo essay will cross the line from photojournalism into NDE, void of social concerns and tragedy. The objective is to reveal intelligent and sensitive pictures with a capacity to look at the landscape as structure, environment, and a source of human pleasure and poetry. Examples of this can be found in the work of Owen Butler and of Philip Perkus.

Robert Frank and Henri Cartier-Bresson are two significant documentary photographers who do not consider themselves photojournalists. They produced two books with essentially the same title: Frank's *The Americans* and Bresson's *America in Passing*. The text of Frank's book, *The Americans*, was written by many authors including Jack Kerouac. This book has been reprinted a number of times over the last 50 years while Bresson's book was published in the U.S. in 1991. Frank's book was the first to extensively use photographs as documents that had a political edge and enormous lyrical grasp of the frame. Bresson's book is a wonderful collection of photographs of America where the genius of composition is apparent.

For 10 years, Magnum photographer Larry Towell worked on the Mennonites book project. Like many projects, this project was developed by the photographer, who later found support for his work after the project was well along. Because of new digital technology, photographers are liberated to work as they want to. This technology has provided independence for photographers and has freed them of the limitations found in the traditional publishing world. A single-edition book is now quite common. Photographers are the complete publisher, organizing Web sites, digital video, DVDs, and other outlets for their work.

The world of documentary photographers is readily visible online. Google the phrase "documentary photography" and a plethora of photographers' work is a click away, such as those

FIG. 11 Oh Say Can You See, New York Harbor. © Owen Butler 2005.

with the world-famous Magnum organization. Magnum Photos is a diverse photographic cooperative, owned by the photographers who are its members. Started with a powerful individual photographic vision, Magnum photographers have photographed the world, interpreting its peoples, events, issues, and personalities. Magnum has editorial offices located in New York, London, Paris, and Tokyo and provides photographs to the press, publishers, advertising, television, galleries, and museums around the world. Most Magnum photographers characterize themselves as documentary photographers.

Magnum and many other agencies house the work of photographers as well as some special collections by non-members. Magnum has a Web site: www.magnumphotos.com.

It is incredible to observe the number of photographers who have created projects that are a consequence of the upheavals in their countries. As the world changes, the voice of narrative documentary and editorial photography is no longer simply that of the white male voice, but rather is made up of the world's ethnicity including Abbas, Raymond Depardon, Philip Jones Griffiths, Josef Koudelka, Susan Meiselas, Martin Parr, Gilles Peress, and Eli Reed.

A wonderful new documentary style is now being produced and influenced by the new technology. It is a more conceptual NDE document and is easily found in the book *Twenty-Two Seconds in Chennai* by Frank Cost. This book captures a 22-second burst of picture-making that resulted in a 75-page-plus soft-cover book available at www.LULU.com. Each frame in this book is literally only what the camera was capable of seeing and not necessarily what the photographer was capable of seeing at the moment.

Easier access to new technology has resulted in a proliferation of book publishing and in the end, created a new voice for this type of work. If the work is invisible, it has no voice. ◉

Orb Photography

MICHAEL R. PERES
Rochester Institute of Technology

Attempts to photograph ghosts began as early as 1861, with a Boston photographer named William Mumler. He claimed that while he was taking a picture of himself in a chair, an unexpected second image appeared in the photograph. For a while this amazing phenomenon was accepted; suspicions arose when it was discovered that the images he produced were of people who were still alive. Mumler was accused of photographic fraud and died in poverty in 1884. His work was imitated by others during that time.

Although not common, during the 1960s a photographer claimed that he could capture images in his mind when using a Polaroid camera. He did this by holding the camera in his lap, aimed at himself, and after a long period of time and with a jerk, trip the shutter. He claimed the jerk was a result of the mental image being projected into the camera. He apparently convinced himself and many others of his powers, including an editor for a major news magazine. When challenged and asked to perform his phenomenon under controlled conditions, he failed completely after two days of attempts. After careful monitoring, he was observed using sleight of hand to trip the shutter. In spite of the photographer's failure and fraud he continued to convince others of his mental powers.

Spirit photography takes various forms, including the recording of invisible energy fields (auras) and personality projections (astral projections), psychographs (invisible handwriting), and even the alleged photographs of flying saucers. With the advent of electronic imaging new forms of spirit photography will undoubtedly emerge.

Today this type of photography has experienced a new following as a direct result of digital technology and the Internet, which provides forums and a high visibility for the photographic results. The photographic recording of what are referred to as orbs, as well as an increased interest in the paranormal is common. The word orb is a name for a round object, especially a sphere. In the world of the paranormal, orb photos are common and can easily be found on the Internet as mysterious balls of light in images. While there are genuine photographs of unexplained phenomena, real spirit photography has been debated since the medium was invented. The majority of orb photos are not paranormal, but rather images that result from the internal reflection of light on the camera lens. Orb photographs can also be a result of something being grossly out of focus in front of the lens. This occurs when the camera's flash bounces back from something reflective in front of the camera that is out of focus, becoming a large, white, ghostlike structure in the photograph. When this happens, it creates a round ball of brightness that is actually just an out-of-focus image. Many people often mistake these orbs for genuine evidence of ghosts. False orbs can also be created by bright lights in an area where the photo is being taken, by angles of light, and by many types of artificial lighting. Despite

(a)

(b)

FIG. 12 Photographs courtesy of Professor Andrew Davidhazy, School of Photographic Arts and Sciences, Rochester Institute of Technology, Rochester, New York.

the hypothesis that different colors of the orbs in photos represent what mood the ghost was in, the colors are actually non-focused images and represents the conditions present when the photos were taken.

FURTHER READING

Broecker, William, (editor), *International Center of Photography Encyclopedia of Photography*. New York: Crown Publishers, 1984.

Eisenbud, Jule. *The World of Ted Serios*. New York: William Morrow, 1967. ✇

Panoramic Photography[11]

ANDREW DAVIDHAZY

The term panoramic photograph defines pictures that include a large horizontal angle of view. It is not normally associated with photographs made with conventional cameras and wide-angle lenses unless the image is cropped at the top and bottom to increase the width-to-height aspect ratio. Many single-use or other film cameras have a panoramic setting that creates a mask at the film plane to create such a ratio.

Panoramic photographs can be produced in various ways. In the era of color slide film and slide projectors, sophisticated multiple-camera systems created separate pictures that were projected side by side, resulting in a large composite image with a wide angle of view. Another panoramic system makes use of an anamorphic lens usually associated with a motion-picture camera that compresses the horizontal dimension of the scene with another anamorphic lens on the projector. The second lens re-establishes the image on the screen with a small height and large width. This is commonly called wide-screen because it requires a screen that has a greater width than required for conventional motion pictures.

Still photographers have also made panoramic photographs by panning the camera, in this case to produce a set of over-lapping images that were combined into a single composite image, but this was a difficult and time-consuming process before digital photography. Panoramic photographs in the late 1980s and into the 1990s were made with panoramic cameras. A panoramic camera is a camera that is able to make a photograph with an aspect ratio greater than 1:3. Many cameras classified as panoramic cameras are simply conventional cameras fitted with a rectilinear wide-angle lens and an internal mask, which may indeed be the camera body itself. Typically these cameras do not exceed a horizontal angle of view much greater than 100 degrees. Their distinct advantage is their simplicity of operation.

On the other hand, to include greater angles of view, there are special cameras that expose scenes sequentially and are able to cover horizontal angles from about 150 to close to 360 degrees on stationary film, to over 360 degrees when the film is moved.

In each of these designs, the lens will scan the scene from side to side and expose film by projecting the image through a narrow slit in front of the film.

There were many variations of this theme. The first camera of this type was characterized by the very successful Panorama cameras manufactured by Eastman Kodak and, more recently, by the Widelux company. In these cameras, which have a limited angle of view, the film is held in a circular arc whose radius is the focal length of the lens. The lens is attached to a shaft whose axis runs through the rear nodal point of the taking lens. The lens is connected to the camera using a flexible light-tight baffle. During exposure the lens pivots about its rear nodal point, scanning the horizon from side to side while the image-forming light passes onto the film by way of a funnel-shaped fan with a slit near the film surface.

Under these conditions the lens produces a stationary image, and the exposure time is influenced by the rate at which the lens is scanned from one side to the other. Because of mechanical factors, these cameras can only cover an angle of about 150 degrees. They are, however, among the simplest of the true panoramic camera types.

A second design uses film that is held around the outside surface of a drum of radius equal to the lens focal length and within which the film supply and take-up spool are usually also stored. An outer drum, of 2× lens focal length radius, carries the lens and a light baffle that has a slit near the film surface and rotates around the inner drum. The lens has a mirror mounted in front of it to reverse image motion direction such that the image appears to stand still as far as the film is concerned. This design has never achieved any commercial success, but many amateur photographers have made prototypes that work quite successfully.

Another type of panoramic camera is the one based on a Cirkut camera, which was also made by Eastman Kodak and exemplified by such cameras as the Alpa Technorama, the Hulcherama, the Roundshot, and the Globoscope. In these designs the film and the lens both move. The lens rotates about its rear nodal point while a slit moves along a circle determined by the focal length of the lens. Simultaneously, film is transported past the slit at a speed that just matches the apparent velocity of the slit past the image, which actually is stationary. This technology is nothing more than an extension of the first type, but instead of having the film set in an arc about the lens as it pivots, the arc is built up behind the lens as the lens scans the scene. In this way, horizontal (or vertical, for that matter) angles of coverage exceeding 360 degrees are possible.

Cameras of this latter type in particular are often used for taking pictures of large groups of people. Because they are scanning cameras, the total time that it takes to make an exposure may be as long as a few seconds to more than 30 seconds, although the effective exposure time of each point in the picture may be as short as 1/10 second. Local exposure time is adjusted by varying the width of the exposing slit or the panning rate of the camera. In the case of a group shot, the subjects remain still during the exposure, as any movement leads to blurring and a compression or expansion-type distortion

[11]Originally published in the *Focal Encyclopedia of Photography*, 3rd Edition. Updated by M. Peres.

of a subject, depending on its direction of motion relative to the scanning direction of the camera. Double-exposure stunts are, however, possible, by one or two members located at the first extreme edge running behind the group, or around the camera, to the other edge and reaching it before the scanning shutter slit of the camera gets there.

Contemporary panoramic photography is accomplished using a digital camera and stitching software. There is an essay describing QTVR technology in the Contemporary issues section of this encyclopedia. ◎

Photojournalism

GUENTHER CARTWRIGHT
Rochester Institute of Technology

Most dictionaries define photojournalism as "Journalism in which the written word is subordinate to pictorial usage." In the third edition of this encyclopedia, Angus McDougall attributes the term photojournalism to F. L. Mott, the Dean of the University of Missouri-Columbia's Journalism School, in 1924. "Photojournalism is the visual reporting of news for publication in newspapers and magazine," he espoused. That definition is succinct but perhaps a bit too narrowly defined in this era. An article about photojournalism in *U.S. News & World Reports*[12] described the photojournalist as "a witness, an adventurer, and an interpreter of history." I have often heard it said, in a more poetic manner, that a photojournalist is a "writer with light."

Regardless of the exact wording of the definition, there has been a change in the perception of what photojournalism is. The term's roots were tied to F. L. Mott's 1924 definition of being related to news and reportage. At that time, the photojournalist was truly an observer or witness. Prior to World War II, most photojournalists were not college-educated; they became photojournalists by working in an apprentice system of first being a lab technician in a newspaper's darkroom and then being promoted to "shooter." In 1944, the G.I. Bill provided educational opportunities, which allowed aspiring photojournalists to attend college. This new breed of photojournalist was now equal to the writers and reporters of the publications for whom they photographed. Not only did this new breed of photojournalist study journalism and photography, but after the 1950s, photojournalists sought degree programs in political science, economics, English, anthropology, and history. Many of these photographers ultimately worked for high-level photography agencies throughout the world.

In 1946 the National Press Photographers Association (NPPA) was formed as a professional organization to provide educational support for its members. The mission statement

of the NPPA states: "The National Press Photographers Association is dedicated to the advancement of photojournalism, its creation, editing and distribution, in all news media. NPPA encourages photojournalists to reflect high standards of quality in their professional performance and in their personal code of ethics. NPPA vigorously promotes freedom of the press in all its forms. To this end, NPPA provides continuing educational programs and fraternalism without bias, as we support and acknowledge the best the profession has to offer."[13] The group has approximately 10,000 members worldwide.

Just as photojournalists have begun to pursue educational opportunities, the readers of publications have also become visually more sophisticated over time. As this confluence of visual literacy emerged, more and more photojournalists have become interpreters of what they've witnessed. Rather than answering the 5 "Ws" of journalism, they are raising more questions than they answer.

As an educator, I am very comfortable with this and it seems that the term photojournalism has much wider definition than ever before. Rather than just including news and reportage, photojournalism encompasses the visual areas of historical documentary, street photography, social documentary, and visual anthropology. It is perceived by some college photojournalism programs that the definition of photojournalism is seen as being too closely allied to news and reportage and they have created program curricula that are titled Visual Journalism or Visual Communication in an effort to be more inclusive.

Throughout its history, photojournalism has faced many challenges. I've been a photographer since the 1960s. I have seen one or both of these headlines at least once every decade: "Is Photojournalism Dead?" or "Photojournalism is Dead!" This question/pronouncement has created many heated debates in the field. It is 2006, and photojournalism is still actively practiced, but the field has evolved, and like any living organism, it is constantly adapting.

Since its origins, many challenges have confronted photojournalism, and a number of future challenges are on the horizon. The democratization of photography is one challenge: As cameras and techniques of photography became easier, amateurs have the ability and opportunity to witness and record history. The word amateur is not pejorative. One of the most famous visual documents of the 20th Century is the 8 mm Abraham Zapruder film of the assassination of President John F. Kennedy in 1963. Any number of amateur photographers can be found on the list of Pulitzer Prizes awarded for spot news.

In the 21st century, millions of people own cellular telephones that are equipped with built-in digital cameras—millions! These camera users may have access and opportunity that rivals the access often reserved for a bona fide members of the media. The quality of the resulting digital image from these cameras is questionable. Yet if the image is important enough

[12]*U.S. News & World Report*, October 6, 1997.

[13]National Press Photographers Association—Mission Statement 2006.

historically, the lack of quality can be overlooked. Consider the following three instances in the past where the lack of technical quality was clearly overshadowed by the importance of the event: Robert Capa's damaged negatives of the D-Day landing, Abraham Zapruder's 8 mm film of the Kennedy assassination, and Thomas Howard's surreptitious photograph of the electrocution of Ruth Snyder. The mobile telephone is ubiquitous and its image quality will only improve; it will certainly create more of the these situations.

Photography is paradoxical by nature. It can often mislead or lead to misinterpretation. When photography was invented in 1839, its sense of realism (although only black and white) challenged both the landscape and portrait painters of the day. Photographs presented illusions of truth. However, it was not long before the photography was utilized to share a person's reality. In 1858, Henry Peach Robinson presented a photograph titled "Fading Away" at an exhibition in England. The photograph shows a dying young girl attended to by her grief-stricken family. Victorian sensibility deemed this photograph offensive, as it intruded in on such a private moment. Robinson then revealed that this photograph was a composite made from five separate negatives. He was chastised for fooling people (see Ethical concerns in the 19th century).

The history of photography is replete with instances of darkroom manipulation, as in the Henry Peach Robinson episode or in the photo essay shot by W. Eugene Smith, for *LIFE* magazine, about Albert Schweitzer. To achieve better composition and drama in that essay, Smith combined two negatives to make one print.

In addition to darkroom-manipulated images, there have been many discoveries of images of wonderful "moments" that were proven, disappointingly, to be staged. The well-known photograph of Robert Doisneau's Paris street kiss is such an example. Some staged photographs from the past were the results of the cumbersome equipment used by photographers. After World War II, smaller cameras and faster film became more popular. As camera, lens, and film technology improved along with portable lighting systems, photojournalists could more easily take images the were both more immediate and more intimate.

The advent of digital photography in the mid-1980s created a host of new opportunities and problems. Since most professional digital single-lens-reflex (SLR) cameras are modeled on 35 mm film cameras, the ability to be immediate and intimate still exists. In addition, the digital SLR allows the photographer to immediately review the images directly on an LCD viewing screen built into the camera back. There is no film to process and the image is generated almost immediately. Photojournalists no longer have to worry about whether they got their shot. The digital camera allows for on-site editing of images and the transmission of images back to the publisher by using a laptop computer and mobile telephone.

The digital revolution has been quite bloodless, in an economic sense. Media publication companies are saving money by not having to purchase film, process film, or buy expensive processing equipment. The environment is helped because newspapers and other media companies are no longer disposing photographic chemicals.

Economically, since photographers no longer have to spend time processing film, more assignments can be covered per day. A photographer can now stay longer at a scene and get a deeper, more complete story. However, along with this new digital technology comes the ability to electronically alter, enhance, or manipulate an image almost undetectably. The original digital technology was so expensive and so complicated that only the largest publishing companies could afford the cost of the imaging systems, had the appropriate space for these large systems, and could hire the full-time technician required to operate this technology. By the mid-1980s computer hardware and software had decreased in size, cost, and complexity—so much so that most newspapers could easily afford to go digital, particularly in light of the overall cost-savings mentioned earlier. Colleges could afford these new systems and educate the new breed of digital photojournalists entering the field today. All daily metro newspapers in the United States have gone totally digital.

With this digital democratization comes some problems. Now more people have access to technology that can easily be used in unethical ways with a minimal risk of detection. The technology is here and so is the temptation! At the turn of the 21st century, debates and conversations about publication ethics have steadily grown and become very important. Newspapers and magazines cannot afford to have their readers question the veracity of the images being published. If you can't believe a photograph in news media, what's the point of having it? The NPPA has taken a lead role in the discussion of ethical issues facing publications today. Photojournalists need to be educated on the importance of this issue. NPPA holds an ethics seminar at every conference, and ethics is part of the curriculum of every reputable college photojournalism program.

Photojournalism has survived the challenge of television and cable news. The Internet provided an initial challenge, yet now, the Internet is being seen by some experts as the newspapers' salvation. The Internet allows newspapers to potentially reach younger readers who are not buying and reading a newspaper everyday. In addition, the Internet allows photojournalists to use multimedia technology and techniques to tell their stories. The business of publishing is adjusting and responding to a changing readership.

In all of this, I am reminded of my own experience with photojournalism. As an eight-year-old refugee from war-torn Germany, I remember coming across a copy of the book *The Family of Man*. Not only could I not read at that time, but I also could not understand English. Yet as I leafed through that old book, I understood what I was seeing, without words — only through pictures. One stood out from all of the rest. The photograph showed a scene of Africans from Bechuanaland, around what appeared to be a campfire. An elderly man was at the center of a crowd of young children. His face and hands, along with his body language, told me that he was speaking to these young children with great passion. The children were giving him their total attention. The photograph transformed

the elder into their story teller. They were all bathed in the light of the campfire, and that connected them. That light at the camp is a metaphor for photojournalism's future. People will always want to know the stories, and we will always be connected by the power of light, regardless of the technology.

FURTHER READING

Hughes, Jim. *W. Eugene Smith: Shadow and Substance: The Life and Work of an American Photographer*. McGraw-Hill, 1989.

Chapnick, Howard. *Truth Needs No Ally*. Columbia, MO: University of Missouri Press, 1994.

Kobré, Kenneth. *Photojournalism: The Professionals' Approach*. Woburn, MA: Focal Press, 2005.

Ignatieff, Michael. *Magnum Degrees*. Magnum/Phaidon, 2003. ◉

Postcard Photography[14]

KATHLEEN FRANCIS

Postcard photography often celebrates the unique aspects of tourist destinations; for some, postcards have become collectible. Postcards accentuate the positive attributes of locations. The picture postcard debuted in 1870, when a French stationer published a postcard to commemorate the visit of a popular military regiment to his city. Brisk sales inspired entrepreneurs in Germany and Austria to put out picture postcards on a commercial basis. By the 1880s, such specialty items as French postcards showing attractive women in suggestive outfits and alluring poses sold well and relatively openly in many countries, including the United States.

By October 1908, when *The Photo Miniature* devoted an entire issue to photographic postcards, Germany continued to be the center of postcard manufacturing. Germans reportedly had sent 1.5 million postcards in 1907. Continental Europe led the rest of the world in this "friendly communication among nations," as the magazine called it. The picture-postcard industry also flourished in Great Britain and the United States, where subject matter included, according to the magazine, "the whole range of human interests appropriate for all seasons and places with uses as widely varied as are human needs."

At that time, the magazine called postcard photography "a new field of pleasure and profit for the photographer." Even those with limited photographic facilities were encouraged to take photographs of special or local interest that commercial postcard makers might miss or overlook.

Today, postcard photography continues to be an area of opportunity for the enterprising photographer. Tourist areas that draw large crowds offer the best chance of selling the thousands of postcards necessary for a profitable line

of picture postcards. Businesses and organizations that use postcards to promote their products and services may hire a photographer to take an attention-getting photograph or to shepherd a chosen photograph through the production process that turns a picture into a postcard.

Just about any entity that needs to present its best side to the public could become a postcard photography customer — from political parties and individual campaigns to restaurants, hotels, motels, resorts, camps, amusement parks, art galleries, museums, athletic facilities, hospitals, universities, and sport teams and the complexes where they play.

Ideally, the client pays for the photographer's time plus expenses to make the picture postcard. Sometimes, the client provides the photograph to be used. By handling the postcard order, the photographer may qualify for a commission from the postcard manufacturer.

Today many art galleries announce the opening of shows using postcards, and although traditional printers can make postcards online, printers such as Modern Postcard offer some of the world's best quality, service, and prices for the discriminating photographer. ◉

Portrait Photography[15]

KATHLEEN FRANCIS

Portrait photography produces pictures that capture the personality of a subject by using effective lighting, backdrops, and poses. A portrait picture might be artistic, or it might be clinical, as part of a medical study. Frequently, portraits are commissioned for a special occasions such as weddings or school events. Portraits can serve many purposes, from usage on a personal Web site to display in the lobby of a business.

In early photographic portraiture, the camera obscura helped artists create mirror-likenesses of their subjects. Portrait studios became more common in Europe and the United States as photographic technologies improved: The emulsions of daguerreotypes and calotypes improved with increased sensitivities and shortened exposure times.

People initially preferred the daguerreotype's highly reflective surface, which captured more visible details when compared to the calotype's appearance. The calotype was, however, the photographic material chosen for famous portrait series made by David Octavius Hill and Robert Adamson in Scotland. These group portraits were initially photographed as reference guides for a large painting. Hill's calotypes used natural poses and effective light and have been described by scholars as some of the most successful early attempts at portrait photography.

Félix Nadar was the preeminent portrait photographer in Europe for the next 20 years. His studio in Paris photographed

[14]Originally published in the *Focal Encyclopedia of Photography*, 3rd Edition. Updated by M. Peres.

[15]Originally published in the *Focal Encyclopedia of Photography*, 3rd Edition. Updated by M. Peres.

FIG. 13 A postcard produced and mailed from Rochester, New York in 1913 during a flood of Main Street. Reproduced courtesy of the Jewish Community Center, Rochester, New York.

many prominent writers, artists, and musicians of the time. By the time cartes-de-visite became popular, portraits were small enough to be added to a person's calling card. Using standard glass negatives dropped the price of making portraits, and more people were able to purchase portraits of themselves.

The French photographer André Disdéri photographed many well-known personalities including Emperor Napoleon III. These portraits were displayed as huge editions. Disdéri

is credited with popularizing the use of studio props such as pillars, draperies, and items indicative of a subject's profession.

Portraits also served to aid political campaigns. The portrait of Lincoln reproduced here was taken on June 3, 1860, in Springfield, Illinois, by a Chicago photographer named Alexander Hesler. The sitting was arranged by the Republican National Committee. Earlier photographs—taken by Hesler

FIG. 14 D.O. Hill R.S.A. "Photographic Portraits" ca. 1843. Photograph by Hill & Adamson, salted paper print. Courtesy of the George Eastman House Collection, Rochester, New York.

FIG. 15 Mr. Nadar, Place de L'Opera, Paris 1890. Photographed by George Eastman. Gelatin silver print, Kodak #2 snapshot. Courtesy of George Eastman House Collection, Rochester, New York.

in 1857—showed Lincoln as unkempt, and the committee hired Hesler to make a new portrait. The 1857 image, one of the earliest known photographs of the future president, is often referred to as the "tousle-haired" Lincoln. Since this portrait was to be used as a model for engravers to produce campaign literature, the Republicans were afraid that that the tousle-haired Lincoln would seem too rustic and uncivilized compared to opponent Stephen A. Douglas.

Celebrity portraiture was popular in the early 1900s. Edward Steichen dramatized the sculptor Rodin and the playwright George Bernard Shaw; Alvin Langdon Coburn's portraits captured writer Henry James and poet W. B. Yeats. Many studios opened across the U.S. and advertised their services using print backing cards such as the example reproduced here.

Today, portrait photography is a huge business. Portrait studios are found virtually in every city worldwide. Sears, J.C. Penny, and many other department stories offer portrait packages with almost-real-time developing services, while high-end portrait work—which can be quite expensive— is still provided by exclusive portrait studios. Many excellent fine-art portrait photographers have become popular, including Arnold Newman, Yousuf Karsh, Richard Avedon, Philippe Halsman, Irving Penn, and Annie Leibovitz. 🌀

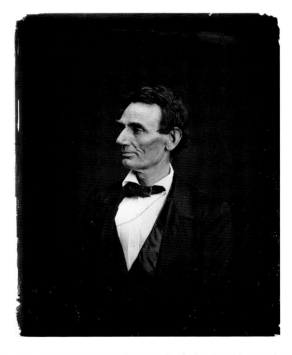

FIG. 16 Hesler's portrait photograph of Lincoln without a beard, Reproduced courtesy of the Special Collections, Bradley University, Peoria, Illinois, and Illinois State Historical Society.

FIG. 17 A portrait postcard from Utica, New York, 1899. Courtesy of Michael Peres.

FIG. 18 An example of contemporary portraiture. Courtesy of Michael Peres.

School Photography[16]

THOMAS GORMAN

Since the beginning of professional photography as a trade, one of the greatest photographic opportunities has been the photography of schoolchildren, which was originally done to provide the school with a pictorial history of its students and their activities. Photographs were often made by the local professional photographer and the prints were then sold to the school for use in their archives.

As photography became a part of everyday life, photographers recognized this work could be expanded to taking individual portraits and class pictures, which would then be sold to the students. This introduced the students, and their families, to the idea of having a professional portrait made for them at an early stage of life.

From the days of black-and-white photography, individual photographers worked for the local schools. School photography has grown into a major industry for specialized companies such as Jostens or Life Touch pictures on the east coast of the United States, who maintain their own photographers on contract. The photographs supplied in school photography now range from wallet-sized pictures to large, framed portraits. The work is now primarily done in color. The specialized companies have their own programs and

[16]Originally published in the *Focal Encyclopedia of Photography*, 3rd Edition. Updated by M. Peres.

FIG. 19 Saul Sidorsky's violin class, Passaic, New Jersey, ca. 1919. Image courtesy of Michael Peres.

marketing divisions to determine the offering best suiting their clients' needs. This often can lead to future visits to the school for special occasions.

With companies specializing in school photography, new opportunities for photographers have developed. School photography companies hire a number of photographers, usually under contract for each school season, to shoot for them. The photographers selected are either practicing professionals, using the jobs to fill in for slow times in their studios, or recent graduates having completed a recognized post-secondary education in photography. A self-taught photographer with a strong portfolio will also sometimes be considered. The locations are contracted by a sales division and scheduled for the photographer.

The photographer is responsible for setting up a portable studio at the school, with equipment usually provided by the company. The shooting of the portraits and class pictures will be done as previously contracted by the sales division. When completed, the digital photographs are sent to the photofinishing firm for developing and printing. The photographs are then forwarded back to the school for distribution or in some cases directly to the students or their families. Sometimes, the photographer will take the prints back and distribute them while trying to secure future portrait sittings for special occasions such as graduation.

Although the programs vary from company to company, they typically provide the student with a number of packages of different-sized prints to choose from. Such packages are predetermined by the photofinisher and based on the printing and finishing costs.

In a large school this work can be repetitive, as little time is allowed for taking each portrait. To photograph a large number of students, capturing the best possible portrait requires both the skills of proper camera use and the ability to manipulate the subject to the right pose quickly. A common background is selected to help reduce the length of time needed to take the portrait. Attention is also given to placing the lights, the posing chair, and the camera in fixed positions that are suitable for most subjects. Sufficient lighting allows the photographer to focus on the initial subject only. When the proper setup has been completed, the photographer will have no need to readjust the equipment during the shooting session. During the shoot, the photographer will reconfirm the focus and lighting, usually at the beginning of each class.

To vary the programs, while keeping the lights and posing chair in the same position, some school photographers make use of a special camera called a rear-projection camera, manufactured to insert a chosen background into the picture. This allows the student to choose a background from a preselected list. A slide of the desired background is inserted into

FIG. 20 A portrait of the 850 students of the French Road Elementary School of Brighton, New York, after being named the number-one school in the United States for raising more than $87,000 for the American Heart Association. © Michael Peres.

FIG. 21 A school portrait of the editor, 1978. Image courtesy of Michael Peres.

the camera before the photograph is taken, and it is photographed simultaneously with the student on the same frame of film. Once again, lights, posing chair, and camera remain in the same position. The set is designed to avoid the practice of having to come back to the school to re-shoot out-of-focus or poorly lit photographs.

In some rural locations, the local professional photographer maintains the school business and will do the selling as well. The photographer selects a photofinisher offering the packages that best suit the clients.

In either case, the competency of the photographers to provide acceptable portraits for the subjects determines their success in the trade. ◉

Snapshot Photography[17]

RICHARD ZAKIA, PH.D.

Snapshots are defined as casual pictures made with hand-held cameras by amateurs. Most of the billions of photographs made each year by other-than-professional photographers are

[17]Originally published in the *Focal Encyclopedia of Photography*, 3rd Edition. Updated by M. Peres.

snapshots. In the hands of artists, a snapshot style has developed that mimics such things as careless framing, harsh flash lighting, tilted horizons, and fuzziness. The term snapshot was coined in 1860 by Sir John Herschel, who saw the aiming and quick snapping of the camera shutter as analogous to the quick aim and snap of a gun trigger used in hunting. Although Herschel envisioned pictures being made quickly at the snap of the camera shutter as early as 1860, snapshot photography did not really come into existence for another 20 years. This was the result of increased film speeds and hand-held cameras, which made it possible to capture both the moment and the movement.

Not long after the beginning of photography, the snapshot's ability to capture the fleeting moment along with its often unplanned composition began to interest painters searching for new ways of expression. Some painters used photography to record fleeting expressions of their models and then used the photographs to create their paintings. Many of the paintings by Edgar Degas (1834–1917), such as his horseracing series and his ballerina series, suggest a snapshot vision. One of his paintings, *The Glass of Absinthe*, painted in 1876, shows a forlorn-looking couple sitting at a table in a brasserie, staring into space. The art historian H.W. Janson, in his book *History of Art*, wrote, "The design of this picture, at first glance, seems as unstudied as a snapshot . . ."

In 1888, George Eastman introduced the No. 1 Kodak camera, a light, portable camera priced at $25 and loaded with enough film for 100 exposures. Kodak marketed this camera with the slogan "You press the button, we do the rest." Customers returned the film to Rochester, New York for processing and printing. This innovation is seen as the beginning of the photofinishing and marketing industry, which now processes and prints billions of snapshots each year.

Snapshots democratized photography by making it simpler and more accessible to the masses as the years progressed. Taking pictures of friends, relatives, travel, and important events and rituals such as births, baptisms, bar mitzvahs, confirmations, graduations, and marriages provided a visual diary for families.

In the early 1900s, snapshots and those who took them began to be looked down upon by professional photographers and those who aspired to be art photographers because the composition and technical quality were, in their view, lacking. This did not deter the growing number of snapshot photographers, and with the advent of the 35 mm Leica camera, introduced in the United States in 1928 by Willard Morgan, snapshot photography took another leap forward. With his wife, Barbara, Morgan toured the country taking snapshots to promote the use of the Leica camera to both photojournalists and interested amateurs. Along with lecturing to camera clubs, he published a number of his snapshots in magazines to accompany articles on how to photograph with a 35 mm Leica camera. In 1932 he founded the "Circle of Confusion" in New York City, a camera club consisting of anyone interested in 35 mm snapshot photography. In 1943, as the first director of photography at the Museum of Modern Art in New York

FIG. 22 An example of snapshot from the Korean War, ca. 1951. Image courtesy of Michael Peres.

City, he arranged an extensive snapshot exhibition. Not only was it unprecedented for its time, but the exhibition was also one of the best attended and, as might be expected, received a fair amount of criticism.

Although snapshot photography was embraced by many, it was rejected by others. This attitude reversed when other serious photographers began to embrace it as a unique way of expression that was not simply mimicking painting and its associated compositional rules. Snapshots were immediate and unpretentious, capturing and freezing a moment in time. A number of photographers and painters worldwide began to use what later came to be called the snapshot aesthetic.

In the early 1900s, Alexander Rodchenko made images with unconventional viewpoints, tilted components, and unusual compositions. André Kertész began photographing informal, spontaneous, everyday human activities. Henri Cartier-Bresson's photographs, which captured the "decisive moment," influenced photographers like Bruce Davidson, who worked in a snapshot genre. Walker Evans began exploring both documentary and snapshot photography in the early 1930s. In

the 1950s, the Swiss-born photographer Robert Frank came to America and photographed various events with a snapshot style. His work was published in a book that was initially severely criticized, eventually becoming a treasured classic. *The Americans*, now a collectors' item, has been reprinted a number of times.

In the 1960s the snapshot aesthetic blossomed with the work of two magazine photographers, Gary Winogrand and Lee Friedlander. Both influenced other serious photographers with the unexplored possibilities inherent in snapshot styles. The movement was further advanced by the lectures and writings of John Szarkowski, then curator of photography at the Museum of Modern Art in New York City. Photographers continue to explore the snapshot aesthetic, giving photography a unique look that does not mimic other forms of imaging. These include Joel Meyerowitz, who began working in the 1970s; Nicholas Nixon; and Bruce Davidson, with his snapshot series of people riding the New York subway in the 1980s. Also in the 1980s, many photographers were playing with a soft-focus, fuzzy, early-snapshot look by using cheap cameras with cheap plastic lenses.

The Eastman Kodak company sponsors a major snapshot photography contest each year called KINSA (Kodak International Newspaper Snapshot Awards). The contest, which is sponsored by about 200 newspapers in the United States, Canada, and Mexico and coordinated by Kodak, began in 1934. Snapshots are solicited by newspapers. An estimated total of around half a million prints are submitted to the participating newspapers. Each newspaper has local judges rate the snapshots and then send their selections to Kodak. Kodak receives about 1200 snapshots from the participating newspapers. A panel of judges selects about 200 winners who receive various awards and are further honored by having their photographs on exhibition for one year in the "Journey Into Imagination Pavilion" presented by the Eastman Kodak Company at the Walt Disney World Epcot Center.

A similar journey began nearly 100 years ago when, in 1901, a seven-year-old French boy, Jacques Henri Lartigue, was given a camera by his father and began to take pictures. He was captivated by the experience and wrote in his diary that "Photography is a magic thing." And indeed it was, as his 70 years of snapshot photography reveals. "He photographed spirited games at his family's country house, excursions in his father's first automobiles, trips to racetracks and seaside resorts, elegant women strolling the Bois de Boulogne, his own honeymoon, and the ceaseless antics of his friends and relatives . . ." (Lartigue, Jacques, Henri, *Diary of a Century*).

In the Afterword of Lartigue's book, which is a select sampling of his personal visual diary, Richard Avedon wrote: "High-speed film was available since the turn of the century but for years it was only used in sports photography . . . as if there were some tacit agreement among photographers to remain within the provinces of painting in the hope of assuring their positions as artists. I think Jacques Henri Lartigue is the most deceptively simple and penetrating photographer in the short . . . embarrassing history of that so-called art. While his

FIG. 23 An example of the simple fun possible in snapshot photography. Image courtesy of Michael Peres.

predecessors and contemporaries were creating and serving traditions, he did what no photographer had done before or since. He photographed his own life. It was as if he knew instinctively and from the very beginning that the real secrets lay in small things. And it was a kind of wisdom — so much deeper than training and so often perverted by it — that was never lost. . . . He was an amateur . . . never burdened by ambition or the need to be a serious person."

The snapshot aesthetic so brilliantly pioneered and displayed in Lartigue's 70 years of photography continues today, and some museums, recognizing the importance of snapshot photography, have been collecting family albums. Just imagine for a moment how our view of the Second World War might change if we had access to all of the snapshots made by our military personnel at that time — or our view of the Great Depression if snapshots had been taken during the Farm Security Administration (FSA) by all the poor farmers and migrant workers who were photographed by photographers hired by the FSA.

Scholars from various disciplines now use snapshots and extend their research. They belong to such organizations as

The International Society for Visual Sociology, The International Visual Literacy Association, and the Society for Visual Anthropology. People with vision, like Jack Debes of the Eastman Kodak Company, realizing the importance of pictorial information back in the late 1960s, began a movement called "Visual Literacy" to encourage the education of students in reading pictures. Cameras and film were provided to students, who took snapshots of things that interested them and later discussed them in classroom settings. Students also learned how to take and organize a series of photographs to create a short narrative. Prepared photographs that formed a narrative were shuffled and given to students to rearrange, a way for them to learn how photographs relate to one another in a narrative form and for the teacher to observe students' visual thinking.

The profound importance of snapshots has not yet been fully realized. Snapshots are not only an honest visual record of events historical and contemporary, but also a quiet movement that has influenced all forms of image making including painting, motion pictures, and television. Snapshot photography has had not only a strong influence on documentary and fine-art photography, but has also been a source of a multimillion dollar industry—photofinishing and marketing. With billions of snapshots made each year using film and digital cameras, there is a great and continuing demand for processing and printing, and of course all the equipment needed for this activity, including mini-lab printing for both analog and digital output.

FURTHER READING

Coe, Brian and Paul Gates. *The Snapshot Photograph*. London: Ash and Grant, 1977.

Broecker, William (editor). *International Center of Photography Encyclopedia of Photography*. New York: Crown Publishers, 1984.

Green, Johnathan (editor). *The Snapshot*. Millerton, NY: Aperture, 1974.

Janson, H. W. *The History of Art*. Englewood Cliffs, NJ: Abrams, 1971.

Lartigue, Jacques Henri, *Diary of a Century*. New York: Penguin Books, 1970. ◉

Sports Photography[18]

KATHLEEN FRANCIS

Sports photography traditionally captures the action of the moment, preserving the athleticism of the subject, the determination, the all-out effort, or the unexpected defeat. A sports photograph may also may capture a facial expression or some

[18]Originally published in the *Focal Encyclopedia of Photography*, 3rd Edition. Updated by M. Peres.

FIG. 24 An example of sports photography. Image courtesy of Michael Peres.

body language that visually expresses player or spectator reaction.

Virtually any photograph taken during a sporting event, during the practices leading up to that event, or during the event's aftermath qualifies as a sports photograph. Virtually anyone who can aim a camera at a sports subject can take a sports picture. Knowledge of the particular sport greatly improves a photographer's chances of making good photographs of its action. So does knowledge of action and how the camera sees it.

Today the camera of choice for almost all amateur and professional sports photography is the DSLR camera. Improvements in digital technology enable sports photographers to use the long-focal-length lenses they need for certain events, such as race car driving, without giving up the sharpness they require for reproduction and enlargement. Using wireless technology, sports photographers around the world record events such as the Olympics and upload images in real time to major consumers of these images, such as *Sports Illustrated* and other publications and news agencies.

Choosing the right vantage point can evolve from following a sport or from reading books and magazines that suggest the camera positions and shutter speeds for various sports. Fast shutter speeds, such as 1/500 second, usually will freeze action; 1/1000 second will stop the action of runners' legs and arms.

For more interpretive action shots, a slower shutter speed combined with a technique called panning will capture a sharp image of a racing car, for instance, against an artfully blurred background. Zone focusing permits the photographer

to pre-focus on a portion of a soccer field or ice hockey rink, for example, in anticipation of the kind of sports actions that never truly can be predicted.

Professional sports photographers often wear more than one camera around their necks so that they can shoot more than one focal-length lens. Two cameras with the same lens can cover for each other and prevent missed opportunities. For hard-to-photograph events like downhill skiing, professional sports photographers augment telephoto coverage with cameras that can be positioned at critical points in the course and remotely tripped.

Sports photographers have been known to hang their cameras from the rafters and then get down to ground level with the help of kneepads. They have a way of getting to a sporting event early, photographing the early rounds, and catching the early hurdles when competitors bunch up. They catch the very start of action. When sports action gets confusing, they'll sometimes follow a single player instead of the ball or the puck.

Position may not be everything in sports photography, but it definitely can provide the winning edge. Pros know how to pick the best camera position for the particular sport and setting—and how to change that position to improve picture variety.

Amateur sports photographers should choose a seat away from any barriers, above the Plexiglas barrier at the ice rink, for instance. To improve camera position temporarily, amateur photographers might ask an usher politely for permission and then take a few shots. Photographs of practice sessions taken from close positions can augment pictures of the sporting event taken from greater distances with 180mm to 500mm lenses.

Although professional sports photographers enjoy using the best equipment available, they agree that long lenses and motor drives don't make great sports photographs. The people who use them do. They advise those who would like to turn pro someday to work their way up through community newspapers. ◉

Stock Photography

HENRY SCHLEICHKORN
Custom Medical Stock Photo

Stock photography is defined as business that represents photographers who offer their photography for licensing and reproduction. A stock photography business maintains a library of images, markets those images, performs picture research for prospective clients, negotiates the terms of the license with the client, prepares the agreement, takes a commission, and reports to the photographer. The future of stock photography is bright, offering more images that will be used in editorial media and commercial advertisements. Stock

images will be used in conjunction with ads on consumer packaging, Web sites and cell phones and just about everywhere. As technology continues to change, so will the demand for stock images.

Stock photography enables the copyright holder of images to grant or sell usage rights to the images. Photographers, illustrators, and stock photo agencies can sell and resell images as either rights-managed or royalty-free imagery.

Stock image libraries "stock," or collect, images to sell or license usage rights to image users. Most image buyers or users of stock photography are magazine and book publishers, graphic designers, and advertising agencies. Stock photos are also licensed for use in Web sites, movies, TV shows, annual reports, calendars, postcards, brochures, and newspapers. Similar agencies sell stock music, sound effects, and clip art.

In the earliest days of stock photography, a successful photographer had to know how to use complex medium-format, large-format, and 35mm cameras. Different subjects and lighting situations required certain films and processing combinations. Today just about anyone with a digital camera can be a stock photographer. Amateurs and hobbyists are creating near-professional looking pictures. What differentiates a successful stock photographer today is the quality of the images and the files produced as well as whether the pictures are part of a vast distribution network that allows a multitude of art buyers access to the images.

During and after the American Civil War (1861–1865) photographers Mathew Brady and Timothy H. O'Sullivan believed they could create photos of that war and then sell them to magazines and newspapers, as well as to consumers — as war souvenirs in the form of stereoscopes. Many historians have described this activity as early stock photography. At the time, the photomechanical process to reproduce pictures economically in newspapers was not invented yet, and because of the death and destruction captured in these battlefield photographs, the public had little interest at the time in buying pictures of the war.

In Philadelphia, Pennsylvania, a young man named H. Armstrong Roberts (1883–1947) realized he could create commercially viable "illustrative" photos in advance of selling them to the printing industry, which was flourishing in the wake of World War I. With experience gained while scriptwriting for movie studios in Edison, New Jersey, he borrowed motion-picture production techniques to use with still photography. He assembled a production crew of photo assistants, lighting technicians, and make-up artists and started to script and execute photo shoots. The images created could be licensed commercially because model releases were secured from every person photographed. Many in the industry believe that he started the first stock photo company, now known by the names robertstock.com and classicstock.com, which is the oldest stock photo company still in existence.

In 1935 German emigrant Otto Bettmann (1903–1998) came to New York City carrying a few trunks filled with photos, illustrations, books, and sheet music. He arrived in New York city during the Great Depression, just as editorial

FIG. 25 One of the earliest examples (ca. 1920) of a stock photograph that was set up and shot on speculation using a production of a "Group in Front of Tri-Motor Airplane." The fact that each person in the photo signed model releases makes this image commercially viable. © Classicstock. Photo by H. Armstrong Roberts, Philadelphia, Pennsylvania.

magazines with a journalistic appeal such as *Look* and *Life* were becoming popular. Because he was based in New York, editors used his resource of images and were willing to pay for the services Bettmann provided. He would research their requests and deliver the images within 24 hours.

As the stock photo industry grew throughout the 1970s and 1980s, stock photos had the reputation of consisting mainly of the reject shots of professional photographers: The best photos went to the paying client that had hired the photographer, while the "B" images filled the drawers of agencies in the form of 35 mm slides and medium- and large-format transparencies. Magazines and textbooks were the largest users of editorial stock photos; however, as travel became more widespread, stock photos were being used commercially. Many of these agencies were owned and operated by entrepreneurial photographers and/or husband and wife teams.

As the Internet became a reality in the early 1990s, many changes occurred within the stock photo industry. In the beginning, few items were sold over the Internet. Businessmen who knew nothing about artist's rights or complex photo licensing, however, saw the stock photo industry as an opportunity. Flowers, clothes, collectibles, even books could be ordered online, but still needed to be shipped. Digital pictures — which come under the category of intellectual property — were a kind of information that could easily and inexpensively be delivered over the Internet. As a business model, the Internet is even more attractive for stock photography when you consider that you can never sell out of your inventory, no matter how many units you sell. This caught the attention of big companies and investors, propelling the industry to a $1.5-billion international business.

Some analysts predict that by 2012 this figure will grow to $4 billion.

Between 1990 and 2005 more than 40 stock photo agencies were purchased by Microsoft Chairman Bill Gates' privately held digital media company, Corbis Images, and by the largest stock photo company, Getty Images. In 1995, the Bettmann Archive, one of the world's largest photo collections with more than 16 million images, was Corbis' first major acquisition. The third-largest stock photo agency is Jupiter Images, which has acquired at least 10 companies.

With the consolidation of general stock agencies, dozens of new companies began specializing in niche collections of stock photography, such as medical, science, minorities, gay and lesbian lifestyles, aviation, maps, panoramic, historical, sports, and celebrity homes.

There are several advantages of stock photography. The most obvious is that the image already exists. Image buyers can see, in advance, exactly what they are buying. The buyer usually has a choice of several images created by various photographers. The look, style, and feel of the photos are often different, which can lead to creative options for designing marketing materials. The buyer doesn't have to hire a photographer or models, seek out locations, or wait for images to be edited and delivered. Most stock photo agencies work closely with their photographers to shoot specific subjects or themes. Stock photo shoots by photographers are often shot on spec (speculation), meaning photographers do not get paid until someone contracts an image-usage license. However, some photographers can make many more times their day rate if they shoot the right stock photograph.

Commissions are paid to artists after the agency sells usage rights to their images. Commissions vary from one agency to another. Initially, rates were 50 percent to the agency and 50 percent to the photographer. However, because of higher costs of doing business, those commissions have changed dramatically. Some agencies offer as little as 10 percent of the gross sale to the photographer. The industry standard is between 30 percent and 50 percent to the photographer. Agencies have to earn the lion's share because of increases in advertising, salaries, taxes, technical support, hardware upgrades, and insurance.

Production companies have emerged as part of the stock photo industry, supplying large amounts of images to many agencies. They take care of everything required for the creation of stock images, including fees for models, locations, and photographers. When an agency sets up and pays for a stock photo shoot they can own all the images. This is referred to as wholly owned imagery. When agencies own their images they do not have to pay commissions, making those images more profitable.

The growth of the stock industry and digital photography helped pave the way for photographers to be stock photographers, shooting specifically for stock photography. A stock photograph is defined by its content and purpose, which is influenced by content, lighting, style, focus, and the overall quality of the image.

FIG. 26 This generic skyline photo can be used with travel brochures and magazine articles featuring Chicago or its lakefront. Image courtesy of ©Panoramic Images. Photo by New Moon, Chicago, Illinois.

Below are some suggestions for creating good stock photography:

1. Make sure that every recognizable person in the photo signs a model release. Use models of different ages. A good model release will state the images are to be used for stock photography purposes. Make sure the release you use does not grant royalties to the models. It is virtually impossible to track image usage once it is submitted to a royalty-free collection. Useful releases are often supplied by your favorite stock agency or can be found online.

Here is an example of an adult model release:

For consideration received, I hereby give (photographer's name), the absolute and irrevocable right and permission, with respect to the photographs that he has taken of me or in which I may be included with others:

To copyright the same in his own name or any other name that he may choose.

To use, re-use, publish and re-publish the same in whole or in part individually or in conjunction with other photographs, in any medium and for any purpose whatsoever, including but not limited to illustration, promotion, stock photography and advertising and trade.

To use my name in connection therewith if he so chooses.

I hereby release and discharge (photographer's name) from any and all claims and demands arising out of the use of the photographs, including any and all claims for libel.

This authorization and release shall also insure to the benefit of the legal representatives, licensees and assigns of (photographer's name) as well as the person for whom he took the photograph(s).

I am over the age of twenty-one. I have read the foregoing and fully understand the contents thereof

Subject Name
Subject Address
Witnessed by:

2. The more potential applications or captions that can be given to an image, the greater its potential for sales. With that in mind do not include trademarks. Trademarks such as the Olympic Rings, athletes, and torch; anything Disney; car emblems from Rolls Royce, Maserati, and Porsche; and professional sports teams and their insignias should be avoided unless property releases are secured, which is unlikely. Make sure models wear generic clothes without corporate labels and names. Props should be generic as well. Use good looking models whenever possible. Shoot horizontal and vertical versions. Shoot the largest digital sizes possible.
3. File size and image quality are extremely important factors to consider. Some agencies are currently offering 75- to 100-MB files. Industry leaders such as Getty and Corbis will dictate the standards of the industry. Whatever they do the industry will follow, or at least will try to follow.

There are four key business models in the stock photo industry today: rights-managed, royalty-free, subscription, and micro.

Rights-managed (RM) refers to a license with restrictions purchased by the user allowing a specific usage, such as a one-time use on the cover of a brochure. If the same client wants to add an additional usage they will need to purchase a license indicating additional use(s). At times a client wants to use an image exclusively. An RM image can be licensed exclusively or non-exclusively.

FIG. 27 Example of a contemporary stock image to illustrate healthcare and surgery without actually showing surgery. The models are ethnically diverse. © Custom Medical Stock Photo/ photo by Mike Fisher & Henry Schleichkorn Custom Medical Stock Photo, Chicago, Illinois.

Royalty-free (RF) means the user pays a one-time license fee to use the image without restrictions. The buyer can use the purchased image in several projects without acquiring additional rights. Exclusivity is not possible.

In the subscription model, clients pay a subscription fee for access to a preset number of downloads from a specific collection of royalty-free imagery.

Micro sites offer stock photos for as little as $1 to $5 each, depending on file size.

Trade Organizations

In the United States, the stock industry's trade organization is the Picture Archive Council of America (PACA). According to their Web site, www.stockindustry.org, their mission is "to foster and protect the interests of the picture archive community through advocacy, education, and communication." In Britain, the British Association of Picture Libraries and Agencies (BAPLA) works to raise the profile of the picture library industry and to promote greater understanding of its value and diversity. BAPLA works to promote good trading practices between libraries, their contributors, and their clients. The Coordination of European Picture Agencies Press Heritage (CEPIC), at www.cepic.org, represents more than 900 picture sources in Europe with members from 17 different European countries. The aim of CEPIC is to be an united voice for the picture library and agency associations of Europe in all matters pertaining to the photographic industry.

The Future of Stock Photography

Around the world, imagery still communicates better than words. Fortunately for photographers, there will always be a demand for high-quality, exceptional images. Areas for photographers to shoot stock include global concepts, medical, business, communication, and technology.

The future of the stock photo industry will be a return to quality imagery by great, well-paid artists creating rights-managed work, says Roger Ressmeyer, PACA's President and CEO of Science Faction Images.

The stock photo industry is growing. Global marketing and distribution as an industry will embrace the changes in technology, and stock photography will continue to thrive. ◎

Wedding Photography[19]

GEORGE SCHAUB

Wedding photography evolved from formal studio portraits of the bride, groom, and their families to what at times might seem like a major media event, involving teams of photographers, videographers, and their assistants. Although the degree of production and number of images made varies by region, religion, and the budget of the bride and groom, the use of highly portable equipment and self-contained flash and continuous light sources has made a more candid and personal approach possible.

Wedding photographers themselves range from highly stylized professionals who work out of their own studios (usually portrait studios) or as part of a stable of photographers in a larger studio operation, to so-called weekend warriors, people who come from all walks of life and use their hobby of photography as a way of making extra income. The training for wedding photographers is usually based on an apprenticeship program, with beginners assisting more-experienced photographers. More formalized training is also available through workshops, how-to books, and videotapes. In the United States, organizations such as the Professional Photographers of America (PPofA) help set standards and give regular classes and seminars on wedding photography.

Typical wedding equipment recently included a medium-format camera; a self-contained, camera-mounted, electronic-flash unit; a separate battery pack; a host of filters; perhaps a compendium matte box for special effects; and even a second stand-mounted flash to create better lighting effects. However, almost all wedding work is now being produced used high-end DSLR cameras. To this end, some manufacturers make cameras that are focused specifically to this market, such as FujiFilm's S3.

[19]Originally published in the *Focal Encyclopedia of Photography*, 3rd Edition. Updated by M. Peres.

FIG. 28 A typical wedding portrait. ©1992 Michael Peres.

The end result of wedding work is the wedding album and, more recently, the wedding video. The album contains a sprinkling of more formalized portraits combined with a chronological coverage of the day's events. In most cases, the album is a predetermined package with certain important shots, such as the cutting of the cake, the tossing of the bouquet, and formal portraits of the wedding party. The video follows basically the same script, though special effects and music may be added during editing. In addition, the video generally takes a more candid, cinema-vérité look at the event and may contain interviews, speeches, and other sound bites that bring the viewer a real sense of being present.

Although wedding photography and the wedding photographer are not always held in high regard, a true practitioner must be a photographic jack-of-all-trades. A typical wedding day includes elements of formalized portraiture, photojournalism, candid work, and still-life photography. The photographer must be a diplomat, friend, advisor, mediator, and technical expert, as well as on-the-spot repairperson and stylist. The pressure of getting the job done right is enormous — it is not an event that can be easily replayed for the camera.

Wedding photographers take part in a wide range of cultural, economic, and emotional experiences. Most of their clientele are in a highly charged state of mind, and the photographers share one of the most important days of their subjects' lives. As such, it can be a highly rewarding activity and a wonderful training and proving ground for other areas of the photographic profession. With the advent of digital technologies, the much-revered wedding proof book has evolved into a Web gallery where viewing can be accomplished using Internet browsers by all members of the wedding party almost immediately after the event. This feature has improved print sales for wedding photographers. ◉

DIGITAL PHOTOGRAPHY

FRANZISKA S. FREY, Ph.D., EDITOR
Rochester Institute of Technology

Digital, a Maturing Technology

FRANZISKA S. FREY, Ph.D.
Rochester Institute of Technology

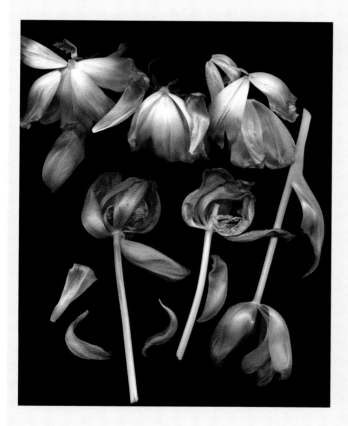

FIG. 1 Image courtesy of © Patti Russotti, School of Print Media, Rochester Institute of Technology, Rochester, New York.

When the first digital cameras were brought to the market in the early 1990s, no one could have foreseen how quickly digital would gain market share and displace film as the dominant technology used to take pictures. In many applications, the conversion is well underway, if not completed. The analog photographic industry as we know it is all but gone. Many companies from that era have ceased to exist, while some are still in the business but have completely changed the way they operate as well as the line of products and services they sell. It will still be a few more years until the shakeup of the industry and the players is complete and the marketplace stabilizes.

Many books and thousands of websites are now available for exploring various aspects of digital photography. It is important, however, to keep in mind that while the tools have changed, many of the underlying principles remain the same.

The life of the digital photographer in this age of constant change has forced many to operate in new and untested ways. While the days of the darkroom are more or less over, many new issues arise today when creating photographs. Every aspect of the process involves many choices—starting with the taking of a photograph and culminating in receiving a hard copy from a printer. Some of the new concerns that challenge photographers today include (but are not limited to): color profiles and color spaces, sharpening and other image-processing actions, monitors, file formats, metadata, and digital archiving. Knowledge and skill sets for photographers have changed quite dramatically: The controls that many master craftsman required in the darkroom have been replaced by the knowledge of computer codes, keyboard equivalents, or knowing someone who knows.

This section of the *Focal Encyclopedia of Photography* highlights some of the important new information that has arisen with the introduction of digital photography.

Lukas Rosenthaler's essay on digital archiving reminds us that digital has not only changed the way we take and print pictures, but it also mandates a different approach to storing and considering the preservation of the photograph, whether for a few months or for many decades.

One of the main changes brought by digital photography is the capture technology in the camera and the way images are formed in the sensors in a completely different way than with film. Romano Padeste describes the process of digital image formation in his essay entitled "Imaging Systems," which details the various camera sensors currently being built.

Part page photograph: Examples of the power of electronic photography. Images courtesy of © Patti Russotti, School of Print Media, Rochester Institute of Technology, Rochester, New York.

Michael Kriss also provides a short overview of materials used in the different sensors.

This industry has experienced explosive change, and Peter Adelstein summarizes the development of standards that are fundamental to the success of digital in the future. With the number of digital cameras on the market, comparing them can overwhelm even the experts. In his essay "Digital Camera Testing," Dietmar Wüller shares the importance of this process, which was once fully standardized in film. In his essay, Dietmar describes a few of the most important concerns regarding camera testing, providing fundamentals in determining what a digital camera can do.

One of the big changes with digital technology is that the photographer needs a complete understanding of electronic color systems to make the right workflow choices. Sabine Süsstrunk has authored a well-rounded evaluation of the fundamentals: image formation, colorimetry, color spaces, color encodings, and color image encodings, concluding with color management. While many of the digital color issues have been solved, considerable challenges still lie ahead. Jean-Pierre Van de Capelle's essay looks ahead to the future of color management.

Camera raw files create the possibility for working photographers to create as near to the subject recording as possible by enabling work to be done at the pixel level of the file, without the processing occurring in the camera. Greg Barnett describes advantages and challenges in working with camera raw files.

The long hours of working in the darkroom have given way to the era of endless hours spent in front of a computer screen. Image processing allows almost unlimited possibilities for reworking a photograph after the shooting. A basic understanding of image processing is important for making the right choices. Lukas Rosenthaler's essay provides an overview of image-processing techniques that can be used and their theoretical background.

The expression "An image is worth a thousand words" has meaning only if one can find the image. Metadata and using it properly opens up many new ways for photographers to organize and locate digital files of photographs. Simon Margulies describes some of these theories required in metadata in his essay.

The electronic darkroom has given artists many new tools to use in the creation of photographic art. Patti Russotti describes her scan-o-grams as photography without a camera. The richness of her imagery as well as her thoughts on other applications of digital photography provide yet another perspective from which to discuss the tools and methods used by photographers in the digital era.

A glossary of digital terminology has been maintained, principally from the 3rd Edition, in this section to provide a language for understanding and communicating about this new technology. ◉

Digital Archiving

LUKAS ROSENTHALER, PH.D.
University of Basel

Long-term archiving of photographic materials has always been a difficult task. The majority of photographic processes have not been designed with longevity in mind. In fact, photography is inherently unstable and *all* photographic materials will decay with time. While B & W photographs have a life expectancy of about 100 to 150 years (until the first effects of decaying become visible), color photography will usually begin its decay much faster. Even modern traditional photographic materials, which are chemically more stable, will decay with time. The decay rate can vary a lot and is dependent mainly on storage conditions, but also will be affected by the materials used, processing methods, handling, and so forth.

Since many objects in archives are unique artifacts that are irrecoverable in case of damage or total loss, each time they are handled poses great risks for damage or total loss. Often, the handling is also impractical and cumbersome. Therefore, many photographs are being digitized. In general, the digitized object has lost all "materiality;" it becomes an immaterial representation of part of the original object. In order to use photography again as a well-suited example, a digitized photograph can capture only the visual elements of the original content of the photograph, whereas most aspects of the material such as physical properties (thickness, surface properties, smell, and so forth) will generally be lost.

Most digitization projects have been launched or are conceived without long-term archiving in mind. These projects are started to improve access to the assets through databases and the Internet. But as soon as the first digital data arrives, the question of archiving arises: The digitization process is slow, expensive, and cumbersome and therefore will usually not be repeated in foreseeable time. As a consequence, anybody involved in digitization processes is suddenly facing the problem of long-term archiving of digital data.

To complicate the situation, most photographs created today are "born digital," that is, they are digital in origin. And not only photographs, but also motion pictures, computer animations, and videos using modern technology result in "originals" of digital nature. This fact will increase the pressure to find solutions for digital long-term preservation very soon.

From our daily experience, digital data seems to be very volatile and unstable. Everybody working with computers of any scale has had the bad experience of data loss: a word-processor document becomes unreadable, an external storage medium cannot be accessed anymore, etc. It looks like "long-term archival" and "digital" are diametrically opposed concepts. However, the very properties of digital data offer the possibility of an unlimited storage time.

Digital Data and Information

In a broad sense, digital data can be defined as anything recorded using a symbol-based code on a medium. Such a code uses a finite set, S, of Symbols—for example the Latin alphabet, Egyptian hieroglyphics, etc.

$$S = \{s_1, s_2, \ldots, s_n\}, n \geqslant 2$$

If $n = 2$ and thus the code uses only two symbols, it would be called a *binary code*. Binary codes are the simplest codes; they can be implemented easily by computing machinery (e.g., $S=\{0,1\}$, $S=\{\text{true, false}\}$, $S=\{+5V, -5V\}$ or $S=\{\uparrow, \downarrow\}$).

Digitization

Most digital data is the result of the conversion of an analog physical signal, which may vary in time, space and other properties. For example, a color movie camera records the amount of light that falls onto a light sensor as a function of time, location within the boundaries of the sensor, and frequency (color) of the light. The digitization process converts such an analog signal into a series of symbols allowed by the code.

$$F(x,y,z,t, \ldots) \rightarrow s_i, s_j, s_k, \ldots \in S$$

This process involves two distinct parts:

1. Sampling, or Rasterization—The physical properties such as time, space, etc. have to be measured at well-defined, discrete points. In the time-domain this process is usually called sampling, and the sampling frequency defines how much time elapses between two measurements. In space, the term rasterization is usually used, and the distance between two points—where the physical property is measured—gives the resolution. However, in the case of color imaging, for example, the frequency of the light is also sampled. Usually only three samples are taken (corresponding to red, green, and blue), but there are multispectral cameras and scanners that use many more sampling points (see, for example, A. Ribes, H. Brettel, F. Schmitt, H. Liang, J. Cupitt, and D. Saunders, *Color and Spectral Imaging With the Crisatel Acquisition System*, PICS03 The Digital Photography Conference (2003)). It is evident that the quality of the sampled signal directly correlates to the sampling frequency: The higher the sampling frequency, the better the quality. The minimal sampling frequency or resolution is given by the Nyquist frequency which is defined as two times the highest frequency that occurs in the signal. If the sampling frequency is below this limit, irreversible artifacts such as distortions or moiré patterns may occur. A well-known example can be seen in many western movies: the wheels of a stage coach suddenly seem to turn backwards (for example, during a chase) if the frequency of the passing spokes of the wheel is higher than the sampling frequency of the film (24 images/second).

2. Quantization—The analog measurements taken at the sampling points have to be converted into a numeric value in a symbolic representation using a finite number of symbols. Therefore the accuracy of such a conversion is always limited. Most often modern computing machinery uses a binary code with the number of symbols a multiple of 8. The number of different values that can be represented

is given by the number of binary digits (called bits) raised to the power of 2 ($n = 8 \rightarrow 256$ levels, $n = 12 \rightarrow 4096$ levels, $n = 16 \rightarrow 65536$ levels). A quantization using n bits is said to have a bit depth of n.

Thus, the result of a digitization process is a series of symbols that represent the original analog signal. In theory, the accuracy of such a symbolic representation is not limited and can be increased by increasing the sampling frequency and the bit depths. However, the size of the resulting digital code will also grow accordingly. In practice, the mechanical, electronic, and other properties of the digitization process will limit the achievable accuracy.

Media convergence

Digital data is able to represent most media types, whether text, sound, image, moving image, or new media types such as hypertext or relational databases, in a unified way. In the end, everything is just a bit stream.

Recording of digital codes

In practice, there is another obstacle: A digital code is only an idealistic, logical construct: in any case, the symbols of a code have to be physically represented by some physical property that in its essence always has an analog nature. (This statement is not true in the world of quantum physics: in this world there are physical properties like the spin of an electron which do have two distinct values: up or down. From this point of view, the spin of an electron might represent a bit in a true digital way.) An example of such properties is the color of the ink that makes the shape of the symbols written on a piece of paper visible; it may consist of a change of the direction of a magnetic field on the surface of a ferromagnetic material or it may consist of a pit imprinted on the reflective layer of a compact disc. Thus, every recording process that makes a digital code "permanent" leaves analog physical marks on the recording medium. These marks represent the symbols of the digital code.

To allow the data to be read after it has been written, these analog marks have to be identified and the appropriate digital symbols have to be assigned to the marks. This is accomplished by reading the analog signals and applying a decision process. In case of a binary code, these decisions may be solved by a simple measurement of the data's threshold of the physical signal, but often, signal processing and more complex procedures such as shape recognition are required. Thus there is no such thing as a "digital recording" of data. All "digital" recordings are analog in nature, and during the read process the digital code is generated "on the fly." (Also within a computer the same thresholding takes place. Each 0 and 1 is represented by electrical current or voltage, and somewhere there must be defined a "tipping" point which distinguishes in between the two states.) Binary codes, which require only two distinct symbols or states, are the most common encodings; there are many examples of encodings using more symbols—the most prominent being written text.

Decoding of digital codes

Decoding a digital code is the process of extracting meaningful information from a sequence of symbols. For a written text to be read and understood, not only the symbols—the characters or signs—have to be identified, but also the language—syntax and semantics—in which the text has been written must be known. Only the famous Rosetta stone, which contains the same text in two languages (Egyptian and Greek), using three scripts (hieroglyphic, demotic, and Greek), finally allowed us to read and understand hieroglyphic scripts. Every digital code has explicit or implicit syntactic and semantic rules, which must be known for proper interpretation of the code.

The meaning of a symbol often depends on its position within the sequence of symbols. Frequently symbols are combined in groups to form new symbols (commonly known as "words") which themselves are combined into higher units ("sentences"). Computers, which use binary codes, typically use words with a size of 8, 16, 32, and 64 bits. The rules, which define the syntax and the semantics of a digital code, are usually known as the file format. The knowledge of the file format is therefore essential for reading digital data. Explicit knowledge is given by open file formats, where a detailed and complete description of the syntax and semantics is available. Such a description may be given by a textual description in plain English (or any other common language) or by the (commented, one hopes) source of a computer program, which reads the data. For proprietary file formats, no such description is available. At most, a binary program or library is available for interpreting the digital code of proprietary file formats.

Thus, reading and understanding a digital code requires two distinct steps:

1. The file format has to be identified.
2. The appropriate syntactic and semantic rules of the file format have to be applied to interpret the digital code.

If a data file is identified as being a TIFF image file, but the specification of the TIFF format is not known, the image represented by the data cannot be extracted. Therefore, if the semantic system of a digital code cannot be identified or is not known, the information contained in the digital data cannot be extracted.

This leads to the following prerequisites for retrieving digital data:

1. The physical property used to create the marks has to be known. For current media types the physical property used to create the marks is usually known. We know that a floppy disk has magnetic marks and that a compact disc has optically detectable marks. However, future digital archeologists might have problems determining which physical property has been used to create the marks, especially for new, emerging recording technologies.
2. The physical marks on the medium must be detectable and convertible into symbols. If, as a result of damage and aging, this is no longer possible, the medium has to be considered "destroyed" and unreadable.

3. The syntactic and semantic system (file format) has to be identified and known.

If any of these tasks cannot be accomplished, the digital data will no longer be readable and the recorded information is lost.

Redundancy, lossless compression, and error correction codes

Claude Shannon's fundamental work about information theory "A mathematical theory of communication" (Claude E. Shannon, A mathematical theory of communication, *Bell System Technical Journal* (1948).) contains two important statements, given here in a simplified form:

1. Any code where the probability of occurrence is not the same for all symbols contains redundancy. In such a case it is possible to find a new code, which minimizes redundancy.
2. If a communication path introduces errors into the transmitted symbols, a new code can be found that allows correcting for these errors.

The first statement addresses the possibility of lossless compression, whereas the second statement deals with the possibilities of error correction codes. Shannon's theory shows that there is a tradeoff between efficiency (lossless compression) on one hand and error correction (redundancy) on the other hand. Many codes, such as written language, contain a lot of redundancy and are therefore quite fault-tolerant. For digital computer systems, however, a high efficiency is required and therefore compression techniques are often used.

It is interesting to note that most computer storage devices use some redundancy internally to gain error-correction capability. In fact, disk drives, optical drives, and magnetic tape drives would not work without internal error correction. The conversion of the analog physical signal into distinct symbols has a non-negligible probability of being wrong. Even with error correction, a typical modern hard disk has a non-zero probability of error: statistically 1 out of 10^{14} bits is wrong (this value is taken from the data sheet of a major hard-disk manufacturer for a 400 GB IDE hard-disk.). These errors are called non-recoverable read errors. This results statistically in one corrupted file each 25th time a 400 GB hard disk is copied.

Checksums

Checksums are the digital equivalent of human fingerprints. For a given sequence of digital symbols (such as a bit stream or a data file), the ideal checksum algorithm calculates a unique new sequence of symbols, which usually is much shorter than the original sequence. However, such ideal algorithms do not exist. In practice, the probability that two files that differ will have the same checksum is negligible. Many checksum algorithms are available that produce checksums of different lengths. The most common checksum types are given in the following table, including the resulting checksums for the ASCII-coded text "*To be, or not to be: that is the question*":

Checksum-Algorithm	Checksum
MD5	eaf606c87569b2f97e230e792049833e
SHA-1	71d7726d2db38295ddea57c5dccd3be388fc0ab5
RIPEMD-160	c5fd0db228230b0f0813ace8376150527bf24588
WHIRLPOOL	ca4685900bbc481f3d8a1c71b17512aa4c62b4fb
	da19df8969da9052a2c54ea2e7073ba524183890
	8cbc865a0d4ac6cc74e284f12f90f4dc90d9864d9
	4fdd900

Checksums are therefore a ideal instrument for checking whether two digital files are identical: If both files have the same checksum, they must be identical.

Properties of digital data

From the preceding section, "Digital Data and Information," the following properties of digital data can be deduced:

Loss of the notion of an "original"

For digital data, the notion of an original is meaningless. Digital data can be copied without any loss by reproducing the same sequence of symbols from the "original" sequence. The two copies will be indistinguishable from each other and therefore it is not possible to determine which one is the "original." However, since the physical representation of a digital code always has an analog nature that may result in errors, the digital copy process is only completed if the two copies have been *verified* to be *identical* either by a symbolwise (or, in case of binary data, bitwise) comparison or by using checksums.

Therefore, digital data can be copied without limits and there will be no generational loss.

Independence of the recording medium

Digital data is independent of the medium it is recorded on as long as the symbols can be deciphered. For example, a binary computer file representing an image using the JPEG format could be engraved into a stone — it would be not very handy to work with, but nevertheless feasible. Thus, digital data can be copied from one medium to any other medium without loss.

Nullification of space

Digital data can be transported through space with the speed of light without the need for moving atoms or matter. This property allows digital data to be telecopied without loss at the speed of light.

Sources of data loss

To understand the problems of long-term archiving of digital data, the possible sources of data loss have to be assessed:

1. **Failure in reading the bits**

 If the symbols of the code can no longer be identified, the recorded data is lost. There are several causes for the

inability to identify the recorded symbols (to "read the bits"):

a. **Physical damage to the medium**

The physical recording marks can no longer be read because of a damaged medium (aging, rough handling of the medium, defects, etc.).

b. **No more reading device available**

The medium cannot be read because the device needed is no longer available. For example, tape drives to read DLTI magnetic tapes are no longer commercially available.

c. **Human error**

The data recorded on the medium has been erased by human error, the medium has been mislabeled, or the data that was supposed to be recorded was never written to it.

Most often, the physical lifetime of a recording medium is longer than the lifespan of a specific recording system. Therefore, the aging of the recording media, if it is properly stored, is usually not the limiting factor. For example, according to John W.C. Van Bogart, magnetic media (tapes) have a lifetime of about 30 or more years (John W.C. Van Bogart, "Magnetic Tape Storage and Handling", National Media Laboratory (1995)). However, the lifetime of the recording system as a whole depends on the availability of support for the necessary hardware and software by the manufacturer(s). This lifespan can be quite short (3 to 10 years) and is usually the limiting factor for the length of life of recorded digital data on one medium.

2. **Failure in reading the file format**

There are several reasons why a file format cannot be read:

a. **File format identification**

If there is no metadata to indicate which file format has been used to write the data, it may be very difficult to identify the file format. There are many thousands of file formats in use (see, for example PNDesign, "Data formats, file extensions database", at http://extensions.pndesign.cz). Some of the most common formats can be easily identified by the so-called "magic number," which consists of the first 4 or 8 bytes of the file. However for all other formats the identification may be very difficult.

b. **File format specification lost**

If the file format can be identified, the next obstacle is to find software that can read and interpret this format. Either there is still usable software available that is able to read the data, or new software has to be written to read the format. The former is often hard to get; the latter requires that the full specification of the format is available to the programmer. Therefore, proprietary formats — where the format specification is not available — are usually not suitable for long-term archival.

3. **Losing the metadata**

Most digital data files are meaningless if not accompanied by describing metadata. A collection of 10000 unknown compact discs labeled "00001" to "10000," with each compact disc containing 50 files named "000.dat" to "049.dat" is

Table of common image file formats with "magic number"

File type	Typical Extension	Hex digits xx = variable	ASCII digits
GIF format	.gif	47 49 46 38	GIF8
FITS format	.fits	53 49 4d 50 4c 45	SIMPLE
Bitmap format	.bmp	42 4d	BM
Graphics Kernel System	.gks	47 4b 53 4d	GKSM
IRIS rgb format	.rgb	01 da	..
ITC (CMU WM) format	.itc	f1 00 40 bb
JPEG File Interchange Format	.jpg	ff d8 ff e0
NIFF (Navy TIFF)	.nif	49 49 4e 31	IIN1
PM format	.pm	56 49 45 57	VIEW
PNG format	.png	89 50 4e 47	.PNG
Postscript format	.[e]ps	25 21	%!
Sun Rasterfile	.ras	59 a6 6a 95	Y.j.
Targa format	.tga	xx xx xx	. . .
TIFF format (Motorola—big endian)	.tif	4d 4d 00 2a	MM.*
TIFF format (Intel—little endian)	.tif	49 49 2a 00	II*.
X11 Bitmap format	.xbm	xx xx	
XCF Gimp file structure	.xcf	67 69 6d 70 20 78 63 66 20 76	gimp xcf
Xfig format	.fig	23 46 49 47	#FIG
XPM format	.xpm	2f 2a 20 58 50 4d 20 2a 2f	/* XPM */

almost worthless if no more information is available. The metadata can be as simple as a human-readable, meaningful filename and a meaningful labeling of the data carriers, or it can be a complex, XML-based metadata scheme. It is important that some metadata be available. The best praxis is to include some metadata in the data file itself. Many data formats (such as TIFF image files) allow the adding of metadata into the file header, which can be extracted automatically for efficient processing.

As a consequence, there are two basic problems regarding the longevity of digital data:

1. *Aging or damage of the media on which the digital data is recorded*

2. *Obsolescence of hardware, software, and file formats.* The rapid development of computer technology results in a system lifetime (hardware and software) of often fewer

than five years. If the data formats are chosen carefully, their lifetimes can last 10 or more years.

Methods of Long-term Archiving of Digital Data

Kenneth Thibodeau, director of the "Electronic Records Archives Program" at the National Archives and Records Administration (NARA), identifies more than a dozen different methods for long-term archival of digital data (Kennith Thibodeau, *Overview of Technological Approaches to Digital Preservation and Challenges in Coming Years*, Conference Proceedings: The State of Digital Preservation: An International Perspective (2002). These can be grouped into five basic methods:

1) Nothing
 Do nothing—future digital archeologists will do the work for you.
2) Computer museums
 Archive the whole system (media, peripherals, and computers—including all software) in working condition.
3) Emulation
 Emulation and virtualization of obsolete systems on up-to-date computers allows obsolete software to run on modern computers.
4) Migration
 Copy (and convert to current, up-to-date format if necessary) the data onto a new medium if the previous medium starts aging or the format is becoming obsolete.
5) Permanent media
 Record the digital data on a medium with very high longevity, either using a self-describing format or preserving the syntactical and semantic information (for example, as metadata).

All of these methods have advantages and drawbacks, but it seems that the first method—relying on the ability of future digital archeologists—is still quite prevalent, despite its obvious drawbacks.

Computer museum: archiving media, hardware and software

A way to preserve not only the media, but also the hardware and software, seems to be a palpable solution to the problem of long-term archival of digital data. However, it is very difficult to maintain complex computing machinery in operable condition. Not only will the media age, but other components of the computers and their peripherals will also not be stable. In addition, with the equipment getting older, finding spare parts will become more and more difficult—as well as finding technicians who still are able to repair old technology. Therefore, while it is important to preserve computing machinery for digital archeology, it is not a generally advisable way to achieve longevity for digital data.

Emulation

Software emulation creates a software environment that allows computer programs to run on a different platform (computer architecture and/or operating system) than the one they have originally been written for. Thus, writing an emulator for an old, obsolete computer system allows the old programs to run on a new computer. With the help of the emulator, file formats used on the old system can still be read on a new system. Emulation has the following problems with regards to long-term archival of digital data:

- Since the emulation usually is not able to emulate the peripheral devices such as floppy drives and magnetic tape drives, the data files have to be migrated to be readable by the host system of the emulation.
- The emulation itself will have to be preserved. This may be achieved by migrating it to new hardware and software (basically rewriting it for every new generation of computers) or using a nested concept of hierarchical emulations (for example, WordStar, a very successful word processor for the CP/M operating system developed in 1978, runs on a CP/M emulation, which runs on an OS-9 emulation which runs on a Windows XP PC). Raymond Lorie proposed a "Universal Virtual Computer" to facilitate the migration of emulators (R.A. Lorie, *Long-Term Preservation of Complex Processes*, Proceedings of the IS\&T Archiving Conference (2005).

Because of the problems that emulation poses in general, emulation may be a solution only for cases in which preserving the computer programs themselves is essential.

Migration

Migration operates on the principle that digital data can be copied without loss. There are two levels of migration:

1. Migration of the bit stream
 In this case, only the data carrier is exchanged, by copying the digital data from one generation of storage medium to the next. If the new medium has a different storage capacity, some repackaging of the data files is required. In general, the copy process is only completed if a bitwise comparison of the data files showed no errors.
2. Format migration
 In this case, not only the data carriers are exchanged, but also the format of the digital data is changed (for example, from uncompressed TIFF to uncompressed JPEG2000). Such a migration step is quite difficult for two reasons:
 a. It has to be guaranteed that no data loss occurs with the format conversion (for example, no lossy compression).
 b. The proof that the copy process succeeded is more difficult. The file in the new format has to be converted back to the old format and then compared with the "original" file. This comparison must be made on a logical level (for example, comparing pixel values in case of images) and not on a bitwise basis of the resulting files. The reason is that the structure of the files may differ, even if they represent exactly the same content

(two TIFF files may differ on a bit level, for example, but represent identical images with identical information content). This is because there are often equally valid variants of common file formats.

With current media, a bit-stream migration is necessary about every five years. Format conversions will be necessary only if a format becomes obsolete; that is, if new software no longer supports the format. However, a format conversion may make sense if there is a new format that has distinct advantages.

Permanent medium

Digital data can be recorded on a permanent medium, which has a high intrinsic longevity. However, the data must be recorded in a way that is self-explanatory and format-independent. In addition, reading back the data must not depend on specialized hardware, which will become obsolete in a short time.

Conclusion

At the moment, for most cases the longevity of digital data can be best achieved by implementing a migration model based on the following rules:

1. Redundancy
 Data must be kept with a high level of redundancy. At least three copies on a minimum of two different types of storage media (such as two copies on hard disk and one copy on magnetic tape) should be kept at geographically different locations.
2. Checksums
 For all data files, checksums should be calculated and archived with the data files. This allows for checking data files at any time for aging-related changes or errors.
3. Proofreading
 Every 12 to 24 months, the data should be proofread and the checksums compared. If errors are detected, a migration should be launched immediately.
4. Migration
 Migrations have to be planned in advance, including financing. A bit stream migration is necessary about every 5 years. A format migration is advised if a new file format becomes standard and the conversion can be done without loss of data.
5. Documentation
 Every step has to be documented in detail and all media must be labeled properly.

By following these rules, you may preserve digital data indefinitely. However, constant care is required. If this care is not possible for a certain length of time, the data will be lost, and only digital archaeology may possibly recover part of the data. ◉

Imaging Systems

ROMANO PADESTE
SINAR AG

Scanner Systems
Tri-linear arrays

Scanner systems were the first systems introduced to professional digital photography that were able to achieve the high number of pixels required for high-end applications. Similar to desktop scanners, these camera systems consist of a linear array sensor and a motor drive. During the capturing of an image, a linear array sensor is moved step-by-step across the entire image area of the camera, thus capturing the image line by line. The sensor is equipped with three lines of pixels, each of which is covered with a red, green, or blue filter, allowing the capture of a color image in a single pass.

The undisputed advantage of a scanning system is the ability to cover a very large image area at a low cost when building the imaging device. The image area covered by a typical scanning system would be comparable to the image

FIG. 2 Tri-linear arrays.

area of a 4 × 5-inch film. This makes this technology particularly attractive for studios equipped with 4 × 5-inch view cameras. In this application, this type of sensor allows for use of the same camera for both analog and digital applications. As a consequence of the relatively large pixel pitch of these systems, no special lenses are required.

It is obvious that this technique may only be used for the photography of stationary subjects and is not suited for moving objects. Any movement of the subject or the camera during the capturing process has to be avoided or image recording will not be organized properly. Hence, sturdy studio stands are a must for this technology. Additional disadvantages of scanning systems include the relatively long times required for capturing an image. Special lights are required when using this technology—usually HMI lights that maintain a constant level of brightness during the capturing process. This is to avoid capturing different exposure during the scanning as the sensor travels across the scene. Regular, AC-powered tungsten or halogen light sources change their brightness several times per minute and would therefore cause brighter and darker lines across the image. The additional expense for these types of lights might be a factor and minimize the advantage of the lower cost for scanning camera systems when compared to large-format, area-array systems.

In the early years of digital photography in the high-end advertising studios, scanner systems were very popular and successful. But with the introduction of large-format, area-array devices their importance has decreased.

One-shot Area Array Systems
One-shot/one-area array sensor with Bayer pattern

Most of today's commonly used digital cameras are equipped with a single area array sensor with red, green, or blue filters located on top of each pixel. The basic concept of this technology is very similar to early analog color imaging systems, such as the Daguerre brothers' autochrome plates. Each pixel will capture only one channel of the scene: red, green, or blue. The missing channels for each pixel are calculated from neighboring pixels. This process is usually referred to as demosaicing or color interpolation. The most popular pattern used to arrange the RGB filters is the so-called Bayer pattern. This pattern features twice as many green pixels as red and blue pixels, taking into account that the green information is particularly important for human vision.

The use of a single area-array sensor to capture the image (its digital information) has several advantages over other systems. Most important, this technology can be used for both moving and stationary subjects. It can be used with any kind of light source and the time required for image acquisition can range from a few milliseconds up to minutes, depending on how much light is available in the scene. There are, in most cases, no mechanical parts associated with the sensor. This sensor allows for the building of very compact and rugged cameras or even the integrating of the technology into compact mobile phones.

FIG. 3 One-shot/one-area array sensor with Bayes pattern.

The main disadvantage of the technology is related to the fact that each pixel records just one channel. The mathematical reconstruction of the missing two channels from the neighboring pixels can result in image artifacts such as color aliasing and color moiré. To minimize these problems, many cameras are therefore equipped with an optical anti-aliasing filter in front of the sensor. Since the distance between the anti-aliasing filter and the sensor is critical, this technique may not easily be used with digital camera backs adapted to conventional medium format cameras. Furthermore, the use of an anti-aliasing filter results in a certain loss of image sharpness.

Another disadvantage of the technology is the relatively long time required to process the images. In area-array sensors, the image quality is heavily influenced by the algorithms that are used to reconstruct the missing color information for each pixel in the sensor. Hence, an image captured with a particular camera may produce completely different results depending on which software is used to process the image.

One-shot/one-area array sensor with pseudo-stochastic pattern

One approach to reduce the risk of producing color moiré with a single area array sensor is to avoid a regular pattern of the red, green, and blue filters in front of the pixels. Arranging the filters in a pseudo-stochastic pattern will eliminate the color moiré quite nicely, but the cost is drastically longer processing times when compared to a regular filter pattern. Therefore, the technology hasn't been very successful commercially, although there have been certain products available that employed this approach.

One-shot/three-area array sensors with beam splitter and RGB filters

Another approach to reduce the risk of producing color artifacts is to use a total of three monochrome sensors in combination with a beam splitter with red, green, and blue filters in front of each of the three sensors. The approach of using a beam splitter to record red, green, and blue simultaneously was used in the early days of analog color photography.

With this technology, all three channels are captured simultaneously for each point of the image area. Therefore, no reconstruction of missing channels is required, the time required to process the image is short, and there is no risk of producing color artifacts, provided that the three sensors are perfectly registered.

A major disadvantage with this technology is that a camera becomes rather bulky. As a result of the additional optical elements in front of the sensor, the technology is not suited for lenses with short focal lengths. Nor is the system suited for view cameras where shifts, swings, and tilts are applied. Furthermore, the beam splitter reduces the amount of light traveling to each sensor by 66 percent, which results in a serious loss of brightness for the system. And finally, using three sensors instead of just one makes the camera considerably more expensive.

One-shot/one-area array sensor with CMY filters

Wherever red, green, and blue filters are used in front of a monochrome sensor to produce a color image, the filters considerably reduce the amount of light that reaches the

FIG. 4 One-shot/one-area array sensor with pseudo-stochastic pattern.

FIG. 5 One-shot/one-area array sensor with CMY filters.

individual pixels. Only one-third of the visible spectrum can possibly pass the individual RGB filters. This results in a loss of sensitivity of the imaging device or a higher noise level of the image. To overcome this problem, systems employing cyan, magenta, and yellow filters instead of the commonly used red, green, and blue filters have been introduced.

Theoretically, the cyan, magenta, and yellow filter set increases the sensitivity of the imaging device by a factor of two, as two-thirds of the visible spectrum can pass these filters. The drawback of this approach is the higher complexity of the mathematical reconstruction of the full color information as well as a loss of accuracy in terms of color rendition.

One-shot/one-multilayer area array sensor

The major breakthrough in analog color photography occurred after the introduction of multi-layer color films in which the red, green, and blue information was captured on a single piece of film with three different emulsion layers, each one sensitive to a different visible portion of the spectrum. The same concept has been adopted in digital imaging sensors as well. The technology takes advantage of the fact that, depending on the wavelength, photons can penetrate to different depths in an imaging device. The full color information may therefore be read out of the imaging sensor at different depths of the individual pixels. The risk of producing color artifacts is therefore eliminated and the technology may be used for both moving and stationary objects in all applications with any kind of light source.

The advantage of this technology is that a full-color image can be acquired with a single area array sensor without the need for additional filters or other optical elements. However, the separation of the red, green, and blue channels is rather difficult and consequently will still require complex calculations to reconstruct a color image.

Multi-shot Area Array Systems
Three-shot/one monochrome area array sensor with RGB filter wheel

Early high-end, digital-color imaging systems were based on a monochrome area array sensor and a filter wheel equipped with red, green, and blue filters. The red, green, and blue channels of the image were captured in a sequence of three shots. This technology was used in the early days of analog photography as well. It may be used with any kind of light source, but it is obvious that color images may only be acquired with stationary subjects. Any kind of movement of the subject or the camera would result in a poor registration of the red, green, and blue channels. Consequently, moving objects can only be captured as grayscale images.

FIG. 6 One-shot/one-multilayer area array sensor.

FIG. 7 Three-shot/one monochrome area array sensor with RGB filter wheel.

Thanks to the physical separation of the color filters and the imaging sensor, the filters in use can be chosen without major restrictions. Hence, an appropriate set of filters can produce excellent color rendition.

The color filter wheel can be arranged both in front and behind the lens. Both arrangements have inherent advantages and disadvantages. If the filters are in front of the lens, flare and non-image-forming light, as well as the physical dimensions of the filter wheel, is a major concern. If the filters are behind the lens, the requirements for the alignment of the filters and the risk that spots, scratches, and dust may be visible in the image are much higher.

Although this technology was very successful in the beginning of high-end digital imaging, it has more or less disappeared from the range of commercially available products.

Four-shot/one-area array sensor with Bayer pattern

Today's commonly used area array sensors with red, green, and blue filters arranged in a Bayer pattern have opened up

FIG. 8 Four-shot/one-area array sensor with Bayer pattern.

the opportunity to introduce a new multi-shot technology to capture the full color information for every pixel in the imaging area. The basic idea is to capture multiple images by physically moving the imaging sensor by one pixel between the individual shots. Because of the arrangement of the red, green, and blue filters in the Bayer pattern, a total of four exposures is necessary to capture the three color channels for every pixel in the image area. The four exposures are then superimposed and combined into one image. Because there are twice as many green pixels on the sensor as red and blue pixels, the green channel is captured twice for every position in the image. The two green channel images are therefore averaged before they are combined with the red and blue channels.

This technology offers high-resolution, full-color images for still-live applications with any kind of light source. Thanks to the type of area array sensor used, the same camera may be used for moving objects in one-shot mode. Hence, these systems are very flexible in terms of application and have become quite popular in many fields of professional imaging.

The small pixel size of today's area array sensors places a very high demand on the mechanical design of these devices, particularly on the part that shifts the sensor between the individual exposures. Most commonly, two piezo drives are used for the horizontal and vertical shifts of the sensor. The registration of the four exposures is very critical and any kind of poor registration will cause artifacts at the edges of the image structures. A very rugged camera and studio stand is therefore required for this type of application. Furthermore, the lighting used during the four exposures needs to be very consistent. Local variations in brightness will show up as artifacts in the final image.

Microscan Area Array Systems
Sixteen-shot/one-area array sensor with Bayer pattern

Microscanning technology takes the aforementioned four-shot technology one step further. It is a fact that not the entire surface of an area array sensor is sensitive to light. Photons that fall between the light-sensitive areas of two individual pixels are therefore simply lost. Consequently, the resolving power of a four-shot system is not as high as it is theoretically thought to be. Microscanning overcomes this problem by shifting the sensor in steps of half a pixel and thus also capturing the image information between the individual exposures of a four-shot image. A total of 16 individual exposures is required to capture the full red, green, and blue information for every position in the image area.

Microscanning offers excellent resolving power, provided that appropriate lenses are used. If the resolving power of the lens is not sufficient, microscanning just captures more pixels, not more image information. And it is obvious that movements of the camera or the object are even more critical than with four-shot technology. Furthermore, the time required to capture an image is considerably longer than with four-shot technology.

FIG. 9 Sixteen-shot/one-area array sensor with Bayer pattern.

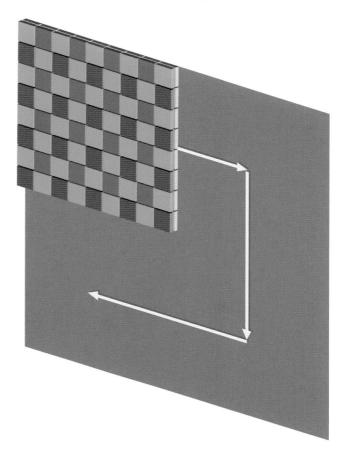

FIG. 10 Multiple tiles with one-area array sensor.

Nine-shot/one area-array sensor with Bayer pattern

Nine-shot technology is based on the same idea as sixteen-shot microscanning: to capture the image information that would fall between two individual pixels in a one- or four-shot exposure by moving the area array sensor to the positions in between. But instead of capturing all three channels at every position within the image area, the nine-shot captures just one channel per position. The missing two channels are then mathematically reconstructed from the neighboring pixels, just as with a one-shot exposure sensor. But the nine-shot sensor features a higher resolution image than a one- or four-shot and requires fewer exposures than a sixteen-shot. The drawback of this technology is that the time required for processing a nine-shot image is far greater than with any other type of multi-shot exposure, and there is still a risk of producing color artifacts. Hence the technology is not as widely used as four-shot or sixteen-shot microscanning systems.

Macroscan Area Array Systems
Multiple tiles with one-area array sensor

Another approach to increasing the resolving power of area array sensors is to capture multiple image tiles by shifting the entire sensor by a small distance, which can be less than its width and height. This shift is referred to as macroscanning. The multiple tiles, which slightly overlap each other, are then stitched together into one large image.

The major advantage of macroscanning is that higher resolving power is not achieved by decreasing the size of the pixels but by increasing the size of the image area. Furthermore, macroscanning can combine multiple one-shot or four-shot image tiles, a combination of both, or even sixteen-shot image tiles, resulting in very large, high-resolution images.

One of the disadvantages of macroscanning is that the camera becomes rather bulky. Also, it is critical that neither the camera nor the captured subject move during the exposure cycle. Otherwise, stitching the tiles properly together may not be possible or artifacts may occur in the overlapping areas of the image tiles.

Commercially, macroscanning was quite successful in the beginning of high-end digital imaging with area array sensors. But with the introduction of larger sensors with higher pixel counts, the importance of this technology has decreased.

Imaging Systems for Special Application
Multi-channel imaging systems

Besides high pixel count, resolution, and other image quality factors, the quality of color reproduction is an important issue in digital imaging. Since the color filters used are today most commonly applied directly onto the surface of the imaging sensor, the choice of dyes used for the filters is often limited. If the color filters are physically separated from the imaging sensor (such as on a filter wheel in front of the sensor or lens) the choice is considerably greater and color reproduction may therefore be better, if the appropriate set of filters is selected. To improve color reproduction even further, such as for the reproduction of important artwork, several multi-channel imaging systems have been suggested. These may either use a monochrome imaging sensor and a filter wheel with several narrow-band filters, or a conventional imaging sensor with RGB filters and an additional set of filters in front. All of these systems acquire multiple channels consecutively. Custom software is then required to convert the multi-channel image into a format that can be processed by standard imaging software. Although the results achieved with multi-channel imaging are quite promising, the systems are still in development and not yet commercially available.

IR imaging systems

Most of today's commonly used imaging sensors are not only sensitive to the visible spectrum, but their sensitivity also expands into the near infrared, usually up to a wavelength of 1000 nm. For standard color imaging, the sensors are therefore equipped with an IR blocking filter, which absorbs wavelengths greater than 700 nm. But for several special applications, such as forensic imaging, the sensitivity of the sensor in the near infrared can be used for IR imaging. In this case, the IR blocking filter is replaced with a clear glass that transmits near infrared. If only the infrared information is of interest, an IR transmission filter that absorbs the entire visible spectrum is used in front of the lens. If an imaging sensor fitted with red, green, and blue filters in front of the individual pixels is used, a combination of visible spectrum and IR imaging is possible as well. For example, the blue information may be blocked with a yellow filter and the "blue channel" then contains the IR information, whereas the green and red channels record green and red as usual. The channel chosen to record the IR information and consequently which filters are used depends, of course, on the spectral sensitivity of the individual channels, which may vary with the type of imaging sensor. ◉

Solid State Imaging Sensors

MICHAEL KRISS, Ph.D.
Digital Imaging Consultant

Frame Transfer Image Sensor

The Frame Transfer image sensor is revealed in Figure 11a and is the least complicated of this group. The substrate is

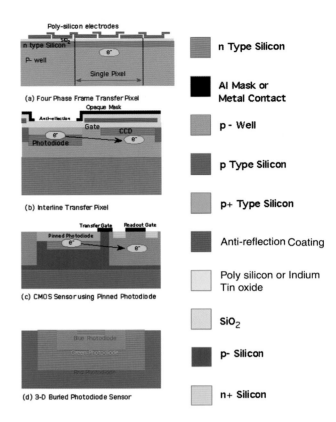

FIG. 11 This figure represents the appearance of four types of imaging sites (pixel) of solid state imaging sensors in cross-section when enlarged: (a) shows a four-phase Frame Transfer (FT) CCD imager; (b) shows an Interline Transfer (IT) CCD imager; (c) shows a CMOS imaging sensor; and (d) shows a 3-D Buried Photodiode (3DBP) imaging sensor.

p-type[1] silicon where the potential well is formed (p-Well) to hold the generated and captured photoelectrons. An epitaxial layer of n-type[2] silicon is grown above the p-Well, which isolates the captured photoelectrons from the insulating SiO_2 layer. On top of the insulating layer, four transparent

[1] p-type silicon consists of silicon doped with a relatively small percentage of material that has only three valence electrons, such as indium. Because a silicon atom has four valence electrons, which form covalent bonds with other valence electrons from other silicon atoms, an interstitial indium atom leaves the local region with an unbalanced number of electrons. This looks like a positive "hole." Because the positive charge can pair with an electron, it is call an acceptor.

[2] n-type silicon consists of silicon doped with a relatively small percentage of atoms that have five valence electrons, such as antinomy, which has one more than silicon. This excess electron is then able to move about in the crystal and is hence called a donor.

conducting electrodes are fabricated to control the transfer of the captured electrons from the body of the sensor to a horizontal CCD that leads to the output amplifier circuitry. The transparent electrodes are either poly-silicon or indium tin oxide. The indium tin oxide electrodes are preferable because they have much less absorption of blue light than the poly-silicon electrodes. The thin n-type layer separates the electrons to be transferred from the boundary between the substrate and the interface with the insulator, resulting in a Buried Channel FT CCD. The four phases refers to the number of transfers required to move the charge from one pixel to the adjacent pixel. It should be noted that during exposure, while the entire pixel can generate photoelectrons, they are collected in a potential well that resides below only one or two of the four transparent electrodes.

Interline Transfer CCD Image Sensor

The Interline Transfer CCD image sensor is shown in Figure 11b. Here the substrate is n-type silicon with a p-Well region grown above it. Within the p-Well structure, n-type silicon and p+ —type silicon (higher concentration of holes or acceptor atoms than the p-Well material) are used to form a photo-diode, a charge transfer gate, and a vertical CCD shift register. The electrodes to control the gate and vertical CCD shift register are made of a transparent conductor such as poly-silicon. SiO_2 is used as the insulating layer. The insulator above the photo-diode is coated with an anti-reflection layer to increase the effective quantum efficiency of the photo-diode. Since the vertical CCD shift register must not capture photoelectrons (other than those captured by the photo-diode) an opaque metal mask is added to all part surfaces of the sensor other than the opening to the photo-diode. The charges collected by the photo-diodes are all transferred at the same time to the vertical shift registers by means of the transistor gate. Small p-type regions are placed at each end of the pixel to prevent electrons generated under one pixel to diffuse to an adjacent pixel during exposure; these are called channel blocks. Similar implants can be used to shunt excess photoelectrons (those that exceed the potential well capacity of the photo-diode) into the substrate and are called overflow drains. The actual imaging area of the Interline Transfer CCD, as defined by the fill factor, is considerably less than that of the Frame Transfer CCD.

CMOS

A typical CMOS imaging sensor is shown in Figure 11c. CMOS stands for complementary metal oxide semiconductor. A p type silicon layer is built upon another p type silicon layer. A pinned photodiode is fabricated within the p-layer by using a p+ and n type silicon. A p-well is fabricated to the right of the pinned photodiode along with two Field Effect transistors, formed by n+ silicon imbedded in the p-well and controlled by two metal electrodes on the surface of the pixel. Just as with the Interline CCD, only a fraction of the surface area of the CMOS sensor is used to capture light. The pinned photodiode

limits the total charge capacity of the sensor (as opposed to the photodiode in Figure 11b). During the exposure cycle, charge is collected in the depletion region of the pinned photodiode. The gate electrode is then used to lower the potential barrier to the charge and allows it to flow into the p-well regions, where it is isolated by returning the transfer gate electrodes to their normal voltage. The second FET is then used to transfer the charge stored in the p-well to an output amplifier by means of sensor lines that have been fabricated on the sensor. There are addressed FETs that enable individual columns and rows, or pixels, fabricated on the chip, but they are not shown in the diagram. The advantage of the CMOS sensor is that all the control circuits can be fabricated on the imaging chip, while this is not possible for the two CCD samples above. Another disadvantage, besides the low fill factor, is that the three to four transistors per pixel will introduce more noise, as will the capacitance of the sensor lines.

The fill factor of both the Interline and CMOS sensors is much less than that of the Frame Transfer CCD sensors. To compensate for the "wasted" light, an array of micro-lenses is fabricated on top of the two sensors. The micro-lenses can increased the captured light up to a factor of three and are used on most IT and CMOS sensors. Color encoding is achieved by placing a Color Filter Array (CFA) between the micro-lens array and the actual sensor.

Buried Photodiode Image Sensor

Figure 11d shows a 3-D Buried Photodiode sensor. A series of photodiodes are formed at the p-n junction, as shown in the diagram. Silicon has a very large change in absorption light over the visible spectrum. There is a ratio of more than 100:1 from blue to red light, with blue light being more highly absorbed. Hence silicon forms a natural filter for encoding color. The blue light is absorbed near the first n-p interface, green light near the next p-n interface and, finally, red light is absorbed deep within the sensor at the next n-p interface. The stored charge is read out by means of circuitry not shown in the diagram. The greatest advantage of the 3-D Buried Photodiode sensor is that the sampling for each color is the same and the much less than any sensor with a CFA. This results in much less aliasing and color artifacts.[3] There is an additional advantage in that the resulting spectral sensitivities are closer to that of the human visual system, thus allowing for potential superior color reproduction. Since the readout circuitry takes up valuable surface area on the chip, 3-D Buried Photodiode sensors also use micro-lens arrays to improve the effective quantum efficiency. ◉

[3]Color aliasing arises from sub-sampled images. When an image is sub-sampled, any frequency content that is above half the sampling frequency (the Nyquist Frequency) will appear as low-frequency information or an aliased signal. When a CFA is used to encode the color data, the three channels are physically out of phase and thus the banding takes on strongly colored edges.

Standards and Imaging Materials

PETER ADELSTEIN, Ph.D.
Rochester Institute of Technology

Importance of Standards

In today's complex society, all industries and technologies must have a code of written and approved standards and specifications. It is absolutely essential if the products of this technology are to be widely used and if they are to make productive contributions. Such standards are required not only on the national level, but with the importance of world trade, they are equally important on the international level.

In the field of photography and imaging, standards take several forms as described in the following sections.

Specifications

The interchange of photographic materials and equipment is the most obvious benefit to the general consumer of photographic materials. The problems resulting from an incompatibility in a media-equipment system were all too apparent with the 1980s Beta-VHS incompatibility in videocassette recording. This caused tremendous financial loss and inconvenience to the consumer, the retailer, and the manufacturer. The issue was finally resolved in the marketplace after these losses occurred, but they would have been avoided if industry standards had been written and adhered to.

As evidenced in the videocassette recording example, every photographic and imaging application requires functioning of media in various types of equipment, and their respective dimensional tolerances must be specified. For example, 35-mm motion-picture negative film manufactured by one company must be capable of being exposed to positives manufactured by another company on printers made by a third party. In digital imaging this is especially important, because there are continual changes in formats and systems. Standards are required for image manipulation and interchange.

Specifications for the sizes and dimensional tolerances of imaging media exist for all the major uses. However, in addition to sizes, format is also critical. Examples are the location and width of soundtracks in motion picture films, the positioning of images in microfilm, and the pertinent software considerations in CD/DVD players. Fortunately, the imaging industry has a good track record in avoiding incompatibility problems through standardization.

The dimensional tolerances and formats referred to above are one form of product specification. Media or equipment also must satisfy minimum performance requirements if they are to meet specific standards. Such specifications deal with product behavior under defined conditions, or passing requirements of physical or chemical tests. Examples are specifications for scale markings for photographic lenses, color encodings for digital image storage, and drop-outs and errors rates in digital recording.

Test methods

Many specifications include minimum requirements when materials are subjected to detailed and specific test procedures. Examples are specifications for color characterization of digital still cameras and methods to determine the effects of light and atmospheric pollution on the stability of digital color images.

1. Recommended Procedures and Standard Practices. A third category of imaging standards includes the recommended procedures for proper performance or behavior, such as maintaining the proper storage conditions for photographic film, prints, plates, magnetic tape, and optical discs. Documents have also been written on the care and handling of tape and discs. These types of standards are very useful because they provide the user with the latest technical information, which has been digested and approved by experts in the field. The user thereby is freed from the necessity of keeping current with the technical literature and deciding which recommendations to follow when they conflict.

2. Nomenclature and Definitions. It is essential that terminology used within a technology be consistent and clear, and that it does not conflict with terminology used within or outside the particular industry. One example is the glossary of terms used to rate permanence of imaging materials and the definitions standardized in information management.

American National Standards Institute
The Institute's role

With the vast number of standardizing bodies in the United States, it was recognized early in the previous century that a coordinating body was needed. Accordingly, in 1918, a national organization was formed called the American Engineering Standards Committee. Subsequently, the name was changed to the American Standards Institute (USASI), and, finally, in 1970, to the American National Standards Institute (ANSI). Several salient points should be noted about ANSI:

1. ANSI is the umbrella organization in the United States. It has the sole authority to designate a document as a national standard.

2. ANSI has established specific procedures for input from interested organizations and individuals, openness of discussion, the balloting process, and requirements that a consensus has been achieved among the parties involved. Any organization or individual with a direct and material interest in the subject matter has a right to participate in ANSI activities. Documents are only accredited by ANSI as national standards of the United States when consensus has been achieved. This is determined by written ballot,

and all ballots must be considered by the working groups and committees involved. Consensus is defined as more than a majority but not necessarily unanimity.

3. As the national coordinating body, ANSI is the official United States representative to the International Organization for Standardization (ISO) and to the International Electrotechnical Commission (IEC). ANSI delegates to ISO and IEC meetings represent the United States and not a particular company, organization, or society.

4. ANSI is a voluntary organization. Professional societies, technical societies, and trade associations are encouraged to submit their standards to ANSI for processing as national standards, but there is no requirement to do so. However, unless these documents are submitted, they are not considered national standards.

5. ANSI is not a U.S. government body. However, government bureaus and agencies participate in standardizing activities, along with industry, consumer groups, and individuals.

6. ANSI itself does not write standards. It approves standards, provided that its guidelines are followed. The actual document preparation is discussed below.

The Institute's governance

ANSI photographic standards are prepared by either of two methods: accredited standards committees or accredited organizations.

1. *Committees.* An accredited standards committee (ASC) is a group accredited by ANSI for the specific purpose of preparing standards to present to ANSI for processing as national documents. An ASC consists of a secretariat and the committee membership. The secretariat is frequently a trade organization that provides all the required administrative, legal, and financial backing. This includes distributing ballots, maintaining rosters, assuring that established procedures are followed, and providing the contact with ANSI.

 Committee membership includes manufacturers, government agencies, and consumers who have an interest in the subject matter and agree to participate. Membership is open, although it may be subject to a committee vote. However, it is very important that there be a balance of interests and no domination by a single interest category. An accredited standards committee elects its own officers and can organize itself in any way to expedite its work assignments. This includes the establishment of subcommittees and task, working, study, or ad hoc groups.

2. *Organizations.* Standards can also be prepared by accredited organizations. Such an organization is usually an industry group, an association of industry experts, or an association of professionals. Its primary focus revolves around a particular technology and may involve exchange of professional or technical information, trade policies, or promotion of industry growth. The preparation of standards also may be one of its functions. To have these standards recognized as national standards, the organization must have written operational procedures and become ANSI-accredited. The prime criteria for accreditation are: recognition of its area of competence, agreement to use ANSI-approved procedures, and allowed participation of those with an interest in the field. Many of the imaging standards have been prepared by such accredited organizations.

General photographic and imaging standards are written by the International Imaging Industry Association (I3A) which has been accredited by ANSI and replaces the now-defunct National Association of Photographic Manufacturers. It is composed of a number of imaging technology (IT) committees that deal with areas such as physical dimensions, image evaluation, physical properties and permanence, and guidelines and specifications for digital still cameras.

Standards for the microfilm industry are prepared by the Association for Information and Image Management (AIIM), which was accredited by ANSI in 1985. It deals with such diverse topics as dimensional requirements, formats, and requirements for electronic imaging systems.

Motion-picture standards are prepared by the Society of Motion Picture and Television Engineers (SMPTE), which was accredited by ANSI in 1984. This organization is concerned with film dimensions, audio recording, television recording, and theatre projection.

In the graphic arts industry, the standardization activities come under the jurisdiction of the Committee on Graphic Arts Technology Standards (CGATS). In the printing industry, there is the Association for Suppliers of Printing and Publishing Technology (NPES).

All standard designations include the year in which they were standardized. They are reviewed every five years for reconfirmation, revision, or withdrawal.

It is apparent that there is a very wide range of standards activities in the imaging industry. This requires coordination to ensure that there is no duplication of effort among the accredited standards committees and accredited organizations. In addition, there is the need to ensure that appropriate groups are working in all the required areas. This function is fulfilled by the Image Technology Standards Board (ITSB), which was established by ANSI. (This board was formerly known as the Photographic Standards Board.) In recent years, digital imaging by electronic means has become more important and consequently the scope has been expanded to include all imaging technologies.

International Standards Organization
The Organization's role

While the importance of national standards cannot be overemphasized, in today's world of international commerce, national standards are not enough. To facilitate trade between nations, international standards are required. The need is particularly

critical in high-technology fields such as photography and digital imaging. Within the past decade, greater effort and emphasis in imaging technology has been devoted to writing international standards than to U.S. national documents.

The first international standards group was the International Electrotechnical Commission (IEC), which was founded in 1906. Its scope includes all international standardization in the electrical and electronic engineering industry. Forty years later, the International Organization for Standardization (ISO) was organized. The mission of ISO is to promote international standards to facilitate international exchange of goods and services. ISO is a worldwide organization of nearly 100 national standards bodies; the work is advanced through the activities of more than 2000 technical groups. There is some overlap between IEC and ISO in the field of information technology. To avoid jurisdictional problems, joint technical committees (JTCs) were set up in 1987 by the merger of several IEC and ISO technical committees. Within JTC1, subcommittee SC11 has responsibility for flexible magnetic media for digital data interchange; SC23 is a parallel subcommittee for optical-disc cartridges.

Unlike ANSI, membership in ISO is through the national standards bodies or the organization in a country that is most active in standardizing activities. In the United States, all participants in ISO work are representatives of ANSI. Their responsibility is to represent the U.S. viewpoint, not necessarily the position of the manufacturer, agency, or company with which they are associated. Member countries are known as participating (P) members if they take an active part in ISO work. They are obliged to vote and, if possible, to attend meetings. Countries that only want to be kept informed of ISO work are observer (O) members.

The Organization's governance

The technical work of ISO is carried out by technical committees (TC). Each TC is identified by a number (such as ISO/TC42) and has a very specific scope that defines its work program. To handle the administrative functions, each ISO technical committee has a secretariat that is one of the national standards bodies within the membership. Technical committees in turn are subdivided into either subcommittees or working groups; the exact division varies with the committee. There are about 170 technical committees in ISO, and well over 2000 subcommittees and working groups.

In the field of imaging, the pertinent technical committees are:

ISO/TC 42 General Imaging
ISO/TC 36 Cinematography
ISO/TC 130 Graphic Technology
ISO/TC 171 Document Imaging Applications

As with ANSI's standards, international standards can be specifications, test methods, recommended practices, and nomenclature. Consensus is determined by the submission of written ballots to the participating members, and ballots are involved at each stage of the standardization process. ISO documents are first prepared as committee drafts, and then become draft international standards. After consensus has been reached within the standardizing body, these documents are published as ISO standards and are readily available to those interested. ISO standards are reviewed every five years.

Each of the technical committees maintains ties with other technical committees or IEC committees with which it shares areas of common interest.

Organization of imaging standards

The technical committee with general responsibility for imaging is TC 42. The secretariat is ANSI, which has assigned this responsibility to I3A.

At present there are twelve committee members classified as P members. The countries and their associated national standardizing bodies are as follows:

Belgium — Institute Belge de Normalisation (IBN)
China — China State Bureau of Technical Supervision (CSBTS)
Commonwealth of Independent States, USSR — State Committee for Product Quality Control (GOST R)
France — Association Française de Normalisation (AFNOR)
Germany — DIN Deutsches Institut fuer Normung (DIN)
Italy — Ente Nazionale Italiano di Unificazione (UNI)
Japan — Japanese Industrial Standards Committee (JISC)
Korea — Bureau of Standards Industrial Advancement Administration (KATS)
Sweden — Standardiserings — kommissionen (SIS)
Switzerland — Swiss Association for Standardization (SNV)
United Kingdom — British Standards Institute (BSI)
United States — American National Standards Institute (ANSI)
There are also 18 O members.

ISO/TC 42 is subdivided into working groups, with scopes that include physical properties, permanence, sensitometry, and electronic still-picture imaging. To date, TC42 has published 174 documents.

Current trends

Traditional photography is a mature industry. Much of its success is due to the extensive body of standards that has been published by national and international organizations. There is still a need to update many of these documents and to prepare additional standards as new information is obtained. However, digital imaging is far from a mature industry — there are constant innovations and new products being developed. This has created tremendous interest in preparing appropriate standards to deal with product improvements and new formats, as well as recommending approaches to ensuring the stability of digital information. ◉

Current Standards for Digital Camera Testing and Characterization

Title	No.	Date	Organization	Edition	TCs
Viewing conditions—Graphic technology and photography	3664	02/01/2002	ISO	2nd	ISO/TC 42 (Photography), ISO/TC 130 (Graphic Technology)
Photography—Illuminants for sensitometry—Specifications for daylight, incandescent tungsten, and printer	7589	09/01/2000	ISO	2nd	ISO/TC 42 (Photography)
Photography—Electronic still-picture cameras—Terminology	12231	06/15/1997	ISO	1st	ISO/TC 42 (Photography)
Photography—Electronic still-picture cameras—Determination of ISO speed	12232	08/01/1998	ISO	1st	ISO/TC 42 (Photography)
Photography—Electronic still-picture cameras—Resolution measurements	12233	09/01/2000	ISO	1st	ISO/TC 42 (Photography)
Photography—Electronic still-picture cameras—Methods for measuring optoelectronic conversion functions (OECFs)	14524	12/15/1999	ISO	1st	ISO/TC 42 (Photography)
Photography—Electronic still-picture imaging—Noise measurements	15739	05/01/2003	ISO	1st	ISO/TC 42 (Photography) 32
Multimedia systems and equipment—Color measurement and management—Part 2-1: Color management—Default RGB color space—sRGB	61966-2-1	10/1999 + 01/2003	IEC	1st + Amd 1	IEC/TC 100 (Audio, video, and multimedia systems and equipment)
Multimedia systems and equipment—Color measurement and management—Part 8: Multimedia color scanners	61966-8	02/2001	IEC	1st	IEC/TC 100 (Audio, video, and multimedia systems and equipment)
Multimedia systems and equipment—Color measurement and management—Part 9: Digital cameras	61966-9	06/2000	IEC	1st	IEC/TC 100 (Audio, video, and multimedia systems and equipment)
Graphic Technology—Color reflection target for input scanner calibration	IT8.7/2	06/21/1993	ANSI	1st	IT8 Subcommittee 4
Colorimetry	15.2	1986	CIE	2nd	CIE/TC 1.3 (Colorimetry)
A method for assessing the quality of daylight simulators for colorimetry	51	1981	CIE	1st	CIE/TC 1.3 (Colorimetry)

Current Accepted Standards for Image Quality Parameters

Title	No.	Image Quality Parameter							
		Spatial Uniformity	Tone Reproduction	Color Reproduction Accuracy	Noise	Dynamic Range	Image Flare	Resolution	Non-Image Quality
Viewing conditions—Graphic technology and photography	3664								X
Photography—Illuminants for sensitometry—Specifications for daylight, incandescent tungsten, and printer	7589								X
Photography—Electronic still-picture cameras—Terminology	12231								X
Photography—Electronic still-picture cameras—Determination of ISO speed	12232								X
Photography—Electronic still-picture cameras—Resolution measurements	12233							X	
Photography—Electronic still-picture cameras—Methods for measuring optoelectronic conversion functions (OECFs)	14524		X						
Photography—Electronic still-picture imaging—Noise measurements	15739				X	X			
Multimedia systems and equipment—Color measurement and management—Part 2-1: Color management—Default RGB color space—sRGB	61966-2-1			X					
Multimedia systems and equipment—Color measurement and management—Part 8: Multimedia color scanners	61966-8	X	X	X					
Multimedia systems and equipment—Color measurement and management—Part 9: Digital cameras	61966-9	X	X	X					
Graphic technology—Color reflection target for input scanner calibration	IT8.7/2			X					
Colorimetry	15.2								X
A method for assessing the quality of daylight simulators for colorimetry	51								X

Digital Camera Testing

DIETMAR WÜLLER
Dietmar Wüller Image Engineering

Measuring Characteristics

While most people will never test a digital camera themselves, they may nevertheless be required to evaluate the results of someone else's camera test when shopping for their next camera or reading technical information about a specific camera. This essay will introduce the issues that are important when testing a camera and describe a few image quality aspects in detail.

The measurement procedures behind the described camera characterization are based on ISO standards.[1, 2, 3, 4, 5, 6] Work on these standards started in conjunction with the development of the cameras themselves. It is important to keep in mind that most of the characteristics that are measured with these tests are also being measured with standardized methods in conventional photography as well. The theories that these tests are based on may use the same tools, which are new for the digital age.[7] However, certain characteristics are important for digital cameras that did not exist for conventional ones.

Measuring specific image quality features can help in characterizing a camera, but these measurements always have to be related to the real-world applications. There are numerous aspects of the real world that we will never be able to measure. It is therefore impossible to completely test a camera without taking pictures of common scenes.

To acquire sufficient characterization information for a digital camera, a couple of characteristic values seem to be mandatory while others may be recommended or optional. The two characteristics that seem to be the most important are the measurement the OECF[2] (opto electronic conversion function) and the resolution.[5] A few others belong to this group as well.

The following aspects are mandatory:

- OECF
- White balancing
- Dynamic range (related scene contrast)

[1]ISO 7589, Photography – Illuminants for sensitometry — Specifications for daylight and incandescent tungsten
[2]ISO 14524, Photography — Electronic Still Picture Cameras — Methods for measuring opto-electronic conversion functions (OECFs)
[3]ISO 12231, Photography — Electronic still-picture imaging — Terminology
[4]ISO 12232, Photography — Digital still cameras — Determination of exposure index, ISO speed ratings, standard output sensitivity, and recommended exposure index
[5]ISO 12233, Photography — Electronic still-picture cameras — Resolution measurements
[6]ISO 15739, Photography — Electronic still-picture imaging — Noise measurements
[7]Don Williams, "Debunking of Specsmanship," www.i3a.org

- Used digital values
- Noise, signal to noise ratio
- Resolution (limiting resolution center, corner)
- Sharpness
- Used digital values

Recommended values are:

- Distortion
- Shading/vignetting
- Chromatic aberration
- Color reproduction quality
- Unsharp masking
- Shutter lag
- Aliasing artifacts
- Compression rates
- Exposure and exposure time accuracy and constancy
- ISO speed

Optional values may be:

- View angle, zoom range (at infinity and shorter distances)
- Hot pixels
- Detailed macro mode testing (shortest shooting distance, maximum scale, distortion)
- Flash capabilities (uniformity, guiding number, light source, etc.)
- Startup time
- Image frequency
- Video capabilities (pixel count, resolution, frame rate, low-light behavior)
- MMS capabilities for mobile phone cameras (resolution, frame rate, compression, etc.)
- Display (refresh rates, geometric accuracy, color accuracy, gamut, contrast, brightness, visibility in sunlight)
- Optical stabilization
- Auto focus accuracy and constancy
- Metadata (Exif, IPTC)
- Watermarking
- Spectral sensitivities
- Bit depth of raw data
- Power consumption
- Battery life
- Detailed noise analysis
- Color resolution

Camera settings

The measured values are influenced by the settings of the camera. To ensure the correct interpretation of the data, it is necessary to mention the proposed settings. Two different methods are used among testers to ensure the correct settings:

1. Use the predefined factory settings; most users do not change these settings. They should have been carefully selected by the manufacturer.
2. Select settings that provide an optimum image quality.

Both methods can lead to the same settings. For example, the manufacturer may choose a high-compression JPEG file

format as the standard format to ensure high-speed image storage and minimum file sizes. The compression leads to an image quality that may not be the optimum image quality of the camera and therefore leads to different results. For the proposed test procedure we chose the settings mentioned in the table below to maximize the image quality provided by the camera. For all aspects that are not explicitly mentioned, the default factory settings should be used.

If it is possible to adjust the parameters, use the following settings:

Parameter	Intention
Sensitivity	ISO 100 is the lowest typical sensitivity to minimize noise and ISO 400, if provided by the camera, to get an idea of how the camera behaves at higher sensitivity levels.
File format	For OECF measurement, a file format that stores uncompressed data is preferred, to avoid compression artifacts and the possible impact of the compression algorithm on the camera's noise. For all other aspects, JPEG in highest quality should be used.
Resolution	Maximum sample rate is used, which shows as many details as possible.
White balancing	Auto white balancing to avoid color casts and to see if the auto balancing works well.
Sharpening	Sharpening should be the default value selected by the manufacturer because of the tradeoff between noise and contrast/resolution.
Contrast/Gamma	Standard contrast setting should be selected. In only a few cases the contrast may be varied to achieve the maximum dynamic range.
Color	The color setting that is optimized to achieve the best color reproduction of the original. If not available use default.
Flash	Generally the flash is switched off. It may be switched on only for those situations where it is explicitly needed.
Macro	The macro setting is needed only for the determination of the maximum scaling.
Focus	Usually the autofocus is activated to get sharp images.

File from camera to computer transfer

The image transfer from the camera/camera phone to the PC depends on the existing interfaces. Interfaces should be checked in the following order:

1. Memory-Card/Card Reader
2. USB
3. Bluetooth
4. Irda
5. MMS

The first interface that is available should be used for the camera being tested.

OECF measurements

The OECF (opto-electronic conversion function) describes how the camera transfers the illumination on the sensor into digital values in the image. This information or at least the images of the test chart are necessary to answer the following questions:

1. What is the maximum contrast in a scene that can be captured by the camera in all its tonal details (dynamic range)?
2. Is the white balance operating correctly?
3. Does the camera use all possible digital values in the image?
4. Is there a gamma or tonal correction applied to the captured linear image?
5. What is the signal to noise value for different gray levels?
6. What is the ISO speed of the camera?

The camera OECF, as specified in ISO 14524,[2] is measured using a test chart with patches of different gray levels aligned in a circle around the center.

Resolution

Unfortunately, people think that resolution is the same as pixel count and, in fact, think of the pixel count as the sample rate is a limiting factor for resolution. When increasing pixel count, the other parts of the imaging system are increasingly the bottleneck for the resolution, such as the ability of a camera to capture fine detail, especially because manufacturers are trying to keep the sensor size as small as possible.

There are several ways to characterize the resolution of a digital camera. Methods developed so far have various drawbacks. Currently there is a new method under discussion in the respective ISO committee.

Visual analysis of the resolution leads to the problems described in Figure 15: moiré effects make it impossible to see which line pairs are still resolved. The slanted-edge analysis with the SFR algorithm as defined in ISO 12233,[5, 8, 9] was found not to represent the resolution of a camera if sharpening or other image-processing algorithms are applied to the edges in the image.

What is desirable is to have an idea of the modulation transfer function (MTF), as shown in Figure 16.

[8] Peter D. Burns, "Slanted-Edge MTF for Digital Camera and Scanner Analysis," PICS conference 2000
[9] Don Williams and Peter Burns, "Diagnostics for Digital Capture using MTF," PICS conference 2001

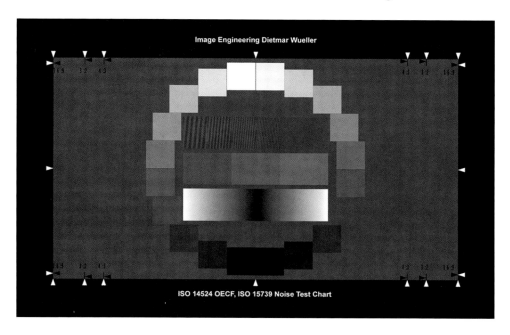

FIG. 12 The OECF chart of ISO 14524 combined with the noise patches of ISO 15739. This is a special version with 20 grey levels and a contrast of 10,000:1.

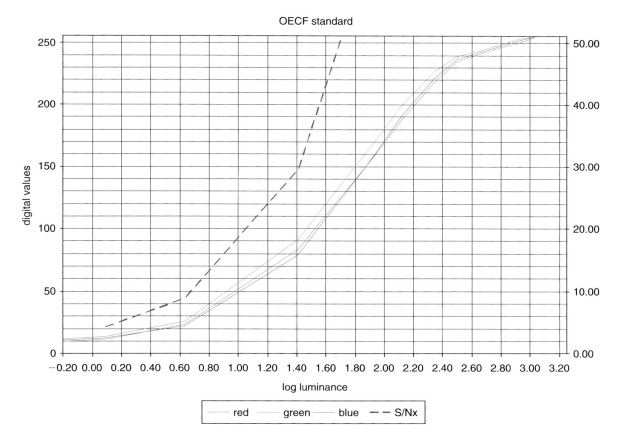

FIG. 13 A sample OECF curve for a camera with a high dynamic range.

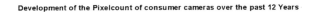

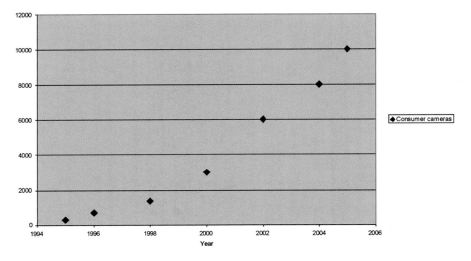

FIG. 14 Development of the pixel count of consumer digital cameras over the past 12 years.

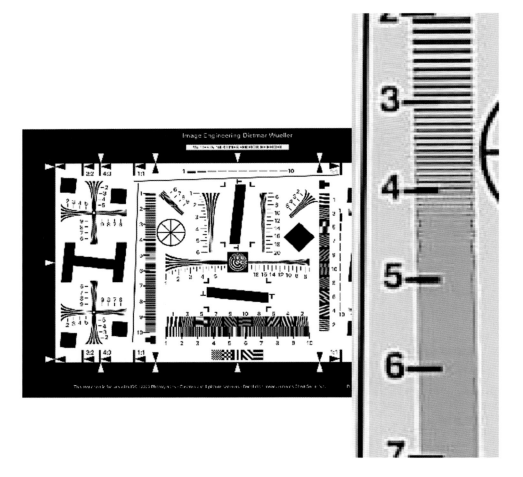

FIG. 15 Visual analysis of limiting resolution is often not as easy as we expect it to be.

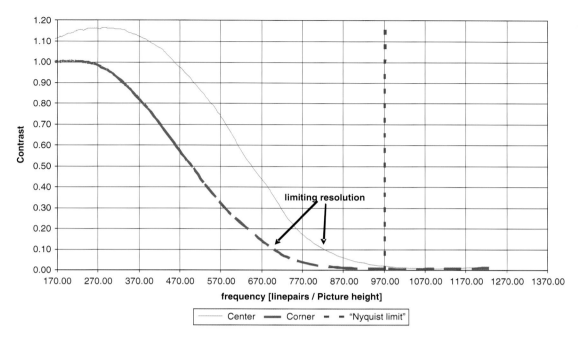

FIG. 16 The MTF for a typical 4 Megapixel camera with the limiting resolution at 10 percent contrast.

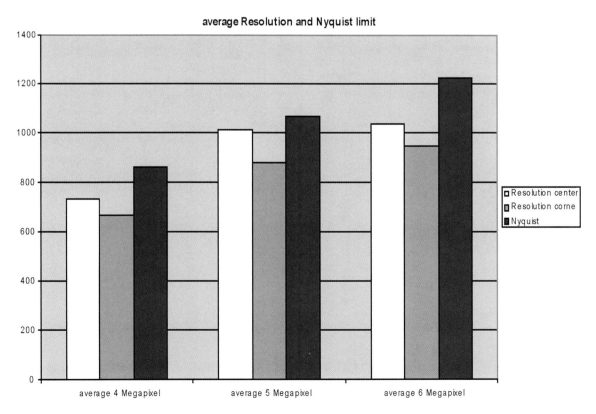

FIG. 17 Average resolution and Nyquist limit for consumer digital cameras.

These are just a few of the tests that have been developed to characterize digital cameras. A full description of more tests can be found on the following website: digitalkamera.image-engineering.de/index.php/Downloads.

The requirements for an ideal digital SLR camera are:

- Live image
- Autofocus accuracy and speed
- Manual focus
- Image quality
 - Exposure control, level correction
 - Color appearance
- Metadata
- Standardized raw format

Image Formation

SABINE SÜSSTRUNK, Ph.D.
Ecole Polytechnique Fédérale de Lausanne

Introduction

Image formation is fundamental to a sensor's response to radiation. In most applications, we are concerned only with the part of the radiation spectrum (approximately 380 to 700 nanometers) that the human visual system is sensitive to. Equally, the sensors considered are sensitive only to such radiation.

Illuminants and light

Light is the part of the electromagnetic radiation that causes the light-sensitive elements (rods and cones) in the eyes to respond. The range (spectrum) of this "visible" radiation is usually described in wavelengths(λ) and uses the units of nanometers. For normal human vision, the sensitivity ranges from approximately 380 to 700 nm.

According to Quantum Theory [WS82], the energy of electromagnetic radiation is given by

$$Q = h \times v = \frac{h \times c}{\lambda} \qquad (1)$$

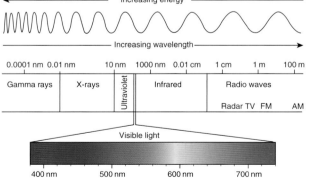

FIG. 18 Electromagnetic radiation spectrum.

where Q is the photon energy in Joules J or eV ($1\,\text{eV} = 1.6 \times 10^{-19}$ J), h is Planck's constant (h $= 6.623 \times 10^{-34}$J s), v is the frequency (s^{-1}), c is equal to the speed of light in vacuum ($2.998 \times 10^{8}\text{ms}^{-1}$), and λ is the wavelength (m).

Radiant power Φ (also called *flux F*) is radiant energy emitted, transferred, or received in unit time intervals (e.g., dQ/dt.) The unit for Φ is W (Watt $= \text{Js}^{-1}$). By definition, $\lambda = cv^{-1}$, and $d\lambda = -cv^{-2}dv$. Over the spectral region $d\lambda$, the radiant power can thus be expressed as $\Phi_\lambda d\,\lambda = -\Phi_v dv$.

The minus sign allows for a decrease in frequency with an increase in wavelength. It follows that:

$$\Phi_v = \Phi_\lambda cv^{-2} = \frac{1}{c}\Phi_\lambda \lambda^2 \qquad (2)$$

The number of *photons* (or quanta) that are emitted in unit time per unit frequency interval is calculated by:

$$N_v = \frac{\Phi_v}{hv} = \frac{1}{hc^2}\Phi_\lambda \lambda^3 \qquad (3)$$

Properties of electromagnetic radiation interacting with matter are synthesized in a set of rules called the radiation laws. These laws apply when the matter is a blackbody. Every object emits energy from its surface when heated to a temperature greater than 0° Kelvin. A blackbody (Planckian) radiator is an "ideal" solid object that can absorb and emit electromagnetic radiation in all parts of the electromagnetic spectrum so that all incident radiation is completely absorbed.

Emission is possible in all wavelengths and directions.[1] The spectral energy distributions are continuous functions of wavelength. The exact radiation emitted from an object is dependent on its absolute temperature.

The three radiation laws most relevant to imaging are Planck's Formula, Wien's Displacement Law, and Stefan-Boltzmann's Law. Planck's Formula states that the *spectral radiant excitance*[2] ($M\lambda$) of a blackbody at temperature T per unit wavelength interval is given by:

$$\begin{aligned} M_\lambda &= \alpha \lambda^{-5}(e^{\beta/T\lambda} - 1)^{-1}\text{Wm}^{-3} \\ \alpha &= 3.742 \times 10^{16}\text{Wm}^{-2} \\ \beta &= 1.4388 \times 10^{-2}\text{mK} \end{aligned} \qquad (4)$$

The SI unit for spectral radiant excitance is Wm^{-3}, but a commonly used unit is $\text{Wm}^{-2}\text{nm}^{-1}$.

Wien's Displacement Law states that the wavelength of the maximum emitted radiation is inversely proportional to the temperature:

$$\lambda_{\text{max}} = \frac{2.897 \times 10^{-3}}{T} \qquad (5)$$

[1] There are no "ideal" blackbodies, but in astronomy, stars are often considered to be blackbodies.
[2] The radiant emittance or excitance (M) (Wm^{-2}) of a source is the radiant power emitted from an infinitesimal.

where λ_{\max} is the wavelength of the peak emission (in meters) and T is the temperature in Kelvin. Stefan-Boltzmann's Law states that as the temperature increases, the amount of radiation at each wavelength increases. The (total) radiant excitance (M) is proportional to T^4:

$$M = \int_0^\infty M_\lambda d\lambda = \sigma T^4$$
$$\sigma = 5.67 \times 10^{-8} W m^{-2} K^{-4} \tag{6}$$

σ is the Stefan-Boltzmann constant and T the temperature in Kelvin.

Radiometry

The radiometric quantities and units are energy, power, radiant excitance, irradiance, radiant intensity, and radiance. The latter four incorporate power and geometric quantities: *Irradiance* (flux density) is power per unit area $d\Phi/dA_{\mathrm{surface}}$ incident from all directions in a hemisphere onto a surface. It is related to radiant excitance, and the unit for irradiance is also Wm^{-2}. The difference is the unit area: radiant excitance refers to the area of a source, and irradiance to the area of a receiver. The symbol for irradiance is E.

Radiant intensity is power per unit solid angle ($d\Phi/d\omega$) and measured in Wsr^{-1}. *sr* is the abbreviation for steradian, which is the solid angle that, having its vertex in the center of a sphere, cuts off an area on the surface of the sphere equal to that of a square with sides of length equal to the radius of the sphere [NIS95]. By dividing the surface area of a sphere by the square of its radius, we find that there are 4π steradians of solid angle in a sphere. The term steradian is related to the radian, the plane angle between two radii of a circle that cuts off on the circumference an arc equal in length to the radius (see Figure 19).

Radiance is power per unit surface area per unit solid angle: $d\Phi/d\omega dA_{\mathrm{surface}}\cos(\phi)$. ϕ is the angle between the surface normal and the specified direction. The symbol for radiance is L.

In imaging, "light" is often characterized by its spectral power distribution $E(\lambda)$. An illuminant SPD denotes the radiant "power" given at each wavelength per wavelength interval of the visible spectrum. Note that the spectral power distribution, using the symbol $E(\lambda)$, should correctly be named spectral irradiance distribution (or radiant excitance distribution, depending on the context). However, in most literature $E(\lambda)$ is called spectral power distribution or SPD. The measurements are usually given in $\mathrm{Wm}^{-2}\mathrm{nm}^{-1}$, or they are relative. This comes from the fact that when we are modeling human vision or an imaging system, we are often more interested in relative than absolute responses. Consequently, it suffices to use relative spectral power distributions that are normalized (either to 1, or to 100 at 555 or 560 nm [WS82]).

Photometry

Radiometry is the measurement of electromagnetic radiation. Photometry is the measurement of light. Photometric quantities are the same as radiometric quantities, except that they are weighted by the spectral response of the eye.

Luminous power (or luminous flux) is calculated from radiant power (or flux) as follows:

$$\Phi_L = 683 \int_{380}^{750} V(\lambda)\Phi_R(\lambda)d(\lambda) \tag{7}$$

where Φ_L is the luminous power (units: lumens), $\Phi_R(\lambda)$ is the spectral radiant power per wavelength (Wnm^{-1}) and $V(\lambda)$ is the luminosity function of the human eye. The luminosity function $V(\lambda)$ is a measure of the sensitivity of the human visual system to radiant power, which differs across the visible spectrum. Figure 20 illustrates $V(\lambda)$, as defined by the CIE [WS82].

The radiometric units and their corresponding photometric units are listed in Table 1. Note that like radiance and luminance, irradiance and illuminance have the same symbol.

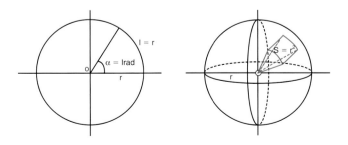

FIG. 19 Radians, solid angle, and steradian.

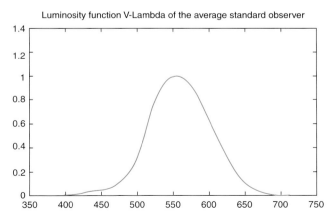

Luminosity function V-Lambda of the average standard observer

FIG. 20 The luminosity function V (λ).

Common radiometric and photometric terms and units

Radiometric Terms	Radiometric Units	Photometric Terms	Photometric Units
Radiant Power or Flux Φ	Watts (W)	Luminous Power or Flux Φ	lumens (lm)
Radiant Excitance M	Wm^{-2}	Luminous Emittance	lm/m^2
Radiant Intensity I	W/steradian (Wsr^{-1})	Luminous Intensity I	candela (cd) (lm/m^2)
Irradiance E	Wm^{-2}	Illuminance E	lux (lm/m^2)
Radiance L	$Wm^{-2}sr^{-1}$	Luminance L	cd/m^2, $(lm/(m^2sr))$

The following comments are helpful to understand photometric quantities in imaging:

- A point light source with an intensity of 1 cd emits a power of 1 lumen per steradian lm/*sr* in all directions (see Figure 21).
- A point light source with an intensity of 1 cd will produce an illuminance of 1 lux at a distance of 1 *m* (see Figure 21).
- Inverse Square Law: The illuminance E decreases with the distance squared, $E = I/d^2$, d = distance (m), $d > 5 \times$ source diameter.
- The luminance L does not decrease with (viewing) distance.
- Cosine Law: The illuminance E falling on any surface varies with the cosine of the incident angle ϕ, $E_\phi = E \times \cos(\phi)$ (see Figure 22).

Illuminants

The Commission Internationale de L'Eclairage (CIE) [CIE86] specifies relative spectral power distributions of typical phases of daylight illuminants. These illuminant SPDs are calculated according to a method proposed by Judd et al. [JMW64], based on the mean and first two principal components of a series of daylight measurements.

$$\text{cosine law: } E = E\phi \cos(\phi)$$

It is common usage to call these illuminants by the letter "D" for daylight, and the first two numbers of the corresponding correlated color temperature. The term correlated color temperature is defined as the temperature of a blackbody radiator whose perceived color most closely resembles that of the given selective radiator at the same brightness and under specified viewing conditions [WS82]. For example, D55 is an illuminant calculated according to the method proposed in [JMW64], respectively [CIE86], with a correlated color temperature of 5,500 Kelvin. Figure 23 illustrates different daylight illuminants, ranging from D45 to D75.

For the purpose of colorimetry, the International Organization for Standardization (ISO) and the CIE have standardized

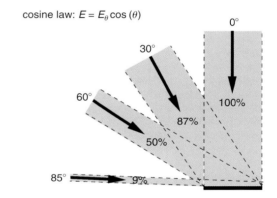

cosine law: $E = E_\theta \cos(\theta)$

FIG. 22 The Cosine Law.

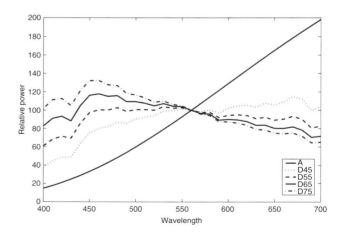

FIG. 23 Relative spectral power distributions (SPD) of CIE daylight illuminants and standard colorimetry illuminants A and D65.

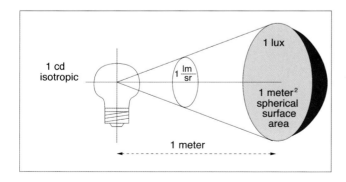

FIG. 21 An illustration of photometric quantities.

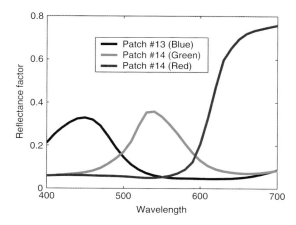

FIG. 24 Reflectance spectra of color patches 13 (blue), 14 (green), and 15 (red) of the Macbeth color checker rendition chart.

two specific illuminants, D65 and A [ISO98]. D65 is a daylight illuminant with a correlated color temperature of 6,500 K. A is a tungsten-filament illuminant whose relative SPD is that of a Planckian radiator at a temperature of 2,856 K.

Reflectance

The color of a (non-transparent) object is characterized by its surface reflectance $S(\lambda)$, ($S(\lambda) \in [0, 1]$). For each wavelength or wavelength interval, a reflectance factor indicates how much of the incoming radiation is reflected. $S(\lambda) = 1$ means that all incoming radiation is reflected, while $S(\lambda) = 0$ indicates that all incoming radiation is absorbed. Figure 24 illustrates three reflectances of the Macbeth color checker rendition chart [MMD76].

Sensors

A sensor is an entity that reacts to light. The term is also often used to denote the sensitivity function $R(\lambda)$ that indicates the sensor's responsiveness to radiation at a given wavelength per wavelength interval.

In general, sensors are considered to be physical entities, such as a CCD or a CMOS photo site, photographic film, or the cones and rods in the human retina, which physically exist and give a positive response when radiation is detected. In imaging, however, we often assume that sensors do not need to be physical and also allow for sensors that have negative sensitivities. From a conceptual point of view, these sensors are the result of some "processing," either by the human visual system or an imaging system (see opponent color mechanisms).

Sensors of the Human Visual System

For the purpose of modeling the human visual system (HVS), several different sensor sensitivities can be considered, derived from physiological and/or psychophysical properties of the human visual system. We limit the discussion here to the "physical" sensors of the HVS, namely the photoreceptors. These light-sensitive elements are the called the rods and cones. They

contain light-sensitive photo-chemicals, converting light quanta into an electrical potential that is transmitted to the brain in a chain of neural interactions. They are located in the retina, the curved surface at the back of the eye (see Figure 25). The names are derived from their typical shape. *See Human Vision.*

Rods and cones are not uniformly distributed in the retina. Cones are primarily concentrated in the fovea, the area of the retina at the end of the optical axis that covers approximately $2°$ of visual angle. Beyond $10°$, there are almost no cones. Rods, on the other hand, are primarily located outside of the fovea.

There are three types of cones, called L (long), M (middle), and S (short) for their relative spectral positions of their peak sensitivities (see Figure 26). There is only one type of rod. The activities of the rods and cones are driven by the general luminance level of a stimulus. Photopic vision (Luminance levels $>10\,\text{cd/m}^2$) refers to visual sensations when only the cones are active; scotopic vision (Luminance levels $<0.01\,\text{cd/m}^2$) when only the rods are active. Mesopic vision refers to the luminance range where both cones and rods are active. Consequently, the ability to differentiate color signals is possible only in photopic or mesopic vision conditions.

Image sensors

The physical image sensors currently on the market are either CCDs (charge-coupled devices) or CMOS (complimentary metal oxide semiconductors). The photosensitive material is silicon, a semiconductor that can relatively efficiently convert photon energy into an electrical current. The photo sites (often called pixels) are arranged either in rows (linear arrays) or in areas (area arrays).

The pixels of a CCD/CMOS capture electrons in proportion to the sensor plane (also called focal plane) exposure. Exposure H is defined as:

$$H = E \times t \qquad (8)$$

where E is the sensor plane illuminance in lux and t is time in s.

The image properties of a sensor (CCD/CMOS) depend on:

- Number of photo sites
- Photo site size
- Photo site capacity
- Noise
- Quantization gain
- Filters
- Filter arrangement

The photo site capacity (also called well or charge capacity), which is related to the photo site size, determines the saturation level. The charge capacity is the maximum charge level where the sensor response is still linear (approximately 80 percent of saturation). The more photons a pixel can absorb, the higher the dynamic range (and bit-depth) of the sensor. The dynamic range is the ratio of charge capacity to read noise, which varies from sensor to sensor (approximately 5–10 electrons for consumer quality camera CCDs).

Silicon is able to absorb photon (quanta) energy into electrical current. The *quantum efficiency* of a sensor can be measured

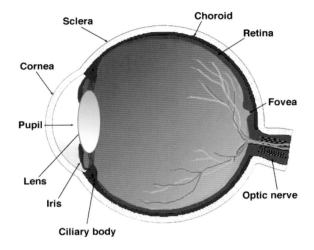

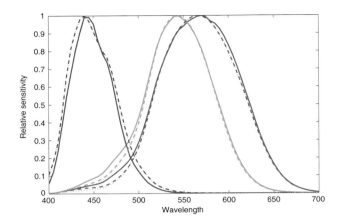

FIG. 26 The normalized cone fundamentals of Stockman and Sharpe (solid line), Smith and Pokorny (dashed line), and Vos and Walraven (dotted line).

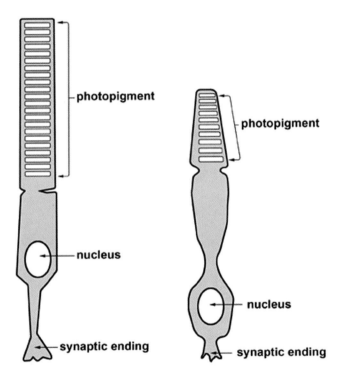

FIG. 25 Top: Cross-section of the human eye. Bottom: This graphic is a rendering of a rod and cone cell which is located in the retina. Cone cells are prdominantly found in the fovea.

for the visible spectrum, with or without the color filters. The quantum efficiency indicates the percentage of quanta that is converted to electrons (see Figure 27). For a real physical sensor, such as a CCD or CMOS, $R(\lambda)$ corresponds to the quantum efficiency function of the sensor combined with the color filters.

Physical image formation

In the case of imaging an object at spatial position x, the spectral irradiance falling on the sensor is proportional to the product of the reflectance $S(\lambda)$ and the illuminant SPD $E(\lambda)$ at that spatial position:

$$C(x, \lambda) \propto E(\lambda)S(\lambda) \qquad (9)$$

$C(\lambda)$ is called the color signal or color stimulus.[3] We ignore here surface characteristics, lighting, and viewing geometry, and assume that we can neglect all these factors that influence the color signal by using a relative SPD $E(\lambda)$ instead of physical irradiance measures. In many color imaging applications, this approximation is sufficient to model image formation.[2]

Thus, we can simplify Eq. 9 and write:

$$C(\mathbf{X},\lambda) = E(\lambda)S(\lambda) \qquad (10)$$

The color response ρ_k of a sensor k with sensitivity $R_k(\lambda)$ at spatial position x can therefore be expressed as:

$$\rho_k(x) = \int_{vs} C(x,\lambda)R_k(\lambda)d\lambda \qquad (11)$$

or

$$\rho_k(x) = \int_{vs} S(x,\lambda)E(x,\lambda)R_k(\lambda)d\lambda \qquad (12)$$

where vs indicates the visible spectrum. For many color imaging algorithms, $R_k(\lambda)$, $C(x,\lambda)$, $E(x,\lambda)$ and $S(x,\lambda)$ can be adequately represented by samples taken at $\Delta\lambda = 10\,\mathrm{nm}$ intervals over the

[3]Note that in case of imaging "light," the reflectance factor $S(\lambda)= 1$ and $C(\lambda) \propto E(\lambda)$.

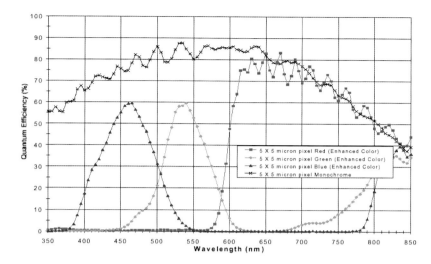

FIG. 27 The quantum efficiency of a CCD sensor. The black line indicates the quantum efficiency of the sensor itself, the colored lines of the sensor plus color filters.

spectral range of 400 to 700 nm [SSS92]. The integral in Eq. (11) can thus be replaced by summation:

$$\rho_k(x) = n\sum_{\lambda=1}^{31} C(x,\lambda)R_k(\lambda) = n\sum_{\lambda=1}^{31} S(x,\lambda)E(x,\lambda)R_k(\lambda) \quad (13)$$

where n is a normalization factor, which usually either normalizes the response $\rho_k(x)$ depending on the number of samples used (e.g. $n = \frac{1}{31}$), or ensures that $\max(\rho_k(x)) = 1$. We assume that such a normalization factor is used, and only note it explicitly when necessary.

Using algebraic notations, color signal $C(x,\lambda)$, reflectance $S(x,\lambda)$, illumination $E(x,\lambda)$, and sensor sensitivity $R_k(\lambda)$ can thus be expressed as 31×1 vectors \mathbf{c}_X, \mathbf{s}_X, \mathbf{e}_X, and \mathbf{r}_X, respectively.

Eq. (13) becomes:

$$\rho_k(x) = c_X^T r_k = s_X^T \text{diag}(e_X)r_k \quad (14)$$

where T is the transpose and diag is an operator that turns \mathbf{e}_X into a diagonal matrix:

$$\text{diag}(e_X) = \begin{bmatrix} e_{1,x} & 0 & l & l & 0 \\ 0 & e_{2,X} & 0 & l & 0 \\ m & & 0 & & M \\ m & & 0 & & M \\ 0 & l & l & l & e_{31,x} \end{bmatrix}$$

Any physical sensor can have a number of filters (or channels) with different sensitivities $R_k(\lambda)$. For the human visual system and trichromatic imaging systems, $k = 1, 2, 3$. Thus, the total color response at position x of a system with three

sensors is a vector with three entries: $\rho(x) = [\rho_1(x), \rho_2(x), \rho_3(x)]^T$. In general, the letters R, G, B are used for color responses with sensors that have their peak sensitivities in the red (long), green (medium), or blue (short) wavelength part of the visible spectrum, respectively, X, Y, Z when the sensors correspond to the CIE color matching functions, and L, M, S when the sensors correspond to cone fundamentals.

The physical image formation model of Equations 9 through 14 is a simplified model and it does not take into account any physical illuminant, surface, or sensor properties. In fact, it is applicable only to a "flat world" with no shadows, a single source illuminant, no surface reflectance interactions, and Lambertian surfaces that reflect incoming light equally in all directions.[4]

REFERENCES

[CIE86] CIE Publication No 15.2. Colorimetry. Central Bureau of the CIE, 2nd edition, 1986.

[ISO98] ISO 10526:1999/CIE S005/E-1998. CIE Standard Illuminants for Colorimetry. Central Bureau of the CIE, 1998.

[JMW64] D. B. Judd, D. L. MacAdam, and G. Wyszecki. Spectral distribution of typical daylight as a function of correlated color temperature. *Journal of the Optical Society of America*, 54:1031–1042, 1964.

[4]Such scene arrangements are usually called Mondrians, so named by Edwin Land to describe his experimental setup that resembled the paintings of Dutch artist Piet Mondrian.

[KFN01] Cone pathways through the retina. In H. Kolb, E. Fernandez, and R. Nelson, editors, *Webvision: The organization of the retina and visual system*. 2001. http://webvision.med.utah.edu/index.html.

[MMD76] C. S. McCamy, H. Marcus, and J. G. Davidson. A color-rendition chart. *Journal of Applied Photographic Engineering*, 2:95–99, 1976.

[NIS95] Guide for the Use of the International System of Units (SI). NIST Special Publication SP811, 1995.

[SSS92] B. Smith, C. Spiekermann, and R. Sember. Numerical methods for colorimetric calculations: Sampling density requirements. *COLOR Research and Application*, 17(6): 394–401, 1992.

[WS82] G. Wyszecki and W. S. Stiles. *Color Science: Concepts and Methods, Quantitative Data and Formulas*. New York: Wiley, 2nd edition, 1982. ✪

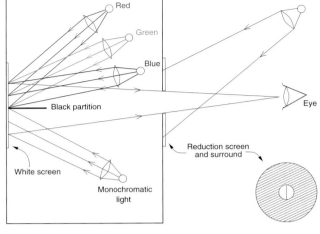

FIG. 28 Typical colorimeter set-up for color matching experiments.

Colorimetry

SABINE SÜSSTRUNK, Ph.D.
Ecole Polytechnique Fédérale de Lausanne

Trichromatic Theory of Color Vision

The trichromatic theory of color vision, also referred to as the Young-Helmholtz three-component theory [You70, vH62], assumes that the signals generated in the three cone types (*LMS*), which are independent and have different spectral sensitivities (*L* for long wavelength sensitivity, *M* for medium wavelength sensitivity, and *S* for short wavelength sensitivity), are transmitted directly to the brain where "color sensations" are experienced that correlate in a simple and direct way to the three cone signals. This theory has been found to hold in a series of color-matching experiments. The experimental laws of color matching assume that for a given observation condition, test color stimulus $C^t(\lambda)$ can be matched completely by an additive mixture of three fixed primary stimuli $C^r(\lambda)$, $C^g(\lambda)$, $C^b(\lambda)$ with adjustable radiant power:

$$C^t(\lambda) = R\, C^r(\lambda) + G\, C^g(\lambda) + B\, C^b(\lambda) \qquad (1)$$

R, *G*, and *B* are the relative intensities of $C^r(\lambda)$, $C^g(\lambda)$, $C^b(\lambda)$, respectively, and are called the *tristimulus values* of $C^t(\lambda)$. Any set of primaries can be used, as long as none of the primaries can be color matched with a mixture of the other two.

The results of color matches obey certain linearity laws, as first formulated by Grassman in 1853 [WS82]. If $C_1(\lambda)$, $C_2(\lambda)$, $C_3(\lambda)$, and $C_4(\lambda)$ are color stimuli and the symbol ≡ has the meaning of "visual match," then:

- Symmetry Law: if $C_1(\lambda) \equiv C_2(\lambda)$, then $C_2(\lambda) \equiv C_1(\lambda)$
- Transitivity Law: if $C_1(\lambda) \equiv C_2(\lambda)$ and $C_2(\lambda) \equiv C_3(\lambda)$, then $C_1(\lambda) \equiv C_3(\lambda)$
- Proportionality Law: if $C_1(\lambda) \equiv C_2(\lambda)$, then $\alpha C_2(\lambda) \equiv \alpha C_2(\lambda)$, where α is a positive factor that increases or

reduces the radiant power of the color stimulus while its relative SPD remains the same.
- Additivity Law: if $C_1(\lambda) \equiv C_2(\lambda)$ and $C_3(\lambda) \equiv C_4(\lambda)$, then $(C_1(\lambda) + C_3(\lambda)) \equiv (C_2(\lambda) + C_4(\lambda))$

These generalized laws of trichromacy ignore the dependence of color matches on the observational conditions, such as different radiant power, viewing eccentricity, stimulus surround, and adaptation to previous stimuli. To control viewing conditions, color matching experiments are therefore usually done with a visual *colorimeter*. A visual colorimeter is a device with a partitioned viewing area, where one half displays the reference color stimulus and the other half the mixture of the three primaries that can be adjusted by the observer to match the reference (see Figure 28).

Color Matching Functions

In 1931, the CIE (Commission Internationale de l'Eclairage) standardized a set of Color Matching Functions (CMFs) based on color-matching experiments by Wright and Guild [WS82] using a colorimeter with a 2-inch bipartite field. Assuming that additivity holds and the luminous efficiency function $V(\lambda)$ of the HVS is a linear combination of the CMFs, they established a set of \bar{r}, \bar{g}, \bar{b} color matching functions with "real" red $C^r(\lambda)$ ($\lambda = 700$ nm), green $C^g(\lambda)$ ($\lambda = 546.1$ nm), and blue $C^b(\lambda)$ ($\lambda = 435.8$ nm), monochromatic primaries based on the chromaticity coordinates of their experimental primaries. These \bar{r}, \bar{g}, \bar{b} CMFs [CIE86] illustrate the relative amount *R*, *G*, *B* of primaries C^r, C^g, and C^b needed to additively mix a monochromatic light source at a given wavelength (see Figure 29).

The CIE additionally standardized a set of \bar{x}, \bar{y}, \bar{z} color matching functions, based on imaginary *X*, *Y*, *Z* primaries, which are a linear combination of the color matching functions derived from the original primaries. The transform was

designed so that the $\bar{x}, \bar{y}, \bar{z}$ CMFs do not contain any negative values, primarily to design physical measuring devices, and that the \bar{y} color matching function corresponds to $V(\lambda)$ [WS82, Hun98]:

$$\bar{x}(\lambda) = 0.49\bar{r}(\lambda) + 0.31\bar{g}(\lambda) + 0.20\bar{b}(\lambda)$$
$$\bar{y}(\lambda) = 0.17697\bar{r}(\lambda) + 0.81240\bar{g}(\lambda) + 0.01063\bar{b}(\lambda)$$
$$\bar{z}(\lambda) = 0.0\bar{r}(\lambda) + 0.01\bar{g}(\lambda) + 0.99\bar{b}(\lambda)$$

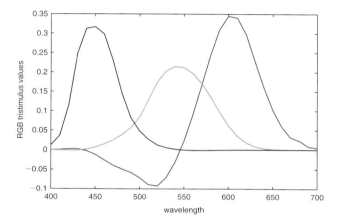

FIG. 29 CIE 1931 2° \bar{r}, \bar{g}, \bar{b} color matching functions, respectively:

$$\begin{vmatrix} X \\ Y \\ Z \end{vmatrix} = \begin{vmatrix} 0.49 & 0.31 & 0.20 \\ 0.17697 & 0.81240 & 0.01063 \\ 0 & 0.01 & 0.99 \end{vmatrix} \begin{vmatrix} R \\ G \\ B \end{vmatrix}$$

The $\bar{x}, \bar{y}, \bar{z}$ color matching functions are also called the CIE 1931 standard observer and are used for colorimetric calculations (see section 2) when the size of the stimulus does not extend 4° of visual angle. These CMFs are still an international standard today, even though Judd [Jud51] and later Vos [Vos78] proposed a modification based on a corrected luminous efficiency function, called $V_M(\lambda)$. The original $V_M(\lambda)$ of 1924 used in the derivation of the CIE 1931 CMFs underestimates the sensitivities at wavelength below 460 nm. Today, the color vision research community almost exclusively uses the Judd-Vos modified 2° CMFs [SS01], while the color science and color imaging communities still use the original CIE 1931 2° CMFs (see Figure 30).

In 1964, the $\bar{x}_{10}, \bar{y}_{10}, \bar{z}_{10}$ color matching functions for the CIE 1964 supplementary standard observer were developed by Judd [WS82], based on experimental investigations by Stiles and Burch [SB59] and Speranskaya [Spe59] with stimuli sizes of 10°.

Cone fundamentals

The color-matching functions described above are not cone sensitivities, or absorption spectra of the cone pigments. They are based on color-matching experiments, and their shape is determined by the choice of the primaries. However, if we assume that the basic principle of the trichromatic theory of color vision is correct, then cone responses also behave additively, and the cone sensitivities (also called *cone fundamentals*) are a linear combination of color-matching functions (divided by intra-ocular medium absorption spectra). While this assumption is somewhat questionable when considering the complexity of the HVS, there are advantages when modeling visual processing.

Physical measurements, such as reflectances and spectral power distributions of light sources, can easily be linearly transformed into cone responses. Using color-matching data and experimental data of color-deficient observers, several sets of cone fundamentals that are linear combinations of either 2° or 10° CMFs were published (see [SS01] for an overview and [SS03] for data). Vos and Walraven [VW71] and Smith and Pokorny [SP75] base their cone sensitivities on the modified 2° X, Y, Z color-matching functions. Stockman and Sharpe [SS00] base their 2° and 10° cone fundamentals on the Stiles and Burch 10° CMFs. Figure 31 illustrates the different 2° cone fundamentals.

As can be seen in Figure 31, the L and M cone sensitivities are very correlated—their spectral distributions overlap significantly. Additionally, they have a broad base. From the point of view of quantum efficiency, broadband sensors are able to capture more quanta and are thus more sensitive to radiation overall. However, from the point of view of coding efficiency, having two nearly identical sensors is inefficient as they both carry similar information [DB91]. As discussed below, the human visual system has found a way to de-correlate these sensor responses by its ability to encode the difference of the signals instead of the absolute responses.

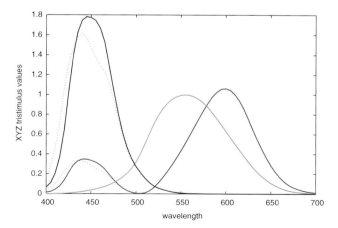

FIG. 30 CIE 1931 2° \bar{x}, \bar{y}, \bar{z} CMFs (solid line) and Judd-Vos modified 2° \bar{x}, \bar{y}, \bar{z} CMFs (dotted line).

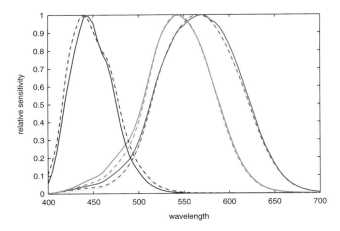

FIG. 31 The normalized cone fundamentals of Stockman and Sharpe (solid line), Smith and Pokorny (dashed line), and Vos and Walraven (dotted line).

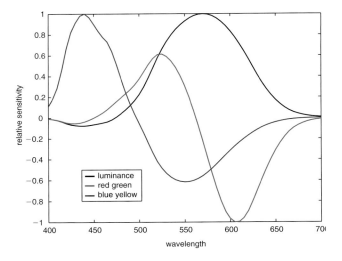

FIG. 32 The normalized opponent sensitivities of Poirson and Wandell [PW93].

Opponent color modulations

The theory of *opponent colors* is commonly attributed to Hering [Her78], although Goethe (1832) [vG91] previously discussed the concept. They both observed that certain colors are never perceived together, i.e. their names do not mix. We never see bluish-yellows or reddish-greens, where as bluish-greens (turquoise) and yellowish-reds (orange) are very common mixture descriptions. Hering also observed that there is a distinct pattern to the color of after-images. For example, if one looks at a unique red patch for a certain amount of time, and then switches to look at a homogeneous white area, one will perceive a green patch in the white area. Hering hypothesized that this antagonism between colors occurred in the retina, and that there are two major opponent classes of processing: spectrally opponent processes (red vs. green and yellow vs. blue) and spectrally non-opponent processes (black vs. white).

Experimental psychophysical support of Hering's theory was first given by Jameson and Hurvich [JH55, HJ57]. They conducted a set of hue-cancellation experiments, where observers used monochromatic opponent light to "cancel" any hue that was not perceived as unique: red was canceled with green, blue was canceled with yellow, and vice versa. Repeating the experiment for all spectral lights and using the amount of opponent light needed as an indicator, they established opponent color curves over the visible spectrum.

Subsequent physiological experiments ([DSKK58, DKL84, LH88, Hub95]) corroborated the presence of an opponent encoding mechanism in the human visual system. Additional psychophysical experiments [CKL75, WW82, SH88, PW93] have shown that such a representation correlates much better with experimental color discrimination and color appearance data than the additive theory of color vision. Figure 32 illustrates the opponent color responses Poirson and Wandell [PW93] derived from a color appearance experiment involving spatial patterns.

Luminance and opponent color sensitivities are considered to be orthogonal, and are generally modeled as a de-correlating transformation of cone fundamentals [EMG01]. Using the image formation model, this assumption allows us to derive opponent color representations from physical measurements. The red-green opponent channel is usually a function of $L - M$, the blue-yellow channel of $(L + M) - S$, and luminance of $L + M$. However, the color opponent responses are not directly related to quantum catches of the cones, due to the neural interactions in the retina. Opposition works in cone contrast, i.e. the relative cone responses compared to the environment.

Contrast can either be taken into account with a Weber-type contrast function, where the difference of stimulus and environmental (background) stimulus is normalized by the environmental stimulus. These contrast signals are then linearly transformed to opponent signals. In color science and computer vision, contrast is usually modeled by a logarithmic or power function. Color responses are normalized by the color response of the environment (a white surface or the illuminant) and then non-linearly encoded to account for lightness perception before being transformed to opponent signals.

CIE colorimetry

Colorimetry is the part of color science that deals with the measurement of physically defined color stimuli and their numerical representation. The CIE [CIE78, CIE86, CIE95, ISO98] has published several standards and recommendations pertaining to colorimetry that are summarized below. However, note that the basic principles of colorimetry remain the same, whether standardized or modified color matching functions are used.

A color response can be characterized by its relative tristimulus values X, Y, Z according to the image formation models, using physical measurements $E(\lambda)$ and $S(\lambda)$ of illuminant and surface reflectance, respectively:

$$X = K \int_\lambda S(\lambda)E(\lambda)\overline{x}(\lambda)d(\lambda)$$
$$Y = K \int_\lambda S(\lambda)E(\lambda)\overline{y}(\lambda)d(\lambda) \qquad (2)$$
$$Z = K \int_\lambda S(\lambda)E(\lambda)\overline{z}(\lambda)d(\lambda)$$

Sensors are either the color-matching functions of the CIE 1931 standard observers (2°) or the CIE 1964 supplementary standard observer (10°), dependent on the stimuli size. The CIE X, Y, Z tristimulus values follow the trichromatic color matching laws described in section 1. For example, two stimuli with equal specifications will look the same when viewed by observers with normal color vision under identical observation conditions, i.e. they color match.

K is a normalization factor that is calculated as follows:

$$K = 100 / \int_\lambda E(\lambda)\overline{y}(\lambda)d(\lambda) \qquad (3)$$

so that $Y = 100$ for a perfect diffuser and $S(\lambda) = 1$ for a perfect reflector. $E(\lambda)$ is the spectral power distribution of the illuminant.

A few more comments on Y:

■ Y represents the luminance of a color.
■ Y_L is the absolute luminance in cd/m² if $K = 1$ and $E(\lambda)$ is not normalized in eq. 2.
■ If $Y = 100$ for a perfect reflector or diffuser, then $Y_{color} =$ reflectance (transmittance) factor in percentage.
■ Most calculations are based on relative values: $Y = 100$ for the whitest point (= white point).
■ X and Z do not correspond to any perceptual attributes.

For the purpose of emphasizing relative magnitudes of the tristimulus values, which are related to color attributes, the X, Y, Z tristimulus values are often normalized by dividing by the sum of their components:

$$x = \frac{X}{X + Y + Z}$$
$$y = \frac{Y}{X + Y + Z}$$
$$z = \frac{Z}{X + Y + Z} = 1 - x - y \qquad (4)$$

The x, y, z chromaticity values therefore represent the percentage of X, Y, Z of a particular color response. x, y chromaticity values are often used to graphically represent tristimulus values. For example, the x, y chromaticity coordinates

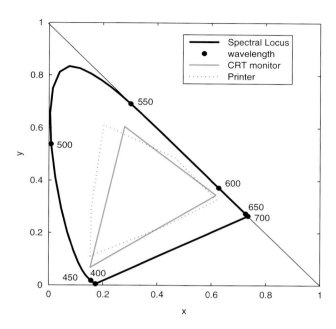

FIG. 33 The x, y chromaticity coordinates of the spectral locus and the x, y gamuts of a printer and CRT monitor.

of the CIE 1931 standard observer spectral X, Y, Z tristimulus values graphically indicate the two-dimensional gamut of the human visual system — the color coordinates that are visually achievable. In the case of CIE 1931 or CIE 1964 \overline{r}, \overline{g}, \overline{b} and \overline{x}, \overline{y}, \overline{z} CMFs, the color gamut boundary is called the *spectral locus*. The gamut of any RGB color encoding whose transformation from RGB to XYZ is known can, of course, also be plotted, as well as the gamut of any device colors (see Figure 33).

When modeling visual or imaging systems and evaluating psychophysical experiments, it is often more useful to measure or predict the *difference* of color responses rather than their actual or relative values. The X, Y, Z and x, y, z color representations are not *perceptually uniform*, i.e., equal Euclidean distances do not equate to equal perceptual color differences [Mac43, Mac44].

In 1976, the CIE therefore published additional, more perceptually uniform representations to facilitate the interpretation of color differences: CIE u',v' chromaticity diagram, CIE L^*, u^*, v^* (CIELUV), and CIE L^*, a^*, b^* (CIELAB) [CIE78].

The CIE u',v' chromaticity values are derived from X, Y, Z and x, y as follows [Hun98]:

$$u' = \frac{4X}{X + 15Y + 3Z} = \frac{4x}{-2x + 12y + 3}$$
$$v' = \frac{9Y}{X + 15Y + 3Z} = \frac{9y}{-2x + 12y + 3} \qquad (5)$$

In the CIE u',v' chromaticity diagram, perceptually equal color differences result in (almost) equal Euclidean distances. In other words, the u',v' chromaticity diagram is a better visual indicator of gamut differences of two devices (see Figure 34).

Both CIELAB and CIELUV [WS82, CIE86, Hun98] are opponent color spaces, where L^* represents the lightness of a color response, a^* or u^* its red-greenness, and b^* or v^* its yellow-blueness. The CIELUV system is commonly used for lighting and display, whereas the CIELAB system is more often used for reflecting stimuli, although the CIE did not specify any preferred usage [Rob90].

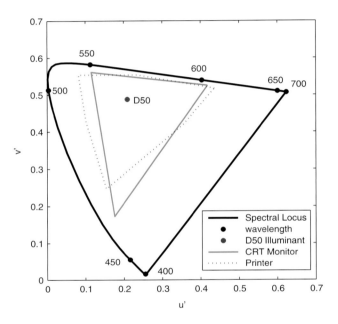

FIG. 34 The u',v' coordinates of the spectral locus and the u',v' gamuts of a printer and CRT monitor.

The transformation from X, Y, Z tristimulus values to CIELUV values is as follows [Hun98]:

$$L^* = 116 \left(\frac{Y}{Y_n} \right)^{\frac{1}{3}} - 16 \qquad \forall \frac{Y}{Y_n} > 0.008856$$

$$L^* = 903.3 \frac{Y}{Y_n} \qquad \forall \frac{Y}{Y_n} \leq 0.008856 \qquad (6)$$

$$u^* = 13L^*(u' - u'_n)$$

$$v^* = 13L^*(v' - v'_n)$$

where X_n, Y_n, Z_n are the tristimulus values of the nominally white object-color stimulus, usually the illuminant normalized to $Y_n = 100$, and u'_n, u'_n its u', v' values.

The transformation from X, Y, Z tristimulus values to CIELAB values is as follows [Hun98]:

$$L^* = 116 \left(\frac{Y}{Y_n} \right)^{\frac{1}{3}} - 16 \qquad \forall \frac{Y}{Y_n} > 0.00885$$

$$L^* = 903.3 \frac{Y}{Y_n} \qquad \forall \frac{Y}{Y_n} \leq 0.008856$$

$$a^* = 500 \left[\left(\frac{X}{X_n} \right)^{\frac{1}{3}} - \left(\frac{Y}{Y_n} \right)^{\frac{1}{3}} \right]$$

$$\qquad (7)$$

$$b^* = 200 \left[\left(\frac{Y}{Y_n} \right)^{\frac{1}{3}} - \left(\frac{Z}{Z_n} \right)^{\frac{1}{3}} \right]$$

$$\forall \frac{X}{X_n}, \frac{Y}{Y_n}, \frac{Z}{Z_n} > 0.008856$$

where X_n, Y_n, Z_n are the tristimulus values of the nominally white object-color stimulus, usually the illuminant normalized to $Y_n = 100$. If $\frac{X}{X_n}, \frac{Y}{Y_n}, \frac{Z}{Z_n} \leq 0.008856$, then $\left(\frac{X}{X_n} \right)^{\frac{1}{3}}, \left(\frac{Y}{Y_n} \right)^{\frac{1}{3}}, \left(\frac{Z}{Z_n} \right)^{\frac{1}{3}}$ in eq. 7 are replaced with $7.787F + \frac{16}{116}$ where F is $\frac{X}{X_n}, \frac{Y}{Y_n}, \frac{Z}{Z_n}$, respectively.

Color differences ΔE are then expressed as the Euclidean distance between the CIELAB coordinates:

$$\Delta E = \sqrt{(\Delta L)^2 + (\Delta a)^2 + (\Delta b)^2} \qquad (8)$$

or

$$\Delta E = \sqrt{(\Delta L)^2 + (\Delta H)^2 + (\Delta C)^2} \qquad (9)$$

where ΔH is a measure of hue difference:

$$\Delta H = \sqrt{(\Delta a)^2 + (\Delta b)^2 - (\Delta C)^2}$$

The hue angle h and chroma C are defined as:

$$h = \arctan \left(\frac{b}{a} \right)$$

$$\qquad (10)$$

$$C = \sqrt{a^2 + b^2}$$

In 1994, the CIE introduced a modified color difference formula, CIE ΔE_{94} [CIE95], which correlates better with visual perception of small color differences. It decreases the weights given to differences in ΔC and ΔH with increasing C. Equation (9) is modified as follows:

$$\Delta E_{94} = \sqrt{ \left(\frac{\Delta L}{k_L s_L} \right)^2 + \left(\frac{\Delta C}{k_C s_C} \right)^2 + \left(\frac{\Delta H}{k_H s_H} \right)^2 } \qquad (11)$$

where $S_L = 1$, $S_C = 1 + 0.045 \sqrt{C_1 C_2}$, $S_H = 1 + 0.015 \sqrt{C_1 C_2}$ and $k_L = k_C = k_H = 1$. C_1 and C_2 refer to the chroma of the two color responses under consideration.

REFERENCES

[CIE78] CIE Supplement No 2 to Publication No 15. Recommendations on uniform color spaces, color difference equations, and psychometric terms. Central Bureau of the CIE, 1978.

[CIE86] CIE Publication No 15.2. Colorimetry. Central Bureau of the CIE, 2nd edition, 1986.

[CIE95] CIE Publication No 116. Industrial Colour Difference Evaluation. Central Bureau of the CIE, 1995.

[CKL75] C. M. Cicerone, D. H. Krantz, and J. Larimer. Opponent process additivity-III. Effect of moderate chromatic adaptation. *Vision Research*, 15:1125–1135, 1975.

[DB91] J. B. Derrico and G. Buchsbaum. A computational model of spatiochromatic image coding in early vision. *Journal of Visual Communication and Image Representation*, 2:31–38, 1991.

[DKL84] A. M. Derrington, J. Krauskopf, and P. Lennie. Chromatic mechanisms in lateral geniculate nucleus of macaque. *Journal of Physiology*, 357:241–265, 1984.

[DSKK58] R. L. DeValois, C. J. Smith, S. T. Kitai, and A. J. Karoly. Responses of single cells in different layers of the primate lateral geniculate nucleus to monochromatic light. *Science*, 127:238–239, 1958.

[EMG01] R. T. Eskew, J. S. McLellan, and F. Giulianini. Chromatic detection and discrimination. In K. R. Gegenfurtner and L. T. Sharpe, editors, *Color Vision: From Genes to Perception*. Cambridge University Press, 2001.

[Her78] E. Hering. *Zur Lehre vom Lichtsinne*. Carl Gerolds & Sohn, 1878.

[HJ57] L. M. Hurvich and D. Jameson. An opponent-process theory of color vision. *Psychological Review*, 64(10): 384–404, 1957.

[Hub95] D. H. Hubel. Eye, Brain and Vision. *Scientific American Library*, 1995.

[Hun98] R.W.G. Hunt. *Measuring Colour*, 3rd Edition. Fountain Press, England, 1998.

[ISO98] ISO 10526:1999/CIE S005/E-1998. CIE Standard Illuminants for Colorimetry. Central Bureau of the CIE, 1998.

[JH55] D. Jameson and L. M Hurvich. Some quantitative aspects of an opponent-colors theory. I. Chromatic responses and spectral saturation. *Journal of the Optical Society of America*, 45(7):546–552, 1955.

[Jud51] D. B. Judd. Report of U.S. Secretariat committee on colorimetry and artificial daylight. In Proceedings of the Twelfth Session of the CIE, volume 1. Central Bureau of the CIE, 1951.

[LH88] M. S. Livingston and D. H. Hubel. Segregation of form, color, movement and depth: Anatomy, physiology and perception. *Science*, 240:740–749, 1988.

[Mac43] D. L. MacAdam. Specification of small chromaticity differences. *Journal of the Optical Society of America*, 33(1):18–26, 1943.

[Mac44] D. L. MacAdam. On the geometry of color space. *Journal of the Franklin Institute*, 238(3):195–210, 1944.

[PW93] A. B. Poirson and B. A. Wandell. Appearance of colored patterns: pattern-color separability. *Journal of the Optical Society of America*, A, 10(12):2458–2470, 1993.

[Rob90] A. R. Robertson. Historical development of CIE recommended color difference equations. *COLOR Research and Application*, 15:167–170, 1990.

[SB59] W. S. Stiles and J. M. Burch. N.P.L. colour-matching investigation: final report. *Optica Acta*, 6:1–26, 1959.

[SH88] S. K. Shevell and R. A. Humanski. Color perception under chromatic adaptation: red/green equilibria with adapted short-wavelength-sensitive cones. *Vision Research*, 28:1345–1356, 1988.

[SP75] V. C. Smith and J. Pokorny. Spectral sensitivity of the foveal cone photopigments between 400 and 500 nm. *Vision Research*, 15:161–171, 1975.

[Spe59] N. I. Speranskaya. Determination of spectrum color co-ordinates for twenty-seven normal observers. *Optics and Spectroscopy*, 7:424, 1959.

[SS00] A. Stockman and L. T. Sharpe. The spectral sensitivities of the middle- and longwavelength- sensitive cones derived from measurements in observers of known genotype. *Vision Research*, 40:1711–1737, 2000.

[SS01] A. Stockman and L. T. Sharpe. Cone spectral sensitivities and color matching. In K. R. Gegenfurtner and L. T. Sharpe, editors, *Color Vision: From Genes to Perception*. Cambridge University Press, 2001.

[SS03] A. Stockman and L. T. Sharpe. Color & vision database, 2003. http://cvrl.ioo.ucl.ac.uk/.

[vG91] J. W. von Goethe. *Zur Farbenlehre* (1832). M. Wenzel, Deutscher Klassiker Verlag, 1991.

[vH62] H. von Helmholtz. *Treatise on Physiological Optics* (1924). Dover Publications, New York, 1962. Translated by J. P. Southall.

[Vos78] J. J. Vos. Colorimetric and photometric properties of a 2° fundamental observer. *COLOR Research and Application*, 3:125–128, 1978.

[VW71] J. J. Vos and P. L. Walraven. On the derivation of the foveal receptor primaries. *Vision Research*, 11:799–818, 1971.

[WS82] G. Wyszecki and W. S. Stiles. *Color Science: Concepts and Methods, Quantitative Data and Formulas*, 2nd edition, New York: Wiley, 1982.

[WW82] J. S. Werner and J. Walraven. Effect of chromatic adaptation on the achromatic locus: the role of contrast, luminance and background color. *Vision Research*, 22: 929–944, 1982.

[You70] Th. Young. On the theory of light and colors (1802). In D. L. MacAdam, editor, *Sources of Color Science*, 51–53. The MIT Press, Cambridge MA, 1970.

Color Spaces, Color Encodings, and Color Image Encodings

SABINE SÜSSTRUNK, PH.D.

Ecole Polytechnique Fédérale de Lausanne

To clearly describe and communicate color information, the color imaging community has defined several color spaces, color encodings, and color image encodings. The following review of the definitions is based on ISO 22028 [ISO04] intended for the imaging community, and might differ from the terminology used in some articles or books. In other words, a color encoding or color image encoding is often simply referred to as a color space.

Color Spaces

According to the CIE [CIE87], a color space is a "geometric representation of colors in space, usually of three dimensions." A color space can be broadly categorized into three types: colorimetric, color appearance, and device-dependent.

For colorimetric color spaces, the relationship between the color space and CIE colorimetry is clearly defined. Besides CIEXYZ, CIELAB, and CIELUV, additive RGB color spaces also fall into this category. They are defined by a set of additive RGB primaries, a color space white-point and a color component transfer function. The additive RGB sensors are a linear combination of the XYZ color matching functions (see Figure 35):

$$\begin{vmatrix} R_{lin} \\ G_{lin} \\ B_{lin} \end{vmatrix} = M \begin{vmatrix} X \\ Y \\ Z \end{vmatrix} \tag{1}$$

where M is a (3×3) non-singular matrix mapping XYZ values to linear RGB values.

The RGB primaries associated with these sensors are the XYZ tristimulus values that correspond to pure red, green, and blue:

$$\begin{vmatrix} X_{red} & Y_{green} & X_{blue} \\ Y_{red} & Y_{green} & Y_{blue} \\ Z_{red} & Z_{green} & Z_{blue} \end{vmatrix} = M^{-1} \begin{vmatrix} 1 & 0 & 0 \\ 0 & 1 & 0 \\ 0 & 0 & 1 \end{vmatrix} \tag{2}$$

A color space white-point is the color stimulus to which the values are normalized, usually a CIE daylight illuminant such as $D50$ or $D65$. For example, a color space with a white point of $D65(X_{\omega}^{D65}, Y_{\omega}^{D65}, Z_{\omega}^{D65})$ ensures that all achromatic colors, i.e., all scalings of $(X_{\omega}^{D65}, Y_{\omega}^{D65}, Z_{\omega}^{D65})$, are mapped to equal code values.

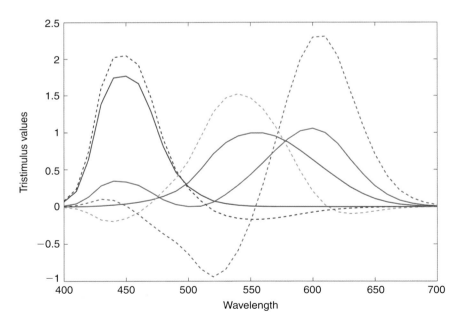

FIG. 35 The CIE 1931 XY Z color matching functions (solid line) and the sRGB [IEC99, ANS01, IEC03] RGB color matching functions.

For the tristimulus values of the white-point itself:

$$\begin{bmatrix} 1 \\ 1 \\ 1 \end{bmatrix} = M \begin{vmatrix} X_\omega^{D65} \\ Y_\omega^{D65} \\ Z_\omega^{D65} \end{vmatrix} \tag{3}$$

For example, the XY Z to sRGB [IEC99, ANS01, IEC03] transform is as follows:

$$\begin{vmatrix} 3.2406 & -1.5372 & -0.4986 \\ -0.9689 & 1.8758 & 0.0415 \\ 0.0557 & -0.2040 & 1.0570 \end{vmatrix} \tag{4}$$

When substituting Equation 4 for M in equation 3, the result for X_ω^{D65}, Y_ω^{D65}, Z_ω^{D65} is equal to 0.9505, 1.0000, 1.0890 which corresponds indeed to the tristimulus values of CIE illuminant D65, normalized to $Y = 1$. A color component transfer function is a function that accounts for the non-linear response to luminance of the human visual system or to the non-linearity of a device. The function used to model device non-linearities is usually called a gamma (γ) function. In case of CRT monitors, this gamma function approximates a power function. Color component transfer functions are thus usually modeled with a logarithmic or power function.[1] A simple gamma function could take the form of:

$$\begin{bmatrix} R \\ G \\ B \end{bmatrix} = M \begin{vmatrix} \alpha R_{lin}^\gamma \\ \alpha F_{lin}^\gamma \\ \alpha B_{lin}^\gamma \end{vmatrix} \tag{5}$$

To continue with the example of sRGB, the non-linear transfer function is a power function with an exponent of $1/2.4$ ($C = $ R,G,B and $C' = $ R',G',B'):

$$C' = \begin{cases} 12.92 \times C & \forall C \leq 0.0031308 \\ 1.055 \times C^{1/2.4} - 0.055 & \forall C > 0.0031308 \end{cases} \tag{6}$$

Luma-chroma color spaces derived from additive RGB spaces are also considered to be colorimetric color spaces. These spaces linearly transform the non-linear RGB values to more de-correlated, opponent representations. Generically, they are often referred to as YCC or YCbCr spaces. The resulting luminance and chrominance values are only loosely related to "true" perceptual luminance and chroma. They depend on the additive primaries, the color component transfer function, and the transform. Such spaces are generally the bases for color image encodings used in compression [RJ02].

[1]Note that using these definitions, CIEXYZ calculated under illuminant D65 is a different color space compared form of to CIEXYZ under illuminant A. Similarly, CIEXYZ under D65 and CIEXYZ under D65 with a logarithmic transfer function are also different.

The transform from non-linear sRGB (R',G',B') values to sYCC (Y,C_b,C_r) is as follows:

$$\begin{vmatrix} Y \\ C_b \\ C_r \end{vmatrix} = \begin{vmatrix} 0.2990 & 0.5870 & 0.1140 \\ -0.16687 & -0.3313 & 0.5000 \\ 0.50000 & -0.4187 & -0.0813 \end{vmatrix} \begin{vmatrix} R' \\ G' \\ B' \end{vmatrix} \tag{7}$$

Color appearance color spaces are the output of color appearance models, such as CIECAM97s [CIE98] and CIECAM02 [MFH+02]. They are generally based on CIE colorimetry and include parameters and non-linear transforms related to the stimulus surround and viewing environment. The color appearance color space values describe perceptual attributes such as hue, lightness, brightness, colorfulness, chroma, and saturation [Fai98].

Device-dependent color spaces do not have a direct relationship to CIE colorimetry, but are defined by the characteristics of an input or output device. For input-device-dependent color spaces, the spectral characteristics and color component transfer function of an actual or idealized input device are required, as well as a white-point. For output-device-dependent color spaces, such as CMYK, the relationship between the control signals of a reference output device and the corresponding output image is specified either using output spectra, output colorimetry, or output density.

Color image encoding describes the original's colorimetry. In most workflows, however, the image is directly transformed from raw device coordinates into an output-referred image encoding, which describes the color coordinates of some real or virtual output. If the rendered image encoding describes a virtual output, then additional transforms are necessary to convert the image into output device coordinates, which is an output device specific color image encoding (see Figure 36).

Color space encodings

A color encoding is always based on a specific color space, but additionally includes a digital encoding method. Integer digital encodings linearly specify the digital code value range associated with the color space range. The color space range defines the maximum and minimum digital values that are represented in the digital encoding. Most RGB color space ranges will typically be defined as [0, 1], while CIELAB may range from [0, 100] for L^* and [-150, 150] for a^* and b^*, respectively.

This usually means that all values smaller than the minimum value (i.e. 0, -150) and larger than the maximum value (i.e., 0, 100, 150) are clipped to the minimum and maximum values, respectively.

The digital code value range defines the minimum and maximum integer digital code values corresponding to the minimum and maximum color space values. For example, an 8-bit-per-channel encoding for an RGB color space with range [0, 1] will associate the digital code value 0 to the color space value 0, and 255 to 1, respectively. Consequently, by varying the digital code value range and/or color space range, one can derive a family of color space encodings based on a single

color space. sRGB [IEC99, ANS01, IEC03] and ROMM/RIMM RGB [ANS02b, ANS02a] are two such examples.

For example, the non-linear sRGB values ($C' = R',G',B'$) are quantized to 8-bit/channel ($C'' = R''_{8\text{-bit}},\ G''_{8\text{-bit}},\ B''_{8\text{-bit}}$) as follows:

$$C'' = \text{round}\,(255 \times C') \qquad (8)$$

The non-linear sYCC values are quantized to 8-bit as follows:

$$Y_{\text{sYCC, 8-bit}} = \text{round}(255 \times Y)$$
$$C_{b,\text{sYCC, 8-bit}} = \text{round}(255 \times C_b + 128)$$
$$C_{r,\text{sYCC, 8-bit}} = \text{round}(255 \times C_r + 128) \qquad (9)$$

Using the color space primaries and the color space range, the color encoding of a gamut can be visually represented in x, y or the more perceptually uniform u',v' chromaticity diagrams. Figure 36 illustrates the color-encoding gamuts of the sRGB and ROMM RGB primaries with a color space range of [0, 1] in x, y and u', v' coordinates. Both are additive RGB color spaces based on a linear transformation of the CIE 1931 CMF's. The encoding gamut of sRGB is smaller than that of ROMM RGB, i.e., more visible colors can be encoded in ROMM RGB than in sRGB. The sRGB sensors were optimized to encompass a CRT monitor gamut for an encoding range of [0, 1], while ROMM RGB was intended to cover the gamut of most printing colors. Note that the ROMM RGB gamut goes beyond the spectral locus, i.e., it encompasses chromaticity values that are not visible to the human eye. Thus, digital code values associated with the maximum color range values do not have perceptual meaning, and so are not "used" in the encoding of image data based on visible radiation.

Color image encodings

Color image encodings are based on a specific color space encoding, but additionally define the parameters necessary to properly interpret the color values, such as the image state and the reference's viewing environment. Image state refers to the color rendering of the encoded image. Scene-referred color encodings are representations of the estimated color space coordinates of the elements of the original scene. Output-referred color encodings are representations of the color space coordinates of image data that is rendered for a specific real or virtual output device and viewing conditions.

Reference viewing conditions need to be associated with these image states so that the color appearance can be interpreted. Generally, image surround, adapted white-point, luminance of adapting field, and viewing flare will all be specified. In case of output-referred color encodings, a reference imaging medium—either a real or idealized monitor or print—also needs to be characterized by its medium white-point, medium black-point, and target gamut.

Note that in theory, a color image encoding could be based on any color space encoding. In practice, color space encodings are usually optimized for a given image state by defining an application-specific digital code value range and color

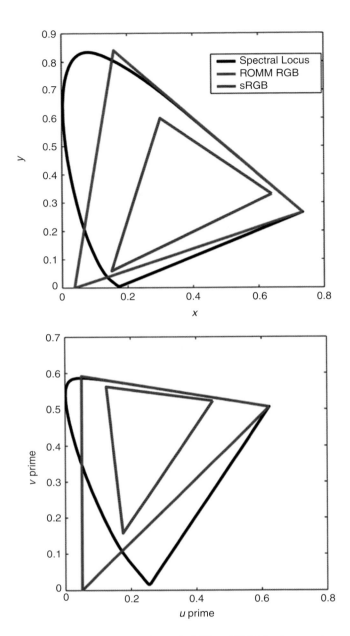

FIG. 36 Top: x, y chromaticities of sRGB and ROMM color encodings. Bottom: same in u', v' chromaticity coordinates.

space range. For example, the sRGB color image encoding for output-referred image representation is optimized for typical CRT monitor gamut and has a limited dynamic range. It is thus unsuitable for most scene-referred image data.

Digital color image workflow

The color flow of a digital image can be generalized as follows [ISO04]. An image is captured into a sensor or source device

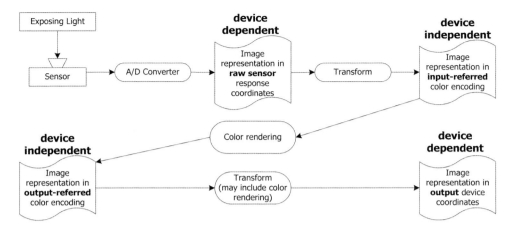

FIG. 37 Schematic representation of a digital color image workflow and the image state concept.

space, which is device- and image-specific, and contains raw device coordinates. It may then be transformed into an input-referred color image encoding, (a standard).

Standard RGB color image encodings will always describe either an input-referred or output-referred image state; most existing standard RGB color image encodings fall into the category of output-referred encodings. Source and output encodings are always device-specific.

Raw sensor response coordinates

When a scene or original is captured, either by a scanner or by a digital camera, its first color space representation is device- and scene-specific, defined by illumination, sensor, and filters. In the case of scanners, the illumination should be constant for each image. With digital cameras, the illumination can vary from scene to scene, and even within a scene. A source-specific RGB is not a CIE-based color encoding, but a spectral encoding defined by the spectral sensitivities of the camera or scanner.

When images are archived or communicated in raw device coordinates, camera or scanner characterization data—such as device spectral sensitivities, illumination, and linearization data—have to be maintained so that further color and image processing is possible. Ideally, the image should be saved in a standard file format, such as TIFF/EP, which has defined tags for the necessary information.

It is highly unlikely that there will ever be a "standard" source RGB encoding. With digital cameras, the illumination is scene-dependent. With scanners, manufacturers would have to agree on using the same light source, sensors, and filters—components that are typically selected on the basis of engineering considerations.

Input-referred image state

The transformation from raw device coordinates to input-referred, device-independent representation is image- and/or device-specific, including linearization, pixel reconstruction (if necessary), white point selection, and followed by a matrix

conversion (Figure 37). If the white point of a scene is not known, as is often the case in digital photography, it has to be estimated. The purpose of an input-referred image color space is to represent an estimate of the scene's or the original's colorimetry. An input-referred space maintains the relative dynamic range and gamut of the scene or original.

Input-referred images will need to go through additional transforms to make them viewable or printable. Appearance modeling can be applied when an equivalent or corresponding reproduction is desired, and the output medium supports the dynamic range and gamut of the original. In most applications, the goal is to create a preferred reproduction, meaning that the image is optimized to look good on a specific medium with a different dynamic range and gamut than the original. In that case, a digital photography reproduction model is applied. Input-referred image spaces can be used for archiving images when it is important that the original colorimetry is preserved so that a facsimile can be created at a later date.

The advantage of input-referred images, especially if the images are encoded in higher bit-depth, is that they can always be tone- and color-processed for all kinds of different rendering intents and output devices at a later date. The quality of the colorimetric estimate depends on the ability to choose the correct scene-adopted white-point and the correct transformations. CIE XYZ, Photo YCC, and CIELAB are all examples of color spaces that describe an estimate of the scene's or original's colorimetry and can be used to define an input-referred color image encoding. Two standard, input-referred color image encodings are ISO RGB and RIMM RGB.

Output-referred image state

Output-referred image encodings describe the image colorimetry on a real or virtual output device. Images can be transformed into output-referred encodings from either raw device coordinates or input-referred image encodings. The complexity of these transforms varies. They can range from a simple video-based approach using a linear transform and a simple

contrast ("gamma") adjustment to complex, image-dependent algorithms. The transforms are usually non-reversible, as some information of the original scene encoding is discarded or compressed to fit the dynamic range and gamut of the output. The transforms are image-specific, especially if pictorial reproduction modeling is applied. The rendering intent of the image has therefore been chosen, and may not be easily reversed. For example, an image that has been pictorially rendered for preferred reproduction cannot be re-transformed into a colorimetric reproduction of the original without knowledge of the rendering transform used.

Output-referred image encodings are usually designed to closely resemble some output device characteristics, which insures that there will be a minimal loss when converting to the output-specific space. Most commercial image applications only support 24-bit image encoding, making it difficult to make major tone and color corrections at that stage without incurring visual image artifacts. Some rendered RGB color-image encodings are designed so that no additional transform is necessary to view the images; in effect, the output-referred RGB color space is the same as the monitor output space. For example, sRGB is an output-referred image encoding that describes a real output device (CRT monitor) and as such is equivalent to a device encoding.

sRGB is currently the most common output-referred encoding. All consumer cameras output sRGB-encoded files, and many professional cameras allow that option also. Another popular output-referred encoding is Adobe RGB, which allows encoding of more colors than the rather limited gamut of sRGB. ProPhoto RGB (ROMM RGB) is a standard output-referred image encoding optimized for print reproduction.

Output device coordinates

Transforms from output-referred RGB color image encodings to output device coordinates are device- and media-specific. If an output-referred space is equal or close enough to real device characteristics, such as "monitor" RGBs, no additional transformation to device-specific digital values is needed. In many cases, however, there is a need for additional conversions. For most applications, this can be accomplished using the current ICC color management workflow. An "input" profile maps the reproduction description in the output-referred encoding to the profile connection space (PCS), and the "output" profile maps from the PCS to the device- and media-specific values.

Aside from graphic arts applications, images today are rarely archived and communicated using output-device coordinates, such as device- and media-specific RGB, CMY, or CMYK spaces. However, many legacy files, such as CMYK separations and RGB monitor-specific images, need to be color managed so that they can be viewed and printed on other devices.

REFERENCES

[ANS01] ANSI/I3A IT10.7667. Electronic still picture imaging-extended sRGB color encoding e-sRGB, 2001.

[ANS02a] ANSI/I3A IT10.7466. Electronic still picture imaging-reference input medium metric RGB color encoding RIMM-RGB, 2002.

[ANS02b] ANSI/I3A IT10.7666. Electronic still picture imaging-reference output medium metric RGB color encoding ROMM-RGB, 2002.

[CIE87] CIE Publication No 17.4. International Lighting Vocabulary. Central Bureau of the CIE, 1987.

[CIE98] CIE Publication No 131. The CIE 1997 interim Colour Appearance Model (simple version). Central Bureau of the CIE, 1998.

[Fai98] M. D. Fairchild. *Color Appearance Models.* Addison-Wesley, Reading, MA, 1998.

[IEC99] IEC 61966 2-1:1999. Multimedia systems and equipment—colour measurement and management—Part 2-1: colour management-default RGB colour space—sRGB, 1999.

[IEC03] IEC/ISO 61966 2-2:2003. Multimedia systems and equipment—colour measurement and management—Part 2-2: colour management—extended RGB colour space—scRGB, 2003.

[ISO04] ISO 22028-1:2004. Photography and graphic technology—extended colour encodings for digital image storage, manipulation and interchange—Part 1: architecture and requirements, 2004.

[MFH+02] N. Moroney, M. D. Fairchild, R.W.G. Hunt, C. Li, M. R. Luo, and T. Newman. The CIECAM02 color appearance model. In *Proceedings of IS&T/SID 10th Color Imaging Conference*, 23–27, 2002.

[RJ02] M. Rabbani and R. Joshi. An overview of the JPEG2000 still image compression standard. *Signal Processing: Image Communication*, 17(1):3–48, 2002. ⊙

Color Management

SABINE SÜSSTRUNK, Ph.D.
Ecole Polytechnique Fédérale de Lausanne

Introduction

Color management is a term that describes the standards, tools, and applications used in color reproduction to insure that the appearance of color image is what the user intended. As a direct result of the different physical characteristics of input and output devices and media, as well as the viewing conditions under which we capture or view color data, certain colors may not be captured or reproduced correctly by certain devices in various applications. The same document, for example, may look different when printed on different printers, viewed on different monitors, printed on a printer and viewed on a monitor, or viewed in a light booth and under office lighting. Devices, drivers, operating systems, and applications also can all interpret and reproduce colors differently. Color management takes into account these issues by providing transformations

from source to destination, taking into consideration the color characteristics of both devices as well as the viewing conditions.

The International Color Consortium (ICC) is an industrial consortium that has standardized most of the color management architecture applied in color reproduction today. The ICC defines color management as the "communication of the associated data required for unambiguous interpretation of color content data, and application of color data conversions, as required, to produce the intended reproductions." [5]. Color content includes pictorial images, but can also be text, line art, and graphics. In this section, the discussion will be limited to ICC color management. Note that the ICC specifications are still evolving, and the specifications [ICC04] and the ICC website (www.color.org) are available for more information.

ICC color management architecture

It is always possible to design a color transform that maps the digital code values from one device to another, based on some color-rendering criterion and specific viewing conditions. However, such a system would not be very general: For each new device, rendering intent, and viewing condition a new transform would have to be designed. The ICC color management architecture thus provides a way to map from a device-specific color space to a standard color space, and vice versa. The transforms from device to standard color space are embedded in the ICC profile. The standard color space is called profile connection space (PCS).

ICC profile

The ICC profile contains the transforms from "device" to PCS. There are several kinds of profiles specified: input device (scanner, digital camera, etc.), output device (printers, film recorders, etc.), and display (CRTs, LCDs, projectors, etc.), but also device link (dedicated device-to-device), color image encoding (sRGB, CIE XYZ, $L^*a^*b^*$, etc.), abstract (effects, PCS-to-PCS, etc.), and named color (Pantone, Truematch, etc.). The profile architecture is thus not restricted to actual physical devices, but can contain any kind of color transform from source to destination.

The color transformation is implemented as a series of look-up-tables (LUTs) and matrices, depending on the complexity of the transform, the PCS color space, and the number of colorants of the device. A profile may also contain more than one color transformation to accommodate different rendering intents. A rendering intent describes a different mapping of color values that may be useful for various imaging workflows. The colorimetric intents preserve the colorimetry of in-gamut colors at the expense of out-of-gamut colors. The mapping of the out-of-gamut colors is vendor-specific. The perceptual and saturation rendering intents modify colorimetric values to account for different devices, media, and viewing conditions.

The media-relative colorimetric intent maps the white-point of the actual medium to the white-point of the PCS illuminant

and rescales the in-gamut color accordingly. The ICC-absolute colorimetric intent applies a chromatic adaptation to map the white-point of the illuminant to the PCS illuminant, but then does not change the (chromatically adapted) in-gamut colors. The media-relative colorimetric transform is useful for colors that have already been mapped to the intended reproduction colorimetry, whereas the ICC-absolute colorimetric transform is useful for spot colors and when simulating one medium on another in proofing applications. Both of these transforms are based on actual colorimetric measurements of an input or output device under specific viewing conditions. The saturation intent is used to render graphics and text. The transforms are vendor-specific, and usually involve tradeoffs for hue to maintain maximum saturation. The perceptual intent is used for general reproduction of images, particularly pictorial or photographic-type images. The goal here is to obtain best appearance on a given output, and not a colorimetric match. The PCS value thus represents the appearance of an image, viewed in the reference viewing environment by a human observer adapted to that environment.

Profile Connection Space (PCS)

The PCS color space is either CIELAB or CIE XYZ under illuminant D50, encoded as either 8 bits or 16 bits per channel for CIE Lab or 16-bit for CIE XYZ. To accommodate the perceptual intent, a reference medium and viewing conditions are also defined. The reference medium is a hypothetical print on a substrate with a white having a neutral reflectance of 89 percent and a density range of 2,4593. The viewing reference corresponds to a graphics arts and photography print comparison environment using a D50 illuminant at an illumination level of 500 lux.

Color Management Module (CMM)

The ICC profile is a file that can be embedded in a color document. The following file formats support the inclusion of an ICC profile: TIFF, EPS, PICT, JFIF, JP2, EXIF, and GIF, as well as proprietary formats. An ICC profile can also reside separately. The common extension for an ICC profile is .icc in the Apple OS and .icm in Windows OS.

The conversion of a document's color data using ICC transforms is done in a color management module (CMM). A CMS can either be a standalone application or be embedded in an application (such as Adobe Photoshop), a device driver, or the operating system (Apple Color-Sync). According to source, destination, and rendering intent, a CMM converts the color data of a document by concatenating the transforms given by the source and destination profiles.

REFERENCES

[5] ICC White Paper No. 5. Glossary. http://www.color.org.
[ICC04] ICC.1:2004-10. File format specification for color profiles (version 4.2.0), 2004. ◉

Color Management in the Future

JEAN-PIERRE VAN DE CAPELLE, Ph.D.
Xerox Corporation

Today's color management in the commercial printing community is dominated by two types of workflows: ICC workflows [1] and more traditional, "device CMYK" workflows. In many cases the device CMYK workflows use ICC color management in the prepress arena to convert digital RGB images to CMYK. Consequently, one could argue that ICC workflows actually dominate the space. For many applications, ICC-based color management fulfills most of the needs of the typical CMYK printing used by a large number of commercial printers, irrespective of how the print-stream data is formatted or which color space is used within that print stream. As such, one should realize that the incremental economic value of different, future color management systems will be relatively small for this market. One can argue that most of the needs of the commercial printer were already fulfilled with the ICC version 2 or version 3 specifications, and that the incremental value of the version 4 specification is rather small. This version provided some clarification as well as rendering intents for input and display devices. This does not mean that today's color management has no problems. The remaining problems are often of a very fundamental nature, such as device color stability, significantly different device color gamut, or the influence of the illuminant on the color rendition of the printed material, which can include metamerism and fluorescence. Metamerism is a psychophysical phenomenon commonly defined as a situation in which two samples of a color match under one illumination condition, but fail to match under another condition.

For other applications, industries, and markets such as packaging, security, decoration, silk, ceramics, automotive, photofinishing, medical imaging, and biological imaging, ICC color management is not sufficient to meet daily needs. Some of the requirements of those applications may also apply to smaller segments of commercial printing; for instance when metallic or spot inks are used, or when there is a need for using automated corrections in the workflow, such as "red eye" removal or contrast adjustments.

In addition to this, color management is almost unilaterally perceived as complex and tedious, and in many cases it is actually expected to work without too much effort. This desired ease-of-use state has not yet been achieved.

In 1993, when the ICC was founded, the agreed-upon principle for color management implied that color rendering is predominantly determined by the data in the profiles and, to a far smaller degree, by the color transformation engine, known as the Color Management Module (CMM). This is often referred to as a "dumb" CMM, and "smart" profiles. One of the main reasons for this choice was the compute-intensive nature of a "smart" CMM. One of the problems with this approach is

that the "intelligent" profiles from different vendors may not work together as well as desired. Given increasingly faster CPUs, this paradigm could be reversed and profiles could be made "dumb"—in other words, to only reflect the device response—and the CMM could be made smart, determining how the color rendering will be done and incorporating the effects of different device color gamuts and viewing conditions. In theory it would even be possible to adapt the color-gamut mapping to the gamut of the image in its "original" color space and the available gamut of the reproduction device to represent this image. This would possibly lead to better reproductions of each individual image. It would also mean that profiles provided by different vendors would be more compatible with one another.

As such there are opportunities for improved color management technologies beyond ICC in different areas of the supply chain, from design to print production and finishing. The landscape implies that there are different futures for color management technology, depending on the type of application and market.

Within its new Vista OS, Microsoft, with its new Windows Color Management System (WCS), has chosen the "smart CMM, dumb profile" paradigm for color management, while maintaining support for the traditional ICC workflows [2]. From the disclosures provided by Microsoft, WCS does not yet provide image-dependent color management. It is worth noting that the procedures used with high-end reprographic scanners in the past incorporated image-dependent and often localized processing techniques, such as black-point and white-point settings, cast removal, tone curve corrections, selective color correction, etc. These procedures were very much dependent on human interaction and judgment, and they usually led to high-quality reproductions at a considerable price, because color was understood by few and the scanner operators were therefore well paid. The incremental economic value of WCS over the current ICC-based workflow remains to be established.

Generally there are a couple of larger technological areas that constitute the incremental fundamentals needed for different applications:

1. Special materials and application, such as metallic substrates and multi-ink or special (non-CMYK) ink systems, and also medical or biological samples.
2. Automated color processing for preferential rendering, automatic tagging, and retrieval of images in searchable image databases.

Additionally there is the underlying assumption that the ease of use for any color management system should improve.

An example of technologies developed in the first main area includes spectral characterization of inks in multi-ink printing processes [3]. Examples of technologies being developed in the second area include "Smart CMMs", such as WCS, and Automatic Image Enhancement for photofinishing applications [4].

Some people may argue that some of these technologies, such as segmentation and image content recognition (ICR), are not strictly color management, but should be considered complementary technologies. Segmentation, for instance, can be used in object-oriented rendering, and ICR can be used for preferred pictorial rendering.

REFERENCES

[1] http://www.color.org/.

[2] Lavanya Vasudevan, Michael Stokes, Windows Color System Overview, http://www.microsoft.com/windowsxp/using/digitalphotography/prophoto/colormgmt.mspx.

[3] http://www.esko-graphics.com/ep/template.asp?ep=95.

[4] http://www.xerox.com/downloads/usa/en/f/FILE_PROD_DC_5000_DocuSP_Specs.pdf. ◎

Digital Camera Raw

GREG BARNETT
Rochester Institute of Technology

Many innovations have come and gone in digital photography's brief existence. However, one major advance that has a bright future and offers precise controls to digital photographers is the camera raw file. At its most fundamental level, the raw file produced by a digital camera is a recording of the sensor data. At the time of capture, it is unprocessed data that represents the luminosity values recorded by each photo site. In photographic terms, the raw file can be considered analogous to the latent image on an unprocessed piece of film. Digital raw does have one benefit never available to film-based photographers, which is the ability to infinitely reprocess the image whenever required.

Currently, the two most widely used sensor technologies found in digital cameras are CCD (charge-coupled device) and CMOS (complimentary metal oxide semiconductor). These sensors record the luminosity values of a scene based on the actual number of photons reaching each sensor site. An electrical signal is generated and is passed on the analog to digital converter, which is then recorded in the file as the raw data. The image data that is produced is grayscale and does not contain color information as we might expect to see it.

Color information is created by way of a CFA (color filter array) that is overlaid on the sensor. In most cases, the metadata corresponding to the color values recorded for each sensor site is included in the file. Also referred to as a mosaic or striped array, the most common arrangement is the Bayer pattern. This pattern provides twice as many green filters to simulate the heightened response of human vision to the green region of the spectrum. The arrangement consists of alternating arrays of red/green and green/blue filters. There are variations of this pattern used by some camera manufacturers that incorporate a fourth color such as emerald in an attempt to boost color fidelity. An alternate technology invented by

Foveon uses three separate filter layers of photo sensors, which effectively allows for full color data at each pixel and does not require demosaicing.

Demosaicing is the process used to extract the color characteristics and layout of the filter array during file processing. This is accomplished with complex algorithms that must also interpolate missing color information (each pixel or sensor site can only record one color value) from the neighboring pixels to create an accurate representation of the original scene. And depending on the algorithm, the process may also map out "hot" or "dead" pixels that were detected within the image.

For a raw file to become recognizable as an actual photographic image, it must undergo further processing, or conversion. This conversion can take place within the camera using built-in algorithms and settings or by using an external, standalone software program. In-camera processing provides the benefit of files (typically JPEG) that are immediately ready for use without further processing. The downside to this approach is that all of the camera settings (JPEG compression, white balance, tone cure, sharpening, etc.) are then "baked" into the finished file. Alterations to the file must then be performed in an image-editing program such as Adobe Photoshop.

The fullest and most powerful features of the raw file reside with the post-processing potentials afforded by standalone converters. Raw files can be processed any number of times, making the image highly functional in many applications. The actual raw image data is never altered. Metadata descriptions of the edits and adjustments are recorded by the processing software and used for rendering a new version of the file to a format such as TIFF, PSD, or JPEG. This also allows for future reprocessing as conversion software continues to improve and evolve. Imagine being able to go back and process a negative from several years ago with a new developer that can extract more detail than was originally thought possible! This is an advantage that simply does not have a parallel in silver halide-based photography.

A further distinction should be noted about the benefits of post-processing: The only camera settings that truly impact the raw data are ISO, f-stop, and shutter speed—in other words, the actual exposure at the moment of capture. All other camera settings are just recorded as metadata tags and, unless using the manufacturer's raw converter, will (can) be totally ignored.

At this time, each camera manufacturer typically provides a proprietary software solution for their raw file processing. There are also many third-party converters that can process files from a number of different cameras. The Adobe Camera Raw (ACR) plug-in is a universal raw converter included with Adobe Photoshop. It supports a large number of file and camera types and is updated regularly as new models are introduced.

In addition to the demosaicing, other steps in the conversion process include colormetric interpretation, white balancing, tone mapping (gamma correction), noise reduction, anti-aliasing, and sharpening of the image data.

The colorimetric interpretation is where the RGB values are assigned to each pixel based on the luminance levels recorded through the color filters. This is typically done using

a colorimetrically defined color space such as CIE XYZ. These values can then be further converted to a specific RGB color working-space destination such as Adobe 1998, sRGB, or ProPhoto.

White balancing is the process of assigning the actual color of the light under which the scene was captured. This is recorded by the camera via the built-in white-balance feature. Most cameras provide several presets based on typical lighting situations, a custom white-balancing option, and the "as shot" setting, which attempts to read the subject as the exposure is taken. White balance can also be determined and/or reassigned in the post-processing stage, independent of the camera settings.

Raw image data is recorded in a linear fashion (a direct correlation between the number of photons captured by a sensor site and the recorded tonal value) that subsequently requires tone mapping or gamma correction to be opened. If viewed without conversion, the image would appear extremely dark and virtually unrecognizable. A gamma correction remaps all of the tonal values to more closely correspond to the way our eyes might interpret image. The linear response of the sensor is totally unlike film, which was designed to mimic human vision.

Many of the current digital SLR cameras use 12 bits of data to encode the capture, resulting in a total of 4096 possible discreet tonal levels. These cameras also have a dynamic range of approximately six stops of useable exposure. Because of the linear distribution of the levels, half (2048) are contained within the brightest f-stop of exposure. In a logarithmic function, the remaining levels are then halved (2048, 1024, 512, 256, 128, 64) for each stop as you progress downward in the tonal scale. By the time you get down to the last stop, there are precious few levels available for the deepest shadows. This has significant implications for correct exposure, and a new paradigm has emerged: "expose to the right," or what might be characterized as exposing for the highlight values of the scene.

Fundamentally, the concept is that photographers should expose to fully populate the brightest areas of the scene without overexposing and blowing out the highlights. This is, of course, highly dependent on the scene luminance and dynamic range of the camera sensor. The term *expose to the right* implies pushing the raw image histogram all the way to the right side, just short of clipping. Clipping refers to pushing highlight pixels all the way to pure white (or black at the other end) and thus losing detail. You then take advantage of this data-rich area of the image and use the tone-mapping controls of the raw converter to more fully populate the mid-tones and shadows. One of the benefits of this technique is that it can help reduce noise in the shadows. Another way of considering this potential is to remember that when working with a raw file, it is almost always better to darken the image (add levels to the shadows) rather than lighten it (pull levels out of the shadows).

Unfortunately, the exposure-metering systems in today's cameras are still designed to produce a middle gray exposure that will yield a pleasing JPEG when processed through the camera. Exposing to the right requires exposure testing

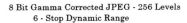
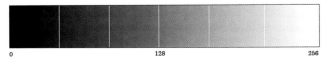
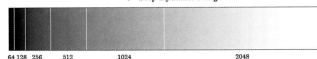

FIG. 38 A graphical representation of the levels placement for an 8 bit JPEG file and a linear 12 bit digital camera raw file. Image courtesy of author.

to determine the response of the sensor so that it can be properly calibrated and matched to the meter's performance requirements.

Noise reduction, anti-aliasing, and chromatic aberration correction are other functions that can be performed in the conversion process. These can help reduce color artifacts introduced at the pixel level. Sharpening may also be performed at this stage but it is usually global in nature and perhaps best left to more specialized software further down the imaging pipeline.

The term "camera raw file" encompasses a large number of different proprietary file formats produced by the various camera manufacturers. As a consequence, photographers now find a modern-day dilemma that has no parallels in the pre-digital photography era. In almost all cases, these manufacturer file formats are unique to a specific camera model and are not publicly documented. Universal converters such as the aforementioned Adobe Camera Raw have worked around this issue by extensive reverse engineering and decoding of these file formats. There is a danger, however, that proprietary data may sometimes be missing from this process and that only the camera manufacturer's software can fully interface with all of the camera-specific metadata. This is akin to being forced to use film and processing provided only by the camera manufacturer. A further issue arises: As these cameras cease to be manufactured and, subsequently, supported, these proprietary raw files may become "orphaned" and no longer convertible. There are already examples of this happening and the problem is sure to worsen with time.

A solution to this dilemma has been provided by Adobe in the form of a universal, fully documented, open-source raw file format called DNG (digital negative). Based on the TIFF-EP format, DNG provides a standardized container for both the raw data and also the associated metadata. By insuring that all metadata is written in a standard way and in known locations, it eliminates the danger of files becoming unreadable

as older conversion software ceases to function with updated hardware and operating systems. Since it is an open format, any hardware or software vendor can use the provided SDK (software development kit) to build DNG compatibility into their product.

DNG is an evolving specification and provides for backward compatibility with earlier versions. It may very well become the much-needed missing component in raw file archive-ability. Adoption is slowly growing and increased pressure from photographers on the camera manufacturers to adopt a universal standard can only speed this process along. ⊚

Digital Image Processing

LUKAS ROSENTHALER, Ph.D.
University of Basel

Introduction

Digital images do not have a physical existence; rather, they are digital data that represents the image. It is only through screen display or hard copy that the data becomes a real physical image. This axiomatic fact should always be kept in mind when dealing with digital images. Digital data representing an image must always be converted by some technical means (such as an LCD screen or a beamer) into an analog distribution of light for humans to perceive as image. The digital representation of an image—the "digital image"—can be created, manipulated, and analyzed by computer algorithms. These functions also form the three basic families of computer algorithms that deal with digital images. These three families can be described as follows:

1. Data → image: image creation, computer graphics
 Within this family, data is converted into images. Computer graphics create images out of geometric, three-dimensional data that can describe a scene, including surface characteristics and illumination of the scene. The photorealistic rendering uses mathematical methods, such as ray tracing and radiosity, which rely on mathematical models of how light propagates and interacts with material, to generate images with a very high degree of "reality." These methods are often used in the motion picture industry to generate special effects.

 If there is scientific data to be presented and subsumed for a human observer, a *visualization* is often a very suitable way to accomplish this. Visualization methods depend highly on methods of computer graphics to present "virtual objects" that illustrate scientific findings to the human observer

2. Image → image: image processing
 Image processing is used to manipulate and modify digital images. Applying image processing routines to a digital image will again result in a digital image, which differs from the original image. This family of methods will be the main focus of this section.

2. Image → data: image analysis, pattern recognition
 Image analysis deals with the problem of extracting data from a digital image. From this point of view, photogrammetry is the inverse of computer graphics: It attempts to extract geometrical data out of images. Image analysis is still a very active field of research with many open problems.

Digital representation of images

To be processed, a digital image has to be represented in computer memory. A computer memory can be considered to be a labeled, linear array of memory cells where each cell holds a value (a number between 0–255 for an 8-bit memory cell and between 0–65535 for a 16-bit memory cell). The label of a cell is also called the "address" of the cell and is used to reference the cell for accessing its value (or "content"). Usually the labels are numbers. In fact, the computer memory resembles a vast cabinet with a lot of drawers, each drawer containing a sheet of paper with a value written on it. All the drawers are consecutively numbered from 0 to n (n being the number of drawers).

A digital image is a subset of the computer memory, in which each memory cell holds a numerical value that represents the brightness, luminosity, or optical density at a predefined position of the image, usually called a pixel. Normally the memory cells are ordered so that the first cell represents the value at the upper left corner of the image, the next cell represents the next value to the right, etc. In case of color or multispectral images, several memory cells are used for each location. The way the memory cells are ordered with respect to their position in the image can differ and may be adjusted to the type of processing required. The following example shows the geometrical arrangement of image data starting at address 100–124 (representing an image of 5 × 5 pixels) where the lowest address represents the upper left corner and the highest address represents the lower right corner of the image.

100	101	102	103	104
105	106	107	108	109
110	111	112	113	114
115	116	117	118	119
120	121	122	123	124

For all of the following examples, this arrangement of pixel values is assumed. Figure 39 shows a gray value image where in each memory cell the brightness value (0 = black, 255 = white) is stored.

Usually, a digital image is treated as a two-dimensional matrix with n_x pixels in horizontal and n_y pixels in vertical direction. The mathematical notation is then as follows:

$$I = f(i, k) \quad \text{where } i = 0 \ldots (n_x - 1), k = 0 \ldots (n_y - 1)$$

Image processing now applies algorithms to this matrix of numerical values, which modify these values.

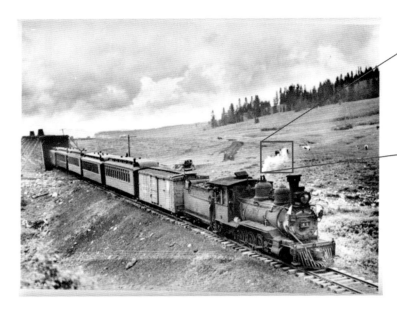

```
155 158 152 153 159 160
156 159 155 155 161 160
152 155 157 160 159 151
159 167 180 175 177 151
170 179 190 201 199 188
191 211 220 206 202 200
209 221 231 212 205 199
218 236 220 230 222 219
221 238 240 231 218 222
225 237 241 228 222 219
```

FIG. 39 Gray value image where memory cell values represent the brightness at a given location. Image courtesy of the author.

Point operations

Point operations are modifications of pixel values, where the new pixel value depends only on the previous value at the same pixel. These operations are used to adjust the brightness dependence of the previous brightness at a given position. For example, if each pixel's brightness-value is divided by 2, the image appears much darker. Figure 40 is an example of a point operation.

Mathematically, this operation would be noted as follows:

$$f'(i,k) = f(i,k)/2$$

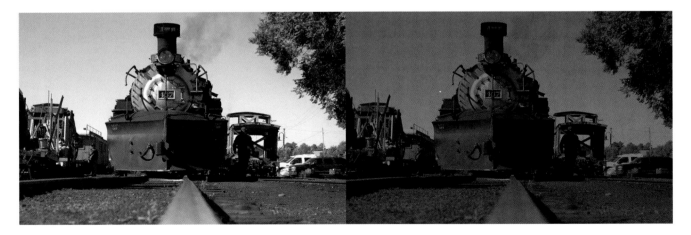

FIG. 40 On the left side is the original image; on the right side the modified image, where each pixel value has been divided by 2. Image courtesy of the author.

In a C[1]-like pseudo code the program would be:

```
for (int k = 0; k < ny; k++) {
        for (int i = 0; i < nx; i++) {
                img[k*nx + i] = img[k*nx + i]/2;
        }
}
```

Please note the rather complex addressing of the pixel. The term $k*nx + i$ is required to translate the two-dimensional matrix of the pixels to the one-dimensional property of computer memory. This snippet of program code applies the transformation (division by two) to each pixel of the image. Point operations are used to adjust brightness, contrast, and gamma.[2]

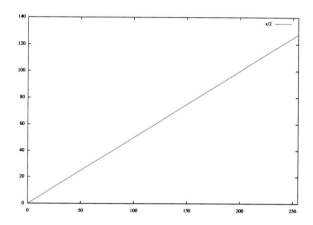

FIG. 41 Graph of point operations $f(i,k)/2$.

Point operations may be visualized by a simple graph, where the x-axis denotes the input values (from 0–255) and the y-axis denotes the output values. The above transformation would be described by the following graph (Figure 41).

Histogram

A common tool for the analysis of the brightness values of an image is the histogram, which plots the frequency of each brightness value. See the shapes of the histograms in Figure 42 for the images in Figure 40.

Arithmetical operations

Arithmetical operations are point operations, which involve different images. To perform this kind of image manipulation, all involved images must have the same dimensions in x and y; that is, they must have the same width and height in pixels. Some of the most prominent arithmetical operations are:

- Difference of two images
- Weighted addition

Figure 43 shows an example of an image difference. The first image is an uncompressed TIFF image; the second image is the same image, but in a heavily compressed JPEG format. The difference image (contrast-enhanced) clearly shows the artifacts introduced by the lossy compression of the JPEG algorithm.

Figure 44 shows how two images can be merged with a third image supplying the coefficients. The mathematical formula is as follows:

$$I(i,k) = I_1(i,k) * K(i,k) + I_1(i,k) * (K(i,k) - 1.0)$$

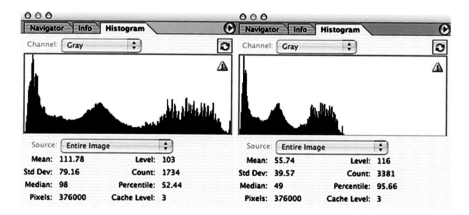

FIG. 42 Histograms for the images in Figure 40. The histogram on the right clearly shows that the image contains no more bright values (the maximal pixel value will be 255/2 = 127).

[1]C is a widely used programming language.
[2]"Gamma" is a non-linear function, e.g. $f'(i,k) = f(i,k)^r$, $r = 1.8$ applied to the pixel values. It is used to compensate for luminance characteristics of computer displays.

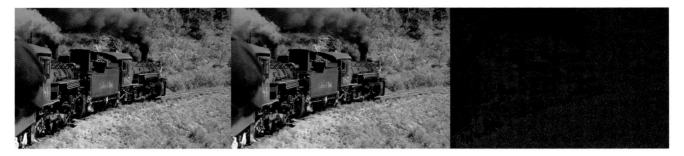

FIG. 43 Example of an arithmetical operation on images: the left image shows an uncompressed version; the middle example is compressed using lossy JPEG compression. The right image shows the difference between the uncompressed and compressed image. Image courtesy of the author.

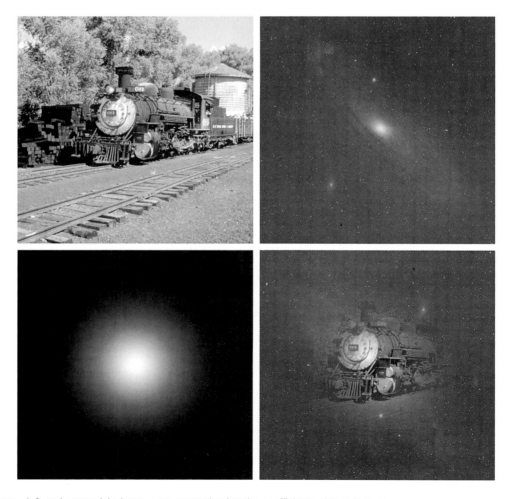

FIG. 44 The upper left and upper right images are merged using the coefficients shown in the lower left image. The result of this arithmetic operation is shown in the lower right image. Image courtesy of the author.

I_1 and I_2 are the two input images; K is the image containing the weights. It is important to note that the image K has to be normalized to a value range between 0.0 and 1.0.

Geometrical transformations

Often, digital images have to be geometrically transformed. Common examples are the image rotation, correction of optical distortions, and rectification of aerial images. Geometrical transformations create a new image in which the pixels of the original image are at different locations as given by the transformation:

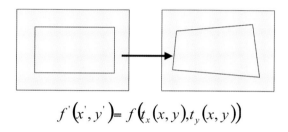

$$f'(x', y') = f(t_x(x, y), t_y(x, y))$$

FIG. 45 Geometrical transformation of an image.

An example of such a transformation is the affine transformation, which is quite common (image rotation, perspective distortion, etc.):

$$x' = a_x x + b_x y + c_x$$
$$y' = a_y x + b_y y + c_y$$

The problem with this kind of geometrical transformation is that the new pixel location may fall in between the pixels. In general, the procedure is as follows: For each pixel in the new image, the position of this pixel in the original image is calculated. If the position is not exactly at the center of a pixel in the original image, the value is interpolated. The simplest interpolation is to take just the value of the nearest pixel (Nearest Neighbor interpolation). A better way is to perform a bilinear interpolation, as shown in Figure 46.

Neighborhood operations (convolution)

Neighborhood operations modify the pixel values depending on the value of the pixel that is processed at a given position and values of the surrounding pixels.

Linear neighborhood operations

Linear neighborhood operations calculate the weighted sum of the neighborhood of each pixel. The resulting pixel values are inserted into a new image so that the original pixel values still are available for calculating the next weighted sum. This kind of operation is also called a convolution; the matrix with the weights is called the kernel of the convolution. The kernel

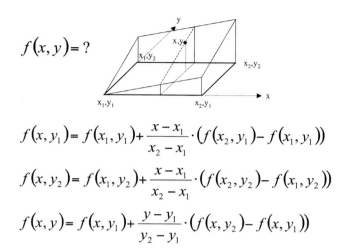

$$f(x, y) = ?$$

$$f(x, y_1) = f(x_1, y_1) + \frac{x - x_1}{x_2 - x_1} \cdot (f(x_2, y_1) - f(x_1, y_1))$$

$$f(x, y_2) = f(x_1, y_2) + \frac{x - x_1}{x_2 - x_1} \cdot (f(x_2, y_2) - f(x_1, y_2))$$

$$f(x, y) = f(x, y_1) + \frac{y - y_1}{y_2 - y_1} \cdot (f(x, y_2) - f(x, y_1))$$

FIG. 46 Bilinear interpolation as used in geometrical transformations of digital images. Often, even a bi-cubic interpolation is used, which gives slightly better results.

usually has an odd dimension (3×3 or 5×5 but also 3×5, 7×11, etc.), because this easily allows assignment of the "central pixel." The weights in the kernel are also allowed to be negative. Most often, the sum of the weights is either 1.0 or 0.0. The kernel is first positioned at the upper left position of the image. Then each pixel is calculated moving the kernel from left to right for every line (top to bottom) of the image.

Linear neighborhood operations (also called linear filters) can be used for eliminating noise and for sharpening, for example, but they can also be used for the enhancement of features such as vertical or horizontal edges. The following examples will illustrate some of the common uses of neighborhood filters.

Figure 48 displays the effect of a smoothing filter, which averages the pixel values within the neighborhood.

In color images the convolution is usually applied separately to each color (red, green, and blue).

Figure 49 shows the effect of a sharpening filter with the following kernel:

$$\begin{pmatrix} -.25 & -.25 & -.25 \\ -.25 & +3.0 & -.25 \\ -.25 & -.25 & -.25 \end{pmatrix}$$

This convolution kernel enhances the edges in the images and adds the result to the original image. Please note that the coefficients sum up to 1.0. As soon as there are negative coefficients in a convolution kernel, the resulting pixel may become negative. In such cases, there are two possibilities: The negative pixel is just set to 0, or an offset is added to all resulting pixel values to avoid negative values. In the example of Figure 49, negative pixel values would have been set to 0 if this occurred.

Example of 3 x 3 convolution

122*0.1 + 130*0.1 + 190*0.1 + 121*0.1 + 127*0.2 + 160*0.1 + 118*01 + 119*0.1 + 128*0.1 = **134**

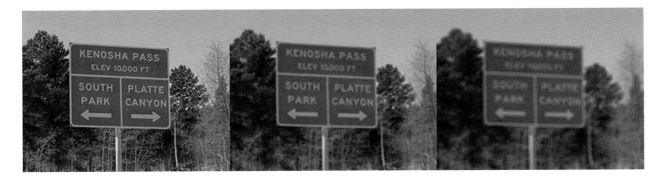

Weights
(3x3 neighborhood) original image resulting image

FIG. 47 Schematics of a convolution with a 3 × 3 kernel. The weights of the kernel sum up to 1.0. Such a kernel has a smoothing effect to an image by calculating a weighted mean. The pixels at the border (indicated by "X" in the resulting image) cannot be calculated, because there are no values defined outside the image.

FIG. 48 Example of a smoothing kernel. On the left is the original image, in the middle is the image with a 3 × 3 averaging kernel applied, and on the right is the same image with a 5 × 5 averaging kernel applied. Image courtesy of the author.

FIG. 49 Convolution with a sharpening kernel. On the left side is the original image; on the right side is the image convoluted with a sharpening kernel. Image courtesy of the author.

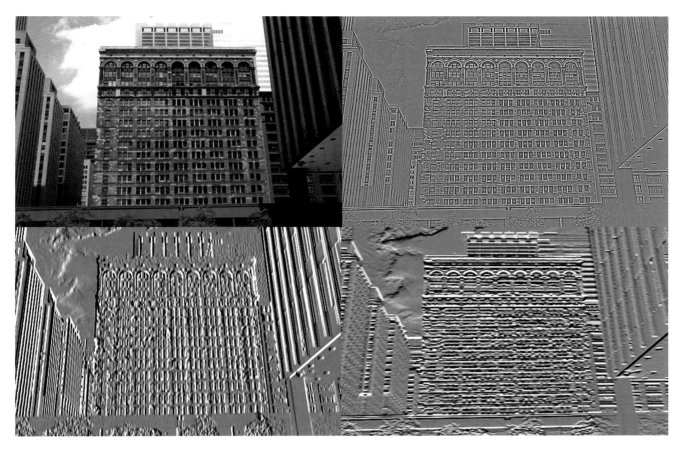

FIG. 50 Effect of some common convolution kernels with a sum of 0. On the upper left is the original image, on the upper right is an isotropic edge detection filter (Laplace filter) applied, on the lower left is the Sobel kernel for vertical edges applied, and on the lower right the result of Sobel filter for horizontal edges is shown. Image courtesy of the author.

Figure 50 shows the effect of a filter where the sum of the kernel coefficients is 0. In this case, negative values have to be expected. Therefore, an offset of 127 is added to all resulting pixels. The following kernels have been used:

$$a : \begin{pmatrix} -1 & -1 & -1 \\ -1 & +8 & -1 \\ -1 & -1 & -1 \end{pmatrix}, b : \begin{pmatrix} -1 & 0 & 1 \\ -1 & 0 & 1 \\ -1 & 0 & 1 \end{pmatrix}, c : \begin{pmatrix} 1 & 1 & 1 \\ 0 & 0 & 0 \\ -1 & -1 & -1 \end{pmatrix}$$

a is an isotropic filter, which enhances edges independent of their orientations. It is called a Laplace filter. b enhances selectively vertical edges; c enhances horizontal edges. These latter two filters are called Sobel filters. Since the sums of the kernels are 0, homogeneous areas will result in the pixel value of 127 (given by the offset) and appear in a neutral gray.

Non-linear neighborhood operation

There are neighborhood operations, which cannot be described by a simple kernel in which the kernel coefficients are the weights of a summation. In non-linear neighborhood operations, often some sort of thresholding or decision-processing is accomplished depending on the pixel values in the neighborhood of a pixel. One of the most prominent non-linear filters is the median filter: The pixel values of the neighborhood are sorted according to their value and the new pixel value is the median value (that is, the "middle" value) of the sorted list of pixel values. The median filter has the advantage of usually not smoothing edges too much but still eliminating shot noise very well (see Figure 51).

There are many other non-linear filters, but using them approaches black magic in its complexity and requires a lot of experience.

FIG. 51 On the upper left is the original image, which contains shot noise. On the upper right is the result of a median filter. Compare these images with the one on the lower left (the result of a 3 × 3) and on the lower right (a 5 × 5 averaging filter). For this kind of noise the median filter is clearly far superior. Image courtesy of the author.

Compression algorithms

Compression algorithms are used to reduce the size of the digital image file. There are two fundamentally different compression schemes: lossy and lossless.

Lossless compression

Lossless compression schemes try to reduce the redundancy that is usually found within digital data. Lossless compression schemes do not depend on specific image properties but can be applied to all kinds of digital data. Since images usually contain some redundancy (a pixel value at a certain position is often similar to the neighboring pixel values), a slight reduction of the amount of data can usually be achieved (about 30 to 50 percent). The reduction will be greater if the image contains large homogeneous areas or areas with repetitive patterns. For images that contain large areas of irregular patterns (random

noise), the reduction will be very small. In some cases, lossless compression may even inflate the size of the image file.

Lossy compression

Lossy compression does eliminate information that the compression algorithm decides is of little interest. Therefore, lossy compression algorithms directly depend on the properties of images and particularities of the human visual system. Lossy compression algorithms do, therefore, *modify* the image in an irreversible way. They usually eliminate only information that is considered of little importance to the viewer. However, if the compression factor is too high or, more important, the compressed image is manipulated with image processing methods in a later stage (such as contrast enhancement), artifacts may become visible. Therefore, lossy compression should be only applied to images that are used only for viewing. Images that are to be archived or are meant to be manipulated in a

FIG. 52 Lossy compression: On the left is the original image, in the middle is the same image compressed with the JPEG algorithm at a compression ratio of approximately 1:100, and on the right is the image compressed with the JPEG2000 algorithm, also at a compression ratio of about 1:100. The image compressed with the JPEG algorithms clearly shows the artifacts, which make the block-structure of the algorithm visible. Image courtesy of the author.

later stage should *never* be stored in a lossy format! Common compression algorithms (and corresponding file formats) are:

- JPEG
 JPEG stands for Joint Photographers Experts Group and is a well-established lossy compression scheme, which uses the Discrete Cosine Transform[3] (DCT) as a basis for the compression. The image is divided into 8×8-pixel blocks. The DCT is calculated for each block. Depending on the compression level, only the major coefficients of the DCT are used. The JPEG algorithm may lead to very particular artifacts that make the block-structure of the algorithm visible. The compression ratio should usually be in the range of 5 to 25. Higher compression ratios will often lead to visible artifacts.
- JPEG2000
 JPEG2000 is a successor of the JPEG algorithm, but uses a totally different approach. It relies on the Wavelet-transform, which builds up a resolution pyramid of the image. It creates less visible artifacts, but the compressed image may give the impression of less sharpness or crispness. There is also a lossless variant of the JPEG2000 algorithm. Another very interesting feature of the JPEG2000 algorithm is that the whole image file doesn't always have to be read. If only the first part is read, the

whole image can be displayed as if it were compressed at a higher compression rate. For example, to display a thumbnail image, only about the first 5 to 10 percent of a JPEG2000 (lossless variant) image has to be read. ◉

Metadata and Digital Photography

SIMON MARGULIES
University of Basel

Definition and Introduction
Metadata is usually described as data about data. More accurately defined, metadata is data that contains information about other data—so-called primary data or a resource for future retrieval needs. Metadata relates to primary data by describing and referencing it. This description provides information that is not apparent from the primary data itself. It makes the primary data meaningful and useful. For example, the metadata associated with digital photography is usually not pictorial data embedded in the image file. It could provide information about its creator, about its copyright protection, about the equipment used during the shot, about its contents, about its file format, etc. A picture stored in a computer system can contain metadata about the file in the filename, the file path, a database entry, or a header tag, as well as other metadata.

A definition of metadata from librarians, who have a long experience in cataloging and creating metadata, is: Structured,

[3] The Discrete Cosine Transform is, like the Fourier Transform, a mathematical method to describe a one- or two-dimensional function in the form of a frequency spectrum.

encoded data that describe characteristics of information-bearing entities to aid in the identification, discovery, assessment, and management of the described entities[1].

This definition introduces the purpose of metadata as a characteristic: Much digital data and especially the content of pictures are (and probably will never be) neither searchable by machines nor self-explanatory to human users without additional textual information. Often additional information such as copyright statements, information for display (such as a color profile), or information about the circumstances of the creation also needs to be stored with the primary data. Summarized metadata should guarantee future retrieval, readability, and usability of its primary data. In digital photography this means that all additional non-pictorial data must be stored as metadata to guarantee that images can be found and linked to their photographer, opened and correctly displayed by a computer system, and used by the final observer. Much of this is achieved by structuring the metadata and filling the structure with coherent content. As a result, metadata links different data, as in a library catalogue: If two different primary data match on one of their properties, and if those properties are stored in the structure of the metadata, the different primary data can be linked together. For example, all the books from a certain author can be found in a library or all pictures of a certain date range can be identified in an image archive.

Use and requirements

Different environments and users will require different metadata strategies, since retrieval, readability, and usability can have different significance. Independent of any usage scenario, metadata needs to guarantee retrieval, readability, and usability of the data. Otherwise the metadata is not an adequate data about data.

For example, an archive or a library that performs long-term preservation of pictures and wants to provide access to many users for retrieval or users in a distant future will need to provide its data with a rich set of metadata. Metadata for digital images in such a scenario should provide vast information about the data format and the color profile, along with details about the contents, the creation, the creator, and the coherence of the collection of the picture. As another example, a company dealing with images needs to focus on its workflow and the requirements of its clients, and optimize the metadata for this purpose.

A photographer storing pictures basically needs to care about metadata as much as an archive does, if he wants to preserve and then retrieve the pictures. Naturally, a photographer won't need extensive content and coherence description when managing a private and familiar collection. If images will be presented on the Internet or shared with other institutions, authors may be well advised to store a copyright notice and content description as metadata to render the images searchable and identifiable. Photographers can thereby profit from the use of metadata for their imaging businesses. Copyright information, password security for displaying the file, and content description should also be added as metadata. Embedding

unique image identification as metadata makes it possible to prove ownership and follow the track of an image from the photographer to his client and to other involved parties. The whole workflow can be supported by metadata. It is then possible to record when and where an image file was processed and changed, allowing users to make invoices and complete transactions. Keywords and captions as metadata could render images searchable by content, providing faster access and processing in the production workflow. Using term-based search tools is far more efficient than browsing thumbnails, especially in large image collections.

Categories

Metadata research has so far not produced a uniform way of categorizing metadata. Often metadata are subdivided into descriptive, structural, and administrative metadata. Sometimes a fourth category is added, technical metadata. Basically, metadata categories help users to group parts of the metadata and to better understand its uses and requirements for the primary data.

Descriptive metadata contains data that is needed for resource identification and discovery. All requirements for a successful search and retrieval of the primary data must be fulfilled. The described resource must be identifiable at least by an ID. In a library this ID corresponds to the shelf mark of the resource. This ID must be unique for the domain in which the resource is referred. If this domain is a database, a primary key must be chosen; if the domain is the Internet, the key should correspond to the syntax of the Uniform Resource Identifier (URI), [2] of which Uniform Resource Locators (URLs) are a subset. As the term *descriptive* suggests, descriptive metadata should also contain information about the content and the coherence of a resource. This is evidenced by a textual description of what a picture displays and why it was taken.

Structural metadata provides data about the context of a resource, if it is part of a complex information object. In this example, a picture could be part of a page of a book and therefore need information about its place on the page and about the book containing all pages. For digital photography this category normally remains secondary.

Administrative metadata are used to manage the object in the information system. This may be copyright and licensing information and also information about the data format and the equipment used to scan the picture. This is why administrative metadata is often split into administrative and technical metadata. This separation makes sense especially in the field of long-term preservation of digital images, because the technical part contains the information needed for the necessary actions to maintain and display the data (such as the data format) and the administrative part contains the information about the actions taken to preserve the data (such as a change log).

Terminology

Metadata consist of four layers, depicted in Figure 53, which describe top down the semantic, the data model, and the

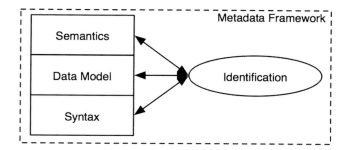

FIG. 53 Components of a metadata framework.

syntax of metadata. The combination of these layers and the mechanism of identifying the described resource is called a metadata framework.

Semantics represents different data fields, their structure, and their content. Data fields are named entities of information, such as creator, title, and date. Often these entities are called elements. The data structure defines the organization and the order of the data fields. For example, metadata about a picture in digital photography must provide information about the camera that was used to take the picture, but can store data from only one camera, because only one camera was used. Data fields and data structure offer the possibility of filling in content and thereby creating semantics.

To guarantee the integrity of such metadata, rules for data content and norms for data values must be used consistently. Content rules for metadata define in what form and with what logical constraints data fields can be filled. One rule, for example, could state that a data field called "creator" must be completed with the name followed by the surname of the creator. Likewise, a date could have the form of YYYY-MM-DD or DD-MM-YYYY. Norms for data values are mutually accepted thesauri or predefined terms by the authority of a domain. These norms are to be used filling the data fields. Such norms, data fields, and data structure often result in a complex arrangement of rules defining an interwoven model of a certain domain. The formal conceptualization of such a model is called an ontology in information sciences.

The data model defines how statements about resources can be made. It states the grammar of the metadata. It represents an abstract layer under the semantic and over the syntax of a metadata framework. Usually a relational data model (tuples containing many attributes), hierarchical attribute/value combinations (like in XML) or statements with subject, predicate, and object (like triples in RDF) are used.

The syntax describes the way the semantics and the data model of the metadata are recorded (for example, in Unicode and XML).

The crucial component of a metadata framework is the mechanism of identification of the described resource, because it is part of every other layer, and not only every resource but also every semantic rule, every data model, and every syntax

used must be unambiguously identifiable to prevent any possibility of a mix-up between different assets.

Metadata and retrieval

By describing data the person recording the metadata classifies the primary data according to its subjective contexts. This means, that the recording person describes the data in the way he understands and interprets it. The result is a subjectively encoded information—the semantics of the data. The recording process is illustrated in Figure 54.

The classification of metadata is fixed before data is ingested: The stored information is organized by structure and content of the data fields of the metadata. Such classifications depend on the recording person or the recording institution. In a broader sense, the classifications are domain-specific. This means that it is possible for every domain to use a different classification and other keywords to describe the data—their data has different semantics.

A researcher who wants to retrieve stored information has his own idea and understanding of the primary data and its metadata. The researcher needs to have sufficient knowledge about the classification of the data undertaken by the recording person to be able to use the system for retrieving information. In Figure 55 these processes are outlined: The person who is searching gets access to the searched primary data by researching the metadata. This metadata was ingested into the system by the recording person in Figure 54. As mentioned above, the recording person created the metadata by subjectively classifying it. This happens before the search and is the reason that the classification of the primary data and of metadata is marked as "historical" in Figure 55.

Only a preceding consistent generation of metadata (input into data fields taking into account the content rules and norm values) can guarantee a later retrieval of the described primary data. To find the searched data, a researcher needs to have prior knowledge and understanding of the data model and the vocabulary used during the ingest of the data, respectively the ingesting organization should consider the habits of the user searching the data. By mapping his own classification

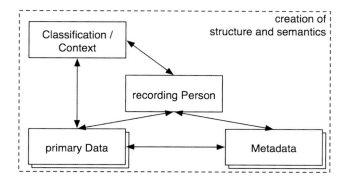

FIG. 54 Creation of structure and semantics in metadata.

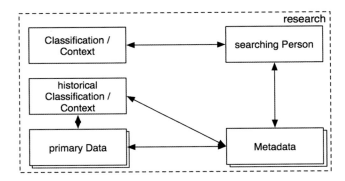

FIG. 55 Searching information in metadata.

of contexts to the historical classification, someone who is doing a search tries to interpret the historical classification to retrieve the searched data. Knowing how the stored information is structured and what terms were used to describe it are both crucial for a successful retrieval.

If various domains share their data, a researcher needs to semantically link different classifications. This gets easier. The more consistently the metadata was ingested and the more a researcher knows about its classifications and its vocabulary, the more functional the metadata can be. If the researcher knows the semantics of each domain, the mapping of the different classifications will be apparent. The semantics of similar subjects of the domains are closer and their mapping can be done more easily. On the other end of the spectrum, information retrieval in an uncontrolled user community and with uncontrolled data—as on the Internet—is more difficult and error-prone to a defined community, which shares only specific kinds of data and a common interest in accurately describing the data. This is why successful data retrieval can be difficult. To make it easier, the various metadata and their vocabulary should be shared across domains. For that purpose, standards for metadata have been defined.

Standards

Dublin Core embodies the smallest common denominator of a metadata standard by defining only 15 core elements, which can be further defined with element refinements. The first 15 elements embrace title, creator, subject, description, publisher, contributor, date, type, format, identifier, source, language, relation, coverage, and rights [3]. Defined especially for Internet resources, this standard is widely used and also suitable for content description of digital images. Standards of the Library of Congress, including MARC, EAD, METS, MIX, and PREMIS, are more widely defined and aimed for an extensive effort in metadata generation. MIX is a schema for technical data elements required to manage digital image collections; PREMIS is a data dictionary. Schemas for core preservation metadata needed to support the long-term preservation of digital materials are valuable references for metadata standards for digital images.[4]

The Exchangeable Image File Format (Exif) was created by the Japan Electronic Industry Development Association and at the moment of exposure is automatically stored in the file header of the recorded file by modern digital cameras. Metadata tags contain information about the data, the camera settings, the geographical location, and manually added description and copyright information. Although widely used, there is currently no public cooperation or official people behind Exif.

The ICC profile of the International Color Consortium describes the file's color [5]. This standard is used to describe color transformations, because every scanning or displaying device needs to provide color management systems with the information necessary to convert scanned color data between the device's color space and a device-independent color space, thereby correctly displaying the color of an image. ICC profiles are widely used and supported by various manufacturers and file formats.

The IPTC-NAA standard of the International Press Telecommunications Council [6] is a widely shared standard for describing audiovisual data and is often used to exchange image data between photographers, digital imaging/stock photography companies, and news agencies.

The Extensible Metadata Platform (XMP) from Adobe Systems [7] is implemented into all Adobe products and therefore widely used in the imaging community. It embodies a metadata framework that tries to standardize the creation, processing, and sharing of metadata in publishing workflows. In addition to the ubiquitous availability of Adobe® products in imaging, this technology offers the advantage of being extensible by other standards or private metadata fields.

Storage and technologies

There are two possibilities for storing metadata: inside the file, mostly in the file header, or outside the file, in a database. While the first approach is more secure, the second approach guarantees a faster access, because the metadata can be indexed in the database. For search and retrieval an external metadata database is crucial. Since much metadata (XMP, ICC profile, Exif) is saved automatically in the file header, it is advisable to store all metadata in the file header. Nevertheless all metadata used to provide search and retrieval facilities can easily be exported into a database by an automated process.

For the long-term preservation of digital assets, it is recommended that metadata be stored in the file header, since preserving the metadata in a database would mean preserving the database system containing the metadata anyway. Various file formats, such as TIFF, JPEG, and JPEG2000, support seamless integration of metadata into the file header. XML, the extensible markup language of the W3C [8], is a markup language is used to express almost all available metadata standards. It offers the possibility of arbitrarily defining markup and therefore storing data in a structural form. By defining an XML schema containing the rules as norms of a metadata standard, XML parsers can control how that metadata gets consistently entered. Schemas can be interlinked by using names, spaces,

and the defining of mappings for different metadata standards. XML markup is usually generated and stored as plain text documents. Such documents can easily be opened in an editor and remain human-readable. Most metadata standards using XML are defined with a hierarchical data model.

The RDF, or Resource Description Framework of the W3C, is a framework for metadata that has been developed to describe data in a machine-understandable way and to allow semantically based retrieval on the Internet. The aim is to provide a standard data model for metadata. The semantics and the syntax are not fixed by the W3C. URIs must be used for identification. The semantics in this framework are integrated by using namespaces and vocabularies. The data model of RDF is the statement as a triple of subject, predicate and object. The object is either a final value or the subject of another statement. The predicate can further be described by adding other statements. This way RDF provides a high expressiveness by defining classes and rules for statements, and defining machine-understandable ontologies becomes possible. In this fashion, a community can provide software agents with the needed information to deduce meaning and context of different source data and metadata. If something matches the concept *picture*, then it has an *author* and a *title*. *Author* is of type *person* and equivalent to *creator*. A *photographer* is a sub-conceptualization of an *author*. Storing an *author* named *John Smith* of a certain *picture* somewhere as metadata and then searching for a *picture* by the *photographer John Smith*, would provide a software agent not only with a possible result, but also a way to deduce that the researcher does not mean *John Smith* the *butcher*, who is obviously another person. Possible examples for the syntax of RDF are Turtle and RDF/XML. RDF/XML is an XML representation of the RDF data model; Turtle uses an easy-to-read text notation.

Unicode of the Unicode Consortium [9] is the basis for all textual metadata; in the past, every computer system used its own encoding for characters in plain text files. Unicode is an internationally used norm for translating bytes into characters and therefore an obligatory standard for encoding metadata into computer systems.

Handling metadata

Using the XMP metadata framework in Adobe Photoshop CS means opening the File Info dialog box (Figure 56).

This dialog box allows you to enter basic metadata information. Camera Data 1 (Figure 57) and Camera Data 2 (Figure 58) provide Exif metadata.

IPTC fields are not shipped with the standard version of Photoshop CS, but can be downloaded from the IPTC website and easily integrated into XMP. The File Browser offers an easier interface with a better overview (Figure 59).

Photoshop allows the creation of metadata templates with predefined values for the author and copyright status, and also allows you to apply the templates to multiple images. Modern

FIG. 56 File Info dialog box in Photoshop CS.

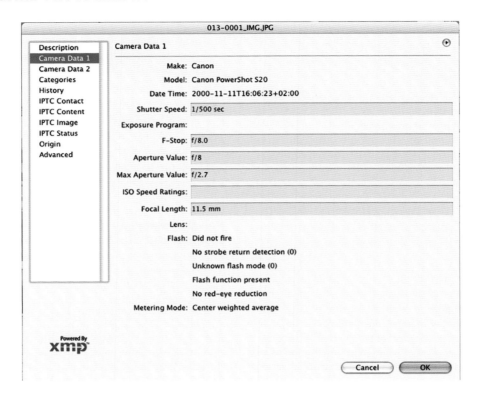

FIG. 57 Camera Data 1 Exif metadata.

FIG. 58 Camera Data 2 Exif metadata.

FIG. 59 File Browser in Adobe Photoshop CS.

computer systems retrieve the XMP metadata directly from the file header and support searching for such images.

FURTHER READING

[1] Summary Report 6/1999. ALA/ALCTS/CCS Committee on Cataloging: Description and Access—CC:DA Task Force on Metadata. June, 1999.

[2] Uniform Resource Identifier (URI): Generic Syntax. Network Working Group Request for Comments: 3986. RFC3986. January 2005.

[3] Dublin Core Metadata Element Set, Version 1.1: Reference Description. Ed. Dublin Core Metadata Initiative. 20.12.2004.

[4] http://www.loc.gov/standards/

[5] http://www.color.org/

[6] http://www.iptc.org/

[7] http://www.adobe.com/products/xmp/

[8] http://www.w3c.org

[9] http://www.unicode.org/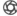

Spectral Imaging

MITCHELL R. ROSEN, Ph.D.
Rochester Institute of Technology

Color reproduction has always relied on both metamerism and on the fact that an observer will confuse pairs of spectral power distributions as being the same color under particular viewing conditions. Metamerism in humans forgives the fact that colorants used to create a copy will typically radiate photonic energies in ratios different from those that come from the color-forming materials of an original. The engineering conveniences of basing color reproduction systems on metamerism are clear, but many applications demand reproductions that maintain their relationship under various viewing conditions or when viewed by various observers. In recent years, spectral reproduction has been explored to address the disadvantages of metameric imaging and as a source of previously unattainable features.

Traditionally, color capture devices have been engineered to emulate the spectral integration found within the human visual system. Thus, typical color capture devices have three channels each of spectrally wide sensitivity, much like the human eye. For image output, a computer monitor is similar to the typical image-capture device in that it relies on three spectrally wide channels. Standard printers have four channels, where a non-spectrally selective black is added to a set of three spectrally wide subtractive primaries. Among the purposes for including black is increasing color gamut for dark colors and improving stability in the neutral tones.

Building cameras that "see" color similarly to humans is a very difficult task. It turns out that for many reasons, the spectral sensitivities of typical cameras are different than those of the standard observer. In Figure 60, the spectral sensitivities of an area array camera popular with high-end imaging studios are optimally transformed to match the human color-matching functions as closely as possible. Note how different the camera curves are from the human functions. Thus, even under perfect conditions, 3-channel cameras will have different metamerism properties than humans.

Spectral color reproduction addresses many of the drawbacks of metameric reproduction. Hill has compared the evolution of three-band systems with the revolution of spectral imaging, concluding, "the solution to the fundamental problems of tristimulus reproduction systems is offered by multispectral technology" [Hill, 2002a]. He found that the following weak points of metameric systems would be addressed by spectral-based systems:

- Differences between device and observer metamerism
- Sensitivities of device profiles to changes in paper and colorants
- Illumination dependence
- Gamut mapping effects
- Deviations of color-matching functions among humans

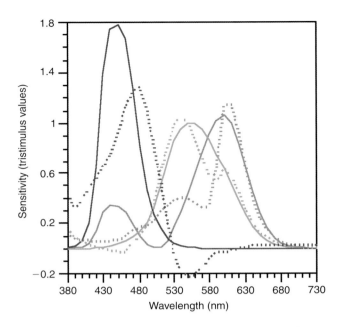

FIG. 60 Camera sensitivities (dashed lines) linearly transformed to optimally match color-matching functions (solid lines).

The advantages of spectral color reproduction are all a consequence of the additional information captured about a source scene. Thus, storing the spectral signal is a far more precise way to archive the original information. Also, image processing can take advantage of the richer data to perform analysis or manipulation routines not otherwise achievable. Material identification, object segmentation, background removal, and facial recognition are all enhanced. Arbitrary output rendering characteristics may be fully exploited.

Spectral imaging captures sufficient information to estimate the spectral radiance, transmittance, or reflectance from an original. Relying on reflectance matching improves the ability of a system to be robust to changes in illuminant and observer. Radiance matching allows for emulation of a reproduction under a change in viewing environment. The reflectance- and radiance-matching tasks referred to above are only the most obvious spectral-based extensions of a color reproduction infrastructure. New capabilities will also present themselves. Some examples include an increased ability to analyze original scenes, improving the recognition and reproduction of certain memory colors such as skin tones, grass, and sky; higher levels of within-gamut reproduction quality through the use of multi-channel input devices that exhibit hardly any instrumental metamerism, something currently unavoidable and the scourge of today's color reproduction world; the introduction of fluorescence as a positive force in color reproduction, unmasked through the acquisition of multiple spectral images taken under different light sources; and improvement in making spot-color and speciality ink choices.

Modern investigation of this branch of color reproduction spans over 30 years. On the input side, as early as 1975, Kotera and co-workers at Matsushita started working with the use of multiple interference filters for spectral scanning [Kotera, 1975, 1976], [Hayami, 1976]. A number of worldwide patents were issued on that work starting in 1978 [Kan, 1978], [Hayami, 1979]. Ohta and co-workers at FujiFilm® demonstrated the use of a spectral camera in 1981 for use in simulating a photographic system [Ohta, 1981a, 1981b], [Takahashi, 1981]. By the mid-1990s an explosion of interest had grown up around spectral estimation from multi-channel camera signals. Imai and Berns showed that off-the-shelf cameras could be configured for high-quality spectral imaging [Imai, 1999, 2002].

On the output side, Ohta was the first to put a stake in the ground with his 1972 simulation of a 12-colorant system for minimizing spectral reproduction error [Ohta, 1972]. Berns of the Munsell Color Science Laboratory began publishing on the topic in 1993 [Berns, 1993] and his group has established the concept of least-metameric reproduction through the research of Berns, Iino, Tzeng, Rosen, Imai, and Taplin. In 1999, Rosen demonstrated a spectral end-to-end reproduction of a complex scene [Rosen, 1999].

Spectral reproduction was actually solved more than 100 years ago. At the turn of the twentieth century, Gabriel Lippmann perfected the production of "grainless" albumen emulsions, enabling a form of photography that recorded self-interference of light waves reflected from a mirror in contact with the photographic plate (see Lippmann history). When appropriately illuminated and placed back in contact with a mirror, the prints accurately reproduced scene spectra [Friedman, 1968]. Lippmann's process was practiced by only a few and represents an anachronism with no influence on current attempts to bring spectra into the color-reproduction workflow.

The remote sensing field made great strides in the direction of spectral imaging. In 1914, Nikolai Morizov traveled in a balloon to obtain spectrograms of the earth's surface during the full eclipse of the sun. E. L. Krinov, whose airborne spectrometry experiments started in 1930, included the use of multiple filters to expose standard photographs at specific spectral regions [Krinov, 1947]. The 1960s saw the first of many launches of multi-channel detectors into space that have produced data with widespread applications in meteorology, astronomy, geology, ecology, and the military. Most of the multi-spectral and hyper-spectral remote sensing detection bands lie outside the visible region of the electromagnetic spectrum. This is in contrast to the practice of color reproduction, which obviously focuses on the visible wavelengths. Another major difference between remote sensing and color reproduction is found in the fact that color reproduction places primary weighting on maximizing the quality of scene rendering. Remote sensing is usually far more interested in deriving non-pictorial information from scene data.

In the 1970s, technology had matured to the point that scientists began to envision spectral reproduction systems, build prototypes, and work through theoretical questions [Kotera,

1975, 1976], [Ohta, 1972]. In the past few years, increased sophistication of filtering techniques, digital cameras, computers, printers, and projectors has brought to the field the potential realization of commercial use of spectral techniques [Hill, 2002b], [Rosen, 2002]. At some future point, consumer-level packages could support a spectral-imaging workflow.

Early contemporary examples of work in the field of spectral photography include that of Jussi Parkkinen and Timo Jaaskelainen of Joensuu University [Parkkinen, 1988], [Jaaskelainen, 1994], in which an acusto-optical tunable filter was used for capturing selected spectral bandpasses of a large variety of objects and scenes (spectral databases are found at http://cs.joensuu.fi/~spectral/databases/index.html). Bernhard Hill and his group at Aachen applied to the German government in 1987 for work on a multispectral camera for color reproduction [Hill, 2002b] and obtained a patent in 1991 on behalf of Linotype Hell for a multispectral scanner [Hill, 1991]. They have engineered spectral capture devices based on multiple interference filters. Yoichi Miyake's lab at Chiba University demonstrated some of the earliest practical uses of visible-spectrum imaging through endoscopic research [Miyake, 1989], [Shiobara, 1996]. They have also made large contributions toward the use of spectral imaging for archiving works of art. [Haneishi, 1997]. Burns and Berns at RIT's Munsell Color Science Laboratory made important analyses of error propagation through multi-channel capture systems [Burns, 1997, 1999] and Imai and Berns advocated the use of commercial trichromatic systems with either supplemental filtration or varying light sources to estimate scene spectra [Imai, 1998, 1999]. The Munsell Lab has also been heavily involved with the use of these systems for fine arts reproduction. [Taplin, 2005].

Spectral spaces include spectral reflectance, spectral transmittance, and spectral radiance. It is possible to calculate spectral reflectance or transmittance from spectral radiance and vice versa if certain parameters are known or assumed. Such parameters include knowledge of the spectral power distribution of the light source hitting an object and knowledge or assumptions around fluorescent properties of media being imaged. As summarized in Table 1, each device type has a spectral space most appropriate for its characterization [Rosen, 2000].

Color input systems interact with spectral radiance. For scanners, where the light source is usually well known and the scanned media is usually flat and uniformly illuminated, it is easy to derive spectral reflectance or spectral transmittance from spectral radiance measurements. Camera systems make the derivation of spectral reflectance much harder. First, the ambient light source is separate from the imaging system, is often unknown, and can be mixed. Also, because of non-uniformity of illumination and inter-reflections between objects in a scene, it is very difficult to know exactly the spectral power distribution of the light that falls onto a scene object. Only under the most controlled circumstances can accurate calculation of reflectance from radiance be accomplished in a camera application. It has been shown in much research concerning spectral reconstruction from cameras

TABLE 1 Spectral Characterization Spaces According to Device Type

Device	Spectral space found where?	Primary spectral space	Secondary spectral space
Camera	Stimulus	Radiance	Reflectance (or transmittance)*
Scanner	Stimulus	Reflectance (or transmittance)	Radiance
Self-luminant display	Response	Radiance	
Print engine	Response	Reflectance (or transmittance)	

* For illuminant controlled studio capture

that minimizing spectral RMS error is often associated with non-minimum colorimetric error (e.g., [Berns, 2005], [Rosen, 2003] and [Day, 2003]). A method for combining optimal colorimetric transformation with optimal spectral transformation based on parametric decomposition [Fairman, 1987] has been used to produce excellent performance [Berns, 2005].

Color output devices fall in two categories: those that produce light and those devices that reflect or transmit light. For self-luminant displays, the only practical spectral characterization space is spectral radiance. For printers, measuring the spectral reflectance or transmittance of the media is convenient. Three categories of approaches have been undertaken to characterize printers for spectral output: purely physical [Mourad, 2001]; a combination of a physical model and empiricism [Tzeng, 1999]; and brute force empirical [Rosen, 2004]. Recently, the Cellular-Yule-Nielsen-Spectral-Neugebauer model (CYNSN) [Wyble, 2000] has shown good results [Chen, 2004]. "Cellular" means that the parameters to the Yule-Nielsen Spectral Neugebauer model are fit within small regions of colorant space, ensuring high accuracy [Viggiano, 1985].

Derhak and Rosen have described a low-dimensional transform of spectral space for use in spectral color management [Derhak, 2006], [Rosen, 2003a]. This space is called LabPQR and is in a class of spaces that fall within the category of Spectral Colorimetry, because of the fact that it has explicit colorimetric portions and explicit spectral reconstruction portions. This space makes it possible to visualize spectral gamuts and to begin thinking about the spectral gamut mapping problem [Rosen, 2006]. The first three dimensions of LabPQR are CIELAB values under a particular set of viewing conditions. A simple 3×31 matrix is used to convert between its CIEXYZ and a distinct spectrum—one from the infinitely large set of metamers for that CIELAB value. The PQR dimensions describe the metameric black [Cohen, 2001] difference between the Lab-derived metamer and the actual spectrum. Thus, the first three dimensions describe colorimetry and the full set of dimensions describe a spectral reconstruction. PQR is derived from a Principal Components Analysis (PCA) of the metameric black space. The PQR dimensions are related to a small number of PCA-derived vectors. Thus, there is a level of inaccuracy introduced by reducing spectral descriptions to this limited number of dimensions.

When attempting to produce a specific response from a color output device, one important consideration is determining whether a request is beyond the device's rendering capability. The request is considered out-of-gamut when it is outside the palette of available responses. An out-of-gamut request must still generate some response from the color output device. A set of rules is needed to guide this process of spectral gamut mapping.

An approach to spectral gamut mapping conceptually has two stages. First and foremost, colorimetric error is driven as low as possible. Spectral fidelity is addressed once the colorimetric aspect of a process is complete. Figure 61 is a flow diagram for the two-stage spectral gamut mapping algorithm.

Today, there are specialized areas where capturing and reproducing the spectra of an original scene or document is considered an important goal. These include reproduction and archiving of artwork, proofing, medical imaging, and catalog sales. There are many other potential opportunities for the use of spectral information in a color reproduction workflow. Some are being actively investigated. One of the most compelling needs of the color reproduction community is to improve camera capture. Instrumental metamerism ensures that even the best cameras currently on the market do not have the same color sensitivities as humans. Spectral capture techniques will improve this situation.

Once spectral data is available, processing it for output is an obvious choice. Among the advantages of creating a spectral reproduction of an original is that the reproduction will match the original for all devices, whether cameras or humans. Another feature of a spectral copy is that as illumination changes, the match between an original and the reproduction persists. New approaches to processing spectral data are being developed. The use of LabPQR within spectral color management is showing promise. The colorimetric aspects of the space make it a very useful hybrid, ensuring that both colorimetry and spectrophotometry can be taken into consideration when spectral gamut mapping takes place.

Photography, the art and science of drawing with light, has been continually updated and improved. Almost 60 years ago, the director of the Kodak Research Laboratories, CE Kenneth Mees, observed that the original methods for photography had at that point become extinct [Mees, 1942]. Yet, what Mees considered then to be modern is found by contemporary digital photography standards to be antiquated and primitive. Each generation has striven to improve the general baseline of imaging ability. Among the possible new technologies being

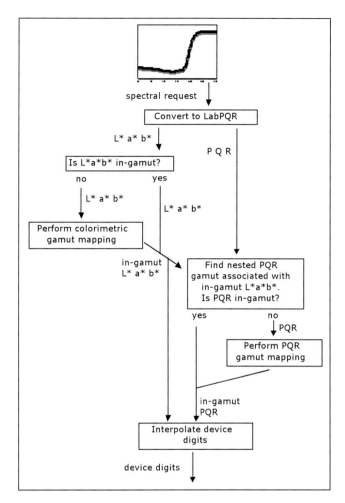

FIG. 61 Flow diagram for two-stage spectral gamut mapping.

developed, spectral reproduction techniques bring important new capabilities and solve many of the current problems.

REFERENCES

[Berns, 1993] R. Berns, "Spectral Modeling of a Dye Diffusion Thermal Transfer Printer," *Journal of Electronic Imaging*, 2, 359–370 (1993).

[Berns, 2005] R. S. Berns, L. A. Taplin, M. Nezamabadi, M. Mohammadi, Y. Zhao, Spectral imaging using a commercial color-filter array digital camera, ICOM-CC 14th Triennial Meeting, pp. 743–750 (2005).

[Burns, 1997] P. D. Burns and R. S. Berns, Error propagation in color signal transformations, CR&A, **22**, pp. 280–289.

[Burns, 1999] P. D. Burns and R. S. Berns, Quantization in Multispectral Color Image Acquisition, Proceedings of the 7th Color Imaging Conference, 32–35 (1999).

[Chen, 2004] Y. Chen, R. S. Berns and L. A. Taplin, Six Color Printer Characterization Using an Optimized Cellular

Yule-Nielsen Spectral Neugebauer Model, *Journal of Imaging Science and Technology*, **48** pp. 519–528 (2004).

[Cohen, 2001] J. B. Cohen, *Visual color and color mixture*, University of Illinois Press, (2001).

[Day, 2003] D. C. Day, *Filter Selection for Spectral Estimation Using a Trichromatic Camera*, RIT Masters Thesis (2003).

[Derhak, 2006] M. W. Derhak and M. R. Rosen, Spectral Colorimetry using LabPQR—An Interim Connection Space, *Journal of Imaging Science and Technology*, **50**, 53–63 (2006).

[Fairman, 1987] H. S. Fairman, Metameric correction using parametric decomposition, CR&A, **12**, pg. 261–265 (1987).

[Friedman, 1968] J. Friedman, *History of Color Photography*, Focal Press, New York (1969).

[Haneishi, 1997] H. Haneishi, T. Hasegawa, N. Tsumura and Y. Miyake, "Design of color filters for recording artworks," Proceedings of IS&T's 50th Annual Conference, 369–372 (1997).

[Hayami, 1976] H. Hayami, H. Kotera, H. Tsuchiya and R. Itabashi "Color Picture Processing System—Application to Automatization of Trace Film Making Process of Textile Printing", *National Technical Report* (Japan), 22, 559–566, in Japanese (1976).

[Hayami, 1979] H. Hayami, R. Itabashi, Y. Kanno, H. Kotera, T. Tsutomu, H. Sugita, H. Tsuchiya, Y. Tsuda and K. Yoshida, "Method and a system for color separation," US Patent 4180330 (1979).

[Hill, 1991] B. Hill and F. Vorhagen, "Multispektrales Farbbildaufnahmesystem," German Patent DE4119489 (1991).

[Hill, 2002a] B. Hill, "(R)evolution of Color Imaging Systems," Proceedings of the First European Conference on Color in Graphics, Imaging and Vision, 473–479 (2002).

[Hill, 2002b] B. Hill, "The History of Multispectral Imaging at Aachen University of Technology", *Spectral Vision*, The multi-spectral color science and imaging newsletter, no. 2, 2–8 (2002).

[Imai, 1998] F. Imai, "Multi-spectral Image Acquisition and Spectral Reconstruction using a Trichromatic Digital Camera System Associated with Absorption Filters," Munsell Color Science Laboratory Technical Report (1998).

[Imai, 1999] F. Imai and R. Berns, "Spectral Estimation Using Trichromatic Digital Cameras," Proceedings of the International Symposium on Multispectral Imaging and Color Reproduction for Digital Archives, 42–49 (1999).

[Imai, 2002] F. Imai and R. Berns, Spectral Estimation of Artist Oil Paints using Multi-filter Trichromatic Imaging, Proceedings of SPIE 4421, 504–507 (2002).

[Jaaskelainen, 1994] T. Jaaskelainen, R. Silvennoinen, J. Hiltunen, and J. Parkkinen, "Classification of the reflectance spectra of pine, spruce, and birch," *Applied Optics*, 33, 2356–2362 (1994).

[Kan, 1978] R. Kan, K. Yoshida, H. Hayami, H. Kotera, T. Shibata, Y. Tsuda and H. Tsuchiya, "Color separating method and apparatus using statistical techniques", US Patent 4090243 (1978).

[Kotera, 1975] H. Kotera, R. Kan, T. Shibata, H. Sugita and H. Hayamizu, "Color recognition based on statistical characteristics of color images", Proceedings of the Japanese Television Conference, 305–306, in Japanese (1975).

[Kotera, 1976] H. Kotera, R. Itabashi, H. Tsuchiya, H. Hayamizu, K. Yoshida, T. Shibata and Y. Tsuda, "Color separation system for design pattern," Proceedings of the Japanese Joint Conference on Imaging Technology, 1–4, in Japanese (1976).

[Krinov, 1947] E. Krinov, "Spectral Reflectance Properties of Natural Formations," National Research Council of Canada Technical Translation, TT-439 (1947).

[Mees, 1942] C. Mees, *Photography, Second Edition*, Macmillan, New York (1942).

[Miyake, 1989] Y. Miyake, T. Sekiya, T. Yano, S. Kubo and T. Hara "A New Spectrophotometer for Measuring the Spectral Reflectance of Gastric Mucous Membrane," *Journal of Photographic Science*, 37 (1989).

[Mourad, 2001] S. Mourad, P. Emmel and R. Hersch, Predicting transmittance spectra of electrophotographic color prints, Proc. SPIE EI Conf., pp. 50–57 (2001).

[Ohta, 1972] N. Ohta and H. Urabe, "Spectral Color Matching by Means of Minimax Approximation", *Applied Optics*, 11, 2551–2553 (1972).

[Ohta, 1981a] N. Ohta, "Maximum errors in estimating spectral-reflectance curves from multispectral image data," *Journal of the Optical Society of America*, 71, 910–913 (1981).

[Ohta, 1981b] N. Ohta, K. Takahashi, H. Urabe and T. Miyagawa, "Image Simulation by Use of a Laser Color Printer," O plus E, 22, 57–64, in Japanese (1981).

[Parkkinen, 1988] J. Parkkinen, T. Jaaskelainen, and M. Kuittinen, "Spectral representation of color images," IEEE 9th International Conference on Pattern Recognition, 2, 933–935 [1988].

[Rosen, 1999] M. Rosen and X. Jiang, "Lippmann2000: A spectral image database under construction," Proceedings of the International Symposium on Multispectral Imaging and Color Reproduction for Digital Archives, 117–122 (1999).

[Rosen, 2000] M. R. Rosen, M. D. Fairchild, G. M. Johnson and D. R. Wyble, Color Management Within a Spectral Image Visualization Tool, Proceedings of the 8th Color Imaging Conference, pp.75–80 (2000).

[Rosen, 2002] M. Rosen, F. Imai, M. Fairchild and N. Ohta, "Data-Efficient Methods Applied to Unconstrained Spectral Image Capture," *Journal of the Society of Imaging Science and Technology of Japan*, 65, pp. 353–362 (2002).

[Rosen, 2003] M.R. Rosen, *Navigating the Roadblocks to Spectral Color Reproduction: Data-Efficient Multi-Channel Imaging and Spectral Color Management*, RIT Ph.D. Dissertation (2003).

[Rosen, 2003a] M. R. Rosen and N. Ohta, Spectral Color Processing using an Interim Connection Space, Proc. of 11th CIC, pp. 187–192 (2003).

[Rosen, 2004] M. R. Rosen, E. F. Hattenberger, and N. Ohta, Spectral Redundancy in a Six-Ink Ink Jet Printer, *Journal of Imaging Science and Technology*, **48**, pp. 192–202 (2004).

[Rosen, 2006] M. R .Rosen and M. W. Derhak, Spectral Gamuts and Spectral Gamut Mapping, Proc. SPIE, **6062** (2006).

[Shiobara, 1996] T. Shiobara, S. Zhou, H. Haneishi and Y. Miyake "Improved color reproduction of electronic endoscopes," *Journal of Imaging Science and Technology*, 40, 494–501 (1996).

[Takahashi, 1981] K. Takahashi, H. Urabe and N. Ohta, "A Simulation System for Color Reproduction Process in Subtractive Color Photography II. Computer Simulation System," Proceedings of the SPSE Symposium on Image Analysis Techniques and Applications, 34–37 (1981).

[Taplin, 2005] L. A. Taplin and R. S. Berns, Practical spectral capture systems for museum imaging, Proc. of the 10th Congress of the International Colour Association, pp. 1287–1290 (2005).

[Tzeng, 1999] D. Y. Tzeng and R. S. Berns, Spectral-Based Ink Selection for Multiple-Ink Printing II. Optimal Ink Selection, Proc. CIC, pp. 182–187 (1999).

[Wyble, 2000] D. R. Wyble and R. S. Berns, A Critical Review of Spectral Models Applied to Binary Color Printing, CR&A, **25**, pg. 4–19 (2000).

[Viggiano, 1985] J.A.S Viggiano, The color of halftone tints, Proc. TAGA, **37**, pg. 647, (1985). ◉

Creative Applications of Digital Photography, the Scan-O-Gram

PATTI RUSSOTTI
Rochester Institute of Technology

Introduction

Many teachers, artists, and practitioners of imaging technologies are fascinated by the multitude of possibilities for creative expression made possible by the digital revolution. Today's technologies can unlock the magic of imaging in ways that could never have been considered just a few short years ago with conventional photography.

Initially, I did not find photography to be a magical experience until I watched my first black and white print develop in the darkroom. The process of picture taking and the image I imagined while pressing the shutter were not always synonymous. I experimented with different papers and fabric, homemade emulsions, toning, hand-coloring, drawing, and marking on images to achieve images that were more what I was looking for. Often, though, there was still something missing. The lack of control in achieving my "mind's eye's" compositions and the experience of serendipitous joy in watching the image appear in the developer tray were, for a period, elusive outcomes for me. The tediousness of the darkroom and the guaranteed cleanup afterward were also less than thrilling for me.

As digital imaging began to emerge, image-makers like me immediately saw the creative potential and possibilities. However, there were not a lot of options in the early days. Software and computers were still very limited. Scanning film (the only input option at that time) was time consuming, laborious, and unpredictable. And then there was the problem of finding a quality photographic "output." There was virtually nothing available except for dot-matrix printers, dye sublimation, or going back to analog materials. But one could see that the technology was coming and exciting things were on the horizon.

The late 80s and very early 90s utilized still video cameras as the direct camera capture technology, which was the forerunner of today's digital cameras. Suddenly (and with great excitement I might add!) the world of image making was changed by the immediacy of the new process. The limitations of film and processing were gone and experimentation was wide open. It was possible to photograph objects—opaque and transparent on a light table using this single fluorescent light source for illumination. The ability to evaluate the image immediately after capture allowed for instant composition and lighting modifications. The resolution of the first cameras was disappointingly low and so was the image quality. At the time, the only accessible output technologies did not allow for marking and drawing onto the substrates. Not long after these experiments, flatbed scanners became more accessible and produced better images. The first subject I worked with on a scanner was a milkweed pod from the garden. I placed it on the glass of the flatbed and tried a scan. The scanner generated so much heat that the pod burst open and I was completely smitten while watching the image appear on my screen. From that experience grew my love of the digital scan-o-gram and using the scanner as a camera.

For many, scan-o-grams are about the relationship of the object to the device. There is a serendipity that occurs when the scanner's internal light source illuminates the object—hidden textures and details are revealed. It is the relationship between the scanner and object that is difficult to replicate with other forms of image making. There is a hyperreal quality to these images that brings the minute details often missed in the world and nature—the space and moments in-between. With today's exquisite output quality and high resolution, it is possible to reveal these gorgeous details that would otherwise go unseen or missed if you were simply walking by.

To produce a scan-o-gram, objects are composed on the flatbed scanner glass. Things are added or removed and then quick pre-scans are performed. Based on what is seen in the software preview window, the composition can be altered or adjusted—just as one might do based on looking at the ground glass from a large-format camera. Once satisfied with the composition, you can make the final scan and save the image using an image-editing software such as Adobe Photoshop®. After years of experimenting, I have found that the best way to "clean" the background is to actually get rid of it. One of the best methods is to create a mask (using a channel-based

technique) around each element in the image and add a new black background layer. This gives the images an incredible depth and a look that I've coined as "Elvis Velvet Black" when printed (via inkjet) with pigment inks on high quality cotton rag paper or fabric.

Today's technology and software allows the scanner to be profiled and calibrated so that the majority of color and exposure adjustments can be done within the scanner interface. When done properly, it is not unusual for the images to need no further color correction within Photoshop. Scanning in 16-bit to a wide-gamut RGB working space (ProPhoto) preserves all of the colors and tonality that the scanner can capture. Then use Photoshop to "paint with light" (dodge and burn on a separate layer) for local control of density.

The following steps represent the workflow that was used for the images reproduced with this essay.

1. Calibrate (determine optimal gamma) and profile the scanner.
2. Clean and re-clean the glass!
3. Adjust the scanner interface to match the output resolution and size requirements.
4. Turn off all auto features (except for focus) and sharpening in the scanning software.
5. Set the bit depth to 16-bit.
6. Assign an RGB working space via the scanner's color management controls (in this case, ProPhoto) and the correct input (scanner) profile.
7. Arrange the objects on the scanner glass.
8. Include a grayscale step wedge for the preview scan.
9. Leave the top of the scanner open.
10. Be aware that if overhead lights are left on, they can create a colorcast and unwanted reflections.
11. Optimize the scan by setting the white, black, and mid-tone utilizing the step wedge.
12. Make the scan.
13. Open the file in an image-editing program such as Adobe Photoshop and make additional corrections, manipulations and, of course, eliminate all the dust and scratches from the scanner glass.
14. The image may be printed on any number of substrates and devices that are available today.

Conclusion

The concept of a scan-o-gram is as old as photography itself. Digital technology enables new levels of creativity for curious image-makers. The important thing to remember when attempting new things with digital image making is that a complete understanding of the technology is imperative to achieve serious, consistent, high quality results. Additionally, a willingness to work through challenges associated with learning the scanner's software and hardware will be required to ultimately free up one's creativity. As the technology becomes more transparent, it allows the creative muses to take over.

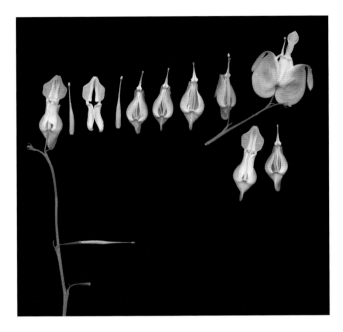

FIG. 62 Scanogram Hearts That Bleed © Patti Russotti, School of Print Media, Rochester Institute of Technology, Rochester, New York.

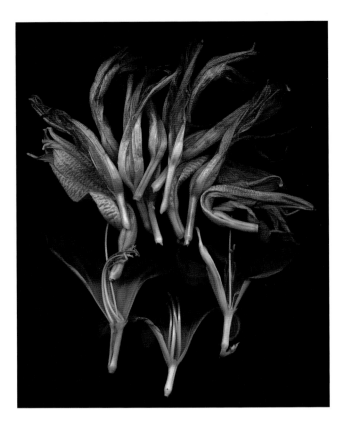

FIG. 64 Scanogram creative_Spent Tigers © Patti Russotti, School of Print Media, Rochester Institute of Technology, Rochester, New York.

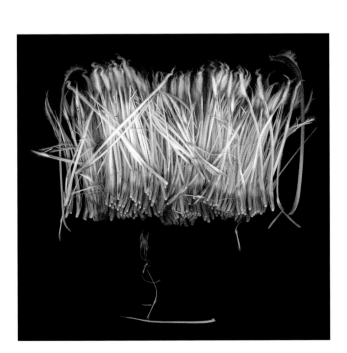

FIG. 63 Scanogram Protea Feathers © Patti Russotti, School of Print Media, Rochester Institute of Technology, Rochester, New York.

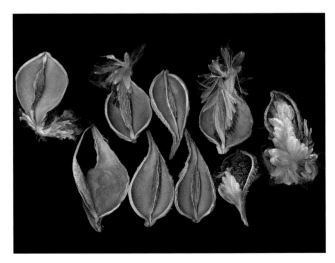

FIG. 65 Scanogram Pod Lineup © Patti Russotti, School of Print Media, Rochester Institute of Technology, Rochester, New York.

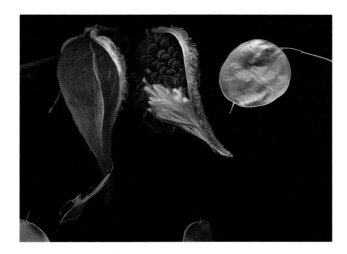

FIG. 66 Scanogram Pods and Pennies © Patti Russotti, School of Print Media, Rochester Institute of Technology, Rochester, New York.

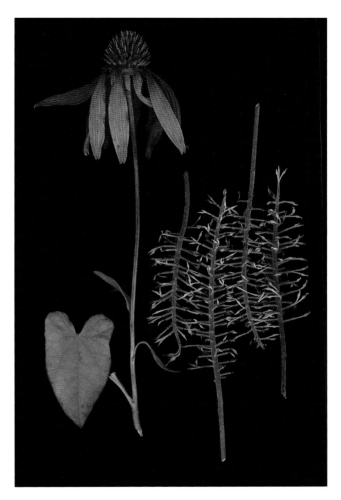

FIG. 68 Scanogram Complimentary Beings © Patti Russotti, School of Print Media, Rochester Institute of Technology, Rochester, New York.

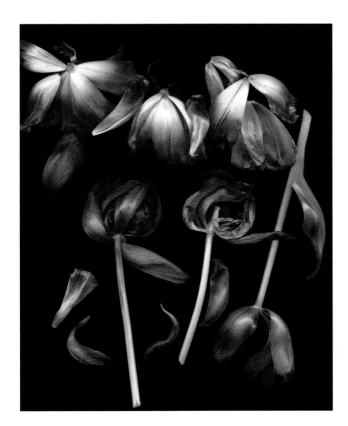

FIG. 67 Scanogram Languished © Patti Russotti, School of Print Media, Rochester Institute of Technology, Rochester, New York.

Glossary of Digital Terminology

Editor's note: The release and application of a new technology often results in new terms and expressions that develop concurrently with the tools and practices from that technology. A classic example of this is evidenced in digital photography and the rise of the Internet. The following pages were originally entries in *The Focal Encyclopedia of Photography*, 3rd Edition, written at a time when digital photography and the World Wide Web were both in their infancy. Most of the entries have been included as they were originally written, with some minor additions where required to make current and accurate. Changes are indicated using [square brackets] and were made by the editor. Additionally, the glossary includes several new entries to make the section

FIG. 69 Scanogram Podettes © Patti Russotti, School of Print Media, Rochester Institute of Technology, Rochester, New York

most complete. This section has been maintained to provide a valuable resource describing the equipment, practices, software, and pieces of digital photography to chronicle digital photography's brief history. Entries originally published in the 3rd Edition were written by: Michael Bruno; Russell C. Kraus, Ph.D.; Tomlinson Holman; John J. Larish; Michael Peres; Leslie Stroebel,Ph.D.; Michael Teres; and Hollis Todd.

AD — Analog-to-digital.

Adapter (card) — There are a variety of memory card formats produced by different manufacturers. They may be referred to as ATA cards, or by their various proprietary names such as Smartmedia, Memory Sticks, Compact Flash, SD, or film cards. These various devices may require an adapter to be used for reading in a computer or maybe be addressable via USB or fire wire or built into the CPU.

ADC — Analog-to-digital converter.

A/D Converter — Analog-to-digital converter. A scanner or other device that converts analog subjects, such as continuous-tone photographs, into a series of numbers or on–off (digital data) that can be processed, stored, and manipulated by a computer.

Address — A name or numeral that designates a particular location in computer memory.

Addressable resolution — In electronic imaging, the maximum number of locations addressable at one pixel per location.

Algorithm — In computers, an algorithm defines the number of steps or the extent of the process required to solve a coding problem. It is a structured, step-by-step course of action.

Aliasing — Low- and medium-resolution computer-imaging systems display normally smooth edges as jagged edges. These *jaggies* are known as aliasing. It may result from undersampling the spatial frequency, or when the detail exceeds the display ability of the monitor.

Alpha channel — Unused 8-bit portion of a 32-bit image. It can be used as a mask to apply filters, color changes, or overlay graphics on top of an image. The alpha channel can be used to control the opacity of the image.

Amplitude — (1) The size dimension of a waveform, usually represented graphically in the vertical plane. The size represents the strength of the unit being measured; for example, sound pressure level for sound. (2) The strength of an analog signal. In computer imaging, it is the voltage level that represents a brightness of a given point in the image.

And/or — In computers, the logical operators are generally part of the arithmetic logic unit (ALU). It provides for the combining of two images pixel by pixel. The *and* function is used to mask off a portion of the image. The *or* function is used to add subimages into a composite output.

Antialiasing — A computer algorithm designed to smooth jagged edges in an image. This can be accomplished by blending an object with its background in a smooth transition. This technique is often used to accomplish the appearance of smooth, large text on a display.

Anti-virus — A software designed to identify and or reject "diseased" software covertly placed into a computer. The virus is designed to disorient, slow down, or "kill" the computer's operating system or data files or the hard disk's directory.

Application — A computer program written for a specific purpose such as a graphics or word-processing program.

Area array — This is a method of pixel organization in a charge-coupled device (CCD). In this method, pixels are located both in the horizontal as well as vertical orientations (*x, y* matrix). A finite number of pixels will exist in each direction dictated by the manufacturing of the CCD.

Arithmetic Logic Unit (ALU) — A component found on the computer motherboard that performs multiplications, additions, or logical operations on data, including images.

Array — The holding of the image in a two-dimensional (*x, y*) configuration. This structure or matrix on the *y* axis equals

the number of lines that makes up the image. The x axis equals the number of pixels per line.

Array processor—Specific computer hardware designed to hold the image in the form of a two-dimensional array. Such devices are "hung onto" the central processing unit (CPU). The device allows for fast image processing. Some array processors have built-in algorithms for specific image processing.

ASCII—American Standard Code for Information Interchange, a byte coding for the standard character set used by most computers; used to transfer text files between computers. [Files are written in the code without any formatting commands and has not been updated since 1987.]

Backing up—In the event of a system failure, a backup operating system and backup files are used to restart the system. Backing up generally refers to making copies of the startup software (operating system) and important applications and data files.

Back porch—In video recording, a brief blackout period between the horizontal sync pulse and the start of picture data. This blackout period is considered to be blacker than black. The setting allows for the distinction between a picture signal that is black and the black resulting from no signal.

Baud rate—The speed of data transmission, usually equivalent to bits per second. Many data transmission protocols support 300, 1200, 2400, or 9600 baud rates over standard telephone lines. Dedicated local area network lines can support baud rates at about 19,200 baud. The higher the baud rate, the more data can be transmitted in the same time. A gray-scale, low-resolution image would transmit in approximately 2.2 minutes at 19,200 baud as compared to a transmission time of approximately 34.2 minutes at 1200 baud.

Bit—A contraction for the term binary digit. A bit is the smallest unit of data transfer. As a basic unit it represents an off (0) or on (1) state. In imaging, the more bits, the more tones that can be displayed in a digitized image. A 8-bit image can display 128 tones including black and white. A 3-bit image can only display a total of 8 tones.

Bit depth—Bit depth refers to the number of shades of gray that an image can display and is assigned to each pixel. The more bits the greater the tonal range possible. For example, a grayscale image that is an 8-bit image will display 256 different tones.

Bitmap—A pixel-by-pixel description of an observable image. When the resolution is high enough, the image is seen as a continuum; however, when there is insufficient data, there will be the appearance of image pixels or picture elements.

Bit plane—The storage of graphical images including text as a graphical representation. The image is stored in random-access-memory (RAM) as a pattern of bits in the sequence in which they are scanned (rastered), thus representing the image.

Blurring—In computers, the attenuation of high-frequency information in the image through the use of neighborhood averaging. The strength of the blur is determined by the size of the kernel. This technique may be used to remove patterned noise.

Board—Generally, in the DOS world a board is a device that plugs into a bus slot to perform a specific task, such as accelerating graphics, driving the monitor, controlling hard and floppy disks, or digitizing video and sound. In the Macintosh world, boards are generally referred to as cards.

Boot—To *start up* a computer. If the computer is off, this is known as a cold boot. If the computer is on but not operating, a warm boot (restart) is performed.

Brightness resolution—The luminance contrast range that a pixel is capable of providing. The higher the resolution, the greater the number of gray levels or tones that are capable of being reproduced. This is also referred to as pixel depth or number of bit depth.

Buffer memory—An intermediate location in an electronic imaging system. A system with a large buffer memory will allow faster functions such as acquisition, reading, and writing to occur. More advanced systems will have greater function in this system feature.

Bug—An error or malfunction in hardware or software that causes the computer to abort. The term results from the actual discovery of a moth in a Mark I computer's electronic relay. The removal of the moth gave rise to the term *debugging.*

Byte—A group of 8 bits. Bits are moved about the computer in groups. These groups may be 8 bits (a byte), 16 bits (2 bytes), or 32 bits (4 bytes). The greater the number of bits moved per cycle, the faster the computer.

CAD—Computer-aided design.

CAM—Computer-aided manufacture.

CAR—Computer-aided retrieval.

CD—Compact disc.

CD-I—Compact disc–interactive.

CD-ROM—Compact disc–read–only memory.

CD-V—Compact disc–video.

CLUT—Color look-up table.

CMYK—Cyan, magenta, yellow, and black.

CODEC—Coder/decoder.

CPU—Central processing unit.

CRT—Cathode-ray tube.

Cache—In computers, a section of reserved memory designed to allow the central processing unit (CPU) to process data faster. Cache can also be used to speed video and Internet access.

Card—In the Macintosh and Amiga world, cards are analogous to boards.

CCD array—An electronic imaging device that uses many charge-coupled devices (CCDs) to convert a large amount of image information to digital values at the same instant.

CCD color scanner—An optical scanner that uses a linear CCD array to capture a row of pixels simultaneously. The array is then moved laterally to scan the image.

Central Processing Unit (CPU)—The brain of the computer that performs all calculations and routes data via a bus to and from other computer components.

Channel—In electronic imaging, the holding of color information in a separate location. Each component of the color data, RGB, is held in a separate channel. In other color modes, four channels are used to hold the CMYK data. Channels can be likened to separation negatives or to printing plates.

Charge-Coupled Device (CCD)—An array of photo sensors that detect and read out light as an electronic signal.

Clone—In electronic imaging, the function by which an exact duplicate of an image or part of an image is made.

Code—The vernacular for any machine or higher-level language instructions.

Color fringing—A noise problem in color video resulting from a registration error in the RGB images; the fringing is most noticeable at the vertical edges of images. Often this is manifested by the appearance of colors that did not exist in the original scene.

Color Graphics Adapter (CGA)—In computers, the original standard for color display on the personal computer. CGA was limited to a spatial resolution of 320 × 200 pixels and 4 colors from a palette of 16 colors. In text mode, characters are formed from an 8 × 8 matrix at a resolution of 640 × 200. Today many monitors are capable of displaying more than 1000 pixels and millions of colors.

Color Look-Up Table (CLUT)—CLUTs provide an algorithm that will allow for the translation of RGB color into some other color space, such as CMYK. If an area of the image that is displayed as red comprises 85 percent red, 10 percent green, and 10 percent blue, then a CLUT would be written to translate the RGB data into 5 percent cyan, 60 percent magenta, 35 percent yellow and 0 percent black. The CLUT exists as a predetermined set of values in tabular form, thus making it unnecessary to calculate the appropriate values for each change in display color.

Compact flash—Flash memory is removable memory that does not a need power supply to maintain the information stored on the chip. Additionally, flash memory delivers faster access times and better shock resistance than hard disks. This media was invented in Japan in 1984, by Dr Fujio Masuoka of Toshiba.

CMOS (complimentary metal oxide semiconductor) chip—Another technology used in chips. In the active pixel CMOS method, the electrical power design has been modified to use power more effectively by linking pixels together to lower power requirements. CMOS chips are not capable of higher resolutions than CCD simply are more efficient. To find CMOS technology more integrated into digital cameras will require industry to reinvent manufacturing.

Color mapping—Color mapping uses a color look-up table (CLUT) for monitor display purposes.

Compact Disc-Interactive (CD-I)—A new standard for the use of CDs containing still images, moving image sequences, and audio tracks. A CD-I device will allow a user to *interact* with the program contained on the disc. It requires a CD-I player and appropriate monitor. The CD-I player has its own microprocessor and represents a higher level of built-in intelligence than a standard CD or CD-ROM player.

Compact Disc Read-Only Memory (CD-ROM)—Discs that can hold text, images, and sound and are a major means of data storage and distribution. Their storage capacity is in the region of 650 MB (megabytes) of data. Since the throughput of CD-ROM players is standardized at 150 KB (kilobytes) per second, these devices are capable of playing audio CDs.

Compiler—A software type program that converts high-level programming language into machine language in preparation for execution. Compiled languages run faster than interpreter languages and can be compiled into executable programs.

Compression—In electronic imaging, image data are compressed to achieve smaller files for storage and/or transmission. LZW and Huffman codes are two compression algorithms widely used on images. Video is often compressed using an interframe process in which redundancy shared by two frames is ignored. In transmission of image data under this scheme only the differences between the frames are transmitted, thus decreasing the time necessary to transmit the data.

Computer-Aided Design (CAD)—The use of computers to assist in design activities such as graphics, architecture, engineering, and page layout.

Computer-Aided Manufacturing (CAM)—The use of computers to assist in the design and monitoring of a manufacturing process.

Computer-Assisted Instruction (CAI)—The use of computers in the classroom to advance teaching and learning. Almost any involvement of computers in providing instruction, questioning, or feedback in the teaching-learning paradigm has been labeled CAI. Currently, CAI has come to mean the use of a computer in the control of multimedia for the purposes of instruction.

Crash—In computers, a slang term meaning to bring the computer to a nonfunctional state. Typically, the computer is unable to recognize any event and it cannot respond in any way. The usual way out of this stalemate situation is to reboot the computer.

CT merge—In electronic imaging, the function of combining the files of two continuous-tone images to provide a smooth transition between the images.

Cursor—A symbol, such as a cross, a blinking line, or a block, that locates on the monitor the insertion point where an action, such as cutting and pasting or input, is to begin or conclude.

Cut-and-paste—A computer operation that is analogous to a scissors-and-glue operation with paper used on an image or text. More sophisticated programs are beginning to replace cut-and-paste with select-and-drag operations that perform the same function but more quickly and visibly.

DA—Digital-to-analog.

DAC—Digital-to-analog converter.

DAD—Digital audio disc.

DAT — Digital audio tape.

DOS — Disk operating system.

DPI — Dots Per Inch. Similar to PPI or point/pixels per inch.

DRAM — Dynamic random access memory.

DRAW — Direct read after write.

DSP — Digital signal processing.

DSU — Digital storage unit.

DTP — Desktop publishing.

Database — In computers, the holding of information in an electronic form in a cross-referenced structured format that allows for rapid retrieval and cross-referring. Large databases are used for a variety of data-intensive fields. Some multimedia applications use databases as the referencing tools to rapidly access and display visual data.

Deblurring — In computers, when an image is blurred from either linear motion in a specific direction or from a lack of depth of field, the image sharpness may be restored by deblurring techniques such as the use of a Wiener filter.

Decoder — A device that takes in composite video and decodes the signal information into separate signals for picture (RGB), sync, and timing. Decoders may be used to input video into a computer when sync signals are weak or when picture signals need boosting in a particular channel.

Degauss — (1) To demagnetize. When done deliberately in a degausser, this means applying first a strong ac magnetic field that can reverse the state of all magnetic domains in the object being demagnetized, and then decreasing the field strength in an orderly way to zero. This process leaves the state of the various magnetic domains utterly random and thus demagnetized. (2) In computers, the act of demagnetizing the cathode-ray tube (CRT) in the monitor. The use of the CRT builds up a charge on the surface of the monitor. Degaussing the monitor prolongs monitor life and minimizes distortion.

Desktop pictures — A digital photograph that is displayed as a background on many home and office computers. Desktop pictures can either be supplied as a part of the system's operating system or imported from personal collections, which is more common.

Desktop publishing — In graphic arts reproduction, a compact publishing system that includes a personal computer, word processor, plate makeup, illustration and other software, PostScript page description language, and image setter to produce halftone films.

Digital halftone — A halftone produced on a digital device such as a laser printer. Typically the dot size is fixed by the resolution of the printer (300 dpi). The digital halftoning creates the effect of variable size by the process of dithering. The dithering process creates a cluster of two or more dots and varies the percentage of black dots to achieve a gray tone. A typical 300 dpi laser printer can produce a dithered cluster of 4×4 cells and achieve a halftone resolution of 75 dpi. However, the number of gray levels is a product of the cluster. In this example, the number of gray tones is 16 (4×4). If the number of required tones is increased, then the resolution (dpi) decreases.

Digital image — An image that is represented by discrete numerical values organized in a two-dimensional array. The conversion of images into a digital form is known as digital imaging. Hence, manipulation of the image in digital form is called digital editing, retouching, enhancement, etc.

Digital plates — Printing plates made directly from digital data.

Digital printing — Printing from digitally produced printing plates.

Digital-to-Analog Converter (DAC) — In computers, a component that converts digital data to analog information. Many cathode-ray tubes (CRTs) are analog-driven devices. For the computer to display the image, the data must be changed from the digital domain to voltage in the analog world. Many A/D boards are also D/A boards. Targa boards, among other capture/display boards, contain both an A/D circuit and a D/A circuit.

Digital video — The images displayed by the monitor are digital representations held by and displayed through the computer. Such an approach to video gives opportunity to the manufacturing of *intelligent* television at high-definition levels.

Digitizer — The device that converts analog data into digital data. The analog data are sampled and quantized. The number of bits that the digitizer is capable of quantizing determines the number of gray levels captured by the digitizer. An 8-bit digitizer can digitize 256 levels of brightness.

Disk — Generically, the platter of magnetically coated material that stores data for the computer. These disks are interchangeable among computers of similar type. Software exists that allows for the reading of disks across platforms. Data are recorded serially in concentric circles called tracks. Disks come in several sizes and density capacities. Originally, the flexible, or floppy, disk was 8 inches in diameter and held more than 360 kilobytes of data on a single side. This was followed by a floppy disk that was 3.5 inches in diameter, double-sided, high-density, with a capacity of 1.44 megabytes of data. [Disks have evolved significantly from those small capacities of 650 MB with compact disks (CDs) or digital video disks (DVDs). Dual-layer recording allows DVD−R and DVD+R discs to store significantly more data, up to 8.5 GB (gigabytes) per disc, compared with 4.7 GB for single-layer discs].

Disk Operating System (DOS) — Personal computing was diskette-based and required system software —the instructions to the computer on what to do and how to operate stored in a form accessible to the computer. Early computers usually lacked hard drives, so a floppy diskette called the operating system diskette was used to store data, programs, and the computer operating system. Current usage has limited the term DOS to describing "antique" operating systems of IBM-type platforms that now use Microsoft's Windows operating systems.

Display monitor — The common monitor in an electronic imaging system is a device for displaying images and is a cathode ray tube (CRT). Another is Liquid Crystal Display

(LCD), which is coated with bands of phosphors that produce red, green, and blue colors. The calibration and brightness of this device is a significant variable in the electronic imaging world.

Dithering—In electronic imaging, the variation in the number of ink dots to represent a tone of gray. Dithering requires that a physical area with a known matrix of dots called a cell be established. For example, a cell may contain an 8×8 matrix. If all 64 locations are filled with ink dots, then the area appears black; if all 64 locations contain nothing, then the area appears white. Varying the number of filled and unfilled cells can give the perception of a gray tone. Electronically adjacent pixels are turned on or off or are assigned different colors, thus creating the appearance of a tone of gray or another shade or color.

Dye sublimation—Refers to a process in which a pixel-for-pixel image is written to a hard copy output device. This type of printing is referred to as a continuous tone image and is considered to exhibit the highest degree of data or similarity to photographic paper. Receiver materials are exposed to cyan, yellow, and magenta dyes and transferred by heat to the receiver material. This type of print is capable of rendering 300 dots per inch and is the most expensive type of digital printer.

Dynamic range—Scenes and subjects contain a range of brightness or reflectance. The difference between the region of highest brightness as compared to the region of least brightness describes a scene brightness range, or dynamic range. CCDs record data more effectively when using a narrow brightness range similar to color slide films. High brightness ranges create problems for chip response.

Dynamic Random-Access Memory (DRAM)—The memory component of the computer. These chips hold data and instructions supplied by the software program in a quickly accessible state, thus reducing the need for the computer's central processing unit (CPU) to continually access the program disk. These chips hold data as long as there is power. Once the power is turned off the DRAM loses its contents.

Edge detection—In electronic imaging, a convolution technique designed to determine local contrast (gray-level) differences across some measure of homogeneity. The zone of change between two different regions is processed by an operator so that the zone itself is obvious.

Electronic photography—Electronic photography was a term that was first used to describe digital and represented the electronic recording of optical images in analog or digital form. Image capture used photo-multiplier devices or linear or area CCDs with the recording on magnetic, optical, or solid-state media. Images were made with a dedicated digital camera or video camera and converted from silver halide originals into electronic form. The combining of silver halide and electronic technology was also known as hybrid technology.

Electronic publishing—The production of printed material making use of a computer with an appropriate software program, which typically accommodates text and illustrations with layout control and a peripheral printer.

Encoder—A device that takes an RGB picture signal and timing signals and composites these data into composite video.

Enhanced Graphic Adapters (EGA)—In computers, this cathode ray tube (CRT) superseded the color graphics adapter (CGA) and provided higher resolution and more color. Typically EGA could provide resolution of 640×350 and 16 colors from a palette of 64 colors. In text mode (one of twelve modes), characters are formed from an 8×14 matrix, thus giving higher text resolution.

Extended memory—A de facto requirement in the processing of images or the use of multimedia on DOS-based platforms. Extended memory occurs above 1 megabyte. Four to eight megabytes has become standard RAM in multimedia machines.

Fax—Facsimile.

File—(1) In computers, the file is the basic structure for saving or storing data. Images, spreadsheets, and text documents are stored as files to be retrieved later by the programs (applications) that created or can operate on the file. (2) In electronic imaging, the digital database that represents a picture or a line image, or a set of instructions.

Fire wire—A cross-platform, high-speed, serial data bus defined by the IEEE 1394–1995, IEEE 1394a-2000, and IEEE 1394b standards capable of moving large amounts of data between computers and peripheral devices. FireWire features simplified cabling, hot swapping, and transfer speeds of up to 800 megabits per second (on machines that support 1394b).

Firmware—In computers, an instruction set or program that is stored and retrieved from programmable ROM or plug-in modules that are self-initiating and do not typically require software. Firmware differs from software in that the application exist as a program on a floppy disk or in a hard drive, while firmware is built into a chip or PROM.

Gigabyte—One billion bytes, or 1024 megabytes.

GUI—Graphical user interface.

Hard copy—(1) A computer-screen image printed out on paper or film. (2) A photographic print from a microfilm or other image projection, as distinct from an image projected only for visual inspection.

Hard disk—A magnetic storage device that is capable of holding thousands of megabytes, in contrast to floppy disks that hold approximately 3 MB. Hard disks are also referred to as fixed disks. These disks contain a platter that is spun at a high speed and a read/write head that accesses data. The hard disk maintains its integrity (data) when the power is off. Density of these disks is measured in hundreds of millions of bytes.

HD—High density.

HDTV—High-definition television.

Histogram—In computers, a description of a continuous-tone image through the tabulation of the number of pixels for each gray level extant. The tabulation is displayed as a

bar graph or histogram with the vertical axis as the number of pixels and the horizontal axis being the number of gray levels.

Home—In some computer applications, *home* is used as a synonym for the main menu. Home is the starting place from which to launch subapplications from the main program. In HyperCard, a relational database, home is the launching pad for stacks.

Icon—A primary graphical object in a graphical user interface. The icon may represent a device such as a drive or scanner. It may also represent a file, message, or application. Icons may change their appearance when an event occurs. An open file may be represented by a differently appearing icon than when the same file is unopened.

Image processing—The alteration, enhancement, and analysis of images for the purpose of improving the pictorial representation or extracting data from the image. Image processing relies on a number of well-tried algorithms that simplify and speed the process. While image processing is applicable to optical and analog approaches, the term's use is mostly limited to digital imagery.

Indexed color—In electronic imaging, a look-up table containing color information that facilitates displaying 24-bit color on an 8-bit driven monitor including only 256 distinct colors.

Initialize—In computers, starting a component for the first time, such as initializing a video board. To write to a disk, the disk must be initialized (formatted) so that it is prepared to receive data. This initialization organizes the sectors and tracks appropriately.

Ink-jet printer—A computer-controlled output device that sprays ink through very fine nozzles. The fineness of the nozzle determines the dot size of the ink spray. Usually, the water-based ink will be sprayed in liquid form or it may be heated and sprayed as a tiny bubble. Ink-jet printers can resolve between 150 dpi to 360 dpi. Many ink-jet printers will offer printer resolutions in different units such as 720, 1440, or 2880 dpi. Black-and-white and color output are both possible with ink-jet printing.

Input/Output (I/O)—A device that allows data to be entered into the computer (mouse, graphics tablet) or a device that accepts data for review (monitor, printer). I/O may also refer to the controller of these devices. I/O compatibility is a major consideration in the fabrication of an imaging or graphics computer workstation.

Input scanner—Any device that can capture an electronic representation of reflection or transmission of original material and convert it into a digital representation of the original.

Interactive—Communication between the computer and the user. There are several levels of interactivity. The highest level occurs in a time span that is real-time or near real-time.

Interlace—The scanning method of displaying images on the cathode-ray tube (CRT) whereby each of two fields is displayed every 60th of a second. The "a" field is composed of every odd line and the "b" field is composed of every even line. The two are interlaced together to represent one frame.

Interpolation—A method of modifying the image size. Digital systems are capable of recording a fixed number of pixels. Sometimes there may not be enough pixels for a particular application or there may be too many and software may be called on to change the number of pixels. This type of image processing is defined as interpolation.

JPEG—Joint Photo Experts Group.

kb—Kilobit.

kB—Kilobyte.

Kernel—A targeted group of pixels in a closely defined array that can be convolved, or evaluated with weighted coefficients. The value of each pixel in the kernel is dependent upon its neighbors. The array of weighted coefficients is called a mask. The size of the mask is the same as the kernel. In many texts the terms kernel and mask have become interchangeable.

Kerning—The adjustment of the space between type characters to improve their visual appeal. Certain page layout programs, including QuarkXPress, and languages such as PostScript allow desktop publishing to adjust spacing.

Keying—Keying is the act of combining pictures from one signal source into a picture sourced from a different signal. Keying can be controlled by frames or by color, such as chromakeying.

LCD—Liquid crystal display.

LED—Light-emitting diode.

Library—In computer parlance the library is a repository of a file from which the software may make calls. The calling of subroutines or procedures from the library can speed software development and provide for standardized approaches to the writing of code.

Linear array—Is another method of pixel organization in a CCD. In this approach, a single row of pixels is located in only the vertical orientations (the y matrix). A finite number of pixels will exist in this direction dictated by the manufacturing of the CCD just as in the area array device. The number of vertical pixels is fixed and the array is moved across the field using a small motor.

Linear output—Output that varies proportionally to the input. Video displays are linear with respect to the accuracy of the tone reproduction.

Liquid Crystal Display Projector—Liquid crystal display (LCD) technology was developed in 1973 and was most commonly used in digital watches and handheld calculators, where its light weight, low power, and high resolution made it the ideal presentation medium. Liquid display material is activated electrically and is now also used to form images for laptop computers and word processors. These items use a duty-type LCD, where the individual pixels are controlled by a liquid crystal matrix. These duty-type LCDs can be used to display color and video images, but they have slow response times that make them impractical for rapidly changing images. On the other hand, active matrix LCDs have a transistor at each pixel point that controls only that

pixel and can respond much more rapidly to image changes. This new generation of active matrix LCDs is competitive with conventional CRT displays (TV monitors). Because these new LCDs provide a quick change-response time, high resolution, impressive picture quality, and excellent color reproduction, they are being used for the video market and high-speed computer displays. LCDs consume very little power and are extremely lightweight compared with conventional CRT displays, making them ideal for use as very large, flat-screen, wall-mounted video image displays. This technology also provides for convergence-free color video projection systems.

Load—The transfer of data or the application from storage (hard or floppy disk) to the memory (RAM) of the computer.

Lock-up—A glitch that prevents a computer from accepting instructions from an input device. In effect, the user is locked out and the keyboard is locked up. In MS-DOS systems, holding down the control, alternate, and delete keys at the same time will undo a lock-up by warm-booting the system. Other computers require a different sequence of keys to escape from a lock-up.

Logic board—The primary circuit board in a computer that holds the CPU, ALU, RAM, ROM, and the bus network for the various peripherals.

Look-Up Table (LUT)—An image-processing operation that accepts input and maps it via a table based on some point-processing algorithm to specific output. The conversion of RGB to CMYK (input to output) relies heavily on a color look-up table (CLUT).

Machine code—The binary language that the computer understands and into which higher-level languages are translated.

Mapping—In electronic imaging, the process of transforming input brightness to output brightness.

Mb—Megabit.

MB—Megabyte.

MBPS—Megabytes per second/megabits per second.

Megabyte (MB)—Loosely, one million bytes. More precisely, 1,048,576 (2^{20}) bytes.

Memory—The active memory, or core memory, of the computer in which all data and instruction reside before and during processing. Data in memory is existent only as long as the system is operating. Once powered down, the memory becomes empty.

Memory card—Digital image files are stored on this temporary location in digital cameras. The memory card is capable of reading and writing both while in the camera or in a card reader inserted to the CPU. Different names have been given by each company to its memory card, such as Smart-Media, Memory Stick, Compact Flash, SD, and xD Media.

Microcomputer—A computer whose basic operating capabilities are on one chip. Using CISC technology, microcomputers are compact and powerful. The microcomputer has become known as a personal computer (PC).

Minicomputer—A mid-size computer having processing power close to that of a mainframe, but at a lower price while surrendering some of the mainframe's key attributes, for example, supporting fewer terminals. Minicomputers have evolved into workstations optimized for specific applications. As processing power, RAM size, CPU speed, and bus speed/width increase for minicomputers and for microcomputers, the distinction among the three levels of computers is difficult to characterize.

Motherboard—In computers, the same as a logic board. In Microsoft MS-DOS systems the motherboard holds all the processing chips and circuitry necessary for the computer to function. The circuitry of the motherboard integrates all the bus slots, hard drives, display boards, and their controllers.

Mouse—In computers, a hand-held input device that controls the cursor when moved about. The mouse has become the most popular pointing device for graphic user interface environments.

MPEG—Motion Picture Experts Group.

Network—In computers, a group of connected computers sharing a common protocol for communications. These networks can be local or wide in area and can connect from several to many thousands of terminals.

NTSC—National Television Standards Committee.

Nubus—A special high-speed bus found in Macintosh II computers. The Nubus is distinguished from other bus designs by its protocol for moving data within the computer. [It was very helpful with 8-bit work in the 1990s but is no longer widely used].

Nyquist theorem—A mathematical way of determining when a sample composed of high frequency will be imaged and displayed without degradation. The theorem states conditions under which the samples can be used to reconstruct the original signal with maximum fidelity. The Nyquist criterion states that the subject must be sample-limited and that the sampling frequency must be at least twice the signal bandwidth of the system.

OCR—Optical character reader/recognition.

On line—(1) In monitoring a process, an almost immediate analysis of the data collected, thus reducing the time lag between the discovery of an error and the correction of the process. (2) In computers, the term simply means that the computer is functioning. Sometimes *on line* is used to mean that the computer terminal is in communication with a host computer operating system.

Optimize—In computers, the optimization of the hard drive causes contiguous sectors on the block to be available for storage, thus achieving faster reads and writes to and from the hard drive.

OS—Operating system.

Paint—A term that describes the changing of pixel data. In image processing there are two fundamental actions, selection tools and paint tools. Paint tools change pixels that were selected in some way, such as by brightness.

Peripherals—In computers, attachments that are connected through a variety of data input/output channels, such as printers, scanners, and plotters.

Pixel—Picture element, the smallest component of a picture that can be individually processed in an electronic imaging system.

Pixel cloning—In electronic imaging, copying a pixel or group of pixels from an area of an image for the purpose of adding them to another area—for example, to remove unwanted detail.

Pixelation—When the spatial resolution of an electronic, computerized image is low, the individual pixels or groups of pixels become visible. This *blockiness* is known as pixelation. The degree of visibility of these blocky pixels depends upon the viewing distance from the cathode-ray tube (CRT).

Plasma display—In computers, cathode-ray tubes (CRTs) are only one form of display technology. As computers become smaller and more portable, the display is a limiting factor in achieving even smaller computers. Plasma displays are flat-screen displays in which a wire mesh sits sandwiched between two sheets of glass in an environment of inert gas. Each crosspoint of the mesh represents a pixel that can be addressed by the computer.

Plumbicon—In electronic imaging, video tube–type cameras use various types of pickup tubes to image a subject. The plumbicon tube is particularly noted for its ability to image under low lighting conditions. It has been used widely in the area of video surveillance.

Pointing device—In computers, the graphic user interface (GUI) functions most efficiently through the use of a pointing device that locates functions, addresses menus, or launches events.

Point processing—In electronic imaging, a point process such as a histogram equalization is used to correct the brightness levels in an image in order to achieve a contrast change.

PPS—Pictures per second.

Pseudo-coloring—In electronic imaging, black-and-white images captured by video or scanned into the computer may be displayed in color. The color displayed will not have any relationship to the actual image, but rather will be colored according to a look-up table that assigns colors according to group brightness levels within the image. For example, a pseudo-coloring program may divide the range of brightnesses within an image into eight levels, each containing 32 brightness levels, and then assign a color to each level. The original black-and-white image will then be displayed in eight colors. In scientific imaging such as radio-angiography, pseudo-coloring is used to make subtle features of the image more visible. The corresponding photographic technique of pseudo-coloring is posterization.

RAM—Random access memory.

Random-Access Memory (RAM)—In computing, the central processing unit (CPU) of the computer will access data and program instructions from an area of the computer called RAM. Any set of instructions or data can be very quickly accessed by the CPU. Data and instructions can be entered into RAM as needed and instructed by the computer. As long as the computer is on line, data will remain in RAM. Once the computer is turned off, all data in the computer will be erased.

Raster—In electronic imaging, the scanning pattern of the electron gun across and down the cathode-ray tube (CRT) as it paints or refreshes the image. In computer graphics, a rectangular matrix of pixels such as a bitmap image.

Raster graphics—In computers, screen graphics are displayed by the cathode-ray tube (CRT) according to a raster pattern that is controlled by the deflection circuit of the electron gun and the circuit of the metal grid inside the picture tube. Graphic characters are created according to which pixels are excited by the electrons. Characters are composed of groups of pixels. The main drawback to raster-drawn graphics is the jagged appearance of text.

Raster image processor—In electronic imaging, used to convert vector images to raster images in computers that use both kinds of image files.

Raster unit—In electronic imaging, the distance between the midpoints of two adjacent pixels.

Resolution—In electronic imaging, the number of horizontal and vertical pixels that comprise the image. The minimum resolution acceptable for scientific image processing is 512×512 pixels. If the term is used to describe brightness levels (contrast resolution), then the minimum levels of brightness are 256.

RGB—Red, green, blue (video).

RIFF—Raster image file format.

RIP—Raster image processor.

ROM—Read-only memory.

RUN—In computers, the instruction to begin execution of a programmed task.

Run-time error—In computers, a program error other than syntax that causes the computer to crash. The error is not identified during compiling and manifests itself only at the time the program runs.

Scaling—(1) The process of comparing the dimensions of a photograph or other image that is to be reproduced to the dimensions of the space allotted to the reproduction, including determining whether cropping will be required because of a difference in the height-to-width proportions of the original and the reproduced images. One method is to make a rectangular outline the same size as the original on paper, draw a straight line through two opposite corners, and add lines corresponding to the dimensions of the space available for the reproduction. (2) In photomechanical reproduction, determining the correct dimensions of an image to be reduced or enlarged to fit an area. (3) In electronic imaging, images are resized by percentage, where 100 percent is the original input image.

Scanner—(1) A scanner is a device that can translate a transmitted or reflected light image into a digital form. Scanners include rotary drum scanners, flatbed scanners, handheld scanners, and dedicated film scanners. (2) In electronic imaging, a peripheral device that allows for the conversion of flat art, photographic prints, and transparencies into

digital data that can be accessed by photographic imaging software.

Scratch disk—In electronic imaging, many image manipulation programs require that a copy of the image being processed be held in storage so that operator errors can be undone. Because of the size of images, the copy image is usually held in a reserved area of the hard disk called a scratch disk. After the image manipulation is complete, the copy image is removed from the hard disk and that area is no longer reserved.

Screen display—Viewing electronic images on a screen is referred to as soft viewing or proofing. This is because there is no hard copy image as of yet. Images viewing this way contain 72 dots per inch.

Separations—In electronic imaging, the creation of four separate files, one for each of the four process colors: cyan, magenta, yellow, and black. The software for separations may be machine-specific or may have various look-up tables to maximize color appearance for specific output devices.

Serial port—In computing, one of the oldest two standard input/output communications ports used by the computer to control external peripherals such as a modem. Serial ports send data one bit at a time in a sequential string. It is a slower transfer than a parallel process.

Slow scan—In electronic imaging, the transmitting of video signals at a rate slower than real time is called slow scan. This is generally done because of bandwidth limitations. Slow scan video can be sent over radio frequencies other than those allocated for broadcast and over standard telephone lines.

Small Computer Systems Interface (SCSI)—In computers, there are several means of accessing peripherals through a port that conforms to a particular protocol for data transfer. SCSI is one protocol that has become a de facto standard for data input/output in the Macintosh platform. Scanners and film recorders connected to a Macintosh exclusively use SCSI. Other peripherals such as removable cartridges and optical drives also employ SCSI.

Smoothing filter—In electronic imaging, an electronic filter used to reduce the cross-hatch noise pattern that can appear with the use of charge-coupled devices.

SRAM—Static random access memory.

Static memory—The retention of information in semiconductor memory without refreshing or recirculating.

Still video—An electronic method of recording individual images using 2-inch floppy disks that hold either 50 field images or 25 frame images.

Terabyte—One trillion bytes (TB)

Tiff—In electronic imaging, images that are captured and saved to a storage medium as a file and are described according to some algorithm. The description is usually written prior to the image data in an area of the file called the header. Tagged image file format, or TIFF, is one such header description widely used by electronic imaging programs. Others include TGA, VST, PCX, PICT, and PIC (to name only a few). The proliferation of a multitude of

image headers has caused serious porting problems. Many image-manipulation software programs only read a limited number of header files. A number of commercial conversion programs allow for the translation of one file format into another.

Trackball—In computers, a graphic user interface device that controls the cursor when rotated. The trackball can be rotated 360 degrees in its cradle, causing the cursor to move to any position on the screen. Buttons on the cradle operate in the same fashion as buttons on a mouse.

True color—In electronic imaging, the use of 16,777,216 colors for display description purposes. This standard is a 24-bit display system: 8 bits for the red channel, 8 bits for the green channel, and 8 bits for the blue channel. True color is the equivalent of photographic quality.

Undersampling—In electronic imaging, the sampling of an analog signal at less than the Nyquist theorem.

Underscanning—In electronic imaging, the displaying of a raster image so that the scanning raster is visible. Underscanning, although infrequently used, ensures that image data are not hidden.

Unsharp masking filter—In electronic imaging, the digital counterpart of photographic unsharp masking. This digital equivalent uses a neighborhood process to subtract an unsharp (smooth) image from the original image.

USB—Universal Serial Bus (USB) is a connectivity specification and provides ease of use, expandability, and speed for the end user. USB is arguably the most successful interconnect in computing history and was co-released in 1995 at 12 Mbps by Intel, USB today operates at 480 Mbps and can be found in over 2 billion PC, CE, and mobile devices.

VBI—Vertical blanking interval.

VCNA—Video color negative analyzer.

VCR—Videocassette recorder.

VDT—Video display terminal; visual display terminal.

VDU—Video display unit; visual display unit.

VFS—Video floppy system.

VGA—Video graphics array.

VHF—Very high frequency.

VHS—Video Home System (trade name).

VHS-C—VHS-Compact.

VTR—Videotape recorder.

Vector graphics—In electronic imaging, graphics that are displayed on the cathode-ray tube (CRT) as represented by a mathematical description. This mathematical description causes the CRT to scan the pattern as described and not according to a raster pattern. The result is a very high-quality graphic without jagged edges. Vector graphics are displayed slowly because of the mathematical description and would be evidenced in Microsoft PowerPoint, for example.

Video Random-Access Memory (VRAM)—In computers, a specialized form of RAM that can simultaneously write data to the display monitor as it is receiving data from the central processing unit (CPU). This form of dual-port chip

greatly speeds up the displaying of images on the cathode-ray tube (CRT).

Virus—A computer program designed to disorient, slow down, or destroy the computer's operating system or data files or the hard disk's directory.

WB—White balance.

Window—(1) In computers, a frame or frames in the cathode-ray tube (CRT) that display different processing operations. For example, one window may display a spreadsheet while a second window on the same CRT displays a word processing document. Window environments are a form of graphic user interface (GUI). (2) In computers, a proprietary graphic user interface (GUI) operating system for IBM and compatible platforms by the Microsoft Corporation.

Word processing—In computers, a software program that allows the user to enter text for the purpose of writing a document. The text may be edited and sent to a printer for hard copy.

Write—In computers, to store data on a floppy disk, hard disk, or optical disk.

Write Once Read Many (WORM)—In computers, a storage device that is written to by a laser. This system allows for a large amount of data to be stored. Optically based, this approach can only write once to a given sector on the optical platter. However, the data can be read from the platter as often as necessary.

Write-protected—In computers, hard and floppy disks can be physically and virtually manipulated to prevent writing over important data that exist on the disk. Writing over data has the same effect as erasing data.

YIQ—In video, NTSC standards abbreviate chrominance as I and Q, and abbreviate luminance as Y. I and Q refer to hue and saturation. Y refers to value or brightness.

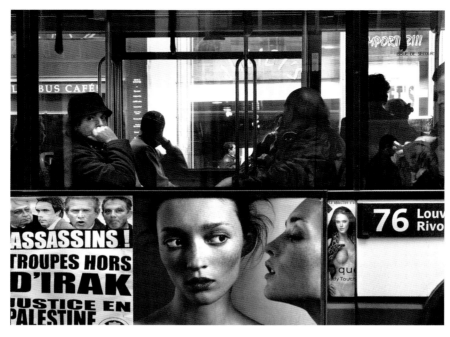

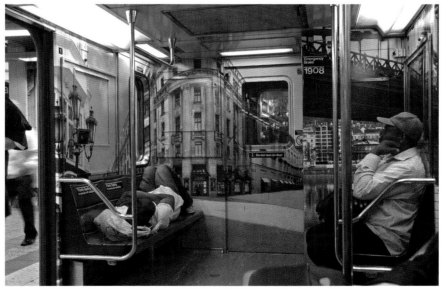

CONTEMPORARY ISSUES

J. TOMAS LOPEZ, EDITOR
University of Miami

A Different Set of Questions for a New Age

J. TOMAS LOPEZ

University Of Miami

Since its inception, photography has functioned as a catalyst for change and revolution, not just in the recording of world events, but as a tool for many disciplines. One could argue that photography's discovery has had the same impact on art, communication, and the sciences as the printing press had on the distribution of literature. The printing press at the time of its invention may have primarily been thought of as simply a tool to facilitate the reproduction of manuscripts and bibles, but what could not be predicted at the time was the impact it would have on the democratic distribution of ideas across social classes and borders that would change the perception of the world. The definitional rights of people would no longer simply be controlled by a few and books became the currency of ideas.

There is very little doubt that photography has changed the way we perceive the world. The early photographs that were made by Eadweard Muybridge (to settle a bet as to the position of a horse's legs when full out running to confirm if they were ever all completely off the ground) established photography as the definitive tool for empirical evidence. Harold Edgerton's high-speed flash images of playing cards ripped by a bullet as well as Lennart Nilsson's life before birth photographs revealing life and creation did not lessen that epistemology. When one considers photojournalism, modern history has been more clearly defined by photographic coverage than by the words that were used to describe the same events.

For the first time in the history of this book, the *Focal Encyclopedia of Photography* has included content that does not simply define chemistry, physics, or the history of photography; rather it describes the contemporary issues found in photography and the contemporary image-making processes. This section also speculates what the future trends and directions in photography may be.

From these larger concerns, I formulated a series of specific queries directed at individual professionals in the field. I chose four topics and sought writers actively engaged in the issues: photographic theory, which included modernist and postmodernist approaches; professional practices, addressing changing methods in professional photography, both in the classroom and in the studio; the process of seeing and perceiving, or decoding images toward an understanding of their function in art and society; and the hypothetical future, examining new directions in technology and their impact on photography.

For the pedagogical section I asked how the transition to digital imaging has impacted schools, faculty, and their curriculums. I queried them as to how this shift affected space, budgets, and the missions and objectives of current photo programs. Specifically I asked how the individual instructors had transitioned from silver to silicon and to briefly share their own personal transition. Margaret Evans elected to write a narrative of personal and professional considerations for the mission of education. John Kaplan's essay addressed the issues of teaching and thinking about journalism as well as how journalistic ethics and practices changed. Fundamentally, "Are there new considerations that must be taught and instilled to this generation of image-makers?"

In the section on signs and codes I asked whether there was such a thing as photographic "seeing" and whether language or the syntax of photography was at risk in considering such a semiological and theoretical argument. Richard Zakia's long and respected interest in the semiotics of sign systems made him uniquely qualified to address these issues in his thorough investigation.

A. D. Coleman is interested in the implications of digital on the world and the chasm between artist and audience. This gap is not just of message or meaning but also of accessibility. Does an artist working at the cutting edge of digital imaging continue to distance himself from those whose hardware/software tools are incapable of accessing? Photography in the 19th century became a tool for creating democratic multiples. Does digital technology return us to an elite world of only the *haves* accessing these art forms and artists?

In considering publishing/distribution Millard Schisler and Barry Haynes were asked to ponder how the digital evolution has impacted that field. New possibilities in hardware and software have made publishing widely accessible, but do these same possibilities present challenges to the future of published material? Mr. Haynes, co-author of *Photoshop Artistry*, releases a new edition of his manual every year (or certainly every time

Part page photograph: Examples of contemporary photography by Professor J. Tomas Lopez. Top: Parisian Dream, © 2006—New York City, USA. From the "Subway Series"—life below ground. Bottom: Assassins © 2002 Paris, France. From the "Non a La Guerre" series—war protests around the world.

the software is upgraded). Has this created a modern day version of Sisyphus? Professor Schisler notes that the transition from "everybody wants to publish" to "everybody can publish" brings along an interesting conundrum: It is at once more democratic yet the economic realities of the digital divide create a new paradigm of privilege and marginalization.

Daniel Burge examined the issue of preservation. Since photographs function across so many interdisciplinary fields, the concern that they remain accessible and vibrant is crucial. Images are not to be thought of as objects placed in a time capsule, they are an essential part of the ongoing debate of culture. Formats, storage, costs, and access are in a crucial stage of development and must be considered.

Doug Manchee provides us with a practical hands-on approach to the studio of the 21st century. What should the considerations be for space, electricity, computers, cameras, and future tools. There have been suggestions that the simplicity and ease of digital image-making will make everyone a professional photographer. It has proven to be a false concept. It is and will still be necessary for master image-makers to provide excellent images for advertising, journalism, portraiture, and fine art.

John Craig Freeman is a hypermedia artist. What is that? Is it a new discipline or is it the next stage in the natural evolution of photography? Hyperlinks offer a generation that is comfortable conflating image, audio, and text in a non-linear way to resolve the interplay between form and content. Does it (or did the invention of photography itself) mark the beginning of a post-literate culture? The inclusion of a glossary of new-media terms helps the reader understand this language with its own syntax and usage.

Daile Kaplan, director of Swann Galleries, has written an essay entitled "Photography Marketplace and Contemporary Image-Makers." She raised the possibility that photography has ascended to become a dominant medium in the art world with prices rivaling those of paintings. It is extremely difficult to visit any international art exhibit without the presence of photography and digital imaging among the celebrated displays. As photographs begin to sell for seven figures, it would seem that the future of this medium is very positive. Michael Peres and David Malin's eassay, *Science as Art*, reminds us that whatever aesthetic or theoretical perspectives one may hold, it is the wonder of the image that unites the viewer in assigning definitions. Whether an image was made for scientific purposes or to explore personal angst, the object the viewer sees must engage and transport the viewer as if by magic. It may be that at this juncture, where art, science and metaphysics touch that we find our most universal pictorial truths.

Academic and Pedagogical Issues: The Impact of Digital Imaging on Photographic Education

MARGARET P. EVANS
Shippensburg University

History

In the fall of 1993, after 20 years of working with a variety of traditional photographic media, I enrolled in the first of four courses in digital photography at Rochester Institute of Technology (RIT). I was between teaching positions at the time. Previously, I had taught photography courses in two separate photography degree programs, using traditional materials, processes, and creative methods. Increasingly, teaching position announcements were calling for knowledge of or experience with electronic imaging. My enrollment at RIT was an effort to prepare myself for one of these new positions. I was the oldest person in all of my classes.

The administration of the School of Photographic Arts and Sciences at RIT had been encouraging all members of the faculty to participate in seminars designed to introduce this new technology, which would eventually be phased into the curriculum as degree component requirements. Nevertheless, some of the photography faculty at the time were reluctant to believe that computer imaging could rival the traditions of film cameras and chemical darkrooms. Admittedly, despite the various forecasts that computer imaging would become dominant, the idea seemed far-reaching in 1993. By today's standards, computers, especially the Apple Macintosh for which most of the computer imaging programs were created, were expensive and slow. The software, including the foremost Adobe Photoshop, was tediously limited. Digital cameras were completely outside of most individual budgets, even for many professional photographers, and the image resolution remained seemingly light years away from that attainable with film. The best the industry could offer at the time was high-quality and expensive drum scanners and film writers that offered a "hybrid" of film and computer technology.

Computer imaging had been a common tradition in the publishing and advertising industries for many years before Adobe Photoshop or Apple Macintosh computers. However, those processes that mysteriously transformed photographic images into composites for the printed page were, in the early 1990s, for technicians rather than the creative minds behind a camera. Camera and darkroom traditions had been around for more than 150 years. By 1993, engineers at companies like Kodak had been tenaciously re-inventing and enhancing the standard technologies of film and photographic chemistry for nearly 100 years.

Yet, twelve years later, on June 16, 2005, Eastman Kodak announced that the production of their black and white enlarging papers would cease. Fifteen thousand jobs throughout the company would be cut by 2007, and a plant in Brazil would close. The announcement coincided with continuing reductions in profits from the traditional photographic market combined with an increase in the production of digital materials and equipment.

These were changes occurring at Eastman Kodak, the world's first and largest photographic company; the company whose motto was "You take the picture, we'll do the rest." That motto has now been transformed: "We make the equipment, you do the rest."

Back in 1993, I interviewed a number of professional photographers regarding the influence of the new media on their work. Everyone, including commercial and news photographers as well as internationally acclaimed artists, spoke of the transitions they were making based on the trend toward computer imaging. These photographers had all become involved in some way with digital imaging technology.

In a rapid transition, the faculty at RIT's School of Photographic Arts and Sciences came to embrace digital imaging as part of the curriculum and in their own work.

Computer imaging technology is now an integral part of the curriculum in nearly every photography degree program across the nation. Every photographer has been touched in some way by the new technology. Most of today's photographers own at least one digital camera.

Mission Statement

Following my year of RIT courses in digital imaging, I did find a new position teaching traditional black and white and digital photography in the Communication/Journalism Department at Shippensburg University, one of the 11 Pennsylvania state university campuses. My initial tasks were to set up a new digital imaging Apple Macintosh computer lab and develop a course in digital photography.

The first step in expanding a traditional photographic curriculum to include digital technologies seemed to develop a mission statement. Faculty members in my department decided to bring in a consultant who had been part of the initial transition to include digital imaging in the curriculum at RIT. Professor Douglas Ford Rea had been the first faculty member at RIT to organize and teach a course in digital photography and was invited to share his expertise.

Professor Rea presented a daylong seminar to the faculty of the Communication/Journalism Department at Shippensburg University. Discussion topics addressed recent shifts in the industry: ways in which to prepare students to use the changing current innovations in digital technology, curriculum planning to include digital imaging, emerging innovations in digital cameras and image capture peripherals, and challenges created by choosing appropriate desktop computers and graphics and visual communication software.

As a result of the seminar with Professor Rea, a department mission statement emerged for developing a computer-imaging curriculum in graphic design, desktop publishing, magazine and book publishing, photographic imaging, and video imaging. It was important to recognize the impact of electronic imaging on commercial markets if our graduates were to be competitive

in the search for professional positions. Instruction in the tools of electronic imaging systems would be incorporated in the curriculum to meet students' needs. The change was inevitable, and the transition would take years of continued research. Grants were written to establish and upgrade computer labs. Searches were conducted for adequately prepared faculty to teach new and upgraded courses. The economic impact of this change would positively affect new student enrollment both in our department and in the university.

Curriculum Issues

Curriculum issues in the teaching of photography in the early 21st century are central. My experience with the transition from traditional imaging to current technologies has been in a department that teaches an array of imaging courses in print journalism, public relations, and electronic media. All these areas have been affected by the change to computer imaging.

We currently operate three state-of-the-art computer imaging laboratories: an Apple Macintosh imaging lab, a PC electronic publishing lab, and an Apple Macintosh electronic media lab. All three labs have been established through successive grants from the university's technology funding administration. Additionally, grants are written each year to upgrade hardware (computers, digital cameras, printers, scanners, and other peripheral equipment) and software, including that which is used to teach digital photography, desktop design and publishing, and video editing. (More on grant writing appears later in this essay.)

Initially this essay will address issues concerning the teaching of photography and the transition to digital imaging, concentrating on the pedagogy of photography and digital photography. The emphasis will be not on isolating the digital imaging process, but on bridging the connection between the two technologies by teaching traditional photography and digital imaging in tandem.

A principal component of teaching photography is to inspire a stronger understanding of critical thinking. Both photography and digital photography are taught as electives in our Communication/Journalism degree program. Students in my courses are juniors and seniors. The courses are technical and skills-oriented, yet students must engage a number of thought processes to communicate an appropriate message.

Traditional photography emphasizes four basic tenets in the Introduction to Photography course:

1. To see as the camera lens does
2. To understand that the camera is a mechanical instrument subject to human control
3. To view and interpret images in various contexts (e.g., art, advertising, documentary)
4. To comprehend that every viewer brings individual biases to the interpretation of images

To see as a camera lens does means to understand that the world through the lens is fragmented into small selected

FIG. 1 © Stephanie Prokop, grayscale image created from a scanned black and white negative 6.2 × 4 inches.

rectangles of information. These rectangles can be vertical or horizontal. They can be flat or reveal depth; include a small detail, a medium view, or a wide vista; and they will include every piece of information in the scene within range of the lens. For example, sometimes, inadvertently, we find a tree growing out of a subject's head. Chords, light switches, and distracting lines may "mysteriously" appear in the frame.

The camera's lens mechanically translates what appears in front of it on film in a series of tones that reveals shadows and light. The image is an abstraction of the real world. Regardless of the mechanical nature of the medium, the photographic record is not the actual real world. Rather, it is a translation or interpretation of that world.

The camera has mechanical controls that determine exposure, depth of field, and point of focus. The photographer controls point of view, aperture or shutter priority, exposure override, type of film, lens focal length, specific focal point, framing, and distance between subject and camera. The various choices of camera settings and points of view will yield diverse results.

Following an initial assignment designed to teach students how to control cameras for correct exposure and focusing, students complete an exercise in equivalent exposure. They must choose three different subjects. Two of those subjects must include some kind of movement. For each chosen subject, once the correct exposure is determined, students must choose from a range of aperture/shutter combinations to produce equivalent exposures with varying results in depth of field and either blurred or stopped-action movement.

Students complete one additional assignment in exposure control by learning to interpret meter readings and bracket exposures. The negatives show that some difficult lighting situations may call for an override of the meter's indication of a correct exposure.

In the darkroom, students learn to print black and white negatives on standard 8 × 10 inch resin coated enlarging paper.

FIG. 2 © Jill Rakowicz, traditional silver halide black and white photograph. Original size 9½ × 6½ inches.

They become increasingly skilled at manipulating the overall and local contrast of the image and in recognizing where, when, and how to enhance detail within the frame. All images are printed full-frame in order to teach the importance of seeing the image at the time of shutter release rather than later in the darkroom.

Viewing the results of exposure preferences helps students to understand how choices in range of focus and frozen or blurred action affect the message of the image. During critiques, students analyze their own results and those of their classmates. They begin to understand how critical thinking about the message within the frame is demonstrated by how the photographer manages the mechanics of the camera.

Elements of composition are taught early in the semester, as many of my students have not studied any form of visual art prior to taking the Introduction to Photography class. A slide presentation in the elements of composition teaches students that the rule of thirds, simplicity, line, shape, balance,

and framing all contribute both aesthetics and meaning to an image.

The abstract concepts I introduce on the first day of class are the similarities between photographic language and written or verbal language. Both languages contain simile and metaphor. During the first class, students explore images by known photographers like Edward Weston and those taken by former students to look for these concepts. Through these exercises, students learn that photographs may look like something other than the literal object they represent and the image subject may be unrecognizable from that original object, despite the mechanical nature of the medium. The photographs may contain symbols that have different meaning for different people. Visual simile and metaphor add to the significance of the photographs by enriching their subject matter with multiple levels of meaning. Successful photographs connect verbal and visual language.

Once students understand the mechanics of the camera and film and have practiced composition in framing their initial assignments, they are given two important projects that demand more advanced critical thinking of the message within the frame. One assignment is a series of portraits taken both in the studio and on a location of their choice. In both cases they must learn to control the lighting and collaborate with their subjects in order to create a portrait that engages the viewer beyond the surface of the photograph.

The second of these assignments addresses photojournalism and documentary photography. These subjects require the greatest amount of critical thinking for students in a communication/journalism major. The study of these topics includes discussion of the concepts of objectivity and truth. All photographs are empirical and conceptual on some level, whether they are journalistic or works of art. There are agendas to be met when taking and publishing photographs in newspapers, magazines, and on the Web. Every photographer views a situation from a different perspective, and every viewer receives the information through a set of individual predispositions. There are no absolute truths. There is no possibility of simple objectivity. Point of view and interpretation are part of every image.

In addition to photographing an event or creating a short documentary, students must choose a controversial photograph from a newspaper, magazine, or book and write a critique, indicating how technique, lighting, perspective, point and range of focus, and framing affect the message of the image. Class discussion of this topic including analysis of images in a slide presentation, written image critiques, and class critique of the completed assignments promote a more complete understanding of how photographs, despite having been mechanically produced, are subject to the rational lens of both the photographer and the viewer.

By exploring the mechanics of photography, analyzing images presented in class, and creating and critiquing photographs from assignments, students learn the power of critical thinking. In a world in which photographic images inform every aspect of our daily lives, it is important to expand the

FIG. 3 © Amyee Faber, black and white image enlarged on watercolor paper coated with liquid emulsion, 5 × 6.3 inches.

depth of our thinking so that we can become more aware of how the camera serves agendas. We must question what we see and how we think about what we see.

Digital Photography

Digital cameras operate very much like traditional film cameras except that the image capture is on removable media rather than on film. No chemical processing is needed and no film is consumed or has to be stored under archival conditions. The results are immediately available, and the capture media can be used repeatedly. Because of the instant gratification nature of digital capture and the "click and undo" aspect of digital image processing, many of the critical thinking steps of traditional film photography have been eliminated. The photographer still has to consider how manipulation of camera controls affects the visual message, but one can effortlessly generate numerous images with different perspectives and ranges of focus faster, covering more possible interpretations of a situation, and subsequently and easily, either eliminate the unwanted views or decide later which is most effective. With film, all of these steps can require laborious, cumbersome, or time-consuming effort. Also, photographic information can be altered more quickly, easily, and spontaneously in the all-digital world than

with the traditional film or the film-to-digital hybrid forms of photography.

For these reasons, I require a course in traditional photography as a prerequisite to enrolling in digital photography. The process of critical thinking is as important as creating the images. As I described earlier, traditional film and chemical processing teach critical analysis with each new step. Eliminating the tactile, hands-on work that promotes satisfaction with each roll of film that uncurls from the reel and every image that emerges in the developer often means taking shortcuts to achieve results that require control and thoughtful creativity. There are many important links between traditional photography and digital imaging. Grain size, contrast, burning and dodging, cropping, and masking all have equivalents in both worlds. The frame of reference from the study of traditional film and darkroom processes allows students to make the transition to digital imaging responsibly and thoughtfully, with their critical thinking fully engaged.

Although my course is called "digital photography," digital cameras and their use are only one component of the syllabus. I present the camera and send students out to take pictures, which are subsequently downloaded and converted to TIFF images. The cameras are available for loan throughout the semester, and students are encouraged to use them to create images for the course as well as for their own creative use. However, much of the course includes working with image processing in Adobe Photoshop and with peripherals such as scanners and printers.

I teach as many hands-on tutorials as possible so that students can learn the processes of image manipulation, while also learning to consider the technical requirements. Thinking creatively is essential. These tutorials also allow students to work together in class, following instructions and learning to use Photoshop tools.

The three major and somewhat demanding major technical areas of digital image processing are presented as lectures and demonstrations. These areas are input (getting images into the computer with digital cameras, scanners, and photo CDs), color management, and output (or printing or optimizing images for the Web and other electronic publication). Each of these steps includes an important course assignment that reinforces the classroom discussions, demonstrations, and presentations.

In the tutorials, students learn how to use selection tools, how to create and manage composite and adjustment layers, how to restore and use color creatively, how to choose and apply filters, how to create effective shadows, and how to blend image elements to create believable composites. The course assignments require that students scan and repair grayscale negatives and prints; scan, repair, and restore color photographs; create composite images; and create posters that depict messages regarding socially relevant issues. The color images are printed on color photo inkjet printers. Many are placed on view in our building's hallway display cases.

Students' previous experience with traditional photography has established knowledge of lighting and image contrast as well as critical analysis of image messages. One of the most

FIG. 4 © Michael Profitt, digitally restored old family color photograph, original size 2.5 × 4.5 inches.

FIG. 5 © Rebecca Myers, digital photographic composite image, original size, 5 × 7 inches.

difficult things to learn in the digital darkroom is when to stop working an image. Someone once said that Henri Cartier-Bresson's famous "decisive moment" has become the "decisive three weeks" in the digital world.

Making the Transition

For an institution that has not yet made the transition but would like to make the move to digital imaging, there are a number of important considerations:

Finances
Equipment and software
Computer lab space
Qualified faculty
Library and other resources
Developing appropriate courses

Financing the establishment of a digital imaging facility, qualified faculty, and library resources is the biggest issue. At my university and throughout the state system in Pennsylvania, grants must be written to establish need, academic integrity,

coordination with other programs, periodic assessment methods, library and other resource needs or sufficiency, impact on educational opportunity, identification of qualified faculty, space availability, and budget requirements for equipment and software. Additionally, since hardware, software, library resources, and faculty qualifications are ongoing costs requiring frequent upgrades, new grants must be written to cover these costs every one to two years. Additionally, faculty must refresh their knowledge and update their presentations to meet the ongoing changes in the field.

A private institution with a large endowment may not require grants to cover initial foundational costs, nevertheless, it may require substantiating narratives in the form of curriculum rationales to add facilities, equipment, and faculty resources.

The most efficient way to gain qualified faculty, if an added tenure-track line is not feasible, is to retrain existing photography faculty to teach the new courses. A photographer

can learn digital imaging fairly quickly. Proficiency rapidly improves over time by working with the equipment and software. If the institution is fortunate enough to have funds for additional faculty lines or if a line opens due to a retirement, there should be no problem filling the position. Qualified MFA graduates with digital imaging credentials are now readily available.

Developing appropriate courses is a matter of writing proposals that list many of the same proponents as grants that establish the facilities, excluding the budget but including a detailed syllabus. At Shippensburg University, one course must be dropped if a new one is to be added. As the curriculum changes to emphasize computer and digital technology in all phases, some previously existing courses will become obsolete. It is usually not difficult to find courses that have not been taught in three years or more.

How to Find the Right Photography Degree Program

Students looking for the right photography degree program should consider the following questions:

Do you want to make photography your career?

What are your goals as a photographer?

How far from home are you willing to go to attend a college or university?

What are your family financial resources?

How much financial aid do you require?

What colleges or universities will offer you the best financial aid package?

Do you qualify for financial aid grants, loans, work-study, or scholarships?

What kind of climate is best for you?

Are you looking for an urban or rural setting?

What approach to learning is best for you?

Do you want to focus primarily on your career skills or are you looking for a more liberal education?

What photography and electronic imaging facilities does the college or university offer?

What degree level do you want to achieve?

What level of diversity of student body are you hoping to find?

Do you want to study abroad for part or all of your education?

When the above questions have been considered, the student can go to the Web sites listed below and begin to search for a photography school that most closely matches personal expectations. A student may have to settle for one or more trade-offs (such as a cold climate when a warmer place is preferred) if the program offered most closely matches one's professional needs. This research requires plenty of time. A prospective student should not be shy about calling a faculty member or admissions office personnel for further information. Sometimes making that personal connection can be the strongest influence in making a final selection. The faculty and administrators are themselves interested in increasing enrollment in their program, and they are customarily friendly and welcome calls from those who are considering their program.

It is advisable to attend admissions fairs. Representatives from many colleges or universities are usually there and will be happy to speak with prospective students and parents. Once three to four applications have been completed, campus visits are advised as they are valuable in making the final decision. Viewing the campus and facilities for a major in photography and meeting some of the faculty give the visitor a definite sense of what to expect once enrolled in the program.

Conclusion

The study of photography opens avenues into a variety of career choices. The technical and visual skills required of a professional photographer provide the essential foundation to communicate ideas. The camera and the images created with it are ways to bring photographers closer to personal experiences and to critically evaluate world views. Digital photography is part of an increasingly large infrastructure of information technology. While electronic communication moves us into the world of the nanosecond, we should not lose sight of the fact that the flow of real content is the goal. Process generates ideas, which in turn produces content. Photography is a language that must be studied slowly, carefully, and methodically to understand its vocabulary.

Photography is an interdisciplinary study that contains rigorous theoretical connections to other disciplines such as philosophy, literature, history, social science, physics, chemistry, mathematics, communication, fine art, and journalism. The photographic medium can organize all of these disciplines through process and analysis of images. Digital photography is a way of advancing the discipline into the technology of the 21st century. However, electronic imaging requires a full and concrete basis in the original traditions of the medium to adequately comprehend the nature of creating images and the significance of those images to both the photographer and the viewer.

ADDITIONAL INFORMATION

http://www.photographyschools.com/
http://www.collegeboard.com/csearch/majors_careers/
 profiles/majors/103185.html ◉

Ethical Photojournalism: Its Authenticity and Impact

JOHN KAPLAN
University of Florida

I had been an avid photographer since ninth grade and enthusiastically decided to enroll in the photojournalism program at Ohio University. With portfolio in hand, 5 years shooting experience, and more confidence than a 19-year-old deserved, I showed my work to renowned professor Chuck Scott.

Chuck was a bull of a man. Brawny and intimidating but also, as I later grew to learn, an unrelenting supporter and coach for the hundreds of young photographers who have come through his door. The master carefully eyed my work. He took particular interest in a scenic photograph of mine from Yosemite National Park. Taken during a multi-year drought in California, the shot showed an evaporated riverbed transformed into a dry, smooth granite earthscape. Captured at night with a tripod, the composition was made stronger by a bright full moon hovering over the textured composition.

The professor reached into his pocket, pulled out a shiny nickel and said, "Hey. Look here. Just about the right size." He laid the nickel on my print and had found a perfect match.

It was true, I said, proud of my naive creativity. When I made the print, I placed a nickel on the piece of enlarging paper as it was being exposed in the darkroom, thinking I had come up with a better solution to my novice, blurry technical rendering of natural full moon. As a freshman in college, I yet knew nothing of the ethics and mores of photojournalism, having no idea that I could likely be fired for doing such a thing as a working photojournalist. Despite the power of his personality and God-like influence within the profession, Chuck was gentle with me. He told me to go back out and make pictures that viewers should have every right to believe in.

At that time, the post-Watergate era of the late 1970s and early 1980s, the public perception of journalism was riding high. Colleges were jammed with would-be journalists and newspaper photography was making a transition from craft to equal counterpart to the writing side of the profession. For example, starting about that time, as a hiring requisite, photojournalists were finally expected to have journalism degrees too.

Because of staunch supporters of visual truth like professors Chuck Scott and Terry Eiler at Ohio, Cliff Edom and Angus McDougall at the University of Missouri, John Ahlhauser at Indiana, and Howard Chapnick of the Black Star picture agency, the photojournalism industry was making an important transition. Strides toward credibility and equality were being made and photojournalism was on the path to no longer being seen as a second-tier operation in the newsroom. Such gains were made by advocacy of honest picture taking and the resulting integrity that it brought.

A few years before my unknowing indiscretion with the Yosemite picture, I remembered how a well-known photographer had shown me how he painted in birds with "spot-tone" ink on scenic photos of his own. And, when I arrived at the *Pittsburgh Press* in 1984, I was told that just until that year, sports editors would keep a bunch of cutout photos of hockey pucks in their desks for those prints that needed to have them glued on when the photographer missed the hard-to-capture timing of the stick slapping the puck past the goalie.

Decades later, the profession pretty much recognizes that pictures should not be "set up." Many newspapers have ethics policies that include staunch photo guidelines. Like most other contemporary professors, I tell my students at the University of Florida not to pose pictures and include an honesty policy with my syllabi. If a spontaneous situation cannot be captured

with good planning and astute timing, it is always better to do a strong, posed portrait rather than create a pretend, tellingly stiff situation. When viewers look at a portrait, there is no "illusion of spontaneity," I say. Viewers should understand that a portrait is posed—the eyes of the subject usually look directly into the eyes of the reader. There is no misrepresentation.

As I mentioned, prior to the past few decades, posed photos rarely were questioned as non-representational of ethical photojournalism. Joe Rosenthal's Pulitzer Prize-winning photograph of American soldiers raising the flag at Iwo Jima during World War II remains one of the most revered "news photographs" of the 20th century. Yet, despite common knowledge that the photograph was an elaborate reenactment made the next day, the photo is still deemed a seminal one.

A minority of photojournalists, including a few famous ones, still espouse that it is okay to consciously stage a scene. By asking their subjects to more dramatically re-create a moment actually makes it easier for their photographs to communicate more intensely, thus revealing a "greater truth," they say. Yet, I remind my students that rationalizing what might seem like minor choreography in photojournalism opens the door to having none of our work seen as believable.

For example, let us say you are a newly hired photojournalist asked to look for a feature picture for the next day's paper. You find a child having fun on a swing set in the local park. To get a better picture, you could say, "Hey Johnny, can you swing a little higher?" Or even, "Can you ask your friend, Jimmy, to come join you on the swing next to you so I can get a nice shot of you happy together?"

These are small things, still true to the reality of the scene, with the good intent of trying to get something more impactful for the next day's paper, right? Well, the kid would likely go home happy, proudly tell his family at the dinner table, and be pleased when seeing his picture in the paper the next morning.

Yet, in some small, but significant, way he will no longer fully trust every other picture he forever sees in the paper, or the pictures he sees online, as well as newsworthy situations portrayed on television. Was it posed, he will wonder? Is it truthful or was it created?

Also, do not forget the issues of financial liability if you asked a child to swing higher and then he fell off!

We must be believable. Each year, I ask my students, all journalism majors, if they trust what they see in the press as truthful. And, almost universally, even budding journalists say they do not.

Our modern-day interpretation of simply knowing not to pose a shot other than a portrait is, in my opinion, a too simplistic foundation for photojournalistic ethics. Merely not setting up a shot is not the same as telling the truth. What about authenticity? Consider deeper questions that every photojournalist should ask himself or herself.

Let us picture a hypothetical situation. A news photographer is sent out to document a routine story about police officers doing surprise vehicle stops to check for seatbelt compliance. An unappreciative motorist argues with officers that he had no right be indiscriminately stopped, leading to an escalation

of tension, an abrupt pushing match, and ultimately a situation of possible police brutality as officers subdue the motorist by force with their nightsticks.

The photographer faces a quandary. She is not sure if the policemen actually crossed the line, perhaps knows one of the officers involved, and may even rationalize that the use of force may have been a one-time indiscretion due to provocation or job stress. If the photographer then chooses not to share the image with an editor, or does not advocate strongly to have the photo published, it is a denial of the truth.

If the photo editor also sees the picture but deems it not germane to the theme of the assignment and also neglects to advocate for its publication, it could be argued that no ethical breach occurred. But the choice of whether or not to publish transcends a simple definition of photojournalism ethics. Not publishing the controversial shot shirks photojournalism's responsibility to society and to the reality of what occurred.

In such a situation, I believe it is always best not to self-censor. Publish the picture and let the readers make up their own minds about the proprietary of the situation. Should publication of the photograph also have the very real ability to possibly incite civil unrest, the photographer and editors would also have a responsibility to carefully, painstakingly, study the image before putting it in the paper, and to seek out both sides of the story before publishing it. This balances the public's right to know with social responsibility. Since the photo was captured in public, privacy is not an issue here.

The ethics of photojournalism must be about so much more than easy definitions of not contriving a shot. It means being true to yourself and true to your community, too. In fact, the modern photojournalism movement was founded more than a century ago through the publication of photographs that cried for a halt to injustice and the move toward social change.

When we lift the camera, we each make both conscious and subconscious decisions about what is interesting, what is relevant, and what is just. When we click the shutter, those decisions are shaped by our backgrounds and belief systems.

Paul Lester of the University of California describes seminal early 20th century events in the history of social documentary photography in *Photojournalism: An Ethical Approach.*

Lewis Hine of Oshkosh, Wisconsin, worked in a factory for long hours during the day when he was a boy. Consequently, his photographs of children suffering for many hours at low pay and with dangerously, fast-moving machines were vivid and disturbing. Child labor laws were passed to protect children, a direct result of his photographs.

Fellow social reformer Jacob Riis used his camera to document *How the Other Half Lives,* a late 1800s photographic chronicle of conditions of terrible poverty among New York immigrants.

Most photojournalists that I know would describe themselves as socially conscious and open-minded. But when the mind is open to one point of view, is it not also closed to others? Although we would all like to pretend we do not possess prejudices, we must even consider our own range of cultural and political influences.

When up-and-coming photographers look at awards, they readily see certain themes repeated. Prize-winning shots are often about various social problems, disease, conflict, and the "negative" sides of life. And, as one builds a reputation in the field, it is only natural to emulate the sorts of topics earning recognition by peers.

Winning awards can certainly be important for career development or landing a better job. Yet awards have nothing to do with our higher calling in photojournalism. We should all ask ourselves the hard questions of truth and authenticity—questions that rarely pose simple answers.

I recommend an annual exercise in authenticity to photojournalists at any level in their careers. At the end of the calendar year, try making at least a dozen prints of your favorite images of the past twelve months. Look carefully at the range of topics and themes presented in what you deem to be your strongest work. Here are some questions to consider. Just remember that in a subjective profession like photojournalism, our diversity as visual communicators can be our collective strength. We are probably not meant to agree on each of the answers.

In your work, have you consciously sought to capture a balance of topics and types of people?

Do your images go beyond just the literal capturing of too-easy images of social problems?

Do the pictures that do show problems also provide insight and induce a feeling of empathy? And, are they intimate without being exploitive?

Do your photographs portray people's lives merely on the surface from the outside looking in, or do they communicate the intimate moments of your subjects from the inside looking out?

Is your best work of the year a balanced portrayal that does not ignore important social problems, but also seeks to show solutions and positive happenings, too?

As my mentor Chuck Scott told me only recently as I interviewed him for my book, *Photo Portfolio Success*, make pictures with "real, meaningful content, not just pretty pictures. They ought to say something important."

Personally, I do not believe in absolute objectivity but I do believe in fairness. When I traveled to West Africa to do a self-assigned portrait series on torture survivors in Sierra Leone and Liberia, to be honest, I was not seeking to be objective in any way. What had occurred in the civil wars of Sierra Leone and Liberia was as horrific a genocide as had occurred anywhere in the world in the past century. My hope was to photograph portraits of the survivors with dignity and to give a voice to the voiceless by telling personal stories of torture largely ignored in the West.

The goal was true to the precepts of what is commonly known as social documentary photography. Like Riis, Hine, W. Eugene Smith, and so many others before me, I wanted the power of the pictures to move people, and to affect them deeply, hopefully doing my small part to galvanize the

movement against the recent use of torture by more than 150 governments, negating any seeming rationale for its use.

My photographs did not seek balance because, when genocide is concerned, there are not two sides of the story. It is horror and nothing else, despite the barbarians who still justify it as a valid information-gathering technique.

Still, when I arrived home after two weeks in the field with achingly dramatic portraits of those who had been tortured, I wondered if I truly had something worth publishing. Or, was I just rationalizing what I term *photojournalistic pornography*, raw imagery with no real redeeming social value?

Truthfully, I badly wanted to see the photo essay published, but tried to ask myself those hard questions mentioned above. I was not absolutely certain the work truly communicated, rather than exploited.

I decided to telephone Kim Phuc, whose name you may know. She was, as a young girl, the subject of another of the most famous 20th century photographs, a Pulitzer winner of a child running from a napalm attack during the Vietnam War. Nick Ut's photograph of her is often credited with hastening the war's end.

Phuc now lives in Toronto and is a happily married mother, directing a human rights foundation bearing her name. After she invited me to send my portrait series for feedback, she convinced me that I must find a way to publish it. Here are her comments:

When I see these pictures they break my heart. I feel the pain and suffering and relate to them from my own experience. I know how these people are feeling, how hurt and how hopeless.

I was also an innocent child surrounded by war. I remember hiding in the temple as we saw the war come to our village. The children ran . . . I saw the airplane. I saw firebombs raining down; fire was everywhere. My clothes were burning off . . .

Now I see these people in Africa, even girls and boys, in a situation because of terrible human behavior. I can feel it because I also have suffered. I can see how these people relate to me, because they also come from a different culture and country. But when I read their stories, it helps me to know that they still can have hope.

We cannot change what has happened in the past but can move on for a better life. Each of these people has their own personal story. People suffer. Their lives are destroyed for nothing. We don't need that. We need love and to help each other. We are all human beings. We must move on and choose the way to find forgiveness.

I cry out to ask people to help each other as much as you can. Do something. Not talk, but action. People have to love and lead with love and compassion.

As Kim Phuc's life so clearly reminds us, pictures can change the course of history, a high ethical calling indeed. My photo essay was published in the *St. Petersburg Times*, and in magazines and books, later winning Overseas Press Club, Pictures of the Year, and Robert F. Kennedy awards. The positive reaction to an inherently negative topic helped me to be confident that the story did indeed have social value.

FIG. 6 Tamba Saidu, 10. Koidu, Kono district, Sierra Leone. "What we should do is to learn to forgive those who have done this act. If we do not learn to forgive the war, it will continue to the next generation." John Kaplan.

Even more satisfying was the United Nations request to use the work to facilitate contact with the victims as part of its Sierra Leone war crimes tribunal. This was certainly no objective journalistic use of the work, but, instead, a deeply meaningful one to me, and to the victims who sought justice.

Portraits from my photo essay, *Surviving Torture*, have won many major awards in the photojournalism field, including the Overseas Press Club Award for Feature Photography, and honors from Pictures of the Year International, the Robert F. Kennedy Foundation, PDN Best of Photography, and The Best of Photojournalism Awards. Kaplan was invited to show the work at the best-known symposium for photojournalism, *Visa Pour L'image* in Perpignan, France.

As technology continues to change how we capture and disseminate images, and impact our work habits, let us keep

FIG. 7 Cumbay Samura, 28. Falabah, Koinadougou district, Sierra Leone. "Her father disappeared in the attacks on Nyaeudou camp. We don't know where he is. Many people lost their lives." John Kaplan.

FIG. 9 Fayia Skeku, 34. Shamabu, Kailahun district, Sierra Leone. "They made me to open my eyes and forced sand into them . . . They made me look at the sun for three hours . . . I don't know where my family is. I got separated from them." John Kaplan.

FIG. 8 Aiah Tomboy, 29. Soewa, Kono district, Sierra Leone. "I was forced to watch as three men lifted a heavy rock and crushed my mother's head. I could not bear to watch and burst into tears. Because I cried, a guy came and cut me in six places with a machete." John Kaplan.

in mind the sage words of Bob Gilka, the former Director of Photography at *National Geographic*. In his career, Gilka has seen the typical photojournalists go from using bulky 4 × 5 inch Speed Graphic cameras, to 35 mm, and now to all-digital image capture. As Bob says, "Bright as he is, man has not developed an electronic successor to creative thinking."

Technology helps us, but also opens a Pandora's Box of temptations to cut ethical corners. When citing ethical lapses of judgment, many refer to the infamous "moving of the Great Pyramid" by *National Geographic* in 1982. When a gorgeous horizontal shot from Egypt did not fit the magazine's cover format, an unwise designer used digital software to slide the

FIG. 10 Fayia Mondeh, 51. Seima, Kono district, Sierra Leone. " 'Lay down your hand,' they said . . . Five were killed in my presence, as if normalcy." John Kaplan.

mighty Pyramid a bit to the left, making for a *better* cover, and a major mistake in ethical judgment. It should be noted that Gilka and his photography staff had nothing to do with the transgression.

In 1994, *Time* severely darkened the face of murder suspect O. J. Simpson for its cover. Reducing the photo's color to nearly black and white while lowering contrast to a murky tone made Simpson appear that much more suspect. Readers may not have noticed if not for the fact that rival magazine *Newsweek* used the same police mug shot without manipulation for its own cover that same week.

In 2003, *Los Angeles Times* photographer Brian Walski transmitted dramatic war photographs back from the Iraq War of a British soldier attempting to calm desperate Iraqi civilians. The problem was that a picture editor from a sister newspaper, the *Hartford Courant*, realized that similar faces in the crowd repeated themselves exactly within the best photo. It was also later determined that, through the misuse of Photoshop software, the soldier's most dramatic gesture was transposed from one photo onto another. When confronted by his boss, *Times* director of photography, Colin Crawford, the photographer owned up to his visual lie, saying "fatigue" had gotten the best of him.

Walski was immediately fired. As Crawford told Kenneth Irby of the Poynter Institute for Media Studies, "What Brian did is totally unacceptable and he violated our trust with our readers . . . If our readers can't count on honesty from us, I don't know what we have left."

The photographer later apologized to his co-workers via e-mail:

This was after an extremely long, hot and stressful day but I offer no excuses here. I deeply regret that I have tarnished the reputation of the Los Angeles Times, a newspaper with the highest standards of journalism . . . I have always maintained the highest ethical standards throughout my career and cannot truly explain my complete breakdown in judgment at this time. That will only come in the many sleepless nights that are ahead.

While the *Los Angeles Times* is a publication that clearly realizes it must be believable, many magazines now intentionally seek out illustrative imagery in their use of photography, rather than literal, narrative photos. With fewer magazines publishing traditional reportage these days, most magazine photographers are self-employed as *editorial photographers*, rather than strict *photojournalists*.

"Editorial photography clearly encompasses more than photojournalism," says Tom Kennedy, another former *National Geographic* Director of Photography. "The environmental portrait, or celebrity portrait, has grown up as a genre. As a matter of economics, the photographer is asked to create a reality rather than be an observer of the human condition. Working hand in hand, there is a direct collusion between the subject and photographer."

As publicists and art directors also shape this "new" view of reality, a photographer runs the risk of forgetting how to capture images spontaneously. By creating artificial realities in highly paid commercial work, the photographer should also be sure that it does not bleed away authenticity, Kennedy says.

"I want to see who you really are. Work out of a wellspring of personal commitment," he advises.

A commitment to authenticity can also extend to a photographer's decision on when to raise the camera, and when not to. So much in today's media culture is about representation of truth, rather than truth itself. For example, *Reality TV* is anything but.

Although several of my good friends are practitioners in the field of public relations, and ethical ones at that, the blurring of news and the world of promotion has allowed those who seek to distort the facts to hide under the cover of calling themselves journalists. Instead, they hawk a clearly biased agenda and the public is none the wiser. Today's typical television viewer may often have trouble differentiating a slanted version of the news promoted on a program such as *The O'Reilly Factor* with organizations that really do strive to be *fair*, rather than purposefully twist the word *fair* into a manipulative sales slogan.

What does this all have to do with photography? Well, when the photojournalist goes on assignment, agendas at every end of the political spectrum will always look to find novel ways to make news. If a photographer is sent to cover a protest, and arrives to see the protestors calmly sitting on the curb waiting for the media to arrive, raising the camera is only asking for a choreographed show. If the protest is created merely for the sake of media coverage, the photographer's overly eager presence encourages such stage acting. The only way to know for sure is to get out onto the scene, be observant, and use wise judgment.

Similarly, when the subject of a story first meets the photojournalist, he or she will often seek to please, perhaps changing a daily routine by doing the sorts of things thought to yield better photos. I was confronted with this issue when doing a project about the diverse lifestyles of American 21-year-olds that later won the Pulitzer Prize for Feature Photography. One of my subjects was Brian, a San Francisco prostitute who left a good home in the Washington suburbs; he was rejected after coming out to his parents.

Brian would turn tricks just often enough to get enough money to buy amphetamines; he would then shoot up in local flophouses. He had a likeable personality, so much that the other streetwalkers had nicknamed him, "The Ambassador of Polk Street." As I documented his tragic life, it became apparent to me that he enjoyed the attention brought by the photographer's presence, and was eager to be photographed in any situation.

Brian lives on the edge and by the needle. He has no permanent home and supports himself on San Francisco's infamous Polk Street. When not on the street, he works the bars. He says he takes precautions to prevent AIDS but many fellow prostitutes have contracted the disease.

From the photo essay, Brian: Shooting Drugs and Selling Himself, published as part of John Kaplan's Pulitzer Prize winning series, *21: Age Twenty-One in America.*

FIG. 11 Brian shoots up speed at a Hollywood, California, hotel. "I need to get high . . . high as a kite and then deal with the world," he says. John Kaplan.

FIG. 12 Without a home and living on the street in Hollywood, Brian scavenges in a trash dumpster. He thought he saw a watch. John Kaplan.

After a few months of photographing him as he drifted from San Francisco, to Sonoma County, and then Los Angeles, my photo story was nearly complete. Since I also was the writer for the project and had interviewed him about his self-professed love of speed, I thought that a picture of him shooting up would show the full scale of his tragic reasoning for becoming a prostitute.

He knew that I was interested in capturing that particular situation and cheerfully asked me one afternoon if I wanted to see him shoot up. I reluctantly agreed but only after a deep discussion about his motivations, and even a conversation about photojournalism ethics. Although I had never previously had occasion to talk about ethics at this level with a

story subject, I had to be as sure as possible that my presence was not serving to encourage his dangerous behavior. Indeed, if Brian had shot up only for my benefit, I could have never lived with the guilt, had he overdosed.

A discussion of photojournalism ethics and authenticity would also be wise to consider another subjective factor, rarely discussed. What about the ethics of interpersonal relationships within the profession? Social responsibility in photojournalism must extend well beyond the shooting process.

I have known otherwise dedicated photojournalists who care deeply about communicating issues through their images, who, at times, cut ethical corners in their relationships with peers back in the newsroom. What good is living up to the highest standards of truth telling with the camera if a photographer is not also willing to carry through by dealing with editors and co-workers with the same care?

As I tell my students, "you are responsible not only for your own success, but also for the success of the group." We have a responsibility to photograph passionately, but also to contribute to the shared goals of the photojournalism community. This will help ensure that up-and-coming photographers have the same zeal for ethical, story-telling photography for generations to come. To my mind, those who tell half-truths to promote their own work, or to slyly demean others, without also making an effort to support and encourage the good work of peers, do a disservice to the cooperative spirit of the world of photojournalism.

When we speak of truth, up-and-coming photojournalists may be reminded that, in a free society, we have the right to be there. To get to the truth, we need to fight together for access. Always assume that in most any public place, the First Amendment guarantees this right. Although diplomacy and good sense are important traits of the photojournalist, if you too eagerly look for permission to shoot, your access will often be denied for no good reason.

Remember that it does not matter which side of a particular story you most identify with personally. Seek to tell the truth and ask yourself the soul-searching questions to consider your own biases and to be sure you are not being manipulated.

When it comes to competition, an adrenalin-producing component of the world of journalism, the most important thing to remember is to only compete with yourself. You cannot control what others do or how they shoot. Contests can be good motivators but are inherently subjective. Five different judges will often yield five different winners. Go ahead and enter them but have the fortitude to follow your own personal sense of vision.

Each and every shooter is capable of great work if he is willing to work toward excellence. When shooting, have patience and wait for the moment. Arrive early and stay late. Take the safe shot first and then dare to be innovative. Try to spend enough time with your subjects so they will soon become comfortable with your presence; that is when the real moments will begin to happen.

Seasoned photojournalists understand ethical guidelines and mechanics of making good photographs early in their

careers. The ones who succeed over the long term possess these three traits:

1. They like people.
2. They have a curiosity about the world.
3. They are committed to telling stories with integrity and honesty.

Lastly, believe in yourself. Do not be perfect. Be passionate. Great, important, pictures will follow.

FURTHER READING

Kaplan, J. (2003) *Photo Portfolio Success.* Cincinnati, OH: Writers Digest Books. ⊚

The Future of Publishing

MILLARD SCHISLER
Rochester Institute of Technology

New hardware products and software developments have made publishing widely accessible to the masses, but these same possibilities also present their challenges to the future of published materials.

Introduction

To talk about the future of anything is definitely a challenge unto itself. Things have changed so much in the last 20 years in the publishing industry and how people communicate that it becomes difficult to predict where this industry will be in the next 20 years. We can, however, talk about some very important ideas and lessons that we have learned in the recent past and make attempts at intelligent remarks on some of the roads the publishing industry is heading.

What is Publishing?

Initially, we must look more carefully at the term publishing. This term has seen a significant change. If one were to look at the Wikipedia definition of publishing, we would see:

Publishing is the industry concerned with the production of literature or information—the activity of making information available for public view. Traditionally, the term refers to the distribution of printed works such as books and newspapers. With the advent of digital information systems and the Internet, the scope of publishing has expanded to include Websites, blogs, and other forms of new media.

Notice the expression "production of literature or information" and then consider the rest of the definition. Publishing today could be encompassed by this underlined phrase. Publishing makes information available for public view. Producing information is the key concept here. The format that conveys the information does not matter. The traditional information channels in this concept are referred to as books and newspapers. These channels are now coexisting with a large array of digital information channels. Information can also be conveyed through photographs, videos, music, Web pages, blogs, electronic newsletters, journals, etc. What is even more interesting is to realize that all these formats might have different modes of capture but they all end up in the same digital data stream.

Even when we talk about ink on paper such as books, magazines and newspapers, the original data that generated them is digital. Therefore, the road ahead holds a shift from publishing to the model of digital publishing. Many traditional printing companies that are eyeing the future have transformed their profiles into communication/publishing companies capable of handling the dissemination of information in all possible venues.

Making something available for the "public view" is also an important notion. If you write or photograph for yourself only and never make this information available to others, one would consider this material as never before seen and/or published. It is when you take this information outside of your own group or circle that we start to consider the concept of publishing.

Publishing and Photography

Hopefully this initial introduction can help explain why publishing and the future of publishing is being discussed and is so relevant in a book like this one. Photography is still the "writing with light," as the name implies. The analog signal is no longer embedded into silver grains but converted to a digital signal. This signal then becomes a part of this larger field of digital information/communication. Therefore, we can consider photographers as publishers of visual information and photography a visual channel, part of the multi-channel publishing universe—magazines, books, Web, screen displays, cell phones, PDAs, prints, blogs, etc.

Photography as a technology is also converging into the electronics industry. The players of the photo world are no longer dominated by Fuji, Ilford, Agfa, and Kodak. Many of the traditional camera manufacturers are out of business. Sony, Epson, Hewlett-Packard, Samsung, Apple, and some of the stronger camera manufacturers like Nikon and Canon are the players in the digital imaging world. Kodak has moved into digital imaging and publishing. The electronics are what bring these companies together. Your phone becomes your camera, your camera becomes your video recorder, your video recorder can be a camera, and your phone/camera can play digital music and access the Internet. These are all devices that work with semi-conductors and digital signals. Certainly we will see more of this convergence in the future.

Therefore, it is easy to understand that photography is deeply tied in as a component of this revolution in publishing from "everybody wants to be published" to "everybody can publish." If we go back to the Wikipedia description, we will

see that traditionally, publishing is related to "the distribution of printed works such as books and newspapers." Being published used to mean that someone took enough interest in your work to print it; to put ink on paper. In non-digital, traditional printing processes, this also meant large up-front costs in the production cycle in hopes of having a successful return on investment. Only select works would be published.

Being published carried and still carries an aura with it. Just the distinguished accomplished this in the prior era of publishing. The common saying "plant a tree, have a child, write a book" as the benchmark of achievement seems to convey three important ideas of leaving a trace in humanity after you are gone. The tree and the children will grow and replicate, the book will disseminate itself throughout time — all ways of leaving something behind, being immortalized. Being published is still for a select minority.

For the other vast majority, it is no longer necessary to wait to be published, and photographers and artists can self-publish for themselves. Publishing is no longer just ink on paper. The many different venues available today have made this possible. You can start a blog or an online journal. These can also have images in them. They can eventually end up as ink on paper with the ease of digital printing. Books can be designed and printed; images and text can be published on the Web. These are just a few of the ways that information can be made available for public view by groups and individuals.

A More Democratic Publishing Network

Publishing has become more democratic and less aristocratic. It is not in the hands of a few decision makers anymore. Independent presses are growing all over the place, community interest groups are producing their own publications, and individuals are acting as independent publishers. This will continue to grow and expand as more people have access to cheaper technologies. The newer generations will have more hardware and software knowledge as they incorporate the tools and products into their daily lives.

This spread has most certainly diminished the impact and aura of publishing, allowed for more ideas to be out in the public, and given all of us a better chance to be seen and heard. Although, in this new paradigm, no one will be immortalized anymore for "writing a book" or for being published.

Changes in Printing

The possibilities of printing have changed. Photo quality and longevity of inkjet printing are common realities as are high quality and lower costs in color laser printing. These printers are declining in price, increasing in speed and quality, and becoming more and more accessible. The home office of today can easily publish "one of a kind" publications in full color.

Large-scaled digital printing presses have made the concept of print on demand (POD), a reality allowing the printing of only one copy if needed of any publication or small runs of a few dozen copies. It would have been cost prohibitive in the past to make printing plates, get an entire press inked up, and run hundreds of sheets of paper to get consistency in ink density and registration to then print a few dozen copies of a job. Digital printing allows us to go from digital files straight to paper. Distributed printing is possible — printing closer to or at point of use. Variable data printing is another possibility. It consists of printing a project connected to a database of names and information so that in a print run of 1000 postcards, for example, each individual card can be personalized based on the database provided.

Digital Divide

The digital divide is something we must not dismiss when considering the fact that anyone can now publish. The digital divide represents the socioeconomic difference among communities in their access to computers and the Internet. It is also about the required knowledge needed to use the hardware and software, the quality of these devices and connections, and the differences of literacy and technical skills between communities and countries. All of these concepts define who can really publish and this should make us re-think the term "everybody can publish." When we think of the World Wide Web, as of today, it does not yet encompass the entire world. Many of the countries on the African continent, for example, have less than 5 Internet users per 100 inhabitants as opposed to the richer countries in the world that have over 50 Internet users per 100 inhabitants. We are seeing a small but decreasing gap in this divide, and this trend will continue.

Lessons We have Learned

Data storage problems, legacy software and hardware, finding and losing digital information, and preservation are still real issues in the digital world. Most users have lost at least some degree of digital information. Digital information is easy to generate, but can be easy to lose and hard to find if careful strategies are not in place. We can type away, take hundreds of pictures with a digital camera, download the digital data from the card, and repeat this process over and over again, and generate hours of digital recording of music or video. The problem is keeping this information, organizing it, seeing it, and not losing it. Much like a traditional library, we need ways to catalog and preserve digital information so that it can become an asset for use in publishing venues, and be available for future generations.

The response to this has been the growth of digital asset management (DAM) and metadata (data about data) as ways of keeping track of digital information. This will allow us to find, retrieve, and commercialize these data. It is clear now that individuals and organizations need to invest in this area to have their data survive in the digital world. Data that do not have metadata attached to it or do not belong in a larger DAM structure will not survive. This can resolve the problem of finding the information, but it still needs to be stored somewhere.

We have realized that hard drives are not permanent storage devices. They have a rather short life span. Even though there

are many variables that affect the duration, many companies that opt to play it safe will move their data to new devices every four to five years. CDs and DVDs of today are contemporary ways of storing data but may not be able to be read in future devices. Even if they could last 50 to 100 years as readable physical objects, the more immediate threat will be technological obsolescence that will make currents discs obsolete within a few years. Think about large 5 inch floppy disks, magnetic tape drives, zip disks, and the more recent 3.5 inch diskette. Very few systems are available today to retrieve information from these devices. And these have been the main storage devices for the past 20 years.

Software is temporary. Upgrades, newer versions, and new concepts make software obsolescence a reality. Publications built in older versions have to be converted, sometimes through cumbersome and lossy processes, to newer formats. If software used to read data becomes unavailable, a migration or emulation technology is needed to access the data.

Consequently, because of software and hardware limitations, consumers and businesses alike need to have a migration plan to new storage technologies and upgrade plans for the format of the digital data if they want their information to survive over time. As we see publishing residing in the digital world, these lessons learned will help us prepare for the future.

What We are Learning Now

There are several things that are becoming mainstream that will have an important effect on the future of publishing. We are learning about the impact of these ideas and technologies and about how they will change our notions of information exchange in the years to come.

XML—Structured Publishing and the Semantic Web

There are several technologies that are works in progress that will push publishing to new directions. XML (extensible markup language) is presenting a wide array of possible models for cross-media publishing. If structured with purpose during the document design stage, a correctly tagged master document could be created once and subsequently published in any array of different formats, hence the term cross-media, which would include screen displays of all kinds (PDAs, cell phones, etc.), the Internet and, of course, print.

The critical transition necessary to fully realize the next generation cross-media publishing model will be a shift away from document structure tags that strictly articulate the format of content, but also articulate the contextual meaning of that format.

To understand the limits of basic document structure tags, consider the following example. If there is a section of text that has a tag like <Bold>text</Bold>, the text contained will be displayed as bold and the function of the tag is to define the appearance of that text. If we consider moving this text to other platforms, from the Web to print, or the Web to a PDA, or print to the Web, the text will still be displayed as bold, as

defined by the tag. This may not always be appropriate for that particular output/device. In this case we would say that the tag is defining the appearance/content of the entity.

In a tagged XML structure, we are able to create and define our own unique structure. We could define that this piece of text is important, thereby creating a markup such as <Important>text</Important>. We can use style sheets to create conversions that are customized to the medium being published to. For example, in printed text we could set the "important" tags to be defined as bold, in a cell phone they could be defined as flashing reversed text, on the Web as a larger font, etc. In this case, we would say that the tag is defining the meaning of the entity. Its appearance is defined based on the style sheets that set how to display this information based on the meaning/XML tag from one source to another.

This concept of structured information will allow us to think in terms of semantics—the study of meaning. This will be the age of semantic publishing. The structure of documents and the Web today are based on the appearance of objects. Upcoming publishing and the Web will be semantic, based on the meaning of objects.

Extensible Metadata Platform

Created by Adobe and immediately made available as a non-proprietary format like XML, extensible metadata platform (XMP) provides a way of embedding metadata right in binary files. This allows us to give meaning or add intelligence to images, illustrations, and page layout designs. Computers only recognize digital images, for example, as bits of information and not what the image means. It is through metadata and XMP, tied into XML-structured documents, that we will build meaning to the digital information that is made available.

E-Paper, Electronic Publications, and Richer Content Creation

Our digital displays have become lighter, thinner, smaller, and more flexible. We have moved from large cathode ray tubes to lightweight liquid crystal displays. These are available in cell phones, PDAs, computer screens, and other display formats. We are moving toward an electronic version of paper, the e-paper. For millenniums paper has been the format for conveying information. It is not surprising that our future displays will be paper-like, emulating the feel of paper.

In an e-paper world, digital publishing will supersede the possibilities of printed ink on paper. Ink on paper will become costly and used mainly for very special, limited editions. Newer generations will be brought up reading on portable, flexible digital displays. We already have interactive electronic publications (PDFs) that go beyond text and images. They can contain sound, videos, hyperlinks to other digital content, and the universal three-dimensional format (U3D). The list of possibilities will grow. Documents with richer content can convey much more information than conventional ink-printed documents. They become less linear and much more dynamic and Web-like. ◉

100 Years from Now....

DANIEL BURGE
Rochester Institute of Technology

Introduction

When the question is asked at conferences, "Where will the photos taken today be one hundred years from now?," one is really asking two different questions. One question is: "Will we still be able to access and print the image *files* stored on our computers and writable compact discs created with this technology?" The second question is: "Will the *prints* I make today have faded and yellowed away into oblivion?" The answers to these questions are vital when considering the purpose of a collection, which needs to be maintained for the long-term while also allowing for consistent accessibility and usability. If content is not accessible, it would just be an isolated time capsule. So the problem isn't just can someone access images produced *in* a hundred years but *for* a hundred years.

Analyzing the life of a print is actually the easier problem. In many ways that answer has been forming over the last 20 years as preservation technologies for traditional photographic prints have dramatically advanced. As you will read, many of the techniques for saving digital prints are the same as for the traditional photographic prints of the last hundred years.

The first question regarding digital image files is more difficult because opening and displaying an electronic file is much more complicated than just looking at a print. To access the image files, we will need to still have access to the software that can interpret the file's data format, an operating system that can run that software, and a computer that can run the operating system. Every component of the imaging system needs to be maintained to get the picture back from the file.

Technological obsolescence and *material decay* are two primary forces that restrict if not eliminate our access to our images in the future, whether as digital files or physical prints. In addition, there is always the possibility of damage due to mishandling or disasters such as fire and flood, but here we will focus on obsolescence and decay.

Obsolescence is the process of new technologies supplanting current technologies in such a way as to make the current technology useless. For example, the automobile made the horse and buggy obsolete as the primary mode of human transportation. In the same way, advances in the field of computer technology have left a wake of dead technologies. Computer speeds and capacities have grown rapidly. Each new increase in computer processor speed results in a new crop of faster running software applications. New applications have led to larger files. Larger files have led to changes in electronic file storage media. It would not be possible to store even a single digital photo on a 5¼ inch floppy disc from the 1980s. Even new versions of popular software evolve so dramatically that files created from the same product three or four versions past cannot run on new versions. As time marches on, we cannot stand still or the wave of technological development will pass over us and leave us dead in the water with software we cannot run and image files we cannot open.

The second force, material decay, is slower but just as insidious. Some may hope that they can overcome the forces of technological obsolescence by printing out all of their images, but all print types decay. Heat, moisture, pollution, and light breakdown the colorants that make up the image as well as yellow and embrittle the support. Decay also slowly damages electronic file storage media (such as CDs and DVDs), hard drives, etc. But obsolescence will probably render the disc and its data useless before Mother Nature can. So what can we do? Who do we ask for help?

In general, the computer and digital imaging industries have contributed only slightly to solving the problems of long-term accessibility of digital images. Most of the corporate information on image permanence is marketing verbiage implying that permanence is somehow a quality of their particular product or of digital systems in general. However, the current lines of hardware and software will soon be supplanted by new ones and the manufacturers have offered little help to users on how to manage their current files for long-term access. Even the producers of printers, inks, and papers attribute their permanence claims to narrowly defined, non-standardized tests. It is extremely difficult to decipher exactly what the claims are based on and what they really mean for users.

Unfortunately there are no easy answers to this problem; in fact, there are no real answers at all. No individual, company, or institution has been able to develop a practical, fail-safe scheme to ensure the long-term accessibility of digital images. There are currently two separate philosophies that have developed on how to approach the problem, but neither has been formulated into an overall, acceptable strategy.

Essence versus Object

These approaches were well described by Andrew Wilson of the National Archives of Australia in his presentation at IS&T's Archiving 2005. He compared the strategy of saving physical objects (the storage media containing the image data or the actual printed image) with saving the "essence" of the images. So what is this essence, and how do we preserve it? For most of us, printing from the original image file offers no additional value to printing from an electronically copied file. Theoretically any copy of the file, as long as it contains no losses in data, is equivalent to the file first created. Wilson stated that their philosophy was that "preserving the object is meaningless" and that The National Archives of Australia focuses instead on maintaining the essence of the image and the interaction between the data and the technology that reads it. The essence consists of data, reading software, and an operating system sufficient to generate a visual representation of the image.

Concerns regarding preserving the essence

This philosophy, a strategy of migrating the image data across media formats, as in CD to DVD, does not reduce the value of the final output or display of the image; neither does converting the file from one image file format to another. By consistently migrating the data as new file formats become introduced and popularized and new file storage media replace older slower, lower capacity types, it is possible to maintain the ones and zeros of the images regardless of changes in technology. It does have its drawbacks in that a great amount of effort and resources are needed to consistently migrate the data through each new advancement in technology. This effort is not to be underestimated, as it requires a staff with high-level computer skills in addition to one with traditional image archiving skills. For consumers this strategy may be completely untenable.

The second strategy involves maintaining the original files and then at some future time accessing them through computer "emulators" (software programs created to make a current computer function like an older computer). Of course these emulators will also need enough of the original operating system and the original image reading software to display the image on a monitor and new drivers to print the image to modern printers. Again this approach would require significant technical skills and knowledge of historical computer systems to create the variety of emulators for all of the types and models of computers used up until that point. And they will have to be created before access in needed. If access is needed periodically, then emulators will have to be created as an ongoing effort for each new generation of computers attempting to access the collection. For consumers this approach is even more untenable unless these "emulators" are available commercially, which has not happened even for the previous generations of computers. Nor is it likely to happen as an emulator would have to be created for every new generation of computer. If you are planning on taking the route of just saving the files in their current formats and using an emulator in the future to access them, know that you are relying on a product that does not currently exist. If no one actually creates the emulators 100 years from now, you must create it or you are out of luck.

Another suggestion has been the development and publication of standardized, non-proprietary file formats; reading software; and operating systems. These certainly can be created and attempts have been made, yet these will likely still suffer the pressure of advancing technology, eventually rendering them obsolete as well. The only advantage would be simply to reduce the number of times migrations would have to be made or the number of emulators that would have to be created.

In many ways the maintenance of a digital image collection is the function of an IT department and not an object archive. The commitment to advancing technology in both the computer and data management is no small task in itself. The strategies of the traditional, artifact-based archivist become a minor subset of the digital archivist's duties and not the main activity. When attempting to maintain an electronic storage of digital image files, it is imperative to become actively involved with professional societies (such as the Society of American Archivists or the Digital Library Federation) that discuss these issues. You cannot afford to fall behind in technological updates or advances in preservation strategies.

It is true that for most of us the essence of the image is what is critical for digital photographs. It seems highly unlikely that a simple one size fits all strategy can be developed. It will be up to each individual or institution to devise strategies that best suit its goals and resources, and with that will also come an acceptance of the limits of what they can and cannot do. Of course, in some cases, especially for fine art, the original print will be more valuable than a reprinted version, as the original will have been handled personally by the artist and the print will have been deemed acceptable to the artist at that time. For these, the essence of the image is what the artist created, not what the computer recreated. It would be analogous to comparing an original Ansel Adams print to a print made from one of his negatives at the local drugstore.

Concerns regarding preserving the object

The second approach to saving a collection is to preserve not the essence but the objects themselves. Within the "objects" strategy there are two separate sub-strategies: preserving the original file storage media or preserving hardcopy output. Preserving the original file storage media is probably a weaker approach than attempting to preserve the image's essence. Not only will emulators still be needed to access the files on future computers but the hardware readers to access the media will either have to be preserved or recreated. Attempting to preserve the original reading devices will likely be unsatisfactory as they will also degrade over time due to internal corrosion. If they are used continuously over time they will also fail due to wear and tear and still have to be physically recreated. The media themselves will also be prone to natural aging and be potentially unreadable in the future as they too are sensitive to the forces of heat, moisture, and pollution.

In addition to attempting to save electronic file storage media on your own, there is saving data for hire in the form of digital repositories. These are large data storage facilities whose prime function is to store digital data files similar to the types of physical storage repositories already in use for traditional photographic films and prints as well as paper documents. While some may be associated with specific institutions, others are businesses who draw revenue from renting the electronic storage space. They too are subject to obsolescence problems and must be responsible to notify you if migration to new file formats is necessary. There is also the risk that the repository may go out of business with access to your collection restricted or even lost completely.

This leaves us with the final strategy of attempting to preserve the prints. One advantage of prints is that they are human readable so no reader system needs to be maintained or recreated. The prints can also be in the form originally produced, which may have some historic or artistic value, though it is possible that future printers may produce prints that would have been more pleasing to the originator. On the other hand,

printing is expensive and prints take up greater space so a larger area will be needed to house the materials. If the area needs to be temperature and humidity controlled, this will also increase the cost of maintaining the collection.

Suggestions for preserving the essence

It is not possible to suggest in this essay which path is most appropriate for any given collection. The decision whether to attempt to save the data that recreate the image upon display or saving a large collection of already printed images must be decided by each individual or institution alone. The advantages and drawbacks of each strategy have been given. Below are suggestions to keep in mind when attempting to implement your particular strategy. They are not to be taken as a preservation strategy in and of themselves. They are merely aspects of the problem which should be considered.

Keep separate master and working versions of files. The master files should only be used to create new working files as needed or for the process of migration to new media or file formats. It is important to make sure that the master copy contains as much information as possible. It must be large enough and have enough resolution for all potential future applications. If only enough resolution is saved to adequately display the image on a monitor, it will not be accessible later in printed form. Of course there will be a trade-off in that larger files will take up more electronic storage space and take more time to copy if the migration strategy is employed.

There are currently a variety of file formats by which the image data is encoded and software programs that can read these formats. Because of this it will be important to select file formats for master copies that have broad acceptance and do not lose information during transfer. To prevent data loss during usage of images select lossless file types such as TIFF. The popular JPEG format is lossy and degrades in quality upon each usage. If a JPEG version of an image is needed then copies should be created from the master file. There is also the question of RAW files versus corrected files. JPEG and TIFF files are corrected by software in the camera to produce images that more closely match human visual responses. RAW files contain the exact, uncompressed data that the light-sensitive chip in the camera collected upon exposure. This would be a great advantage except that each camera manufacturer has its own proprietary version of a RAW file. This would make it close to impossible to open years from now if that format fell out of use. There has been an attempt to create an industry standard RAW format by Adobe Systems called DNG (for digital negative). Having an industry standard should be helpful, however, Adobe still owns the format. Having a format published by ISO would be better, but has not happened. For now the best strategy may be to pick either a popular, lossless-corrected format or Adobe's DNG format.

Data also need to be protected in terms of security from viruses, worms, and computer malfunction. It is critical to protect the computer systems which create, house, and read the images from infiltration by criminals or vandals. Keeping up-to-date with the last anti-virus software and preventing unwanted access through the use of firewalls is critical, but may not be 100% effective. For this reason all images should be backed up onto other computer systems and/or written to stable, appropriately stored and handled file storage media. Multiple copies of the media can be created and stored in separate locations to prevent loss due to fire, flood, or accidental damage.

Suggestions for caring for electronic file storage media

While file storage media should not be viewed as an appropriate archiving format, it is still imperative that current use of the data is not lost through negligence in the handling of those materials today. *The Care and Handling of CDs and DVDs—A Guide for Librarians and Archivists* by Fred Byers and published by the National Institute of Standards and Technology suggests the following:

1. Handling discs by their outer edges or the center hole.
2. Using a non-solvent-based felt-tip permanent marker to mark the label side of the disc.
3. Keeping dirt or other foreign matter from the disc.
4. Storing discs upright (book style) in plastic cases specified for CDs and DVDs.
5. Returning discs to storage cases immediately after use.
6. Leaving discs in their packaging (or cases) to minimize the effects of environmental changes.
7. Opening a recordable disc package only when you are ready to record data on that disc.
8. Storing discs in a cool, dry, dark environment in which the air is clean.
9. Removing dirt, foreign material, fingerprints, smudges, and liquids by wiping with a clean cotton fabric in a straight line from the center of the disc toward the outer edge.
10. Using CD/DVD-cleaning detergent, isopropyl alcohol, or methanol to remove stubborn dirt or material.
11. Checking the disc surface before recording.

Temperature and relative humidity recommendations for the storage of optical disc file storage media are given in ISO 18925 Imaging Materials—Optical Disc Media—Storage Practices. In general, optical disc media should be stored at room temperature and within a range of 20 to 50 percent for relative humidity. Cooler than room temperature conditions are encouraged to reduce the rates of deterioration reactions.

In addition to controlling the storage environment, it is important to select and use appropriate enclosures for housing the media. The purpose of the enclosure is to protect the surfaces of the disc from damage due to handling. Jewel cases provide the greatest protection for individual discs, but they are thicker than paper or plastic sleeves so fewer discs can be stored within a given area. Long-term reactivity between enclosure products and the various media have not been adequately studied. Certainly plasticized films, such as polyvinyl chloride (PVC), should not be used, as oily deposits may be transferred to the media over time.

Suggestions for preserving prints

As with electronic image files, it is important to keep separate master and working copies of each print. Make sure that the master copy contains as much information as possible. The print must be large enough and have enough resolution for all potential future applications. Of course there will be a trade-off in that larger prints will take up more physical storage space than smaller prints. These prints should not be used themselves; copies of these prints should be created as needed so that the original is not at risk for damage.

There are a variety of systems now available to print out digital photographic images. These include inkjet, thermal dye transfer, and electrostatic/photographic as well as traditional photographic papers. Because there is a wide range of quality for these materials both in terms of initial image quality and long-term stability, it is not possible to make specific recommendations. However, it is generally agreed that pigment colorants are longer lasting than dyes. No matter what the original print material, their life expectancies will be increased through the use of proper storage.

Currently there is no ISO standard that provides recommended storage conditions specifically for digital hardcopy outside of traditional silver halide images. It is likely though that since the same forces that drive the decay of traditional photographic images are the same as those for most digital hardcopy, the storage recommendations for the former should apply to the latter. The current ISO standard for the long-term keeping of color reflection prints is ISO 18920 Photography—Processed Reflection Prints—Storage Practices. Unfortunately, the temperature required for the long-term keeping of color prints is below 2°C (35°F), and as such requires special storage facilities. The temperatures suitable for human comfort cannot ensure long life for many of these prints, though future advancements in colorant and support technologies may result in prints that may be kept at room conditions.

In addition to proper storage environments, the use of safe enclosure materials is also necessary to ensure the longevity of digital prints. All enclosures should meet ISO 18902 Imaging Materials—Processed Photographic Films, Plates and Papers—Filing Enclosures and Storage Containers. They should also meet ISO 14523 Photography—Processed Photographic Materials—Photographic Activity Test for Enclosure Materials (soon to be renamed 18916) to ensure that they will not fade or stain the image over time. In addition, Mark Mizen and Christopher Mayhew showed at IS&T's NIP17: International Conference on Digital Printing Technologies in 2001 that when images are stored in albums, plastic page protectors offer additional protection from atmospheric reactions. These will also offer protection from abrasion and liquid spills.

Suggestions for displaying prints

One of the first preservation problems to be found with digital prints was their sensitivity to fade by light, especially those sources high in UV radiation such as fluorescent lights and sunlight. The manufacturers quickly went to work finding ways to make their prints last longer on display. It was such a problem that light stability came to be synonymous with image stability. Manufacturers started quoting print life expectancy based on their material's ability to resist change in the light. Unfortunately, there are many other problems in determining print life expectancy that the light tests did not reveal. The most significant of these was print sensitivity to fading from airborne pollutants such as ozone. In fact, some prints faded faster on exposure to ozone than they did to light. Ozone exists in the atmosphere everywhere. It is also generated in human environments in a variety of ways including electronic air cleaning devices and laser printers. Another problem set of pollutants are the nitrogen oxides. They are also generated in many ways but a big contributor is automobile exhaust.

Because digital prints should not be directly exposed to sunlight or fluorescent light for extended periods of time and airborne pollutants at all, they should be displayed in sealed frames with a UV-protecting glass or plastic in front. It is highly recommended that the print not be placed directly against the glass or plastic glazing, but that a mat spacer be used. This will prevent potential adhering of the print surface to the glass or plastic over time. It may be impossible at times to remove a print that has bonded to glass. The matting and mounting materials used to frame the image should be of the same quality as the materials used for storing prints in the dark.

Additional suggestions for both essence and object

Information about each image including a description of the image's content, its date, its location, the photographer, the owner of the image, etc., are all critical components of the image. Many traditional photographic prints contained this information in pencil or ink inscriptions on the reverse side or on the enclosure whether an envelope, mat, or album page. Collections of images which have lost all their identifying information become useless when they become detached from original owners who used personal memory to keep track of their images. Adding descriptive information is critical to both images stored as data or printed images. Stored image files can be identified either as a function within their file name (e.g., DEC25 05 Dallas Xmas Jones) or as fields in a database. Large volumes of images with camera original alphanumeric identifiers or incomplete shorthand naming will likely be lost simply as they become unidentifiable within large masses of other image files.

Even if images are stored electronically with logical naming systems and attached descriptive information, the discs themselves need to be labeled, housed, and stored in such a way that the intended disc can be easily retrieved from hundreds or thousands of discs. A drawer full of unlabeled CDs is useless.

No matter whether the file containing data or actual prints is being preserved, redundant copies should be stored at a different location to provide against total loss if one facility experiences a significant disaster such as fire, flood, or earthquake. Another form of redundancy is saving both the image file as well as a hardcopy printout. Of course this requires even greater efforts on the parts of the person or persons responsible

for ensuring the long-term access to the image. Also, stored image files or prints should be periodically inspected to ensure that they are still accessible and usable.

Unintended effects of digital image preservation on traditional image preservation

An unintended effect of the rapid change from traditional photography to digital may be the eventual decline in availability of negative printers and film projection systems needed to access photographic negatives, slide films, and motion pictures. If these materials remain in collections, the appropriate play-back devices must be maintained for the given formats.

The same is true for magnetically recorded video tape. Ironically, many people transferred film-based home movies to video tape which is a less stable media, and that media is in danger of being replaced again by optical discs. If the original movies were not saved, the optical disc version will need to be created from a video tape with likely reduced image quality.

Summary

Lee Mandell and Sue Kriegsman of Harvard University wisely observed at IS&T's (the Society for Imaging Science and Technology) Archiving 2005 that "Trying to keep up with digital preservation is similar to standing on a sand dune and having the bottom shift out from under you at unpredictable times. Preservation of digital images cannot be based on technology alone, be they stored in computer systems or output from hardcopy printer systems. There still needs to be people valuing the preservation process, so that human effort, time, and financial resources are continually applied. In fact, this is the key. Perusing computer and digital imaging publications in order to find the "right" software, electronic file storage media, or printer systems will not suffice. Nothing short of continuous action upon these issues as a way of life can bring about the much desired result of long-term accessibility to our cherished image collections.

FURTHER READING

A Consumer Guide for the Recovery of Water-damaged Traditional and Digital Prints. Image Permanence Institute, November 2004.

A Consumer Guide to Traditional and Digital Print Stability. Image Permanence Institute, November 2004.

Byers, F. (2003). *Care and Handling of CDs and DVDs—A Guide for Librarians and Archivists.* Gaithersburg, MD: National Institute of Standards and Technology.

ISO 14523 Photography—Processed Photographic Materials—Photographic Activity Test for Enclosure Materials.

ISO 18902 Imaging Materials—Processed Photographic Films, Plates and Papers—Filing Enclosures and Storage Containers.

ISO 18920 Photography—Processed Reflection Prints—Storage Practices.

ISO 18925 Imaging Materials—Optical Disc Media—Storage Practices

Mandell, L. and Kriegsman, S. (2005). Digital Repository Planning and Policy. IS&T's 2005 Archiving Conference. Washington, DC, April 26, 2005, pp. 5–8.

Mizen, M. B. and Mayhew, C. M. (2001). Influence of Enclosure and Mounting Materials on the Stability of Inkjet Images. NIP17: International Conference on Digital Printing Technologies. Fort Lauderdale, FL, October 2001, pp. 231–234.

Wilson, A. (2005). A Performance Model and Process for Preserving Digital Records for Long-Term Access. IS&T's 2005 Archiving Conference. Washington, DC, April 26, 2005, pp. 20–24. ◎

Perception, Evidence, Truth, and Seeing

RICHARD ZAKIA
Rochester Institute of Technology

In 1978 Henri Cartier-Bresson reminded us that *Photography has not changed since its origin except in its technical aspects, which for me are not a major concern.* (Zakia, 2000, p. xv) This statement, by one of the great artists in photography, is worth pondering particularly with the increasingly sophisticated imaging technology now available. Regardless of the medium used, how high tech it might be, and with what speed images can be captured, manipulated, and transported, it is the human factor that is most important. Pictures, regardless of how they are created and re-created, are intended to be looked at. This brings to the forefront not the technology of imaging, which of course is important, but rather what we might call the "eyenology" (knowledge of the visual process—seeing). What is known about vision and the visual process is overwhelming; what is directly applicable to pictures is not, and this is some of what will be covered in this section.

In the early 1900s, perceptual psychologists at the Berlin Psychological Institute were involved with research in how we see. Out of their research emerged a number of important and practical principles sometimes referred to as the Gestalt laws. They also put forth the concept of a *ganzfeld,* a completely homogeneous visual field in which nothing exists, no objects, no surface texture—just light. When a person is subjected to such a visual field for a prolonged period of time he feels disoriented, may hallucinate, and some experience a temporary loss of vision. The eye must have something on which to fixate for the visual system to function properly. The closest we come to experiencing a homogeneous visual field, other than in a laboratory, includes situations in which a person is completely enveloped by dense fog or a severe snowstorm (a "whiteout"), which causes plane accidents in addition to accidents on the road.

To see, we need something on which to focus. To be able to determine the size of an object in our visual field we need to be able to compare it to a familiar object. **Perception is relative**.

The painting, "La chamber d' ecoute (The Listening Room)." by Rene Magritte illustrates this very point. An apple rests in the middle of what appears to be a normal size room but is not. It is miniature, and because of this the apple is seen as gigantic, filling up the entire room. So-called "table top photography" and miniature movie sets such as those used in the film epic *Star Wars* are also examples of how relative our perception is. As long as all the objects on the table or in the movie set are of similar scale, things will appear normal.

Figure–Ground

What we visually attend to at any time is called figure, and it is always against some kind of background. The first step in perception is to distinguish figure from ground. The Danish psychologist Edgar Rubin demonstrated this in 1915 with two profile faces facing each other (Figure 13). A person normally sees the faces as figure but with a little suggestion he can see the space (ground) between the faces as figure and forming a goblet. (As early as the 1700s French and German artists were *embedding* faces in landscapes. One such is titled "Concealed Profiles of the Rulers of Europe" by Christian Schwan. It is in the Metropolitan Museum of Art, New York.)

A few important observations regarding figure–ground include

1. Figure and ground cannot be seen simultaneously, but can be seen sequentially.
2. Even though the figure and ground are in the same physical plane, the figure often appears nearer to the observer.
3. Figure is seen as having contour; ground is not.

The importance of ground to our perception of figure cannot be overstated. One has only to look at *illusions*, such as the Herring illusion, Wundt illusion, and other such illusions to witness how ground can make lines that are physically straight look bowed.

The measurable physical reality shows that the lines are straight. The visual reality is that the lines are indeed bowed. Remove the ground however, and the lines will look straight.

The importance of ground is further demonstrated in looking at colors. A blue object surrounded by a complementary yellow color as ground will look much more saturated than if the ground is a neutral or green color. The physical color (the colorant) remains the same but the color (our visual experience—perception) does not. Perception is relative.

Common contour

When figure and ground share a *common contour*, a competition or rivalry is set up for possession of the contour (Figure 13). This causes our perception to shift back and forth as we choose to see one or the other as figure. The Dutch artist Maurits Escher was keenly aware of this as one can see in his intriguing work. Of this he wrote

The borderline between two adjacent shapes having double functions, the act of tracing such a line is a complicated business. On either side of it, simultaneously, a recognizability takes shape. (Zakia, 2002, p. 151)

In a playful mood Edgar Rubin in 1921 created a double profile outline of a face of a man and a woman trying to kiss but not being able to since their lips share the same contour and shift back and forth (Figure 14).

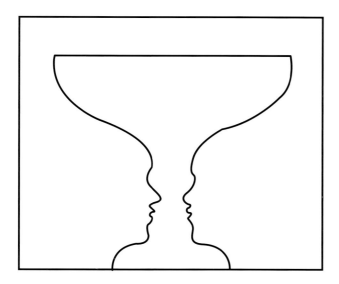

FIG. 13 Figure–ground reversal by Danish psychologist Edgar Rubin, 1915. One can see two profile faces or a goblet. Perception will alternate between the two.

FIG. 14 Kiss by Edgar Rubin, 1921. The kiss is denied since they both share the same lips (common contour).

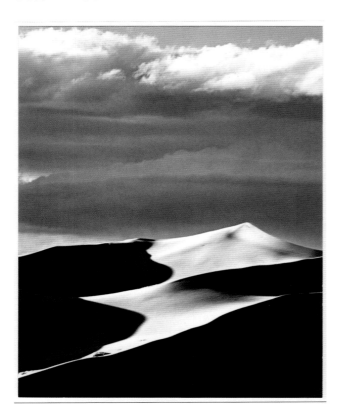

FIG. 15 Dunes-Colorado, Dr. Thomas L. McCartney. The white and dark areas share a common contour for which there is a competition. The area seen as figure will possess the contour.

FIG. 16 Beach Chairs by Gordon Brown. The chair on the left shares a common contour with the horizon, collapsing our perception of depth.

Photographic examples of common contour or contour rivalry can be seen in photographs of sand dunes by Edward Weston and in others where a sharp edge exists between a dark area in the shadows and a light area in sunlight. (Photographs mentioned and not shown can be seen on the Internet. For example, click on Google, Image, Weston.) Rivalry for the possession of the contour between the dark area and the light area shifts the figure–ground relationship. Our perception of this exchange activates the area, giving it a dynamic dimension. The greater the contrast at the contour, the sharper the edge, the greater the effect. This can be seen in Figure 15, Dunes — Colorado by Dr. Thomas L. McCartney. The contours are common to both the light areas and dark areas setting up a visual rivalry. When the light areas possess the contour, they are seen as figure. When perception shifts to the dark areas as figure, the contour belongs to them. The rivalry is greater at the hard edges than the soft edges.

Another important facet of common contour is the ability to collapse depth. If a camera is positioned so that a distant contour shares a near contour, overlap as a depth cue is eliminated and the experience of depth is lost. Near and far objects are seen as occupying the same plane. This can be seen in Pete Turner's photograph called Push.

The contour of the flat part of the top of a trash can on a beach shares the same contour as the horizon line in the distance. Depth is collapsed where the contours meet but not in other areas of the photograph where parts of the scene near and far overlap. The loss of depth in one part of the photograph but not in other parts sets up a visual ambiguity, which adds interest to the photograph. Figure 16 shows a similar situation in a photograph by Gordon Brown. The top of the beach chair on the left shares the same contour as the horizon line. The top of the chair is seen as being out there where the horizon is while the bottom stands on the sand. The beach chair on the right overlaps the horizon line, providing a necessary depth cue and feeling of distance.

Embedding

Having two shapes share the same contour is an effective way of *embedding* or concealing images. One only has to pick up a children's magazine and look at the "Hidden Pictures" illustration challenge. Children and even adults take pleasure in finding hidden/embedded images. This can be seen as a form of "hide-and-seek" or even "peek-a-boo," that fascinated us as little children. Both involve a sense of discovery. We play the game whenever we go to a flea market or garage sale or go hunting or fishing. As serious photographers, when we go out to photograph, there is something we hope to find, capture, and share with others. This search and discovery can be thought of as an *archetype*, part of our collective unconscious, a term Carl Jung introduced.

Camouflage

Camouflage can be thought of as a way of confusing the relationship between figure and ground, a way of creating visual

noise. In wartime the razzle-dazzle patterns on ships, planes, trucks, and personnel break up the continuity of contours and shapes and therefore the figure–ground relationship. Cubism, as practiced by Picasso, Braque, and others, provided some of the inspiration for camouflage. Artists played an important role in creating such camouflage for the military, by breaking up and confusing figure and ground. When artists became part of the military camouflage units in WWI, an American army officer remarked "Oh God, as if we didn't have enough trouble! They send us artists!"

Gestalt

The Gestalt school of psychology, which originated in Germany in about 1912 by Dr. Max Wertheimer, provides some simple and convincing evidence about how we organize and group individual visual elements so that they are perceived as wholes.

At that time scientists such as Faraday and Helmholtz, who were researching electrical, magnetic, and gravitational phenomena, hypothesized that a type of electrical, magnetic, and gravitational "field" existed, and that physical elements within that field are held together by some type of sympathetic force. The field elements influence one another. They are either attracted or repelled. Their strength is a function of such things as size, position, and nearness.

Wertheimer might have argued that physical fields have their counterpart in visual fields. The main tenet of Gestalt psychology supports this. The way in which an object is perceived is determined by the total context or field in which it exists. Put differently, visual elements within a person's visual field are either attracted to each other (grouped) or repelled (not grouped). The Gestalt psychologists put forth a number of concepts to describe how grouping of visual elements occurs within a context of a field.

The same principles, interestingly enough, were used by Kurt Lewin to study the behavior of people within a particular environment, how they interact with each other in various settings such as school, office, factory, and so on. Photographers doing weddings and group portraits find themselves and their equipment as part of the group dynamics. Gestalt therapy, or Family therapy as it is sometimes called, is yet another example of how Gestalt principles are used. A problem a child may be having at home involves the whole family and how they interact. Similarly, a problem a student may be having in school involves the teacher, classmates, and the environment—the entire field.

Gestalt principles

The Gestalt psychologists were especially interested in figure–ground relationships and in the things that help a person see objects or patterns as "good figure." They suggested a number of principles including proximity, similarity, continuation, and closure.

Proximity (nearness)

The closer two or more visual elements are, the greater the probability that they will be seen as a group or pattern.

In Figure 17 the configuration of dots in A are all equally spaced and can be seen as forming a square. In B and C, by changing the proximity or nearness of some of the dots, we see them as forming a row or column of dots. It is helpful to think of the space between the dots as *intervals*; in this way one can see their importance as they relate to the interval of time in music. Changing the size or time of the interval changes the visual or auditory perception. It is also helpful to think this way when preparing a slide presentation with PowerPoint or editing film or video. The importance of proximity is both spatial and temporal.

Similarity

Visual elements that are similar (in shape, size, color, movement, meaning, and so on) tend to be seen as related and therefore grouped.

In Figure 18 we again see the configuration of dots in A as having the same proximity and are all similar in size and shape. To separate the arrangement so that we have rows and columns as seen in B and C, we need only change the shape or color of some of the dots. The proximity remains the same. We naturally group visual elements that are similar. Gyorgy Kepes, former head of Advanced Visual Studies at MIT, has written "Some elements are seen together because they are close to each other; others are bound together because they are similar in size, direction, shape." (Zakia, 2002, p. 44) A classic example of proximity and similarity working together can be seen in the 1914 photograph Jungbauern Westerwald (Young

FIG. 17 Proximity. Visual elements that are near each other will be seen as belonging together and grouped.

FIG. 18 Similarity. Visual elements that are similar in appearance or movement will be seen as belonging together and grouped.

Farmers) by the great German photographer, August Sander. Three men with the same dark suits, white shirts, and dark hats stand at attention holding canes in their right hands. The two men at the right are seen as a pair because of their nearness or proximity, and because of the interval between them and the third man on the left. In addition, one notices that all three men have similar postures and expressions, but the two on the right hold their canes vertically and their hats are straight, while the man on the left has his hat and cane tilted. He also dangles a cigarette from his mouth. This dissimilarity provides a counterpoint to the similarities in the photograph and adds interest. A similar gestalt arrangement can be seen in Eroded Sandstones, Monument Park, Colorado by William H. Jackson, in Sea Urchins by Anne Brigman, and in Three Nuns by Henri Cartier-Bresson.

Symbolic associations can be seen as a form of similarity thus providing a connection between what is seen in the photograph and what resides in memory. For example, Bruce Davidson's untitled photograph on the cover of his *East 100th Street* book shows a child partially naked with straggly hair and head titled standing limp on a fire escape against a steel bar railing, which takes the form of a cross. Although not consciously intended by Bruce, it serves for many as a reminder of paintings of the crucifixion. Similarity by association can also be seen as a rhetorical form of *simili*. The photograph looks like a crucifixion.

Continuation
Visual elements that require the fewest number of interruptions will be grouped to form continuous straight or curved lines.

The array of dots in Figure 19 is easily grouped and seen as forming an X. This is because of the similarity and proximity of the dots as well as their continuation. One can also easily see a diamond shape. It would be more difficult, however, to see a large W or M (inverted W). This is because continuity would have to be disrupted. It takes more visual effort. A photograph that serves as an excellent example of the importance of continuity is Edward Weston's favorite photograph of his wife Charis, titled Nude 1936. . She sits with one leg tucked under her body and the other upright with her tilted head resting on it. Both arms embrace the legs in an oval shape with

FIG. 19 Continuation. Visual elements that are more easily seen as being continuous in direction will be grouped.

hands joined together at one knee. Her face is not visible, just the top of her tilted head, with her hair clearly parted. If one were to trace the contours of her arms and legs they would see a graceful continuation of curved lines.

Closure
Nearly complete familiar lines and shapes are more readily seen as complete (closed shapes) than incomplete.

The array of dots in Figure 20 is more likely to be seen as forming a circle than discrete dots. Again, similarity and proximity are working to assist in the formation of the circle, of closure. In Michelangelo's painting "The Creation of Adam" (Figure 21), the critical space (interval) between the finger of God and Adam invites closure. By forming closure we participate in the painting. If the interval had been wider or shorter, the perception would be different.

FIG. 20 Closure. Visual elements that can be seen as an incomplete familiar shape will be grouped to form closure and complete the shape.

FIG. 21 "The Creation of Adam" by Michelangelo. Each time we view this painting, we are invited to continue the movement and direction of the hand of God the Creator and form closure—the creation of Adam. The interval between the fingers of God and Adam is critical—the decisive distance.

Henri Cartier-Bresson's famous photograph "Place de l'Europe, 1932" shows a man leaping over a large pool of water in a flooded street and his reflection in the water. One of the things that makes this photograph memorable is that the man appears to be suspended in air. As he leaps, his forward motion is captured on film the instant before the heel of his outstretched right foot touches its reflection in the water. The decisive moment becomes the decisive distance—the critical interval that invites the viewer to participate in the photograph by completing the jump.

Forming closure on what is being looked at provides satisfaction and balance. However, there are times when making it difficult for a viewer to form closure can provide a challenge. Photographs that are ambiguous do just that. They provide a visual riddle that requires extended looking and participation to form a closure.

Pragnanz

The Gestalt principles of organization describe the way we tend to segregate and group visual elements into units or patterns. The overall rationale as to why we do this is explained in part by the law of *pragnanz*, which states that "Psychological organization will always be as good as the prevailing conditions allow." This can be seen in Figure 22 in which cube A

(A) (B)

FIG. 22 Perception is facilitated by good organization and design. Illustration (A) is easily seen as a cube, while (B) is not. (Scientists studying crystal growth under a microscope first observed the tendency of (A) to flip-flop.)

is stable as a three-dimensional pattern and B as a two-dimensional pattern. It is difficult to see them otherwise.

Digital seeing

We live in a world of color. The sky is blue; the grass, green; a sunflower, yellow. Blue, green, and yellow describe only one of the three attributes of color and that is hue (dominant wavelength of light). The other two are saturation (chroma), which describes how strong a particular hue is, and brightness (luminance), which describes the intensity of light.

When a photograph is made on black and white, only the brightness of the colors is recorded on film or on a charge-coupled device (CCD) light sensor in a digital camera set for black and white capture. The brightness of the colors is recorded and seen as neutral colors, that is, grays. To provide a vocabulary for identifying the scale of neutral gray tones from black to white, Ansel Adams and Fred Archer created a numbering system using Roman numerals (Figure 23). They established what came to be called The Zone System, a method for calibrating all the components that go into making a silver gelatin print—camera, film, development, paper grade, and printing—to consistently arrive at a predictable quality print. One could think of this sequence as the color management of neutral colors.

In using the Zone System, the first and most important stage is visualization. With black and white photography, one must learn to see colors as having only brightness, void of hue and saturation. This takes considerable practice and skill. A Wratten 90 orange filter is sometimes used to assist in the process. Exposure is usually placed at zone I. The film is then developed so that highlight detail falls at zone VII or VIII.

With digital photography and color reversal slide film, the situation is reversed. Exposure is based on the highlights and placed in zone VIII. The shadows fall where they may depending upon the brightness range of the scene. A normal scene has a brightness ratio of 128:1, 7 zones, 7 stops, 2^7.

With black and white film, the range of exposures on the negative that is printable covers 7 to 9 zones, depending on the detail required in the shadow and highlight areas. The same is true for color negative film, but not for color reversal film such as slides and transparencies. These have a printable range of

0 I II III IV V VI VII VIII IX

FIG. 23 Zone System scale from black (zone 0) to white (zone X) in increments of one stop (a factor of 2, a log exposure of 0.3).

only 4 or 5 zones, as does digital photography, both color and black and white. A CCD or MOS sensor can only record about 4 or 5 zones with detail, which is about the same that an inkjet print will display.

Brightness ranges

The Zone System allowed film photographers to make silver gelatin black and white photographs of what they saw and how they wanted to render them by making adjustments to the brightness range of a subject using development variations. They had to learn to "see photographically" as Edward Weston put it. A short brightness range scene could be expanded by increasing development, a long brightness range compressed by decreasing development. Further adjustments were possible by local "burning" and "dodging" the print and even using bleach to whiten highlights. However, none of this was possible with color film, which contained three integral red, green, and blue sensitive emulsion layers that later, after development, are converted to cyan, magenta, and yellow (c, y, m) dye layers. Any attempt to control the brightness range by adjusting development in one layer would affect the other two integral layers and cause undesirable changes in color and contrast. The same is true for color negative film, but not for color reversal film such as slides and transparencies since the film in the camera was the final image.

Latitude

Exposure latitude refers to the amount of over or under exposure allowable before detail is lost in the image. Negative films, both black and white and color, have the greatest latitude and color slides and transparencies the least. Negative films are more forgiving for overexposure than for underexposure. Pro-Digital SLR cameras allow plus or minus two stops exposure latitude and RF digital cameras, plus or minus one stop (Figure 24). Color film slides have the least exposure latitude; plus 1/3 of a stop, minus 2/3 of a stop. Since negative films have considerably more latitude than digital sensors, they provide an advantage for image capture. The film negative can later be printed or scanned and used as a digital image for manipulation and printing. However, the short dynamic range of a digital camera can be extended by blending two images, one that has been exposed for the highlights and the other for the shadows. This allows one to render the range of tones much like the eyes see them in nature. A photographer can now create color images that are impossible with film photography. Another important fact is that the image can be seen in real time, immediately after it has been taken. This provides a great assist in translating the three-dimensional world to a two-dimensional image. Digital also provides an opportunity to enhance colors to bring out subtle effects not possible with film photography. Minor White would refer to this as

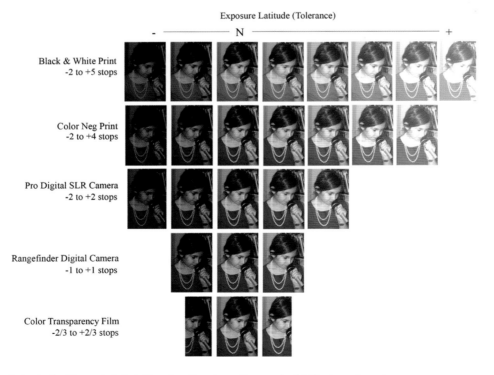

FIG. 24 Exposure latitude for film and digital. Negative films have the greatest latitude and greater for over exposure than under exposure.

"Interpreted Real." In the extreme, one can go from the real to the surreal easily.

George DeWolfe, who for many years used and taught the Zone System and was strictly a black and white photographer, on a personal note, wrote, "I think one of the major perceptual things that changed for me when digital arrived was my ability to make color images that I had traditionally seen and felt in the real world but found impossible with traditional photography." One might speculate that Ansel Adams and Edward Weston, both of whom are not noted for their limited color photography, might have been more successful had they had digital photography available.

Visualization

The zone scale, which had been widely used for film photography, can also be helpful for digital photography. Visualization is independent of the medium used. There is a difference in how to interpret the zone scale for digital photography, however, since digital provides a more linear recording of light. The zones will record differently on the digital print. Generally, the low zones will register lighter in the print while the higher zones will register darker. For example, what is visualized as a zone VII will print darker and look more like a zone VI. A dark zone II will print more like a brighter zone III. Zone V, the middle gray, remains about the same. This, of course, presents no real problem when using digital since there are so many options available with software such as PhotoShop. "Curves" can be used to correct and adjust any of the zones in the final print. Even lighting and color can be manipulated. As practiced with film photography, one can make local changes using "dodge" and "burn" tools. In a sense, digital photography provides unlimited opportunities for post-visualization. Photographers can now become "painters."

Infrared

Some photographic films and digital sensors can "see" infrared radiation to which the eye cannot. Many objects reflect and transmit infrared radiation differently than light. The chlorophyll in green leaves, for example, is highly reflective of infrared radiation, causing the leaves to appear very dark on infrared negative film and white in the print. In short, when photographing in the infrared, what we see is quite different from what film and digital sensors see. This makes visualization, focus, and exposure difficult and prone to error. Digital photography takes some of the guesswork out of this. Now a photographer can actually see the infrared image on the liquid crystal display (LCD) of an infrared-filtered digital camera, make what changes are deemed necessary, and take another photograph if needed.

Capture and ritual

In comparing the process of creating a photograph on film, especially on a large-format camera with that of digital, an important component that can be lost is the actual process of capturing the image. With film photography, more time is usually spent in carefully studying what is to be recorded and how best to render it, realizing that the nearly unlimited options available with digital are not available with film. Further, large-format cameras, such as view cameras, present the image inverted on a ground glass for viewing. The photographer looks at the inverted image under a black cloth, which blocks out the light—in effect, a little outdoor darkroom. This is much different from looking at a small LCD display on a digital camera in daylight. Quiet time in the dark, alone, studying the scene to be photographed, and making adjustments can be thought of as a form of meditation. In an unpublished manuscript, Ralph Hattersley wrote about printing in a darkroom as an opportunity for meditation, a quiet time that can be therapeutic. Further, the upside-down image on the ground glass tends to engage the right side of the brain, the artist's side, more than the technical, left side of the brain.

Color modality

Color film transparencies look different from color prints, and the image on a monitor looks different from an inkjet print. This should not be surprising. Prints are viewed by reflected light while the image on a film transparency is viewed by *transmitted* light and the image on the monitor by *emitted* light. The modality under which a color image is viewed influences how it is seen. The blue that we see in the sky, which does not belong to any object, and the blue we see in the water of a crystal clear lake are not the same. The modality of one is referred to as aperture color and the other as volume color.

Digital seeing has extended the versatility of photography by allowing immediate visual access to what is being photographed. The LCD display on the camera allows one to view the image before it is taken and after. If necessary, adjustments can be made to correct for exposure, sharpness, lighting, and composition. This is especially helpful when doing close-up photography. Prior to printing an image, it can be displayed on a monitor, studied, and a multitude of adjustments can be made. Digital photography does more than provide immediate visual feedback when capturing and manipulating a photograph. It provides confidence and assurance after the photograph has been taken, especially if the camera has a histogram representation to check the exposure of the "digital zones." One does not have to anxiously wait till film is processed, hoping that the captured image is what was intended. Further, since nearly unlimited options are available for adjustments, the digital photographer now has, prior to printing, a monitor screen, a "canvas" on which to add or remove color, increase or decrease saturation, adjust sharpness, introduce blur, etc., much like a painter. But unlike a painter who cannot easily remove the color of paint once it is applied to the canvas, the digital photographer can. In a sense, with digital the photographer becomes both a painter and a photographer. Digital seeing provides the same immediate feedback a painter has when creating an image.

Evidence and Truth

One of Marshall McLuhan's one-liners was "A man walked into an antique shop and asked, *What's new?*" When it comes

to photographic truth, nothing is new as the history of photography reveals. Composite photography, for example, can be traced back to the 1857 photograph Two Ways of Life by Oscar Rijlander. It was a large 31 × 16 inch photograph printed, not from a single negative, but from some 30 different negatives. Henry Peach Robinson, a fellow painter turned photographer, combined five negatives a year later to create Fading Away. The photographs were allegories and intended to be seen as such. Taken literally, they are fakes.

Spirit photography, the attempt to capture ghosts on film, came into vogue during and after the Civil War. Ghostly images of deceased loved ones would "mysteriously" appear in family photographs. Many people truly believed in such photographs at the time. P. T. Barnum knew they were fake and that people who had lost loved ones in the war were being exploited. Interest in spirit photography and similar phenomena continues today. One only has to go on the Internet, type in "google" and "spirit photography" to be astonished or entertained, depending on his belief.

Seeing is believing

Seeing is believing and believing is seeing. This chiasmus rings true when we stop and think about it. Seeing is believing and the reverse, are not separable. The image incident on our retina is not seen until our brain processes it. What we see, we see to some extent, by choice and by *expectancy* — a condition in which a person is more receptive to seeing what he or she anticipated or wants to see rather than what is. Some people see flying saucers in images, a Loch Ness monster, the Virgin Mary splattered on a wall or on a slice of toast, and so on. Others, do not.

Imagination also plays an important role in seeing as Leonardo da Vinci reminds us in his Treatise on Painting:

You should look at certain walls stained with damp, or stones of uneven color . . . you will be able to see in these the likeness of a divine landscape adorned with mountains, ruins, rocks, woods, great plains, hills and valleys in great variety . . . (Zakia, 2002, p. 209)

We see what we choose to see. In the 1960s an amateur magician, Ted Serios, had convinced a number of people that he was able to make mental images, images of what he was thinking about when he clicked the shutter of a Polaroid camera. He even had a psychiatrist so thoroughly believing this that he wrote a book on the phenomenon, which was later proven to be fake.

Context and cropping

Whenever a photograph is taken, it is always out of the larger context from which it was selected. It is not unlike quoting words out of context; meaning changes with context or lack of context. As such, every photograph looked at can be misread. For example, a photographer on assignment to photograph a large crowd at a protest gathering discovers, not a crowd of 1000 or more as expected, but less than 100. By carefully positioning his camera, he records only the small crowd and speaker and not the empty surround. The result is a misleading photograph that is completely filled with the protestors and nothing more. The visual implication is that there are more protestors "outside the frame" of the picture — hundreds more. When we look at a picture, we can only see what it shows, nothing more. In effect, the photographer has camera-cropped what he did not want the photograph to show. Cropping is usually done after a photograph has been made, which photo editors do routinely but not necessarily to mislead.

Stretch or shrink

Photographs can be subtly expanded or compressed in a vertical or horizontal direction to create an *anamorphic* image in which a person or object is seen as a bit thinner or wider. If carefully executed and there is no valid reference, the slight change is not distinguishable. At times this is done, for example, to make a female model look thinner in a fashion magazine, or to look wider for an advertisement on losing weight. Stretching is also used in some advertisements for automobiles to give them a slick elongated look. Photo editors sometimes stretch or shrink a photo to fit a layout of a page. What is seen is not necessarily what is.

Photographs as evidence

The ability to doctor photographs by adding, subtracting, multiplying, or substituting things has been with us since the beginning of photography. It has now not only accelerated with digital photography, but has become nearly impossible to detect. Unlike film photography in which one could refer to the original film negative as a physical record, digital cameras not using RAW files leave no tracks behind, so to speak. RAW files are not processed in the camera as are JPEG and TIFF files. They can therefore be considered as the digital equivalent of a film negative and the processing software as equivalent to what goes on in a darkroom to make a print from a negative.

"Photo fakery is everywhere," proclaims the author of *Photo Fakery*, who is a retired CIA expert. In some cases it is impossible to detect. Even a battery of experts can disagree on the truth of a photograph. The Loch Ness monster photo taken and published in 1934 was never proven to be a fake. It remained for one of the perpetrators, on his deathbed in 1994, to reveal that it was faked.

Proving the authenticity of some photographs is painstaking and laborious, requiring much research and analysis. With the advent of digital photography, it has become much more so. Photographic prints now can be a result of a marriage of both film and digital. For example, one could, with the right equipment, write a digital image onto film at a resolution so high that it would look like an "analog" optical image under a high-power microscope. The final print could be a result of capture with a digital camera and digital printing — digital all the way, or it might have had its origins as a film negative or transparency that was subsequently scanned into a computer to create a digital file. In either case, the file could easily have been manipulated before printing. To track down evidence of

alterations, one would need access to the source, either the film original or RAW files.

Manipulating a photograph for artistic or dramatic effect is not a problem, unless the photograph is intended to be used as evidence or as documentary. Forensic photography, scientific photography, and medical photography need to be accepted as truthful, although at times, to secure grants or promotions, some fraud is, unfortunately, involved. With photojournalism and documentary photography, there is also an expectation on the part of the viewer that the photographs are indeed factual and not tinted with fiction. And as we have seen in political elections, photographs that are used to promote a candidate should be viewed with the same skepticism as any advertisement.

If critical judgment is to be made regarding the contents of a photograph, then the cliché "buyer beware" becomes "viewer beware." Be critical in assessing the content of a photograph and the legitimacy of its source. The Internet has become notorious for displaying fake and deceptive images and will continue to do so. Fake photographs that get on the Internet spread like a virus and are difficult to stop.

FURTHER READING

Adams, A. (1981). *The Negative.* Boston, MA: Little Brown.

Arnheim, R. (1974). *Art and Visual Perception.* Berkeley, CA: University of California Press.

Brugioni, D. (1999). *Photo Fakery: The History and Techniques of Photographic Deception and Manipulation.* Dulles, VA: Brassey's.

Eisenbud, J. (1967). *The World of Ted Serios.* New York: Wm. Morrow.

Hattersley, R. (2004). Printing as meditation. *Shutterbug.* December, pp. 154, 170, 171.

Kennedy, R. (2005). The ghost in the darkroom. *The New York Times.* September 4.

Rosenblum, N. (1984). *A World History of Photography.* New York: Abbeville Press.

Zakia, R. (2002) *Perception and Imaging.* Boston, MA: Focal Press. ✆

The Photo Marketplace and Contemporary Image Makers

DAILE KAPLAN
Swann Galleries

Not so long ago artists were viewed as bohemians who, unconventional by nature, worked in studios devoid of creature comforts and displayed little interest in promoting their work. The economic reality of selling pieces, though acknowledged, was far removed from an artist's lifestyle. Dealers, on the other hand, were commonly seen as refined gentlemen and women of leisure who discretely "placed" (never sold) artwork.

This perception was subsequently passed down from generation to generation. Public auctions were highbrow events in which tony patrons purchased materials from estates accompanied by detailed family histories. Today, such quaint notions associated with the art world are as dated as the silver halide darkroom. Indeed, the making, buying, and selling of art is big business. And, a photographer-artist with dreams of making it recognizes that being commercially savvy is as integral to their success as their work itself.

What exactly constitutes "the market"? The art market is composed of two distinct, but interrelated, components. The gallery system is the primary market. Gallerists, in contemporary parlance, discover new talent and foster mid-career artists by mounting shows. There's nothing quite like the thrill of a well-conceived exhibition in which an artist's latest objects are beautifully installed in a gallery setting, creatively promoted in the press, reproduced in an elegantly produced catalog, and, of course, actively sold. Expositions are the principal vehicles in which private collectors, museum curators, critics, and art advisers not only have an opportunity to see work but learn more about it. As any collector knows, gallery directors are often trained art historians as well as skilled salespeople.

Being represented by the right gallery is often the difference between having your work in the permanent collection of a blue chip museum or a celebrated private collection, and seeing it languish. With the growing popularity of photography the volume of art–photography galleries increases worldwide every year, but so does the number of artists seeking representation. Art galleries typically feature a roster of contemporary and historical figures, though most opt for a non-exclusive association. Finding the appropriate commercial venue is highly competitive and the most challenging task an artist faces. Publications like *Photograph* and *ARTnews* are useful tools for a photographer interested in pursuing a career as a fine artist. It is best to first research the universe of galleries to understand what they specialize in and which photographers they already work with. *Art in America* annually publishes an international gallery and museum guide that provides a panorama of useful information. Alternatively, if seeing your work in a public exhibition is not a top priority, another option is working with a private dealer. Art advisers build (curate) collections for private collectors, and also frequently act on behalf of corporate clients; for example, hotels, hospitals, and businesses that are buying art for decorative purposes.

The secondary or resale market is synonymous with auctions, a dynamic environment that simultaneously trades on social and commercial interests. Celebrities, collectors, curators, dealers, and agents alike are active players in international venues where works by contemporary artists who employ photographs as well as prints by classical photographers are sold amid spirited bidding. Auction houses specializing in fine art may be found in metropolitan centers throughout the world including New York, Los Angeles, Paris, London, Berlin, Madrid, Stockholm, Rome, Vienna, Sydney, and Tokyo, where public sales are conducted at least twice a year, in the spring and the fall. Historically, most of the material available at

auction came from estates. Today, houses also rely on connoisseurs parting with well-respected collections, institutions de-accessioning duplicate pictures, dealers selling inventory, and speculators "flipping" (quickly turning over) works by cutting edge artists.

Galleries are destinations, places to meet artists and fall in love with artwork. Within the past decade, however, a new trend has developed: Collectors are buying at auction. Auction houses conduct previews, which are open to the public, at which time it is possible to sit and examine a treasured object. With the recent stratification of artists buyers increasingly seek out objects by a select group of "art stars." Perhaps a collector wishes to purchase work by an artist–photographer for whom a gallery has a long waiting list. An auction offering work by this figure may be seen as a singular opportunity. However, a typical scenario is that, after the auctioneer announces the lot, frenzied bidding by multiple buyers results in a realized auction price often exceeding the retail value. Auction salesrooms, which were once settings of high decorum, are now volatile market barometers, powerhouses of the new "art world economy." It is impossible to escape the attention paid by the media to stratospheric prices routinely paid for fine photographs as stories about "who outbid whom to pay what" are dramatically recounted in the art and business press. Since artists do not benefit directly from these robust sales figures by, say, garnering royalties, what impact does this new economy have on someone working today?

Photography was invented in 1839 but an international marketplace for fine art photographs became apparent only 30 years ago. Marge Neikrug, Lee Witkin, and Tom Halsted opened the first photography galleries in the late 1960s and early 1970s. Simultaneously the first auctions dedicated to 19th and 20th century photographs were conducted at Parke Bernet (later Sotheby's Parke Bernet), Christie's, and Swann Galleries in Manhattan. Auctions are historically prevalent in England but, from the beginning, New York set the pace for the photograph market and is to this day the center of the marketplace. Photographs, albums, and photographically illustrated books, broadly estimated from $10 to 3000, were sold to the highest bidder. Top prices featured an Ansel Adams photograph of Moonrise over Hernandez for $3000 or an issue of Alfred Stieglitz' elegant magazine *Camera Work*, with multiple photogravure plates, for $200. In 1977, *The New York Times* reported that a pair of Carleton Watkins's albums containing 100 photographs, which were found in a janitor's broom closet, fetched an astounding $100,000 at Swann Galleries. Subsequently, public curiosity grew about a field that, for all intents and purposes, seemed accessible to anyone who operated a camera.

Today banner headlines hailing photography as "the medium of the moment" or "the art form of the century" are typically found in the press. It may be hard to believe that photography was not always such a well-regarded medium. Excoriated and ridiculed in the 1970s, a burgeoning community of photographers, dealers, curators, and collectors were undeterred. They struggled to counteract the critical perception that, since photography relied on a mechanical instrument (the camera), it was not an authentic art form. Curators such as John Szarkowski, Maria Morris Hambourg, and Weston Naef furthered a popular understanding of the medium as a distinctive art form. Exhibitions devoted to Diane Arbus, William Eggleston, Robert Frank, Eugene Atget, and Alfred Stieglitz presented photographic expression as a pictorial language at once accessible and distinguished. Publishers like Aperture, Twin Palms, Abrams, and Bulfinch produced sumptuous monographs, historical surveys, and collectors' guides that went out of print quickly, and are now avidly sought by photographic literature collectors.

A landmark transaction that redefined photography's status as a highly prized collectable occurred in 1984, at which time The Getty Museum, in a carefully orchestrated, highly secret deal, purchased the most important international collections of fine art photography in private hands. The price was a staggering $25 million—an extraordinary "steal" in today's high-powered art market, especially given the high prices collectors regularly pay for Impressionist and Modernist paintings. Consider that Man Ray's Glass Tears—an icon of 20th century photography—was reportedly purchased privately for $1 million more than 5 years ago. Vintage masterworks by Edward Weston and Paul Strand have sold for $500,000, and contemporary pictures by Andreas Gursky, Richard Prince, or Cindy Sherman routinely sell in the mid-six figures. Although contemporary artists represent a strong segment of the market, the highest prices paid at auction are for classical photographs by 19th century photographers. Gustave LeGray's proto-modernist albumen seascape Grande Vague, Sete (1859) realized $871,739, in 2002, while an early architectural daguerreotype by Joseph Philbeit Girault de Prangey, Athenes Temple de Jupiter Olympien pris de l'Est (1842), measuring 7 × 9 inches, realized a remarkable $979,721 in 2003.

The story of how the Getty entered the photography market is a fascinating parable. To this day, for example, museums garner attention for their multimillion dollar acquisitions, blockbuster exhibitions, and sumptuous coffee table books. In truth, however, it is a market. Connoisseurs perceive value and beauty in artworks that are not sanctioned by the canon or, for that matter, the marketplace. Visionary photograph collector Sam Wagstaff, who may be best known for his patronage of a young photographer named Robert Mapplethorpe, spoke eloquently about photography as a uniquely democratic medium, one that made no distinction between a vintage Dorothea Lange Migrant Mother and a great vernacular snapshot of Bonnie and Clyde. This radical approach was the organizing principle of his own collection, which was one of the founding collections purchased by the Getty. The ability to recognize both new talent and innovative trends is vital to a field's intellectual discourse, as well as a vigorous marketplace.

However, without the benefit of a personal introduction to a potential patron or prominent gallerist, how does an artist connect with the trade? Art or photography fairs, which include scores of galleries from around the globe, are extraordinary networking events. The Association of International

Photography Art Dealers (AIPAD), which hosts a trade show every February in New York City, is not only an occasion to look at great vintage and modern prints, but also to see the sort of work a gallery presents and, ideally, meet its principal. Additional fairs include Photo San Francisco (late July); Photo Los Angeles (late January); and national trade events such as the Armory Show, in New York, Site Santa Fe, ArtMiami, and the Chicago Art Fair. International fairs include Paris London (May), Paris Photo (November), ArtBasel (June), Arles (July), Perpignon (August), and Paris's FlAC (October).

For photographers who simply do not have the ambition to ply their trade in the rough-and-tumble art world, there are more populist approaches. Benefit auctions (where the proceeds of a sale are directed to a not-for-profit organization) are wonderful opportunities to have your photographs seen by collectors and curators, who are always on the lookout for great new images. A photographer looking for exposure might check out *Black & White*, a periodical with excellent production values that features full-page ads consisting of a photographer's statement, a representative photograph, and contact information. Those who love doing portraits can create a market niche by focusing on pets or pregnant women or couples or children. For photographers interested in working for a picture agency, there are more and more options. Although Getty and Corbis continue to dominate the field, *Photo District News* regularly reports about upstart agencies with specialty interests chipping away at these behemoths' market share. And e-businesses, such as, LiveBooks, offer photographers the technology to market their pictures directly to art buyers around the world.

Today the photographic marketplace is in transition. Increasingly segmented opportunities nonetheless abound. Classical photography galleries have not yet addressed the role of digital photography, highlighting instead vintage or modern prints by master practitioners. Contemporary galleries opt for the high concept, and technique is frequently overshadowed by an artist's reputation. As digital technologies rapidly transform ideas associated with making images and, concomitantly, the definition of photography, the medium continues to thrive, continually reinventing itself to reflect the tenor of the times. Photography, once an "illegitimate" art form, now occupies front and center stage in the market. After a mere 30 years, the best is yet to come. ◎

The Photographic Studio of the 21st Century

DOUG MANCHEE
Rochester Institute of Technology

Some Introductory Thoughts
A studio may be defined simply as a space a photographer would make photographs. The studio may also be considered a space that has been designed for and equipped with equipment specifically for the objective of making photographs. Studios may be described as the whole space where a photographer works even though some regions of this space may not be directly used for the making of photographs. Because photography followed painting, early studios were modeled after painters' studios. A studio would need to have at least one large window or a skylight to be operational. Having a lot of light was important because of the slow emulsions of the time and the minimal availability of artificial lighting. The quality of the light could be adjusted using large translucent curtains. With the advent of electricity, all of that changed in significant ways with many lighting choices coming onto the market at the time of its invention. Today, contemporary studio lighting is almost always accomplished using artificial light, however, some photographers still make use of window light where appropriate. The famous English portrait photographer Lord Snowdon uses natural light exclusively in his studio.

The Studio in the 21st Century
This essay will discuss some of the basic issues required for designing and equipping a professional photographic studio in the 21st century. Photographers who lease or own a professional photography studios on a full-time basis, however, are becoming increasingly rare; especially in large metropolitan areas. In the 1980s, industrial space was relatively inexpensive and full-service studios were common for most professional photographers. This is no longer the case. Today, most photographers will rent studios on a daily or weekly basis for specific projects. In large metropolitan areas an entire industry has developed to service this trend. A typical rental studio will consist of a building with a number of different size spaces for rent. Other options might include cyclorama walls (to be discussed later), full kitchens, professional hair and makeup capabilities, and natural light-only spaces. Lighting and grip equipment is also available to rent as well as high-end digital capture stations (which come with an operator or "digital technician"). Most photographers will now only rent an office space and an area to store equipment, drastically lowering their operating expenses. In smaller markets with lower real estate costs, photographers continue to lease existing space on a yearly basis. These days it is very rare to see a photographer build a studio from the ground up.

The Impact of Digital Photography on the Professional Photography Studio
Since the beginning of the century the impact of digital technologies in photography cannot be understated. In professional photography, digital is rapidly replacing film as the method of image capture. As mentioned, most rental studios offer the capability of digital capture as well. Another service these studios offer is the archiving of digital files for a set period of time. High-end digital files are very large and storing them can cause problems for photographers who are not set up to do this. All files need to be backed up as well, preferably on another machine. Many rental facilities now offer this service. Additionally the photographer, or client, may view the

files and place orders online. More on digital archiving will be developed later in this essay. Aside from these issues, digital capture has not necessitated a major change in how people think about studio photography. Lower costs and the ability to rent systems allow photographers to use high-end digital systems for almost any project. Most mid-range digital single lens reflex (DSRL) cameras now work with studio strobes as well as all continuous-source lighting systems. For studios utilizing a digital workflow it is necessary to have one, or more, computer stations. Typically, these are on moving carts and contain a CPU, monitor, and a large hard drive for image storage. These stations are used to download files, evaluate images on screen, perform minor retouching, and burn CD or DVD discs. For those photographers designing a studio from the ground up it is important to consider what is necessary to support digital capture, especially electrical requirements. This should be done even if the photographer has no plans to shoot digital.

When Looking for Space

Since the majority of photographers who will be looking to create a studio will be looking at existing buildings and spaces, there are several considerations before deciding on a space. Once a lease is signed, breaking the lease is difficult if the space is not suitable to a specific need. When looking for a space to use as a professional studio, one should consider several things.

Access

Most studios need to be accessible to both passengers and freight. If the studio is on the ground level, a front entry for clients and some deliveries will be necessary. A back entry is desirable to bring in props, equipment, surfaces, and anything else that is large. If the studio is on an upper floor it should be accessible by both a passenger and freight elevator. The ability to bring large objects (or a lot of small ones) is very important in a professional studio.

Ceiling

The ideal studio would have high ceilings. The fewer pipes, electrical metal conduits, and HVAC piping, the easier it will be to adjust the lights and the sets that will be required for projects. Anything that hangs from the ceiling can get in the way. Some ducts and pipes may occur naturally in the studio, such as the fire sprinkler system. As a renter, you will not be able to move these fixtures. When a drop ceiling is present installing a track-lighting system or the use of fixtures for equipment support may be tough to accomplish since this ceiling will take up valuable height.

Flooring

The studio flooring can be made of anything that provides a smooth surface to work on. Wood or tile is nice because either could be used as part of a room in a photo setup. The feel of a facility is heavily influenced by its flooring and much of the

studio's design is influenced by its big open floor. It is worth maintaining the floor for both the sake of appearance but also for some not so obvious reasons. A well-maintained floor will stay smooth and flat longer. Water damage may cause buckling and a floor may become uneven. A smooth floor of concrete will help when moving lights, stands, and booms that have wheels requiring smooth surfaces to operate easily. Often products for catalogs will arrive in carts and bumpy floors can cause damage. Concrete can easily be painted with various colors as needed.

Having a level floor is not a big factor, but it is much easier to make things level when the floor itself is level. The floor should not be too flexible, as is often the case in older buildings, because the set may move when someone walks too heavily or there is vibration resulting in blurred images when long exposure times are used. Since liquids are often used, it is best to not use a carpet in the shooting space. Not only will hard floors assist in cleanups, but they will prevent residual damp spots or odors that will make the next setup more difficult.

Dimensions

An efficient photography studio needs to be divided into several separate and distinct areas and be as big as can be afforded. Take the time to evaluate whether the space will accommodate the studio's clientele and allow for an efficient work environment. For a professional studio there should be separate and distinct areas for: shooting, the office, camera storage, prop and surface storage, client/reception area, and a kitchen.

Design

The design of a studio is based on individual tastes, space availability, rental costs, and the type of photography that will be undertaken in the space. If the studio will support catalog work, having a large space to enable the building of many sets makes sense. For a portrait studio, having a medium to small space seems logical to start. Once a space has been determined, a way to proceed is to use graph paper and plan space usage before starting to divide the space up. Each square on the grid paper should represent a unit of distance, e.g., one square equals one foot. Everything that will be in the studio can be drawn to scale on pieces of paper and cut out to allow them to be moved around in a scale drawing. This allows one to visualize relationships and how the space can be laid out.

Building and renovation

Building in the studio space typically means building a few walls to divide the large open space into areas such as a shooting area, dressing area, or storage area. Consideration should be given to building walls that are strong enough to hang backdrops or which allow the attachment of shelving. It is often practical to have walls that will accommodate the hanging of prints, office notes, ongoing work in the finishing area, or newly completed work in the reception area. A great

wall covering for this purpose is called Homasote, which can be painted with burlap and glue and then the studio colors. Homasote comes in standard 4 × 8 foot sheets and allows the temporary hanging of papers with push pins.

Electricity and power requirements

There are never enough outlets in any space used for photography in this era. Computers, lights, cameras, and many other pieces of equipment all require electricity. If there is not enough power or outlets, new wiring will need to be put into the space. This should be done by a licensed electrician and must conform to local building codes. It is never a good idea to be deceitful with this installation. An error with wiring can cause electrical fires and jeopardize the studio's safety.

The electrical power requirements for the studio will depend on the type and amount of lighting that will be used at any one time. Electronic flash equipment is the most common; however, photographers still use tungsten hot lights. Having enough electrical amps in the system is important. When talking about electricity, three terms are used to describe the system: watts, volts, and amperes. A watt defines the fundamental electrical power in a system, a volt is the unit of electrical force, and the ampere is the volume of electrical flow. An analogy for a volt might be found in water pressure. The ampere is the equivalent flow rate and the amount of current flowing at a given pressure defines its power. The power or wattage of a circuit is defined as watts = volts × amperes.

Electrical wiring can be purchased in different grades or thicknesses depending on the wattage to be carried by the wire. The wire must be of the correct thickness to carry the expected amount of electricity or load to the outlet boxes and to the general lighting. Common household wire would be characterized as 14/2 gauge.

Keeping the building safe is the purpose of a fuse or circuit breakers. Fuses or circuit breakers are located in a box near where the main line comes into the building. The fuse box is the terminal where the electricity is distributed to various outlets and to the lighting used in the studio. Circuit breakers stop the flow of electricity if a load is too great for the system that is pulled through the wires. If a high load is required, there is a danger that the wire's insulation could melt resulting in a fire. A fuse is also a part of many pieces of equipment and is calibrated to the exact amount of electricity for which the line/equipment is rated. When a higher load is drawn on the circuit, the fuse wire will melt and stop the flow of electricity before a problem occurs.

Circuit breakers accomplish the same thing and consist of a switch that closes, or trips, when too much electricity is drawn. This switch can be reset after the problem is corrected. The circuit breaker has a visible on/off position that makes it easier to determine which circuit has tripped; a fuse requires looking at the metal band to see if it has melted. Of course, to most easily locate the tripped breaker, each circuit in the junction box should be clearly labeled to indicate which set of lights or outlet boxes connect to each breaker. Circuit breakers have a built-in time delay that allows this surge to occur without tripping. The surge is not long enough to melt insulation and start a fire, so the time delay circuit breaker prevents nuisance tripping of the circuit when electrical equipment is first plugged in or turned on.

The power required by most studio flash equipment would be 20 amps. If each outlet in the studio is connected to a 20 amp circuit and each box supports one pack, there should be no problem with having enough amps to run the flash equipment. Having sufficient power for each strobe pack allows the equipment to operate properly and recycle quickly.

Finally, when considering the power requirements for a studio do not forget to consider the computer and heating or cooling requirements of the space. Run an imaging computer system as well as a window air conditioner with the photography studio lighting equipment and the electrical consumption will significantly increase.

Climate control

It will be expected by visitors, clients, guests, and employees that the indoor temperature of a studio will be comfortable. Comfortable might be described as a temperature of 20°C or 68°F. When temperatures significantly deviate from this, various things might happen that would be evidenced by lower productivity in the staff or product changes, e.g., flowers spoiling or models perspiring and damaging their clothes. The equipment that is used to make pictures also generates heat, which contributes to the warm temperatures found in midsummer in the United States where the average temperature of 85°F is common in August in New York City. The average winter temperature in New York in January is 28°F. Attention should be made to determine the capacity of the system that is located at the studio and its capability to maintain a comfortable environment during these extremes. The heating ventilation air conditioning system (HVAC) should also be capable of simply circulating air as well.

Windows

It is not a problem to have windows in a studio area and the reality is, there may be no choice. Having fresh air and a bright open space leads to a pleasant place to be when not making pictures. When working in a studio though, it will be necessary to block all light transmitted by windows for total control of the lighting. Extraneous light competes with the artificial light on subjects. When doing multiple exposures there must be no ambient light at all. Blackening all window light can be difficult. There are products such as blackout shades for windows that photographers can buy. Rolls of black paper or plastic can be used quite easily and hung over the window frames, but this is a hassle. Many kinds of photographs, especially fashion and furniture, can benefit from window light or with window light as an addition to artificial light. If the space does not have windows and is located in a hot climate, make sure the building has central air conditioning. Photography equipment generates a lot of heat.

Security and insurance

Security, insurance, and safety issues are things to seriously consider. Camera equipment has long intrigued thieves of small portable and expensive items. A studio most of the time will have many pieces of equipment such as laptop computers and digital cameras that must be secure as well as clients' products that are maintained in the studio. Perhaps even more important, the photographer might also be storing irreplaceable negatives, transparencies, and digital archiving equipment in the studio. Even though these materials may not have resale value, they have great importance to the photographer for future sales. To help with security, the doors into the studio from outside should all be solid core or metal with deadbolt or other industrial "type" locks. A studio should absolutely purchase an insurance policy for potential theft and loss coverage but also for personal liability coverage for accidents incurred while in the studio. A client could fall or experience a personal injury as a consequence of simply being there. In either case, not being personally responsible for such events should be a studio's goal. A sizable loss from either type event could be so large a financial burden that it could close the studio.

Having a security alarm is an absolute. Security systems can be an inexpensive or professionally installed system. Features of alarms might include motion or fire sensors as well window and door switches. A good alarm is in constant communication with a central alarm monitoring facility that notifies the proper authorities when triggered. These systems normally require monthly fees.

Studio storage

A studio will never have enough storage space. Space to store the photography equipment, backgrounds, and props is just the beginning of this problem. Clients will often bring things to the studio that will remain there for many months. The supplies required to build sets such as lumber will seemingly multiply with each job and then there it is, all over the place.

The storing of equipment includes cameras, computer and imaging equipment, and lighting equipment and its related accessories as well as props and backgrounds. Camera and computer equipment must be stored so as to minimize the chance of damage. It will require a good shelving system, which provides a safe and sturdy place for putting things. Keeping cameras in their cases leads to them staying cleaner and well protected from accidental damage from water and dust when not in use.

Backgrounds come in many types and sizes. Standard 108-inch seamless paper must be stored vertically or it will bend and may develop ripples. It should also be kept in its box with a plastic bag to minimize fading and damage from moisture. There is a rack system that can be purchased for this type of storage as well. This system requires very little floor space and keeps the seamless paper easily available on a wall rack. Formica and other surfaces for photo shoots are also common background materials that will need to be stored. Plexiglas also involves special considerations because it is so easily scratched, which can ruin it. Cloth drops can be rolled or folded and stored on shelves as well.

Props are more difficult because they will be a variety of sizes and shapes or even breakable. Even though photographers these days depend more and more on stylists for providing props, there are always some items that are used repeatedly for a particular client or to create a particular look; for example, small pillars for portraits, special chairs, or vases.

Image Archiving

The digital capture environment has its own storage issues. Although a refrigerator-sized system is not necessary, most high-volume studios will need a server system (two or more computers configured together to handle large storage capacity) set up to handle the large files generated and produce a backup file of all images captured digitally.

Many photographers still have a large archive of transparencies and negatives that are stored safely in metal filing cabinets. Filing cabinets that lock should be considered for extra safety and development of a cataloging system. Many photographers store important materials relevant to a shoot, its layouts, overlays, receipts, invoices, etc., together with the resulting photographic materials for a period of time. A very convenient way to store these materials uses a vertical filing or "job" jacket system. Photographic prints can be stored in flat files or print portfolios as well. These boxes are designed to protect the prints from the effects of light fading or environmental influences. Color and inkjet prints do not require archival storage. All boxes will require labeling. Some materials should be stored using acid-free materials. This type of storage would be characterized as archival.

A big problem for older established studios is the storage of transparencies, negatives, and prints from previous years. A database is often the solution for cataloging all the images in storage. This consists of a list of all jobs with a short description of the subject that was shot. A filing code should be established. It can be oriented to the date or to the client and it should be simple. Excellent database software products for this would be Extensis portfolio® or FileMaker Pro®).

It is a good idea to list the client in these databases. Many photographers will include a description of the type of photo shoot it was (product, architecture, portrait), the type of client (agency or direct), and the amount billed as a means of tracking the type of photography most often done. This allows for quick access to all previously photographed jobs and to information that is critical to planning the future of the studio. This job log is crucial to the efficient running of a studio.

Digital imaging archive

While digital image archives do not take up as much room as film archive—given an equivalent number of pictures—they have their own issues. Image backup is probably the most important. It is recommended that at least three copies of each file be kept. Two can be at one site (the studio) and one should be kept off site. Two files should be kept on site because of the

potential for file corruption; that is, data in the file deteriorating for some reason, making it unusable. This is unique to digital capture since film rarely deteriorates, at least during the lifetime of the photographer. A copy should be kept off site in the event of theft or a fire. Digital capture has an advantage in this respect since multiple copies of any file can be generated with no quality loss. Files can be kept on large hard drives, magnetic tape, or DVD discs. Sophisticated archiving software now exists allowing the photographer to find files specific to any project.

Cyclorama Wall

Having a large coved wall is a huge advantage for a studio. This wall is called a hard, seamless background or a cyclorama (cyc). A cyc solves several problems for a studio. It is readily available for shooting and can quickly be repainted and maintained rather than buying seamless paper, it cannot be damaged by rolling heavy subject matter across it (computers, cars, etc.), or it will not be torn by models walking or dancing across it. It can also be constructed wider than the commonly available width of seamless paper. Cyclorama walls were more common years ago when studio space was plentiful and cheap. They are very common in rental studios but might not be found in a small studio today. A cyclorama should be located in a dedicated space that is not used for any other purpose.

Studio Safety

One common function of all photography studios is the importance of safety. A photography studio is a complex place, consisting of cords, cables, lighting and camera equipment, light stands, grip equipment, and the objects or people photographed. The studio is also a dark place; when pictures are taken the only light should be on the subject itself, which means the rest of the studio can be very dark. Further, there may be clients and non-professional models present people who are unfamiliar with this type of environment. The last thing a photographer wants to experience in the studio is an accident: damaging expensive equipment, or worse, injuring a client or model. With this in mind there are several things that can be done to make the studio environment safer:

1. Make sure any cords and cables in the way of foot traffic are securely taped to the floor. The tape should run parallel to the cord so all of the cord is covered. If the photographer, when designing the studio, has the ability to place electrical outlets where he desires they should be placed behind the areas where most sets will be constructed. This means that the electrical cables will, for the most part, be out of the way.

2. When photographing models, make sure they have a clear path to the set. Having a model step over and around cables and lighting equipment should be avoided whenever possible.

3. When shooting, try to have some ambient light in the studio so people can find their way around. If strobe lighting is used, this should not create any color temperature inconsistencies in the photographs. If hot lights are used,

care must be taken so that the ambient light does not affect the lighting on set.

4. When using a boom arm for a light or light-modulating equipment use a counterweight whenever possible. A better way to ensure that a boom arm does not fall over is to place it directly over one of the legs of the light stand. With this method, the weight of the boom is absorbed by the leg and it is impossible for the stand to fall over. Placing the boom between two legs is not recommended, even if a counterweight is used.

5. Make sure all clamps and grips are securely tightened. This is common sense but photography equipment is heavy and slippage can occur. The worst that can happen is that your equipment will collapse; it is also possible that a light will slip and change positions, altering the lighting on the subject.

6. Communicate with your clients and models. Make them aware of these issues and encourage them to be careful when they are in the studio environment.

Types of Studios

JOSEPH DEMAIO[1]

There are as many types of studios as there are photographers. The requirements of each person's photography will determine the way the studio will be used and how it should be designed. In general, studios can be broken down into four broad types: the professional studio, the artist studio, the amateur studio, and the location studio.

The professional studio

The professional studio, designed to take a wide variety of photographs to fit the specifications of different clients, is more complete than any other type of studio. If you are about to design a professional studio space, try to visit some existing studios. During trade shows in larger cities there are often studio tours in which several of the local studios are open for visitors. The professional photographic organization in your area may also have an occasional tour of local studios. Also, photographers are usually very proud of their studios and will often be amenable to a visit. Seeing how other people solved the design problems of their studios can be invaluable. An efficient professional studio should consist of the following seven areas:

Shooting area
The shooting area should be as free of extraneous objects as possible. It should not be used as a storage area for props, camera, lights, surfaces, or computers. If any of this equipment needs to be in the shooting area it should be stored on moving carts that will allow the greatest flexibility for set construction and lighting. Clients and models will also be in the shooting

[1]Originally published in the *Focal Encyclopedia of Photography, 3rd Edition.*

area so you want to keep that area as open as possible (see the section on studio safety). The larger the shooting area the better, but consider a smaller area if this will allow the storage of non-essential items to be elsewhere.

Reception and display area

The professional studio needs some areas that other types of studios do not require because the professional studio is a place that is visited by clients. The studio entrance should lead to a reception area for the convenience of clients during meetings or a shoot. The reception area usually contains facilities for the display of the photographer's work. This is not only for the entertainment of clients but may also suggest to a client a different type of work that the photographer is capable of doing. This is a subtle way of increasing sales. This area is not only for the display of print work, but also for the display of transparencies and electronic media. It is also nice to have a magazine table or some sort of shelf where photographers can put brochures, magazines, catalogs, etc., that contain samples of their photographs for viewing by clients.

Conference area

There is often a separate room or space with a large table where the requirements of the photo shoot can be planned and discussed with the client. This space should be provided with a telephone for client use during a shoot. Very often clients will want to conduct business or do design work while waiting for a shot to be set up. A room such as this will provide space and privacy for the client. A large flat screen monitor at a high-speed workstation that is connected to the Web is, of course, an absolute.

Kitchen

For those photographers who are going to do food photography, a large kitchen area is necessary. This area is often adjacent to or even within the studio. If located in the studio, it can also be used as part of a set for photographing food preparation. This kitchen should contain an unusually large amount of counter space. This is necessary because food for photography is often prepared in multiples; six turkeys, four apple pies, etc. Also, the food stylist will need room to prepare the dishes and lay out the props in preparation for transferring them to the set. Even if the photographer is not going to specialize in food photography, at least a small kitchen is handy for the preparation of the occasional food shot or for the convenience of clients.

Dressing room

Most studios have a dressing room for models. It should be large enough for the model to feel comfortable or even for the makeup artist to work. Outlets for hairdryers and curling irons are required. A small sink for washing off makeup or for the application of certain kinds of hair or facial treatments is a nice convenience. Since shoots with models often require a large number of garments, a space for hanging them in a way

that they can be seen and selected makes things more convenient. Mirrors are a must, of course.

Finishing and shipping area

Since prints usually have some finishing work required, and work is often shipped to clients either by mail or overnight delivery, it is very helpful to have a print finishing and packing area where the materials used for these procedures are stored and readily accessible. A counter with cabinets will hold all packing materials and provide a surface for postage meter, scale, and retouching area. The retouching area can be equipped with a magnifying lamp that makes any retouching procedure much easier.

Workshop

When preparing for shoots or just performing simple maintenance, the photographer is often called upon to do various sorts of building or altering of products and props. A workshop for simple equipment repair or for building sets and preparing props is not only a help but almost a necessity. There should be a sturdy workbench with convenient electrical outlets. The bench might have a vise and behind it shelves or a peg board for hanging tools. This work area is sometimes enclosed or in some way separated from the studio area because of the dust that may be generated by sawing wood or using a file. For those photographers who do a lot of scale model work, the installation of a spray booth for model preparation may be necessary.

The artist studio

An artist's photographic studio will depend on what type of work the artist in interested in doing. If the artist is essentially a photographer who finds subjects in the outside world, then the studio may contain only a desk, storage, darkroom, and an area for looking at finished work and work in progress. Those artists who also work in studio settings, whether for portraits, nudes, dance, etc., will require a studio shooting space with some of the areas described above. Artists often have studios in their homes.

The amateur studio

The requirements of amateur photographers are often modest because of the expenses required to maintain a formal studio. Usually some portion of their living space is set aside for their hobby. This does not mean that they have to do without many of the things that the professional finds necessary. With a little ingenuity and some compromise, the amateur can have an efficient, versatile, and still modest studio.

The location studio

These days more and more commercial photography is done on location at the client's facility since it is difficult to bring operating machinery and computers to a studio. Even art photography has its location studio contingent. This is exemplified by Irving Penn and his famous location studio

portraits. Mr. Penn has made a career of moving entire studios complete with large cloth backdrop to such exotic locations as the jungles of New Guinea and the Peruvian city of Cuzco, the ancient Incan capital. For a location shoot, photographers put together what can be called a portable studio. All the necessary equipment (cameras, lighting, backdrops, imaging computers, etc.) is packed in a way that is both convenient to move and to get at on the job. There are specialized packing systems to make location work easier. These usually consist of a canvas bag that holds many accessories for the lighting system. These bags can be unfolded at the job site and hung on light stands so the contents are visible and accessible. A major requirement for a location studio is a strong assistant. ◉

Photographic Virtual Reality

JOHN (CRAIG) FREEMAN
Emerson College

Photographic virtual reality is a type of digital media that allows a user to interact with photographic panoramas, objects, or scenes on a computer display using software called a viewer or player. Sometimes referred to as immersive photography, photographic virtual reality is designed to give the user the sensation of being there.

History

Photographic virtual reality has its roots in the work of the Irish painter Robert Barker, who, in 1787, created a cylindrical painting of Edinburgh. The painting was viewed from the center of a cylindrical surface. Baker patented the invention and coined the term panorama from the Greek word *pan*, meaning all, *horama*, meaning a view, and from *horan*, meaning to see. This intent to immerse the viewer into a scene and the striving to invent a form of experiential representation was continued throughout the 19th and 20th centuries with panoramic and stereo-optic photography. One of the earliest examples of true photographic virtual reality was the Aspen Moviemap project developed in 1978 by a team of researchers from MIT working with Andrew Lippman with funding from DARPA. The research team, which included Peter Clay, Bob Mohl, and Michael Naimark coined the term Moviemap to describe the work they were producing. A gyroscopic stabilizer with 16 mm stop-frame cameras was mounted on top of a car and a fifth wheel with an encoder triggered the cameras every 10 feet. The car was carefully driven down the center of every street in town. The playback system required several early laser disc players, a computer, and a touch screen display. The user could navigate throughout the virtual space.

Although there were many other experiments, it was not until Apple Computer Inc. released the QuickTime VR capabilities for its popular QuickTime Player in 1995 that photographic virtual reality became an established medium. For the first few years, authoring photographic virtual reality was cumbersome and quite technical. Photographers created work by executing a series of pre-written, modifiable programming scripts in an application called Macintosh Programmers Workshop. In August of 1997 Apple launched the QuickTime VR Authoring Studio application, which greatly automated the process. In the late 1990s iPix began developing software and equipment to support the creation of full 360° horizontal by 180° vertical panoramic imagery. This allowed users to look in all directions including straight up and straight down. Since that time developers have been expanding the possibilities of this emerging form by creating new authoring and viewer software as well as specialized camera equipment and techniques.

Photographic Virtual Realty Panoramas

A photographic virtual reality panorama is a panoramic image that the user can pan left and right, tilt the view up and down, and zoom the view in and out creating the sensation of looking around from a point of view located inside the scene.

Equipment

Generally, the process of generating photographic virtual reality media begins with the creation of source material, which is typically a series of photographic still images, although panoramic imaging devices are available that can create the entire source for a panorama in one image. Source material can be created with a digital camera, a video camera, PhotoCD, or a film camera, where the film is subsequently scanned on a flatbed or film scanner. In some cases photographic virtual reality source materials can be created in a computer graphics software application.

A wide variety of equipment is available for the creation of source material. This can include traditional camera equipment, which has been augmented with specialized tripod heads, ultra-wide fisheye lenses, or parabolic mirrors, as well as, dedicated rotational image capture systems. Most approaches to photographic virtual reality require that multiple images be made of any single scene. It is imperative that all of the images in the sequence match in point of view, exposure, color, and focus. Therefore it is recommended that a tripod with a special panoramic head be used and that all camera controls be operated in manual mode.

Perspective continuity between images is maintained by placing the nodal point of the camera lens directly above the rotation point of the tripod head. The nodal point of the lens is where light rays converge in the barrel of the lens, not the film plane nor the front of the lens element. This assures that the point of view of each image is maintained at the exact point in space as the camera is rotated. Panoramic tripod heads, or camera rigs, are designed with adjustable brackets for this purpose. The bracket will usually also allow the camera to be rotated into portrait orientation for greater vertical coverage. Tripod heads will also often have graduated scale and clutch for accurate rotation of the camera, as well as sprit levels to assure that the rotation plane is level.

The number of shots required for a panorama depends on the field of view of the lens, whether the camera is mounted in

TABLE 1 Lens and number of images

Lens (mm)	Number of images
6 fisheye	2
14, 15, 18, or 20	12
22, 24, or 27	18
35	20
42	24
50	28

This table indicates the number of images necessary to achieve at least 50 percent overlap using a 35 mm film camera.

portrait or landscape orientation, and the amount of overlap of each image. It is a good idea to overlap the images by at least 50 percent.

Exposure and contrast range can be a serious concern with virtual reality photography as the lighting conditions can vary so much in a single scene. Therefore, it is important that lighting be metered for the entire scene and an average exposure setting set manually and maintained in subsequent shots. If the camera is set to automatic exposure, the exposure will change as the camera is rotated toward lighter or darker areas of the scene. The result will be that the image brightness will vary from shot to shot and will match poorly when combined in the stitching process. It is also recommended that automatic white balance not be used for the same reason.

Film cameras were designed to record light so that it could be reproduced on photographic paper. Digital cameras were developed to display images on a computer screen. Both photographic paper and computer screens fall far short of the dynamic range, or ratio between light and dark, which the eye perceives. By taking a series of pictures with different exposure settings the range can be captured and the images can be combined into a single high-dynamic range image called a radiance map.

In most cases it is recommended that the focus be set manually to the hyperfocal distance at smaller apertures to achieve acceptable sharpness for the entire scene.

Software

Once the source material has been collected and digitized if necessary, it must be digitally processed. A variety of software applications exist for processing photographic virtual reality source material, which range from free downloadable applications on the Internet to expensive full-feature packages.

Stitching

The first step in processing the sequence of source material images is to combine them into a single image in a process called stitching. The stitching process prepares the perspective of the image for one of three projection methods and blends the edges of adjacent images to form a single contiguous image. When the right side of a 360° panoramic source image leaves off where the left side begins the image is considered wrapped. This creates a seamless edge when viewed in a player. Although a panorama does not need a full 360° yaw, or horizontal rotation, to be viewed in a player, it would not be considered wrapped. The resulting stitched image is referred to as source image.

Source image

The type of projection method used in a source image depends on the type of source material and what form the final output will take. The three most common projection methods used in photographic virtual reality include cylindrical projection, spherical projection, and cubic projection.

A cylindrical projection image appears with correct perspective when it is mapped onto the inside surface of a cylinder and viewed from the center point of the cylinder. This type of projection is what slit cameras make, and it is the most common projection method used in photographic virtual reality. Cylindrical projection allows for a full 360° yaw, but the vertical tilt, or pitch, is limited to about 110° before perspective distortions will begin to occur.

For pitch angles greater than 110°, a spherical projection method is recommended. A spherical projection image appears with correct perspective when it is mapped onto the inside surface of a sphere and viewed from the center point of the sphere. It can display a full 360° yaw and 180° pitch from nadir to zenith. This kind of an image can only be created if the camera lens has a 180° field of view or greater, or if the source material is collected and stitched in rows as well as columns. Spherical projection can also be referred to as an equirectangular projection. The nadir and zenith points appear stretched into lines at the bottom and top of a flattened spherical projection image so that when it is mapped onto a sphere, these lines converge at the poles of the geometry.

Another solution to full 360° yaw and 180° pitch photographic virtual reality is cubic projection. A spherical panorama can be converted into the six faces of a cube. The cube faces are actually 90° × 90° rectilinear images. Cubic projection is sometimes referred to as cube strip projection or hemicube projection.

Output

Once a source image is complete it must be compressed into an interactive movie file or mapped onto geometry and assigned a user interface so that it can be navigated in a player. The image is assigned a default pan, which is the horizontal direction that the image will face when it is initially opened in a player. The pan range is determined by the yaw of the source image. In most cases this is 360°, but it can be less if the image is not wrapped and the interface will stop the pan when the edge is reached.

The default tilt is the vertical direction that the image will face when it is initially opened in a player. The tilt range can

be set from 0° (no tilt at all) to 180° (complete tilt from nadir to zenith) and is determined by the pitch of the source image.

The default zoom is the magnification of the image when it is initially opened in a player. The zoom range is determined by the resolution of the source image. Low-resolution images will appear unacceptably soft, or pixelated, if the zoom range is not limited.

Photographic Virtual Reality Objects

A photographic virtual reality object is an image of an object that can be rotated, tumbled, and the view can be dollied in and out, creating the sensation of holding the object and examining it. It is created by photographing an object every few degrees as it is rotated, or by rotating the camera around the object's y-axis as it is photographed. The images are then reassembled and compressed into an interactive movie file. Special tabletop rigs are available for capturing object files. Object rigs are designed to keep the object and camera in registration during shooting to assure smooth playback. Tumble can be added by capturing rows of images as the camera or object is pitched on the object's x-axis. This allows the user to turn the object over. In some cases the object can include animation by adding multiple frames to a single view of the object. This technique is referred to as view states. An example of this would be an image of a car, which the user can rotate as well as open and close the doors.

Photographic Virtual Realty Scenes

A photographic virtual reality scene can be made up of multiple panoramic nodes and objects as well as audio and links to other digital media and Internet addresses. Additionally a photographic virtual reality scene can be made from three-dimensional models, which have been rendered in a computer graphic application. By combining these media, a virtual world can be created, which is capable of telling a complex story in a unique and dynamic way. Photographic virtual reality scenes are also referred to as hypermedia. This differs from multi-media, which is generally organized in a linear structure. Hypermedia can be entered, or accessed, from multiple points, navigated in a non-linear, exploratory experience and is often open ended. It has its foundation in the hyperlink, which was invented for the World Wide Web in 1990 by Tim Berners-Lee as a way to organize and access digital documents and other resources. The hyperlink led to the invention of hypertext, which could accommodate true interactive narrative. Hyper-media takes this to the next level by creating a multi-sensory experience. Through these technologies it is now possible to enter and inhabit an image, which is what Robert Barker was trying to achieve over 200 years ago.

FURTHER READING

Berners-Lee, T. and Fischetti, M. (1999). *Weaving the Web: Origins and Future of the World Wide Web.* San Francisco: Harpers.

Cailliau, R., Gillies, J., and Cailliau R. (2000). *How the Web was Born: The Story of the World Wide Web.* Oxford: Oxford University Press.

Debevec, P. E. and Malik, J. (1997). Recovering high dynamic range radiance maps from photographs. In *Proceedings of SIGGRAPH 97, Computer Graphics Proceedings, Annual Conference Series* (Whitted, T., ed.), pp. 369–378. Los Angeles: Addison Wesley.

Oettermann, S. (1997) *The Panorama: History of a Mass Medium.* Boston: MIT Press.

GLOSSARY

Barrel distortion — Distortion in an image from a lens, where straight lines are bent outward from the center of the image.

Cubic projection — A projection method, which represents a spherical panorama as the six faces of a cube.

Cylindrical projection — A projection method, which appears with correct perspective when mapped onto the inside surface of a cylinder.

DARPA — Defense Advanced Research Projects Agency.

Default pan — The horizontal direction that a virtual reality image will face when it is initially opened in a player.

Default tilt — The vertical direction that a virtual reality image will face when it is initially opened in a player.

Default zoom — The magnification of a virtual reality image when it is initially opened in a player.

Dynamic range — The ratio between light and dark.

FOV — Field of view.

HDRI — High dynamic range imaging.

High dynamic range imaging — A set of techniques that allows for a far greater dynamic range of exposures than normal digital imaging techniques. The intention is to accurately represent the wide range of intensity levels found in real scenes, ranging from direct sunlight to the deepest shadows.

Hyperlink — Also referred to as a link, describes a reference in a digital document to another document or other resource. It is derived from the use of citations in literature, but has been adapted to networked computer technology, allowing instant access to referenced document or resource. The World Wide Web is structured on the hyperlink.

Hypermedia — A term used to describe a form of digital media made of images, audio, video, text, and hyperlinks organized and accessed according to non-linear principles. It is generally understood that hypermedia requires computer technology for its creation and its distribution.

Java VR — A multi-platform computer language used to give Web pages more functionality. Java Applet programs like PTViewer or the iPIX Java viewer are used for displaying photographic virtual reality files on a personal computer using the World Wide Web.

Laser disc — The first commercial optical disc data storage medium.

Mapped — When an image file is applied to the surface of a piece of geometry.

Multimedia — The use of a variety of media to convey information. Multimedia is generally understood to be linear in structure and in presentation. Multimedia is often associated with digital media and computer technology. However, a computer is not an essential component of multimedia and its development predates the advent of the computer, as in the case of piano accompaniment at early silent film. The term multimedia is also used in visual arts to describe works created using more than one medium.

Nadir — The lowest point of a spherical photographic virtual reality image.

Nodal point — The point within a lens at which all the light rays converge.

Pan range — The amount that a virtual reality image will rotate on the y-axis when it is viewed in a player from 0° to 360°.

Pitch — The up-to-down rotation of a panoramic tripod head or the rotation of a virtual reality image around the x-axis.

Pixel — The smallest unit of a digital image file that can be assigned its own color and value.

Pixelated — An effect caused by displaying a digital image at such a large size that individual pixels appear square to the eye.

Player — A piece of software, which is designed to present digital media files. A player is sometimes referred to as a viewer.

QTVR — QuickTime virtual reality.

QuickTime VR — QuickTime is a high-performance multimedia technology developed by Apple Computer Inc. for displaying digital media files. QuickTime VR is a functionality of QuickTime that allows the display and navigation of photographic virtual reality files. It can operate as a stand-alone application or on the World Wide Web.

Radiance map — A high-dynamic range image.

Rectilinear — The type of image created by a standard camera lens where straight lines appear straight. Rectilinear lenses have a FOV less than 180° and do not create barrel distortion.

Remap — To convert an image from one type of projection to another.

Resolution — The dimension of a digital image in pixels. The resolution determines the file size and level of detail of an image.

Scanning or slit camera — A type of camera that exposes a narrow vertical slice of an image as it rotates around the vertical axis.

Source image — A single panoramic image created by stitching together a sequence of source material images.

Source material — An image or sequence of images created for processing into a virtual reality panorama.

Spherical projection — A projection method that appears with correct perspective when mapped to the inside surface of a sphere.

Stitching — The process of combining several discreet images into a contiguous panoramic image.

Tilt range — The amount that a virtual reality image will rotate up and down on the x-axis when it is viewed in a player from 0° to 180°.

Uniform resource locator — A standardized address naming convention for locating and accessing resources on the World Wide Web. Also known as simply a URL.

URL — Uniform resource locator.

User interface — The functional and sensorial attributes of software that is relevant to its operation.

Viewer — A piece of software designed to present digital media files. A viewer is sometimes referred to as a player.

Virtual reality — An interactive computer-simulated environment.

VR — Virtual reality.

VRML — Virtual Reality Modeling Language.

View states — When a photographic virtual reality object includes multiple frames of animation in a single view of the object.

World Wide Web — An information network in which the items are located and accessed on the Internet.

Wrapped — When the right side of a 360° panoramic source image leaves off where the left side begins creating a seamless edge when viewed in a player.

Yaw — The side-to-side rotation of a panoramic tripod head or rotation of a virtual reality image around the y-axis.

Zenith — The very top, or apex, of a spherical photographic virtual reality image.

Zoom range — The amount that a virtual reality image will magnify when it is viewed in a player. ◎

Potlatch, Auction, and the In-between: Digital Art and Digital Audiences

A. D. COLEMAN

Independent Photography Critic, Historian, and Curator

Two models of digital art-making and dissemination dominate the current discourse on this subject: *potlatch* — the open-handed giveaway of one's bounty, as practiced by the Kwakiutl Indians of the Pacific Northwest — and *auction*: sale of one's work to the highest bidder. As an alternative, let us explore a fertile middle ground, which I'm calling here "the in-between." Among the issues involved are the politics of access, the challenges of unstandardized technology, and the imminent shift in systems for the distribution, presentation, and financial support of digital art.

As we move into the 21st century, only a small fraction of the world's population enjoys the privilege of computer use and Internet communication. Except in certain museum and public-display contexts, on the levels of both production and distribution the making of digital art and the engagement with it as an audience member presently involve access

to a computer and, in many cases, to the World Wide Web. Even in first-world countries, this represents disparities—of economics, of education level, of class, and of race, among other inequities.[1]

From a political and pedagogical standpoint, therefore, some of our attention and energy must concentrate on heightening awareness of who's tacitly excluded from this discourse, so that we and they can join in steadily expanding the audience and dissolving those borders.

We also need to keep in mind that every technological advance in the digital field, however exciting it may prove for the artists who adopt it, leaves some segment of the existing audience behind. The already vast and ever-growing diversity of computer hardware, software playback media, project design and display programs, and Internet data-transmission and display systems effectively guarantees that some significant percentage of the computer-equipped and computer-literate and Web-ready audience for any work of digitally transmitted art will find itself unable to open, view, download, or otherwise access that work on perfectly good and reasonably up-to-date computers adequately connected—if necessary for that project—to the Internet. This problem will only grow worse over the next decade, I venture to predict. It certainly won't be solved by the advent of so-called "Web services," whereby software will be stored online and accessed via subscription by users; who knows what compatibility will exist between the artwork one creates and the software-subscription decisions of any prospective viewer thereof?

Add to this, by the way, the fact that as this or that generation of hardware and software obsolesces and disappears, digital artwork created with and for one or another variant thereof all too frequently obsolesces with it, unless and until it's repurposed and reconfigured for the newer technology.

So . . . want an art-and-science project? Apply your insights and imaginations to the creation of Digiomnivore, a form of artificial intelligence 'bot capable of ingesting any form of digital media and playing it back according to its programmed purpose. Maybe it should take organic form, as a genetically engineered digestive-regurgitative-excretive biosystem—something not necessarily as unlikely as you might think, given recent biotech advances that enable the bar-coding of molecules, the creation of nanobots,[2] and the introduction of miniaturized electronic circuitry into microorganisms. Or maybe, since we ourselves seem poised to become the first generation of cyborgs, you can devise this as an implant, a

media-input slot in some inconspicuous, otherwise unused area of the body.

Whatever form it takes, until its invention artists and audiences alike remain fated to struggle with the real but generally undiscussed problem of systems proliferation without standardization—incoherent distribution. This bewildering multiplication of encoding, storage, distribution, and retrieval systems confronts the bottleneck of comparatively unevolved display technology. At present, the audience encounter with purely digital art—art that takes no analog form—happens on the VDT or computer monitor, a device that's changed very little over the past twenty years. Designed for single-user viewing, the VDT functions as the end-point of digital-art distribution, the physical site at which that art meets its audience. Its limitations determine the impact of that art, and need to be factored in by the artists working with these technologies. New forms of VDT—including a paint-on, emulsion-based liquid and a fabric-like version—seem obvious alternatives, but the invention and manufacture of more varied forms of digital-art display may well be artist-driven.

During a PBS interview on the Charlie Rose Show[3] the great composer, arranger, and producer Quincy Jones spoke eloquently about his studies in Paris after World War II with the legendary music teacher Nadia Boulanger. As a jazz musician, working with the assumption of improvisation and the freedom it implies, he was struck forcibly by her insistence on the value—the creative value—of structure and boundaries as stimuli in the making of art. And Jones came to agree with her: whether the constraint was the 3-minute duration of the standard 10-inch 78 rpm record or the 12-bar structure of traditional blues form, these boundaries served the artist who used them well. The more restrictions you have, the freer you become," Jones said, or words to that effect. In that regard we can recall what John Keats, one of its most devoted servants, said about the strictures of sonnet form: that he discovered therein "not chains but wings.

I can't imagine any digital artist speaking that way about the VDT, perhaps because as a container for creativity it doesn't offer anywhere near the challenge that sonnet form or 12-bar blues does. Up till today, looking at digital art largely means squinting at stuff on the equivalent of small- to medium-sized television sets. Imagine, for comparison's sake, if photography for the last century and a half had found itself viable only in the form of the daguerreotype, and only in the standard 19th-century sizes for that medium's plates. Surely that would eventually—if not quickly—have reduced photography's audience. The same holds true, I'd contend, for digital art. We can anticipate a major surge in the audience and market for work in this form once it's liberated from the pixellated prison of the now-standard computer monitor or screen.

Let us turn next to the issue of the bugginess of just about all the software that anyone uses in doing any digital art project. In late 2001 Bill Gates made headlines in the trade

[1] One can only regret that the late French sociologist Pierre Bourdieu never turned his attention to the subject of computer usage and the Internet. Perhaps one of his followers will bring to those subjects the strategies of analysis that Bourdieu applied to the ways in which issues of class shaped other discourses, as in his work with Alain Darbel and Dominique Schnapper, *The Love of Art. European Art Museums and their Public* (Stanford, CA: Stanford University Press, 1990).

[2] "'Nanobots' may be future of medicine," Associated Press; datelined Washington, June 29, 2000.

[3] "The Charlie Rose Show," November 22, 2001.

publications by pledging Microsoft to the production of less defective software. I can't imagine any other industry in the world in which it would be newsworthy—on a cover-story level—for a leading manufacturer to declare that his company's product should be "trustworthy" and "reliable."[4] In what other realm would Gates's announced determination to vend goods that merely work dependably merit media attention, praise for speaking "the language of leadership," and the adjective "ambitious"?

In any other industry, untrustworthy and unreliable goods get called what they are: lemons, junk, shoddy and inferior merchandise. Somehow, in computer software, we tolerate a level of defect and a frequency of failure that would have us up in arms if we encountered it in our telephone systems, our cars, our CDs and stereos—and especially in our typewriters and cameras and trombones and toe shoes and stage lights and amplifiers and all the other tools we employ to produce art.

For decades now, the software industry has forced consumers—including digital artists and photographers—into paying for the privilege of serving as its beta testers. They've even got their own software piracy police force out there right now, in hot pursuit of anyone with the temerity to refuse to pay for the error-ridden programs Gates and others belatedly acknowledge they've been foisting off on us for all these years. They have yet to apologize for this—or for the incomprehensibility of their documentation, the appalling quality of their tech support, or their ridiculous no-return-once-it's-opened policies.

As for the "rigorous industry standards" one trade magazine refers to—just exactly what are those? No software I've ever installed comes up to even the minimum requirements of the "Software Bill of Rights" proposed at www.amrresearch. com. I'll believe Gates's promise—and the assumption that this signals some tectonic shift—when I see results. And I'm not holding my breath.

What this industry needs isn't high-minded internal memos on code quality from Bill Gates. It's some whopping settlements in some major class-action suits against them for false advertising and deceptive business practices, and victories for the plaintiffs in some substantial individual suits for damages. Hit 'em where it hurts: make it unprofitable for them all to put their bug-riddled, conflict-prone, endlessly patched, frequently crashing programs on the market.

Bringing back the pillory for the worst offenders wouldn't hurt, either. Gates himself is a prime candidate for the stocks; given Microsoft's market share, no company has put more bad code on the market. And for all of Gates's vaunted business savvy, it's not even good business—customer relations

entirely aside—for them to have done so. In his book *Software Engineering: A Practitioner's Approach*,[5] author Roger Pressman shows that for every dollar spent to resolve a problem during product design, $10 would be spent on the same problem during development, and that would multiply to $100 or more if the problem had to be solved after release. Meanwhile, statistically speaking, one out of every ten lines of programming code is incorrectly written at birth. And the most efficient systems in place for quality control right now reduce that to only one faulty code line in every hundred.

This represents an aspect of the situation of digital-art production that goes so widely unmentioned that it appears to be the form's dirty little secret, though it's in no way the fault of any digital artist. From its origins until today the field of digital art has confronted a problem without much if any precedent in the history of art-making. Digital artists work under a tremendous handicap—to wit, a continuous, exhausting, psychologically debilitating struggle with defective, ineptly designed tools in whose conception and development those artists had little or no voice. Just as you can't understand the dynamics of the New York art world from 1970 through the present without factoring in the skyrocketing cost of real estate in that city during that period, so you can't really grasp the context in which digital art gets made without an awareness of this inherent instability in the technical end of the production system.

The amount of time, energy, money, and frustration expended by digital artists on grappling with this severely impaired toolkit constitutes an important but neglected aspect of the sociology (and psychology) of digital-art making from its origins till the present day. I foresee no rapid resolution to this situation. And this refers only to those artists who've actually committed themselves to working digitally, and not to those many others who might well have pursued serious efforts in this medium and contributed substantially to it but became discouraged by these faulty products and turned their attention elsewhere.

Moving to another subject: Digital art-making offers artists everywhere—again, that is, those with access to the technologies—the opportunity to make artworks without making objects. This constitutes the true dematerialization of art. But how will such work—which will take the generic form of what we now call "files"—reach its audiences? It will come to them either encoded and embedded in some physical software medium (computer diskette, CD-ROM, DVD, or variant thereof) or housed at a server and made available over the Web. Neither method particularly suits—or, for that matter, requires—the distribution and sales systems for art that have dominated the past two centuries: museums, commercial galleries, non-profit spaces, private dealers, auction houses, book publishers and booksellers, magazines and their editors and writers. Digital art-making, in conjunction with

[4] For example, see the special issue of *Information Week* for January 21, 2002 (issue 872), devoted to "The Sorry State of Software Quality." Note therein particularly Stephanie Stahl's Editor's Note, "Poor-Quality Software Needs Zero Tolerance" (p. 8); George V. Hulme's cover story, "Software's Challenge" (pp. 22-24); and Bob Evans's "A New Era for Software" (p. 72).

[5] Roger Pressman, *Software Engineering: A Practitioner's Approach* (New York: McGraw-Hill, fifth edition, 2001).

technologies of delivery already in place and soon to come, enables a direct artist-to-audience communication, and an equally direct feedback loop.

These methods of digital distribution will force digital artists to rethink their fundamental assumptions about the financial support systems for their work. In a direct producer-to-consumer relationship, what model should one follow? And, when one has opted for the creation and distribution of intangible work in the form of "files," however transmitted, what strategies of pricing and what payment structures work best? Purchase? Rental? Subscription and/or membership may come to the fore as new approaches to patronage and audience support and as new ways for artists to subsidize their work.

Let us consider a model. Imagine, if you will, a website for Digital Artist X (DAX), parts of which are free and open to all but other parts of which require a password, which changes regularly and is available on a subscription basis. For $25 per year for an individual subscription, or $250 per year for an institutional one (allowing access for all members of a school's media-arts department, for example), visitors get the following:

* Monthly posting of completed work, work in progress, and other examples of what DAX currently has on the front burner.

* Access to an archive of past work by DAX, and of course all the relevant boilerplate—DAX's CV and biography, critical commentary on DAX's work, etc.

* Notes, journal extracts, quotations from whatever DAX's reading that she feels pertains to her work.

* A chat room where DAX and invited guests—critics, curators, other artists, other teachers—discuss issues relevant to DAX's work.

* A bulletin board where subscribers can post their comments about all that and interact with each other.

* Periodic, pre-scheduled live studio visits, via streaming audio and video, in which subscribers actually get to see DAX at work, clips from these to be archived at the site.

* Periodic, pre-scheduled live chats with DAX, in which DAX engages in online dialogue with subscribers.

* By-appointment-only online critiques by DAX of student work.

If DAX found a thousand individual subscribers worldwide, or a hundred institutional subscribers, DAX's site would earn $25,000 per year. I know a number of digital artists—and even analog photographers—who could put such revenues to good use. Yet I know of no experiment with such a model by an artist, so it stands untested. This distribution model may not work, but assuredly there are others that will, and it's up to artists to discover them.[6]

This brings us, inevitably, to the issue of intellectual property, which lies at the heart of any discussion of the distribution of art. I acknowledge the oh-so-Sixties trendiness of asserting that "the Net should be free," and the more recent fashionability of proposing, as does the Electronic Freedom Foundation's John Perry Barlow,[7] that "information wants to be free," and I certainly consider art a type of information. But the 'Net is simply a vehicle for the dissemination of information, with no inherent objection to compensation for that act; and information, including art-as-information, no more "wants to be free" than does cat food. The translated locution really means that those who take this position would like to see the free distribution of art-as-information.

So would I. But, this side of paradise, that can take place only if art's producers happen either to come from the wealthy classes (and are therefore able to give their work away) or else if they're subsidized by private patrons, the corporate state, the academic sector, or the government—all of which, of course, filter (that is, censor, both tacitly and overtly) everything they underwrite. Artists in the States envy the level of government support available as a matter of course to—for example—artists from the Netherlands, Canada, and the Nordic countries. Curiously, however, and perhaps not coincidentally, as a rule they can't name a single Nordic, Dutch, or Canadian visual artist they consider a major contributor to the current field of ideas. Conversely, Nordic, Dutch, and Canadian artists envy the corporate support of the arts we've achieved in the States, usually without recognizing how it's defanged whatever authentically oppositional, anti-corporate impulses our artists once felt.

At the risk of sounding untrendy, I must say that as a maker of intellectual property of various kinds (including poetry, fiction, and visual art, as well as ratiocinative prose), I believe in the necessity of laws protecting intellectual property and copyright, and believe they will endure well into the digital age. It's no accident that the basis of intellectual copyright law was written into the U. S. Constitution in the late 1700s, and not as an afterthought or amendment but right up front—Article I, Section 8, right in there with Congress's empowerment to coin money and declare war. The survival of makers of intellectual property—including digital art—depends on protecting their ability to control and make a living from the production and distribution of their work. The digital environment offers them remarkable opportunities to do so, in a context that makes possible the elimination of middlemen and gatekeepers who, historically, have interfered in the artist-audience relationship at least as often as they've facilitated it.

But that same digital environment also offers various means of hijacking the labor of others, and has engendered a culture of entitlement whose members feel free to take what they want. So any pedagogy of digital art distribution needs

[6]A project of my own, the Photography Criticism CyberArchive (photocriticism.com), represents my own experiment with this model. A password-protected, subscription-based repository, it includes hundreds of my essays and hundreds of texts by dozens of other writers past and present on photography and related matters.

[7]Notably, Barlow has yet to put his money where his mouth is by placing his own income-producing lyrics to Grateful Dead songs into the public domain.

to include an inquiry into the concept of intellectual property and the various alternative forms of financial support for artists, along with familiarization of both students and faculty with copyright law—both national and international—and subsidiary-rights licensing, and even encryption technology.

When museums ask artists to transfer copyright and all other rights to them along with the works themselves, as they've begun to do here in the States, then artists (and their teachers) need to join the battle initiated by such organizations as the National Writers Union in the U.S., in such lawsuits as the landmark *Tasini vs. Times* case. No single action will more directly affect your control over the distribution of your work than surrendering all rights to it.

Finally, it seems evident that as the technologies of data transmission and information display change, the very environment of digital-art distribution will shift with it. From the wireless Internet-in-your-pocket option to broadband Internet-everywhere innovations, we can expect to carry digital data with us, show images on our clothing, turn our walls and furnishings into monitors, walk through and interact with digitally generated and holographically credible 3-D spaces—perhaps even have digital receptors implanted in our bodies.

The advent of media arts/time-based arts programs in colleges, universities, and art schools signals an unprecedented merger between what we once considered hard science—computer theory, programming, and such skills—with both media studies and the fine and applied arts. This hybridizing hothouse promises to be among the most fecund sources of innovation in 21st-century communication. In that context, production and distribution find themselves inextricably intertwined; it's almost impossible to consider one without the other.

In the title of this paper I juxtaposed *potlatch* and *auction*. Digital distribution of digital art facilitates each of these systems, as most artists' websites bear witness to at one end

and eBay's art section demonstrates at the other. Nothing truly innovative there—just old wine in new bottles.

But the next several decades, I anticipate, will see a lot of experimentation in what I've called *the in-between*, with digital artists and their digital audiences collaborating in testing unprecedented, and potentially healthier, ways of getting artwork to its optimum user base while making it possible for artists to survive and even thrive on the fruits of their labors. That's the challenge, and I for one can't wait to engage it as both a maker of intellectual property and a member of the audience for art.

The Pressure to Stay Current

BARRY HAYNES
Photographic Author

Beginning in 1975 with the first computer science class that I enrolled in at the University of California, San Diego—where in 1978 I received a BA in Computer Science—I have been involved in this cycle of keeping up with technology. Since 1988 that technology has been focused on photography and its interaction with the software Adobe Photoshop and computers. It has been my experience that technology can take over one's life and get in the way of creativity. It is important to learn how to manage the need for technology but not let this need dominate the motivations to use it. This essay will share my story and experiences on this treadmill called keeping current. In this 30-year journey I have developed some personal rules to manage the abundance of technology

FIG. 25 A before and after Photoshop illustration from Barry Haynes' latest book, *Photoshop Artistry for Photographers Using Photoshop CS2 and Beyond*.

in this field without it managing me. This essay will also feature a short history of how quickly digital photography has quickly moved into the ultimate solution for shooting and printing that is currently used today.

My Journey with Photography and Technology

I've been working with photography and technology most of my life. My first camera was an Instamatic 104, which I took to England on a trip when I was 14. The Instamatic camera used 35 mm film but the film was preloaded into a plastic cartridge that was simply dropped into the camera and then you started shooting. The image format was square, versus the traditional 1×1.5 aspect ratio of 35 mm. I got some good pictures on that trip and this started an interest in photography that has become stronger and more pronounced during my life.

A Navy photographer

After two hard working quarters in 1972 as a freshman at University of California at San Diego's Revelle College, I found the beach more interesting than school where I was studying pre-med. Originally I went to Revelle because it was a beautiful place and far away from San Jose. After 6 weeks I realized that I was at the last possible time to drop all my classes and not flunk out. I was not ready for school so I went to the Navy recruiter's office and I got a commitment in writing on my enlistment contract that I was to be a Navy photographer.

After boot camp, where I was one of only two out of 80 in my company who had any college experience, I went to the navy photography school at the Pensacola Naval Air Station in Pensacola, Florida. This was a very large building filled with hundreds of little darkrooms each having faucets with flowing developer, stop-bath, and fixer. You did not drink out of those taps but it was great for a photographer. I got to use every kind of camera of that time including Leica 35 mm cameras, Mamiya twin lens 120, 4×5, and even a 16mm Aeroflex movie camera with sound track on the film. The photography training there was very good, even if it was not artistically inclined. I lucked out and got to stay and took every course they offered including photojournalism and motion picture. I learned the technology of traditional film photography of that time, 1974. After spending the rest of my Navy time on the shooting crew at the Fleet Training Center back in San Diego, I decided to go back to school at University of California, San Diego (UCSD).

BA in computer science and UCSD Pascal

The prior pre-med competition experience had convinced me I no longer wanted to be a biology major and that I actually really liked photography. I almost took a photo job at an ad agency in Los Angeles but I said, I've got to finish college first now or maybe I never will. During those first two quarters in college before the Navy, my friend, Roger Sumner, had scared me away from computers because he was at the computer center for what seemed like 24 hours a day, his eyes were usually red from lack of sleep, and he spent most of his time reading through piles of computer printout listings of massive Algol programs that ran the main Burroughs 6700 computer at UCSD's computer center.

I took an initial computer class to learn how to program in a computer programming language called Pascal. The following quarter I was helping to teach the class and had decided that Computer Science was going to be my major. Thus began a 13-year hiatus from photography and a deep immersion into technology.

I learned all about computers: how they work, how to program them, how to write compilers and assemblers to translate from human-like languages into the numbers that computers understand, and how to teach and help others understand. As I learned about computers, I also taught others the entire time I was there. You may think you understand something but when you have to teach it to someone else, that is when you really learn it! I worked on the UCSD Pascal project where we created a portable computer programming system and ported it to other new "micro" computers. Most of these new computers were the micro-computers that were just becoming popular in the late 1970s. The Apple II, based on the 6502 chip, was one of the first. I ported the UCSD system to the Intel 8086, a hot new chip that several years later became the base for the IBM PC. When you port a system like this, you get a chip on a board in a box with an instruction manual sharing the instructions of the computer chip and a description of how they work. This is basically the numbers you have to feed into that computer to make it add, subtract, etc. I had to write the program, which included an assembler that would translate the human-understood computer language into numbers that the computer would understand. I then had to write the assembly language instructions to run the UCSD system on that particular computer. I had to get the entire UCSD system up and running on this new computer. This is much harder than pushing the button to bootstrap, or start, you computer. You are writing all the computer instructions that the new computer has to go through to actually run itself. Obviously, I was into this technology at that time and I learned a lot about how computers work. Ken Bowles, who started and ran the UCSD Pascal project, was honored by UCSD in the fall of 2004 as one of the most innovative professors and creating a computer system that became well known and used throughout the computer industry. What I learned on this project gave me the confidence and knowledge to work anywhere in this new field.

Ten years at Apple Computer

In 1979, I became tired of school and wanted to get a job in the motion picture industry. I interviewed for these jobs and while I was waiting for their answers I went to San Jose to visit my family. While I was there I went to have lunch with my college friend who worked at a small company called Apple Computer. It was a long lunch and by the end of the day they had offered me a job.

I worked at Apple from January of 1980 until I took a leave of absence to work on my personal photography in August of

1989. During almost 10 years at Apple I did Apple II Pascal, based on UCSD Pascal; worked on Apple III Pascal; created the Lisa Pascal Development System; and also built Mac Smalltalk, an object-oriented programming system for the Macintosh. I was heavily into software development environments; the tools that allow other programmers to create software.

Seeing Photoshop got me back into photography

This all changed one day in 1988, I believe, when I was walking down the hall at Apple and saw a bunch of people crowded around a cubicle. It was Russell Brown from Adobe showing off a new program called Photoshop about a year before it ever shipped. At the end of his demo I asked him if I could get a copy. He reached into his shirt pocket and handed me my first copy of Photoshop on a diskette.

Soon after that I left the field of software development environments and was developing the technical end of a research corporate alignment, the "Medianet Project," between Apple Computer and Nynex, the phone company in Manhattan. I got to spend a lot of time in New York and learn all about the publishing industry and how it dealt with images. Even back in the late 1980s, broadband fiber high-speed networks were available in New York City and people in the publishing industry were very concerned about how to transport large color digital files around on these networks.

Back in the late 1980s, the advertising industry used million dollar Scitex computer systems to manipulate color photographs. They would pay a "Scitex Shop" $300 an hour to use these special computers to do things that Photoshop could easily do on an iMac today. I was this guy from Apple visiting the multimillion dollar Scitex shops in New York and telling them "you'll be able to do all that on a Mac soon." They all thought I was nuts, but most of them went out of business just a couple of years later when what I had told them came true. Most of the typesetters had lost their jobs a year or two before that when Lisa then Macintosh and other PCs were suddenly able to use CompuGraphic software to set type, which had previously been an art form done by hand. I had helped the CompuGraphic team port their typesetting software to the Lisa.

The Medianet project was fun and I worked on it until I decided to leave Apple in late 1989 to pursue my own photographic interests. I learned a lot about digital photography during those last two years at Apple and certainly decided that it was now to become my main focus. I became very good a Photoshop, but trying to actually make color digital prints at that time was still quite frustrating. The desktop computers in the late 1980s were fast enough to do design and layout, but working with a 3 megabyte Photoshop file back then was probably slower than working with a 600 megabyte file today.

Away from technology, back to the craft of photography

My time at Apple was a great experience, I was there when everyone wanted to work at Apple. It was the place to be and there were lots of great people there. Lots of big egos too though! When I started there were fewer than 500 employees including manufacturing and when I left the company had grown to over 10,000. Apple's technology was always better than Microsoft. UCSD Pascal was better technology than Microsoft and the UCSD system actually competed with Bill Gates to be the initial software on the IBM PC. The best technology does not always win the political battles though. Individuals and different teams at Apple were working against each other instead of working together to beat the, at that time unexciting, competition of Microsoft. Poor marketing decisions, bad relationships with dealers and distributors, noncommittal to corporate alignments, and in-battles between engineers, were the things that gave Microsoft a leg up when Apple really had the better technology. A lot of great technology ended up in the round file. Most of the technology we all take for granted today was included in ideas and discussions we had during meetings for the Medianet project—back in 1988. A "My Yahoo"-like thing on the Internet, Java-like transportable objects, downloadable movies, virtual tours, DVDs, and many other ideas were floating around back then. My Medianet boss, Mike Liebhold, is the one that convinced Apple to have a CD player built into every system. What a great idea! It sometimes takes a long time for ideas to become actual products that people use on a daily basis.

I was really ready to get back to the craftsmanship required in photography where the tools were not changing all the time and a person could focus on things like making a really great print. Working at Apple there was a new operating system version every week or two. You could usually play with the latest technical toys by just calling the company up and saying you worked at Apple and wanted to try it. I had a budget in our group of $100,000 a year to buy new digital photography toys. This was when the original Nikon 35 mm scanner cost $10,000; the first Canon "Still Video" digital camera was $10,000; and the Dupont Forecast, the first dye-sub color printer, cost $60,000. I wanted something that was stable, that actually worked, and that I personally could afford.

I took a one-year leave from Apple in late 1989 and finished the darkroom I had built into my house. I purchased a Jobo processor so I could process my own color and black and white film and also make my own Cibachrome prints. I had a nice Bessler enlarger with a color head and started shooting film with my new 4 × 5 camera. I took a Cibachrome masking class from Charles Cramer of the Ansel Adams darkroom behind the Best Studio up in Yosemite. Charlie was making dye transfer prints at the time and I was quite impressed with these. They were far better than anything a computer printer could do. I thought about learning the dye transfer process from Charlie.

I still have my finger in digital too

I got invited to a National Photographer's Association (NPPA) event at Martha's Vineyard in 1989 where I met Russell Brown of Adobe, Shelly Katz of *Time* magazine, and George Wedding

of the *Sacramento Bee*, among others. Everyone who attended wanted to learn this new digital technology and we had some early digital cameras and Kodak dye sub-printers, which were really quite good.

Because of my experiences and contacts from the Medianet project and the Martha's vineyard event, Apple Computer and the Seybold Publishing Conference hired me for two years, 1990 and 1991, to conduct a live demonstration at the Seybold publishing conference sharing everything from scanning to final pre-press output using desktop computers and peripherals as contrasted to those million dollar Sytex systems. I produced a full-color brochure using the Mac and sold copies of it to Nikon and other companies to use as promos at tradeshows. Sometimes I would get phone calls from people in the Midwest who had my brochures and suggested "I'm sure you did that on a Scitex machine," but I produced them on the Mac with a Nikon scanner and Linotype image setter.

I taught my first Photoshop workshop for the *Sacramento Bee* in 1990. Not many people were teaching Photoshop back then. I then went on to teach at the Kodak Center for Creative Imaging in Camden, Maine. This was the first place in the country to have a great set-up for teaching digital workshops. At that time, it seemed that Kodak was positioned to be a leader in this new digital revolution. Apparently they were having their own internal political wars between the new digital folks and the old guard film and paper group. From what I heard, the film and paper group won out at that time and many great digital printer and other products and ideas went down the toilet. The Center for Creative Imaging was cut from the Kodak budget and soon went out of business. Years later Kodak had to pay for this lack of vision about digital technology with massive layoffs and loss of market share. Now, of course, film and film cameras are going away fast. I hope to still be able to get 120 format and 4 × 5 Velvia, but I do not use 35 mm film cameras anymore and digital certainly beats them all. I use a Pentax 6 × 7 from time to time, but these days it is hard to find a good place to properly process the film.

I met my wife, Wendy Crumpler while giving a Photoshop talk at the Daystar booth at the Macworld conference in 1993. Wendy initially hired me to teach Photoshop to her commercial clients in New York City where she lived and worked. I was in Santa Cruz, California, and a long-distance romance started. We wrote our first Photoshop Artistry book while also having our first child together in 1995. Our son Max was born two weeks after the book was published. He is 12 years old now and we're just finishing the 8th edition of our book.

Since the early 1990s I have taught Photoshop and digital printmaking workshops at the Seybold Publishing Conference, Palm Beach Photographic Workshops, University of California Santa Cruz, Mac Summit Conference, Santa Fe Photographic Workshops, Anderson Ranch, International Center of Photography, Fotofusion, and many other places. Wendy and I have also been teaching workshops in our studio for the last 7 years. Teaching workshops or providing a place to teach workshops is a separate technology issue because you have to buy new computers, scanners, printers, and other equipment every year or two as image data continue to get bigger and Photoshop requires more RAM.

Finding a Digital Printer for Photographers

It was approximately 1988 when Photoshop was first on the scene and desktop computers started to be used for digital photography. One could create beautiful images on the computer screen, but it was not until approximately 1993 when affordable photographic quality desktop digital printers became available. The first somewhat affordable digital printer that actually made "big enough" photographic quality prints was the SuperMac ProofPositive Dye Sublimation printer. SuperMac called me to evaluate a unit in 1993. I jumped for joy to have this printer because I could now finally do beautiful prints from all my digital landscape images. There was a $20,000 price with this printer and it made 12 × 17 inch prints. This is the same size as the Epson 2200, which cost $700 and had much better quality. I also got a special deal on the ProofPositive and later purchased the unit for half price at $10,000. The trouble with these prints though was that when you put them up on the wall in a frame, the colors turned magenta after about 3 years. All dye sub-prints were of limited color permanence.

Color permanence was a problem with digital printers until the Epson 2000, 7500, and 9500 came out about 5 years ago. They had permanent color, marketed at 200 years, but it was hard to calibrate them and get the colors you actually wanted. Those colors also had a metamerism problem. Metamerism is a condition where the colors change when viewed with different types of lights. The prints would look great with 5000 Kelvin print proofing lights, but when you took them out in the sun these same prints were green.

In 2003 Epson came out with the 2200, 7600, and 9600 with Ultrachrome inks and this solved most of the problems for making color prints. Photographic quality was very sharp with a good dynamic range and the metamerism problem had been mostly solved for color prints. It was still hard to make black and white prints with absolutely no metamerism unless you used third party print drivers, such as the ImagePrint product from ColorByte. Imageprint makes great black and white prints on Ultrachrome printers but it costs more than $500. Some papers, especially glossy, could also have a bronzing problem with Ultrachrome prints. Sometimes you could see a reflection in solid black areas when looking at the prints from an angle.

In 2005, Epson came out with the Ultrachrome K3 2400, 4800, 7800, and 9800, which have a larger dynamic range than regular Ultrachrome and an even better ink set that makes wonderful color and black and white prints using the Epson profiles and drivers without metamerism or bronzing.

There are other color printers. HP has several good printers as well that some photographers use. The inks for the Ultrachrome and Ultrachrome K3 ink sets have a color permanence of 80 years or more on most papers, even longer for black and white. This seems to be much better than the old C print or Ilfochrome traditional photography color prints that were

marketed with a color permanency between 12 and 25 years. Darkroom black and white prints have been king for quality and permanence, but now I believe the new Ultrachrome K3 inks will give them a run for their money in longevity.

Digital Cameras for Photographers

I mentioned the Canon still video digital camera that I bought for $10,000 on Apple's budget. It photographed using a 640 × 480 pixel array that was video quality. I can get the same thing from my 10-year-old video camera. This was not a camera that came anywhere close to 35mm film in quality. At the time, I was not going to buy a digital camera until it could stop motion, shoot 3 to 4 frames per second, and the quality was close to what I could get by scanning a piece of 35mm film at 4000dpi.

Getting a great digital file by scanning film with a desktop scanner is something I have been able to do for about the last 10 years. I have tried lots of digital cameras over the years. There have been many commercial digital cameras costing $20,000 or more, although some of them could not stop motion. For my situation though, as a landscape photographer, why pay that much money when you can shoot film for cheaper and get better quality? For many commercial shooters, they could justify the $20,000 5 years ago so they would not have to pay for film or wait and pay for processing anymore.

I wanted a digital camera of at least 35mm quality that would stop motion and shoot 3 to 4 frames per second and be able to use my existing Canon lenses. The Canon IIDx certainly fit the bill, but it was $8000 when it first came out. Had I been a commercial photographer, I could have saved that much in the cost of film and processing, not to mention those clients who are chomping at the bit to have a digital file to take home at the end of the shoot! The 6 megapixel Canon D60, at $4000, and 10D, at $2000, were certainly equivalent in quality to the Digital Rebel, but they did cost considerably more when they were released. When the Canon Digital Rebel came along with the same quality as the D60 and 10D but at a cost of $1000, then it was time for me to buy!

I've shot over 11,000 images with my Digital Rebel and I can make high-quality prints up to 22 inches in size. For some images, I can go even larger. If I had been shooting film over the last few years, I never would have shot that many images and I would have missed some great shots. With digital photography, I just shoot it and do not worry about it. I have more fun shooting and I get to see the pictures right away. Editing and correcting the images is much faster, even though I shoot more images. I have all the images instantly available to show prospective clients. With film I only would have had the time to scan a few of them. I bet many readers of this essay who shot film still have thousands of images on film that were "going to be sorted and scanned one of these days." Most of the digital stuff I shoot now gets sorted and filed on the same day. I LOVE IT!!! Now I am eyeing the Canon 5D, which has the same size sensor as a 35mm, is 12 megapixels, and costs only $3000. I've tried one with the 24-105 zoom and I'll be getting

it as soon as I get $3000 I can spare. Until something better comes along by that time, which it will of course.

Speaking of better, I was recently talking to well-known landscape photographer Charles Cramer and he is getting a $30,000 digital back which may replace the 4 × 5 film he has been shooting for 30 years. Since he spends $8000 a year for film and processing, this actually makes financial sense too. Check out his article about this in the essays section of www. LuminousLandscape.com. If Charlie is going digital, that tells me something.

The march of all the other digital toys, too

The brief history I have given you sharing the evolution of digital printers and cameras also exists for desktop film scanners, flatbed scanners, Macs, PCs, CRT monitors, LCD monitors, all the versions of Photoshop (I have used versions .087, 1, 1.1, 2, 2.5, 3, 4, 5, 5.5, 6, 7, CS, and CS2 so far), and all those third party Photoshop plug-in filters and virus protection software.

Then there is the history of backup storage devices which began with punch cards (yes, I used punch cards), reel-to-reel magnetic tape drives, optical storage disks (extinct), DAT tape drives (extinct), CDs, and now DVDs. What will be next, holographic storage devices? The power strips and surge protectors and the newest thing, camera memory cards are constantly changing. Both my digital cameras have the compact flash format, which I like. For the last 9 years or so there have been the monitor calibrators; scanner, printer, and film profile-making software; spectrophotometers; etc. These are things that can take up a lot of your time and can also take a big slice out of your pocketbook.

Let us not forget to mention digital projectors. I have been giving lectures with a computer hooked up to a projector since 1988 and probably even before that when I worked at Apple. I love my Epson Powerlight 745c, which weighs very little and can project 1024 × 768 real pixels and fill up a large room with my computer's screen. Millions of colors are projected accurately and I use it all the time when giving talks and teaching workshops. You may be thinking: Why is he writing about the obvious? It is very important to know that many years of teaching Photoshop color correction using a 640 × 480 projector—where the projected color and contrast could not even begin to approximate the colors on my computer screen—gives me flashbacks to an unhappier era. I would have to say over and over again: "If you could actually see the colors on the projection screen then...." My son likes it too for projecting DVDs and we have learned that if you project them from a 1024 × 768 computer like my old G4, versus a VHS DVD player, you get essentially HDTV quality. Do not get a big screen TV, buy an Epson projector instead and use it for your business presentations and also for movie night.

It is interesting to recall the different types of computer memory chips that I purchased and installed over the years. I always enjoyed installing my own memory chips and have done that on the original Intel 8086 board (64K maybe), the Apple II (I had the one and only special 80K one so I could

re-compile the Pascal computer), Apple III (128 K), Lisa (1 megabyte, wow!), Original 128 K Mac (I had 4 megs in mine for Mac Smalltalk), Mac II (32 megs, I believe), Mac CI, Mac Quadra 900 (the most expensive Mac I ever bought: 32 megs cost $1000 and I had 128 megs), Mac Power PC 201?, Mac Power PC 8600, Mac aqua G3 tower (seldom worked properly), PowerMac G3 (I still use it with 750 megs), iMac (we have 4 at 256 to 750 megs), EMac (we have 4 at 750 megs to 1.25 Gigs), Mac Duel Processor G4 (my previous computer, 1 Gig, we use it to watch DVD movies), Mac Duel Processor G5 (my current computer which is great, 2.25 Gigs). I do also own one PC but it runs NT or Windows 98 and has the original AMD Athlon processor, which I tested Photoshop on for my friend at AMD. I received this machine in lieu of a payment for evaluation so technically I have never actually purchased a PC! I guess my next Mac will have an Intel processor and the family is due for a new portable. Maybe Apple will send me one after reading about all the Apple computers I have bought and used over the years.

Simplifying your march with digital toys
Part of the reason I have told you this long story is so you will understand and appreciate the words of wisdom I am about to share. The advice I will give is coming from someone who has been deeply involved in technology for the last 30 years and who now wants to focus on personal photography.

I know many photographers tend to be gadgeteers. Photographers are people who have spent lots of time looking at the latest cameras and films to analyze their inherent qualities. With digital photography there are a lot more gadgets to keep up with and if you feel that you always have to know the latest of everything, you will find that this can take up most of your time. If you need to buy the latest of everything, it can take up most of your money too.

You do not have to be independently wealthy or have unlimited amounts of time to spend to be able to produce beautiful prints with today's digital cameras and printers. If you are just entering this field, you have chosen the correct time. Digital cameras have evolved to the point where I can say for 99 percent of the population, "don't bother with film." If you want to do really large landscape pictures and cannot afford $5000 to $30,000 for the best digital cameras, then maybe shoot 120 or 4 × 5 film. If you start shooting film now, you will have to buy a scanner and have to find a quality place to get the film processed. You may need a scanner anyhow to scan film that you have shot in the past but otherwise, I'm now ready to say skip it. Film is going out and digital cameras are really great these days.

Limit the size of your digital gear bag
The software applications I use most are Adobe Photoshop, Bridge, and Netscape Navigator for e-mail and the Web. Because I write books, create training videos, and have a Web site, I also use Adobe GoLive, Acrobat, Premiere, and InDesign. Most of these Adobe applications come in one bundle, reasonably priced, called Adobe Creative Suite. TextEdit,

which I use for letters, is free with the Mac. I do not use Microsoft Word or any Microsoft products, it is simpler that way because you never know if Microsoft will be feuding with Apple and something you rely on will suddenly not work on the Mac. I also use Color Vision Optical to calibrate my monitor and Snapz Pro X to make screen grabs for books and articles. I do not use any third party Plug-ins because with my Photoshop Artistry book and workflow techniques you can actually do most things a photographer would need to do just by using Photoshop. I no longer make scanner or printer profiles because the canned profiles that come with Epson printers and even third party papers these days are just fine. If my monitor does not exactly match my print, I can fix that with either Optical or Photoshop.

I have previously tried third party Photoshop plug-ins, had lots of profile making software and hardware, used various scanners (which I still use occasionally), tried USB hubs, still used Microsoft Word, and had Filemaker, Excel, Illustrator, etc., just in case I needed it. The problem is that when you have all this stuff you need to drag it around with you and update it all the time. This takes extra time and costs money too.

For example, a software company had kindly let me borrow a spectrophotometer, which had a serial cable hookup along with $3000 worth of software to make profiles. Now this was a $2500 device! A year later, I upgraded my computer and wanted to also upgrade the software so I could talk about it in a new version of *Photoshop Artistry*. I called the company and they sent me a new $2500 device, now with a USB cable instead of a serial cable, and a new set of software worth $3000. I installed all the software, got the new spectrophotometer hooked up, and nothing would work because the USB dongle (a copy protection device) was incompatible with the new software. After calling this company several times to get a new dongle and not getting one, I just had better things to do and I have not used this stuff since. Imagine how frustrated I would have been if I would have paid for all that paraphernalia! Note: Every company I've known that has used a dongle for copy protection has eventually gone out of business!

Don't believe the marketing flyers—try it yourself
I have been buying digital equipment for 30 years and I seldom believe the marketing hype. You can read the marketing materials for the specs about a particular device, but to really decide if you want it, test it yourself or get advice from someone you trust who has used it. One manufacturer's 6 megapixel camera will not perform the same as another company's product, and so one camera may have more digital noise, may not be as sharp as another, or may capture the color in a way that you do not like. If you find a manufacturer you can trust, get to know a local store that carries their stuff or ask a local rep from the company. They will be able to tell you 90 percent of what you need to know. When a new product comes out that you want to buy, contact the local store or representative and see if you can borrow one for a day or week before you buy it. If you are a good customer, especially with photography equipment, this can usually be arranged. For example, I've been

shooting Canon cameras all my life and I have also been using Epson printers for the last 10 years. During that time, I have grown to rely on their products and trust the people I know at these companies. The same is true for Apple and Adobe. It would take a really great product to get me to switch to Nikon cameras, HP printers, or a PC workstation. I do know they have good products, but switching from what you know takes time and money to adjust. By the way, over the years I have known many photographers who have switched from PCs to Macs but very few have gone the other way. Lately, I have also come across quite a few Nikon lifers who are now buying Canon digital cameras, but in my travels I have not seen much activity going in the other direction. Folks with a lot of Nikon lenses should also consider the Fuji digital cameras, which are compatible with Nikon lenses.

Find friends who read and/or do their own tests

There is so much information out there these days that you could spend 24 hours a day reading information just on Photoshop Web sites. There are some good sites online though. Just go to www.Google.com and type in the kind of information you are looking for; for example, "digital camera reviews," "Adobe Photoshop downloadable training videos," Epson 2400 printer reviews. The most useful sites on the Web change frequently so, instead of my listing them, I suggest that you Google the things you are interested in and then decide for yourself who is just spewing marketing hype and who has useful information. I just spent 30 minutes doing a search because I got distracted by some of the stuff I found testing the above phrases using Google. Be careful, the Internet can suck up your time. Occasionally I subscribe to magazines but they are also a time sinkhole. Find a friend who reads all the photo magazines or better yet who performs their own tests. I have lots of photographer friends. Some, like Charles Cramer and Bill Atkinson, are people I have known for many years and realized that they share a lot of my interests and they also spend more time in some areas of photography than I do. I just read one of Charlie's articles on Luminous Landscape (a great site by the way). There is lots of great information and also amazing images at www.charlescramer.com and www.billatkinson.com. Charlie and Bill also teach workshops, which you can find out about on their sites.

My friends in Corvallis, Oregon, Dave McIntire and Thomas Bach, are also photographers. I got to know them via the local Corvallis Photo Arts Guild. Dave makes amazing landscape prints and I have learned a lot about photography from him. Thomas Bach performed substantial research on inks and printer issues at HP but now he makes art prints for himself, painters, and illustrators who want exact copies of their one-of-a-kind art so they can sell the reproductions. Thomas is a wealth of knowledge about printers, how to clean clogged inkjets, papers, etc. (www.photobach.com). Bruce Ashley, a commercial photography friend in Santa Cruz (www.bruceashleyphotography.com), used to do most of Apple's product photography and we became friends when I worked at Apple and we were both interested in this "new" digital photography. Bruce always knows about the latest cameras and monitors and many other things and I always appreciate

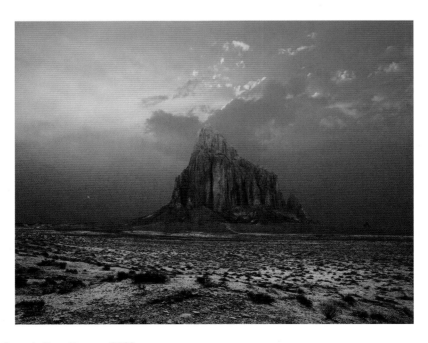

FIG. 26 Ship Rock Fire Sunset. Barry Haynes, 2006.

his advice. Maria Ferrari is a commercial photographer in New York (www.mariaferrari.com) whose work I really admire and she knows a lot about commercial photographers as well as their Photoshop needs and priorities. She also teaches Photoshop workshops in New York. Carl Marcus is a great landscape photographer and friend in Telluride, Colorado, who also likes to hike and photograph. I appreciate his opinions about cameras, printers, papers, etc. I call these friends to get their opinions and I trust what they have to say. I get ideas from them and then I often also try new products out myself. If I bounce something off these people and they do not agree with what I am saying or thinking, then I know I better look at it more closely. It is good to find your own group of photography friends; you can all learn from each other.

When I moved to Corvallis, Oregon, 8 years ago, most people in the Photography Guild there were just using film. I was the digital guy. Now many of them are digital experts themselves. Find smart friends who can afford expensive toys and then let them buy first. One of my friends has a Canon II Ds Mark II, a Canon 20D, and the newer Canon 8 megapixel Digital Rebel. No way that I could afford to get all three. I think he got the 20D first then decided he wanted bigger files so he bought the IIDs Mark II, and finally he decided that both of those cameras were too heavy for his extended backpacking trips so he bought and uses the 8 meg Digital Rebel for that. It is a really light camera but since I already have the regular Rebel, I am shopping for the 5D next. What my friend told me about his uses of these cameras was very helpful information. Many of my workshop students have all the latest and often most expensive camera and computer equipment but they take workshops from us to learn how to use them and make really great digital prints. We try out their toys and often help them figure out how to use them. Since we don't have to buy them either, it is great fun.

Get the most from the equipment you have

You do not always need the new version of everything. If you are taking pictures and making beautiful prints, be happy and create your art. If you need to do it faster or better or with higher quality then look into getting something new. With online update checking, computer software is always out there seeing if there is a new version of something. I set up my computer so it NEVER automatically installs anything. If your computer automatically installs something, this may break something else. You want to know when something changes and you want to know what changed so if something no longer works properly, it is possible to figure out what went wrong. As I mentioned earlier, when I was at Apple, we had a new operating system available to us almost every week. The person in the next office was always upgrading to the next version. He also always had all the extra software, control panels, desktop toys, Photoshop plug-ins, etc., that he could find. His computer was always crashing or something was not working properly. I kept on getting things done while he had the "hood open" on his computer trying to figure out what was wrong.

Let other people do the testing

When I do update things, I tend to assume I will have to update several things, learn new stuff, and deal with conflicts. When a new version of the Mac OS comes out, or a new computer like the new Macs with Intel Processors, I let other people bang their heads against the wall. People who are the first to try that new Mac OS or that new Intel Processor are often the ones who discover that some of the software they use and rely on does not work anymore. They have to lose productive time discovering this and then they have to spend time and money getting new versions. The worse situation is updating to a new OS then finding out that there is not a new version of the software you need that works on that OS. Usually after a new OS or computer has been out for a year or so, most of these problems get solved and other people spend their time figuring them out.

Buy the older version at a discount

When a new computer or software comes out, you can usually get the better configuration of the previous model for a lot less than it ever was before and also a lot cheaper than the new version. I am using a duel 1.8 GHz Mac G5, which is great for the workflow I have. Photoshop might be 20% faster sharpening a file if I had the 2.5 GHz model or had 4 Gigs of memory instead of 2.25, but for my workflow this would only save me 5 minutes a day. I would rather spend that extra cash on more hard disk space or the Canon 5D that I want. If I were sharpening images every 5 minutes 8 hours a day, then that faster machine would be worth it.

The pressure to be up-to-date

Because we make part of our living from our *Photoshop Artistry* books, we have to be using the latest version of Photoshop. We are now using Photoshop CS2 and it is one of the best Photoshop updates ever. I love all the new features, but I could still make wonderful prints using Photoshop CS or even Photoshop 7. There would be certain features I would not have in those older versions, but my creativity would still be very close to the same. The CS2 version does allow me to work with digital camera files much more efficiently so I upgraded my camera to the digital world and it also helped to upgrade Photoshop. Updating for a good reason is great but American society, marketing, and keeping up with the Joneses puts pressure on us to always have the latest of everything and this is not necessary. Take an extra photography vacation instead. Are you learning about the new versions of Photoshop? Play with it. Try things out, make prints, try this, try that. If you have a hunch, try it. Go through the menu bar and look for new features. Use the online help system or the help menu to look things up. The only other Photoshop book I have ever read thoroughly, besides my own, is the Photoshop manual for very early versions of Photoshop (say, version 2). I learned 90 percent of what I know about Photoshop from trying things out. When I need to learn something new, I will check the online help system and that will usually explain 60 percent of what I need to know. It will tell me what a tool does and what

the options are (some of them at least). Then I learned the rest, how best to actually use the tools, by trying things and experimenting. Do not always believe the manual either or even my book or anyone else's book. You may discover a better way. I do have several other Photoshop books, but I usually use them as a reference to see what other authors do with particular features. They often do things in different ways or have different opinions than I do. We all learn from each other. I try one way, I try another, and I often come up with something different from either. You need to learn how to do this too. Trying something with a backed-up digital file has zero risk. When you get a totally new piece of software, you sometimes have to break down and read all or most of the manual or some book about that software. After using computers for so long, most software is similar to something else I have used before and I am able to feel my way around and figure it out. Many years ago, when I first started at Apple and in college, I used to always read the entire manual for things. You can learn a lot of useful things that way but to really understand them and have the information useful for the future, it is better to actually use those things and try them out under different circumstances. This is what we have our workshop students do. They try our color correction workflow and techniques on their own images. Making a great print with your own image is always more satisfying and a better learning experience. Have fun in this, now digital, photography world! ◎ ◉

Science as Art

MICHAEL R. PERES
Rochester Institute of Technology
DAVID MALIN
Anglo-Australian Observatory; RMIT University

Since its invention, photography has been recognized as both an art and a science, linked by the technology through which its images are captured and then preserved. It is natural that aspects of these three components, in varying degrees, would be evident in photographic images. The extent to which art, science, or technology dominates the photographic expression is in the hands and the imaginative eye and mind of the practitioner. The importance of the motives in photography is as relevant in the digital age as it was for Daguerre and Fox Talbot, both of whom made some of the first photographs of scientific subjects.

Once its potential was realized, the intent of scientific photography has always been to make images without the photographer's personal biases being unduly evident. However, true objectivity is not possible, since someone has to press the shutter, light the subject, and frame the scene. In addition, the myriad of considerations necessary to convert a three-dimensional view into a two-dimensional image are almost all influenced by the photographer or imposed by the

FIG. 27 It is a slight departure from scientific methods to photograph and present in ways that are not scientific. Dr. David Teplica is both a practicing plastic and reconstructive surgeon as well as a photographic artist. (Photograph by David Teplica, M.D., M. F. A.)

technology. So while the intent may be complete objectivity, subjective influences inevitably intrude.

Most scientific photography is done with visible light and traditional cameras, but it may also be used to record invisible objects with dimensions of atomic or cosmic proportions, exploiting almost any region of the electromagnetic spectrum and in ways that are unconventional or highly specialized—holography and electron microscopy come to mind here. Scientific imaging also embraces the representation of scientific data that have no visual counterpart, such as a radiograph, or that is purely numerical, such as a fractal. Many of the subjects are recorded specifically because they have not been observed before, or cannot be observed directly, or simply because an image is the most convenient way to capture a rich stream of data, as in an outward-looking astronomical telescope or downward gazing earth-orbiting satellite. Consequently, a frame of reference is often absent from many science pictures, and when presented without scale, title, or context, they may appear as abstract images to the uninformed viewer.

It is clear that scientific photography offers a vast opportunity for anyone with a creative eye, although many of its practitioners would not consider themselves artists. Indeed many would not admit to being photographers in any conventional sense either. Nonetheless, it is hardly surprising that images made for science can be aesthetically pleasing or even inspirational, since they often reflect aspects of the world of nature, of science, and of technology that are not easily observed. Sometimes this world is inaccessible, unseen, or non-visible, yet can produce images that are mysterious, revealing, provocative, or inspirational to the science community and beyond.

Much of this was foreseen by the French astronomer Arago, who introduced Daguerre's revolutionary invention to the French government in July, 1839, with the intention of making the details public in return for a generous life pension for Daguerre. The full text is in Eder's *History of Photography*. It was clear that Arago saw the new process as useful in archeology, astronomy and lunar photography, photometry, microscopy, meteorology, physiology, and medicine, while noting "...

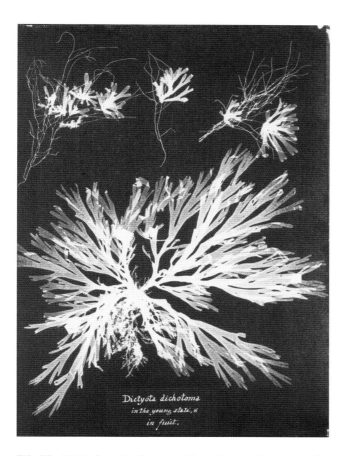

FIG. 28 Image from the first scientific publication illustrated with photographs of British algae produced by Anna Atkins as cyanotype impressions. This plate from her book is of *Dictyota dichotoma* in the young state and in fruit. (Image courtesy of the New York Public Library, New York.)

its usefulness in the arts." Thus from the beginning, the value of photography in the sciences was recognized.

The objective of preserving scientific data through permanent images was a key motivation before photography itself was invented. The idea of recording the outlines of leaves and insect wings using light alone was suggested 1802 by the photographic pioneer Thomas Wedgwood. This became a practical reality with Fox Talbot's calotype salt-paper prints and through John Herschel's cyanotype (blue-print) process, invented in 1842. A year later this led to the first book to be illustrated with photographs, Anna Atkins' *British Algae: Cyanotype Impressions.*

Atkins' book contained over 400 shadowgraphs and appeared a year before Fox Talbot's much better known *Pencil of Nature*. In the preface to her book Atkins wrote, "The difficulty of making accurate drawings of objects as minute as many of the Algae and Confervae has induced me to avail myself of

Sir John Herschel's beautiful process of Cyanotype, to obtain impressions of the plants themselves, which I have much pleasure in offering to my botanical friends." Despite its prosaic title and unusual subject matter, it contains images of science that are delicate and often quite beautiful, revealing the variety, transparency, and detail of natural forms in a way that no drawing can.

Atkins' skillful work showed that photographs had the potential to replace the pencil drawings often used for botanical specimens and to provide a new and visually compelling means of expression. It had also convinced some people, uninterested in algae, science, or even photography itself, that the forms and textures captured by this new process could be intriguing or even beautiful. It is in these ways, through inspiration, insight, and expression, that images of science may also occasionally, by chance or design, be works of art. It is a rather small departure from this to deliberately make scientific images that are intended to be aesthetically pleasing but that almost incidentally include scientific subjects and use scientific equipment, ideas, or techniques.

There were other early practitioners of science photography whose work was groundbreaking in both its photographic results as well as its aesthetic qualities. In her chapter on "The Search for Pattern" in *Beauty of Another Order*, Ann Thomas writes, "Mid-nineteenth century art critic Francis Wey (1812–1982) while puzzling over whether photography was an art of science, decided ". . . it was a kind of hyphen between the two. In fact art-science was the term nineteenth century astronomer Thomas W. Burr used to describe the recording of magnetic and meteorological data in 1865."

There were many pioneers dedicated to using photography as a means of scientific enlightenment, and initially most were British or European, though the work of New Yorker, John William Draper caught the eye of another pioneer, the distinguished astronomer, Sir John Herschel. Commenting on Draper's *Experimental Spectrum*, a daguerreotype made in 1842, he refers to ". . . the beauty of the specimen itself as a joint work of art and nature. . ." Later, and exploiting an entirely different property of photography, Thomas Eakins, Eadweard Muybridge, Étienne-Jules Marey, and Harold Edgerton at various times showed how it can be used to stop motion with arresting images. Later still we find photography firmly allied to the microscope to explore the hidden beauty of the very small or to the astronomical telescope to reveal unseen cosmic landscapes.

Many of these early practitioners were scientists who turned to photography to add to their understanding. More unusual was the photographer who turned to science for inspiration. The exemplar of this approach might be found in the pioneering woman photographer, Berenice Abbott, who made her reputation with her monumental Federal Art Project documentation *Changing New York* (1935–1939). Berenice Abbott proposed a new role for herself as science photographer, but she found little encouragement for her interest. In later life she turned her considerable talents to capturing scientific ideas in images, and wrote that photography was ". . .the medium

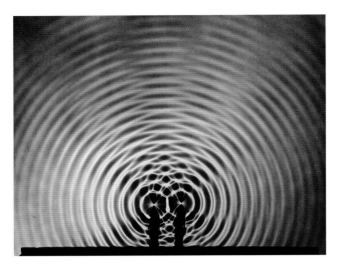

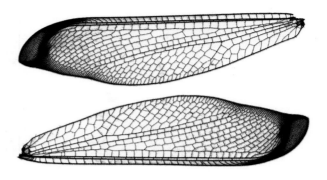

FIG. 29 A scientific image made for science purposes that is also pleasing to the eye, by Berenice Abbott. (Image courtesy of the Museum of Contemporary Photography, Columbia College, Chicago, Illinois.)

FIG. 30 A scientific image revealing an interesting and difficult-to-see aspect of nature, presented as an abstract image. The wings of the lacewing are imaged using a desktop scanner. (Photograph ©David Malin, 2006.)

pre-eminently qualified to unite art with science. Photography was born in the years which ushered in the scientific age, an offspring of both science and art" (see Figure 29).

When we look at scientific images taken 150 or more years ago, many now seem to be minor works of art, partly because of their rarity, but also because many of those who embraced photography in its early days had some artistic training or temperament. Many of the early processes also had a delicacy of tone or color that lends a grace and style rarely seen today, however, few of the early science pictures that we now see as artistic, neither sought nor received the attention that we accord them today. They were exchanged between friends or colleagues, shown at the meetings of the learned societies of the day, and sometimes exhibited as examples of the art of photography. The world's first photographic exhibition was held in Birmingham, England, in 1839. It consisted of 56 photographs by Fox Talbot, of which half were pictures of grasses, seeds, ferns, and other botanical specimens. Many of these "photogenic drawings" have not survived, but by description they are clearly images of science.

Not all practitioners had Fox Talbot's eye for composition and as photography became more specialized and complex, pictures for scientific purposes were often made without aesthetic considerations. However, as photography became more widely available in the 1880s, largely through the efforts of George Eastman, and more widely published through magazines such as the *National Geographic*, specialists in geography and geology, botany and anthropology, to name but a few, soon found their images were more desirable for publication if they were also good to look at. Thus scientific photography overlapped with photojournalism, and as photojournalism reached

its zenith in the 1960s, interest in scientific images as visually interesting artifacts similarly increased.

As Ann Thomas writes in *Beauty of Another Order*, "scientific photography is a subject long overdue scholarly attention and several publications and exhibitions have paved the way for more comprehensive treatment." Among them she lists are *Once Visible* at The Museum of Modern Art, New York, in 1967; *Beyond Vision* at the Science Museum, London, in 1984; and *Images d'un Autre Monde* at the Centre National de Photographie, Paris, in 1991 as well as several other important exhibitions worldwide.

Another notable activity designed to promote an aspect of scientific photography as art is the Nikon Small World photomicrography competition, which was started in 1974. The entries are exhibited widely throughout North America. The Japanese Society of Scientific Photography has also had an annual exhibition since 1979 and a similar but more recent series of *Visions of Science* competitions and associated exhibitions are held annually in the UK. "Image-aware" institutions such as the Rochester Institute of Technology also support scientific imaging and their *Images of Science* exhibition has traveled widely.

Nowhere has the inspirational nature of the scientific image penetrated further into the public consciousness than in astronomy. Since the early 1980s, true-color photographs of distant stars and galaxies from ground-based telescopes became commonplace. Now more than a decade later, the stream of stunning images and groundbreaking science from the Hubble Space Telescope have transformed our view of the universe both scientifically and aesthetically. In addition, several generations of probes and satellites have visited the outer solar system. Not surprisingly, the most photogenic of the planets, the ringed world Saturn, provides the most remarkable

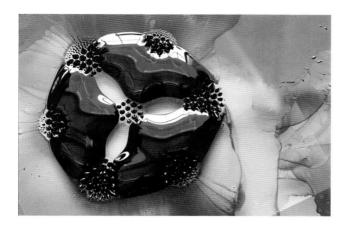

FIG. 31 Photograph by Felice Frankel, *Envisioning Science: The Design and Craft of the Science Image*. Cambridge, MA: MIT Press.

FIG. 32 Among the dense hairs on the leaf of a Lavender plant nestles a yellow capsule of the plant's essential oil. Image courtesy of Oliver Meckes and Nicole Ottawa, Eye of Science.

and haunting images from the joint USA-European Cassini spacecraft. The beauty of these pictures is no accident; space agencies long ago realized fine images and frontline science were both perfectly compatible and complementary.

At the other end of the scale, optical and electron microscopes are also capable of producing striking images, sometimes in the cause of science and sometimes for art's sake. The scanning electron microscope is especially adept at this since its magnification can be so high yet create images of great depth.

Figure 31 is an image taken by Felice Frankel, a well-known "scientific artist" at high magnification and author whose work has been widely published and exhibited worldwide. In the image, a drop of ferrofluid (magnetite suspended in oil) is on a slide on top of a yellow slip of paper, and magnets under the paper are pulling the magnetite particles into place.

Another contemporary example of photographers working on the frontiers of art and science are Oliver Meckes and Nicole Ottawa whose work is compelling, powerful, and fascinating. Their photographs portray their subjects with scientific accuracy and visual elegance. Figure 32 shows a section through the leaf of a lavender plant. The rounded structure (pale tan, lower center) is an oil gland that produces lavender's aroma. The color in this image was digitally added later since scanning electron microscopes are only capable of producing monochrome images.

A more conventional scientific photographer whose work transcends mere scientific illustration is Professor Andrew Davidhazy of the Rochester Institute of Technology. For more than 40 years, Professor Davidhazy has developed or refined unusual scientific imaging techniques, many of which manage to combine the concepts of time and motion into one picture, often with surprisingly beautiful results as seen in Figure 33.

More than 170 years after the first science pictures were created, there is still an ambiguity associated with this type of photography. Just as the intent of the photographer decides

FIG. 33 This photograph, titled Double Screw, reveals how a series of still images taken of a subject will be imagined when the sample is rotated past moving imaging slit rather than a traditional shutter. (Image courtesy of Professor Andrew Davidhazy, School of Photographic Arts and Sciences, Rochester Institute of Technology, Rochester, New York.)

what category of image will be made, so it is the mindset of the beholder that decides if it is art.

FURTHER READING

Ede, S. (2000). *Strange and Charmed: Science and Contemporary Visual Arts*. London: Calouste Gulbenkian Foundation.

Eder, J. M. (1978). *History of Photography*. (E. Epstean, translator). New York: Dover Publications. (Originally published by Columbia University Press in 1945.)

Frankel, F. M. (2002). *Envisioning Science: The Design and Craft of the Science Image*. Cambridge, MA: MIT Press.

Frankel, F. M. and Whitsides, G. M. (1997). *On the Surface of Things*. San Francisco: Chronicle Books.

Kemp, M. (2000). *Structural Intuitions: The 'Nature' Book of Art and Science*. Oxford, UK: Oxford University Press.

Thomas, A. (ed.) (1997). *Beauty of Another Order: Photography in Science*. London and New Haven, Yale University Press, in association with the National Gallery of Canada.

Valens, E. G. (1969). *The Attractive Universe: Gravity and the Shape of Space*. Cleveland, OH: World Publishing Co.

ADDITIONAL INFORMATION

British Photographic Exhibitions, 1839–1865
http://www.peib.org.uk/
Science, Art, and Technology (The Art Institute of Chicago)
http://www.artic.edu/aic/students/sciarttech/2f1.html
Art–Science Collaborations, Inc.
http://www.asci.org/artikel2.html
Oliver Meckes and Nicole Ottawa, *Eye of Science*
http://www.eyeofscience.com/
Images from Science, Cary Graphic Arts Press, 2002
http://images.rit.edu
http://www.ncbi.nlm.nih.gov/entrez/query.fcgi?cmd=Retrieve&db=PubMed&list_uids=14805684&dopt=Abstract
http://japan-inter.net/ssp/e/index4_e.html
http://www.britishcouncil.org.ua/w3/photos/default.asp?e=120505
Visions of Science
http://www.visions-of-science.co.uk/

SCIENTIFIC PHOTOGRAPHY
Expanded Vision

DAVID MALIN, EDITOR
Anglo-Australian Observatory, RMIT University

The Aided Eye

DAVID MALIN
Anglo-Australian Observatory, RMIT University

Scientific photography may be described as many things by different people and consequently this section has tried to tease out the many threads that make up its rich tapestry.

Scientific photography's beginnings can be traced to the beginning of science itself.

The invention of the telescope and the microscope occurred at about the same time, 400 years ago. Together, these technologies extended human vision and human imagination, laying the foundation for modern science. However, no mere description could communicate the unexpected worlds that Galileo and Leeuwenhoek discovered. It was their drawings of the mountains of the moon and astonishing variety of life in a drop of water that captured the imagination of the literate few and spread the idea that there was more to the universe than was visible to the unaided eye. These discoveries changed man's perceptions of life, the universe, and everything contained in it.

Photography made its debut 240 years later, extending human vision much further, and in many unexpected directions. As it matured, photography made many new branches of science and technology possible. Images of science now grace the pages of popular magazines and are seen on television and the Internet, opening the eyes of billions to the excitement of discovery, learning, and the hidden beauty of the world.

What is Different About Scientific Images?

Scientific photography might be considered to be more a state of mind, than a single technology. It is the motivation behind the picture that differentiates an image of science from an everyday photograph. Two pictures might look identical, but the scientific photograph will carry with it some information, perhaps a record of where, when, how, or why it was made and maybe something about what it shows. Better still, it will have a dimension, a calibration, a context, and a description. If it does not carry at least some of this detail, it is just another picture. The inclusion of data implies that the image was deliberately made to convey information, rather than an impression. A scientific picture will only spawn a thousand words if it is seeded with a few of its own.

Only one of the senses, vision, is able to absorb the essence of an image. Images can be made of places and things that man can never hope to see directly, and at wavelengths that the human vision system cannot detect with our senses. Most photographic images are made with electromagnetic (EM) radiation, the form of radiant energy that includes light. The spectrum of EM is enormous, ranging from highly energetic gamma rays with wavelengths of atomic dimensions to radio waves hundreds of kilometers from crest to crest (10^{-14} to 10^6 m). Visible radiation is located in between X-rays and radio waves, with the rainbow hues of nature occupying a very tiny part (4×10^{-7} to 7×10^{-7} m) of the spectrum between the ultraviolet and infrared.

As might be expected, much of this range is beyond normal imaging detectors like photographic film or the charge-coupled device (CCD). No matter how it is detected, the radiation carries with it information about the origins of the radiation itself and of its interactions with matter on the way to detection. A major role of scientific imaging is to transform information generated by almost any wavelength—interacting with an object of any size, at any distance, and in all four dimensions—into something two-dimensional that we can see. As a consequence, a scientific photograph may be presented to the eye as a conventional-looking picture, but it also may contain information that has been captured by a detector quite unlike

Part page caption: This image represents the whole sky, indeed the whole Universe, seen in the microwave band, and as it was about 300,000 years after the Big Bang, which occurred in 13.7 billion years ago. The image was acquired by an earth-orbiting satellite over several years and has been refined to reveal minute variations in temperature around 2.725 K, close to absolute zero. The variations are shown as a mottled structure. The data embedded in the fine structure has allowed astronomers to derive many of the fundamental parameters of the universe to a new level of precision and led to the surprising discovery that the expansion of the universe appears to be accelerating. While the image itself may be less than eye-catching its implications are profound, and it is a perfect example of both the complexity of image acquisition and the importance of understanding the entire imaging chain in its subsequent interpretation. Image created by: WMAP (Wilkinson Microwave Anisotropy Probe) Science Team/NASA.

the eye or film, manipulated in ways that the brain cannot match and finally emerging with colors and contrasts that never existed in reality.

Of course, this is the broadest view of all possibilities, and many images of science are made with familiar equipment and materials. However, irrespective of its origins, no image can ever be totally objective, not even a scientific image made with objectivity in mind. Someone has to decide what manipulations and adjustments are necessary to create the final output, when to capture the image, and how to present the end result. A practical knowledge of how the information is influenced by the disparate sequences of collection, detection, data handling, and transmission are essential skills for a scientific photographer. The creator of the image has to understand each of these steps to convey and interpret the information it contains. Scientific photography is thus not simply everyday picture-making of a scientific subject, although it may be in some daily application.

The terms detector, output, information, and transmission are used here quite deliberately because a scientific image is not just a photographic representation, but rather it is data, and is thus subject to the same concepts of attenuation, noise, and distortion as any other data-set. That does not mean that pictures made for a scientific purpose need to be so burdened with information that they are visually uninteresting. Indeed they are much more effective if they are good to look at, but aesthetics must never compromise the underlying science.

A Challenging Variety

Scientific photography embraces an enormous range of disciplines, and a wide variety of skills that, at first glance, do not seem to have much connection with imaging. However, the science part of scientific photography allows us to think of it in a way that is not normal in the more traditional branches of image making. We can thus divide the subject into several overlapping domains.

These domains often deal with the interaction of EM radiation with the object of interest as an entity in its own right, such as the study of a virus, a butterfly, or a planet. This interaction might involve the absorption, reflection, polarization, diffraction, or scattering of the incident energy and the resulting image as formed by a microscope, camera, or telescope, or collected by a satellite and returned to earth as a radio transmission. Many such images are necessarily made in natural light but others demand special lighting skills, optics, or access to aircraft or even rocketry.

In some cases the objects of interest emit their own radiation naturally (a galaxy or a firefly) or under stimulation from other radiation (a gaseous nebula or a fluorescent microbe).

With self-luminous specimens, the distribution, nature, and intensity of the emitted radiation is of interest; often this radiation is weak. Consequently, exposure times are long, which presents capture challenges as well.

Sometimes (as in astronomy) there is no control over the lighting and placement of the objects of interest and photography requires one to make the best of what nature offers. Elsewhere, as in optical and electron microscopy, the preparation of the specimen is the essence of the technique, and recording it is more of a formality. Often the researcher, preparer, and photographer are the same person. Another role of scientific imaging is to reveal places that are too remote to be seen directly or that are otherwise inaccessible, such as the deepest ocean, the brain, or the far side of the moon. Here the photographer may be a remotely controlled submarine, a radiographer, an astronaut, or a satellite. While the earth's surface is where we live, the photography of it from space has provided new insights into the nature of processes on and under the surface, especially meteorology, oceanography, geology, and even demography.

Photography also possesses a unique ability to compress, reverse, and expand time, so we must consider the temporal domain of imaging as well. This is mainly evident in time-lapse and high-speed photography. Also, the travel time of light is finite, so in astronomy distant things are seen as they were long ago, and the most distant things are seen as they were near the beginning of time itself. Here, photography, or its digital equivalent, is a component of a time machine.

In addition to direct imaging with various kinds of optics, pictures can be built from data that exist in another physical domain, such as Fourier space, as a hologram, or as a stream of data as in scanning electron microscope image. Some of these activities are so specialized that they are not mentioned in this section. But specialized methods involving unexpected wavelengths and exotic imaging techniques can quickly become part of the mainstream, such as ultrasonic imaging of the unborn and magnetic resonance imaging of living tissue. This last imaging technique involves radio waves, strong magnetic fields, and Fourier image reconstruction techniques over an extended time. The image recording itself is almost automatic, but the underlying physics of the imaging process is fascinating.

Where there is an interesting application such as this we will mention it. However, if we have omitted your specialty we apologize. Once upon a time it was possible for one person to know something about most aspects of scientific photography. This is no longer true.

ADDITIONAL INFORMATION
http://www.rps-isg.org/imag.shtml

Acoustic Holography

DAVID MALIN
Anglo-Australian Observatory, RMIT University

The acoustic analog of optical holography allows the visualization of image information contained in a sound field. A diffraction pattern (a spatial Fourier transform) is formed by an object irradiated by ultrasonic sound interfering with a mutually coherent reference wave. The resulting interference pattern is recorded by means of microphones to form a hologram, which is subsequently illuminated by a light beam. This results in diffraction from the hologram that can form a three-dimensional visual image of the object. This technique is used to visualize and quantify noise sources from ships, machinery, vehicles, and aircraft. ◎

Aerial Photography

DAVID MALIN
Anglo-Australian Observatory, RMIT University
DONALD L. LIGHT
Airborne and Space Systems for Mapping and Remote Sensing

Aerial photography has a surprisingly long history and reflects the photographer's ever-present urge to seek a better vantage point for the camera. The possibility of a bird's eye view proved irresistible, and in 1858, Gaspard Felix Tournachon (Nadar) took aerial photographs of a French village from a captive balloon, a feat that was repeated in the United States by James Wallace Black. His picture of Boston in 1860 (Figure 1) is the earliest existing aerial photograph.

In the first decades of the 20th century improvements in photographic technology allowed cameras to be carried by rockets, kites, and birds and, by 1909, in aircraft. The military potential of this was obvious and aerial photography was widely used in WWI. It was soon found that vertical views were the most useful but could be difficult to interpret, thus the art-science of photo interpretation was born. In recent years the subject has broadened considerably and is now embraced by the term "remote sensing," which includes downward-looking observations from earth-orbiting satellites as well as aircraft. This topic is dealt with in a later section, as is multispectral imaging, also pioneered by aerial photographers.

Apart from military surveillance, applications are enormously varied, and include agriculture, archeology, forestry, environmental monitoring, and demographics as well as urban planning, geology, minerals prospecting, and surveillance of all kinds. However, aerial photography is most often used for cartography, where the science of photogrammetry is used to remove the distortions inherent in all photography. This

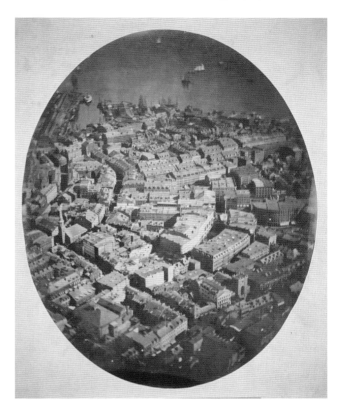

FIG. 1 Boston in 1860. The first surviving aerial photograph. It was made from a tethered balloon by James Wallace Black. (Courtesy Boston Public Library, Boston, MA.)

enables accurate dimensions and topography to be derived for mapmaking.

For this, special-purpose, downward-looking, automated mapping cameras were developed that used 9-inch (about 23cm) roll film. Since cartography and surveying use large amounts of film, suppliers made special emulsions, including high-contrast, high-resolution monochrome and color films and infrared-sensitive products to penetrate atmospheric haze. Some of these emulsions were available in smaller formats, and cameras using 70 and 35mm film are also used for aerial photography. Not all such images are intended for mapmaking or for accurate dimensional surveying, so very useful aerial images can be made very conveniently with these smaller formats. Today, film or digital media can be used and operated manually from aircraft or remotely from kites, tethered balloons, or remotely piloted aircraft. Balloons and remotely piloted aircraft can operate at a lower altitude than piloted aircraft, which is a great advantage over residential areas.

For cartography and survey purposes, it is usual to make a series of images along a predetermined flight line at a fixed altitude. The images are made in a sequence so that there is

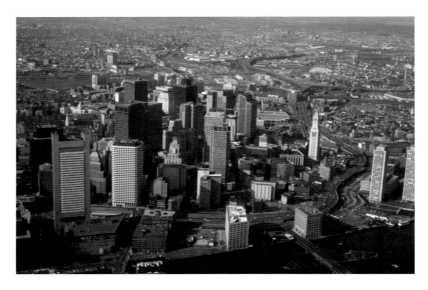

FIG. 2 Aerial image taken of downtown Boston. (Photo courtesy James Harrington, Saugus Photos Online, 1986.)

approximately 30 percent side lap and 60 percent forward overlap. This allows for complete ground coverage and for stereo viewing of overlapping pairs of pictures. Each image may include some ground control points (GCPs) whose positions are accurately known by using global positioning satellite (GPS) measurements. GCPs by GPS measurement are precise to a few centimeters. Using these data points and calibrated cameras, accurate coordinate systems can be developed by photogrammetry for a variety of applications including mapping. Where it is not possible to have GCPs, the camera position, time of exposure, and precise orientation in three dimensions are recorded with the imagery data. This new technology utilizes GPS and inertial measuring units called position and orientation systems (POS) that obviate the need for GCPs.

The traditional, large-format film cameras developed during WW II became the workhorse around the world for mapping and photogrammetric applications. These cameras used 9-inch wide film for black and white, color, or color infrared photography. The most common lenses had focal lengths of 6 inches (152.4mm), with some 12-inch (304.8mm) focal lengths for higher ground resolution. By the late 1980s these cameras and their associated films were a mature technology, and later still often incorporated forward motion compensation, angular motion stabilization platforms, high lens and film resolution with virtually no distortion, and a camera shutter interfaced to the GPS to give a precise position at the moment of the exposure. These gradual improvements brought about significant increases in the overall usefulness and effective resolution of modern mapping cameras which today achieve an area weighted average resolution (AWAR) of 40 to 50 line pairs per mm. The AWAR depends on the film type, atmospheric conditions during exposure, turbulence, etc.

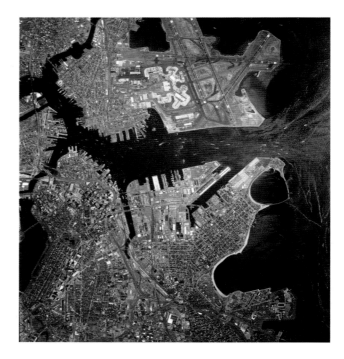

FIG. 3 A conventional false-color aerial picture of Boston 1992. (Photo courtesy of www.wetmaap.org.)

While the film mapping cameras were reaching a mature state, by the late 1980s, solid-state charge-coupled devices (CCDs) began to appear in military aircraft and in the marketplace. CCD detectors are sensitive to wavelengths between

TABLE 1 Digital Camera Systems for Airborne Applications: 2005

Company	Leica Geo Systems	Wehrli & Associates	Z/I Imaging	DIMAC Systems	Vexcel	Applanix	Spectrum Mapping
Sensor name	Airborne digital sensor (ADS40)	Digital aerial camera (3-DAS1)	Digital mapping camera (DMC)	Digital Modular Aerial Camera	Ultra Cam-D	Digital Sensor System (DSS)	NexVue
Sensor type	3-line scanner	3-line scanner	Framing	Framing	Framing	Framing	Framing
Year of introduction	2000	2004	2001	2004	2003	2001	~2003
Focal length (mm)	62.7	110	120 (25MS)	60–150	100 (28 MS)	35 and 55	50 and 90
Total FOV (degrees)	62.5	64 or 42	74 ×-track, 44 in track	44	55 × 37	37 Color and CIR (55.4 color only)	40 and 23
Shutter speed & F#	To 1.25ms, f/4	f/2–f/16	to 1/1000 sec, f/4–f/22	—	1/500 sec, f/5.6	1/1000 sec, f/22	—
Array size (pixels)	2 lines 12,000 × 1 staggered	3× Kodak Tri-Linear 8,023	13,824 × 7680 pan 3,000 × 2,000 MS	5440 × 4080	7500 × 11,500 pan 2672 × 4008 MS	4092 × 4,079	4080 × 4080
Pixel size (μm)	6.5	9	12	9	9	9	9
Radiometric res (bits)	12 raw, 8 output	14 raw	12 raw to 8 output	8 or 16	14 raw	12 raw	12 raw
Spectral resolution (nm)	465–680 (pan)	3 × Kodak Tri-linear 8023	400–850 (pan)	Red	Pan	Color (Bayer)	Color (Bayer)
	430–490 (blue)	RGB	400–500 (blue)	Green	Red	CIR (Bayer)	CIR (Bayer)
	535–585 (green)	—	500–650 (green)	Blue	Green	—	—
	610–660 (red)	—	590–675 (red)	—	Blue	—	—
	703–757 (nir)	—	675–850 (nir)	—	NIR	—	—
	835–885 (nir opt)	—	—	—	—	—	—
Read out frequency	800 lines/sec	310–745 lines/sec	0.5 images/sec	0.5 images/sec	0.75 images/sec	0.25 image/sec	0.67 image/sec
Stabilization	Leica PAV 30	Stabilized platform	Z/I Platform	Gyrostabilized mount	Zeiss T-AS	DSS mount	Stabilized mount
Data recording	MM40 Memory	2TB HDD	840GB disk	240GB disk	Raid disk	Raid disk	1500 color frames
Georeferencing	Applanix POS 410	Integrated GPS/INS	POS Z/I 510	GPS/INS	POS Z/I 510	Applanix POS AV	Applanix POS AV
Height/base for stereo (H/B)	1.26	1.29	3.3	4.7	3.7	2.38 @ f = 35mm 3.74 @ f = 55mm	3.40 @ f = 50mm 6.12 @ f = 90mm
Forward motion compensation	Yes	Yes	Yes	Yes	TDI controlled	No	No

0.4 and 1.0 μm, covering the visible and near-infrared parts of the spectrum and compete directly with film as a focal plane detector for aerial imaging.

The introduction of the digital detector began a slow transition from film to all-digital systems, and by the turn of the century, this change was in full progress. Photogrammetrists and mapmakers now have a choice of film or digital media. Most organizations today are able to scan the film and turn it into digital pixels for use in soft-copy workstations; the transition to the digital era is happening even though many organizations still use their time-proven film cameras. Converting to digital data is essential for those who use geographic information systems (GIS)—a powerful tool in today's imagery-driven mapping business.

The first consumer digital cameras in the early 1990s had sensors that were typically 12×18 mm and produced 1200×1600 pixel (about 2 megapixel) images. By 1995 this had grown to a 2×3 k array (about 6 megapixels), and by the turn of the century professional camera backs for large format cameras offered 4×5.5 k sensors (22 megapixels). However, to achieve useful results from normal 9×9 inch aerial film, it must be scanned at 2400 ppi to produce a $20,000 \times 20,000$ ppi image, equivalent to 400 megapixels per frame. Although basic megapixel count is not the only consideration in digital imagery, the manufacture of sensor chips approaching this size for the relatively small aerial and remote sensing market is complex and expensive. In addition, computer hardware and specialized software to analyze it is also costly, which is why the transition to all-digital systems has been slow.

However, digital CCD detectors are comparable to film for spatial resolution and offer many other advantages. Early in the new millennium, the two major film mapping camera manufacturers (Zeiss/Intergraph Imaging and Leica) introduced digital systems. For their digital mapping camera (DMC), Z/I Imaging combines four CCDs to produce one complete 13.8×7.7 k panchromatic frame camera capable of up to 2 frames per second. The camera also has multispectral capabilities, electronic forward-motion compensation, and a field of view of 74×40 degrees with its 120 mm focal length lens.

In contrast, the Leica ADS40 Digital Sensor uses a different approach, with seven linear arrays to sense panchromatic and multispectral bands. The panchromatic band employs linear arrays of $2 \times 12,000$ pixels staggered by one-half pixel, and all seven bands use one set of optics to provide near-perfect registration of the bands. The field of view for the ADS40 is 62.5 degrees.

Both the DMC and the ADS40 are high-end, multispectral digital cameras of a kind destined to take over the mapping-camera market in a few years. They offer spatial resolution as small as 15 cm, and they are becoming a formidable competitor in the world-wide mapping-camera market. Table 1 tabulates the DMC and the ADS40 along with the other smaller, but capable digital cameras that are available, reflecting the transition in this field. These sensors use CCDs and compatible magnetic oxide semi-conductors (CMOS) and other solid-state detector technologies that promise improved capability

in the visible, near IR, short wave IR, and thermal IR ranges for a wide variety of remote sensing applications.

See also the following articles

Infrared Photography · Military Photography · Multispectral Imaging · Photogrammetry · Remote Sensing · Strip and Streak Photography

FURTHER READING

Garnett, W. (1996). *William Garnett, Aerial Photographs.* Berkeley, California: University of California Press.

Light, D. L. (1996). Film cameras or digital sensors? The challenge ahead for aerial imaging. *Photogrammetric Engineering & Remote Sensing* **62**, 285–291.

McGlone, C. (ed.) (2004). *Manual of Photogrammetry, 5th edition.* Bethesda, Maryland: American Society for Photogrammetry and Remote Sensing.

Wolf, P. R. and Dewitt, B.A. (2000). *Elements of Photogrammetry with Applications in GIS.* New York: McGraw-Hill.

ADDITIONAL INFORMATION

Geospatial Resource Portal
http://www.gisdevelopment.net/index.htm
Imaging and Geospatial Information Society
http://www.asprs.org/ ◉

Anthropological Photography

JOHN FERGUS-JEAN
Columbus College of Art and Design

At its inception in 1839, photography was celebrated for its realistic visual representation of things. The precision, clarity, sharpness, impartiality, truth to nature, and compelling believability of the photographic image were a revelation to society.

Consequently, photography quickly assumed a documentary role in anthropology, based on the underlying premise that photographs are visual transcriptions of reality, which appear to contain fact, evidence, and truth in an objectivity that is the cornerstone of factual documentary reporting. Objectivity also requires the image maker to be as unobtrusive and candid as possible in taking photographs, and to reveal visual information impartially in a manner that can both describe visual contexts and alter events as little as possible from reality. However, the photographer also has to frame the scene and choose the moment, so perfect objectivity is not possible. It is not always possible to be unobtrusive; for example, if a dark scene has to be lit with electronic flash.

Within these limitations, anthropological photographers adopt a strictly documentary approach and combine it with scientific method to interrelate, synthesize, and finally interpret visual and written information. When used in this way,

photography is a valuable adjunct to anthropological and ethnographic research.

As a research tool, photography's apparent verisimilitude creates a special category of document, which can be used as a visual counterpart to written observation, merging direct observation with realistic representation. Within its limitations, photography thus provides a consistent, tangible record for analysis and recordkeeping in an objective and commonly understood visual language. It is also a reliable means of storing, ordering, and interpreting visual information.

Most of the photographic evidence that finds practical use in anthropological research is concerned with counting, measuring, comparing, qualifying, and tracking. More specifically, the primary applications of anthropological photography demonstrate patterns in cultural diversity and its integration, societal control, religious behavior, marriage customs, festivals, etc., as well as to document the effects of these patterns on both the culture and the environment of interest. Photography is especially useful in this regard, because it allows the wholeness of each behavioral pattern to be essentially preserved while maintaining the spatial and contextual separation necessary for analytical cross-referencing and scientific study.

This seemingly objective scientific methodology also presents a fundamental quandary for visual anthropologists. The complication centers around photography's uniform way of depicting time and space with its rectilinear framing and formatting, and the loss of information inherent in representing a three-dimensional world on a flat surface. Digital photography brings additional challenges as a result of digital photography's capacity for after-the-fact image manipulation, which is both undetectable and transparent unless special care is taken.

Thus, contemporary critics point out that, in addition to supplying basic visual data, the visual language of photographs may also contain unintended biases, cultural and other types. Over time, these biases can form an unnoticed interpretive matrix in which the original context of a place or event mirrors the held values, syntax, semantics, and symbolism of an intended scientific audience. Such rational and scientific valuation systems risk obscuring rich cultural contexts by imposing problem-solving strategies, which may then be folded into academic social theories.

As a consequence, theorists have viewed anthropological photography as tacitly ideological, often serving scientific classification systems, and designed to produce measurements, grids, and hierarchical academic models, which tend to locate subjects outside of their own cultural community.

However, as a practical research tool, photography is exceptionally useful in several aspects of anthropological research: physical anthropology, a natural science involved with the biological aspects of human beings such as ethnic differences, human origins, and evolution; cultural anthropology, which studies human behavior; archeology, which describes and dates the remains of ancient buildings, artifacts, ecofacts, and manuports that may describe a culture; and applied anthropology,

FIG. 4 Kwakiutl house frame, Memkumlis. (Photo by Edward S. Curtis. From Library of Congress, Prints & Photographs Division, Edward S. Curtis Collection, reproduction number LC-USZ62-108425.)

which uses the research of cultural and physical anthropologists to formulate social, educational, and economic policies.

Historically, many documentary and social documentary projects to some degree have served an anthropological function. For example, the work by John Thomson, Lewis Hine, photographers of the Farm Security Administration, Paul Strand in the Mexican Portfolio, and others have used photography to report on the human condition. An example of a scientifically criticized but nevertheless anthropologically useful project is Edward S. Curtis' monumental documentation of the native tribes of North America, *The North American Indian, 1907–1930*. In 20 photographically illustrated volumes and 20 portfolios, Curtis documented the rapidly disappearing American Indian culture through its architecture, customs, and appearance in 2228 photographs.

More, purely anthropological studies also exist. Perhaps the seminal model for current visual anthropologists is the 1942 study done by Gregory Bateson and Margaret Mead, *The Balinese Character: A Photographic Analysis*. This study used over 25,000 35 mm exposures as well as 22,000 feet of movie film. By placing relevant photographs side by side, the study pointed to intangible relationships found in different types of standardized cultural behavior patterns. It viewed the Balinese culture as a system of understandings and behaviors that also functioned as an expression of personal identity and experience. This study broke ground for much of the current methodology used in the quantification and correlation of photographic data in accordance with standard anthropological practice.

FURTHER READING

Bateson, G. and Mead, M. (1942). *Balinese Character: A Photographic Analysis*. New York: New York Academy of Sciences.

Berger, J. and Mohr, J. (1982). *Another Way of Telling.* New York: Pantheon Books.

Collier, J. and Collier, M. (1986). *Visual Anthropology: Photography as a Research Method.* Albuquerque: University of New Mexico Press.

Hall, E. (1959). *The Silent Language.* Garden City, New York: Doubleday.

Hockings, P. (ed.) (1995). *Principles of Visual Anthropology.* New York: Mouton de Gruyter.

Sontag, S. (1979). *On Photography.* London: Penguin Books.

Sturken, M. and Cartwright, L. (2001). *Practices of Looking: An Introduction to Visual Culture.* New York: Oxford University Press. ◎

Archaeological Photography

MATT SCHLITZ
Biosis Research Pty, Limited

Archaeology is the study of material remains of past human activity and excavation is a process of controlled destruction. Thus, from the outset, archaeologists recognized the potential of photography to permanently record their scientific work and to disseminate research ideas. Archaeological photography is the visual documentation of terrestrial or underwater cultural landscapes and associated sites, features, and artifacts. The archaeologist photographs the pre-excavated site, relationships between the site and surrounding landscape, site features and standing structures, artifacts, spatial association between artifacts, trench stratigraphy and excavation layers, field survey finds, and the final site exposed and cleaned. The archaeological photographer also records team members using equipment to illustrate archaeological methods for lectures and publications.

It is critical that archaeologists create the best possible image archive for future generations. The archaeologist as photographer knows what artifact detail or site viewpoints should be recorded for posterity. Archaeologists are required to develop good skills in photography as commercial photographers would rarely be employed for this type of photodocumentation. The resulting images should be correctly exposed and focused, suitably lit, and free of distortion with attention paid to accurate color representation. To indicate size it is essential to use a contrasting metric scale, a human figure, or the insertion of a hand. Photographic backgrounds, scales, and other information must not compete with the subject for attention. Documenting artifacts for museum publications, exhibitions, or public lectures may require some interpretative approach.

The archaeological photographer is often challenged by heat, moisture, cold, wind, dust, terrain, vegetation, and the pressure of rescue archaeology with limited time. Dealing with high contrast on a site in bright sunlight and achieving contrast

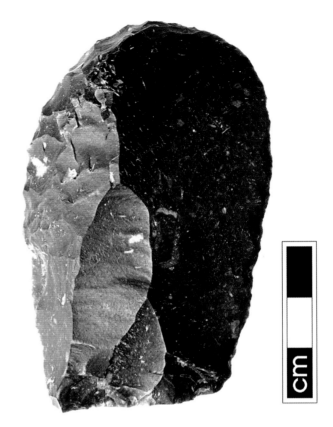

FIG. 5 Diffused sunlight, white card reflector, and underlit flash reveals the manufacture of a flint end-nose scraper, a stone tool knapped (edge chipped) by Kim Akerman, Australia.

in a wet trench are other challenges. The archaeological photographer must apply different composition and lighting methods to a wide variety of artifact types and composite materials such as pottery, coins, glass, bone, metal, stone, wood, and textiles. Aerial photography and satellite imagery are extremely useful recording, prospection, and analytical tools for the archaeologist. Low-level aerial archaeology platforms such as kite aerial photography, balloon photography, and photographic booms are constructed by specialists to obtain aesthetic vertical and oblique site images that are also useful when creating large-scale photo mosaics, site plans, and three-dimensional topographic models.

Scientific photographers employ infrared, ultraviolet, and multispectral imaging techniques to highlight detail in ancient textiles, painted wood, canvas, leather, and the ink on parchment such as revealed on the Dead Sea scrolls. Fluorescence photography can distinguish the presence of organic and mineral elements on wall paintings and textiles and xerora-diography can assist conservators in the restoration of metal artifacts. Archaeologists exploring tombs or confined spaces

utilize endoscopic photography and optical fiber technology. Photomicrography and scanning electron microscopy are tools for archaeologists to analyze animal and plant residues. Stereoscopic imagery can bring out variations in texture or technological construction in features or artifacts. Although video has not figured prominently in methodical archaeological imaging, it has played a large role in recording celebrity archaeologists and objects for popular television documentaries. Maritime archaeologists use either purpose-built underwater camera systems with electronic flashes or housings for land cameras.

The greatest change in archaeological photography is the development of digital imaging. It is critical that digital cameras and other devices provide high-quality archival records. The use of large format or medium format cameras with digital backs is still the ideal in archaeology because of the level of detail and image enlargement obtainable from the negative or file. However, most archaeological photographers tend to use 35-mm SLR and digital SLR equipment because of the expense of the larger formats and for ease of handling on site. Macro lenses are a must for artifact photography and additional equipment is required to replicate studio conditions in the field.

Digital imaging offers the potential to speed up the documentation of endangered sites due to development, weather, and war. The digital images can be processed anywhere for virtual exhibitions and archives. The development of close-range three-dimensional laser scanning allows archaeologists to create virtual monuments, record ancient interiors, and illustrate sites using "fly-through" movies. Photogrammetric cameras and software can be used to survey panels of rock art or document heritage buildings. Photomodeler software provides a photo-realistic, three-dimensional model of the ship, artifact, building, or site by measuring from and incorporating the original photographs. High-resolution document scanners can be used to record low-profile artifacts such as ceramic shards, glass beads, and bone. Archaeologists use image registration software to rejoin mosaics, architectural columns, and pottery from scanned or photographed fragments. Digital image processing has shed light on difficult-to-detect rock art images, providing the archaeologist with a new dating tool and a potentially vast corpus of art.

As in many other disciplines, digital imaging has provided greater opportunities for archaeologists to store, retrieve, and disseminate research images over the Internet, via image databases, or on optical media. Low-cost CD/DVD burners, USB ports, memory cards, card readers, and wireless technology make duplicating and image transfer between field, laboratory, or office easy. The challenge is to ensure authenticity of the original digital image when manipulation of the image may affect research outcomes. Image duplication and preservation must be carefully considered in the future as file formats change. The RAW file format will emerge as the glass plate negative of old, but it is not yet standard among camera manufacturers. Digital asset management software such as Fotostation, Extensis Portfolio, and Cumulus are efficient tools to manage archaeological image workflows. Adobe PhotoShop software can be used to create composite illustrations by combining photographs, vector, and raster information.

Archaeological photographers need to be comfortable with digital imaging technology. World wide, countless archaeological images will be uploaded to image servers to provide comparative artifact typologies and site analysis. Knowledge of color management software, digital asset management, file workflows, and format conversion will become critical for maintaining the integrity of images. Archaeologists now provide daily posting of digital images or real-time video to project Web sites. Archaeologists in the field are also able to process images faster by wireless technology and developing mobile phone technology will provide immediate feedback for isolated survey teams. Some digital SLR models provide global positioning satellite (GPS) connectivity to enable spatial EXIF data to feed into geographic information systems (GIS) databases. Hand-held three-dimensional laser scanning cameras may be eventually developed, with instrument software to provide three-dimensional "point clouds" corresponding with texture from photographic frames. Unmanned aerial vehicles (UAVs) will be used by archaeologists in the future to undertake low-level aerial archaeology projects as well.

Archaeological photography has been revolutionized by digital imaging and further convergence of the technology will lead to innovative applications in the field and laboratory. However, archaeologists today still rely on the glass negatives and prints from the past, which have stood the test of time. Whatever the technology, the challenge for archaeological photographers is to provide a permanent archive of our cultural heritage that is equal to or surpasses the photographic standards of the past.

GLOSSARY TERM

3D tomography—The three-dimensional visualization of external or internal structure by the combination of data gathered from several positions or cross-sections integrated by computer to generate a virtual object or structure. Data sources may range from photographic, scanning, radar, electronic, sound, seismic, and nuclear medicine. The name is derived from the Greek "to cut or section."

FURTHER READING

Bearman, G. H. and Spiro, S. I. (1996). Archaeological applications of advanced imaging techniques. *Biblical Archaeologist* **59**, 56–66.

Bowman, A. K. and Brady, M. (2004). *Images and Artefacts of the Ancient World.* Oxford: Oxford University Press.

Cookson, M. B. (1954). *Photography for Archaeologists.* London: Max Parrish.

David, B., Brayer, J., McNiven, I., and Watchman, A. (2001). Why digital enhancement of rock paintings works: rescaling and saturating colours. *Antiquity* **75**, 781–792.

Deuel, L. (1973). *Flights Into Yesterday: The Story of Aerial Archaeology*. Harmondsworth: Penguin.

Deutches Archäologisches Institut. (1978). Archäologie and Photographie: Funfzig Beispiele Geschichte and Methode. Mainz am Rhein: Philipp Von Zabern. Dorrell, P. (1996). *Photography in Archaeology and Conservation* (2nd ed.). Cambridge: Cambridge University Press.

Harp, E. J. (1975). *Photography in Archaeological Research*. Albuquerque: University of New Mexico Press.

Howell, C. and Blanc, W. (1995). *A Practical Guide to Archaeological Photography* (2nd ed.). Los Angeles: Institute of Archaeology, UCLA, California.

Myers, J. W., Myers, E. E., and Cadogan, G. (1992). *The Aerial Atlas of Ancient Crete*. Berkeley: University of California Press.

Riley, D. N. (1987). *Air Photography and Archaeology*. London: Duckworth.

ADDITIONAL INFORMATION
http://www.stratigraphy.org/

Astrophotography

DAVID MALIN
Anglo-Australian Observatory, RMIT University
DENNIS DI CICCO
Sky Publishing Corporation

Astronomy is the study of the sun, moon, planets, stars, galaxies, and other celestial objects. Historically, it was primarily an observational science, so the public unveiling of photography in 1839 was immediately recognized as important. Although Daguerre's discovery was championed by astronomers Francois Arago and John Herschel (who was the first to use the word photography in English), the early photographic processes were too insensitive to record anything but the brightest objects in the sky. Nevertheless, by 1851 professional astronomers had succeeded in making daguerreotypes of the sun, moon, Jupiter, and the brilliant star Vega, setting the stage for future advances.

It was not until the early 1880s, after the introduction of the dry gelatin process, that long exposures of the night sky became practical. And these exposures revealed objects that were too faint to be seen by the eye even with the largest telescopes. The dramatic transformation of photography from a recorder of the visible to a detector of the unseen, opened a window onto a universe that was much bigger and more mysterious that anyone had imagined.

The introduction of photography into astronomy also led to a revolution in telescope construction, with refractors giving way to ever-larger reflectors, most of which were designed from the outset as huge cameras. Photography also changed the way astronomy was done. While astronomers still spent many hours at the eyepiece, they were guiding the telescope as it focused light on to a photographic plate, and the image became the data that were later analyzed.

Conventional (silver-based) photography was still used in professional astronomy until the 1990s when its gradual replacement by a variety of electronic detectors was almost complete. It is a remarkable achievement that such a seemingly simple technology as emulsion-based photography served as the workhorse of astronomy for about 100 years.

The Amateur Connection

While it was often a blurry line that separated professional and amateur astronomers during the 19th century, "gentleman scientists" in Europe and America achieved many of the milestones that transformed photography from astronomy's interesting curiosity to one of its greatest tools. During the 1850s Warren De la Rue advanced lunar photography using wet-collodion plates with his homemade 13-inch reflector at Kew Gardens near London. He also initiated the first photographic patrol, making daily photographs of the sun between 1858 and 1872, and, in July 1860, he obtained the most significant results during the first total solar eclipse to be successfully photographed.

In the United States, New York "private scientist" Lewis Morris Rutherfurd made great strides in photographing star clusters and other celestial objects in the 1860s using telescope objectives of his own design that were optimized for photography. Fellow New York amateur astronomer Henry Draper obtained the first photographic record of a star's spectrum in 1872 and the first photograph of the Orion Nebula in 1880, two years before his untimely death at age 45.

It was, however, another amateur's photograph of the Orion Nebula that proved pivotal in the history of astrophotography. A 37-minute exposure of the nebula by English engineer Andrew Ainslie Common in January 1883 showed stars fainter than those seen with the world's largest telescopes—the photographic plate had proved that it could look deeper into the universe than the human eye.

The juxtaposition of astrophotography's escalating successes and the culmination of several extensive, but disappointing, projects done by traditional visual astronomy, almost certainly was the impetus for many professional astronomers to embrace photography during the latter half of the 1880s. By the beginning the 1890s there was no looking back—the photographic plate had become astronomy's detector of choice. And it was now professionals who were spearheading the advancement of photography in astronomy.

Throughout most of the 20th century there was a distinct division between astrophotography done by professional and amateur astronomers. Although there were noteworthy exceptions on both sides of the divide, professionals used photography for science while amateurs used it to pursue aesthetic goals. Amateurs, however, were quick to exploit the latest photographic technology for their hobby, and this was especially true following the introduction of color emulsions, which were largely ignored by professionals. At the close of the 20th century many amateurs followed their professional

counterparts in switching from conventional silver-based photography to digital imaging, and this also renewed interest among amateurs in using imaging for science.

The Roles of Photography in Professional Astronomy

Photography had three primary roles that changed in importance over time. The main one was direct imaging, especially the making of sky surveys and the morphological study of galaxies, star-forming regions, etc. The first survey (begun in 1887) was concerned with astrometry, the accurate measurement of star positions. The last all-sky photographic surveys were completed in the late 1990s and are still used for a wide range of astronomical research; their digitized data is publicly available on the Internet.

Photography was often used quantitatively in photometry, the measurement of the brightness of individual stars and non-stellar (extended) objects. Comparison of images taken through various color filters allowed the temperatures of stars to be determined for the first time. If the distance and temperature were known, the energy output of a star could be calculated. However, photography is a difficult and quirky tool for photometry, especially for point sources such as stars, and it was gradually replaced by photoelectric photometry beginning in the 1920s and more recently by charge-coupled devices (CCDs).

Perhaps the most important application of photography in astronomy was its most challenging and least visually spectacular; the recording of spectra. From spectra, astronomers can learn the chemical composition, rate of rotation, age, velocity of recession, and more about stars and galaxies. By looking at the photographic spectra of galaxies, the expansion of the universe was discovered early in the 20th century, and in the 1960s the spectra of some star-like objects showed them to be quasars, ultra-luminous galaxies at enormous distances, shining in the early universe. Various kinds of electronic detectors displaced photography from this role from the mid-1970s onward.

Telescopes are primarily designed to collect light and focus it onto detectors. This is also a definition of a photographic lens, but an astronomical telescope takes this process to extremes. Most modern telescopes are reflectors, and use huge concave mirrors many meters in diameter to capture and focus light. The focal length and focal ratio varies between instruments, but the largest have mirrors 8 to 10 meters in diameter with focal lengths of 17 to 20 meters, giving them focal ratios of around f/2. The prime-focus fields of these very fast telescopes are quite small, so images are usually made at the Cassegrain focus. This involves adding a smaller secondary mirror, usually a hyperboloid, which folds the optical system and produces a much larger field of view, but at a longer focal length and slower focal ratio. The focal surface can be much larger than any currently available solid-state detector. For example, the generation of 4-meters telescopes that were built in the 1970s and designed for traditional photography had fields of one degree (the full moon is a about half a degree), which were recorded on photographic plates 250 millimeters

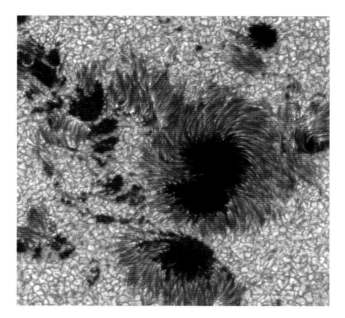

FIG. 6 One of the sharpest pictures of the Sun shows its surface covered by bright convection cells, each on average as big as Texas. This image also shows dark sunspots, cooler areas produced by the intense magnetic fields that permeate the sun. (This image was captured by Goran Scharmer and processed by Mats Lofdahl, using adaptive optics on the 1m Swedish Solar Telescope.)

(10 inches) square. To use these instruments effectively with digital detectors, images are made by scanning a strip of sky with a linear array of CCDs, or as a series of small tiles that are "stitched" with software into wide-field images. Even the largest astronomical Schmidt cameras, which were designed for photographic surveys of the sky using plates up to 356 millimeters (14 inches) square covering 6.5 degrees on a side, have been re-fitted with scanning or tiled CCD systems.

Challenges and Changes

This variety of configurations and research applications presented many challenges to the makers of photographic emulsions, and for more than 60 years the Eastman Kodak Company manufactured a range of "spectroscopic" plates specifically for astronomy. Initially these were designed to be extremely sensitive to faint light by having high efficiency at low photon-arrival rates (plates having little low-intensity reciprocity failure, LIRF). But they also had high granularity and low resolution. In the late 1960s it was realized that for many astronomical applications a high signal-to-noise ratio was of primary importance, so fine-grain materials were designed that offered high resolution and contrast. These had lower sensitivity than earlier astronomical emulsions, but they were able to reveal faint objects against the uniform glow of the natural night sky and were ideally suited to Schmidt cameras.

They also responded very well to several hypersensitizing techniques that astronomers developed, especially the technique of "soaking" the emulsion in hydrogen gas (or a less-dangerous mixture on hydrogen and nitrogen known as forming gas) before exposure. These "gas-hypering" techniques effectively eliminated LIRF, so plates retained as much sensitivity during a 60-minute exposure as they had for a 0.01-second exposure. The penalty paid for this hypersensitizing process was a very short shelf life (hours instead of years), high chemical-fog levels, and, for optimum results, the necessity to expose the treated plates in an atmosphere of dry nitrogen.

This became a very specialized business, and as digital imaging advanced in the 1980s most observatories were relieved to exchange photographic specialists for a new generation of electronics experts who could provide small-area, instant-readout detectors that captured 80 percent and more of the incident photons instead of large-area, chemically developed detectors that had less than 10 percent efficiency.

Today professional telescopes all use solid-state, pixellated arrays for imaging and spectroscopy. These are often expensive and custom-made; however, they cover a much wider spectral range than photography ever could, and their construction, operation, and management require many more in-house specialists than did photography. But for many astronomical applications their benefit is equally substantial. In addition to much higher efficiency at recording photons, most digital detectors respond linearly, meaning that they consistently produce twice the signal for double the exposure, unlike photographic plates. This makes digital detectors ideal for measuring the brightness of astronomical objects.

Of course, not all professional telescopes are on the ground, and some of today's finest astronomical images are made from space, where digital imaging is essential. The most conspicuous success is the Hubble Space Telescope, launched in 1991. Although initially hobbled with flawed optics, it was soon repaired and has provided a stream of astonishing images and groundbreaking science ever since. Several upgrades have given this rather small (2.3 meters) telescope a series of ever more sophisticated detectors, with capabilities far outstripping its original expectations.

Other earth-orbiting telescopes are making images at X-ray, gamma-ray, and ultraviolet wavelengths that cannot be recorded at ground-based observatories because they are absorbed by the earth's atmosphere. At longer wavelengths, other kinds of solid-state arrays sensitive to infrared radiation both reveal and penetrate dusty regions where stars are forming in the arms of spiral galaxies, and outline the otherwise invisible arms themselves.

From both the ground and in space, the pixel arrays of digital detectors also offer accurate spatial information without resorting to the intermediate step using a measuring engine to derive positions on a negative. Precision astrometry has become as simple as clicking a computer mouse in the digital age. Indeed, once solely the domain of professional astronomers, astrometric measurements of asteroids and comets are now routinely done by amateur astronomers imaging with CCD cameras.

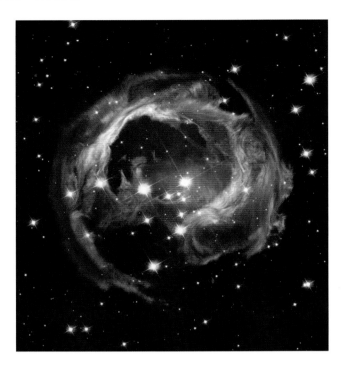

FIG. 7 In 2002, a young star, 20,000 light years distant brightened suddenly and quickly faded. The star is surrounded by a halo of dust that reflects the expanding pulse of light from the outburst, revealing its own structure, which appears to evolve with time as the light passes through it. This image was made with the Hubble Space Telescope in 2004. (From NASA and The Hubble Heritage Team AURA/STScI.)

Amateur Astrophotography

Although astronomy is filled with transient phenomena that offer unique photographic opportunities — solar and lunar eclipses, meteor showers, auroral displays, comets, etc. — outside of our solar system stars, star clusters, nebulae, and galaxies change relatively little with time. This makes astrophotography an endeavor driven as least as much by technique as opportunity. And considering the vastness and diversity of the universe, it is not surprising that astrophotography constantly adapts to the latest developments across the length and breath of modern photography.

From wide-angle photographs of the Milky Way captured with fisheye lenses having effective apertures of a few millimeters to pictures of planets and small nebulae made large-aperture telescopes having focal lengths of 10,000 mm and more, there are astrophotography applications requiring virtually every lens and telescope made today. The range of exposures is equally diverse, spanning from 0.001 second for the sun (even after 99.999 percent of its light is blocked by appropriate solar filters) to hours for the faintest nebulae.

While many astronomical sights visible to the unaided eye, such as constellations, planetary groupings in a twilight

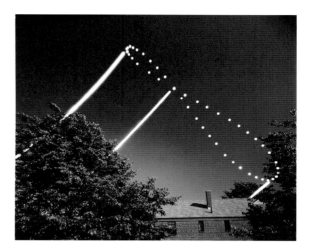

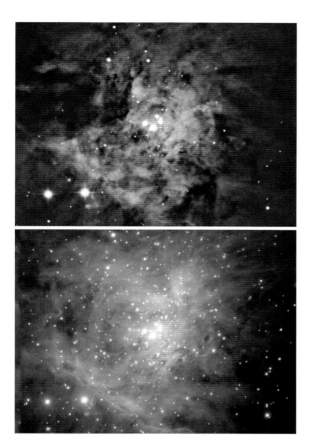

FIG. 8 Astronomical images are no longer restricted to light that we can see. This picture shows the dusty central regions of the Orion Nebula, a star forming region, photographed in visible light (top) and in the near-infrared. The longer wavelength IR penetrates the dust, revealing numerous, normally hidden stars and other structures. (Upper image, Anglo-Australian Observatory/David Malin. Lower image, European Southern Observatory/Mark McCaughrean.)

FIG. 9 Known since antiquity and familiar today to fanciers of sundials, the figure-8-shaped analemma depicts the sun's position in the sky at the same time of day throughout the year. It was first photographed in 1979–1980 on a single piece of film with a simple 4 × 5 inch camera fixed in a window. The sun's images were captured through a dense filter about once a week at the same time of day, while the foreground was exposed without the filter when the sun was out of the scene. Three time-exposures record the sun's daily track during the Northern Hemisphere's summer, spring, and winter (left to right, respectively). Similar results can be obtained with digital cameras. (From Dennis di Cicco.)

sky, meteor showers, and auroral displays can be recorded with cameras mounted on fixed tripods, most astrophotography relies on having a camera track the sky's diurnal motion as objects rise in the east and set in the west. For work with wide-angle and normal lenses, the tracking tolerances are relatively liberal, and quality results have been obtained with hand-driven mounts made from scrap materials (examples can readily be found on the Internet by entering "barn-door mount" into any search engine).

The tracking requirements for longer focal lengths are more demanding, and today there are numerous camera mounts and telescopes with motorized drives specifically made for astrophotography and marketed to amateur astronomers. The once-tedious task of manually guiding a telescope to keep it precisely aimed at its target as it moved across the sky can now be relegated to electronic "autoguiders."

Although the switch from photographic emulsions to digital detectors has benefited amateur astrophotography as much as it has professional research, the real "digital revolution" involves what happens after the exposures are made. Today the conventional darkroom is almost extinct in the world of astrophotography, replaced by myriad computer programs that perform once laborious darkroom manipulations with the blink of the eye. And these programs can accomplish tasks that were all but impossible even for the most skilled darkroom technicians.

The most significant of these manipulations involves combining, or stacking, multiple exposures to produce an image with a higher signal-to-noise ratio than found in any of the individual exposures used for the "stack." In principle the process is similar to the elaborate darkroom schemes developed in the early 1960s to combine multiple negatives from aerial reconnaissance missions to produce photographs showing finer detail than recorded by any one negative. In astronomy a variant of this technique was used to create deep images that showed extremely faint features of galaxies and other "extended" (i.e., non-stellar) objects. It has also been used to create detailed images of the planets, but the complexity of the darkroom work limited its widespread adoption. Digital imaging, however, makes the combining process so simple that today it is rare to find any astronomical photograph made from a single exposure.

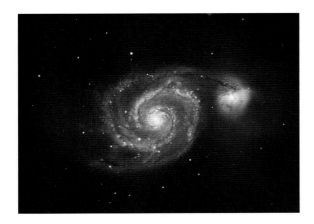

FIG. 10 M51 is a beautiful, face-on spiral galaxy, over 30 million light years distant, interacting with a close companion. The interaction has produced many hot blue stars that define the spiral arms. This image was made by Robert Gendler from combined luminance and RGB data taken by Jim Misti with his 32-inch telescope using a CCD detector. Total effective exposure time for all four channels was 135 minutes. (Photograph by Robert Gendler.)

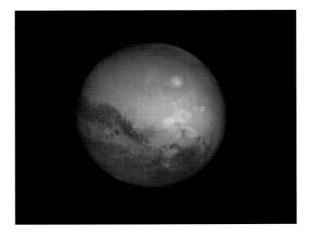

FIG. 11 Mars was relatively close to Earth at a distance of 70 million kilometers when this image was made on November 6, 2005, using a 14-inch telescope, a webcam and software to select and combine the sharpest frames. Many fine details, including the giant volcano Olympus Mons (the large bright patch), can be seen across the Martian disk. (Photograph by Damian Peach.)

The ready ability to combine multiple images in register makes it the method of choice for color astrophotography. Commercial color films were never designed for long exposures. Though pleasing results were obtained using color film to photograph the brighter galaxies and nebulae, exposures were very long, and sometimes elaborate and inconvenient techniques such as chilling the film with dry ice were required. Professional astronomers, however, had long been making monochrome images on blue- and green-sensitive plates, primarily to measure the colors (and thus the temperatures) of the stars. It was but a small step to make a corresponding red-light plate. From this trio of exposures using conventional darkroom equipment, separate positive copies that could be combined onto color film to produce a true-color picture were made.

This additive, color-separation process mimicked that used to create the world's first color picture made by the physicist James Clerk Maxwell in 1861. It also allowed processes such as unsharp masking and enhancement to be used before the color separations were combined into a color picture. This allowed complete control over dynamic range, hue, and contrast, and could reveal detail in heavily exposed regions. These controls are mimicked in modern digital image editing software.

Another aspect of astronomical photography to reap tremendous benefits from the ability to stack images is planetary imaging. To that end, today's cameras of choice for planetary photography are simple computer webcams that record digital movies with frame rates between 5 and 30 frames per second. Software (some of it available for free on the Internet) then sifts through these frames selecting the sharpest ones recorded during moments of low atmospheric turbulence and automatically stacks them. It is not uncommon to see planetary pictures made from stacks of hundreds of frames culled from brief movie clips containing thousands of frames. Amateur planetary images made with modest backyard telescopes often rival those obtained with the Hubble Space Telescope, and they are getting better with time.

From the earliest days of wide-field astrophotography it has been known that dark skies away from urban lighting are necessary for the best results. This remains true today even though digital image processing can extract noteworthy pictures from exposures made under heavily light-polluted conditions. While many astrophotographers pursue their hobby by transporting equipment to rural locations for a few nights each month around the time of the new moon, a growing number are observing under dark skies via their computers, controlling remote telescopes and cameras and downloading images over the Internet. Some are using commercial facilities that rent observing time on an hourly basis, while others have established private "robotic" observatories built with entirely off-the-shelf hardware and software.

These developments reflect the enduring interest in the sky that has sustained amateur astro-imaging for many generations. Making images of the fleeting stars and distant planets is not easy, and it attracts people who enjoy a challenge. Some even make their own telescopes, though this is not as common as it once was. Others are interested in photography or digital imaging and wish to stretch their skills. Yet others see the CCD as the silicon eye of the computer and are interested in extracting all the information that they can from the detector. Some endure the layers of technology because they find imaging the sky inspirational and the images beautiful. The most successful manage to combine all or most of these diverse interests.

See also the following articles

Hypersensitization; Remote Sensing; Night-Time and Twilight Photography

FURTHER READING

Covington, M.A. (1999). *Astrophotography for the Amateur.* New York: Cambridge University Press.

Reeves, R. (2005). *Introduction to Digital Astrophotography: Imaging the Universe with a Digital Camera.* Richmond, VA: Willmann-Bell.

ADDITIONAL INFORMATION

Amateur and professional astronomy associations, publications archives, links etc.: http://dmoz.org/Science/Astronomy/

Anglo-Australian Observatory/David Malin images Web sites: www.aao.gov.au/images.html and www.davidmalin.com

Hubble Space Telescope: http://hubblesite.org/newscenter/

Michael Covington: http://www.covingtoninnovations.com/astro/index.html

The leading American amateur astronomy magazine: www.SkyandTelescope.com ◎

Autoradiography

DAVID MALIN
Anglo-Australian Observatory, RMIT University

Autoradiography is the creation of a photographic image using radiation emitted from a specimen in direct contact with a photo-sensitive material, so the image is a self-portrait of the radiation-emitting parts of the specimen. The technique can involve tagging specimens of almost any sort with radioactive tracers that are selectively taken up by molecules, chemical compounds, cells, gels, cracks, or interfaces.

Because the specimen is in contact with the light-sensitive material, the developed images are often finely detailed and may need interpretation by microscopy. The results can also be quantitative since the amount of developed silver is directly proportional to the amount of radiation, and there is no reciprocity failure.

The French physicist Henri Becquerel (1852–1908) accidentally made the first autoradiograph in 1896, when he stored crystals containing radioactive uranium against a photographic plate wrapped in opaque paper. The developed plate showed structure in the crystals. This was one of Becquerel's many discoveries concerning radioactivity that led to the 1903 Nobel Prize in physics which he shared with Marie and Pierre Curie.

See also the following article

Nuclear Track Recording

ADDITIONAL INFORMATION

http://www.kodak.com/US/en/health/s2/references/autorad.jhtml ◎

Ballistics Photography

PETER W. W. FULLER
Consultant in Instrumentation and Imaging Science

Ballistics is the study of the motion, behavior, and effects of projectiles of all kinds. It is one of the many areas of armament research. The application of photography to ballistics also extends to most other areas in the field. In many instances, photographic or photonic studies may be the only way to obtain some of the parameters required. Photographic methods are particularly important in ballistics research because of the multiple types of information that can be obtained from a picture. For example, a pressure gauge will usually only provide pressure readings, but a good interferometer photograph may provide information on the state of the projectile, the distribution and pressures in the flow field, the projectile velocity, and the angle of yaw and its general aerodynamic excellence at that velocity.

In ballistic research, events are of relatively short duration. The range of subject movement is significant, e.g., 2 m/s is consistent with a parachute flare-burn observation and up to 7 km/s for projectiles launched from two-stage light-gas guns. Exposure times will generally be very short to freeze motion and prevent blur; consequently, framing rates will be high. The ballistic environment can also be very hazardous to equipment and operators, due to blast, shock, high pressures and temperatures, flying debris, high noise levels, and light flash.

There are five main areas of interest to the ballistics researcher, internal, intermediate (muzzle exit), exterior flight, and impact or terminal for guns as well as dynamic processes for other areas such as explosives, propellants, ignition devices, mechanism action, rockets, wind and shock tunnel models, shaped charges, etc.

Many general, high-speed photographic techniques are employed in ballistics work, but other specialized high-speed techniques developed specially for ballistics applications are also used. Some of the more important ones are described below.

Projectiles in Flight

Probably the earliest ballistics photograph (of a cannon ball in flight), was taken using a simple home-made camera by T. Skaife in 1853 at Woolwich Arsenal, London. This was in an era when photography was in its early infancy and most pictures were made of static subjects using long exposures, and Skaife was repeatedly asked how he managed to stop the cannon ball in flight in his picture.

Until the end of the 19th century the only available way of imaging high-speed events was the use of electric sparks. In 1884, Ernst Mach began photographing bullets and their flow fields by using spark schlieren photography. By 1892, Charles Boys in England was doing similar work using shadowgraphs. At normal atmospheric pressures this method was as good as schlieren and much easier to set up. Modern research still uses both techniques, but with sparks, flash tubes, or lasers as the light source.

Producing a basic shadowgraph only requires a point light source and a sheet of film. The subject, e.g., a projectile in flight, is arranged to pass between them. At the correct instant, often triggered by the arriving projectile, the light is fired and the shadow of projectile and its wake is produced on the film. The area must be in darkness while the film is uncovered.

A more convenient method uses a retro-reflective screen and a camera by the side of the light source, which photographs the shadow projected onto the screen. The picture records the rate of change in air-density gradient caused by the passage of the projectile. There are other flow field techniques that are more sensitive for lower-than-normal atmospheric pressure environments, such as schlieren and interferometry. Schlieren photos and shadowgraphs only portray a projectile and their flow fields as shadows. To obtain front-lit pictures of the projectile, other methods are required. Holography, a more recently developed method, is now used, which provides multiple three-dimensional images of the flow field and the objects in it.

When photographing projectiles, pictures are usually taken at right angles to the trajectory, requiring very exact synchronization using very short exposures. To allow for synchronization errors, the imaging system can be moved back from the trajectory to ensure the projectile is in the field of view, but with this method the image size will be smaller.

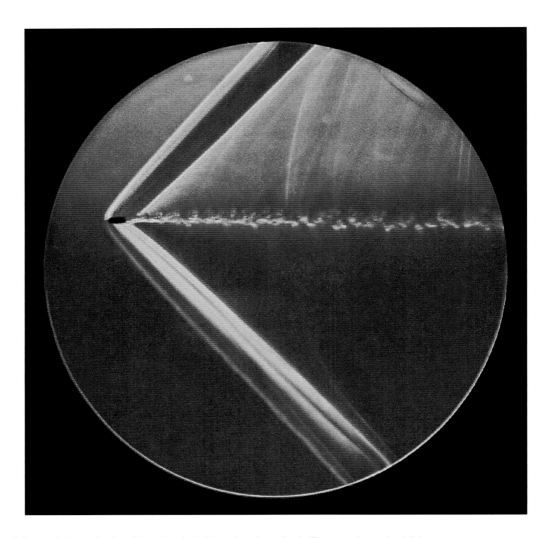

FIG. 12 A schlieren photograph of a .22 caliber bullet traveling through air. The wave is made visible as a consequence contrast produced from a color schlieren system. The density variations of the air caused by the compression from the flying bullet refract light rays into different regions of a color filter gradient creating color contrast. (Photo courtesy of Andrew Davidhazy, School of Photographic Arts and Sciences, Rochester Institute of Technology, Rochester New York.)

The Synchroballistic System

The required system uses a camera set to streak mode, i.e., without conventional shuttering. The basic principle is used in the sporting "photo-finish camera." The camera is oriented parallel to the trajectory. The objective is to synchronize the speed of the film and the speed of the projectile image falling upon it while both move in the same direction, so that film and image are relatively stationary to one another. This is achieved by correct placement of the components, and the appropriate choice of characteristics for the lenses that are used. To prevent blur, the image passes through a fine vertical slit placed in front of the lens, this effectively reduces the exposure time because the image is formed by a series of narrow vertical strips. This offers reduced exposure time without increased lighting intensity. Slight synchronization errors will elongate or compress the image dimensions in the horizontal or length direction.

If the film motion is at right angles to the trajectory, and the slit placed parallel to the trajectory, the projectile forms a diagonal streak across the film. Projectile velocity can then be found, using the film velocity and the system optical magnification.

The synchroballistic camera produces high-quality, front-lit images making full use of the film frame size in the direction of film motion. The image can also provide projectile characteristics including velocity, attitude, and spin rate. The system also records all objects passing along the trajectory while the camera is recording. This is useful for detecting objects that

may cause unexplained spurious triggering. Both film and electronic image-converter cameras can be used in the system.

Each system station only provides one small section of the trajectory. If a close-up cine record is required for a large part of the flight, the camera must be panned to follow the projectile. While possible in lower speed events such as motor racing, it is not possible in ballistic research where very high transitional rates occur. A special system must be used.

The Flight Follower

Originally developed at the Royal Armament Research and Development Establishment (RARDE) in England in 1962, this system keeps the camera stationary, while the image is conveyed to it by a very fast panning mirror mounted on a large galvanometer coil (Figure 14a). To track the projectile, the mirror must follow a parabolic curve of acceleration and deceleration, peaking when the projectile is normal to the system axis (Figure 14b). In the first systems, the coil was

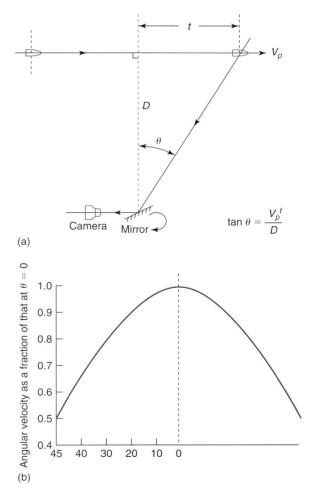

(a)

(b)

FIG. 14 (a) The flight follower system optical arrangement in basic layout; (b) angular velocity for correct tracking.

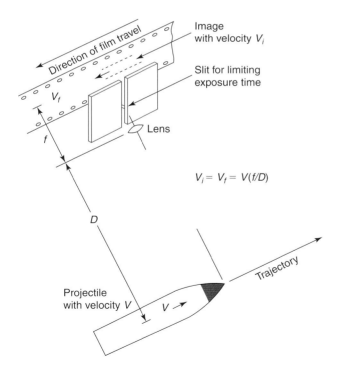

FIG. 13 The synchroballistic system.

accelerated by a series of positive pulses, then decelerated by reversing the polarity. To allow for mirror inertia change, the system was triggered before shot exit, and the mirror view and projectile synchronized at the muzzle. The system worked well and has now been modernized using a servo-galvanometer controlled by a microprocessor. The cine record can be recorded on a film or video camera. In the newer system, the mirror is still triggered before shot exit, but now, feedback from velocity detectors near the muzzle can switch the computer to control the mirror acceleration curve to match the velocity, thus ensuring that the reflected image remains in the camera field of view. Mirror swing-angle can be in the region of 90 degrees giving trajectory coverage governed by the stand-off distance. For longer coverage, several stations can be set up and electronically triggered to take over as the previous camera reaches the end of its tracking swing.

Aeroballistic Ranges

If a full projectile analysis of projectile trajectory is required, a scale model will be fired in an aeroballistic range. Spaced at intervals along the range will be many orthogonal photographic stations, which will take two simultaneous spark or laser flash shadowgraphs of the projectile and fiducial markers. Marker beads will be strung at known positions on three catenary wires running the length of the range. The two orthogonal photographs will each contain a view of the projectile and two marker wires, one common to both shadowgraphs. The projectile will trigger its own photograph, and the trigger

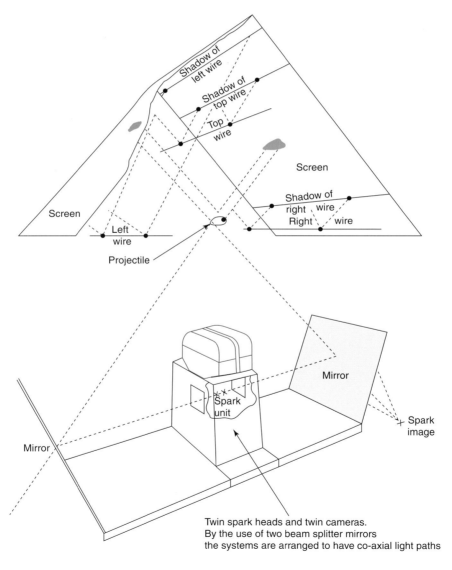

FIG. 15 Layout of one orthogonal photographic station in a ballistic range.

instants will be recorded. From the known range geometry and analysis of all the shadowgraphs, the projectile yaw, pitch, precession, mutation, velocity, and three-dimensional position at all stations can be obtained and the projectile's full aerodynamic coefficients found.

For long range rockets or missiles fired on large open ranges, trajectory tracking can be achieved by triangulation from the results from widely spaced cine theodolite stations recording azimuth and angle. Tracking is often assisted by placing a bright flare on the missile tail.

Lighting for Ballistic Photography

For ballistics photography, daylight, tungsten halogen lamps, and xenon discharge lamps are used as continuous light sources. Flash bulbs are relatively cheap short-duration sources, but triggering must allow for burn-up time to reach full brightness. Overlapping ripple firing of a series of flash bulbs can provide a 0.5 second or more continuous light source, or many bulbs can be fired simultaneously to give intense light levels for a short time. For single pictures, spark sources, flash tubes (single or strobed), argon light bombs/candles, and pulsed lasers are used.

Flash X-rays are used extensively for in-bore photography, in intermediate ballistics, to see the state of projectile arming mechanisms and internal integrity, and for impact experiments to show the penetration of projectiles and shaped charge jets into opaque targets. If the time history of such phenomena is required, cine X-ray will be employed, using a long duration X-ray pulse, an image intensifier, and an image converter camera which provides the required shuttering. Alternatively, multiple, short X-ray pulses are used with an image intensifier and conventional cine or video cameras. High-quality, high-accuracy triggering and synchronization is essential in ballistic research. Methods of projectile/event detection include make

or break screens, electric or magnetic fields, interrupted light or microwave beams, emitted or reflected radiation from the object, detection of sound, local pressure changes, or shock waves.

Ballistic Cine/Video Photography

In the equipment used for high-speed cine/video photography, as framing rates increase and exposure time decreases, the available number of frames per event is reduced. As the very high framing rates are approached, direct film usage gives way to electronic imaging.

In both general and ballistic high-speed photography, the past decade has seen video systems make a strong challenge to conventional film cameras in the high-speed and very high-speed region. Their relative ease of use, versatility, and immediate results are very important in cutting costs and shortening the time for ballistic trials. Conventional cine cameras often have a correlation between exposure duration and framing rate, which limits the minimum exposure time available. They have been given wider application possibilities by coupling them with lasers. Pulsed metal vapor lasers can be triggered from these cameras at the point where the shutter is fully open, giving the possibility of a cine system with exposure times down to tens of nanoseconds.

Apart from some high framing rate but lower resolution video systems, beyond about 45,000 fps, longer established systems such as drum cameras, rotating mirror/prism cameras (both framing and streak), and image converter and image intensifier cameras are still used.

Framing and Streak Cameras

Rotating mirror/prism cameras and image converter cameras are often used in either mode. In framing cameras the event is shuttered to provide recognizable pictures taken at discrete

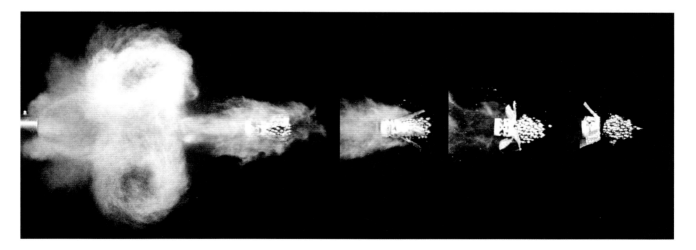

FIG. 16 A composite image showing the various stages of a shot gun shell releasing buckshot. (Photo courtesy of Andrew Davidhazy, School of Photographic Arts and Sciences, Rochester Institute of Technology, Rochester, New York.)

intervals. However, no information is obtained in the intervals between frames. If a continuous record is needed, e.g., in studies of propellant burn or explosive behavior, a streak camera is used. In this mode there are no lost intervals as there is no shuttering employed. The image is focused onto a slit and the slit can be parallel to the film motion or at right angles to it. If the system is at right angles to the motion, recognizable pictures are produced (see the section Synchro-ballistic System), if parallel-to-film motion pictures are required, the images will require interpretation as only the recorded moving boundaries between solids or incandescent gas and the surrounding air will be imaged.

Knowing the speed of the recording medium or sweep speed of the electronic system, highly time-resolved measurements can be made. Typical writing speeds for rotating mirror systems can be in the order of tens of millimeters per microsecond with a resolution of 2 to 3 nanoseconds. For electronic cameras writing time can be 1000 millimeters/microseconds with a resolution of 0.15 nanoseconds.

Combined systems that include the best attributes of film-camera mechanics and charge-coupled device (CCD) recording are now in use, e.g., in some image intensifier and rotating mirror/prism cameras where a limited number of sequential still exposures are combined to form a cine sequence. In these cameras, film has been replaced by multiple CCD detectors that offer great processing, versatility, and comparatively short turnaround times.

"Still" video cameras using CCD recording can give a limited number of high framing rates with short duration exposures onto one frame as the CCD detector is capable of fast response. The image is not downloaded as in video systems but all pictures are recorded and downloaded later. Operation modes are either two half-frame exposures, e.g., before and after penetration in an impact sequence, or several exposures where the subject remains in the field of view, but moves such that each image location does not obscure the previous image. This is similar to making a stroboscopic picture using film and multiple flashes.

No doubt, as high-resolution video capabilities and framing rates increase, video systems will be used increasingly in ballistics research, but replacement of ultra-high-speed film cameras still seems to be in the distant future. Meanwhile, video systems form a useful rapid access adjunct to film or electronic cameras to prove a technique that is practicable before using other high-resolution film or electronic cameras for the final results.

Precautions

Because of the inherent dangers in ballistic research, the cameras used must be robust and shock resistant. Often special protective housings or walls, temporary or permanent, are used to provide necessary protection. Cameras will often view the scene through very thick glass windows or through use of sacrificial relay mirrors, while the cameras remain protected from blast or debris.

See also the following articles
Chronophotography; High-Speed Cinematography; High-Speed Still Photography; Military Photography; Schlieren and Shadowgraph Photography; Streak and Strip Photography ⬡

Biological Photography

JOSEPH M. OGRODNICK
New York State Agricultural Station—Cornell University

Introduction and History

Dating back to the cave paintings of primitive man, biological themes have long been popular subject material for artists. It is of little surprise then, that soon after the invention of photography, practitioners of this new method of illustration were doing likewise. Among other things, Henry Fox Talbot was making photographic records of botanical subjects as early as 1844 reproduced in *Pencil of Nature*, and the daguerreotype was used similarly soon after its invention a decade later.

In 1863, an entomologist (a scientist who studies insects), C. J. Cox wrote in the *Proceedings of the Entomological Society of London*: "I do not overestimate the great value this art will ultimately prove in rapidly delineating, with most perfect accuracy, either single specimens or groups of insects. And I also believe we are on the threshold of a very marked period in the advance which the science of natural history is now likely to take, aided by a power so quick in action, so accurate in detail, and so exquisitely beautiful in its general character as photography."

This prediction more than 150 years ago could not have been more prophetic. Photography has since become an invaluable tool not only for entomologists, but for researchers in all areas of the biological sciences. Biological photography now includes aspects of optical and electron microscopy (especially scanning electron microscopy), photomacrography, and photography in the ultraviolet and infrared regions of the spectrum. These topics will be explored elsewhere in this encyclopedia.

Photographs of biological subjects can be found in encyclopedias, textbooks, scientific journals, popular periodicals, on posters, and in lecture support materials for scientists and teachers. They also form a significant part of the collections of scientific photography libraries, botanical gardens, and zoos.

Two important milestones in the development of photographic equipment applied to biological photography were the introduction of the 35 mm camera, particularly the single lens reflex (SLR), and the electronic flash. The SLR was first introduced in 1909, but its rapid development in the 1970s included a wide variety of interchangeable lenses—from macro lenses ideal for insects and other small invertebrates as well as many botanical subjects, to fast telephoto lenses for larger varieties of wildlife and birds that, for one reason or another, were otherwise inaccessible.

FIG. 17 The extremely short duration of an electronic flash was able to capture the instantaneous release of fungal spores.

FIG. 18 This small freshwater fish was photographed in the laboratory in a small aquarium.

Synchronized electronic flash became widely available at about the same time and provided action-stopping capability, a critical factor when working with live subjects both in the laboratory and the field (Figure 17). Electronic flash also generates large quantities of light, useful at night and in caves or when doing macro photography where small apertures are needed for greater depth of field. A third advantage of using electronic flash is that it generates no heat, which could cause injury or even the death of small fragile organisms.

Over time, both black and white and color films became faster with finer grain, and in the case of color materials, more fidelity. The most recent significant development in photography is of course digital imaging, which offers many opportunities for biological photographers otherwise not possible with film.

Subject Handling

Biological photography is a specialty in which subject handling and preparation can be as important as the selection of camera equipment, lighting, and the recording medium. It can often be the most time-consuming and challenging aspect of this photographic specialty. In the photography of insects and other arthropods, they can be cooled down and consequently slowed down in a conventional refrigerator (not the freezer compartment). An alternate method is through use of carbon dioxide gas to render the insect temporarily unconscious. This is done by introducing a small hose connected to a bottle of the compressed gas to a vial or bottle containing the insect. The carbon dioxide causes the insect to assume unnatural positions at first, but as it becomes more animated, natural-looking photographs can be made. Timing is important — if the photography is done too soon the insect will not look life like, if done too late the subject will be out of the field of view or even gone altogether. Since insects, especially the larval (caterpillar) forms, seem to at times have insatiable appetites; many insects (and numerous other organisms for that matter) can be easily photographed while they are preoccupied with feeding.

Aquatic Subjects

Waterproof camera housings make it possible to photograph the numerous organisms that inhabit the oceans, lakes, rivers, and other bodies of water that collectively cover nearly three-fourths of the earth's surface. There are conditions, however, which make photography of aquatic flora and fauna in their natural habitats difficult and often impossible. Turbid water, excessive depths, freezing temperatures, and the availability of hiding places for potential subjects are just a few of these.

Photography can often be carried out more successfully in the laboratory (subject size permitting of course) with the organism confined to an aquarium. Lighting, water clarity, and background can be better controlled and the subject's movement can be limited to some extent. Smaller aquaria are best and even smaller ones can be constructed with small pieces of glass and aquarium cement. The size and activity of the subject should determine the dimensions of the aquarium.

Electronic flash, for all the same reasons mentioned above, is the preferred choice when photographing specimens in aquaria. Care must be taken to aim the flash or flashes at an angle to the glass to avoid reflections into the lens. Illuminating the aquarium from the top or at a 45-degree angle above, below, or off to the side of the camera will eliminate reflections. Another troublesome source of reflections is the camera and lens and everything behind it (including the photographer). Camera parts can be covered with a black card with a hole cut out to fit over the lens, the photographer can stand off to the side with a long cable release, and the room can be darkened to eliminate other sources of reflections. Small reptiles, amphibians, and even mammals can also be successfully photographed in various sizes of aquaria.

Backgrounds

There are many considerations to be made when selecting a background for biological photographs. If a natural background is used, its content should not be contradictory to the environment and surroundings where a particular organism

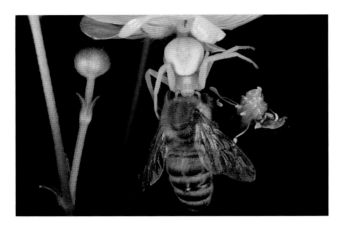

FIG. 19 A crab spider with a captured honeybee was photographed in a deep wooded area with electronic flash. The flash provided more than enough light, and arrested any movement.

might be found naturally in nature. The larva of an insect which feeds on apple should not be photographed on a cabbage leaf for instance, a freshwater fish should not be photographed in front of a piece of coral, and a lizard that makes its home in the desert southwest should not be photographed amid lush vegetation. While aesthetics should always be an important element in any photograph, the accuracy and veracity of the image must not be compromised for the sake of appearance if the image is intended for a scientific purpose.

Another precaution regarding backgrounds, especially natural backgrounds, is to make certain that some element of that background is not misconstrued as a part of an organism's anatomy. Some objects in a natural background might also appear very bright and be distracting. Both of these problems often go undetected until the lens stops down at the moment of exposure.

Plain backgrounds are often used, especially when the photograph is to appear in a scientific journal where it is important that the subject is seen unobstructed and devoid of problems and interferences such as those mentioned above. When choosing a color background, the photographer should be careful that the color does not alter the color of the subject itself. Black backgrounds, in the form of black velvet cloth, are often used since they are neutral and do not influence the color of the subject.

Photography in the Field
Often times it might be necessary to do photography in the field. The reasons for this are many. Certain varieties of wildflowers, which are protected by law, cannot be picked. Subjects like birds, with the exception of those housed in aviaries and zoos, cannot easily be photographed in captivity, and some other subjects are better portrayed in their natural habitat. With trees, for instance, there is no choice.

Photographs taken in the deep forest, on overcast days or with long telephoto lenses, might require the use of a tripod. For many subjects, electronic flash once again is the obvious

choice especially when doing close-up work. Many manufacturers offer flash units for close-up work comprised of what amounts to two separate flash units thus duplicating the main/fill light configuration of studio lighting. As for color temperature issues, electronic flash is compatible with daylight.

Tide pools are another specialized environment in which to shoot because of the air/water interface. Tide pool photography is much like photographing organisms in an aquarium except there is no glass. Ordinary ambient daylight usually provides adequate illumination, but electronic flash can be used to supplement it if necessary. The same rule governing reflections as regards to the angle of illumination to the surface of the water applies here just as it does with an aquarium. Polarizing filters might be needed to extinguish reflections independent of those that might originate from the flash unit(s).

Biophotography in the Digital Age
Digital imaging has altered the way biological photographers take and look at photographs. For the biological photographer, as for many others, probably the most important feature is the ability to instantaneously view a recorded image. In the (still recent) days of film, photographers who photographed small, fast-moving, and sometimes elusive subjects did not know if they had been successful until the film was processed. Since one of the most time-consuming aspects of biological photography is subject handling and preparation, the ability to repeat a shot while everything is set up and the specimen is still available is a tremendous advantage.

Similar advantages apply in field photography when a reshoot might mean traveling some distance or the possibility that the subject might be difficult to find again or may no longer be there.

Image editing and processing software has further advanced the work of the biological photographer, often allowing the photographer to do the work that was once the province of the layout artist, such as showing the various stages of an insect (egg, larva, pupa, and adult) in a single image. Capturing all these stages at once on a frame of film was a daunting, frustrating, and sometimes impossible endeavor, especially if the adult happened to be a winged variety such as a moth or fly. Imaging software has also offered the biophotographer the ability to label images and add other annotations such as arrows. This technology also allows for "digital repairs" to be made to images. This can be as simple as removing distracting elements from a photograph, especially in a background, or as complex as adding a missing part to an organism. This should only be done as a last resort and only if executed in such a way that the result appears life-like and the "fix" is not obvious.

In general, all scientific photographers should be aware of the possibility of introducing artifacts into digital pictures by over-enthusiastic manipulation and retouching. If the image is an essential part of a scientific paper, it is good practice to retain the native image file in an unaltered state. In addition to work with a digital camera, a simple flatbed scanner is a useful way to make detailed images of biological subjects, especially those that are essentially two-dimensional to begin with such

as leaves, flowers, feathers, etc. The advantage of this technique is found in its simplicity with a main disadvantage of the limited lighting possibilities. The key question, as with any other technique, is to determine if scanning is an appropriate imaging method for the subject.

Other Sources of Information

In the United States, the BioCommunications Association (formerly the Biological Photographic Association; http://www.bca.org/) is a professional society of biological and medical photographers and communications specialists. In collaboration with three other societies, it publishes the *Journal of Biocommunications*, which incorporates the *Journal of Biological Photography*. Similar organizations exist in the UK and Australia and can suggest courses and other resources for scientific and biological/medical imaging.

See also the following articles

Botanical Photography; Electron Photography; Infrared Photography; Photomacrography and Close-Up Photography; Photomicrography; Underwater Photography

FURTHER READING

Angel, H. (1982), *Nature Photography*. London: Alfred A. Knopf, Inc.

Hicks, N. (1999). *Professional Nature Photography*. Woburn, MA: Focal Press.

LeBeau, (1995). The use of automatic cameras in small biomedical object photography. *The Journal of Biological Photography*. **63**, 3–13.

Lefkowitz, L. (1982). *The Manual of Close-Up Photography*. New York: Amphoto.

Ogrodnick, J. M. (1996). Bugs, bellows and Beethoven— Photographing insects. *The Journal of Audiovisual Media in Medicine*. **19**, 17–21.

FIG. 20 This plant card sample called a holotype is representative of laboratory photography in herbariums. This photograph features *Asimina longifolia* as a card sample collected from Lake Jackson, Florida, in 1957. (Courtesy of New York Botanical Gardens.)

Botanical Photography

PAUL HARCOURT-DAVIS
Professional photographer and author

In the purest definition, botanical photography is used to depict plants accurately with respect to their form and color, providing relevant information documenting plant morphology and function, the environment, plant life histories, diseases, the effects of pollution, and relationships with other life forms. Successful botanical photography, however, is much more than this. It is as much an art as well as a science and requires a detailed knowledge of plants and their habitats as well as a keen eye for a picture. It also poses technical challenges since it involves at least familiarity with a gamut of techniques from the photomicrography of plant parts and

microscopic specimens to satellite imaging showing enormous plant communities. Single plants and individual flowers demand the techniques of portraiture or macrophotography, while habitats can be photographed as wide-angle landscapes, complete with foreground plants. Most plant photography utilizes light in the visible spectrum but infrared-sensitive films and digital imaging can provide information about pollution, and ultraviolet light reveals striking flower markings— guidance systems for pollinators on apparently uniformly colored flowers.

The delicate colors, subtle forms, and textures of plants also inspire photographers in search of more "artistic" images, where limiting depth of field can be used to highlight details, and soft focus to create moods and the patterns within flowers or on leaves to form the basis for abstract images. Whether or not this usefully contributes to information about plants is open to question, but it surely encourages an appreciation of their intrinsic beauty.

Digital Imaging

Digital imaging is a boon to botanical photography in several ways. Small, largely automatic cameras can be used to obtain instant images of a plant site, complete with imprinted data as to time and exposure, and some digital SLRs can be coupled to a GPS system providing positional and altitude details. The color fidelity of color slide film has always been a problem with those materials of ISO 50 and below. The image's blue color palette often suffered because of the tendency of some plant pigments to reflect infrared wavelengths invisible to the human eye but recorded on film. Even basic digital cameras now allow accurate tuning of the color through the white balance or later manipulation on a computer (provided monitors have been calibrated), especially if digital images have been recorded as RAW files. In the field, studio, or laboratory, the immediacy of digital imaging allows a photographer to make fine adjustments to color and composition and capture plant images that not only exist as records but are also more pleasing to the viewer.

Compact digital cameras have similarly made photomicrography much easier. Although the fixed lenses do not allow TTL focusing, a relay lens placed between the camera optic and a microscope eyepiece permits high-quality images to be obtained easily: video output from the camera to a monitor screen facilitates focusing and composition.

Lenses

Many wide-angle lenses on digital cameras have a useful close focus that allows a plant to be captured in its intimate environment. Using a small aperture to create greater depth of field also allows both plant and surroundings to be in focus within a wider landscape. The resulting accentuation of a foreground flower, for example, parallels the way humans tend to see plants, with the flower, literally, as the focus of the attention. Setting the subject at the hyperfocal distance for a particular aperture ensures everything from subject to infinity is in focus. But often the flower is just not close enough and precise focus of both distant landscape and the flower might only be achieved using the movements of a view camera or an SLR with tilt and shift lens. Fortunately, slight softening to infinity can accentuate the object of interest, producing greater impact with a still-discernable landscape to set the scene.

Moderate telephotos, whether zoom or fixed focus, can be used to reach otherwise inaccessible plants on ledges or tree flowers, for example. With long lenses, focus falls off quickly outside the plane of sharp focus, usefully isolating a main flower against a soft-blurred background. However, catadioptric (mirror) lenses often create doughnut-shaped highlights (a circle of confusion from a point light source or a specular highlight), which some users find annoying. This is particularly obvious with sparkling water shots or dappled foliage photographed against a bright sky. A wider range of images is possible if a close-up lens is added to the kit. Most of these focus to 1:1 (life size) without extension tubes and many utilize internal focusing: they also make excellent general portrait lenses for plants.

Tripods and Supports

The advice to use a firm tripod is as relevant now as ever. In the field or studio it is essential when using camera equipment at slow shutter speeds for any roll and sheet film or digital cameras. Modern carbon-fiber tripods are light and stable. Where weight is at a premium and there is no tripod available, photographers can make use of tree trunks, stones, walls, camera bags—anything to provide support and bracing. With digital cameras the effective ISO rating can be increased allowing shorter shutter speeds, but there is increased risk of "noise" in the final image. Telephoto lenses with electronic image stabilization give about two stops more tolerance to camera vibration when hand-holding.

Light Sources and Reflectors

Natural light is the preferred source by botanical photographers for color accuracy and a natural feel to the picture. Avoid direct sunlight where possible as it creates high contrast with hard shadows as well as exaggerated colors: A light "hazy" cloud covering is an ideal natural diffuser. Surprisingly, dull, rainy days are good for plant photography because colors are more saturated as a result of the even and flat illumination. When using film the lower levels of infrared radiation reflected by chlorophyll make blues easier to reliably record and the environment's color temperature is higher which tends to emphasize blues.

Photographs of plants in the shade or with hard shadows can be improved by using portable, neutral-colored reflectors to soften and direct light where it is needed. Many prefer the warmer feel of light in early morning or evening, when the light is naturally redder. A digital camera with white balance set to cloudy or dull produces the same warming effect.

A flash system, used with care, can also produce excellent results where natural light levels are low. A fill-in flash with the flash set a stop or two below ambient light level improves color contrast. Exaggerated colors and harsh shadows can be avoided by using the built-in wide-angle diffuser available for many flash guns. The closer the flash is to the plants the softer the shadows will be since it acts as a broad light source. Major camera manufacturers and a few independent firms manufacture so-called "macro-flash" units with one or two small, relatively low-power flash heads that can be set at different intensities to vary lighting ratios for macro photography.

Filters

The ability to manipulate images in digital photography has made many color-balance filters redundant. However, a polarizing filter still has a place in any botanical photographer's camera bag, though a "circular polarizer" will be needed with an auto-focus camera, some models of which are sensitive to the polarization of light. A polarizer is used to reduce reflections from non-metallic surfaces such as leaves and flowers, where it seems to intensify color. The effect is strongest at an angle of view of about 54 degrees (the Brewster angle) and is especially marked with reflections from still

FIG. 21 Frangipani (*Plumeria rubra*). Paying attention to composition does not compromise the botanical record but produces a more pleasing result.

water, where plant colors and other details beneath the surface are clearly seen. A polarizing filter also reduces glare and accentuates the blue of a clear sky, especially at right angles to the sun's direction. This has to be used with care with fields of flowers to avoid unnaturally darkened skies.

Backgrounds

It is nearly impossible to find a colored background that is not obviously artificial. Black backgrounds can be very effective with plants and are a matter of taste and fashion. Black flock paper, obtainable from craft suppliers, offers the best true black but in close-up work black backgrounds occur naturally when any background is too far to be illuminated by the small flash guns used. Many photographers set plants against a neutral background and then use image manipulation programs to select and cut out flowers or plant parts and change the background as required. Great care in making the selection and feathering of edges is essential to produce a natural-looking result.

Camera-free Photography

A simple flatbed scanner can create a virtual digital herbarium, where specimens never fall apart or fade. To avoid squashing and distortion it is essential to lift the lid slightly above the specimen with supports and cover with a black cloth to avoid light seepage into the scanner. The effect is extremely good and many scanners have an unexpected depth of focus, high resolution, and well-modeled lighting, which are perfect for leaves and working well with flatter flower heads. This can often be a substitute for some kinds of close-up and macrophotography.

Some mistakenly believe that plant photography with its static subject material offers an easier form of nature photography than any other. In reality, it offers as many challenges as any branch of image-making and with the facilities offered by digital cameras, imagination is the only limit. Information

capture in botanical photography is paramount, but no one need say "its only a record" as aesthetics are also important.

See also the following articles

Biological Photography; Infrared Photography; Nature Photography; Photomacrography and Close-Up Photography; Photomicrography; Remote Sensing

FURTHER READING

Davies, P. C. (2003). *Nature Photography Close Up.* New York: Amphoto (2003) ISBN 0-8174-5019-X.
Davies, P. C. (2002). *Photographing Plants and Flowers.* London: Collins and Brown.
Davies, P. C. (1998). *The Complete Guide to Close-up & Macrophotography.* Newton Abbot: David & Charles (1998) ISBN 0-7153-0800-9.

ADDITIONAL INFORMATION

Macro, Nature, and Travel Photography
www.hiddenworlds.co.uk ◎

Cave Photography

DAVID MALIN
Anglo-Australian Observatory, RMIT University

Caves, lava tubes, and their man-made relatives sewers and mines, are challenging and rewarding photographic subjects. Some are also potentially dangerous. They are a part of the natural world that is mostly inaccessible to many people.

A few walk-in caves may be photographed as easily as any other dark space, but others are very big and an on-camera flash will not be adequate. In addition, the unusual and wonderful formations found in caves are best revealed with off-axis lighting so anything other than direct on camera snapshots will require some specialized skills, imagination, and perhaps customized equipment.

There are many problems to be faced by the serious speleological photographer. These include water and condensation; confined, slippery, and muddy conditions; and sometimes poor ventilation as well as the more obvious dangers of caves in general. There is also (usually) a complete absence of natural light. This last problem can be turned into an advantage, since the photographer has complete control over the lighting that is used. On the other hand, some of the most spectacular caves are vast, so lighting and composition can be a challenge. Also, access to some caves which may be under water or severely cramped, will limit the size of camera and light sources that can be conveniently carried in. As a consequence of the variety of locations and many possible variations, it is impossible to be specific.

For anything other than on-camera flash, the darkness of a cave allows the photographer to paint the scene with light using

a series of carefully aimed flashes with the camera shutter left open. This requires some practice to produce natural-looking yet dramatic results. The process can be simplified by using a slave with a flash, triggered by the main flash. Of course such slaves can be triggered by anyone else's flash as well, so caution may be necessary. Some serious cave photographers prefer the superior light output of flashbulbs, but these are difficult to obtain and are bulky in quantity. In most cases an experienced helper is an advantage and is essential in situations where a fall or other potential injuries could be life-threatening.

A more flexible alternative is to use a digital camera and take a series of images with different lighting without moving the camera. These can be composited in software at an appropriate time with appropriate adjustments of the separate images as individual layers. This approach allows the incorporation of as many images as necessary to obtain the desired result, eliminating those that add nothing. This method also allows focus shifts and the incorporation of natural light (from cave entrances, for example).

Whatever method is used, protection of equipment from knocks and scrapes, mud, and water is essential. Fast, wide-angle lenses are preferable, but a zoom may be useful for inaccessible detail. Other requirements are powerful flash guns and flash-activated slaves or flashbulbs, with an appropriate power supply. Big caves seem to soak up light, so a powerful flashlight is essential for focusing and composition— autofocus may not work in high humidity, or where contrast is low. It will be useful to know the guide number of your flash gun, but beware of fog from breath or clothing reflected flashlight, especially from on-camera flashes. When practicing film techniques with small formats and fast lenses, an ISO 200 film is a reasonable compromise between speed and quality for middle and long shots. For larger formats (and thus slower lenses) ISO 400 to 800 should be considered.

Finally, a cave can be a delicate yet potentially very dangerous natural environment that is easily and permanently damaged by unthinking visitors, especially those inclined to wander.

I want to thank Paul Fretwell with his help with this topic.

See also the following articles
Geological Photography; Nature Photography; Underwater Photography ◉

Chronophotography

ANDREW DAVIDHAZY
Rochester Institute of Technology

Chronophotography, as its name suggests, is the photographic capture of movement over time by means of a series of still pictures, which are usually combined into a single photograph for subsequent analysis. This differs from cinematography in that the final result is a single photograph comprising a series of still images that can be studied at leisure, without the complex projection equipment needed for motion pictures.

Muybridge's Experiments
Among the first applications of chronophotography were the investigations conducted in Paris by Professor J. Marey around 1870, which related human and animal motion by means of various mechanical devices. He called the photographic records chronographs. An American racehorse owner, Governor Leland Stanford of California, doubted the results of some of Marey's investigations into the locomotion of racehorses—in particular the hypothesis that there was one instant when a trotting horse had all of its feet off the ground simultaneously. E. J. Muybridge, an English photographer living in San Francisco, was commissioned to confirm Marey's findings.

In 1877, Muybridge succeeded in proving that Marey was right, and in doing so produced what was the first true chronophotograph. These classic pictures were made by arranging for a horse and rider to pass in front of a row of cameras with shutter releases connected to threads stretched at regular intervals across the path. As the horse came opposite each camera in turn, it broke the thread operating that particular shutter and took its own photograph. The series of photographs, when printed on one sheet of photographic paper, yielded a continuous chronophotograph.

In 1880 Muybridge devised a projection instrument, which he called zoopraxiscope, to demonstrate the movement. Between 1884 and 1885 he extended his chronophotography to the movement of a great variety of animals and humans. In this series he used up to 36 cameras with shutters electrically operated by a clockwork device.

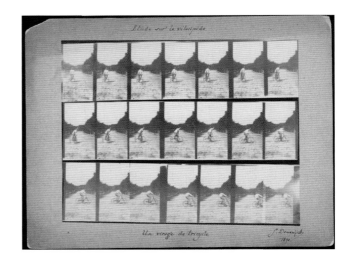

FIG. 22 An example of chronophotography by Étienne Jules Marey. "Etude sur le Velocipede," 1891 albumen print. Image courtesy of George Eastman House Collection.

Marey's Single Negative

Muybridge's experiments prompted Professor Marey to adopt the photographic approach to his own research and experiments. He constructed various cameras designed to record the whole series of chronophotographs on the one negative. His first apparatus, constructed in 1882, consisted of a plate camera equipped with a spring motor-driven rotary disc shutter with a number of regularly spaced apertures. As each aperture passed in front of the plate, it recorded the position at that instant of an object moving across the field of the camera. A small object moving quickly recorded a series of separate images on the plate, the space between depending on how fast the shutter was rotated.

If the subject was large in relation to the speed or rotation of the shutter, the successive images overlapped and gave a confused picture. Marey overcame this difficulty by putting his subject into a black suit with a white strip sewn down the arm and leg facing the camera. He then took the photographs against a black background and obtained a series of separate images of the white stripes. This way he was able to produce records of the movements of the limbs of people walking or running past the camera.

Marey's next development was a "gun" that took a series of pictures of a moving subject and recorded them separately on a single plate. The gun carried a circular plate in front of which was a disc with 12 openings around its circumference. In front of this disc was a second disc pierced with a slit. On pressing the trigger of the gun, a clockwork mechanism rotated the discs. The disc carrying the 12 frames rotated 1/12 of a revolution while the disc carrying the shutter slit revolved once, so that each of the 12 openings appeared in turn behind the lens and was exposed through the slit. The result was a plate carrying 12 separate photographs showing successive attitudes of the moving subject. This gun successfully recorded chronophotographs of birds in flight, taking 12 successive pictures per second with a shutter speed of 1/720 second.

In 1883 the French government established a department of physiological research in Paris, where Marey carried on chronophotographic investigation of the movements used by humans and animals in various forms of activity. Marey subsequently recorded chronophotographic sequences on long rolls of paper and finally, roll film and in 1892 was able to project them.

All of his instruments for this study suffered from an inherent disadvantage: The sensitized material had to be transported fast enough to separate the image and brought to a sudden stop at each instant of exposure. In practice this meant being restricted to very small images to reduce the amount of shift of the material between each exposure. This type of record could be useful only if the individual pictures were large enough to be examined in detail, because the sensitized materials of the time would not permit a high degree of enlargement. For this reason a number of workers in this field chose to develop the Muybridge approach of making the successive exposures in a number of separate cameras.

Other Systems

The apparatus used by General Sebert in 1890 consisted of six full-sized cameras mounted in a circle with an electric motor in the center. The motor carried an arm that rotated and operated the shutters of each camera in turn. This arrangement was used for photographing projectiles.

A year or two after this, Albert Londe constructed a camera in which sets of lenses equipped with electromagnetic shutters formed separate images regularly arranged to occupy a single plate. One six-lens camera used a 13×18cm plate, while one with 12 lenses covered a 24×30cm plate. In these cameras, there was a separate clockwork selector switch, governed by a metronome that operated each of the shutter solenoids in turn, allowing a variable time interval between the successive exposures according to the speed and range of the action to be analyzed.

In the mid-1880s, O. Anschutz, working in a parallel direction to Muybridge, constructed and used chronophotographic arrangements of up to 20 cameras. Like Muybridge, he devised a method of reproducing the movement from his results. He mounted his pictures on a drum that could be rotated to bring each picture in turn into a viewing aperture. As each picture came into view, it was illuminated by an electric spark so that as the drum rotated, the observer saw a moving picture.

Present Day Use

Researchers in other countries have also been interested in depicting movement by means of chronophotographs, but, although chronophotography was directly responsible for the development of cinematography, it pursued its own distinct course right up to the present time. There is a basic difference between these two methods of photography. In both, a series of still pictures for detailed study is recorded, each picture freezing a particular phase of the action. In cinematography the object will produce a moving picture of the entire event, while in chronophotography the image is stationary, but captures its motion.

The still pictures taken in chronophotography are usually of a larger format and of a higher standard of definition than a motion picture would be. Today some of the most important applications of chronophotography are in time-and-motion study.

A special type of chronophotography that is reminiscent of Marey's early apparatus is carried out today with electronic flashes operating as stroboscopic light sources. The subject moves against a dark background and is illuminated by an intermittent flash while the camera shutter is left open. This produces a succession of images on the same frame, each image displaced both in time and space from the preceding one by an amount that depends on the frequency of the flashes and the speed of the movement.

Chronophotographs can also be made on a single sheet of film with the moving subject remaining essentially in the same general location over time. In this manner H. E. Edgerton, in the mid-1900s, produced a significant body of work examining the motion of athletes, most notably golfers and tennis players, and various animals.

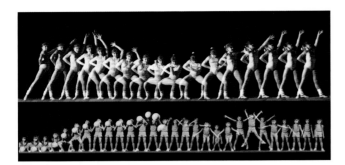

FIG. 23 Stroboscopic chronophotographs made with a flashing light source and with the film moving in the camera. The separation between consecutive images of a subject that was moving but remaining essentially in the same location is controlled by the rate of the flash flashing and the rate at which the film moved within the camera. (Images copyright Andrew Davidhazy.)

These photographs typically can only record action over a short period of time because the sequence of exposures interferes with images recorded earlier in the action. To overcome this limitation, photographers have swung the camera while recording the action, but this calls for very large dark studios, and the length of time available for recording motion is limited by the time it takes the subject to traverse from one side of the viewfinder to the other.

A variation on this approach, but one that is also a true chronophotograph, involves moving the film while the action, illuminated by a stroboscopic flash, takes place in a restricted location in space against a dark background. The duration of the event that is studied now can be much longer, extending easily into tens of seconds of several minutes at usual sampling, or flashing, rates of 10 flashes per second or so.

Because of the short duration of the flash, it is possible to analyze extremely rapid motion, while movements of a dancer or athlete photographed in this way can produce scientifically informative and artistically beautiful images.

Digital Techniques

The arrival of digital imaging has offered several new possibilities for chronophotography. A unique digital technique for generating chronographs came about with the introduction of a "frame store" instrument that stores changing image information within successive frames captured at various rates by a conventional video camera. The device would store only information from consecutive frames that was either of a higher or lower value than that preset within the memory device. If one chose a dark background to begin with and the subject everywhere reflected more light than the level for which the system was set, then as long as the subject remained stationary it would simply rise to some level due to the lighting present and stay there no matter how long the exposure. However, if parts of the subject, or the whole subject, moved between frames, the memory device would keep the initial stationary image on the screen but show where the moving subject's parts were at a later time. Unlike a film record the device does not "overexpose" stationary parts of a subject because exposure is not cumulative, but is rather a visual representation of a particular level during the exposure time associated with a single frame.

A further development in chronophotography came about with the advent of digital imaging technology and the application of computer programs or software to the production of images that mimic traditional techniques, which are also possible to duplicate with conventional digital still cameras.

Most of the software-based digital techniques rely on the capture of a record of a subject's motion typically based on the use of a traditional motion picture camera or other motion capture device such as a camcorder, firmly affixed to a tripod. Each frame of a short action sequence captured at speeds of 15, 30, or 60 frames per second is digitized (if original is "analog") and subsequently The digitized frames comprising the action are then examined and those where the action appears to visually connect from one frame to the other are extracted and stored. One might select every frame or every "n"th frame depending on how many frames can be practically used to describe a brief action, such as that of a skier completing a jump. A frame without any action is used as the reference frame, and the image of the subject in action is extracted from each frame (and stored) based on the fact that each frame remains the same from frame to frame except where the subject covers a different area of the frame. This is done for all the frames in the sequence. They can then be pasted one after the other in their proper place within the original frame that did not include any action. The images are often "cleaned up" for small imperfections. Software that almost completely automates the whole process of assembling a chronographic record is now available.

The big advantage of chronophotographic assembly based on this digital approach is that unlike stroboscopy, it is possible to show events in full daylight if needed. There is no danger of "overexposing" the background. The shutters of digital motion cameras can also be adjusted for very brief exposure times to keep blurring of most moving images within acceptable limits.

See also the following articles

High Speed Cinematography; High Speed Still Photography; Medical Photography; Streak and Strip Photography; Time-lapse Photography ◉

Darkfield Illumination

DAVID MALIN
Anglo-Australian Observatory, RMIT University

Darkfield illumination is usually encountered when an image is formed from light entering the subject obliquely and off the optical axis. The most common application of darkfield

FIG. 24 This photograph, made of a disposable soft contact lens, is an excellent example of the benefits of darkfield illumination using a camera magnification of 1:1. (Photograph by David Curtis.)

FIG. 25 This photomicrograph of a Bryozoan statoblast reveals structures as a result of the illumination that otherwise would be invisible. Magnification at capture ×10. (Photograph by Chiedozie Ukachukwu.)

illumination is found in optical microscopy, but the technique is widely used or recognized for creating contrast in low-contrast situations. In a perfectly clear, transparent medium the field would remain dark, but in the presence of a refractive index boundary or a scattering surface or particles, light is deflected into the optical axis and is observable, such as dust in a sunbeam. The key component is a method for preventing on-axis light from the main source of illumination flooding the focal plane. The scattering of light by normally unresolved particles or otherwise invisible refractive index boundaries is a key feature of the technique.

Though this sounds rather elaborate, a simple example is a home aquarium set against a dark background and lit from the top. The technique is useful also for macro specimen photography—especially revealing the subtle structures of cataracts in eye lenses, jellyfish, amoeba etc.—using ring-illumination. On a larger scale the zodiacal light (from dust in the solar system) and the detection of the backscattered light in the shadow of the planet that led to the discovery of the rings of Jupiter are also good examples of darkfield illumination at work. ◉

Dental Photography

WOLFGANG BENGEL, DDS
Dentist

Dental photography deals with the special photographic procedures associated with dentistry. There are some specific challenges in this field, which justify it as a specialty within medical photography. The aim is to document the state and changes in teeth, mucous membranes of the mouth, and the perioral region under conditions that can be readily reproduced.

In intraoral photography one of the main problems is difficult access to the objects to be photographed, which are hidden in the oral cavity. This makes illumination difficult and special equipment is needed to create good images. Other problems are the highly reflective areas in the mouth and objects that show big differences in brightness, which leads to exposure difficulties. As the main purpose of taking photos is documentation, a certain standardization is necessary with respect to framing, inclination of the camera, magnification ratio, and illumination. In addition, objects of interest are tiny, which means working in the macrophotography regime, where magnification ratio, depth of field, perspective distortion, illumination, etc., become important. At the highest magnification ratios we need lighting that shows the outline of the object, the surface texture, the color, and even some inner structures of our semitransparent teeth as well.

Technical Equipment
The camera system mainly used for dental photography consists of an SLR camera (today normally a digital one), a macro lens, and a flash.

Camera body
Every major camera manufacturer offers one or more camera bodies for the advanced amateur, many of which are suitable for dental photography. More expensive professional bodies and cameras with full-format digital sensors are not absolutely necessary for use in dentistry. A resolution of 6 megapixels is

sufficient for most purposes. A viewfinder screen with a grid is very helpful for aligning the camera to get reproducible results.

Macro lens

The reproduction ratio required for dental work may be approximately 1:3 (perioral region) as defined on the chip size and 2:1 (upper middle incisors filling the frame, or individual molar). In conventional film dental photography, a 100 mm macro lens was the recommended standard lens. Because most digital cameras use smaller detectors than film, a lens factor (typically 1.5) has to be taken into account, so a 60 mm macro lens will also work and will produce a different working distance. The advantage of a shorter focal length is that the whole system is rather small. Because of the short object distance, a macro flash or a ring flash should be used in combination with a 60 mm lens. A twin flash will create problems when combined with a 60 mm lens because of the lighting angle.

Flash

As intraoral photography is photography within a cavity, a ring flash or ring flash-like macro flash is widely used. An inexperienced user will quickly achieve good results with such a flash, even when taking shots of the especially challenging molar regions. The disadvantage of ring flash lighting is that results mostly lack image plasticity and look rather flat. Better results can be obtained when using twin flash systems. Their light output is higher, which results in larger depth of field and illumination shows more three-dimensionality. A disadvantage of using twin flashes is that for every single shot, the position of the reflectors has to be checked and corrected.

Other Considerations

Important accessories for intraoral photography are lip and cheek retractors, photographic mirrors, and contrasters, which are black backgrounds placed behind the teeth to improve image composition and eliminate distracting background. Mirrors may be made of metal or (better) surface-coated glass, and cutting off one end of the retractor facilitates mirror photography, especially the occlusal views. Mirrors with plastic or metal handles are easier to use. These mirrors create their reflection from the top surface rather than the traditional rear surface.

Standard Views

Reproducible conditions for photography are sensible because they save time and achieve consistent results. For these reasons it makes sense to take the basic intraoral views in a standardized approach. The essentials of this are that the optical axis should run through the occlusal (bite) plane—photographing from below distorts the perspective of the incisors. In lateral views, photographs should be perpendicular to lateral teeth (with the aid of a mirror), and occlusal views should be as near perpendicular to the camera as possible (also with the aid of a mirror). Finally, the occlusion plane should be parallel to the horizontal frame of the photograph.

The correct orientation is an important factor in producing reproducible images and to improve perception. The basic intraoral views can differ for an orthodontist, who specializes in the prevention or correction of irregularities of the teeth, and the periodontist, who deals with the treatment of the gums, soft tissues, and bones that support the teeth. However, it is important to continue to follow the same standardized procedure once chosen.

Other, often-used special fields of dental photography are basic techniques such as copy work, generating teaching visuals, portrait photography, object photography, and photography in the operating theater. Here the general guidelines of the specialties have to be followed. In portrait photography, standardization is mandatory: Framing, camera position, patient position, and illumination should be reproducible.

The main problems of dental object photography are that objects of interest are tiny in most cases and some are highly reflective polished metal. Others have a very low object contrast (e.g., white casts) or are semitransparent. Beside

FIG. 26 A ceramic inlay using a photographic mirror as background to create a contrast background. (Photograph courtesy of Wolfgang Bengel, DDS.)

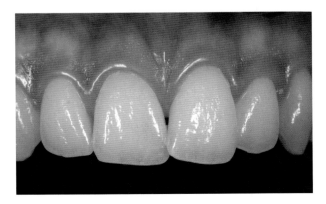

FIG. 27 This photograph reveals the proper orientation for a front view of the teeth. (Photograph courtesy of Wolfgang Bengel, DDS.)

general problems of macrophotography, innovative lighting techniques (light tent, transmitted light, etc.) have to be used for optimum results. Finally, in dental surgery, access to the operating field is difficult and it is not easy to get a clean and dry situation. Thus, even with modern techniques and equipment, dental photography is challenging.

See also the following articles

Medical Photography; Photomacrography and Close-Up Photography 🔾

Electron Imaging

RICHARD ZAKIA
Rochester Institute of Technology
DOUGAL G. McCULLOCH
RMIT University

Electron imaging is the production of images using electrons rather than light. For example, the image on a cathode ray tube is produced by a scanning electron beam, which excites phosphors, which in turn emit light on the screen. Electron images can be viewed directly as on a television screen, radar screen, or oscilloscope, or they can be photographed. If high resolution is required, then special electron-recording film or charge-coupled device (CCD) cameras are used to record the electron beam image directly.

See also the following article

Electron Microscopy 🔾

Electron Microscopy

DOUGAL G. McCULLOCH
RMIT University

Introduction

Electron microscopes are scientific instruments that use beams of energetic electrons to examine objects on a very fine scale. Based on the design of optical microscopes, electron microscopes exploit the fact that fast moving electrons have a much smaller wavelength than visible light, which results in high-resolution images. Electron microscopes can routinely image at magnifications over 1,000,000×, compared to light microscopes which are limited to magnifications of the order of 2000×.

Electron microscopes use an electron gun to generate the beam of energetic electrons. Whereas the light microscope uses glass lenses to magnify and focus images, the electron microscope uses magnetic lenses to magnify and focus images. Since electrons cannot travel freely in air, electron microscopes are built into airtight metal tubes or "columns" and use vacuum pumps to remove all the air from within the microscope.

There are two main types of electron microscope: (1) the transmission electron microscope (TEM) and (2) the scanning electron microscope (SEM). Figure 28 compares images of a dinoflagellate (Gymnodinium), which is a type of unicellular algae, taken using (a) an ordinary light microscope, (b) a TEM, and (c) a SEM. In general, the TEM image provides high-resolution information on the internal structure of a specimen while the SEM provides a detailed image of the surface structure of a sample. It is clear that both electron microscopes provide higher resolution images than is possible using a light microscope.

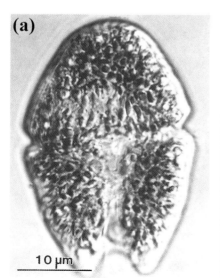 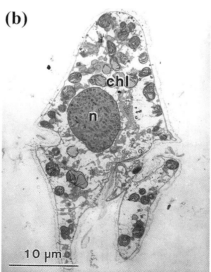 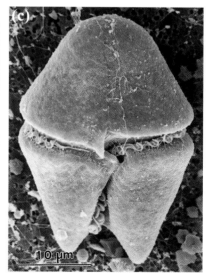

FIG. 28 Images of the dinoflagellate Gymnodinium taken using (a) an optical microscope, (b) a TEM of a thin section, and (c) SEM. (Copyright 1999, Australian Key Centre for Microscopy and Microanalysis, The University of Sydney, Australia.)

The Transmission Electron Microscope (TEM)

The basic layout of a TEM is shown in Figure 29. It consists of an electron gun as the source of "illumination" at the top of a column containing a series of lenses, the specimen, and the imaging system. The layout of the TEM closely resembles that of a compound light microscope, which is also shown alongside for comparison purposes. Both microscopes use a condenser lens to focus the illuminating beam (either electrons or light) onto the sample and an objective lens to produce a focused and magnified image of the illuminated area. One or more projector lenses are then used to project a magnified image of the specimen onto the imaging system. In the case of an optical microscope this is the eye, film, or a charge-coupled device (CCD), while in a TEM images are viewed on a screen that fluoresces when struck by electrons. Traditionally, grayscale still images were captured on silver halide film or plates situated beneath the viewing screen that were exposed to the electron image and then processed to a negative, as in conventional photography. Photographic capture of images is gradually being replaced with digital capture using electron-sensitive CCD cameras.

Two factors complicate the imaging of samples in a TEM. First, due to the limited penetration of electrons in matter, specimens for TEM must be extremely thin (approximately 0.1 micron). Second, since the specimens must be inserted into the electron microscope column which is under vacuum, they must be completely dry. This latter point requires biological samples to be dehydrated and fixed prior to viewing. There is a range of TEM specimen preparation techniques available depending on the type of sample. Solid, inorganic samples can be thinned using a combination of mechanical, chemical, and

ion beam thinning. Thin biological specimens are normally prepared using ultramicrotomy, which involves slicing thin sections of the sample using a sharp glass or diamond knife. Surfaces can be replicated as thin films of carbon and shadowed with heavy metals to produce remarkably realistic images of surface relief. As with most kinds of microscopy, specimen preparation is an important and specialized area of expertise.

Contrast in TEM images can arise in several ways. Variation of mass and/or thickness gives rise to contrast due to greater absorption or scattering of electrons from heavier and/or thicker parts of the specimen. To increase contrast in biological specimens, tissues are often "stained" with heavy metals. Another contrast mechanism is known as phase contrast. Unlike phase contrast in optical microscopy, phase contrast results from the interference between electrons, which have different phases after passing through the specimen. Phase contrast can be used to directly image the crystal structure of a specimen at atomic resolution.

Electrons passing through a specimen can be "reflected" off planes of atoms in a process called diffraction. In addition to producing images, a TEM can be configured to produce electron diffraction patterns from specimens. Similar to X-ray crystallography, electron diffraction can be used to determine the structure of a crystalline specimen.

The Scanning Electron Microscope (SEM)

The layout of the SEM is very different from a TEM, as shown schematically in Figure 30. The SEM column consists of the electron gun and then several magnetic lenses, which are used to focus the electron beam into a small spot onto the sample surface. Unlike the TEM, there are no lenses after the specimen in a SEM. Scan coils are used to deflect the finely focused electron beam to create a tiny rectangular grid of parallel lines (a raster, as in a cathode ray tube) over the area of interest, while detectors measure the number of electrons that are displaced from each point on the surface. An image of the scanned area is generated on a video display, which is synchronized with the scan coils of the SEM so that the relative position of features is correctly displayed. The magnification of an SEM image is governed by the difference between the dimensions of the video display (normally fixed) and that of the area scanned on the specimen surface. Increasing magnification is achieved by scanning smaller and smaller areas on the specimen. Grayscale images are captured and stored digitally. The resolution of an SEM is determined primarily by the size of the electron spot, which is of the order of 1 to 2nm on modern instruments.

Specimens for conventional SEM need to be electrically conducting so that charge built up in the surface from the incident electron beam can be conducted away. This problem can be overcome by insulating specimens with a covering of thin, electrically conducting coatings, typically of gold or platinum. Conventional SEMs are also limited by the fact that a high vacuum must be maintained in the sample environment, requiring completely dry specimens. Low vacuum or "environmental" SEMs can overcome both these limitations. These

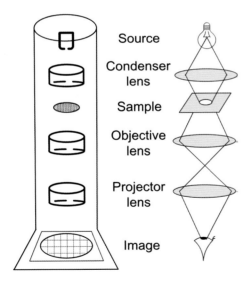

FIG. 29 Schematic showing the basic layout of a TEM. The design is similar to that of a conventional light microscope (shown on the right). Note that the projector lens in the light microscope is normally called the ocular or eyepiece.

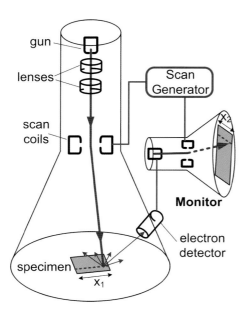

FIG. 30 A schematic showing the layout of an SEM.

FIG. 31 Colorized image of a maggot using multiple detectors in an SEM. (Courtesy of J. Ward, CSIRO & Scion, Australia.)

instruments use pressure-limiting apertures to maintain the gun and column at high vacuum while allowing much higher pressures in the specimen area. Therefore hydrated specimens can be imaged in their natural state. In addition, specimen charging is neutralized as positive ions are attracted to the surface from the surrounding gas, so non-conducting specimens can be imaged without the need for coatings.

There are two main types of electron detectors used in an SEM. The first measures the number of electrons, which have backscattered off the sample surface (known as backscattered electrons). The second detector measures the number of electron, which are ejected from the material (known as secondary electrons) following collisions with the incident electron beam. Images generated using secondary electrons are extremely sensitive to surface morphology, while those generated using backscattered electrons are sensitive to the atomic weight of different regions of the sample. In both kinds of microscopes, it is relatively easy to make stereo pairs of images by tilting the specimen a few degrees along an axis parallel to the viewing direction. These often give a much better impression of the surface relief than single pictures.

Although images derived from collected electrons in an SEM are grayscale, color images can be artificially generated by combining secondary and backscattered images collected from the same sample. An example of a colorized SEM image of an insect is shown in Figure 31.

Elemental Identification in Electron Microscopy

When an electron beam interacts with matter, X-rays and other electromagnetic radiation can be emitted as a result of collisions between the incident electrons and electrons within the atoms that make up the specimen. The energies of the emitted X-rays are characteristic of the element from which they originated. It is thus possible to perform elemental analysis on minute specimens and samples in an electron microscope by measuring the energies of these X-rays. Modern electron microscopes also allow the spatial distribution of elements in a sample to be determined in a technique known as elemental mapping. Some materials such as CRT phosphors, minerals, and some organic compounds emit light when bombarded with electrons, and "cathodoluminescent" images can be made using this light in the SEM. By using three exposures and color filters, true-color images of the luminescence can be reconstructed that have a useful diagnostic value.

Complimentary Techniques

Another technique, which does not involve electron optics or beams, can be used to provide high magnification images of specimens. This is scanning probe microscopy (SPM), where an atomically sharp, needle-like tip (called a probe) is scanned across the surface to be studied. As this tip is scanned, variations in the topography of the surface are measured. An atomic-scale image of the surface can be built up by rastering the probe over an area of the surface. The two main variants of SPM are scanning tunneling microscopy (STM) and atomic force microscopy (AFM). STM uses a small electrical current that can pass between the tip and the surface of a conducting sample to monitor variations in surface topography. In AFM, variations in the surface are detected via the inter-atomic force between atoms on the tip and those on the surface of either an insulating or conducting sample.

FURTHER READING

Goodhew, P. J., Humphreys, J., and Beanland, R. (2001). *Electron Microscopy and Analysis (3rd Edition).* London: Taylor and Francis. ⊚

Endoscopic Photography

ANDREW PAUL GARDNER, BSc ABIPP MIMI ARPS RMIP
UCL Ear Institute Photographic Unit

Endoscopic photography includes the acquisition of an image from inside any inaccessible space using some form of optical transmission lens system. Images are viewed using a mirror or conveyed through a series of lenses and prisms in a rigid tube, through flexible fiber-optic devices or captured by miniature sensors at the end of a suitable probe. Endoscopy, which means to look inside, is derived from the Greek *endon* "within" and *skopein* "look at."

Endoscopy is a routine procedure in medicine and veterinary science used to explore body cavities and internal structures either through natural orifices or through small incisions during "keyhole surgery." A range of surgical procedures may be performed using miniature instruments passed through channels alongside the optical components of the endoscope.

Endoscopes are also used to inspect cavities and other inaccessible parts of buildings, machinery, and any other physical structures. They allow covert observation and photography of activity within enclosed spaces such as animal or bird nests or during security and surveillance operations. Specially reinforced endoscopes are used to inspect extreme and hostile environments such as within combustion chambers or nuclear facilities. Endoscopes can provide realistic views and "walk-throughs" of architectural models by providing a ground level viewpoint of a scaled street scene.

Endoscopes date from antiquity and were either bladed devices to enlarge an existing opening or simple open tubes, often tapered to permit easy insertion and to allow light to enter the cavity. Archaeologists have discovered Roman instruments designed to examine the human ear, nose, throat, vagina, and rectum. Early endoscopists used either sunlight or candlelight for illumination. Although endoscopes had greatly improved by the early nineteenth century, lack of adequate illumination prevented the pioneers of medical photography from obtaining endoscopic photographs. John Avery, MD, a surgeon at the Charing Cross Hospital, London, may have experimented with endoscopic photography in the 1840s. Using a mirror held at the back of the throat, Johann Nepomuk Czermak obtained the first endoscopic photograph, a view of the larynx, in 1860. In 1878, Theodor Stein made a camera, the "Heliopiktor," which could be used with different optical devices including endoscopes. By the late 1880s, doctors began to obtain useful endoscopic images, taking advantage of improvements in photographic emulsions and aided by miniature electric lamps built into the endoscope tip.

Modern rigid endoscopes have a complex optical design developed by Professor Harold Hopkins in the UK. "Hopkin's Rod" endoscopes deliver bright and high quality circular images that may be focused through a lens onto a film or image sensor. Some have a straight optical axis, but others include a prism at the tip to provide an angled view.

In 1957, Basil Hirschowitz introduced fiber-optic endoscopes, which allowed an image to be carried along a long, flexible, instrument that could be guided through the digestive tract. These use a "coherent" fiber-optic bundle in which the relative position of each fiber is the same at the entrance and exit face to ensure the correct transmission of an image. This is made up of a regular dot pattern, corresponding to the pattern of fibers at the exit face, and limits the resolution available.

As smaller image sensors were developed, endoscope manufacturers designed equipment in which the image was captured directly at the endoscope tip rather than carried optically to a camera attached to the eyepiece. This "chip on a stick" technology can be implemented in the larger diameter endoscopes, either rigid or flexible, to produce very high-quality digital still images or video. A far higher resolution is possible than with fiber-optic endoscopes.

Endoscopic illumination is now typically provided by non-coherent fiber-optic guides that run alongside the image path. In many biomedical applications, where heat can damage delicate tissues, a cold light source is used in which heat is filtered from the light. Portable, battery-powered, light sources are available for industrial and other off-site applications.

The most recent development is capsule endoscopy, where a small capsule containing a miniature video device with its own light source can be swallowed, which transmits images to a recorder worn in a belt. This permits recording throughout the digestive system, including those areas beyond the reach of other endoscopes.

See also the following article
Medical Photography

FURTHER READING
Berci, G. (1976). *Endoscopy*. New York: Appleton-Century-Crofts.

Hecht, J. (1999). *City of Light: The Story of Fiber Optics*. New York: Oxford University Press.

Katzir, A. (1993). *Lasers and Optical Fibers in Medicine*. London: Academic Press.

Ray, S. F. (1999). *In Scientific Photography and Applied Imaging*. Oxford: Focal Press, p. 497–508.

Reuter, M. A., Reuter, H. J., and Engel, R. M. (1999). *History of Endoscopy: An Illustrated Documentation*. Vol. I–IV. Stuttgart: Nax Nitze Museum.

Zetka, J. R. (2003). *Surgeons and the Scope*. Ithaca, NY: Cornell University Press.

ADDITIONAL INFORMATION
Given Imaging
 http://www.givenimaging.com
Karl Storz Endoscopy
 http://www.karlstorz.com/
Richard Wolf GmbH
 http://www.richard-wolf.com

False-Color Photography

DAVID MALIN
Anglo-Australian Observatory, RMIT University

The word "false" in this application means unreal or artificial; it does not necessarily mean fraudulent. False-color images can be made in many ways but in general they are the combined display of two or three monochrome images (information channels) taken of the same subject at different wavelengths or showing variations of some kind. These images may be made in radiation that we cannot see (UV or IR), or cannot photograph in any conventional way (acoustic, gamma ray, radio etc.).

Photographic or digital processes can then be used to apply a color to the monochrome information channels and combine them to reveal or emphasize their differences. If these separate information channels approximate to visible parts of the spectrum and they are combined using similar passbands, the result is a true-color image. Where any one or all of the channels is made of invisible radiation or the recombination is made with non-corresponding colors the result is a false-color picture. Because the human eye can discern a much greater variety of colors than gray tones, subtle differences and often unexpected relationships become obvious in the reconstructed color images that are not seen when comparing the black and white originals side by side.

Where two colors are involved a more natural-looking result is obtained if the channel colors are complementary (e.g., blue and orange), so that adding equal parts produces gray or white. The same is true with three channels (RGB), but in scientific false-color imagery the colors are often selected for optimum scientific return rather than a visually pleasing result. Because of the tri-color nature of the human visual system, using more than three channels can result in loss of information. Note that colorized monochrome (single channel) images are described as pseudocolor.

The most common false-color pictures and the false-color materials most accessible to the general photographer are those made with infrared film. This emulsion is a tri-pack color film, but with the uppermost of the three layers specially sensitized to infrared light. Like most color films the layers are also sensitive to UV and blue light, so it is used with a sharp-cut minus blue (i.e., yellow) filter, which does not allow blue light or UV to reach the film. The result is that infrared radiation appears as red and green reproduces as blue while red reproduces as green. Similar results but more versatility can be obtained with a digital camera and the appropriate software.

Applications for false-color imaging include detecting plant disease, camouflage, examining buildings for heat loss, masking, scientific recording including UV microscopy, scanning electron microscope imaging, differential autoradiography, all kinds of astronomical and satellite imaging and, of course, unusual pictorial effects.

See also the following articles

Aerial, Infrared, Multispectral Imaging; Pseudocolor; Remote Sensing ◎

Fluorescence Photography

DAVID MALIN
Anglo-Australian Observatory, RMIT University

Fluorescence is electromagnetic radiation emitted by gaseous, liquid, or solid materials as a result of an irradiation with light, X-rays, or electron beams. In fluorescence, all or part of the absorbed energy is re-emitted at the same or longer wavelengths. If the emission of energy continues after the excitation source is removed, the phenomenon is called phosphorescence. The emission can be in the visible or ultraviolet (UV) region of the spectrum if a molecular electronic transition is involved, or in the infrared region (IR) if it is a vibrational transition. The transitions to this state are brief, so the emission occurs within nanoseconds. Other mechanisms are involved with fluorescence outcomes induced by electron beams and X-rays.

Ultraviolet Fluorescence

In most applications of interest to photographers, the exciting radiation is UV energy, often from a "blacklight," a mercury vapor tube coated with Woods glass (Kodak Wratten 18A or equivalent) to filter out the visible emission lines. Some flash units also strongly emit in the UV region, especially if their UV filters are removed and a Woods glass filter is used. UV energy is dangerous to the eyes and skin of humans and its effects are not immediately observed, so care is essential when working with continuous UV sources.

There are two principal types of UV fluorescence: primary (autofluorescence), in which fluorescence is intrinsic, and secondary in which fluorescence occurs because of the treatment of the sample with a fluorescing substance (a fluorochrome). Primary fluorescence is most often seen in mineral specimens, and a common example of secondary fluorescence is clothing that has been washed in "whiter-than-white" detergents. The selective dyeing of specimens with fluorochromes is important in fluorescence microscopy. For completeness, it should be mentioned that many of the colorful clouds of glowing gas (emission nebulae) seen in astronomical photographs are fluorescent hydrogen and other elements excited by UV radiation from hot stars. The earth's atmosphere filters out much of the UV radiation from the sun.

Apart from the astronomical applications, to photograph these effects the camera is usually set up in a darkened room or enclosure containing the UV source. Two filters are normally required. One is a blocking filter that restricts the subject illumination to the required wavelengths, and is often Woods glass. A visually colorless, UV-absorbing barrier filter is used on the camera lens. This prevents UV radiation from reaching the film or detector and obscuring the fluorescence effect. The filter also prevents components of the lens itself from fluorescing. Since the light to be recorded is visible light, both film and digital cameras can be used, however, exposure times can be long and are usually determined by trial and error. Also, Woods glass filters have a "red leak" that does not affect

film but may be visible to charge-coupled devices (CCDs), so an additional cyan filter may be required on a digital camera.

UV fluorescence photography is used in forensic, geological, medical, and ophthalmologic photography.

Infrared Fluorescence

In this situation, the fluorescence is the emitted radiation (rather than the exciting radiation). Certain materials emit IR radiation when visible or UV radiation is absorbed. This property is sometimes called luminescence but is actually a special form of fluorescence. Again, two filters are required. A pale blue-green, heat-absorbing filter is placed over the light source as a blocking filter and prevents any IR emitted by the source from reaching the subject. A second, barrier filter such as a Kodak Wratten 88A that only allows IR to pass is placed over the camera lens. This is visually opaque and its function is to block all visible light. In most cases exposures are very long, though the excellent IR sensitivity of some digital cameras can be usefully exploited. Some astronomical objects also emit IR fluorescence from interstellar hydrocarbons.

The exciter filter can be omitted if the incident radiation can be limited to visible wavelengths by using a source that emits only wavelengths shorter than IR. Wavelength-tunable lasers provide such a source, and they have the added advantage of easily selecting from a wide range of wavelengths for exciting fluorescence in the infrared or other areas of the spectrum. Applications include document photography for forensic work and examining works of art. Chlorophyll also has a natural IR fluorescence and the technique is also used with fluorochromes to differentiate cell types in medical imaging, or with nanocrystal materials (quantum dots) for use in biology, drug development, and diagnostic procedures.

X-ray Fluorescence

The most common example of X-ray fluorescence is the intensifying screen used to record radiographs. X-ray film is placed in close contact with two sheets coated with the fluorescing material. The effect of the excited fluorescence on the silver halide particles is greater than from direct absorption of X-ray energy alone, thus reducing the required X-ray dose.

Most elements fluoresce under sufficiently powerful X-rays and images can be made of this X-ray fluorescence. Uses include archaeology, semiconductor research, crystallography, and many applications where non-destructive chemical analysis and the spatial distribution of trace elements is required. These techniques require rather elaborate sources and detectors.

Cathodoluminesence

Some compounds emit visible light when bombarded by an electron beam. The most familiar example is the face of a CRT TV screen. However, in a scanning electron microscope (SEM), the visible-light luminescence induced by the beam can be collected with a photomultiplier and used to make images in the same way as normal SEM images, revealing differences in chemistry and composition on small scales. The same electron beam can generate X-rays that can also be imaged in the same way.

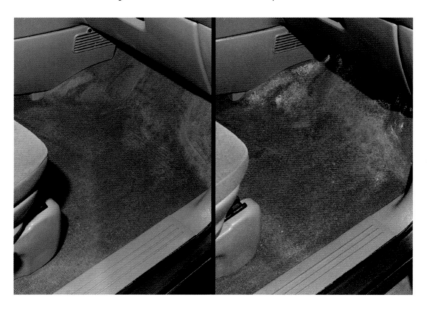

FIG. 32 Photographs of the floor of an automobile, which showed no visible sign of blood (left). After spraying with Luminol (right), parts of the carpet exhibit blue luminescence, revealing traces of blood. Luminol does not require a light source to produce the chemiluminescent reaction. The image at the right is a double exposure suing a long exposure in darkness (to capture the blue glow) with a fill flash. (Photograph by Keith Mancini, Westchester County Forensic Lab, New York.)

Forensic Photography535

Nanocrystal materials—(sometimes called quantum dots) for use in biology, drug development, and diagnostic procedures.

See also the following articles
Electron Microscopy; Forensic Photography; Geological Photography; Medical Photography; Ophthalmic Photography

Kodak Publication No. M-27 (1968). Ultraviolet & Fluorescence Photography. Rochester, NY: Eastman Kodak Company.
Stroebel, L. (1990). *Basic Photographic Materials and Processes.* Boston: Focal Press.

A detailed review of UV and IR fluorescence
http://msp.rmit.edu.au/Article_02/00.html
Images of flowers seen under UV light and by their UV fluorescence
http://www.naturfotograf.com/UV_POTE_ANS.html
Spectral selectivity, filters, IR, and UV photography
http://www.photo.net/photo/edscott/spectsel
Ultraviolet and infrared photography summarized
http://www.rit.edu/~andpph/text-infrared-ultraviolet.html

Forensic Photography

RMIT University

Forensic photography refers to the making of images to record objects, scenes, and events to be used for and within the legal process. Forensic photographs may be taken specifically for documentation, analysis, intelligence, or for court presentations. To be used in court, pictures must be allowed under the rules of evidence that apply in a particular jurisdiction. These rules will indicate whether the images provide information relevant to the court and thus can be admitted as evidence.

Imagery may also be used to extract forensic data such as the measurement of distance, dimension, or location, or to disclose normally invisible detail (e.g., X-ray, infrared, ultraviolet). In the latter cases, the photography may be introduced in court to demonstrate where the data came from, but the resulting testimony associated with the presentation of the images would be more analytical.

Offices of the medical examiner or coroner, police, government agencies, or even insurance companies may employ forensic photographers. Forensic photographers have specific knowledge of the technical nature of photography as well some understanding of laws pertaining to the use of photographs as evidence. However, any photograph may become a "forensic" photograph if it adds information required by the court and can be admitted as evidence.

In all cases, the photograph must be verified with respect to its accuracy and interpretation by the person who created the photograph, a person familiar with the scene or object or by an expert in the field of photographic analysis. This opens up the possibility of experts having a different interpretation of the photograph; however, in the end, all opinions must be supported by a scientific analysis.

Some photographers may offer their services as freelance forensic photographers, while some in the academic community may offer their experience and services to create or interpret images as expert witnesses or consultants. These photographers and experts will have specialist knowledge in areas such as photogrammetry, optics, materials, and processes as well as other technical expertise useful in the interpretation or verification of the authenticity of photographs.

Forensic photographs must demonstrate a fair and accurate representation of the scene, object, situation, or event and be able to be analyzed for information required by the courts. The forensic photographer should be experienced, knowledgeable, and able to anticipate questions that may be asked in an adversarial environment about what the photograph may reveal. These questions may include cross-examination with regard to the accuracy of color, measurements derived from the images, spatial relationships, and the resolution of fine detail; indeed, any point that may undermine or enhance the value of the image as evidence. A qualified forensic photographer will attempt to anticipate these questions and use photographic procedures, protocols, and techniques to cover all contingencies.

Forensic photographs span a wide variety of techniques and use a variety of equipment. Almost anything that will produce an image of forensic relevance, from electron microscope to medical X-ray, is a possible application. The primary

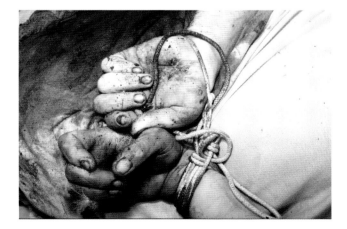

FIG. 33 Evidence may be transient such as how a knot was tied to bind a victim in a homicide. After removing the rope at autopsy the only record of how the knot was tied will be the photograph. A need may arise to compare the photograph with similar crimes to link a perpetrator to various events.

motivation that dictates the process is what questions may be asked in court and what is determined to be relevant. The photographer's knowledge must be wide and cover legal issues from local rules of evidence to an understanding of fundamental methodology, optics, light, and to a capture material's performance in certain situations. For thorough forensic analysis, it is not enough to simply take photographs of an object at a crime scene. Forensic photographers should document the scene from several locations and orientations to establish as much objectivity as possible showing any forensically relevant detail within the entire scene. Where possible, scales should be included and measurements and technical camera data and position should be diligently recorded.

A photograph, whether taken for forensic purposes or not, cannot testify for itself; that is, someone must establish its credibility and verify the information of interest in it. The photograph may be made by a forensic photographer, a police photographer, a specialist in photomicrography/photomicrography, or even an amateur at the scene. Images may be taken while an event is occurring, such as a surveillance video, just after the event, or some time later—even years. Similarly, contemporaneous photography of some historical event may be interpreted years later to yield new forensic evidence or insight.

Police photographers primarily take photographs for the police records, documentation, and investigation. Depending on the protocols set out by their agencies, the procedures may be more or less rigorous. Police photographs may be presented in court. These may be in a set taken by the police photographer covering the entire scene or selected photographs. Police photographs should be taken with the same scrutiny as a forensic photograph. They may not be taken with the same thought of future analysis.

Analysis

In analyzing a photograph as evidence, it is important to clearly identify the question that is asked of the photograph. Is it a question of color, detail, spatial relationships, distances, or identification? A photograph may be technically correct in exposure, processing, and printing, but still unable to demonstrate or quantify a specific requirement. For example, black and white photography cannot indicate the color of objects it depicts, unless the spectral sensitivity of the combined detector and filter is known. It may be equally impossible to greatly enlarge an area to gain sufficient detail for an identification of an object or person.

Similarly, precise photogrammetric measurements may not be possible if the original photograph is out of focus or if the focal length of the lens is not known. If there is not enough resolution or sharpness in the original, an enlargement will not reveal additional detail. In fact, enlargement may introduce artifacts that may mislead those not knowledgeable about imaging processes. Finding or identifying a specific point for measurements will be difficult if not impossible and may create varying opinions, thus weakening the use of the image as evidence.

The determination of the size of objects may not be possible without a known scale of size included in the photograph or other technical details noted at the time the photograph was made. Information such as the focal length of the lens and the camera-to-subject distance may prove invaluable in the analysis of the image.

Considerations for Defining a Forensic Photograph and Photographer

Do the photographs tell a complete story? Are they an unbiased, objective approach to the subject or scene? Are they of sufficient quality to be analyzed? Has all the technical data been recorded? Can the photographer explain in court how the photographs were taken and offer assistance in their interpretation? Are post-production methods clearly outlined? This is especially important for digital images.

Forensic photographs should be well-documented as to when and where the photographs were taken, who was the photographer, and what equipment was used. The specific time may be important to add information later if a "reconstruction" is required. The position of the sun and shadows may add additional information about date, time, or season of the year.

In low-light situations where photography is used to reconstruct or demonstrate the event, consideration must be given to the different responses by the human eye and the film, video, or digital capture device, especially with regard to color. The forensic photographer must therefore have more than rudimentary knowledge about how photographic recording differs from visual perception (see *Night-Time and Twilight Photography*).

A forensic photographer must be aware of the importance of camera point of view, the created photograph's perspective. The compression or expansion of perspective through the use of extremely wide angle or telephoto lenses may lead to misinterpretation by a people who do not understand this phenomenon. The relationship between viewpoint and perspective must be fundamental to the working and theoretical knowledge of a forensic photographer.

Zoom lenses are not recommended for forensic applications since their focal length cannot be determined. This can confuse measurements and comparisons of objects in space.

Final Words

Forensic photography is as much a state of mind as a discipline. Forensic imaging is a branch of scientific photography and its practitioners should be guided by strict procedures and protocols and supported by documentation in every aspect of creating the photographs. This includes recording details of equipment/materials, processing and printing information as well as noting time, conditions, distances, scales of size, and the like. Enhanced detail and color may also be questioned in digital and video imaging since much of the processed image comes from interpolation. The concept of the "chain of evidence" is central to forensic photography and is especially true of digital images where their credibility may be questioned due to the ease of manipulation. Ideally, for digital still photography, the original RAW files should be retained as primary

evidence in cases likely to be contentious. This approach marks forensic photography as an integral part of scientific imagery.

Organizations
Evidence Photographers International Council (U.S.)
 www.epic-photo.org
Royal Photographic Society, Imaging Science Group (UK)
 www.rps-isg.org
The Institute of Photographic Technology, (Australia)
 www.iptaustralia.com
Biomedical Communications Association (U.S.)
 www.bca.org
Crime Scene and Evidence Photography (U.S.)
 www.crime-scene-investigator.net
International Association for Identification (Scientific Working
 Group on Imaging Technologies (SWIGT; U.S.)
http://www.theiai.org/guidelines/swgit/

GLOSSARY TERMS
RAW files—An unaltered digital image downloaded from a digital camera with a header that records the camera identification number, camera settings, and other data about the image. May also be referred to as a native file.

See also the following articles
Fluorescence Photography; Image Manipulation; Infrared Photography; Night-Time Photography; Photomicrography and Close-Up Photography; Police Photography

FURTHER READING
Blitzer, H. L. and Jacobia, J. (2002). *Forensic Digital Imaging and Photography*. London: Academic Press. ◉

Geological Photography

ANTHONY H. COOPER
British Geological Survey

Geological photography records the rocks, deposits, and processes that characterize the earth's crust and landscape. It includes photomicrography and photomacrography as well as the photography of specimens including rocks, fossils, and minerals on location, aerial photography, and remote sensing. It includes the photography of natural rock exposures, land-scapes, caves, mines, quarries, and the recording of geological processes such as volcanism, landslides, and erosion. The dividing line between photography and digital imaging in geology is blurred, with computer-dependent techniques like multispectral scanning, imaging spectrometers, 3D tomography, and image enhancement providing powerful visualization and recording tools for rocks, minerals, and fossils.

History of Geological Photography
Geological photography goes back almost to the start of photography itself. Some of the earliest geological photographs were landscape pictures taken by Timothy H. O'Sullivan (1842–1884) during American frontier expeditions in the 1860s and 70s. In England, Victorian photographers and keen geologists such as William Jerome Harrison (1845–1908) and Godfrey Bingley (1842–1927) used the then new medium to record quarries and exposures, with Harrison publishing the first geological book illustrated with photographs in 1877. From 1885 onward, photography began to replace engraving as the main recording instrument for geological monochrome illustrations in books, and geological surveys began their photographic collections.

Photography in the Field
Camera equipment for field use has to be lightweight, easy to use, and capable of returning results suitable for lectures and publication. A light, 35 mm SLR camera (or a compact camera) with a 28–70 mm zoom lens that has a close focusing facility is ideal. Alternatively, a small water-resistant 5–8 megapixel digital camera with a spare battery and large amount of memory makes an ideal field camera. A tripod is useful, but often impractical to carry on fieldwork. A walking pole with a camera mounting screw in the handle is a useful substitute; alternatively a rucksack or pile of rocks can make a good camera support where slow recording speeds are required. A polarizing filter is handy for removing reflections from wet exposures or rocks in streambeds.

The landscape is geology, so good landscape photography can make good geological photography: If it can be taken near dawn or dusk it can also be beautiful, but harsh midday light, or strongly oblique light, may be required to illuminate some geological features. Pictures of geological exposures can range from whole cliffs to sedimentary structures and fossils. The inclusion of a scale is important and a person set to the side of a photograph is useful, but a scale of known length is better. Geologists commonly include a hammer, lens cap, or coin in photographs for scale. Unfortunately, hammers that range

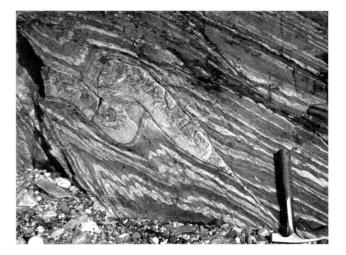

FIG. 34 Water-worn surface of folded and cleaved mudstones and sandstones, Isle of Man. Hammer 279 mm (11 inches) long.

from 100 g to 1.5 kg can all look the same on film; coins and lens caps are similarly variable. The best scale is one marked in centimeters and 10-cm sections placed near the edge of the photograph. Rock exposures are rarely memorable so a good practice is to take two photographs and include location details on one of them (grid reference or latitude and longitude) written in felt tip pen on a piece of rock or paper. For close-up photographs the screen information of a global positioning system can be included. The angle of the light on the exposure is important for showing weathered textures, but smooth rock exposures can benefit from being wetted and photographed using a polarizing filter. Photography underground is specialized and the techniques of cave and mine photography are similar (see *Cave Photography*). Geology is not just static and processes such as erosion and deposition should be recorded. Geological hazards affect human lives, so floods, glaciers, volcanoes, landslides, and subsidence lend themselves to reportage-type photography.

Photography in the Laboratory

Camera equipment for use in the laboratory can be similar to that for the field, but the addition of a macro lens and extension tubes on an SLR, or a close focusing facility on a digital camera are essential. Good macro photography technique and the elimination of camera shake are important. A strong tripod or copy stand and cable release (or remote control) are essential. Lighting can be simple using small desk lamps, but an 80A filter for film, or digital cameras with white balance adjustment are required. Flash can be difficult to use especially if it is on the camera as the lack of any modeling light makes good results difficult.

Paleontological photography is like portrait photography, where harsh light and heavy shadows lose detail. Light should be diffuse, but directional lighting is also needed to show the fossil form. This light must come from the upper left, otherwise the fossil relief may appear inverted. Heavy shadows can be removed by photographing the fossil on a glass plate suspended above a neutral gray or white background. To show subtle features fossils can be selectively whitened by puffing sublimed (heated) ammonium chloride onto the specimen, a thin coating emphasizes sutures and fine surface details. For dark gray carbonaceous fossils on dark gray rock, detail can be shown by photography under water or alcohol, and with the light sources and lens covered by polarized filters. Digital imaging with computer manipulation (separating and combining channels and/or focus) can be used to tease information from unpromising specimens. X-rays, infrared, and ultraviolet photography may also help to image difficult subjects.

Minerals vary from glassy and transparent to metallic and earthy. Lighting techniques for photographing glassware (backlighting and darkfield illumination) can show details. For reflective specimens, careful angling of the light and the use of polarizing filters can control the illumination and show detail.

Photography of microfossils and thin sections is best done through a modern microscope with dedicated photographic attachments. Reasonable results can be achieved using camera attachments on microscopes, or by using a copy stand and

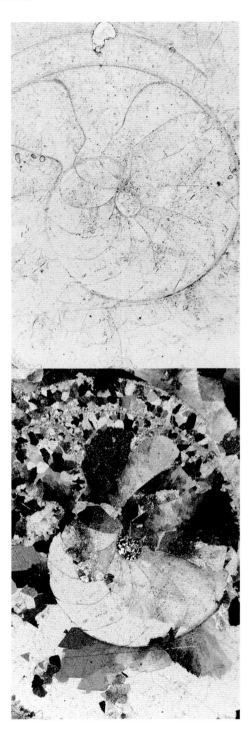

FIG. 35 This composite photomicrograph reveals the advantages of using polarized light microscopy when examining a fossil thin section in a microscope. The subject, a polished fossil of a Cephalopoda, was ground to a thickness of 20 μm. (Photographs by Michael Peres.)

light tight trap between the camera (lens removed) and the microscope eyepiece; attachments to fit small digital cameras to microscopes are also available. Vibration from SLR shutters is a problem with microscope photography so the use of flash, or timing the light source will be useful. In geology, thin sections of rock are ground and polished to a standard thickness (0.02–0.03 mm); the transparent section can then be photographed with either transmitted light or crossed polarized light. With crossed polarized, transmitted light, one polarizer is located beneath the thin section and one at right angles above the objective. This situation gives bright polarization colors that help to define the mineral types. Reflected light microscopes and photography are used for metallic minerals and small opaque microfossils.

See also the following articles

Cave Photography; Nature Photography; Photomacrography; Photomicrography

GLOSSARY TERMS

Anisotropy—A descriptor for a physical property (e.g., density, refractive index) that varies depending on the direction in which it is measured.

Crossed polarization—Illumination of a transparent solid placed between two polarizing materials (polaroid or crystal polarizers) positioned so that the planes of polarization are at or near to right angles to each other. The material near the light source is the polarizer and the material near the viewing source is the analyzer. When crossed, very little or no light passes through the analyzer, but the presence of certain minerals or plastics effectively rotates the plane of polarization of the light, allowing it to pass through the analyzer. The technique shows strain structures in plastics and the characteristic polarization colors of minerals that help with their identification.

FURTHER READING

Bengtson, S. (2000). Teasing fossils out of shales with cameras and computers. *Palaeontologia Electronica* Vol. 3, issue 1, art. **4**, 26, http://palaeo-electronica.org.

Crabb, P. (2001). The use of polarised light in photography of macrofossils. *Palaeontology* **44**, 659–664.

Delly, J. G. (1988). Photography Through the Microscope. Eastman Kodak Company, Kodak Publication P2, p. 106.

Harcourt Davies, P. (2003). *Small Things Big, Close Up and Macro Photography*. Newton Abbot, UK: David & Charles, p. 160.

Howe, C. (1977). *Images Below*. Cardiff, UK: Wild Places Publishing, p. 280.

Kummel, B. and Raup, D. (eds.) (1965). Handbook of Paleontological Techniques—Prepared Under the Auspices of the Paleontological Society. San Francisco, CA: Freeman and Company, p. 852.

Loveland, R. P. (1970). *Photomicrography* (2 vols.). New York: John Wiley & Sons, p. 1052.

Scovil, J. A. (1996). *Photographing Minerals, Fossils and Lapidary Arts.* Missoula, MT: Geoscience Press, p. 224.

Sutton, M. D., Briggs, D. E. G., Siveter, D. J., and Siveter, D. J. (2001). Methodologies for the visualization and reconstruction of three-dimensional fossils from the Silurian Herefordshire Lagerstätte. *Palaeontologia Electronica* Vol. 4, issue 1, art. **1**, 17, http://palaeo-electronica.org.

Wilson, W. E. (2005). Advanced lighting techniques for mineral photography. Axis Vol. 1, No 2. pp. 1–36, http://www.MineralogicalRecord.com ◎

High-Speed Cinematography

PETER W. W. FULLER
Consultant in Instrumentation and Imaging Science

High-speed cinematography involves motion picture recording at rates exceeding about 50 pictures, or frames per second (fps). It is used to photograph movement and events too fast to be perceived by the unaided eye or by lower framing rate methods. Such recording requires camera and lighting systems specially built for the task.

High-speed cine is also capable of expanding time. If an event is photographed at a high framing rate, with standard film cameras (see Group 1 and 2 below), it can later be replayed at a lower framing rate, apparently slowing the rate at which events occur and allowing the unaided eye to follow the motion. For cameras in Group 3 and 4, the same basic principles can be used, but playback and analysis is more complex. Originally, film was the only available recording medium, but now much of the recording is achieved using electronic systems. Present techniques enable framing rates up to about 100,000,000 fps to be achieved.

The various regions of high-speed cinematography have been defined in many ways and have been extended as the technology advanced. One classification system is as follows: high speed is 50 to 500 fps using intermittent film motion and mechanical shuttering; very high speed is 500 to 100,000 fps using continuously moving film, image compensation, and digital video systems; ultra high speed is 100,000 to 10 million fps using a stationary film with moving image systems and image converter cameras; and super high speed is in excess of 10 million fps where film has been largely superseded by purely electronic imaging and recording.

The boundaries between groups are not precise as cameras employ combinations of techniques. It is unfortunate that the superlatives were initially used too readily before the abilities of the last two groups became possible.

High-speed cameras of Group 1 are specially developed versions of normal cine cameras. Framing rate is limited by the physical strength of the film. The stresses imposed by starting and stopping the film as it is moved intermittently through the gate can exceed the breaking point of the film base, with tears usually occurring at the sprocket holes.

The fastest framing rates are 300 fps for 35 mm film and 1000 fps for 16 mm film. On the higher quality cameras in this range pin registration is used. During the exposure phase, the film is precisely located by pins to ensure accurate alignment and stability. These cameras are limited to about 500 fps.

In Group 2 cameras, film stress is relieved by moving it smoothly and continuously through the camera. However, to avoid blur, some form of image compensation is required to ensure the image is focused on the film and moving at the same speed during the exposure period.

In cameras of Groups 3 and 4 the film is stationary or completely supported on a drum and the image is moved along the film. As the required framing rates rise, electronic cameras increase in importance and take over from film.

Rotating Prism Compensation

These cameras were designed by F. J. Tuttle in the 1930s. A rotating glass prism of regular form (a parallel sided block, cube, or octagon) is placed between the objective lens and the moving film in this type of camera. Prism rotation, shutter opening, and film transport are synchronized by gearing. By refraction or reflection, the incoming image is moved in the same direction and at the same speed as the film. Thus during exposure there is no relative motion between image and film. Suitable masks can be used to limit exposure time to the period when compensation is possible. Smaller apertures can be used to produce shorter exposure times.

Film strength limits its rate of transport speed through the camera and maximum full frame rates are limited to 20,000 fps for 8 mm film and 10,000 fps with 16 mm film. Increasing the number of facets on the prism can increase frame rates to 20,000 for half-height frames on 16 mm and 40,000 for quarter-height frames. This limits possible applications but can still be used on, for example, projectiles in flight, where the reduced height is acceptable.

Rotating Drum Systems

Some improvement in speed, at the expense of total recording time, can be obtained by attaching a length of film to a rotating drum so that the film is supported and the limit is set by the strength of the drum. Drum cameras can include a simple type where the film is on the outside of the drum and the image is focused by means of a lens and a slit at right angles to film motion. This forms a simple streak camera. This can be changed to a framing camera by removing the slit and illuminating the event with a short duration multiple pulse laser or strobe light. In both cases access to the film must be limited to one complete resolution to prevent overwriting.

In more complex camera types, the film is placed on the inside of a rotating drum and image compensation provided by a spinning multifaceted mirror with the image conveyed to the film by a stationary mirror. Again, image access must be limited to prevent overwriting. Framing rates may reach 100,000 fps. The films produced do not correlate film frames with sprocket holes, so for projection purposes considerable manipulation of the record is required. For the highest speed drum cameras it may be necessary to evacuate the drum chamber to overcome air drag.

Rotating Mirror Cameras

Development of these very high framing rate cameras was necessary to satisfy the need to photograph atomic bomb research toward the end of World War II. They are designated as working on the "Miller" principle, named after the inventor.

In these cameras the film is stationary and fixed inside a circular housing and can cover an arc of 90, 180, or 360 degrees. The subject is imaged near the surface of a rotating mirror and is then reflected to be re-imaged onto the film by an arc of lenses. As the mirror rotates the incoming image passes sequentially across the lenses and on to the film at a very high rate. Exposure time can be varied by changing

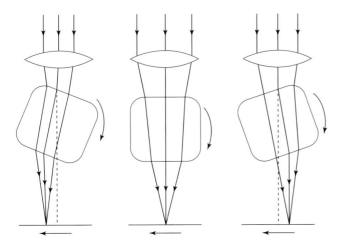

FIG. 36 Compensation for film movement using a rotating glass block. Block rotation rate and film speed are synchronized by common gearing. The image refracted by the glass block remains stationary relative to the moving film.

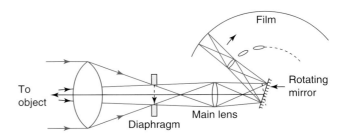

FIG. 37 Rotating mirror framing camera. The objective lens images the subject onto a rotating mirror via a relay lens. The reflected image is then focused onto the film by a bank of small lenses. As the mirror rotates, successive images are exposed on to the stationary film.

aperture stops. Mirrors can have one or more faces, allowing another to take over when the first loses the image, and recording continues by an alternative optical path.

These cameras do not produce photographic records directly that are available for projection as with cine films. To avoid the reprinting required and as the number of frames is usually small, analysis is done frame by frame.

Because of the nature of these recording systems and the high level of synchronization required, drum and rotating mirror cameras are often allowed to control the event and its lighting. Using multiple programmed switching, a sequence can be set off by the camera so that by the time it is ready to record, lighting is on, access shutters open, the event has reached the required part of its sequence, and the recording is made. When all film has been used the capping shutter is shut.

Capping Shutters

Capping shutters are used in two main applications: when photographing self-luminous subjects with high-speed cameras, where the luminosity can continue after the required exposure has been completed, and again when using rotating drum or rotating mirror cameras. In the latter case, they are used to open the shutter at the instant when the mirror or drum is in the correct position to start recording and to close the shutter after all the film has been exposed, to prevent over-writing.

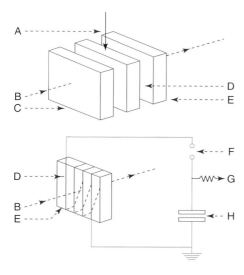

FIG. 38 In the shatter shutter a glass block is sandwiched between two Plexiglas plates. At the end of the exposure an explosive charge shatters the glass and so obstructs the light. In the spattered wire shutter (bottom), a pulse of high-tension current fuses a lead wire wrapped around a glass block in the light path, splattering lead over the glass and obstructing the light. (A) explosive force, (B) light path, (C) Perspex plates, (D) glass block, (E) lead wire, (F) trigger, (G) high-tension supply, and (H) high-tension capacitor.

Such capping shutters are required to operate in $10\,\mu s$ or shorter increments, either in opening or closing mode. These timing requirements are much beyond the capability of normal shutters, so special systems must be used. Cut-off systems include the spattering of lead wire onto a glass window by passing a high current through the wire or by explosively spraying an opaque mixture (e.g., lamp black plus a greasy binder) onto a window, explosively shattering a glass window sandwiched between two sheets of Plexiglas such that it becomes opaque by multiple scattering, or explosively collapsing tubes through which the beam is passed.

Cut-on systems are mostly operated by electronically or explosively removing a barrier in the beam. Most capping systems involve a discharge circuit requiring thousands of volts and large capacitors.

Multiple cameras

A series of pictures taken in sequence by a number of single-shot cameras can be considered as a form of cine photography (see the section Stroboscopic Photography in *High-Speed Still Photography*). Advantages are better image quality per frame, flexibility in frame interval, and a reduction of image movement.

The basic principle of these systems is illustrated by reference to the Cranz-Schardin type of shadowgraph camera. For non-self-luminous events, an arrangement of short duration light sources is grouped together and correlated with a similar grouping of cameras or camera lenses. The event takes place between light sources and cameras. All light source beams are passed in turn through a common condensing lens or via a concave mirror, allowing them to illuminate the event. The beams are then focused by their associated lenses onto individual cameras, or onto a common film. Framing rates up to 100,000 fps can be achieved. However, the number of frames is relatively small, 10–20. The pictures obtained tend to be qualitative rather than quantitative, and analysis is difficult because each picture is taken at a slightly different angle to the others.

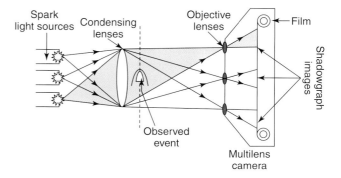

FIG. 39 Cranz-Schardin multi-frame shadowgraph camera. Light from each spark source travels through a common lens and the image is relayed to each spark's companion camera.

Kerr cell and Faraday shutters have been used in these systems (see *High-Speed Still Photography*), but their use has mostly been superseded by electronic camera systems having their own high-speed shutters.

Optical Delay Cameras

A convenient quantity to remember is that light travels approximately 1 foot (about 30 cm) in 1 ns. Thus if the incoming image is sent over a number of increasingly long paths to the camera, a series of photographs can be obtained with very short intervals between frames. The increasing path length for successive beams is achieved by the use of beam splitters and mirrors. A disadvantage of the systems using beam splitters is that the image intensity gets progressively weaker due to losses in the beam splitters. Alternatively, the image can be presented successively to each path mirror by reflecting the incoming image from a mirror rotating at high speed.

Electronic Cameras

Over the last decade the abilities and usage of electronic cameras has increased rapidly. In the lower framing rate regions up to around 50,000 fps, charge-coupled device (CCD) video cameras are now used, often in preference to film cameras. There are several advantages, including almost immediate access to the record, and in some cameras the ability to change framing rate during an event. Image storage is on magnetic tape, disk, or solid-state memory, and processing and analysis is done using a computer. There is also the ability to check lighting levels and image quality under event conditions before committing to actual tests. These advantages allow operation without a photographically trained operator as well as giving general overall savings in time, money and manpower.

For higher framing rates the image converter camera has become widely used. The essentials of such a camera is shown in Figure 42. The shuttering and deflection properties of image tubes can produce a short sequence of pictures on one tube with shorter exposures and higher deflection rates than other techniques. They can even intensify the available light, which makes it possible to record events previously not sufficiently bright to record on ordinary systems.

An advanced production camera, the Imacon 468, has eight combined camera systems, which record images in sequence with an exposure range of 10 ns to 1 ms, independently variable in 10-ns steps, with framing rates from 100 to 100,00000,000 fps. This is made possible by using a complex form of pyramid beam splitter that relays the image simultaneously to all eight cameras, which are arranged in a circle around it. The images are recorded by intensified CCD cameras, which are exposed in sequence. During the interval between each successive exposure for an individual camera (cyclic interval period), there is time for the image to be stored and the camera made ready for its next picture.

Timing

Moving-film cameras require timing marks to be recorded along the film to assist analysis. In many cases the film never achieves a steady velocity, so marks recorded at known time intervals along the film edge are needed to indicate film velocity (more precisely, the time resolution), at any point on the film. These timing marks can be produced by a variety of techniques and are regulated by an independent stable reference source. Earlier systems used a tuning fork interrupting a light beam. Current systems are mostly electronic and use adjustable crystal oscillators to drive argon, neon, or xenon lamps or light-emitting diodes (LEDs). Their light is imaged onto the film edge via narrow slits. At fixed intervals a longer mark will indicate the passing of a complete period.

Some sophisticated systems can project coded signals onto the film, which can give information such as time since start.

At framing rates below 1000 fps, an analog or digital clock can be imaged in the field of view and is visible during projection. In rotating mirror cameras, the mirror can be used to sweep a beam of light alongside the film, where it can, via suitable masks, record timing marks. Simultaneously, the beam is received by a photo-electric detector that can send out electrical pulses suitable for triggering events, light sources, and making measurements of camera sweep speed.

Illumination

Up to 50,000 fps a variety of light sources can be used, which include tungsten lamps, photofloods, flash bulbs, and electronic flash tubes. There are also several systems in which devices such as xenon arc lamps can be overdriven for a short period to produce a high-intensity source. In very high-speed cameras, metal vapor lasers can also be synchronized with mid shutter-open time to illuminate the event with a short duration pulse, allowing much shorter exposure times than that of the built-in shutter. For recording at the higher framing rates more illumination is required. Some events are sufficiently self-luminous to provide adequate light, otherwise high-power flash tubes, lasers, or argon flash bombs can be used, synchronized to the event and camera.

Streak Cameras

In this special type of high-speed camera, a very narrow segment of the subject is selected for analysis and continuous successive exposures of this segment are made so that all the visual changes during the recording period are observed. Thus the final photograph has exchanged one of its two space dimensions for a dimension in time. In its simplest form, the subject is imaged by the objective lens onto a narrow slit, thus selecting the portion to be analyzed. The slit image is then re-imaged onto the film. In this system the film motion must be at right angles to the slit orientation, or if the image is swept across stationary film, the slit must be at right angles to the axis of sweep. In electronic systems the same principles must be applied. The movement of the event is along the axis of the slit.

The main point of streak cameras is that the record has no inter-frame loss and is continuous. It is thus very useful for

TABLE 2 Typical Abilities of Different Types of Streak Cameras

	Drum	Rotating Mirror	Image Converter
Maximum writing speed (mm/μs)	0.3	20	1000
Recording time available (μs)	2900	15	0.075
Time resolution at maximum streak rate (ns)	14.5	5	0.15

fine resolution of very fast-changing subjects. The drawback is that the pictures produced show the changing positions of the boundaries between dissimilar media, i.e., a solid medium and its surrounding gas or flame fronts in media. As the record is one spatial dimension versus time, it is not a normal two-dimensional image and it can only be interpreted with background understanding of the manner in which the event is investigated.

The writing speed of streak cameras may be quoted in two ways, either as the relative speed of the motion of the slit image and film, or by the time it takes for the slit image to be moved by an amount equal to its own width. The first is quoted in millimeters per microsecond and the second in terms of time (seconds or fractions of seconds). This is the time resolution of the camera.

For cameras that are not continuously viewing, the event must be synchronized to the period during which the event can be recorded. Some cameras are designed to record both streak and framing records. These are very useful as the framing record can be used to help interpret the streak record.

For higher writing speeds, drum, rotating mirror, or image converters are used. In image converters, a slit-image of the subject is imaged on the photocathode. A streak image is produced by electronic deflection within the tube.

Synchroballistic Cameras

A technique that fits between streak and framing categories is the synchroballistic system. Here, the basic system is as in streak photography but the subject motion is parallel to the film or sweep motion. It is widely used in ballistic experiments to photograph projectiles with high image resolution. The set up is arranged using appropriate positioning of the system elements and chosen lenses, so that the slit is at right angles to film motion and the slit image on the film is moving in the same direction as the film and at the same speed. Each portion of the projectile will be photographed in turn and the film will record a still picture of the whole projectile. This is a streak image of the changes in a given slit in space, but it is also equivalent to a very short exposure with a focal plane shutter. During the recording period, all objects traveling along the same path will be recorded. If the velocities of the swept image and film are not exactly equal, the images will be elongated or compressed accordingly. The system is a high-speed version of

the photo-finish camera used to record the relative positions of competitors at the instant the first reaches the winning post.

Streak versus Framing Cameras

The cameras are not comparable as they are complementary. Framing cameras record two spatial dimensions at programmed intervals in time, thus it is possible for a change to occur between two frames that are not evident in either frame. On the other hand, a streak camera records one spatial dimension continuously in time, such that no change within the time period is missed. The streak camera is ideal for studying events of uniform growth or decay, e.g., an expanding sphere, where the rate of dimensional change is to be measured; however, the images can be easily misinterpreted. Streak cameras are also known as velocity recording cameras. A combination streak and framing camera provides the maximum amount of information and minimizes interpretation errors.

Applications

For application of up to about 20,000 fps, the subjects for high-speed cinematography cover a vast number of fields in both industry and research. The technique has made a huge difference in solving problems in industrial machines, e.g., in cigarette manufacture, where a small error in the setting of a minor part of a large machine can cause huge losses and long down time. These problems were originally solved by very long and tedious trial-and-error adjustments. High-speed photography allows the mechanism movements to be shown in slow motion, and the faults to be readily located. In safety research, typical applications are the impact of birds on aircraft windscreens and their ingestion into jet engines.

In research areas such as the development of internal combustion engines, high-speed cinematography allows the observation of burning processes and the behavior of items such as fuel injection mechanisms. For higher speed cameras the accent is on research in regions where subject movements are very fast indeed, e.g., armament research, missiles and explosives (both conventional and nuclear), supersonic aircraft research and space exploration, plasma studies for atomic energy reactors, and crack propagation in materials such as glass.

See also the following articles

Ballistics Photography; Chronophotography; High-Speed Still Photography; Streak and Strip Photography

FURTHER READING

Proceedings of the International Congress on High-Speed Photography and Photonics, held every two years, in locations round the world. Published by SPIE, The International Society for Optical Engineering. Bellingham, Washington.

Ray, E. S. (2002). *High-speed Photography and Photonics, 2nd edition*. SPIE and British Association for High-speed Photography and Photonics. ◎

High-Speed Still Photography

PETER W. W. FULLER
Consultant in Instrumentation and Imaging Science

High-speed photography embraces a variety of techniques that capture short duration events by means of one or more very short exposures. In general this topic covers photographs taken with exposure times shorter than 1/1000 of a second.

Leaf or diaphragm mechanical shutters in still cameras generally have a minimum exposure limit of about 1/500 of second, while modern focal plane shutters have achieved exposure times of 1/8000 of a second. Thus, for shorter exposures, other types of capturing methods, usually electronic, will be used. Short exposures may also be made with a spark, flash gun, or strobe flash combined with an open shutter. In all cases the aim will be the same, to arrest motion (avoid blur) in a picture. An alternative is to move the camera or the imaging detector so that it is synchronous with the subject. In this case static elements in the scene will be blurred.

It should be noted that in film cameras, diaphragm and leaf shutters expose all the detecting area simultaneously. Focal plane shutters build up the image by exposing the detecting area sequentially, via a narrow moving slit.

An empirical formula for the maximum permissible exposure time is:

$$T = L/500 \times V \text{ seconds}$$

where L is the largest subject dimension to be recorded and V is the subject speed in the same units as L per second.

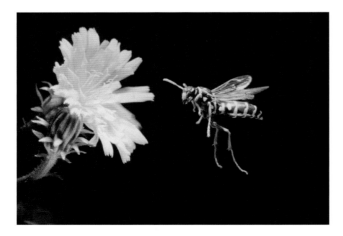

FIG. 40 This photograph of a Vespid wasp in flight was made by the wasp's own movement through a trigger light aimed in front of the flower using a high speed flash fired at 1/20,000 of a second. (Photo courtesy of Andrew Davidhazy.)

For example, if a car was moving at 100 kph (62 mph), equivalent to 27 m (100 feet) per second, the longest frame dimension would be about 14 m (50 feet).

Thus (using imperial units) $T = 50/(500 \times 100)$ or $T = 1/1000$ of a second.

This would be just on the limit for a normal shutter and no camera motion. Note that both V and L determine the exposure time—increasing V or decreasing L both demand shorter exposures. Many research subjects are both faster and shorter than a car.

A better method for determining exposure time is using the concept of maximum allowable blur based on subject dimensions. A decision as to what this dimension is will be subjective and depends on user-defined criteria. These may include a total absence of noticeable blur at a given degree of magnification of the reproduction, size of the smallest object within the subject of which useful detail needs to be recorded, etc. The formula also includes a factor that is of vital importance, i.e., the direction of subject motion relative to the camera film plane.

$$T = \frac{\text{size of smallest detail within subject}}{K \text{ (velocity of subject) (cos A)}}$$

where K is a quality constant, generally a number from 2–4 and A is the angle between the film plane and subject direction.

For example, a projectile traveling at 100 m/s (360 kph), within the imaging field of view where it is desired to perceive detail as small as 1 mm will require an exposure of 1/200,000 of a second (5 μs). In this example, angle A is zero degrees and the quality constant is 2. A rifle bullet will have a velocity several times greater than this example.

The two main methods of taking high-speed still photographs are the use of a suitable high-speed shutter system or the use of a short duration flash while the shutter is open. High-speed shutters may be magneto-optical, electro-optical, or completely electronic in the form of image converter tubes. High-speed flash systems may use electronic flash discharges, sparks, or single or multiple laser discharges. Other systems available include argon bombs, super-radiant light sources, and X-ray discharges for high-speed radiography.

Magneto-optical Shutter

The orientation of the plane of polarization of light passing through a transparent medium can be rotated by application of a strong magnetic field. This effect, discovered by Faraday, can be used to produce a fast-acting magneto-optical shutter. Dense flint glass is often used as the transparent medium as it reacts well to a strong magnetic field. The glass cell, surrounded by a magnetic coil, is placed between two crossed polarizers that effectively cut off the passage of light. When a strong magnetic field is applied to the glass cell via current in its surrounding coil, the plane of polarization is rotated through 90 degrees to be the same angle as that of the second polarizer, allowing a light beam to pass. The current is

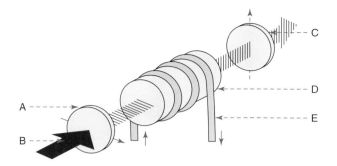

FIG. 41 Magneto-optical (Faraday) shutter. (A) First polarizer; (B) light ray from subject; (C) second polarizer; (D) glass cylinder; (E) coil. The second polarizer passes light only when the glass cylinder rotates the plane of polarization under the influence of the magnetic field. This is created by a high-voltage pulse passed through the coil.

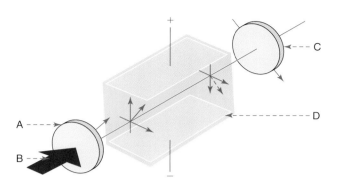

FIG. 42 Electro-optical shutter (Kerr cell). (A) first polarizer; (B) light beam from subject; (C) second polarizer; (D) electrodes in liquid cell. The liquid becomes birefringent on application of a high-voltage pulse to the electrodes.

substantial (e.g., 1000 amperes driven by 10,000 volts), and is supplied by discharging a capacitor through the coil using a spark gap switch. The duration of the open time of the shutter can be controlled by varying the discharge and the number of turns in the coil.

Typical exposure times can be as short as $1\,\mu s$ in duration. The system is placed in front of the camera lens or within the optical system. Magneto-optical shutters have an optical efficiency of around 70 percent and pass light throughout the visual spectrum range. However, the required magnetic field is very high and takes time to activate and remove, which limits the minimum shuttering time.

Electro-optical Shutter (Kerr Cell Shutter)

In 1875, John Kerr discovered that certain media, when placed in an electric field, exhibited birefringence so that light polarized in one plane has a different velocity in the medium to light polarized in a plane at right angles. A typical Kerr cell consists of a glass cell fitted with parallel plate electrodes between which the beam passes and the cell is filled with nitrobenzene. The cell is placed between two polarizers. The assembly is placed in line with the camera system, or within the optical path.

The first polarizer is set such that its polarizing plane is at 45 degrees to the original plane of polarization, i.e., at 90 degrees to each other. If a suitable voltage is applied to the plates (20,000 volts), the phase difference produced by the varying velocities is such, that on recombining at the second polarizer, the resultant plane polarized beam is in angular agreement with this polarizer. When no voltage is present, no phase change occurs and no light passes. Kerr cells can have opening times down to a few thousandths of a microsecond and have good imaging qualities.

The development of image tubes has meant that the use of Kerr cells and electromagnetic shutters has now been reduced

and are now they are only used in special types of research. For everyday use, the need for high voltage and high current supplies is a drawback. Whilst having low image degradation, the Kerr cell has poor optical efficiency with around 50 percent loss due to the polarization function, so operating light levels need to be very high. Another problem is that nitrobenzene is opaque to blue and ultraviolet light, a spectral range much used in high-speed photography.

Image Tubes

Beyond the capabilities of mechanical/film cameras the electronic camera takes over. A very important class of devices among the electronic cameras are those with image tubes. These include image converters, orthicons, image orthicons, and image intensifiers. Some of these can be used as high-speed shutters. Some metals, particularly cesium, have the property that, in a suitable electric field, they emit electrons when irradiated by light (the photoelectric effect). Conversely, some materials can emit light when bombarded by electrons (e.g., the phosphor on a television screen). A combination of such materials in an evacuated tube can act as an image converter.

The Image Converter

In an image converter, the input window is called a photocathode and acts as a light detector, while the output screen is the light emitter or phosphor screen. An image is focused onto the photocathode by a lens. The photocathode transforms the light image into emitted electrons, which are directed by suitable electric and magnetic fields, to the light emitter, re-forming a new light image that can then be recorded on film or CCD video cameras.

As an electron "image," the beam can be accelerated (and thus amplified), shuttered, and deviated electronically similar to an oscilloscope or television tube. At the phosphor screen the accelerated electrons are transformed into photons and

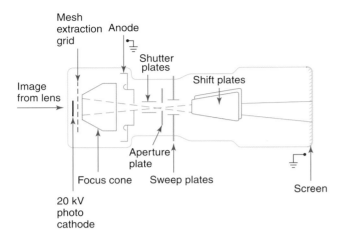

FIG. 43 Image converter camera. The incoming light image is transformed into an electron "image" by the photocathode. The electrons are accelerated and manipulated electronically within the tube and converted back into light images by the phosphor screen (right).

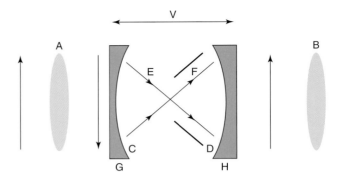

FIG. 44 Image intensifier system G1. First generation, electrostatically focused single-stage image intensifier tube G1. (A) Imaging lens, (B) relay lens, (C) photocathode, (D) phosphor screen, (E) photoelectrons, (F) focusing cone, (G) faceplate, (H) fiber-optic plate, and (V) applied voltage.

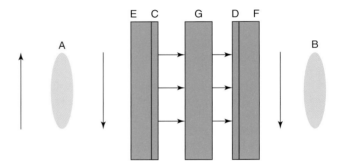

FIG. 45 Microchannel plate (MCP) image intensifier tube G2. Proximity focus type. (A) Lens (B) relay lens, (C) photocathode, (D) phosphor screen, (E) faceplate, (F) fiber-optic plate, and (G) MCP.

result in an amplified light output. When the accelerating voltage is pulsed, the device can act as a fast shutter. The most widely used systems are now image converters and image intensifiers often combined into a system, either to present the image converter with an amplified light image or to amplify the output image before recording on film or CCD cameras.

The essential difference between image intensifiers and image converters is that intensifiers just produce an intensified light image, whereas converters can act as both intensifiers and manipulators of the image, i.e., a complete camera. Both can act as shutters. Image converters can also convert UV, IR, and X-ray radiation to visible light using appropriate input windows.

Image Intensifiers

In general use are Generation 1, 2, and 3 (G1, G2, and G3) types. G1 proximity-focused types are relatively simple. They have input and output fiber-optic windows on which are deposited a photocathode and phosphor screen, respectively. Applying a short high-voltage pulse (5–15 kV) across the tube allows light amplification of around 15 to 100 times and can also acts as a fast shutter.

G2 types incorporate a micro-channel plate (MCP) amplifier between the photocathode and phosphor screen, which allows a greater luminous gain and also shorter shutter times as the necessary shuttering voltage excursion is much smaller. This a smaller and lighter device. Light amplification can be up to 400 times.

G3 types also use an MCP, but in this case the channel surfaces are coated with gallium arsenide (GaAs), which improves response.

Flash Photography Lighting Techniques

Flash photography is closely related to the early developments of photography. W. H. Fox Talbot made the first high-speed photograph using a spark-gap in 1851. At that time and until the beginning of the 20th century, sparks were the only short duration light sources available. In a demonstration at the Royal Photographic Society, he photographed a piece of newsprint glued to a rapidly revolving disk. When the plate was developed the print could be clearly seen and read.

Electronic flash is widely used to supplement available light, but can also be used to arrest motion using an open shutter and short flash exposures. Normal photographic electronic flashes have flash durations of 100–1000 µs which is too long for most high-speed subjects. However, employing special techniques and components, spark durations can be reduced to microsecond or sub-microsecond duration, while still providing photographically practical intensities, but with more limited camera to subject distances.

As the exposure time shortens, illumination levels must increase. These constraints may bring with them the problems of a material's reciprocity law failure in high-speed photographic application.

Light sources normally used for high-speed photography include flash tubes, sparks, and argon bombs. Sparks are produced by discharging a high-voltage capacitor between tungsten, steel, or copper electrodes. Spark gaps can take many forms to suit specific needs, e.g., a point source for shadowgraphs or a line source for schlieren photography. Line sources can take different random paths between electrodes, choosing the most easily ionized route. To keep the discharge in the same position each time a preferred ionization path is provided by blowing a fine jet of argon gas across the gap via a hollow electrode. For spark and flash tube sources the afterglow may continue after the main discharge, giving a phantom tail to a moving object. This afterglow is often eliminated using quenching circuits or fusible links.

Another short duration light is obtained by the vaporization of a thin metal wire. A large capacitor bank is discharged through the wire, switched by the breakdown of a spark gap. In vaporizing the wire, the electrical energy is turned into a bright flash of light.

High-speed X-radiology units are available to give submicrosecond pulses for internal studies of dynamic processes, such as the penetration of a projectile into a target. As the voltage applied to the X-ray tube is increased, the energy of the X-ray beam increases (i.e., the rays becomes "harder") and penetration distances increase.

Argon bombs consist of a simple tube filled with argon, with a transparent window at one end and an explosive charge at the other. During its travel down the tube, the shock front of the detonated explosive produces a highly luminous output from the argon gas. Exposure time can be varied about the $1\,\mu s$ period by adjusting the length of the tube and hence the shock travel time through the gas. Because of the need for explosive in these devices, their use is normally restricted to government research establishments.

Currently, high-power laser pulses of nanosecond duration can be used in single or multi-pulse mode. As laser light is controllable to be in a single spectral band, this light source can be used to photograph highly self-luminous events such as explosions. The camera is fitted with a narrow-band filter, which allows only the laser light to be recorded while the self-luminosity is cut out.

Stroboscopic Operation

Using a still camera and a repetitive light source (stroboscope), a moving subject can be photographed in a series of positions in one picture. This is very useful for studying movement sequences of sportsmen or dancers to help them improve their technique. Often the images produced are artistically pleasing.

Alternatively, for rotating subjects, such as a fan, regularly spaced synchronized flashes illuminating the subject in exactly the same position at each revolution can give the illusion that it is stationary, which allows the observation of any changes under rotating conditions to be seen and photographed. Stroboscope flash units are adjustable for repetition rate and normally operate from 100 to 1000 flashes per second.

Lighting Techniques

High-speed, short duration exposures require intense subject lighting. However, self-luminous subjects may give adequate light levels, but extra lighting may be needed to illuminate backgrounds or shadowed areas.

Non-luminous subjects, and those where the self-illumination is not to be recorded, can be lit using either constant intensity sources or flash sources synchronized with camera shutters. In outdoor filming, bright sunlight may be adequate, but of course cannot be relied upon. Tungsten halogen lamps are used for general lighting and low voltage types are very useful where mains voltages are not available. Vortex stabilized argon arcs can produce impressive light intensities. A 300 kW version using a 6 m parabolic reflector can produce a 6 m diameter beam giving a peak irradiance of 400,000 lux at 100 m.

Xenon gas discharge lamps, of the short arc, high-intensity point-source types, can provide intense collimated beams where small areas are to be illuminated. A more recent development is the high-intensity photographic illuminator (HIPI), which runs in two modes—normal and boost—that last for 5 seconds. Luminous flux density in its boost mode is 750,000 lux at 75 feet (25 m) distance (1 lux equals one lumen per square meter).

Flash Bulbs

These have a useful run time of about 20 ms so they can be used for both still and cine illumination. Although they only last for a single flash, the light output in relation to weight, size, portability, and battery operation makes them efficient sources. Output is up to 100,000 lumens per second. When fired simultaneously in large numbers they are briefly equivalent to several kilowatts of light output. Alternatively, ripple firing, where the output of several bulbs is overlapped, can give a longer duration light output. For example, eight ripple-fired bulbs can give about 0.5 seconds of high intensity light. An important consideration for synchronization is an allowance for burn-up time to full brightness (5–35 ms).

Light-emitting Diodes

For short distances, continuous or flash illumination can be provided by light-emitting diodes (LEDs). A typical unit comprising a grouping of 24 diodes, each with a special reflector surround, can provide a nominal output of 28,000 lumens in continuous mode or 28,000 lux at a distance of 58.8 cm. Alternatively the LEDs can be pulsed to generate strobe lighting up to 5000 Hz. Some types of LEDs can be over-driven by a short pulse to produce very short duration, high-intensity light pulses.

Synchronization

In high-speed photography the precise time at which an exposure is made (to capture the event) is as important as the duration of the exposure (to minimize blur).

To synchronize the exposure to the event, a variety of event sensors (detectors) and associated variable delay devices can be used to initiate a photographic sequence. This sequence may be very simple or very complex depending on the type of event, the camera in use, the lighting requirements, and so on. Event sensors will be selected to suit the event conditions, and can include simple make or break switches, detection of radiation emitted by or reflected from a subject, interruption of an external radiation source by the interposition of the subject, detection of sound emitted by the subject or caused by subject movement, detection of local pressure changes or shock waves from the subject, and detection of changes in electrical or magnetic fields caused by the presence of the subject.

For self-luminous events, radiation detectors can be used and their trigger sensitivity level set such that the exposure is not made until the light level is high enough.

If a common signal source is used, it is essential to be aware of the response time of all the system components, which can include the time for the camera to reach an operation-ready condition, or the burn-up time of flash bulbs, so that appropriate delays can be set for all the individual component start times. This becomes increasingly important as subject velocities increase and exposure times become shorter.

Often in the photography of projectiles an appropriate trigger device will be selected, so that when the projectile reaches the camera field of view it will virtually take its own picture. For example, Ernst Mach (1880s) used a simple wire switch, which made contact when struck by the projectile, and fired the photographic spark.

Supersonic projectiles will produce a shockwave that can be detected and used as a trigger. Moving the acoustic detector along underneath the line of flight, the triggering instant can be fine tuned to vary the instant of the light flash.

Applications

High-speed still cameras are used in the same kind of contexts as high-speed cine cameras. Many of the systems developed for armament research have been applied to more peaceful purposes, e.g., in industry, medicine, complex mechanical processes, and the study of atomic processes for the production of electricity using nuclear power.

Reciprocity law failure

With very long and very short exposures, the normal reciprocal relationship between the effective exposure, the light reaching the detector and exposure time breaks down. This is relevant with silver-based films and is known as reciprocity law failure.

When using film with short exposures and high light intensity, the sensitivity and contrast reaches a minimum with exposure times of about $10\,\mu s$. Reciprocity failure at high intensity normally gives a decrease in gamma (image contrast) and a decrease in effective emulsion speed. An increase of development times of about 80 percent for flash photography of $10–100\,\mu s$ is recommended and for less than $1\,\mu s$ exposures an energetic developer is suggested.

Reciprocity failure can be minimized by choosing emulsions with the smallest departure of its published reciprocity failure data (see manufacturer's data). The effects of reciprocity failure are small for modern black and white

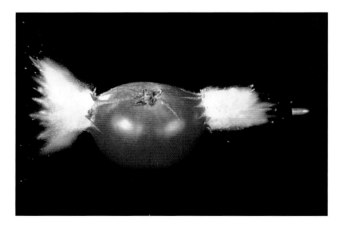

FIG. 46 A bullet traveling at supersonic speed is caught and frozen in flight just after having smashed its way through a juicy red tomato. The photograph was made using an electronic flash lasting only 1/1,000,000 of a second and was triggered by the sound of the gun tripping a sound-activated synchronizer while the camera shutter is left open in darkness. (Photo courtesy of Andrew Davidhazy.)

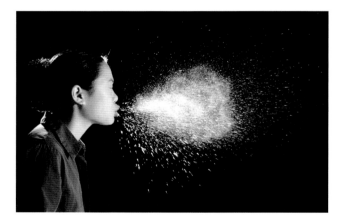

FIG. 47 An example of a high-speed image from medicine shows the outcome of a human sneeze when photographed using a delayed sound trigger using a flash duration of 1/20,000 of a second. (Photo courtesy of Andrew Davidhazy.)

emulsions, but larger for color film where the color balance may also be affected. Note also that the color output of flash tubes and spark gaps may vary with changes in duration or intensity. In practice, experimental trials using similar emulsions and exposure times to those of the anticipated event trials are necessary to find suitable processing conditions. This will avoid costly failures with the actual event. Digital cameras also may exhibit changes of sensitivities based on duration and hence their sensitivity settings may need to be adjusted.

Stroboscopic Flash

Electronic flash tubes can be fired repeatedly at high frequencies of hundreds to thousands of flashes per second. This method of use has various applications in high-speed photography and motion study. A stroboscopic flash operates like a normal flash discharge circuit but with some modifications to allow a high-repetition rate. Flash tubes were developed from simple spark units by enclosing them in a sealed tube containing a low-pressure gas such as xenon, which enhances the light intensity of the discharge. Following 1931, much of the pioneering work on strobe development was carried out in the United States by Dr. Harold Edgerton. Edgerton was inspired to work on this project as a result of watching bright discharges of mercury arcs in rectifiers.

Theory of the Single Flash Tube

Light is produced when electrical energy stored in a charged capacitor is discharged into a flash tube. During the discharge, the instantaneous power is quite large (it may be several million watts).

However, the practical criterion is the light energy produced. Thus the second most important component of a flash unit after the flash tube itself is the capacitor. The capacitor is the energy store for the unit and it must be able to slowly charge over a period of seconds or minutes and then discharge all its energy in a few microseconds. This cycle places huge electrical and physical stresses on the capacitor and the insulation between its storage plates. Thus flash unit capacitors are constructed specially for the task and have been steadily improved in performance and endurance over many years.

Electronic flash tubes are made in many sizes and shapes to satisfy different requirements, such as straight, U, or spiral shapes. Gas pressures and electrode separation are arranged so that the tube will not strike under normal working voltages. It requires a trigger pulse to be applied to a trigger electrode to start the ionization process and allow the tube to flash.

Most flash tubes are filled with low-pressure xenon gas. High-speed photographic studies of the arc formation reveal an initial thin filament discharge, which quickly grows to fill the tube.

Flash duration can be defined by plotting light output against time on an oscilloscope through the initial delay, the

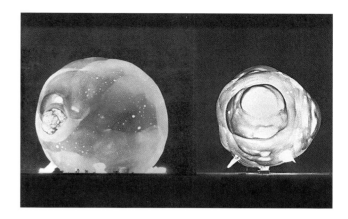

FIG. 48 Two photographs of very short exposures of the first few milliseconds made of two 1950s atomic bomb tests. The fireball has a very high surface brightness and the exposures were typically a few millionths of a second, made using Kerr shutters and a Rapatronic camera. (Image courtesy of the Lawrence Livermore National Laboratory.)

initial rise, the peak, and decay. Provided the motion of the subject is frozen, the total duration of the flash is not critical. A common way to indicate duration is to measure the interval between half-peak value on the rise and fall of the light output curve. However, light intensity below these points may still be capable of forming an image and blurring the subject outline. Thus, this measurement only gives an indication and must be confirmed by actual experiment.

The electronic flash tube has an unusual volt-ampere characteristic. Initially with no discharge, the resistance is infinite. As current starts to flow, the resistance drops to a few ohms during the main discharge. Finally, as current ceases the resistance becomes infinite once more. The circuit is thus similar to the discharge of a capacitor through a resistor, and flash duration can be approximated by the equation:

$$\text{Flash duration} = RC/2 \text{ seconds}$$

where C is capacitance in farads, and R is resistance in ohms.

When choosing a flash tube for a specific application, the following factors are important.

The shape—linear, U-shaped, spiral, etc.—of the tube is a factor. Compact tubes are more effective in a reflector to give maximum light control. Each tube has its maximum efficiency for a particular input. Although the tube should be used at or near its maximum efficiency, it may be necessary to operate below this to avoid overheating.

The flash duration is governed by the tube and associated circuitry, so if a particular flash duration is required then choice is limited. Often the most efficient flash tube cannot be used for stroboscopic work, as the high repetition rates and high power required will cause heat storage and conductivity problems.

Stroboscopic Photography

The term stroboscopic photography has come to mean multiple-flash photographs on a single plate or frame. The word stroboscopic is derived from the Greek *strobes*, act of spinning. The first multi-exposure photographs were made by Eadweard Muybridge, using multiple separate cameras along the line of the subject's movement, and by Etienne Marey, who used a moving plate and a slotted rotating disk as a shutter. The modern method is to use a succession of electronically produced flashes separated by accurately controlled intervals.

When a flash tube is used intensively as a stroboscopic source several major problems may arise, largely because of the effects of heat build-up. For example, a flash tube may miss occasional flashes, or the gas in the flash tube fails to de-ionize, so the capacitor current continues to leak through the tube and prevents the build up of a full charge, a condition known as "holdover." A hot flash tube may also short-circuit the triggering spark through surface conduction or may even fail from melting and tube collapse. Quartz tubes are preferred as quartz has a higher melting point than glass.

Another point may be self-flashing of the tube during the charging cycle. Again this is caused by incomplete de-ionization or lower stand-off voltage due to heating of the tube or gas filling. Special circuit elements such as the mercury-pool control tube (MCT) and the hydrogen thyratron can assist in preventing these problems.

Mercury-Pool Control Tube

The MCT is connected in series between the charging capacitor and flash tube and must be capable of handling the peak currents that flow as the tube discharges. The MCT is filled with mercury vapor and includes its own trigger circuit. When fired, it presents the full capacitor voltage across the flash tube and after discharge de-ionizes quickly, shutting down the current path to the flash tube and preventing holdover.

Hydrogen-Thyratron Tube

The hydrogen-thyratron tube (HTT) is similar to a conventional triode valve, and can be triggered by a pulse applied to the grid. It is filled with hydrogen giving it the ability to pass high currents without internal damage. The capacitor and flash tube are connected in series. The HTT circuit is placed in parallel across the capacitor and flash tube. When triggered it completes a current path including capacitor and flash tube, via a common earth. It has a very fast de-ionization time, again effectively preventing holdover current. In current equipment these two systems are often replaced by solid-state components.

Multi-Capacitor Circuits

When a limited number of flashes are required the circuits can be arranged so that each flash is powered by a separate capacitor, feeding either into a common flash tube or into separate tubes. Each circuit will have its individual trigger system. If many flashes are required, such a system can become very bulky. To prevent variations in the light source position a common flash tube is often used. This system allows the variation of flash discharge interval by settings from a master multi-trigger unit. Unless each circuit is very well shielded electrically and visually from its neighbors, there is sometimes the danger of sympathetic triggering of more than one circuit at a time. The above remarks can also be applied when spark sources are used instead of flash tubes, and this may occur when a point light source is necessary.

Applications

Stroboscopic flash has two main applications: analyzing a rapid movement by photographing successive movements on one frame or plate or arresting a rapid cycle or other periodic movement for direct visual observation or photography.

Examples of the first application are multiple photographs of dancers or movements in sport, e.g., detailed study of a golf swing. It is important that the flash repetition rate is adjusted so that successive changes of subject position do not overlap each other too closely, otherwise the picture may become very difficult to analyze. Sequences taken for artistic purposes rather than analysis may be deliberately allowed to merge (see *Chromophotography*).

For the second type of application, the flash frequency is matched to the cyclic period of the motion under study. For instance, a machine component rotating at 5000 revolutions per minute will be illuminated by a flash lamp operating at 5000 flashes per minute. If the rates are accurately matched, the flash will illuminate the same phase of the movement each time apparently freezing the motion of the component, which can then be studied visually or photographed. By slight phase-shifting various elements of a large complex motion can be studied in turn.

See also the following articles

Ballistics Photography; Chronophotography; High-Speed Cinematography; Schlieren and Shadowgraph Photography; Streak and Strip Photography

FURTHER READING

Proceedings of the International Congress on High-Speed Photography and Photonics, held every two years, in locations round the world. Published by SPIE, Bellingham, WA.

Ray, E. S. (2002). *High-speed Photography and Photonics, 2nd edition*. SPIE and British Association for High-speed Photography and Photonics. ◉

Hologram

SEAN JOHNSTON
University of Glasgow Crichton Campus

A hologram is a recording of the interference pattern formed by overlapping direct (reference) coherent light and that

reflected from an object. Coherent light waves have a constant frequency and phase and are usually produced by a laser. When appropriately lighted, the hologram acts as a window or mirror to reconstruct a three-dimensional view complete with parallax. Color, computer-generated, and animated varieties (and, using a pulsed laser, images of living subjects) can be produced on photographic emulsions, thermoplastics, and embossed foils.

See also the following article
Holography

FURTHER READING
Saxby, G. (2003). *Practical Holography (4th edition).* Bristol: Institute of Physics Press.
Unterseher, F., Hansen, J., and Schlesinger, B. (1982). *Holography Handbook: Making Holograms the Easy Way.* Berkeley: Ross Books. ◎

Holographic Interferometry

SEAN JOHNSTON
University of Glasgow Crichton Campus

Invented at a variety of laboratories during the mid 1960s and successfully commercialized over the following decade, holographic interferometry relies on the optical interference produced between two separate holographic images. By recording two holograms and superimposing the images that they reconstruct, any optical differences can be detected via the resulting pattern of interference fringes. Each fringe represents a shift by half a wavelength of light (scarcely 300 nm), and may be produced by motion or deformation of the object between exposures, or by changes in the density of the intervening air. In time-lapse or time-averaged interferometry, a single hologram is recorded while the object moves or oscillates. This can reveal modes of oscillation, such as the vibrations of a musical instrument. In double-exposure interferometry, two separate recordings are made to detect changes that have occurred in the interim. Typical applications include study of aerodynamic flow. In real-time double-exposure interferometry, the image reconstructed by a single hologram is compared with the object itself when sighted through the hologram, yielding so-called live fringes. This permits the object to be mechanically or thermally stressed, for example, to detect strain interactively. In a third variant known as holographic contouring, a single hologram is recorded using a laser that produces two closely spaced frequencies, yielding two separate interference patterns on the same plate. When a single laser frequency subsequently reconstructs the hologram, the images interfere to generate a pattern of fringes that map the depth of the object.

See also the following articles
Hologram; Holography

FURTHER READING
Smith, H. M. (1969). *Principles of Holography.* New York: Wiley-Interscience.
Vest, C. M. (1979). *Holographic Interferometry.* New York: Wiley. ◎

Holography

SEAN JOHNSTON
University of Glasgow Crichton Campus

Introduction

The word hologram is derived from Greek roots meaning whole picture and is frequently used today in credit card emblems and as an imagined technology in Star Wars and Star Trek. It has a history extending back to the mid-twentieth century. Holography is a subject that grew around holograms and had a difficult birth. It created a new kind of technical imaging professional, the holographer. Conceived by Dennis Gabor in 1947 as a means of improving electron microscopy, his approach used wavefront reconstruction. It began to quickly evolve into holography in the 1950s when physicists and electrical engineers working mainly in classified laboratories combined findings in information theory and coherent optics. Yuri Denisyuk, an engineer and graduate student at the Vavilov State Optical Institute in Leningrad (now St Petersburg), developed the so-called wave photography in 1958. At the University of Michigan's Willow Run Laboratories, in 1953, Emmett Leith worked on synthetic aperture radar (which has theoretical similarities to wavefront reconstruction). In 1960, with colleague Juris Upatnieks, he worked on the development of so-called lensless photography. From late 1962 their insights from electrical engineering and communication theory were combined with newly available lasers to yield a powerful imaging technique; by the end of 1963 their research had yielded astonishingly realistic three-dimensional imagery.

Despite the popularization of lensless photography, the analogy between the hologram and the photograph is nevertheless a loosely defined one. The Leith-Upatnieks hologram is a kind of transparency, but the image is observed by looking through the hologram as though through a window. It is a two-step process and it creates the featureless surface often described as storing the image information necessary to later reconstitute a visual representation of the original scene. Thus a photographic contact copy of a hologram does not yield a negative image, but another positive. And unlike a photograph, the hologram can recreate a view of the entire image from any part; the pieces of a broken hologram still work. The dynamic range (variation from bright to dim in the image) is much larger in holograms than in photographs. But the

technique is restrictive: Only small laboratory scenes (normally a few cubic meters at best) can be recorded. The first generation of holograms was made using the laser as a light source. The laser was not just for initial recording but also required for subsequent viewing of the holograms. Despite these unfamiliar attributes, photography was to be a convenient guide to understanding the new medium of holography and to forecasting its future development.

From 1966 Willow Run and other laboratories extended what was known as holography to create stunning displays and exquisitely sensitive optical measurement techniques. Within a decade about 100 books, 200 theses, and several thousand scientific papers had been published on the subject. Commercial and military funding skyrocketed, and predictions for applications multiplied.

Concepts and Technique

Gabor, Denisyuk, Leith, and Upatnieks developed distinct optical geometries for holography, but all of them relied on a two-step process. Initially two beams from a single coherent source of light (usually a laser) are combined to yield interference fringes. One of those beams (known as the reference beam) strikes the photosensitive surface directly. The other (the object beam) is reflected onto the surface, or otherwise modulated, by the object to be imaged. The combination of the two beams yields a fine pattern of interference fringes. This is a series of dark lines at positions where the two beams differ in phase by a half-wavelength of light and bright lines where the difference amounts to a whole wavelength. The average scale of this pattern (known in communication theory as the carrier frequency) is related to the angle between the reference and object beams. In Leith-Upatnieks holograms, the angle is typically between 10 and 100 degrees; in Denisyuk holograms, the angle is about 180 degrees and the reference beam strikes the photosensitive plate from the side opposite the object beam. Because the optical setup must remain motionless to a fraction of a fringe during exposure, the Denisyuk technique demands even more scrupulous vibration isolation than does the Leith-Upatnieks method.

The details of the interference pattern bear no obvious relationship to the object itself, but depend on the light scattered from every point of the object, its relative distance, and the intensity of reflection. In general, every point recorded on the holographic plate is a combination of light from every part of the reflecting object. The pattern amounts to an encoded recording of the wavefront of light scattered from the object.

The microscopic pattern—consisting of hundreds to thousands of irregular lines per millimeter—can be recorded on conventional high-resolution silver halide photographic film and processed by standard techniques. Such recordings, known as amplitude holograms, can also be made on photoresist materials. Alternatively, the fringes can be recorded as variations in refractive index or thickness in materials such as bleached silver halide emulsions, dichromated gelatin, synthetic photopolymers, or thermoplastics. Embossed holograms, available since the 1980s, record height variations of

the fringe pattern by various proprietary processes. These may begin with a silver-halide hologram or photoresist from which a master, usually in metal, is produced. Copies can then be made by either casting or (more commonly) embossing in PVC and then applying a reflective coating. This yields an inexpensive product, stamped by little-modified conventional printing presses to yield a copy of the fringe pattern in the form of fine surface corrugations. All of these so-called phase holograms produce the same effect in the second step of imaging, but yield brighter images than amplitude holograms.

The second (reconstruction) step is less technically demanding than the first (recording) step. In the hologram, the illuminated copy of the original reference beam is used. The complex fringe pattern of the hologram causes diffraction of the beam and regenerates as an image that is, in all visual respects, a copy of the wavefront that originally reached the recording plane.

Types of Hologram

The description above is incomplete because, in practice, holograms are usually created in ways that allow them to be viewed in white (non-coherent) light. These variants allow the reconstruction step to be considerably eased, although still more demanding than viewing a conventional photograph.

The most elegant white-light holograms are those made using Denisyuk's geometry. Such holograms record an unusually minute fringe pattern through the depth of the emulsion. Like Gabriel Lippmann's color photography process, which won the 1908 Nobel Prize for Physics, these planes selectively reflect a narrow range of wavelengths. Denisyuk's reflection holograms reconstruct a high-quality yellow or green image, even when illuminated by white light, but require thick, high-resolution emulsions and are less amenable than other types to mass production.

The first white-light holograms created in the Western world, however, were known as image-plane holograms. These holograms were created by focusing an image using a lens or the real image reconstructed from a master hologram, onto or near, the hologram plane. For points close to the plane, the image appears sharp and colorless (by contrast, Leith-Upatnieks holograms, which record objects behind the plate without lenses, act as complex diffraction gratings and produce an image smeared into a spectrum of colors when viewed in white light).

A third popular type is the white-light transmission hologram, or rainbow hologram, developed by Stephen Benton of Polaroid Corporation in Cambridge, Massachusetts. This interposes a narrow slit between the object and the hologram plate. By doing so, it allows the hologram to reconstruct an image in white light, but sacrifices vertical parallax in the process, so that moving from side to side still allows the viewer to look around the object, but vertical movement merely shows the same sharp image in different spectral colors.

The image-plane and rainbow techniques are frequently combined in display holograms, and can be further combined with other techniques, notably integral holograms (also known

as holographic stereograms). An integral hologram is synthesized as separate side-by-side vertical strip holograms from individual two-dimensional images such as movie frames. Each eye views a different strip image, yielding a binocular stereoscopic view. In the earliest commercial version developed by Lloyd Cross in San Francisco and known as multiplex holograms, animated rainbow images could be viewed by walking around a cylindrical hologram illuminated by an unfrosted light bulb at its base. Later versions were usually recorded on flat surfaces, and sometimes aluminized to allow them to be mounted on a wall and illuminated by a halogen lamp.

Applications

The applications of holography have changed in the decades since its invention. During the 1960s, companies such as Conductron Corporation in Ann Arbor, Michigan, attempted to market Leith-Upatnieks and Denisyuk holograms for product displays and magazine inserts with little success, and developed pulsed lasers to record live subjects for advertising displays. The most successful application at that time was holographic non-destructive testing (HNDT) based on holographic interferometry. Through the 1970s, HNDT became popular with automotive and aerospace manufacturers as an extremely sensitive technique for mechanical engineering design.

Since 1969, a handful of artists have taken up holography with a few major exhibitions (notably New York in 1975, Stockholm in 1976, London in 1977–1978, Tokyo in 1978, and Rome in 1979), which touted the potential of the medium for fine art and commercial display. Such applications were also supported by regular conferences organized by the International Society of Optical Engineering, by wider ranging activities of the New York Museum of Holography (1976–1992), and by accredited teaching programs such as the Holography Unit of the Royal College of Art in London (1985–1994).

Despite the sprouting of a cottage industry and artisan holographers, display holograms failed to attract a large market. Specialist applications developed during the 1970s, though, for military and corporate sponsors. Holographic optical elements (HOEs), which allow the combination of reflective, lens-like, and diffractive optical properties in a single compact device, became increasingly sophisticated, finding their way into products such as camera viewfinders and bar-code scanners. Head Up Displays (HUDs) used in fighter aircraft also incorporated HOEs to combine an image of the instrument panel with the view out the cockpit window.

The applications took a new and more profitable turn with the development of embossed holograms as a low-cost medium. From 1983, embossed holograms graced magazine covers (notably National Geographic covers of 1984, 1986, and 1988) and reflective stickers for toys, but the flexible backing and their viewing under uncontrolled lighting made the image quality unreliable; they fell from favor by the end of the decade.

On the other hand, a sustained market for embossed holograms appeared in 1983 with the introduction of holographic security patches on MasterCard credit cards, an application

first promoted by American Bank Note. These proved popular, spreading to most credit cards by the end of the decade, and then to security holograms on product packaging, currency, and identity documents. A similarly growing market was holographic packaging, in which imagery was sacrificed for attention-getting optical effects. For both applications, reliance on optically recorded holograms gradually fell, with more complex patterns achievable by computer-generated holograms. At present, security and packaging holography applications dominate the market.

Changing Status

In 1971, Gabor was awarded the Nobel Prize in Physics for his seminal work in what had become a burgeoning new field. Since then, holography has been taken up by a broad group of technical communities. The original cluster of scientists and engineers, who were originally supported by military and industrial contracts, were later joined in the early 1970s by artists and artisans. They recast the methods and goals of holography, transforming it from an expensive and delicate art into a publicly accessible medium. But while investigating and applying this new invention and aesthetic medium, these new communities of workers found that their early expectations were not entirely realized: Holography failed to make sustained progress in many of its forecast directions. Although it had been popularized as an extension and analog of photography, the subject did not evolve in the same way. Schools and galleries of the 1970s and cottage industries of the 1980s began to close, research groups retrenched, and the number of artists active in the medium diminished.

Today, research and development in holography has been channeled to a small number of important applications such as anti-counterfeiting measures, mechanical testing, and graphics for packaging, but it continues to attract new communities of enthusiasts. While publishing and conference activities have diminished by half compared to their peak during the 1980s, patents in holography continue to rise. Two areas, both reliant on increased computer power and its integration with modern optics, are of particular interest. The first of these is the long anticipated potential of holography as a convenient display technology for portraiture, based on improvements in automated digital hologram printers, an application being pursued by Japanese firms. The second is the generation of real-time holographic displays from computer-generated data, a tour de force of calculation that is becoming increasingly feasible. Most recent applications of holography, however, are in relatively arcane branches of modern optics, where it has been gradually integrated.

See also the following articles

Hologram; Holographic Interferometry

FURTHER READING
Hariharan, P. (1996). *Optical Holography: Principles, Techniques and Applications (2nd edition).* Cambridge: Cambridge University Press.

Johnston, S. F. (2006). *Holographic Visions: A History of New Science*. Oxford: Oxford University Press.

Saxby, G. (2003). *Practical Holography (4th edition)*. Bristol: Institute of Physics Press.

Unterseher, F., Hansen, J., and Schlesinger, B. (1982). *Holography Handbook: Making Holograms the Easy Way*. Berkeley: Ross Books. ✺ ◎

Hypersensitization

DAVID MALIN

Anglo-Australian Observatory, RMIT University

This section covers methods of enhancing a silver halide material's sensitivity before exposure, usually to offset the effects of low-intensity reciprocity failure (LIRF). LIRF reduces the effective speed of an emulsion when exposure times are longer than a few seconds. Hypersensitization is distinguished from latensification, which involves treatment after the image exposure. The term embraces a variety of methods that affect the chain of events involved in the formation of the latent image. Hypersensitizing (hypering) may be part of the manufacturing process or a user-applied pre-exposure procedure. Though important during most of the 20th century, "hypering" is now mainly of historical interest.

LIRF was first noted by astronomers in the 1890s, who began to explore ways of minimizing it, even though they were not initially aware of the photographic mechanisms involved. Because they often derived photometric data from their plates, astronomers were used to making precise measurements of emulsion sensitivity, so they were able to monitor and document the effects of exposure time on their photographic experiments.

The major suppliers of photographic materials were also keen to improve the speed of their products intended for general use, so there was some collaboration between astronomers and photographic researchers. This was especially true in the United States, where the Kodak Research Laboratories were directed by the English chemist, C. E. Kenneth Mees, who was interested in astronomy. From about 1931 to 1996, Kodak produced a range of spectroscopic plates where the effects of LIRF were intentionally minimized. These emulsions were usually coated on glass and were intended for scientific research involving long exposures, especially astronomy and spectroscopy, and the recording of optical spectra.

Practical, user-applied hypersensitizing techniques evolved over most of the last century and fall mostly into four types of treatments. These broadly involved liquid phase (washing), gas phase (out-gassing and baking and hydrogenation), the use of cold cameras, and pre-flashing.

Washing plates in water, dilute ammonia, triethanolamine, or (more recently) silver nitrate solutions was found to be very effective, especially for red- and infrared-sensitive materials.

Later types of fine grain, near-IR-sensitive plates were unusable without such hypersensitizing. However, much skill and persistence was required to obtain consistent and uniform results, especially with large plates, which were often treated at unsocial hours in observatory darkrooms on remote mountain tops.

Some of the earliest gas-phase hypersensitization methods involved exposing the plates to mercury vapor before exposure to light. This was beneficial but was also hazardous and unreliable. More amenable was baking the plates in air in a moderate oven. Used from about 1940, this produced modest speed gains in the then-current coarse-grained emulsions. From about 1970, baking (about 65°C for hours) or prolonged soaking (20°C for weeks) in a flow of nitrogen was used and could achieve a factor of 10 gain in speed for a one-hour exposure.

This was especially important for the new generation of high detective quantum efficiency, fine-grained (but slow) plates Eastman Kodak had developed in the late 1960s. In 1974, researchers at Eastman Kodak announced that plates treated in pure hydrogen after nitrogen treatment were more sensitive at all exposure times than untreated plates, and this was quickly adopted by many observatories, some of whom used non-explosive "forming gas" (a 4 to 8 percent mixture of hydrogen in nitrogen) for reasons of safely. The latest gas-phase processes combine the effects of both drying with nitrogen and reduction sensitization with pure hydrogen to give a sensitivity gain of about 30 times for an hour-long exposure. This also worked very well with fine-grain, high-resolution emulsions on film, typified by Eastman Kodak's Tech Pan. They are also effective with negative and reversal color film, but are unpredictable and can produce serious changes in color balance.

The liquid-phase of plate washing techniques operates by removing residual soluble bromides or iodides from the emulsion, thereby increasing the silver ion concentration in the vicinity of the photosensitive grain. The gas-phase method, especially nitrogen baking, involves the removal of traces of oxygen and water from the gelatin matrix, which increases the efficiency of the first stages of latent-image formation. Finally, hydrogen is a chemical reducing agent that "seeds" the dry, de-oxygenated silver halide crystal with a few atoms of silver. These are stable, sub-latent image clusters that subsequent photoelectrons from exposure to light can build into a several-atom latent image speck that catalyzes the development of the whole silver halide crystal. Photographic gelatin soaks up ambient moisture rapidly, so in humid climates "hypered" plates were usually exposed at the telescope in an atmosphere of nitrogen.

It had been known since the 1930s that LIRF was less severe during low temperature exposures. Accordingly, many experimenters built film cameras with "cold backs," metal plates in contact with the film, often cooled with solid carbon dioxide. These were awkward to use because of film embrittlement and condensation, but some good results were obtained with color film. The low temperatures decreased the probability that the initial silver atom would be recombined with a halide ion but

did not otherwise seem to affect the formation of the latent image.

Pre-flashing is not strictly a hypersensitizing technique but it was often used in conjunction with Kodak's spectroscopic emulsions, sometimes together with hypering. It involves a brief, uniform, low-intensity flash of light sufficient to produce a small increase in the unexposed fog level. This was usually done just before a long exposure and gave modest increases in effective speed, but only if the main exposure was filtered or otherwise arranged so that the faint image being recorded was free from sky background or scattered light. The main effect was to change the shape of the toe of the characteristic curve. In photographic terms, pre-flashing lowered contrast and improved the shadow detail without affecting the highlights.

See also the following article
Astrophotography

FURTHER READING

American Astronomical Society Photo-Bulletins, Vol. 1–43, 1969–1986. Individual issues available online from ADS Abstract service and have practical detail on astronomical photography (http://adsabs.harvard.edu/bulletins_service.html).

Babcock, T. A. (1976). A Review of Methods and Mechanisms of Hypersensitization. American Astronomical Society Photo-Bulletin, No. 13, 3–8.

Eccles, M. J., Sim, M. E., and Tritton, K. P. (1983) *Low Light Level Detectors in Astronomy.* Cambridge: Cambridge University Press

James, T. H. (ed.) (1977). *The Theory of the Photographic Process (4th edition).* New York: Macmillan.

Sturmer, D. M. and Marchetti, A. P. (1989). Silver halide imaging. In *Imaging Processes and Materials*, *Neblette's eighth edition* (Sturge, J., Walworth, V., and Shepp, A., eds.), New York: Van Nostrand Reinhold.

Image Manipulation: Science Fact or Fiction

DAVID MALIN
Anglo-Australian Observatory, RMIT University

In many branches of science, an image can be the primary source of data and the results of an experiment. The integrity of the imaging data may thus be central to a new result or discovery. However, it must also be recognized that no image is totally objective. The making of a picture for science requires an imaging opportunity, the selection of imaging tools, the processing of the data, and the analysis or interpretation of the resultant picture itself. The imaging scientist must choose the moment, the method, the medium, and much else when making an image. At each phase of the input process, subjective choices are inevitable. For this reason, accurate recordkeeping and the preservation of records and original materials has always been an important part of scientific photography.

In an era of digital photography, new opportunities for subjectivity arise in the image processing and output stages. Readily available image editing software encourages the creators of scientific images to make them look as convincing and attractive as possible. This enhancement may be especially tempting when the images are intended for publication. Using the term enhancement in this context may be thought to detract from the integrity of the photograph as a scientific record, and at worst may be construed as a fraudulent. This is not an ethical issue for scientists alone; it concerns anyone who uses images for information or communication.

Changing how an image looks is not a new issue in science. Creative cropping, selective shading, and other forms of enhancement have been practiced in the darkroom from the earliest times, although the skilled darkroom operator was often not the person who made the original picture. In the digital age, however, almost every scientist is his own photographer and imaging expert, hence in "complete" control of input, processing, and output. Many varied and subtle image enhancement procedures can be easily applied, with more or less skill, by anyone with the appropriate software. Often, sharpening, artifact removal, or color enhancement may be done innocently or for purely cosmetic reasons. However, it is all too easy to make an picture more convincing than the data might warrant. It is also nearly impossible to detect, especially in the absence of the original, unaltered image file.

Suggested General Guidelines for Scientific Imaging Applications
Because of the diversity of scientific imaging and the enormous variety of issues associated with them, it is impossible to develop specific guidelines for all disciplines; however, some general principles may apply to all situations. The main issue is that digital images should be regarded as quantitative data from the moment of capture and treated as such.

Any process that can be used to alter the captured data before, during, or after original capture should be recorded, especially if the final image is intended for research or publication, irrespective of the capture medium. Image transmission and reproduction should also be considered as part of this process. In this context, it is imperative for scientific photographers to be alert to the influences and limitations of the recording media, equipment, and techniques, and their effect on the end results.

These effects can, in principle, be reproduced and thus quantified or calibrated if necessary. For an image to be truly considered a scientific record, information about the imaging equipment, the environment, and the detector must be recorded as diligently as experimental technique allows, so that an independent investigator can, if necessary, reproduce the conditions under which the picture was made.

All RAW or equivalent image files used for, or reported in, a publication must be archived in an unaltered state along with the other experimental data, for that is what the native image

data was. Lossy image compression (e.g., JPG) always results in some corruption of data and introduction of digital artifacts. For this reason, it is unsuitable for archiving. Re-sizing an image file, irrespective of the file format, also introduces artifacts. If any of the published images are pertinent to the reported results, the native image file(s) should be available to the referees or editors.

If the data is enhanced in some way, that enhancement should be limited to global changes of brightness, contrast, or color balance, and the changes applied should be described in the image caption. If cleaning, re-touching, or sharpening has been applied and the image is central to the result, this clarification of the data should be conspicuously referred to in the text and/or caption. In general, it is not acceptable to distort or move components in an image or to include parts of several images unless for comparison purposes, and then only with clear acknowledgement. Where necessary, grayscales, scale bars, and orientation marks should be included, always without obscuring essential information.

In appropriate cases, the native image files or unaltered copies of them should be available online as a supplement to the publication or on request from the authors. They should be archived with the same diligence as any other raw data.

See also the following articles
Forensic Photography; Police Photography

ADDITIONAL INFORMATION
Digital Imaging Ethics
Potentially the most dangerous dialog box in Adobe Photoshop
 http://swehsc.pharmacy.arizona.edu/exppath/resources/
 handouts.html
Digital Image Manipulation
 http://wiki.media-culture.org.au/index.php/Digital_Image_
 Manipulation
The Ethics of Digital Image Manipulation: Annotated
 Bibliography
 http://wiki.media-culture.org.au/index.php/The_Ethics_of_
 Digital_Image_Manipulation:_Annotated_Bibliography
The Integrity of Journalistic Photographs in Digital Editing
 http://www.digitalcustom.com/howto/mediaguidelines.
 asp ◎

Infrared Photography

ANDY FINNEY
Atchison Topeka and Santa Fe Limited

Light and Heat: Near and Far Infrared
Light that is detectable by the human visual system occupies a tiny part of the electromagnetic spectrum, which extends from the long wavelengths of low-energy radio radiation at one end to very short wavelength and high-energy gamma rays

at the other. The visible spectrum has a range of wavelengths from 400 to 700 nm. Infrared radiation lies between visible red light and microwave radio waves and, for the purposes of this article, is divided into the near-infrared (NIR; from 700–1200 nm, 0.7–1.2 μm) and the far-infrared (FIR) from about 2–30 μm. This also includes the region sometimes described as the mid-infrared.

The existence of radiation outside the visible spectrum was first discovered in 1800 by Sir William Herschel. He was experimenting with thermometers to measure the temperature of the bands of colored light produced by a prism, and placed thermometers outside either end of the visible spectrum as controls. To his surprise, the thermometer beyond the red end of the spectrum warmed up more than the rest, and he realized that there was radiation there that we could not see.

NIR is very similar to "ordinary" light in that it can be focused by normal lenses and recorded on special films or captured by imaging chips. The most common sources of NIR are those that also emit visible light and might include the sun, incandescent lamps, and flash guns. The making of images with NIR and traditional camera equipment can correctly be referred to as photography.

FIR is the radiated heat of an object detected by special electronic detectors and is sensed by its effect on the skin. FIR sources are usually the objects themselves, and images are made by recording the emitted thermal radiation. FIR imaging is thus known as thermal imaging or thermography and is described later.

Expressions such as white-hot and red-hot have real meanings in science, although these expressions are often used in every day language. The hotter an object is the more energy at all wavelengths each unit area of its surface radiates. An object (such as a human body) with a temperature of 310 K (about 40°C) will be radiating at wavelengths of around 8000 to 9000 nm (8–9 μm) in the FIR. A soldering iron can reach a temperature of 1000 K (about 700°C) and will be radiating strongly at 2 μm and weakly in the red part of the spectrum, so will glow a dull red. By contrast the sun has a surface temperature of about 5500 K (about 5200°C) and appears white. Physicists use an idealized concept known as a "black body" in order to describe how the wavelength distribution of emitted radiation varies with temperature. In the visible part of the spectrum the relationship between temperature and radiated light gives us the idea of color-temperature.

The peak wavelength of energy radiated by an object is given by a simple empirical formula known as Wein's Law: 2898 μm/T where T is in Kelvins. This wavelength is governed only by temperature: The nature of the object has no effect.

Near-Infrared: Light We Cannot See
The boundary between visible red light and infrared (NIR) is approximately at 700 nm wavelength but is not a well-defined location. Between 700 nm and about 1200 nm, NIR can be photographed with photographic film or captured using a charge-coupled device (CCD) or CMOS sensor of the kind

used in digital cameras and camcorders. In these situations NIR generally behaves like light. In particular it passes through glass and is reflected and refracted by conventional optics, but some image differences will be evident as a result of imaging with the longer wavelengths.

Blue and red visible light will behave differently in a glass lens, but the effects are often overlooked because they are minimal. Blue and red light will be refracted differently and lens designers must compensate to avoid chromatic aberration. Additionally, the color energy will be scattered to different degrees as the energy passes through the atmosphere. Rayleigh (small particle) scattering is why the sky is blue and distant mountains are hazy. However, the large particles of dust storms, industrial pollution, and the water vapor in clouds are opaque to NIR. If we assume that whatever happens with red light (as opposed to blue) will be more pronounced with NIR (and extreme with FIR), it is possible to deduce some of the characteristics of an infrared photograph.

The lens focus when using NIR will be different than when photographing visible light. Since IR energy is refracted differently, a scene focused at infinity will have to be focused as if it were closer. On many lenses originally used with film cameras, there was often a red mark on the barrel to indicate the corrected infrared focus. This location may be different for the wide-angle and telephoto ends of a zoom lens. Using a small aperture to increase the depth of field will reduce the focus error potential. Autofocus systems used on many digital cameras that sense the sharpness of the image as seen by the sensor may compensate automatically for focus error.

Virtually no NIR is scattered by the atmosphere when the atmosphere is clear, so a clear sky appears black or dark in a monochrome infrared photograph. As a result there is less scattered light reaching the shadows so they also appear darker. Bodies of water under an open sky will similarly look dark because there is no sky to reflect.

The effect of natural atmospheric haze is reduced or removed. The longer the wavelength, the less the scattering effect, so at NIR wavelengths the haze will often disappear. This is a mixed benefit for landscape photography as haze provides depth cues in an image. Haze particles in the air measure less than 1000 nm (1 μm) and are of the same order of size as NIR wavelengths. Fog, clouds, and dust, on the other hand, have particles ten times larger and so remain opaque until the imaging wavelengths approach the size of the particles, when it is possible to "see" through them.

In visualizing how a scene might look in an infrared photograph, it is helpful to think of NIR as an invisible color since color is an indication of which wavelengths of light an object absorbs, scatters, or reflects. This means that something that is dark in visible light may become light when viewed in NIR; in particular, artificial fibers and dyes used in clothing can reflect NIR strongly. Infrared photographs are popular at weddings, and the photos often show up the lapels and piping on the groom's dark tuxedo quite dramatically. In addition, NIR penetrates a few millimeters into skin, often giving a milky and flattering appearance to portraits. There have even been embarrassing instances of flimsy clothing being transparent in the NIR. Some visually opaque substances, such as certain woods and plastics, also transmit some NIR, so photographic darkslides and processing tanks have been known to allow fogging of infrared film.

The high reflectance from green plants between 700 and 1300 nm results in green foliage appearing white in an infrared photograph, particularly when the leaves are in direct sunlight. The effect is so distinctive that NIR images are often mistaken for snowy scenes. This is because NIR is strongly scattered by the cell walls of leaves in the way that visible light is scattered by small crystals of transparent water-ice. However, some of the light passes through the leaves, so there is more NIR under a canopy of foliage than green light, which is mostly reflected. Chlorophyll is transparent to NIR and plays no part in this process: Any infrared fluorescence is of such low intensity as to have no photographic effect.

The white foliage phenomenon (see Figure 48) is known as the Wood Effect, named for Professor Robert Williams Wood. He was the first person to publish infrared (and ultraviolet) photographs and discussed both in his benchmark presentation to the Royal Photographic Society in London in 1910.

Shooting the Invisible

Both film and electronic cameras can be used for NIR photography, and the light sources involved are much the same as for conventional photography. The sun, flash guns, or tungsten lights work well, but some visible light sources, such as television screens, fluorescent lights, and narrowband lighting used for streets and buildings, produce little or no NIR.

Digital still and video cameras have either CCD or CMOS imaging sensor chips that are as sensitive to NIR as to visible light (see Figure 50). Ultraviolet exposure may be evidenced as a blue cast to images shot at high altitudes; NIR interferes with correct color reproduction. In the case of UV contamination, a UV-blocking filter is used over the lens. To filter out the NIR, an infrared-blocking filter, also known as a hot mirror, is usually built into the camera or its sensor.

Using a digital camera to make infrared photographs requires either removing the IR blocking filter or taking long exposures in bright sunlight. In either of these techniques visible light is removed by using a visually opaque filter that passes NIR. It should be noted that removing the blocking filter can be difficult and not always possible, since it is often an integral part of the imaging chip assembly. In some of the early digital camera models, the IR cut-off filter was coupled to an anti-aliasing filter. Similarly, early generation digital cameras are also susceptible to noise and other artifacts when taking long exposures.

Digital photographs taken through an infrared filter can appear to be colored, even though NIR is essentially monochromatic. The colors range from subtle to bizarre depending on the imaging chip used (see Figure 50). They are due to the different NIR responses of the color filtering and processing in the red, green, and blue channels of the camera and are not

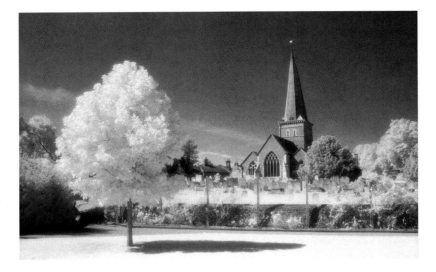

FIG. 49 Godalming Church. This photograph was taken using infrared film (Kodak HIE) and shows the characteristic bright foliage and dark sky. (Photo by Andy Finney.)

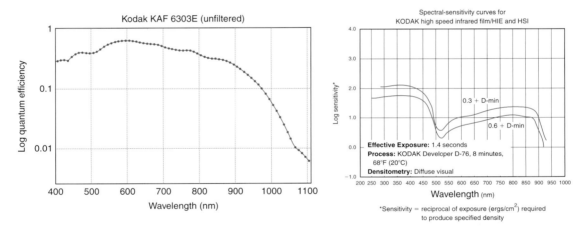

FIG. 50 The sensitivity curve for a typical CCD sensor, with no infrared blocking, and for HIE infrared film. Although not directly comparable, the relative sensitivities to visible light (400–700 nm) and NIR (over 700 nm) can clearly be seen. (Graphs courtesy of Kodak.)

necessarily representative of anything in the scene itself. The digital result is completely different to the result produced by color-infrared film, which is described below. A digital infrared photograph is likely to need some adjustment in a computer, especially to sort out black and white levels and compensate for any unwanted coloration.

One key benefit of using a digital camera to shoot NIR images is that the results can be seen immediately. If it is possible to see "live" images using the camera's screen or electronic viewfinder then the infrared effects can be seen as the shot is composed. However, the opaque filter makes it impossible to see anything through the viewfinder of an SLR, and in this case the shot must be composed before the infrared filter is fitted.

Infrared Film

Infrared photographs can be taken using film with most 35 mm cameras if the lens can be focused manually. There are a few cameras that use infrared sensors for film loading and transport. These sensors can fog the film and so should be avoided. Possible leakage of infrared through seals, bellows, the film edges, and even some plastics used in camera bodies

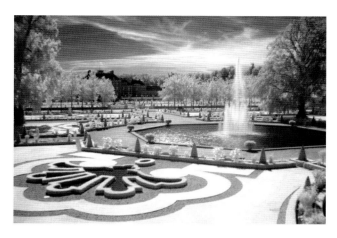

FIG. 51 Het Loo Palace in The Netherlands photographed using a consumer compact digital camera from Canon. To overcome the infrared blocking in the camera an exposure of one second was required at f/2.8 through a visually opaque NIR filter. (Photo by Andy Finney.)

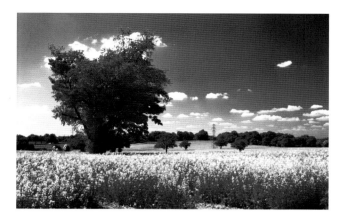

FIG. 52 Tree in a field of oilseed rape photographed using color infrared film. (Photo by Andy Finney.)

should also be checked. An emulsion specific to infrared photography has been made by several manufacturers since the 1930s, but currently only Kodak in the United States and Hans O Mahn and Co. in Germany continue to produce IR films.

Kodak's high-speed infrared film, known as HIE, is a monochrome negative film and is notable for having its own idiosyncrasies that add to those of NIR itself. There is no anti-halation layer in this film, consequently, the highlights in the print will have a distinctive "glow." This is an artifact of the film and is accentuated in the NIR because silver halide emulsions are quite transparent at these wavelengths. It is also possible for patterns caused by reflections of IR from the camera's film pressure plate to be recorded in the film. The lack of an anti-halation layer also means that light can enter the film through an outside edge of the film and then be piped through the substrate and fog the whole roll even through the tail of film juts out from a "daylight-loading" film cassette. HIE must always be loaded and unloaded in complete darkness. The Kodak film is panchromatic, with a "dip" around 500nm and an NIR sensitivity extending to just under 900nm. It is also grainy, but the halation and grain are often considered to be part of the character of infrared photographs taken with this material.

The Mahn film (branded Maco), is also a black and white, panchromatic negative film and has been available both with and without an anti-halation layer. The NIR sensitivity of the film is slightly narrower than the Kodak and its spectral sensitivity curve is relatively flat.

These films are sensitive to visible and ultraviolet light, so a filter must be used to make an infrared image. A visually opaque NIR-pass filter produces the strongest NIR effects, but a deep red filter is almost as effective and allows composition of the shot through the viewfinder of an SLR. Alternatively a

twin-lens or range-finder camera can be used or an infrared filter can be mounted between the film rails inside the camera, in which case the viewfinder is unobstructed.

Color infrared film is a false-color material made exclusively by Kodak as Ektachrome Professional Infrared (EIR) reversal film. When the film was introduced in 1943 it was intended for camouflage detection and other military use. The way the color dyes are coupled to the sensitized layers results in a shift of colors such that near-infrared in the scene is reproduced as red, red appears as green, and green as blue. Blue and UV are removed from the scene by shooting through a yellow filter as all layers are blue- and UV-sensitive. The resulting images feature red or magenta foliage and deep blue skies (see Figure 51). EIR is less prone to the light-piping effect of HIE so it can be loaded in subdued light.

The NIR sensitivity film deteriorates relatively quickly at room temperature and shelf life is greatly prolonged if the films are stored in a fridge or freezer. They should be allowed to warm to room temperature before use to avoid condensation.

The ratio of NIR to visible light varies with the time of day, the light source, and the filtration among other factors, so a normal exposure meter provides only a rough guide. Information on filtration, exposure, and development of these films can be found in the manufacturer's data sheets; however, it is important to avoid any sources of infrared light during handling and processing. Leakage through the walls of some plastic development tanks and infrared sensors used in commercial processors have caused problems.

Some Applications of NIR
Art

It is possible to use infrared photography to great artistic effect looking for the qualities that are unique to photographing in this spectrum. The glowing foliage and black skies can add drama to landscape scenes and the unusual appearance of skin and eyes in infrared makes for novel portraits. Prints of infrared landscapes also respond well to hand-coloring. Color

infrared film is less used artistically but can produce startling results with appropriate subjects.

Art restoration

The ability of NIR to penetrate more deeply through some materials—such as vellum—and the different reflectance characteristics of inks and pigments give infrared imaging a place in the diagnostic stages of art restoration. NIR photography has been used to see through the back of works of art when the base material is thin enough and transparent at NIR wavelengths. Longer NIR wavelengths, for example, $2-3\,\mu m$, can be used to reveal even more information in works of art by "seeing" further through the paint materials from the front. In this way, many over-painted preliminary drawings and other hitherto hidden works have been discovered. This technique is called infrared reflectography. NIR is non-invasive and, by definition, is a lower energy radiation than visible light. This naturally adds to its suitability for use with rare and delicate works of art.

Agriculture

The relative amounts of green and NIR reflected by foliage are a sensitive indicator of its condition. This is best seen using false-color infrared photography where a shift from red toward magenta in the image indicates that the plants are under some kind of stress from factors such as disease, infestation, or lack of water which, in turn, can also be an indicator of localized external factors, such as obstructions just below the surface or changes in the water table.

Remote sensing using NIR is particularly useful in forestry. The foliage of different kinds of trees has different infrared reflectivity, but not enough to differentiate species. In general, hardwoods look darker in black and white infrared than softwoods, and there is some infrared darkening of conifers as they age even though their visible appearance remains the same. This has the artistic effect of giving mixed woodland a more varied tonal range than is seen in visible light, especially if hardwood and softwoods are mixed together.

Astronomy

In this most remote of remote sensing applications, infrared imaging is invaluable. The better-resourced professionals tend to use FIR wavelengths, where the ability to peer through fine dust to see the first stages of star formation is of enormous value. However, at great distances, the expansion of the universe shifts visible light and even UV light into the infrared, so IR detectors are essential for studying the most distant objects. FIR observations are made from earth-orbiting satellites to avoid atmospheric absorption. Amateur astronomers also use the infrared for imagery, and this field is becoming increasingly popular.

Cinematography

In the heyday of black and white motion pictures, infrared film was used to simulate night-time shooting during the day,

known as "day-for-night". It was also one of the ways that a traveling matte could be produced so that the background of a scene could be changed. Neither of these techniques is used today.

Photography in the dark

NIR can be used to take photographs in total darkness. Normally the light source (flash or lamps) is filtered to remove any visible component and will not be seen unless the subject looks directly at it. By this means images have been taken of audiences in cinemas, to study their reactions, and to record people sleeping. Infrared cameras are also present in the bedrooms of the Big Brother television program and are used for animal behavior studies as well as wildlife television. NIR is widely used for surveillance, where a combination of infrared floodlights and infrared video cameras allows security personnel to observe activity around buildings at night without needing to illuminate them with visible light. Some industrial processes that have to take place in darkness, such as photographic development, can be observed in this way.

Forensics

NIR will often show up features that are invisible to the naked eye. An example of this is modification to a document as a result of fraud or forgery. This might be detectable using reflective infrared photography or by changes in infrared fluorescence, which can also be photographed. Similarly, faded or writing on charred paper may become visible using NIR techniques. Some inks are transparent to NIR and this can provide a way of examining otherwise obliterated portions of documents.

Medicine

Since NIR penetrates a few millimeters into the skin and may be reflected differently by skin pigmentation, thus it can be used as a diagnostic aid. Patterns of blood vessels near the surface can be seen. Infrared photos have proved useful in showing changes in blood vessels caused by a variety of conditions including breast cancer, cirrhosis of the liver, and varicose veins. NIR can pass through eye defects such as some cataracts and cloudy corneas. Because the pupil does not react to NIR, studies of pupil dilation in very low light can be carried out.

Zoology and botany

The penetrative powers of NIR can aid photomicrography of specimens such as small insects by allowing a view through the insect's chitin, or hard external skeleton. On a larger scale, some insects and even larger animals that are difficult to see because they blend into their surroundings can become easily visible using NIR.

Thermal imaging

The essential thing about thermal imaging in the FIR is that objects are detected by means of the radiation that they emit because they are warm. FIR images of a scene may share some

features with a visible or NIR image but this is superficial. The way in which objects—solids, liquids, dust, and gas—absorb, reflect, refract, or scatter visible light has little influence on the formation of a thermal image, so thermal infrared images do not look like normal photographs. However, many regions of the FIR spectrum are strongly absorbed by the atmosphere and are affected by humidity, so the full FIR range is only accessible from space.

All objects that are warmer than absolute zero (0 K, −273°C) emit some radiation because of the thermal motion of their constituent atoms. The warmer an object is, the more vigorous the thermal vibration and the more radiation is emitted, over an increasing range of wavelengths. As the temperature increases it will eventually extend into the visible region, where it is first seen as dull red (red-hot). Long before red heat is reached, warm objects emit radiation in the FIR part of the spectrum which extends from about two to over 30 μm (microns, millionths of a meter).

Thermal imaging in the FIR thus detects and displays patterns of heat radiated by objects and the environment. This means that if an object is at a different temperature when compared to its surroundings it can be "observed" and its temperature measured by means of its radiated energy. In general, the cooler an object, the longer the wavelength it emits, and the more complex is the equipment required to acquire an image. This becomes obvious when it is realized that the imaging optics and camera itself may be warm enough to be FIR radiators themselves.

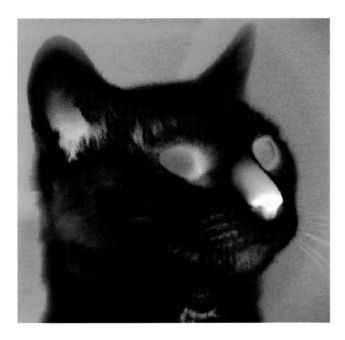

FIG. 53 Cat's head imaged in FIR. This is a false-color represen-tation of a monochrome image covering the 3–5 μm wavelength. The orange areas are the warmest and the white-blue areas are the coolest. (Image courtesy SE-IR Corporation, Goleta, CA.)

For all these reasons a good deal of FIR imaging is confined to specialist technical applications, where the complexities of cooling an imaging system with liquid nitrogen or even liquid helium are acceptable. However, not all FIR imaging requires cryogenic cooling and many manufacturers offer cameras for less demanding applications. Many commercial uncooled IR sensors operate in the 8 to 12 μm range, where source energy is high and atmospheric absorption is low. With a strong signal, it is possible to discriminate quite small temperature differences, such as heat leaks from buildings and changes in skin temperature due to poor blood circulation. These imagers are sturdy and versatile enough to be used by firefighters searching for people who are alive but unconscious in smoke-filled buildings, and to detect intruders at night. Even a hand placed briefly on a surface will leave a heat trace, briefly visible as a hand-print in the FIR.

Thermal imaging cameras are still expensive items but their price is falling. However, all of them capture an essen-tially monochrome image. The camera displays can be in false color or black and white, and many models allow the user to choose the mode of display. In false-color modes the tempera-ture is represented by color, often blue for "cold" and red for "hot" (see Figure 53). In black and white mode, the brightness is proportional to temperature. Color modes are often used for industrial survey and medical applications, while black and white is used for surveillance. Since the imaging wave-lengths are relatively long, and the dynamic range often trun-cated, it is not possible to achieve the imaging resolution possible in visible or NIR images. The images generated by thermal cameras are usually of standard definition television quality or less.

Some Thermal Applications
Astronomy

Beyond NIR wavelengths astronomical imaging is mostly done from above the atmosphere due to atmospheric absorption. Astronomers usually refer to NIR as extending to 5000 nm (5 μm) and refer to the band from 5 μm to 25/40 μm as mid-infrared with far-infrared extending from here to 200/350 μm. The split between these bands derives from the kinds of detec-tors required.

At a wavelength of 2 μm, particles of dust that might obscure the center of our galaxy become transparent. As the temperature and energy of the objects of interest reduces imaging moves to longer wavelengths, so that objects as cold as 140 K are visible and the stars seem to be absent. However, the earliest stages of star formation, occurring in cold, opaque molecular clouds, can be seen, as well as the central regions of galaxies such as the Milky Way, normally shrouded in dust.

Preventative maintenance

It is a common misconception that NIR photographs can be used to show how well a building is insulated; however, this is a common application for FIR and thermal imaging, where areas of heat leakage are easily detected. FIR sensors also

can remotely monitor the temperature of components in machinery to detect friction or electrical overheating, and a thermal image of industrial plant can allow an engineer to detect potential trouble spots at a glance.

Medical

One medical application of FIR is as a remote-sensing thermometer. Thermal imaging cameras are marketed specifically for this purpose, and one application is to quickly scan arriving international passengers for an elevated head temperature, which might indicate an infectious illness such as SARS or Avian Flu. Thermal imaging can similarly show patterns of temperature on the surface of human and animal bodies. This is a painless and non-invasive technique that is useful for showing patterns of blood flow, such as changes due to disease and subtle changes in skin temperature caused by tumors.

Night vision/remote surveillance

The human body radiates strongly at a wavelength around 9.3 μm, corresponding to a temperature of 37°C (310 K), whereas open ground at, say, 15°C (288 K) will radiate at 10 μm. Thus it is possible to differentiate between body heat and the ambient temperature, particularly at night. Law enforcement and military personnel use FIR cameras mounted on helicopters to follow action on the ground when visible light cannot be used. It is also easy to detect recently used automobiles by the FIR glow from a still-warm engine and hot spots in forest or building fires that are otherwise masked by smoke.

Many remote applications involve detecting small temperature differences. This aids in searching for people lost in landscapes, the sea, or trapped under buildings. The body heat will be detectable at a distance and a hidden body may warm the local environment enough for detection if the camera has sufficient temperature resolution. Work has been done in using FIR to detect clear-air turbulence or volcanic ash as an aid to aircraft safety. Vulcanologists can use FIR to map lava flows and temperature changes on the ground that result from hidden volcanic activity. Of course, lava temperatures are such that it often registers in NIR and even visible light images.

See also the following articles

Astrophotography; Forensic Photography; Medical Photography; Military Photography; Multispectral Imaging; Photogrammetry; Remote Sensing

FURTHER READING

Amhurst Media publishes a range of books on various aspects of infrared photography, www.amherstmedia.com.

Gibson, H. L. (1978). *Photography by Infrared: Its Principles and Applications 3/e.* New York: John Wiley and Sons. (This is the most authoritative work on the subject but is long out of print.)

Milsom, H. (2001). *Infra-Red Photography: A Complete Workshop Guide.* Faringdon, Oxfordshire: Fountain Press.

ADDITIONAL INFORMATION

Author's infrared Web site—Invisible Light. This site includes an extensive bibliography and list of Web links on the subject. www.infraredphotography.info (also reached by www.atsf.co.uk/ilight)

Astronomy resource but including substantial information on all kinds of infrared imaging: coolcosmos.ipac.caltech.edu:

Infrared photography FAQ: www.cocam.co.uk/CoCamWS/Infrared/INFRARED.HTM

Medical and scientific infrared photography resource: http://msp.rmit.edu.au/Article_03/index.html ◉

Kirilian Photography

DAVID MALIN
Anglo-Australian Observatory, RMIT University

A Kirilian photograph is a photographic recording of the faint corona discharge induced by the application of a high voltage but low current electrical field to an object which is in direct contact with a photographic material. If recorded on color film, the plasma of the corona may exhibit a remarkable range of hues, mostly from atmospheric oxygen and nitrogen ionized by the applied electric potential, plus some direct exposure of the underlying emulsion by electrons.

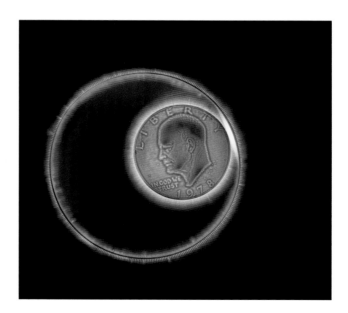

FIG. 54 Kirilian image of an American coin and a glass filter, showing the coronas from passing high voltage for a short duration and captured on a 4 × 5 color transparency film. (Photo by Michael Peres.)

The normal process involves placing an insulated metal plate beneath a sheet of photographic film (or instant film such as Polaroid) and completing the circuit through a specimen, which is put in contact with the film, usually in a light-tight bag or a darkroom. However, a conventional camera can also be used to record the corona discharge if the electrode in contact with the specimen is a transparent plate.

With inanimate objects such as a rock, the characteristics of the corona that are produced will be predictable and reproducible, provided the object is dry and the humidity constant. With some biological specimens the corona pattern may vary from time to time, probably due to local humidity changes in the air in the region between the living organism or object and the photographic layer. For example, if the object is a human finger, the degree of perspiration, its cleanliness, or pressure on the plate may affect the appearance and color of the corona.

Similar discharge coronas are observed in nature, as "St. Elmo's fire," reported by sailing ships at the edge of an electrical storm at sea. A smaller electrical discharge is seen when removing silky or polyester clothing in the dark under dry conditions. These unusual phenomena, related to Lichtenberg figures (frozen lightning) are well explained by conventional physics. Despite this they have become part of "New Age" philosophies, with the high-voltage aura proposed as revealing something of the "natural energy" of living specimens or human subjects. There is no evidence to support this. ◉

Medical Diagnostic Imaging

DONALD McROBBIE
Charing Cross Hospital

Introduction

Medical imaging and the discipline of diagnostic radiology began just over a century ago with Wilhelm Conrad Roentgen's dramatic and accidental discovery of "X-rays" in 1895. Visit a local hospital today and one will find a battery of diagnostic imaging modalities: X-ray, nuclear medicine, MRI, and ultrasound. These are often connected to each other and distributed throughout the hospital via sophisticated computer networks.

Medical imaging is used for the diagnosis of diseases, for assessing acute injuries, for assessing the severity of disease or the response to a particular therapy, for guiding surgical interventions, and for health screening, as in mammography. Its practitioners are not primarily photographers but instead medical diagnostic specialists: technologists or radiographers, who acquire images and radiologists who interpret them using invisible energy in the electromagnetic spectrum.

With the exception of ultrasound, all medical imaging modalities utilize portions of the electromagnetic (EM) spectrum (Figure 55). As if to emphasize the modern physics view of the unity of matter and energy, in medical imaging these EM interactions all relate to the behavior of atoms.

The basic wave is equation is

$$c = f\lambda \tag{1}$$

where c is the speed of light ($3 \times 10^8\,\mathrm{ms}^{-1}$), f the frequency in hertz (Hz), and λ the wavelength in meters (m). As the speed of light is constant, wavelength and frequency bear a reciprocal relationship to each other.

According to quantum mechanics, light has a dual nature, possessing the properties of both waves and discrete particles. The smallest unit or quantum of EM radiation is the photon, which has an energy E (joules) given by de Broglie's equation

$$E = hf \tag{2}$$

where h is Planck's constant ($6.6 \times 10^{-34}\,\mathrm{Js}$). The higher the frequency (i.e., the shorter the wavelength), the greater the photon energy.

X-rays are formed principally by the deceleration (Brehmsstrahlung) of electrons as they collide with a target material (usually tungsten) in an X-ray tube (Figure 56). Additionally, characteristic X-rays are produced when an atomic electron moves between shells to fill the gap caused by the ejected electron. A spread, or spectrum, of different energies (and hence wavelengths) is produced. The small wavelength of the X-rays is comparable with the dimensions of an atom and means they can penetrate biological tissues. The X-rays interact with matter through a combination of photoelectric absorption and Compton scattering. In the former, the X-ray photon is fully absorbed by the atom and an electron is ejected. In the latter, some of the X-ray photon's energy is transferred to an electron and the photon is deflected (or scattered) with reduced energy. The relative contribution of these interactions depends upon the atomic weight of the element in question. In general, the heavier the atom, or the denser the material, the greater the absorption will be.

X-Ray Imaging

Like photography, a conventional X-ray produces a two-dimensional planar image. Unlike photography, radiographs are shadowgraphs, revealing the internal structures of objects. Conventional X-rays are thus projection images, they have no depth information, and all opaque and semi-opaque structures in the beam are superimposed.

The image contrast is generated by differences in the attenuation of the X-ray beam described by the linear attenuation coefficient μ

$$I_0 = I_i \exp(-\mu x) \tag{3}$$

where I_i is the incident beam intensity, I_0 the resultant intensity, and x the distance through the material. The attenuation coefficient itself comprises contributions principally from photoelectric absorption and Compton scattering. The mass attenuation coefficient is

$$\mu_m = \mu/\rho \tag{4}$$

where ρ is density. The probability of photoelectric absorption has a dependence on atomic weight, Z, to approximately Z^3, while Compton scattering is proportional to electron density

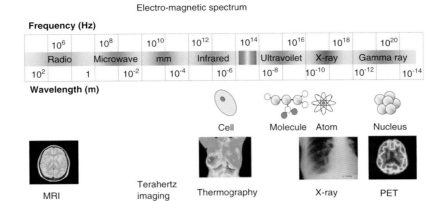

FIG. 55 The electromagnetic spectrum and medical imaging applications.

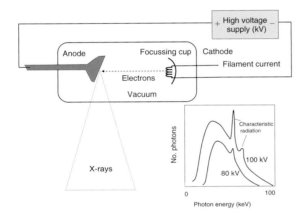

FIG. 56 Principle of X-ray production. Inset shows X-ray spectra for tube potentials of 100 and 80 kV.

TABLE 3 Attenuation of X-Rays in tissues and CT numbers shown in Figure 55

Tissue	Linear attenuation coefficient for 30 keV X-rays (cm^{-1})	CT number (Hounsfield Units)
Bone	1.3	>1000
Fat	0.3	−95
Liver	0.44	50
Muscle	0.26	40
Blood	0.45	42
Brain, gray	0.37	30
Brain, white	0.36	30
Water	0.18	0
Air	0	−1000
Lung	0.27	−750

and is broadly independent of Z. At lower photon energies photoelectric absorption is the dominant mechanism.

Differences in linear attenuation coefficient of tissues are shown in Table 3. As the densest tissue, bone produces a shadow in the image. The X-rays blacken the film, hence bone with the greatest attenuation shows up as lighter. To improve the visualization of soft tissues, contrast media are sometimes used. These contain heavy elements, e.g., barium or iodine, which absorb more X-rays than the surrounding tissues. Scattered radiation results in a loss of image information and contrast and may be reduced by using a grid of lead strips, which only accept rays within a certain angle of incidence.

Film-Screen Combinations

Historically, the first X-ray detector was photographic film. In radiography a two-stage detection process is usually employed that uses film-screen cassettes (Figure 57a). In these cassettes, the X-rays impinge upon a phosphorescent intensifying screen that produces visible light photons, which then expose the photographic emulsion. Intensifying screens typically employ rare earths (such as gadolinium, lanthanum, or yttrium) for their photoelectric absorption properties, with light emissions primarily in the blue-green region. Conventional X-ray film has a double emulsion layer (used with two screens) 5–10 μm thick consisting of silver iodide and silver bromide grains (1–2 μm in diameter) suspended in gelatin. Photographic processing is required. As in conventional photography, X-ray film has a limited latitude or dynamic range and a non-linear characteristic curve. Dental X-rays do not use intensifying screens but rely on the direct effect of the incident X-ray photons. These films must be processed in a radiographic film developer.

Computed Radiography

In computed radiography (CR) the X-rays interact with a photo-stimulable phosphor plate that stores the latent image, which can then be read out by exposing the plate to a scanning

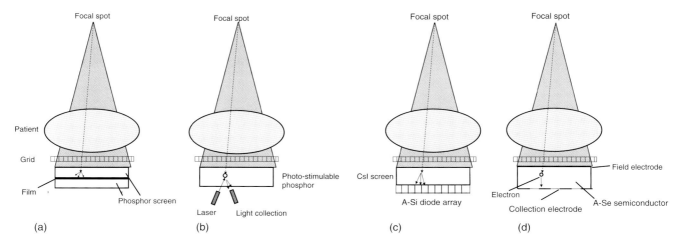

FIG. 57 Radiographic detectors: (a) film-screen, (b) CR, (c) DR using scintillator and photodiode array, and (d) DR using amorphous selenium detector.

laser beam (Figure 57b). The CR plate may be reused and the dynamic range of CR exceeds that of X-ray film. The resultant image is of a digital nature and is compatible with image processing and medical image computer networks or Picture Archiving and Communication Systems (PACS).

Digital Radiography

In digital radiography (DR), a solid-state semiconductor detector array is used. The conversion process may be two-stage (Figure 56c) where incident X-rays interact with a phosphor screen (often cesium iodide) to product light photons, which then are converted to electrical signals by the semiconductor array, usually amorphous silicon (a-Si). Alternatively an amorphous selenium (a-Se) detector array is used to directly convert the X-rays to electrical signals (Figure 57d). The semiconductor arrays used are much larger than in, e.g., DR, as they have size equivalent to that of an X-ray film.

Fluoroscopy

In fluoroscopy, dynamic, real-time X-ray images are produced. These enable surgical guidance, e.g., the positioning of a catheter in the heart for angiography, angioplasty for repairing arteries, or the placement of implants and other medical devices. Fluoroscopy originally involved the radiologist or doctor staring at a fluorescent screen directly in the radiation beam. The development of the image intensifier in the 1950s enabled good quality fluoroscopy to be achieved at the fraction of the radiation dose for both patient and doctor. In the image intensifier, X-rays are converted to light photons that impinge on a photo-cathode which produces electrons. These are then accelerated across a vacuum and hit the output phosphor producing an intensified optical image. This can then be captured by a television or charge-coupled device (CCD) camera and digitized. More recently digital flat panel detectors have been deployed. These utilize large semi-conductor arrays as in digital radiography.

FIG. 58 Multi-slice CT scanner.

Computer Tomography

X-ray computed tomography (CT or computer-assisted tomography) permits the visualization of the internal anatomy as a series of thin slabs or slices. To do this the CT scanner acquires various views or projections of the body from different viewing angles. A complex mathematical algorithm known as filtered backprojection permits the reconstruction of the image as a thin slice. The term tomography derives from the Greek *tomos* which means slice. In a CT scanner, the X-ray tube and detector are mounted on a gantry which rotates about the patient in one second or less (Figure 58). The image intensity in CT uses hounsfield units (HU) defined as

$$HU = \frac{\mu^{time} - \mu^{water}}{\mu^{water}} \times 1000 \qquad (5)$$

Formerly only one slice could be acquired at a time. To perform a full examination a slice was acquired then the

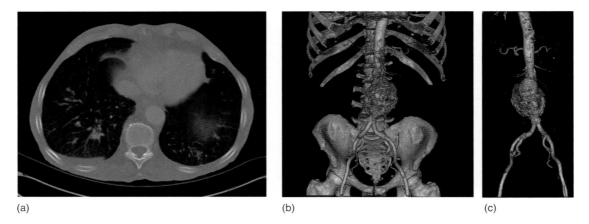

(a) (b) (c)

FIG. 59 CT images: (a) slice through the lungs and heart, (b) 3D reconstruction of abdomen and pelvis showing aortic aneurysm, and (c) cut-away view of aneurysm.

patient moved to a new position, the whole examination was performed stepwise. In spiral CT a whole volume of data is acquired while the patient is moved continuously through the gantry. This allows for faster scans, better three-dimensional information, and the possible reduction of the radiation dose. In multi-slice scanners the X-ray detector consists of a two-dimensional array and multiple slices are obtained simultaneously. Current commercial models may capture up to 64 slices. Both spiral and multi-slice CT techniques enable multiplanar reformatting where different views of the anatomy are possible (Figure 59).

Other X-Ray Techniques
Mammography
Mammography is a technique optimized for imaging the breast, particularly for detecting microcalcifications that could indicate breast cancer. A lower energy X-ray beam is used to achieve greater image contrast. Mammography film utilizes a single layer emulsion with one intensifying screen and has a higher spatial resolution than conventional radiography. Digital techniques (CR and DR) are also available but have lower resolution.

DEXA
Dual-energy X-ray absorptiometry (DEXA) is a low-dose technique used for bone scanning, particularly for the detection of osteoporosis and for determining body composition. The use of two photon energies enables an estimation of the relative contributions of photoelectric and Compton absorption and an indication of the average Z of the tissue, which can be used to categorize bone versus soft tissue.

Nuclear medicine
Radioactivity was discovered by Becquerel and the Curies in 1896. When unstable atomic nuclei disintegrate, quanta of EM radiation known as gamma rays may be produced. Gamma rays have a higher energy than X-rays and are highly penetrating. In nuclear medicine a gamma ray emitter with a short half-life (commonly technetium 99m) is attached to a larger molecule and injected into the bloodstream. The distribution of this radiopharmaceutical can then be traced through the body. Nuclear medicine is often used to assess the function of the kidneys and the heart.

Gamma camera
The most commonly used nuclear medicine imaging system is the Anger or gamma camera. This consists of a large sodium iodide crystal that converts the incident gamma rays into light which is then detected by an array of photomultiplier tubes. Subsequently a digital image is produced. The image is usually noisier and of less spatial resolution than an X-ray image but has the advantage of containing information about organ function by tracking the distribution or time course of the concentration of radioisotope.

PET and SPECT
As for X-ray imaging, tomographic images or slices may also be produced. The simplest way to achieve this is to rotate the gamma camera around the patient and have the computer reconstruct the slices. This is called single photon emission computed tomography (SPECT). Another way involves a different technology called positron emission tomography (PET).

When a positron encounters an electron, annihilation occurs. This results in destruction of both particles and the production of a pair of high-energy gamma rays traveling 180 degrees in opposing directions. By precisely detecting these pairs of photons, the PET scanner can determine the path of the photons. Fluoro-deoxy-glucose (FDG) is a commonly used positron-emitting radiopharmaceutical incorporating fluorine 18. The positron-emitters are usually produced by a cyclotron. PET is useful in oncology, detecting metastases and also for studying brain metabolism.

TABLE 4 Typical Radiation Doses in Radiology

Examination	Radiation dose (millisieverts)	Equivalent risk
Limbs	<0.01	Negligible
Chest X-ray:	<0.05	Radiation from 1 transatlantic flight
Abdomen	1.0	75 cigarettes
Lumbar spine	2.0	Around the world flight
Nuclear medicine bone scan	3.0	One year's natural background radiation in the United States
CT abdomen or pelvis	8.0	20,000 miles of road travel
PET scan	10	3 years of natural background radiation

Radiation dose

The energy of X-rays and gamma rays is such that they may dislodge an electron from its parent atom, producing a positively charged ion plus a negatively charged electron. X- and gamma rays are types of ionizing radiation. Ionization can lead to damage to biologically significant molecules (e.g., DNA) and can produce free radicals, which chemically cause further damage to cells. The biological consequences of ionization depend upon the amount and type of radiation absorbed. Broadly two types of effects occur. The first are acute tissue reactions or deterministic effects, which include loss of fertility, skin burns, and cataract formation, but these require large amounts of radiation in excess of 1 gray (Gy) and rarely occur in diagnostic radiology or nuclear medicine. The second effect is cancer induction, including leukemia and solid tumors, but with a long latency of ten or more years after the exposure. These are stochastic effects where the probability, rather than the severity, of the effect is related to the radiation dose. Usually a linear relationship between risk and radiation dose is assumed. Typical radiation doses are shown in Table 4. The sievert (Sv) is the unit of effective dose (E) which relates to the health detriment defined as

$$E = \sum_T w_T \sum_R w_R \cdot D_T \qquad (6)$$

where w_T is the tissue weighting factor (an indication of the tissue's radiosensitivity), w_R is the radiation weighting factor (= 1 for X- and gamma rays), and D_T is the mean absorbed dose (Gy) in each organ.

Magnetic resonance

Magnetic resonance imaging (MRI) also uses EM radiation generated by the atom, this time the nucleus, but without causing it any damage. The original name for this technique was nuclear magnetic resonance (NMR) imaging, but it was changed to MRI to avoid the negative connotations of the word nuclear. MRI makes use of the magnetic properties of the nucleus, particularly of the hydrogen nucleus, two of which are found in every water molecule. The hydrogen nucleus consists of a single proton, which possesses both angular momentum (or spin) and electrical charge and by the laws of electromagnetism acts like a tiny magnet. Under quantum mechanics the proton spin may only assume two orientations when subject to an external magnetic field: either parallel to the field or anti-parallel. There is a natural preponderance for protons to adopt the lower energy orientation, parallel to the field. In magnetic resonance, protons are induced to change their orientation by the application of EM fields at the appropriate frequency, known as the Larmor or resonant frequency. This happens to fall in the radiofrequency (RF) portion of the EM spectrum. Once stimulated or excited the protons return to their preferred state by processes known as relaxation, and in doing so they emit a photon of EM radiation at the Larmor frequency. This can be detected by an RF coil. Magnets used in MRI are very strong with field strength, typically between 0.5 and 3 tesla (T), often using superconductivity to produce the field. By comparison the earth's magnetic field is of the order of 0.05 mT. The wavelength of the RF photons used in MRI is long, and MRI consequently produces no ionization. It is not believed to have any serious side effects.

Magnetic resonance imaging
To form an image, temporary variations in the applied magnetic field are introduced resulting in a localized variation in the Larmor frequency given by

$$f = \gamma B(x,y,x) \qquad (7)$$

where γ is the gyromagnetic ratio (for hydrogen equal to 42×10^6 Hz T^{-1}) and B is the magnetic field (Tesla). Thus if B is a function of position, then so is frequency. A process known as two- or three-dimensional Fourier transformation converts the MR signals into their constituent frequencies and hence localizes the origin of the signals, forming the image.

In MRI usually only water and fat are visible. The images relate to the water (or proton) density and also to the freedom of movement of the water. In addition to producing static and angiographic images, MRI can be used to investigate organ function, e.g., heart wall motion, valvular function, the velocity of blood, and many other parameters. In functional MRI of the brain (or fMRI) localized changes in oxygenation can be detected that relate to cortical neuronal activity, thus indicating the part of the brain active in a given task (Figure 59).

MR spectroscopy
Hydrogen nuclei, which are part of larger molecules, may be shielded from the external magnetic field resulting in a slightly reduced Larmor frequency. In MR spectroscopy (MRS) this feature, known as the chemical shift, is exploited to yield

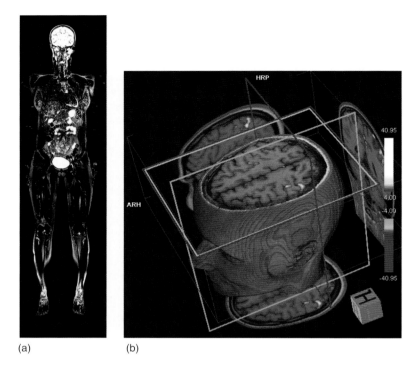

(a) (b)

FIG. 60 MR images: (a) whole body MRI and (b) fMRI scan showing brain activation.

information about the chemical environment of the nuclei. Imaging techniques may also be applied simultaneously to yield maps of metabolites, or the body's chemistry. MRS is useful in examining the response of tumors to therapy. MRS may be applied using other nuclei, most notably phosphorus (P^{31}), giving an indication of energy metabolism.

Ultrasound

Ultrasound was developed in the 1950s following the development of SONAR in World War II and is unique in not involving EM radiation. Instead, acoustic pressure waves are transmitted into the body and the reflections detected by a piezo-electric transducer. The strength of these reflections, or "echoes" are dependent upon the mechanical properties of the tissues. By computing the time between transmission of an ultrasonic pulse and the detection of the echoes from that pulse, the depth within the tissue can be determined, assuming the speed of sound in tissue ($1540 \, ms^{-1}$). Echoes arising from flowing blood display a velocity-dependent frequency shift, subject to the Doppler effect, similar to the change in pitch heard from a moving siren on an emergency vehicle. This enables ultrasound to image blood flow and measure blood velocity. The ability of ultrasound to image in real time and its sensitivity to flow, through the Doppler effect, have been key factors in its widespread role in obstetrics, cardiology,

abdominal and vascular disease, real-time biopsy guidance, and minimally invasive surgery. Ultrasound is also non-ionizing and carries minimal risks.

Image Networks

Modern medical images in the Digital Imaging and Communications in Medicine (DICOM) format are freely exchangeable between a wide variety of devices and different vendor's equipment. This makes it possible to share images over a computer network in aPACS. In this form they may be viewed in multiple locations, e.g., on the ward or in the operating room or clinic. Medical informatics is a rapidly expanding field.

GLOSSARY TERMS

Angiography—Imaging of blood vessels, from Greek *angeion* meaning vessel.

Angioplasty—An operation to repair a damaged blood vessel or unblock a coronary artery.

Atomic number—The number of protons in an atomic nucleus.

Atomic weight Z—The total number of protons and neutrons in an atomic nucleus, denoted by the letter Z.

Backprojection—Algorithm to reconstruct a slice from projection data, as in CT scanning.

Compton scattering—The deflection of an incident photon through partial energy transfer to a free or orbital electron.

Deterministic effect — Tissue reaction to radiation in which severity is proportional to radiation dose.

DICOM — Digital Image and Communications in Medicine. The international standard used for transferring, storing, and displaying medical images.

Effective dose — Unit relating physical amount of absorbed dose in tissue (grays) to health detriment (sieverts).

Electron — Negatively charged sub-atomic particle.

Gray (Gy) — Unit of absorbed radiation dose in matter. 1 Gy = 1 J/kg.

Gyromagnetic ratio — Constant of proportionality relating external magnetic field to magnetic resonance frequency.

Hounsfield unit — Intensity of a CT image.

Isotope — Forms of the same element that contain equal numbers of protons but different numbers of neutrons in their nuclei.

Larmor frequency — The resonant frequency in MRI, usually in the RF portion of the electromagnetic spectrum.

Mammography — X-ray imaging of the breast with low-energy X-rays.

Metastases — Secondary tumor sites.

Neutron — Uncharged sub-atomic particle.

PACS — Picture Archiving and Communications System. A computer network used for sharing medical images electronically.

Photoelectric effect — An absorption process in which a photon (e.g., X-ray photon) transfers its entire energy to an inner (e.g., K or L) shell electron of the atom.

Photomultiplier tube — A device that converts light into electrical current.

Positron — Positively charged equivalent of an electron.

Proton — Positively charged nuclear particle.

Radiopharmaceutical — The combination of a radioactive isotope with a pharmaceutical.

Sievert (Sv) — Unit of effective dose. The uniform irradiation of an adult human with 1 Gy of X- or gamma rays results in an effective dose of 1 Sv.

Stochastic effect — An effect whose occurrence depends upon chance.

Superconducting magnet — An electromagnet that has wires which exhibit superconductivity. These can maintain a high current without the need for a driving voltage or power supply.

Tomography — A cross section through a human body. From Greek *tomos* meaning slice or section.

FURTHER READING

Bushberg, J. T., Seibert, J. A., Boone, J. M., and Leidholdt, E. M. (2001). *The Essential Physics of Medical Imaging*. Philadelphia: Lippincott Williams and Wilkins.

McRobbie, D. W., Moore, E. A., Graves, M. J., and Prince, M. R. (2003). *MRI From Picture to Proton*. Cambridge: Cambridge University Press.

Thomas, A. M., Isherwood, I., and Wells, P. N. T. (eds.) (1995). *Invisible Light: 100 Years of Medical Radiology*. Oxford: Blackwell Science.

ADDITIONAL INFORMATION

GE Healthcare Biosciences Medcyclopaedia http://www.amershamhealth.com/medcyclopaedia/medical/index.asp

National Electrical Manufacturers Association (2005). DICOM homepage. http://medical.nema.org/.

Medical Photography

STAFFAN LARSSON
Karolinska Institute
JONAS BRANE
Scientific and Technical Photography Consultant

Introduction

The ability to make accurate, permanent, and objective images of medical conditions, outcomes, and observations has been vital to the progress of medical science for over 150 years. Medical photography is a highly specialized profession, demanding much more than technical skills from its practitioners, which is why it is also known as biomedical photography. In this extensive discipline the images are made to document all of the prominent features of a subject without exaggeration, enhancement, distortion, deliberate obliteration, or the addition of details that might lead to misinterpretation by the viewer. These subjects may include clinical photographs, surgical procedures, surgical specimens, autopsy and forensic material, tissue slides, bacterial specimens, laboratory preparations, graphic and fine art renditions, medical equipment, and public relations features, as well as illustrations for publications and presentations. Of course, not all biomedical photographers will be masters of all these techniques, but any competent practitioner will be familiar with most of them. Medical diagnostic imaging (MRI, CT scanning, and other specialized techniques) and medical radiography are considered elsewhere in this encyclopedia.

A Brief History of Medical Photography

Illustration has been an important feature of medical documentation since the time of Vesalius and thus has a long history. However, the first application of photography to medicine appears in 1840, when Alfred Donné of Paris photographed sections of bones, teeth, and red blood cells using an instrument called the microscope-daguerreotype. Conventional medical photography apparently began in France when J. G. F. Baillarger photographed cretins (1851), which was followed by a Dr. Behrendt of Berlin photographing his orthopedic cases in 1852, and in the same year by Dr. Hugh Welch Diamond photographing mental patients at the Surrey County Asylum in England.

During the American Civil War (1861–1865), countless photographs were made of wounds; these photographs are preserved at the National Library of Medicine, Washington, D.C. In 1861 Jacob Gantz made stereoscopic photographs for

T. Billroth at the Chirurgical Clinic in Zurich. J. N. Germack made photographs through the endoscope (1862), and the human retina was photographed by William Thomas Jackman and J. D. Webster in 1885.

A new era in medical photography occurred when E. J. Muybridge synthesized motion studies (chronophotography) of humans and animals (1877–1893), which greatly stimulated other investigators in medical photography, and the French physician Étienne-Jules Marey endeavored to analyze human and animal motion by serial photographic studies (1882) and devised a chronophotographic apparatus and projector (1890), which was the forerunner of the modern motion-picture camera. By the turn of the century, applications were too numerous to mention, but in 1927 R. P. Loveland made a medical teaching film using cinephotomicrography, demonstrating the life history of the yellow fever mosquito, and in 1929 F. Neumann in Germany made a time-lapse film of living bacteria.

The first medical publications illustrated with photographs were *Album de Photographies Pathologiques and Mecanisme de la Physiologie Humaine* (1862) by G. B. Duchenne, the founder of electrotherapy. The *Photographic Review of Medicine and Surgery* (1870), by F. F. Muary and L.A. Duhring, was the first medical journal illustrated with photographs. Albert Londe in 1888 published a book, *La Photographie Moderne*, containing information on medical photography and also the first book specifically devoted to medical photography, *La Photographie Medicale* in 1893.

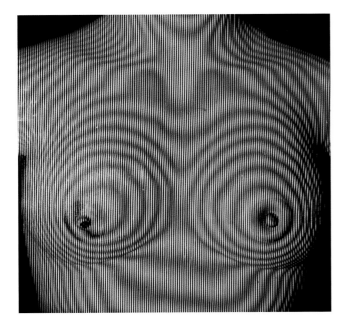

FIG. 61 The special technique of Moiré topography can be used to show differences before and after plastic surgery.

The Medical Photographer

From the photographic perspective, the medical photographer is obliged to be versatile and innovative, possessing a broad knowledge of the photographic process and ancillary activities such as digital image editing. One of the prime requisites of a medical image is that it be permanent, properly classified, recorded, and filed for easy retrieval. The photographer is thus expected to have a good knowledge of computers for storage, indexing, retrieval, and distribution of images. Images may be recorded on conventional silver halide based films, on video tape, on digital imaging media, or other contemporary recording material, so the capabilities of these media is also important. The medical imager is thus responsible for managing a large inventory of images that is constantly being augmented. When these are tied to patient records an extremely valuable resource is created.

A medical photographer may be called upon to use a variety of specialized techniques, such as infrared and ultraviolet reflected or fluorescence imaging, endoscopy and fiberoscopy, polarized light, intra-oral photography, stereo imaging and photogrammetry, contour mapping, and photomacrography and photomicrography. An area that has been traditionally a big part of the work in medical photography has been reprographics, photographing texts, charts, and graphs; and radiographs for lectures, posters, presentations, and publication. With the evolution of digital imaging methods, this activity has changed dramatically, so layout and desktop publishing is now often done in-house and by the medical photographer. Medical photographers also sometimes manage audiovisual services for medical conferences, so they must understand the basic principles of audiovisual presentations such as the characteristics of microphones, sound amplification, audio recording, projector equipment, and screen requirements.

Apart from the obligatory photographic, multimedia, and administrative skills, the medical photographer must have a good general knowledge of anatomy and an elementary knowledge of physiology and histology and be familiar with the common everyday terms used in pathology, bacteriology, radiology, and surgical procedures. In addition, the photographer should possess a reasonable knowledge of medical prefixes, suffixes, and abbreviations frequently used in medicine, and be familiar with all hospital protocol, particularly regarding obtaining informed-consent patient releases for all visual or audio recording and reproduction purposes.

The photographer also needs to have an understanding of, and sensitivity to, a patient's condition and state of mind and be able to provide for the patient's safety and dignity during the photographic procedure. Tact and patience has to be exercised to make the patient comfortable, even under stressful circumstances. Work in theatres, wards, and post-mortem rooms can also be very stressful for the photographer. At the same time the photographer needs to be aware of the infectious nature of certain diseases and take precautions to avoid contact and to protect fellow employees from hazardous circumstances.

FIG. 62 A publicity photograph: "At the gene therapy vector lab."

FIG. 63 This iconic image from Lennart Nilsson of a human egg and uterine wall, helped promote the Swedish photographer's name world wide in the 1960s. Nilsson became famous for making the invisible visible and pioneering techniques taking viewers places they could not go without cameras.

Medical Photography in Practice

The range of equipment employed in medical photography will vary with the application and the institution. The standard setup includes the popular 35 mm single lens reflex (SLR) film camera with a comprehensive range of lenses, lighting equipment, and accessories or digital equivalents. The digital cameras may be of the same make as the film cameras to ensure the ability to share all the various accessories, especially lenses. The availability of compact digital equipment means that the photographer can often go to the patient ward, especially in large institutions, though a well-equipped studio is usually an essential. Other equipment, depending on the application, may include large format cameras, video cameras, photomicrography setups including time-lapse configurations, photomacrography setups including flatbed scanners, endoscopic and ophthalmic cameras, and a host of other specialized equipment designed for specific imaging techniques. Many departments will have a suite of computers for editing, storing, and filing images, often connected to the institutional network for rapid transmission of results.

A wide range of films are available; some brands are preferred by medical photographers for their good color reproduction and resolution, while digital cameras can be balanced for flash lightning. Whatever is used, it is important to be able to precisely reproduce lighting conditions. The first picture that is taken should give a neutral rendition of the patient or area. Two studio flashes set at 45 degrees will create even illumination for the most accurate color reproduction. The light is then adjusted to reveal cutaneous structures, such as a swollen tissue or the color of a disease as required. A general view of the area is photographed and then a close-up of the detail is also taken. Where completely shadow-less lighting is required at close distance, and for photographing cavities, a circular flash tube (ring flash) around the camera lens is used.

Photography in the operating room (theater) is among the most challenging tasks for the medical photographer. It requires careful attention to the emotional and physical environment in the room, especially sterile protocol, and, of course the photographer must remain unruffled during any emergency. The photographer will often confer with the surgical team in the placement of the camera, lights, and recording equipment. Before entering the theater, the photographer must discuss with the surgeon the procedure, from what position and angle to photograph the operative field, and the anticipated end-use of the material. Where possible, during the photography swabs and dirty drapes should be removed and replaced so that nothing distracts from the area of interest.

In the studio, a neutral background that does not introduce a color cast that could change the appearance of the skin is desirable. If a black background is used, care has to be taken to light the subject so that the profile and hair of the patient are not lost in the photograph. Other background colors preferred are white, gray, and blue. A plain white sheet can serve as a background when photographing on the ward. When photographing in the theater it is advisable to change the drapings if soiled before taking the photograph. It is also important to

FIG. 64 Photographs made for an article and a presentation about the cochlear ear implant.

remove objects and makeup that will disturb the view that is to be photographed unless it causes the condition.

Medical photographs can share a great deal about a patient's condition and serial photographs taken over a period of time may reveal much about the progress of disease or response to treatment. This makes the medical image a valuable asset for the patients medical record as well as in teaching, patient information, PR, and medico-legal work. For this to be effective it is important that the only variable should be in the patient and everything else should stay the same—viewpoint, positioning, lighting, color, magnification, and background.

To standardize the magnification when photographing the different parts of the body, a set of standards referred to as the Westminster Scales should be used. Practical details can be found in any good medical imaging textbook. By using these settings, closely matching images can be achieved over a period of time, independent of the number of photographers involved in the work. Guidelines have been set up to ensure that certain conditions and views are documented in the same way for a variety of relatively common conditions such as cleft lip and palate, mole mapping, the nine positions of gaze, scoliosis (spinal deformity), etc.

The Westminster Scales were originally set up for 35mm film and they will have to be modified when using digital cameras as the CCD sensor usually is smaller than the film. When choosing a lens for 35mm film, a focal length of around 100mm allows distortion-free images in most clinical situations, but a shorter focal length of around 50–60 mm will be needed for full-length photographs, or when working in a confined space.

While many photographic specialties are disappearing, the modern medical photographer finds their skills, versatility, and experience in demand, and many medical imaging departments now offer a comprehensive photographic and graphic image service to their institutions.

See also the following articles
Biological Photography; Dental Photography; Endoscopic Photography; Forensic Photography; Infrared Photography; Medical Diagnostic Imaging; Ophthalmic Photography; Photomacrography and Close-Up Photography; Photomicrography

FURTHER READING
Institute of Medical Illustrators (1996). *Institute of Medical Illustrators. A Code of Responsible Practice.* London: Institute of Medical Illustrators,p. 6.

Nayler, J. R. *Clinical Photography: A Guide for the Clinician*, http://www.bioline.org.br/request?jp03070#ft9.

Stack, L., Storrow, A., and Patton, D. (2000). *Physician's Handbook of Clinical Photography.* Philadelphia: Hanley and Belfus (Vetter, J. P. (ed.) (1992).

Biomedical Photography. Boston: Focal Press, pp. 258–9.

ADDITIONAL INFORMATION
An online resource for medical and scientific imaging techniques http://msp.rmit.edu.au

Military Photography

JOHN SIDORIAK
Independent Photography and Multimedia Contractor

Military photography began in 1855 with the English photographer Roger Fenton, who made over 300 photographs of the Crimean War under trying circumstances. However, the true nature of armed conflict was first exposed by Mathew Brady, an Irish immigrant, who, with others, photographed the American Civil War in the early 1860s. He used wet collodion plates that were prepared, exposed, and processed on the battlefield. Other conflicts followed, and by the turn of the 19th century aerial and reconnaissance photography were possible. They came of age in World War I. This, and other technical advances enabled military photography to become an important arm of military intelligence as well as a historian and publicist of military activity. Although many new technologies have emerged and the nature of warfare has changed, this varied and challenging role remains basically the same today.

With increasing specialization no one person can be expert in all aspects of the craft. However, the military photographer must have skills in advertising, photojournalism, forensic, and location photography, as well as still life and portrait photography. In addition, a military photographer may face rapid overseas deployment, combat and survival training, and must have an understanding of policies and protocol that allow the military photographer to be fully engaged in the military atmosphere.

Many people, operating at various levels, engage in military photography. Combat camera personnel are obliged to maintain mobility status, and are deployed at short notice to document domestic and overseas operations. They are trained

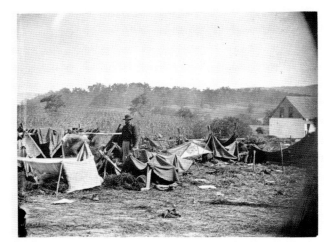

FIG. 65 An early example of war photography as photographed by Mathew Brady, U.S. Civil War from his Album Gallery 36. (Image courtesy of George Eastman House Collection.)

to survive and photograph in hostile conditions, while visual information and multimedia services photographers provide base-level local support for military operations and functions. In most cases the military photographer's role is to document historical events and provide support for military contingencies. True combat camera members are military personnel trained by the military and at photography institutions. Their training mirrors that of photographers in the private sector. One might expect that all military photographers are active duty or reserve members of the military, but this is not so. Increasingly, at least in the United States, contract photographers provide some services to the military, releasing more specialized photographers for combat duty.

Many duties in support of the military activities include location, studio, alert and emergency services photography, and photography in support of graphics. Location photography consists of recording historical ceremonies, public relation events, documentation of military inspections, and military exercises, few of which are organized with a photographer's needs in mind, all of which have to be photographed. Conditions can range from an extremely dark radar room or a nighttime "blacked out," red-light only special-operations mission to a welder's torch or an outdoor ceremony with sunny backlight, so a photographers ability to authenticate a once-in-a-lifetime event or large-scale exercise is routinely challenged. The photographer must be able to quickly assess the problem and devise a strategy to capture all the important elements and details without interrupting the event. The most common compliment received was "I didn't even know a photographer was there."

This is important in other contexts, where being unobtrusive but effective while recognizing military protocols and procedures earns respect from military leaders and supervisors, sometimes allowing access to privileged areas to document the inner workings of the military. Additional location photography in support of the military includes providing alert and emergency photography services for the Office of Special Investigations and Security Forces. Image documentation includes forensic/crime scene investigations, military mishaps, and autopsy documentation in a military environment.

Military photography can involve some remarkable extremes and can be a test of persistence, endurance, and courage, sometimes all at once; often, it just tests patience. It is not uncommon to provide photography support during special operations and finding oneself weightless inside an aircraft doing maneuvers, or using night-vision optics during a live-fire night training mission. Although these instances occur, many days are spent producing passport images, head and shoulder or full-length studio photography, and traditional grip and grin ceremonial photography. During those monotonous days, the memory of exciting assignments sustains the military photographer until another motivating opportunity arises.

In the last decade, photographers everywhere have been obliged to be cleaner and greener, by minimizing hazardous waste. Fortunately, this coincided with, and has encouraged the transition to digital photography. The traditional wet-process

FIG. 67 A Thunderbird F-16C aircraft, part of the Air Force's official air demonstration team, sits prominently on the tarmac during an early sunrise. (USAF photo by John Sidoriak.)

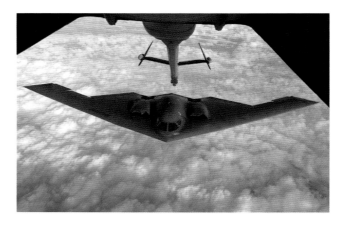

FIG. 66 Transfer cases of military service members arrival back to the United States to a repatriation ceremony. (USAF photo by John Sidoriak, care of thememoryhole.org)

FIG. 68 B-2 Spirit Stealth Bomber Refueling. A B-2 Spirit Stealth Bomber approaches the boom of a McGuire Air Force Base tanker, using a KC-10A Extender. (Photograph courtesy of Scott H. Spitzer, 2004.)

facility has evolved to a state of the art digital and multimedia department. Today's photographers have adapted to this change and increased their versatility by expanding their knowledge-base to include multimedia design and graphic design. Under these new conditions, photographers must educate them-selves to efficiently operate and maintain a host of computer hardware and software that is common in today's environ-ment. New technologies involved in digital photography lead to a dramatic decrease in the time from image capture to final output. The overall download, edit, caption, transmit, and view of the final image can take place within minutes rather than days. Image capture is instantaneous and editing is done on the camera monitor. The evolution of the World Wide Web has created the ability for photographers to post current imagery and be viewed by a broader audience quickly and efficiently. The viewer is additionally capable of providing input and requesting imagery to the photographer via a simple e-mail.

Additionally, photographers are able to transmit full resolution, captioned images to publishers for immediate printing.

Along with the many advantages of digital photography, some give cause for concern. A film camera was sturdy and required no batteries. This is less true in the digital age, espe-cially with regard to peripherals such as a computer. The mili-tary environment is always demanding on equipment and often there's only one chance. It is essential that the military photographer understands the capabilities and limitations of the equipment in hand under the conditions experienced. Conditions such as air turbulence, dust, heat, vibration, noise, and the ingress of water can cause mechanical failure.

The ease with which digital images can be altered, even unintentionally, has created a negative view of its use for reconnaissance. At times publications have manipulated images in order to enhance a viewer's perspective. The removal of power lines or addition of personnel to an image has created inaccurate evaluations for military exercises, therefore creating the possibility of operation failure. Overall, controversy will always be forthcoming, but advantages of digital photography in a military environment outweigh the disadvantages.

A military photographer maintains the ability to provide a vast array of services. They must have the expertise in all the photographic venues to support all the functions that are placed before them. As technologies evolve, duties remain the same, but adjustments to support military contingencies also develop as the military photographer advances their capabilities.

See also the following article
Aerial Photography

Multispectral Imaging

DAVID MALIN
Anglo-Australian Observatory, RMIT University

Multispectral imaging involves making images using more than one spectral component of energy from the same region of an object and at the same scale. It is clearly not a new method of imaging; color film is a three-channel multispectral detector and special infrared-sensitive color films have long been available to achieve the above-mentioned condition. A contemporary definition of multispectral imaging implies that the channels or passbands will be separate, and that they may contain image data obtained outside the range of sensitivity of photographic materials. Often there may be more than three sets of data. Multispectral imaging may also be quantitative, in that the separate channels are well-defined spectrally and often calibrated radiometrically. They may also have a temporal element, in that the images may be made at different times.

In practice, each channel of a multispectral image may be displayed as a grayscale representation, or in combinations of two or three channels as a color composite image. If the data channels contain images made in blue, green, and red light, a true-color picture can be made; however, if any or all of the channels contain data from outside the visible spectrum, the result will be a false-color image. Separate channels may also be subtracted from each other to reveal subtle differences between them. Much of this was not practicable before

the digital imaging revolution, and reflects the dual nature of multispectral imaging, as a source of spectral data to be analyzed and of images to be visualized. This in turn determines how the data are handled.

The information obtained from multispectral images can be from self-luminous sources such as the sun, stars, and nebulae or reflective sources such as the planets (including the earth), documents, biomedical subjects, or foliage. The data may be both radiometric, recording brightness or intensity in a broad, defined passband, or may consist of many narrow passbands, recording the spectral energy distribution at higher resolution. This is in addition to the texture, geometry, and context that would normally be expected from images.

Interpretation of a multispectral image requires an understanding of the characteristics of the filter-detector combination used to obtain the data so that the spectral signature of the scene can be recovered. The multispectral imaging systems themselves operate over a broad range of wavelengths, from ultraviolet to the visible and into the thermal infrared (200 to 15,000 nm), so the types of detectors used vary widely.

Development of multispectral imaging includes superspectral imaging, which can involve ten or more spectral channels, each with narrow bandwidths, enabling greater spectral resolution. Developments also include hyperspectral imaging or imaging spectroscopy, which can make images in a hundred or more contiguous spectral bands. However, as the radiation collected from the scene is divided into ever narrower channels both the spatial resolution and signal-to-noise may be degraded.

The main application of these multispectral systems is in remote sensing, especially from earth-orbiting satellites and aircraft. Multispectral imaging is especially useful in astronomy, agriculture, oceanography, geology, pollution monitoring, and mine-laying detection, but also in heat sensing, medicine, and forensic work, including microscopy, and the copying of documents for archival purposes.

See also the following articles
False-Color Photography; Pseudocolor Remote Sensing

ADDITIONAL INFORMATION
Compendium of remote sensing-related Web sites and tutorials: http://www.crisp.nus.edu.sg/~research/links/rs-mul.html
A very comprehensive remote sensing tutorial: http://rst.gsfc.nasa.gov/Front/tofc.html
A hyperspectral and multispectral imaging course: http://www.aticourses.com/hyperspectral_imaging.htm
A forum of scientific cooperation in the field of spectral color science: http://www.multispectral.org/
A detailed introduction to hyperspectral imaging (pdf download): http://www.microimages.com/getstart/pdf/hyprspec.pdf

Nature Photography

PETER EASTAWAY
Magazine Publisher and Professional Photographer

Nature photography includes almost all branches of natural history, except anthropology and archaeology. Photographs that are posed, set up, or manipulated in any way that alters the truth of the presented image goes against the fundamental philosophies of the nature photographer. Therein lies the dilemma. Nature photography embraces a myriad of photographic styles: landscapes; seascapes; underwater; underground; wildlife and flora; close-ups of flowers and insects; and representations of climates, weather, and seasons, among others. The list is extensive, but different photographers have different interpretations of what a "nature photograph" really is.

Some photographers believe that "the hand of man" must not be visible in a nature photograph—indeed this appears in the rules of many nature photography competitions. A nature photograph should thus depict nature alone, without any trace of human intervention. This definition can make life difficult for the nature photographer, because it is hard to go anywhere in this world without seeing some sign of *Homo sapiens*—whether it is a power pole, or the vapor trails of an airliner over the sheep-manicured fells of the English Lake District.

Similarly, animals photographed in zoos can be thought unacceptable, because the look or demeanor of the subject after years in captivity could be considered unnatural, even if there is no hint of a cage. As our species' influence on the planet expands, nature photography may have to accept some incidental signs of human activity. For instance, many animals are only found in large game reserves whose borders and preservation are artificial, but this should not disqualify photographs of them from being "natural." However, the distinction between a large zoo and a small game reserve can be blurred.

Other lines of demarcation are similarly inconsistent. Nature photographers often photograph insects or flowers in a controlled environment, perhaps removing the subject from its natural habitat and placing it in a studio context. In the field, photographers may keep a reptilian subject outside overnight, cooling it so it stays relatively still the following morning for a photography session. Does this represent the hand of man? Undoubtedly, but if it is not evident and the creatures are not harmed, the superior photographs that result are probably sufficient justification.

Today it is easy to alter a photograph to remove or hide artifacts, thus qualifying it as a nature photograph, but this is unacceptable for other reasons. At its core, a nature photograph must have integrity because it purports to be a true representation of the natural world, and people recognize it as such. Although digital photography makes it easy to remove a power pole in a landscape, it also could be used to replace a missing petal on a flower. While this might create a perfect picture, in so doing the photographer has changed the essence of the image, and it is no longer a true record of nature.

Photographers are still discussing the extent of the acceptable range for editing a digital photograph. Darkroom skills were always used to enhance and correct images in pre-digital days, but anything much more than adjusting contrast or color balance was considered unethical in nature photography. The basic premise is that editing should not change the fundamental structure of a nature photograph, so adding, removing, or moving elements within the image is taboo. Of course, photographers could employ digital skulduggery and not be caught out, but the ethics of a true nature photographer would never allow this.

Many nature photographers are often experts in other fields—biology, zoology, botany, geology, geography—and their experience allows them to create more authentic nature photographs. An entomologist is more likely to know where and when to find suitable insects and to choose the most appropriate way to display their main characteristics. Similarly, the best wildlife photographs will be taken by a photographer with a working knowledge of wild animals and their habitats.

This insight is important. Just as the photograph itself must be authentic and "real," so should the location, pose, and characteristics of the subject. One of the primary roles of nature photography is to educate, so it is important that the subject is photographed in an authentic manner. A true nature photographer would not photograph a hippopotamus walking in the desert or a caterpillar feeding on the wrong kind of leaf. Many people viewing nature photography will take what they see as the truth, so the context has to be authentic.

Given this, it is no surprise that nature photographers are exceptionally good technicians. Nature photographers were slow to adopt digital photography because early digital cameras simply could not retain the same amount of detail and information as film. Nature photographers tend to use the slowest, finest-grain films available so the texture and pattern of the film itself (the film grain) does not interfere with the rendering of the subject. Similarly, nature photographers would also tend to use medium and large format cameras, instead of the smaller 35 mm format, because the larger the negative or transparency, the more information that can be recorded.

Today digital photography has matured so that professional digital cameras can match or exceed the quality provided by film. Because digital images do not have a grain structure, they can be cleaner and clearer, providing a superior rendition of nature.

Whether film or digital capture, nature photographers rely on a range of camera and lighting techniques to ensure maximum image quality. The most elementary technique is control of depth-of-field using lens aperture. In nature photography, many images require sharp focus throughout the image so that the entire animal, flower, or landscape is rendered clearly and with detail, while some are more effective

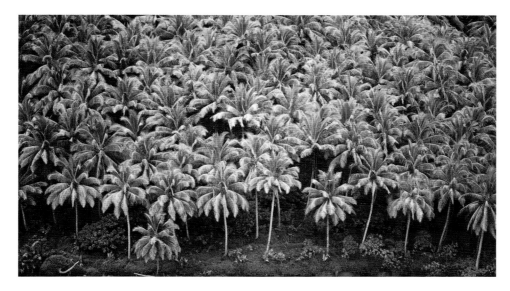

FIG. 69 The natural world reveals pattern, form and structure on all scales, especially when familiar objects are seen from an unusual perspective.

with an out-of-focus background. Similarly, nature photographers will generally use a tripod and a cable release to avoid camera shake. A characteristic of nature photographers is their methodical and deliberate approach.

Appropriate lighting is also important. High-contrast lighting can be problematic if it produces deep shadows, which hide important details. Sometimes the subject can be posed or positioned so dark shadows do not fall on important parts of the subject, but generally it is easier to use supplementary lighting — such as a flash or a simple reflector — to remove the shadows. Fill-in flash is the technique where ambient and flash lighting are combined. The flash illumination fills in shadows produced by the ambient lighting, which results in a photograph with less contrast and full of subject detail. Flash is also used to photograph nocturnal animals.

One of the biggest challenges for the nature photographer is small subjects. For close-up and macro photography, more depth-of-field and more light are required to produce satisfactory images. To maximize depth-of-field, very small apertures are required, which in turn require more light if the shutter speeds are going to be fast enough to freeze an active subject. Many nature photographers use one, two, or more flash units to provide the necessary illumination. In all of these cases, artificial light is just that, and is not truly part of the natural scene, but is often an essential ingredient to make a picture that is truthful, informative, and attractive to the eye.

See also the following articles

Astrophotography; Biological Photography; Botanical Photography; Cave Photography; Geological Photography ◉

Night-Time and Twilight Photography

DAVID MALIN
Anglo-Australian Observatory, RMIT University

Taking pictures at night may be considered to be both more limited and more challenging than daytime photography because there is relatively less light available. However, night-time and twilight photography provides many opportunities for unusual, creative, and scientifically interesting imaging. The technical challenges that the night photographer faces are numerous. Night time photography requires the measuring of exposures at low light levels, managing very long exposure times, and sometimes the inclusion of the light source(s) itself in the image, as well as the mixed lighting and the changing lighting levels during an exposure. It is also useful to have some prior knowledge of how the light and color will change in the twilight and the brightness of moonlight. Sometimes additional extra equipment is required, but often nothing more than a cable release, tripod, and electronic flash or flashlight are necessary.

Star Trails and Moonlight Photography

The most natural existing light at night comes from the moon and stars, and from the natural luminosity of the atmosphere itself. This latter is only noticeable in places that are completely free from artificial light at night. Even 300 km (200 miles) from a large city or 50 km from a small town, the reflective glow of its street lights can be seen close to the horizon, masking the air-glow in that part of the sky. However, if truly dark places can be found beautiful then intriguing images are possible.

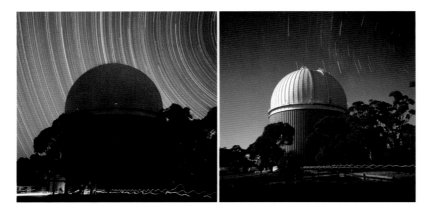

FIG. 70 The sky photographed on a night of full moon (right) with a Hasselblad, 20 minutes exposure at f/5.6 using 200 ISO Ektachrome, push-processed to 400 ISO. On the left is the same scene captured with the same camera and film on a night without the moon. The exposure was about 8 hours and it shows the Anglo-Australian Telescope dome illuminated by the light of the stars alone. The wavy lines are the flashlights of wandering astronomers. (Photographs by David Malin.)

Among the easiest night-time photographs are star trails, which reveal the motion of the earth spinning in space by the tracks of stars across the sky. The idea is simple in principle but there are many subtleties. The camera is focused on infinity, fixed to a tripod (or laid on its back), and the shutter left open for as long as required. There is no "correct" exposure in these circumstances; in general the longer the exposure time, the longer and more numerous are the star trails. Pointing the camera east or west produces more or less straight trails at an angle to the horizon that reflects the local geographic latitude. Pointing the camera north (in the northern hemisphere) or south in the southern hemisphere produces circles around the north or south celestial poles. The camera records more star trails in this direction, because toward the celestial pole the star images are tracking ever more slowly across the film or sensor.

If the sky is bright because of light pollution or the moon, stopping down the lens affects the sky more than the star trails, all but the faintest of which are overexposed. De-focusing the lens in a series of steps during the exposure spreads the star images on the film or detector, reducing the effective exposure and revealing their colors.

The simplest equipment for star trail photography is a mechanical film camera that is not battery operated. It should be loaded with 200–400 ISO reversal (slide) film, or 400–800 ISO film with larger formats. The camera should be fitted with its standard focal length lens and operated at approximately f/4. It is possible to make star trail pictures with digital cameras, but creating a single and very long exposure is still not easily achieved, so a series of shorter exposures must be combined using image processing software to achieve a seamless result.

For photography by moonlight with the full moon overhead, illuminance is merely 450,000 times (about 18.6 stops)

fainter than the sun's illuminance. For a variety of reasons to do with the nature of moon's surface, its illuminance dims more rapidly and in a non-linear fashion from the time of full moon. The normally "unnoticed" blue sky produced by the full moon is just as effective at filling the shadows as is the daytime blue sky. However, if moonlit exposures are longer than a few minutes, the moon's movement across the sky will increase its effective angular diameter so that shadows running roughly north to south will appear softer. Moonlight has a slightly lower effective color temperature than sunlight (4100 K vs. 5500 K) so its light is slightly yellow compared to sunlight.

With an ISO 200 film and brilliant sunlight overhead an exposure time of 1/1000 seconds at f/5.6 might be indicated for an average daytime landscape. With the full moon overhead an exposure time of about 450 seconds (about 7.5 minutes) would be calculated from the above information. However, film suffers from low intensity reciprocity failure (LIRF), so is less efficient at exposures longer than a few seconds. LIRF varies from film to film, and with exposure time, but manufacturer's data sheets often give exposure factors to compensate for LIRF. However, LIRF also varies with exposure temperature, so exposures will be shorter on winter nights. LIRF may affect the separate layers of color film differently, giving rise to difficult-to-correct color balance shifts.

Many of these problems vanish with digital cameras; however, not all such cameras are able to take adequately long exposures and when they do the images are often "noisy." The long-exposure detector noise in digital cameras will usually be lower under very cold conditions (but so will battery efficiency).

The Twilight
The twilight and its approach offers the photographer many opportunities, including long shadows and colorful skies with

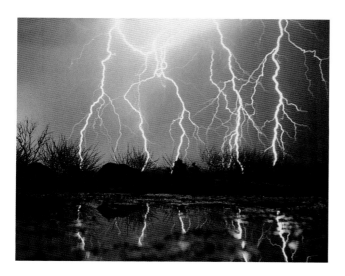

FIG. 71 Lightning is easy to photograph at night, but luck and a severe storm is helpful at twilight when the shutter cannot be left open for long. A low camera angle and foreground puddle add visual interest. (Photograph by David Miller.)

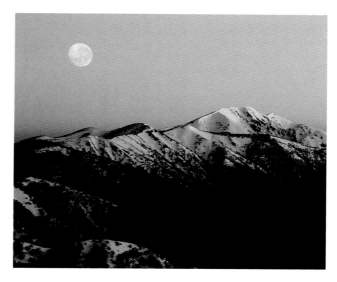

FIG. 72 A twilight landscape. Moonrise over Mt. Feathertop above the earth's shadow. (Photograph by David Miller.)

a strong brightness gradient and strange color casts, often all at once. Twilight begins at sunset, but it is not truly dark until the sun is 18 degrees below the horizon (astronomical twilight). For most photographic purposes it is dark at the end of "nautical twilight," when the sun is 12 degrees below the horizon. This occurs less than an hour after sunset at the equator but lasts for weeks within the arctic and antarctic circles. The length of twilight thus increases with geographical latitude.

As darkness approaches, the color sensitivity of the eye alters as it transitions from the color-sensitive photopic vision of daytime to the dark-adapted monochrome scotopic vision of the night. The faint but rich colors of the late twilight appear muted and our ability to estimate photographic exposures by eye is also distorted. The inexperienced film photographer resorts to bracketing exposures at this time; those with digital cameras have the advantage of almost instant feedback.

With experience, twilight exposures can be judged so that a trace of bright horizon remains on a star trail photograph, adding interest and color, especially if there is a distinctive foreground. Twilight photographs taken over lakes and still rivers double the angular extent of the evening or morning glow and are especially effective for capturing the subtle colors of the earth's shadow. Twilight also makes an interesting backdrop for campfire shots or architectural studies of large buildings or industrial landscapes, especially if combined with artificial light. The period when all the ingredients are in perfect balance is surprisingly short, so digital photographers may take several shots from the same position and combine them in software for the best effect.

The Urban Landscape

Most of the possibilities outlined above assume a natural setting with little or no artificial light, although few of us live in such surroundings. More often our streets and cities are well lit by night and these can be rewarding subjects. Light levels are often such that film cameras perform well, but the instant access and convenience of digital is always useful, especially when the sources of light are in the scene. Under these circumstances the lens must be scrupulously clean and it is useful to use a lens hood. Star or haze filters can be used to ornament or exaggerate light sources and flash may be used to fill in the foreground. However, the brightness range of such scenes is very wide and there is usually no single "correct" exposure. Firework and lightning displays often occur over long periods with street lights in the scene, so to avoid too much glare the camera should be shielded as well as possible and (with fireworks) a dark card or cloth used to cover the lens when they are not visible. As usual, digital camera users may combine multiple exposures to good effect.

Many buildings are floodlit at night, sometimes for security purposes or to highlight architectural features. Neither kind of lighting is installed with photography in mind, especially that pointing skyward from ground level. If the building is of modest size a few well-placed flash guns can be used fill in the shadows, but if the building is huge a more ambitious approach using hundreds of flash guns is needed. This painting with light technique requires a good deal of organization but is very successful.

All of the above ideas suggest that both camera and subject are stationary during a longer-than-usual night-time exposure. This is not strictly necessary. Weird and interesting results can be captured if the same subject is photographed in different positions with multiple flashes, or if a moving subject is partly

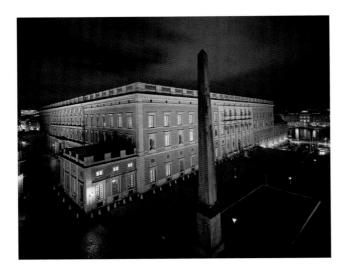

FIG. 73 A night time painting-with-light photograph made of the The Royal Palace in Stockholm, Sweden, October 9, 2003; Exposure time: 45 seconds at f/16. Air temperature 17°C. Film: Kodak 400 NC. Time 7:30 p.m. (Stockholm time). Camera: Sinar F with 65mm lens. External lighting on the palace was provided by multiple hand-held electronic flash units operated by approximately 350 participants. (Produced by the Rochester Institute of Technology School of Photographic Arts and Sciences, The Lennart Nilsson Conference, and The Swedish Royal Palace.)

lit then "frozen" with a single flash. The camera moves during the exposure as well of course, as can the settings on a zoom lens to create the impression of motion. The possibilities are limited only by the imagination of the photographer.

See also the following article
Astrophotography

FURTHER READING
Carucci, J. (1995). *Capturing the Night with your Camera.* New York: Amphoto Books.

Krisciunas, K. and Schaefer, B. E. (1991). A model of the brightness of moonlight. *Publications of the Astronomical Society of the Pacific* **103**(667), 1033–1039.

Shaw, J. A. (2005). The digital blue sky at night. *Optics and Photonics News* **16**, No. 11, pp. 18–23.

Shaw, J. A. (1996). What color is the night sky?, *Optics & Photonics News* 7(11), 54–55

ADDITIONAL INFORMATION
Definitions of twilight: http://aa.usno.navy.mil/faq/docs/RST_defs.html

Moonlight and night images: http://home.earthlink.net/~kitathome/LunarLight/index.html

Night photography resources http://www.thenocturnes.com/

Nuclear Track Recording

DAVID MALIN
Anglo-Australian Observatory, RMIT University

Among the first ways of studying extraterrestrial cosmic rays was to fly blocks or sheets of photographic emulsions at high altitudes in balloons or aircraft. The highly penetrating cosmic rays interact with the atomic nuclei of the emulsions producing protons, electrons, and mesons. In the emulsion they leave latent image tracks that can be made visible by development. Tracks from nuclear particles can also be rendered visible in a Wilson cloud chamber or a liquid-hydrogen bubble chamber or spark chamber, often attached to a particle accelerator such as cyclotrons and synchrotrons. These chambers were once commonly used as detectors associated with so-called "atom smashers."

Energetic ionizing particles such as cosmic rays can also produce radiation damage in a variety of dielectric solids, which are insulating materials (polymers) and minerals (mica and glasses). These tracks can be made visible by using various etchants and can give an indication of the direction or intensity of the radiation.

These methods are now of largely historical interest. ⟲

Ophthalmic Photography

CHRISTYE P. SISSON
Rochester Institute of Technology

Ophthalmic photography is a specific branch of scientific and medical photography that deals exclusively with the eye and its related parts. Ophthalmic photography is a highly specialized but growing photographic field that depends as much on knowledge of anatomy and physiology of the eye as it does on photographic techniques and technologies. This unique combination of art and science allows the ophthalmic photographer to work very closely with physicians, typically ophthalmologists, to optimize the images for best patient care.

Documentation versus Diagnostic Information
There are a number of reasons and methods for the photographic procedures of the eye. As with traditional biomedical photography, a large part of ophthalmic photography is documentation, or the recording of a particular disease or condition at a moment in time. This sort of documentation provides the physician with a photographic record that can be compared to past and future records as patient care continues.

One aspect of ophthalmic photography that makes it particularly unique is the diagnostic role that it plays in ophthalmology. In particular, one type of ophthalmic photography,

fluorescein angiography, is the only application of photography that is diagnostic, which means it shows information not otherwise visible by the naked eye. This information is immensely helpful in diagnosing specific eye diseases. Obviously, there are many other forms of diagnostic medical imaging, but fluorescein angiography is the only imaging method that is grounded in traditional photographic methods.

The ability to reveal important diagnostic information from a relatively straightforward, non-invasive procedure is in large part responsible for the continued growth of the field. Ophthalmic imaging is a valuable and inexpensive adjunct to visual examination of the eye that can be used in developed and developing countries to detect the ophthalmologic effects of a number of diseases, such as diabetes, that may otherwise go unnoticed. Fluorescein angiography goes a step further, showing vascular damage and abnormalities, information that is essential for treatment. With the advent of telemedicine applications, ophthalmic photography can now be brought to remote locations to treat populations that may otherwise go without ophthalmologic care. The images can be transferred electronically to centralized reading centers that can screen individuals for signs of retinal disease, such as diabetic retinopathy, age-related macular degeneration, or glaucoma.

External Photography

The region, and the anatomy documented, will traditionally define the categories of ophthalmic photography that are performed. External photography of the eye utilizes a traditional 35 mm SLR or, increasingly, a digital SLR camera equipped with a macro lens to record the external structures of the eye, including the lids, conjunctiva (the vascular membrane covering the globe), cornea (the clear front portion or the eye), pupil, and iris. Lighting is typically from specialized flashes such as ring lights or macro-type, camera-mounted flash setups.

Slit Lamp Biomicrography

To achieve a higher level of magnification on these external structures, a slit lamp biomicroscope is typically used. A slit lamp is commonly used by an ophthalmologist to see if there are defects or anomalies in the anterior segment, which is everything in the eye from the lens forward, including the iris, lens, cornea, and conjunctiva. The slit lamp is mounted to a movable table top that includes an integrated chin rest to keep the patient's head stationary. The light source produces a beam of light that is projected onto the area of interest, which is in turn viewed by the examiner with the biomicroscope portion of the apparatus. The biomicroscope allows the user to adjust the image magnification from approximately $1.5\times$ up to $4\times$ life size. This equipment is modified for photography by incorporating a beam splitter for the camera and flash system that uses the same light path as the tungsten examination illumination.

The slit lamp biomicroscope earns its name by the type of lighting it produces, which is a very thin, less than 1 mm beam of light that can be raked across the surface of the eye. This is a specialized form of dark-field illumination that might be considered to be similar to the effect of closely drawn curtains on a sunny day where a thin beam of sunlight reveals every speck of dust floating in the air against a dark background. The slit lamp works the same way on the cornea or lens of the eye, which are normally optically clear. The thin slit beam allows the photographer or the physician to visualize any abnormalities or opacities by creating in effect an optical section of the cornea or lens.

Specular Biomicrography

Another form of anterior segment ophthalmic photography is called specular biomicrography and is used to visualize a very specific portion of the cornea known as the corneal endothelium. The single-cell layer corneal endothelium acts as a metabolic pump for the cornea, keeping this structure dehydrated and therefore optically clear. When these cells fail, adjacent cells swell to take up the space left by the dead cell. Over time, this endothelial cell death results in the cornea becoming hydrated, causing opacities. Visualizing this layer helps to provide the corneal ophthalmologist with cell count information used to determine overall corneal health, usually as it relates to corneal transplant. While traditional specular biomicroscopes used film and required direct contact with the cornea for imaging, modern instruments are digital and highly automated, with many of them being non-contact.

Fundus Photography

The posterior segment, or all regions behind the iris, including the vitreous, a clear gel that fills the globe and the retina, is referred to as the fundus. The retina is made of up several layers including the photoreceptors, which are responsible for the eye's ability to distinguish light and dark, color, and acuity. The retina lines the rear surface of the globe, and in ophthalmology, is an area of primary concern if visual loss is an issue not traceable to refractive error or problems in the cornea. To photograph the retina, it is usually required that the iris be dilated with pharmaceuticals (to prevent its closure when a light source is used) and photographed with a mydriatic fundus camera (mydriatic means the iris must be dilated to form an image).

A fundus camera is an integrated camera system with a circular, axial flash lighting setup integrated directly into the lens. This donut-shaped light source is designed specifically to fit inside the dilated pupil when the camera is placed at the correct working distance. Like the slit lamp, a fundus camera is mounted to a movable tabletop with integrated chin rest for the patient. There are some specialized hand-held fundus cameras available, primarily for use with bed-ridden or otherwise immobilized patients. There are also non-mydriatic fundus cameras, highly automated cameras of limited capability that are designed primarily for screening purposes.

While fundus cameras are traditionally film-based, the recent trend has been digital imaging fundus camera systems, which allow the photographer and the physician to view the images as they are taken on a computer monitor. The images are then transferred to a specially designed patient database

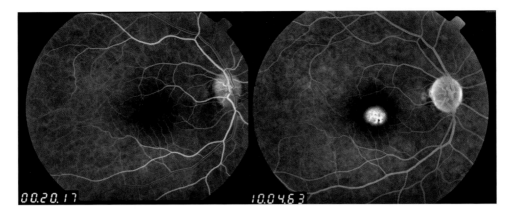

FIG. 74 The fluorescein-laden blood shows up as white immediately after injection (left) in the 'early' image. The area in the center, the macula, is supposed to stay dark. This example shows a fluid buildup just beneath the macula after about 10 minutes ('late' image, right).

for later local or remote viewing and/or integration into an electronic medical records system.

Angiography of the Eye

In addition to documentation of the retina, the fundus camera is also used for different forms of diagnostic dye tests, in which a dye is injected into the body and its progress is tracked through the retinal vessels. The most common of these, fluorescein angiography, uses fluorescein sodium dye. This dye fluoresces under a very specific wavelength of blue light near UV, provided by the fundus camera through a set of filters. This fluorescence is then recorded on monochromatic film or digital system as white.

The dye itself is injected into a vein in the arm or the hand. The timing and speed of this injection are critical, as the dye only takes about eight seconds post-injection to reach the eye in a healthy individual. The photographer must anticipate the arrival of the dye in the eye, as the first split seconds of the angiogram are considered the most critical. Once this critical "early" phase passes, the patient and photographer then wait five or more minutes before taking more photographs, known as "lates."

The appearance of the retina changes rapidly over the course of the angiogram, requiring frequent photographs as the dye enters the arteries and veins. A timer is imprinted on the film or digital file as each photograph is taken to indicate the exact timing of the entire test.

Since this fluorescent dye travels everywhere the blood does, this test shows areas of leakage or blockage in the retinal vessels not otherwise visible. This allows the physician to treat these areas, if required, by using the fluorescein angiogram as a "road map" for laser photocoagulation of the affected areas.

Another dye, Indocyanine Green (ICG), is occasionally used when it is important to visualize a portion of the retina that is deeper than the retinal vasculature, known as the choroid. ICG also fluoresces but only in the infrared region, which allows for the visualization through the retinal pigment. Because of the inherent sensitivity of digital cameras to infrared, ICG is only done with an integrated digital system. If an ICG test is administered, it is usually done in conjunction with a fluorescein angiogram as a complement to the information it provides, not a replacement.

Professional Certifications and Organizations

Ophthalmic photography is very specialized and its practitioners usually work very closely with ophthalmologists. There are national and international professional societies for ophthalmic photography, a few of which grant recognized professional levels of certification. The only current professional certification, known as CRA., or Certified Retinal Angiographer, awarded by the Ophthalmic Photographer's Society, is considered to be a professional achievement, but is not required as a license to practice. The certification requires a minimum of 1–2 years in practice, depending on education, as well as the successful completion of a professional portfolio, written test, and practical exam. The CRA requires continuing education in the field in order to maintain the certification.

See also the following articles

Darkfield Illumination; Fluorescence Imaging; Medical Photography; Photomacrography and Close-Up Photography

FURTHER READING

Martonyi, C. (1985). *Clinical Slit Lamp Biomicroscopy and Photo Slit Lamp Biomicrography*. Twin Chimney Publishing at www.twinchimney.com.

Ophthalmic Photographer's Society. *Journal of Ophthalmic Photography*.

Saine, P. J. and Tyler, M. (2002). *Ophthalmic Photography: Retinal Photography, Angiography, and Electronic Imaging (2nd Edition)*. Twin Chimney Publishing at www.twinchimney.com.

Tyler, M., Saine, P. J., and Bennett, T. (2002). *Practical Retinal Photography and Digital Imaging Techniques*. Twin Chimney Publishing at www.twinchimney.com.

Photogrammetry

CLIFF OGLEBY
The University of Melbourne

Photogrammetry is the art, science, and technology of making measurements from photographs. The discipline started in the 1880s, but more recently the advent of digital imaging has dramatically changed the accessibility and application areas of photogrammetry. Originally used for the measurement of buildings, and then adopted for producing maps from aerial photographs, the applications now encompass mapping, architecture, engineering, medicine, forensics, 3D modeling, and the creation of low polygon models of objects suitable for display on the Internet.

The word photogrammetry was coined originally in the 1880s, using words of Greek origin, to describe a process developed for measuring and documenting buildings. Following the advent of hot air balloons, and later, aircraft, the photogrammetric camera was taken aloft and used to make maps. The technology for measuring from photographs has dominated map making for about the last 100 years; the vast majority of small- and medium-scale maps are made using photogrammetry.

The original photogrammetric cameras were large, heavy, and engineered to have precisely known and non-changing, parameters such as the focal length and a flat film plane. Aerial cameras used a vacuum system to hold the film flat, and terrestrial cameras often used glass plates as the photographic medium. The photographs were taken from predetermined locations, and planned so that a significant area of each photograph overlapped the next, thus changing the parallax. Such overlapping images are known as a stereo-pair and this mimics the way humans see in three dimensions. This overlapping area could be viewed three-dimensionally, or in "stereo," using yet another piece of specialized equipment. Providing some measurements such as scale, tilt, or flying height were known, or able to be derived, the stereo-model could be oriented so that accurate distances and heights could be measured.

While the primary use of photogrammetry up until the 1970s was aerial mapping, there were also applications in architecture, archaeology, medicine, and manufacturing.

Once computers became more readily available, it was possible to calibrate the camera systems rather than rely on high manufacturing tolerances. This ability meant that many cameras not designed for photogrammetry could be used to give accurate and reproducible measurements. The next stage in the evolution of photogrammetry was the development of digital imaging sensors.

Digital imaging has completely changed photogrammetry. Almost any imaging device, from a multi-mega-pixel camera through to a pinhole spy camera can be calibrated so that it can be used for measurement and modeling. The "metric" parameters that were originally engineered into the cameras are now solved, and compensated for, by software.

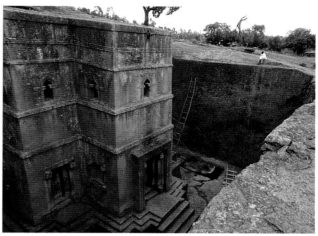

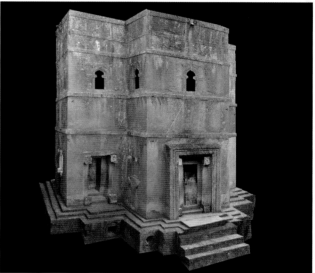

FIG. 75 The site of the Bet Giorgis rock-cut church, Lalibela, Ethiopia, is impossibly cramped for photography. Below is an image of the church derived from a three-dimensional texture-mapped model produced from 42 convergent images, each acquired with a 6 megapixel digital camera. (Upper photograph by Armin Gruen, lower by Clive Fraser.)

Photographs no longer need to be taken from predetermined locations, and much of the software available is optimized for convergent photography where the axes of the cameras point toward the object. There are expensive software systems that have application in professional aerial mapping and the production of orthophotographs—photographs free from any distortion—whereas other, inexpensive systems are versatile enough to enable non-skilled users to create 3D models of objects. Some of these systems do not even advertise as photogrammetric software packages, they are marketed as "photographic modeling" systems. The images these packages use

can come from image sensors as diverse as consumer digital cameras or earth-orbiting satellites.

The major shift in the analytical approach to photogrammetry came about by considering each image as representing a bundle of rays from the center of the lens system through points on the image to the object photographed. These individual rays could be corrected for distortion in the lens system (for example, consider the barrel distortion common with wide-angle lenses), the focal length of the lens and the geometry of the film, plate, or digital chip. With several images from different stand-points, the bundles of rays would then intersect in space where they would have struck the real object.

There are a variety of sources of additional information and examples of the ever-increasing fields of application. The International Society for Photogrammetry and Remote Sensing (ISPRS) is the international body that organizes conferences and symposia on photogrammetry, and the conference proceedings give the most up-to-date theory and application of measuring from photographs. Examples include applications in medicine, where limbs, bodies, faces, and even viruses are measured and modeled from an image source; architecture and archaeology, where the images are used to derive plans, elevations, and the framework for computer visualization; mechanical, civil, and aerospace engineering, where relative accuracies of 1:200,000 of the maximum dimension can be obtained; and still topographic mapping. Most countries have their own similar organizations, and they are generally members of ISPRS. Another organization that promotes and publishes photogrammetric applications is CIPA Heritage Documentation, a scientific committee of the International Council on Monuments and Sites (ICOMOS), which serves as a liaison body between ICOMOS and the ISPRS. Most of these examples are oriented toward cultural heritage applications, and many examples are available from the Web sites.

Photogrammetry has become a very versatile measurement tool, and developments in the process are continuing. Automated extraction of features from images (for example, the derivation of building roofs and profiles from aerial imagery), image "understanding" where pixels are interpreted to be objects (for example, facial recognition), and the combination of images with other data sources are all current areas of development. One recent innovation has been the production of 3D laser scanners, and although the operation of some of these use the time-of-flight of a laser beam, others use photogrammetric triangulation as the method for measuring the surface relief of objects. Some close-range laser scanners project a laser stripe onto the object, which is imaged by a camera at a known distance and orientation to the laser. Photogrammetric principles and procedures also have application in satellite and radar remote sensing, providing calibration, coordinates, and a measurement capability for satellite-borne imagery.

Measurement from images now forms the basis of the information systems that manage the built and natural environments, systems that oversee manufacturing and processing quality control, forensic analysis, the documentation of cultural heritage, medical diagnosis and treatment, and even exploration of the solar system. It has become a mature, non-contact, and reliable method of measurement and monitoring.

See also the following articles
Aerial Photography; Remote Sensing

FURTHER READING
Atkinson, K. B. (ed.) (1996). *Close Range Photogrammetry and Machine Vision.* Caithness, UK: Whittles Publishing, 2nd edition now in press.
Journals and Conference Proceedings of both the ISPRS and the ASPRS. The Photogrammetric Record, http://www. blackwellpublishing.com/journal.asp?ref=0031-868X

ADDITIONAL INFORMATION
Inexpensive software
www.photomodeler.com
www.realviz.com
Map Production Systems:
http://www.gis.leica-geosystems.com/products/lps/
http://www.vexcel.com/services/mapping/
Organizations
CIPA Heritage Documentation: cipa.icomos.org
International Council on Monuments and Sites (ICOMOS): http://www.international.icomos.org/
The International Society for Photogrammetry and remote Sensing: www.ipsrs.org
The American Society for Photogrammetry and Remote Sensing: www.asprs.org ◉

Photomacrography and Close-Up Photography[1]

MICHAEL R. PERES
Rochester Institute of Technology
JOHN G. DELLY

Close-up and photomacrography, sometimes incorrectly called macro photography, are techniques that allow closer than usual camera-to-subject distances to be used for picture taking. The term close-up normally implies no true image magnification has occurred and will produce images between 1/20 of the normal size down to about life size on the film or charge-coupled device (CCD). This imaging outcome an also be expressed as the image's reproduction ratio, (image size:object size), which in this case is defined between 1:20 and 1:1 life size. Photomacrography typically covers reproduction ratios from 1:1 to about 50:1, or life size to 50 times magnification, which is often written as ×50. Equipment and

[1] Revised in part from the *Focal Encyclopedia of Photography 3rd edition.*

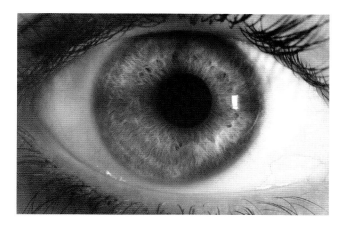

FIG. 76 The human eye is the perfect subject to illustrate the transition from close-up to macro. This image was captured at a reproduction ratio of 1:2 using an SLR digital camera. (Photograph by Alycia Yee.)

techniques beyond 1:1 magnification become increasingly specialized, so close-up photography and photomacrography will be considered separately in this section, although there is considerable overlap between them. Photography above $\times 50$ magnification is normally regarded as photomicrography and is discussed in that essay.

Close-Up Photography

A close-up picture may play an important role in the documentation of all kinds of subjects, including technical, documentary, artistic, nature, or for personal applications. In medicine for example, almost all dermatological, dental, and ophthalmic pictures are in the close-up realm. Many applications are also found in botanical, biological, and geological photography, close-ups of flower, butterflies, rocks, as well as a fingerprints, coins, or a postage stamp. There are several ways to make close-up images using simple equipment or accessories. In applications where the images are required for scientific or documentation purposes, it is a good practice to include a calibration scale near to the object field.

Lenses for Close-up Photography

Many relatively inexpensive digital cameras are fitted with zoom lenses that are adequately corrected for moderate close-up distances, despite being designed primarily for use at infinity focus. This development is possible because of the digital viewfinder, which bypasses the reflex viewing arrangement necessary for film cameras at close distances allowing shorter lens-to-subject distances to be achieved. However, if the camera is an SLR type, there are a wide variety of close-up lenses available, both in fixed and variable focal lengths. A zoom lens with close-up abilities is often described as macro zoom. True macro lenses may be designed to produce magnifications of 1:1 or greater. They will also operate in

situations where the lens-to-detector (or film) distance is always equal to, or greater than, the lens-to-subject distance.

The more expensive macro lenses have elaborate internal mechanisms that allow groups of lens elements to move independently as the lens focusing is extended to close distances and producing excellent life-size (1:1) or slightly larger images. These lenses often have reproduction ratios inscribed on the barrel, have fairly modest maximum apertures, and use longer than normal focal lengths to simplify subject access at close range.

When images are made at a 1:1 reproduction ratio, both the working distance and the image distance will be equal to twice the focal length of the lens. Thus longer focal lenses will provide increased working distance. This feature allows access for more effective lighting and becomes more important when it is not prudent to have close proximity to things such as heat or infectious diseases.

Supplementary Lenses

The design of most fixed focal-length camera lenses is optimized for long camera-to-subject distances so they are usually limited to a minimum focus distance of about 50 cm. This distance can be reduced (and the image size increased) by using supplementary or close-up lenses, which are simple magnifying lenses. These lenses will either be single lenses or achromatic doublets that attach like filters. These lenses were sometimes called plus lenses or diopters, and are the easiest way to achieve close-up imagery with a simple camera.

The optical power of supplementary lenses increases as the diopter number, increases, e.g., 1+, 2+, up to 20+. The diopter number of a lens is the reciprocal of its focal length in meters. Hence the formula:

$$D = \frac{1}{f}$$

where f is 1000 mm. Thus the focal length can be calculated from:

$$f = \frac{1}{D}$$

A 1+ close-up lens will have a focal length of 1 m (1000 mm); a 4+ close-up lens will have a focal length of 0.25 m (250 mm) and so on.

The dioptric power of the camera lens used can also be computed. For example, an ordinary 50-mm focal length camera lens has a dioptric power of 1000 mm (1 m) divided by 50 mm (0.05 m), or 20. To calculate the focal length of a combination of camera lens and supplementary lens, the dioptric power of the supplementary lens is converted to focal length, and then the following equation is used:

$$f_c = \frac{f_1 \times f_2}{f_1 + f_2}$$

where f_c is the combined focal length of the camera lens and supplementary lens, f_1 is the focal length of the supplementary lens, and f_2 is the focal length of the camera lens.

Alternatively, one can convert all values to diopters and then convert their sum to focal length. For example, a 50-mm lens has a power of 20 diopters. Add a 2+ supplementary lens and the sum is 22 diopters. The combined focal length is 1000 mm divided by 22, or, about 45.4 mm.

It is necessary to know the combined focal length of the camera lens and supplementary if it is required to calculate the lens-to-subject distance using the well-known lens equation:

$$u = \frac{v - f}{f}$$

where u is object distance and v is image distance.

Supplementary lenses can be combined to obtain even greater magnification. However, when combining close-up lenses, the strongest should be closest to the camera lens. Image degradation will increase dramatically when more than two supplementary lenses are combined. Supplementary lenses can also be used in combination with extension rings and bellows in order to minimize the total amount of lens extension. Shorter lens extension produces shorter exposures. Shorter exposures may, for many subjects, offset the theoretical advantage of using a camera lens with extension tubes alone. Using a small lens aperture may minimize the aberrations introduced when using simple, positive close-up lenses. Simple supplementary lenses are unsuitable for telephoto lenses. Two-element achromats are available for longer focal-length lenses for improved performance.

Teleconverters are precision optical accessories that can be mounted in between compatible lenses and the camera body. Teleconverters increase the focal length of the primary lens and create a shorter working (object) distance. A teleconverter used in combination with a 200-mm close-focusing lens, for example, will yield a life-size (1:1) image and does so while maintaining a 71-cm (28 in.) minimum object distance. This amount of working distance is advantageous for many biomedical, industrial, and natural history applications. An increased working distance allows for considerable freedom in arranging lighting.

Lens Extension for Close-Up Photography
Cameras with interchangeable lenses will allow for extension tubes or a bellows to be used, which extend the lens–image distance. Increasing the image distance rather than changing the focal length will often produce a better optical result than through the use of supplementary lenses. Extension tubes are cylindrical tubes of various lengths, used singly or in combination to change the reproduction ratio in fixed steps. Tube lengths vary from 5 to 100 mm, and extensions of 250 mm or more are often used. They are fitted together with threads or bayonet-type mechanisms and some allow the camera's automatic diaphragm features to be retained.

Extension-tube sets are relatively inexpensive but cannot achieve continuously variable lengths. This shortfall is overcome by the use of bellows. A bellows is more costly but is essential for professional work because it will allow precise control over the lens–image distance, which results in more

FIG. 77 This photograph of a studio light lamp was made to reveal the broken, coiled coil filament. Using brightfield illumination and an in-camera magnification of 1:2, this photograph effectively demonstrates "scientific method." (Photograph by Daisuke Nakamura.)

control of image magnification. Of course, large format view cameras are already so equipped.

The chief problem in the use of extension tubes or bellows for close-up work lies in the use of ordinary lenses close to the subject. Most ordinary camera lenses are corrected for long object-to-lens distances and short lens-to-detector distances. When they are used with short working distances, the resultant images may be degraded as a result of lens aberrations. Optical performance can be markedly improved by using the normal camera lens reverse mounted, so that the rear element of the lens is closest to the subject. Manufacturers supply reversing rings for this purpose.

A key asset of a good close-up lens is its ability to deliver edge-to-edge image sharpness with no curvilinear distortion or curvature of field. Many enlarger lens are designed with similar optical characteristics and can be adapted for many close-up applications. This type of lens is called PLAN or flat field.

Focusing, Depth of Field, and Diffraction
To achieve a specific image size in close-up photography using an SLR camera, traditional technique will need to be abandoned. To achieve critical focus in close-up work, the required reproduction ratio should be determined and (if available)

set on the lens barrel. The camera should now be focused by changing the working distance, which usually involves moving the subject or camera closer, or further from one another. This may be most conveniently done with a focusing rail. A good rail may have calibration marks, smooth adjustment slides, and locks for precise control over its movements.

The range of sharp focus in a picture is referred to as its depth of field (DOF). Assessment of this is subjective and viewer dependent, but in close-up photography, depth of field will be noticeably small, and becomes smaller still with increasing magnification. In everyday photography the image DOF can be increased by using smaller apertures, but as the magnification of 1:1 is approached a very small aperture will produce diffraction that ultimately softens the image's crispness. Diffraction effects are dependent on a sample's characteristics. In general photography there tends to be more DOF behind the subject than in front. In close-up photographs though, the distribution is more equal in the front of and behind the subject.

Determination of Exposure

As image magnification increases, the amount of light reaching the detector from a given area of the subject is correspondingly reduced. However, exposure evaluation with through-the-lens (TTL) metering equipment is straightforward if the system permits and the subject is "average" in its reflection. With a hand-held exposure meter, allowances must be made for light loss due to the lens-to-detector distance. As an example, at 1:1 magnification the rear element of a 50-mm lens may be up to 100 mm from the detector. At this reproduction ratio, there will be two full stops of light loss. The amount of light loss for any reproduction ratio can be calculated. The good equation for use with close-up photography provides the exposure factor in terms of reproduction ratio:

$$\text{Exposure factor} = (R + 1)^2.$$

In this equation 1 represents one focal length of any lens used. R is the reproduction ratio expressed as a decimal, but since the reproduction ratio always corresponds to the increase in extension, the R can be thought of as an increase. In the case of a reproduction ratio of 1:5 (i.e., 1/5 or 0.2), the exposure factor is $(0.2 + 1)^2 = (1.2)^2 = \sim 1.4$.

Another equation for the exposure factor where there are bigger changes of image distance or focal length is:

$$\text{Exposure factor} = \left(\frac{\text{image distance}}{\text{focal length}}\right)^2$$

The $(R + 1)^2$ version is easier to use if scales or rules are substituted in the specimen plane to determine reproduction ratio. The (image distance/focal length)2 version is easier to use if graduated bellows are used to determine image distance (remember to add the focal length to the bellows extension reading to get the entire image distance if the bellows scale reads 0 at the infinity focus position). The exposure time indicated for a selected f-number, with hand-held exposure meters, is multiplied by the exposure factor.

There have been many pioneers in this application of photography including H. L. Gibson, Alfred Blaker, and Lester Lefkowitz, all who authored important books at their time. Copies of many of these books still exist and can be found in used books stores or on eBay: Gibson, H. L., *Close-up Photography and Photomacrography*, Rochester, NY: Kodak, 1970; Lefkowitz, L., *Manual of Close-up Photography*, Garden City, NY: Amphoto, 1979; and Blaker, A., *Handbook for Scientific Photography*, San Francisco, CA: W. H. Freeman, 1977, ISBN 0716702851.

Photomacrography

Photomacrography usually is defined as producing image magnifications in the range of 1:1 (life size) up to about 50:1 (fifty times life size), but is more aptly defined by the equipment that was used to create that magnification. Photomacrography equipment is generally more elaborate and professionally-oriented than the equipment used for close-up work.

There are several ways to produce photomacrographs, including the use of a simple microscope, which is defined as using a single stage of magnification such as a magnifying lens. An enlarging lens is a de facto macro lens, and is as good in quality as a fixed focal-length camera lens when used reverse mounted. However, the best macro lenses are those designed for this purpose and have special features that will be shared below. When using a simple microscope, the object is placed at an distance equal to or closer than two focal lengths from the lens but not nearer than one focal length. Additionally, the image must travel a distance to the detector that is greater than two times the focal length of the lens.

In this magnification range, it is essential to have a rigid support for the components, ideally equipped with some means of moving each independent element (object, lens, and detector) precisely along the optical axis and securing it firmly. This is why photographs in this magnification range are often made with the ubiquitous low-power stereomicroscope. Stereo microscopes will often have a zoom objective lens and possess a relatively low numerical aperture. It is excellent to use for long working distances and usually equipped with rack and pinion adjustment of object distance influencing the fine focus. However, photographers should be aware that the tilted optical axis necessary for stereo viewing can result in photographs that have similarly tilted DOF effects. A binocular microscope has two eyepieces, but does not produce a stereo images.

Bellows and Laboratory Setups

A bellows is, in effect, a variable length extension tube with a lens board at one end and a location for the camera to be attached. The camera and lens boards will be mounted on a dovetail, or similar focusing rail. The bellows extension can easily be adjusted over a very wide range to achieve the correct and precise magnification for the sample under evaluation. Although a bellows is a seemingly simple piece of equipment, it often causes problems for photographers, mainly because the spacing of the key elements (detector, lens, and subject) is

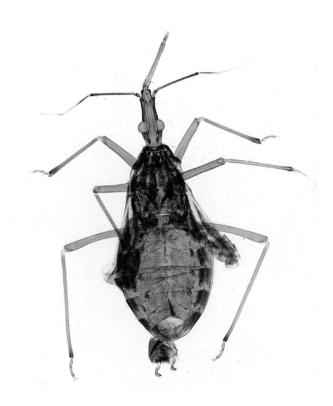

FIG. 78 The Assassin Bug prepared as a whole mount by entomology experts was photographed using brightfield illumination at a camera magnification of ×5. A Zeiss 25-mm macro lens was used with a bellows and an SLR digital camera. (Photograph by Michael Peres.)

Macro Lenses and Optical Considerations

The laboratory photomicrography camera system described above will usually accept a wide range of apochromatic macro lenses optimized for specific magnification ranges, but will be versatile enough to be used with a true compound microscope and eyepieces. This link between micro and macro endured for many years, since macro lenses often had Royal Microscopical Society (RMS) treads for mounting.

True macro lenses are special purpose lenses designed for magnifications greater than infinity. These lenses may have other names reflecting their size, such as short mount or thimble lenses. Macro lenses are unlike close-up lenses in several respects. The first and most obvious difference will be that this lens has no focusing collar because the lenses are used with a bellows on a stand. Consequently, most macro lenses will have only a lens diaphragm ring and focus is controlled through changes in working distance as a function of bellows length. The aperture range is usually smaller than for traditional lenses used for other technical purposes. True macro lenses will typically have maximum apertures of f/2.8 and minimum apertures of f/16 or f/22. At high magnification, small apertures produce undesirable diffraction effects and poor resolution and are rarely selected.

The diaphragm rings of macro optics are seldom marked with conventional f-numbers. The f-numbers on ordinary camera lenses are defined in terms of an object photographed at infinity, which is never the case. These lenses work at a short lens-to-subject distance. The effective f-number therefore increases as bellows extension increases. For this reason, some macro lens diaphragm settings are designated by a simple numerical sequence, for example, 1, 2, 3, 4, 5, 6, where each number is a factor of two (one stop) difference in exposure. Other lenses use Stolze numbers, for example, 1, 2, 4, 8, 15, 30, where each step is proportional to relative exposure time.

Alternative Lenses

Different manufacturers such as Carl Zeiss, Nikon, Leitz, Canon, and Olympus have produced true specialized macro lenses of excellent quality in the recent past. In most of these companies, these lenses are not currently sold. They may be found in the used camera equipment marketplace. Perfectly serviceable lenses by Bausch & Lomb or Wollensak lenses might also be found there. Many of these lenses are readily available on www.ebay.com. Also, as a consequence of the evolution from movie film to video in recent past, wide-angle and normal focal lenses for 16 mm cine cameras can easily be found and adapted for use in this magnification range. The 16, 25, and 50 mm lenses work well for photomacrography when reverse-mounted. Cine lenses are not as well corrected as true macro lenses, but they can make a satisfactory "poor man's" substitute.

Exposure Compensation

As the lens is moved further from the imager to increase magnification, significant light loss occurs in the image plane,

not fixed, which means that working distance, magnification, and focus are independent and interdependent. In a "normal" camera, two of these three variables are usually fixed. Although some bellows can accept a wide variety of cameras and lenses, many are designed for specific manufacturers' lens mounts.

While a bellows may be more portable than a stereomicroscope, the distinctly non-portable, laboratory version of a photomacrography setup is built around a vertical bellows, which is fixed on a sturdy rail mounted on a large, solid stand that can also double as a copy stand. The focal plane and lens are often on a dovetail slide, which is in turn is on a separate dovetail to raise and lower the camera as one unit. The camera end of the bellows may have eye-level reflex viewing and fittings for large format photography. The base often has a transillumination system with several condensers to give a large, evenly lit field of view for transparent specimens, and sometimes fitted lamps for reflected-light photography. This allows excellent control over combined top and transmitted light for translucent subjects such as petri dishes. Most cameras of this type are no longer manufactured but are easily modified to accommodate digital cameras.

following the inverse square law of illumination. A camera with an internal metering system will automatically adjust for this loss; however, with many set-ups, especially large-format cameras and macro stands, exposure must be determined by an external meter. Some meters for scientific applications have sufficient sensitivity so that readings can be made at the image plane, which automatically compensates for the loss of light in the system. Most photographers will need to determine the exposure by reading the incident light with a hand-held exposure meter or reflected light with spot meter and apply an exposure factor. This is commonly referred to as the bellows factor and is applied to the indicated reading to obtain correct exposure.

There are several equations that can be used to determine this exposure factor, but the two most widely used are

$$\text{Exposure factor} = \left(\frac{\text{extension} + \text{focal length}}{\text{focal length}} \right)$$

This equation is equivalent to the previous one because the image distance is the lens focal length plus any extension, making the equation

$$\text{Exposure factor} = \left(\frac{\text{extension}}{\text{focal length}} + \frac{\text{focal length}}{\text{focal length}} \right)^2$$

but extension/focal length is equal to R, and the second term is 1, which bring us back to

$$\text{Exposure factor} = (R + 1)^2.$$

On many film cameras the exact position of the focal plane is indicated by a circle with a line through it, which is inscribed on the camera body. The exact position to measure on a lens (the conjugate point) is not inscribed but is generally accepted to measure from the diaphragm location. In digital cameras a "best guess" is suggested as to where the CCD is located.

The best way to calculate the magnification of a single lens system is by using the equation:

$$v = (m + 1)F$$

where v is the image distance, m is the magnification of the system, and F is the focal length used. This equation can be used effectively for magnification calculations in close-up photography or photomacrography, independent of the format of the camera system utilized.

In the case of film photography, exposure compensation must be calculated taking into consideration film reciprocity law failure, the non-linear relationship between the total light intercepted by the film and the intensity of that light. A long exposure to very faint light does not have the same photographic effect as the same amount of light arriving in 1/100 of a second. This is only of practical importance for exposures longer than one second and shorter than about 1/1000 of a second. However, exposures of one second or longer are not uncommon with the high magnification found in photomacrography. Manufacturer's data usually includes information

about this correction, which may include a color shift. With digital cameras reciprocity failure with long exposures is not as much of a concern as is the build up of digital noise. A camera with a cooled chip has great value in this application or a camera with noise reduction software and long exposure compensation.

Lighting

Lighting for photomacrography can be very simple to the very complicated, depending on the intention of the photographer. The nature of the specimen will often dictate which illumination methods should be used. Fiber-optic light sources and electronic flash units are popular ways of lighting specimens in photomacrography because they do not create heat, which is an important consideration for many kinds of specimens, including living things.

For transparent specimens, transmitted light (diascopic illumination) is used, often from a built-in condenser system. For opaque specimens various episcopic (surface) illumination options are available, including the use of one or more auxiliary tungsten lights, fiber-optic units, or flash. Flatter illumination is achieved by means of a ring light made of either incandescent, fluorescent, or flash. Direct contrasty light can be achieved using an axial half-mirror attachment together with a wide open aperture on the front of the lens, or through the use of using a very thin piece of flat glass supported at a 45 degree angle above the specimen that will work in a similar way. A Lieberkuhn mirror—a type of mirror with a concave surface—reflects light coming from below and is useful when mixed transmitted-reflected lighting is needed. The mirror surrounds the lens, which protrudes from a hole in its center.

Depth of Field

The DOF is the distance in front of and behind the object plane that is in acceptable focus. It increases as the lens is stopped down, but unfortunately there is a fundamental limit as to how far a lens can be stopped down without degrading the image, even in the plane of sharpest focus. That effect is diffraction, which is caused by the bending of light as it passes through a very small slit or opening.

Resolution of the image is assumed to be diffraction limited, and points on either side of the specimen focal plane will be blurred by the combined effects of optical and diffraction blur. Subsequent enlarger magnifications further affect the final results. In practice, any aperture can be used when magnifications are less than $\times 5$, but as the magnification goes beyond this point, image degradation becomes obvious both in the viewfinder and on the subsequent print.

Scanning Photomacrography 1

Originally patented by Peter Zampol in 1954, deep field scanning photomacrography is a method of obtaining images

of small, three-dimensional objects with a high degree of resolution as well as a large DOF. Those two desirable qualities have long been considered mutually exclusive in photomacrography.

In scanning photomacrography, the lens aperture is set to its highest resolution potential (large aperture), which creates a very shallow DOF. The sample is photographed during time

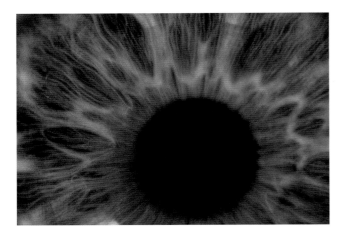

FIG. 79 Structures in a human iris revealed using slit lamp illumination and image capture at 1:2. The iris is difficult to photograph because of the cornea's refractive qualities as well as its highly reflective surface. (Photograph by Kevin Langton.)

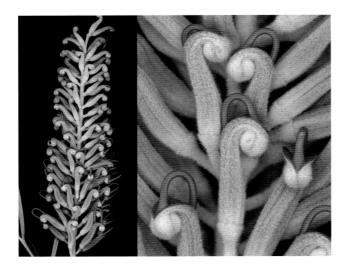

FIG. 80 Flatbed scanners can make close-up images and macro images of flat objects in the same scan. The whole grevillia (left) is 100 mm long. Alongside is detail of the same scan of a region about 20 mm wide on the original flower. (Photograph by David Malin.)

exposure, by moving the subject slowly and precisely along the optical axis. The object passes through a sheet of light that is perpendicular to the optical axis and positioned at the focal point of the lens. The sheets of light may be created using narrow light beams collimated so that they are narrower than the DOF. Thus, only in-focus parts of the specimen are illuminated and photographed. Multiple light sources may be used to create 360 degree coverage.

The specimen is mounted on a motorized platform capable of controlled, vertical movement that introduces no vibration. Beginning with the specimen below the illuminated plane, the stage slowly moves the entire specimen through the light beam. Exposure is principally controlled by varying the speed of the sample stage. The slit width can also be varied in small ways or the lens aperture can be changed to modify the image's exposure.

An observer looking at the ground glass of the camera would see a brightly lit contour of the specimen focused in one plane, constantly changing shape as it traverses the beams of light. The final image is the summation of all of these changing exposure locations on the capture material. Only on seeing the processed image can the effect of the process be known. The procedure works best with opaque objects that have no concave surfaces. Specimens that absorb light, such as certain fibers and crystals, are not suitable for this technique. One of the most interesting aspects of images produced using this technique is the fact these images have no perspective. Since all locations in the image will be photographed at the same object distance, there is no vanishing point of magnification differences from the front to the back. This phenomenon is described as resulting in an image with zero perspective (isoperspective image), which is useful for measurement since there is no shape factor change.

Scanning Photomacrography 2
Some flatbed scanners make remarkably good photomacrographs of specimens that are reasonably flat such as flowers and leaves, insects, coins, and postage stamps as well as other similarly sized objects. Some models combine very high resolution with a useful DOF, especially those with CCD detectors. These scanners have complex optical arrangements and fluorescent tube illuminators and are quite bulky. Slimline scanners use a different optical system and have a much shallower DOF. DOF can easily be determined by scanning a reflective plastic ruler with one end of it lifted off the scanning surface by a known amount.

Scanner and print resolution can translate directly into useful magnification. If an image is made with a flatbed scanner with true optical resolution of 1000 ppi, and the resulting file is printed at 250 dpi, the image magnification will be ×4.

See also the following articles
Botanical Photography; Biological Photography; Medical Photography; Ophthalmic Photography; Photomicrography; Underwater Photography

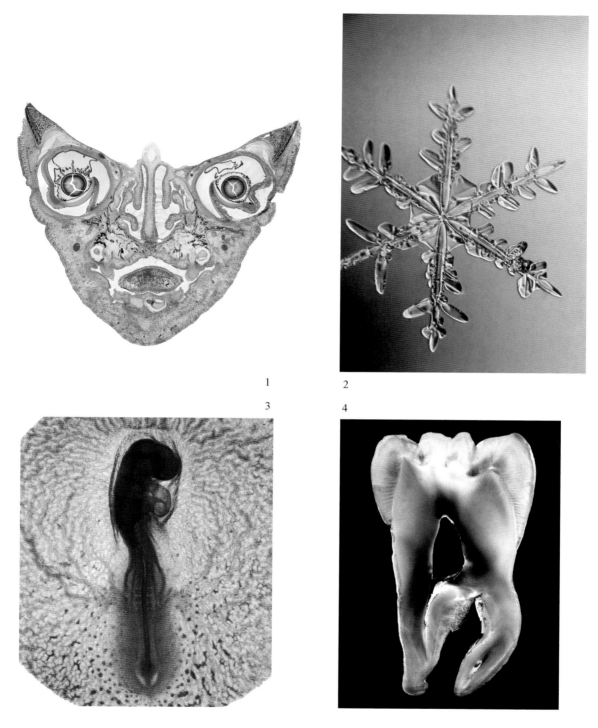

1

2

3

4

FIG. 81 The following photographs are examples of what might be possible using low magnification and close-up imaging systems. Image 1 is a longitudinal section of a fetal cat made at a magnification of 1:1 at capture. Image 2 is a snowflake 5× magnified at capture. Image 3 is a 96-hour chick embryo and was 12× magnified at capture. Image 4 is a longitudinal section of a human adult molar and had a capture magnification of 6× using 4 × 5 black-and-white film. (All images courtesy of Michael Peres.)

FURTHER READING

Eastman Kodak Company (1977). Kodak Professional Photoguide, by Professional and Finishing Markets Division.

Kodak *Techbits* (Summer, 1988). New Photographic Possibilities through the Use of Scanning Photomacrography, pp. 7–11.

Stroebel, L. (1967, second edition, 1972). *View Camera Technique.* New York: Hastings Houise.

The Professional Photo Source Book, by B&H, self-published in New York, (1998)

ADDITIONAL INFORMATION

http://www.cladonia.co.uk/photography/cu_macro_micro/index.html

http://sebaw.online.fr/eng/technique.htm

http://www.modernmicroscopy.com/main.asp?article=60

http://www.microscopy-uk.org.uk/mag/artapr01/dwscanner.html ✇

Photomicrography

MICHAEL W. DAVIDSON
SCOTT OLENYCH
NATHAN CLAXTON
Florida State University

Introduction

Photomicrography is a specialized form of micro-projection where images of minute specimens, magnified by a microscope, are captured using some form of detector. For most of the twentieth century, the primary medium for photomicrography was the silver halide emulsion on glass or film. These materials served the scientific community well by faithfully reproducing countless images produced from the optical microscope beginning almost when photography started. Now, digital imaging has largely displaced film and is cheaper and easier to use than conventional photography. The term photomicrography should not be confused with microphotography, which describes the process by which miniature photographs are made of large objects, such as microfilms of books and documents.

The range of light detection methods and the wide variety of imaging devices currently available to the microscopist makes the selection of equipment difficult and often confusing. In particular, the characteristics of the imaging device have an important influence on the resolution achieved and on the dynamics of visualizing the specimen.

This section is intended to aid in understanding the basics of digital photography as applied to microscopy and as a guide to selecting a suitable imaging detector type appropriate for the variety of optical microscopy techniques.

Historical Perspective

Recording images with the microscope dates back to the earliest days of microscopy. During the late seventeenth century, Dutch microscopist Antoni van Leeuwenhoek and the famed English scientist, Robert Hooke, both produced exquisite and highly detailed drawings of miniature creatures and other materials observed in their single- and double-lens compound microscopes, respectively. Microscopes developed in this period where incapable of projecting images, so observation was limited to careful inspection of specimens through a single lens of very short focal length.

The first compound microscope capable of projecting images was developed by Henry Baker, who described a "solar microscope" based on the camera obscura in 1743. In 1771, George Adams, another English microscopist, produced one of the first projection microscopes employing artificial illumination from an oil lamp. However, there was no way to record the projecting images until 1802, when Thomas Wedgewood reported the use of a solar microscope to produce photomicrographs on paper treated with a sensitized coating of silver chloride. Unfortunately, these images were not permanent because no process of fixing had been discovered.

True photographic images were first obtained with the microscope in 1835 when William Henry Fox Talbot applied his then-experimental process to capture photomicrographs of natural subjects. These specimens were magnified less than 20 times and required exposures of about 15 minutes. The late 1830s and early 1840s witnessed an explosive growth in the application of photography to recording microscope images, using a variety of processes including the daguerreotype. In 1840 John Benjamin Dancer utilized a microscope with gas illumination to photograph a flea magnified enough to fill a 5×7 inch daguerreotype plate. Twelve years later, in 1852, the wet collodion process was first applied to photomicrography by J. Delves, and for the next 150 years, the capturing of images formed by a microscope evolved hand-in-hand with improvements in photographic technology. During the mid to late 1800s, many significant advances were made, especially in Germany, where Carl Zeiss and Ernst Abbe had perfected the manufacture of specialized optical glass and used them for many optical instruments including compound microscopes. Many describe this period as microscopy's golden age where many advances essential for photography through the microscope were developed.

Microscope Cameras

In principle, photographing with a microscope does not require a conventional camera, since the microscope produces its own image, which can be projected on to a suitably mounted detector. For film enthusiasts, the camera can be as simple as a light-tight box fitted with a focusing screen and a film holder, which is then supported over the microscope with a shutter and light-baffle near the eyepiece. This simple "purist" approach produces the best images in theory, since there are no superfluous optical components in the light path. However, almost any style of conventional camera can be used if the lens is set to infinity and the camera positioned very close to the eyepiece. Ideally the eyepiece's exit pupil should be located at the front nodal point of the taking lens. The resulting images

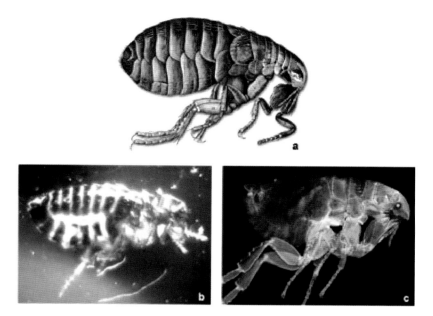

FIG. 82 Evolution of recording images with the microscope. (a) Drawing of a flea prepared by Robert Hooke from observations made in his compound microscope; (b) Photograph of a flea made with a modern camera using a Hooke microscope (note the poor contrast and specimen detail recorded by the camera compared to the articulate image prepared by Hooke) (c) autofluorescence in a flea recorded with a color charge-coupled device (CCD) camera system and a modern research-level microscope. (Photo courtesy of Professor Brian J. Ford, Beyond Distance, University of Leicester, Leicester, UK.)

from this system are likely to be vignetted since the eyepiece lens will make a small circle of good definition and not cover the imaging area. A wide range of adapters are offered by the microscope and aftermarket product manufacturers for attaching many of the popular "point-and-shoot" digital cameras to modern microscope eyepieces. This is one of the most economical solutions for amateur microscope enthusiasts.

Professional photographers who prefer to use film also have a number of choices when coupling an advanced camera system to the microscope. Many adapters for single-lens reflex cameras (minus the lens) are available for both generic and specific brand-name microscopes. These devices are divided into simple extension tubes with adapter couplings and more elaborate units that contain magnifying lens elements. Some adapters can be mounted directly on the central tube of a trinocular microscope, or coupled to the eyepiece tube with or without an imaging or photo eyepiece.

Until recently, microscope manufacturers marketed specialized eyepiece cameras in 35mm and 4 × 5 formats that coupled directly to the microscope without external support. These devices incorporated an eyepiece telescope, beam splitter, intermediate lenses, and film holding/transport mechanism. The beam splitter divided the light between the focusing telescope and film. This system enabled a sharp focus of the specimen to be achieved for both observation and at the film plane for recording. High-end models included programmable automatic exposure metering. These systems were costly, making them accessible only to researchers and serious professionals. Now digital cameras have taken over the consumer and scientific markets and these systems are no longer manufactured though they can still be found at used instrument dealers or on eBay.

In the late 1970s and early 1980s, video cameras were used with optical microscopes to produce time-lapse image sequences and real-time videos in much the same way as still cameras, with or without a lens. More recently, the CCD has heralded a new era in digital photomicrography and film is no longer used. These numerous and gradual changes in the way optical microscope images are recorded suggests that the term photomicrography may no longer be appropriate. It may be considered that the capturing of electronic images with the microscope may be best described as digital or electronic imaging.

Photographic Films

Although film is rapidly being supplanted by digital imaging, a number of microscopists still use it. Because the microscope is a relatively stable platform with good illumination properties, films in the 50 to 200 ISO range are commonly used. Modern film magazines have a so-called DX code that allows camera backs to automatically recognize the film speed and switch the control device to the proper setting. Microscopes can form photographically demanding images and films were designed or adapted to address the image contrast and color saturation

challenges of color photomicrography. One special emulsion was a Kodak aerial film that had additional contrast and enhanced blue and red color response and was repackaged as Kodak Photomicrography Color Film, a very popular emulsion in many microscopy labs for years. Because there were more daylight films produced than tungsten-balanced emulsions, microscope manufacturers often supplied a daylight conversion filter (e.g., Kodak Wratten 80A) as a standard accessory. Most research microscopes would have a daylight color temperature conversion filter built in. Creating color slides with a high degree of color saturation is difficult with film and a didymium glass filter was often used to bolster color reproduction of samples that had a pink or blue hue to them.

Film photomicrography in black and white was notably more difficult than color work, especially capturing small tonal differences in thin sectioned, lightly stained materials that are, for example, light pink and blue. Contrast filters such as Kodak Wratten 11 helped, but Kodak Technical Pan was a legendary emulsion for its application for microscopy. It could be rated as low as ISO 25 and up to ISO 400 depending on the developer used. This emulsion could be developed to a contrast index of 0.40 all the way to 3.0 and had the potential to resolve up to 200 lp/mm in the highest contrast situations. It was an ideal emulsion for chromosome mapping and the production of karyotypes as well as some many other challenging applications, and not only in microscopy. Other "home recipes" of emulsion and developer combinations were devised to photograph the near invisible in the optical microscope. One intriguing combination paired Kodak Kodalith film with 1 part of Kodalith A & B developer with an equal amount of paper developer to yield high contrast with midtones.

Digital Photomicrography

Since the mid-1990s, digital camera technology has dramatically improved and now over 60 manufacturers offer a wide variety of models and features to suit almost every application and budget. Similar advances have occurred with digital cameras designed for microscopes. These image directly onto an electronic image sensor without focusing eyepieces since the image may be displayed in real time at the imaging workstation.

The number of pixels in camera sensors directly influence the amount of information captured by digital cameras, and at this moment in time, it is impossible to differentiate images made using either technology.

One of the main advantages of digital imagery is that it offers many opportunities for digital image manipulation, perhaps more aptly described as clarification or visual improvement. This is a skilled process and care must be taken not to affect the scientific content of the image. Manipulation implies deceit while clarifying does not carry a negative connotation (see essay entitled *Image Manipulation: Science Fact or Fiction*).

Selection of an electronic camera requires careful thought about its proposed use. For example, this can include the consideration of whether fixed specimens or live specimens will be photographed, whether there is need for true color images or whether only grayscale images are required, whether the sensitivity to low light such as in fluorescence applications with associated long exposures will be encountered, whether sizable resolution is required for print application, whether speed of image acquisition is required, whether there will be qualitative or quantitative investigations, and whether there will be a video feed required into a computer (via frame grabber card) or VCR.

The two general types of electronic cameras available for microscopy incorporate tube types (Vidicon family) of cameras or CCD cameras, although the less rugged tube cameras are rapidly becoming obsolete. Either device can be intensified for increased sensitivity to low light, usually with increased image noise, which may affect image contrast and visibility. The silicon intensified tube (SIT), or ISIT, is useful for further intensification of tube cameras, while high-performance, research-level CCD cameras are often equipped with an electron multiplying gain register that enables them to work at low brightness levels. CCD chips can also be cooled to increase their sensitivity and improve signal-to-noise ratio for long exposures. These kinds of devices can be designed to respond to light levels undetectable by the human eye, and several companies have products for this type of imaging.

Selection criteria for a camera specifically for microscopy include consideration of the quantum efficiency of the chip, its signal-to-noise ratio, spectral response, dynamic range, and the linearity of response. Also important is shutter lag and the speed of image acquisition and display, as well as the geometric accuracy of images and the adaptability to the microscope. A very important criterion for the newer digital CCD cameras is digital resolution, not to be confused with optical resolution. Current chips range from as few as 64×64 pixels and more than 5000×5000 required for very specialized applications. Larger arrays are continuously introduced and, at some not too distant time, digital image resolution will be able to match the microscope optical resolution at all magnifications.

CCD cameras are usually of small size and generally feature no geometrical distortion, little or no shutter lag, and good linearity of response. Each pixel of the CCD camera is an individual sensor (or well) for storing the photoelectrons generated by the incoming photons for subsequent readout. The capacity of these wells determines dynamic range and thus influences the number of gray levels the camera can differentiate which is important in difficult to image situations. Binning of adjacent pixels by joining them together into super pixels can be employed to speed readouts in slow-scan CCD cameras.

An emerging technology that shows promise as the possible future of digital imaging is the active pixel sensor (APS) complementary metal oxide semiconductor (CMOS), also known as a camera on a chip. Mass production of CMOS devices is very economical and many facilities that are currently engaged in fabrication of microprocessors, memory, and support chips can be easily converted to produce CMOS optical sensors. In the center of the APS CMOS integrated circuit is a large array of optical sensors that are individual photodiode elements covered with dyed filters and arranged in a periodic matrix. Each pixel element is controlled by a set of

three transistors and an amplifier that operates simultaneously to collect and organize distribution of optical information. The array is interconnected much like memory addresses and data busses on a dynamic random access memory (DRAM) chip so that the charge generated by photons striking each individual pixel can be accessed randomly to provide selective sampling of the CMOS sensor.

The Microscope

Figure 80 is an illustration of a modern epifluorescence microscope equipped with an advanced megapixel digital imaging camera system with Peltier cooling designed to image specimens over a wide exposure range recorded in a 24-bit color using low light levels. This setup might be characterized as a high-end imaging microscope but in reality, any reasonably good compound or stereo microscope can be used for photomicrography and digital imaging. An instrument that is decades old may still be able to produce highly resolved images if it has good optical components. Probably the most important components of any microscope are the objectives and

eyepieces, which should be of the highest quality affordable. Most important for digital or film imaging is the quality of the objectives and substage condensers, especially if they have high numerical aperture (NA). Equally important is the degree of correction of the eyepiece projection lens and the collecting lenses of the illumination system of the microscope.

Objectives

Microscope objectives are designed to form a diffraction-limited image at a fixed location (the intermediate image plane) defined by the microscope's tube length and located at a specific distance from the rear focal plane of the objective or from the front focal point of the eyepiece. Specimens are placed at a very short distance from the lens, which is defined as the front focal point of the objective, so the optical train is influenced by the medium that the sample is surrounded by or its refractive index. It is thus important to be aware of refractive aberrations. Samples are typically surrounded by air, water, glycerin, or specialized immersion oils. Microscope manufacturers offer a wide range of objective designs to meet the

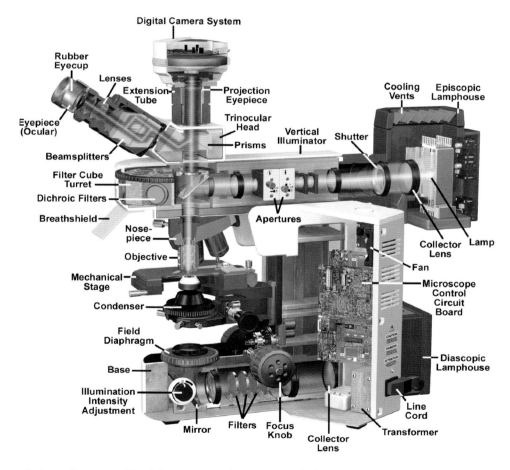

FIG. 83 Cut-away diagram of a research-level fluorescence microscope coupled to a modern color CCD digital imaging camera system.

performance needs of specialized imaging methods (discussed below) to compensate for cover glass thickness variations, and to increase the effective working distance of the objective.

The least expensive (and most common) objectives are the achromatic objectives, which are corrected for chromatic aberration in two colors (red and blue) and spherical aberration is corrected for one wavelength, green.

The limited correction of achromats leads to image artifacts that are especially obvious in color photomicrography. When the focus is optimized on a contrasty subject (or in green light), blue-red (magenta) haloes are evident. This is known as residual color. However acromats are satisfactory for black and white imagery if a green color filter is used.

A better level of correction is found in the more-expensive fluorite objectives. These have optical elements that contain low-dispersion materials such as fluorspar or newer synthetic substitutes to permit greatly improved aberration correction. Like achromats, fluorite objectives are also corrected chromatically for red and blue light, but their spherical aberration is corrected for two colors. This allows larger numerical apertures and consequently better resolution and contrast.

The highest level of correction (and expense) is found in apochromatic or APO objectives, which are corrected chromatically for three colors—red, green, and blue—effectively eliminating chromatic aberration. Spherical aberration is also corrected for two colors. Apochromats are an excellent choice for color photomicrography or digital imaging, but they are expensive. An achromat 10× PLAN lens might sell for $350 while its equivalent APO cousin could list for $3500. Many of the newer, high-end fluorite and apochromat objectives are both color and spherical aberrations corrected for four colors.

All these objective types suffer from field curvature to a greater or lesser extent, so their images are not in perfect focus across the field of view. However, lens designers have produced flat-field-corrected versions that have edge-to-edge sharpness. Such lenses are known as plan achromats, plan fluorites, or plan apochromats, and although this degree of correction adds to the cost, these objectives are best for photomicrography. Figure 84 reveals the important characteristics of a microscope objective, as well as an explanation of the nomenclature engraved or printed on a typical lens barrel.

Numerical Aperture

When characterizing a traditional photographic lens, a useful measure is to describe the maximum lens aperture as its f-stop and is used as an approximate indicator of light transmission. The aperture number is determined by dividing the focal length of the lens by the maximum clear diameter of that same lens when the lens is focused at infinity. Microscope lenses are also described by their light-transmitting potential; however, this information is provided as the objective's numerical aperture. There are several factors, which influence the objective's performance including the refractive index(es)

of the material in which the lens is being used and the acceptance angle of the diffracted rays of light it can gather.

$$NA = n \, Sine \, \mu$$

The NA of the objective is among other factors influenced by the focal length of the objective. Shorter focal length objectives will have a shorter working distance and consequently a greater angle of acceptance. As an objective's magnification goes up, so does its corresponding numerical aperture. The objective's NA will also influence the smallest of structural details that can be resolved when using the lens.

Eyepieces

Eyepieces (also known as oculars) work in combination with microscope objectives to further magnify the real intermediate image, allowing specimen details to be better observed. Better results in microscopy require that objectives be used in combination with eyepieces that are matched in correction with the type of objectives in the instrument. Inscriptions on the side of the eyepieces describe their particular characteristics and function. Often inferior and poorly corrected eyepieces are the cause of poor images.

Substage Condenser

The substage condenser is perhaps the least understood component in an optical microscope. This lens group gathers light from the lamp and produces a cone of light that illuminates the specimen with a uniform intensity spanning the entire view of field, while influencing the energy that will form optical resolution. It is critical that the condenser height be properly adjusted to optimize the intensity and angle of light entering the sample and subsequently the objective lens. Each time an objective is changed, a corresponding adjustment must be performed on the substage condenser aperture iris diaphragm

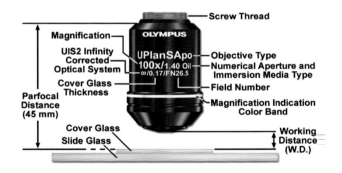

FIG. 84 Modern microscope objective specifications and nomenclature, including the definition for parfocal and working distances. A constant parfocal distance between similar objectives in a nosepiece ensures that each objective of increasing magnification will be in approximately the same focus as the others. Working distance is a measure of the free space between the objective front lens and the cover glass or specimen.

to provide the proper light cone for the numerical aperture of the new objective. Like objectives, condensers come in a variety of configurations and are classified as Abbe, flip or swing out, and/or Achro-Aplanic. There are numerous special types of substage condensers such as phase contrast and darkfield, just to name two.

There are two apertures on a compound microscope and aperture adjustment as well as proper focusing of the condenser is critical in realizing the full resolution potential of the objective. Specifically, appropriate use of the adjustable aperture diaphragm (incorporated into the condenser or just below it) is critical in producing uniform and even illumination, image contrast, image resolution, and image depth of field. The opening and closing of this aperture diaphragm controls the angle of illuminating rays that exit through the condenser, then enter the specimen, and then into the objective. Condenser height is controlled by a rack and pinion gear system that allows the condenser height to be adjusted for proper illumination. Correct positioning of the condenser with relation to the cone of illumination and focus on the specimen is critical to quantitative microscopy and optimum photomicrography. Care must be taken to ensure that the condenser aperture is opened to the correct position with respect to objective's NA. When the aperture is opened too much, stray light generated by refraction of oblique light rays from the specimen can cause flare and lower the overall image and system contrast. On the other hand, when the aperture is closed too far, the illumination cone is insufficient to provide adequate resolution, and the image looks as though it was made without critical focus and void of fine detail but full of image contrast.

The NA of the combined objective/condenser optical system determines the maximum useful magnification that an objective/eyepiece combination can achieve. As a rule of thumb, magnifications greater than about 1000× of the system numerical aperture enter the realm of 'empty magnification:' the image may appear bigger, but there is no new information revealed. However, this factor is somewhat dependent on both the wavelength of observation and on the viewing distance of the final image—images in blue or UV light usually have higher resolution than those made at longer wavelengths.

Resolution

The resolution in an optical microscope is defined as the shortest distance between two points that can be distinguished by the observer or camera system as separate locations. The resolution of a microscope's objective is described as its ability to distinguish between two closely spaced point sources of light (in practice Airy disks) found in the diffraction patterns produced by the illumination of the specimen. Three-dimensional representations of the diffraction pattern near the intermediate image plane reveal the point spread function.

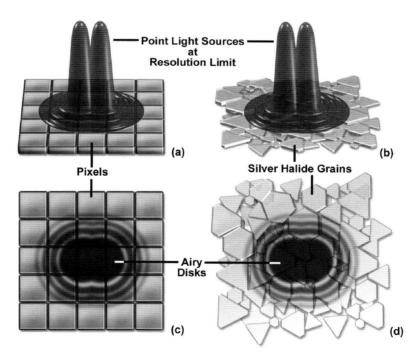

FIG. 85 Film grain size or CCD pixel size determines detector resolution. Superimposed on a CCD array (a) is the point spread function of two light points at the limit of optical resolution. The same situation for silver halide grains in film is illustrated in (b). The Airy disk patterns on the CCD (c) and film grains (d) indicate the affected sensor elements.

The final specimen image is represented by a series of closely spaced point light sources that form overlapping Airy patterns. The separation distance of these point sources on the detector surface in relation to the detection of spatial resolution (eye retinal cell, CCD pixel, or film grain size) determines the resolution of the detection system, as illustrated in Figure 82.

Correct alignment of the microscope optical system is also of importance to produce the system's maximum resolution. The substage condenser's NA must be matched to the objectives and the subsequent adjustment of the aperture diaphragm for accurate light cone formation and specimen illumination. The wavelength of light that is used to image a specimen is also a determining factor in the degree of resolution afforded by the microscope optics. Shorter wavelengths are more capable of resolving finer details than the longer wavelengths. The principal equation used to express the relationship between NA, wavelength, and resolution is

$$\text{Resolution } (d) = \lambda/\text{NA} + \text{NA}$$

In this expression, d is resolution (the smallest resolvable distance between two points), NA is the microscope objective and condenser numerical aperture, and λ is the wavelength of light. The resolution equation is based upon a number of factors (including a variety of theoretical calculations made by optical physicists) to account for the behavior of objectives and condensers and should not be considered an absolute value of any one general physical law. In some instances, such as confocal and fluorescence microscopy, the resolution may actually exceed the limits placed by any one of these calculations. Other factors, such as low specimen contrast and improper illumination may serve to lower resolution and, more often than not, the real-world maximum value of r (about 0.25 μm using a mid-spectrum wavelength of 550 nm) and an NA of 1.35 to 1.40 are not realized in practice.

The wavelength of light is important in determining the resolution of an optical microscope. At any given NA, shorter wavelengths provide higher resolution (smaller values for d). The highest practical resolving power is obtained in ultraviolet light, and it gradually diminishes towards the red part of the spectrum. Most microscopists use white light to illuminate the specimen, and the mean wavelength of the visible spectrum is at about 550 nm, which coincides with the maximum sensitivity of the human eye. With self-luminous and reflective sources (as in fluorescence and dark-field illumination), objects that are much smaller than the theoretical limit can be readily detected (but not resolved) against a dark background by their emitted, scattered or diffracted light.

Resolution is a somewhat subjective concept in optical microscopy because at high magnifications, an image may appear unsharp but still be resolved to its maximum. Numerical aperture determines the resolving power of an objective, but the total resolution of the entire microscope optical train is also dependent upon the NA of the substage condenser. In general, the higher the NA of the total system, including the objective and condenser, the better the system resolution.

As discussed above, the primary factor in determining resolution is the objective NA, but resolution is also dependent upon the type of specimen, coherence of illumination, degree of aberration correction, and other factors such as contrast-enhancing methodology either in the optical system of the microscope or in the specimen itself. In the final analysis, resolution is directly related to the useful magnification of the microscope and the perception limit of specimen detail.

Illumination

The microscope operation is built upon the concept of conjugate planes, which incorporate two interacting pathways that occur concurrently in the optical pathways of the instrument. One conjugate pathway consists of four field planes and is referred to as the image-forming path, while the other consists of four locations and is known as the illumination conjugate pathway. Proper alignment of the microscope illumination for photomicrography and digital imaging requires that these conjugate plane sets are focused (with the light beam centered) at the correct locations. Because various locations are in focus and others are not forms the basis of the Köhler illumination, named for its inventor August Köhler. Illumination is perhaps the most critical factor in determining the overall performance of the optical microscope. It is under the conditions of Köhler illumination that the requirements are met for having two separate sets of conjugate focal planes, field planes, and aperture planes in precise physical locations in the microscope. The details of adjusting a given microscope to satisfy the Köhler illumination conditions depend to some extent upon how the individual manufacturer engineers the microscope.

The basic requirements for setting up Köhler illumination are very simple (illustrated in Figure 83). A collector lens on the lamp housing must focus the lamp filament to the front aperture in the condenser while completely filling the aperture diaphragm. With the lamp's image relayed to the proper location, the sample should be focused to create the objective's proper working distance. With this condition met, the condenser must be adjusted to bring the image of the field diaphragm to the proper location found within the optical axis of the microscope (the sample is also in focus at this location). Meeting these conditions will result in a bright, evenly illuminated specimen plane, even with an inherently uneven light source such as a tungsten-halogen lamp filament (the filament will not be in focus in the specimen plane). With the specimen and field stop now in focus, the focal plane conjugates will be in the proper position so that aperture diaphragm can be set for optimized resolution and contrast.

The imaging and illumination ray paths through a microscope adjusted for Köhler illumination are presented in Figure 86, with the focal conjugates of each plane set indicated by crossover points of the ray traces. Illustrated diagrammatically in the figure is the reciprocal nature of the two sets of conjugate planes that occur in the microscope. The optical

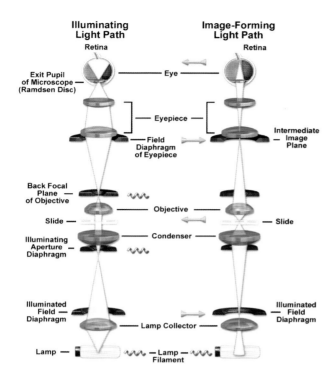

Illuminating Light Path — **Image-Forming Light Path**

FIG. 86 Light paths in Köhler illumination. The illuminating ray paths are illustrated on the left side and the image-forming ray paths on the right. Light emitted from the lamp passes through a collector lens and then through the field diaphragm. The aperture diaphragm in the condenser determines the size and shape of the illumination cone on the specimen plane. After passing through the specimen, light is focused on the back focal plane of the objective and then enters and is magnified by the ocular before passing into the eye.

relationship between the conjugate planes is based upon the fact that, in the illuminating ray path, the spherical wave fronts converge and are brought into focus onto the aperture planes, while in the imaging ray path, the spherical waves converge into focused rays in the field planes. Light rays that are focused in one set of conjugate planes are nearly parallel when passing through the other set of conjugate planes. The reciprocal relationship between the two sets of conjugate planes determines how the two ray paths fundamentally interact in forming an image in the microscope, and it also has practical consequences for operation of the microscope.

Other Microscopy Techniques

There are many contrast-producing methods for both qualitative and quantitative microscopy, including darkfield, Rheinberg, phase contrast, polarized light, Hoffman Modulation Contrast, differential interference contrast (DIC) metallurgical and fluorescence. Many of the newer fluorescence microscopy

techniques have also been further developed into high resolution imaging methods for biological applications.

The oldest and most common technique, brightfield illumination, is used with specimens with inherent contrast, which are often stained with naturally occurring or synthetic dyes. The resultant image will appear colored against a white field. Many times though the sample does not arrive in this condition. Sometimes creating contrast is required or the sample will remain invisible.

An older and more useful technique is the darkfield technique, which is used especially for transparent objects. It may also be referred to as darkground illumination. Darkfield illumination can make use of commercially available condensers or be achieved by removing the systems central order of light with opaque stops. They are usually placed near or in the condenser. The field and aperture diaphragm are completely opened and oblique angle light enters the sample. The object will be brightly illuminated against a black background. In the absence of an object the field is dark.

Rheinberg illumination, developed by British microscopist Julius Rheinberg, is a striking variation of low to medium power darkfield illumination. This technique uses colored gelatin or glass filters to provide rich and different colors to the specimen and background. The central opaque stop used in darkfield is replaced with a semi-transparent, colored, circular stop inserted into a transparent ring of a contrasting color. These stops are placed under the bottom lens of the condenser. The result is a specimen rendered in the color of the ring with a background having the color of the central spot.

Polarized light microscopy is an easy technique to configure and is readily available to both amateur and professional microscopists. A linear polarizer is placed beneath the condenser and a second polarizer—often referred to as an analyzer—is placed behind the objective (nearly anywhere in the light path) at a 90-degree angle to the first filter. This technique is excellent for examining and recording images composed of birefringent materials, such as recrystallized organic compounds, insect chitin, plastics, liquid crystals, and a wide variety of similar specimens. Materials with multiple refractive indices are described as anisotropic, while materials of a single refractive index are described as isotropic.

Phase contrast microscopy, developed by Frits Zernike in the early 1930s, was engineered to make unstained objects visible by producing contrast by changing the light phase relationships. Unstained specimens that do not absorb light are called phase objects. In the phase microscope, they alter the phase of the light diffracted by the specimen. In phase technique the zero order of illumination is retarded one-fourth of a wavelength relative to the sample beam of light passing through or around the zero order. Special objectives and condensers are needed for phase contrast. A substage phase contrast condenser equipped with phase annulus is matched to an objective with a complementary phase ring. Each objective condenser setting is matched. A universal condenser might be used in phase and usually has a brightfield position and a darkfield setting, as well as the various phase settings.

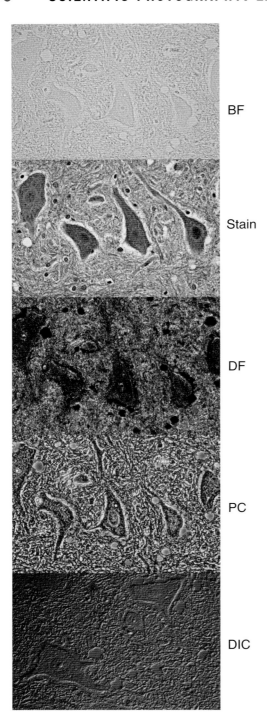

BF

Stain

DF

PC

DIC

FIG. 87 This composite image reveals how a preparation of mammal nerve cells would appear when using a 10× objective. From the top: an unstained sample with brightfield illumination stained with hematoxylin and eosin; darkfield illumination phase contrast technique; and DIC technique. (Photographs by Michael Peres.)

The Hoffman Modulation Contrast (HMC) system, invented by Dr. Robert Hoffman in 1975, is used to increase visibility and contrast in unstained and living material by detecting optical gradients (or slopes) in the sample and converting them into variations of light intensities. An optical amplitude spatial filter, termed a modulator by Hoffman, is inserted at the rear focal plane of the objective. This filter is complemented by an off-center slit that is placed in the microscope condenser. Light intensity passing through this system varies in intensity above and below the median brightness, which by definition, is then said to be modulated. The system produces images that are very high in contrast with a high degree of coherence, capable of producing sharply focused sections. In the resulting images shapes and details are rendered with a shadowed, pseudo three-dimensional appearance. These appear brighter on one side, gray in the central portion, and darker on the other side, against a gray background. Some have called HMC poor man's Nomarski.

DIC (also known as Nomarski contract) is a specialized technique developed by the French optics theoretician Georges Nomarski in the 1950s for detecting optical gradients in specimens and converting them into intensity differences creating contrast. In DIC, light from the lamp is passed through a polarizing filter located beneath the substage condenser, in a location similar to that used in polarized light microscopy. Next in the light path (but still beneath the condenser) is a Wollaston prism, which splits the entering beam of polarized light into two beams traveling in slightly different directions. The two rays intersect at the front focal plane of the condenser where they travel in parallel and extremely close together with a slight path difference, but they are vibrating perpendicular to each other and are therefore unable to cause interference. The beams enter and pass through the specimen where their wave paths are altered in accordance with the specimen's varying thickness, structure, and refractive indices. When the parallel beams enter the objective, they are focused above the rear focal plane where they enter a second Wollaston prism that recombines them. For the beams to interfere, the vibrations of the beams of different path length must be brought into the same plane and axis. This is accomplished by placing a second polarizer (analyzer) after the second Wollaston prism. The image then proceeds toward the eyepiece where it can be observed and recorded as differences in intensity and color. Similar to HMC, the images appear obliquely illuminated and reveal an almost pseudo-relief.

Fluorescence microscopy is an excellent tool for studying material that can be made to fluoresce, either in its natural form (primary or autofluorescence) or when treated with chemicals capable of fluorescing (secondary fluorescence). This form of optical microscopy is now one of the fastest growing areas of investigation in microscopy.

The basic task of the fluorescence microscope is to expose a sample to excitation energy and then to separate the much weaker fluorescence signal from the brighter excitation light. In this manner only the fluorescence emission reaches the eye or other detector. The resulting fluorescence shines against a

dark background with sufficient contrast to permit detection. This separation of excitation from emission light requires the use of specialized filter sets. It should be noted that this is the only mode of microscopy in which the specimen, subsequent to excitation, gives off its own light.

Fluorescence microscopy has unique advantages not offered by other optical microscopy techniques. The use of fluorochromes, commonly called fluorophores, has made it possible to identify cells and sub-microscopic cellular components and entities with a high degree of specificity amidst non-fluorescing material. An extremely small number of fluorescing molecules (as few as 50 molecules per cubic micron) can be detected. Although the fluorescence microscope cannot provide spatial resolution below the diffraction limit of the objective, the presence of fluorescing molecules below such limits is made visible.

Fluorochromes are stains, somewhat similar to the better known tissue stains, which attach themselves to visible or sub-visible organic matter. These fluorochromes, capable of absorbing and then re-radiating light, are often highly specific in their attachment targeting and have significant yield in absorption-emission ratios. This makes them extremely

valuable in biological application. The growth in the use of fluorescence microscopes is closely linked to the development of hundreds of fluorochromes with known intensity curves of excitation and emission and well-understood biological structure targets. When deciding which label to use for fluorescence microscopy, it should be kept in mind that the chosen fluorochrome should have a high likelihood of absorbing the exciting light and should remain attached to the target molecule. The fluorochrome should also be capable of providing a satisfactory yield of emitted fluorescence light. Fluorescence microscopy has given birth to a number of sophisticated techniques that rely on the fluorescent properties of biological molecules to produce images. Several of the more important techniques are now reviewed.

Confocal laser scanning microscopy (CLSM) is a popular mode of optical microscopy in which a focused laser beam is scanned laterally along the x and y axes of a specimen in a raster pattern (Figure 88). The emitted fluorescence (reflected light signal) is sensed by a photomultiplier tube and displayed in pixels on a computer monitor. The pixel display dimensions are determined by the sampling rate and the dimensions of the raster sensor. Signal photons that are emitted away from

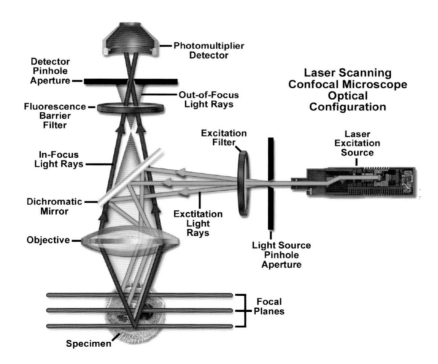

FIG. 88 The confocal principle in epifluorescence laser scanning microscopy. Coherent light emitted by the laser system (excitation source) passes through a pinhole aperture that is situated in a conjugate plane (confocal) with a scanning point on the specimen and a second pinhole aperture positioned in front of the detector (a photomultiplier tube). As the laser is reflected by a dichromatic mirror and scanned across the specimen in a defined focal plane, secondary fluorescence emitted from points on the specimen (in the same focal plane) pass back through the dichromatic mirror and are focused as a confocal point at the detector pinhole aperture.

the focal plane are blocked by a pinhole aperture located in a plane that is confocal to the specimen. This technique enables the specimen to be optically sectioned along the z-axis.

Deconvolution fluorescence microscopy is a technique that applies algorithms to a stack of images acquired which has been along the optical (z) axis to enhance photon signals specific for a given image plane or multiple focal planes in an image stack. The microscope must be equipped with a stepper motor attached to the focus gearset to guarantee image acquisition at precisely defined intervals between focal planes in the specimen. In a typical application, deconvolution analysis is utilized to deblur and remove out-of-focus light from a particular focal plane of interest using fluorescence excitation and emission (although the technique is useful for other illumination modes as well). The most sophisticated applications apply deconvolution analysis to an entire image stack to produce projection views or three-dimensional models.

Total internal reflection fluorescence microscopy (TIRFM) is designed to probe the surface of fluorescently labeled living cells with an evanescent wave generated by a light beam traveling between two media of differing refractive indices. In practice, an incident laser beam is reflected at a critical angle (total internal reflection) when it encounters the interface between a microscope glass slide and the aqueous medium containing the cells. Fluorophores within a few nanometers of the surface are excited by the evanescent wave, while those farther away are unaffected. This technique is commonly employed to investigate the interaction of molecules with surfaces, an area which is of fundamental importance to a wide spectrum of disciplines in cell and molecular biology.

Two photon (multiphoton) microscopy is a derivative technique of laser scanning confocal microscopy where fluorochrome excitation is based on an infrared or long wavelength visible light laser beam whose energy density is adjusted to allow frequency doubling or tripling at the point of beam focus in the specimen. Fluorophores in the specimen are simultaneously excited by two or three photons to produce excited state transitions that are equivalent to single-photon fluorescence. For example, two- and three-photon excitation at 900 nm is equivalent to excitation by higher energy photons of 450 and 300 nm, respectively. Multiphoton microscopy enables deep penetration into thick tissues and eliminates the need for a pinhole aperture because fluorescence emission is restricted to a single focal plane.

See also the following articles

Biological Photography; Fluorescence Imaging; Ophthalmic Photography

FURTHER READING

Hibbs, A. R. (2004). *Confocal Microscopy for Biologists*. New York: Kluwer/Plenum.

Murphy, D. B. (2001). *Fundamentals of Light Microscopy and Electronic Imaging*. New York: Wiley-Liss.

Rost, F. and Oldfield, R. (2000). *Photography with a Microscope*. Cambridge, U.K.: Cambridge University Press.

Police Photography

LARRY S. MILLER
East Tennessee State University

The first known use of the camera for law enforcement purposes was in the mid 19th century, initially to record still images of arrested individuals and to document crime scenes. This is still important today, but police also now use camera and video to record interrogations, traffic stops, surveillance, public thoroughfares, and traffic accidents. They also frequently use cameras to document physical evidence at a crime scene before it is collected into evidence. Fingerprints developed with fluorescent powder or illuminated by an alternate light source (ALS, an intense light source with filters capable of illuminating a wide range of wavelengths from the short-wave ultraviolet (230 nm) through the near infrared (900 nm), commonly used to search for trace evidence at a crime scene) is an example of this. The police photographer must have an understanding of how the camera can record not only the visual and audio components of an interrogation or traffic stop but also how it can record images at invisible ultraviolet (UV) and infrared (IR) wavelengths. The police photographer must also have a good working knowledge of other specialized techniques such as close-up (macro) photographs, the effective use of fill-flash and bounce flash, and photography in less than desirable conditions such as night-time with limited ambient lighting.

Most police agencies use a hybrid system for their photographic needs. This hybrid system is composed of a digital camera, a 35 mm single lens reflex (SLR) camera, and a video camcorder. When the digital camera emerged in the late 20th century, it was touted as the replacement for traditional film cameras. This proved not to be true, at least into the early 21st century. Nonetheless, digital cameras are very useful in police photography. They are able to capture images in the invisible range, particularly in the IR. Other advantages of digital cameras include the ability of the photographer to see the immediate results of the photo, the ability to send digital photos over the internet and to computer-equipped police cars, the ability to record images over a wide range of the spectrum from the UV into the IR, and storage capability. However, digital cameras may not perform well in low light situations, when enlargements of greater than about 24 \times 36 cm (11 \times 14 inches) are required, or when a crime scene must be recorded at night using a painting-with-light technique. In these situations a film camera should be used. A 12 megabyte digital camera might be able to produce an acceptable 24 \times 36 cm enlargement, but the cost of such a camera may be prohibitive for a police department. As a result, most law enforcement agencies use the same make of digital camera as their film camera in order to use the same accessories. For instance, if a police agency uses a Nikon 35 mm SLR camera then the digital camera is going to be a Nikon SLR so that the same lenses, filters, flashes, etc., can be used for both cameras. In this way, the department does not have to invest in different

accessories to fit each camera. An exception to this is the video camcorder, which typically uses different lenses and filters.

The major function of the police photographer is to document crime scenes and injuries that may be used as evidence in court. Any photograph or video used as evidence in court must be admitted into evidence based on the rules of evidence. The photographer must be able to testify that a photograph or video accurately represents the scene or the victim, and that the photograph was not altered or manipulated in any way to distort the scene or injuries. This has been a particularly difficult task with digital photographs which can be easily altered. However, most departments have strict protocols when using digital images and typically archive images as RAW files to maintain integrity of the original. Photographs admitted into evidence must be relevant and not intended to bias the jury. Photographs of deceased or injured individuals may be objected to on the basis of how shocking the photographs are to a jury. Unless a particularly gruesome photograph can be shown to be relevant to the facts of the case, it may not be admitted into evidence. One exception to this rule is during sentencing hearings, where the prosecution wants to show a jury how heinous a particular crime was. A general rule for police photographers is to tell a story with the photographs. For crime scenes, this means showing surrounding areas, entrances and exits to the scene, articles of evidence in their original locations and close-ups of that evidence, as well as the physical environment (i.e., was food on a table, dishes in a sink, property disturbed, etc.). This helps the jury understand the context and what was going on at the time of the crime.

To document crime scenes and injuries, the police photographer may have to use specialized photographic techniques. Close-up or macro photography is used to focus closely on a specific item of evidence (i.e., fingerprints, shell casings, bullet holes, footprints and tire prints, etc.). Either a digital SLR camera or a 35 mm SLR camera fitted with a macro-capable lens will usually be suitable. Years ago, special fingerprint cameras were used that were based on 4 × 5 film Graflex cameras or Polaroid equipment. Today, a macro lens and SLR camera is generally preferred by most professional police photographers. Documenting the location of invisible evidence is also a specialized photographic task. UV and IR light sources extending to 230 nm in the UV and to 900 nm in the IR are often used to locate trace evidence that might not be seen readily by the naked eye under normal lighting conditions (i.e., fluorescent fingerprints, blood, semen, fibers, hair, dust, gunpowder residues, etc.). Of course, the camera and its detector must be able to record images in these widely differing wavelengths. The digital camera is especially well suited to this type of photography. The CCD or CMOS chip that records the image in a digital camera is sensitive to these wavelengths and can record images with ultraviolet or infrared illumination only with appropriate filtration. Conventional film, while sensitive to UV, is not particularly useful for IR wavelengths so a special infrared film must be used in this case. UV and IR light can also reveal bruises, bite marks, and other injures long after they have faded, even tattoos on a decomposed body may be detected.

While photographing light at invisible wavelengths is a useful way of revealing the unseen, visible light remains a very versatile medium. One method often used at night time or in unlit interiors is painting-with-light. With this technique, the camera is on a tripod or other firm support and the f-stop value at f/22 or higher. With the shutter open the photographer fires a series of electronic flashes at various points in the scene (see *Cave Photography*). In this way, one photograph captures the scene as though it was lit with simultaneous multiple flashes (see Figures 89 and 90). Film cameras are best suited for this technique since digital cameras produce noise with long exposures. However, with digital cameras the same technique can be emulated by using multiple flash units with one or more slave attachments. Other light-directing techniques the police photographer may use are fill-flash, bounce flash, and grazing. Grazing incidence (low angle) light allows the photographer to capture shadow details in low profile footprints or tire prints. A scale, such as a ruler, must be placed in

FIG. 89 Outdoor crime scene photograph taken with a single flash.

FIG. 90 Same outdoor crime scene photograph taken with a single flash fired multiple times using the painting-with-light technique.

these types of photographs so that, if a suspect's shoe or tire is recovered, it can be compared to the photograph.

The police photographer may be called upon to assist with surveillance photography, often employing both still images taken with a digital or 35mm SLR camera, and movies with a video camcorder. Surveillance photographs can document a crime in the act of commission and may provide evidence for a search warrant. They may also identify arson suspects or capture images of suspected individuals in public areas for terrorist investigations. Regardless of the case, the photographer must be able to capture the identities of people and location in the photograph or video. Facial and body features, unambiguous location identifiers with street addresses, car tags, and the like must be visible in the recorded images. In most cases, police surveillance photography is covert, requiring that the photographer and the camera be hidden from view. Thus the use of telephoto lenses and high-speed film for low light conditions may be required. There are several 35mm films available with speeds of ISO 3200 and higher that can be used for this purpose. Also, some digital cameras and camcorders are capable of high-speed recording and infrared illumination recording using the nightshot feature on many digital cameras.

See also the following articles
Fluorescence Photography; Forensic Photography; Image Manipulation; Infrared Photography; Photomacrography and Close-Up Photography; Night-Time Photography

FURTHER READING
Blitzer, H. L. and Jacobia, J. (2002). *Forensic Digital Imaging and Photography*. San Diego, CA: Academic Press.
Miller, L. S. (2006). *Police Photography (5th edition)*. New York: Lexis-Nexis. ◎

Pseudocolor

DAVID MALIN
Anglo-Australian Observatory, RMIT University

The human vision system can only distinguish about 30 shades of gray in a monochrome image, but it can distinguish thousands of different colors. Pseudocolor is an artificial color scheme that can be applied to monochrome images that allow the highlighting of subtle contrast and density gradients. Today this is done using imaging software with color look-up tables, which assign a mix of RGB colors to pixel grayscale intensity values. The ratios of the RGB colors can be varied according to taste, and more advanced methods of pseudocoloring take into account the non-linear human response to color and the spatial frequency of the data, thus further enhancing the usefulness of a monochrome dataset. Apart from its myriad scientific uses, pseudocolor is widely used to make monochrome images more visually appealing, as in sepia color.

See also the following article
False-Color Photography

ADDITIONAL INFORMATION
http://www.bioquant.com/features/pseudocolor.html
http://www.research.ibm.com/people/l/lloydt/color/color.HTM ◎

Remote Sensing

NICHOLAS M. SHORT, PH.D.
NASA
DAVID MALIN
Anglo-Australian Observatory, RMIT University
DONALD L. LIGHT
Airborne and Space Systems for Mapping and Remote Sensing

Introduction
Remote sensing may be broadly defined as the collection of data which leads to the observing of objects, area, or phenomenon, without human physical contact. In this section data that can be viewed as images will be emphasized, but the term remote sensing may also embrace non-image data. The image information is usually derived from capturing electromagnetic radiation that is emitted, reflected, absorbed, or scattered in a way that reveals something about the object or scene of interest. This energy may be of natural origin, such as sunlight, or it may be artificial, such as radar or laser scanning, leading to the concepts of active and passive remote sensing. Energy can be detected and recorded by photographic film and digital detectors, while more sophisticated radio frequency receivers, radar systems, thermal sensors, radiometers, and other sensing instruments are required for other wavelengths and imaging regimes.

Remote sensing is used in a wide range of applications, including agriculture, forestry, geology, cartography and land cover mapping, meteorology, water resources control, hydrology, oceanography, and environmental management, and of course, the military, just to mention a few. Today, aerial and ground photography are considered subsets of remote sensing (see *Aerial Photography*). Remote sensing is essentially earthward-looking. Apart from atmospheric research, upward-looking remote sensing is astronomy, and that is also discussed elsewhere in this volume (see *Astrophotography.*)

History
The remote sensing of images began with the invention of photography. Close-up photography (proximal remote sensing) began in 1839 with the images of Daguerre. Distal remote sensing from above the ground started in the 1860s from balloons. With the invention of the airplane, aerial photography showed its value in the World War I. Before the World

War II more sophisticated photographic methods had evolved, a few simple electronic sensors were used, and radar was being developed. At the end of WW II, radar had come into civilian use, thermal sensors were being developed, and the concept of multispectral photography was finding applications. It was these developments that led to the term "remote sensing," which was first used in the 1950s by Evelyn Pruitt, a geographer/oceanographer at the U.S. Office of Naval Research. However, at that time, most remote sensing was still carried out photographically from the ground and airborne platforms.

As rockets became more reliable, remote sensing could cover large areas of the earth and look outward toward the planets and the cosmos. Early efforts involved installing automated sensors and cameras on captured German V-2 rockets. Though they never attained orbit, they took the first high-altitude aerial images, beginning in 1946. This was followed by the development of meteorological satellites in the 1960s, the first of which was the Television Infrared Observation Satellite (TIROS-1). Further refinements in imaging sensors revealed the surface of the earth (literally) in a new light and the modern era of multispectral imaging had begun. The value of the multispectral aspects of imagery from space was tested by using multi-band imagery from manned aircraft, where it is still widely used.

This early phase led to the birth of the Earth Resources Technology Satellite (ERTS, later renamed Landsat) that was launched in 1972. Six other Landsat satellites followed, each of which had several visible-light and infrared bands. The success of such missions led to a remote sensing industry and to more satellites (e.g., SPOT, JERS, IRS) each with improved capabilities. The first geostationary weather satellites were launched in the mid 1970s and also carried instruments to monitor solar activity, X-radiation from space, and the earth's magnetic field. Most earth-observing sensors operate in the scanner (pushbroom) mode, some using mirrors to sweep across the scene as the satellite platform moves in orbit. Multispectral data are produced by using bandpass filters to isolate various parts of the reflected spectrum.

The early satellites were passive observers, but in 1978, Seasat was launched and used radar to produce images of ocean currents and surface detail that in turn revealed the presence of unsuspected features on the sea floor. Imaging radar has also been used from the Space Shuttle, where it produces remarkable images of landforms below the vegetation cover and other unexpected features such as ancient riverbeds in the Sahara desert. The military uses satellites equipped to image in the visible and infrared wavelengths for high resolution surveillance. These satellites use powerful telescopes and images from them are not widely available.

The Basis of Remote Sensing
While the results of remote sensing are normally seen as images, it is data that are gathered and displayed. Initially, remote sensing data were captured on photographic film using a special camera, however, film was not practical for earth-orbiting satellites, although in a few cases, film was used and jettisoned for retrieval on land. In a very few instances the film was captured in mid air. The advent of digital data gathering was a significant development, and it quickly revolutionized the way information was obtained and handled in all branches of remote sensing and beyond.

It is useful to disentangle the stages of data gathering, since at each stage the instrument involved adds its own characteristics to the final output, However, these characteristics can be quantified and calibrated so that the output is free from instrumental artifacts.

A basic remote sensing system is a digital camera, although it would rarely be considered as such. Light entering the camera is focused by a lens, which will absorb, scatter, and reflect some energy, especially in the ultraviolet. The incoming light is filtered at the lens or at the chip to a passband, and the energy passes through a diaphragm to govern its intensity and a shutter to determine the duration and instant of the exposure. The light is focused on a sensor or detector, which is a charge-coupled device (CCD) chip or its equivalent. Incoming photons from the target are converted into electrons as a result of the photoelectric effect, the efficiency of which is in turn wavelength-dependent. The photoelectrons are briefly stored and removed sequentially as a variable current, which is proportional to the number of electrons created in the pixel. The dynamic range of the image and non-image noise is determined in large part by the capacity and the nature of the pixels. The resulting stream of digital signals is passed through a processor that reassembles the image organized in the original spatial arrangement on the array. This is saved as a digital file and can be displayed in a variety of ways. The resulting picture is thus a reconstruction of the luminance and spatial distribution of the elements of the scene, modified by the complete chain of physical, electronic, and data processing influences from object to image.

In the case of consumer-grade cameras, the detector is overlaid with filters to record blue, green, or red light on separate pixels, which read out as separate channels and are ultimately re-combined into a true-color image. The same functions are achieved in remote sensing systems in a wide variety of ways.

Most sensors record at a single, narrowly defined wavelength (passband), which can be located anywhere in the electromagnetic spectrum. In remote sensing this is usually in the visible or infrared part of the spectrum, but it can be a stream of radar data that is collected. These monochrome "channels" can be combined into a true-color (if the channels are RGB) or false-color image. The monochrome channels themselves my be colorized to emphasize intensity differences (pseudocolor). The individual channels can also be added, subtracted, or divided into other data channels to extract subtle differences between them. The image data can be obtained in a single shot (as in a digital camera) or scanned at several discrete wavelengths at once with elaborate mirror and filter systems and at scan rates set to give optimum coverage as the satellite or aircraft moves over the terrain. Thus, unlike traditional photography, the data are initially in digital form, so various calibration and corrections can be applied in real time, enabling it to be used quantitatively. The specialized software that is used for this can provide data that is spatially correct, allowing for optical, geometrical, and translational distortions, and that is

radiometrically corrected so that specific intensities can be measured. This is important for the accurate characterization of soils and rock types and to study the condition and thickness of vegetation. These concepts are more fully described in the section *Multispectral Imaging*.

A basic requirement for remote sensing is an energy source to illuminate or provide electromagnetic energy to the target of interest. For passive instruments, this is usually the sun; for active instruments, the sensor itself emits an pulse of energy. As the energy travels from either kind of source to or from the target it may be attenuated by the intervening atmosphere. Ultimately, the energy recorded by the sensor has to be transmitted to a receiving and processing station where the data are processed into an image. The processed image is interpreted, visually or digitally/electronically, to extract information about the target in ways that depend on the particular problem.

In addition, the data channels can also be images taken from slightly different perspectives so that stereo pairs can be made to reveal surface topography. If the technical details of the imaging system are well characterized (as they usually are), photogrammetric techniques can be used to make accurate measurements of surface relief and the other spatial dimensions. Images taken at different times can be superimposed in software to uncover changes with seasonal or other factors and combined with, or made into, maps coded to show an enormous number of variables.

The Electromagnetic Spectrum

The visible region of the spectrum is small, with wavelengths between 0.4 and 0.7µm (micrometers, microns, millionths of a meter). Part of the near infrared (NIR) is made up mostly of reflected radiation, but radiation emitted from thermal processes

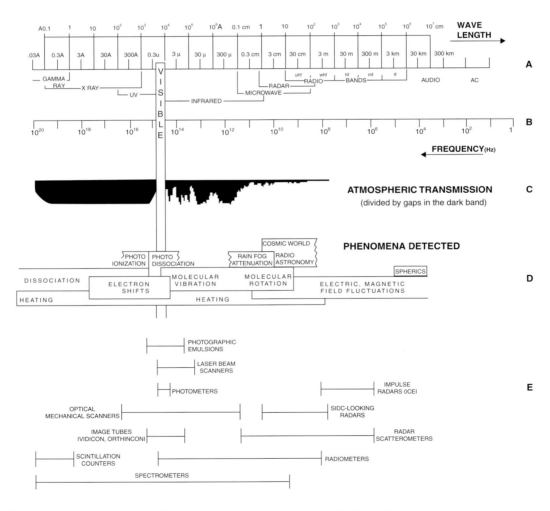

FIG. 91 The electromagnetic spectrum, atmospheric windows, mechanisms of radiant phenomena, and sensor types. (Adapted from Lintz, J. and Simonet, *Remote Sensing of Environment*, Addison Wesley Publishing Company, 1994.)

(heat) is detectable at about 3μm. Much of the radiation in this part of the spectrum is absorbed and/or scattered by the atmosphere; however, there are some gaps shown in the irregular dark band in Figure 91, and the atmosphere is essentially transparent at visible wavelengths. At shorter wavelengths, the atmosphere is effectively opaque, so remote sensing detectors above a source will receive weak or no signals. The attenuation properties of the atmosphere are thus an important consideration in remote sensing. On the other hand, telescopes in earth orbit looking out into space are above the atmosphere and can sense radiation at all these wavelengths, including radio radiation, originating from cosmic sources.

Recent Advances

Since the early days of multispectral remote sensing, the major advances include completely new types of detectors. A small number of individual detectors in a row (silicon for visible light, lead sulfide for longer wavelengths) were replaced by the CCD chip, usually consisting of many smaller detectors in a two-dimensional X-Y pattern. Pixilated arrays can be made to be

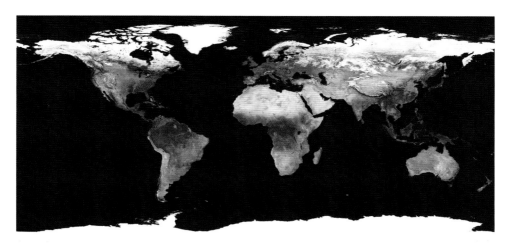

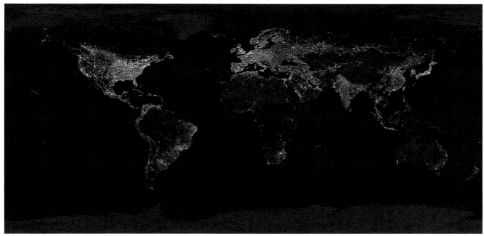

FIG. 92 These are real images of the planet earth, gathered in many individual passes of several kinds of satellites over a long period to eliminate cloud cover and other interferences. They show the ability of remote sensing to record features of the planet and represent them in a way that the eye cannot see. The MODIS daytime image shows the highly reflective ice and snow of the polar regions and the deep green of the equatorial rain forests, with the sandy hues of the mid-latitude deserts in between. Superimposed are global city lights, derived from 9 months of observations from the Defense Meteorological Satellite Program. These data are shown separately in the lower image, and indicate artificial light directed uselessly into space. (Blue marble (top image) courtesy of NASA Goddard Space Flight Center, MODIS Team, USGS EROS Data Center, DMSP. Earth at night courtesy of C. Mayhew & R. Simmon (NASA/GSFC), NOAA/NGDC, DMSP Digital Archive.)

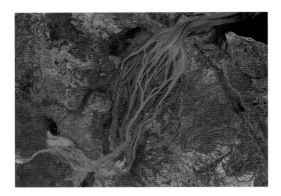

FIG. 93 The Betsiboka River estuary in Madagascar, after heavy flooding in March 2004. The river estuary is clogged with silt caused by loss of topsoil from prolonged and extensive logging of the highlands. Regions of rich vegetation are colored bright red while cleared areas with little vegetation are a lighter red. The Advanced Spaceborne Thermal Emission and Reflection Radiometer (ASTER) on the Terra satellite captured this image in the green, red, and near infrared bands. They are displayed here as blue, green, and red, respectively. (Image courtesy of Jesse Allen based on expedited ASTER data provided by the NASA/GSFC/MITI/ERSDAC/JAROS, and U.S./Japan ASTER Science Teams.)

sensitive to a very wide range of wavelengths. This in turn has permitted greatly improved spatial and spectral resolution. The latter is now associated with hyperspectral sensing in which the bandwidths are reduced to 0.01–0.02 μm. A micrometer is a millionth of a meter; another term is nanometer which is 1000 μm, thus 0.55 μm is 550 nm. With hyperspectral sensing the 200 or more channels cover a continuous range of wavelengths can extend from less than 0.4 to over 2.5 μm. Also much extended is the ability to record data at longer wavelengths, including thermal regions at 5–6 and 8–14 μm and into the passive microwave spectral region (millimeter wavelengths) and the active, where scene-illuminating radiation is produced by the sensor system (e.g., radar). Finally, much better computer-based image processing is available.

As software and imaging systems continue to improve, remote sensing is focused on developing methods to quantify the data extracted from imagery. As a result, more and more work is done to directly measure environmental factors and (for example) help to increase agricultural yields. This involves correcting for atmospheric degradation of these images and removing their effects on the final image brightness. In addition to the collection and correction of remote sensing images and the display and application of the data, a broad range of scientific disciplines are benefiting from these improvements. Among the disciplines developing or using remote sensing techniques are optical, imaging, and photographic scientists,

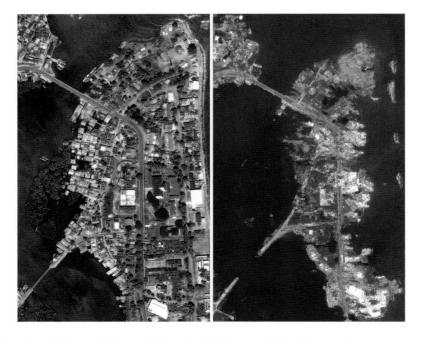

FIG. 94 The Banda Aceh region of Sumatra before and after the 2004 tsunami. The images show heavily eroded shoreline and complete destruction of vegetation, buildings, boats, and roads extending far inland. Images from the Quickbird satellite, which has a high-resolution panchromatic sensor capable of 0.6 m ground resolution and a multispectral IR sensor with 2 m resolution from an altitude of 400 km. (Courtesy of DigitalGlobe QuickBird satellite.)

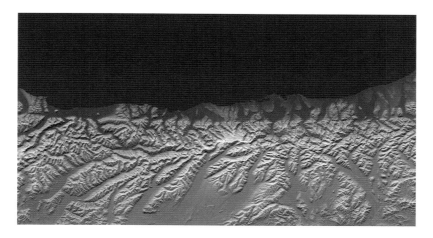

FIG. 95 The Shuttle Radar Topography Mission (SRTM) uses synthetic aperture radar aboard the Space Shuttle Endeavor to obtain high-resolution images of the earth's topography. The image is about 300km wide and shows the distinctive Alpine fault on the west coast of New Zealand's South Island. Two visualization methods were combined to produce this image from monochrome data. Image shading was derived by computing topographic slope in the northwest–southeast direction, so that northwest slopes appear bright and southeast slopes appear dark. Color coding is directly related to topographic height derived from the radar signal. Green is used for lower elevations, rising through yellow and tan, to white at the highest elevations. (Courtesy of NASA/JPL/NGA assembled.)

as well as geographers, geologists, agronomists, foresters, environmental scientists, and archaeologists.

Besides meteorological, oceanographic, and land-observing remote sensing from satellites (and manned spacecraft), remote sensing is also a key part of the exploration of the planets (e.g., Mars Orbiters) and the cosmic exploration of stars, galaxies, and intergalactic regions using sensors tied to such exceptional space platforms as the Hubble Space Telescope and the Chandra X-Ray Telescope. Almost their entire functions are remote-sensing based.

See also the following articles

Aerial Photography; Infrared Photography; Multispectral Imaging; Photogrammetry; Space Photography; Streak and Strip Photography

FURTHER READING

Avery, T. E. and Berlin, G. L (1992). *Fundamentals of Remote Sensing and Air Photo Interpretation (5th edition)*. New York: MacMillan Publishing Company.
Drury, S. A. (1987). *Image Interpretation in Geology*. London: Allen and Unwin.
Lillesand, T. M. and Kiefer, R. W. (2000). *Remote Sensing and Image Interpretation (4th edition)*. New York: John Wiley & Sons.
Lintz, Jr., J. and Simonett, D.S. (eds.) (1976). *Remote Sensing of Environment*. Addison-Wesley Publishing.
Sabins, Jr., F. F. (1987). *Remote Sensing: Principles and Interpretation (2nd edition)*. New York: W. H. Freeman & Company.
Short, N.M. (1982). The Landsat Tutorial Workbook: Basics of Satellite Remote Sensing. NASA Reference Publication 1078.
Short, N. M., Lowman, Jr., P., Freden, S., and Finch, W. (1976). Mission to Earth: Landsat views the world. NASA SP-360.
Shott, J. Various Editors (1997–1999). *Manual of Remote Sensing*, 3 vols. In book and CD-ROM formats. Prepared by the American Society of Photogrammetry and Remote Sensing, Bethesda, MD.

ADDITIONAL INFORMATION

DigitalGlobe high resolution imagery: http://digitalglobe.com/
Geospatial Resouce Portal
http://www.gisdevelopment.net/technology/rs/techrs26b.htm]
Imaging and Geospatial Information Society, list of current and planned satellites: http://www.asprs.org/news/satellites/
NASA images and animations of our home planet/AVIRIS: http://visibleearth.nasa.gov/
NASA Shuttle Radar Topography Mission (SRTM): http://www2.jpl.nasa.gov/srtm/Quickbird satellite, http://www.satimagingcorp.com/
Remote sensing and Image Analysis: http://www.cnr.berkeley.edu/~gong/textbook/
Remote sensing sources: http://sedac.ciesin.columbia.edu/tg/
Remote sensing tutorial: http://rst.gsfc.nasa.gov

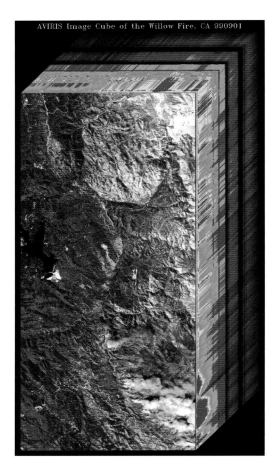

FIG. 96 Aerial images of a Californian forest fire made using the Airborne Visible/Infrared Imaging Spectrometer (AVIRIS). This instrument captures images in 224 separate spectral channels. Here they are shown stacked into a data cube, which covers 400–2500 nm. The pattern along the edges of the cube is thus a pseudocolor spectrum, ranging from black and blue (low response) to red (high response), while the top picture is the image data in one of the channels. These rich datasets allow analysis of temperature variations and adjacent vegetation types and biomass, as well as the water content of leaves in the vegetation, all important factors in firefighting. (Courtesy of NASA Visible Earth/AVIRIS, http://visibleearth.nasa.gov/.) ◉

Schlieren and Shadowgraph Photography

PHRED PETERSEN
RMIT University

Schlieren and shadowgraph photography are related methods of imaging that reveal localized changes of refractive index found in transparent media, including gases, liquids, and solids. These gradients may be static, such as irregularities seen in glass, or dynamic, such as those induced by pressure, density, composition, or temperature gradients in fluids. Both methods use optical systems that show localized displacements of light rays against a uniform background illumination gradient, which is projected onto a viewing screen or camera focal plane.

Shadowgraphy is the simplest method of visualizing refractive index gradients, requiring only a point source of light and a screen or surface upon which to cast the subject's shadow. Direct rays from a point source will evenly illuminate a viewing screen. The deflection of some rays by a local change in refractive index results in decreased illuminance at the point on the screen from which those rays have been displaced, and increased illuminance at the location those rays now strike the screen. Examples of natural shadowgrams visible on a sunny day are the shadows cast by imperfect window glass or active heat sources. This effect also produces the "shadow bands" briefly visible during an eclipse of the sun.

While a shadowgram is simply a shadow, a schlieren image is an optical image formed by a lens or mirror system. Schlieren methods offer higher sensitivity than shadowgraphy, but are more difficult to set up. This technique was first demonstrated by Robert Hooke (c. 1672), but found little contemporary interest outside of a few who used it as a method for testing the optical quality of glass lens blanks. August Toepler "reinvented" the technique between 1859 and 1864, and was the first to apply it to generic inhomogeneities in transparent media. He named it schlieren, from the German "*schliere*," meaning streak or striation.

Schlieren images are most often made in a parallel beam of light, as shown in Figure 98, which illustrates a compact setup. A light source is focused on to a slit that is placed off-axis and exactly one focal length from a lens or mirror. This produces a parallel beam of light that illuminates the test specimen. The test field is limited by the size of the major optical elements, so mirror arrangements are more common than refracting systems because large mirrors are easier to find. The collimated light containing the specimen image is focused onto a finely adjustable knife edge by another, similar mirror or lens, where it is partially blocked. Any change of refractive index in a transparent medium causes part of the light to be refracted in or out of the part of the collimated beam that passes the knife edge, thus appearing brighter or darker than the background in the focused image. The inclusion of the knife edge is the fundamental distinction between schlieren and shadowgraph methods.

The final image is brought into focus on a viewing screen or in a camera. Color filters may be used in place of the opaque knife edge or elsewhere in the setup to make a multi-colored image that can be interpreted to determine the direction of ray displacements. This moveable knife-edge method is also the basis of the Foucault knife edge used for focusing telescopes and testing optics. Larger schlieren systems can be created with an arrangement of a large light source grid and a

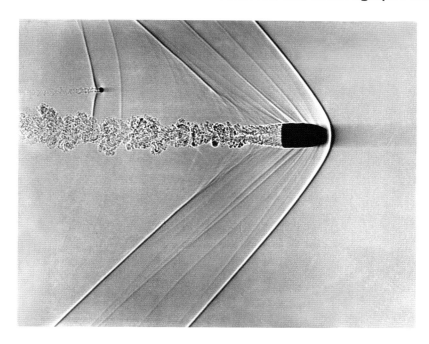

FIG. 97 This shadowgraph of a supersonic bullet and bullet fragment in flight, flying at almost Mach 1.5, reveals air compression as it pushes its way through "thinner air" causing a classic "V" shaped shock wave to appear reminiscent of the "bow" wave of a boat moving on a smooth water surface. This is imaged as a high-contrast shadow directly onto film. (Courtesy of Andrew Davidhazy.)

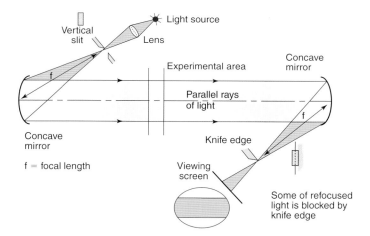

FIG. 98 Typical arrangement of a dual-mirror Schlieren system showing deflected rays.

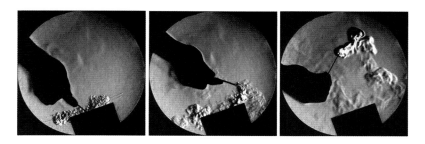

FIG. 99 A series of Schlieren images showing the heat and combustion gases given off as a match is ignited.

corresponding negative cut-off grid placed in camera. Subject areas as large as 2×3m have been studied in this manner.

Schlieren methods have applications in glass technology, aerodynamics, ballistics, heat transfer and convection studies, explosion and shockwave research, gas leak detection, boundary layer studies, and combustion research. It has also found application as a component of large screen television light valve projection systems.

See also the following articles
Ballistics Photography; High-Speed Still Photography

FURTHER READING
Settles, G. (2001). *Schlieren and Shadowgraph Techniques.* Springer-Verlag ◉

Scientific Visualization

MASAHIRO TAKATSUKA, PH.D.
The University of Sydney

Introduction
Visualization is the process of transforming data into some sort of graphical representation. The data visualized may be real numbers, abstract theoretical quantities or relationships, or may reflect a series, a gradation, or a change in some quantity with respect to others. These datasets are often thought of as image information. The visualization process maps them onto their inherent variables, which determine the shapes and appearances of pictorial figures representing the data. These pictorial figures are then placed on a display screen. The main task of these figures is to convey as much information about the dataset as possible when they are displayed and observed by viewers. Because the eye and brain are intimately involved in this process, visualization requires some understanding of the workings of the human visual system and perception. Visualization techniques have also been widely adopted by the entertainment industry.

There are two different types of visualization depending on the types of data they are concerned with. Information visualization usually deals with abstract data such as socio-demographic, linguistic, and financial. These types of datasets usually do not have physical shapes and appearances associated with them. Scientific visualization, on the other hand, aims to construct images of scientific and engineering data obtained through experiments on, and simulation of, physical subjects or theoretical concepts such as the interiors of stars or the accretion disk of a black hole. Hence, they usually have physical geometry or appearances associated with them.

What is Scientific Visualization?
Scientific visualization was officially recognized in the Report of the National Science Foundation's (NSF) Advisory Panel on Graphics, Image Processing, and Workstations published in 1987. It was introduced as "visualization in scientific computing" and was described as a discipline covering data representation, data processing, user interfaces, and visual representation including multi-modal sensory representation. The necessity of scientific visualization emerged as a result of rapid advances in computing and electrical engineering technologies, especially high-performance computing during the mid-1980s. Since that time, scientists and engineers have been flooded with the increasing amount of data from experimental equipment and computer simulators. They are now required to process these massive and complex datasets to understand the various natural phenomena they have observed and to evaluate validities of theoretical models. To assist the process of understanding complex natural phenomena, a suite of technologies, which compose scientific visualization, needed development.

The basic elements of scientific visualization are listed below.

Data acquisition through experiments and simulations—Data for scientific visualization can be obtained through various numerical analyses such as a finite element method, and experimental and other observational processes such as satellite imaging and medical imaging.

Data processing to transform, extract, and enhance information—If the raw data is thought to be unsuitable for deriving appropriate geometries and visual appearances, the data would require adequate data transformation processes. Such processes would enhance and possibly extract information in different forms.

Computer graphics—Two- and three-dimensional geometrical modeling, rendering, and animation processes are used to convert scientific data to a displayable form.

Observation and interaction—Visualization is an iterative process and a user may generate new data through interactive exploration of visualized data to gain better understanding of the nature of the information.

Visual Representation in Scientific Visualization
Among the four elements described above, visual representation derived through modeling and rendering processes may have the most significant impact on how visualized images are perceived by viewers. In particular, good selection of rendering methods and parameters could produce striking photorealistic images. Various global illumination algorithms are usually used to create such photorealistic renderings.

There are a number of global illumination algorithms regularly used in scientific visualization such as ray tracing, radiosity, and photon mapping. Ray tracing, for instance, is a method of tracing the path (ray) of the light from a light source to a surface of an object. Although it can generate very good realistic results, it is a computationally heavy process. To overcome this problem many algorithms have been developed. A radiosity algorithm computes effects on surfaces caused by photons from light sources. Such effects are used by a recursive ray tracing algorithm to create a more realistic image.

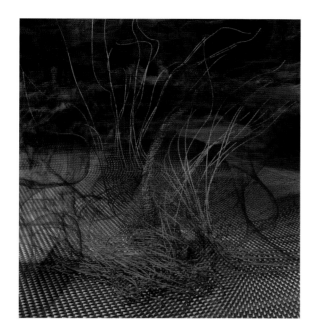

FIG. 100 A 3D image created by NCSA's Experimental Technologies Division from data generated by a tornado simulation calculated on the center's IBM p690 computing cluster. The orange and blue tubes represent rising and falling airflow in and around the tornado. The tornado is shown by spheres that are colored according to pressure. The tilting cones represent wind speed and direction at ground level.

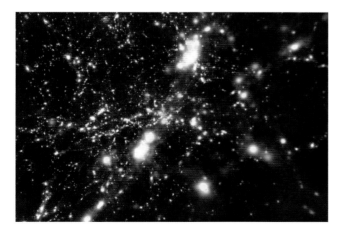

FIG. 101 This image was created by the National Center for Supercomputing Applications' (NCSA) Virtual Director from Paul Bode and Jeremiah Ostriker's large-scale-structure of the universe simulation. Dark matter is colored by velocity-dispersion, which is highest (yellow-white) in condensed knots and filaments. (Both illustrations courtesy of NCSA and the Board of Trustees of the University of Illinois.)

Photon mapping is based on a ray tracing algorithm and simulates the interaction between light and different objects. This algorithm is particularly useful in computing the refraction of light through transparent materials such as water, and the scattering by particulate materials like smoke.

Designers and programmers of scientific visualization systems now have to consider the influence of the human visual system on how such visual appearances are perceived. Along with the parameters of rendering, colors and parameters of animations are also important in effectively conveying information. How such parameters would affect human perception is studied more rigorously in the field of information visualization. This is because it typically deals with abstract data, which are often unassociated with any physical shapes and appearances. Hence, the selection of appropriate geometries and visual features for rendering holds the key to generating good information visualization.

Scientific Visualization for Other Fields

Scientific visualization as a discipline may have started as a way to assist scientists and engineers to improve and strengthen their understanding of their subjects of study. However, many software and hardware technologies developed for scientific visualization are now routinely used in other fields and industries.

Many medical imaging systems, such as ultrasound imaging, X-ray, computed tomography (CT), and magnetic resonance imaging (MRI) are non-invasive and produce various types of images revealing the internal anatomies of samples. These medical imaging systems typically produce cross sections (image slices) of a sample. Although those sliced images contain an enormous amount of useful information, only trained medical practitioners are normally able to recognize it. Scientific visualization, especially volumetric visualization in this case, is actively used to produce a three-dimensional image from a set of sliced images. Such volumetric representation is not only helpful for interpreting and improving understanding of otherwise unobtainable medical images, but it is also useful for training purposes.

Another industry that fully utilizes the technologies developed for scientific visualization is the entertainment industry. Movies and television programs such as *Shrek*, *Matrix*, and *Walking with Dinosaurs* have used 3D geometrical modeling techniques to create imaginary creatures, dinosaurs, worlds, and environments of the past. Although both physical modeling (such as clay and wire frame modeling) and computer modeling consumes a large amount of the film and television production process, models of those objects themselves do not give an impression of reality, especially when animated. The realistic representations seen in those movies and television programs are the result of various rendering techniques. Since the early 1990s many photorealistic rendering systems have been developed. Some of them were developed specifically for the entertainment industry and fully exploit the state-of-the-art ray tracing methods, radiosity methods, and global

illumination models. Pixar's RenderMan is probably the most well-known rendering system among other similar systems (such as YafRay and Mental Ray) because of its high rendering quality. RenderMan is an industry standard and has many features such as shading language, anti-aliasing, and motion blur to produce photorealistic renderers. Such rendering systems are usually used to produce the final output images for 3D modeling systems like Maya, Houdini, and Blender.

Scientific visualization has gone through significant changes and improvements in the last couple of decades, supported by marked advances in computing and graphics hardware technologies. Modern commodity computers and graphics cards are now powerful enough to carry out many sophisticated scientific visualization tasks. Scientific visualization is no longer just for "making the invisible visible." It now allows for the invisible imaginings of both scientist and artist with very realistic appearances due to the recent advances in rendering techniques. Such eye-catching and striking photorealistic images are very effective in appealing to human visual systems and are able to convey information previously hidden in the invisible non-pictorial datasets. Although many modeling and rendering techniques were developed for scientific visualization, they are now used for other fields such as the entertainment industry. Furthermore, many computer graphics techniques developed for non-scientific fields are now used to advance scientific visualization. It is getting much more difficult to define a clear boundary between scientific visualization and artistic computer graphics, though the motivational differences, scientific understanding, and entertainment remain distinct.

FURTHER READING

Banvard, R.A. (2002). The Visible Human Project image data set from inception to completion and beyond. In Proceedings CODATA 2002: Frontiers of Scientific and Technical Data, Track I-D-2: Medical and Health Data, Montréal, Canada.

BBC (2000). *Walking with Dinosaurs*: BBC television series, http://www.bbc.co.uk/dinosaurs.

Card, S. K., Mackinlay, J.D., and Shneiderman, B. (eds.) (1999). *Readings in Information Visualization: Using Vision to Think*. San Francisco: Morgan Kaufmann Publishers.

Jensen, H. W. (2001). *Realistic image synthesis using photon mapping*. AK Peters.

McCormick, B.H., DeFanti, T.A., and Brown, M. D. (1987). "Visualization in Scientific Computing" the 1987 Report of the National Science Foundations' (NSF) Advisory Panel on Graphics, Image Processing, and Workstations.

Ware, C. (2004). *Information Visualization: Perception for Design (2nd edition)*. San Francisco: Morgan Kaufmann.

Watt, A. and Watt, M. (1992). *Advanced Animation and Rendering Techniques*. New York: ACM Press.

Wolff, R. S. and Yaeger, L. (1993). *Visualization of Natural Phenomena*. Santa Clara, California: TELOS, The Electronic Library of Science.

ADDITIONAL INFORMATION

Blender, open source graphics creation software: http://www.blender3d.org/

Integrated 3D modeling, animation & rendering software: http://www.alias.com/

Mental Ray rendering engine for generating photorealistic images: http://www.mentalimages.com/2_1_0_mentalray/index.html

PIXAR, RenderMan: https://renderman.pixar.com/

Side Effects software, Houdini 3D animation tools: http://www.sidefx.com/

YafRay, Platform independent raytracing software: http://www.yafray.org ⊚

Space Photography

PAUL E. LOWMAN, PH.D.
Goddard Space Flight Center, NASA

This term is a broad one that could, in principle, be applied to any photograph taken in "space," or above approximately 100 km (50 miles) altitude and include images acquired on film or electronically. Weather satellites alone generate hundreds of images of the earth from space daily. However, this section will summarize photographs of the earth's surface and those on and near the moon taken by astronauts, and their influence on remote sensing.

The first pictures of the earth from space were acquired shortly after World War II, when rockets launched from White Sands Proving Ground in New Mexico reached altitudes of 160 km (100 miles) or higher. Many of those images were of high photographic quality, and resulted in panoramic views of the southwestern United States that are impressive even today. These photographs helped stimulate interest in the meteorological applications of images from space, leading to the first weather satellite, TIROS 1, in 1960. However, they also interested geologists in the use of space photography to study poorly mapped areas and geologic structures of regional extent such as the San Andreas fault zone. P.M. Merifield suggested that the first American astronauts, of Project Mercury, be asked to take geologically useful photographs during their short missions. On the very last such mission, lasting 34 hours, L. Gordon Cooper obtained many excellent color pictures of southern Asia, Tibet in particular, which was then a poorly mapped area. Cooper's pictures, taken with a 70-mm hand-held camera and on Anscochrome film, led to the inclusion of synoptic terrain photography on almost all of the Gemini missions.

The Gemini flights of 1965 to 1966 were part of the Apollo program, and were used to develop the technology and space operational methods such as rendezvous for the eventual Apollo missions to the moon. They lasted as long as 14 days, and the astronauts returned approximately 1100 color pictures, mostly on Ektachrome, useful for geology,

geography, and oceanography. Published widely when space flight itself was still something of a novelty in magazines such the *National Geographic*, these spectacular pictures generated enormous public and scientific interest. Weather satellite pictures were familiar by the mid-1960s, but the high-resolution, 70-mm color photos were a revelation.

The most general effect of the Gemini terrain photographs was to accelerate progress in remote sensing as a whole. However, a specific result was to trigger a series of events that led to Landsat. One of the "events" was that the U.S. Geological Survey along with other agencies, proposed an electronic earth resources satellite called the Earth Resources Observation Satellite (EROS). An interagency disagreement ensued as NASA felt that satellites were its business alone. However, it was decided that the Goddard Space Flight Center would develop the Earth Resources Technology Satellite (ERTS) for the use of the Interior Department or any other potential customers.

ERTS-1 was launched in July, 1972 carrying two sensors, the RCA Return Beam Vidicon camera, and the Hughes Multispectral Scanner. Both worked well and began returning high-quality color images of the earth's surface. Although initially termed "a solution in search of a problem" by some, Landsat (as ERTS was shortly re-named) soon demonstrated its value. The first such demonstration was the difficulty Goddard scientists had in identifying the area covered by the very first image. It turned out to be Fort Worth and Dallas, hardly a remote area but one in which new reservoir, airport, and highway construction had changed the landscape drastically from that shown on the latest topographic maps. So map revision turned out to be the first "solution" to a "problem."

Landsat-1 was followed by several successors, each more capable than the last. The electronic "photographs" returned, now numbering in the millions, and taken in a wide variety of spectral bands, have become indispensable tools for innumerable applications from planning petroleum exploration to mapping Antarctic penguin rookeries. Furthermore, the early success of Landsat stimulated other nations, first France, to develop their own earth resources satellites. The first of these, Systeme Probatoire pour l'Observation de la Terre (SPOT), was launched in 1982 and produced excellent pictures. Other countries, such as the Soviet Union and India, produced comparable satellites. Space photography has long since been privatized, and high-resolution color photos are now commonplace. Thousands of once-classified military satellite photos, taken by American satellites under the Corona Program, were released in the mid-1990s.

Hand-held space photography like that taken by Gemini astronauts was resumed in the 1980s, when the shuttle started flying. It used a wider range of hand-held film cameras, including both 35-mm and large format systems. This Space Shuttle Earth Observations Program, administered by Johnson Space Center, has produced many stunning pictures of the earth. The best of these were taken by astronaut Jay Apt and published by the National Geographic Society in *Orbit*, where he was also its senior author. A big step forward was taken in preparation of this book, in that the original films were digitized, exploiting

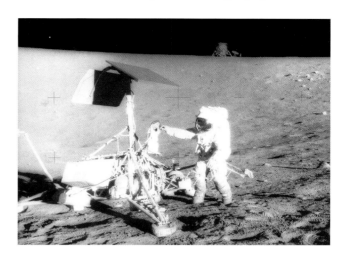

FIG. 102 Apollo 12 astronaut, from lunar module (background) inspects Surveyor 3 spacecraft, landed 31 months earlier, and found to be in almost perfect condition, though non-functioning. (NASA photograph AS12-48-7133.)

their high resolution and color fidelity. A few of the older space photos were also digitized, with comparable results.

The crews of the International Space Station have also been taking pictures, this time as part of EarthKam, a program in which students submit requests for photographs of specific areas. These are taken with a digital camera, permitting them to be transmitted to earth almost as soon as they are taken.

The golden age of space exploration was crowned by the Apollo Program, with 6 manned landings on the moon, as well as 2 non-landing missions (Apollo 8 and 10). The entire moon was photographed by the robotic Lunar Orbiter spacecraft, a reconnaissance program to help pick landing sites for the Apollo landings. These photographs are still among the best pictures ever taken of the moon The Apollo astronauts on all lunar missions took thousands of hand-held photographs from lunar orbit, which although not providing systematic coverage are valuable for their rendition of unusual or complex features.

The astronauts who actually walked on the moon took thousands of pictures with hand-held (actually chest-mounted), 70 mm photographs with modified versions of the Hasselblads used on all missions since the third Mercury mission (MA-8). The best of these pictures were published in a David Light's collection *Full Moon*. Produced by digitizing the original pictures, color and black and white, the surface photographs are a striking tribute to the skill of the astronauts and the ability of the photographic technicians who chose the equipment and specified the techniques.

The lunar surface photographs were perhaps the most difficult ever taken by hand-held film cameras. The illumination, full-spectrum sunlight, is literally "unearthly." The photometric function of the surface is anomalous by terrestrial standards, with strong backscattering in down-sun views. At first glance the lunar surface is a montage of black and white

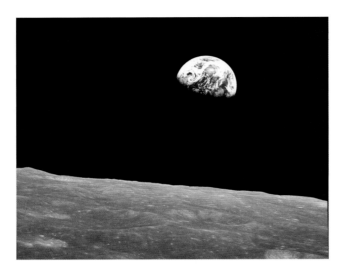

FIG. 103 One of the most famous astronaut images was taken at Christmas, 1968, with a 250-mm telephoto lens attached to a Hasselblad. It shows the distant blue Earth rising above the desolate lunar landscape.

with little inherent color at close range. This is because of the near-total absence of ferric iron oxides that account for the browns and reds of terrestrial rock and soils. However, there is more color than one would think—subtle browns and grays that depend strongly on the viewing direction. The astronauts eyewitness descriptions are valuable in reproducing their photographs accurately, but their eyes had to peer through plastic face-plates, generally with lowered visors. Despite these technical challenges, the Apollo surface photographs were generally perfectly taken and visually stunning, to say nothing of scientifically valuable.

Several years passed between the last American manned mission and the first launches of the space shuttle in 1981. Astronaut photography from the shuttle became an extensive activity, evolving into the permanent and formal Space Shuttle Earth Observations Project. A few flights used a remarkable large format camera (LFC), which was mounted in the shuttle payload bay. This 405-kg camera had a 305 mm, f/6 lens and a 23 × 46 cm format. At a typical altitude of 300 km (186 miles), a frame covers ground dimensions of about 225 × 450 km (140 × 280 miles). Some shuttle flights also included an IMAX large-format movie camera.

Given the variety of equipment and requirements, shuttle crews are obliged to match optimal equipment with the subject and receive extensive training in photography and in subjects such as geology, meteorology, oceanography, and ecology. However, the Hasselblad 70 mm is still the workhorse, usually with Ektachrome 64 film. Astronauts have also used an electronic (digital) still camera successfully on recent flights.

The value of space photography was almost totally unpredicted before space flight actually began, except for meteorology and military purposes. However, images of and by astronauts have changed our view of our planet, its satellite, and their place among the stars. In the last few decades, it has become a shining example of serendipity, one that alone would go far toward justifying the expense of space flight.

See also the following articles
Aerial Photography; Remote Sensing

FURTHER READING
Apt, J., Helfert, M., and Wilkinson, J. (1996). *Astronauts Photograph the Earth.* National Geographic Society: Washington, DC.

Light, M. (2002). *Full Moon.* New York: Alfred A. Knopf.

Lowman, Jr., P. D. (1972). *The Third Planet: Terrestrial Geology in Orbital Photographs.* Zurich: Weltflugbild Reinhold A. Muller, Feldmeilen.

Masursky, H., Colton, G. W., and El-Baz, F. (1978). Apollo Over the Moon: A View From Orbit. NASA special Publication 362, National Aeronautics and Space Administration.

National Geographic Society (1998). *Satellite Atlas of the World.* National Geographic Society: Washington DC.

ADDITIONAL INFORMATION
http://www.gsfc.nasa.gov
http://earthobservatory.nasa.gov

Streak and Strip Photography[1]

PHRED PETERSEN
RMIT University
ANDREW DAVIDHAZY
Rochester Institute of Technology

Streak and strip photography are generic terms for a variety of specialized imaging techniques that capture a continuous record of events over time, along one dimension the resultant photograph. This is accomplished either by exposing a piece of film as it moves past a narrow slit located at the image plane or by repeatedly imaging a linear array of pixels in a digital detector. Both of these situations result in the camera recording only a single line of the subject image at any moment in time. Exposure time for a film camera is governed by the slit width and the speed of film motion. With digital cameras, exposure is controlled by the scan rate assigned to the pixel array. In either method, the final photograph is a chronological compilation of the individual line images continuously recorded by the camera during an event by introducing a time dimension to the image in a direction at right angles to the orientation of slit or pixel array. Streak and strip photographs display time as a visual component in a single "still" image and are effectively a link between normal still photographs and motion picture photography. These

[1]Adapted from the *Focal Encyclopedia of Photography, 3rd edition.*

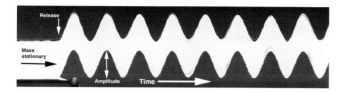

FIG. 104 This is a streak record of the up-and-down movement of a loaded spring as displayed by a streak camera. The vertical dimension represents the position of the spring in a vertical orientation while the horizontal dimension represents time and the duration of one or more periods and thus frequency. (Photograph © Professor Andrew Davidhazy, Rochester Institute of Technology. Rochester, New York.)

images are always intriguing, often informative, and sometimes quite beautiful.

Streak and strip cameras share a common fundamental principle. In their application, the image is continuously focused along the film or when being captured by the detector as a single, long streak. Either the film is exposed continuously by a slit, with the film effectively moving behind the slit during the exposure, or the image is built up rapidly by repeating image capture with a linear photo sensor array, it is the specific application of the camera that sets the different categories apart. It is the specific application of the camera that sets the different categories of photography apart. The differences between streak photography and strip photography are most clearly defined by the direction of subject motion relative to the slit orientation. In streak photography subject images remain relatively stationary over the slit or move parallel to the slit orientation (and thus at right angles to the direction of film motion) during photography. In this situation, images will be reproduced as a continuum of streaks that look nothing like the original subject.

In strip photography recognizable records of subjects are made by making their image move over, or across, the camera's slit parallel with the direction the film is moving. When strip cameras photograph subjects whose images at the camera's slit are stationary, the camera is more properly called a streak camera.

Streak Photography

A streak camera, sometimes called a velocity recording camera, is related to strip or smear cameras, and there is no universally accepted nomenclature for these instruments. At the fundamental level they simply move film past a slit located at the image plane. For recording very rapid events, the image of a slit containing the subject image is moved over stationary film. In the fastest streak cameras, the whole image-recording portion of the camera is electronic in nature, and a camera is simply used to make a photograph of a fluorescent screen or a cathode-ray tube. An electronic image intensifier may be used to amplify the intensity up to 10,000 times before the image is recorded photographically.

Streak cameras record events that occur over a period of time, and thus do not produce images that resemble the subject. The slit built into these cameras limits the field of view to the length of the slit, which defines the spatial dimension of the image in this direction. The spatial dimension at right angles to the slit orientation; however, is effectively eliminated by the narrow slit, the width of which, together with the velocity of the film, governs the temporal resolution. Continuous capture of the many adjacent, dimensional slit images as the film moves past the slit builds the time or temporal dimension of the image along the direction of this motion. The resulting photograph is a continuous record of the image disposition along the slit axis over time. In effect, streak cameras behave as strip-chart recorders, but instead of using mechanical pens to draw on moving paper they record the color and gradation of optical images, with time as the third dimension.

One of the greatest advantages of streak records, when compared to still photographs or motion picture records, is the low cost and the ease with which uninterrupted timing and velocity information can be obtained.

A major characteristic by which streak cameras are classified is their ability to resolve small units of time. This is determined by the relative rate of movement of the film and by the slit width. The simplest streak camera designs transport a roll of film past a fixed slit from a supply spool to a take-up spool. For higher film transport speeds, the film may be attached to the outside of a drum that rotates past the slit.

Such drum-type streak cameras need no synchronization devices to record a single, brief self-luminous event. However, since film length is limited with drums, synchronized shutters are necessary to prevent film overwriting with longer or multiple events. At very high speeds, mechanical limitations of film strength and film transport mechanisms dictate that the film be kept stationary. Instead, an image of the fixed slit containing the subject image is wiped onto the film surface by a rotating mirror system. Again, complex timing, synchronization, and shuttering schemes are usually required to make sure that the event behavior is recorded along a relatively short length of film, and that the film is not rewritten by continued rotation of the mirror.

Ultra high speeds are attained with electronic counterparts of the basic film systems. A photocathode at one end of an electron tube produces electron analogs of the optical image. The electrons are accelerated and focused by rapidly changing electrostatic fields, and swept across a large phosphor screen at the other end of the electron tube to produce a self-luminous streak image. Temporal resolutions of 10^{-14} seconds can be achieved with these instruments.

Streak cameras are often used to study the simultaneity of events in the fields of detonics and ballistics, and they are also particularly suited for applications requiring subject velocity information.

Strip Photography

Strip photography uses the same camera design as streak photography and like streak photography, it depends on a

recording medium that is in motion behind an exposing slit placed at the image plane of the camera or a digital equivalent. However, unlike streak photographs, in which the original subject is unrecognizable, strip photographs produce an image that has some resemblance to the subject.

The essential feature of strip cameras is that the image they record must move across the slit assembly installed in the camera, rather than along it. This is the result of the translational or rotational motion of the subject. Strip photography and strip cameras are typically referred to by their specific applications rather than the generic strip term. Strip photography and cameras can be subdivided into several categories, such as linear-strip, panoramic, and peripheral photography, and within categories systems are often referred to by their particular function, such as synchroballistic and photofinish cameras. The strip method of making photographs is associated with several well-known pictorial, industrial, scientific, and military photographic camera systems.

Photofinish cameras

The most widely recognized application of strip cameras is probably their use at racetracks as photofinish cameras. The camera is placed to view the entire width of the track at the finish, and the slit in the strip camera is carefully aligned with the finish line. The film is moved at the expected velocity of the images of the subjects participating in the race. Because the visual content of the image is comprised solely of objects exactly at the finish line, and the time dimension is recorded along the film as it moves, photofinish cameras provide an almost indisputable record of the order of finish in a race. Only tampering with the alignment of the camera relative to the finish line could result in misleading results. The misalignment would have to be considerable to actually create a photograph that was an incorrect record of time.

In digital photofinish cameras, the slit and moving film mechanism is replaced by a linear charge-coupled device (CCD) photosensor, which is typically 1–3 pixels wide by 1300–1500 pixels long. The sensor is read out at rates between 100 and 10,000 times per second, depending upon the speed of the participants in the race. When the camera is properly aligned, each line image is of the finish line only, so race participants are recorded only as they cross the finish line. All images have individual timing information automatically attached, and are saved to a computer system where the software builds a continuous composite of the line images in chronological order to give an overall image of the finishing order of all race participants. Because each individual line image is indexed with its discrete time from the start of the race, it is a simple matter to determine the time of each individual finisher as well. A digitally introduced line that is parallel with all of the individual images (and therefore the finish line) can be moved along the composite image, the time of each individual image can be displayed. The hairline can be moved within the image, but cannot be tilted or otherwise manipulated, making errors in timing virtually impossible. Digital photofinish cameras have almost completely replaced film cameras in horse racing, greyhound racing, cycling, rowing, track and field, and motor sports.

Panoramic cameras

Strip cameras are also widely used as panoramic cameras. The camera rotates about the rear nodal point of the lens and scans the surrounding scene with the slit built into the camera. At the same time the film is advanced through the camera at the velocity of the image passing by the camera slit. With these cameras it is quite easy to cover angles of view of up to 360 degrees or more. The length of film exposed per 360-degree

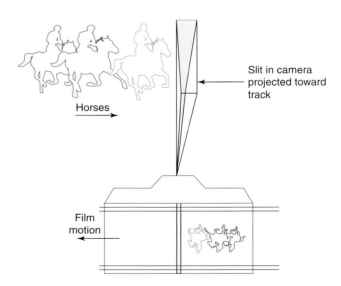

FIG. 106 Photofinish camera. Linear strip photography. Objects move past a stationary camera as moving film is exposed through a slit.

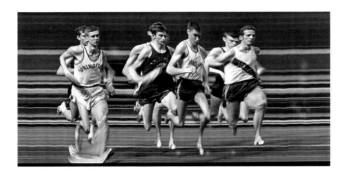

FIG. 105 An example of photofinish strip photography. (Courtesy of Andrew Davidhazy.)

revolution is a function of the lens focal length (*f*), and is given by the formula $2\pi f$.

The earliest panoramic cameras to be commercially manufactured were offshoots of the panoramic cameras patented by William J. Johnston in 1904 and David A. Reavill in 1905. The commercial version of this camera was patented by Frederick Brehm in 1905 and eventually manufactured by various divisions of the Eastman Kodak Company under the name of Cirkut. Modern cameras such as the Globuscope, Hulcherama, Alpa Rotocamera, Spinshot, and Roundshot are spin-offs of the basic strip panoramic camera principles introduced by the Cirkut camera. Two electronic versions of these

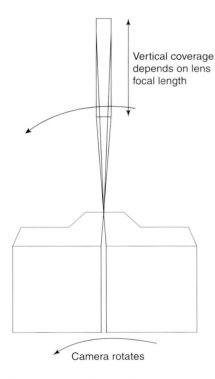

Vertical coverage depends on lens focal length

Camera rotates

FIG. 107 Panoramic strip photography. Camera rotates as moving film is exposed through a slit.

cameras were placed on the surface of Mars by each Viking Lander in 1976 and transmitted stereo views of the Martian landscape back to earth.

Peripheral cameras

Several methods exist for recording rotational motion to make photographs of the outside surfaces of subjects. Strip cameras can make peripheral photographs by rotating a subject in front of the camera with the camera slit aligned to the center of rotation of the subject. The film velocity is matched to the velocity of the subject's image, and a continuous 360-degree view of the surface of a regular cylindrical subject can easily and accurately be reproduced. Most strip cameras can only accurately reproduce subjects of one given diameter at a time. Larger and smaller diameters on the subject are compressed and elongated, respectively, as all subject circumferences on any subject are reproduced on the same length of film. Nevertheless, the advantage of reproducing all subject surface features on one flat sheet of film or paper often makes up for this shortcoming.

Synchroballistic cameras

Synchroballistic cameras, also known as ballistic-synchro and image-synchro cameras, are nothing more than photofinish cameras, but they are used to photograph missiles and cannon rounds once fired. Because the synchroballistic camera moves the film at the expected velocity of a missile's image rather than trying to use a short exposure time to freeze motion, continuous light sources can be used to make blur-free images. Excellent spatial resolution can be obtained and information that could not be visualized by other means can be recorded relatively easily. By placing regular, pre-measured markings on the missile it is possible to determine velocity and, in certain cases, even spin rate and other in-flight missile characteristics.

Aerial strip cameras

Aerial strip cameras, such as the stereoscopic Sonne camera, are flown over terrain while moving the film at the same velocity as the image of the ground moves within the camera. In early cameras, the camera operator made this adjustment manually.

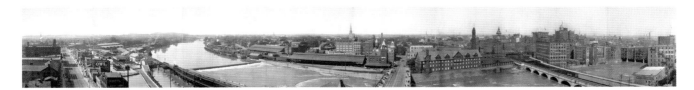

FIG. 108 A early example of strip photography as demonstrated in a panoramic view of Rochester, New York, taken from the Rochester Business Institute and made by Frederick Brehm, William & Rogers. (Image Courtesy of the Library of Congress, Prints and Photographs Division Washington, DC.)

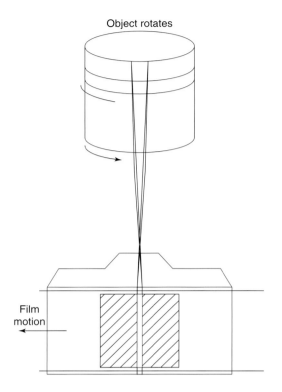

FIG. 109 Peripheral strip photography. Object rotates as moving film is exposed through a slit.

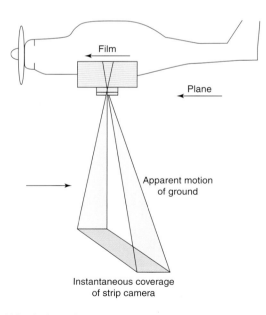

FIG. 110 Aerial strip photography. Camera moves over stationary terrain as moving film is exposed through a slit.

Modern designs rely on electronic sensors linked to forward-looking radar to match the two velocities. Military versions of these cameras are sometimes used for reconnaissance purposes because image velocities are often considerable and normal aerial camera shutter speeds are not fast enough to produce adequately sharp images for interpreters. The strip aerial-reconnaissance camera records may be distorted because of lateral movement of the image while it travels across the slit, and they may even be slightly stretched or compressed, but often they contain more detail than an instantaneous photograph which may have motion blur. A special version of the aerial strip camera has been used to record the condition of long stretches of highway.

Circular strip cameras

A strip camera developed by Professor Andrew Davidhazy from the Rochester Institute of Technology uses film that is moved in a circular fashion while the subject is also rotated. This enables the camera to make distortion-free peripheral photographs of conical objects. Because the slit in this camera lies along the radius of the circularly moving film, it can match the different image velocities associated with the changing surface velocity of the cone from the base to the apex. This camera also can correct for differential image motion that occurs along the slit in panoramic photography when the camera is tilted up or down rather than using the rising/falling front movements possibly available on the camera. The records produced by this camera reproduce a 360-degree peripheral view of a cone or a 360-degree panoramic view of a surrounding scene on a portion of the film taking up less than the complete 360-degree film circle.

See also the following articles

Ballistics Photography; Chronophotography; High-Speed Cinema Photography; High-Speed Still Photography; Streak and Strip Photography; Time-Lapse Photography

FURTHER READING

Ray, S. F. (ed.) (1997). *High Speed Photography and Photonics.* Bellingham, WA: SPIE Press. ◉

Technical Photography

TED KINSMAN
Kinsman Physics Productions

Technical photography is a broad description that embraces a very wide range of techniques, applications, disciplines, and industries. The individual topics are dealt with in more detail under their specific headings. Here we attempt to give a broad overview.

This specialty involves the production of images created with the ultimate goal of being analyzed for their information

content or for measurement purposes. The informational content in the image may relate to all four dimensions, and thus can include any combination of motion, location, position and size, and their changes with time and environment. The wavelength of the recorded radiation is another variable. Of course not all of technical photography deals with all these parameters and many such images simply record an experiment, equipment, situation, or phenomenon. The information contained in the image may be qualitative, quantitative, or educational in nature. In many instances the role of technical photography is to solve or document industrial or manufacturing problems. Given this variety, the technical photographer must know why an image is needed, who will be using it, and for what purposes. The resulting images are not usually intended to have aesthetic value, but it is not excluded.

Some photographic techniques that fall into this area are infrared, high-speed flash, ultraviolet, streak, schlieren, medical, forensics, thermal, and radiography (X-ray). In many instances several of these techniques can be combined to solve unique or challenging imaging problems. For example, high-speed flash radiography is used to study the interaction

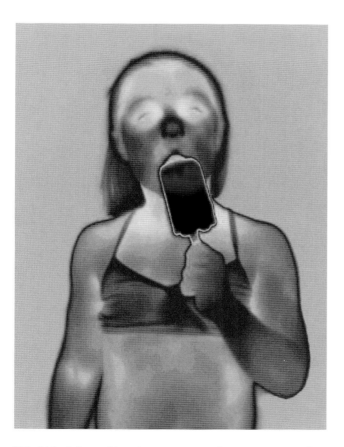

FIG. 111 A thermal imaging camera revealing temperature differences of a young girl eating an ice cream bar. (Photo courtesy of Ted Kinsman.)

of gun powder, shell casing, and bullet within a firearm at the moment when the gun powder ignites.

High-speed flash work is characterized as requiring a short duration of electronic flash or pulsed light source with a time of 1/10,000 of a second or less. In the case of the pulsed-light system, the role of the camera shutter to control the light for the camera is changed and the duration of the light pulse becomes the shutter. The role and versatility of high-speed flash imaging continues to progress in parallel with laser technology. This form of technical photography is quite common in industry as it is used to diagnose and research events such as machine actions or processes that happen at rates faster than the eye can resolve. Recently, this technique has been combined with robotic vision systems to prevent blur in digital images and allow optical recognition techniques to identify flaws in products. An example of such an application would be for identification of empty bottles on a bottle filling system used in the soft drink industry.

Infrared photography once involved bulky electronic cameras and specialized film. With the use of contemporary infrared imaging systems and far-infrared transparent materials in optical components, it has expanded to image heat radiation at a wavelength of 13 μm and beyond, a wavelength ten times longer then film could detect. This is the so-called thermal infrared, and commercial imaging systems of this type are known as microbolometers. The microbolometer uses solid-state pixelated detectors like a charge-coupled device (CCD), but is able to detect heat radiation. This form of imaging is used in many industrial applications to detect overheating in electronics and heat loss in homes, and has recently been used in medicine to observe abnormal blood flows. Infrared imaging has long been used in security applications as it can yield an image without the use of visible light. Recent applications of this imaging technology are found in the evaluation of airplane passengers with elevated body temperatures indicating possibly contagious infections (e.g., SARS), or the imaging of cattle before processing to quickly gauge body mass not visible behind the tangle of the animal's coat.

Streak photography is a technique where the sensor or film travels along with an image of the object that is to be recorded. This technique dates back to the turn of the 20th century and is often described as "photofinish" photography and has long been used, particularly in horse racing. Modern use of this imaging technique is sometimes combined with ultrasound technologies where a baby's heart can be imaged *in utero* as a sine wave. The frequency of the sine wave related to the beating of the heart shares its structural information not observable in any other way.

Schlieren photography is a technique that uses a special optical system to measure changes in the refractive index of a transparent medium that is contained within or surrounds the subject in question. This technique is commonly used to observe and measure the differences in air density when evaluating aerodynamic models in wind tunnels.

Forensic photography is a specialized form of photography where evidence, or other relevant subjects that are important

to a crime, including the locations of objects, are photographed in a standardized approach. The resulting images can then be analyzed as appropriate for future presentation in a court of law. All forensic images collected must contain all relevant information including dimensional scales. In forensic photography, image processing can result in photographic information being compromised, and the integrity of the picture being challenged, so the preservation of the chain of evidence is important.

Radiography or X-ray imaging is commonly used in medicine, industry, and security work. Although the medical use of X-ray imaging is well documented, the industrial use of X-rays and radioactive sources to detect and certify metal welding is its largest use. Recent advances in computer imaging make applications like CT scans a common diagnostic medical procedure to evaluate soft tissue where traditional X ray imaging is challenged to differentiate structure. Other advances in digital X-ray detectors such as backscattered X-ray systems allow security inspectors to look for concealed weapons under clothing and inside luggage and complete vehicles.

As in all of technical photography, the role of X-ray imaging continues to grow as detectors gain sensitivity, decrease in cost, and use advanced imaging and image analysis techniques. ◎

Time-Lapse Photography

DAVID MALIN
Anglo-Australian Observatory, RMIT University

Time-lapse photography is the use of photography to compress elapsed time in a still or moving image. In motion media, the playback time will be shorter than the recording time. Time-lapse photography allows processes or phenomena that take place over a period of time to be evaluated at a more convenient pace or in a manner where the subtle changes that occur during the event are more easily observed.

For moving images, digital cameras and webcams can be used to acquire a series of still frames over an extended time that can readily be made into video footage, and time-lapse VCR recorders (often used with low-resolution surveillance cameras) are also available. More sophisticated video time-lapse systems combine programmable pan, tilt, zoom, and similar actions. Facilities with high-quality film and video cameras add a studio-like dimension to time-lapse footage. Such systems can be programmed to work unattended for extended periods.

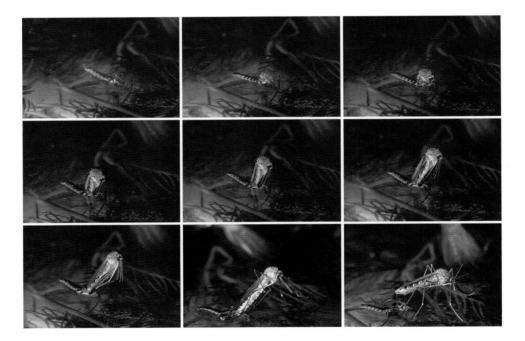

FIG. 112 Mosquito emerging adult. In its pupal stage mosquitoes have a comma-shaped form which, unless disturbed, floats at the surface of the water while breathing through two small tubes called trumpets. When it is time for the adult to emerge from the pupal case, the insect straightens its abdomen—a cue to prepare to start photographing. The insect then uses pressure from trapped air beneath the pupal skin to split the case and emerge as an adult mosquito. In the first frame of this series the fissure can be seen on top of the pupal case. The transformation occurred in a petri dish that held mosquito larvae, water, and aquatic plants. (Photograph courtesy of Joe Ogrodnick.)

Essentially, any slow-moving action can be captured and converted into a dynamic time-lapse sequence, ranging in subjects from a comet moving through the solar system or the division of bacteria under the microscope. In these two examples there is the requirement of additional specialized equipment. The more typical applications of time-lapse photography include plant and crystal growth, living cell division, sports photography, weather patterns, sun and moonrise sequences, traffic flow, and building construction.

Still images can also record action over time, either by the use of a long exposure on the same frame of film (as in a star trail) or by combining many separate frames into a single image (as in an analemma or chronophotography). Central to time-lapse imaging for scientific use is planning and a knowledge of the event duration in real time. This governs the number of images or frame rate required to record the sequence.

See also the following article
Chronophotography

ADDITIONAL INFORMATION
Analemma: Denis di Cicco: http://sundials.org/links/local/pages/dicicco.htm
Kinsman Physics Productions: http://www.sciencephotography.com/how2do2.shtml
Plant growth: Roger P. Hangarter: http://sunflower.bio.indiana.edu/%7erhangart/plantmotion/starthere.html
Star trails: David Malin: http://www.aao.gov.au/images/general/about_trails.html

Underwater Photography

ERIC H. CHENG
Underwater Photographer

Introduction
Underwater photography covers the range of all still and motion picture imaging below the surface of the water, from single-use, waterproof, and disposable cameras to unmanned submersibles at the bottom of the ocean. However, the term usually refers to underwater photographs taken by scuba divers in rivers, lakes, caves, and beneath the surface of the ocean.

Historical Background
German inventor William Bauer tried to take pictures through the portholes of a submarine he built for the Russian navy as early as the Crimean War (1853–1856). Most sources, however, credit English photographer William Thompson with taking the first underwater photograph. In 1856, he used a camera in a watertight box to take photographs of seaweed and sand in the waters near Weymouth, England. Other early attempts were made by Ernest Bazin (1860s), who tried to

make photographs from within a diving bell, and Eadweard Muybridge (1870s), who used a camera inside a watertight container in San Francisco Bay.

Frenchman Louis Boutan is widely considered to be the father of underwater photography. In 1893, Bouton and a mechanic named Joseph David snapped the first, clear, underwater photographs in the bay near the coastal town, Banyuls sur Mer. To light their subjects, they used a magnesium flashgun developed by Chauffour.

In the early 1900s, Jack Williamson, an American journalist, photographer, and writer, invented a device that made underwater cinematography practical. Camera and crew worked inside a sphere connected by a long tube to a surface support-vessel. The first commercial motion picture adaptation of Jules Verne's *20,000 Leagues Under the Sea*, among other movies, benefited from use of the device; it soon led to improved housings for motion picture equipment.

In 1927, *National Geographic* published the first underwater color still photographs; they were reproduced from Autochrome plates by Dr. William Longly, an ichthyologist, and Charles Martin, a staff photographer. The development of the Cousteau-Gagnan aqualung generator in 1943 freed divers from heavy, cumbersome diving equipment and inspired them to design and build their own complementary photographic equipment.

In 1943, Jacques Yves Cousteau and Emile Gagnan developed the first, self-contained, compressed-air underwater breathing system, which used a demand valve to deliver pressurized air upon intake of breath. The Aqualung revolutionized diving, and gave photographers tremendous freedom to experiment with underwater photographic equipment.

Professor Harold E. Edgerton of the Massachusetts Institute of Technology worked with Cousteau. Edgerton's technical innovations include photographic units capable of withstanding tremendous water pressure, cameras capable of taking 2000 35 mm pictures at signaled time intervals, underwater electronic flash, and even a sonar (radar-like) device capable of positioning a camera accurately within a few feet of a sea floor 15,000 feet or more below the surface.

In 1957, also with Cousteau's guidance, a Belgian inventor named Jean de Wouters developed the CalypsoPhot 35 mm underwater rangefinder camera. This eventually led to the development and commercialization of Nikon's Nikonos series cameras, which dominated the underwater photography market until digital cameras became commonplace.

Meanwhile, in the motion picture world, Al Giddings and Leroy French were taking underwater cinematography to a new level by designing home made housings out of a dive shop in San Francisco. In the 1970s, Giddings experimented with the use of dome ports, which were probably pioneered by Hans Hass. These were optimized for underwater and wide-angle optics and are now used universally by underwater photographers. Other pioneers in deep water, underwater exploration and photography are Emory Kristof and Chris Nicholson, who used remotely operated vehicles (ROVs) to produce images and video documentaries of deep shipwrecks

and the bizarre life found around deep sea thermal vents. Engineers and researchers are now experimenting extensively with autonomous unmanned vehicles (AUVs), which are capable of self-navigation and multiple waypoint missions without remote pilot control.

Each advance in consumer-oriented movie cameras, ranging from the 8-mm film cameras of the 1960s to more recent, high-definition video, have been accompanied by advances from manufacturers of underwater housings. Almost any respectable camera can now be used underwater. Camcorders are housed for underwater use in resin, Plexiglas, and aluminum housings from companies such as Gates, Sea & Sea, Ikelite, Light & Motion, and Amphibico in the United States and Canada. At the high end, underwater videographers and cinematographers use broadcast-quality Sony HD camcorders and housed IMAX and IMAX 3D cameras.

The late 1990s signaled a new era of photography with the release of compact digital still cameras. The digital age broke the 36-frame barrier for underwater still photographers, who no longer had to surface after shooting a single roll of film. The release and widespread adoption of 6 megapixel digital cameras in 2002 was the turning point in the transition from film to digital in underwater imaging. New digital cameras are quickly adapted for underwater use almost as soon as they appear, and only the dedicated few prefer film.

Challenges and Opportunities

While underwater photography opens new horizons, it also poses a number of serious challenges. Photographers venturing underwater enter a new and hazardous environment. Underwater photographers must be expert scuba divers and may have to deal with life-support failures, cold temperatures, strong currents, aggressive wildlife, and bad visibility, not to mention water's light-stripping qualities. Although visibility can approach 330 m (1000 feet) in Antarctica, in more common destinations it is usually between 3 and 40 m.

The most obvious challenge is keeping the camera dry, and this is usually done by enclosing it in a waterproof housing with a clear window and external access to its controls. However, because water has a much greater refractive index than air, a flat port reduces the lens angle coverage by a factor of about 0.3, so a 28 mm lens becomes a 35 mm lens and a 50 mm lens becomes a 65-mm and so on. It also reduces focal range of a lens because the nearby distance is distorted by 33 percent, so a lens cannot focus as close as it would in air. A flat port also suffers chromatic aberration (color fringing) at the edges of the image as well as geometric distortion, limiting angular coverage. For all these reasons, dome ports are preferred for wide-angle photography.

Most wide-angle underwater photography uses hemispherical dome ports, which allow light to pass through to the camera lens perpendicular to the first optical surface, thus reducing chromatic aberration and distortion. The camera lens should be positioned so that the lens node (in practice, the diaphragm) is at the center of curvature of the dome, but this can be difficult to achieve in practice.

The curvature of the dome port introduces a lens of negative power in front of the camera, which makes objects appear further away. To compensate, it requires an equally strong positive lens (a close-up lens or diopter) on or in the camera lens. The strength of this lens is determined by the curvature of the dome and is often around 3 diopters; without it, many lenses would not be able to focus at all. Because some lenses can achieve focus underwater when used behind a dome port, corrective positive diopters are only used when necessary.

Some housed cameras do not allow for the use of a dome port; instead, they offer wet-mate wide-angle adapters, which are designed for placement in front of the camera's lens, with water between the optical elements. Wet-mate accessory lenses are versatile because they can be attached and removed even when underwater.

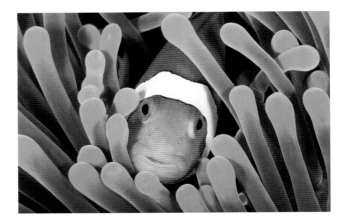

FIG. 113 A false clown anemonefish (*Amphiprion ocellaris*) takes refuge in her host sea anemone (SE Sulawesi, Indonesia). (Photograph by Eric H. Cheng.)

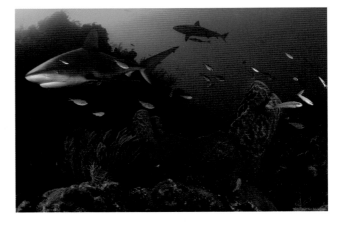

FIG. 114 Caribbean reef sharks (*Carcharhinus perezii*) in their home territory, a healthy reef filled with gorgonians and colorful tube sponges (Bahamas). (Photograph by Eric H. Cheng.)

Because macro lenses have long focal lengths of 50–200 mm, close-up photographers are able to use flat ports without significant image degradation. Long focal-length macro lenses are common because so many underwater subjects are quite small, and they are often used in conjunction with diopters or teleconverters. Nikonos underwater lenses are corrected for the water interface effect, even for those using a flat port.

Water both absorbs and scatters light. Most of the scattering is variable depending on conditions, but the absorption is intrinsic and acts as a blue-green filter, first removing red light and then the remaining colors of the rainbow. Anyone who has taken a waterproof, disposable camera underwater knows that photographs taken without artificial lighting are predominantly green or blue. Nearly all underwater photography is accomplished with artificial, full-spectrum, continuous lighting (for video) or strobe lighting (for still images), which reveals the true colors of underwater objects. Because water also filters strobe light, colorful subjects in underwater photographs are usually photographed within 2 m of the light source. Photographers also place strobes and lights on long arms that extend out as far as a meter from the camera because angled lighting minimizes backscatter, unsightly illuminated particles in the water column between camera and subject.

The most common films used underwater are Kodak and Fuji slide films in the ISO 50–100 range. Especially common is Fuji's Velvia 50 film, which is popular for its vivid color and pleasing, deep blues. Digital photographers have the luxury of approximating different types of film during post-processing, but most shoot at a low ISO in order to minimize image noise.

Sometimes photographers choose to shoot without artificial lighting, allowing only ambient light for an exposure. The reasons for doing so are varied, but most of the time it is done to reduce drag while swimming or for specific, aesthetic reasons. Ambient-light photography often benefits from the use of color-compensating filters, which are sometimes designed specifically for underwater use. Digital and video cameras can, to some extent, use their electronic white balance settings to compensate for underwater color shifts.

These challenges also provide plenty of opportunities for creativity. Wide-angle scenes are exposed naturally, allowing ambient light to create dramatic backdrops for foreground subjects that are lit by full-spectrum strobe lighting. Macro subjects are usually exposed to maximize depth of field, often with aperture values of f/22 and smaller; the usual creative use of depth of field is difficult underwater. Cool, ambient light in a fluid, dynamic environment with strange distortions — and even stranger creatures — is unique, quite unlike any above-water studio.

In modern times, notable underwater photographers and videographers such as Howard Hall, Chris Newbert, and David Doubilet have produced a body of work that has inspired countless people into taking cameras into the watery world of lakes, caves, and oceans. Photographic imaging is also important in marine science, underwater archeology, and remote exploration of the vast expanses of ocean that are too deep for divers. However, to start taking underwater photographs, all one needs is a snorkel and an underwater camera with or without a strobe. For the more adventurous, a SCUBA diving certification allows the diver to go deeper for longer.

It has never been easier to take a camera underwater, but the challenges and opportunities remain. Advancements as wet and dry suits, portable air compressors, waterproof strobe lights, self-contained underwater cameras, mixed gas diving, deep submersibles, and habitats for extended water stays have made underwater photography easier, safer, and more effective. Remote-controlled devices take equipment to the depths required for ocean mapping, mineral exploration, and biological research.

See also the following articles
Biological Photography; Cave Photography; Photomacrography and Close-Up Photography

FURTHER READING
The Focal Encyclopedia of Photography, 3rd edition. Burlington, MA: Focal Press.

Hall, H. and Skerry, B. (2002). *Successful Underwater Photography*. New York: Watson-Guptill Publications.

Newbert, C. (1994). *Within a Rainbowed Sea*. Oregon: Beyond Words Publishing, Inc.

Wu, N. (2003). *Diving the World*. Hong Kong: Hugh Lauter Levin Associates, Inc.

ADDITIONAL INFORMATION
Backscatter Underwater Video and Photo (Web site selling equipment): http://www.backscatter.com/

Eric Cheng, travel photography and journals: http://echeng.com/travel/

Digicam history site: http://www.digicamhistory.com

Digideep.com—The online directory for digital underwater imaging equipment. http://www.digideep.com

Digital imaging for divers: http://www.wetpixel.com

Digital Underwater Photography and Videography (News, Reviews, and Forums): http://www.wetpixel.com

Edgerton Explorit Center: http://www.edgerton.org

Essential course in advanced underwater photography: http://www.seafriends.org.nz/phgraph/

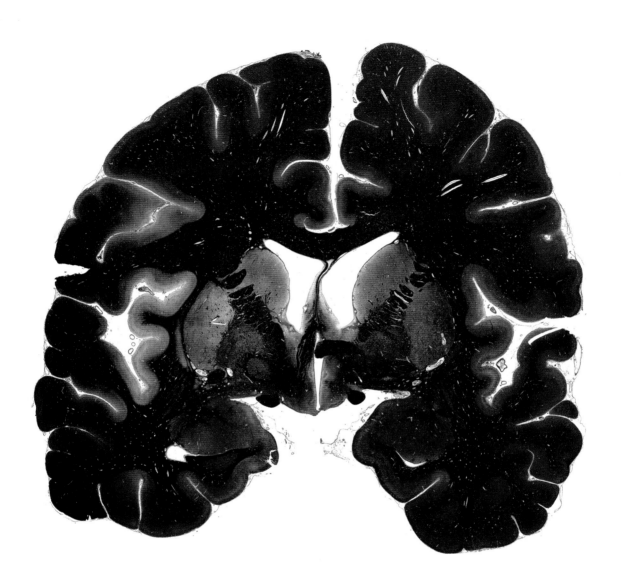

HUMAN VISION

KRYSTEL R. HUXLIN, PH.D.
University of Rochester Eye Institute

The Human Visual System

KRYSTEL R. HUXLIN, PH.D.
University of Rochester Eye Institute

The human visual system has often been compared to a photographic camera, an analogy that fails quickly upon serious examination. Indeed, visual perception, with its colored, emotionally charged and contextually modulated, three-dimensional view of the world differs markedly from the rapid flow of two-dimensional information captured by the eye, or for that matter, a photographic camera. This sensory system allows humans to form the cognitive, emotional, and creative insight that drives them to take photographs in the first place. It also provides a biological means to make sense of the results. How is this possible? What makes the human visual system so different from a machine? This question will be explored by first delving into visual system structure and organization, before examining some of the more important aspects of visual processing.

Basic Structure of the Human Visual System

Input to the visual system occurs through the eyes. The eyes are sensory organs, and their primary role is to detect light energy, code it into fundamental "bits" of visual information, and transmit it to the rest of the brain for analysis. In the higher levels of the brain, the information bits are eventually recombined to form mental images and our conscious visual perception of the world. The visual system is perhaps the most complex of all sensory systems in humans. This is evidenced by the multiplicity of brain areas devoted to vision, as well as the complexity of cellular organization and function in each of these areas.

The human eye is a globe cushioned into place within a bony orbit by extraocular muscles, glands, and fat. The extraocular muscles move the eyes in synchrony to allow optimal capture of interesting visual information. Eye movements can be either involuntary, reflex reactions (e.g., nystagmus, convergence during accommodation), or voluntary actions. Light rays enter the eye through a circular, clear, curved cornea, which converges them into the anterior chamber of the eye (Figure 1). The number of light rays allowed to pass through the rest of the eye is controlled by the iris — a contractile, pigmented structure that changes in size as a function of light intensity, distance to the object of interest, and even pain or emotional status. The iris controls not only the amount of light entering the posterior chamber of the eye, but also the focal length of this light beam, and thus the overall quality of the image achievable. After the iris, light passes through the lens, a small, onion-like structure whose different layers vary in refractive index which provides final focusing power to precisely position the visual information on the retina. The retina is the most photosensitive component of the human central nervous system and covers most of the

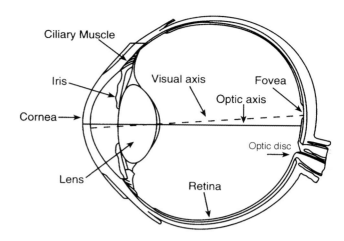

FIG. 1 Schematic of a light path from a single point of fixation to the retina.

inner, back surface of the eye. Its highly regular neuronal structure is normally organized into seven cellular and fiber layers (Figure 2), with the light having to pass through all these layers, plus several vascular plexuses, to reach the photoreceptors. Photoreceptors are neurons, which fall into two classes — rods and cones. Although both rods and cones respond to a range of wavelengths of light, the perception of color, as well as vision at high (photopic) light levels, depends primarily upon the cones. Rods distinguish between colors only on the basis of lightness, but their specialty is detecting tiny amounts of light (even a single photon at a time) under low (scotopic) light levels.

The retinal architecture is disrupted at two locations: the optic disc and the fovea (Figure 1). The optic disc, which creates each eye's "blind spot," is a region devoid of neurons, in which the axons of retinal ganglion cells exit the eye and enter the optic nerve. These axons are the only means by which visual information is transmitted from the eye to the rest of the brain. Their loss or dysfunction in diseases such as glaucoma or optic neuritis causes blindness. The fovea is a retinal specialization dedicated to achieving high-resolution vision along the visual axis of the eye. In this small region, the many neural and vascular layers of the retina are displaced sideways to allow light rays to reach photoreceptors directly. Unlike photoreceptors in imaging systems, the photosensitive elements of the eye are not distributed randomly. The fovea contains the highest concentration of photoreceptors in the retina (about 200,000 cones/mm^2). Its view of the world is relatively unimpeded by distortions due to overlying neural tissue and blood supply. The concentration of cones decreases rapidly away from the fovea, to a density of 5000/mm^2, at the outer edges of the retina. On the other hand, there are no rods in the fovea, but their concentration increases rapidly

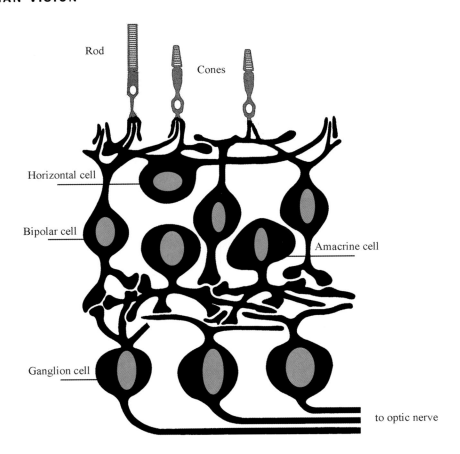

FIG. 2 Cellular organization of the retina.

to a maximum about 20 degrees off the visual axis and then decreases gradually toward the outer edges of the retina.

While the capture and initial processing of visual information occurs in the eye, it is generally accepted that our conscious sense of visual perception occurs because of processing in the brain, and in particular, in the many cortical areas devoted to vision (Figure 3). On its way to the cerebral cortex, visual information that leaves the eye is first partitioned among different subcortical nuclei. These nuclei determine the ultimate use of the visual information. The great majority of visual information is sent to the lateral geniculate nucleus (LGN) of the thalamus. After some limited processing and sorting, LGN neurons transmit this information to the primary visual cortex (V1), located in the occipital lobes of the brain in most mammalian species (Figure 3). This information flow is the primary route that gives rise to conscious visual perception. The rest of the visual information originating from the eye is sent to three clusters of subcortical nuclei for processing. One cluster, the pulvinar/lateral posterior nucleus/superior colliculus group, is thought to play a role in visuomotor processing, visual attention, and other integrative functions in conjunction with the visual

cortex. A second cluster (comprised of the intergeniculate leaflet, ventrolateral geniculate nucleus, and olivary pretectal nucleus) mediates responsiveness to light, especially the reflex regulation of pupil size. Finally, the suprachiasmatic nucleus and associated structures control circadian pacemaker functions for the entire body. Visual input to the suprachiasmatic nucleus provides signals for photic entrainment of the organism.

The proportion of the cerebral cortex devoted to visual processing in primates is significantly greater than that devoted to any other sensory or motor modality. Most of the visual information generated by the eyes and processed by intermediate, subcortical centers reaches the primary or occipital visual cortex first. It is then distributed to at least ten other visual cortical areas in the human brain (V2, V4, MT, inferior temporal contex; Figure 3). Each visual cortical area contains a separate map of visual space. In addition, neurons in different visual cortical areas exhibit different electrophysiological responses to visual stimulation, suggesting that individual cortical areas carry out different forms of visual processing (Figure 3). Consistent with this notion is the observation that damage to different visual cortical areas affects different aspects of vision.

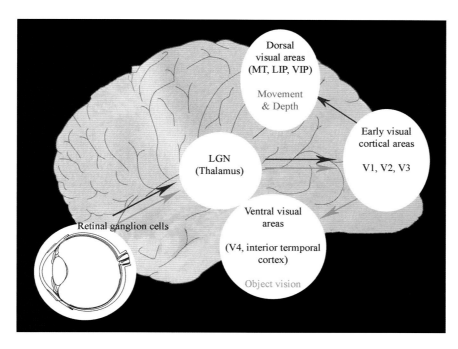

FIG. 3 Anatomical and functional organization of the central visual system of a human.

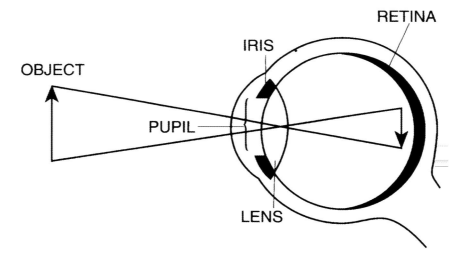

FIG. 4 Similarities in the optical systems of cameras and the human eye.

Function of the Human Visual System
Ocular Optics

One striking similarity between the optical system of the eye and that in a camera is that they both form inverted images on the retina or image capture location (Figure 4). Furthermore, retinal diameter is about the same as the 24-mm dimension of the image area on 35mm film. However, the effective focal length of the typical eye is about 17mm, which results in a larger depth of field for the eye than in most common camera systems. This short focal length combined with a curved rather than flat retina, produces an angle of view of approximately 180 degrees in humans, compared to a normal angle of view

of about 50 degrees for the camera. The iris muscle, which controls the diameter of the circular pupil, makes it possible to change the size of its opening from about 2 to 8 mm. These diameters correspond to f-numbers of f/8 and f/2, respectively. In addition to controlling the amount of light that enters the eye, pupil size alters image definition and depth of field. For people with normal vision, the best compromise for image definition between reducing optical aberrations with a small opening and minimizing diffraction with a large opening is obtained with a pupil diameter of about 4 mm, or an f-number of f/4, which is midway between the maximum opening of f/2 and the minimum opening of f/8. Since depth of field is directly proportional to f-number, the depth of field is increased by a factor of four from f/2, the largest opening in dim light, to f/8, the smallest opening in bright light. Basic lens formulae can be used to calculate the scale of the reproduction image, object distances, and focal length for the eye. However, since the refractive index of the air in front of the eye and the liquid in the eye are different, the principal points and the nodal points will not coincide, as they do with air on both sides of a camera lens.

Another difference between the eye and photographic cameras is that while cameras have uniform resolution across the image captured, there is a non-uniform density of photoreceptors and other neuronal elements across the width of the retina. This means that visual perception, including resolution, differs between the visual axis and the retinal periphery. Indeed, while we can detect movement and gross shapes and distinguish between light and dark in the peripheral retina, the finest detail can be resolved only over a narrow area close to the fovea. In this area, visual acuity, measured as the ability to resolve detail in a test target, is greatest, reaching as much as 60 cycles (1 cycle = the critical distance between two barely distinguishable parts of the test target) per degree of visual angle.

In addition to the neuronally related loss of visual information, human vision is further degraded by non-neural elements. Even in healthy individuals, light that enters the optical system of the eye is deviated from its optimal, image-forming path because of corneal or lens defects, reflection, and scattering. Light that is reflected and scattered within the optical system will reach the retina as veiling light, with a non-linear reduction of image contrast. Physiological differences in the eyes of various individuals cause corresponding differences in optical quality and thus acuity. Some of the most common optical causes of decreased acuity in humans are problems at the level of the cornea, resulting in defocus (myopia and hyperopia) and astigmatism. In myopia, or nearsightedness, rays of light come to a focus in front of the retina. With hyperopia, or farsightedness, the rays of light focus behind the retina. Astigmatism causes off-axis object points to be imaged as mutually perpendicular lines rather than as points, thus reducing visual acuity. Several of these conditions are also aberrations found in camera lenses.

The intraocular lens is another major source of optical distortions (Figure 4). The relaxed lens of a person with normal vision has reasonably flat surfaces, which focus rays of light from distant objects onto the retina. Accommodation, which makes the lens more convex, enables the person to focus on objects at closer distances. The closest distance that can be focused on is called the near point. The near point for a young child may be as close as 3 inches, but the near point increases with age and may eventually reach 30 inches or more. Because the distance at which the relaxed eye focuses also tends to increase with age, it is not uncommon for nearsighted individuals to find their acuity improving with age for large distances but deteriorating for small distances. Normal aging can affect the optical system of the eye in many ways. Changes in tension of the ciliary muscles, attached to the zonule fibers at the edge of the lens, control the thickness of the lens and therefore the focal length. These changes in focal length are not large enough to produce an obvious change in image size, as would occur with a zoom camera lens, but they are sufficient to permit the eye to fine-focus on objects at different distances. As a person ages, the lens becomes less flexible. This makes focusing on near objects more difficult, something that eventually requires external correction, such as reading glasses. In addition to losing flexibility, the lens becomes yellowish with age, which affects the appearance of some colors, especially the complementary color blue. The lens can also become cloudy with age, a defect identified as a cataract, which increases the scattering of light in the eye. This is primarily corrected via surgical removal and possible replacement with an artificial, intraocular lens.

Advances in wavefront sensing technology, which was adapted to ocular imaging from astronomy, have allowed us to precisely measure the optical aberrations imposed by our imperfect ocular materials. As demonstrated by David Williams, Austin Roorda, and their colleagues, it is now possible to combine wavefront sensing with adaptive optics, and correct these optical aberrations to the point where single cells, including photoreceptors, can be imaged in the living, human eye. Ongoing research could one day allow us to design spectacles, contact lenses, intraocular lenses, and even refractive surgical procedures that correct not only basic distortions of the eye such as defocus and astigmatism, but also finer scaled, higher order monochromatic and chromatic aberrations.

Detection of light

Light is detected through a chemical reaction that occurs in retinal photoreceptors at the very back of the eye. In humans, just as in all primates, there are two major types of photoreceptors — rods and cones. When photons enter photoreceptor cells, they are absorbed by specialized pigment molecules, altering their conformations and rendering them unstable, to the point where they break down into their components opsin and retinal (the latter being a derivative of vitamin A). The light-induced conformational change of pigment molecules starts an intracellular chain reaction that ends up generating an electrical signal in the photoreceptor. This signal is transmitted through a chemical synapse from the photoreceptor to a bipolar neuron, which in turn, transmits it, also through a chemical synapse, to a retinal ganglion cell (Figure 2). The ganglion cell sends its electrical signal away from the eye to the brain. Once it reaches the visual cortex, this signal is then

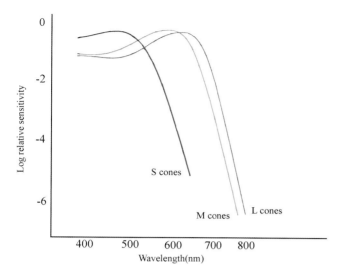

FIG. 5 Relative spectral sensitivities of the rods and the three classes of cones in a normal human retina.

consciously perceived. Within the retina, the transfer of electrical information initiated by the absorption of light quanta in photoreceptors is modulated by many lateral interactions (both excitatory and inhibitory, via horizontal cells and amacrine cells [see Figure 2]) designed to amplify and better isolate the light signal from surrounding noise.

Under low light-level or scotopic conditions, rods are the main contributors to vision; under high light-level or photopic conditions, cones become the main contributors to vision, and the overlap region where rods and cones contribute fairly evenly to vision is termed mesopic. Rods are specialized for the detection of dim light because of a more photosensitive visual pigment (rhodopsin) and greater amplification of the light signal than in cones. The ability of the rod system to capture sparse photons is further enhanced by the fact that many rods converge onto single retinal bipolar cells. However, while rods are about 20 times more numerous than cones, this convergence of their output signals sacrifices their resolution. Nevertheless, rods do serve the useful function of detecting motion and lightness differences in the visual periphery, thereby signaling viewers to quickly shift their gaze in the appropriate direction for a more critical examination with their central (foveal) cones.

The human retina contains three types of cones, each containing a different cone opsin pigment that is sensitive to light in different parts of the visible spectrum (Figure 5). Broadly, defined, human cone opsins fall into three major categories — S cone opsin is most sensitive to short wavelengths of the visible spectrum (peak sensitivity at 420 nm), M cone opsin is most sensitive to middle wavelengths (peak sensitivity at 530 nm), and L cone opsin is most sensitive to long wavelengths (peak sensitivity at 560 nm). The major role of the cone system in humans is high-resolution, color vision.

Perception of color

Color greatly enriches our interpretation of the visual world, providing definition and complexity. The earliest investigators of the phenomenon of color vision did not think it possible that the visual system could contain a separate mechanism for each of the large number of colors we can distinguish (it is estimated that humans can discriminate two million different colors). One of the original color vision theories, the Young-Helmholtz theory, correctly suggested that there were only three different ocular sensors that responded to red, green, and blue light. While an interesting similarity between the eye and color photographic films is that they both analyze colors by responding to their red, green, and blue components, this similarity breaks down when these components are combined to create the colored percept. Indeed, even at the retinal level, information from the three-color channels (three cone types) is combined into an opponent organization. Without knowing its anatomical substrates, Ewald Hering, in the late nineteenth century, proposed an opponent theory of color vision, with three distinct opponent mechanisms: a red-green system excited by red and inhibited by green or vice versa; a blue-yellow system; and a light-dark or achromatic system. Anatomical and electrophysiological substrates for these three channels were only subsequently discovered. Fundamentally, signals from the three types of cones are combined through the retinal circuitry, so that by the time the information reaches ganglion cells, opponent inputs are clearly evident with one of the colors having an excitatory and the other an inhibitory effect on the rate of firing of the cells. The opponent theory can account for the results of additive mixtures of different colors of light, including combinations that appear neutral, as well as the visual effects produced by various types of color vision defects. It is also consistent with hue shifts of certain colors with variations of ambient illumination levels. Opponent information is transmitted out of the eye by different classes of retinal ganglion cells, which terminate primarily in the LGN (Figure 3). This nucleus largely preserves opponent information as it transmits it to the visual cortex. However, once in cortex, color information is further combined to develop a multiplicity of color channels (far exceeding three), each with its own selectivity and sensitivity to a particular, smaller domain of color and lightness. Furthermore, at the cortical level, color is no longer an attribute that can be separated from other object properties such as shape, texture, and movement. Each of these contextual properties can now be seen to influence the perceived color of objects both at the cellular and perceptual levels.

Human color vision defects are typically associated with the X-chromosome visual pigment genes (L and M cone opsin genes) and are extraordinarily common — affecting 8–10% of men with European ancestry. Due to the X-linked recessive nature of the trait, only 0.4% of females have a red/green color vision defect. Color vision defects caused by a loss of L photopigment function (usually through a loss of the L photopigment gene) are termed protan; those caused by a loss of M photopigment function (usually through a loss of the M pigment gene) are termed

deutan. Deutan color vision defects are by far the most preva-lent, affecting about 6% of men. Within the protan and deutan classes of color vision defects, there are two broad subcatego-ries — dichromacy and anomalous trichromacy. Anomalous trichromats do not have the normal S, M, and L photopig-ments, rather they base their vision on an S pigment and either two different M pigments (protanomals) or two different L pigments (deuteranomals). They are trichromats, in that they have three different pigments, but are different from normal (anomalous). Dichromats base their vision on an S pigment and a single pigment in the L/M region of the spectrum. As might be expected, the dichromats (protanopes and deuteranopes), with only one photopigment, have very little color discrimina-tion. They distinguish most colors on the basis of saturation and lightness variations alone. Anomalous trichromats have slightly better color discrimination, but in most cases nowhere near that of normal individuals. Monochromats are individuals who are truly "color-blind," completely lacking functional cone photo-receptors. Though rare, there are also individuals with function of a single cone type (cone-monochromats) who can achieve minimal color discrimination under certain lighting conditions.

Perception of form

Just like color vision, object or "form" vision depends criti-cally on cortical processing, particularly within the ventral visual pathway that stretches from the primary visual cortex, through various cortical areas, to the inferotemporal cortex (Figure 3). Visual cortical neurons beyond the primary visual cortex are especially tuned to respond to contours of objects, both real and illusory. Cells higher up in the ventral visual hierarchy are important for the ability to discriminate patterns and shapes. At the highest levels of the ventral hierarchy, in the inferotemporal cortex, neurons have receptive fields so large that they often encompass most if not all of the visual field. This endows them with positional invariance; that is, they do not care about the orientation, size, or precise loca-tion of an object in space, but rather the identity of that object. Furthermore, these neurons respond most optimally when presented with really complex stimuli, such as particular objects, hands, or faces. Sometimes, what they respond to is not so much the whole face, for example, but a certain spatial relationship between the eyes and the nose/mouth, or a facial expression. This observation led to the early interpretation that the visual system was organized in a hierarchy, whose top levels consisted of "grandmother cells," each responding to a particular object or small range of objects. Recent research has decreased the popularity of this interpretation. However, the inferotemporal cortex is still considered one of the highest levels of the visual cortical system, with its neuronal responses clearly modulated by inputs from other sensory and cognitive centers in the brain, which make this a truly integrative area.

Perception of motion

Motion perception is one of the most important aspects of vision because it provides us with the information necessary to successfully interpret and navigate within our dynamic environment. Our sensitivity to motion is indeed highly developed with no less than three separate motion-sensitive components to the human visual system. First, there are the direction-selective retinal ganglion cells that are best excited by objects that move in a certain range of directions. These ganglion cells cannot resolve much detail about the moving objects and thus do not contribute to the direction selectivity found in the primary visual cortex, which preserves detailed information about the moving objects and arises primarily (via the LGN) from convergence of information from neighboring ganglion cells. However, visual motion processing does not stop with the primary visual cortex. It undergoes further refinement at higher levels of the visual cortical system to which the primary visual cortex sends a projection. One of the most important higher level areas involved in the processing of visual motion is the middle temporal (MT) visual cortex. Neurons in this area combine their inputs in a complex manner. This endows them with larger receptive fields than in the primary visual cortex, which allows them to integrate motion information over large areas of visual space and to extract motion signals from a noisy environment.

Perception of depth

Unlike photographic cameras, the visual system combines input from two eyes to create most of the three-dimensional images we perceive. Binocular vision refers to sight with two eyes distinctly different from monocular vision, which refers to sight with one eye. Because at distances greater than 100 feet, the images formed by an object on each retina are almost identical, monocular cues can be primarily used to create far-field depth perception. This is achieved by use of monocular depth cues such as familiar size of objects, occlusion, linear and size perspective, motion parallax, and our own familiarity with the natural distribution of light and shadows. At distances shorter than 100 feet, stereoscopic cues come into play and contribute to depth perception. Stereopsis occurs because the two eyes are horizontally separated (by about 6 cm in humans) and each eye thus has a slightly different view of the world. More specifically, close objects form slightly different images on the two retinas. This slightly different information from the two eyes is first combined onto single neurons in the primary visual cortex. It was in the late 1960s that Horace Barlow, Colin Blakemore, Peter Bishop, and Jack Pettigrew first discov-ered cortical neurons selective for horizontal disparity. While they play a major role in depth perception, these cells, just like most other visual cortical neurons, also contribute to a variety of visually related functions. For example, disparity informa-tion plays a critical role in ocular alignment when the eyes are trying to focus at a particular depth in the visual field — the eyes rotate nasally (convergence) when looking close and temporally (divergence) when looking far. This reflex develops very early in postnatal life and the ability of the brain to code visual disparity information is critical to this phenomenon.

The changing visual percept

One major difference between the human (or any other living) visual system and a camera is that the biological perception

of the visual world is never static. It constantly changes based on prior experience, stored visual memories, and planned actions. This plasticity of visual perception is currently also a hot topic of research, both at the cellular and behavioral levels. It is hoped that knowledge gained will one day provide a usable substrate for machine learning and the development of "smart," computerized the vision algorithms. At the cellular level, it is becoming increasingly clear that visual learning as a result of experience and intensive practice, both during development and throughout adult life, occurs as a result of molecular and structural changes in visual neurons at every level of the visual system. New, more efficient connections are formed, both within and between different visual centers. These structural and molecular changes alter the electrophysiological properties and visual processing abilities of visual neurons and lead to improved visual performance that is largely restricted to the trained visual function. Practice makes perfect, even in the visual system.

Adaptation

Visual adaptation is a process of adjustment of the visual system to its environment — one particular form of visual plasticity has great implications for photographers and photography. The dynamics of the visual system are such that it attempts to de-emphasize stable stimuli of long duration to preserve sensitivity to potential changes. This principle applies to a wide variety of stimulus attributes including lightness, color, size, motion, orientation, pattern, and sharpness. Brightness/lightness adaptation enables a person to see the environment with enormous variations in light level, such as from sunlight to starlight, which represents an illuminance ratio of about a billion to one. The increase in sensitivity that occurs with decreased light levels is a gradual process, requiring about 40 minutes to reach maximum dark adaptation. Dilation of the iris can increase the amount of light admitted to the eye by only about 16 times. Most of the increase in sensitivity that occurs during dark adaptation is the result of changes in the pigments in the retinal receptors and in neural processing. In contrast to dark adaptation, light adaptation occurs within a few minutes. Photographers who need dark adaptation to see clearly in low light-level situations, such as for certain darkroom operations and night photography, can avoid its quick dispersion by using dark eyeglasses when exposure to higher light levels is unavoidable. A fairly intense red light can be used in darkrooms without affecting dark adaptation because of the insensitivity of rod photoreceptors (which contribute most to vision at these light levels) to red light. Because of the change in sensitivity of the visual system during light and dark adaptation, the eye is a poor measuring device for absolute light levels. This is typical of most other human sensory systems as well. In visual environments containing a variety of tones, the adaptation level tends to be adjusted to an intermediate value that is dependent upon the size, luminance, and distribution of the tonal areas. This local adaptation enables a person to see detail over a larger luminance range, but is not so great so as to interfere with the judgment of lighting ratios on objects

such as portrait models, where experienced photographers are able to judge 1:2, 1:3, and 1:4 lighting ratios, for example, with considerable accuracy.

Chromatic adaptation occurs primarily because of bleaching of cone pigments in the retina. Upon exposure to short-wavelength or blue light, for example, the pigment in the S cones is bleached, rendering them less capable of absorbing photons of that wavelength. The net effect is that the blue-sensitive cones become less sensitive to blue light, which causes neutral colors that are viewed immediately following exposure to the blue light to appear yellowish (explained by blue-yellow color opponency — see the above section Perception of Color).

Adaptation to orientation and other, more complex spatial and temporal characteristics of our environment have also been reported and are mediated to a large extent by cortical mechanisms. For example, if a person wears prism eyeglasses that make everything appear upside down for several days, they will eventually perceive the world as normal again. If the glasses are then removed, the world again appears to be inverted until several days pass and it resumes a "correct," perceived orientation.

Visual Consciousness

It seems appropriate to conclude this exploration of human vision with some thoughts on perhaps the least understood of visual processes — visual consciousness. It is certainly paradoxical that it should be least understood since it is the most fundamental property of the human brain that (still) separates humans from machines. According to Christof Koch and Francis Crick, the primary function of visual consciousness is first, to produce the best interpretation of the visual world around us, taking into account previous experiences and maybe, our goals. A second role for consciousness is to make this information available to those brain regions involved in the planning and execution of motor outputs. Much current research is devoted to finding the neural substrates of conscious visual perception, largely by contrasting them with neural substrates of unconscious vision. To date, medicine has not discovered a single brain area where this function resides or mechanism by which it arises. Instead, many, perhaps all, parts of the visual system appear to contribute to its existence. Like the prototypical "smart" robot in science fiction movies, with brightly colored electrical signals zooming across it central processing unit, it is possible that visual consciousness arises from the global, simultaneous activity of the entire visual system. Devising experiments able to capture this phenomenon mechanistically remains one of the greatest challenges faced by visual neuroscience this century.

GLOSSARY TERMS

Accommodation — A process, associated with convergence of the eyes, by which ocular focus is shortened due to contraction of the ciliary muscles, which increases the convexity of the crystalline lens in each eye.

Acuity — A measure of the ability of a person to detect visual detail. The Snellen eye chart, which contains black letters of various sizes, is one target used for testing this aspect of vision.

Adaptive optics — An optical technique, usually involving a deformable mirror, which allows correction of optical aberrations of a given system.

Blind spot — Portion of the visual field where blindness can be demonstrated, even in normal observers. Caused by the presence of an optic disc in each retina, where no photoreceptors are present, and light consequently cannot be detected. Can only be observed monocularly.

Chemical synapse — Location where information transfer between two neurons occurs through chemical means via the release of a specific substance, called a neurotransmitter, by one neuron and its capture by the second cell.

Ciliary muscle — Smooth muscle attached to the crystalline lens and scleral wall of the eye, whose contraction and relaxation provides control over the convexity of the lens

Circadian pacemaker — Cellular structure that controls circadian rhythms of the organism. In mammals, this is the suprachiasmatic nucleus of the brain. Circadian rhythms are daily cycles in bodily functions that occur within a period of about 24 hours.

Disparity — The production of unequal images created from each eye by a single object as a consequence of the object's image falling on non-corresponding points of the retinas in the two eyes.

Nystagmus — A condition in which the eyes are seen to move in a rhythmical manner in a particular direction. Can be a normal reflex or pathological, as a result of brain damage.

Occipital lobes — The most posterior part of the cerebral cortex of the brain, containing primary visual cortical centers.

Photic entrainment — Ability to alter the circadian rhythm of an organism using light.

Photons — Fundamental particles that represent the smallest units of electromagnetic radiation that can exist, regardless of wavelength, frequency, energy, or momentum. Photons can be created and destroyed when interacting with other particles, but are not known to decay on their own. Unlike most particles, photons have no detectable intrinsic mass or "rest mass" (as opposed to relativistic mass). Photons are always moving at the speed of light, which varies according to the medium in which they travel with respect to all observers.

Receptive field — The set of stimulus characteristics that a neuron responds to optimally. For visual neurons, this might be a particular shape or a particular region of space. For auditory neurons, it might be a particular range of sound frequencies.

Stereopsis — Process of the human visual system that extracts depth information from a viewed scene and builds a three-dimensional understanding of that scene.

Sub-cortical centers — Concentrations of neurons that reside in regions of the brain deep to the cerebral cortex.

Synapse — Small gap separating neurons allowing the transfer of information from one neuron to another. The synapse consists of (1) a presynaptic ending that contains neurotransmitters, mitochondria, and other cell organelles; (2) a postsynaptic ending that contains receptor sites for neurotransmitters; and (3) a synaptic cleft or space between the presynaptic and postsynaptic endings.

Thalamus — A large mass of gray matter — clusters of neuronal cell bodies — deeply situated in the forebrain. This region relays electrical signals to the cerebral cortex where information received from diverse brain regions and from every sensory system except olfaction (sense of smell) is sent.

Vascular layer — Layer of the retina containing many blood vessels.

Veiling light — Diffuse, unfocused light.

Wavefront sensing — Method of measurement for wave aberrations of an optical system, which can be performed using machines such as the Shack-Hartmann wavefront sensor.

X chromosome — A sex chromosome that is present in duplicate in females of species with heterogametic males.

Zonule fibers — Arise between the grooves of the processes of the ciliary body overlying the ciliary muscle of the eye and insert into the capsule of the crystalline lens.

FURTHER READING

Chalupa, L. M. and Werner, J. S. (2004). *The Visual Neurosciences*. Cambridge, MA: The MIT Press.

Kandel, E. R. and Wurtz, R. H. (2000). Constructing the visual image. In *Principles of Neural Science, 4th ed.* (Kandel, E. R., Schwartz, J. S., and Jessell, T. M., eds.). New York: McGraw-Hill Companies.

Koch, C. and Crick, F. (2004). The neuronal basis of visual consciousness. In *The Visual Neurosciences* (Chalupa, L. M. and Werner, J. S., eds.). Cambridge, MA: The MIT Press.

Lennie, P. (2000). Color vision. In *Principles of Neural Science, 4th ed.* (Kandel, E. R., Schwartz, J. S., and Jessell, T. M., eds.). New York: McGraw-Hill Companies.

Tessier-Lavigne, M. (2000). Visual processing by the retina. In *Principles of Neural Science, 4th ed.* (Kandel, E. R., Schwartz, J. S., and Jessell, T. M. eds.). New York: McGraw-Hill Companies.

Wurtz, R. H. and Kandel, E. R. (2000). Central visual pathways. In *Principles of Neural Science. 4th ed.* (Kandel, E. R., Schwartz, J. S., and Jessell, T. M., eds.). New York: McGraw-Hill Companies.

Wurtz, R. H. and Kandel, E. R. (2000). Perception of motion, depth and form. In *Principles of Neural Science, 4th ed.* (Kandel, E. R., Schwartz, J. S., and Jessell, T. M. (eds.). New York: McGraw-Hill Companies.

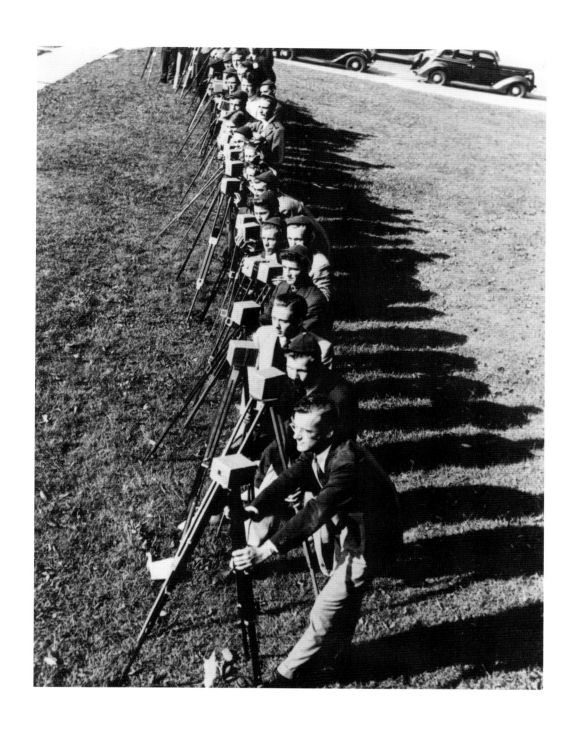

20TH CENTURY MATERIALS AND PROCESS ESSENTIALS

SCOTT WILLIAMS, PH.D., EDITOR
Rochester Institute of Technology

Twentieth Century Materials and Process Essentials

SCOTT WILLIAMS, PH.D.
Rochester Institute of Technology

The 20th century will be remembered by its images. We are among the first generations to let pictures and motion media tell the story. We know not only the story of Al Capone, but we can place him in the scenes associated with Chicago and the Prohibition. The flag raising by U. S. Marines at Iwo Jima, post-World War II celebrations in Time Square, McCarthy, Elvis, the missile crisis in Cuba, the man on the moon, *Saturday Night Fever*, hostage crises in Munich and Iran, World Series victories and the ball that got by, Reagan, a return to space and the day that lives "slipped the surly bonds of earth to touch the face of God" are images that flash in memory. The remarkable ingenuity of the creative 20th century inventors enabled memories to be recorded by ordinary individuals. That is what is special and unique about this period in time. Photo albums, picture frames, shoe boxes, and desk drawers, around the world, contain stories of birthdays, graduations, weddings, new birthdays, retirement, and memorials through images. The 20th century will most likely be known as the "film era." Those closer to the technology will remember it as the silver halide era. Either way, most have been touched by photography largely due to the developments of materials and methods during this time period.

Industries grew around the consumption of photography. Chemistry, optics, and engineering converged to produce products and processes capable of reproducing scenes with life-like quality. Cameras were transformed from tripod-fixed behemoths to instant cameras that could be sent with the kids to a campout. Films were invented and perfected to capture any scene in almost any lighting condition. Photographic papers came in all kinds of shapes and sizes from postage-stamp-sized Polaroid prints to large-format canvas media. The 20th century started in the light and progressed to flash photography that could freeze the beat of a humming-bird's wing. Our memories were first captured in color during this period. Photographic technology developments

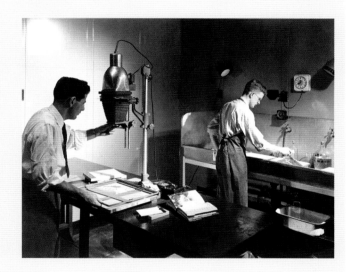

FIG. 1 Photography students work in the RIT darkrooms. (Image courtesy of the Wallace Memorial Library Special Collections, Rochester Institute of Technology, Rochester, New York.)

were translated to enable advances in other industries like aerospace, defense, medicine, and printing. Then, there was change. Digital photography emerged and neatly put all of the developments of film or silver halide photography into an historical context.

This section is organized to briefly chronicle the rise of photography as a consumer-driven industry. The topic arrangement was selected to illustrate a temporal cross-section of the innovations in materials and methods. Silver halide developments led into the production of black and white photographic materials. Color photography is summarized with an

Part page photograph: School of photographic Arts & Sciences freshmen students with pinhole cameras, ca. 1930. Image courtesy of the Rochester Institute of Technology Archives and Special Collections, Rochester, New York.

emphasis on silver-dye bleach technology that made a brief but important appearance. The science of development and how the darkroom was used to create images were necessary additions to this section. Camera evolution and how images were displayed are treated. In addition to the camera, there are many 20th century developments that carry over into the digital age of the new century. Digital photography depends on lighting techniques, color measurement and theory, and optics learned in the film age.

The artisan and consumer will practice photography using 20th century material and methods for the foreseeable future. Film-based photography remains more versatile as the digital technology matures. Disposable film cameras are being developed with more features and purchased by consumers to record memories in places that would not be practical with a digital camera. This section preserves the lessons learned in the past century. We must understand this technology to preserve the stories of this most recent past.

Silver Halide Materials: General Emulsion Properties

ALAN HODGSON, PH.D.
Alan Hodgson Consulting

Why Use Silver Halides?

Many light-sensitive substances are known to exist with a wide variation in their sensitivity characteristics. More than 2000 years ago the Phoenicians of the city of Tyre found that the pale yellow slime of the Purpura snail turned purple when exposed to air and light. Although not used in any photographic sense, this process was used to produce the rich Tyrian Purple cloth.

Around 1826 Joseph Nicéphore Niépce created the earliest camera photograph still in existence, utilizing bitumen as the light-sensitive substance. An exposure time of around 8 hours was used and the resulting image, View from the Window at Le Gras, is currently in the Gernsheim Collection at the University of Texas at Austin. However, only a few substances have ever made their way into commercial systems; for example, some of these photopolymers have found use in applications such as holography and photoresists in electronics manufacture and printing. Coming closer to photography, the diazo process has been used for document reproduction. However, the most successful systems for photography are based on the chemistry of silver.

In the 1720s a German professor, Johann Heinrich Schulze, observed that silver compounds darkened when exposed to light. Although he recorded some shadows in his work he did not produce actual photographs. By 1800 an English chemist, Thomas Wedgwood, had produced images on leather treated with silver compounds.

Commercial photographic materials now rely almost exclusively on the light sensitivity of silver halides. These are compounds formed by the combination of silver with elements known as halogens — in this case bromine, chlorine, and iodine. In the 1830s Louis Jacques Mandé Daguerre found that silver iodide exhibited much greater light sensitivity than Niépce's bitumen. Independent of Niépce, William Henry Fox Talbot was using a similar system based on silver chloride.

The reason that silver halide systems are so attractive for photography is that the system can be made to be extremely sensitive to light. During the chemical development process large visible changes can be produced in the recording material from only a minimal amount of light exposure. This amplification step in development is either missing in some other processes such as diazo or much smaller in others, which leaves silver halide a big sensitivity advantage. Unlike some other processes, the unexposed silver salts can be easily removed, fixing the image and markedly increasing permanence.

Photographic products containing silver halide emulsions have been produced where the action of light alone produces a printed out image. Because the wet chemical development step and the associated gain in sensitivity are missing, they were much slower in sensitometric terms than conventionally processed materials. However, they did find use in contact printing and oscillograph recording papers.

Mention should also be made of photothermographic technology using compounds such as silver behenate. These are "dry silver" processes where the silver compounds are reduced to metallic silver to form the image using heat. A number of commercial products have appeared using this process.

Silver Halide Emulsions

The use of the word *emulsion* in this context is actually a misnomer. Photographic emulsions are in reality suspensions of minute crystals of silver halide in a polymer matrix. Although this polymer is now often gelatin, other chemicals, notably latex polymers, are added to the gelatin to modify its characteristics.

The relative proportions of silver halide and gelatin vary with the type of product required. In general, photographic films and papers tend to have much more gelatin by volume than silver halide. This gelatin excess allows the product to swell when wet, facilitating effective chemical processing (see below). However, some products are much more concentrated in terms of volume fraction of silver halide. In practice, the upper limit is around equal volume fractions of silver halide and gelatin. Nuclear emulsions and plates are silver-rich products that are manufactured at these concentrations. They are designed to produce continuous lines of grains recording the passage of energetic particles through the concentrated emulsions.

The silver halide crystals in emulsions are sometimes referred to as grains. Unfortunately the same word is also used to describe the developed grains of metallic silver that make up the developed image.

The Silver Halide Grains

As described above, silver halides are compounds made from silver and chlorine, bromine, or iodine. In commercial emulsions it is not normal to produce a pure silver chloride, bromide, or iodide. Instead, a mixed halide is produced where two halides are present in each individual crystal, although not necessarily in the same proportion throughout each grain. For example, in emulsions designed for the production of negatives, the halide employed is often silver bromide with a small quantity of iodide, known as an iodobromide emulsion. In emulsions for photographic papers the halide mix may be silver bromide, silver chloride, or a chlorobromide.

The photographic recording action of silver halide can be described as follows. A silver halide crystal consists of an ordered matrix of positively charged silver ions (denoted as Ag^+) and an equal quantity of negatively charged halide ions (such as Br^-). When a photon of light is absorbed by the crystal an electron is liberated that combines with a silver ion to produce a silver atom. After this particular crystal has absorbed a small number (around 3+) of photons, a small, stable cluster of silver atoms is formed. This small cluster is

known as a latent image as it is still too small to be seen, even with an electron microscope. When the crystal is processed in a photographic developer, the latent image promotes the reduction of the whole crystal to a visible particle of silver. The silver from all of the crystals that have recorded a latent image in this manner make up the processed recorded image.

The Gelatin Medium

The polymer matrix used as a binder for the grains must be more than just a passive entity. It has to have some very important characteristics. It must be chemically compatible with the emulsion-making process. In addition to the requirement to work in aqueous solutions, the polymer must ensure that the resultant silver halide grains remain separate and stable. It must be optically clear so as to allow light to reach the silver halide grains during exposure. This means that it must be transparent at the relevant wavelengths. Its low refractive index ensures that light interacts effectively with the high refractive index silver halide crystals.

When dried, the polymer must bind the grains to the base and give the photographic layer the requisite physical characteristics to work in a photographic process. For example, roll film must resist abrasion, scratching, and sticking in cameras and photographic papers must be able to be packed in stacks in a box without sustaining damage. During photographic processing the polymer must allow the solutions to penetrate and then be adequately washed clean for archival permanence. Gelatin also has the advantage that the swelling characteristics with pH are well suited to the pH at which typical developers are active.

After processing the polymer must again impart suitable physical characteristics, quite often different to those pre-process. For example, in photographic papers the surface should now have the right optical gloss characteristics and resist finger marking. One of the first binders used was collodion. The major disadvantage of this chemical was that it needed to be exposed while still wet or the ability to effectively process the emulsion was lost. This requirement made the use of collodion plates difficult but gave rise to the name "wet collodion."

Collodion was rapidly replaced by the use of gelatin, which had four major advantages.

1. The emulsions could be exposed while dry. Not only was this a major convenience with glass plates, but it paved the way for film-based products that could be stacked or rolled, before and after exposure, with processing delayed until convenient.
2. Only water was needed as a solvent in manufacture. This not only made the emulsions cheaper to produce due to the absence of organic solvents but also reduced fire and explosion hazards in manufacture.
3. Plates coated with a gelatin-based emulsion were found to be a number of stops higher in sensitivity to light than the corresponding collodion preparation. These early photographic

chemists had happened upon the science of chemical sensitization. Long exposures became possible, extending the sensitivity beyond that of the eye and allowing faint objects such as unseen stars and spectra to be recorded.

4. The use of gelatin to bind photographic emulsions stems from the 1870s and since then it has become the preferred binder for emulsions. Chemically modified gelatins and mixtures with other polymers such as polyvinyl alcohol (PVA) are used, but gelatin is still essential in the photographic process.

Gelatin is manufactured from collagen, a natural product extracted from the hide and bones of animals. As it is produced from a natural product it can be of variable composition and in an unpurified form can contain many additional compounds that are photographically active. As a result there is a considerable art and science in purifying and blending gelatins to ensure an end product of uniform characteristics.

Gelatin has survived as the preferred medium for silver halide technology over the last century. This is not only because of many useful properties in a photographic context but also because the photographic process has evolved around gelatin-based emulsions. The useful characteristics of gelatin in a photographic context can be described as follows.

Gelatin is hydrophilic and readily disperses in water. The resultant solution makes a convenient medium for the chemical reactions that produce silver halide. Once the silver halide crystals have been formed the gelatin coats the surface of each crystal, keeping them individual and dispersed in the liquid. From a manufacturing standpoint the fact that gelatin works in aqueous solution without the need of high temperatures or expensive, flammable solvents has done much to keep production costs low.

In warm aqueous solution a gelatin-based emulsion has relatively low viscosity, which allows it to be pumped and coated onto base material. However, when chilled it sets rapidly to a jelly giving the coating some physical stability during the drying process. Chemicals can be added during the coating processes that cross-link the gelatin molecules. These can promote adhesion of the emulsion to the base material and improve the characteristics of the layer by making it more physically robust.

Gelatin has very good optical properties from a photographic point of view. It is transparent throughout the range of visible wavelengths and is not optically active. This transparency extends out into the near infrared for scientific, creative, and surveillance applications and out into the near ultraviolet too. Only in a limited number of scientific or technical applications requiring far ultraviolet or charged particle detection are special coatings needed where the bulk and/or the surface of the emulsion layer has a high silver halide:gelatin ratio.

The exposed photographic layer is processed using aqueous solutions. When the gelatin layer is placed in these solutions it takes up the solution and swells. This has the double benefit of bringing the processing solution quickly into contact with the silver halide crystals, which promotes rapid processing and the

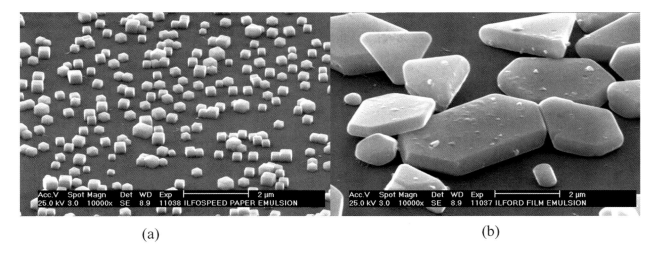

(a) (b)

FIG. 2 The camera film emulsion can be seen to have much larger grains than the paper emulsion and is consequently much higher in speed. It also illustrates pictorially the difference in grain size distributions between the two. This paper emulsion has grains that are fairly uniform in size. Because of this the grains tend to behave in a very similar manner on exposure, all recording a latent image at very much the same exposure level. As a result the contrast of this emulsion will be comparatively high. The camera film emulsion is, however, rather different in that it consists of a much wider variation in grain sizes and consequently has a much lower contrast.

swelled layer allows effective exchange of residual chemicals with washing solutions. This facilitates the efficient removal of chemicals in the final washing stages.

As mentioned above, emulsions made in gelatin are significantly faster than those made in collodion. This is because gelatin can also contain compounds that act as sensitizers to silver halide. Although this is no longer an issue now that the science of sensitization is better understood, it was a major advantage a century ago. Gelatin also plays an important role in determining the size, size distribution, shape, and sensitivity of the silver halide grains, as discussed below.

The Relevant Properties of Silver Halide Grains

There are a number of key parameters that influence the photographic properties of silver halide grains. First and foremost among these are the size, size distribution, and shape of the individual crystals. However, also of importance is the chemical and spectral sensitization of the grains.

Grain size is of great importance because in general terms the probability that a silver halide crystal will absorb a photon of light is a function of the volume of the crystal. As a general rule, large crystals make sensitive emulsions. However, although large crystals are good for sensitivity, they compromise the image quality parameters of the emulsion. This is because large crystals produce poor definition in the final image and also increase the perception of graininess. Grain size is therefore a compromise between sensitivity and image quality.

One very useful method of gaining extra sensitivity without increasing grain size is to employ chemical sensitization techniques. These use the addition of chemicals to increase sensitivity and because they do not imply an increase in grain size they carry none of the image quality penalties described above. However, there may be a penalty to pay in terms of background fog. Once more we are back to a compromise between sensitivity and image quality.

Grain Size and Distribution

The grain size and size distribution are key parameters determining the characteristics of an emulsion. In practice, all other things equal, the sensitivity to light increases with around the second or third power of grain diameter. The grain sizes used in commercial emulsions vary widely as the emulsions are designed for different applications. Figure 2 illustrates this with emulsion grains imaged with a scanning electron microscope.

The grain size distribution is therefore an additional variable to be considered. Rather than estimate this visually from pictures such as Figure 2, instruments are used to quantify particle size variations to produce data such as that in Figure 3.

Grain Shape

Figure 2 also illustrates the fact that silver halide crystals can be manufactured in different shapes. One of the reasons to use this variable in some products is that it can produce advantageous gains in sensitivity without undue increases in graininess. Whereas the intrinsic sensitivity of a grain is a function

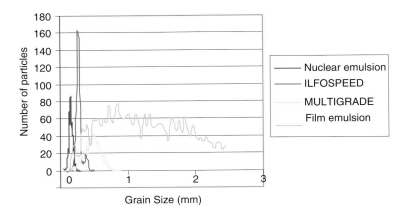

FIG. 3 The curves show four different emulsions designed for quite different applications. The nuclear emulsion, designed for charged particle recording, has a very small crystal size and a tight crystal size distribution. The Ilford Ilfospeed paper emulsion is somewhat similar in distribution but with a larger average size. This is the same emulsion as that illustrated in Figure 2a. The other paper emulsion, a component of an Ilford Multigrade product, has a larger crystal size and wider distribution, as does the camera film emulsion. These lead to progressively faster and lower contrast performance.

of the volume, the sensitivity of a grain with sensitizing dyes attached is more a function of the grain surface area. Thin, flat grains of the type illustrated in Figure 2b give a better speed: grain ratio when used with sensitizing dyes to increase spectral sensitivity.

Spectral Sensitization

The intrinsic sensitivity of silver halides is limited to the restricted wavelengths where they absorb light. This absorption spectrum is a function of halide type. Silver chloride appears almost colorless, absorbing (and therefore sensitive) predominantly in the ultraviolet. Silver iodide is yellow as the absorption (and therefore the sensitivity) extends into the blue end of the visible spectrum. Silver bromide is a pale yellow and has characteristics between the two.

This limited spectral sensitivity need not be a problem in some applications; however, products such as camera films require recording over the entire visible spectrum. In this case the wavelength sensitivity is extended by the use of sensitizing dyes. These are dyes adsorbed on the surface of the crystals that add additional sensitivity over their absorption spectrum. Judicious choice of these organic dyes can extend the sensitivity beyond the visible spectrum and into the infrared.

The Stability of the Latent Image — Reciprocity Failure

It was mentioned earlier that the latent image consists of small groups of neutral silver atoms in a silver halide crystal. These atoms accumulate at sites of imperfections within the grain, usually deliberately introduced during manufacture. The purpose of chemical sensitization is to facilitate the process of the accumulation of these latent images and to promote their

stability. Types of chemical sensitization are covered in a later part of this essay.

One important aspect of latent image stability concerns the phenomenon of reciprocity failure. The Reciprocity Law states that the amount of photographic exposure is dependent on the amount of energy employed, irrespective of the time over which it is delivered. Put in equation form this can be written as

Photographic exposure = light intensity × exposure time

For exposures typical of consumer cameras this relationship works well. However, for very short (below around 1 ms) or long (above around 1 second) exposures this relationship breaks down and higher overall exposure than expected is required to achieve the same recorded result. This is a very important factor in the calculation of exposure in certain circumstances. This breakdown in the Reciprocity Law is known as Reciprocity Failure.

High exposure reciprocity failure is associated with short exposures of high intensity. Extreme examples include the exposure of holographic films and plates using pulsed lasers for times measured in nanoseconds (10^{-9}). Products designed to minimize the effects of high-intensity reciprocity failure tend to be chemically sensitized with gold.

Low-intensity reciprocity failure is associated with very long exposures under low-light intensities. A typical application would be astronomical photography. Silver halide emulsions in general exhibit low-intensity reciprocity failure, but chemical sensitization using sulfur is effective in minimizing this. However, low-intensity reciprocity failure does have virtues in normal circumstances as it tends to reduce the long-term accumulation of fog due to thermal effects, even in complete

darkness. For astronomical photography, where low-intensity reciprocity failure must be eliminated, hypersensitization techniques are used.

Sensitometry

The usual way in which to define the sensitivity characteristics of a photographic process is a graph showing optical density as a function of the logarithm of exposure. This S-shaped plot is often referred to as the characteristic curve of the product. The use of logarithmic scales approximates the response of the eye, giving a presentation that is closely related to the visual impression of the image-recording characteristics. The shape of this curve is determined by many variables, not just the characteristics of the emulsion and the coated assembly. It is also a function of exposure and development conditions and the method used to measure the resultant optical density. Because of this it is important to note that the form of the characteristic curve is a measure of the complete photographic system, not just the recording emulsion.

There are a number of key parameters that can be extracted from the characteristic curve. The first of these is the fog level, the optical density of the processed material at zero exposure. This is a strong function of the emulsion type and the development conditions. Fine-grain emulsions such as illustrated in Figure 2a tend to have a low fog level. This is particularly important in a paper product where the process is often designed to give a clear white image in the unexposed areas.

The slope of the characteristic curve is a measure of the image contrast of the recording system. Emulsions with crystals all of very similar size (see the nuclear emulsion in Figure 3) are known as monosize emulsions and tend to have very high contrast, whereas those with different crystal morphologies and sizes (see Figure 2b) tend to have lower contrast. The slope of the characteristic curve can also vary across the exposure range giving the subtly different characteristics sought by creative photographers.

The exposure range giving rise to densities between fog level and the maximum density (known as D_{max}) is a measure of the exposure range over which the system can record detail. High-contrast products, with very steep characteristic curves, therefore, tend to have small exposure ranges.

The photographic speed of the system is usually expressed by some measure of the exposure required to achieve a specific developed density. There are various International Standards to define this for pictorial photography. Because of the application these are defined in photometric units. However, for scientific applications it is sometimes more applicable to define these in radiometric units.

Making Silver Halide Emulsions

Over a period now spanning more than a century the process of making silver halide emulsions has been greatly refined. One of the major advances during this period was the phased addition of different halides during crystal growth, resulting in what is known as core-shell grains where the center is of a different halide constitution to the outer layers.

The major players in this industry have all developed their own ways of efficient and effective manufacture, many of the details of which still remain commercially confidential. However, the underlying science of silver halide emulsion preparation remains the same and the fundamental steps are listed below.

Emulsification

A solution containing silver in a soluble form (usually silver nitrate) is mixed with another containing the relevant halides. This mixing takes place in a gelatin solution. This stage, often referred to as emulsification, can produce significantly different results depending on the conditions employed. Knowledge of these and the relevant process control tolerances are part of the art and science of emulsion making. Silver nitrate and halide concentrations, temperature, rate of mixing, and gelatin type and concentration are all key parameters in this step.

When silver nitrate and a halide such as potassium bromide are mixed in solution a silver halide (in this case silver bromide) is produced. The relative amounts of the reactants are arranged to be such that the concentration of the silver bromide produced is greater than its solubility. As a result, small crystals of silver halide fall out of solution. These crystals grow as they act as seed nuclei for other silver halide to fall out of solution. This is a key stage in the production of silver halide emulsions and many of the final characteristics of the emulsion are determined at this stage.

Gelatin is important even at this early stage of emulsion manufacture. The gelatin is absorbed onto the surface of the individual grains, preventing them from clumping together to form aggregates and protecting them from damage during subsequent stages.

Ripening

The primitive emulsion is held under conditions where there is significant solubility of silver halides. This is done using a combination of elevated temperature and the presence of silver halide solvents, notably ammonium compounds. To facilitate this step further chemicals may be added to the mix. The ripening step can be considered as a combination of two processes, both of which modify the particle size distribution and hence the final characteristics of the final emulsion.

Ostwald Ripening

Smaller grains of silver halide are re-dissolved and the silver halide re-deposited on larger grains. The result is that the average size of the silver halide particles increases and size distribution changes. This is a process best described as grain coalescence. Here two or more crystals grow into each other forming a fused unit. Alternatively one or more crystals can grow from the edge or corner of an existing crystal. These mixed grains contain crystal lattice imperfections and defects that influence the final sensitivity of the emulsion. Both of these processes have a profound effect on the sensitometry of the final emulsion.

Washing

The emulsion at the start of this stage consists of silver halide grains dispersed in a gelatin solution that also contains a number of soluble by-products of emulsion manufacture. These dissolved chemicals must be removed at this stage as they may adversely affect the shelf-life or performance of the emulsion. The term "washing" for this process is an archaic description stemming from the time when emulsions were chilled causing them to set then shredded and washed in water. This process was time-consuming, involved much heating and cooling, and required copious quantities of pure washing water. As a result, modern processes evolved such as chemical flocculation and reverse osmosis.

Flocculation works because gelatin can become unstable in solution at some pH (acidity/alkalinity) levels. This results in the silver halide, which contains emulsion, to be precipitated out of solution and then collected and washed as above. Once cleaned it can be re-dispersed simply by moving the pH back into the soluble range.

Reverse osmosis takes advantage of the fact that neither the silver halide grains nor the long-chain gelatin molecules can pass through the very fine pores of a semi-permeable membrane. However, the soluble impurities we wish to remove are able to pass through these pores. If the impure solution is placed under pressure on one side of such a membrane then water and soluble impurities will be forced through these pores leaving the emulsion remaining purified and concentrated.

Digestion and Sensitization

The purpose of this step is to increase the sensitivity of the emulsion. This is done primarily through the addition of certain chemicals to the emulsion. Some of these chemicals influence the overall sensitivity of the emulsion to light or charged particles. Others, known as spectral sensitizers, change the balance of wavelengths to which the emulsion is sensitive.

There is a balance to be made in sensitization between the benefits of increased sensitivity against the disadvantage of increased fog. For some products such as high-speed camera or aerial films there is a need for high sensitivity at the expense of some increase in fog. However, in other products such as high-quality printing papers and autoradiography emulsions the balance is on the side of reduced fog.

Sensitizing chemicals can be conveniently described in a number of classes.

Sulfur Sensitization

It was stated previously that a gelatin binder produced a more sensitive emulsion than one made with collodion. In the 1920s it was realized that this was due to some natural sources of sulfur compounds in gelatins that were acting as a sensitizer. Most photographic-grade gelatins today have this sulfur removed at the purification stage so that precise amounts can be added during sensitization.

These sulfur compounds work by producing silver sulfide centers on the crystal surface that act to stabilize the latent image. This increase in stability is greater at low exposure intensities so sulfur sensitization tends to have the greatest effect on low-intensity reciprocity failure.

Reduction Sensitization

Small amounts of reducing agents such as aldehydes can also increase photographic sensitivity. These types of compounds were again found in early gelatins and work by producing silver (rather than silver sulfide) centers on the crystal surface, which again act to stabilize the latent image. Reduction sensitization is commonly used in conjunction with sulfur sensitization.

Gold Sensitization

Gold compounds have been widely used, particularly in high-speed emulsions. In this case the effect is greatest at high exposure intensities, so it is particularly effective in dealing with high-intensity reciprocity failure. The major drawback with gold sensitization is the propensity to increase fog levels.

Other Chemical Sensitizers

There have been a number of patents and technical papers on the subject of other organic compounds for use as sensitizers such as formate ions. Although there have been widespread claims for these compounds they have not become mainstream in silver halide technology. The separate issue of spectral sensitization is dealt with previously.

Coating Finals

A number of other chemicals are commonly added before the emulsion is coated. Anti-foggants are chemicals used to restrain fog when processed in developers of high activity. However, some such compounds reduce emulsion sensitivity on exposure. Development accelerators may be incorporated, particularly in products requiring very fast processing times such as some medical and aerial films. Some products actually have developers incorporated into the emulsion that only require activation with a pH change.

Hardening agents work by cross-linking the gelatin molecules. These reduce the swelling of the emulsion layer in processing solutions and generally make them more robust. They may also have a positive effect on the adhesion of the emulsion to the base material. However, as this cross-linking process influences the flow properties of the emulsion, these hardeners must be added immediately prior to coating.

Stabilizers are added to restrain the further slow ripening of the coated emulsion that may occur on keeping. This ripening can cause sensitivity changes and fog. Once again, some of these compounds can act to reduce emulsion sensitivity on exposure.

Wetting agents are widely used to allow the emulsion to uniformly wet the surface of the base during coating. Inadequate wetting produces streaks of non-uniformity or bubbles, which result in artifacts in the processed image.

Emulsion Coating

In parallel with emulsions, coating technology has made many advances over the past century. Coating machines have evolved covering a wide spectrum of capabilities from small-scale systems for coating onto individual sheets of glass to huge web coaters that can simultaneously coat multiple wet layers on flexible substrates. As one of the major variables in this process is the emulsion support, this should be our first consideration.

Types of Emulsion Support

In the majority of cases the silver halide emulsions are coated onto some type of support, commonly referred to as the "base." However, there are a few exceptions that find use in scientific applications. The first is the use of pellicles. Pellicles are sheets that are cast from molten emulsion to thickness of up to 1 mm. They are used in the detection of charged particles in particle physics experiments. Because of the laborious nature of the processing and the difficulties in handling this type of product, this is not a common application.

Much more usual is the use of liquid emulsions in autoradiography. In this technique, micro-autoradiographers use a bottle of emulsion and coat their own samples.

The most common base materials are now plastic film and paper. However, rigid substrates of which the most common is glass, are still important. Historically, glass was the base of choice.

The Coating Process

Originally, emulsions were applied to the base by pouring from a receptacle (for example, a teapot) and spreading the emulsion out with a tool. Modern coating machines, where the emulsion falls in a steady flow onto the moving base, are capable of much higher speeds and uniformity. However, the underlying science of the process remains the same.

The clean base must be prepared to ensure good adhesion and wetting of the emulsion. This is done by first coating the base with a thin layer of a substance such as hardened gelatin. The emulsion layers are then coated onto this base by passing them under a coating head. The coating head can be made to dispense several layers on top of each other as a stable curtain or cascade of liquid. In this way multiple layers can be coated in one pass, giving the assembly designer many options in terms of photographic and physical properties design. This design often incorporates a protective non-stress supercoat to reduce the effects of abrasion and to give photographic papers the requisite gloss characteristics. This type of coating process is often referred to as Slot Die.

The coating is then chilled to set the coated layers, which are then dried. The rate and conditions of drying are also a variable determining the characteristics of the final product.

Film and paper products are coated as large rolls, typically over a meter in width and hundreds of meters long. These are then slit, chopped, and perhaps reeled into the required sizes. Glass plates are coated on glass of various areas and thickness depending on the application. Small plates are prepared by coating larger sheets of glass and cutting them down to the required size.

The Silver Image — Image Quality Attributes

When considering the silver image, there are a number of important attributes that characterize the recording medium. In addition to the macroscopic characteristics covered above under the section Sensitometry, there are micro-scale issues because the image is made up from individual grains of silver, coated as a thin layer that has unusual light-scattering and absorption properties, and is processed in a developer.

Granularity and Graininess

A property that becomes immediately obvious when looking at a large enlargement, or a negative under high magnification, is made up of individual silver grains. On a microscopic scale this means that even an area that measures as uniform optical density on a standard densitometer does in fact exhibit statistical density fluctuations when measured on a microscopic scale. The objective measure of these statistical fluctuations is made with a device known as a microdensitometer and the measure is known as granularity.

This granularity gives the image the visual property known as graininess. Graininess can be defined as the subjective consequence of granularity. Granularity and graininess are a function of both the emulsion type and the processing conditions employed. In general, fine-grain emulsions produce images with low graininess and granularity. Different developers will also produce different levels of graininess and granularity at the same densities from the same emulsion product.

A further level of information on the emulsion's properties is provided by the noise power or Wiener spectrum of the granularity. This splits the photographic noise signal into individual frequency components in a fashion analogous to audio noise analysis. This type of analysis is useful in separating lower-frequency components that give the visual impression of mottle from other noise signals.

Edge (Adjacency) Effects

The characteristic curve covered earlier described the macroscopic recording characteristics of an emulsion. However, it is found that this does not adequately describe the recording characteristics of fine detail and around the edges in an image. In such cases the recorded density is also a function of the density of adjacent areas. As a result such phenomena are known generically as adjacency effects.

Adjacency effects are primarily driven by development conditions and, in particular, by changes in development conditions across edges and fine detail. This can be explained with reference to Figure 4, which illustrates the situation in a stylized fashion for clarity.

Adjacency effects are a function of developer formulation and the level and type of agitation employed. As is illustrated in Figure 4, there is no reason for the enhancement to be symmetrical around the edge.

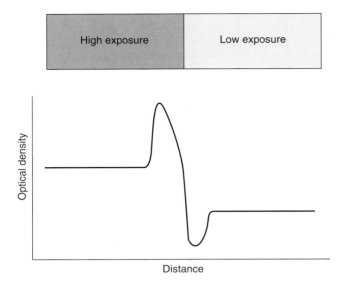

FIG. 4 Development occurs vigorously over the area of high exposure and as a result the activity of the developer becomes locally depleted around the high-developed density region. However, the area just to the high-exposure side of the boundary has access to fresh developer from the low-exposure side, resulting in extra development. By a similar argument development is retarded on the low exposure side of the edge. This can result in significant edge sharpening and an apparent enhancement of the recorded detail.

Resolution and Sharpness

One of the oldest metrics of image quality of optical systems is resolution, which can be defined as the ability to record fine detail. A chart such as that illustrated in Figure 5 is used and the resolving power is the maximum number of lines and spaces per millimeter that can be individually distinguished.

In practice, resolution measurement of photographic films was found to be a fairly good measure of their image recording characteristics when the image was meant to be read directly from the film. An example of such an application is aerial film where the interpretation would often be done from the negative. However, in most cases negatives involve an additional imaging step such as printing before viewing. These processes have their own imaging characteristics so resolution measurements are less applicable. As a result these types of measurements have fallen from favor. With the widespread availability of film scanners, this situation may change as film resolution appears to be a reliable measure of the image recording characteristics of camera films for scanning.

The resolution of a photographic emulsion is much lower than would be expected from the grain size, by one or two orders of magnitude. This difference is due to light scattering and reflections within the emulsion layer. However, fine-grain emulsions, in general, do yield a higher resolution than larger grain varieties.

FIG. 5 A typical test target used to evaluate photographic resolution.

It should be noted that there is a poor correlation between perceived sharpness of a film and resolution. Measurements of Modulation Transfer Function (MTF) are much more applicable in such cases.

Modulation Transfer Function

The MTF in photography is the optical equivalent of the frequency response plots commonly produced for audio systems. In the case of optical systems it is the spatial frequency response in lines and spaces (line pairs) per millimeter that is measured rather than sound waves in cycles per second (Hz). In both cases the normalized response is plotted as a function of the relevant frequency measurement.

MTF measurements have a better correlation to perceived sharpness and "sparkle" of an image than resolution. However, they are a good deal more difficult and expensive to perform and generate a curve rather than a single number. For scientific applications there is the advantage that the MTF curves for successive steps in an imaging process can be cascaded to produce an MTF of a complete system.

The Future of Silver Halide

For many years pundits have been forecasting the death of silver halide photography but it has stubbornly refused to disappear. Although there is a definite trend to digital photography for general consumer and professional photography, some key areas such as creative and scientific photography look set to retain an analog component in the longer term. There are also imaging applications of silver halide technologies that are not photographic. Research papers have been published citing liquid crystal displays, charge-coupled device (CCD) sensors, thin layer electronic devices, photo catalysts, and dye-sensitized solar cells as potential applications.

Silver halide technology looks set to be with us for some time yet!

FURTHER READING

Dainty, J.C. and Shaw, R. (1974). *Image Science*. San Diego, CA: Academic Press.

Society for Imaging Science and Technology. (2000). International Symposium on Silver Halide Imaging: Recent Advances and Future Opportunities in Silver Halide Imaging. St. Adele, Quebec, Canada.

GLOSSARY

Chemical sensitization The use of chemical additives to increase the sensitivity of an emulsion.

Collodion A viscous solution of gun-cotton (cellulose nitrate) in an organic solvent mixture.

Diazo An imaging technology based on diazonium salts used for document reproduction.

Emulsification The chemical reaction between a soluble source of silver (usually silver nitrate) and a source of halide conducted in a gelatin solution. The result is a suspension of silver halide particles.

Fog Non-image-wise silver produced during development. This could be produced because of an unintended latent image from inadvertent exposure to light, heat, or ionizing radiation or may be produced randomly, particularly with highly active developers.

Hypersensitization Techniques used to enhance the sensitivity of an emulsion before exposure. Usually used to mitigate the effects of low-intensity reciprocity failure.

Latent image A small cluster of silver atoms in a silver halide crystal that renders the crystal capable of development.

Micro-autoradiography A scientific imaging technique using liquid silver halide emulsions. A sample (commonly biological) containing a radioactive tracer is coated with the emulsion. The emulsion is sensitive to the radiation, which produces a latent image dependent on the concentration of the radioactive tracer below it. After development, the silver image becomes visible, indicating the area where the radioactive tracer resides. Because of the capability of silver halide emulsions, this technique can be used to image structures to a resolution of a few microns. Macro-autoradiography uses X-ray type film to give images of lower resolution.

Ostwald ripening A process in emulsion manufacture where smaller silver halide grains are dissolved and the silver halide re-deposited on larger particles.

Photopolymer A polymer produced by the action of light on a monomer. The polymer can be made to have different properties than the monomer that makes the media suitable for forms of photographic recording.

Photoresists A photosensitive coating that after exposure resists chemical etching.

Slot Die An emulsion coating process used to produce photographic products. ◉

Black and White Films and Papers

MIKE GRISTWOOD
Formerly of Ilford Imaging UK

Black and White Films

Black and white films are silver halide emulsions (silver bromide with a small quantity of silver iodide) coated on to a flexible transparent base and designed to produce a negative image.

Overview

The development of new films was mainly driven by the relentless increase in popularity of 35 mm cameras in the second half of the 20th century. This led film designers to concentrate their efforts on improving image quality, especially grain and sharpness. The biggest improvements came in the higher speed ISO 400/27 film group where the scope for

improvement was greater. Also, for these films, the quality of push-processed images became an important product attribute, which was essential for success in this market segment. New emulsion technology allowed manufacturers to introduce high-quality, ultra-high speed films. The steadily improving quality of the newer medium and high-speed films meant that sales of the slow films declined and most have now been discontinued.

Nostalgia for older films is rather rare; generally, the advantages of the newer films outweighed any disadvantages. One exception was in the field of very large format photography. This uses sheet film where the negatives are contact printed so fine-grain and high sharpness are not the most important characteristics. The preferred film here was a very old design favored for its tonal qualities. Similarly, the new emulsion technology medium- and high-speed films failed to completely supplant the conventional alternatives, which mostly remained in production and were sold alongside the newer films.

Most product development has concentrated on improved chromogenic films which have utilized the technology used to great effect in color films to produce very fine-grain black and white films.

Support

Three main types of support have been used for black and white negative emulsions.

Glass

Plates of glass became an important emulsion support from very early in the history of photography. However, as flexible film supports became available they rapidly replaced glass in most applications due to its disadvantages. In particular, glass plates are fragile, very heavy, and take up a large amount of storage space. However, because of some very useful properties as a photographic base there are still some applications for which glass is particularly well suited.

Optical glass is particularly clear, colorless, low in light scatter, and can also be manufactured free of birefringence effects. This latter property is important in techniques such as holography, where the exposing light is polarized and required to go through the base onto the emulsion. Glass plates are also rigid, which is another reason why glass is the preferred substrate for holography where the plate must remain stable to fractions of the wavelength of light during exposures that can last many seconds. Glass is dimensionally stable and undergoes very little in dimensional change with humidity or during processing. As a result, it finds applications in scientific imaging techniques such as X-ray tomography and spectroscopy where precise measurements may be made on the plates after processing and need to be equated to positions or angles in the original exposure.

Cellulose Triacetate

Early film base was made from nitrocellulose, also known as cellulose nitrate or celluloid. The use of this product has now been discontinued due to its high flammability. The first fully acceptable replacement was cellulose triacetate (often known simply as triacetate or acetate base), which is still widely used. This has much lower flammability and is also called "safety base." Like glass, it has low birefringence and can be used for demanding technical applications such as holography. This is used for 35 mm, 120/220 roll film, and some 70 mm products. The 35 and 70 mm films are generally coated on dyed base for anti-halation protection (see below). These films do not have a backing layer to balance the curl caused by the emulsion layer and use base that is treated to produce a reverse curl in manufacture. 120/220 films are generally coated onto clear base that has not had this anti-curl treatment and use a dyed gelatin backing layer to provide anti-halation protection and to reduce curl. Cellulose triacetate base is not as stable as polyethylene terephthalate base and is susceptible to a form of degradation known as "vinegar syndrome" in high-temperature, high-humidity storage conditions.

Polyethylene Terephthalate

Another important film base is polyethylene terephthalate, also known as polyester or PET. This product is much stronger than cellulose triacetate and has much better dimensional stability. As a result of this latter property it has became the base of choice for measurement applications such as aerial survey. The extra strength means that a thinner base can be used, which allows a greater length to be packed into a smaller volume. This is very useful in a number of applications but especially in high-speed photography. It is also an extremely stable plastic and is the best choice of base for images intended for very long term storage. However, a number of important drawbacks have stopped it from completely replacing the triacetate base. One is the result of the manufacturing process, where the product is stretched while it is softened by heat. This stretching locks the molecules in a fixed configuration, providing excellent dimensional stability, but resulting in birefringence that limits applicability in polarized light. Also, inferior performance compared to triacetate base, in terms of roll set curl and light piping, limits its usefulness for roll film applications; nevertheless, it is the preferred support for sheet films. It is also used for some special purpose roll films as well as some microfilms and motion picture films.

Spectral Sensitivity

Most films are panchromatically sensitized, i.e., they are sensitive to blue, green, and red light. Also available are orthochromatic films sensitive only to blue and green light, which are mainly used for copying. There are also films with extended red sensitivity used for such diverse applications as photography of the hydrogen spectral lines in solar flares or in conjunction with red filtered flash units for use in front-facing speed limit enforcement cameras and even for creative photography with deep red filters as an alternative to infrared films. Finally, there are the infrared films originally designed for scientific purposes but also widely used to produce "other-worldly" pictorial images.

Film Sensitivity

The sensitivity of a film, i.e., the amount of light required to secure a correct exposure, is often referred to as the film speed. Broadly films fall into four categories: slow- (ISO 25/15 or 50/18), medium- (ISO 100/21–200/24), high- (ISO 400/27), and ultra high-speed films. The ultra high-speed films are designed to be exposed as though they were films with a speed of ISO 1600/33 or even ISO 3200/36. However, they achieve these very high effective speeds through push-processing in speed-increasing developers and the true ISO speeds range from ISO 640/29 to ISO 1000/31. The trade-off for increasing sensitivity is increased granularity and reduced resolving power. Slower films generally have higher sharpness levels, but some of the newer technology medium-speed films can outperform them. The high-speed films and, especially, the ultra high-speed films, also offer the possibility of push-processing (see below) where they are exposed at a higher exposure index and given extended development in compensation.

Film speed is measured using a method specified in the International Standard ISO 6. This method is essentially the same as that used since the revision of the old ASA standard in 1960, which introduced what is essentially a minimum exposure criterion. This was intended to reduce graininess on negatives processed to relatively high contrast in commercial photofinishing. Only a very small proportion of black and white films are now processed in this way and many careful users processing their own films find that the effective speed is often significantly lower than the "official" ISO speed. This is often misinterpreted by users as indicating that the film speed quoted by the manufacturer is wrong; however, this is rarely the real explanation. The requirement to quote film speeds using a standard developer was dropped a number of years ago, but reputable manufacturers use popular "standard" developers such as Ilford ID11, Kodak D76, and Kodak HC110 to determine the official ISO speeds for their films. Many enthusiasts prefer to use other developers that produce lower effective speeds than the "standard" developers and to develop their films to a lower contrast, further reducing the speed. As a result, they may find that an ISO 400/27 film needs to be exposed at an exposure index of 200/24 or even 160/23 when using their preferred developer and processing time.

Push-Processing

This is a popular technique with photojournalists and other users of high-speed and ultra high-speed films working under unfavorable conditions. It involves exposing the film at a higher than usual speed rating and then giving extended development, preferably in a speed-increasing developer. The extended development increases the effective speed of the film a little and expands the density range of the negative which is then reduced by deliberate underexposure. In the days of graded papers the increased development required was that which would ensure that the negative would print on the same grade as if it had not been underexposed or, for more extreme underexposure, one or two whole grades higher. The result of this constraint on the choice of development times was often

rather grainy negatives. The advent of high-quality variable contrast papers with the flexibility of smaller contrast increments allowed the use of shorter development times giving better image quality. Indeed, for some films the manufacturers' recommendation is that no increase in development time is required for a one-stop push.

Although extravagant claims have been made for some developers marketed as suitable for push-processing, the absolute limit is a three-stop push, i.e., EI 3200/36 for an ISO 400/27 film. However, the image quality will be very poor and it is generally preferable to use an ultra high-speed film at this rating and above.

Film Design

Most films use a combination of a fast and a slow emulsion. The slow emulsion improves overexposure latitude and allows the designer to achieve the required curve shape in the highlight region of the characteristic curve. These two emulsions can be blended together and coated as a single emulsion layer or, more common, as a bipack with the slow emulsion underneath. Alternatively it can be coated as a partial blend with each emulsion layer containing both emulsions in variable proportions. Although two emulsion components is the most common design, up to four emulsions have been used in some of the modern ultra high-speed films.

Anti-halation Protection

Anti-halation protection is provided by the use of a dyed base (typically gray, blue-pink, or blue) on most 16, 35, and 70 mm films on both acetate and polyester base. 120 and 220 roll films and sheet films are coated onto clear base and have a dyed backing layer that bleaches during processing. This layer also balances out the curl imparted by the emulsion layer and can, if required, be modified to accept retouching.

Chromogenic Films

Chromogenic films, which were first introduced by Ilford and Agfa in 1980, use color film technology to produce a black and white image. These films are significantly finer grained than conventional films of the same speed, but this comes at the expense of lower sharpness. These films are increasingly popular with social photographers looking for a cost-effective way to produce black and white pictures for their customers. They vary significantly in their degree of complexity. Some use a simple bipack assembly with a blend of color couplers designed to give an essentially neutral image tone suitable for printing onto black and white paper. This is the approach that gives the best image sharpness. The arrival of chromogenic films coincided with the rise of the one-hour mini-lab, which provided users with a quick and convenient way of getting their film processed and a set of prints made on color paper. However, these films were never designed with printing onto color paper in mind, and it took some skill on the part of the mini-lab operator to get acceptably neutral prints. Also, even when this was achieved with correctly exposed negatives the

color varied on prints from under- and overexposed negatives. An alternative approach adopted by other manufacturers was to use a multi-layer assembly that prevented competition between the color couplers causing color variations. This gives a more consistent image tone and improved printing onto color paper. Typically these films are even finer grained than the simple type but at the expense of still lower sharpness. Finally, there are films designed solely for producing black and white prints on color paper. These have a distinctive yellow/orange appearance similar to a color film and produce acceptably neutral prints on color papers using the typical printer settings used for making color prints.

These films also offer the best performance for scanning, especially using less expensive film scanners, because the non-scattering dye image is more suitable for the specular light sources used.

However, in spite of all of its advantages chromogenic film has failed to supplant conventional film because of a number of significant disadvantages. For example, one of the joys of black and white photography for many users is the scope for experimentation provided by the almost inexhaustible supply of different developer formulas. Similarly, aficionados of the Zone System felt that its benefits outweighed those of the chromogenic films. There are also concerns over the permanence of dye images compared to silver images. Also counting against these films for some users is the fact that they cannot be push-processed.

Black and White Papers

Photographic papers are silver halide emulsions (silver chloride, silver bromide, or a mixture of the two) coated on to an opaque base and designed for producing black and white prints.

Overview

The drive in the development of photographic papers in the latter part of the 20th century was toward increased convenience for end users. Initially, this was about improved papers with even grade spacing and, especially, matched speeds across the grades. Later there were the first attempts to speed up processing through the use of activation/stabilization systems. However, although these systems provided very rapid processing, the prints remained unstable and needed to be conventionally fixed and washed if they were required for medium- or long-term use.

The first black and white RC papers came onto the market from about 1970 and were an immediate success. Concerns about inferior image quality and the longevity of RC prints were raised by some high-profile users, and this provoked something of a backlash against these papers. Manufacturers responded by introducing new baryta base papers aimed at the high-quality end of the market. Nevertheless, the extra convenience of RC papers proved irresistible and they became and remain the biggest selling type of paper on the market. As a result, the range of baryta base papers available shrank very significantly.

Although variable contrast papers had been around since the 1940s, they remained inferior to grade papers until significantly improved products were introduced in the late 1970s. Although these new products remained inferior to the best graded papers in terms of image quality and contrast range, the extra convenience offered by having all grades available and improved methods for exposing them ensured that sales grew very rapidly at the expense of graded papers. Intense competition between the major manufacturers ensured that the quality of variable contrast papers, both RC and fiber/baryta, improved greatly.

The final phase of the product development of variable contrast papers concentrated on products for particular niches, including warm tone papers, cold tone papers, and even a paper for commercial photofinishing.

Support

Traditional black and white papers use a paper base coated with a thick layer of barium sulfate in gelatin which prevents the emulsion from sinking into the paper base and ensures good definition. Typically these papers were manufactured in both single weight (around $135 \, \text{g/m}^2$ paper base weight) and double weight ($240–250 \, \text{g/m}^2$ paper base weight). A few specialist papers designed for the fine art print market were manufactured using an extra heavy $300 \, \text{g/m}^2$ paper base.

These baryta coated papers (also called fiber base papers in the United States) offer superb image quality and prints with excellent longevity when properly processed. However, the thick emulsion and baryta layers and the paper base absorb large quantities of processing chemicals. Ensuring good print performance requires that all the residual fixer be washed out. This takes a long time because the cellulose fibers in the base hold on to the chemicals. This gives washing times of 30 minutes or more for single weight papers and 60 minutes or more for double weight using considerable quantities of water. Water consumption and wash time can be reduced by using a soda bath or sulfite-based hypo-clearing agent, but the problem of very long drying time remains. Also, considerable effort is required to get the prints dry without excessive curl. In spite of all the disadvantages, the very high image quality and proven longevity makes baryta coated papers the first choice for photographers producing prints for sale. For commercial purposes the convenience of resin coated papers proved irresistible. These papers use a resin coated (also called polyethylene laminated) paper base that consists of a mid-weight paper (typically $180 \, \text{g/m}^2$) laminated on both sides with a thin layer of polyethylene. The face-side polyethylene layer contains a white pigment to ensure good image sharpness. The thin polyethylene layer necessitates the use of a pigment with a higher refractive index than barium sulfate, and titanium dioxide is used sometimes in combination with zinc oxide.

These papers do not absorb large quantities of processing chemicals and are quick to wash and dry. They also keep their rigidity when wet allowing very rapid processing in roller transport machines. In spite of some image quality problems with the earliest papers, the improved convenience of these

papers ensured that they were, and remain, a considerable commercial success.

Surface

Both resin coated and baryta coated papers have been produced with a variety of different surface textures and finishes. Glossy papers are coated on a base with a smooth surface. Textured surface papers such as luster or stipple are coated on a base with a textured surface. On a baryta base this is manufactured by embossing the baryta layer with a textured roller. On resin-coated papers the same effect is achieved by the use of a textured chill roller after laminating. Matt and semi-matt papers can be produced on both smooth and textured base papers by incorporating a matting agent in the supercoat layer. Starch has been used, but silica gives a better maximum density and richer blacks at the expense of a more fragile surface.

Tone and Tint

Another important characteristic of black and white photographic papers is the tone or color of the silver image, sometimes called the image color. Papers can be warm tone (with a brownish color), cold tone (with a bluish color), or essentially neutral. The color of the image is mainly determined by the design of the emulsion but can be influenced to some degree by the use of special developers. However, the high degree of control possible with some well-known and long discontinued warm tone papers is not available on modern designs. Similarly the color of the base can be altered to provide a different tint and, in the past, photographic papers were offered with a range of different base colors apart from white such as cream or ivory. These types of paper are no longer available and the base color is now normally adjusted on each paper to complement its particular image color.

Contrast Grades

Photographic papers are manufactured in a range of contrast grades or in variable contrast versions, but the term *contrast* in this context has a rather different meaning than it does when applied to film. Papers generally all have similar density ranges so what varies as the slope of the curve increases or decreases is the exposure range of the paper.

A good photographic print generally exhibits a full range of tones from very close to base white to almost black. This is achieved by choosing a paper with an exposure range (sometimes called printing capacity) that matches the effective density range of the negative. High-contrast negatives with a wide density range require a low-contrast paper with a long exposure range. Conversely, a low-contrast negative with a narrow density range requires a high-contrast paper with short exposure range. The density range of silver image negatives varies with the specularity of the light source used to print it, the degree of development, and the brightness range of the original scene. Although theory suggests that the density range of the negative, measured on the enlarger baseboard,

should be an excellent predictor of paper grade required, this is not always true. Although variations in density range due to degree of development or degree of specularity do need to be corrected, it is not always necessary or desirable to fully correct for variations in scene by brightness range. This is because rendering either very contrasty or very flat scenes as though they were of average contrast is not likely to produce a satisfactory print. This has also been confirmed by practical experience with systems designed to scan negatives to measure the density range, and with chromogenic negatives that vary less in terms of processing and are not affected by the specularity of the light source.

The number of grades available varies but general-purpose papers usually have contrast grades numbered from 0 (low-contrast, wide exposure range) to 5 (high-contrast, narrow exposure range). Contrast spacing between the grades is at the discretion of the manufacturer, but spacing them out at equal exposure range intervals is a popular design philosophy. Grades 0–4 are matched to have the same speed (measured at 0.6 density) with grade 5 half that speed. This arrangement greatly simplifies switching between grades.

Variable Contrast Papers

An increasingly popular alternative to the fixed-grade papers described above are the variable contrast papers. The first of these, Ilford Multigrade, was introduced in 1940 but it was not until the late 1970s and early 1980s that the new generation of variable contrast papers appeared that were good enough to begin supplanting fixed-grade papers in the market.

Variable contrast papers can be adjusted from low- to high-contrast by varying the color of the enlarging light. These papers behave as if they are a blend of low-contrast emulsion sensitive to green light and a high-contrast emulsion sensitive to blue light. However, a paper like this would suffer from serious deficiencies and the technology employed in all current variable contrast papers is a much more elegant solution.

The emulsion layer consists of two (or sometimes three) emulsion components blended together. Each of these components, if coated separately, would produce only a partial characteristic curve but together they produce a full curve. The emulsions are all very high in contrast but differ in their spectral sensitization. They have the same speed to blue light but have different amounts of blue-green sensitizing dye giving them different speeds to blue-green light. If the paper is exposed to blue light the composite curve is high contrast, while exposing the paper to blue-green light produces a low-contrast composite curve. Varying the relative proportions of blue to blue-green light allows the contrast to be adjusted to any intermediate contrast level.

The color of the exposing light can be changed using special filters that allow contrast to be adjusted in half-grade steps from the equivalent of grade 1 (00) to grade 5. Alternatively they can be exposed using the yellow and magenta filter channels of a colorhead or by using one of a variety of enlarger heads designed for exposing variable contrast papers. Depending on the design these can offer grade spacing in steps from a

one-half grade to as small as 1/10 of a grade. Colorheads allow the contrast to be continuously adjusted, but most will not allow the full maximum contrast of the paper to be achieved.

The benefits offered by variable contrast papers are considerable, including the ability to fine-tune the print contrast, the ability to print different areas of a print at different contrasts, and the convenience and economic benefits of having all the contrast grades available in one box. Nevertheless, there are some disadvantages, some more serious than others. These include slightly higher safelight sensitivity and lower sharpness on prints made with the low-contrast filters.

Inferior highlight rendition on prints are made with the lower contrast filters because the foot of the curve is formed by a single emulsion component. This means that prints have higher contrast in the highlights than those made on graded papers. This is a much less significant problem on the latest variable contrast papers.

Spectral Sensitivity

Fixed-grade papers are blue sensitive allowing for bright safelighting. Variable contrast papers have extended sensitivity into the blue-green and green regions of the spectrum, but the best designed paper can be used in safelighting only slightly less bright than that used for fixed-grade papers. There are also special-purpose panchromatic papers designed for making black and white prints from color negatives or for use with laser/LED/CRT digital color printers.

Chromogenic Papers

In recent years a number of panchromatic papers have been introduced that are designed for processing in the processing chemistry used for color papers. Some of these produce an essentially neutral image while others produce a sepia image. These papers allow processing labs to offer a black and white print service from color and chromogenic black and white films using the same equipment as used for color prints.

Image Stability of Resin Coated Papers

Stories of inadequate print performance have dogged black and white resin coated papers since their introduction in the early 1970s, but the very obvious advantages still ensured that these became and remain the dominant type. Many of the scare stories in circulation in the early days had no foundation and were based on a poor understanding of how this type of base is manufactured. Nevertheless, some problems with displayed prints did emerge soon after these papers were introduced. These were cracking of the face-side polyethylene layer sometimes accompanied by image oxidation in the form of red spots of more generalized brown/yellow discoloration and sometimes silver mirroring at the boundaries of high-density areas. The titanium dioxide pigment used in the face-side polyethylene layer is photoactive and produces singlet oxygen when exposed to light. These oxygen radicals attack the polyethylene molecules causing chain scission making the layer less flexible

and leading to cracking of the layer as it expands and contracts with the emulsion layer. These oxygen radicals also attack the silver image causing oxidation and the discoloration described above. The solution was to incorporate a stabilizer in the resin-coated base, either in the face-side polyethylene or in the paper core, to mop up the oxygen radicals. This modification, adopted by all the major manufacturers, eliminated the problem of base cracking but problems of image discoloration remained. Most, but not all, of these could be attributed to the effects of external atmospheric pollutants. A question remains over whether resin-coated prints framed under glass or plastic are particularly vulnerable to this base-induced oxidation, but very careful testing using frames made only from inert materials has failed to show the effect on papers made with a stabilized base.

The problem of image oxidation by atmospheric pollutants is a different issue. Anecdotally, reports of problems are more common on resin-coated prints but many more resin coated prints are made and they are often displayed in a way that would be unthinkable for a baryta/fiber base print that had taken a lot of time and effort to produce. Also, reports of discolored baryta/fiber prints have increased in recent years. Nevertheless many (but not all) experts believe that resin-coated prints are more susceptible to the effects of oxidizing pollutants than baryta/fiber base papers. The reasons for this have not been fully explained but probably relate to the use of an impermeable base that does not absorb pollutants and or oxidation products before they can cause discoloration. Also important, at least for some papers, are the design constraints required to make resin-coated papers with the required characteristics. These include a lower hardening level to increase development rate, the use of gelatin substitutes to reduce water-load and to reduce curl, and higher levels of emulsion stabilization to reduce the risk of staining in high-temperature processing. ✆

The Chemistry of Developers and the Development Processes

SCOTT WILLIAMS, PH.D.
Rochester Institute of Technology

Photography was moved from the artisan into the consumer's hands by 20th century innovations in film and paper improvements. Important events were also imaged and preserved in color, for the first time during this century, with realistic sharpness and vibrancy. Most photographic media innovations, whether on film or paper, relied on the same key element for image creation — silver. As a result, the development and fixing processes developed in the 19th century were largely carried over into the 20th century and remained, for the most part, unaltered. This essay will highlight the general schemes that were applied to the specific formulations used during this important time period of photographic history.

The fundamental photographic objective can simply be illustrated by the chemical reaction shown below.

$$Ag^+ + 1e^- \rightarrow Ag^0$$

Silver ion to silver metal conversion, by the addition of one electron, is inherent in every silver halide grain. This presented a unique challenge. To create an image-wise silver distribution, the silver formation rate of the light-exposed grain must exceed that of the non-exposed grain. Chemical development methods have been used to exploit the differential development of latent image-containing grains over non-exposed silver halide grains. Once the image is resolved, chemical solutions must be applied to remove the unwanted silver halide in the non-image areas, thus preserving the image for a useful period of time. These solutions, known as fixing solutions or "fixers," would "fix" the image, imparting the archival properties observed with these modern materials. Washing steps would then complete the photographic development process by the removal of by-products produced in the prior steps.

FIG. 6 RIT faculty member C. B. Neblette instructs a photography student on how to process film (circa 1930s). (Image courtesy of the Wallace Memorial Library Archives and Special Collections, Rochester Institute of Technology, Rochester, New York.)

Development Processes

Two general developer classes were used throughout the latter part of the 19th century through the 20th century. Developing solutions, defined as chemical compositions or solutions capable of resolving a latent image, were placed into one of the two classes based on the source of the metal ion used for image amplification. Silver was the metal of choice, but not exclusively. Other metal ion sources will be discussed below. In physical development, the metal ion source was external to the silver halide grain containing the latent image. Silver ion, for example, would be added to the developing solution when silver was to comprise the image mark. Direct, or chemical, development was reserved for those processes that would use the metal ion reserve, typically silver, present in the latent image-containing grains. Economic and stability considerations would weigh in favor of direct development as the predominant choice in commercial photographic applications.

Regardless of the developer type, developer solutions were required to possess several attributes to be commercially successful. These solutions all had to be able to reduce a metal ion to form a stable metal. The metal reduction must be selective for the light-exposed area of the medium. In the case of color photography, metal reduction was immediately followed by a color dye forming reaction, which likewise, had to result in a dye product that was stable to chemical decomposition. The developer components had to be sufficiently soluble and chemically stable with time and environmental factors such as the presence of oxygen. Finally, in all cases, the reaction by-products, that would promote time-dependent image decomposition, had to be preferably colorless and soluble to facilitate prompt removal in the finishing steps of development. Increasingly, as the art matured, there was a desire for developers to have minimal toxicity and environmental impacts.

The root reaction mechanism is also common to both developer classes as the end game is the same — metal reduction to a visible image mark. Both direct and physical development can be characterized by an electrochemical cell model involving a chemical reaction class known as redox, or reduction-oxidation, reaction. These reactions are thermodynamically selected to favor metal reduction.

A minimum of two reactants must participate in the image forming process, an oxidizing agent and a reducing agent. The metal ion, which will be reduced to a visible metal speck, is known as the oxidizing agent. Silver ion, for example, is the agent that causes developer oxidation. The reducing agent is the developing agent, or developer, which will become oxidized in this process. Although confusing at first, the main concept is that silver ion is converted to silver metal by the addition of an electron from the developer. Photographic chemists keep the term twists in order by noting that the oxidizing agent gains an electron on its way to reduction (gain of an electron is a reduction reaction, GeRR). The developer agent loses an electron in the process (loss of electron is an oxidization reaction, LeO). These reaction agents must always work together. One cannot have LeO without the GeRR, or GeRR without LeO, based on a word play off the king of beasts. The generalized reaction,

shown below, illustrates the transfer of the electron that results in a stable image metal speck.

$$\text{Metal Ion ()} + \text{Developer (e}-) \rightarrow \text{Stable Metal (e}-) + \text{Oxidized Developer ()}$$

Physical Development
The physical development method involves a metal addition reaction. In other words, the metal ion that will be used to resolve the image will be added by the photographer's careful skill. Image quality attributes can all be modulated by the principle variables in photographic development — time, temperature and agitation. In addition, for silver halide processes, physical development affords an additional control element on image quality by the choice of the metal ions selected, and whether the process would be carried out in the presence or absence of the exposed silver halide grain. The former process is known as pre-fixation physical development, and the latter, post-fixation physical development. Physical development can also be subdivided into two main areas of practice categorized by the selection of the developing agent. The most common 20th century practice was the addition of silver nitrate in the developing solution containing an organic developer, like pyrogallol; or, the addition of a silver halide solvent that will dissolve the grain providing a bath of available silver in solution, less common, but widely used for esthetic effects, are the processes that use a metal ion as the developing agent.

Using a Metal Ion Developing Agent
The generalized physical development reaction scheme is shown below.

$$M^+ + M^{n+} \rightarrow M^0 + M^{(n+1)}$$

$$\text{Example 1: } Ag^+ + M^{(n)+} \rightarrow Ag^0 + M^{(n+1)+}$$

$$\text{Example 2: } Ag^+ + Fe^{+2} \rightarrow Ag^0 + Fe^{+3}$$

There are two requirements for successful image creation using physical development. First, the developing agent must only lose one electron in the exchange; and second, the oxidized developer must be stable and soluble in the solution for proper removal. Iron is selected most often when using this method of development.

The second requirement can be satisfied by the addition of a developing compound known as a chelating agent. The primary role of the chelating agent is to aid in the solubility of the metal components. Oxalate, tartrate, citrate, and EDTA salts were often added to aid in the metal ion transport in and out of the image support. When silver was the metal added to create the image, removal of the metal-based developer agent was critical for image permanence. Implicit in the electrochemical cell model, which will be described in more detail below, the silver can be just as easily oxidized by the same developer agent that caused the silver to be reduced. Removing the oxidized developer, therefore, was one primary role for the chelating agent.

The best example of a physical development process, using a metal ion developing agent, was largely practiced by the

artisans in the 20th century. Such processes were the iron-based methods developed in the 19th century by William Herschel, which involved image formation through the addition of silver or a "noble" metal such as platinum, palladium, or gold. In these processes, the image was captured in light-sensitive iron, which was used as the developing agent to create an image with a second metal. As illustrated by the platinum-palladium process, all of the necessary components that define a successful developer work to produce an image that began in one metal and was fixed in another.

$$PtCl_4^{-2} + PdCl_4^{-2} + xFe(C_2O_4)_2^{-2} + x(C_2O_4)^{-2} \rightarrow Pt/Pd^0 + xFe(C_2O_4)_3^{-3} + 8Cl^{-1}$$

Using an Organic Developing Agent
Physical development, using a familiar organic developer and used mainly with silver halide image materials, was more common throughout the 1900s. Developing solutions were prepared either by the addition of silver nitrate or a silver halide solvent salt, such as sodium sulfite. Developers containing a significant concentration of silver halide solvent were often categorized as fine-grain developers. Two common examples of each type mentioned are listed in Table 1.

The mechanism of its action is similar to that described below using direct developers with the difference being the supply of reducible silver ion. As mentioned, the reducible silver ion, in the case of a physical developer, comes from a silver solution bath. In other words, a silver speck developed by the physical development process would comprise silver that was originally part of some other grain or prepared initially by the photographer. In direct development, the silver speck is produced from the silver content that was originally part of the same latent image grain. In general, silver-added physical developer solutions are unstable and are often prepared by adding the silver nitrate component just prior to use.

Image Quality Attributes
While physical development is used primarily for black and white film, it is more often seen in paper development processes. Grain size, morphology, and metal purity directly impact the

TABLE 1 Kodak D-23 (Fine Grain) and "Gallo-Nitrate of Silver"

Component	Kodak D-23	Gallo-Nitrate of Silver
Solution volume (final)	1000 ml	130 ml Part A + B mixed before use
Developing agent	7.5 g Metol	65 ml of pyrogallol (saturated in water)
		Part A
Grain solvent	100 g sodium sulfite	—
Silver nitrate	—	0.7 g in 65 ml of acidified water
		Part B

image quality attributes with these materials. Tone and resolution are influenced by the size and shape of the image speck. Light scatter plays the largest role in determining image tonality. How the exposed grain develops into an image metal speck is largely governed by whether the physical development process begins with the latent image still embedded with the silver halide grain or existing as a free nucleation site. Pre-fixation physical development results in silver filament growth due to the interfacial nature of the latent image and the limited access of fresh developer blocked by the silver halide grain. Image speck morphology is more varied with post-fixation. In the presence of slow time-extended development, the silver image specks can adopt a hexagonal shape. A slightly faster development rate results in rounded image silver. An elliptical image silver shape results when the development rate is increased through concentration, time, temperature, or agitation. These varying shapes will contribute to image tonality; small/rounded shapes tend toward cooler tones compared to larger/multi-sided specks, which exhibit a more neutral tonality appearance in reflective prints. As a result, physical developers are often used as tone modifiers.

Direct, or Chemical, Development

Indisputably, the predominant development method practiced in photography is the direct (or chemical) development process. In direct development, the image-forming silver originates from the silver halide grain containing the latent image site. The chemical reduction of silver ion proceeds at one or more points on a grain until the majority of the silver reserve on the grain is converted to silver metal. With direct development, grain morphology is more uniform with variations in tone mostly resulting from the extent of physical development in proportion to the grain solvent content of the developer. The greater the relative rate of direct versus physical development, the more filamentous and neutral the image tonality. Of course, the control of time, temperature, and agitation also has an impact on tone.

Kodak DK-50 is used to illustrate the typical components that comprise a photographic direct developer.

TABLE 2 Kodak Developer DK-50

Order of Addition	Name of Ingredient	Quantity	Purpose of Ingredient
1	Water, about 125°F (50°C)	750 ml	Solvent
2	Kodak Elon developing agent	2.5 g	Developing agent
3	Sodium sulfite, desiccated	30 g	Preservative
4	Hydroquinone	2.5 g	Developing agent
5	Balanced alkali (Kodak)	10 g	Alkali
6	Potassium bromide	0.5	Restrainer
7	Water to make	1 L	Solvent

The largest chemical component is the solvent, which is typically water. There is much debate as to whether the water should be deionized or straight out of the tap, and one could reconcile any position on this matter. Tap sources are cheap and readily available. If the water is too hard, however, metal-developer complexes could form resulting in staining reactions. Other experts support a view that deionized water may not be the best source because it could provoke an adverse osmotic gradient to form between the developing environment and the image gelatin. This latter position may be less likely since developers can contain as much or more salt per unit volume than that contained in the gelatin layer.

The developing, or reducing agent, is the key ingredient in a developer. Table 3 lists the names and general properties of the most popular developing agents used in chemical development processes.

Upon inspection, there are common structural properties that lend themselves to an effective developer. These common properties are governed by the Kendall-Pelz rule, which states that the general structure for a developer can be represented by the structure

$$\text{General Developer Structure: } a - (A = C)_n - b$$

where for $A = C$, a carbon, the developer is referred to as a Kendall developer; when $A = N$, a nitrogen, the developer is called a Pelz developer. The integer value of n can be from zero to any practical integer number limited largely by solubility. In most practical cases, the Kendall developer is used whereby n = 3, a benzene ring of six carbons. The lowercase a and b can be any combination of hydroxyl or amine moiety. Hydroquinone is a Kendall developer, for example, while 1-phenyl-3-pyrazolidone is a Pelz developer. Hydrazine would be an example of a hybrid n = 0 Kendall-Pelz developer, but as this compound is the active ingredient in the Space Shuttle solid rocket propellant, this molecule may not be the wisest choice for the photographic darkroom. Overall, the propensity of a developer to reduce silver ion to silver metal rest more in the side groups (a, b) rather than the fine-tuning that the heterocyclic moiety (A) places on the chemical activity. The Kendall-Pelz rule specifies that the side groups can be in either the para or ortho position on the benzene ring (the typical backbone), but not the meta position. Hydroquinone is an example of two hydroxyls substituted para to each other. Catechol illustrates an ortho example. Resorcinol, 1,3-dihydroxybenzene would seem to be a poor choice under the Kendall-Pelz rule, but in fact, this reducing agent has been used in photographic development. As a side note, by applying a generalized understanding to developer structure, any organic reducing agent that has the general developer structure may satisfy the requirement. Developers prepared from coffee and mint leaves have been successfully applied as a method of image development.

Following the addition of the developing agent to water, a preservative is added. When the preservative is sodium sulfite, which is the most common choice, two functions are performed. First, sodium sulfite preserves the solution by scavenging oxidizing agents, such as dissolved oxygen, which can

TABLE 3 Properties of the Major Developing Agents

Common Name	Hydroquinone	Chloro-hydroquinone	Catechol	Pyrogallol	para-Aminophenol	Amidol
Scientific names	1,4-dihydroxybenzene; para-dihydroxy-benzene	2-Chloro-1,4-di-hydroxybenzene; 2-chloro-1,4-benzenediol	1,2-Dihydroxy-benzene; ortho-dihydroxy-benzene	Pyrogallic acid; 1,2,3-trihydroxy-benzene; 1,2,3-benzene triol	4-Amino-1-hydroxybenzene hydrochloride; para-hydroxyaniline	2,4-Diaminophenol dihydrochloride
Commercial names	Quinol, Tecquinol, Hydroquinol	Adurol, Chloroquinol	Pyrocatechin	Piral, Pyro	Activol, Azol Kodelon, Para, Rhodinal	Acorl, Dianol
Form	Needle-shaped crystals	Needles or leaflets	Needles from water	White crystals	Freebase: plates from water. Hydrochloride salt: crystalline	Crystals
Molecular weight	110.11	144.56	110.11	126.11	Freebase: 109.12. Hydrochloride salt: 145.5	197.01
Melting point (°C)	170	103	105	131.133	Freebase: 190 Hydrochloride salt: decomposes about 306	205
Solubility in water (g in 100 ml at 20°C)	8	92	30	40	Freebase: 1.2 Hydrochloride salt: 10	25
Solubility in solvents	Soluble in alcohol and ether. Slightly soluble in benzene	Soluble in alcohol. Slightly soluble in ether and chloroform	Soluble in alcohol, benzene, chloroform, ether, pyridine	Soluble in alcohol and ether. Slightly soluble in benzene and chloroform	Freebase soluble in alcohol and ethyl methyl ketone, slightly soluble in ether, almost insoluble in benzene and chloroform. Hydrochloride salt is soluble in alcohol and slightly soluble in ether	Freebase is slightly soluble in alcohol and acetone, very slightly soluble in ether and chloroform. Hydrochloride salt is soluble in alcohol
Human toxicity	Relatively safe in very low concentrations. Ingestion of 1 g or more may cause serious complications. Contact with skin may cause dermatitis		Can cause eczematous dermatitis. Ingestion can cause very serious complications. Avoid contact with large areas of skin	Severe poisoning may result from percutaneous absorption. Inhalation can cause asthma	Can cause dermatitis and skin sensitization. Inhalation can cause asthma.	Pure compound or oxidation products may cause eczematoid contact dermatitis or bronchial asthma

	Monomethyl-para-aminophenol sulfate; para-methylamino-phenol sulfate	para-(Hydroxyphenyl) glycine; para-hydroxy-phenylamino acetic acid	para-Diaminobenzene; 1,4-diaminobenzene	L-Xyloascorbic acid; hexuronic acid	1-Phenyl-3-pyrazolidone; 1-phenyl-3-pyrazlidinone
Scientific names	Monomethyl-para-aminophenol sulfate; para-methylamino-phenol sulfate	para-(Hydroxyphenyl) glycine; para-hydroxy-phenylamino acetic acid	para-Diaminobenzene; 1,4-diaminobenzene	L-Xyloascorbic acid; hexuronic acid	1-Phenyl-3-pyrazolidone; 1-phenyl-3-pyrazlidinone
Commercial names	Elon, Genol, Graphol, Pictol, Photol, Rhodol	Athenon, Glycin, Monazol, Iconyl	Freebase: Diamine, Paramine, Metacarbol. Hydrochloride salt: Diamine H, PD.H., p.p.d.	Vitamin C, many pharmaceutical names such as Ascorin, Cevitex, Cevimin	Phenidone, Graphidone
Form	Crystal	Leaflets from water	White crystals	Crystals (plates or needles)	Leaflets or needles from benzene
Molecular weight	344.38	167.16	108.14	176.12	162.19
Melting point (°C)	Freebase: 87. Sulfate salt: 260 with decomposition	Browns at 200, begins to melt at 220, completely melted at 247 with decomposition	Freebase: 145–147. Hydrochloride salt: Decomposes without melting	190–192 some decomposition	121
Solubility in water (g in 100 ml at 20°C)	4	0.02	1	30	2
Solubility in solvents	Freebase very soluble in alcohol, ether, and hot water. Sulfate salt slightly soluble in alcohol and ether, insoluble in benzene	Low solubility in alcohol, acetone, ether, and benzene	Freebase solution in alcohol, chloroform, ether. Hydrochloride salt soluble slightly in alcohol and ether	Soluble in alcohol and propylene glycol. Insoluble in ether, chloroform, benzene	Soluble in alcohol and benzene. Almost insoluble in ether
Human toxicity	Can cause skin irritation or sensitization	—	Pure compound or oxidation products may cause eczematoid contact dermatitis or bronchial asthma	Essential vitamin in human nutrition	Low oral toxicity. No reported cases of dermatitis

degrade developer activity. Secondly, with its intrinsic metal chelating ability, sodium sulfite performs a grain solvent function in proportion to its concentration. Fine grain developers may contain as much as 15% weight per volume of sodium sulfite making it the major added component. To serve as a preservative, only a few percent would be required.

With some developers, particularly both developing agents listed above for Kodak DK-50, sulfites are known to undergo a substitution reaction that inhibits the formation of quinones; thereby, providing yet another preservative function. In early Technicolor applications, quinone formation was desired to promote tanning reactions. The formation of quinone and semi-quinone intermediates is also a key requirement in modern chromogenic color process. In black and white applications, this formation is undesirable as quinones self-react to form polymeric products that may result in brown stain formation. Sulfites do find their way into chromogenic formulas, but they are typically in concentrations that primarily serve the scavenger function. Other sulfite salts are selected such as sodium metabisulfite as well as the potassium form of these additives.

A buffering agent, also known as an accelerator, is typically added next. The accelerator function is self-explanatory. The developing agents are most active in their anionic state, in the case of those developers comprising a hydroxyl group; and in a neutrally charged state for the amine class. In either case, the preferred state is a form of the developing agent that raises the propensity for the developer to deliver its electrons for silver reduction. The ionization sweet spot corresponds to the developer's ionization constant or pKa (negative log of the acid dissociation constant). A simple experiment can be conducted whereby strips of black and white film, all similarly exposed, are developed in a series of developing solutions of increasing pH (negative log of the hydronium ion concentration) from a pH of 5 to 14. For hydroquinone, there will be two pH values whereby a dramatic increase in activity results. The two regions roughly correspond to the two pKas ($pKa_1 = 10$ and $pKa_2 = 11.6$, one for each hydroxyl group) that exist for the molecule. Therefore, by modulating the pH, developer activity can be varied by pH control. A popular choice for a buffering, or accelerating, agent is sodium tetraborate (Borax). Borax, however, has a tendency to cake upon storage. This led Kodak to develop its Kodalk alternative which is sodium metaborate. Sodium carbonate may also be used, but this choice may promote blistering processes to occur through the formation of carbon dioxide release with variations in temperature. Phosphate salts, although excellent buffering agents, provide a rather healthy medium for biological activity that would reduce the shelf-life of the developer.

A final ingredient falls into a class of compounds known as restrainers. As the name suggests, restrainers serve to impart fine control over the development process. Their effect is greatest in the highlight region. A typical restrainer is potassium bromide, but organic restrainers (also called anti-foggants) have been used, such as benzotriazole. Organic

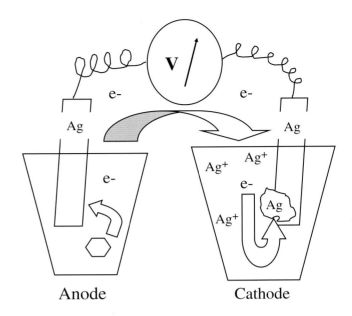

FIG. 7 Electrochemical cell model.

restrainers inhibit development through an absorption process that impedes developer access to the exposed latent image site. Organic restrainers are very efficient and used in sparingly low concentrations in the developer formula. Potassium bromide works by a mass action process that favors the formation of silver bromide as opposed to silver metal development. Potassium bromide is cheaper to use, soluble, and has a better health and environmental impact perspective than its organic alternatives.

Mechanism of Action

Electrochemical and adsorption catalysis models are the two theories that detail the mechanism of photographic development. The electrochemical model is the most likely model from a kinetic and thermodynamic viewpoint (see Figure 7).

In the electrochemical model, photographic development can be viewed in the same way a battery or galvanic works. On the anode, or negative pole, a silver metal pole is suspended into a solution of photographic developer. The silver metal pole would represent the silver latent image site on a silver halide grain. The developer adsorbs onto the latent image site and becomes oxidized via electron transfer to the silver metal pole. The electron travels down the "wire," the bulk of the latent image site, until it encounters a silver metal ion. Silver mobility is facilitated by the migration of halide ion into the developer solution. The silver metal ion, in close proximity to the silver latent image site, receives the electron, thereby, becoming reduced. The macroscopic effect would be a growth of silver on the surface of the cathode, the positive pole. Silver

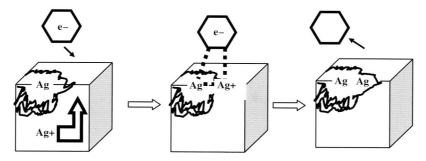

FIG. 8 Absorption catalysis model.

would continue to collect onto the cathode silver until either all the silver ions are used up or all of the developer becomes depleted. These two conditions are satisfied in the microscopic example of a silver halide grain during development.

The less likely model, for kinetic reasons, is the adsorption catalysis theory (see Figure 8). The process and end result are not that much different than the electrochemical model except that there is a point in the process whereby a transient developer-silver ion complex forms on the surface of the latent image site. The silver metal catalyzes the concerted transformation from silver ion to silver metal. Concerted reactions are very rare in nature, but plausible.

In either case, the reaction is believed to involve the adsorption of a developer molecule to the latent image surface. In this process, a thin layer of developer molecules are oxidized and diffused away or are made anew by the oxidation of a fresh developer that happens to move into close proximity to the oxidized developer lying directly in contact with the latent image site. The activity difference between Metol or phenidone compared to hydroquinone is largely due to the surfactant properties of each developing agent. Even though hydroquinone is superior to Metol as an electron donor, Metol adsorbs onto silver metal more strongly than hydroquinone. As a result, Metol is said to be an excellent shadow developer (in reference to the characteristic curve). Notice in the formulae, however, that these two developing agents are used and work better together than the sum of their separate activities. This is known as superadditive development, and is the reason why developing agent combinations are common. One developing agent is superior at latent image adsorption while the other serves to keep the adsorbed developer replenished with a supply of electrons. Once the silver image speck grows large enough for the stronger electron donor to take over, the development rate dramatically increases.

Color Development

Color development has been practiced primarily using two different schemes. The largest application involved the color photographic process known as chromogenic development. Chromogenic development may be further categorized into color negative and color positive processes. The primary alternative process was known as silver-dye bleach which will be discussed in a separate section. Early and fine art color prints were also developed using color separation dye transfer processes, but these will not be discussed in this section. Instant photographic methods, which rely on dye migration, will also be featured in the section on Color Photography.

Chromogenic color development takes advantage of the by-products of silver halide chemical development and may involve as many as 14 to 16 different chemical solution or exposure applications. The first step(s) in chromogenic development requires a black and white development function. Consider, as an example, the making of an image of a black and white chessboard. If the capture medium was a color negative material, the first step would be a black and white development in proportion to the amount of exposure in each of the spectrally sensitized color subtractive layers. In the case of the chessboard, the white squares would be rendered by equal neutral densities in each of the cyan, magenta, and yellow layers. There would be no silver density development in the black square regions, hence a negative material. Chromogenic color develops alongside silver development by the formation of a color dye via a reaction between the oxidized developing agent, typically derivatives based on the Kendall developer para-phenylenediamine, and an incorporated color coupler. Incorporated color coupler refers to a pre-dye that is added in the emulsion upon manufacture and is only activated upon reaction with oxidized developer in the proximity of a silver image speck. For example, a cyan dye is resolved by a reaction between the oxidized developer, known as a quinonediamine, and the incorporated pre-dye 1-napthanol. The development is then stopped by an acid bath application. The silver is then removed by a bleach-fix (BLIX) step that involves the conversion of the silver back to silver halide followed by a fixing, or removal of the silver halide. In the case of the chessboard, the visual density on the negative material would appear neutral. By measuring the color densities, one would find about equal red, green, and blue color densities corresponding to equal formations of cyan, magenta, and yellow dye, respectively, in each of the color layers of the medium. The commercial applications of this type of color

negative film development are usually referred to as C-41 (Kodak), CN-16 (Fuji), and AP-70 (Agfa). Color print development applications are referred to by the names RA-4 (Kodak) and MP45 AC (Fuji), for example.

Chromogenic color positive development, such as that used to produce color slides, involves a similar development scheme to color negative development except that a reversal strategy is applied. Consider, again, the image making of a black and white chessboard using a color positive material, such as Ektachrome (Kodak) or Velvia (Fuji). These materials possess similar incorporated color pre-dye stuffs, in each of the emulsions layers, similar to those found in color negative materials lying in wait for an oxidized developer. After exposure, a black and white developer, using developing agents that will not react with the color coupler component such as hydroquinone and phenidone, is applied and used to fully develop the material. The development is then stopped and rinsed leaving a black and white negative image of the chessboard. At this stage, the non-image silver halide is still present on the medium. The color positive material is then uniformly exposed to white light exposing only the remaining non-image silver halide. This uniform exposure is then resolved by development using similar color developing agents, for example, derivatives of para-phenylenediamine, capable of reacting with the incorporated pre-dye stuffs. The steps following color development are similar to those described for the color negative processes. What remains, after washing, is a color positive. In this case, neutral densities corresponding to the black squares comprised of equal spectral contributions of cyan, magenta, and yellow dyestuffs in their incorporated layers. The most common commercial application of this type of development is usually referred to as an E-6 process. The Kodachrome process is similar to E-6, but with two main variations on the theme. One, the pre-dyes are not incorporated into the sensitized emulsions which requires that they be added during development, thereby two, creating many more steps than is typically practiced in E-6 development. Kodachrome processing may involve as many as 14 steps requiring carefully controlled, expert applications for a successful image.

At the heart of chromogenic development is the reaction between oxidized developer and a pre-dye creating a colored product. Formation of the oxidized form of the color developer, usually a derivative of quinonediamine, requires the reduction of two silver atoms. Depending on the pre-dye selected, the reaction of the oxidized developer with the pre-dye is immediately followed by the intramolecular conversion to the visible dye form. The pre-dye that promotes this type of color formation is known as a two-equivalent coupler. There is, however, a class of couplers that, once the reaction between the oxidized developer and pre-dye occurs, forms a colorless or "leuco" dye. To convert the leuco dye to a color dye, a reaction between the leuco dye and another oxidized developer agent is required. Since two oxidized developer agents, each formed from the reduction of two silver ions, are required per color dye formed, those couplers are referred to as four-equivalent color couplers.

These nuances, associated with the color couplers, relate more to technology incorporated into the color photographic medium and not part of the developer formulation. Other development regulating strategies are also built into the film or paper base such as development inhibition releasing (DIR) couplers or agents. DIR couplers are molecular systems that release a silver development inhibitor upon photographic development and serve to regulate the rate of oxidized developer-color coupler reaction by scavenging the oxidized developer in proportion to the development rate. These strategies have been used to fine-tune the color-forming process in these materials.

Post-Development Processes
Stop Bath
To arrest the photographic development process, one must adjust the one key condition making development possible, pH. A stop bath is a simple solution of acidic pH. In the presence of an acidic pH (less than seven), the propensity for electron transfer by the developing agents is greatly reduced, and the gelatin returns to a pre-development, non-swollen state slowing solution permeation. These two changes serve to immediately stop development, as well as prepare the photographic medium for the fixing step. Another name for this solution is short stop. Stop bath is typically a 3 percent solution of acetic acid in water. The vinegar smell in the darkroom may be attributed to this photographic solution. The reported acetic acid concentrations in water have ranged from 1 to 5 percent, but the exact concentration is not critical. What is critical is the pH maintenance in the region of pKa for acetic acid, which is 4.75. To monitor pH condition, an indicator stop bath is commonly selected. Indicator stop bath is an aqueous acetic acid solution with the addition of less than one-tenth of a percent of bromocresol purple indicator dye. This dye turns from a pink color, in acidic conditions, to an increasingly purple hue in alkaline conditions.

Fixation
Fixation is the step whereby the unused silver salts are removed for image permanence. The active ingredient in these solutions are silver salt solvents that work by forming water-soluble chelating complexes. The active ingredients, therefore, are typically thiosulfate salts, but other ingredients such as urea, ammonia, and cyanide salts have been used. A typical fixer solution comprised of sodium thiosulfate (hypo) is listed below. Sulfite addition, which is a grain solvent function, produces a slightly acidic solution pH. As shown in the formula, the hypo concentration can be as high as 20 to 30 percent.

TABLE 4 Simple Acid Fixer

Sodium thiosulfate	8–10 ounces, 200–300 g
Sodium bisulfite or potassium metabisulfite	1 ounce, 25 g
Water to make	40 fluid ounces, 1 liter

TABLE 5 Potassium Alum Fixer

Sodium thiosulfate (5 H_2O)	240 g
Sodium sulfite, anhydrous	15 g
Boric acid	7.5 g
Acetic acid, 28%	48 ml
Potassium alum	15 g
Water to make	1 liter

TABLE 6 Rapid Fixer

Ammonium thiosulfate	135 g
Boric acid	7 g
Sodium acetate	10 g
Sodium metabisulfite	5 g
Sodium sulfite	6 g
Water to make	1 liter

There are several popular fixer solution variations that are selected for permanence reasons.

When aggressive development strategies are used with high temperature or pH, a hardening fixer may be selected. These fixer compositions often comprise organic or inorganic hardening agents to help maintain gelatin emulsion layer structural integrity. The potassium alum fixer composition is one such fixer composition (see Table 5).

Potassium alum is the dodecahydrate salt of potassium aluminum sulfate ($KAl(SO_4)_2 \cdot 12(H_2O)$) and works by forming intermolecular cross-links with neighboring gelatin chains, thereby providing enhanced molecular-level support.

Rapid fixer is the most common fixer composition, and takes advantage of the solvation properties of thiosulfate with those of ammonium ion. This buffered solution is shown below with ammonium thiosulfate as a key ingredient (see Table 6).

Rapid fixer is more efficient, and therefore faster (more rapid), at removing silver salts than its hypo variation.

Photographic emulsion exposure to fixer solutions must be well monitored. Since sulfur compounds are found in every one of these fixer formulations, they may impart some silver sulfide toning quality to the image. Fixer solution contact with acidic conditions also may cause the liberation of hydrogen sulfide (the rotten egg smell) gas presenting the need for adequate darkroom ventilation. Excessive exposure to fixer may also cause silver bleaching to occur in the image highlight regions.

The mechanism of action for the hypo-fixing process is shown below.

$$m\ Ag^+ + n\ S_2O_3^{2-} \xrightarrow{\hspace{2cm}} [Ag_m(S_2O_3)_n]^{(2n-m)-}$$

Soluble argentothiosulfate complexes are formed and are subsequently removed from the emulsion. When the silver concentration becomes too large, through repeated use of the fixer solution, the reaction no longer favors complex formation, which results in a longer clearing time. Clearing time refers to the time required for a strip of photographic film to be dipped into the fixer solution, and the time required for the base to become transparent or visible. Generally, when the required time to clear a piece of film doubles, the solution should be discarded by one of the several silver reclamation procedures. Spent fixer must never enter the environmental waste stream. A 5 percent potassium iodide solution test is also conducted whereby 1 ml of the potassium iodide solution is mixed with 25 ml of fixer solution. If the resulting cloudy solution, newly formed silver iodide, does not re-dissolve upon shaking the mixture, the solution should be replaced.

Washing

Washing the photographic media in a rinsing solution, or water, is important to ensure the removal of development by-products. Archival image quality may directly depend on the efficiency of the removal of deleterious chemicals. The washing solutions, washer configurations, and washing time will be selected based on the need for archival products and the type of medium washed. The table below illustrates the recommended length of washing times for various photographic media.

	Without Hypo-Clearing (minutes)	With Hypo-Clearing (minutes)
Films	20–30	5
Resin coated paper	4	Not recommended
Single-weight fiber-based paper	60	10
Double-weight fiber-based paper	120	20

Hypo-clearing agents are used to improve the efficiency of thiosulfate removal. Hypo-clearing agents include 2 percent sodium sulfite as well as low concentration citrate and sulfate salts. Acidified silver nitrate solutions may be prepared to test for the presence of residual thiosulfate, remaining on a print, through the formation of brown silver sulfide stains. The stain density may be related to the efficiency of the washing step. The acidified solution is typically 7 g of silver nitrate dissolved in a 100 ml of 3 percent acetic acid aqueous solution.

Toning

Black and white print tone may be varied through the application of a toning procedure. Toning procedures are typically

conducted on a black and white fiber-based print after careful and complete washing; however, there are toning baths that may be added at the development or pre-fixation stage. Toning may be segregated into four main categories: metal replacement, silver salt toning, metal ferricyanide toning, and dye toning.

Gold and mercury toning would be a metal replacement example where some silver is oxidized in favor of the reduction of some other metal such as gold. The gold tonality would be added by the coexistence of the two metals within the same image speck. The more popular methods of toning involve the conversion of the silver image into a stable silver salt. Sepia and selenium toning are two examples of the silver converting into a stable silver sulfide or selenide salt, respectively. Metal ferricyanide toning processes are performed by the conversion of silver into a silver ferricyanide complex followed by subsequent conversion to a ferricyanide salt of a different metal such as copper, uranium, and iron.

Dye toning methods involve the formation of a dye cloud in proximate juxtaposition with the silver image spec. These methods use a procedure similar to the dye coupler strategies discussed with color development such as the K-14 Kodachrome process. A black and white print would be bleached, under room light, in a re-halogenating bleach. Redevelopment would then occur using a color developer solution, such as that used for the Kodak RA-4 process, with the dropwise addition of a color coupler dissolved in a volatile solvent such as acetone. The silver would remain to contribute to the image tone. ◎

From Exposure to Print: The Essentials of Silver-Halide Photography Required for Long-Lasting, High-Quality Prints

RALPH W. LAMBRECHT, M.E. ARPS
Independent Writer and Photographer[1]

Photography has significantly matured in a variety of ways since its official invention in 1839. Nevertheless, the basic principle of using a negative and positive to create the final image has dominated analog photography since the invention of the calotype process by William Henry Fox Talbot in 1841.

The calotype process had the great advantage over the earlier daguerreotypes in that it allowed for multiple copies of the same image, but at the unfortunate cost of inferior image quality. The process used an intermediate paper negative, which was first waxed, to make translucent, before it was contact printed onto sensitized paper to produce the final positive image.

[1]Portions of this essay were originally published in *Way Beyond Monochrome*. Reprinted Courtesy of Fountain Press, Newpro UK Limited, Faringdon, United Kingdom.

Glass, being almost transparent, would have been a far better material choice for a negative carrier. However, this was not a viable alternative until 1851, when Frederick Scott Archer discovered the means of coating glass sheets with a light-sensitive emulsion, which had to be exposed while still wet. His collodion wet plate process was not improved until 1871, when Richard Maddox discovered a way to coat glass plates with a silver emulsion, using gelatin, which resulted in the more convenient dry plate process.

The invention of celluloid allowed for the introduction of the first flexible film in 1889, and clear polyester polymers eventually replaced celluloid in the 20th century, providing a safe and stable substrate for silver-gelatin emulsions. These and other material advances aside, the fundamentals of creating silver-based images have not changed much since 1841, but modern image quality can be far superior to the humble beginnings of photography, if appropriate exposure and processing techniques are respected.

Image Quality

Good image quality is required to support the visual expression of a valuable photograph. An interesting photograph, well composed and filled with captivating impact, but technically executed poorly, does not do the subject or the photographer justice. A photograph of high technical image quality has excellent tonal reproduction throughout the tonal range. This includes the following:

1. Specular highlights have no density and are reproduced as pure paper-white, adding brilliance. Diffuse highlights are bright and have a delicate gradation with clear tonal separation, without looking dull or dirty.
2. There is good separation, due to high local contrast, throughout the mid-tones, clearly separating them from highlights and shadows.
3. Shadow tones are subtle in contrast and detail, but without getting too dark under intended lighting conditions. The image includes small areas of deepest paper-black without visible detail, providing a tonal foundation.

Good image quality is secured by every step in the photographic process. In the preparation phase, image quality depends on the right selection of negative format, film material, camera equipment, and accessories. In the execution phase, it depends on subject lighting, film exposure, contrast control, and the skilled handling of reliable tools. In the processing phase, the goal is to first develop a "perfect" negative, and then from it, a "fine" print.

Negative Quality

It is quite possible to create a decent print from a mediocre negative, employing some darkroom salvaging techniques, but a good print can only come from a good negative. Taking focus and adequate depth of field for granted, film exposure and development are the most significant controls of negative

quality. Consequently, a good negative is one that came from a properly exposed and developed film. Proper exposure ensures that the shadow areas have received sufficient light to render full detail. Proper development makes certain that the highlight areas gain tolerable density for the negative to print well on normal grade paper.

The photographers of the 19th century were already well aware of the basic influence of exposure and development on negative quality. They knew that the shadow density of a negative is largely controlled by the film exposure, whereas the highlight density depends more on the length of development time. These early photographers summed up their experience by creating the basic rule of photographic film and negative process control, "expose for the shadows and develop for the highlights."

Film Exposure

In technical terms, photographic exposure is the product of light intensity and the time of irradiation. In practical terms, exposure is the first step in securing negative quality and largely responsible for negative density. The goal is to provide adequate shadow density, allowing the shadows to be rendered with appropriate detail in the print. Exposure controls shadow detail!

In all but a few cases, the photographer has full control over balancing the light intensity reaching the film and the time of exposure. If, for example, a given lighting condition does not provide enough exposure, the aperture could be opened to increase the light intensity, the shutter speed could be changed to increase the exposure duration, or a more sensitive film could be used. Light intensity and exposure time have a reciprocal relationship: as one is increased and the other decreased by the same factor, the exposure remains constant. Consequently, the mathematical relationship of light intensity and time of irradiation is called the Reciprocity Law, and any deviation from it is referred to as reciprocity failure.

The Reciprocity Law only applies to a limited range of exposure times. Outside of this range, it fails for different reasons. At very brief exposure times, the time is too short to initiate a stable latent image, and at very long exposure times, the fragile latent image partially oxidizes before it reaches a stable state. In both cases, total exposure must be increased to avoid underexposure. As reciprocity failure deviates from one type of emulsion to the next, it is recommended to determine the required reciprocity compensation for a specific film through a series of tests.

Irrespective of our best efforts, exposure variability is unavoidable, due to various reasons. Shutters, apertures, and light meters operate within tolerances; lighting conditions are not entirely stable; films do not respond consistently at all temperatures and all levels of illumination; and no matter how hard we try, there is always some variation in film processing. Sometimes the photographer is fortunate, and the variations cancel each other out; other times, they unfortunately add up.

Conveniently, modern films are rather forgiving to overexposure. The "film exposure scale" is the total range of

exposures, within which, film is capable of rendering differences in subject brightness as identifiable density differences. Compared to the subject brightness range (SBR) of an average outdoor scene (about 7 stops), the typical film exposure scale is huge (15 stops or more). However, the entire exposure scale is not suitable for quality photographic images. The exposure extremes in the "toe" and "shoulder" areas of the characteristic curve exhibit only minute density differences for significant exposure differences, providing little or no tonal differentiation or contrast. Therefore, the useful exposure range, suitable for recording quality photographic images, is somewhat smaller than the total exposure range. Still, it is significantly larger than the normal subject brightness range, and consequently, offers leeway or latitude for exposure and processing errors. The limits of this film exposure latitude depend on how much image detail is required in shadows and highlights to consider it a quality print. For practical photography, the film exposure latitude is defined as the range of exposures over which a photographic film yields images of acceptable quality. Most modern films have an exposure latitude of 10 stops or more after normal processing.

Strictly speaking, film has only latitude toward overexposure keeping shadow exposure constant. Ignoring a slight increase in grain size, there is no loss of visible image quality with overexposure, unless the overexposure is exorbitant, at which point enlarging times become excessively long. Film has no latitude toward underexposure, because film speed is defined as the minimum exposure required to create adequate shadow density. Underexposed film does not have adequate shadow density. Practically speaking, however, film has some underexposure latitude, if we are willing to sacrifice image quality. For example, a loss in image quality might be tolerated, where any image is better than none, as might be the case in sports, news, or surveillance photography.

The images in Figure 9 illustrate the influence of under- and overexposure on image quality. All prints were made of negatives from the same role of film, and consequently, received the same development. The base print (ASA 400) was made from a negative exposed according to the manufacturer's recommendation. The other six prints were made from negatives that have been under- and overexposed by 2, 4, and 6 stops. In these prints, highlight densities were kept consistent through print exposure, and an effort was made to keep shadow densities as consistent as possible by modifying print contrast. Prints from the overexposed negatives ($+2$, $+4$, and $+6$ stops) show no adverse effect on image quality. Actually, the opposite is true, because shadow detail increases with overexposure in these prints. On the other hand, prints from the underexposed negatives show a significant loss of image quality (-2 stops), an unacceptable low-quality print (-4 stops), and the loss of almost all image detail (-6 stops). Practically speaking, film has far more latitude toward overexposure than underexposure.

The aim is to be accurate with exposure, knowing that there is some exposure latitude to compensate for error and variation. However, print quality is not negatively affected by

FIG. 9 These images illustrate the influence of under- and overexposure on image quality. All prints were made of negatives from the same role of film, highlight densities were kept consistent through print exposure, and an effort was made to keep shadow densities consistent by modifying print contrast. Prints from the overexposed negatives show no negative effect on image quality. Prints from the underexposed negatives show a significant loss of image quality. (Images courtesy of Ralph W. Lambrecht.)

overexposure, but is very sensitive to underexposure. Consequently, when in doubt, it is better to overexpose.

Negative Development and Contrast Control

Film development is the final step in securing a quality negative. Unlike print processing, we rarely get the opportunity to repeat film exposure and development, if the results are below expectations. To prevent disappointment, film processing needs to be controlled tightly. Otherwise, fading moments could be lost forever. Once film exposure and development is mastered, formerly unavailable manipulation possibilities allow us to manage the most challenging lighting conditions. Many photographers value the negative far higher than a print, given the fact that not just multiple copies, but in addition, multiple interpretations of the same scene are possible from just one negative.

Film Processing in General

The light reaching the film during exposure has left a modified electrical charge within the light-sensitive silver halides of the emulsion. This change is invisible to the human eye, and therefore, leaves only a so-called "latent image," but it has prepared the emulsion to be responsive to developer chemicals. These chemicals convert the exposed silver halides to metallic silver, but unexposed silver halides remain unchanged. Highlight areas with elevated exposure levels develop more metallic silver than shadow areas, where exposure was low. Consequently, highlight areas develop to a higher transmission density than shadows, and a negative image can be made visible on the film through the action of the developer. For this negative to be of practical use, the remaining and still light-sensitive silver halides must be removed without affecting the metallic silver image. This is the essential function of the fixer, which is available

either as sodium or ammonium thiosulfate. The fixer converts unexposed silver halide to soluble silver thiosulfate, ensuring that it is washed from the emulsion. The metallic silver, creating the negative image, remains. Figure 10 illustrates a complete film processing sequence.

Developers and Water

The variety of film developers available is bewildering. The search for a miracle potion is probably almost as old as photography itself, and listening to advertising claims or enthusiastic darkroom alchemists, may bring more confusion than enlightenment. An arsenal of too many chemical alternatives is often just an impatient response to disappointing initial attempts or immature and inconsistent technique. It is far better to improve craftsmanship and final results with repeated practice and meticulous record keeping for any given combination of proven materials before blaming it on the wrong material characteristics. There are no miracle potions!

Nevertheless, film developer is a most critical element in film processing. A recommendation, based on practical experience, is to begin with proven standard film developers like D76 (Kodak), ID11 (Ilford), or Rodinal (Agfa) and stick to a supplier-proposed dilution. This offers an appropriate compromise between sharpness, grain, and film speed for standard pictorial photography. Unless you have reason to doubt your municipal water quality or consistency, you should be able to use it with any developer. However, distilled or deionized water is an alternative, providing additional consistency, especially if you develop film at different locations. Filters may be used to clean tap water from physical contaminants.

Characteristic Curve, Contrast, and Average Gradient

Film characteristic curves are used to demonstrate material and processing influences on tonal reproduction, and they illustrate the relationship between exposure and developed film densities. However, there is need for a quantitative method to evaluate and compare characteristic curves. Over the years, many methods have been proposed, mainly for the purpose of defining and measuring film speed. Several have been found to be inadequate or not representative of modern materials and have since been abandoned. The slightly different methods used by Agfa, Ilford, Kodak, and the current ISO standard are all based on the same "average gradient" method.

Negative contrast is defined as negative density increase per unit of exposure. The same exposure range can differ in negative density increase according to the local shape of the characteristic curve. Toe and shoulder of the curve have a relatively low increase in density signified by a gentle slope or gradient, and the gradient is steepest in the midsection of the curve. These local gradients are a direct measure of local negative contrast, but a set of multiple numbers would be required to characterize an entire curve (Figure 11a).

The average gradient method on the other hand, identifies just two points on the characteristic curve to represent significant shadow and highlight detail, as seen in Figure 11b. Here a straight line, connecting these two points, is evaluated on behalf of the entire characteristic curve, while fulfilling its function of averaging all local gradients between shadows and highlights. The slope of this line is the average gradient and a direct indicator of the film's overall contrast. It can be calculated from the ratio a/b, which is the ratio of negative density range over log exposure. The average gradient method is universally accepted, but the consequences of selecting the end points are rather critical and different intentions have always been a source of heated discussion among manufacturers, standardization committees, and practical photographers. A practical method to deal with this problem is shown later in this text.

Time of Development

Exposure is largely responsible for negative density, but film development controls the difference between shadow and highlight density and therefore, the negative contrast. The main variables are time, temperature, and agitation, and controlling development precisely requires that these variables be controlled equally well. Data sheets provide starting points for developing times and film speeds, but complete control can only be achieved through individual film testing.

With increased development time, all film areas, including the unexposed base, increase in negative density, but at considerably different rates. The shadow densities increase only marginally, even when development times are quadrupled, where simultaneously, highlight densities increase significantly (Figure 12). This effect is key to harnessing subject brightness range and a way to keep the negative density range constant, allowing the printing of many lighting conditions on a single grade of paper with ease. Other paper grades are not used to compensate for difficult-to-print negative densities anymore, but are left for creative image interpretation. Development controls negative contrast!

Normal, Contraction, and Expansion Development

Normal development creates a negative of normal average gradient and contrast. A negative is considered to have normal contrast if it prints with ease on a grade 2 paper. An enlarger with a diffused light source fulfills the above condition if the negative has an average gradient of around 0.57. A condenser enlarger requires a lower average gradient to produce an identical print on the same grade of paper.

In a low-contrast lighting condition, the normal gradient produces a flat negative with too small a density difference between shadows and highlights, and the average gradient must be increased to print well on normal paper. In a high-contrast lighting condition, the normal gradient produces a harsh negative with a negative density range too high for normal paper, and the average gradient must be decreased. Either increasing or decreasing the development time can achieve the desired average gradient, but the appropriate development times must be determined through careful film testing.

processing step		time [min]	film processing	comments
0	Pre-Soak	3 - 5	Prepare the film with an optional water soak at processing temperature.	A water soak prior to film development brings processing tank, spiral and film to operating temperature. It also enables and supports even development with short processing times.
1	Developer	4 - 16	Develop in inversion tank at constant agitation for the first minute, then give 3 - 5 inversions every 30 seconds for the first 10 minutes and once a minute thereafter. Alternatively, develop in film processor with constant agitation. Control the developer temperature within 1°C, and use the developer one-time only, or track developer activity for consistent development.	After filling with developer, tap tank bottom against a solid surface to dislodge any air bubbles. Development time is dictated by the negative density required for the highlights and varies with film, developer, processing temperature, rate of agitation and water quality. Supplier recommendations can serve as a starting point, but precise development times must be obtained through individual film testing. Times below 4 minutes can cause uneven development, but negative fog density increases with development time. A consistent regime is important for consistent results. Only the exposed portion of the original silver halide emulsion is reduced to metallic silver during the development of the negative. The remaining, unexposed and still insoluble portion of the silver halide impairs both, the immediate usefulness of the negative and its permanence, and hence must be removed.
2	Stop Bath	1	Use at half the supplier recommended strength for paper and agitate constantly. Relax temperature control to be within 2°C of developer temperature until wash.	The stop bath is a dilute solution of acetic or citric acids. It neutralizes the alkaline developer quickly and brings development to a complete stop. However, the formation of unwanted gas bubbles in the emulsion is possible with some unusual film developers (carbonate). This is prevented with a preceding water rinse.
3	1st Fix	2 - 5	Use sodium or ammonium thiosulfate fixers without hardener at film strength. Agitate constantly or every 30 seconds in inversion tank. Use the shorter time for conventional films and rapid fixers, and the longer time for modern T-Grain emulsions or sodium thiosulfate fixers. Monitor silver thiosulfate levels of 1st fix to be below 3 g/l, or use fresh fixer every time. Always use fresh fixer for 2nd fix.	In the fixing process, residual silver halide is converted to silver thiosulfate without damaging the metallic silver of the image. The first fixing bath does most of the work, but it is quickly contaminated by the now soluble silver thiosulfate and its complexes. Soon the entire chain of complex chemical reactions can not be completed successfully, and the capacity limit of the first fixing bath is reached. A fresh second bath ensures that all silver halides and any remaining silver thiosulfate complexes are rendered soluble. Fixing time must be long enough to render all residual silver halides soluble, but extended fixing times are not as critical as with papers. The conventional test to find the appropriate time for any film/fixer combination in question is conducted with a sample piece of film, which is fixed until the film clears and the clearing time is doubled or tripled for safety.
4	2nd Fix	2 - 5		
5	Wash	4 - 10	Remove excess fixer prior to toning to avoid staining and shadow loss. The choice of toner dictates the washing time.	Excess fixer causes staining and shadow loss with some toners. This step removes enough fixer to avoid this problem. For selenium toning, a brief 4-minute wash is sufficient, but direct sulfide toning requires a 10-minute wash.
6	Toner	1 - 2	For full archival protection, tone for 1 min in sulfide or 2 min in selenium toner and agitate frequently.	Brief toning in sulfide, selenium or gold toner is essential for archival processing. It will convert sensitive negative silver to more stable silver compounds. Process time depends on type of toner used and the level of protection required.
7	Rinse	1	Wash briefly to remove excess fixer and to prolong washing aid life.	Residual fixer contaminates the washing aid and reduces its effectiveness. This step removes enough fixer to increase washing aid capacity.
8	Washing Aid	2	Dilute according to supplier recommendation and agitate regularly.	This process step is highly recommended for film processing. It makes residual fixer and its by-products more soluble, and reduces final washing time significantly.
9	Wash	10 - 30	Regulate the water flow to secure a complete water exchange 4 - 6 times per minute, and relax the temperature control to be within 3°C of developer temperature. Drain entire tank every 2 1/2 minutes.	The fixed negative contains considerable amounts of fixer together with small, but not negligible, amounts of soluble silver thiosulfate complexes. The purpose of washing is to reduce these chemicals to miniscule archival levels, and thereby, significantly improve the stability of the silver image. Film longevity is inversely proportional to the residual fixer in the film. However, traces of residual fixer may actually be helpful in protecting the image.
10	Drying Aid	1	Use a drying aid as directed, or use a mixture of alcohol and distilled water (1+4).	Using distilled or deionized water will leave a clear film base without intolerable water marks. Replacing some water with more readily evaporating alcohol will speed up drying.

FIG. 10 Your negatives are valuable, and maximum permanence is achieved if these processing recommendations are considered.

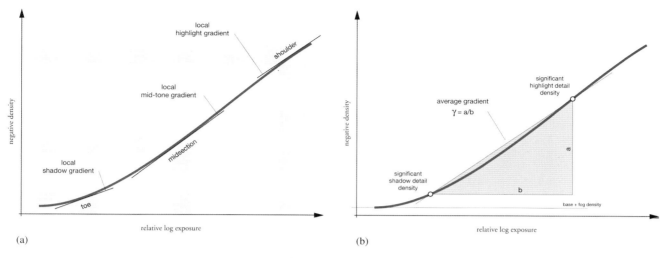

(a)

(b)

FIG. 11 (a) Negative contrast is defined as negative density increase per unit of exposure. The same exposure range can differ in negative density increase according to the local shape of the characteristic curve. The local slope, or gradient, is a direct measure of local negative contrast. (b) The average gradient method identifies two points on the characteristic curve representing significant shadow and highlight detail. A straight line connecting the points is evaluated on behalf of the entire characteristic curve.

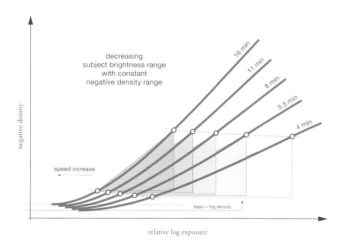

FIG. 12 The average gradient increases and the subject brightness range decreases with development time, when the negative density range is kept constant.

One important side effect requires consideration. The shadow points, having a constant density above base and fog density, require less exposure with increasing development time, in other words, film speed increases slightly with development. Consequently, film exposure controls shadow density and development controls highlight density, but film speed has to be adjusted when development is altered.

Time and Agitation

The standard developing temperature for film is 20°C. Photographers living in warmer climates often find it difficult to develop film at this temperature and may choose 24°C as a viable alternative. However, development temperature is a significant process variable, and film developing tests must be repeated for different temperatures and then tightly controlled within 1°C. Do not underestimate the cooling effect of ambient darkroom temperatures in the winter or the warming effect of your own hands on the inversion tank. The temperature is less critical for any processing step after development. The above tolerance can be doubled and even tripled for the final wash, but sudden temperature changes must be avoided. Otherwise reticulation, a wrinkling of the gelatin emulsion, may occur.

Agitation affects the rate of development, as it distributes the developer to all areas of the film evenly, as soon as it makes contact. While reducing the silver halides to metallic silver, the developer, in immediate contact with the emulsion, becomes exhausted and must be replaced through agitation. Agitation also supports the removal of bromide, a development by-product, which otherwise inhibits development locally and causes "bromide streaks." A consistent agitation technique is required for uniform film development. Increased density along the edges indicates excessive agitation, and uneven or mottled negatives indicate a lack of agitation.

Processing errors during film development are not as critical as exposure errors, since final print contrast is a combination of negative and paper contrast. If, for example, the negative has too much contrast to print well on normal paper, a lower contrast paper is chosen to compensate. However,

subjective image evaluation studies have shown that prints on slightly harder paper are preferred over "soft" prints with weak mid-tone separation. Consequently, when in doubt, it is better to underdevelop (and increase paper contrast).

The Zone System

Photographers take a look at the scene and may have a clear vision of the final print. Sometimes the image turns out just as they expected, but as often as not, the final print is far from what they intended. In the first half of the 20th century Ansel Adams and Fred Archer developed a system to replace the guesswork with much needed control over the photographic process. They called it the Zone System.

For most serious fine art photographers, whether amateur or professional, the Zone System is today's accepted standard to control the entire black and white tonal reproduction cycle from subject to print. The Zone System organizes the many decisions that go into exposing, developing, and printing a negative, and once mastered, it provides a practical method to ensure negative and print quality through the visualization of the final print and a thorough understanding of equipment and materials.

Briefly, the Zone System works like this: The photographer takes reflective light readings of key elements in the scene and then decides on how light or dark they should be in the final print. This is done to either obtain a literal recording of the scene or a creative departure from reality. The film is then exposed and developed to create a negative capable of producing the visualized print.

Several good books have been written about the Zone System. Some are very technical, while others try to simplify the system to make it available to a larger audience. This text gives an overview to understand what the Zone System is all about. How far the reader may take it from there depends on the type of photography and the individual level of interest in photographic craftsmanship. However, a basic understanding of the Zone System is usually required to get the most out of quality photographic publications, and it will increase confidence even if one decides to continue to use ordinary exposure and development techniques.

Zones

Good photographic paper is capable of showing bright white highlights, which transition smoothly to deep black shadows with an abundance of gray values in between. The Zone System divides this continuous transition from bright white to deep black into eleven zones, which are numbered with Roman numerals. Figure 13 shows the resulting zone scale. Zones III, V, VII, and VIII are of the greatest interest and consequently highlighted, but they all require some definition.

Zone 0 is the darkest a photographic paper can get. It is the paper's black.

Zone I is almost black. Here, the first signs of tonality are observed, but it has no pictorial value.

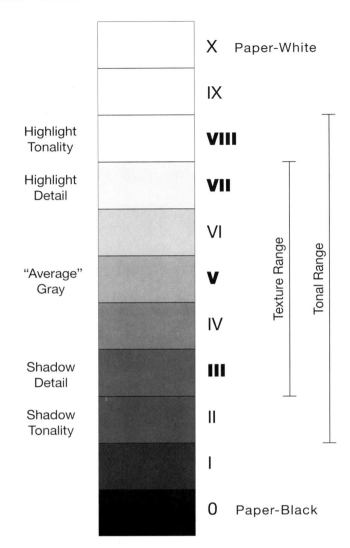

FIG. 13 In the Zone System, all gray values, from deep black to bright white, are divided into eleven zones, creating the zone scale.

Zone II is where a clear difference between tonal values of black and very dark gray is seen, but it is difficult to make out any details.

Zone III is as dark as textured shadows ought to get, to see the important details clearly.

Zone IV shows darker areas with full texture and detail.

Zone V is a fully textured middle gray of 18% reflectance. The "Kodak Gray Card" can be used as an exposure guide for this zone.

Zone VI shows lighter areas with full texture and detail.

Zone VII is as light as textured highlights should get, to see the important details clearly.

Zone VIII is where a clear difference between tonal values of very light gray and white is seen, but it is difficult to make out any details.

Zone IX is almost white. Here, the last signs of tonality are observed, but they have no pictorial value.

Zone X is as bright as the photographic paper's base. It is the paper's white.

The definitions above describe the zones in terms of tonal values as they appear in the photographic print. Nevertheless, it is important to realize that in the subject scene, zones are exactly one stop of exposure apart. Therefore, the light meter will find Zone III to be two stops darker than Zone V and Zone VIII three stops brighter than Zone V.

Visualization

This is the first step in the Zone System. Before the actual picture is taken, the scene is viewed with the final photograph in mind. The brightest highlight cannot be brighter than the paper's white, and the darkest shadow cannot be darker than the paper's black. The Zone System practitioner looks at the scene and forms a mental representation of the final photograph with the zone scale (Figure 13) in mind.

During this visualization, the textured shadows are placed on Zone III, and either the textured highlights are targeted for Zone VII, or alternatively, the very light grays are considered for Zone VIII. All other values will fall onto their respective zones. To obtain a literal recording of the scene, zone placement depends on the tonal values of the subject, but for a creative departure from reality, zone placement is entirely up to the photographer. In order for this to work, film exposure and development must be carried out in a way that supports the visualization.

Exposure and Development

The photographers of the 19th century summed up their experience by creating the basic rule of photographic process control, "expose for the shadows and develop for the highlights." The Zone System is based on this advice while applying the principles of sensitometry, which were pioneered by Ferdinand Hurter and Vero Driffield in 1890. Nevertheless, only after the invention of reliable light meters did it become an accurately controllable system.

Exposure

According to the basic rule expose for the shadows and develop for the highlights, the Zone System practitioner measures the light reflected from the textured shadow area of the scene, which was placed on Zone III during visualization. This reading alone will determine the film exposure.

This is best accomplished with a specifically designed 1° spot meter, but a 5° spot attachment for an existing meter may serve as a substitute. The exposure recommended by the meter must be adjusted however, since most light meters are only calibrated for the average gray of Zone V and not the relatively dark tones of Zone III. To accomplish this, an exposure reduction of two stops is applied, since in the subject, Zone V is two stops brighter than Zone III. Some meters, specifically designed for the Zone System, handle this exposure adjustment by placing a measurement directly onto Zone III. At this point, the basic exposure is locked in, determined purely by the textured shadows of the subject.

Contrast

At this point, it is time to check the highlights. The experienced Zone System practitioner wants the textured highlights to fall on Zone VII and for that to happen automatically, they must be four stops brighter than Zone III. This is the case in a "normal" contrast scene, but not all lighting situations are normal. In a low-contrast scene, such as a foggy morning landscape, the difference between shadows and highlights is less. In a high-contrast scene, such as a sunny day at the beach, the difference is greater.

If, in a low-contrast scene, the difference is only three stops, it will be labeled as N + 1 since the missing stop must be added later in the development of the film. If, in a high-contrast scene, the difference is six stops, it will be labeled as N − 2 since the extra two stops must be removed later in the development of the film.

Development

The Zone System practitioner is now ready for the last portion of the statement — expose for the shadows and develop for the highlights.

It is a fortunate fact that highlights and shadows respond differently to film developing chemicals. Highlights develop quickly and build up negative density at a fast pace. Shadows also develop quickly at first, but soon negative density becomes retarded. Leaving the film in the developer increases shadow density only moderately, but it increases highlight density significantly. This creates an opportunity.

A film exposed in a high-contrast lighting situation must be developed for less than the normal time to keep the highlights from becoming too dense to print. The reduced development time will affect the shadows to the point that exposure must be increased to prevent underexposed shadows.

A film exposed in a low-contrast lighting situation must be developed for more than the normal time to build enough density in the highlights. The increased development time will not affect the shadows significantly, but it will get the highlights dense enough for those "brilliant" whites in the print.

Customizing Film Speed and Development

A good negative has plenty of shadow and highlight detail and prints easily on normal graded paper. The aim is to create such a negative by controlling film exposure and development as closely as practically possible. Sufficient film exposure ensures adequate shadow density and contrast, and avoiding film overdevelopment keeps highlights from becoming too dense to print effortlessly.

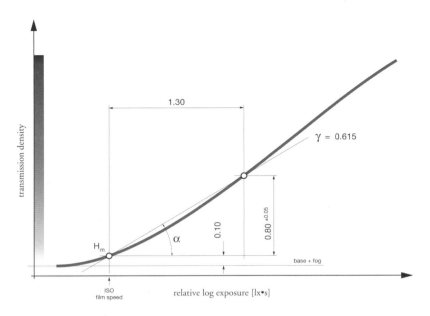

FIG. 14 Film exposure and development in accordance with the current ISO standard.

Film manufacturers have spent a lot of time and resources establishing the film speed and the development time suggestions for their products. Not knowing the exact combination of products we use for our photographic intent, they have had to make a few assumptions. These assumptions have led to an agreement among film manufacturers, which were published as a standard in ASA PH 2.5-1960. It was the first standard to gain worldwide acceptance, but it went through several revisions and was eventually replaced by the current standard ISO 6-1993, which combines the old ASA geometric sequence (50, 64, 80, 100, 125, 160, 200,. . .) with the old DIN log sequence (18, 19, 20, 21, 22, 23, 24,. . .). As an example, an ISO speed is written as ISO 100/21.

Figure 14 shows a brief overview of the ISO standard. According to the standard, the film is exposed and processed so that a given log exposure of 1.30 has developed to a transmission density of 0.80, resulting in an average negative gradient of about 0.615. Then the film speed is determined by the exposure, which developed to a shadow density of 0.10. This makes it an acceptable standard for general photography. However, the standard's assumptions may not be valid for every photographic subject matter, and advertised film speeds and development times can only be used as starting points.

In general, advertised ISO film speeds are too optimistic and suggested development times are too long. It is more appropriate to establish an "effective film speed" and a customized development time, which are personalized to the photographer's materials and technique. In most literature, the effective film speed is referred to as the exposure index (EI). Exposure index was a term used in older versions of the standard to describe a safety factor, but it was dropped with

the standard update of 1960. Nevertheless, the term EI is widely used and is now an accepted convention when referring to the effective film speed.

A fine art photographer appreciates fine shadow detail and often has to deal with subject brightness ranges, which are significantly smaller or greater than the normal seven stops from the beginning of Zone II to the end of Zone VIII. In addition, the use of certain equipment, like the type of enlarger or the amount of lens flare, influences the appropriate average gradient and final film speed. This requires adjustment of the manufacturer's recommended film speed and development suggestions.

In Figure 15, film exposure and negative development have been adjusted to work in harmony with the Zone System. The speed point has been raised to a density of 0.17 to secure proper shadow exposure, and the development has been adjusted to fit a normal subject brightness range of 7 zones into a fixed negative density range of 1.20, which is a normal range for diffusion enlargers and grade 2 paper. Development modifications will allow other lighting conditions to be accommodated for them to fit the same negative density range.

One question still remains: How does one establish the effective film speed and developing time to cover different subject brightness ranges? An organized test sequence can provide accurate results but demands the availability of sophisticated density measurement equipment like a densitometer. However, a few basic calibration steps can already make a big difference in picture quality. Introduced here is a simplified method to arrive at your effective film speed and customized development time. It is a very practical approach, which considers the entire image producing process from film

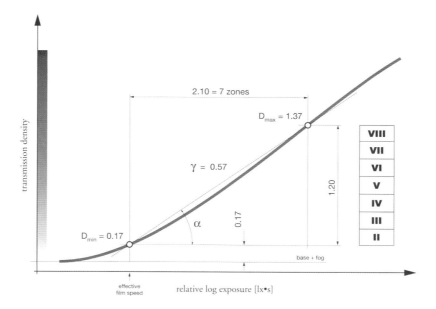

FIG. 15 Film exposure and negative development have been adjusted to work in harmony with the Zone System. The speed point has been raised to secure proper shadow exposure, and the development has been adjusted to easily print a normal subject brightness range onto normal-graded paper.

exposure to the final print. The results are sufficiently accurate for fine art photography, requiring three simple tests but no special equipment.

Paper Black Density Test

This test will define the minimum print exposure required to produce a near-maximum paper density. Make sure to use a blank negative from a fully processed film of the same brand as to be tested. Add a scratch or a mark to it, and use it later as a focus aid.

1. Insert the blank negative into the negative carrier.
2. Set the enlarger height to project a full-frame 8 × 10 inch print and insert contrast filter 2 or equivalent.
3. Focus accurately, then measure and record the distance from the easel to the film.
4. Stop the lens down by three stops and record the f-stop.
5. Prepare a test strip with 8-, 10-, 13-, 16-, 20-, 25-, and 32-second exposures.
6. Process and dry normally.
7. In normal room light, make sure that you have at least two but not more than five steps, which are so dark that they barely differ from one another. Otherwise, go back to steps 4 or 5 and make exposure corrections.
8. Pick out the first two steps, which barely differ from one another and select the lighter of the two.
9. Record the exposure time for this step.

This is the exposure time required to reach a near-maximum paper density (Zone 0) for this aperture and magnification. If

you can, leave the setup in place as it is, but record the f-stop, enlarger height, and exposure time for future reference.

Effective Film Speed Test

This test will define your normal effective film speed, based on proper shadow exposure.

1. Select a subject, which is rich in detailed shadows (Zone III) and has some shadow tonality (Zone II).
2. Set your light meter to the advertised film speed.
3. Stop the lens down four stops from wide open, and determine the exposure time for this aperture, either with an incident meter pointing to the camera, or place a Kodak Gray Card into the scene, and take the reading with a spot meter. Keep the exposure time within 1/8 and 1/250 of a second or modify the aperture.
4. Make the first exposure.
5. Open the lens aperture or change the ISO setting of your light meter to increase the exposure by 1/3 stop (i.e., ISO 400/27 becomes ISO 320/26) and make another exposure. Record the exposure setting.
6. Repeat step 5 four times, and then fill the roll with the setting from step 4.
7. Develop the film for 15 percent less time than recommended by the manufacturer. Otherwise, process and dry the film normally.
8. Set your enlarger and timer to the recorded settings for the Zone 0 exposure from the previous test.
9. Print the first five frames, then process and dry them normally.

An evaluation of the prints will reveal how the shadow detail is improving rapidly with increased negative exposure. However, there will come a point where increased exposure offers little benefit. Select the first print with good shadow detail. The film speed used to expose the related negative is your normal effective film speed for this film. Based on experience, it is normal for the effective film speed to be up to a stop slower than the rated film speed.

Film Developing Time Test

This test will define your normal film development time. A rule of thumb will be used to adjust the normal development time to actual lighting conditions, where needed.

1. Take two rolls of film. Load one into the camera. On a cloudy, but bright day, find a scene that has both significant shadow and highlight detail. A house with dark shrubs and a white garage door is ideal.
2. Secure your camera on a tripod, and set your light meter to your effective film speed, determined by the previous test. Meter the shadow detail, and place it on Zone III by reducing the measured exposure by 2 stops.
3. At that setting, shoot the scene repeatedly until you have finished both rolls of film.
4. In the darkroom cut both rolls in half. Develop one half roll at the manufacturer's recommended time. Develop another half roll at the above time minus 15 percent and another half roll at minus 30 percent. Save the final half roll for fine-tuning.
5. When the film is dry, make an 8 × 10 inch print from one negative of each piece of film at the Zone 0 exposure setting, determined during the first test. The developing time used to create the negative, producing the best highlight detail, is your normal film developing time. You may need the fourth half roll to fine-tune the development.

Considering your entire image-making equipment, you have now determined your effective film speed, producing optimum shadow detail, and your customized film developing time, producing the best printable highlight detail for normal lighting conditions.

However, film exposure and development have to be modified if lighting conditions deviate from "normal." The rule of thumb is to increase the exposure by 2/3 stop whenever the subject brightness range is increased by one zone (N − 1), while also decreasing development time by 15 percent. On the other hand, decrease the exposure by 1/3 stop whenever the subject brightness range is decreased by one zone (N + 1), while increasing development time by 25 percent.

These tests must be conducted for every combination of film and developer you intend to use. Fortunately, this is not a lot of work and will make a world of difference in your photography, because it will improve negative and print quality significantly.

Print Quality

The photographic printing process is the final step toward influencing image quality. At the printing stage,

all image-relevant detail captured by the negative must be converted into a positive print to produce a satisfying image.

To achieve the subjective image quality requirements mentioned earlier, the experienced printer follows a structured and proven printing technique and makes a selection from several paper choices available, which appropriately supports the subject and the intended use of the image. This includes paper thickness, surface texture, and the inherent image tone.

In addition, technical print quality is used to control adequate image sharpness and to ensure the absence of visible imperfections, possibly caused by stray, non-image forming light, or dust and stains. The printer is well advised to make certain that safelights, enlarger, lenses, and other printing equipment are and remain at peak performance.

Nevertheless, subjective print quality is predominantly influenced by print exposure and contrast, which is rarely limited to overall adjustments, but often requires local optimization including laborious dodging and burning techniques.

Print Exposure

The amount of light reaching any photographic emulsion must be controlled to ensure the right exposure. When exposing film in a camera, the amount of light reaching the emulsion is controlled by an interaction of lens aperture and shutter timing. In that case, the lens aperture, also called f-stop, controls the light intensity; the shutter timing, also called "shutter speed," controls the duration of the exposure. The f-stop settings are designed to either half or double the light intensity. The shutter speed settings are designed to either half or double the exposure duration. This is accomplished by following a geometric series for both aperture and time. Therefore, an f-stop adjustment in one direction can be offset by a shutter speed adjustment in the opposite direction. Experienced photographers are very comfortable with this convenient method of film exposure control and often refer to both, aperture and shutter settings, as f-stops or simply "stops."

In the darkroom, the need for exposure control remains. Splitting this responsibility between the enlarging lens aperture and the darkroom timer is a logical adaptation of the negative exposure control. However, the functional requirement for a darkroom timer is different from that of a camera shutter, since the typical timing durations are much longer.

Negative exposure durations are normally very short, fractions of a second, where enlarging times typically vary from about 10 to 60 seconds. Long exposure times are best handled with a clock-type device which functions as a "countdown." Some popular mechanical timers, matching this requirement, are available. More accurate electronic models, with additional features, are also on the market. Some professional enlargers go as far as featuring a shutter in the light path. This gives an increased accuracy, but is only required for short exposure times.

Arithmetic Timing

A typical traditional printing session is simplified in the following example. The enlarging lens aperture is set to f/8

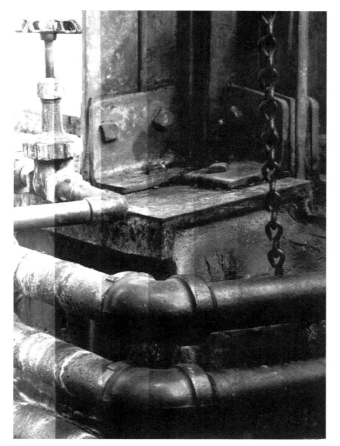

FIG. 16 The exposure test (left) shows a traditional test strip in 5-second increments, following an arithmetic series. The other test (right) shows an alternative test strip in 1/3-stop increments, following a geometric series.

or f/11 to maximize image quality and allow for reasonable printing times. The printer estimates from experience that the printing time will be around 25 seconds for the chosen enlargement. Typically, a 5- to 7-step test strip, with 5-second intervals, is prepared to evaluate the effect of different exposures times. A sample of such a test strip is shown in Figure 16a and was used to test exposures of 10, 15, 20, 25, 30, 35, and 40 seconds. The test strip is then analyzed and the proper exposure time is chosen. In this example, a time of less than 20 seconds would be about right, and the printer may guess and settle on an exposure time of 18 seconds. Now, a so-called "base exposure" time is established. This sequence may be repeated for different areas of interest, for example, textured highlights and shadows. If they deviate from the base exposure, dodging and burning may be required to optimize exposure locally.

This is a reasonable approach to printing, but it does not utilize some of the benefits of geometric timing. In the traditional, arithmetic timing method, uniform time increments produce unequal changes of exposure. As seen in Figure 16a, the difference between the first two steps is 1/2 stop, or 50 percent. However, the difference between the last two steps is only 14 percent, or slightly more than a 1/6 stop. Therefore, arithmetic timing methods provide too large a difference in the light steps and too little a difference in the dark steps of a test strip. This makes it difficult estimating an accurate base exposure time for the print.

Geometric Timing

Considering the typical design of darkroom timers, it is understandable why arithmetic timing has been the predominant method of exposing photographic paper. Nevertheless, it is worth considering geometric timing not just for film exposure but also for print exposure, because it has significant advantages when it comes to test strips, print control, repeatability, and record keeping. Because lens aperture markings also follow a geometric sequence, geometric timing is often referred to as "f-stop timing."

FIG. 17 An analog f-stop dial from 8 to 64 seconds in 1/3, 1/6, and 1/12-stop increments.

Figure 17 provides an analog version of an f-stop timing sequence, which will help to illustrate the effect. It is a continuation of the well-known camera shutter speed doublings from 8 up to 64 seconds, and it is subdivided first into 1/3 then 1/6 and finally 1/12 stop. These ranges were selected because times below 8 seconds are difficult to control with an analog timer, and times well above one minute are too time-consuming for a practical darkroom session. Increments down to 1/12 stop are used, because that is about the smallest exposure increment, which can still be appreciated. For normal paper grades, between grade 2 and 3, enlarging time differences of a 1/3 stop (~20 percent) are significant in tonal value, 1/6 stop (~10 percent) can easily be seen and differences of a 1/12 stop (~5 percent) are minute, but still clearly visible, if viewed next to each other. Smaller increments may be of use for paper grades 4 and 5 but rarely required. The analog dial clearly shows how f-stop timing fractions increase with printing time. Fixed increments of time have a larger effect on short exposure times and a smaller effect on long exposure times.

Assuming a base exposure time of 25.4 seconds, exposure is held back locally for 5.2 seconds to dodge an area for a 1/3 stop, and a 10.5-second exposure is added locally to apply a 1/2 stop burn-in. Base exposure time and f-stop modifications are entered into the print record for future use. The exposure time must be modified if print parameters or materials change, but dodging and burning is relative to the exposure time, and consequently, the f-stop modifications are consistent.

The numerical f-stop timing table in Figure 18 is a more convenient way to determine precise printing times than the previous analog table. It also includes dodging and burning times as small as 1/6-stop increments. It can be used with any darkroom timer, but a larger version may be required to see it clearly in the dark. Base exposure times are selected from the timing table and all deviations are recorded in stops, or fractions thereof. This is done for test strips, work prints, and all fine-tuning of the final print, including the dodging and burning operations.

Test Strip
Assuming a typical printing session, select the following timing steps in 1/3-stop increments from the timing table: 8, 10.1, 12.7, 16, 20.2, 25.4, and 32 seconds. The resulting test strip is shown in Figure 16b. Please note that the range of exposure time is almost identical to the arithmetic test strip. However, a comparison between the two test strips reveals that the geometrically spaced f-stop version is much easier to interpret. There is more separation in the light areas and still clear differences in the dark areas of the test strip. After evaluation of the test strip, it can be determined that the right exposure time must be between 16 and 20.2 seconds and a center value of 18.0 seconds may be selected or another test strip with finer increments may be prepared.

Work Print
The next step is to create a well-exposed work print, at full size and exposed at the optimum base time. This base time is usually the right exposure time to render the textured highlights at the desired tonal value. In this example, the first full sheet is exposed at 18.0 seconds, developed, and evaluated. The result is, of course, the same as with the traditional timing method, but with more confidence and control.

Dodging and Burning and Record Keeping
Fine-tuning of all tonal values, through dodging and burning, takes place once the right base printing time has been found. It is recommend to test strip the desired exposure times for all other areas of importance within the image and then to record them all as deviations from the base exposure time in units of f-stop fractions on a printing map. The printing map will be stored with the negative and can be used for any future enlarging scale. A new base exposure time must be found, when a new enlarging scale becomes necessary, but the f-stop differences for dodging and burning always remain the same. This printing map will remain useful even if materials for paper, filters, and chemicals have been replaced or have aged. It will also be easier to turn excessive burn-in times into shorter times at larger lens apertures to avoid reciprocity failures.

Geometric timing does not require any additional equipment. With the tables provided, any timer can be controlled to perform f-stop timing, especially when the exposure times are longer than 20 seconds. However, there are a few electronic f-stop timers available on the market. They usually provide

	dodging [f/stop]					base exposure	burning [f/stop]											
-1	-5/6	-2/3	-1/2	-1/3	-1/6		+1/6	+1/3	+1/2	+2/3	+5/6	+1	+1 1/3	+1 2/3	+2	+2 1/3	+2 2/3	+3
-4.0	-3.5	-3.0	-2.3	-1.7	-0.9	8	1.0	2.1	3.3	4.7	6.3	8.0	12.2	17.4	24.0	32.3	42.8	56.0
-4.2	-3.7	-3.1	-2.5	-1.7	-0.9	8.5	1.0	2.2	3.5	5.0	6.6	8.5	12.9	18.4	25.4	34.2	45.3	59.3
-4.5	-3.9	-3.3	-2.6	-1.9	-1.0	9.0	1.1	2.3	3.7	5.3	7.0	9.0	13.6	19.5	26.9	36.3	48.0	62.9
-4.8	-4.2	-3.5	-2.8	-2.0	-1.0	9.5	1.2	2.5	3.9	5.6	7.4	9.5	14.5	20.7	28.5	38.4	50.9	66.6
-5.0	-4.4	-3.7	-3.0	-2.1	-1.1	10.1	1.2	2.6	4.2	5.9	7.9	10.1	15.3	21.9	30.2	40.7	53.9	70.6
-5.3	-4.7	-4.0	-3.1	-2.2	-1.2	10.7	1.3	2.8	4.4	6.3	8.3	10.7	16.2	23.2	32.0	43.1	57.1	74.8
-5.7	-5.0	-4.2	-3.3	-2.3	-1.2	11.3	1.4	2.9	4.7	6.6	8.8	11.3	17.2	24.6	33.9	45.7	60.5	79.2
-6.0	-5.3	-4.4	-3.5	-2.5	-1.3	12.0	1.5	3.1	5.0	7.0	9.4	12.0	18.2	26.1	36.0	48.4	64.1	83.9
-6.3	-5.6	-4.7	-3.7	-2.6	-1.4	12.7	1.6	3.3	5.3	7.5	9.9	12.7	19.3	27.6	38.1	51.3	67.9	88.9
-6.7	-5.9	-5.0	-3.9	-2.8	-1.5	13.5	1.6	3.5	5.6	7.9	10.5	13.5	20.4	29.3	40.4	54.4	72.0	94.2
-7.1	-6.3	-5.3	-4.2	-2.9	-1.6	14.3	1.7	3.7	5.9	8.4	11.1	14.3	21.7	31.0	42.8	57.6	76.3	99.8
-7.6	-6.6	-5.6	-4.4	-3.1	-1.6	15.1	1.8	3.9	6.3	8.9	11.8	15.1	23.0	32.8	45.3	61.0	80.8	106
-8.0	-7.0	-5.9	-4.7	-3.3	-1.7	16	2.0	4.2	6.6	9.4	12.5	16.0	24.3	34.8	48.0	64.6	85.6	112
-8.5	-7.4	-6.3	-5.0	-3.5	-1.8	17.0	2.1	4.4	7.0	10.0	13.3	17.0	25.8	36.9	50.9	68.5	90.7	119
-9.0	-7.9	-6.6	-5.3	-3.7	-2.0	18.0	2.2	4.7	7.4	10.5	14.0	18.0	27.3	39.1	53.9	72.6	96.1	126
-9.5	-8.3	-7.0	-5.6	-3.9	-2.1	19.0	2.3	4.9	7.9	11.2	14.9	19.0	28.9	41.4	57.1	76.9	102	133
-10.1	-8.8	-7.5	-5.9	-4.2	-2.2	20.2	2.5	5.2	8.4	11.8	15.8	20.2	30.6	43.8	60.5	81.4	108	141
-10.7	-9.4	-7.9	-6.3	-4.4	-2.3	21.4	2.6	5.6	8.8	12.5	16.7	21.4	32.5	46.4	64.1	86.3	114	150
-11.3	-9.9	-8.4	-6.6	-4.7	-2.5	22.6	2.8	5.9	9.4	13.3	17.7	22.6	34.4	49.2	67.9	91.4	121	158
-12.0	-10.5	-8.9	-7.0	-4.9	-2.6	24.0	2.9	6.2	9.9	14.1	18.7	24.0	36.4	52.1	71.9	96.8	128	168
-12.7	-11.1	-9.4	-7.4	-5.2	-2.8	25.4	3.1	6.6	10.5	14.9	19.9	25.4	38.6	55.2	76.2	103	136	178
-13.5	-11.8	-10.0	-7.9	-5.6	-2.9	26.9	3.3	7.0	11.1	15.8	21.0	26.9	40.9	58.5	80.7	109	144	188
-14.3	-12.5	-10.5	-8.4	-5.9	-3.1	28.5	3.5	7.4	11.8	16.7	22.3	28.5	43.3	62.0	85.5	115	153	200
-15.1	-13.3	-11.2	-8.8	-6.2	-3.3	30.2	3.7	7.9	12.5	17.7	23.6	30.2	45.9	65.7	90.6	122	162	211
-16.0	-14.0	-11.8	-9.4	-6.6	-3.5	32	3.9	8.3	13.3	18.8	25.0	32.0	48.6	69.6	96.0	129	171	224
-17.0	-14.9	-12.5	-9.9	-7.0	-3.7	33.9	4.2	8.8	14.0	19.9	26.5	33.9	51.5	73.7	102	137	181	237
-18.0	-15.8	-13.3	-10.5	-7.4	-3.9	35.9	4.4	9.3	14.9	21.1	28.1	35.9	54.6	78.1	108	145	192	251
-19.0	-16.7	-14.1	-11.1	-7.9	-4.2	38.1	4.7	9.9	15.8	22.4	29.8	38.1	57.8	82.8	114	154	204	266
-20.2	-17.7	-14.9	-11.8	-8.3	-4.4	40.3	4.9	10.5	16.7	23.7	31.5	40.3	61.3	87.7	121	163	216	282
-21.4	-18.7	-15.8	-12.5	-8.8	-4.7	42.7	5.2	11.1	17.7	25.1	33.4	42.7	64.9	92.9	128	173	229	299
-22.6	-19.9	-16.7	-13.3	-9.3	-4.9	45.3	5.5	11.8	18.7	26.6	35.4	45.3	68.8	98.4	136	183	242	317
-24.0	-21.0	-17.7	-14.0	-9.9	-5.2	47.9	5.9	12.5	19.9	28.2	37.5	47.9	72.9	104	144	194	256	336
-25.4	-22.3	-18.8	-14.9	-10.5	-5.5	50.8	6.2	13.2	21.0	29.8	39.7	50.8	77.2	110	152	205	272	356
-26.9	-23.6	-19.9	-15.8	-11.1	-5.9	53.8	6.6	14.0	22.3	31.6	42.1	53.8	81.8	117	161	217	288	377
-28.5	-25.0	-21.1	-16.7	-11.8	-6.2	57.0	7.0	14.8	23.6	33.5	44.6	57.0	86.7	124	171	230	305	399
-30.2	-26.5	-22.4	-17.7	-12.5	-6.6	60.4	7.4	15.7	25.0	35.5	47.2	60.4	91.8	131	181	244	323	423
-32.0	-28.1	-23.7	-18.7	-13.2	-7.0	64	7.8	16.6	26.5	37.6	50.0	64.0	97.3	139	192	259	342	448

FIG. 18 The f-stop timing table, including adjustments for dodging and burning. Determine the base print exposure time, rendering significant print highlights to your satisfaction, and find this "base exposure" in the center column. Base exposure times are incremented in 1 stop (black), 1/3 stop (dark gray), 1/6 stop (light gray), and 1/12 stop. After adjusting overall print contrast, rendering significant print shadows as desired, find related dodging and burning times in 1/6 stop increments left and right to the base exposure to fine-tune the print.

f-stop and linear timing with a digital display. Some even come with memory features to record the sequence of a more involved printing session.

Two significant advantages of f-stop timing are obvious. First, test strips become more meaningful, with even exposure increments between the strips, which allow straightforward analysis at any aperture or magnification setting. Second, printing records can be used for different paper sizes and materials without a change. This is particularly useful for burning down critical areas or when working at different magnifications and apertures. Several well-known printers record image exposures in f-stops to describe their printing maps. Using f-stop timing makes printing more flexible and it becomes simple to create meaningful printing records for future darkroom sessions.

Paper Contrast

After an appropriate print exposure time for the significant highlights is found, shadow detail is fine-tuned with paper contrast. Without a doubt, the universally agreed units to measure relatively short durations, such as exposure time, are seconds and minutes. However, when it comes to measuring paper contrast, a variety of systems are commonly used. Many photographers communicate paper contrast in the form of "paper grades," others use "filter numbers," which are often confused with paper grades, and some photographers, less concerned with numerical systems and more interested in the final result, just dial in more soft or hard light when using their color or variable contrast enlarger heads. Nevertheless, a standard unit of paper contrast measurement has the benefit of being able to compare different equipment, materials, or techniques while rendering printing records less sensitive to any changes in the future.

The actual paper contrast depends on a variety of variables, some more and some less significant, but it can be precisely evaluated with the aid of a reflection densitometer or at least adequately quantified with inexpensive step tablets. In any case, it is beneficial to apply the ANSI/ISO standards for monochrome papers to measure the actual paper contrast.

Contrast Standards

Figure 19 shows a standard characteristic curve for photographic paper, including some of the terminology, as defined in the current standard, ANSI PH 2.2 as well as ISO 6846. Absolute print reflection density is plotted against relative log exposure. The paper has a base reflection density and processing may add a certain fog level, which together add up to a minimum density called D_{min}. The curve is considered to have three basic regions. Relatively small exposure to light creates slowly increasing densities and is represented in the flat toe section of the curve. Increasing exposure levels create rapidly increasing densities and are represented in the

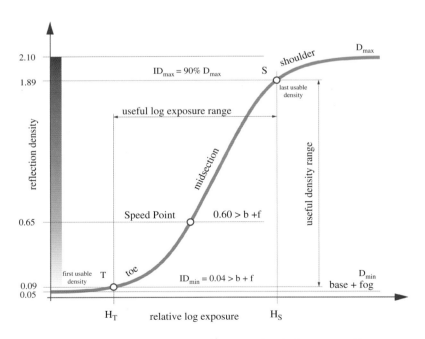

FIG. 19 The ISO standard paper characteristic curve shows how the paper density increases with exposure. It also defines the "speed point," which is used by paper manufacturers to compare paper sensitivity. The useful log exposure range and the useful density range ignore most of the flat toe and shoulder portion of the curve to avoid compressed highlights and shadows.

steep midsection of the curve. Further exposure to light only adds marginal density to the paper in the shoulder section, where it finally reaches the maximum possible density called D_{max}. The extreme flat ends of the curve are of little value to the practical photographer. In these areas, relatively high exposure changes have to be made in order to create even small density variations. This results in severe compression of highlight and shadow densities. Therefore, the designers of the standard made an effort to define more practical minimum and maximum densities, which are called ID_{min} and ID_{max}. ID_{min} is defined as a density of 0.04 above base + fog, and ID_{max} is defined as 90 percent of D_{max}.

Please note that ID_{max} is a relative measure. At the time the standard was developed, the maximum possible density for any particular paper/processing combination was around 2.1, which limited ID_{max} to a value of 1.89. This is a reasonable density limitation so the human eye can comfortably detect shadow detail under normal print illumination. Modern papers, on the other hand, can easily reach D_{max} values of 2.4 or more after toning, in which case a relatively determined ID_{max} would allow shadows to become too dark for human detection. Therefore, a fixed ID_{max} value of 1.89 is a more practical approach for modern papers than a relative value based on D_{max}.

While limiting ourselves to the useful log exposure range between these two densities, we can secure quality highlight and shadow separation within the paper's density range. With the exception of very soft grades, the useful density range is constant for each paper and developer combination. However, the useful

log exposure range will be wider with soft paper grades and narrower with hard paper grades. It can, therefore, be used as a direct quantifier for a standard paper grading system.

Prior to 1966, photographic papers were missing a standard nomenclature for paper grades, because each manufacturer had a different system. The first standard concerned with paper grades was listed as an appendix to ANSI PH 2.2 from 1966. It divided the log exposure range from 0.50 to 1.70 into six grades, which were given numbers from 0 through 5 and labels from "very soft" to "extra hard." Agfa, Ilford, and Kodak had used very similar systems up to that time. A never released draft of the standard from 1978 added the log exposure range from 0.35 to 0.50 as grade 6 without a label. In 1981, the standard was revised, and the numbering and labeling system for grades was replaced. In this ANSI standard as well as the current ISO 6846 from 1992, different contrast grades of photographic papers are expressed in terms of useful log exposure ranges. In Figure 19, we see that the useful log exposure range is defined by HS-HT, which is determined from the points S and T on the characteristic curve. In the standard, the useful exposure ranges are grouped into segments referred to as paper ranges, which are 0.1 log units wide and expressed as values from ISO R40 to ISO R190 (see Figure 20). To avoid decimal points in expressing the ISO paper ranges, the differences in log exposure values are multiplied by 100.

Figure 20 also shows a comparison of the variable contrast filter numbers used by Agfa, Ilford, and Kodak, with the two standards. It is easy to see that there is only a vague relationship

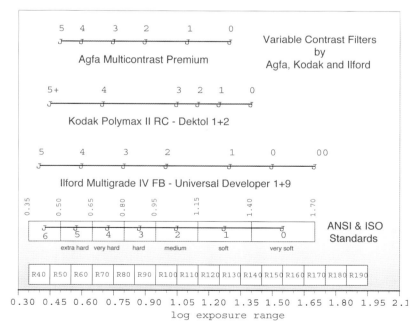

FIG. 20 The ANSI and ISO standards specify common paper grades and ranges. Manufacturer's VC filter numbers have only a vague relationship to standard paper grades.

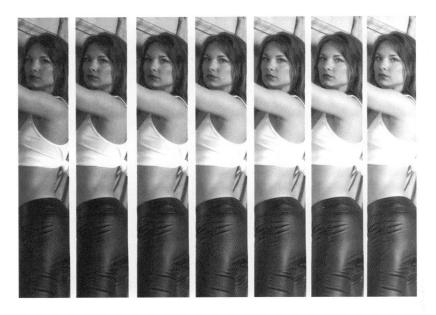

FIG. 21 The test strip shows the same area of the image with increasing exposure from right to left to determine highlight exposure.

between filter numbers and the old standards. Manufacturer dependent variable contrast (VC) filter numbers should not be confused with standard paper grades. They should always be referred to as filters or filter numbers, to eliminate any possible misunderstanding.

The paper grading system of the old ANSI appendix and the standard ISO paper ranges are both used to measure and specify paper contrast, for several reasons. Manufacturers do not use their own grading systems anymore, but they have not switched completely to the new standard either. Graded papers are still available in grades from 0 to 5, even though standard paper ranges are typically also given for graded and variable contrast papers. In addition, photographers seem to be much more comfortable communicating paper grades than paper ranges, and the confusion between filter numbers and paper grades has not helped to speed up the acceptance of standard paper ranges.

Basic Photographic Printing

Turning the negative film image into a well-balanced positive print, with a full range of tones and compelling contrast, can be time-consuming and frustrating at times, unless a well-thought-out printing sequence is considered. Optimizing a print by trial and error is rarely satisfying and often leads to only mediocre results. A structured printing technique, on the other hand, will quickly reveal the potential of a negative and works well in most cases, but it should be viewed and understood to be a guideline and not a law. Photographic printing is primarily art and only secondarily science. The method described here is a valuable technique for beginning and more experienced printers alike, and with individual modifications, it is used by many master printers today.

The image example in Figure 21 contains the usual challenges. The picture was taken with a Hasselblad 501C and a Carl Zeiss Planar 80 mm f/2.8 at f/11 with an exposure time of 1/2 second on TMax-100. The film was then developed normally in Xtol 1+1 for 8 minutes at 20°C.

Expose for the Highlights

A printing session starts by preparing a simple test strip. This initial step should not be skipped, because a test strip provides invaluable information that will support a structured approach and save time. "Expose for the shadows and develop for the highlights" is the old maxim for exposing negative film. For exposing prints, this rule is modified to "expose for the highlights and tune the shadows with contrast."

The first test strip is always made with only the highlights in mind. In this example, the model's top is the most prominent and important highlight in this image, and that is why this area of the print was chosen for the test strip (Figure 21). Grade 2, which is a slightly soft default contrast for diffusion enlargers, was used. The beginning, and sometimes even the experienced, printer has a difficult time to keep from judging the contrast in the first test strip as well. It is highly recommended to resist all temptation or to make any evaluation about contrast in the first test strip and wait for a full sheet to do so. For now, only getting the best exposure time for the delicate highlights must be of any interest.

The test strip shows increasing exposure times from the right at 14.3 seconds to the left at 28.5 seconds, in 1/6-stop increments at a constant aperture of f/11. The model's top is slightly too light in step 5 (22.6 seconds) and slightly too dark in step 6 (25.4 seconds). Consulting the f-stop timing chart,

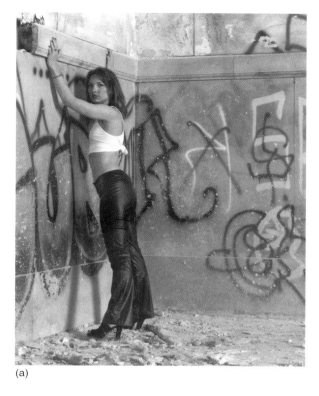

(a)

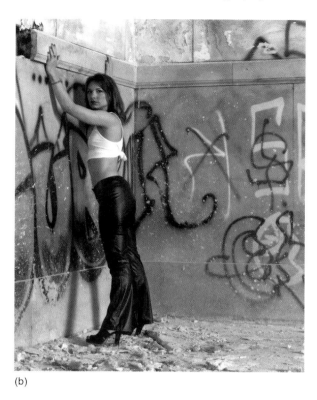

(b)

FIG. 22 (a) This is the first full-sheet test print with proper exposure to the highlights. The overall contrast of grade 2 is too weak. (b) Here the contrast has been raised to grade 2.5, but now the light wall above the model's head is distracting. (Images courtesy of the Ralph W. Lambrecht.)

we may settle for an exposure time of 24.0 seconds while still ignoring the shadows.

Tune the Shadows with Contrast

Proper global contrast can only be evaluated on a full sheet exposure. Consequently, and still at grade 2, a full sheet was exposed with the newly found highlight exposure, followed by normal processing and image evaluation. These initial image evaluations need to be conducted under fairly dim incandescent light. A 100-W bulb about 2 m (6 feet) away will do fine. Fluorescent light is too strong and will most likely result in prints that are too dark under normal light.

The first full sheet in Figure 22a is dull and lacking in shadow density. It needs more contrast. Another sheet, Figure 22b, was exposed at grade 2.5, but the exposure was kept constant to maintain highlight exposure. The 1/2-grade increase in contrast made a significant difference and any further increase would have turned some of the shadows, in the dark clothing, into black without texture. The global contrast is now adequate, but further work is necessary.

Direct the Viewer's Eye

The human eye and brain have a tendency to look at the brighter areas of the image first. An expressive print can be created if some attention is paid to how a potential viewer may "scan" the print, and by using this information, to direct the viewer's eye through the print. This can be accomplished by highlighting the areas of interest and tuning areas with less information value down. Dodging and burning are the basic techniques to do so.

The light wall above the model's head in Figure 22b is drawing too much undeserved attention. The viewer is most likely distracted by it and may even look there first. The photographer would like the viewer to start his visual journey with the model, which is the main feature of this image.

Figure 23 shows a test print in which additional exposure was given to darken the upper wall, making it less distracting. The print received the base exposure of 24.0 seconds at grade 2.5 and then an additional burn-in exposure of 2/3 stop (14.1 seconds) to the upper wall, using a simple burning card. To achieve a more uniform tonality across the top wall, an additional burn-in of 1/3 stop (6.2 seconds) was required to the top left corner. Dodging and burning tests are not necessarily performed on a full sheet, but can be done on smaller test strips for all areas of interest.

The face of the model was too dark to attract immediate attention. Therefore, the face was dodged with a small, oval dodging tool, for the last 4.9 seconds (1/3 stop) of the base

FIG. 23 Top wall sequentially burned-in for 1/3 and 2/3 stop.

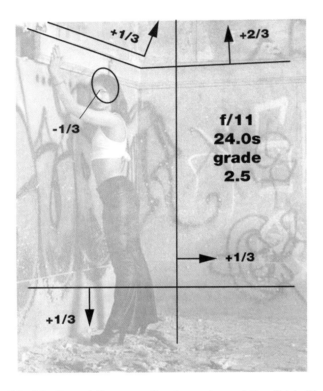

FIG. 24 The printing map. (Image courtesy of the Ralph W. Lambrecht.)

time, while rapidly moving the tool, so not to leave any visible marks. To attract further attention to the model, a 1/3-stop edge-burn to the right and lower side was applied. All of the exposures were collected into the printing map shown in Figure 24. This can be done temporarily on scrap paper or the back of the print, but after the darkroom session, the print map should be saved as a permanent record and filed with the negative for future use. The final image is shown in Figure 25.

FIG. 25 The final image.

With a few methodical steps a much more communicating image was achieved. The viewer's eyes are not left to aimlessly wander around, and the model is not obscurely blending into her surroundings anymore. She is clearly the main focus of the attention. The background now has the important, but secondary function, of supporting and emphasizing the difference between the urban decay and the young woman's beauty.

Archival Processing

In an exponentially changing world, one increasingly looks backwards for a sense of stability. It is comforting for photographers to know that their images will survive the ravages of time to become an important legacy for the next generation. Although the need for archival processing is often a personal ambition rather than a necessity, the qualities of a print will depend on circumstance. For instance, prints destined for collectors of fine art require archival qualities, simply due to the extremely high, but justified, customer expectations of this special market.

Additionally, fine art prints, exhibition work, and portfolio images not only require archival processing, but they also demand the extra effort of careful presentation and storage. With reasonable care, the lifetime of a silver image can approach the lifetime of the paper carrier. Fiber-base (FB) prints

combined with a carefully controlled full archival process have the best chance of permanence. True natural age photographic images from the mid-1800s confirm this. Although, resin coated prints also benefit from archival processing, our knowledge of their stability is based on accelerated testing rather than true natural age. This lack of historical data may limit serious application to fine art photography but should not be a concern or serious issue for commercial photography.

In short, archival processing requires the developed image to be (1) well-fixed to remove all unexposed silver, (2) toned appropriately to protect the remaining image silver, and (3) washed thoroughly to remove potentially harmful chemicals from the emulsion and the paper fibers. Archival storage requires the final photograph to be mounted and kept in materials that are free of acids and oxidants, meeting the requirements of ISO 18902. They must also be protected from temperature and humidity extremes, as well as other potentially harmful environmental conditions and pollution.

Fixing

The light-sensitive ingredient of photographic paper is insoluble silver halide. During development, previously exposed silver halides are reduced to metallic silver in direct proportion to the print exposure, but the unexposed silver halides remain light sensitive and, therefore, impair the immediate usefulness of the photograph and its permanence. Consequently, all remaining silver halides must be made soluble and removed through fixing.

Commercial fixers are based on sodium or ammonium thiosulfate and are often called "hypo," which is short for hyposulfite of soda, an early but incorrect name for sodium thiosulfate. Ammonium thiosulfate is a faster acting fixer and is, therefore, referred to as "rapid fixer." Unfortunately, some practitioners have extended the erroneous term and often refer to any type of fixer as hypo now.

Fixers can be plain (neutral), acidic, or alkali. Plain fixers have a short tray life and are often discounted for that reason. Acidic fixers are the most common as they can neutralize any alkali carryover from the developer, and in effect, arrest development. Alkali fixers are uncommon in commercial applications but find favor with specialist applications, such as maximizing the stain in pyro film development and retaining delicate highlights in lith-printing. At equivalent thiosulfate concentrations, alkali fixers work marginally faster than their acid counterparts and are removed quicker during the final print washing.

Fixing Process

For optimum silver halide removal and maximum fixer capacity, prints are continuously agitated in a first fixing bath for 2x the "clearing" time (typically 1–2 minutes), followed by an optional brief rinse and another fix in the second bath for the same amount of time. The clearing time is the least amount of fixing time required to dissolve all silver halides and is determined through a separate test. This process continues until the first fixing bath has reached archival limits of silver contamination, at which point it is exhausted and therefore discarded. The second bath is now promoted to take the place of the first, and fresh fixer is prepared to replace the second fixing bath. After five such changes, both baths are replaced by fresh fixer. The optional intermediate rinse reduces unnecessary carryover of silver-laden fixer into the second fixing bath.

During the fixing process, the residual silver halides are dissolved by thiosulfate without any damage to the metallic silver forming the image. The resulting soluble silver thiosulfate and its complexes increasingly contaminate the fixing bath until it no longer dissolves all silver halides. Eventually, the solution is saturated to a point at which the capacity limit of the fixer is reached. The fresher, second bath ensures that any remaining silver halides and all insoluble silver thiosulfate complexes are rendered soluble.

Fixer Strength

Kodak recommends for paper fixer to be about half as concentrated as film fixer. For archival processing, Ilford recommends the same "film-strength" fixer concentration for film and paper. Kodak's method exposes the paper to relatively low thiosulfate levels for a relatively long time, where Ilford's method exposes the paper to relative high thiosulfate levels for a relatively short time. It has been suggested that this reduces fixing times to a minimum and leaves little time for the fixer to contaminate the paper fibers. Conversely, whatever fixer does get into the fibers is highly concentrated and takes longer to wash out.

The best fixing method is the one that removes all residual silver, while leaving the least possible amount of fixer residue in the paper fibers during the process. Which of the above methods is more advantageous depends greatly on the composition of the silver halide emulsion and the physical properties of the fiber structure onto which it is coated. It is recommended to start with the manufacturer's recommendation, but ultimately, it is best to test the chosen materials for optimum fixing and washing times at low and high fixer concentrations.

The process instructions, shown in Figure 26, assume the use of rapid fixer at film-strength (10 percent ammonium thiosulfate concentration). A primary concern with strong fixing solutions and long fixing times is the loss of image tones due to oxidation and solubilization of image silver. Figure 27 shows how film-strength fixer affects several print reflection densities over time. Fixing times of 2–4 minutes do not result in any visible loss of density, but excessive fixing times will reduce image densities considerably. The density reduction is most significant in the silver-rich image shadows; however, the eye is more sensitive to the mid-tone and highlight density loss. Data are not available for density loss using paper-strength dilution, but it is conceivable to be significantly less.

Fixing Time

By the time it reaches the fixer, each 16×20 inch sheet of FB paper carries 25 to 35 ml of developer and stop bath. The fixing time must be long enough to overcome dilution by

processing step		time [min]	print processing	comments
1	Developer	3 - 6	Develop fiber-base paper with constant agitation at supplier-recommended strength, using factorial development times.	The exposed portion of the silver halide emulsion is reduced to metallic silver during development. It is best to develop fiber-base papers using factorial development. The emerging time of important mid-tones is recorded and multiplied by a factor. This factor (typically 4x - 8x) is kept constant to compensate for temperature deviation and developer exhaustion but can be modified to control image contrast. The unexposed portion of the silver halide emulsion remains and impairs the immediate usefulness of the photograph, until removed in the fixing bath.
2	Stop Bath	1	Agitate lightly in supplier-recommended strength, to terminate print development.	The stop bath is made of either a light acetic or citric acid. It will neutralize the alkaline developer quickly and bring development to a complete stop. Alternatively, a plain water rinse may be used.
3	1st Fix	1 - 2	Use ammonium thiosulfate (rapid) fixer without hardener at film strength. Agitate prints during fixing, and optionally rinse briefly between baths to prolong the activity of the second bath. Check silver contamination of the first bath frequently with silver estimators, and promote 2nd fix to 1st fix when first bath has reached 0.5 - 1 g/l silver thiosulfate. Replace both baths after five such promotions.	During fixing, the residual silver halide is dissolved by thiosulfate without damaging the metallic silver image. The first fixing bath does most of the work but becomes increasingly contaminated by the soluble silver thiosulfate and its complexes. Soon, the entire chain of complex chemical reactions cannot be completed successfully, and the capacity limit of the first fixing bath is reached. A fresh second bath ensures that all remaining silver halides and silver thiosulfate complexes are dissolved. An intermediate rinse is optional, but it protects the second bath from contamination. fixing time must be long enough to render all residual silver halides soluble, but not so long as to allow the fixer and its by-products to permeate the paper fibers; the former being far more important than the latter. Conduct a test to determine the optimum fixing time for any paper/fixer combination.
4	Rinse	1		
5	2nd Fix	1 - 2		
6	Wash	10 - 60	Remove excess fixer prior to toning to avoid staining and highlight loss. The choice of toner and toning process dictates the washing method and time.	Excess fixer causes staining and highlight loss with some toners. This step removes enough fixer to avoid this problem. For selenium toning, a brief 10-minute wash is sufficient. For direct sulfide toning, a 30-minute wash is required. However, the bleaching process required for indirect sulfide toning calls for a complete 60-minute wash prior to toning. Otherwise, residual fixer will dissolve bleached highlights before the toner has a chance to 'redevelop' them.
7	Toner	1 - 8	Choose a time and dilution according to the supplier recommendations or the desired color change and agitate frequently.	Sulfide, selenium or gold toner is essential for archival processing. They convert sensitive image silver to more stable silver compounds. Process time depends on type of toner used, the level of protection required and the final image color desired, but indirect sulfide toning must be done to completion. Some toners can generate new silver halide, and therefore, require subsequent refixing, but this is not the case with sulfide or selenium toner.
8	Rinse	5	Rinse briefly to remove excess toner to avoid staining and to prolong washing aid life.	To quickly remove toner residue, and to avoid highlight staining with sulfide toners, toning must be followed by a brief, but rapid, initial rinse before the print is placed into the wash. Excess toner also contaminates the washing aid and reduces its effectiveness. This increases washing aid capacity.
9	Washing Aid	10	Select a dilution according to supplier recommendation and agitate regularly.	This process step is a necessity for serious archival processing. It significantly supports removal of residual fixer in the final wash. Washing aid also acts as a 'toner stop bath' after direct sulfide toning. This protects the image from 'after-toning' in the final wash.
10	Wash	30 - 60	Use tray or syphon for single prints or vertical print washers for multiple-print convenience. Make sure to provide even water flow over the entire print surface at 20 - 27°C, and wash until residual thiosulfate levels are at or below 0.015 g/m².	The fixed photograph still contains considerable amounts of fixer together with small, but not negligible, amounts of soluble silver thiosulfate complexes. The purpose of washing is to reduce these chemicals to miniscule archival levels and thereby significantly improve the stability of the silver image. Print longevity is inversely proportional to the residual fixer in the paper. However, traces of residual fixer may actually be helpful in protecting the image. A simple test will verify washing efficiency.
11	Stabilizer	1	Use the supplier-recommended strength, wipe surplus from the print and dry normally.	Silver stabilizers, applied after washing, will absorb soluble silver formed by oxidant attack. Consequently, they provide additional archival protection but are a poor replacement for toning.

FIG. 26 Maximum permanence and archival qualities in FB prints are achieved with these processing recommendations. Resin coated prints will also benefit, but reduce development to 90 seconds, each fix to 45 seconds, drop the washing aid, and limit washing to 2 minutes before and 4 minutes after toning. All processing times include a 15-second allowance, which is the typical time required to drip off excess chemicals.

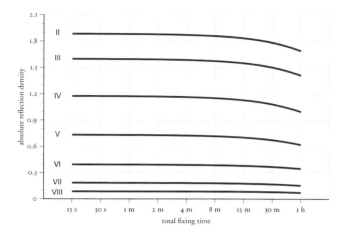

FIG. 27 Fixing times of 2–4 minutes do not result in any visible loss of density, but excessive fixing times will reduce image densities considerably.

these now unwanted chemicals, penetrate the emulsion layer, and convert all remaining silver halides. However, if the fixing time is too long, the thiosulfate and its by-products increasingly contaminate the print fibers and become significantly harder to wash out. Consequently, archival processing has an optimum fixing time.

Testing for the Optimum Fixing Time

The recommended fixing times shown in Figure 26 have been tested and work well for current Ilford (1 minute) and Kodak papers (2 minutes), but the optimum fixing time depends on the type of emulsion, the type of fixer, and the concentration of the fixer. It is suggested to use the following test to establish the optimum fixing times for each paper/fixer combination.

1. Cut a 1 × 10 inch test strip from the paper to be tested. Turn on the room lights fully exposing the test strip for a minute. Avoid excessive exposure or daylight, as this will leave a permanent stain.
2. Dim the lights and divide the test strip on the back into patches, drawing a line every inch. Mark the patches with fixing times from 45 seconds down to 5 seconds in 5-second increments. Leave the last patch blank to use as a "handle."
3. Place the whole strip into water for 3 minutes and then into a stop bath for 1 minute to simulate actual print processing conditions.
4. Immerse the strip into a fresh fixing bath, starting with the 45-second patch, and continue to immerse an additional patch every 5 seconds while agitating constantly.
5. Turn the lights on again, wash the strip for 1 hour under running water to remove all traces of fixer, and tone in working-strength sulfide toner for 4 minutes. Wash again for 10 minutes and evaluate.

If the entire test strip is paper-white, all fixing times were too long. If all patches develop some density in the form of a yellow or brown tone, all fixing times were too short. Adjust the fixing times if necessary and retest. A useful test strip has two or three indistinguishable paper-white patches toward the longer fixing times. The first of these patches indicates the minimum clearing time. Double this time to apply a safety factor, allowing for variations in agitation, fixer strength, and temperature. The result is the optimum fixing time. However, make sure not to use a fixing time of less than 1 minute, as it is difficult to ensure proper print agitation in less time, and patches of incomplete fixing might be the result. Use the optimum fixing time (but at least 1 minute) for each bath, allowing the first bath to be used until archival exhaustion. After all, incomplete fixing is the most common cause for image deterioration.

Optimum print fixing reduces non-image silver to archival levels of less than $0.008\,g/m^2$, but periodically, a process check is in order. As seen, incomplete fixing, caused by either exhausted or old fixer, insufficient fixing time or poor agitation, is detectable by sulfide toning. Apply a drop of working-strength sulfide toner to an unexposed, undeveloped, fixed, and fully washed and still damp test strip for 4 minutes. The toner reacts with silver halides left behind by poor fixing and creates brown silver sulfide. Any stain in excess of a barely visible pale cream indicates the presence of unwanted silver, and consequently, incomplete fixing. Compare the test stain with a well-fixed material reference sample for a more objective judgment.

Fixing Capacity

The maximum capacity of the first fixing bath can be determined either by noting how many prints have been processed or, more reliably, by measuring the silver content of the fixer solution with a test solution or a silver estimator. Silver estimators are supplied as small test papers, similar to pH test strips, and used to estimate silver thiosulfate levels from 0.5 to 10 g/l. A test strip is dipped briefly into the fixer solution, and its color is compared against a calibrated chart after 30 seconds. For archival processing, the first fixing bath is discarded as soon as the silver thiosulfate content has reached 0.5 to 1.0 g/l. This occurs with images of average print density after each liter of chemistry has processed about 20 8 × 10 inch prints. At the same time, the silver thiosulfate content of the second fixing bath is only about 0.05 g/l. For less stringent commercial photography, many printers process up to 50 8 × 10 inch prints per liter, allowing the first bath to reach 2.0 g/l silver thiosulfate and the second bath to contain up to 0.3 g/l. These levels are too high for true archival processing.

Hardener

Some fixers are available with print hardener optional or already added. Hardeners were originally added to fixers to aid in releasing the emulsion from ferrotyping drying drums, but this type of drier is not popular anymore because its cloth-backing is difficult to keep clean of chemical residue, which

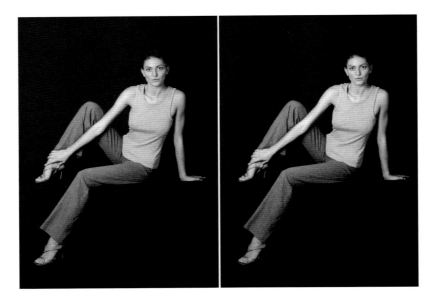

FIG. 28 Toning protects the image against premature deterioration, but causes an unavoidable change in image tone and density. In many cases, a pronounced tonal change is desired, because it appropriately supports the aesthetic effects intended. However, an obvious change in image tone and density is not always suitable or wanted. (Images courtesy of Ralph W. Lambrecht.)

may contaminate the print. The hardener also protects the print emulsion from mechanical handling damage during the wet processes. Unfortunately, toning and archival washing are impaired by print hardener, leading to longer processing times. The disadvantages are hardly worth the questionable benefit, and consequently, print hardener is not recommended for archival processing, unless when using a mechanized print processor whose rollers may cause scratches.

Toning

Toning converts the image-forming metallic silver to more inert silver compounds, guarding the image against premature deterioration due to environmental attack. The level of archival protection is proportional to the level of image silver conversion, and anything short of a full conversion leaves some vulnerable silver behind. ISO 18915, the test method for measuring the resistance of toned images to oxidants, recommends at least a 67 percent conversion. Nevertheless, toning causes an unavoidable change in image tone and density. In many cases, a pronounced tonal change is desired, because it appropriately supports the aesthetic effects intended. However, an obvious change in image tone and density is not always suitable or wanted. To avoid any tonal and density changes, some printers consider toning an option and rely on post-wash treatments, such as Agfa's Sistan silver stabilizer, alone. The image silver will likely benefit from the stabilizer, but some toning is certainly better than none. An informed printer makes an educated choice, balancing the aesthetics of tonal and density changes with the benefits of image protection (Figure 28).

There are three commonly agreed archival toners: sulfide, selenium, and gold. Platinum may also deserve to be added to this list, but its high cost is hard to justify, since it does not provide increased image protection in return. Additional toners are available, including iron (blue toner), copper (red toner), and dye toners. However, they are actually known to reduce the life expectancy of an image, compared to a standard black and white print, and consequently, these non-archival toners should only be considered for aesthetic toning purposes.

The exact mechanisms of silver image protection are not completely understood and still controversial, but the ability of archival toners to positively influence silver image permanence is certain. Nevertheless, many toners contain or produce highly toxic chemicals and some are considered to be carcinogenic. Please closely follow the safety instructions included with each product.

Sulfide Toning

For aesthetic or archival reasons, sulfide toners have been in use since the early days of photography. They effectively convert metallic image silver to the far more stable silver sulfide. Sulfide toning is used either as direct one-step (brown) toning or as indirect two-step, bleach and redevelop, (sepia) toning. Even short direct sulfide toning provides strong image protection with minimal change in image color. Indirect sulfide

toning, on the other hand, yields images of greater permanence, although a characteristic color change is unavoidable. Indirect toning requires print bleaching prior to the actual toning bath. The bleach leaves a faint silver bromide image, which the toner then redevelops to a distinct sepia tone. Several sulfide toners are available for the two different processes.

Indirect Sulfide Toner

1. Sodium sulfide toners, such as Kodak Sepia Toner, are indirect toners. They produce hydrogen sulfide gas (the rotten egg smell), which is toxic at higher concentrations, can fog photographic materials, and is highly unpleasant, if used without sufficient ventilation. Nevertheless, this was the toner of choice for most of the old masters. The indirect method had the added benefit of lowering the contrast and extending the contrast range. This salvaged many prints, which were not very good before toning, and 100 years ago, variable contrast papers were not available.

2. Odorless toners use an alkaline solution of thiourea (thiocarbamide) to convert the image silver to silver sulfide. They are effective indirect toners and are more darkroom-friendly than their smelly counterparts, but they are still a powerful fogging agent. Some thiourea toners allow the resulting image color to be adjusted through pH control.

Direct Sulfide Toner

1. Polysulfide toners, such as Kodak Brown Toner (potassium polysulfide) and Agfa Viradon (sodium polysulfide), can be used for direct and indirect toning. These toners also produce toxic hydrogen sulfide gas and the offensive odor that goes along with it, but when direct toning is preferred, they are highly recommended for use on their own or in combination with a selenium toner, as long as adequate ventilation is available.

2. Hypo-alum toners are odorless direct toners. They require the addition of silver nitrate as a "ripener." Consequently, they are not as convenient to prepare as other sulfide toners, and toning can take from 12 minutes in a heated bath up to 12 hours at room temperature. These "vintage" toners give a reddish-brown tone with most papers.

Residual silver halide, left behind by poor fixing, will cause staining with sulfide toners. Therefore, prints must be fully fixed before any sulfide toning. Complete fixing eliminates unwanted silver halides.

Furthermore, residual thiosulfate can also cause staining and even highlight loss with sulfide toners. To avoid fixer staining, it is essential that FB prints are adequately washed prior to sulfide toning. For direct polysulfide toning, a 30-minute wash is sufficient, and this wash is also required for toning subsequent to selenium toning, as selenium toner contains significant amounts of thiosulfate itself. Nevertheless, the bleaching process required for indirect sulfide toning, calls for a complete 60-minute wash prior to bleaching. Otherwise,

residual fixer will dissolve bleached highlights before the toner has a chance to "redevelop" them. Likewise, a brief rinse is highly recommended after bleaching, because the interaction between bleach and toner can also cause staining. Washing minimizes the risk of unwanted chemical interactions between fixer, bleach, and toner.

Indirect toning, after bleaching, must be carried out to completion to ensure full conversion of silver halides into image forming silver. If warmer image tones are desired it is often tempting to pull the print from the toning bath early, but it is far better to control image tones with adjustable thiourea toners and tone to completion. Otherwise, some residual silver halide will be left behind, since the toner was not able to redevelop the bleached image entirely. This is rare, because indirect toning is completed within a few minutes, but if residual silver halide is left behind by incomplete toning, the print will eventually show staining and degenerate, similar to an incompletely fixed print.

Some polysulfide toners have the peculiar property of toning faster when highly diluted, and extremely dilute toner can leave a yellow- or peach-colored stain in highlights and the paper base. To quickly remove toner residue and avoid highlight staining, direct polysulfide toning must be followed by a brief, but intense, initial rinse before the print is placed into the wash. Nonetheless, toning will continue in the wash until the toner is completely washed out. To prevent after-toning and possibly over-toning, or staining of FB prints, a 5-minute treatment in 10 percent sodium sulfite, ahead of washing, must be used as a "toner stop bath." A treatment in washing aid, prior to the final wash, also acts as a toner stop bath, because sodium sulfite is the active ingredient in washing aid. For the same reason, never treat prints in washing aid before sulfide toning, as it would impede the toning process.

Sulfide toner exhaustion goes along with an increasing image resistance to tonal change, even when toning times are significantly extended. Polysulfide toners also lose some of their unpleasant odor and become distinctly lighter in color.

Selenium Toning

This is a popular fast-acting toner, used by most of today's masters, which converts metallic image silver to the more inert silver selenide and gives a range of tonal effects with different papers, developers, dilutions, temperatures, and toning times. Selenium toner has a noticeable effect on the silver-rich areas of the print, increasing their reflection density and consequently, gently darkening shadows and mid-tones. This slightly increases the paper's maximum black (D_{max}) and also the overall print and shadow contrast. For this reason alone, some practitioners make selenium toning part of their standard routine in an attempt to conserve some of the wet "sparkle," which a wet print undoubtedly has, when coming right out of the wash, but otherwise unavoidably loses while drying. Selenium toners are available as a liquid concentrate, and due to its high toxicity, preparing selenium toner from powders is not recommended.

Depending on the paper, prolonged use of Kodak Rapid Selenium toner, diluted $1 + 4$ or $1 + 9$, makes a very pronounced effect on paper D_{max} and image color. Alternatively, a dilution of $1 + 19$ can be used for 1 to 4 minutes, at which paper D_{max} is still visibly enhanced, but the image exhibits less color change. Light selenium toning mildly protects the print without an obvious color or density change. As toning continues, and starting with the shadows, the level of protection increases and the print tones become darker and warmer in color. To increase image protection, selenium toning can be followed by sulfide toning.

As with sulfide toners, residual silver halide, left behind by poor fixing, will also cause staining with selenium toners, and prints must be fully fixed before toning. FB prints also benefit from a 10-minute wash, prior to toning, to prevent potential image staining and toner contamination from acid fixer carryover. Prints processed with neutral or alkali fixers do not require a rinse prior to selenium toning.

Selenium toner exhaustion is heralded by heavy gray precipitates in the bottle, the absence of the poisonous ammonia smell, and the lack of an image change, even with extended toning.

Gold Toning

Gold toner is a slow, expensive, and low-capacity toner, which is easily contaminated by selenium or polysulfide toners. The resulting image is stable and, in contrast to sulfide toner, "cools" the image with prolonged application toward blue-black tones. Process recommendations vary from 10 minutes upwards. Gold toning, in combination with selenium or polysulfide toning, can produce delicate blue shadows and pink or orange-red highlight tones.

Some gold toners generate silver halide, and therefore, require subsequent refixing to ensure image permanence. Nelson's Gold Toner specifically requires such refixing. If refixing is skipped, the print will eventually show staining and degenerate, similar to an incompletely fixed print. The subtlety and limited working capacity of gold toner inhibits its exhaustion detection, therefore, it is often reserved for prints requiring a specific image tone, rather than being used for general archival toning.

Combination Toning

Strong image protection is achieved by combining selenium and polysulfide toning, converting the image silver to a blend of silver selenide and silver sulfide, which protects all print tones. Combination toning can be carried out by mixing polysulfide and selenium toner, creating a combination toner, or by simply toning sequentially in both toners.

When preparing a selenium-polysulfide toner, final image tones can be influenced by the mixing ratio. Kodak recommends a working-strength selenium to polysulfide ratio of 1:4 for warm image tones. Adding 1 to 3 percent balanced alkali will stabilize the solution, otherwise, consider the mixture for one-time use only. As with plain, direct polysulfide toning, prints must be fully fixed and washed for 30 minutes prior to combination toning, which is then followed by an intense rinse and a washing aid application, before the print is placed into the final wash.

When using selenium and polysulfide toners sequentially, final image tones depend on toning times, as well as toner sequence. A very appealing split-tone effect can be achieved when selenium toning is done first. The selenium toner will not only darken the denser mid-tones and shadows slightly, but it will also shift these image tones toward a cool blue and protect them from much further toning. This will leave the lighter image tones, for the most part, unprotected. The subsequent polysulfide toner then predominantly tones these, still unprotected, highlights and lighter mid-tones, shifting them toward the typical warm, brown sepia color. This, in turn, has little consequence on the already selenium-toned, darker, blue image tones. The result is an image with cool blue shadows and warm brown highlights. This split-tone effect is most visible at highlight and shadow borders and can be controlled with different times in each toner. As a starting point, a selenium to polysulfide ratio of 1:2 at 2 and 4 minutes, respectively, is recommended. For this toning sequence, prints must be fully fixed and washed for 10 minutes prior to selenium toning, and they must be washed again for 30 minutes prior to polysulfide toning, which is then followed by an intense rinse and washing aid, prior to the final wash.

When the split-tone effect is undesired or does not support the aesthetic intent of the image, the toning sequence may be reversed and polysulfide toning is done first. When selenium toning is done last, prints must be fully fixed and washed for 30 minutes prior to polysulfide toning, which is followed by an intense rinse, washing aid, selenium toning, wash aid again, and then the final wash.

Washing

A fixed, but unwashed, print contains a considerable amount of thiosulfate, which must be removed to improve the longevity of the silver image. Even if the print was already washed prior to toning, the remaining thiosulfate levels are still far too high for archival image stability, and some toners (i.e., selenium toner) contain thiosulfate themselves. The principal purpose of archival washing is to reduce residual thiosulfate to a concentration of 0.015 g/m^2 or less, including the usually small, but not negligible, amount of soluble silver thiosulfate complexes, which otherwise remain in the paper.

The three essential elements for effective washing are the use of washing aid, water replenishment, and temperature. Ilford, Kodak, and others market washing aids, also known as hypo-clearing agents. These products help displace thiosulfate and improve washing efficiency. Washing aids are not to be confused with hypo eliminators, which are no longer recommended, because ironically, small residual amounts of thiosulfate actually provide some level of image protection. In addition, hypo eliminators contain oxidizing agents that may attack the image. There is little danger of over-washing FB prints without

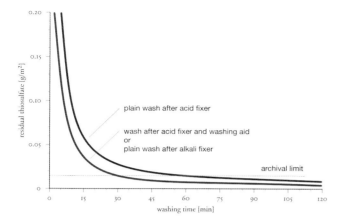

FIG. 29 The use of washing aid is highly recommended when using acid fixers. It conserves water, reduces the total processing time by about 50 percent, and lowers residual thiosulfate levels below those of a plain wash.

the use of hypo eliminators. However, over-washing is a risk with some resin coated papers, and the use of washing aid is therefore discouraged for resin coated processing. Nevertheless, with FB prints, the use of a washing aid is highly recommended, because it conserves water, reduces the total processing time by about 50 percent, and it lowers residual thiosulfate levels below those of a plain wash (Figure 29). Its use increases washing efficiency in cold wash water and overcomes some of the wash retarding effects of hardener. Processing times vary by product, but all washing aids dramatically reduce the archival washing time, also limiting the potential loss of optical brighteners from the paper.

Water replenishment over the entire paper surface is essential for even and thorough washing. Washing a single print in a simple tray, with just a running hose or an inexpensive Kodak Print Siphon clipped to it, is effective archival washing, as long as the print remains entirely under water, but washing several prints this way would take an unreasonably long time. When many prints require washing at the same time, it is more practical to use a multi-slot vertical print washer. They segregate the individual prints and wash them evenly, if the correct water flow rate is controlled properly.

When using a vertical print washer, the emulsion side of the paper can stick to the smooth wall of the washing chamber and never get washed. To prevent this, only textured dividers must be used in vertical print washers and the textured side must always face the emulsion side of the paper.

Washing efficiency increases with water temperature, and a range of 20 to 27°C (68 to 80°F) is considered to be ideal. Higher washing temperatures will soften the emulsion beyond safe print handling. On the other hand, if it is not possible to heat the wash water, and it falls below 20°C (68°F), the washing time should be increased, and the washing efficiency must be

verified through testing. Washing temperatures below 10°C (50°F) must be avoided. Also, research by other authors indicates that washing efficiency is increased by water hardness. Water softeners might be good for household plumbing, but they are not a good idea for print washing.

Testing Washing Efficiency

Residual thiosulfate, left by the washing process, can be detected with Kodak's HT2 (hypo test) solution. The test solution is applied for 5 minutes to the damp print border. The color change is an indicator of the residual thiosulfate level in the paper. The color stain, caused by the test solution, is compared with a supplied test chart to estimate the residual thiosulfate levels and their limits to satisfy archival standards. HT2 contains light-sensitive silver nitrate. Consequently, the entire test and its evaluation must be conducted under subdued tungsten light, and if they are needed for later evaluation, the test area must be rinsed in salt water to stop further darkening.

It is also recommended to verify the evenness of the print washing technique with a whole test sheet. Fix and wash a blank print, noting the washing time, water temperature, and flow rate. Apply the test solution to the wet sheet in five places, one in each corner and one in the center. After 5 minutes, compare the spot colors with the test chart and compare their densities as an indicator for even washing.

The washing efficiencies in Figure 30 are based on recent tests and the research by Martin Reed of Silverprint, published in his article "Mysteries of the Vortex" in the July/Aug and Nov/Dec 1996 edition of *Photo Techniques*. In addition, Figure 29 illustrates the washing performance of prints fixed in alkali and acid fixers of similar thiosulfate concentrations, with and without a consecutive treatment in washing aid. Prints fixed with alkali fixer, followed by just a plain wash, have the same washing performance as prints fixed with acid fixer and treated in washing aid.

Image Stabilization

Agfa markets a silver-image stabilizer product called Sistan. It contains potassium thiocyanate, which provides additional protection to toning in two ways. At first, it converts still remaining silver halides to inert silver complexes, and while remaining in the emulsion, it converts mobile silver ions, created by pollutants attacking the silver image, to stable silver thiocyanate during the life of the print. The resulting silver compounds are transparent, light-insensitive, and chemically resistant, thus protecting the image beyond toning. Fuji markets a similar product called AgGuard in some markets.

Stabilizers are applied in a brief bath after archival washing. Following this treatment, the print is not to be washed again. The stabilizer solution must remain in the emulsion ready to react with any oxidized silver to prevent discoloration. Stabilizers are not an effective replacement for toning, but they offer additional silver image protection.

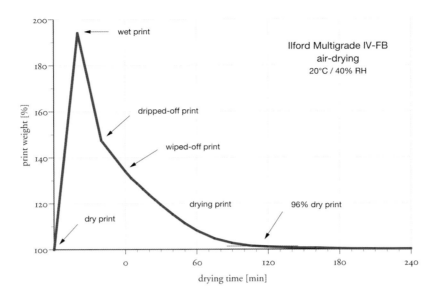

FIG. 30 A dry print soaks up enough liquid almost doubling its weight while going through wet processing. Simply letting excess liquid drip off, for a few seconds, loses about half of that weight gain, and a final wipe reduces it further. The remaining damp print dries within 2 to 4 hours at normal ambient conditions.

Print Drying and Flattening

With the conclusion of the last wet process, the print is placed onto a clean and flat surface draining into the sink. Any excess liquid must be safely removed from both sides of the print to avoid staining. A window squeegee and an oversized piece of glass from the hardware store make perfect tools for this step. However, for safe handling, the glass must be at least 1/4 inch, or 6 mm, thick, and all sharp edges must be professionally ground to protect your hands and fingers from nasty cuts. In addition, make sure that your hands and equipment are clean at all times, and handle the print slowly and carefully. The paper and emulsion are extremely sensitive to rough handling while wet, and kinks and bends are impossible to remove.

To dry prints sensibly, place FB prints face down, and resin coated prints face up, on clean plastic-mesh screens. Resin coated prints easily dry within 10 minutes at ambient temperatures. FB prints are either dried at ambient temperatures, within 2 to 4 hours (see Figure 30), or in heated forced-air industrial driers within 30 minutes. If space is at a premium, hang the prints on a line to dry. Use wooden clothespins to hold them in place, but remember that they will leave minor pressure marks and possible contamination on the print. Consequently, this method requires that the print be trimmed before mounting or storage. Film hangers or plastic clothespins will not contaminate the print, but depending on their design, may leave objectionable pressure marks or trap humidity.

After drying, resin coated prints lay extremely flat, but FB prints have an unavoidable, natural curl toward the emulsion side of the paper. The amount of curl differs by paper brand, but if considered intolerable, it can be reduced with some attention to the applied drying technique. Dry prints at ambient temperatures, because curling increases with drying speed (and toned images may lose color). Place FB prints face down to dry, as the weight of the wet print works against the curl, or hang two prints back-to-back with clothespins at all four corners, as the two curls will work against each other.

The techniques above will reduce, but not eliminate, the natural curl of FB prints. To store or mount prints, further print flattening is often required. One simple and moderately successful method is to place dry prints individually, or in a stack, under a heavy weight for a day or two. A thick piece of glass, laden with a few thick books, makes for an effective weight without contaminating the prints. Another outstanding and expeditious practice to flatten numerous dry prints is to place them sequentially into a heated dry-mount press for a minute or two, and then leave them to cool under a heavy sheet of glass for several minutes.

An alternative approach is to utilize gummed tape and affix the still damp print to a sheet of glass where it is left to dry. This type of tape can be purchased wherever framing supplies are sold, as it is also used for matting prints. For this technique to work, print the image with a large white border, and wipe the print, front and back, to remove any excess liquid. Place the print face up onto the clean sheet of glass, moisten a full-length piece of tape, and secure one print border to the glass. Repeat this for the remaining print borders and leave the print to dry overnight. The next day, cut it loose and remove the taped borders by trimming the print. While drying, the

shrinking paper fibers are restrained and stretched by the tape, leaving a perfectly flat print, ready for storage or presentation.

Image Deterioration

From the instant of its creation, a silver-based image faces attack from a variety of sources. Some are internal and essential to the materials photographic papers are designed and manufactured with. They come in the form of chemicals, inherent or added to the paper, the emulsion, or the coating. They are either a fundamental part of the paper characteristics or meant to improve them.

Other sources of attack are of external origin. Nevertheless, some are intrinsic to the photographic process and can only be minimized but not completely avoided. All processing chemicals fall into that category. In the very beginning of a print's life, and only for a few minutes, we need them to be present and complete the task for which they are designed. After that point, we like to rid the print of them entirely. Fortunately, these sources of image deterioration are under our control, but no matter how attentive our work might be, unavoidable traces of them will remain in the print forever, and given the right environmental conditions, they will have an opportunity to attack the very image they helped to create.

The remaining extrinsic sources of image attack are hiding patiently in our environment, ready to start their destructive work, as soon as the print is processed and dry. They can broadly be separated into reducing and oxidizing agents. Roughly until the introduction of the automobile, reducing agents were the most common sources of image deterioration. Then, oxidizing agents like aldehyde, peroxide, and ozone took over. Their presence peaked in the Western World around 1990, and fortunately, started to decline.

Image oxidation follows a pattern. Initially, image silver is oxidized into silver ions. Then, these mobile silver ions, supported by humidity and heat, migrate through the gelatin layer and, if the concentration is high enough, accumulate at the gelatin surface. Finally, the silver ions are reduced to silver atoms, which combine to colloidal silver particles. They are brownish in color, but at the print surface and viewed at a certain angle, they are visible in the form of small shiny patches. This more advanced defect is referred to as "mirroring," and it occurs exclusively in the silver-rich shadows of the print.

There is evidence that resin coated prints are more susceptible to image oxidation than FB prints. One possible reason is that the polyethylene layer between emulsion and paper base in resin coated prints keeps the mobile silver ions from dissipating into the paper base, as they can in FB prints. In resin coated prints, the ions are more likely to travel to the emulsion surface, since they have no other place to go. Another reason for resin coated image oxidation is that light absorption by the titanium dioxide pigment in the polyethylene layer can cause the formation of titanium trioxide and oxygen. This will increase the rate of silver oxidation if the prints are mounted under glass, preventing the gases from escaping. As a preventive measure, modern resin coated papers made by the major manufacturers contain antioxidants to reduce the chance of premature oxidation. Proper toning and image stabilization practice will help to protect against image deterioration.

Print Storage

Besides emphasizing the importance of careful processing, the difference between light and dark storage in regard to print longevity must be considered. A print stored in the dark has a much longer life expectancy than a print stored in similar temperature and humidity conditions but exposed to light. Therefore, prolonged exposure to light, and especially ultraviolet radiation, presents one of the dangers to print survival. This does not mean that all prints must be stored in the dark and should never be displayed, but it does mean that all prints destined for long-term display must be processed with the utmost care, and the print in the family album is more likely to survive the challenges of time than the one exposed to direct sunlight. However, the latter may not be true if the album is made from inferior materials or is stored in an attic or a damp basement, because other significant dangers to print longevity are the immediate presence of oxidants, non-acid-free materials, and extreme levels and fluctuations of humidity and temperature.

A summary of the most important process, handling, and storage recommendations is listed below. Simple, reasonable care will definitely go a long way toward image stability and longevity.

1. Prints should only be processed in fresh chemicals. Without exception, they must be well fixed, protectively toned, thoroughly washed, and stabilized.
2. Minimize print handling, and always protect finished prints from the oils and acids found on bare hands by wearing clean cotton, nylon, or latex gloves. Avoid speaking while leaning over prints.
3. Store valuable prints in light-tight, oxidant and acid-free storage containers, or mount them on acid-free rag board, protected by a metal frame and glass, if destined for frequent display.
4. The storage or display environment must be free of oxidizing compounds and chemical fumes. Before redecorating a room (fresh paint, new carpet, or furniture), remove prints and store them safely elsewhere for at least 4–6 weeks before they are brought back.
5. Store or display prints at a stable temperature at or below 20°C (68°F) and at a relative humidity between 30 and 50 percent. Do not use attics (too hot) or basements (too damp) as a depository for photographic materials. Store prints in the dark, or when on display, minimize the exposure to bright light to the actual time of exhibition, and always protect them from direct exposure to daylight.

The recommendations above are not nearly as strict as standard operation procedures for a museum, conservation center, or national archive would demand. Nevertheless, they are both practical and robust enough to be seriously considered by any discerning amateur willing to protect and occasionally

exhibit valued prints at the same time. A concerned curator is obligated to verify that all photographic enclosures meet the specifications of ANSI/PIMA IT9.2-1998 and that they have passed the Photographic Activity Test (PAT), as specified in ANSI/NAPM IT9.16-1993. Regular consumers can contact their suppliers to confirm that their products satisfy the above standards.

Image Permanence

Archival processing is preparation for an unknown future. If it is done well, the print will most likely outlast the photographer who processed it. On the other hand, if it is done carelessly, or just plain sloppy, then the print may look fine for years or decades before deterioration suddenly becomes evident. There is research evidence that modern environmental conditions can shorten the life of a print, even when processed perfectly. And of course, we have no idea how the chemical cocktail of future environments will affect new and old silver-based images, making any prediction about a print's potential life expectancy problematic, or at best, demoting them to professional guesswork. Also, the print's long response time to processing errors or environmental attack makes reliable process and storage instructions difficult, if not impossible, and all too often highly argumentative. We can only build on the experience of previous photographic generations and combine this with reasonable disciplines, which are based on the current understanding of the underlying chemical and physical principles. That is the purpose of this text and the most sensible way to deal with image protection and permanence.

Additional Research

Obtaining assurances and longevity statements from photographic companies is difficult, although Crabtree, Eaton, Muehler, and Grant Haist of Kodak have published maximum fixer capacities for commercial and archival printing. Valuable information also comes from more recent research reported by Larry H. Feldman, Michael J. Gudzinowicz, Henry Wilhelm of the Preservation Publishing Company, James M. Reilly, and Douglas W. Nishimura of the Rochester Institute of Technology (RIT) and the Image Permanence Institute (IPI), and by the ISO Working Group. Leading photographers have publicly challenged some claims for silver image stability. Nevertheless, their findings also show that silver image stability is improved with two-bath fixing, toning, thorough washing, and the final application of an image stabilizer.

Claims of archival lasting prints are based on accelerated testing and not actual natural age. Accelerated testing is usually run under high humidity, high temperature, and high light levels. These tests may serve as an indicator and comparator, but it would be naive to expect reliable absolute print life predictions from their results. Even though current lifetime predictions are mostly based on accelerated testing and are prone to interpretation. This is especially true of monochrome prints made with colored inks, for the brain can detect even the subtlest change in image tone with ease.

It cannot be claimed that the advice mentioned here or current wisdom are the final word in archival print processing. The research on silver image stability is likely to continue. However, processing a FB print according to these recommendations will significantly increase its chance for survival, while protecting the memories and feelings it has captured. Resin coated prints definitely benefit from similar procedures, and modern resin coated papers rival the stability of FB papers. Nevertheless, until we have the true actual natural age data, confirming this stability, FB papers remain the best choice for fine art photography.

FURTHER READING
Lambrecht, R. W. and Woodhouse, C. (2003). *Way Beyond Monochrome*. St. Paul, MN: Voyageur Press.

Color Photography

JON A. KAPECKI
Imaging Consultant

Early Years
Ever since the first days of photography in the early 1800s, its practitioners sought ways to create images that reproduced the colors of the world around them. Some resorted to hand coloring of the daguerreotype, a system invented in 1833, while others looked to create direct color photographs by finding the right combination of chemicals to form colors on exposure. An American, Levi L. Hill of Westkill, New York, may have been the first to produce a color daguerreotype (which he called a hilotype) by direct exposure, but his technique was not successfully reproduced during his lifetime. In 1891, Frenchman Gabriel Lippmann, building on the work of Claude Niépce de Saint-Victor and physicist Wilhelm Zenker, used standing waves reflected off a pool of mercury on to a silver bromide emulsion. The developed image when held at a specific angle gave a colored image.

But direct color techniques failed to yield a commercially viable system. Rather, the future of color photography lay in technologies which partitioned and captured the color information of the scene in two or more (usually three) separate or adjacent color records and then recombined that information by either chemical, physical, or optical means to reproduce the final color image.

Probably the first and certainly the most famous example of such a system was demonstrated by Scottish physicist James Clerk Maxwell to a meeting of the Royal Institution of London in May of 1861. Maxwell built upon the color theory of Thomas Young, who in 1801 had proposed that the human eye contained three types of color sensors or cones, each sensitive to a portion of the white light spectrum and that by stimulating those sensors proportionally any color could be

perceived. Extended by Hermann von Helmholtz, the Young-Helmholtz theory of color vision, as it came to be known, was the basis of color printing. In his classic experiment, Maxwell's colleague, Thomas Sutton, had photographed a tartan ribbon onto separate photographic plates through a red, green, or blue filter. These black and white negatives were converted to positive lantern slides and then projected separately through the same three filters and superimposed on a screen to yield a full color image. The photographic implications of this experiment were of little interest to Maxwell, who viewed it primarily as a verification of his theories of colorimetry, and he did not pursue the work further.

Ironically, although Maxwell did not know it, his experiment worked for the wrong reasons. Because silver halide is natively sensitive only to blue and ultraviolet light, his silver iodide separation negatives were not accurate carriers of the red and green scene information and, as would be shown by R. M. Evans in 1961, the color reproduction resulted in part from ultraviolet reflectance through the red filter and some blue-green information passed through the green filter. Indeed, it would take the German photochemist Herman Vogel's 1873 discovery of sensitizing dyes, which extended silver halide's response to red and green light, to produce orthochromatic (and later panchromatic) black and white films that accurately reproduced colors as shades of gray and would later allow film emulsions to separately analyze the scene for its red, green, or blue content for producing color images.

Additive Color Systems

Maxwell's color projection was an example of an additive color system. Because each of the so-called additive primaries removes two-thirds of the white light spectrum (blue, for example, is white minus red and green), each additive filter requires its own light source and cannot be superimposed except in projection. This not only creates registration problems, but is also an extremely inefficient use of light, both in originating and displaying the color image.

Beginning in 1868, the prodigious French inventor, Louis Ducos de Hauron, would propose, patent, and sometimes demonstrate a wide variety of photographic systems, including a technique for making color prints on paper, a camera for creating three-color separation negatives in a single exposure (necessary to photograph moving objects) by the use of beam splitters, a camera for motion pictures (never built), and perhaps most presciently the basics of the technically superior subtractive system for color photography. Independently, Charles Cros in Paris would make a similar proposal for subtractive color photography in a article appearing in *Les Mondes* in 1869.

Despite this, it was the additive system that produced the first successful color photographic materials. In 1873 in Dublin, John Joly designed a screen of thin, alternating red, green, and blue filter stripes that could be positioned in front of the taking and projected film. This permitted all the color information to be recorded on a single piece of film, albeit with a loss of resolution and the other disadvantages common

to additive systems. When the negative was converted to a positive and placed in front of a white light source, the image formed by black developed silver metal would block or pass light through the appropriate filter stripes, corresponding to the color of the original image. The commercial successor to Joly's invention, Dufaycolor, developed by Louis Dufay, used a square grid of filter elements. This was introduced in 1908 and would continue to be sold until the 1940s.

But the most successful of the early additive color films was invented by the Lumière brothers, Augusta and Louis. They were prolific inventors who patented their Autochrome plates in 1904 and introduced them to the market three years later. The Autochrome system used a screen of minute (0.015 mm) potato starch grains dyed with the additive primaries (most likely orange-red, green, and violet) with the spaces in between the grains filled by powdered charcoal and superimposed over a silver bromide panchromatic emulsion. After a reversal development process to produce a positive image, the photograph was viewed through the same screen. Though expensive, the Autochrome system was relatively easy to use and achieved significant popularity, despite requiring exposures that were as much as 50 times longer than comparable black and white materials. In 1914, Agfacolor brought significant improvements to the Autochrome process, including the use of colored resin particles that could be applied in a close-packed distribution, which eliminated the need for the optically wasteful charcoal fillers and improved the effective film speed by a factor of six or more.

Though many examples of early additive color photographs have survived, perhaps the most impressive is the collection by Russian chemist Sergei Prokudin-Gorski. In 1905 he proposed and ultimately constructed a spring-operated camera that took three monochrome separations in rapid sequence. Prokudin-Gorski, who also patented prism-based techniques for projecting color slides and color motion pictures, proceeded with the tsar's patronage to document the Russian Empire from 1909 through 1915 taking nearly 2000 images. This stunning collection, restored digitally, is currently owned by the U.S. Library of Congress.

Additive systems also served as the basis for most of the early color motion picture films. Fortunately, George Eastman, who founded the Eastman Kodak Company in Rochester, New York, in 1880, had largely solved the biggest challenge facing the motion picture pioneers in 1888. He did this by coating photographic emulsions on a flexible and transparent nitrocellulose base and making such materials commercially available. But again, a major difficulty plaguing additive systems was trying to keep the color images in register.

Kinemacolor, marketed in 1906, attacked this problem by using two color records, red-orange and blue-green, on consecutive frames that were photographed and then subsequently projected through a rotating color filter. While the projection speed of 32 frames per second was sufficient to integrate color image through persistence of vision, it was not always fast enough to capture identical images on the paired frames, which resulted in color fringing of the moving image.

FIG. 31 An example of an autochrome. Photo by Charles C. Zoller, Parade Float ca. 1928. Color plate, screen (Autochrome) process. (Image courtesy of the George Eastman House Collection.)

FIG. 33 Photo by Charles C. Zoller, Children on Slide, Ontario Beach Park, ca. 1910. color plate, screen (Autochrome) process. (Image courtesy of the George Eastman House Collection.)

FIG. 32 Photo by Charles C. Zoller, Charles Zoller with Bicycle, ca. 1920. Color plate, screen (Autochrome) process. (Image courtesy of the George Eastman House Collection.)

FIG. 34 Photo by Charles C. Zoller, Jones Children in Costumes with Flags at Jones Park, ca. 1918. Color plate, screen (Autochrome) process. (Image courtesy of the George Eastman House Collection.)

The Gaumont system (1913) and the similar Opticolor and Roux Color systems solved the motion fringing problem by recording three simultaneous images through three lenses on successive frames, but reintroduced registration issues and required the film to run through the projector at a very high rate of speed.

Biocolor (1912), another two-color system with records on consecutive frames, eliminated the need for a special projector with a filter wheel or device by dyeing alternate frames red-orange and blue-green, which allowed movie theaters to show

color films on the same projectors used for black and white. However, this 1912 system suffered from problems in the uniform application of dye.

In 1915, Herbert Kalmus and Daniel Comstock, both graduates from the Massachusetts Institute of Technology, along with machinist W. Burton Wescott, founded the Technicolor Corporation, deriving the name in part from their alma mater. Their first motion picture product, introduced in 1917, was a two-color additive system using a beam splitter with red and blue-green filters to record images on consecutive frames, similar to Kinemacolor. A prism was used in the projector to align the overlap with minimal registration problems. Like many two-color systems, the Technicolor entry could produce believable, though often inaccurate, color because of the limited palette.

In 1928, Kodak introduced the first Kodacolor product, a three-color motion picture system using a film embossed on the back with a fine pattern of cylindrical lenses or lenticules, spaced at about 25 per millimeter. The film was exposed through a lens whose top third was a red filter, the middle third a green filter, and the bottom third a blue filter. The lenticules, which ran parallel to the filters, served to focus a miniature copy of the lens and its corresponding color information on the panchromatic film. After development, the film was projected through a similar lens system to yield the color image.

The Horst process, introduced in 1930, was one of several that placed three additive colors on a single frame, and using an optical system with three projection lenses to reassemble the color image. Not surprisingly, the reduced image size exacerbated the light problem and also yielded grainy images.

Though these systems were certainly ingenious, as technically superior subtractive color systems were invented, additive color largely disappeared from the market. In 1977, however, the Polaroid Corporation, known for its instant color print products, introduced an instant Super-8 motion picture film called Polavision based on the additive model, followed in 1982 by Polachrome, an instant color slide film. In many ways this technology was a sophisticated updating and merger of Joly's 1873 system and Polaroid's instant black and white systems. The source of the color was a finely detailed additive grid of alternating red, green, and blue lines, 394 color triplets per centimeter of film width in Polachrome and 590 triplets in Polavision. The slide film could be exposed in an ordinary 35 mm camera and the rewound film cartridge placed in a proprietary processing unit with a package of processing materials, which included a developer, silver complexing agent, and stripper sheet. When the unit was cranked, the chemicals were applied to the stripper sheet which was laminated to the back of the exposed film. Development immobilized the exposed grains as silver metal and the complexing agent caused the remaining ionic silver to migrate to a receiving layer adjacent to the color screen, where additional chemistry converted it into a positive image in black silver metal. After 60 seconds, continued cranking caused the stripper sheet to peel away the layers containing the negative silver image and return it to the reagent package. The technology of the movie film was similar. Because of the inherent light inefficiencies of additive

technology, both systems had a relatively low ISO camera speed of 40, and the projected images were darker than those of conventional products.

Though now largely forgotten in silver halide color products, the additive color system has achieved dominance in digital display. There pixels provide red, green, and blue elements that visually fuse into a full color image at normal viewing distance.

Subtractive Color Systems

As early as 1870, the prolific photographic innovator Louis Ducos de Hauron recognized the many advantages of a subtractive color system, but the technologies of the time were not ready to exploit those ideas. Because the three subtractive primaries — cyan, magenta, and yellow — block or modulate only a third of the white light spectrum, separation positives composed from the subtractive primaries can be overlaid and viewed with a single light source. Optimally implemented, the film, not an external filter, now carries the dyes, eliminating many of the problems related to registration and special equipment. Further, because each subtractive primary passes twice as much light as an additive primary, the use of light is far more efficient, both in the capture and in the reproduction stage. Ultimately the subtractive process would become the basis for virtually all color photographic systems; in these systems the three subtractive primary dyes would either be formed in register (e.g., Kodacolor), destroyed in register (e.g., Cibachrome) or diffused in register (e.g., Polacolor instant print film, Technicolor) to form the full color image.

But significant technical hurdles remained. To implement the integral tripack envisioned by de Hauron and others — three emulsions stacked on top of one another — required technology enabling those silver halide layers to selectively analyze the scene for its red, green, and blue content and then turn that latent image into the corresponding subtractive primary dyes of cyan (controlling red), magenta (controlling green), and yellow (controlling blue). Since the additive primaries can in turn be produced by overlaying the subtractives (e.g., white light passed through cyan and yellow filters removes red and blue, leaving green), the path to a full color image is achieved.

The discovery of sensitizing dyes, which could capture the energy of red and green light and transmit it to the silver halide grain to form a latent image, was the key to solving the first challenge. Vogel's accidental discovery in 1873, when he found that a plate treated with the dye coralline to reduce light scatter or halation also had increased the emulsion's sensitivity to yellow-green light, led quickly to the investigation of other synthetic and natural dyes, such as chlorophyll, by de Hauron, Cos, Becqueral, Waterhouse, Adolphe Miethe (of Agfa), and others. This yielded a fully panchromatic black and white film by 1904, with the first widely used commercial plates coming from Wratten and Wainwright in 1906.

It was not until the mid-1920s, however, that Brooker and his collaborators in the Kodak Research Laboratories synthesized a systematic series of non-diffusing dyes that could be used to sensitize silver halide in gelatin to any portion of the white light spectrum. Cyanine dyes, consisting of two heterocyclic

moieties linked by a variable length conjugated chain, could be tuned to the desired spectral response and would adhere well to the silver halide grain, which efficiently transmitted the energy of the received light. Cyanine dyes continue to be the most widely used sensitizing chemicals and literally thousands have been synthesized over the years.

The second key to creating a modern subtractive color film was a technology for reading back the color information held in the latent images to form the appropriate cyan, magenta, and yellow dyes. In 1912, Rudolph Fischer and colleagues patented a technique that could produce these dyes as a function of silver development by utilizing a new kind of developing agent based on para-phenylenediamines which, when oxidized by the exposed silver halide, produced a species called a quinone diamine. This single oxidized developer could then react with different dye formers, called couplers, to produce the three subtractive primary dyes in proportion to the silver development.

Fischer further anticipated how this could be assembled into a multi-layer color film. He described a film containing a top silver halide layer sensitive to blue light and containing a coupler that could form a yellow dye, a middle layer sensitized to green light and containing a magenta dye-forming coupler, and a bottom layer of red sensitized silver halide containing a cyan dye-forming coupler. Because Fischer knew the red and green sensitized layers would also retain their native sensitivity to blue light, he considered interposing between the blue and green sensitive layers, a layer containing a yellow dye which would filter out any blue light before it reached the layers below. The yellow dye would be destroyed as a function of the process.

Essentially, Fischer described the structure and chemistry of most modern color films. However, he was unable to devise a practical example because he could not find a way to keep the three dye-forming couplers as well as the sensitizing dyes from wandering within or between their respective layers.

Meanwhile, photographic inventors looked for other ways to implement subtractive color systems. In 1914 John Capstaff at the Eastman Kodak Company devised the first film to bear the Kodachrome name. The system used two negatives, one exposed through a green filter and the other through a red filter. After silver development, a bleaching process removed the silver and hardened the gelatin in inverse proportion to the silver image. The film was then dyed in complementary colors—red-orange for the green exposure and blue-green for the red exposure—with the less hardened gelatin absorbing more dye and yielding color positives that could be attached to opposite sides of a piece of glass. The film produced remarkably good flesh tones, though it did less well in outdoor scenes where blue sky and vegetation dominated. In 1916, Capstaff adapted his process to a motion picture film, but World War I interrupted the company's plan to market the product. It would wait until the early 1930s before a few studio movies would be made using Capstaff's process.

The first commercially successful subtractive color movie film and the only real competitor to Technicolor in the 1920s

was Prizmacolor (successor to a previous additive color film of the same name). Like Capstaff's Kodachrome it was a duplitized film with a red-orange record on one side and a blue-green one on the other and could be projected without filters or special equipment. With modification, this two-color technology would continue to be used, especially for low-budget films, as late as the 1950s in products like Cinecolor and Trucolor. Although it could give good flesh tones, cinematographers had to be careful that they did not exceed the limited color palette that the system could reproduce.

Technicolor's first subtractive color film entered the market in 1922. Like some of its immediate predecessors, it used two separate films, an orange-red record and a blue-green one, each half the normal thickness, cemented back to back. The originals had been photographed on consecutive frames of Kodak black and white film stock using a beam splitter. Unfortunately, in the projector the thick duplitized film with gelatin images on both sides was scratched easily and also deformed due to unequal heating of the two sides. Six years later Technicolor would replace this product with its first dye transfer film with red and green images printed on the same side of the film and carrying a silver sound track, considered significantly superior to dye-based sound tracks, to accommodate the increasing popularity of the "talkies."

Technicolor's inventors, however, recognized the limitations inherent in any two-color system, and in 1932 they introduced the first version of what would become their flagship product: an ingenious process for creating a three-color subtractive projection film produced from three black and white negatives exposed in a single camera. The camera contained a partially silvered mirror or beam splitter. Light passing through the mirror was directed to a piece of black and white film moving behind a green filter, while light directed to the side reached a magenta filter which passed blue and red light to a bipack composed of an orthochromatic film bonded, emulsion to emulsion, to a panchromatic film. The orthochromatic film, insensitive to red light, recorded only the blue information while the panchromatic film recorded the remaining red light. In later years, Technicolor would add a red-orange filter dye that could be removed during processing to the surface of the blue-sensitive film to keep any stray blue light from reaching the red recording film. The Technicolor camera, designed by William Young, a machinist from Springfield, Illinois, cost about $30,000 and used Kodak film stock with an effective film speed of ISO 5.

To produce the projection positive, each negative was printed onto a special black and white film, called a matrix. After development, the silver image was removed to leave behind a positive relief map of the image in hardened gelatin, which could absorb dye proportionally to image density. The three matrices, which could be reused, were imbibed with the corresponding cyan, magenta, or yellow subtractive primary dyes and then in succession forced under high pressure against a prepared receiver film to transfer the dye and create the full color image. The receiver was a black and white film coated with dye-absorbing compounds called mordants. Prior to the

FIG. 35 Leopold Godowsky, Jr. and Leopold Mannes, inventors of the 1938 Kodachrome process dye imbibition (Eastman wash-off relief) print, ca. 1940, from a wash-off relief print made from Kodachrome transparency. Photo by Dr. Walter Clark. (Image courtesy of George Eastman House Collection, Rochester, New York.)

FIG. 36 The original box Kodachrome slide film was sold in 1936. (Image courtesy of the George Eastman House Collection, Rochester, New York.)

dye transfer the receiver film was exposed and processed to create the silver sound track, frame lines, and a low density "key image" of the green record, which improved contrast and perceived sharpness of the final print. The process demanded registration tolerances of better than .0001 inch at each step. The new Technicolor process gave dramatically improved color reproduction and was a commercial success, despite its complexity and cost.

Meanwhile, two classical musicians with a long-standing interest in color photography, Leopold Mannes and Leo Godowsky, were exploring the chromogenic methodology initially proposed by Fischer in 1912. The two had created an additive film in 1919, but decided it would not give satisfactory color reproduction. After setting up a home laboratory in New York City in 1922, they attracted the attention of C. E. K. Mees, director of the Eastman Kodak Research Laboratory. In 1930 he invited them to continue their work at the company headquarters in Rochester, New York. Mannes and Godowsky, or "Man and God" as they were nicknamed by some of their co-workers, decided to solve Fischer's coupler wandering problem by diffusing the dye-formers into the film during the process rather than incorporating them in the emulsion during manufacture. Once the dyes were formed by reaction with oxidized developer, they were sufficiently insoluble so as to remain in the film while the unused coupler was washed out during the process. Researchers at the Kodak Laboratories provided the other piece of the puzzle: sensitizing dyes that adhered to the silver halide grain and did not wander. The final film, which again took the name Kodachrome, had five layers, each between 1 and 3 μ thick, on a celluloid support. From the top, there was a blue-sensitized layer with a yellow filter

dye (to make sure no blue light reached the layers below), a gelatin interlayer, a green-sensitized layer, another interlayer, and a red-sensitized layer.

However, the decision to diffuse the three subtractive dye-formers into the film as a function of development created an extremely complicated process involving as many as 28 steps. All versions of the Kodachrome process involved an initial black and white development step. This created a negative image in silver metal, which was removed by a chemical called a bleach and left behind three positive records in unreacted silver halide.

After light re-exposure to turn that into a positive latent image, color developer and a water-soluble cyan dye-former diffused into the film and formed a positive cyan image in all three color records. After washing and drying, a special bleaching solution was carefully diffused into only the upper blue and green records, where it oxidized the silver back to silver bromide and decolorized the dye. The depth of penetration was controlled by the bleach viscosity and time and temperature profile of the step. Since the red layer no longer contained any silver halide, the process could be repeated now for the green and blue layers, but using a developer containing a magenta dye-forming coupler. Again, the selective bleaching was carried out, this time only in the blue layer. Finally, the blue was developed to form yellow, and all the remaining silver metal was bleached and fixed out of the film.

The new Kodachrome was originally marketed as a 16 mm home movie film, but it was quickly adapted into professional versions, including one sensitized for artificial lighting and also in an 8 mm format. By 1936, Kodak was selling the product in 35 mm cartridges and other formats for still photographers, ushering in a new era of color photography among amateurs and professionals.

FIG. 37 The 1939 Kodachrome ready mount. (Image courtesy of the George Eastman House Collection, Rochester, New York.)

By 1939, Kodak had significantly modified the Kodachrome process to eliminate the touchy differential bleaching steps, replacing them with selective re-exposure, made possible by the invention of sensitizing dyes that would remain on the grain during most of the process and reduce the number of processing steps to 18. Following the black and white development and bleaching steps, the film was re-exposed through its base with red light. Treatment with a developer containing a cyan dye-forming coupler resulted in silver development and a dye image only in the red record. Re-exposure from the top with blue light and development with a yellow dye-forming developer created the blue record. The green record remaining in the middle was re-exposed, initially with just white light, later with a chemical fogging agent, and then processed with a developer containing a magenta dye-forming coupler. The film was then fully silver bleached and fixed to produce a dye-only color image. Over the years, color reversal films from companies like Ilford, Dynacolor/3M/Ferrania, and Sakura/ Konishiroku would adopt this process. Ultimately, the Kodachrome process would be shortened from its original 3.5 hours to a 6-minute time while the film speed would be increased by more than 20-fold.

Meanwhile, Wilhelm Schneider and Gustav Wilmanns of Agfa in Germany were pursuing a film design closer to Rudolph Fischer's original vision. Agfacolor Neue, introduced in 1936, used couplers bearing a long hydrocarbon chain, called a ballast, terminating in a carboxylic or sulfonic acid group. The ballast served to immobilize the couplers in their corresponding red-, green-, and blue-sensitized layers while

the acid groups enabled them to form micelles that could be dispersed in the aqueous gelatin as well as loosely tether the couplers to the gelatin chains. This vastly simplified the processing to the extent that amateur photographers could do it in a home darkroom. After the black and white development step, the film went into a para-phenylenediamine color developer to produce the full color image in a single step, followed by bleaching, fixing, and washing to remove the silver. In 1942, with the outbreak of World War II, the American company Ansco introduced a near identical film sold in the United States, France, and other Allied countries.

The advantages of what became known as incorporated coupler processes were hardly lost on Eastman Kodak. In fact, several early patents of Mannes and Godowsky included claims for such films. But there were advantages to the Kodachrome technology as well. Because the film layers did not have to be thick enough to hold coupler in addition to the silver halide, they could be much thinner, which reduced optical scatter and improved sharpness. Further, because incorporated couplers were in the film before processing and remained there for the life of the processed image, any coupler instability could result in problems. Kodachrome did not have that issue.

Nonetheless, in late 1941 when Kodak introduced Kodacolor print film, a film that produced negatives in complementary colors to be subsequently printed as positives onto reflective photosensitive paper, it had turned to incorporated coupler technology with its much simpler process. The method used to anchor the dye-formers in Kodacolor was different from Agfa's technology, using much shorter carbon chains with no ionic solubilization. These couplers were suspended in the gelatin layer in small droplets of a water-immiscible, high-boiling organic liquid termed a "coupler solvent" (though it really acted more like a plasticizer). Initially this approach was used to avoid the Agfa patents, but it was quickly realized that these couplers were more easily manufactured and purified and afforded greater opportunity for "tuning" photographic parameters. Ultimately, even Agfa, as well as other film companies, would adopt this technology.

With time, the structure of what was called an "integral tri-pack" would become more complicated, incorporating as many as 17 layers. In many films, each of the three color-recording layers would be split into two or three layers with a more light-sensitive emulsion on top followed by less sensitive layers below. This provided technology for both increased latitude and reduced granularity. A filter layer above the blue-sensitive pack removed ultraviolet light that would otherwise be recorded by the blue record. Additionally, an anti-halation layer, designed to reduced sharpness degradation resulting from backscattered light, was coated under the bottom layer or on the back of the film.

The negatives from Kodacolor print film and similar products could be converted to paper-based prints by exposing the negative onto a piece of reflective paper coated with three photosensitized layers likewise using the incorporated coupler technology and simple process. Because the printing was done with three separate primary color exposures, significant

control over the tone and color of the print was possible for both quality improvements and artistic creativity. Though the prints from what became known as the "color neg-pos process" were initially expensive, they would steadily drop in price over the next 50 years, making this the most popular photographic system in history.

It was not until 1946 that Kodak adapted its incorporated coupler technology to a color slide film, Ektachrome, whose much simpler process, with its single color development step, permitted processing in the home darkroom. By 1975 this became the E-6 process and the standard for nearly all color reversal films marketed world-wide. It consisted of a black and white reversal step followed by chemical treatment to form a positive latent image on the remaining silver halide. Single-step color development was followed by treatment with an oxidizing agent, called a bleach, which converted the uniform silver deposit into silver ion for complexation and removal by the thiosulfate fixing agent.

By 1950, with further invention, the Kodacolor technology was incorporated into a family of motion picture films called Eastman Color, including negative, print, and intermediary films for duplicating. In addition to breaking the near-monopoly Technicolor had on movie print films, the new process was cheaper and faster, though it did not provide Technicolor's highly stable silver originals for archival purposes.

The multiple generations of film involved in the color neg-pos process (as many as four in the motion picture chain) served, however, to emphasize the colorimetric imperfections of the subtractive primary dyes. Ideally, a cyan dye, for example, should control only red light by absorbing between 600 and 700 nm. But virtually all cyan dyes also had significant unwanted absorptions in the blue-green. This led to desaturated or "muddy" colors, especially in successive generations of film. The ingenious solution to this problem was a technology called "integral color masking," invented by W. T. "Bunny" Hanson of Kodak and introduced in Ektacolor films in 1949. The technique added "colored couplers," which bore an attached pre-formed azo dye, to the normal colorless coupler in the layer. For example, the added cyan dye-forming colored coupler carried a blue-green dye that would be released and washed out of the film to the extent that cyan dye with its unwanted blue-green absorption was formed. The result was equivalent to a "perfect" cyan image dye overlaid with a uniform density to blue green. While this gave the negative an orange cast, it required only a longer cyan exposure in making the positive print. So revolutionary was this improvement that virtually all negative films would adopt this technology once it was free of patent restrictions.

Trends during the second half of the 20th century as color film technology matured involved continuous improvement of the image structure (grain and sharpness), color, and speed of films to enlarge what was called "photospace coverage" or the breadth of conditions under which a picture could be taken while maintaining or even improving image quality. Fuji Photofilm of Japan would introduce an ISO 400 speed color negative film in 1976 and soon thereafter film speeds from the

major companies would increase to over ISO 1000. This was coupled with the increasing popularity of 35 mm cameras, the introduction of the Instamatic drop-in cartridge in 1963, and the even smaller format 110 (13×17 mm frame) and novel disc (8×11 mm frame) films in 1972 and 1983, respectively. These smaller form factors placed greater demands on the film to gather and manipulate information, which led researchers to two major breakthroughs in film technology: high aspect ratio or tabular grains (called T-grains by Kodak) and image modifying chemistries.

The information content of a film is determined at exposure. That information can be partitioned among the various display attributes (grain, sharpness, contrast) or lost, but it cannot be increased. Tabular grains replace the near-cubic shape of traditional silver halide with flat, generally hexagonal crystals of about 0.1 mm thickness having a much higher surface to volume ratio. These grains not only gather far more information per unit mass, but, because they tend to align themselves nearly parallel to the film support during coating, they can significantly reduce optical scatter and improve sharpness. T-grains were first used in a 1000 speed Kodacolor film in 1982.

Image modifying chemistries provided the tools to take that additional information stored in the latent image and selectively distribute it as appropriate for the film's intended application. Foremost among the image modifiers was developer inhibitor releasing (DIR) couplers which, on dye formation, released a silver development inhibitor (usually a sulfur or nitrogen heterocycle that could complex with the silver halide surface) that provided a kind of chemical negative feedback loop in the information transfer process. Depending on the ultimate spatial distribution of the inhibitor, it could perform several tasks. By allowing each silver grain to develop only partially, the inhibitor could force the system to use more silver grains or information-carrying centers to produce the dye image, increasing the signal to noise ratio of the system, a result manifested in reduced granularity or the perceived non-uniformity of the dye image. Another way to achieve a similar effect is by using "competing couplers" that compete with the image-forming coupler for the oxidized developer but produce a soluble or colorless "dye" product, again forcing more silver halide centers to contribute to the image.

Released inhibitor that moved between layers could be used to provide correction for unwanted dye absorption, similar to colored couplers, but via a different mechanism. For example, inhibitor released from a DIR coupler in the cyan layer could diminish development of density in the adjacent magenta layer to compensate for the unwanted green absorption of the cyan dye. This is referred to as an interlayer interimage effect.

Finally, released inhibitor traveling laterally in the layer can be used to create a concentration gradient that would slightly suppress dye formation in the center of the image area while increasing the density change at the edge. This "edge effect" gives the visual impression of improved sharpness. DIR couplers would find their first application in a motion picture internegative film in the late 1960s and in the introduction of Kodacolor II film in 1972. Controlling the diffusion of the

inhibitor between and within the layers to achieve the desired image-modifying effects was hindered by its mechanism of operation—adherence to the silver halide grain. This led to an extension of the technology, delayed release DIR couplers, which released an inhibitor precursor that could diffuse in a controlled fashion before releasing the active inhibitor.

Although the disc film in 1983 was the first product to incorporate magnetic information encoding, it was the Advanced Photo System (APS) technology, introduced in 1996, that brought this concept to fruition. A joint development by Kodak, Fuji, Canon, Minolta, and Nikon, APS combined the advantages of traditional silver halide with a recording of digital information on a transparent magnetic coating that covered the film surface and on a data disc on the end of the film canister. The Information Exchange or IX tracks included data relating to selected picture format (classic, HDTV, or panoramic), date, title, print copies desired, shutter speed, aperture, focal length information, film speed, exposure compensation, and what was called Print Quality Information, such as flash use, subject brightness, backlighting status, and other scene information dependent on camera sophistication. These data could be used during the processing and printing steps to both automate the system as well as dramatically improve print quality. The system also allowed detailed backprinting on prints and production of a keyed index print. Additional tracks were reserved for future information acquisition.

The APS system featured an autoload cartridge in which the developed negatives were returned to the customer to both protect and codify the images, as well as allow mid-roll film change. Negative size, on a new, stronger polyethylene naphthalene (PEN) film base with less "memory" for curl, was 30×17 mm, midway between traditional 35 mm and the 110 format, and permitted the design of smaller, thinner cameras as well as an effective increase in film speed by focusing the same amount of light on a smaller surface. Advances in both emulsion and image-modifying technologies since the disc product allowed the smaller format to produce pleasing pictures up to 8×10 inches. Despite these advances, with the concurrent emergence of highly automated 35 mm cameras and non-film digital capture technologies, the APS system did not meet with the market acceptance its sponsors had anticipated.

Despite the inroads of digital capture, about 2.5 billion rolls of film and over 400 million single use cameras were sold worldwide in 2004, yielding almost 90 billion prints, according to research by the Photo Marketing Association. Some 656 million film units were sold in the United States with over 22 billion prints produced.

FURTHER READING

Collins, D. (1990). *The Story of Kodak*. New York; Harry N. Abrams.

Coote, J. H. (1993). *The Illustrated History of Color Photography*. Tolworth, England: Fountain Press.

Eastman Kodak (1989). *Journey: 75 Years of Kodak Research*. Rochester, NY: Eastman Kodak Company.

Eder, J. M. (1945). *History of Photography, 4th edition* (E. Epstean, trans.). New York: Dover Publications.

Friedman, J. (1968). *History of Color Photography* (2nd edition). London: Focal Press Limited.

Friedrich, L. E. and Kapecki, J. A. (2001). Color-forming materials. In *Handbook of Imaging Materials* (2nd edition), (Diamond, A. S. and Weiss, D. S., eds.). New York: Marcel Dekker, Inc.

Frizot, M. (1998). *The New History of Photography*. Köln: Könemann Verlagsgesellschaft mbH.

Hunt, R. W. G. (1987). *Reproduction of Colour* (4th edition). Tolworth, England: Fountain Press.

James, T. H. (ed.) (1977). *Theory of the Photographic Process* (4th edition). New York: Macmillan Publishers.

Kapecki, J. and Rodgers, J. (1993). Color photography. In *Kirk-Othmer Encyclopedia of Chemical Technology* (4th edition). New York: John Wiley & Sons.

Rosenblum, N. (1984). *A World History of Photography*. New York: Abbeville Press.

Van de Sande, C. C. (1983). Dye diffusion systems in color photography. *Angewandte Chemie International Edition* 22, 191–209.

Wall, E. J. (1925). *History of Three-Color Photography*. Boston, MA: American Photographic Publishing Company. ◎

Silver Dye-Bleach Photography

MATTHIAS SCHELLENBERG, (ING. CHEM. ETHZ) RETIRED
Ilford Imaging Switzerland GmbH

ERNST RIOLO
Ilford Imaging Switzerland GmbH

HARTMUT BLAUE
Ilford Imaging Switzerland GmbH

Basic Color Photographic Principles

Color photographic systems are based in general on the subtractive principle, where the image dyes absorb the complementary color of the white light.

Almost all of the commercially available color films and papers are based on chromogenic processes. The image dyes are formed during processing were needed to reproduce the original picture as a negative or a positive image. The color developer is oxidized by exposed silver halide and reacts with color couplers, which are incorporated in the layers, under formation of dyes. The complex chemistry of chromogenic image formation is described in Chemistry of Developers and the Development Processes.

Silver dye-bleach materials use a chromolytic process to give a color reproduction of the original image. The photographic material contains the full concentration of the image dyes cyan, magenta, and yellow required to reproduce black. The dyes that are not needed for the image are bleached during

processing. This procedure leads to a positive picture, because in areas with white exposure all dyes are bleached and the layer becomes transparent, areas with no exposure maintain the full amount of all original dyes and are consequently black.

History of Silver-Dye Bleach

The first suggestion of a silver-dye bleach process was made in 1905 by Schinzel. He destroyed the dyes by oxidation reactions using hydrogen peroxide. The image was distributed and silver metal catalyzed the reaction. The reductive silver-dye bleaching was invented and patented by Christensen in 1918. Strong reducing agents such as sodium dithionite or stannous chloride were used. This reductive bleaching was also catalyzed by silver metal formed in a preceding development. No commercial product resulted from these early inventions.

Bela Gaspar developed the first useful silver-dye bleach system in 1930. He received a number of patents from his process and produced positive print materials that were sold for some time under the name Gaspar Color. Gaspar color materials contained water-soluble dyes in three layers with appropriately sensitized silver halides. The dyes were bleached by a so-called catalytic action of silver when immersed in hydrobromic acid or an acid solution of thiourea. Effectively the developed silver metal was already the reducing agent for dye bleaching in this early process.

Kodak developed a silver-dye bleach material under the name Azochrome until 1941 but never commercialized it. Ciba started research work on silver-dye bleach after 1950, but it was not until 1963 that the first material under the name Cibachrome was commercialized. The silver dye-bleach systems continually improved to a top quality in color reproduction and image stability, but the market share remained limited due to the low photographic speeds and the high prices of the materials. In 1989 the brand name Cibachrome was changed to Ilfochrome and Ilfochrome II print materials were sold as professional products with a high reputation.

Not only did the Cibachrome materials improve from 1963 to its current highly sophisticated levels, but the processing was drastically simplified and shortened from initially almost an hour down to just a few minutes.

Basic Structure of Silver Dye-Bleach Materials

A gelatin layer containing a cyan dye and silver halide sensitized for red light is coated on a paper or film base. On top of the cyan layer is a magenta layer containing silver halide sensitized for green light. This is followed by a yellow layer with blue-sensitive silver halide. After the red, green, or blue exposure of this material, a silver image can be developed in the cyan, magenta, or yellow layer, respectively. In practice the effective structure of silver dye-bleach materials is sophisticated enough to correct for several unwanted interferences during exposure and processing.

Processing Fundamentals

In the first step, the exposed silver halide of a Silver dye-bleach material is developed to a metallic silver image by a conventional black and white developer. The second step is a bleaching bath, where the silver metal is used to bleach the dyes. The bleaching reaction takes place in the immediate vicinity of the silver grains. The chemistry of this step will be discussed below.

The third step requires the oxidation of any excess silver that has not been used for dye bleaching. The oxidation agent is generally copper sulfate in the presence of bromide, which transforms silver to silver bromide. The separate silver bleach is eliminated in all modern silver dye-bleach processes. Dye and silver bleaching have been combined in one bath that bleaches dyes and all excessive silver (see below).

The last step dissolves the silver halides in a fixing bath. Finally, a wash eliminates all silver compounds and the reaction products of dye bleaching. Every processing step is separated from the previous and subsequent steps by a wash. The result of this process is a positive reproduction of the original image.

Silver dye-bleach systems have clear advantages and disadvantages when compared to chromogenic imaging. The main advantage is a simple and stable process that leads to a direct positive image. Consequently, these pictures are very sharp. The high resolution is due to the absorption of scattered light by the image dyes (cyan absorbs red light, magenta absorbs green light, and yellow absorbs blue light). An excellent micro film is based on the silver dye-bleach principle: At low speed the absorption of the dyes in the sensitization range of the silver halide emulsions in the same layer reduces the photographic speed of silver dye-bleach materials (e.g., for red-light-sensitized silver halide emulsion is embedded together with the cyan dye in the same layer and the dye removes a part of the red light, which is no longer available to expose the emulsion grains).

The application of pure and stable azo dyes in the coated material results in a brilliant final picture of an excellent stability against light exposure and under archival conditions. Consequently, silver dye-bleach materials are ideally used for the printing of slides or colored originals. For classical camera applications, the photographic speed is too low.

Fastidious and delicate manufacturing problems of silver dye-bleach materials kept the production yields relatively modest, which resulted in high prices per square meter of coated material. Silver dye-bleach never conquered large market segments, but it filled specific market gaps in the professional field.

The advantage of light stability compared to chromogenic systems was a strong marketing argument. Silver dye-bleach pictures are best suited for large format applications that are exposed to sunlight. Silver dye-bleach materials have been sold mostly to professional photographers for artistic applications and exhibitions.

Specific Components of Silver Dye-Bleach Materials
Dyes

Image dyes are very specific components of silver dye-bleach materials. In early experiments, several classes of dyes were investigated but in practice only azo dyes have been used.

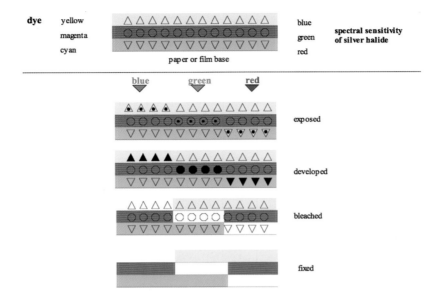

FIG. 38 Schematic structure of a silver dye-bleach material after a blue, green, or red exposure and the processing steps development, bleaching, and fixing.

Image dyes have to fulfill a number of fundamental requirements to work:

Optimal spectral absorption in the coated layer and the final image.
Irreversible bleaching to colorless reaction products on processing.
Good water solubility of the dye for coating and of the bleach products, which have to be washed out at the end of processing for a stable final picture.
No diffusion into neighboring layers, neither during coating nor processing.
No influence on the viscosity of coating solutions.
No influence on the sensitization of the silver halide grains.
Reproducible association of the dye molecules in the gelatin matrix.

The important requirement of water solubility and diffusion fastness becomes possible mainly by controlled association of the azo molecules, but a delicate problem exists. The association of dye molecules is often coupled with a spectral shift and change in light stability. Every change in the manufacturing procedure or a batch change of coating components can influence the spectral behavior of the dyes.

Non-conjugated bis-azo components are used in Ilfochrome as yellow and magenta dyes; conjugated compounds as cyan dyes.

Other Basic Components
Basic components such as gelatin, wetting agents, and silver halide emulsions, which are sensitized to the appropriate spectral range, are comparable to chromogenic color materials.

Development
Normal black and white developers of the super additive type on the base of hydroquinone-phenidone are used for silver dye-bleach materials. The goal is a low contrast silver image, since the transformation into the dye image in general leads to a contrast increase. Special additives to silver dye-bleach developers are mentioned in the section on Additives.

Bleaching of Dyes and Excessive Silver
The most important step in silver dye-bleach processing is the transformation of the initial silver image into a dye image. The relatively noble silver metal has to act as a reducing agent. The bleach bath contains iodide to lower the redox potential of silver and a strong acid. The overall equation for the bleach reaction is

$$R\text{-}N = N\text{-}R' + 4Ag + 4H^+ \ 4I^- \rightarrow R\text{-}NH_2 + H_2N\text{-}R' + 4AgI$$

R = substituted aromatic rest of the dye molecule

Whereby the reaction takes place in two steps, leading primarily to a hydrazo compound followed by the cleavage to the

Yellow

Magenta

Cyan

FIG. 39 The structure of typical silver dye-bleach dyes.

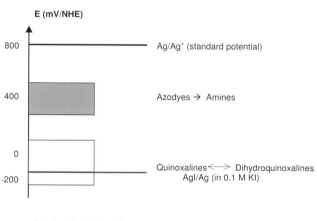

FIG. 40 Redox equilibria of quinoxalines in acid solution. (The standard potentials of quinoxalines are near 0 mV against a normal hydrogen electrode.)

AH_{2H} AH_{2H}

FIG. 41 Tautomeric rearrangement of the active 1,4-dihydroquinoxaline to the inactive 1,2-dihydroquinoxaline.

Range of redox potentials in a SDB Bleach bath

E (mV/NHE)

800 ——————————————— Ag/Ag⁺ (standard potential)

400 Azodyes → Amines

0
-200 Quinoxalines ⟷ Dihydroquinoxalines
 AgI/Ag (in 0.1 M KI)

2,3-dimethylquinoxaline :
$E^1 = + 20$ mV/NHE
$E^2 = -160$ mV/NHE

FIG. 42 Range of redox potentials in a bleach bath.

amines as a final product (see below). The bleach bath has to be strongly acidic, as the reaction consumes protons and the bleach products are aromatic amines that have to be protonated for dissolution. The pH of practical bleach solutions is 0–1. It is established by sulfuric acid.

Silver and dyes are fixed in the gelatin layer; a direct exchange of electrons for the bleach reaction is excluded. Therefore, a redox catalyst is needed for the transport of electrons from silver to the azo compound. 1,4-diazines, mostly quinoxalines, are used for this purpose. In acid solution they are reduced reversibly to radical cations and 1,4-dihydroquinoxalines in fast reactions.

The 1,4-dihydroquinoxaline reacts with an azo group in a first step to the corresponding hydrazo compound and in a second step under formation of two amines. On the other side, the 1,4-dihydroquinoxaline is unstable and rearranges

in a reversible (relatively slow) reaction (half-life 1 to several seconds) to the more stable tautomeric 1,2-dihydroquinoxaline, which does not react directly with azo compounds.

The quinoxaline is reduced in the bleach bath at the silver surface and diffuses a radical or dihydroquinoxaline to the azo dye, which in turn is reduced to amines under regeneration of the quinoxaline. The relative redox potentials of the bleach components are represented in Figure 42.

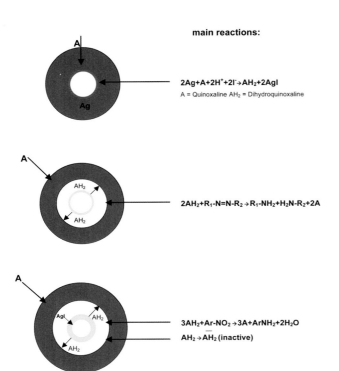

main reactions:

$2Ag + A + 2H^+ + 2I^- \rightarrow AH_2 + 2AgI$

A = Quinoxaline AH$_2$ = Dihydroquinoxaline

$2AH_2 + R_1\text{-}N=N\text{-}R_2 \rightarrow R_1\text{-}NH_2 + H_2N\text{-}R_2 + 2A$

$3AH_2 + Ar\text{-}NO_2 \rightarrow 3A + ArNH_2 + 2H_2O$

$AH_2 \rightarrow \overline{AH_2}$ (inactive)

FIG. 43 Formation of a bleach hole.

The standard potential of silver is reduced from 800 mV/NHE to −150 mV/NHE by addition of 0.1 M KI. Silver metal is now a strong reducing agent able to reduce the bleach catalyst. Azo compounds can be reduced to the corresponding amines in irreversible reactions at around 400 mV/NHE. During dye bleaching a spherical hole without dye is formed around every silver grain.

Simultaneously silver is transformed into silver iodide. The growth of the bleach holes becomes slower with increasing bleach time, because more reducing agent is needed with increasing radius of the hole.

The range of the active reducing agent 1,4-dihydroquinoxaline is limited by the tautomerization reaction to the inactive 1,2-dihydroquinoxaline. An aromatic nitro-compound is added to the bleach bath as a mild oxidizing agent. This agent also limits the reach of the dihydroquinoxaline and is used to oxidize any excess of silver. The electron transfer from silver to the nitro compound is also catalyzed by quinoxaline. The addition of an oxidizing agent to the bleach bath makes a separate silver bleach bath superfluous (see below).

During dye bleaching all silver is transformed into very insoluble silver iodide.

Components of the Bleach Bath

A strong acid, normally sulfuric acid 0.1 to 0.2 M with a pH of 0 to 1.

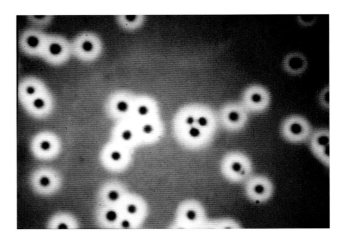

FIG. 44 Micro cross-section through a partially bleached magenta layer with bleach holes. (Every hole still contains silver metal.)

Potassium iodide as a strong silver ligand.

An aromatic nitro compound as a mild oxidizing agent to bleach any excess of silver metal, normally m-nitro-benzene-sulfonic acid is used.

A quinoxaline as bleach catalyst.

A bleach accelerator.

A reducing agent to prevent the oxidation of iodide to iodine. Ascorbic acid has been used for this purpose. The normally used bleach accelerator (see below) has reducing properties and makes the addition of another reducing agent unnecessary.

Fixing

The last step of silver dye-bleach processing is the fixing or dissolution of all silver compounds. This processing step is slower and less efficient than fixing in conventional color photographic systems. The reason is the low solubility of silver iodide and the continuously increasing concentration of iodide during the utilization of the fixing bath. High concentrations of ammonium thiosulfate are used and certain organic solvents help increase the fixing speed.

Figure 45 shows a microscopic cross-section through a silver dye-bleach with copy material developed for graphic applications and fast processing. Gelatin interlayers separate the dye layers containing the appropriately sensitized silver halide crystals. These empty layers are needed to suppress unwanted long distance bleaching in neighboring dye layers (bleach coupling). The interlayer between yellow and magenta contains a yellow filter to eliminate the blue light that could expose the silver halide in the magenta and cyan layer (exposure coupling). The yellow filter layer contains some yellow dye and a small amount of colloidal silver; just enough to bleach the yellow dye completely in the bleach bath. A transparent

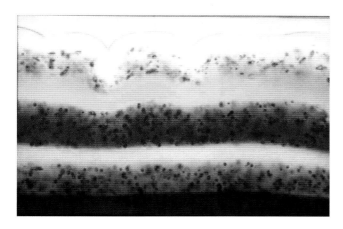

FIG. 45 Cross section through an Ilfochrome copy material (six layers).

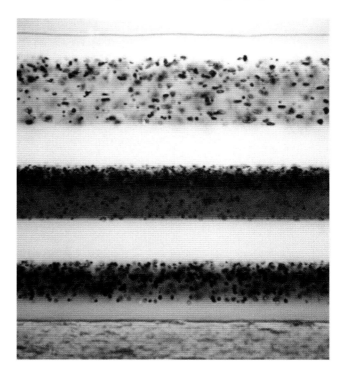

FIG. 46 Cross-section through an Ilfochrome professional material (nine layers).

gelatin layer is coated on top to physically protect the photographic layers. Figure 45 shows the material in a wet and therefore swollen state after development and before bleaching.

High quality silver dye-bleach print materials used for slide copies are coated with supplemental emulsion layers on top of every dye layer to increase the practical speed and to reduce the contrast. Distant bleaching down to the lower neighboring dye layer is desirable. Distant bleaching to the upper dye layer over the empty interlayer (so-called bleach coupling) is impossible. This kind of silver dye-bleach material contains higher concentrations of dyes and therefore has no need for a supplemental yellow filter.

Figure 46 shows the situation after a white exposure and development. From the top one can see an empty gelatin protection layer, a blue-sensitive emulsion layer, a yellow layer containing blue-sensitive silver halide emulsion, an intermediate masking layer containing some colloidal silver (not visible), a green-sensitive emulsion layer, a magenta layer containing green-sensitive silver halide emulsion, an empty intermediate layer, a red-sensitive emulsion layer, and a cyan layer containing red-sensitive silver halide emulsion below a gelatin undercoat and the polyester base.

Specific Problems of Silver Dye-Bleach Photography
Unsatisfactory Color Reproduction
The color reproduction of the simple six layers of silver dye-bleach material is insufficient for some applications; mainly in colors located in the blue tints. The reason is the unwanted side absorptions of all image dyes: the high absorption of magenta in the blue spectral range between 400 and 500 nm and of cyan in the green and blue range.

A pure and saturated blue reproduced on such a simple silver dye-bleach material (dashed line) is quite dark, because it has a considerable light absorption (between 400 and 500 nm)

due to the side absorption of the unbleached magenta and cyan. If this dark blue is copied a second time on the same material, the blue shifts even more toward black, because the transparency for blue light is further reduced. Every copy thereafter results in a supplemental shift toward black.

A color masking system based on the diffusion transfer of silver thiosulfate is a reasonable solution. An automatic correction of this problem, a so-called self-masking system to increase the color reproduction, needs to depend on the blue speed on the green and red exposure. The blue speed has to be inversely proportional to the green and red exposure. This interdependence can be managed by chemical means.

As mentioned above, the yellow filter layer of a self-masking silver dye-bleach material contains a small amount of colloidal silver metal. The blue-sensitive emulsion in the yellow layer is pure silver bromide, whereas the green- and red-sensitive emulsion contains a certain amount of silver iodide.

A small concentration of sodium thiosulfate is added to the developer. Thiosulfate is a strong complexing agent for silver. A minor part of the AgBr is dissolved during development and diffuses down as a silver-thiosulfate complex in the intermediate layer containing some colloidal silver. There the complex is reduced to metallic silver under the catalytic influence of the colloidal silver nuclei (known as physical development). The supplemental silver formed in the yellow filter layer contributes to yellow bleaching in the following bleach

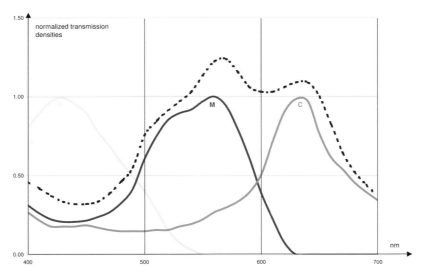

FIG. 47 Absorption spectra of silver dye-bleach dyes in transmission.

bath and increases the blue speed of the system. It is important to remember that distant bleaching is blocked by an empty gelatin interlayer but is possible into a direct neighboring layer.

Iodide is liberated during the development of the magenta layer, and these ions diffuse up in the yellow filter layer, where they efficiently block the colloidal silver nuclei and stop their catalytic action of the physical development of silver.

The silver diffusion transfer from the blue-sensitive yellow layer into the yellow filter layer is possible when the magenta layer remains unexposed and, consequently, there is no development and no liberation of iodide ions. Increasing exposure of the magenta layer producing increasing iodide concentration on development slows down the physical development and reduces the blue speed.

Figure 49 demonstrates the following basic facts:

1. The yellow contrast for pure blue exposure is enhanced, giving more brilliant saturated blues. (The dashed line shows the contrast for non-masking processing.)
2. The yellow density for full green exposure is enhanced, giving yellowish, warmer green hues.

The influence of the development of the cyan layer on the silver diffusion transfer is comparable but weaker.

One negative consequence of masking by silver diffusion transfer is a sluggish silver bleaching process. The addition of thiosulfate to the developer to get physical development in the masking layer provokes a more compact form of all developed silver. Another negative consequence is the probability of a formation of silver sulfide traces at the surface of the silver grains. This occurs because of the instability of silver thiosulfate in acid solution. Both effects reduce the reactivity of silver.

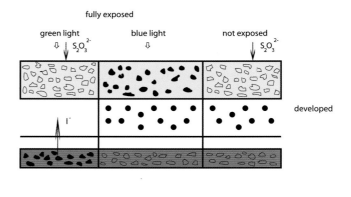

FIG. 48 Silver dye bleach masking principle with thiosulfate in the developer.

The bleaching is delayed further by the formation of very insoluble silver iodide on the surface of the silver metal grains. Silver iodide is one of the products of the bleach reaction. Deposed at the surface, it hinders the access of the bleach catalyst. Filamentous silver remains more reactive; more compact

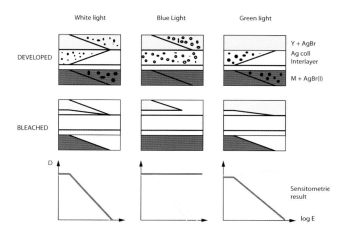

White light Blue Light Green light

DEVELOPED

Y + AgBr
Ag coll
Interlayer

M + AgBr(I)

BLEACHED

D

Sensitometric
result

log E

FIG. 49 Silver dye-bleach self-masking: sensitometric behavior after a wedge exposure.

silver particles are strongly inhibited. Overall the bleach reaction is slowed down considerably and has to be accelerated by the addition of a bleach accelerator.

Silver Sludge Formation in the Developer

Sodium thiosulfate in the developer dissolves some silver bromide from the silver dye-bleach material. The silver thiosulfate complex is unstable in the developer and is reduced by hydroquinone in the bulk of the developer solution to metallic silver. The silver precipitate as a black sludge intolerably contaminates the processing machinery and the surface of the photographic material.

Remedy for These Problems

To correct the silver dye-bleach processing problems discussed above, the following tailor-made components have been used.

Bleach Accelerator

Silver ligands forming strong silver complexes at low pH (0–1) are useful as bleach accelerators. Thiourea and a number of other organic sulfur compounds have been investigated. Some are active as accelerators but all have clear disadvantages: they have a bad smell, form insoluble reaction products, are corrosion stimulating, or are suspected to be carcinogenic.

Aliphatic phosphines are excellent silver ligands, but they are quite basic (pK 8–9). Aliphatic phosphines are not useful in strongly acidic solutions where they are protonated; moreover they are very sensitive to oxidation. Aromatic phosphines, or tris-cyanoethyl-phosphine, have low pK values but have low water solubility.

An ideal ligand for our purpose is an aliphatic phosphine with very low basicity. This has been invented and patented by Ilford.

$$3BZ \; (NCCH_2CH_2)2PCH_2CH_2CH_2SO_3K$$
Biscyanoethyl-sulfopropyl-phosphine pK ∼ 1

The stability constants for Ag(3BZ) and Ag(3BZ)$_2$ are $10^{9.5}$ and $10^{16.1}$.

The substitution of one cyanoethyl group by a sulfopropyl group increases the water solubility remarkably. 3BZ forms very stable silver complexes even in strongly acidic solutions and is not extremely sensitive to oxidation. Nevertheless, 3BZ protects all components of the bleach bath from oxidation including iodide. No further antioxidant has to be added to a bleach bath containing 3BZ. On oxidation, 3BZ is transformed to the corresponding phosphine-oxide.

Silver dye-bleach processing can be simplified to a two-bath sequence if iodide as silver ligand in the bleach bath is completely substituted by 3BZ. Under these conditions all silver is bleached and dissolved (fixed out) in the bleach bath. Two-bath processes are not very stable due to the continuously changing silver potential over the exhaustion of the bleach bath. Two-bath processes are only of interest for special applications.

Clear Holder for Physical Developer

It was known that physical developers containing thiosulfate can be kept clear for a limited time by the addition of a small amount of mercaptanes. Mercaptanes block the surface of any silver nuclei and suppress the precipitation of silver sludge, but higher concentrations lead to fogging of the silver halide emulsions because silver is developed everywhere. Mercaptanes are oxidized to disulfides by the oxygen in the air. Ilford has found that solutions containing only the oxidation product disulfide keep clear. A detailed investigation of disulfide-containing developers has shown the following fact. Sulfite, which is a component of every black and white developer, and disulfide in alkaline solution in equilibrium form the corresponding mercaptane and a substituted organic thiosulfate, a so-called Bunte-salt (Hans Bunte, Karlsruhe, 1848–1925). Kolthoff did research work on equilibria of this kind long ago, but the kinetics of these reactions had not been investigated.

The clear holder used in silver dye-bleach processing for Ilford professional materials is the disulfide (MSSM) of 3-phenyl-3-mercapto-propionic acid (MSH).

$$C_6H_5CHSHCH_2COOH \; (MSH)$$

The Bunte Equilibrium
$$MSSM + SO_3^{2-} \leftrightarrow MS^- + RSSO_3^- \; (R = C_6H_5C+$$
HCH_2COOH) produces from disulfide and sulfite a certain quantity of mercaptane, which is effectively the clear holding substance. Under practical concentration conditions (MSSM ∼ 0.003 M, Na$_2$SO$_3$ ∼ 0.2 M, pH ∼ 9.6) about 20 percent of the disulfide is transformed to the mercaptane. The equilibrium is established within about an hour.

Keeping the developer clear is related to the mercaptane; the disulfide has no reactivity toward the silver surface.

Two intrinsic properties of the clear holder system are fundamental for the practical effect:

1. The concentration of the active mercaptane is buffered.
2. The establishment of the equilibrium is relatively slow.

The mercaptide ion (M) is an excellent silver ligand; the stability of the silver mercaptide complex is considerably higher than that of the silver thiosulfate complexes.

Stability constants for silver thiosulfate and silver mercaptide:

$$AgT = 108.1 \qquad AgM = 1013.6$$
$$AgT2 = 1012.6 \qquad AgM2 = 1015$$

pK (MSH) 10.2

T = thiosulfate; M = mercaptide

The silver mercapto complexes are much more stable under the conditions of practical developer (pH 9–10) than the silver thiosulfate complexes. The mercaptane is an efficient inhibitor of the nucleation reaction of silver metal. In the absence of the clear holder, nucleation and, consequently, the formation of silver sludge in the developer starts during development. With clear holder in the developer the sludge problem is eliminated.

The Behavior of Clear Holder Under Practical Conditions

There seems to be an interesting contradiction. On one side the mercaptane ion efficiently suppresses the silver sludge formation in the developer; on the other hand, it does not inhibit the masking process. Remember that the masking process is based on diffusion transfer of silver thiosulfate complex into the neighboring layer and the deposition of silver there. Why is the growth of silver nuclei in the developer inhibited and in the masking layer absolutely possible?

When exposed, silver dye-bleach material is soaked in the developer; thiosulfate and a small concentration of mercaptane penetrates into the top layer which contains pure AgBr. Both ligands react here under quantitative formation of the corresponding silver complexes. The developer, now free of mercaptane, arrives in the masking layer. The silver thiosulfate complex forms a silver image by diffusion transfer, which is controlled by iodide ions emanated from the lower magenta and cyan layers.

The silver mercapto complex is very stable and therefore inactive. The reformation of mercaptane by the Bunte equilibrium is sufficiently slow enough to be neglected during the few minutes needed for the practical development process.

Basic Requirements for this Very Efficient, Buffered, and Robust Clear Holding System

A pure silver bromide photographic layer has to be coated on top of the masking layer that contains colloidal silver. No silver iodide is allowed in the top emulsion, because iodide inhibits physical development. The AgBr layer transforms the mercaptane in the penetrating developer quantitatively to silver mercapto complexes.

The silver mercapto complexes have to be more stable than the silver thiosulfate complexes. The equilibrium concentration of mercaptane must be small compared to the thiosulfate concentration, giving more silver thiosulfate complexes for physical development in the masking layer and only a few of the inactive silver mercapto complexes.

The establishment of the Bunte equilibrium producing mercaptane from the initially added disulfide has to be slow enough to avoid any significant reformation of mercaptane in the masking layer during development. At the same time it must be fast enough to guarantee a continuously sufficient concentration of mercaptane in the bulk of the developer to keep the solution sludge free.

The disulfide of 3-phenyl-3-mercapto-propionic acid is the best clear holder known today. It is also used in X-ray developers containing high concentrations of sulfite, which can dissolve a considerable amount of silver. This kind of developer is also susceptible to silver sludge formation.

Manufacturing Aspects of Silver Dye-Bleach Materials

Conventional silver halide emulsions used for other photographic films and papers are used for silver dye-bleach materials. Therefore no special technique is used to produce them. Due to the absorption of the embedded dyes, high-speed emulsions are needed to get a reasonable speed for silver dye-bleach materials.

Dyes are applied as aqueous solutions. Concentrations of only up to 2 percent can be prepared due to the low solubility of the available dyes. This fact leads to a high water load of coating solutions, which limits the production speed.

Additives

In addition to the main components of the photographic system (silver halide emulsions, sensitizers, and dyes), stabilizers, wetting agents, moistener, and gelatin hardener complete the final coating solutions. These additives are mostly conventional components used in the photographic industry. Except the small quantity of sensitizers, which are dissolved in alcohol, all of these additives are applied as aqueous solutions.

Although manufactured with the same technique and installations as other photographic materials, silver dye-bleach material production needs some special requirements.

The speed of silver dye-bleach materials not only depends on the silver halide emulsions but also on the amount of dyes contained in it. An increase of dye by 10 percent lowers the speed of the corresponding layer by about 0.2 logE. Therefore, to achieve a good reproducibility of silver dye-bleach materials regarding speed and filtration, a sophisticated flow metering system for coating solutions is needed to get an accurate coating weight.

In chromogenic materials image dyes are built up during processing proportional to the preceding exposure. In silver dye-bleach materials dyes that are not needed for the image are bleached. That means that for silver dye-bleach materials coating disturbances and inhomogeneities are mostly detected in highlights of an image, the most critical area for the human eye for homogeneity and color variations. Therefore a much higher accuracy in coating is needed in silver dye-bleach production.

Further complications for silver dye-bleach manufacturing arise from the fact that coating solutions containing dyes are,

depending on concentration, more or less non-Newtonian (thixotropic). Standard coating heads used in the photographic industry are designed for Newtonian fluids. When using such coating heads with silver dye-bleach coating solutions, non-acceptable cross profiles result. For the same reason as mentioned above, silver dye-bleach materials are very susceptible to color variation across the coated width; maximum variations of ± 0.5 percent are acceptable. Therefore specially designed coating heads had to be developed. Development work to continuously improve the coating quality was as important as research work for improvement of silver dye-bleach materials and processing chemistry.

Marketing Arguments for Silver Dye-Bleach Systems

Compared to chromogenic color processes in which not only the color dyes are formed during the chemical treatment along with some disturbing impurities, the Cibachrome/Ilfochrome chromolytic process is free of such annoying side products. The dyes are incorporated into the sensitive layers of the Cibachrome materials during manufacturing. Only the most pure and light stable dyes are used for the production of the various silver dye-bleach products.

A processed sheet of Cibachrome/Ilfochrome material shows the following features:

Impressive color rendering and reproduction
Excellent sharpness
Superb color purity
Outstanding light stability

Cibachrome/Ilfochrome Classic transparent and print materials are coated on a polyester base, which makes the materials outstanding in their remarkable dimensional stability and the super glossy surface of the white opaque prints material. Since 2005 Ilfochrome Classic is the world's only direct positive color material. This permits a unique way to print from original transparencies and the ultimate way to print from digital files.

Copy Materials

Cibacopy materials have a simple six-layer structure (as shown in Figure 45) and a fast processing speed. Cibacopy is a high-contrast material specially designed for the direct reproduction of artwork, drawings, reports, and other documents with repro cameras. Its high resolution even allows a brilliant and extremely sharp reproduction of screened pictures combined with small typefaces.

The Copy System was launched in 1978 at Photokina in Germany. Color copies, either in the form of prints on a white resin coated paper (CCO) or as transparencies (CTR) for use as overhead projection slides, were made on a daylight operating camera/processor with a very short processing cycle of 6 minutes.

Microfilm

The Color Micrographic films are available as master film (CMM) and print film (CMP) in 35 mm rolls and in selected sheet sizes. The micrographic films are processed in the silver dye-bleach process P-5.

The main features of the film materials are excellent resolution and light and archival stability.

Sophisticated Silver Dye-Bleach Systems for Highest Quality: Market Development

In 1967 a few highly specialized professional labs started the production of brilliant and light stable color enlargements on media coated on white opaque triacetate base processed in P-7A chemistry. The treatment lasted almost an hour. A transparent material (CCT) was introduced in 1969 for the production of long-lasting large display transparencies.

During the 1970s several significant improvements were made to both materials and the process chemistry. The print material was coated on white-pigmented polyester and the transparent material on clear polyester base. Both were processed in the improved four-bath process P-10 in 36 minutes.

A new shorter processing chemistry (15 minutes) was introduced later under the code P-18. It was the first three-bath process with combined dye and silver bleaching working at 30°C.

Cibachrome-A Print System for Hobbyists

A complete Cibachrome system for the hobbyist's darkroom was introduced in America by Ilford Inc. in 1974. This system consisted of a pack of print material, a set of P-30 chemicals, color correction filters, a small developing drum, and user instructions. The processing time was 12 minutes. There were only three working strength solutions — developer, bleach, and fix — all of which were discarded after use. The working solutions were prepared from liquid concentrates (P-30) and later from easily soluble powders (P-30P).

Shortly after the successful introduction in North America the system was launched in Europe and other countries worldwide. Cibachrome-A gained widespread popularity during the late 1970s and this remarkably improved the degree of brand awareness of Cibachrome all over the world.

Cibachrome II Print Materials

In 1980 a new Cibachrome II material was introduced together with P-3, a new three-bath process requiring 18 minutes at 30°C. The major improvement was the introduction of the self-masking system described above. The product range included:

Cibachrome II print on white pigmented polyester base (CPS II)
Cibachrome II print on resin coated paper base (CRC II)
Cibachrome II transparent on clear polyester base (CTD II)

The introduction of self-masking meant that first development became more critical and, consequently, Cibachrome II materials were intended for use by laboratories using processors with automatic solution replenishment.

The net result of this new self-masking Cibachrome II system was a great improvement in the reproduction of most colors — especially blues, purples, yellows, browns, and

greens. Flesh tone rendition also was better than in unmasked Cibachrome prints.

In 1987 an additional low-contrast print material (CF) was introduced. It was coated on white-pigmented polyester and adapted to high-speed automatic printing equipment.

A new fast professional three-bath process (P-3X) was introduced to provide better productivity to commercial labs. This replenished three-bath process has a processing time of 11 minutes, 30 seconds at 36°C and is compatible with all existing Cibachrome print materials. The replenishment rates are low and therefore waste production is reduced.

Private Label Silver Dye-Bleach Products — Photo-Me International

In 1976, Photo-Me, a company specialized in "while-you-wait" portrait kiosks, became interested in using Cibachrome photo material for their color prints. The Cibachrome process available at the time (P-10) was far too slow for the production of dry-to-touch color portraits in less than 4 minutes. Ilford R&D was able to develop entirely new solutions that reduced the processing time from 36 minutes down to 4. Photo-Me was then able to introduce their new generation of photo booths based on Cibachrome technology all over the world.

Short History of Cibachrome Market Introduction

1963	First presentation of a Cibachrome print at Photokina in Cologne, Germany.
1964	Introduction in Switzerland of a Cibachrome printing service for hobbyists/amateurs (P-7A).
1967	Introduction of the first professional Cibachrome materials on white-pigmented triacetate base.
1969	Introduction of the first Cibachrome transparent material.
1973	New generation of opaque and transparent materials (CCP and CCT). New professional process P-10 (4 baths, 24°C, 35 minutes).
1975	Introduction of Cibachrome-A together with the one-shot process P-30 (later P-30P) for hobbyists and users having a low throughput.
1978	Introduction of the Cibacopy range (later Ilfochrome Rapid) for color graphic applications and the copy process P-18 (3 baths, 30°C, 18 minutes). P-18 was replaced later by P-22 and finally by the fast P-4.
1980	New generation of masked materials, Cibachrome II. New professional process P-3 (3 baths, 36°C, 18 minutes).
1987	New Cibachrome CF DeLuxe material on white polyester with a lower contrast, adapted to high-speed automatic printing equipment.
1990	New fast professional process P-3X (3 baths, 36°C, 11½ minutes) compatible with all existing emulsions, providing better productivity and improved photographic quality.
Late 1990s	Introduction of digital Ilfochrome media compatible with the latest generation of photo digital enlargers.

Brand Product Names

Cibachrome/ Ilfochrome	General brand name for silver dye-bleach materials produced by Ciba
	General brand name for silver dye-bleach materials produced by Ilford
Cibacopy	High-contrast materials for graphic applications
CCO	Cibacopy coated on resin-coated paper
CTR	Cibacopy coated on transparent polyester base
CMM	Master microfilm
CMP	Print microfilm
Microfilm	High-resolution silver dye-bleach microfilm
CMM	High-contrast master film
CMP	Low-contrast print film
Cibachrome Print Materials	Professional materials for display application
CCP	First Cibachrome print material on triacetate base
CCT	First Cibachrome transparent display material
CCP-A	Print material for hobbyists
Cibachrome II Print Materials	Improved professional display materials
CRC II	Print material on resin-coated base
CPS II	Print material on white opaque polyester base
CTD II	Display material coated on transparent polyester base
CF	Low-contrast print material on white opaque polyester base

Processing Chemistry

P-7A	First Cibachrome process
P-10	4-bath process for Cibachrome print materials
P-18	3-bath process for Cibacopy materials
P-5	3-bath process for microfilm
P-30/P-30P	3-bath one-shot process for hobby application
P-3	Replenished 3-bath process for Cibachrome II materials
P-3X	Fast replenished 3-bath process for Cibachrome II materials
P-22	3-bath process for Cibacopy
P-4	Fast 3-bath process for Ilfochrome Rapid

FURTHER READING

Christensen, J. H. (1921). Eder's Jahrbuch, 29, Knapp, Halle
Gaspar B. (1935). *Z. Wiss. Photogr.*, **34**, 119.
Meyer, A. (1972). Practical aspects of silver dye-bleach processing. *The Journal of Photographic Science* **20**, 81–86.

Schellenberg, M. and Schlunke H. P. (1976). *Die Silberfarbbleich-Farbphotographie. Chemie in unserer Zeit* **10**, 131–138.

Schinzel, K. (1905). *British Journal of Photography* **52**, 608.

(1977). *The Theory of the Photographic Process*, 4th edition. New York: Macmillan, pp. 363–366. 🜨

Photographic Optics

TERRANCE KESSLER

Laboratory for Laser Energetics, University of Rochester

Optics is the branch of physics that deals with the generation, propagation, and detection of light. Electromagnetic (EM) wave and quantum mechanical photon theories coexist to explain the phenomena of light. The wave theory of light is derived from EM fields and is generally sufficient for imaging and photography. Physical optics deploys EM theory directly whereas geometrical optics deploys the more intuitive concept of light rays to evaluate and illustrate the performance of an optical system.

A transverse electromagnetic (TEM) wave contains electric and magnetic vectors that are mutually perpendicular to the direction of light travel, or the propagation vector, as shown in Figure 50. The EM spectrum contains long wavelength (low frequency) radio waves to short wavelength (high frequency) cosmic rays. The visible part of the EM spectrum is generally considered to extend from 400 to 700 nm, although there is some variation in this range among individuals depending on the brightness and viewing conditions. Although the human eye does respond to near-ultraviolet and near-infrared light, useful image formation is rare at these wavelengths. Classically, light travels as rays in straight lines (rectilinear propagation), at a constant velocity in vacuum of approximately 3×10^8 m/second or 186,000 miles/second. A reduced velocity is given in other media, depending on their density. The characteristic distance between two adjacent peaks of the amplitude is called the wavelength and is commonly measured in micrometers (μm), nanometers (nm), or Angstroms (Å). Light may also be characterized by its frequency. For example, light of wavelength 600 nm has a frequency of 5×10^{14} cycles per second, or Hertz (Hz).

The phase of the waveform represents its position with respect to an arbitrary temporal or spatial reference and is usually expressed in terms of an angle between 0 and 2π radians. A wavefront is a two-dimensional surface of constant phase. A converging wavefront represents a focusing beam whereas a diverging wavefront represents an expanding beam. A field that oscillates in a particular plane is called plane polarized light. Non-polarized light oscillates in all possible directions while circularly polarized light contains an electric field that oscillates within a continuously rotating plane. The component of light with which most materials interact is the electric field. For square-law detectors such as photographic film and electronic sensors, light intensity is proportional to the square of the electric field amplitude, referred to as the electric field intensity.

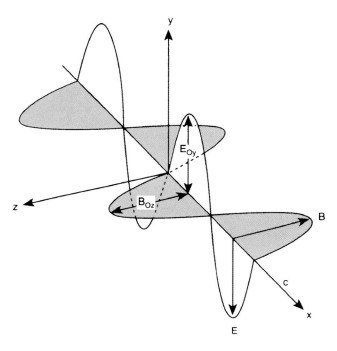

FIG. 50 EM radiation.

Frequency (Hz)	Wavelength (nm)	Type of Radiation
10^2–10^4	10^{16}–10^{14}	Long radio waves
10^5–10^6	10^{13}–10^{12}	AM radio
10^7–10^8	10^{11}–10^{10}	FM radio and television
10^9–10^{10}	10^9–10^8	Short radio waves
10^{11}–10^{12}	10^7–10^6	Microwaves
10^{13}–10^{15}	10^5–10^3 (1 mm)	Infrared radiation
10^{16}	10^2	Light (~400–700 nm)
10^{17}	10	Ultraviolet radiation
10^{18}	1 nm	Soft X-rays
10^{19}	0.1 (1 Å)	Hard X-rays
10^{20}–10^{21}	10^{-2}–10^{-3}	Gamma rays
10^{22}–10^{23}	10^{-4}–10^{-5}	Cosmic rays

Light energy is conserved during interaction with optical elements according to the equation,

$$A + R + T = 1$$

where A, R, and T are the coefficients of absorption, reflectance, and transmittance, respectively. Light incident at a

semi-transparent surface is partially reflected at the surface, partially absorbed, and partially transmitted, undergoing refraction at this interface between two optical media. The transmitted ray in the second medium slows down if the medium is denser. The ratio of the speed of light in a vacuum to that in the medium is the refractive index of the medium. The refractive index varies with wavelength, causing chromatic aberration in optical systems. A birefringent material has a refractive index that is dependent on the polarization of light, while a non-linear material has an irradiance dependent refractive index.

Refraction takes place because the velocity of light varies according to the density of the media through which it passes. The angle of incidence is defined as the angle between a ray of light incident on a surface and the normal to the surface at that point. The angle of reflection is defined as the angle between a reflected ray of light as it leaves a surface and the normal to the surface at that point. The angle of refraction is defined as the angle between a deviated ray of light as it leaves a surface and the normal to the surface at that point. The relationship between the angle of incidence (θ_i) angle of refraction (θ_r) and the refractive indices n_1 and n_2 of the two media is given by the law of sines.

$$n\,(\lambda)_1 \sin(\theta_i) = n\,(\lambda)_2 \sin(\theta_r)$$

Refraction is toward the normal to the surface when the rays enter a denser medium. Shorter wavelengths slow down more, thus refract a greater amount. This phenomenon is called refractive dispersion. When light travels from a denser material to a less dense material it may fully reflect back into the denser medium. This phenomenon is called total internal reflection and occurs when the incident angle reaches the critical angle given by $\theta_i = \sin^{-1}(n_1/n_2)$. For a glass–air interface the critical angle is typically greater than 40 degrees. Total internal reflection is used instead of coated surfaces in certain prisms as well as fiber-optic cables.

A glass window with plane parallel sides does not rotate an incident oblique ray, but the emergent ray is laterally displaced. When placed in a lens system, this can cause image aberrations or a focus shift. A prism is a block of glass with triangular cross-section. Due to material dispersion, a prism spectrally separates white light as shown in Figure 51.

Reflection (or refraction) occurring directionally over a beam of light is called specular reflection (or refraction). We commonly refer to this as mirror-like reflection of light from a smooth surface such as polished metal, glass, plastic, and fluids. However, the reflection (or refraction) of light in many directions is called diffuse reflection (or refraction). A Lambertian material produces a perfectly diffuse reflection which has the same luminance regardless of the angle from which it is viewed. Properly prepared surfaces of Teflon are very close to Lambertian, while matt white paper is close enough for calibration in the field.

Certain properties of light are explained only by considering light as a wave motion. When two coherent waves are equal in magnitude they can be made to interfere, and the resultant intensity may vary between zero for complete destructive interference, when the two waves are exactly 180 degrees out of phase, to a doubling of intensity by constructive interference when they are exactly in phase. Coherence exists between two waves when their relative phase is constant.

An uncoated piece of glass reflects a certain percentage of incident light depending on the change in refractive index between the glass and the surrounding medium. The surface reflectivity can be derived from the basic Fresnel equations. Near normal incidence, the reflectivity of uncoated glass is given by:

$$R = [(n_s - 1)/(n_s + 1)]^2$$

where s denotes substrate. For a glass with an index of 1.5, approximately 4 percent of the light is reflected at each interface.

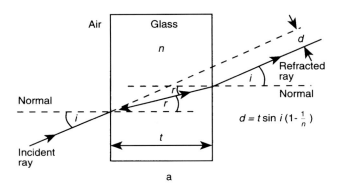

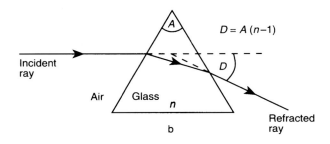

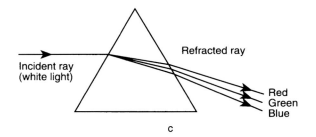

FIG. 51 Dispersion.

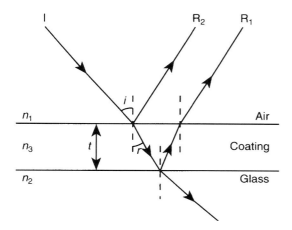

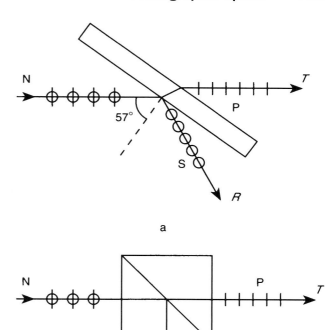

a

FIG. 52 Anti-reflective coating.

FIG. 53 (a) Beam splitter and (b) pellicle beam splitter.

For applications where this light loss is undesirable, an anti-reflection (AR) coating is deposited on the surface of the glass to prevent reflection (Figure 52). The optimum coating causes the reflections from the two interfaces to be equal in magnitude and opposite in sign. Destructive interference occurs in reflection and thus light fully transmits through the interface. The condition for equal magnitude is given by:

$$R = [(n_s - n_c^2)/(n_s + n_c^2)]^2$$

The overall reflectivity R is zero when $ns = n_c^2$. For a glass of index 1.51, a suitable material is magnesium fluoride with index 1.38, near to the ideal value of 1.23. The condition for an opposite sign is met when the individual reflections are out of phase by 180 degrees or π radians. This corresponds to an optical path difference of $\lambda/2$ between the two reflected components. Since the component reflecting from the coating to glass interface propagates through the coating twice, the sign condition is given by:

$$2(n_c\, t) = \lambda/2$$

Hence, the optical thickness ($n_c t$) is $\lambda/4$, and this layer is referred to as a quarter-wave coating. This AR coating is optimum for a narrow range of wavelengths. Additional layers can be used to increase the range of wavelengths for which the AR coating is useful. Modern coating equipment, techniques, and materials, plus fast digital computers allow extension of single coatings to stacks of separate coatings. By suitable choice of the number, order, thickness, and refractive indices of individual coatings, the spectral transmittance may be selectively enhanced to a value greater than 0.99 for a wide region of the visible spectrum.

Coatings with 20 to 30 layers are routinely deposited for high reflectivity applications such as mirrors, filters, polarizers, and beam splitters. A beam splitter divides incident light or radiation into two or more portions based on wavelength or polarization. The two examples shown below would add aberrations to a normal imaging system (Figure 53a, b). However, thin pellicle beam splitters have virtually no effect on image formation when the transmitted component is used for image recording.

Diffraction is the tendency for light to spread at the edge of an aperture rather than travel in a straight line. The branch of physics that deals with this phenomenon, and that can account for arbitrary perturbations to a plane wavefront, i.e., general aberrations, is called physical optics. A perfect, aberration-free lens still suffers from diffraction, which causes the image of an object point to be given as the Airy pattern of alternating dark and light rings from interference effects. The Airy disc is the diameter (*d*) of the first dark ring of the pattern given by:

$$d = 2.44\lambda f/D = 2.44\lambda F\#$$

where *f* is the focal length, *D* in the effective aperture diameter, and *F#* is called the *f*-number of the lens. For light of wavelength (λ) 500 nm, d is approximately 10 μm for an f/8 lens (Figure 54).

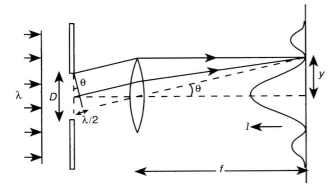

FIG. 54 Airy disc.

When the focusing or imaging performance of a lens is limited only by the effects of diffraction, the lens is said to be diffraction-limited. Diffraction-limited lenses of large aperture, corrected for use with monochromatic light, are used in microlithography for production of integrated circuits and laser experiments where ultra-high intensity beams are focused to micron size spots. The resolving power (RP) or resolution of a lens is directly related to the size of its focal spot. For imaging applications, the Rayleigh criterion is often used to define resolution. This criterion is met when the respective Airy patterns from two closely spaced point sources are separated such that the central peak of one is superimposed on the first dark ring (minimum) of the other. The expression for their separation distance is:

$$r = 1.22\lambda f/D = 1.22\lambda F\#$$

To continue with the example above, a lens with an Airy disc diameter of 10 μm possesses a resolution of $1/r = 1/5$ μm or 200 line-pairs per millimeter.

Holography is by its very nature a high-resolution, diffraction-limited, imaging technique. A hologram captures complete wavefront information from the object recorded. Whereas photography records only the irradiance of a scene, holography records both wavefront and irradiance information. A three-dimensional scene is recorded on photographic material by interference between a reference light beam and one reflected or transmitted by the subject. Holograms are recorded on materials with resolving powers exceeding 10,000 line-pairs per millimeter. When viewed under the proper conditions, reconstructed images are presented to the left and right eyes, producing the appearance of three dimensions. Holograms can provide imagery where the viewer can change the viewing angle and see the subject from different perspectives thus providing significant parallax; sometimes revealing hidden information. Holograms are actually complex diffraction gratings that bend and focus light to form three-dimensional images. The grating equation

$$d[\sin(\theta_d) - \sin(\theta_i)] = m\lambda$$

describes the relationship between the angle of diffraction (θ_d), angle of incidence (θ_i), wavelength λ, and groove spacing d. It is important to note that long wavelengths are diffracted more than shorter wavelengths, which is opposite the dispersion from a prism. Talbot imaging is the name given to the periodic self-imaging exhibited by grating arrays. It is a very useful concept in understanding the relationship between diffraction and image formation.

Photographic Imaging

The basic properties of a lens system can be determined using a geometrical construct involving rays of light. This is referred to as geometrical optics. The first order properties of an optical system can be calculated using small-angle approximation. Paraxial optics involves rays passing through the central zone of a lens at small enough angles of incidence so that the sine and tangent of an angle are taken as equal to the angle. Angles are measured in radians that are derived from a ratio of two distances having the same units. Typically, paraxial imaging involves angles less than 15 degrees and provides accurate estimates with errors of only a few percent.

A thin, positive lens causes parallel incident light to converge toward a plane of focus, called its focal plane, which is the image plane for objects at a distance approaching infinity. Although there are two refracting surfaces for a lens, there exists an apparent plane of refraction for a ray of light called a principal plane. The distance from this equivalent refracting plane to the focal plane is called the focal length (f). The lens power is defined as the reciprocal of the focal length and is measured in inverse meters or diopters. Power is useful because it is additive for a series of closely spaced thin lenses. The f-number of a lens is a ratio of its focal length to its diameter as measured at its principal plane. Since image illuminance is inversely proportional to the square of the f-number, it is used as a metric for exposure control. The effective f-number is obtained by dividing the image distance by the effective aperture diameter.

A modern photographic lens consists of a number of separated elements or groups of elements, the physical length of which can be greater than its focal length. This multi-element, compound lens is often referred to as a thick lens. The term equivalent focal length (f) is often used to denote the composite focal length of such a system. For example, for two closely spaced thin lenses of focal lengths f_1 and f_2, the equivalent focal length is given by

$$1/f = 1/f_1 + 1/f_2 - d/f_1 f_2$$

where d is the axial separation between lenses. For a thick lens with more than two elements, the analytical equations are more cumbersome. Thin lens formulas can be used with thick lenses if conjugate distances are measured from the first and second principal planes. These are equivalent refraction planes that have unit transverse magnification as shown by the upper ray in Figure 55.

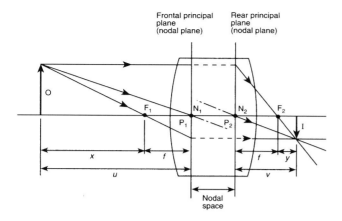

FIG. 55 Thick lens.

For thin lenses in air the principal planes are coincident. However, for thick lenses in air the principal planes are separated and coincident with the nodal planes. An oblique and non-refracted ray directed at a point on the first nodal plane appears to emerge on a parallel path from a point on the second nodal plane. A ray of light entering the first plane emerges from the second at the same height above the axis. Although the ray of light can actually change direction only at the lens surfaces, it appears to travel in a straight line toward the object nodal point and to leave in a straight line away from the image nodal point. The entering and departing rays will be parallel but displaced. When there is the same medium such as air in both the object and image spaces, then the nodal and principal planes coincide. Focal length and image conjugate distances are measured from the rear nodal point, and object distances are measured to the front nodal point. A useful property of a nodal point is that rotation of a lens about its vertical axis does not shift the image of a distant object.

The focal plane is the closest to a lens an image can be formed. As the object moves in from infinity, the image moves away from the lens and its focal plane. The relationship between the conjugate distances and lens focal length are given by the Gaussian and Newtonian equations as follows:

$$1/u + 1/v = 1/f \text{ Gaussian}$$

$$x\,y = f^2 \text{ Newtonian}$$

A real image is a reconstitution of an object in which the divergent rays from each object point intersect in a corresponding conjugate point. The pattern of points formed constitutes a real image in space that can be made visible by a screen placed in this plane or be recorded by a square-law detector such as photographic film or an electronic sensor. Real images are not directly observed by the human eye. On the other hand, a virtual image can be viewed directly but cannot be recorded. An object inside the front principal focus

will give a virtual image, as formed by a simple magnifier. Virtual images are usually upright, not reversed, and directly observed in microscopes and telescopes.

Image magnification is defined as the size of the image relative to the size of the object. For most photographic lenses, the image is much smaller than the subject and the magnification is less than unity. However, magnification can be greater than unity for applications in photomicrography Three types of magnification are useful to define: lateral or transverse (m), longitudinal (L), and angular (A), with the relationship AL = m. As defined, m = I/O = v/u, and L = m². Transverse magnification (m) is most commonly used in photography; however, for afocal instruments such as telescopes, angular magnification is more often used.

The aperture stop is the physical diaphragm in an optical instrument that limits the area of the lens through which light can pass to the image plane. A pupil is the virtual image of the aperture stop. When viewing from the front of the lens the entrance pupil is seen, and from the rear the exit pupil is seen. The aperture stop may be within or outside the elements of the optical system. For example, a telecentric lens has an aperture stop located at the focal plane of the lens so that either the entrance or the exit pupil is located at infinity. The image field is then limited to the physical diameter of the lens. This arrangement is used when it is necessary that the image is formed by parallel rays rather than a divergent cone. This provides error reduction when using imaging to accurately measure object size. A field stop is the physical diaphragm in an optical system that determines the extent of the object that is captured in the image. The visual appearance of a darkening of an image toward the edges or periphery is called vignetting. Natural vignetting by a lens is due to the cos4 θ law of illumination. Mechanical vignetting can occur if a stop is incorrectly positioned between the elements of a thick lens.

A perfect lens cannot have an infinitely small focal spot since it is limited by diffraction. Its resolution increases for smaller f# and shorter wavelength. For all but the most expensive lenses, a point is not imaged as an Airy pattern but rather is seen as a blurred patch of light. Most photographic lenses are limited by aberrations that lower the lens performance below the diffraction limit. Even a perfectly manufactured lens has aberrations due to the variation in refraction over its spherical surfaces. Interestingly, diffraction limited imaging is not natural and must be highly controlled to achieve. The magnitude of an aberration usually increases with an increased angle of view causing a greater obliquity factor. A ray trace through a lens surface-by-surface depends on repeated applications of the laws of refraction. An expansion of sin(θ) in a power series yields:

$$\sin(\theta) = \theta - \theta 3/3! + \theta 5/5!$$

Keeping only the first term (θ) yields the first order or paraxial approximation, where sin(θ) = θ (radians). For instances when the ray angles cannot be assumed too small, a real-ray trace is carried out without approximation to obtain more accurate realization of image performance. However,

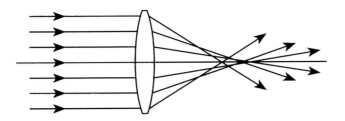

FIG. 56 Spherical aberration.

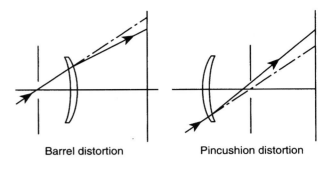

Barrel distortion Pincushion distortion

a

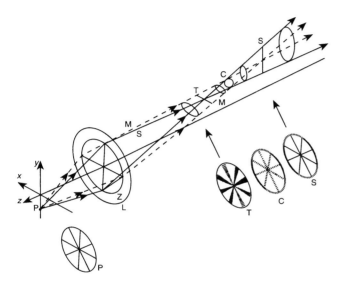

FIG. 57 Astigmatism.

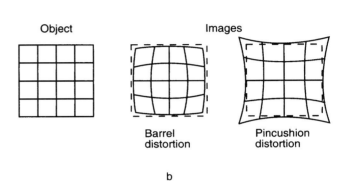

Object Images

Barrel Pincushion
distortion distortion

b

FIG. 58 Curvilinear distortions.

paraxial ray tracing provides enough accuracy to calculate five monochromatic aberrations, called the Seidel aberrations, and two polychromatic aberrations.

The Seidel aberrations, caused by refraction at spherical surfaces, are spherical aberration, coma, astigmatism, curvature of field, and distortion. Since aberrations depend on curvatures, thicknesses, refractive index, spacing of elements, and stop position, it is possible to use multi-lens compensation. Aberrations in one element or group of elements are reduced by equal and opposite aberrations in a subsequent group.

Spherical aberration (SA) exists when the focal length of a lens is a function of the radial distance from the axis. Figure 56 shows parallel incident rays progressively brought to a focus closer to the lens as they are refracted by zones farther from the axis. A lens suffering from SA will be overall degraded and show a focus shift as it is stopped down. Coma is similar to a spherical aberration for off-axis object points. Its name is derived from the comet-like shape of the image point. An aplanatic lens is corrected for spherical aberration and coma.

Astigmatism is illustrated in Figure 57. The image of an off-axis point from the vertical axis contains two lines separated along the direction of propagation.

The horizontal line nearer to the lens is tangential to the image circle and is called the tangential (meridional) focus. The line further from the lens is radial to the optical axis and is called the sagittal (radial) focus. Similarly, astigmatism causes an off-axis point from the horizontal axis to focus to a vertically oriented tangential focus. The line-separation is a measure of the sign and magnitude of astigmatism, and the position of best focus, or circle of least confusion, lies between them. Such a lens is an astigmat, meaning it does not produce a point. An anamorphic lens system also produces two orthogonal line foci; however, this is an on-axis effect caused by cylindrical power along one of the axes. Anamorphic lenses are used to obtain different magnifications along two axes for the purpose of mapping a square image format to a rectangular format.

A lens that yields a distortion-free image is said to be orthoscopic. However, variations of the shape and proportion of the object, an aberration referred to as image curvilinear distortion, is caused by a two-dimensional variation in image magnification. Distortion does not affect the sharpness of an image, only its shape. When straight lines in the subject are rendered as curving inward (outward), it is called barrel (pincushion) distortion as shown in Figure 58.

Curvature of field, known as Petzval curvature, exists when off-axis object points are imaged to a curved surface. In practice, the focal plane and image planes are often curved and

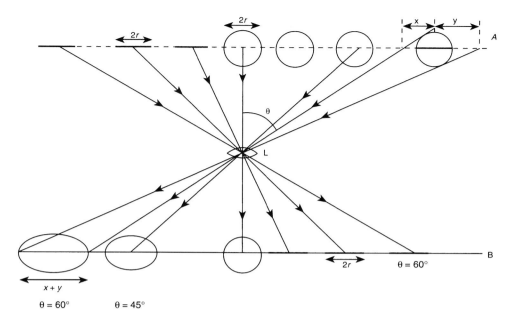

FIG. 59 Geometric distortions.

only approximate a plane close to the optical axis. The amount of Petzval curvature depends on the net power and refractive indices of the individual lens elements. Although high resolution can be maintained over the field by curving the recording plane, this is not a reasonable option with electronic sensors.

Geometric distortion is due to increasing obliquity through a lens and is not the result of lens design limitations (Figure 59). Due solely to viewing angle, the peripheral detail of an object with depth suffers increasing elongation that is oriented along the radial direction. The image elongation is proportional to the secant of the field angle. This effect is not present for a flat object located normal to the optical axis.

Similarly, perspective distortion is not the result of lens aberrations. For correct perspective, the viewing distance of a photograph is related to the focal length of the lens and the print magnification. Viewing the final print at a distance inconsistent with the actual recording conjugates causes this distortion.

Two polychromatic aberrations are also included in paraxial lens evaluation. Refractive dispersion causes the focal length of a simple lens to increase with wavelength. This is shown as a separation of focus along the axis for a positive lens and is called axial or longitudinal chromatic aberration.

Lateral or transverse chromatic aberration is an off-axis aberration, the effect of which increases with field angle. Correction is accomplished by a combination of suitable positive and negative lenses of different glasses. The term achromatic is applied to a lens corrected for longitudinal chromatic aberration to bring light rays of two colors (wavelengths) in the visible spectrum to the same focus. A lens optimized for three wavelengths is called apochromatic.

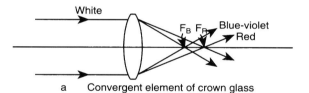

a Convergent element of crown glass

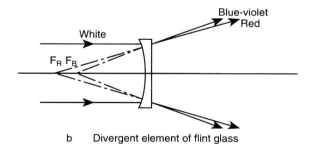

b Divergent element of flint glass

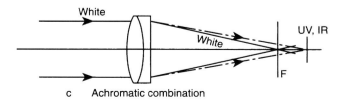

c Achromatic combination

FIG. 60 Polychromatic aberration.

RESOLVING POWER TEST TARGET

FIG. 61 USAF resolution target.

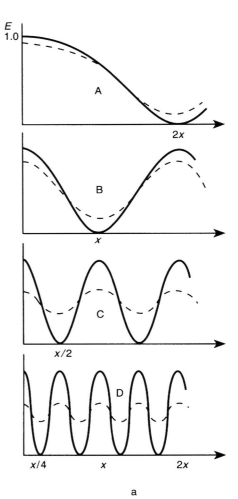

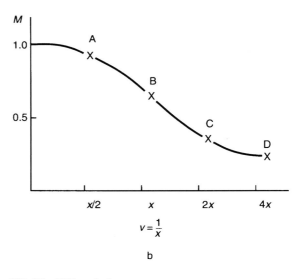

FIG. 62 MTF analysis.

Whether a lens is diffraction-limited or exhibits some amount of uncorrected aberration, its resolving power (RP) is directly related to its ability to resolve fine detail. The Rayleigh criterion is often used as a basis for lens evaluation. According to his criterion, two adjacent point sources are just resolved if their Airy disc images overlap to the extent of their radii, hence

$$RP = 1/1.22\lambda F\#$$

given in units of line-pairs per millimeter (lpm). For example, an Airy disc of 10 μm corresponds to an RP of 200 lpm. Only the very best custom lenses ever achieve this level of performance.

A useful means to evaluate image performance is to determine the ability of an imaging system to resolve separation between closely spaced lines in the image. Resolving power is determined using a test target consisting of sets of alternating light and dark bars. The set of bars that can be distinguished in the image, with a specified contrast, is used to estimate the resolving power of the imaging system.

A more sophisticated means to evaluate image performance involves a frequency domain representation of the image. The Fourier transform is a mathematical operation whereby an image is resolved into a set of sinusoidal components referred to as spatial frequencies in units of cycles per millimeter. The image is then completely represented by coefficients indicating the magnitude and phase of each of these components. The modulation (m) of a pattern is defined by

$$m = (I_{max} - I_{min})/(I_{max} + I_{min})$$

The change in modulation is given by the modulation transfer factor M = mI/mO for each frequency separately,

where I and O denote image and object, respectively. The modulation transfer function (MTF) is a curve of M plotted as a function of spatial frequency. MTF theory is applicable to every component in an incoherent imaging chain, and their individual responses can be cascaded together to give the overall response of the system. A single MTF curve does not fully describe lens performance. Many curves should be generated at different apertures, wavelengths, focus settings, conjugates, and orientations for a thorough evaluation. MTF curves can be interpreted to provide both image RP and sharpness. For example, depending on the shape of the MTF curve, lenses may be characterized as high image contrast but limited RP or moderate contrast but high RP.

Photographic Lenses

A typical lens design begins with a suitable configuration of elements based on over a century of documented experiences. A lens is designed using the variables of glass type, number of elements, element thickness and curvature, element separation, and position of the aperture stop. In addition, the modern lens designer is able to use aspheric surfaces, diffractive lenses, and gradient lenses to obtain superior lens performance with fewer optical elements.

Modern computers can perform rapid and extensive ray tracing to determine the imaging capability during the evolution of a lens design. The software packages for lens design have become very sophisticated since gigabyte class processors are commonplace, which contain libraries of glass types and useful starting designs. By repeated application of the refraction equation at each interface, and the transfer equation to reach the next interface, the passage of a ray of light can be traced through a lens. Computers are capable of rapidly tracing millions of rays, for many surfaces, and can automatically evaluate the MTF and point spread function after each trace. Modern lens design software uses interactive display to provide the designer with visual understanding of the layout and performance of the lens system in real time.

Familiarity with simple refractive lenses aids a lens designer in choosing the optimum starting point for a new design. The refractive lens types can be categorized as either positive or negative. The positive lens is thicker in the center and is referred to as a converging lens since it causes a wavefront from an object at infinity to focus. This lens is needed to produce an image that is recordable. The negative lens is thinner in the center and is referred to as a diverging lens since it causes the wavefront of an object at infinity to diverge. This lens produces a non-recordable virtual image. Imaging lenses may contain both positive and negative lenses; however, the overall power of the compound lens must be positive to form a real image.

The lens maker's formula, for a thin lens in air, determines the focal length from the index of refraction (n) of the substrate material, and the radius of curvature of the two surfaces.

$$\frac{1}{f} = (n-1)\left[\frac{1}{R_1} - \frac{1}{R_2}\right]$$

The basic positive (negative) lens has one surface convex (concave) while the other surface is flat. A biconvex (biconcave) lens is a single element with both of its faces curved outward (inward) from the center, so that the lens is thicker (thinner) at the center than at the edges. The meniscus lens is a single element with both spherical surfaces curved in the same direction such that one is concave and the other is convex. Depending on the relative radii of curvature, the net power of a lens will be either positive or negative. Similarly, spherical mirrors may be concave or convex and have different imaging properties than lenses. Convex mirrors have a negative power while concave mirrors focus light. A mirror is assigned a refractive index (n) equal to -1 and the lens maker's formula becomes $f = R/2$ for reflective imaging.

The schematic in Figure 63 illustrates the relationships of some basic lens configurations including the (a) achromatic doublet, (b) triplet, (c) symmetrical, (d) Petzval, (e) Tessar, (f) zoom variator, (g) telephoto, (h) retrofocus, (i) Double Gauss, (j) rapid rectilinear, (k) fisheye, (l) double anastigmat, (m) Celor (process), (n) Plasmat, and (o) quasi-symmetrical lens. The determination of the focal length for these lens configurations involves equations that are more complex than the lens maker's formula; however, this is easily accomplished with commercially available lens design software.

The doublet at the top of the chart can be used as a simple magnifier that allows close and detailed inspection of a subject or image. With an object at the front focal plane, the rays of light leave the magnifier, enter the eye traveling parallel, and an enlarged and erect virtual image is seen with normal eye accommodation. The power is commonly given in terms of the size of the image viewed through the magnifier from a distance of 250 mm, which is taken as the average reading distance. The magnification is determined by dividing this distance by the focal length of the magnifier in millimeters. For example, a lens with a 25 mm focal length has a 10x magnification.

The early doublet had evolved along several branches to meet the requirements for a wide range of applications in photographic imaging. A symmetrical lens configuration uses two similar sets of elements arranged on either side of the aperture stop. The aberrations of one group can be almost canceled out by the equal and opposite aberrations of the other, provided the magnification is close to unity. Symmetry is necessarily broken for lenses operating at other magnifications.

Since image size is proportional to focal length, an increase in focal length gives a larger image. Depending on the focal length and maximum aperture required, lens configurations such as the achromatic doublet, Petzval, symmetrical, and Double Gauss lenses have all been used to increase image size.

The telephoto is a compact configuration to achieve long focal length. A negative component is placed behind a front positive component of long focal length, which displaces the principal planes in front of the lens. A teleconverter is a simple optical attachment that is placed between the camera lens and body to increase the focal length. It is a group of elements of net negative power and operates on the principle of the telephoto lens.

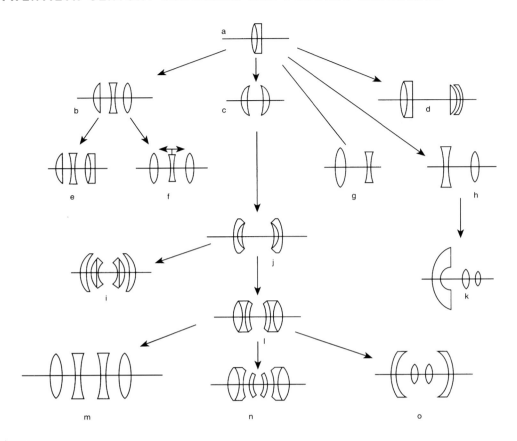

FIG. 63 Lens types.

The retrofocus lens, or reverse telephoto lens, uses the telephoto concept in reverse to increase the field of view. This is the basic concept behind many wide angle lenses having significantly greater covering power than a normal lens of equal focal length, thereby permitting the use of shorter focal length lenses to obtain a larger angle of view. The fisheye lens contains a very large angle of coverage where orthoscopic image formation can be maintained for field angles approaching 120 degrees. If barrel distortion is permissible, then the angle can be increased beyond 180 degrees.

The zoom lens has a focal length that can be varied continuously between fixed limits while the image stays in relatively sharp focus by means of compensation. Optical compensation is where the moving elements are coupled together, while mechanical compensation has two or more groups moving at different rates and in different directions. The latter generally provides better compensation, but high mechanical precision is needed for the control linkages. The zoom lens is arranged to keep the f-number constant as its focal length is altered by controlling the size and location of the exit pupil of the system. The variable focus lens is the alternative approach to changing magnification where sharp focus drifts as the focal length is changed, necessitating a focus check after each change. The f-number and image illuminance also change as the focal length is changed.

A macro lens is optimized for shorter conjugates and used for close-up and life-size photography where the magnification is greater than or equal to unity. A close-up attachment is a positive supplementary lens used to reduce the effective focal length of the lens on a camera having a limited focusing range. This allows the camera to be moved closer to a portrait subject to obtain a larger image. A soft focus lens is designed primarily for portrait photography. Spherical aberration can be used to form a diffuse image that is characterized by a sharp core with a halo. The term Bokeh has been given to the quality of blurring obtained outside the object plane. Desirable Bokehs give artistic purpose to less than perfect volume imagery.

Several additional lenses are important to the field of photography. Enlarger lenses are used to produce large prints while reduction lenses are used to generate very small features in photosensitive materials. A field lens is usually a single-element lens that is located at or near the focal plane of another lens. Field lenses have no effect on the focal length of the prime lens in this position. Their functions include flattening

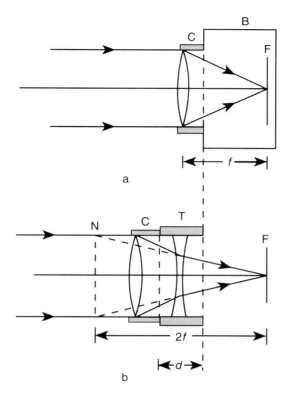

FIG. 64 Telephoto lens design.

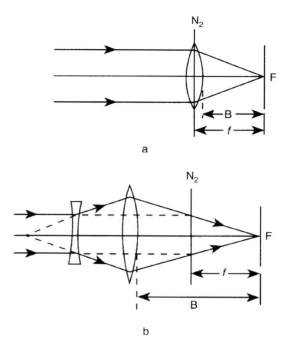

FIG. 65 Retrofocus lens design.

the image plane and redirecting peripheral rays in the image plane to avoid vignetting. Copying, enlarger, and process lenses require very flat fields. An afocal lens contains two groups of elements that are separated by the sum of their focal lengths, placing the principal plane at infinity. The incident and exiting rays are both parallel, but the diameter of the beam is changed. The magnifying power of the system is given by the ratio of the focal lengths of the two components. Keplerian and Galilean telescopes are examples of afocal lens systems.

Modern lenses have significantly evolved with improvements in glass types, anti-reflection coatings, and the development of aspheric lenses. The aspheric lens has one or more non-spherical surface that reduces spherical aberration. Advanced developments in computer-controlled generation and molding of aspheric surfaces have resulted in lenses with fewer elements and greater performance. Advancements in lithographically formed optics have provided the lens designer with a hybrid lens that forms an image with both refraction and diffraction of light. These new lenses contain one or more elements that have a patterned micro-structure on one of its surfaces. Chromatic aberration can be significantly reduced with a hybrid lens because the dispersions from the refractive and diffractive surfaces can be opposite in sign and made to compensate.

Photographic Filters

Filters are optical elements that either attenuate or separate light through several means including absorption, obscuration, dispersion, and interference. Filters can also attenuate light by deflection using refraction and diffraction. A filter that is part of an image-forming system must be of high optical quality in terms of the flatness and thickness uniformity. Filters used in illumination systems such as over lamps or in enlargers can be of a lower quality. Filters are available in various forms such as gelatin, cellulose acetate, polyester, plastics or resins, solid glass, gelatin cemented between glass, patterned gratings, and MLD (multilayer dielectric) coated substrates.

The component of incident radiation that is not reflected or transmitted is referred to as absorbed light. Absorption occurs when radiation incident on a substance is converted to another form of energy such as heat, transformed into light of another color, and emitted. This results in some chemical or electronic change in the substance, as is the case with photographic emulsions and electronic detectors. The amount of light absorption that occurs in a filter is typically wavelength dependent.

Absorption filters are the most common filters in photography and thus they warrant a physical description. An incident beam of light undergoes multiple reflections as it transmits through a filter as shown in Figure 66. The overall transmittance of the filter is defined as

$$T_F = I_t/I_I$$

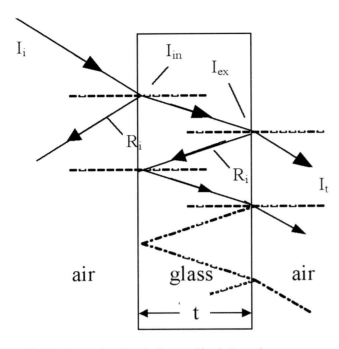

FIG. 66 Absorption filter design used in photography.

where I_i is the incident intensity and It is the transmitted intensity. The internal transmittance accounts for absorption and is defined as

$$T_A = I_{ex}/I_{in}$$

where I_{in} is the intensity transmitted by the input surface and It is the intensity transmitted by the output surface.

For a filter with smooth, uncoated, plane-parallel surfaces, the reflectivity is given by the Fresnel equations. At normal incidence the reflectivity R is polarization independent and given by

$$R = [(n-1)/(n + 1)]^2$$

The surface transmittance (T_s) accounts for losses due to reflections at the material interface.

The expression for surface transmittance, often used by filter manufacturers, is

$$T_s(\lambda) = 2n_\lambda/(n_\lambda^2 + 1);$$

however, this is an approximation with fractional percent level error for high absorption materials. The overall filter transmittance is the product of internal and the surface transmittances.

$$T_F(\lambda) = T_A(\lambda) \times T_s(\lambda)$$

Lambert's law describes the multiplicative operation of filters as

$$t_1/t_2 = \log[T_{1A}(\lambda)]/\log[T_{2A}(\lambda)].$$

For example, doubling the thickness of a filter with 10 percent transmittance yields a more absorbing filter with 1 percent transmittance. The density of a filter is a measure of its ability to attenuate light. Density is defined as the common logarithm of the ratio of the light received by the sample to that transmitted or reflected by the sample; mathematically expressed as

$$D = \log(1/T) = \log(I_o/I),$$

where D is the density, I_o and I are the incident and output irradiances, respectively, and T is the transmittance. A neutral density filter does not selectively absorb wavelengths in the visible region but absorbs all wavelengths of interest to about the same degree, giving a gray appearance to the filter.

A polarizing filter consists of a layer of aligned molecules that transmit light waves polarized in one plane and absorbs the orthogonal polarization. Multi-layer dielectric coatings and liquid crystal optics are also used to polarize light. Linearly polarizing filters are used to darken a blue sky by removing the light polarized by scattering and to increase contrast in a scene by removal of surface reflection from glass, wood, and plastics.

Interference filters are MLD coatings designed for constructive and destructive interference at specific wavelength intervals. The transmission band depends on the number of layers, their thicknesses, and chemical composition. A dichroic filter contains an MLD coating to transmit and reflect complementary bandwidths or wavelength ranges. An infrared filter is a visually opaque filter that transmits only a very small percentage of the far red wavelengths, but transmits the near-infrared region up to 1 μm. There are two important examples of MLD filters. A hot, or diathermic, mirror reflects heat and transmits the visible wavelengths, whereas a cold mirror will reflect the visible and transmit the infrared energy.

Certain filters operate specifically on ultraviolet light. For example, the haze filter is a very pale yellow filter used to absorb scattered UV and extreme blue light produced by atmospheric scattering. The barrier filter is used over the camera lens in ultraviolet fluorescence photography to absorb direct and scattered UV radiation so that only the fluorescent wavelengths are recorded.

A color filter is a passive absorption filter that absorbs particular regions of the visible spectrum.

A color filter is named by the wavelength it transmits. Color filters are characterized by their spectral transmittance. In addition, optical density and absorption can be plotted as a function of wavelength, giving a spectral characteristic curve as produced by a spectrophotometer. Beer's law, functionally related to Lambert's law, states that the spectral absorption of a substance is proportional to both the concentration of the

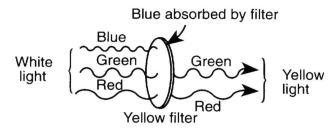

FIG. 67 Color filters.

absorbing material in that substance and to the path length through the material. Changes in concentration can be offset by changes in path length through the filter.

Color filters have many applications in photography. For example, safelight filters are meant to provide the darkroom worker with enough light to navigate while absorbing the emitted wavelengths to which photographic material is sensitive. Color compensating (CC) filters are pale filters used to produce small but significant color shifts in the rendering given by color film. CC filters are available in blue, green, red, yellow, magenta, and cyan colors of various optical densities; indicating absorption of complementary light. They are used for alteration of color balance when exposing color prints, correction of processing shifts, local color effects, reciprocity failure effects, batch differences, and special effects. Color separation filters are a set of three filters—red, green, and blue—each transmitting approximately one-third of the visible spectrum and used when making color separation negatives directly from the scene or from a color transparency.

Contrast filters are used in black and white photography to modify the relative strength of selected colors in a scene relative to their surroundings. The tone may be darkened or lightened by using a contrast filter of the complementary or same color, respectively. Thus, for a red subject on a green background, a red filter would lighten red and darken green, while a green filter would have the reverse effect. Variable contrast filters are used with variable contrast black and white printing paper to vary the image contrast. These filters alter the color of the exposing light to selectively expose the two different emulsions of the paper.

Color conversion filters are blue and orange filters used to modify a light source for which the film is not balanced. For example, to use daylight type color film balanced for 5500 K with studio lamps of color temperature 3200 K, a deep blue color conversion filter is required. To use artificial light film balanced for 3200 K in daylight, an orange conversion filter is required. A light balancing filter is a pale yellow or blue color filter used to give small corrective shifts of color temperature to the light transmitted by a lens when used with color film, especially reversal types. Typical uses are for reducing the blue cast given in open shade on a sunny day or for the variations in color temperature with the season or time of day.

A skylight filter is a pale pink filter used particularly with color reversal film to remove blue color casts in dull weather or subjects in open shade that are illuminated only by blue skylight. Sky filters are used to control the tonal rendering of the sky, especially in the presence of clouds. The contrast between blue sky and white cloud can be progressively increased by the use of yellow, orange, and red filters, which in turn transmit less blue light to which panchromatic film is especially sensitive. A viewing filter, also called the panchromatic vision filter, is a pale purple filter used to show the subject in terms of its approximate brightness values as would be recorded with panchromatic black and white film.

Extending beyond traditional photographic applications, filter technology had significantly advanced near the end of the 20th century. The optics community had pushed the performance of narrowband MLD filters in the development of dense wavelength division multiplexing (DWDM) for the telecommunications industry. DWDM filters now approach the spectral resolution of standard grating monochromators. Narrowband filters can be used to record light produced from new physical phenomena as scientists explore high-temperature matter in the laboratory and astrophysical events in the universe.

FURTHER READING
Optics
Collier, R. G., Burckhardt, C. B., and L. H. Lin (1971). *Optical Holography*. San Diego, CA: Academic Press.

Cowan, W. B. (1995). *Handbook of Optics, Volume I.* New York: McGraw-Hill.

Defense Supply Agency (1962). *Military Standardization Handbook—Optical Design*. Washington, D.C., October 1962.

Hecht, E. and Zajac, A. (1975). *Optics*. Reading, MA: Addison-Wesley.

Jenkins, F. A. and White, H. E. (1976). *Fundamentals of Optics*. New York: McGraw-Hill.

Malacara, D. and Thompson, B. J. (eds.) (2001). *Handbook of Optical Engineering*. New York: Marcel Dekker, Inc.

Smith, W. (1966). *Modern Optical Engineering*. New York: McGraw-Hill.

Optics and Imaging
Engle, C. E. (1968). *Photography for the Scientist*. London: Academic Press.

Gaskill, J. D. (1978). *Linear Systems, Fourier Transforms, and Optics*. New York: Wiley Interscience.

Sears, F. W. (1958). *Optics*. Reading, MA: Addison-Wesley.

The Practical Application of Light, Melles Griot, 2005

Zakia, R. and Stroebel, L. (eds.) (1993). *The Focal Encyclopedia of Photography, Third Edition*. Burlington, MA: Focal Press.

Lens Design, Performance, and Aberrations
Kingslake, R. (1983). *Optical System Design*. New York: Academic Press.

Malacara, D. and Z. Malacara (2004). *Handbook of Optical Design.* New York: Marcel Dekker.

OSLO (1987). Optical Design, Sinclair Optics.

Smith, W. (1992). *Modern Lens Design.* New York: McGraw-Hill.

Zemax (2001). Optical Design Program, Focus Software.

Photographic Filters

Eastman Kodak (1989). *Kodak Filters.* Rochester, NY: Eastman Kodak.

Hoya Corporation (1989). Hoya Color Filter Glass.

Jacobson, R. et al. (1988). *The Manual of Photography, 8th edition.* London: Focal Press.

ADDITIONAL INFORMATION
Optics

http://mysite.verizon.net/vzeoacw1/applet_menu.html

http://pdg.lbl.gov/~aerzber/aps_waves.html

http://www.canon.com/technology/s_labo/light/003/03.html

Optics and Imaging

http://webphysics.davidson.edu/physlet_resources/dav_optics/Examples/optics_bench.html

http://www.dcviews.com/tutors.htm

http://www.lhup.edu/~dsimanek/scenario/raytrace.htm

http://www.shortcourses.com/choosing/lenses/10.htm#Zoom%20lenses

Lens Design, Performance, and Aberrations

http://www-ee.eng.buffalo.edu/faculty/cartwright/java_applets/ray/MultiLensSys/

http://www.luminous-landscape.com/tutorials/understanding-series/lens-contrast.shtml

http://www.olympusmicro.com/primer/lightandcolor/lenseshome.html

http://www.photo.net/learn/optics/lensTutorial

http://www.schneideroptics.com/info/white_papers/optics_for_digital_photography.pdf

http://www.vanwalree.com/optics.html

Photographic Filters

http://dpfwiw.com/filters.htm

http://www.digicamera.com/features/filterprimer/

http://www.photographers.co.uk/html/photographic-filters.cfm ◎

Additional Lens Types

MICHAEL R. PERES
Rochester Institute of Technology

At the time of purchase, many basic cameras come with a standard lens. Cameras that do not have a removable lens are the most common types of cameras sold and represent principally amateur and some prosumer camera models. Many special camera types may also have an attached lens. Single-use and some point-and-shoot cameras are examples of cameras with a fixed lens. Lenses that are attached at manufacture will vary in their focal length from wide angle to normal view. Many of these cameras might also have a zoom lens instead of a fixed focal lens, which is not removable. The standard lens for such cameras would be calculated by the angle of view requirement that is needed for the illumination to cover the film/sensor diagonal, which is a view similar to that of the human eye or 53 degrees. For more about lenses, please refer to the Photographic Optics essay. In the professional and advanced amateur markets, interchangeable lenses are desirable and offer a wide choice of alternative focal lengths. Many specialized lens types were designed and sold during the 20th century. Their features were influenced by the application/purpose of their design.

Afocal Lens—A lens with two elements that are separated by the total of their focal length together. An afocal lens produces magnification and is found in astronomical telescopes. Afocal lenses may also have variable-power attachments.

Anamorphic Lens—A lens that produces images having different scales of reproduction in the height and width of the image dimensions. Most anamorphic lenses compress only one direction. The anamorphic lens was first demonstrated in 1927 by H. Chrétien, but did not become popular until the introduction of wide screen projection, primarily in cinematography, became popular.

Aspheric Lens—A lens that has one or more of its surfaces that are not spherical. A lens' refractive error, which might result in spherical aberration, is reduced with this feature so fewer elements may be needed. Aspheric single-element lenses may be used in simple cameras or for specialized work. Aspheric lenses are difficult and costly to make, so the price of these lenses is high. For illumination systems, however, condenser lenses with molded, rather than ground aspheric surfaces, are cost-effective to produce.

Catadioptric Lens—Special lenses that are used where long focal distances are required. Telephoto lenses were invented to minimize the long lens to detector distances and catadioptric (cat) lenses further this compacting by using lenses that are characterized as folded or shortened. Cat lenses use both lenses and mirrors to form images. The name is derived from the dioptrics (reflecting lens surface and catoptrics) refracting lens. The image is formed as the light from the scene passes through a glass element except for the central region where there is an

opaque disc. It is there that a concave mirror and then another smaller mirror reflects and focuses the image on its way to the detector. The glass lens helps to control the aberrations that are typical of mirror lenses. Location of the lens focal length is determined using traditional methods. Catadioptric lenses are capable of forming images of excellent definition, but as a consequence of the lens focal length, which is very long, the lens does not have a variable aperture.

Condenser Lens—A lens system that controls the light from a source, which forms an evenly illuminated image field of the light source. Condenser lenses form illumination that may be directed into the entrance pupil of another lens. Condenser systems were and are used in enlargers, projectors, camera viewfinders, and microscopes. Since the illumination is forming but is not an image, the optical quality of these lenses can be inferior. The subject would be located between the condenser and the image-forming lens, which is nearer to the condenser. In a condenser enlarger, various lenses are used for the different formats. In a microscope, the substage condenser is rated by its numerical aperture and is usually color corrected.

Convertible Lens—Designed so that one or more of the elements can be removed, which subsequently changes the lens' focal length. Generally removing one of the positive elements will increase the lens' focal length, Since the focal length and lens-to-detector distance is changed, the marked f-stop scale is not accurate and most often will have an additional set of information provided for use in both situations. The image quality will be different with the two focal lengths. Stopping the lens down will minimize any aberrations and other image defects that may surface from this situation.

Enlarger Lens—Used to produce images for projection printing applications. The lens aberration corrections are for short object distances and produce a plan or a flat image field relatively free from distortions. Performance is optimized for a given magnification. The lenses may successfully be used on cameras for magnification work and copying when used in reverse.

Field Lens—Usually a simple lens that is located at or near the focal plane of another lens. Field lenses may flatten the image from the primary lens and is used to avoid the darkening in the corners of illumination and imaging systems such as in viewfinders and in microscopes and endoscopic imaging systems.

Fisheye Lens—A lens that has an extreme angle of view. The limits of physics of such lenses define the angle of coverage of distortion-free images to about 120 degrees. The design of retrofocus configurations allows for easy use in a single-lens reflex (SLR) camera. There are two versions of such fisheye lenses. The quasi-fisheye has a circle of illumination that circumscribes the film format and gives a 180 degree angle of view across the diagonal while a true fisheye lens produces a circular image.

Flat-Field Lens—A lens that is highly corrected for curvature and produces a flat image surface to accurately match the focal plane. Copying, enlarger, microscope, close-up, and process lenses all have flat fields.

Fluorite Lens—A lens using one or more elements of calcium fluoride (CaF_2) made from synthetic crystals. This lens has a very high color correction.

Fresnel Lens—A converging lens found in the form of a thin panel of plastic or glass with a series of concentric stepped grooves or rings. Each groove's face has a different angle. Fresnel lenses are used in theater focusing spotlights, field lenses for focusing screens, the overhead projectors, and in electronic flash units.

Long-Focus Lens—A lens with a focal length markedly longer than the diagonal of the format in use. The image size is always proportional to lens focal length, and an increase in focal length will also produce a larger image. Telephoto and catadioptric designs are smaller and can possess similar focal lengths.

Macro Lens—A term used to describe a lens designed for close-up photography capable of good results up to an image magnification of 1:1. A macro lens has been designed to control aberrations at close working distances and requires the object distance to be pre-set. Macro lenses are optimized for shorter conjugates. As a consequence of these corrections, most lenses of this type have a maximum aperture of approximately f/4. For magnifications greater than x1.0, when using a bellows or extension tubes, the lens should be reverse mounted to improve performance. Most automatic features will be lost when reverse mounting.

Macro-Zoom Lens—A type of zoom or variable focal length lens that also allows close focusing. This feature will rarely create images that are possible using a fixed focal length macro lens. Macro zoom lenses will often create images with some resolution change as well as other performance loss when used in the macro mode. It is, however, a very convenient feature nonetheless and was first demonstrated in 1967.

Meniscus Lens—A single element thin lens that has both of its surfaces curved in the same direction. Meniscus lenses can be either positive or negative. If the convex surface radius is smaller, the lens is thicker in the center and is positive. Meniscus lenses are commonly found in supplementary lenses used in close-up photography and simple camera lenses.

Micro-Imaging Lens—A lens of the highest quality whose performance is limited only by diffraction, which approaches the theoretical limits of resolving power. This lens is used to produce micro images. Performance is achieved by having a fixed reproduction ratio, a fixed large aperture, and a very small field.

Mirror Lens—An image-forming lens that uses flat and curved mirrors instead of glass elements. A mirror lens has minimal chromatic aberration problems and visual focusing when used in the infrared and ultraviolet regions. Many astronomical telescopes use mirror lenses.

Negative Lens—Another term for a diverging lens, which is a lens of negative refracting power. In a system where an aerial image is observed, this lens would be indicated. In a simple

negative lens, the middle will be thinner than the periphery. Negative lenses produce virtual images.

Orthoscopic Lens—A term describing a lens that produces an image with no curvilinear distortion, either pincushion or barrel. Orthoscopic lenses were considered essential in applications such as copying, architectural photography, aerial survey, and photogrammetry.

Perspective-Control/PC Lens—A wide angle lens that has extra covering power. The image circle exceeds the diameter of the imaging area and these lenses are designed to allow movement of the lens to control image shape without vignetting the image. PC lenses are used on small and medium format cameras that do not have camera movements. Both a vertical and horizontal shift is possible. Contemporary image-processing software such as Adobe Photoshop can correct for this same perspective control.

Portrait Lens—A general term used to describe lenses desirable for portraiture that typically have a long focal distance. These lenses are minimally corrected for aberrations, which are often preferred by creating images with softness and lower contrast or soft-focus lenses directly.

Positive Lens—Another name for a converging lens or a simple lens that is thicker in the middle than on the periphery. For distant subjects, the light image is focused as a real inverted image on the opposite side of the lens on a screen.

Process Lens—A lens found on process cameras that is used for precision copying and color separation work used for photomechanical reproduction application before scanners. Process lenses were corrected for near unit magnification and were apochromatic and essentially distortion free. Long focal lengths were needed to cover large size film formats such as 16 × 20 Kodak Kodalith type 2556.

Projector Lens—A lens used for the projection of magnified images on a screen for general viewing as in the cinema or for viewing small format color transparencies or currently found in video projectors. A common focal length for projectors would be twice the diagonal of the format used, but various focal length versions are used also, depending on the projector-to-screen distance. Zoom or varifocal lenses are popular because of the convenience in setting up, but some curvilinear distortion is inevitable. Projection lens systems are prone to a keystoning effect, a condition where an image's magnification is larger at the base and smaller near the top.

Reduction Lens—A lens used in a system such as an optical printer to produce an image in a smaller format by optical reduction.

Relay Lens—A lens or group of lenses that is used to transfer an intermediate real image formed by one lens group of an optical system to another part by optical projection. In a microscope, a change of magnification will occur—the image will be inverted or lengthened in the optical path in an imaging system or viewfinder.

Soft-Focus Lens—A lens designed primarily for portrait photography by the deliberate introduction of spherical aberrations that produce images diffused and unsharp with correct color. Some are characterized by a sharp core focus with halo as the outer area of the lens is involved. Stopping the lens down will reduce the aberrations and halo effect.

Split-Diopter Lens—A supplementary close-up lens in the form of a half-lens or semi-circle to cover one half of the front element of the prime lens. It is used to enable two subjects at different distances to be recorded in sharp focus.

Supplementary Lens—A lens that is added to the front of the prime camera lens to change that lens' focal length and frequently allowing shorter working distances. The term supplementary is typically used to describe positive and negative simple lenses. A negative meniscus lens will increase a lens' focal length; however, the lens' focusing system will require additional separation.

Teleconverter Lens—An optical attachment that is inserted between the camera lens and body to increase the focal length of the camera's prime lens. Teleconverters are not strictly a simple lens but rather a group of lens elements. They will often double or triple the focal length of the prime lens acting as a telephoto of short physical length. The entrance pupil of a lens with a teleconverter is unaffected. However, the doubling or tripling of the focal length will mean that maximum aperture is decreased by two or three stops, respectively, e.g., a 200 mm f/4.0 lens with a x2 converter becomes a 400 mm f/8.0 telephoto. The minimum focusing distance will not change.

Telephoto Lens—A long focus lens distinguished by a different optical construction providing a more compact design. Telephoto lenses and microscopes were invented to see more distant objects more clearly. Long focal length lenses will achieve image magnification; however, their focus distance is impractical based on the camera limitations. A negative lens group, which is located behind a positive lens of longer focal length, displaces the nodal planes in front of the lens and shortens the image focusing distance requirements. Telephoto lenses are well corrected, possibly with some residual pincushion. The use of ED glass and internal focusing have given rise to a class of lenses called super telephotos, which have focal lengths from 200 to 800 mm and maximum apertures f/2 to f/5.6, depending on focal length. Use of a teleconverter increases their focal length.

Variable Focal Length Lens—A term used to describe a zoom lens.

Wide Angle Lens—A lens having significantly greater covering power than a normal lens of equal focal length. Early versions suffered from poor covering power and fall off. A wide angle lens may be defined as a lens having a focal length of less than 53 degrees, the angle of coverage of a normal lens. A fisheye lens, although quite unique, is a wide angle lens. Common wide angle lenses might include a 20, 24, or 35 mm lens. Contemporary wide angle lenses have a retrofocus design.

Retrofocus produces a short focal length with a long back focal distance by shifting the nodal planes. The asymmetry can cause some residual barrel distortion, but reflex mirrors or beam splitters can be inserted between lens and film. Such lenses have increased complexity, bulk, and cost, but they

provide less fall off of light toward the corners of the film than conventional wide angle lenses of the same focal length.

Zoom Lens—A lens with a variable focal length that can be changed continuously between fixed limits while the image stays in acceptably sharp focus regardless of focal length. The visual effect in the viewfinder is that of a smaller or larger image as the focal length is decreased or increased. Zoom ratios of 2:1 to 8:1 are available for still photography cameras and 10:1 to 20:1 might be found in cine and video.

For a working photographer, the ideal solution to picture making is having the right lens for all situations. There are two basic methods for achieving movement of the lens elements in zoom lenses to accomplish focal length changes. One method is to link the elements so everything moves together at the same distances. This method is an optical design. The other method to achieve variable focal lengths is referred to as mechanical where various elements move separately. This type of design is very complicated to manufacture.

FURTHER READING

Kingslake, R. (1989). *A History of the Photographic Lens.* London: Academic Press.

Stroebel, L. (1999). *View Camera Technique. 6th ed.* Boston: Focal Press.

Ray, S. (2002). *Applied Photographic Optics.* London and Boston: Focal Press

GLOSSARY

Keystone effect—A convergence of parallel subject lines in the image when a camera or projector is tilted up or down. Elimination of convergence in a camera requires the film plane to be parallel to the subject, and elimination in a projected image requires the transparency to be parallel to the projection screen.

Prosumer—Describes a group of customers for photographic products that are above amateurs but maybe not professional. Some might characterize them as the advanced amateur market. ✸

Some Other Filter Types

MICHAEL R. PERES
Rochester Institute of Technology

Barrier Filter—Used in fluorescence photography to completely absorb all excitation energy in the system such that only wavelengths of energy longer than the excitation energy reach the imaging system.

Colloidal Silver Filter—The yellow filter that is integrated into a tripack color negative film. It is located below the blue emulsion and in front of the green-sensitive layer. This filter, which contains small particles of silver that are suspended in gelatin, strongly absorbs blue light. The filter is removed during C-41 processing and may also be referred to as the Carey-Lea layer.

Davis Gibson Filter—A filter made by using two separate liquid cells use solutions of copper and cobalt salts and other ingredients. These filters were adopted in 1931 to convert CIE illuminant A (2848 K) to an approximation of sunlight (illuminant B) or north skylight (illuminant C) and were first published by R. Davis and K. Gibson in the *Transactions of the Society of Motion Picture Engineers* in May 1928.

Dichroic Filter—A filter composed of two filters. One filter is seen using transmission and the other filter is observed using reflection. Its color is the complement of the first. The filter does not operate using absorption, but its action is a result of interference between the various filter layers made of thin refractive materials. Many layers may be used in the variety of dichroic filters producing very accurate and narrow spectral band transmission or reflections. This filter is also called an interference filter.

Exciter Filter—A filter used as the first filter found in a fluorescence imaging system. Its wavelength needs to be of the correct spectral wavelength required to stimulate a fluorescence emission from the sample in question.

Fog Filter—A colorless filter used at the camera with a treated surface which simulates the effect of foggy conditions. Filters such as a fog filter have seen fewer applications since image processing software all comes with numerous "special filters" in the various menu options such as Gaussian blur.

Graduated Filter—A filter that does not have a consistent color or density across its surface but exhibits a continuous transition across the density range from one of the elements to the other variant of the filter. The filter should be positioned in the system some distance in front of the lens to create a subtle transition. Similar to the fog filter, graduated filters have seen fewer applications since image-processing software all comes with numerous "special filters." Image processing easily introduced post-image capture, which creates a multitude of effects rather than the single outcome each filter is capable of.

Haze Filters—Filters used to control tones and color of the sky especially in cloudy conditions. Haze filters might also be called ultraviolet or skylight filters. All of these filter types might often be used as a lens protection filter and more or less be left on the lens all the time.

Heat Filters—Filters used primarily in an illumination system to remove infrared energy or heat. Various forms of filters might be used including colorless glass. In various digital cameras, a hot mirror may be built into the camera to remove IR from the system before reaching the chip.

Infrared Filter—A visually opaque filter that transmits principally near-infrared energy by absorbing the visual range of the EMR. The designation of the filter such as Wratten 87 or 88 may indicate its peak wavelength transmitted, such as 870 or 880 nm. Some of these filters may be made of gelatin and used with IR film or a digital camera by placing the filter at the lens or over the light.

Neutral-Density Filter—A filter type that does not selectively absorb any specific wavelength in the visible spectrum

but absorbs all wavelengths evenly providing a gray appearance. It is usually referred to by its optical density, e.g., ND.3. Such filters can be used with any type of imaging systems and work well in situations where there is too much brightness or where long exposure times are desirable.

Spatial Filter—A mechanical element found principally in laser beam applications. This filter consists of an opaque material with an aperture of suitable diameter upon which the laser beam can be focused using a short-focus lens.

Spatial Frequency Filters—Mechanical devices required in image formation when using coherent light, where the image is illuminated using a coherent laser and the far-field diffraction pattern produced is then imaged to form the picture. Filters in the shape of patch stops, annuli, or other shapes can be placed in this Fourier transform plane to selectively remove spatial frequencies by simply blocking their path to the imaging lens.

Star Filter—A clear glass or plastic filter with fine engraved lines in a regular pattern on its surface, which causes the directional spread of small high brightness from the scene to create a starburst effect to these regions without seriously compromising other areas of the scene.

Status Filters—Filters used in a densitometer that are designed to produce appropriate spectral responses in various applications.

Status A filters are used for color transparencies that will be viewed directly.

Status D filters are used for measuring color prints.

Status G filters are used with inks used in photomechanical reproduction.

Status M filters are used with color negatives and transparencies that would be printed.

Status V filters are used for visual densitometry.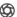

Perspective[1]

LESLIE STROEBEL, PH.D.
Rochester Institute of Technology

Perspective—Refers to the appearance of depth when a three-dimensional object or scene is represented in a two-dimensional image, such as a photograph, or when the subject is viewed directly.

Types of perspective—The fact that we humans have two eyes is often credited for our ability to perceive depth and judge relative distances in the three-dimensional world with such accuracy. If we close one eye, however, the world does not suddenly appear two dimensional because there are other depth cues, cues that photographers can use to represent the three-dimensional world in two-dimensional photographs.

Linear perspective—Linear perspective is exemplified by the convergence of parallel subject lines in images and by

the decrease in image size as the object distance increases. Linear perspective is so effective in representing depth in two-dimensional images that it is often the only type of depth cue provided by artists when making simple line drawings.

Early Egyptian artists drew pictures without linear perspective, where a boat in the foreground and a boat on the horizon were drawn the same size. Brunelleschi, an Italian architect, is credited with devising a mathematically proportional system, which he used in architectural drawings in 1420. In 1435 Alberti, another Italian architect, originated the concept of thinking of the picture plane as a window through which he looked at the visible world, which enabled him to record the images of objects with the correct size-distance relationships. Alberti is also credited with the concept of vanishing points, where parallel subject lines that recede from the viewer meet in the image.

Overlap—If a subject is arranged so that a nearby object obscures part of a more distant object, the viewer is provided with a powerful cue as to which object is closer. Overlap by itself, however, does not provide any information concerning the actual distances or even relative distances of the near and far objects.

Depth of field—Refers to the range of object distances within which objects are imaged with acceptable sharpness. When a camera is focused on an object at a certain distance and closer and more distant objects appear unsharp in the photograph, the viewer is made aware that the objects are at different distances. When the depth of field is very large and objects at all distances appear sharp in the photograph, the viewer may become confused about relative distances unless there are other depth cues such as relative sizes. Photographs in which a pole in the background appears to be growing out of the head of a person in the foreground is an example of confusion resulting from a large depth of field.

Lighting—Depth can be emphasized with lighting that reveals the shape, form, and position of objects. A lack of tonal separation between the dark hair of a model and a dark background, for example, destroys the appearance of distance between the model and the background. Uniform front lighting on a white cube with three visible planes can make it appear two dimensional, whereas lighting that produces a different luminance on each plane will reveal the cube's true form. With curved surfaces, as on the human face, form and depth are revealed with lighting that produces gradations of tone on the curved surfaces. Shadows on objects on the opposite side from the main light and shadows of objects cast onto other surfaces can emphasize both the form of the objects and their locations.

Aerial haze—The scattering of light by small particles in the atmosphere makes distant objects appear lighter and with less contrast than nearby objects. With a series of mountain ridges that increase in distance, each more distant ridge appears lighter than the one in front of it. Heavy fog is a more dramatic example of the same effect, where a person walking away from the camera can appear to fade and then disappear in a short distance. The appearance of aerial haze, and therefore the apparent distance, can be altered considerably by the choice of

[1]Originally published in the *Focal Encyclopedia of Photography, 3rd edition.*

film and filter. Since the haze consists of scattered light that is bluish in color, use of a red filter with panchromatic film will decrease the appearance of haze and a blue filter will increase it. Black-and-white infrared film used with a red or infrared filter will decrease the appearance of haze and depth and increase the detail that is visible in the more distant objects. Smoke in a smoke-filled room creates the similar effect of increasing the appearance of depth in interior photographs. Fog machines are used by some photographers and cinematographers to achieve a haze effect.

Color—As applied to perspective, red is identified as an advancing color and blue as a receding color. The terms indicate that if a red card and a blue card are placed side by side and there are no other cues as to their distance from the viewer, the red card will tend to appear nearer. If the explanation for this effect is that it is due to association, it can be noted that with aerial haze, the haze becomes more bluish with increasing distance. Also, blue sky is thought of as being at a great distance. Researchers in visual perception have considered the possibility of a physiological explanation based on a difference in focus on the retina in the eye for red light and blue light. It is not uncommon for artists to use red and blue colors to achieve perspective effects in their paintings.

Stereophotography—Attempts have been made since the early days of photography to make photographs more realistic through the use of stereoscopic vision. All such attempts involve two (or more) photographic images made from slightly different positions, each of which is then presented to the appropriate eye of the viewer. The stereoscope is an individual viewing device that holds the pictures side by side with a separate viewing lens for each eye. The first stereoscope, designed by Wheatstone in 1832, before the invention of the daguerreotype process, made use of multiple mirrors and pairs of stereoscopic drawings. It is possible, with practice, to fuse the two images of a stereograph without a viewing device. The centers of the two images must not be farther apart than the pupils of the eyes, which varies among individuals but is about 64 mm (2.5 inches) average, since the axes of the two eyes cannot normally be made to diverge. Wedge-shaped lenses in the improved stereoscope introduced by Sir David Brewster in 1849 eliminated eyestrain and made stereophotography practical. With contact-size stereographs, it is recommended that the lenses in the stereoscope have approximately the same focal length as the lenses in the camera, but most were somewhat longer. The imposed limitation on the size of the stereograph images in the viewer is not a problem, because the viewer perceives an image projected into space similar to the effect of looking at the original scene. During the years following the introduction of the Brewster stereoscope, many photographers, including the famed landscape photographer William Henry Jackson, made stereoscopic photographs in addition to conventional photographs. By 1900 stereoscopes were common parlor room fixtures and photographic stereographs were sold by the millions.

A limitation of the stereoscope is that it is an individual viewing device. Various processes have been developed to produce stereoscopic images that could be viewed by more than one person, and even large groups in theaters. The anaglyph consists of superimposed red and green images. By looking through a red filter with one eye and a green filter with the other, viewers see the appropriate image with each eye and perceive a three-dimensional image.

Superimposed images that are polarized at right angles produce depth perception when viewed through polarizing filters that are also rotated at right angles to each other. By using polarizing filters in front of two projectors, color stereographic slides or motion pictures can be viewed by groups of people wearing polarized glasses. It is necessary for the screen to have a metallic surface, such as aluminum paint, to prevent the reflected images from being depolarized.

Viewing devices can be eliminated by using a system that combines the two photographs as very narrow alternating vertical strips over which is placed a plastic layer containing a lenticular pattern that refracts the light from each set of strips to the appropriate eye. Stereoscopic cameras with four lenses have been manufactured, a design that represents a refinement of the lenticular stereoscopic process.

Three-dimensional images have been presented on conventional television receivers with a process that requires the viewer to wear glasses that place a neutral density filter over one eye. The filter causes that eye to adapt to a lower light level, which reduces the time resolution and produces a delay in the perception of the image in that eye.

Motion perspective—Identifies a changing image pattern with respect to the angular size and separation of objects in a three-dimensional scene as the distance between the scene and the viewer or camera changes.

Linear perspective—In a static situation it refers to a fixed point of view. A change in distance between a scene and the viewer may be due to movement of the viewer, the subject, or both. It is more convenient, however, to think of the observer as a fixed reference point around which there is a continuous flow of objects, even when it is the viewer who is moving.

When a distant point is selected as representing the direction of movement of the viewer, the parts of the scene appear to move away from this point in all directions. For example, when driving through a tunnel, the opening at the far end expands away from the center at an increasing rate and the edge of the opening passes around the car on all sides as the car emerges from the tunnel. The flow of objects away from the distant vanishing point is most rapid closest to the viewer, because the rate of movement is inversely proportional to the distance between the object and the viewer.

When one approaches a photograph of a three-dimensional scene rather than the scene itself, the effect is entirely different. Now the images of objects at different distances do not change in relative sizes, and the rate of movement of the parts away from the center of the photograph is unrelated to the distance of the objects from the camera. The illusion of depth in two-dimensional photographs is therefore less realistic when the viewer alters the viewing distance (or horizontal position) than when the viewing position remains constant.

This is one factor that contributes to the realism of depth in slides and motion pictures that are projected on a large screen where the viewing position remains constant.

The consequences of motion perspective can be seen in motion pictures and television pictures when the camera moves directly into or away from a scene in comparison to using a zoom lens from a fixed position. The use of the zoom lens has an obvious advantage in convenience, and in many situations, the difference in effect is unimportant. But zooming in on a scene tends to reduce the illusion of depth in a manner similar to that of moving in relation to a still photograph because the images of near and far objects increase in size at the same rate.

Also, using a long, fixed focal-length lens decreases motion perspective because the image of an object moving toward the camera increases in size more slowly. This technique was used effectively in the motion picture *Lawrence of Arabia*, where the viewer is kept in suspense when the image of a distant horseman (friend or enemy?) very slowly increases in size, even though he is obviously riding rapidly toward the camera. Conversely, use of a short focal-length lens for a car race seems to exaggerate speed due to motion perspective.

Motion parallax—When a person moves sideways, whether just moving one's head a few inches or looking out the side window of a moving vehicle, the relative positions of near and far objects change. The basic concept is the same as for stereoscopic vision. The two eyes view an object from slightly different angles and the relative position of the background is different for the two eyes, but with continuous lateral movement the foreground–background changes are also continuous. If one fixates a foreground object, the background appears to move in the same direction the person is moving. If one fixates a background object, the foreground appears to move in the opposite direction. During the movement, the person has a strong impression of the distance between foreground and background objects. A similar perception results when viewing moving images produced with a motion-picture or video camera that was moving laterally.

Holography—Holographic images also present different viewpoints to the two eyes, and, within limits, the viewer experiences motion parallax with lateral movement. A hologram is made by recording on a photographic material the interference pattern between a direct coherent light beam and light from another beam from the same source after it is reflected or transmitted by the subject. By viewing the hologram with a beam of coherent light, positioned the same as the direct beam used to expose the hologram, an image is produced that has the same three-dimensional appearance as the original subject.

Linear perspective variables—The relative sizes of the images of objects at different distances is determined by the position of the eye when we look at the objects directly and the position of the camera lens when we photograph the objects. Although lenses of different focal lengths change the size of the entire image rather than the relative sizes of parts of the image, strong perspective is associated with short focal-length wide-angle lenses and weak perspective with long focal-length telephoto lenses. This is in part due to the fact that the focal length of the camera lens determines the camera-to-object distance required to obtain an image of the desired size—small for short focal-length wide-angle lenses and large for long focal-length telephoto lenses. In addition to the relative image sizes, which largely determine the viewer's impression of the perspective in photographs, psychological factors involved in changes in viewing distance also influence the perception.

Object distance and image size—Two objects of equal size placed at distances of 1 foot and 2 feet from a camera lens produce images having a ratio of sizes of 2:1. If the ratio of the object distances is 1:3, the ratio of image sizes will be 3:1. The relationship between image size and object distance is that image size is inversely proportional to object distance. Linear perspective is based on the relative size of the images of objects at different distances. With movable objects, the image sizes and linear perspective can be controlled by moving the objects. In situations where the subject matter cannot be moved easily, it is necessary to move the camera and/or change the focal length of the camera lens to alter image sizes.

With two objects at a ratio of distances of 1:2 from the camera, moving the camera farther away to double the distance from the closer object does not double the distance to the farther object, therefore, the ratio of the image sizes will not remain the same. If the ratio of object distances changes from 1:2 to 2:3 by moving the camera, the ratio of image sizes will change from 2:1 to 3:2 (or 1.5:1). Moving the camera farther away not only reduces the size of both images, but it also makes them more nearly equal in size. The two images can never be made exactly equal in size no matter how far the camera is moved away, but with very large object distances the differences in size can become insignificant.

The linear perspective produced by moving the camera farther from the objects is referred to as a weak perspective. Thus, weak perspective can be attributed to a picture in which image size decreases more slowly with increasing object distance than expected. The images of parallel subject lines also converge less than expected, with weak perspective. Another aspect of weak perspective is that space appears to be compressed, as though there were less distance between nearer and farther objects than actually exists.

Conversely, moving a camera closer to two objects increases the image size of the nearer object more rapidly than that of the farther object, producing a stronger perspective. For example, with objects at a distance ratio of 1:2, moving the camera in to one-half the original distance to the closer object doubles its image size but reduces the distance to the farther object from 2 to 1.5, therefore increasing the image size of the farther object to only 1.33 times its original size. Moving the camera closer to the subject produces a stronger linear perspective whereby image size decreases more rapidly with increasing object distance, and the space between the closer and farther objects appears to increase. Strong perspective is especially flattering in architectural photographs of

small rooms because it makes the rooms appear to be more spacious, and it permits the building of relatively shallow motion-picture and television sets that appear to have normal depth when viewed by the audience. Strong perspective is inappropriate, however, for certain other subjects where the photograph is expected to closely resemble the subject.

Changing object distance and focal length—In many picture-making situations it is appropriate to change lens focal length and object distance simultaneously to control linear perspective and overall image size. For example, if the perspective appears too strong and unflattering in a portrait made with a normal focal-length lens, the photographer could substitute a longer focal-length lens and move the camera farther from the subject to obtain the same size image but one with weaker perspective. Since short focal-length wide-angle lenses tend to be used with the camera relatively close to the subject and long focal-length telephoto lenses tend to be used with the camera at relatively large distances, strong perspective is often associated with wide-angle lenses and weak perspective is similarly associated with telephoto lenses, but it is the camera position and not the focal length or type of lens that produces the abnormal linear perspective. The change in linear perspective with a change in object distance is more apparent when an important part of the subject is kept the same size by simultaneously changing the lens focal length.

In situations where a certain linear perspective contributes significantly to the effectiveness of a photograph, the correct procedure is to select the camera position that produces the desired perspective first, and then select the focal-length lens that produces the desired image size. For example, if the photographer wants to frame a building with a tree branch in the foreground, the camera must be placed in the position that produces the desired relationship between the branch and the building. The lens is then selected that produces the desired image size. A zoom lens offers the advantage of providing any focal length and image size between the limits. With fixed focal-length lenses, if the desired focal length is not available, and changing the camera position would reduce the effectiveness due to the change in perspective, the best procedure is to use the next shorter focal-length lens available and then enlarge and crop the image.

Cameras cannot always be placed at the distance selected on the basis of linear perspective. Whenever photographs are made indoors, there are physical limitations on how far away the camera can be placed from the subject. Fortunately, the strong perspective that results from using short focal-length wide-angle lenses at the necessarily close camera positions enhances rather than detracts from the appearance of many architectural and other subjects. There are also many situations where the camera must be placed at a grater distance from the subject than would be desired. This, of course, applies to certain sports activities where cameras cannot be located so close that they interfere with the sporting event, block the view of spectators, or endanger the photographer.

Not all subjects are such that the perspective changes with object distance. Since two-dimensional objects have no depth,

photographs of such objects reveal no change in the relative size of different parts of the image with changes in camera distance. Also, photographic copies of paintings, photographs, printed matter, etc., made from a close position with a short focal-length wide-angle lens, and from a distant position with a long focal-length telephoto lens, should be identical.

Viewing distance—Although it might seem that the distance at which we view photographs would have no effect on linear perspective, since a 2:1 ratio of image sizes for two objects at different distances will remain constant regardless of the viewing distance, changes in viewing distance can alter the perception of depth providing that the photograph contains good depth cues. Photographs of two-dimensional objects or subjects that have little depth appear to change little with respect to linear perspective when the viewing distance is changed, whereas those that contain dominant objects in the foreground and background or receding parallel lines that converge in the image can change dramatically.

Seldom do we encounter unnatural-appearing linear perspective when we look at the real world. Such effects tend to occur only when we look at photographs or other two-dimensional representations of three-dimensional objects or scenes. The reason perspective appears normal when we view three-dimensional scenes directly at different distances is that as we change the viewing distance, the perspective and the image size change simultaneously in an appropriate manner. Because we normally know whether we are close to or far away from the scene we are viewing, the corresponding large or small differences in apparent size of objects at different distances seems normal for the viewing distance.

To illustrate how the situation changes when we view photographs rather than actual three-dimensional scenes, assume that two photographs are made of the same scene, one with a normal focal-length lens and the other with a short focal-length lens, with the camera moved closer to match the image size of a foreground object. When viewers look at the two photographs, they assume that the two photographs were taken from the same position because the foreground objects are the same size, but if the perspective appears normal in the first photograph, the stronger perspective in the second photograph will appear abnormal for what is assumed to be the same object distance.

Viewers can make the perspective appear normal in the second (strong perspective) photograph, however, by reducing the viewing distance. The so-called correct viewing distance is equal to the focal length of the camera lens (or, more precisely, the image distance) for contact prints, and the focal length multiplied by the magnification for enlarged prints. This position is identified as the center of perspective.

The correct viewing distance for a contact print of an 8×10 inch negative exposed with a 12-inch focal-length lens is 12 inches. Since we tend to view photographs from a distance about equal to the diagonal of the photograph, the perspective would appear normal to most viewers. If the 12-inch focal-length lens is replaced with a 6-inch focal length wide-angle lens, the print would have to be viewed from a distance of

6 inches for the perspective to appear normal. When the print is viewed from a comfortable distance of 12 inches, the perspective will appear too strong. Conversely, the perspective of a photograph made with a 24-inch focal-length lens will appear too weak when viewed from a distance of 12 inches. It is fortunate that people do tend to view photographs from standardized distances based on their size rather than adjusting the viewing distance to make the perspective appear normal, for that would deprive photographers of one of their more useful techniques for making interesting and effective photographs.

Wide-angle effect—In addition to the association of short focal-length wide-angle lenses with strong perspective, they are also associated with the wide-angle effect. The wide-angle effect is characterized by what appear to be distorted image shapes of three-dimensional objects near the edges of photographs. This effect is especially noticeable in group portraits where the heads near the sides seem to be too wide, those near the top and bottom seem to be too long, and those near the corners appear to be stretched diagonally away from the center.

The image stretching occurs because rays of light from off-axis objects reach the film at oblique angles rather than at a right angle as occurs in the center of the film. If the subject consists of balls or other spherical objects, the amount of stretching can be calculated in relation to the angle formed by the light rays that form the image and the lens axis. Thus, at an off-axis angle of 25 degrees, the image is stretched about 10%, and at 45 degrees the image is stretched about 42%. (The image size of off-axis objects changes in proportion to the secant of the angle formed by the central image-forming ray of light and the lens axis. The reciprocal of the cosine of the angle may be substituted for the secant.) Normal focal-length lenses, where the focal length is about equal to the diagonal of the film, have an angle of view of approximately 50 degrees, or a half angle of 25 degrees.

Why don't we notice the 10% stretching that occurs with normal focal-length lenses? It is not because a 10% change in the shape of a circle is too small to be noticed, but rather that when the photograph is placed at the correct viewing distance, the eye is looking at the edges at the same off-axis angle as the angle of the light rays that formed the image in the camera. Thus, the elliptical image of the spherical object is seen as a circle when the ellipse is viewed obliquely. The image would also appear normal even with the more extreme stretching produced with short focal-length wide-angle lenses as long as the photographs were viewed at the so-called correct viewing distance. Because the correct viewing distance is uncomfortably close for photographs made with short focal-length lenses, people tend to view them from too great a distance, where the stretching is obvious.

If two-dimensional circles drawn on paper are substituted for the three-dimensional balls, the circles will be imaged as circles in the photograph, and there will be no evidence of a wide-angle effect. The distinction is that when one looks at a row of balls from the position of the camera lens, the outline shape of all of the balls will appear circular, whether they are on- or off-axis, but off-axis circles drawn on paper will appear

elliptical in shape because they are viewed obliquely. The compression that produces the ellipse when the circle is viewed from the lens position is exactly compensated for by stretching when the image is formed, because the light falls on the film at the same oblique angle at which it leaves the drawing.

Viewing angle—As was noted above, even when viewers are directly in front of photographs they look obliquely at the edges of the picture, which alters the shape of images near the edges. There are situations where it is necessary to view the entire picture at an angle, as when sitting near the sides or the front of a motion picture theater. At moderate angles, viewers tend to compensate mentally for the angle so that they perceive a circle in the picture as a circle even though the shape is an ellipse at the oblique viewing angle, a phenomenon known as shape constancy. At extreme viewing angles, viewers may have difficulty even identifying the subject of the photograph. Some early artists were fascinated with slant perspective, where the image had to be viewed at an extreme angle to appear realistic. Oblique aerial photographs also display slant perspective, which must be rectified if the photographs are to be used for mapping purposes.

View camera perspective controls—In addition to accommodating lenses of varying focal lengths, which allows the camera to be placed at different distances from the subject with corresponding variations of linear perspective, view cameras have tilt and swing adjustments on the front and back of the camera that provide considerable control over the shape and sharpness of the image. Tilt refers to a vertical rotation around a horizontal axis and swing refers to a horizontal rotation around a vertical axis. The tilt and swing adjustments on the lensboard control the angle of the plane of sharp focus vertically and horizontally, but do not alter the shape of the image. The same adjustments on the back of the camera are normally used to control the shape of the image, although they can be used to control the angle of the plane of sharp focus also if they are not needed to control image shape. It is the change in image shape, such as the convergence of the image of parallel subject lines or the relative sizes of the images of objects on opposite sides of the photograph, that represents a change in linear perspective.

To illustrate how changing the angle of the film plane in a view camera affects the linear perspective, assume that the camera is set up to copy a subject consisting of a grid of parallel vertical and horizontal lines. With the back of the camera parallel to the subject, the vertical and horizontal subject lines will be parallel in the image. Tilting with top of the camera ground glass (or film) away from the subject will cause the vertical subject lines to converge toward the bottom of the ground glass, or the top of the picture since the image is inverted on the ground glass. Tilting the ground glass will have no effect on the shape of the horizontal lines, however. When the camera back is tilted in this way, it is in a similar position to the back of a conventional camera that has been tilted up to photograph a tall building, where the vertical building lines converge toward the top of the picture. Thus, it is the angle of the film plane that controls convergence of vertical subject

lines, not the angle of the body and lens of the camera. If a view camera is tilted up to photograph a tall building, it is only necessary to tilt the back of the camera perpendicular to the ground and parallel to the vertical lines of the building to prevent convergence of those lines in the photograph. If the photographer wanted to exaggerate the convergence of the vertical lines, perhaps to make the building appear taller, the camera back would be tilted in the opposite direction, increasing the angle between the building lines and the film plane.

Although this explanation has been written in terms of the convergence of parallel subject lines, it could just as well have been in terms of the relative size of objects at different distances from the camera. With the same subject, we can think of the width of the building at the top and the bottom. If a camera is tilted up and no adjustment is made in the angle of the back, the top of the building, which is farther from the camera than the bottom, will be narrower than the bottom in the photograph. With the back of the camera tilted so that it is perpendicular to the ground, the top and bottom of the building will have the same width in the image.

The same principle applies to the control of the convergence of horizontal subject lines by swinging the back of the view camera. The only time horizontal subject lines will be parallel in a photograph is when the film plane is parallel to the horizontal subject lines. When photographing a box-shaped object, such as a building, it is common practice to show two sides of the object. If the back of the camera is swung parallel to the horizontal lines on one side of the object to prevent convergence of those lines, the angle between the camera back and the other side of the object will be increased, which will exaggerate the convergence of the horizontal lines on that side of the object. Even though converging vertical lines are just as natural as converging horizontal lines when we look at objects directly, professional photographers consider converging vertical lines to be less acceptable than converging horizontal lines in photographs.

Trick perspective—Because the three-dimensional world is represented with two dimensions in photographs, it is possible to fool the viewer concerning the perspective of the subject of the photograph. One of the most common accidental illusions occurs when the main subject and the background are equally sharp in the photograph, and an object in the background appears to be sitting on or to be a part of the object in the foreground. Motion-picture photographers make use of the same concept in the glass shot, where part of a scene, which is commonly an imaginary and dramatic large expanse, is painted on glass. The painting is then photographed in combination with action, which is seen through clear areas on the glass. When skillfully done, the painting is accepted by the viewer as part of the three-dimensional world.

Projected backgrounds and traveling mattes are also used so that actors can be photographed under controlled conditions, usually in a studio, commonly on a mockup of a supposedly moving vehicle such as a car, train, plane, or ship, with a projected image of a distant scene appearing in the background.

A trick perspective effect is achieved in the famous Ames room whereby objects appear twice as tall when placed in the right-hand corner as when placed in the left-hand corner. Even though both corners appear to be at the same distance, the left-hand corner is actually twice as far away. The effect is achieved with a ceiling that slopes down and a floor that slopes up from left to right so that, due to linear perspective, the room appears to be rectangular in shape from one position. From any other position the illusion is destroyed.

Scale models have been used by architects to show what a proposed building will look like, and when photographed skillfully, the model can appear to be a full-size building. Motion-picture photographers commonly make use of scale models to depict disaster events, such as a large ship capsized in a storm, where the actual event would be prohibitively expensive or impossible to photograph.

Still photographers have long combined parts of different photographs, such as the image of a clothing model with a photograph of the Egyptian pyramids, to save travel time and money and to produce dramatic effects. With computer software programs that are now available, sophisticated and undetectable special effects can be achieved easily with video and still video images. ◉

Photometry, Radiometry, and Measurement

CARL SALVAGGIO, PH.D.
Rochester Institute of Technology

The terms that we use as practitioners and researchers in a field of study define the discipline itself as well as the effectiveness with which we can communicate among colleagues and others members of our profession. The long-lived fictional character, Humpty Dumpty, from the Lewis Carroll classic *Through the Looking Glass*, said to Alice "When I use a word, it means just what I choose it to mean, neither more nor less." Alice replied by saying "The question is, whether you can make words mean so many different things." The fields of photometry and radiometry have a long history of terminology that is used differently among its participants. Whether in descriptive terms or symbols in equations, this inconsistency often gives rise to confusion and misunderstanding. It is intended that, in this section, the reader will gain an understanding of the concepts that make up these two fields and with that understanding be able to look past the words people use to describe topics and find the meaning in what they are saying.

Radiometry is broadly defined as the measurement and characterization of optical radiation. Optical radiation includes energy with wavelengths in the ultraviolet portion of the electromagnetic (EM) spectra through the long wave infrared region. These wavelengths span the range from 0.01 to $1000\,\mu m$ $(1 \times 10^{-6} m)$. Photometry is defined as the measurement of light, the EM energy that the human visual system is

sensitive to, weighted by the spectral response function of the eye. These wavelengths, depending on the age and health of the person, span the range from 360 to 830 nm (1×10^{-9} m). As one can see already, the terminology changes when referring to the wavelengths encompassed by these two fields, nanometers for photometry and micrometers for radiometry. Others might refer to the frequency of the energy measured and use units of inverse centimeters (cm^{-1}). Look past all the terminology and understand that no matter how one refers to the energy, it remains just that, energy, and exhibits the same properties no matter how one references it.

So as we begin, the difference between radiometry and photometry is primarily that radiometry includes energy over the entire optical spectrum, while photometry has a more limited scope, limited to those wavelengths that humans can see. The terminology used in these two fields is different because of historical influence only. The behavior of energy does not change, just the way it is described.

Definitions

Begin by looking at some of the common terms used in the fields of radiometry and photometry. It is important to understand the concept of area as it is used in these fields as many radiometric and photometric quantities are defined in terms of energy and area.

Projected area is defined as the rectilinear or two-dimensional projection of any volumetric or three-dimensional surface onto a plane normal to the unit vector. The projected area, $A_{projected}$, is proportional to the original volumetric surface area by a factor equal to the cosine of the angle between the original surface and projected surface normal vectors. This can be noted by

$$A_{projected} = \cos\theta \int_A dA$$

where the surface integral of dA represents the original volumetric surface area. For example, the projected area of a circular disc with a radius of 1 cm whose surface normal is oriented 30° from the surface normal of the surface that it is projected onto is found as

$$A_{projected} = \cos\theta(\pi r^2) = \cos(30°)\pi(2)^2 = 10.9 \text{ cm}^2$$

This projected area is 1.6 cm^2 smaller than the original disc's area. Why is this important? The amount of energy per unit area that one may measure with a detector may be significantly less than the energy that is actually received from a particular direction in space. How much less? The energy is reduced by the factor shown above, namely $\cos\theta$. To make an absolute measurement of energy per unit area, one needs to be cognizant of the relative orientation between the incident energy and the detector that is used to make the measurement.

A common but sometimes misunderstood radiometric concept is the solid angle. In plane (two-dimensional) geometry, an angle can be defined as located between two radii of a circle with the vertex at the circle's center. When the length of

the arc cut off on the circumference of the circle by these radii is equal to the radius of the circle, the angle between the two radii is one radian (rad). A solid angle extends this concept to three dimensions. A solid angle is defined in three dimensions as having its vertex in the center of a sphere and with a rectangular projection on the surface of the sphere defined by two plane angles, usually denoted by $d\theta$ and $d\phi$. When an area on the surface of a sphere is equal to the area of a square whose sides are equal in length to the radius of the sphere, the solid angle is said to be one steradian (sr).

Radiometry

Having these abstract quantities defined, it is now possible to define some of the common terms that are used in radiometry.

Energy (Q) is generally defined as the work that a physical system is capable of doing when changing from its actual state to a specified reference state. In photography, the primary interest lies in the energy carried by photons and the energy released or consumed when electrons transition between energy levels (or bands) in the atomic structure of materials. The unit used to represent energy is usually the Joule (J), which may also be defined as watt-seconds ($W \times s$).

Power (F) or radiant flux is the derivative of energy with respect to time, dQ/dt. The unit used is typically the watt (W).

So energy is the integral of power over time. Energy is usually the quantity of choice when referring to an integrating detector (those that build up more signal or contrast with longer exposure) or a pulsed source like a photographic emulsion/charged-coupled device or a mechanically chopped laser. Power is the typical quantity when referencing non-integrating detectors or continuous sources such as a cadmium cell or a tungsten lamp.

We can now look at power with respect to the geometric quantities that were previously presented—area and solid angle.

Irradiance (E) or flux density is a measure of power or radiant flux per unit area on a surface. It is arrived by computing the derivative $d\Phi/dA$. Irradiance is the amount of illuminating power originating from all directions within a hemisphere falling onto a surface. A similar term with identical units is radiant excitance. Radiant excitance (M) represents the power per unit area leaving a surface into a hemisphere above that surface. The area in the definition of irradiance is that receiving power, while in exitance, it refers to the area emitting power. The units usually used for both these terms are watts per square meter (W/m^2).

Radiant exitance can be computed on a per wavelength basis for a blackbody at a known absolute temperature using Planck's blackbody equation. A blackbody is a hypothetical object that absorbs all incident radiation and is a perfect emitter of radiation because of incandescence. Incandescence is the emission of EM radiation by an object as a result of its temperature. Planck's blackbody equation is

$$M = \frac{2hc^2}{\lambda^5 \left(e^{hc/\lambda kT} - 1 \right)}$$

where h is Planck's constant having a value of $6.6262 \cdot 10^{-34}$ J·s, c is the speed of light with a value of $2.9979 \cdot 10^8$ m/s, λ is the wavelength of the energy in units of meters, k is Boltzmann's constant which is $1.3807 \cdot 10^{-23}$ J/K, and T is the absolute temperature of the blackbody in degrees Kelvin.

Radiant intensity is the time rate of flow of power or radiant flux emitted by a point source in a given direction computed as the derivative of power with respect to solid angle, $d\Phi/d\,\Omega$. The units on this quantity are watts per steradian (W/sr). By definition, the intensity of a source is invariant with distance; however, an implied assumption is that the source emits equally in all directions. Virtually no real-world sources demonstrate this behavior. This quantity is strictly defined for point sources, but in application is used for those sources whose dimension is less than 1/10 the distance from which they are observed.

Radiance (L) is the power per unit projected area per unit solid angle and is defined as the derivative of power with respect to projected area and solid angle, $d\Phi/(dA \cdot d\Omega)$. The units are typically watts per square meter per steradian (W/m²/sr). The radiance of an extended source (a non-point source or a source whose maximum dimension is less than 1/10 the distance from which the source is observed) is invariant with viewing distance. The radiance of a Lambertian diffuser is invariant with viewing angle because the reduced power reflected off axis is balanced by a reduction in projected area.

Photometry

The concepts defined in the previous section for radiometry have direct equivalents in photometry. The formal difference between these two fields, as stated previously, is that photometry is strictly limited to those wavelengths of energy to which the human observer is sensitive (what is commonly referred to as light). Radiometry is the science of measuring any form of EM radiation.

Luminous intensity (I_v) is the time rate of flow of light (visual power) emitted by a point source in a given direction. The SI unit for luminous intensity is the candela (cd). Specifically, the candela is the luminous intensity, in a given direction, of a point source that emits monochromatic radiation at a wavelength of 555 nm (5.4×10^{14} Hz) and that has a radiant intensity in that direction of 1/683 W/sr. The specific wavelength was chosen since it is at this wavelength that the human observer has peak photopic sensitivity. A point source whose luminous intensity is 1 cd emits 1 lumen into 1 sr of solid angle.

The candela was originally based on the light emission from the flame of a candle. Over time, the definition has changed dramatically. The unit of measurement was later defined as the light emitted from flame lamps, carbon filament incandescent lamps, and molten platinum. This proved unsuitable for many reasons; a few of which were the difficulty in constructing platinum blackbodies, the susceptibility of platinum to contamination resulting in an uncertainty associated with the melting point of platinum (2042 K), and the fact that the relative spectral radiance changes drastically over the visible portion of the spectrum. The choice of the 1/683 W/sr, while appearing arbitrary, is consistent with the previous definition of the

emission from a $1/60\,cm^2$ of platinum source at its solidification temperature.

The definition for the candela given above indicates that this fundamental SI unit is no longer necessary as it is defined in terms of another fundamental SI unit, the watt. It is, however, still formally defined and in use in the field of photometry.

Luminous flux (Fv) is defined as the flow of light (visual power) emitted by a point source in all directions in space. If a source emits uniformly in all directions, the luminous flux from this source is equal to the product of the source's luminous intensity multiplied by 4π, the number of steradians in a sphere, namely

$$\Phi_v = I_v \cdot 4\pi$$

This quantity's unit of measure, the lumen (lm), as stated previously, is the luminous flux into a solid angle of 1 steradian emitted by a source whose luminous intensity is 1 candela.

Most real world sources do not emit uniformly in all directions, and as such, the relationship between candelas and lumens is empirical. To measure the total flux (lumens), the luminous intensity is measured is as many directions in space as possible using a goniophotometer. These measurements are then integrated numerically, in solid angle space, to arrive at the total flux.

Since most sources are directional in nature, the measure of lumens (luminous flux) may often prove to be misleading. As many applications are concerned with the amount of light falling on a specific object in a specific direction, it is often more informative to measure the candelas (luminous intensity) falling in that direction. The bulbs that we use every day in lamps in our households are typically specified in terms of lumens. It is usually to your advantage to purchase a bulb with high lumens and low power consumption (low wattage) and long life expectancy.

The inconsistency of these two photometric terms often serves as a point of confusion, and possible error, to users. While a bare tungsten filament and a fluorescent bulb may both exhibit the same intensity in a given direction, the visual power is spread over a much larger area in the fluorescent bulb. This gives rise to the photometric term of luminance.

Luminance (Lv) for a source is given by the quotient of the luminous intensity and the projected area of the source in a given direction. The units are typically given as candelas per square meter (cd/m²) or lumens per square meter per steradian (lm/m²/sr). The units for this quantity often are referred to by a special name, the nit. This quantity is most often used to refer to the "brightness" of a flat emitting or reflecting surface such as a laptop computer screen.

Luminance is the property of visual power that most closely correlates with perceived brightness. Perceived brightness is not a very reliable measure due to the adaptive and contrast enhancing nature of the human visual system. It is for this reason that reflected-light meters are used to quantify luminance in many photographic applications.

Reflected-light meters measure the luminance of a scene. A scene can be considered to be an infinite number of individual

TABLE 7 Conversion Factors for Illuminance Units

	Lux	Foot-candle	Phot
Lux	1	0.0929	0.0001
Foot-candle	10.8	1	0.00108
Phot	10,000	929	1

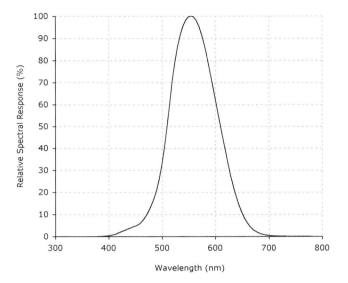

FIG. 68 The CIE $V(\lambda)$ function describes the relative sensitivity of the average light-adapted human visual system to electromagnetic radiation.

point sources, each the result of light reflected from every element in the scene. These meters will measure the average luminance within the meter's field of view. Typical acceptance angles for these meters are in the neighborhood of 25 degrees or 1 degree in the case of a spot meter.

Illuminance (E_v) is a measure of the visual power per unit area incident on a surface. The SI unit for this quantity is the lux and is specified in terms of lumens per unit area. The lux is the number of lumens incident on a $1\,m^2$ surface $1\,m$ distant from the source. Other common units used to specify illuminance are the foot-candle or the phot (see Table 7).

Illuminance is a function of source intensity, the distance from the source to the surface, and the angle at which the light strikes the surface. Illuminance from a point source falls off at a rate proportional to the square of the distance to the source, namely

$$E_v \propto \frac{I_v}{d^2}$$

Illuminance from a point source at an angle q from the surface normal is reduced further because the power is spread over a larger area on the surface. The fall off with angle obeys the cosine law

$$E_v(\theta) = E_v(0°) \cdot \cos(\theta)$$

where $E_v(0°)$ is the normal illuminance.

Photographic exposure (H) is defined as the product of image-plane illuminance and the exposure duration

$$H = E_v(0°) \cdot t$$

and is usually given in lux seconds (lux s).

So-called incident light meters measure the power per unit area falling on a surface and are therefore a type of illuminance meter. Note, however, that many meters designed for use in determining photographic exposure are not filtered to match the spectral sensitivity of the standard photopic observer (the CIE V(l) function). Consequently, they may not indicate true illuminance as defined.

Measurement of Energy/Light

Radiometry and photometry include two broad categories of measurement: (1) measures of energy/light emitted (or reflected) from point or extended area sources, and (2) measures of energy/light falling onto surfaces. While fundamental physical differences exist between the two cases, it is important to note that many of the characteristics of both measures are common

and that the surface upon which the energy/light falls reflects some fraction of the energy/light and may be considered an extended source itself.

Electromagnetic radiation is carried in traveling waves made up by electric and magnetic fields that vary periodically in time and position. The spectrum of EM radiation spans 20 orders of magnitude, from gamma rays to electric power transmissions. Electromagnetic radiation can be described by it wavelength (l), the distance over which the wave completes one full cycle. Electromagnetic radiation can also be described by its frequency, the number of cycles the wave undergoes per unit time. The common unit of measure for frequency is the Hertz (Hz), the number of cycles per second. The frequency is equal to the reciprocal of the period, where the period is the length of time it takes for the wave to go through one complete cycle. Since all EM radiation travels through a vacuum at 3×10^8 m/s, its wavelength (measured in meters) and frequency (measured in cycles per second) are related by

$$c = \lambda \cdot \nu$$

where c is the speed of EM radiation in a vacuum, λ is the wavelength, and n is the frequency.

The human eye is not sensitive to the majority of the energy in the EM spectrum. The sensitivity is restricted to a very narrow range of wavelengths nominally spanning the range from 400 to 700 nm. In addition to this restricted range, the visual system is not uniformly sensitive within this region. The CIE $V(\lambda)$ function describes the average relative sensitivity from 350 to 750 nm under daylight conditions. The peak response for the human visual system in daylight is approximately 555 nm or 5.4×10^{14} Hz.

Source Measurements

The simplest case of radiometric or photometric source measurement involves a theoretical point source of radiant energy, defined as an infinitely small source, emitting energy equally in all directions. This theoretical point source does not exist, but small sources observed at a large distance serve as a reasonable approximation. Usually, if the viewing distance is ten times greater than the source's greatest dimension, this approximation holds true.

As was mentioned previously, radiant or luminous intensity is the measure of energy into a solid angle in any given direction. The intensity of the source is invariant with distance from the source. The intensity is, however, variant with direction due to the non-uniform-emitting behavior of real-world, non-theoretical point sources. For example, the filament of a tungsten lamp enclosed in a clear bulb will exhibit more intensity when viewed from its side than it does when viewed down its length. Intensity does not serve as a very useful quantity for many applications because of this variance in magnitude due to direction and the fact that implied in its definition is an ever-increasing surface area on an encompassing sphere onto which the energy falls. To have a constant measurement of intensity, the detector would need to grow proportionately to this increase in projected surface area.

For these reasons, irradiance or illuminance are typically better measures for most imaging or photographic applications. Remember that irradiance or illuminance is a measure of energy per unit area falling onto a surface (watts or lumens per square meter). The irradiance or illuminance emitting from a point source is inversely proportional to the square of the distance between the source and the detector used to measure it. For instance, if the intensity emanating in a particular direction is measured using a $1\,cm^2$ detector at a distance of $1\,m$ away from a source, the area of the detector can be thought of as the area on the surface of a sphere through which the energy propagating is measured. If the distance at which this intensity was measured was now doubled, that is $2\,m$ away, the surface area through which the energy would now propagate

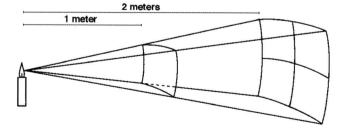

FIG. 69 Inverse square law. As the distance from an approximate point source is doubled from 1 to $2\,m$, the area illuminated on the surface of a sphere within the same solid angle is 2^2 or 4 times the area at $1\,m$. This causes the irradiance or illuminance, energy per unit area to fall off inversely to the square of the distance from the source.

for the same solid angle would be 4 times as large (since the surface area of a sphere is $4\pi^2$). Now if the same detector is placed at this new distance, it would only capture 1/4 of the photons in this solid angle, and therefore the irradiance or illuminance at this point in space would be 1/4 the value it was at a distance of $1\,m$.

This phenomenon is known as the inverse square law; namely that the illuminance or irradiance produced by a point source is inversely proportional to the square of the distance from the source. In radiometric terms, this is represented by

$$E = \frac{I}{r^2}$$

where I is the radiant intensity emitted by the source and r is the distance (or radius of a sphere surrounding the source) at which the energy in measured.

In addition to irradiance and illuminance falling off with distance from a source, the measured irradiance or illuminance will fall off with angle from the normal to the surface onto which the energy is incident. As a surface is tilted with respect to the direction of the incoming energy, the projected area onto that surface increases in proportion to the cosine of the tilt angle. As such, the energy measured by a detector that is parallel to the surface will fall off with this same proportionality since the effective area that it presents to the source gets smaller (e.g., hold a coin by its edges between your fingers and slowly tilt it so that the normal to its face points away from your eye—the area that you see gets smaller). In radiometric terms

$$E_\theta = E_0 \cos(\theta)$$

where E_0 is the irradiance measured with a detector perpendicular to the incident energy, E_θ; is the irradiance measured by the tilted detector, and θ is the angle at which the detector is tilted.

Surface Measurements

Energy reflected from a surface serves as a secondary source with measurable radiance. These surfaces serve as extended sources. The radiant output from an extended source is described in terms of the rate at which energy is emitted into a solid angle in a given direction per unit area of the source, or its radiance as we referred to this earlier.

The radiance of an extended source is invariant with viewing distance. Because the surface of the extended source can be thought of as an infinite collection of point sources, the loss of energy from each point due to viewing distance is exactly made up for by the increase in the surface visible within a given solid angle as the distance increases.

The radiance in a particular direction reflected from a surface is proportional to the irradiance falling onto the surface at a particular angle to the source. In radiometric terms, this is given by

$$L(\theta) = \frac{E_0 \cos(\theta)}{\pi}$$

Measurement Devices

There are many different devices used to measure energy or light. These devices vary in design as well as in the sensitive material that they use to detect the amount of incident energy. Whether we are talking about radiometry or photometry, the design of these instruments is the same, the difference between radiometers and photometers is that the detector of a photometer is spectrally filtered by the CIE $V(\lambda)$ function mentioned earlier. This will become apparent later in the discussion of spectroradiometers.

Radiometers

Instruments that measure any of the radiometric quantities mentioned previously are called radiometers. Radiometers must rely upon detectors that are sensitive to the energy range of interest. There are at least two common classes of radiometers in use today.

The first class measures radiant power indirectly by monitoring the secondary effect to a material's physical properties of the incident EM radiation. An example of this type is the bolometer. Incident energy causes thermal variation within the detector material. This thermal variation causes the electrical resistance of the material to change. The radiometric incident energy is therefore calculated by comparing the resistance to the resistance of the material in the absence of any incident radiation.

A second class of radiometers is based on photoelectric detectors. These detectors are made of materials whose electronic characteristics change as a function of incident radiant power. There are several different types of photodetectors used in radiometers. Photoemissive detector materials release electrons when struck by radiant energy. Photomultiplier tubes are one example of a photoemissive detector. Photovoltaic detector materials are semi-conductor devices in which incident energy creates a potential difference across a boundary layer, converting incident energy to an electrical voltage. Selenium cells are an example of a photovoltaic detector. Photoconductive detector materials change the conductance in proportion to the amount of incoming radiant energy. Cadmium sulfide cells are an example of this type of detector material.

The detector materials mentioned above, as well as other materials used for detectors, vary in the way they react to incident radiation not only due to the magnitude, but also due to the wavelength of the incident radiant energy. For instance, a selenium cell may produce a greater potential difference (voltage) when exposed to 50 lumens per square meter of radiation at 550 nm than it does to an equivalent illuminance at 450 nm. A plot of the relative response of a detector material to the amount of incoming monochromatic radiant energy is known as a spectral response function for that material. If a constant response from a detector for a constant amount of incident energy at every wavelength were required, then correction factors would need to be computed for each wavelength.

Spectroradiometers

It is quite often desirable to describe the radiant energy emitted by a source or reflected from a surface as a function of wavelength rather than as a single quantity. There are many methods to achieve this goal, some of which are illumination of the material with a monochrometer, dispersion of the energy with a prism or grating, or through the use of interferometers and Fourier mathematics. The common thread among all these techniques is that in the end, the response from the detector material for the amount of incident energy at each wavelength is known. It must be noted that this response is a factor of several different factors: (1) the spectral distribution of energy for the source used, (2) the spectral distribution of the material off of which the energy is reflected (if this is the case), and (3) the relative spectral response of the detector material itself. So the spectral radiant energy at any wavelength may be represented as

$$\Phi(\lambda) = \Phi_S(\lambda)\, \rho_T(\lambda)\, \beta_D(\lambda)$$

where $\Phi_s(\lambda)$ is the radiant energy from the source incident on the target material, $\rho_r(\lambda)$ is the spectral reflectance of the material, and $\beta_d(\lambda)$ is the spectral response function for the detector used.

Light Meters

There are two different types of light metering techniques commonly used by photographers—reflective and incident. For meters that use these techniques, there are many different designs and approaches.

Reflective light meters measure the light reflecting off of a subject or the luminance. Designs can include center-weighted metering, spot metering, or matrix metering.

Center-weighted metering looks at the luminance reaching the meter from a large percentage of the scene observed. Typically the angular field of view of these meters is on the order of 25° (a 35 mm format camera equipped with a standard 50 mm lens has a horizontal field of view of 40° and an angular field of view of 46°—very close to the field of view of good visual acuity for the standard human observer). This type of design is typically found in older, non-computerized cameras and also in many hand-held light meters.

Spot metering looks at a very small portion of the scene photographed. The typical field of view for spot meters is 1 to 5°. This design can be modally found in many modern cameras as well as in a host of hand-held meters. The use of a spot meter allows the photographer to determine the luminance for a particular object within the scene photographed to properly determine exposure for that area or to make multiple measurements within the scene to measure the amount of contrast between various scene elements. This latter technique allows the photographer to assign appropriate zone values to scene elements when using the Zone System for exposure determination.

Matrix metering is found in many modern, computer-driven cameras with through the lens (TTL) metering built in. The

scene is broken up into as few as 3 or as many as 50 different segments, each of which is metered. These data are then delivered to an algorithm that determines exposure based upon assumptions made about typical scene content. For example, the algorithm might guess that the upper right and left corners of a scene are bright sky, the lower left and right corners are darker ground, and the center is composed of the main subject. With these assumptions made, the individual narrow field of view measurements made at each location are combined in a weighted fashion to arrive at the proper exposure. This will only prove appropriate if the actual scene content and composition meet the assumptions made. More advanced matrix metering systems will track the photographer's eye within the viewfinder and place the heaviest weighting on the segment, or group of segments, that is co-aligned with the photographer's gaze.

Metering with a reflective light meter is very intuitive but can prove to be very problematic. For example, if one was at the zoo photographing a polar bear and a black bear under identical illumination conditions, then it is clear that the exposures given to both scenes should be the same. However, if a reflective metering design is used to determine the exposure, one will likely underexpose the scene containing the polar bear while overexposing the scene with the black bear. The reason is that a measurement of the luminance coming from a scene dominated by a highly reflective object, such as the white fur of the polar bear, will be greater than the luminance from the scene dominated by the darkly colored fur of the black bear. The former case will cause the photographer to choose a shorter exposure time or smaller aperture setting than the latter. The reality is that an exposure somewhere between these two would be most appropriate for both.

Reflective light meters used for photographic purposes are almost always designed to compute photographic exposure based on the speed of the film used and the shutter speed or aperture setting that is desired. The proper shutter speed or aperture setting is determined to allow an object that exhibits an average reflectance of 12 to 18 percent across the spectral range of the detector material to produce a density value or digital count in the middle of the dynamic range of the film or digital camera's detector. With this knowledge, the photographer can choose to accept the suggested exposure or to, in an educated fashion, over- or underexpose the scene to move this exposure point up or down, respectively, to obtain the contrast that is desired.

Incident light meters measure the light or illuminance falling onto a scene. This is typically accomplished using a small white dome, referred to as a cosine receptor or integrating hemisphere, positioned over the detector. This dome is positioned in front of the subject photographed and pointed toward the camera. The dome collects energy falling onto the subject from all directions. This is the illuminance that will be reflected from the subject toward the camera. Again, these meters are most often designed to determine exposure parameters for a particular film speed. The exposure determined will cause a scene element whose reflectance is somewhere between 12 and 18 percent to fall in the middle of the density or digital count dynamic range.

Many modern digital cameras have the ability to produce a digital count histogram for an image that is captured. Digital count histograms represent the number of pixels in the image that have a particular digital count or brightness value. This turns out to be a very useful tool for the photographer and may in time make the use of a light meter less common. The photographer can collect several images of a scene with different exposure settings or illumination setups. Once the images are collected, the histogram can be looked at to determine if a significant number of pixels are collected at either the lower or upper end of the digital count scale. If they are concentrated at the lower extreme, then the image was underexposed and the shutter speed should be decreased or the aperture opened up, whichever is more appropriate. If the opposite is true and a significant number of pixels are collected at the upper end of the digital count range, the image was overexposed and the shutter speed should be increased or the aperture stopped down. While this may not make the "traditional" photographer happy, it is a very viable technique that is becoming more prevalent in its usage.

The detector materials used for both types of meters mentioned above vary, but there are some common ones that are used in the majority of light meters in production today or that you may have in your equipment collection. Each of these materials has benefits and detriments. Some of the more common detector materials used in photographic light/exposure meters are selenium cells, cadmium sulfide, silicon photodiodes (or silicon blue cells), and gallium arsenide phosphide cells.

Selenium cells were used almost exclusively in meters and cameras prior to the 1970s. Selenium produces a small electrical current when exposed to light, the amount of current proportional to the amount of incident energy. The spectral response function of selenium is comparable to that of typical black and white films. It made for a wonderful detector material that needed no batteries to operate, since it produced its own electrical current. It also functions very well in cold weather when other systems that rely on battery power may begin to fail. This photovoltaic material was great in so many ways except that over time, with exposure to light and moisture, it began to physically deteriorate (a bad quality for a material used in a light meter). Protective measures were used with these meters such as protective caps and the use of desiccant when storing the meter for prolonged periods of time. These measures extended the life of the detector material, but in time they all failed. Oversensitivity to ultraviolet radiation tended to make meters based on this type of detector material produce artificially high response levels that tended to produce underexposure. In addition, the linearity of the detector material tended to fall off at higher brightness levels, producing less current than might be expected, which resulted in overexposure of the photograph.

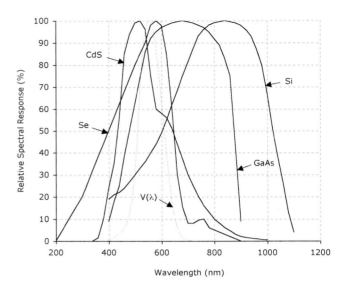

FIG. 71 Relative spectral response. The relative spectral response functions for some common detector materials: selenium, cadmium sulfide, silicon, and gallium arsenide phosphide.

FIG. 70 Light/exposure meters. Three light/exposure meters spanning the last 40 years of technology: Sekonic L-246 lux meter (selenium), Gossen Luna-Pro (CdS), and the Sekonic L-558 DualMaster (silicon photodiode).

Cadmium sulfide is still in use in light/exposure meters today, although it is not as prevalent as it had been in the previous two decades. As part of the photoconductive series of detector materials, the resistance of this material changes as a function of incident energy. As more light falls onto this material, the resistance decreases, thus allowing more current to flow through a circuit containing this component. This material works very well in low light situations, a weakness of the previously mentioned selenium-based meters. Although this meter is not overly sensitive to ultraviolet energy, it does have

an enhanced sensitivity to red light and infrared energy. Many systems use a filter to compensate for this enhanced sensitivity, but others do not, so care needs to be taken to understand the characteristics of your meter. If the system is not filtered, underexposure may result for scenes that contain a significant amount of red subject matter or for those that are collected under sources with significant infrared energy, like tungsten lamps.

The main drawback of cadmium sulfide stems from its "memory." The resistance of the material is slow to increase after exposure to a high luminance scene element. This is typically noticed as a sluggish response from the meter's output display. One must be sure to give the meter enough time to react when subsequently pointed at a low luminance element, which can sometimes be several minutes in the case of a very bright initial reading.

Silicon photocells (or photodiodes) are the most common detector material used today. These are a semi-conductor material that produces a small electric current due to the promotion of electrons to higher energy states or bands in the material when exposed to incident photons. Although these are photovoltaic in nature, a battery is typically used to drive an amplifying circuit to boost the sensitivity or response of the material. In addition, as is the case for all photovoltaic materials, silicon photocells respond to changes in illuminance levels more than three orders of magnitude faster than the photoconductive materials, such as cadmium sulfide, so there is no significant memory for this material. Meters based on this material also suffer with an enhanced sensitivity to the red end of the spectrum, as was the case with cadmium sulfide; so particular

attention needs to be paid to the filtering that is employed in the meter's design.

Gallium arsenide phosphide cells are photovoltaics and similar in all aspects to silicon photocells except that there is no oversensitivity to energy at the red and longer wavelength regions of the spectrum. This material is more costly to manufacture and is therefore only available in a few cameras in production today.

As with anything in life, there are always trade-offs. It is important that you know the characteristics and behavior of the detector material used in your light or exposure meter and compensate for it either quantitatively by adjusting for the material's spectral response function, or qualitatively by, for example, knowing you need to open up one stop when your scene contains a lot of red subject matter.

Color Temperature

One last topic that will be discussed is that of color temperature. As we mentioned previously, the spectral power distribution of the source illuminating a scene is combined with the spectral reflectance characteristics of a scene element and the spectral response function of the detector material used to determine the amount of sensed energy, either as a spectral radiance measurement (as in the case of a spectroradiometer) or as a band integrated value (as in the case of a light meter). The source of irradiance or illuminance falling onto the scene element therefore warrants attention.

Some light is said to be "warmer" than others. What does this mean? Typically, when light appears to be warmer, it tends to have a greater red component. We previously looked at the blackbody radiance equation that computed the spectral radiance for a blackbody source at a particular temperature and

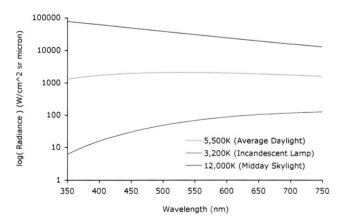

FIG. 72 Blackbody spectral radiance. The radiance for a blackbody radiator at 3200 K (household incandescent bulb), at 5500 K (average daylight), and at 12,000 K (midday skylight—no direct solar irradiance) as a function of wavelength in the visible portion of the spectrum.

wavelength. Figure 72 shows the spectral radiance produced by a theoretical blackbody source at 6000 K (sunlight) and at 2875 K (household tungsten lamp).

It is immediately evident that a 3200 K source produces significantly more energy at the longer wavelength end of the spectrum. For this reason, objects illuminated with energy at this "color temperature" appear redder than if they were illuminated by a source at 5500 K. The flat shape of the curve for a 5500 K source implies relatively equal amounts of energy in each portion of the spectrum, which implies that the light is "white" in nature. The 12,000 K curve represents midday skylight (which may have a color temperature within the range 9500 to 30,000 K, depending on the time of day and season). This curve indicates that the illuminant will appear quite blue for those objects photographed in shadowed areas.

While images taken under tungsten illuminance are often said to be warmer than those taken under daylight illuminance, it is clear that this is not "reflected" in the temperatures of the sources. For this reason, another unit is often used when measuring color temperature, the mired (micro reciprocal degrees). The mired is simply computed as the reciprocal of the temperature in Kelvin times 1,000,000. This scale has two advantages: (1) as the value increases, the illuminant appears warmer; and (2) interval changes in the value on the mired scale result in proportional changes in color. This second point addresses the issue that the same change in color temperature expressed on the Kelvin scale results in disproportionate changes in illuminant color. A change of 1000 K at low color temperature is much more significant than this same change for a high color temperature source.

Color Temperature Meters

There are a number of meters on the market that have the specific function of measuring the color temperature of the incident illuminant with the purpose of selecting the proper color correction (CC) filter. Color correction filters are typically blue or amber in color, which raise or lower the color temperature, respectively. The Kodak series of Wratten filters is designed to adjust color temperature. The 81 and 85 series are amber in color and the 80 and 82 series are blue in color. These series of filters have a letter designator that indicates the relative strength of each filter for changing the color temperature. The color temperature scale, mired scale, and correction filters required are illustrated below for use with a daylight color-balance film.

In general, color temperature meters available on the market today are comprised of three silicon photodiodes filtered for red, green, and blue sensitivities appropriate for color film. These devices measure the relative amount of energy present in these three wavelength regions and determine the color temperature based on the shape of the blackbody curve that best fits through these metered readings.

Color temperature meters report back to the photographer either the observed color temperature or the mired deviation or the proper Wratten filter number required to achieve

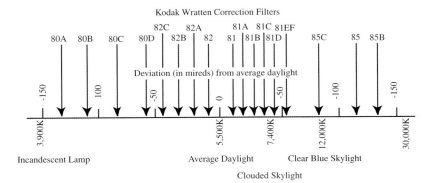

FIG. 73 Color temperature correction. The color temperature Kelvin scale, mired deviation scale, and associated Kodak Wratten CC filters required are shown for daylight color-balanced film.

a proper color balance under the current illumination with respect to the desired color temperature. These meters typically allow the user to set the reference color temperature for the particular film they are using (daylight balanced to 5500 K, tungsten-A balanced to 3400 K, and tungsten-B balanced to 3200 K). Many of these meters are capable of measuring either ambient or strobe illumination, or the combination of the both sources. ☸

Color Theory

MITCHELL R. ROSEN, PH.D.
Rochester Institute of Technology

Introduction

What are they playing?" asked Tock, looking up inquisitively at Alec. "The sunset, of course. They play it every evening about this time . . . and they also play morning, noon and night, when, of course, it's morning, noon, or night. Why, there wouldn't be any color in the world unless they played it. Each instrument plays a different one," he explained.

Norton Juster, The Phantom Tollbooth.

In the children's fantasy *The Phantom Tollbooth*, Chroma is conductor of an orchestra that "plays" the colors of the world. Tones emitted by a collection of instruments do make a good metaphor for the complex properties of a scene's spectral radiance. Like the intricate combination of sound frequencies that comprise an orchestral piece, spectral radiance from any point in a scene consists of a rich mixture of photon frequencies.

Newton's prism experiments, such as the one illustrated in Figure 74, explained how light and its interaction with matter give rise to the conditions in which color may be seen:

From all which it is manifest that if the Sun's light consisted of but one sort of rays, there would be but one colour in the

FIG. 74 A Newton experiment contributing to knowledge about the relationship between light and color.

whole world . . . and by consequence, that the variety of colours depends upon the composition of light. . . . Colours in the object are nothing but a disposition to reflect this or that sort of rays more copiously than the rest.

For a given material and an encountered photon of a certain wavelength, there are certain events that may happen. The photon may be transmitted, reflected, or absorbed. Absorption may lead to, among other things, reconversion back to visible radiation through fluorescence or phosphorescence. All these processes are stochastic. The result is a spectral power distribution emitted from an illuminated object.

Philosophers may argue metaphysical questions about whether or not a color belongs to an object, but it is scientifically accepted that the appearance of color requires a mental process: "There may be light of different wavelengths independent of an observer, but there is no color independent of an observer, because color is a psychological phenomenon that arises only within an observer." Thus, the spectral power distribution encountered by an eye when focused from an object in a given environment gives rise to the viewer's idea of the object's color.

In 1802, Thomas Young presented to the Royal Society his conclusion that human perception of color is based on three

primaries. "It is almost impossible to conceive each sensitive point of the retina to contain an infinite number of particles, each capable of vibrating in perfect unison with every possible undulation, it becomes necessary to suppose the number limited, for instance, to the three principal colors, red, yellow, and blue." The mid-19th century saw much work in the refinement and verification of Young's hypothesis with the participation of James Clerk Maxwell, Hermann von Helmholtz, and Arthur König. Proof of trichromacy was supposed to have occurred in 1861 with Maxwell's successful public demonstration of the first three-channel full-color photography. Although the theory Maxwell was pursuing was correct, Maxwell's experiment itself was flawed. [1]

Ewald Hering came soon afterward and found that trichromacy was insufficient to explain all color phenomena. For one thing, he noted, after images required a more complex solution. How, for example, are yellow and blue related, as each is the other's after image. Hering promoted the concept of an opponency platform where certain color sensations are at polar odds with others. Although this new theory appeared to be in direct conflict with Young's theory, it would eventually be proven that the two ideas are indeed compatible and represent different stages in the physiology of color vision.

Other important innovations in color science also took place in the mid-1800s. For example, the inventor of linear algebra, Hermann Grassmann. applied his new tool to color vision. He determined several laws concerning metamers formed through the additive mixing of lights. His first law is that of additivity: By equally adding to each of a pair of metamers the same additional light, the match will not be broken. Second is Grassmann's scalar law: A metameric match is not broken by equally

increasing or decreasing the intensity of each of a pair of metamers. Finally, Grassmann described the associative law: If a and b make a metameric pair and c and d are also metameric, then a + c and b + d is also a metameric pair.

The breakthroughs in color science of the 19th century were necessary to the successes of color reproduction in the 20th century. These fundamental understandings of color vision provided engineers with means to create trade-offs based on minimizing their visual impact. Further, it laid the foundation for modern color-matching experiments leading to the specification of the standard observer and the definition of standard colorimetry.

Physiology

The ability to see color occurs in the brain. When light enters the eye under normal illumination conditions it will interact with specialized neurons. There, photonic energy is converted into electrical and chemical signals that are relayed to the rest of the brain by way of the optic nerve. Neural connections made both within the eye and extending into the bulk of the brain create psychological attributes of the scene, some of which are interpreted by the observer as color. Under normal illumination levels, the set of photoreceptors in the retina known as cones are functional. Figure 76 illustrates a cone photoreceptor. There are actually three types of cones that are differentiated by their sensitivity to ranges of visible light wavelengths creating the trichromacy of human vision. In low light situations, cones are unable to gather enough light to be effective, but the very sensitive rods are active. See Figure 75 for an illustration of a rod photoreceptor. All rods have essentially the same wavelength sensitivity profile, relatively broad in comparison to that of cones. This ensures maximal use of light since rods are used when photons are at a premium, but this comes at the cost of color being unrecognizable in dark viewing environments since trichromacy is necessary for color vision. More details on the physiology of vision can be found in the Human Vision section of this book.

Low light conditions, such as experienced in a dark room at night, are known as scotopic environments. Scotopic vision is without color sensation. A normal illumination environment, one that is sufficiently photon-rich that all the rods have been bleached and are no longer able to respond to further stimulation, is called photopic. Here three types of cones work in unison and their differential response to spectral power distributions give rise to the experience of color. Mesopic vision takes place at illumination levels that are high enough so cones respond but dim enough so rods are not fully bleached. Thus, both rods and cones are active in mesopic environments that might be found at dusk.

The three types of cones are distinguished by their relative sensitivity differences to light wavelengths. Those most sensitive to the longer visible wavelengths, the reds, are called L-cones. Their peak sensitivity is around 610 nm. The S-cones, so called for their response to the shorter visible wavelengths such as the blues, have peak sensitivity at approximately

[1] James Clerk Maxwell's demonstration using color photography in 1861 deserves extra discussion due to the fact that it should not have been possible. He exposed three negatives, one each through red, green and blue filters and then printed them on glass. The three slides were projected through their respective filter and were superimposed to give the appearance of the original colors. (Hanson, 1986).

The strange thing about the success of the experiment was that spectral sensitization dyes for film would not be invented for another 12 years. In contradiction, it would have seemed that Maxwell's experiment relied on emulsions sensitive to green and red light. The material he was working with should only have had intrinsic blue and ultraviolet sensitivities. Thus, the red and green filtered records should have been blank.

Evans, in a 1961 article, explained that Maxwell was probably helped by a series of happy coincidences. Blues and greens from a ribbon he imaged were separated because the transmittance of the green filter used by Maxwell leaked slightly into the blue region and the strong green on his ribbon had slight reflectance in the blue. He employed a relatively high exposure time for the green photograph correcting for the low level of reflectance. For the red separation, Maxwell's red filter happened to have a secondary transmission in the ultraviolet and synthetic red dyes like those likely on the ribbon tend to have, coincidentally, secondary reflectances in that same spectral range (Evans, 1961).

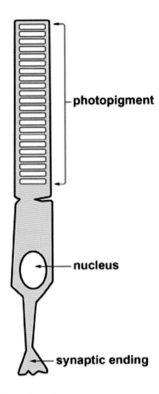

FIG. 75 Illustration of a rod.

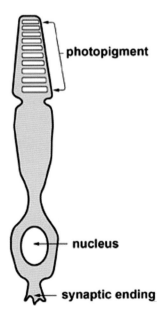

FIG. 76 Illustration of a cone.

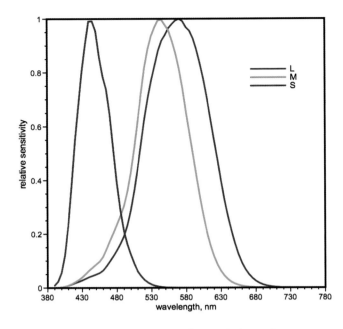

FIG. 77 Relative sensitivity curves for a typical set of cones.

430 nm. The M-cones have middle or green sensitivity with a peak at about 560 nm. Sensitivity curves for a typical set of cones are displayed in Figure 77.

As Hering had noted, colors seem to have their opposites in human color vision. This is noted in after images. For example, staring at a blue field for 10 or 20 seconds will cause the appearance of yellow if the observer turns to a white field afterward. Green will have a magenta after image and red will show cyan. The reverse is also true as yellow has a blue after image, magenta has a green one, and cyan has a red after image. Further, Hering sought to explain why there were certain color concepts that were unavailable to the human imagination such as a yellowish-blue. Hering theorized an opponency system where yellow and blue were at odds as were red and green.

Neural wiring in the human visual pathway can easily be used to explain the visual phenomena that Hering observed. This is not at the expense of Young's trichromacy because color begins with the red-, green-, and blue-sensitive cones. In the human eye, the S-cones antagonize with a combination of M- and L-cones. When both the M- and L-cones are stimulated, the human response is that of yellow; thus, Hering's blue/yellow opponency. The other opponent channel can also be shown through additional opponency wiring of the S-, M-, and L-cone. A third channel, that of luminance, is created by combining the responses from all three cone signals into a synergistic relationship.

The brain creates color. Starting with the trichromatic system of L-, M-, and S-cones — or red, green, and blue sensitivities — the signals are then transformed into two opponent

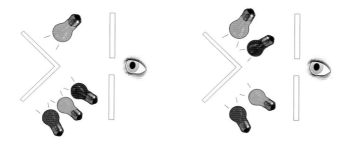

FIG. 78 Classical color matching experiment. Left: red, green, and blue primaries adjusted to match the test light. Right: red primary added to test light side to desaturate it indicating a "negative red" response for that color.

channels and one luminance channel. This is accomplished through neurons applying simple algebraic sums to the cone signals. As the information moves into the brain, additional processing yields other visual sensations such as those of hue, saturation, and lightness.

CIE Color Spaces

In the 1920s a series of experiments by Wright and Guild were undertaken to determine the psychophysical response of humans to individual spectral colors. These involved a now famous experimental setup using a method of adjustment where a round bipartite field was presented to a subject; one-half of the field was illuminated with a particular spectral light and the other half was illuminated by the combination of three primary light sources. The experiment participant was given the task of adjusting the three primaries to create a metameric match (see Figure 78). The intensity levels assigned to each of the primaries for each of the spectral colors became the color matching functions for that individual for those primaries.

It was found that for some of the spectral colors, particularly in the green region of the spectrum, no combination of the primaries was sufficient to match the color. To solve this problem, one of the primaries, usually red, was allowed to be added to the spectral color to desaturate it and then a match was possible. Adding a primary to the spectral color was the equivalent of a negative sensitivity and thus, some of the color-matching functions went negative in certain regions of the spectrum.

A very important year for color was 1931. It was then that Kodak released its Kodacolor process, the first color photographic product for the masses. Another landmark in the world of color technology was also underway. The Commission International de l'Eclairage (CIE) released its first attempt at standardizing a system describing human color response. This system is now known as the 1931 Standard Colorimetric Observer. A set of color matching functions referred [au63] to as $\overline{x}(\lambda)$, $\overline{y}(\lambda)$ and $\overline{z}(\lambda)$ were defined. These were a linear

transformation away from the combined results of Wright and Guild. This special transformation yielded color-matching functions based on theoretical primaries where there were no negative responses and where the $\overline{y}(\lambda)$ response was taken as $V(\lambda)$, the earlier derived human luminance response function.

The 1931 Standard Observer provided the world, for the first time, with unambiguous color specification. A color sample described by its XYZ tristimulus values, the scalars derived by multiplying a spectral radiance vector by the three color-matching functions and integrating each, should visually match another sample described by the same XYZ tristimulus values under identical viewing conditions. The ability to measure colors by means of a spectrophotometer and to transform measurements to XYZ values created a "universal and fundamental language of color." The 1931 Standard Observer was important for the growth of color science. As Hardy's 1936 *Handbook of Colorimetry* pointed out, "Students of history agree that man's progress was slow until he had developed a language that enabled him to impart to others the experience that he had just acquired."

The formula for calculating XYZ from the spectral reflectance factor of an object, R(λ) viewed under a light source with spectral radiance described by S(λ) is as follows:

$$X = k \int S(\lambda)R(\lambda)\overline{x}(\lambda)d\lambda$$
$$Y = k \int S(\lambda)R(\lambda)\overline{y}(\lambda)d\lambda$$
$$Z = k \int S(\lambda)R(\lambda)\overline{z}(\lambda)d\lambda$$

where constant k is calculated to guarantee that the perfect reflecting diffuser under the light source returns a value of 100 as follows:

$$k = -\frac{100}{\int S(\lambda)\overline{y}(\lambda)d\lambda}$$

The Wright and Guild matching experiments illuminated only the fovea. During the 1950s, Stiles showed that such experiments were not completely accurate for larger fields. Stiles and Burch went on to reinvestigate the color matching functions for a larger 10° field of view, versus the original foveal 2° field of view. Their new color-matching functions were adopted as the 1964 Standard Colorimetric Observer. Both colorimetric systems are still widely used. In the graphic arts industry and, by extension, in color management, the 1931 2°, Standard Colorimetric Observer is usually utilized.

By 1934, transformations of the XYZ system were developed for superior correlation between calculated distances within a color space and human visual perception of color difference. Known as uniform color spaces or uniform color scales, many XYZ transformations were offered. Earliest attempts at improving the non-visually-uniform nature of the XYZ space concentrated on the two-dimensional projection known as the chromaticity diagram (see Figure 79).

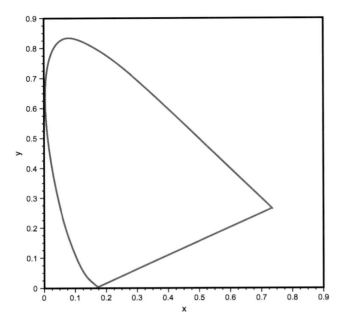

FIG. 79 Chromaticity diagram.

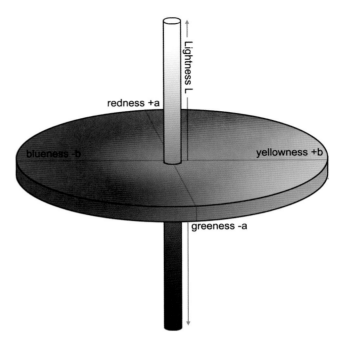

FIG. 80 Schematic of the CIELAB space.

MacAdam, one of the original researchers in this area, reminisced in 1985:

Analogous to Mercator charts and other kinds of maps of the world that misrepresent the ratios of distances, the chromaticity diagram does not represent perceptually equal color differences by equal distances between points that represent equally luminous colors. The noticeability of color differences was not considered—very few data were available—when the chromaticity diagram was devised and adopted. However, as soon as it came into use, anomalies were encountered in interpreting the configurations of points on the diagram. Inconsistencies between distances and perceived magnitudes of color differences were evident.

Many uniform color spaces have been offered between 1931 and today. In 1976, the CIE recommended the use of either of the two-color difference formulae. One of these color difference formulae was based on the 1976 CIELAB space. The color difference associated with this space and its subsequent derivatives have become the dominant ways of specifying color and color difference throughout many industries.

CIELAB is a defined as having one luminance channel (L^*) and two opponency channels (a^* and b^*). The L^* channel has a luminance response with a log-like fall off as the brightness of the color increases. The a^* channel describes antagonism between green and magenta appearance where negative a^* indicates greenness and a positive a^* indicates magentaness. The b^* channel describes antagonism between blue and yellow appearance whereas negative b^* indicates blueness and positive b^* indicates yellowness (see Figure 80).

The formula for converting from XYZ to CIELAB is as follows:

$$L^* = 116[f(Y/Yn)] - 16$$
$$a^* = 500[f(X/Xn) - f(Y/Yn)]$$
$$b^* = 200[f(Y/Yn) - f(Z/Zn)]$$

where Xn, Yn, and Zn are the tristimulus values of a perfect reflecting diffuser under the viewing environment and where

$$f(X/Xn) = (X/Xn)1/3; \text{ for } (X/Xn) > 0.008856$$

and

$$f(X/Xn) = 7.787 \times (X/Xn) + 16/116; \text{ otherwise,}$$
$$f(Y/Yn) = (Y/Yn)1/3; \text{ for } (Y/Yn) > 0.008856$$

and

$$f(Y/Yn) = 7.787 \times (Y/Yn) + 16/116; \text{ otherwise,}$$
$$f(Z/Zn) = (Z/Zn)1/3; \text{ for } (Z/Zn) > 0.008856$$

and

$$f(Z/Zn) = 7.787 \times (Z/Zn) + 16/116; \text{ otherwise.}$$

The CIE color difference formula based on the CIELAB color space was originally specified as the Euclidean distance in that space. This was called ΔE^*ab. In 1994 and again in 2000, the CIE published updates to the color difference. The

first was named ΔE*94 and the latter CIEDE2000. The equation for CIEDE2000 is as follows:

$$\Delta E_{00} = \left[\left(\frac{\Delta L'}{k_L S_L} \right) + \left(\frac{\Delta C'_{ab}}{k_C S_C} \right) + \left(\frac{\Delta H'_{ab}}{k_H S_H} \right) + R_T \left(\frac{\Delta C'_{ab}}{k_C S_C} \frac{\Delta H'_{ab}}{k_H S_H} \right) \right]^{1/2}$$

where

$$L' = L^*$$
$$a' = a^*(1 + G)$$
$$b' = b^*$$
$$G = 0.5 \left(1 - \sqrt{\frac{\overline{C}_{ab}^{*\,7}}{\overline{C}_{ab}^{*\,7} + 25^7}} \right)$$
$$S_L = 1 + \frac{0.015(\overline{L}' - 50)^2}{\sqrt{20 + (\overline{L}' - 50)^2}}$$
$$S_c = 1 + 0.045\overline{C}'$$
$$S_H = 1 + 0.015\overline{C}'T$$
$$T = 1 - 17\cos(\overline{h}' - 30) + 0.24\cos(2\overline{h}') + 0.32\cos(3\overline{h}' + 6)$$
$$\qquad - 0.20\cos(4\overline{h}' - 63)$$
$$\Delta\Theta = 20\exp\left(-\left(\frac{\overline{h}' - 275}{25} \right)^2 \right)$$
$$R_c = 2 * \left(\frac{\overline{C}'^7}{\overline{C}'^7 + 25^7} \right)^{1/2}$$

FURTHER READING

Byrne, A. and Hilbert, D. (2002). Color realism and color science. *Behavioral and Brain Sciences* **26**, 3–21.

Evans, R. (1961). Some notes on Maxwell's colour photograph. *Journal of Photographic Science* **9**, 243–246.

Grassmann, H. (1853). Zur Theorie der Farbenmischung. *Annales de Physique–Leipzig* **89**, 60–84. [English translation *Philosophical Magazine London* **7**, 254–264 (1854).]

Hanson, W. (1986). Color Photography: From Dream, to Reality, to Commonplace. In *Pioneers of Photography, Their Achievements in Science and Technology* (E. Ostroff, ed.). Springfield, VA: SPSE.

Hardy, A. (1936). *Handbook of Colorimetry*. Cambridge, MA: Technology Press.

Juster, N. (1988). *The Phantom Tollbooth*. New York: Random House.

MacAdam, D. (1985). *Color Measurement, Theme and Variation, 2nd edition*. New York: Springer-Verlag.

Newton, I. (1717). *Optics, 2nd edition, 1717, Great Books of the Western World*, Vol. 34 (R. M. Hutchins, ed.) Encyclopedia Britannica, Inc.,

Palmer, S. (1999). *Vision Science: Photons to Phenomenology*. Cambridge, MA: MIT Press.

Pokorny, J. (2004). The evolution of knowledge: Trichromacy as theory and in nature. *Clinical Experiments in Optometry* **87**, 203–205.

Robertson, A. (1977). The CIE 1976 Color-Difference Formulae. *Color Research Applications* **2**, 7–11.

Sipley, L. (1951). *A Half Century of Color*. New York: Macmillan.

Young, T. (1801). On the theory of light and colors. *Philosophical Transactions of the Royal Society* **91**, 12–49. ◉

Color Measurement

DAVID R. WYBLE
Rochester Institute of Technology

Introduction

At the most basic level, the perception of color exists as a three-part system: a light source, an object, and an observer. Color measurement involves the careful determination of the physical properties of all three parts of that system. The psychological nature of color cannot be understated: Because color only exists as a perception, when color is measured, and the observer is replaced by a detector, the perception aspect is lost. Therefore a large amount of effort has gone into the correlation of instrument output—"measured color"—with perceived color.

In general, there are two main applications of color measurement. The first is to correlate measured color with perceived color. This might seem obvious: Suppose a manufacturer desires to make widgets that are all identical in color to the standard widget. To improve consistency and reduce cost, an instrument is used to make quality control judgments instead of a human. The comparison of a standard color to a sample is referred to as color difference.

The second important application is to correlate measured color with some physical property of a material. Often, a material is a mixture of several substances, which contribute to its eventual color. Consider the procedure involved in matching paint to a fabric sample. Yes, the overall goal is to minimize the color difference between the paint and fabric, but to get there, measurements of the paint are used to adjust the quantities of the constituent pigments. This task is often referred to as formulation.

The applications of color difference and formulation rely on similar instrumentation. After exploring some historical background, we will describe the components of a spectrophotometer, followed by the instrument configurations and the applications.

Historical Perspective

Given that neither of the above two applications of color measurement are particularly new, it is useful to follow the path that developed since the first enabling steps were made early in the 20th century. In the 1920s, as today, the international organization most concerned with color measurement was the Commission Internationale de l'Eclairage (CIE). Today

we always use the acronym CIE, but in the 1920s the English title International Commission on Illumination; was used. Older works refer to it as the ICI. In 1924, the CIE established the Standard Photopic Observer. This spectral curve, $V(\lambda)$, can be used to predict the lightness of a material for a typical observer. By creating a detector with a spectral response of $V(\lambda)$, a device can predict lightness instrumentally. The CIE 1931 Standard Observer Functions extended this to full color. The three curves, \bar{x}, \bar{y}, and \bar{z}, when combined with the input stimulus and integrated, generate three signals that relate closely to perceived color. These signals, called tristimulus values, and denoted as X, Y, and Z, form the basis of most popular and useful color spaces and color difference models.

There are two forms of color measurement devices: those that measure spectral reflectance (spectrophotometers) and those that measure only tristimulus values (colorimeters). The technical details of these instruments will be explored below, but the main difference is that spectrophotometers measure a physical property (spectral reflectance) from which tristimulus values are calculated. Colorimeters typically pass the light through specially designed filters allowing tristimulus values to be calculated directly from detector output levels. Initially, of course, these devices were entirely analog. In the case of spectrophotometers, the reflectance was often recorded directly onto paper via a chart recorder. Workers then transcribed the data and computed the multiple and sum for tristimulus values by hand. Later, electrical integration schemes were developed to sum tristimulus values during the reflectance measurement.

Modern systems benefit from several innovations in controls, miniaturization, and computing power to greatly increase the ease of use, improve operator efficiency, and provide more reliable measurements. Measurement times are reduced from five or more minutes for a single measurement to a few seconds or less per measurement.

Definitions and Terminology

Spectrophotometry is the measurement of the reflectance, transmittance, or absorptance of a material as a function of the wavelength of the incident light. More specifically these properties are spectral reflectance, spectral transmittance, and spectral absorptance. Reflectance and transmittance will be fully explored below; absorptance can be calculated from these, and will not be mentioned further. A spectrophotometer is a device that measures the ratio of two quantities, one of which is always an actual or theoretical standard. For spectral reflectance, the ratio is the flux reflected by the sample divided by the flux reflected by a perfect white surface. The perfect white surface, called the perfect reflecting diffuser, is a theoretical construct. Therefore the ratio is accomplished by calibration, not by the use of an actual perfect white surface. For spectral transmittance, the ratio is the flux transmitted by the sample divided by the flux transmitted by a perfectly clear standard. For the wavelengths of interest in color measurement and over the very short path lengths within the instrumentation, air is sufficiently clear for use as a calibration standard.

For these ratio quantities, the range of values is nearly always between zero and one, although exceptions are discussed below. The values are sometimes expressed as a percentage, but the fractional values are more useful for computation. So a very white material reflecting an equal amount of flux as the perfect reflecting diffuser is assigned a reflectance of 1.0.

Spectroradiometry is the measurement of light in narrow bands across the spectrum. Spectroradiometers are devices that make this measurement. Spectroradiometers do not measure ratios, but output an absolute amount of light measures. Therefore, the range of output values is not zero to one, but in theory has no upper bound except as determined by the instrument's own limitations. The most common quantities measured are luminance (flux emitted by a surface per unit area and solid angle) and illuminance (flux incident on a surface per unit area). There are numerous units for these quantities, but the values are typically expressed as candelas per unit area (cd/m^2) and lumens per unit area (lm/m^2) for luminance and illuminance, respectively.

In summary, spectrophotometers measure ratio quantities of the properties of materials, and spectroradiometers measure absolute quantities of flux from a light source. Hence, spectrophotometry is used to quantify the reflectance or transmittance of paints, filters, papers, etc., and spectroradiometry is used to measure the luminance or illuminance of surfaces such as computer monitors, light booths, or studio lights.

Components of a Spectrophotometer

The various spectrophotometer designs all share a set of common systems that are analogous to the vision system's perception of color; namely, there will be a light source, an object to be measured, and a detector. Since multiple quantities need to be measured (i.e., the wavelength bands), the dispersing element separates the light into components, and these components are individually measured.

Light Source

The important properties of the light source are stability, spectral content, and brightness. For consistent measurements, the light output should be stable over time. Instruments may

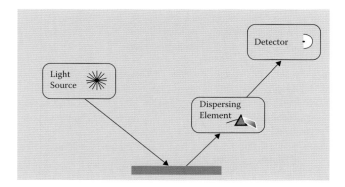

FIG. 81 Polychromatic illumination.

have secondary detectors that provide feedback for brightness control, but inexpensive instruments may simply rely on the constant output over time. Good light sources should have sufficient quantity of flux at all the wavelengths of interest. Considering the ratio measurement described above, the denominator of the ratio will be the amount of flux reflecting from the perfect white. If, in certain wavelength regions, this value is low, then the amount reflecting from the sample can only be lower. The ratio of two very small numbers tends to amplify the noise, so a high quantity across the spectrum is ideal.

If an instrument is to be used for measuring fluorescent samples, the spectral content of the light source becomes more important. There must be sufficient content in the areas of excitation for the fluorescent samples of interest.

Detector

In most modern instruments, the detector is in fact a linear array of detectors. The wavelengths of light are dispersed and imaged onto the array. A measurement of the entire spectrum becomes a single sampling of the array, which is typically very fast. The two important aspects of the detector are its dark current output and photometric linearity. Dark current is the small level of output that every detector produces even in the absence of any incident light. The calibration procedure of most spectrophotometers records the dark current once, and assumes it is constant thereafter. For quality measurements, a detector should have low, uniform dark current. The photometric scale of a detector is the relationship between incident light and the detector output. This relationship must be linear for the calibration assumptions to be valid. More details on calibration are below.

Dispersing Element

The dispersing element separates the reflected or transmitted light into its constituent wavelengths. Schematically shown as the familiar prism, these are more typically a diffraction grating. Modern instruments disperse the reflected light and image it onto an array detector to capture the amount of light present at all wavelengths simultaneously. For example, an instrument might use a 1024 element linear CCD array, and measure the wavelength range of 380 to 730 nm. Each element of the CCD array corresponds to a particular wavelength band of reflected light. The quality of the dispersion is evaluated by how efficient the system rejects undesirable wavelengths and to what degree the dispersed light is distributed around the wavelength of interest. A particular wavelength of reflected light, e.g., 450 nm, should pass through the dispersing element and be imaged onto the 450-nm region of the detector array. Rejecting undesirable wavelengths means that the reflected 450-nm light is imaged on the appropriate detector element and further, no light of any other wavelength is imaged onto that element. The degree to which the dispersed light is distributed around the desired wavelength is called bandpass. Theoretically, the measurement should be made of monochromatic light at the detector, i.e., the light of precisely one wavelength and no other. In practice a single wavelength of light is insufficiently bright. Therefore detectors are not configured to detect single wavelength, instead narrow sections of the spectrum centered around the wavelength of interest are detected.

Polychromatic versus Monochromatic Illumination

The dispersing element can be placed in two locations in the optical path. Most modern instruments position it after the sample, so the path is light source, sample, dispersion, detector. This configuration is called polychromatic illumination, because the sample is illuminated with the entire spectrum of the light source. Alternatively, the incident light can be dispersed prior to the sample. In this case, called monochromatic illumination, a single narrow band in the spectrum is incident on the sample, and the visible spectrum is scanned, one band at a time. Therefore the detector can only measure one single wavelength band at a time. Since the polychromatic case allows for a single measurement, and is therefore much faster, it is the choice for most modern instruments.

The case can be made for either mono- or polychromatic illumination. For non-fluorescent samples, they should result in identical results; hence the leaning toward polychromatic illumination for the speed with which measurements can be made. For more discussion on illumination, see below under the section Design of Spectrofluorimeters.

Calibration Procedure

Instrument manufacturers typically recommend a calibration procedure daily, at the start of each shift, or more frequently should the operator feel it is necessary. The instructions for calibration should be provided by software either on an attached computer or on the instrument itself. Spectral reflectance calibration first involves the measurement of a light trap (a nearly fully absorbing sample) to determine the dark current of the detector. That measurement is followed by a standard of known reflectance, typically a white tile. From these two measurements and the known data for the standard tile, the software builds an equation used to calculate spectral reflectance of measured samples.

The calibration for transmittance is similar, except that the standard is usually replaced by an open measurement of air. The dark current should still be measured first, and can be accomplished by blocking the beam of light by placing an opaque card in front of the detector.

Measuring Light: Spectroradiometers

A spectroradiometer has some components in common with a spectrophotometer. Because it is designed to measure sources of light, an internal light source is not required. A dispersing element and detector are still needed. Additionally, more specialized input optics are required. The considerations of the dispersing element and detector are the same as those described above. To evaluate the input optics, the primary questions are at what distances the device can focus and what is the angular size of the detector. Spectroradiometers are often sold with a variety of lens designs and detector

port sizes, so they can be customized to the requirements of the application.

Other Devices

Devices sampling wider spectral bands than 20 nm are often called abridged spectrophotometers or colorimeters. A colorimeter has three or four filters that attempt to simulate the color-matching functions, or a linear transform thereof. These devices output tristimulus values, not spectra, and therefore are limited to a fixed illuminant and standard observer combination. This might prove too limiting for many users, but some industries have long settled on the color measurement conditions, and the use of a colorimeter might not be unreasonable. Colorimetry can, of course, be calculated from spectral reflectance or transmittance data, so the use of a spectrophotometer can serve to replace a colorimeter.

Some industries rely on densitometry and densitometers. A densitometer measures optical density. After determining the relationship between a specific colorant (e.g., cyan, magenta, or yellow ink) and the optical density, a densitometer can be used to estimate the amount of that colorant present. The measurement of color mixtures and the measurement of arbitrary colorants will not yield a useful color measurement. Again, a spectrophotometer can be used in place of a densitometer in most situations.

Gloss meters provide information about the surface characteristics of a material. In general, there is no color information, although gloss is an important attribute of color. Like spectrophotometers, these devices shine light on a sample and measure light reflecting off the sample. The geometry of a gloss meter is quite different: The incident and measured light beams are always at equal and opposite angles. That is, gloss meters measure only the specular and near-specular angles of reflected light. The specific designs of spectrophotometers are described below. For now, understand that spectrophotometers generally strive to eliminate the light at the specular angles. Gloss meters come in a variety of configurations, such as 20°, 60°, etc. The number of degrees indicates the angle of the incident and detected light.

Spectrofluorimeters are a special type of spectrophotometer designed to measure fluorescence. To adequately characterize the fluorescence of a sample, the illumination and detection must be monochromatic. In this case, the optical path is light source, dispersion, sample, dispersion, detector. A spectrofluorimeter does not output a single array of spectral reflectance data, but rather an array of data for each incident wavelength. This results in an M × N matrix of data, where there are M incident wavelengths and N detected wavelengths. M is typically larger than N because the incident wavelengths should include the ultraviolet where fluorescence is most often active.

Phenomenology and Design

There are two standardized spectrophotometer configurations: bidirectional and hemispherical. These will be described along with appropriate applications for each. The difference between configuration relates to the methods of illuminating the sample and detecting the reflected light. The CIE notation used to designate a configuration is i:v where i and v are the illuminating and viewing conditions, respectively.

Bidirectional Spectrophotometers
Geometric Definition

The CIE standard bidirectional configurations are 45:0 and 0:45. These are shown schematically below.

The CIE provides very specific guidelines on the definition of bidirectional geometries. For the case of 45:0, the incident light is 45° to the sample normal and the detector is positioned

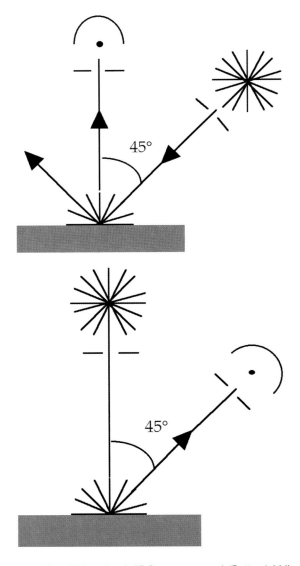

FIG. 82 (Top) Bidirectional 45:0 geometry and (Bottom) bidirectional 0:45 geometry.

at the sample normal. The illumination can be from a single source at 45° or from any number of sources as long as all are 45° from sample normal. A popular configuration is circumferential illumination with many individual incident beams. To eliminate the need to control several sources, circumferential illumination is often implemented using fiber optics from a single physical source. Circumferential illumination avoids the case of textured samples that might have orientation-specific reflectance. For example, consider a paint sample with parallel brush strokes. A bidirectional device with a single incident beam might measure differently depending on whether the light source is parallel or perpendicular to the strokes. If the sample is simultaneously illuminated from the entire circumference, this issue is largely avoided.

The alternative recommended bidirectional geometry, 0:45, amounts to optical reversal of the 45:0 case. The light source is now a single beam from the sample normal and detectors(s) are at one or more radial angles, always at 45° from the sample normal. The reversibility of optics implies that these two configurations should report identical measured data. For flat uniform surfaces this should be the case.

Applications
From the diagram of the 45:0 bidirectional geometry it can be seen that the surface gloss is reflected 45° to normal. This is sufficiently far from the detector to assume that the detector measures none of the gloss. This geometry works well for applications where the primary use of the color measurement correlates with visual observations. Consider measuring the color of a glossy photographic print. Without other instructions, observers evaluating the print color will typically position it for viewing so that the eye is viewing approximately normal to the print and no gloss is seen from the light source. This orientation is well-approximated by the 45:0 geometry.

Hemispherical Spectrophotometers
Geometric Definition
As the name implies, hemispherical spectrophotometers either illuminate or detect the light from the entire hemisphere above the sample. This is accomplished by the use of an integrating sphere, shown schematically below in Figure 83. As with the bidirectional case, there are two versions: 0:d and d:0. In these versions the "d" stands for diffuse, and hence at all angles. Also like the bidirectional case, the CIE provides very specific guidelines to which manufacturers should adhere if they are claiming that instruments are d:0 or 0:d. The left diagram shows the d:0 geometry. The light beam enters the sphere diffusely from the port at the right and is further diffused by many reflections off the white sphere walls. Some of this is eventually incident on the sample, and some of that incident light will be reflected in the direction of the detector, located at a near-normal angle.

The 0:d case is shown on the right of the figure. The light is incident upon the sample from a near normal angle. The light reflected from the sample is collected over the entire hemisphere by the integrating sphere. Some of the light will eventually bounce into the detector. Note the baffles in each

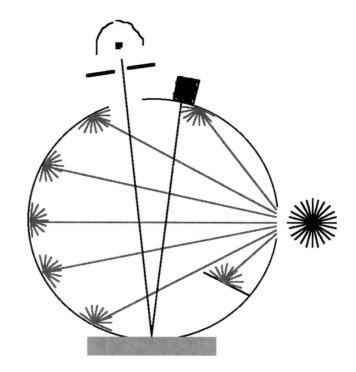

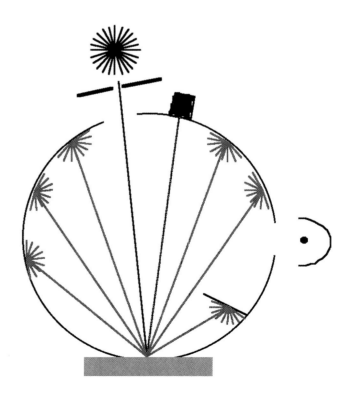

FIG. 83 (Top) Hemispherical d:0 geometry. (Bottom) Hemispherical 0:d geometry.

configuration. These are to prevent the light source beam from being directly incident on the sample (d:0) or to prevent light reflected off the sample from directly entering the detector (0:d). Without the baffles, the diffuse assumption of either configuration could be violated.

Accounting for the Specular Component

Comparing the geometries, it is apparent that the hemispherical geometry does not eliminate the surface gloss. The nature of the integrating sphere is to keep all reflected light within the system. This may be seen as a shortfall, but integrating spheres are usually built with a port (an opening) to control the handling of the surface gloss. Shown as a black rectangle in the hemispherical diagram, this specular port is positioned at an angle equal and opposite to the detector (0:d) or the light source (d:0). If the specular port is covered with a light trap, surface gloss is absorbed and therefore removed from the measurement. If the specular port is covered with a diffuse white material, specular gloss is reflected back into the sphere, and remains in the measurement. Including the specular gloss is called specular component included (SCI) and excluding it is called specular component excluded (SCE). SCI is also referred to as specular component included (SPIN) or SIN in older texts. Likewise SCE is sometimes referred to as SPEX or SEX.

As samples become more glossy, more specular light is present at the specular port. Therefore the difference between SCE and SCI reflectance will increase with surface gloss.

Applications

The justification for the use of SCE follows a similar argument to that of the bidirectional geometries: Excluding the gloss component can better correlate to visual color assessment. However, the CIE recommendations for hemispherical geometry do not include specific details on the specular port configuration. The angular size of the specular port as viewed from the sample port determines the amount of gloss that is removed from the measurement. Different implementations have naturally varied, and without CIE guidelines the size of specular ports can be found to vary by more than 100%. Therefore it cannot be expected that two instruments of different design will necessarily predict the same SCE reflectance for glossy materials.

When comparing instruments, the use of SCI will be more useful, since the significant variable of specular port size is removed. Other design aspects might still differ (e.g., the sizes of the detector and sample ports), but reflectance variations due to these differences should be mostly eliminated by proper calibration.

Analysis of Design and Applications

In many industries, the use of color measurement is well established, and the definition of measurement geometry has been long decided. In cases such as these, the user who wishes to continue interacting with such an industry should use the defined geometry. When communicating color, it is always important and proper to use the most similar geometries as the

hardware allows. For the best correlations, identical models of instruments should be used. This avoids the small implementation variations that might be important depending on the specific instruments and sample properties. For example, as discussed above, glossy samples have a large specular component, and therefore will be more susceptible to variations in specular port design.

Design of Spectrofluorimeters

Spectrofluorimeter design can include bidirectional or hemispherical geometry. There are issues related to the implementation of either choice that need to be addressed by the instrument manufacturer. The use of hemispherical geometry is particularly challenging because the sphere will capture the fluorescently emitted light and some of this light will be incident upon the sample. Should this incident light excite more fluorescent emissions, the calibration equation of the instrument is no longer valid, since the detector has no way to know whether the emitted light was excited by the light source or by re-excitation as described above. The effect will seem as though the light source were not stable.

Implications for Color Measurement Instrumentation
Instrument Evaluation

Spectrophotometers are evaluated in three primary ways: repeatability, reproducibility, and accuracy. Repeatability is the ability of an instrument to make consistent measurements. Accuracy is the ability of an instrument to make measurements that closely match known values. These aspects are evaluated with different methods.

Repeatability

The evaluation of repeatability takes several forms, relating to the time interval between measurements. Short-term repeatability is the comparison of measurements taken as fast as the instrument can measure. Medium-term repeatability compares measurements taken over a work shift or single day. Long-term repeatability compares measurements taken over several weeks, months, or even years.

The comparison made is the difference between the initial and subsequent measurements. The statistical analysis is beyond the scope of this work, but methods vary from simple color difference to complex multivariate analyses. Most instrument manufacturers will quote an average DE*ab for a set of replicate measurements of a white tile. For a good instrument this average will be small, perhaps 0.1 DE*ab or less. As the time span increases, the repeatability can be expected to worsen somewhat. It is difficult to cite a specific performance that should be expected. The needs of applications will vary and, perhaps more important, manufacturers rarely specify medium- or long-term repeatability performance.

Reproducibility

When one or more measurement conditions have changed, the evaluation is termed reproducibility. These conditions may

be a different operator, instrument, or procedures. Reproducibility is reported with similar metrics as repeatability, and is basically the color difference that can be attributed to the condition change.

Accuracy

The above methods evaluate an instrument's performance to itself, evaluating the consistency of the device. Accuracy compares an instrument's measurements to known values provided by a national standards laboratory or other high-accuracy organization. Note that "known" values should not be confused with "truth." Even national standards laboratories have uncertainty in their measurements and never claim truth.

Accuracy evaluation is performed separately on the subsystems described above under the section Components of a Spectrophotometer. The detector is evaluated for photometric linearity and the dispersing element/detector combination is evaluated for wavelength accuracy.

Other Evaluation Methods

Also of interest are the inter-instrument agreement and inter-model agreement. Inter-instrument agreement compares instruments of identical design. Inter-model agreement compares instruments of different design. Proper analysis of either of these methods requires sophisticated multivariate techniques. However, both methods are often reported using measurement and analysis techniques similar to repeatability.

Instrument Selection

There are several considerations when selecting an instrument for a given measurement task.

Type of measurement data. Does the application require spectral data, or can a less expensive colorimeter suffice?

Instrument geometry. Is there an existing convention for the measurement application? Can a specific type of sample be identified as representative?

Precision and accuracy. What is required? Is a more expensive instrument worth it?

Bandpass and wavelength sampling interval. Are the spectral data very smooth or sharply changing? Smooth data can be adequately measured with fewer wavelengths.

Light source. This is very important if fluorescence is an issue.

Functionality

Time of measurement. Faster instruments require less operator time.

Software interface. A useful interface delivers the relevant data quickly and operates on the platforms that are currently in use.

Service and support. A large, reputable company should be able to provide good service.

Robustness. Is the instrument for the laboratory or the factory floor? What is the level of training the operators will receive?

FURTHER READING

Billmeyer (Industrial Color Technology) & Wright (CIE Jubilee) historical articles
Berns'
W&S
Hunter & Harold
Völz
CIE 15.2004
ASTM E2214-02 ◎

Twentieth Century Photographic Lighting

JON TARRANT

Freelance Technical Journalist, Former editor of *British Journal of Photography*, Teaching faculty of Physics at Jersey College for Girls, Jersey, Channel Islands, UK

Introduction

Without light there can be no photography. The history of photographic lighting is therefore inexorably linked to the history of technology and most especially the development of a reliable and widespread electricity distribution system. Prior to the advent of electricity, artificial light was provided primarily by the combustion of oil, wax, tallow, or coal-gas. Even as late as the 1940s kerosene lamps were still being used for domestic lighting in rural parts of what would otherwise be considered to be some of the most developed areas of the world.

Although these light sources are sufficient to enable human vision they are not very actinic; they do not have a great effect on photographic emulsions. The "actinic value" is a measure introduced in Germany in 1941 by Otto Reeb to indicate the ratio between the lumen output of a standard daylight lamp and that of an artificial source when both produce a film density 0.1 above the normal fog level. This proved to be a rather problematic definition, not least because a UV source could produce the necessary film density without any visible light (and therefore zero lumens since the lumen is derived from the candela, which applies specifically to a precisely defined frequency of yellow light). Despite such difficulties, the qualitative idea of actinity as a qualitative indication of a light source's photographic efficaciousness has stuck to this day.

The fact that the common artificial light sources proved poorly suited to photographic needs led 19th century photographers to look elsewhere for their sources of light. The most obvious recourse was to take all photographs using daylight, and studios were often designed with large north-facing windows that admitted a soft, shadow-free quality of natural light. Despite daylight's effectiveness, convenience, and zero cost, it was not the ideal source simply because it was neither predictable nor controllable to the extent that photographers

would have liked. Nevertheless, for most photographers—especially the growing band of enthusiastic amateurs—it was all that was available until well into the 20th century.

Professional photographers were served better as their fee-paying clients allowed them to explore new forms of artificial lighting that were effective with the film emulsions of that time. In particular, this meant a form of artificial lighting that was rich in near-UV light to which silver halide crystals are naturally sensitive. One solution came in the form of a soft gray metal called magnesium.

Chemical Flash Lighting
Open Systems

Sir Humphrey Davy first deduced the existence of magnesium in 1808, which was also the year in which he demonstrated the first electric arc light (see below). By coincidence magnesium was finally isolated by Alexandre Bussy in 1829—the year in which Davy died. Despite being metallic, a thin strip of magnesium ribbon is relatively easy to ignite and burns steadily with a bright white light. The first photographic applications of this observation were suggested in 1859 by English chemist and *Photographic News* editor William Crookes in response to a reader's request for a method of lighting cave interiors. The first portrait taken using magnesium light is attributed to Alfred Brothers in 1864.

The first commercial magnesium burner for photography was manufactured by Edward Sonstadt's Magnesium Metal Company in 1862. It used magnesium wire that was fed through an alcohol lamp to generate an intense white light of whatever duration was required to make the exposure. More rapid combustion of the magnesium, and therefore shorter exposure times, came with the invention of "blow-through" lamps that used a puff of air, provided by a pressed rubber bulb, to propel a cloud of magnesium powder into an alcohol flame. Exposures as short as one-tenth of a second were possible using devices of this type such as The Marion Economical Magnesium Flash Lamp and the Leisk Centrifugal Flash Lamp.

Inclusion of the word "economical" in the Marion's model name was significant because magnesium was as expensive as silver at this time, thereby making efficient use of the resource a prime consideration. For even better results the puff of air could be replaced by a blast of pure oxygen, resulting in what must have been a near explosive flash of light.

Pure oxygen atmospheres were also employed in the early flashbulbs, but before they arrived flash powder underwent a process of evolution that saw the introduction of compound oxygen in powder form (as potassium perchlorate, for example) that was intimately mixed with the powdered magnesium before ignition. The most important initial work was undertaken by J. Traill Taylor, who was also an editor of the *British Journal of Photography*. Although Traill Taylor announced the first blended flash powder in 1865, the price of magnesium was still too high for it to find widespread use. It was to be another twenty years before this situation changed significantly.

Throughout this time those who could afford to use magnesium-based light sources also had to cope with the vast amount of white smoke that was produced in the form of magnesium oxide. It is only thanks to the fact that light travels considerably faster than smoke particles can diffuse through the air that it was feasible to take indoor portraits using magnesium powder. Various schemes were devised to cope with the smoke, ranging from assistants running around the room with fine fabric bags to capture the cloud, to elaborate ventilation systems coupled with remote powder ignition systems that delivered their light to the sitter through reflective or translucent surfaces. Clearly a more elegant solution was required.

A major step forward in smoke reduction was achieved by Adolf Mieche and Johannes Gaedicke in 1887. So successful was their flash powder formula, which used manganese peroxide as the oxidizing agent, that the product was marketed in Germany by Agfa for many years. Typically it required only about one gram of flash powder to make a successful exposure and the mixture could be ignited by a single spark rather than requiring a naked flame.

In the early years of the 20th century flash powder was common, albeit with improved formulations that reduced exposure times down to 1/100 of a second. Little improvement was either necessary or made to flash powder for the remainder of its useful life.

More important, all of the flash exposures made thus far (and many that were to follow) required photographers to use a technique wherein, owing to the somewhat unpredictable nature of combustion, the camera shutter had to be opened before the lighting system was triggered. The only alternative was to arrange the flash so that it would burn for an extended time at high brightness to allow the shutter to be opened and closed during the period of illumination, but this inevitably meant that not all of the light reached the film. Automatic synchronization was clearly impossible and there was a certain amount of compromise in early artificial light photographs as photographers endeavored to discover the best way of matching innovative lighting systems with the need for consistent operating procedures.

Enclosed Flashbulbs

To pick up the thread for the next line of development in magnesium-based artificial lighting it is necessary to return to 1893, when French diver and photographer Louis Boutan asked Monsieur Chauffour, an electrical engineer, to devise a way of providing artificial light underwater. Chauffour's solution was to place a piece of magnesium ribbon in an oxygen environment inside a heavy glass jar, and to ignite the magnesium using electricity. The inevitable white smoke reduced the light output, and the heat and pressure generated by the reaction shattered many of these early flashbulbs, but the concept of a self-contained device was born. In 1925 Paul Vierkotter patented a flashbulb in which the atmosphere surrounding the magnesium was reduced to a near vacuum with just enough

oxygen to react with the metal. By removing the 80 percent of the air that is inert nitrogen, Vierkotter was able to reduce the maximum pressure generated by the heat of the reaction, thereby reducing the likelihood of shattering. A further advantage was the ability to insert a greater volume of oxygen, thereby allowing the combustion of more magnesium than would otherwise have been oxidized. Typically the flashbulbs that followed contained about half an atmosphere of oxygen (which compares with approximately one-fifth of an atmosphere of oxygen in natural air).

Although Vierkotter demonstrated how to make a safe flashbulb it fell to fellow German Johannes Ostermeyer to develop the first commercial product, which was marketed by the firm of Hauff. Ostermeyer used the same basic design but replaced the magnesium with ultra-thin (half-micron) aluminum foil in a similar low-pressure oxygen atmosphere. The foil was ignited by a small filament that was coated with an explosive primer paste and heated to incandescence by a small battery. General Electric started manufacturing the Vierkotter/Ostermeyer flashbulb under license in England in 1929 using the Sashalite name which, owing its origin to top London celebrity photographer Sasha (born Alex Stewart in Edinburgh in 1892), appears to have been possibly the first instance of product endorsement in the photographic industry. Three years later, in 1932, Osram began manufacturing and marketing the same product under the Vacublitz name in Germany.

Early advertisements for the Sashalite flashbulb carried the slogan "Perfect pictures in your own home with safety and cleanliness," making it clear that General Electric was aiming its new product at amateur photographers. The fitting at the base of the flashbulb was deliberately made the same as the fitting used in torches. This inspired move, and the fact that a mere 4.5 V was needed to fire the flashbulbs, enabled amateurs to experience flash photography with minimum of fuss and outlay. There were, however, disadvantages in the form of variable light output caused by the random arrangement of the foil inside the flashbulb.

A different approach was taken by the Dutch firm of Philips, which in 1930 introduced a flashbulb that generated light by the reaction of two gases: carbon disulfide vapor and nitrogen monoxide. Although this system was effective, the bulbs were very large and were subsequently replaced by another Philips innovation that addressed the problem of unpredictable foil arrangements inside the flashbulb. In 1932 the company developed an aluminum-magnesium alloy (93 percent Al, 7 percent Mg) that had high ductility and strength, which allowed very fine (32 μ) wires to be drawn at high speed on a commercial scale. The wires, which Philips called hydronalium, burned more evenly and consistently than did foil, thus opening the door to automated shutter synchronization, which had previously been impractical because of the unpredictable nature of early flashbulbs and flash powders before them.

Aluminum-magnesium wire flashbulbs quickly displaced foil types, but there was also a third design that employed metallic pastes. All flashbulbs used a paste primer that burned

quickly and vigorously to ignite the wire or foil so it was a logical idea to experiment with all-paste designs. The mixture contained a reactive metal and an oxidizing agent that was surrounded by an oxygen atmosphere. Ignition was almost immediate, with a typical delay of less than 10 ms, and was followed by rapid combustion that lasted for approximately the same time. The entire exposure was therefore initiated and completed in as little as d1/50 of a second with a very high degree of consistency.

Probably the most important flashbulb of all time was General Electric's Midget #5, which broke with the previous convention of using an Edison screw mounting in favor of a new bayonet fixing. This in turn prompted a new generation of dedicated flashbulb holders and led to the Midget #5 becoming extremely popular with amateurs and professionals alike. (General Electric pulled off the same trick again in 1953 when its M2 miniature flashbulb introduced yet another base fitting and provoked a new round of more compact flashbulb holders.) In 1941, two years after its Midget #5, General Electric unveiled its Speed Midget flashbulb, which was the same size as its predecessor but offered a significantly faster burning time of just 1/200 s.

This advance was a true advantage because by now cameras were being fitted with automated systems to open their shutters and trigger the flashbulb as a carefully timed sequence of events. The first camera to incorporate this feature (following a range of external accessories that had been offered previously) was the 1935 Ihagee Exacta Model B. In 1940 Kodak's Six-20 Flash Brownie and Agfa's Shur-Flash signaled the final demise of the open flash technique and with them brought easy-to-use flash photography to the masses.

It is worth noting that, despite its decline, magnesium ribbon was still used in its raw form as a slow-burning artificial

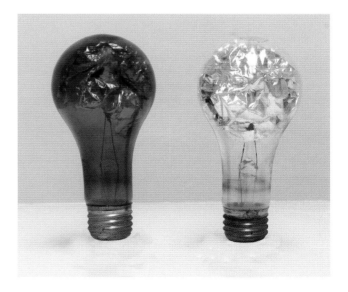

FIG. 84 An example of daylight and tungsten flashbulbs.

light source during these pre-war years. In his 1938 book *Life-like Portraiture*, W. H. Doering includes the following technique for lighting with magnesium ribbon. "The main point to note is that after the ribbon is ignited it should be allowed to burn steadily for a small part of the exposure, after which it should be waived in a semi-circle in order to soften the shadows." The book goes on to say that although photoflash bulbs had sufficient power for many uses flash powders were still the choice for most amateur photographers.

Duration and Synchronization

Flash powder continued to be manufactured until, and during, World War II (when it was used to illuminate the landscape for aerial photography) as flashbulbs became more and more reliable. The most significant safety advance was the addition of a tough lacquer inside the bulb to catch flying debris and another on the outside to protect users against the danger of shattering bulbs. This was complemented by an operational improvement in the form of a chemically active (cobalt salt) Blue Dot that turned pink if the flashbulb had leaked and was therefore defective.

So consistent did flashbulbs become that the American Standards Association (ASA) was able to introduce three categories that defined the light-time characteristics of different products: short peak (Type F), normal peak (Types M and S), or broad peak (Type FP). These characteristics were broken down into five time zones as follows:

1. Contact time (the delay between electrical contact and the first appearance of light)
2. Time-to-peak (the delay between electrical contact and maximum brilliance of the flashbulb)
3. Flash duration (defined by the ASA as the time interval between 5 and 95 percent light emission)
4. Time-at-half-peak (the time for which the flashbulb's brilliance is above 50 percent of its maximum)
5. Median time (the delay between electrical contact and the mid-point of the time-at-half-peak)

A number of characteristics can be deduced from these figures. If the flashbulb has an asymmetric distribution of light output with respect to time then the median time will not match the time-to-peak; the greater the time-at-half-peak value the longer the exposure time; the time-to-peak value is

a practical indication of how quickly a picture may be taken after the flashbulb has been triggered.

The reason for the differences between flashbulbs, in addition to the differing combustion characteristics of foil, wire, and paste, was to accommodate different modes of automatic synchronized flash photography. Typically, a fast peak (Type F) flashbulb achieved its maximum output in no more than 10 ms, a medium peak (Type M) took just over 20 ms, a slow peak (Type S) took about 30 ms, and a broad peak (Type FP) burned at close to maximum output throughout 30–60 ms after triggering. Of these, FP flashbulbs gave out the most light over the longest time, whereas Type S achieved an even greater effect for a shorter period of time. Therefore, Type S flashbulbs were ideal for lens-shuttered cameras and Type FP flashbulbs were necessary when a focal plane shutter was used. It is for this reason that Type FP flashbulbs are so named when the names of the other three relate directly to their speed of achieving peak brightness.

Within each of these categories there existed a variety of different size flashbulbs with different light outputs to suit a range of applications, as indicated by Table 8.

Ironically, given the original need to produce chemical flash systems that produced a blue or UV-rich light sufficiently actinic to affect the relatively insensitive film emulsions of the early 20th century, later flashbulbs were sometimes deliberately designed to have a more red-rich spectral curve. The reason was a need to provide either good tone rendering in monochrome photography or accurate colors for those who were experimenting with newly available color emulsions. Considerable work was undertaken during the 1930s to determine both the lighting efficiency and the color temperature of different types of flashbulb fillings. Not surprisingly, given the practical experience of earlier years, aluminum was found to be a more efficient producer of light (in lumens per milligram) than magnesium, and an aluminum alloy containing about 7–8 percent magnesium was found to be better still. The color temperature of burning aluminum was found, by various workers, to range from 3500 K to about 4700 K compared with 3700 to 4000 K for magnesium: the Al 8 percent Mg alloy gave a color temperature of between 3800 and 4100 K. The problem is that none of these color temperatures matched either of the common color balances for color film, which is either around 5500 K for daylight photography or 3200–3400 K for

TABLE 8 Characteristics of Type M Flashbulbs Designed for Battery Triggering (Up to 30 V)

Model Number	Time to Peak (ms)	Time at Half Peak (ms)	Total Light Output (lm s)	Flashbulb Length (mm)	Flashbulb Diameter (mm)
PF3	20	8	5500	50	20
PF14	20	10	10,000	65	30
PF25	20	14	18,000	72	36
PF38	20	16	30,000	100	50
PF60	20	17	62,000	115	60

tungsten-light photography (which by this time had become very practical thanks to widespread electric lighting; see below). The solution, given the nearness of the lower color temperature, was to apply a colored layer to the flashbulbs to produce better color rendering when the lamps were used with tungsten-balanced film.

An even more extreme example of customized color output was provided by a variety of flashbulbs coated to absorb all visible light and emit only infrared light. These flashbulbs could only be used with infrared-sensitive films, of course, but still proved popular.

After World War II the only thing that still marred photographers' experiences with flashbulb photography was an occasional failure caused by the low triggering voltage used, which was itself necessary to avoid using so large a battery that the flashbulb holder became unwieldy. The difficulty arose not from insufficient voltage to ignite the primer and fire the flashbulb, but rather from the build-up of tarnish or corrosion on the metal contacts that delivered the battery's energy to the flashbulb. A greater voltage would overcome this problem but could not be allowed to hinder the handling and portability of the flashbulb holder. The answer was to install a capacitor in the circuit and to charge the capacitor from the battery before directing this accumulated energy, at a higher voltage, to the flashbulb. Using this method a 3V battery could become as effective as a 15–20V supply—provided the photographer was prepared to wait while the capacitor charged up. This was not an unacceptable limitation when flashbulbs were handled one at a time, and had to be removed (carefully, as they were hot after firing) from the holder before a fresh bulb could be inserted, but it became less convenient when General Electric introduced its four-in-one Flashcube, which was let down by poor contacts. An ingenious, battery-free solution was devised by Sylvania for its Magicube system, which was fired by a sprung pin that acted on a miniature percussion cap.

Modern Flashbulbs

Although it is tempting to assume that flashbulbs are now a thing of the past, this is simply not true. In County Clare, Ireland, Meggaflash continues to manufacture flood, medium peak, and slow peak flashbulbs, as well as custom-made designs for specialist applications. According to the company's Web site (http://www.meggaflash.com) there is a lead time on all flashbulbs: "We regret this delay in supply due to current demand." So why do flashbulbs continue to be popular? Because, for their size, they offer more light output than any other portable source. Meggaflash's PF330 flood flash, for example, can deliver an average level of 60,000 lumens for approximately two seconds, making it ideal for applications such as high-speed sequential photography.

Continuous Electric Lighting Systems
Introduction

The advent of continuous electrical lighting brought with it the need for a clarification in terminology. This has not

been entirely successful throughout history, as the careless modern use of the term "lightbulb" illustrates, and has also been confused by the adoption of different nomenclature in England and in America. Therefore it is worth noting that a device that produces light is often referred to as a "fixture" in the United States and as a "lantern" in Great Britain (where the term can be traced back to such machines as magic lantern film projectors). A largely successful attempt has been made to unify the terminology by adoption of the word "luminaire," which comes from the French for light source. Since this term is used only in professional circles, this essay will generally refer to light fittings simply as lights and to the sources themselves as "lamps."

The story of continuous electric lighting starts in 1879 when Joseph Swan, in England, and Thomas Edison, in America, both demonstrated carbonized filament lamps. It appears that Swan had the idea first, having demonstrated an open-air filament that lasted only a few seconds in 1840, but Edison was the more astute businessman who obtained not only American but also British patents for his design. After much legal wrangling the two men subsequently joined forces to manufacture carbon-filament lamps from 1883 until 1906. It was true that carbon-filament lamps possessed only a low color temperature and therefore, like the chemical lighting systems such as kerosene and gas lamps that preceded them, had a relatively low actinic effect. Swan's and Edison's inventions opened the floodgates for the development of new ways in which electricity could be turned into light for the benefit of photographers.

Unfortunately, the invention of the carbonized filament lamp came forty years after the invention of photography itself, and as a result the most important early photographic electric lighting system used a completely different principle.

Arc Lighting

It is important to realize that Swan and Edison were primarily concerned with distributing electric lighting to the masses: other workers had already considered ways in which the discovery of electrical energy could be used to provide light in more specialized applications. Once again the genius of Sir Humphrey Davy played an important part. It was Davy who first observed the electric arc phenomenon, which can be thought of as a "continuous spark." Davy did not construct his device as a means of providing lighting but rather to investigate the phenomenon in its own right.

The essential ingredients of an electric arc lamp are two carbon rods and a DC electricity supply similar to what might be provided by a chemical battery. Such lights are rated not by the amount of power they draw (as is more normal) but by the current they require when running: typical figures range from 40 to more than 200Å. When the two pointed carbon rods are brought together these very high currents flow through them, and when the rods are pulled slightly apart the current continues to flow causing a bright light to be emitted. The tips of the rods are white hot and erode, leading to a pit developing in the positive rod that eventually extends the gap to such a

degree that a current can no longer flow and the light ceases. It was therefore necessary to design a mechanism that would maintain the appropriate distance between the two rods over a prolonged period of time.

The negative rod is also eroded but this process is slower and does not degrade the rod's pointed profile. Around 95 percent of an arc lamp's light is generated from the incandescent crater in the positive rod with only a minority of the light coming from the arc that joins to the negative rod.

In 1836 Englishman William Staite developed a way to regulate the movement of the carbon rods using a clockwork mechanism, and in 1876 Russian engineer Paul Jablochkoff (Yablochkhov) devised an even more ingenious design featuring parallel vertical rods that required no adjustment. The Jablochkoff Candle, as it became known, was brighter than a gas lamp and also simpler and cheaper than any arc lamp. It was used to light streets and dock areas in Paris and London but was eventually superseded by lamps that had reliable rod-moving mechanisms, which overcame the need for the Jablochkoff Candle to have its entire rod assembly replaced each time it was reused. The final two improvements to the arc lamp were the addition of color-producing combustible salts to the carbon rods and the introduction of enclosures around the rods, which reduced erosion considerably.

The use of "cored carbons" stabilized the arc and transferred the light generation from the positive rod to the arc itself (described as "flaming" in such lights). The colored effect of the salts was exploited to correct the cyan tinge of an ordinary carbon arc lamp principally through the deployment of rare earth fluorides that gave spectral lines so closely packed they seemed to be virtually continuous. The effective color temperature of a high-intensity arc lamp was around 5000 K compared with the very discontinuous spectrum of an ordinary carbon arc lamp, which approximated to 3700 K.

From a photographic perspective arc lamps were important not only because of their brightness but also because of their actinic effect and point-source geometry. In certain applications, including motion picture and theater use, the attendant disadvantages of noise, smell, and high UV radiation were acceptable drawbacks. The point-source geometry of arc lamps was particularly useful because it allowed lights to be fitted with reflectors and lenses that could project near-parallel beams over a considerable distance. This advantage was also put to use in military searchlights by Colonel R. E. B. Crompton, who was one of the foremost advocates of electric lighting in Britain during the late 19th century.

Creatively, however, the point-source geometry was at a disadvantage since the light produced by arc lamps is hard-edged and unflattering. This fact led the leading mid-20th century American portrait photographer William Mortensen to comment: "the point source is of no use by itself." Nevertheless, it is a general principle that hard lighting can be softened more easily than soft light can be made harder, and that a harder light source is better for revealing surface texture — which is useful in some situations but is clearly not the aim when trying to record portraits with a smooth skin tone.

Early Filament Lamps

The advent of the filament lamp did not depose arc lamps, instead it extended the use of electric lighting in general thanks to lower costs and less hazardous operation. That said, cost has to be put in the context of salaries at that time. Brian Fitt and Joe Thornley, in their 1995 book *Lighting By Design: A Technical Guide*, estimate that in the last two decades of the 19th century the price of one domestic lightbulb was equal to 16 percent of an engineer's weekly wage. In addition, carbonized filaments could not be made hot enough to generate actinic light so their use in photography, especially considering the low emulsion sensitivities at that time, remained impractical.

In 1902 the first lightbulbs using osmium filaments were produced commercially and in 1906 the tungsten-filament lamp was launched. These filaments were more versatile than their carbon ancestors in that they could be looped and coiled and operated at much higher temperatures to produce a whiter (though still distinctly yellow) color of light. Tungsten, which has the higher melting point of the two metals, melts at about 3410°C and can be heated to almost this temperature inside a lightbulb to generate light over a considerable period of time. Ultimately, the evaporating tungsten that turns from solid directly into vapor darkens the glass bulb and reduces the diameter of the filament, which causes the filament to break wherever it becomes thinnest. This problem was eventually solved by the advent of tungsten-halogen lamps but was previously aided by changing from evacuated glass bulbs to ones that were back-filled with a mixture of nitrogen and inert gases to reduce tungsten evaporation — an idea that was introduced in 1913 by New Yorker Irving Langmuir (who also went on to design a mercury-vapor condensation pump that made possible nearly perfect vacuums).

The fact that tungsten filament lamps contain a considerable length of wire — there is more than a meter of wire in a modern 100 W domestic lightbulb — made possible different geometries to produce different qualities of light. The larger light-emitting area of a filament lamp contrasted strongly with the point-source nature of arc lamps and brought with it the ability to create a naturally softer lighting quality. As a result many of the photographic lights found in studios at this time used very large lamps contained within proportionately large housings that were intended either to scatter the light generally or to produce a more directional effect with soft-edged shadows.

Although the size of a lamp was directly linked to its wattage, more light (and a greater actinic effect) could be obtained from any given lamp by over-running it, albeit with the disadvantage of a considerably shortened lifetime. Once again this was a drawback that photographers could tolerate even though it would have been unacceptable in lamps that were intended for general use. At a time when ordinary domestic lightbulbs were designed to last at least 1000 hours with a typical color temperature of 2850 K, Type B photographic lamps used a slight over-voltage to give a 3200 K color temperature but with only a 50- to 100-hour lifetime. Type S photographic lamps employed an even higher over-voltage to

give a color temperature of 3400 K, but a lifetime that was just 1/10 that of a Type B lamp.

As a general rule the power rating of a photographic lamp was indicated by its fitting. Low-power lamps up to 250 W had bayonet caps, high-power lamps from 1000 W upwards had bi-post fittings, and intermediate lamps had screw caps.

Improved Filament Lamps

To provide a greater projected brightness without paying a penalty in terms of reduced lifetime some photographic lamps were manufactured with integral reflectors. This was achieved by applying an aluminum coating to the inside of the back of the glass bulb (a process sometimes referred to as "silvering") and was often accompanied by external frosting of the front of the bulb. The overall effect was an increased forward illumination without a hard, specular effect. Banks of lamps could be assembled to create a bright yet soft lighting effect—something that would have been impossible if each lamp had to be mounted in its own external dish reflector. This same idea was developed in the later 1960s by Colortran in the guise of its Cine-Queen, which became the ubiquitous parabolic aluminum reflector lamp (PAR-64) that was used in applications as diverse as stage lighting and car headlights. Banks of six or nine PAR-64 lamps, which had the highest lumens-per-watt rating of any 3200 K lamp then developed, were used to replace the Fresnel-lensed 225 A Brute arc lamps that had hitherto been regarded so warmly in the film industry. The later alternatives were more compact and offered a range of different coverage angles thanks to a variety of different sealed-beam designs. PAR lights are not used extensively in stills photographic studios but may be employed when it is necessary to light a large area.

A more recent development, Derek Lightbody's Optex AuraSoft, is now widely employed in the film industry and also finds similar use for area-lighting in stills photography. The AuraSoft, and its AuraFlash cousin, relies on a large (60, 70, or 80 cm) specially designed dish reflector that is covered in spheroidal convex mirrors and is fitted with a semi-opaque front baffle. Behind the baffle can be placed a variety of light sources; tungsten-halogen (with switchable output levels), MSR (conventional or high-frequency), and electronic flash. The light is favored for use outdoors thanks to its ability to simulate natural sunlight, but it also provides very flattering flash illumination for studio-based fashion and portrait stills photography. AuraSoft is unique among light fittings because it received accolades from both the Academy of Motion Picture Arts and Sciences and the Academy of Television Arts and Sciences.

Returning briefly to the pre-PAR era another problem, caused by the expanding use of color film, was the change in color temperature that tungsten lamps suffered as they aged. According to the 1952 book *Artificial Light and Photography* by G. D. Rieck and L. H. Verbeek, quoting the authors' own work and that undertaken by others, the color temperature of a 500 W Photolita lamp dropped by approximately 150 W over its (maximum) six-hour lifetime. This is a significant shift in a very short space of time that could result in unpleasant

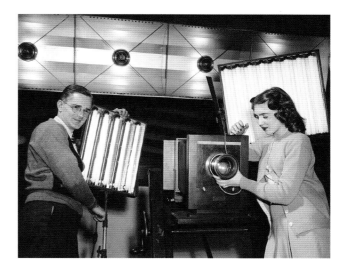

FIG. 85 Students at RIT pose with some recently acquired studio lighting equipment and cameras in the early 1950s. (Image courtesy of the RIT Archives and Special Collections, Rochester Institute of Technology, Rochester, New York.)

color differences if new lamps were mixed with old in the same lighting arrangement. It might also produce inconsistent results if the same sitter or object were photographed at different times or even during one extended session.

Tungsten-Halogen Lamps

The solution to this problem came in the form of tungsten-halogen lamps. These employed a halogen gas in the bulb's atmosphere rather than opting for an inert environment. Improved lamp life and color stability results because the halogen is able to combine with any evaporated tungsten vapor. This prevents both thinning of the filament and darkening of the glass bulb by retaining the tungsten in a gaseous state provided that the bulb's surface temperature is kept above 250°C. When tungsten-halide gas molecules approach the hot filament, by random movement inside the bulb, they decompose as soon as they encounter a temperature above 1400°C. This deposits metallic tungsten on the filament, thereby maintaining a more uniform wire thickness than would otherwise be possible. The liberated halogen is then free to combine with other vaporized tungsten atoms and continue the tungsten-halogen cycle. Sadly for users, but fortunately for lamp manufacturers, the process is not perfect because the hottest parts of the filament, where there is greatest metal vaporization, are at about 3000°C and therefore not prime sites for tungsten deposition. Even so, failures are most often due to mechanical damage caused by movement or rapid cooling of the lamp when it is switched off not to evaporation of the filament.

The first tungsten-halogen lamps were developed in the early 1960s using a quartz envelope (no longer globular in shape and therefore not correctly referred to as a bulb) that

contained iodine vapor in its atmosphere. Quartz was needed because the tungsten-halogen cycle requires the glass envelope to be kept very hot to prevent the tungsten halide compound from solidifying on its inside surface, and the temperatures required are in excess of those that can be tolerated by ordinary glass. Because of their distinctive components the new lamps were referred to as "quartz-iodide." Although these lamps were a significant improvement over the plain tungsten bulbs that they replaced, they suffered from a slight pink tinge that is characteristic of iodine vapor. In addition, quartz is easily attacked by mild alkalis, leading to premature failure of the envelope itself. Consequently, bromine was later used in place of iodine and synthetic "hard glass" (borosilicate glass, i.e., heat-resistant Pyrex) replaced pure quartz.

With carbon-arc lights it was felt that the whitest light was obtained by the addition of fluoride salts, therefore fluorine would be the best halogen to use in a tungsten-halogen lamp. This would indeed be the case were it not for the fact that fluorine is a very aggressive gas that attacks glass (hydrofluoric acid is used for etching glass). Another less reactive halogen, bromine, is preferred because it has a pale yellow color consistent with the color temperature of incandescent lighting and therefore can be regarded as colorless in this context.

A further complication introduced by the use of tungsten-halogen lamps was UV radiation, which is absorbed by conventional glass but transmitted by pure quartz. Focusing lights, which employ glass lenses, do not suffer from this problem. But in close-up portraiture it is necessary to avoid sunburn by fitting a toughened glass safety screen that protects against both lamp failures and unwanted UV emissions.

Such lights are still used in photographic studios today, often in the guise of 800 W "redheads" and 2000 W "blondes." These nicknames were coined by the Italian manufacturer Ianiro because of the casing colors used for its lights. In general these terms are used even when referring to the same wattage open-face lights produced by manufacturers such as Arri, all of whose lights are cased in blue.

Recent developments have focused on compact low-voltage lamps and high-quality optical designs to improve efficiency. One of the most advanced ranges is that designed by Dedo Weigert and sold under the Dedolight name. These lights are renowned for their high-light, low-heat output together with ultra-compact size and precision engineering quality. They are low-voltage systems that run at either 12 or 24 V and employ a patented focusing mechanism with dual-lens aspherical optics to ensure perfectly uniform illumination with no stray light, coupled with a 20:1 flood-to-spot ratio that is beyond the capability of any Fresnel lens system. Weigert was given a Technical Achievement Award by the Academy of Motion Picture Arts and Sciences in 1990 for his work.

Early Discharge Sources

The first attempts to pass electricity through a gas, with no solid conductor to carry the current, hark back to the experiments of Englishman Michael Faraday, who developed a device comprising two metal rods inside a glass container,

called the "Electric Egg," which could be evacuated and back-filled with different gases. The results of these early investigations into discharge phenomena were reported in Faraday's 1839 publication *Experimental Researches in Electricity*. Discharge phenomena also captured the interest of Dutchman Heinrich Geissler, who worked with his brother Friedrich to seal platinum wires through glass-walled containers so that very low pressures could be maintained inside. Other experimenters found that mercury vapor could be made to emit a dull glow, but it fell to Geissler to produce a sustained light from a discharge tube. Heinrich Geissler used his own low-pressure mercury pump to create the rarefied atmosphere needed for electrical conduction through gases, and he is now considered to be the father of gas discharge lighting. As reviewed in the section on Silver Halide Materials, the low sensitivity of then-available emulsions meant that Geissler's lighting technology was not immediately considered for photography, but rather was seized upon as both a scientific achievement and an attractive curiosity (because of the various colors that could be created).

French physicist Georges Claude experimented with Geissler tubes while developing a commercial method for liquefying air. The two aspects came together when Claude was able to extract xenon and neon from the air, in spite of their exceptionally low concentrations, and thereby obtained the gases that would be most important for electronic flash lighting (see below) and the everyday discharge lighting that was unveiled in Paris in 1910 and is known today as neon tube lighting. Neon lighting was both too dim and too ineffective (because of its red color) to be of any use in photography. Carbon dioxide tubes, which were used by Daniel McFarlan Moore in 1898 to light up a chapel in Madison Square Garden in New York, emitted a whiter light but remained too dim to be of much use for photographic lighting. The same cold-cathode technology was, however, subsequently developed as a light source for black and white darkroom enlargers until the demise of optical photographic printing at the end of the 20th century.

In all cases discharge lighting works by exciting the electrons in an atom from one state to another using the electricity supply provided. It then allows those same electrons to return to their former stable state accompanied by the emission of photons of light that may be inside or beyond the visible range of the spectrum. The changes in electron energy state are very precisely defined (quantized) and as such result in light of a very definite color (frequency) being produced. The spectral characteristics of a discharge lamp are therefore very different from those of daylight and incandescent lamps, both of which comprise a wide variety of colors emitted at the same time.

Controlling Color

The overall color of an incandescent lamp is directly related to its temperature, which in turn depends on its resistance and the applied voltage, and is described as a color temperature that is measured in degrees Kelvin. Although zero degrees Celsius is approximately 273 K, the two scales have the same incremental value so that, for example, 100°C is equal to 373 K and so on. If an incandescent lamp is too red in color (has

(a)

(b)

FIG. 86 These images demonstrate how a mineral will appear under (a) white light and in a (b) fluorescence imaging system. (Images courtesy of Kelly L. West, 2005.)

too low a color temperature) then its light can be made more yellow, and ultimately more white, by increasing the applied voltage and accepting a shorter lifetime for the lamp (at a higher color temperature). The same is not true of discharge lighting, where the color of the light produced depends on the energy-level changes that the electrons undergo. The result is a fixed, discontinuous spectrum of light that is dominated by certain colors and bears little similarity to the appearance of natural daylight.

The next leap forward addressed this problem by using the phenomena of fluorescence and phosphorescence, whereby some substances are seen to glow (emit visible light) when irradiated with UV light. Geissler had previously placed a droplet of mercury in his discharge tube and then evacuated the atmosphere so that only low-pressure mercury vapor remained. Under these conditions the emitted light is mostly UV, which is highly actinic on photographic film but also largely invisible. In 1893

the Serbian-American physicist Nikola Tesla, whose multiphase AC electrical systems deposed the DC systems preferred by Edison to become the dominant technology for electricity distribution, applied phosphor coatings to Geissler tubes to increase the amount of visible illumination. The result was a phosphorescent effect that differs from fluorescence because it can persist after the exciting energy has ceased. Even today this can be seen in some so-called fluorescent tubes that continue to exhibit a dull glow after they have been switched off.

By choosing a coating that fluoresces or phosphoresces toward the red end of the visible spectrum it is possible to balance the visible violet glow with a UV-induced red light, thereby giving a more natural overall color. The visual impression is one of white light; this is in fact an optical illusion. Sadly, photographic emulsions are not so easily fooled and the highly discontinuous spectrum emitted by a discharge tube will often create a strong color cast in pictures that are captured on film even when the lighting looks natural to the human eye.

At the end of the 1980s, after many years in the wilderness, fluorescent lighting became fashionable with stills and motion picture photographers with the advent of Kino Flo. These lights employ either daylight or tungsten-balanced fluorescent tubes and were born from a need to provide unobtrusive lighting in one scene for the 1987 film *Barfly*. Frieder Hochheim, who worked as gaffer to the film's Director of Photography, Robby Mueller, was so frustrated by the variable color of the fluorescent tubes he was forced to use that he set about obtaining lamps that could be deployed alongside other sources without introducing color casts. The result was Kino Flo, a brand name formed by truncating the German word for cinema with an abbreviation for fluorescent lamps.

To emphasize the difference between general-purpose fluorescent tubes and those intended for critical lighting applications a Color Rendering Index figure is used. Figures above 95 (on a scale that runs to 100) indicate good photographic quality and are a characteristic of Kino Flo lamps. Hochheim's work was recognized by a Technical Achievement Award from the Academy of Motion Picture Arts and Sciences in 1995.

The 1990s saw a growth in digital capture for which low-temperature, modest-cost continuous lighting was required. Among the manufacturers that responded was the now-defunct British lightbox company Hancocks, which mounted a bank of photographic-grade fluorescent tubes in a single housing to provide the same light output produced by a 1000 W incandescent lamp while drawing just 216 W of power and providing around 6000 hours of daylight-quality illumination. A different design, which bundled six 24 W tubes in a protruding cylindrical assembly, was devised by American softbox designer Gary Regester and sold under the Scandles name. In each case the softness of the source was complemented by the tubes' low operating temperatures and, therefore, the ability to place such lights very close to a set without risking undue heating of the sitter or any object photographed.

Banks of photographic-quality fluorescent tubes can also be employed as "active reflectors" to lighten shadows in areas

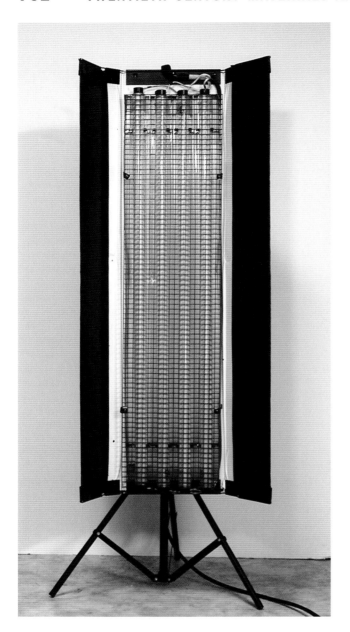

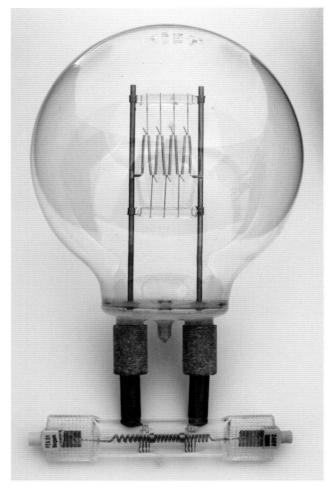

FIG. 88 Full-size glass-enveloped tungsten lamp and the modern equivalent lamp in compact quartz-tungsten-halogen form. Both lamps are rated at 2000W. (Photograph © Jon Tarrant.)

High-Power Discharge Sources

Lighting technologies come full circle when considering high-power discharge sources, which are the most advanced of all the available photographic lighting systems. Just as tungsten lamps evolved into tungsten-halogens, so discharge and arc lamps combine to produce ultra-bright sources epitomized by Osram's Hydrargyrum Medium-Arc Iodine (HMI) lamps, which first appeared in 1969. Other manufacturers followed suit with other acronyms, such as Philips' Medium Source Rare-Earth (MSR) lamps, but the technologies are all similar and Osram's HMI designation is often used generically.

These lamps were daylight-balanced and had four times the watts-to-lumens conversion efficiency of a tungsten-halogen lamp. Like fluorescent tubes they rely on the excitation of electrons in a gas or vapor environment, but in this case the distance between the electrodes is short enough for an arc

FIG. 87 Inspired by successful applications in the motion picture industry, daylight-balanced fluorescent tubes, in the form of Kino Flo lights, have been adopted for still photography. (Photograph © Jon Tarrant.)

that the light from other sources cannot reach. This possibility becomes especially important when each and every light source is baffled to affect a specific area, leaving no stray light to be directed into the remaining shadows. Large Kino Flo assemblies, which may be more than two meters long and typically comprise four tubes in a single panel, are ideal for this purpose.

to be formed. Unlike carbon-arc lights, which usually draw a direct current, HMI/MSR type lamps use an alternating current that can be either matched to the mains frequency or up-rated via a high-frequency ballast. The latter was important to avoid flicker when such lights were used with the scanning digital backs that were common in the mid-1990s, but is a less important consideration today now that digital capture is as instantaneous as film capture.

Residual drawbacks of HMI/MSR type lights include high capital and lamp-replacement costs, coupled with relatively modest lamp lifetimes (around 250 hours) and high UV emissions. This is not entirely surprising given that the spectrum produced is very similar to that of daylight, and were it not for the UV-absorbing property of the earth's ozone layer we would all be horribly irradiated with high-energy UV light from the sun. Fortunately, a simple glass screen is all that is needed to absorb the UV radiation produced by photographic HMI/MSR lamps.

At this point the largest single lamp of this type is used in the SoftSun light manufactured by Lightning Strikes. This lamp is rated at 100 kW yet can be dimmed down to just 3 percent of its maximum output without any color shift.

Light Modifiers

Modern continuous lights have evolved to become perfect solutions for particular lighting requirements. The uses for which specific lights are best suited can be judged by the external appearance of the unit and also by the geometry of the lamp that is inside. Small lamps tend to be used in lights that are fitted with lenses and generate hard-edged shadows. Larger lamps, which may be tubular or employ baffles to mask the filament itself, are better for area lighting. In many cases the geometry of the reflector mirrors the geometry of the lamp itself: tubular lamps are generally fitted inside reflectors that have cylindrical symmetry whereas near-point-source lamps are often used in circularly symmetrical parabolic reflectors.

Lightweight lens assemblies are created using the Fresnel design, which recognizes the fact that light is refracted when it crosses the boundary between two different optical media and that the volume of glass between the front and rear surface of a lens does nothing to focus the light. Fresnel lenses, which have also been employed in lighthouses, may feature a dimpled rear surface that helps to disperse the image of the filament that might otherwise be projected onto the set being lit. Fresnels differ from conventional lenses because their front surfaces feature a series of steps that retain the curvature of the lens without its bulk. Conventional lenses are employed whenever an image is deliberately projected, using a gobo shadow mask, for example, or when ultra-bright, hard-edged pools of light are required.

Although hard lighting can be softened by placing a diffusing screen between the source and the set (the same way that clouds in the sky diffuse the hard-edged light of the sun), this can be difficult in a smaller studio since it requires additional space. It also involves a loss of both brightness and contrast owing to the fill-in effect arising from light that is reflected from the rear of the diffuser and, thereafter, the studio walls. As well as avoiding such difficulties specialist softlights also permit greater control of forward illumination. One way in which this can be done is by fitting an "egg crate" (a series of protruding baffles) on the front of a softlight to restrict its angle of coverage without affecting the hardness of the illumination.

Overall, given the fact that continuous light sources are normally designed for specific purposes at the outset, there are fewer accessories available for these units than there are for modern electronic flash heads (see below), which are frequently designed to be as versatile as possible.

Electronic Flash Lighting
Early Ambitions

Early experiments with flash lighting were far more concerned with observing high-speed events indiscernible by the unaided eye than they were with providing a source of illumination for photography. It is a fundamental failing of the human visual system that we cannot perceive as a distinct identity any event that exists in a continuous sequence of events. This means that when a piece of ceramic is broken by a hammer or an object falls into a pool of liquid we cannot see the initial fracture nor the size and distribution of the droplets that are thrown into the air, respectively. Nineteenth century scientists who were keen to learn about such things needed a way of observing these brief events: They noticed that individual raindrops were apparently frozen in the air by a flash of natural lightning and sought to use electricity as a means of generating sparks that could serve the same purpose in a laboratory.

Although the scientific work in this area was led by Sir Charles Wheatstone, who is best remembered for devising a device that bears his name (the Wheatstone Bridge) to enable accurate comparisons of electrical resistances, it was William Henry Fox Talbot who performed the experiment that is generally credited as having first married flash lighting and photography. Extensive research into this event has been undertaken by Pierre Bron and Philip Condax as part of their excellent book *The Photographic Flash.* Research led them to conclude that the oft-cited version of Fox Talbot's experiment is unlikely to be completely accurate.

The usual version of the story, which records events that took place in 1851, has Fox Talbot photographing a front page of *The Times* newspaper that had been attached to a rapidly-rotating wheel. It moved with such speed that the newspaper was just a blur to the naked eye. The story also suggests that the spark that was used to illuminate the newspaper after the room had been darkened was provided by an electric charge that had been accumulated in Leyden jars. This last point is particularly appealing because Leyden jars were the first forms of capacitors. They provided a means of accumulating electrical charge over an extended period of time then releasing it in a split second, thus concentrating the electrical energy to produce a greater effect than would otherwise have been possible.

FIG. 89 Use of a stroboscope shares the location and speed change of a tennis ball over time when imaged using a 20 pulse per second flash rate. (Photo courtesy of Professor Andrew Davidhazy, School of Photographic Arts and Sciences, Rochester Institute of Technology, Rochester, New York.)

Unfortunately, Bron and Condax (drawing on letters exchanged between Fox Talbot and Michael Faraday) suggest that Leyden jars were not used, and that the electrical energy was drawn directly from a substantial battery. They also suggest that the amount of light generated would have been insufficient to illuminate an entire newspaper page, and propose instead that a small clipping could have been used. Fox Talbot's letter to Faraday reports that in the photograph "the image of the printed letter was just as sharp as if the disc had been motionless," which may mean that the printed paper, far from a newspaper, bore just a solitary character. Unfortunately the original glass plate has not survived so we may never know the truth.

James Killian, writing in the 1954 second edition of Harold Edgerton's landmark book *Flash!: Seeing the Unseen*, attributes the birth of the stroboscope to the independent efforts of Joseph Plateau in Ghent and Simon Stampfer in Vienna, both of whom devised (non-photographic) devices in 1832 that gave the illusion of movement from a sequence of still images — a principle that also gave birth to the better known zoetrope. Although it seems that Plateau probably led the way (some sources date his invention a year earlier), it was Stampfer's term "stroboscope" that triumphed over Plateau's less elegant "phenakistoscope."

The idea of using sparks to illuminate moving objects continued to fascinate scientists as photography developed, but the discoveries and techniques needed to manufacture an electronic flash tube simply did not exist. Xenon, which is the preferred gas for flash tubes because of its near-daylight effect on photographic film, was not extracted from the air by Georges Claude until the start of the 20th century. But other gases were used, especially at low pressure in discharge lighting, and Andre Crova appears to have used low gas pressures with spark electricity to create a stroboscope for freezing repetitive motion in 1873.

The first picture-based machine was Ottomar Anschutz's electrotachyscope, which was unveiled in 1887. As its name suggests, this was a device that used electricity to examine how things changed with time: This idea was not dissimilar to Crova's, but its application here was entirely photographic (Anschutz was a portrait photographer by profession). The machine employed a large hand-cranked wheel, around the perimeter of which was arranged a series of pictures taken using a bank of cameras in a manner similar to that employed ten years previously by Eadweard Muybridge to analyze a horse's gallop under the patronage of Leland Stanford. When the wheel was rotated each picture in turn was placed in front of a flash tube that fired to project the image for viewing. The flash tube was connected to a different battery for each frame, thereby avoiding the need to accumulate more energy from the same source in a very short period of time, and the sequence of projected images gave the impression of real-time movement. Immediately hereafter the majority of allied photographic efforts were focused on capturing and replaying motion (leading to the development of motion picture film) and also on recording very high-speed events as part of scientific and engineering investigations.

High-Speed Developments

In 1917 Etienne Oehmichen, an engineer working for Peugeot who invented and built the first helicopters, developed an electrical stroboscope to examine engines while they were running. By 1935 he had succeeded in capturing pictures at a rate of 1100 frames per second, but it was the brothers Augustin and Laurent Seguin who provided the important breakthrough of accumulating electrical charge in capacitors to create sparks with more energy than could be provided instantaneously from a battery. In addition they realized that a second electrical source could be used to excite the gas in the flash tube, thereby making it conductive and able to convert the stored electrical energy into light. They also identified the fact that the triggering circuit could be activated by the mechanical movement of the object examined. Until this point workers had all used a single electrical circuit that both ionized the gas and caused it to emit light. Heavy-duty switches were needed to bring the substantial amount of electrical energy employed to bear on the gas-filled tube, making the necessary equipment bulky, hazardous, and unsuitable for connection to other machinery.

The Seguin brothers, who commenced manufacturing in 1926 after several years of practical research and development, realized that for the entire time the gas in a flash tube is non-conducting it can be connected directly to a source of electrical energy without diminishing it. As soon as the gas becomes conductive it can then draw on the already connected supply of electrical energy without any requirement for making and breaking a mechanical contact. They sold two electrical flash systems, Stroborama A and Stroborama B (both using neon tubes), to car and locomotive manufacturers who needed to study repetitive mechanical motion, and

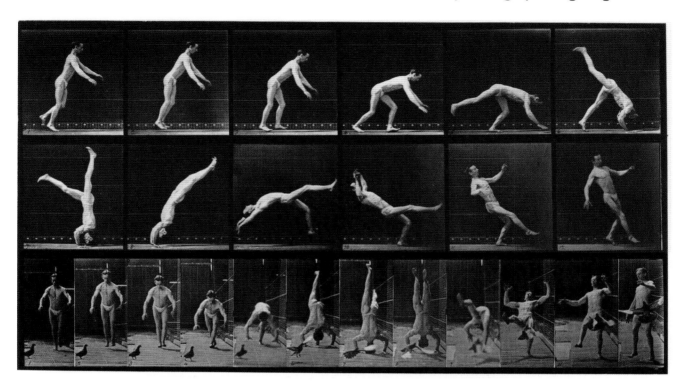

FIG. 90 Head-spring, a flying pigeon interfering Animal Locomotion, Philadelphia, 1887 by Eadweard J. Muybridge, ca. 1884–1887. Collotype print [GEH1978:0802:0365]. (Image courtesy of George Eastman House Collection.)

by 1931 had achieved a flash duration of just 1/1,000,000 of a second. Impressive though this was, it would have been a fairly meaningless achievement if the moment of exposure had not been linked to an event that no human could possibly react to with equal speed to capture such pictures at the exact instant required. It is for this reason that the Seguin brothers, and not Etienne Oehmichen, are credited with having invented the electrical flash system as we know it.

Harold Edgerton

Three factors combined to make Harold Edgerton the most important figure in the history of modern electronic flash lighting. First, all the necessary foundations had already been laid and reliable flash lighting systems had proved their worth in science and industry as a means of capturing information that simply could not be seen with the naked eye. Secondly, by the 1930s books were starting to feature good quality photographic images (some even in color) without having to bear an uncomfortably high price penalty. Thirdly, photography as a whole was becoming more attractive to the general public thanks to improved emulsion sensitivities and the development of color films. Harold Edgerton's expertise built on these foundations to create a flash system that had the same intensity as 40,000 standard 50 W bulbs of the type that were

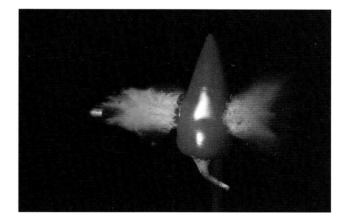

FIG. 91 The motion of a .22 caliber bullet traveling at 660 feet per second as it splits through a red pepper is recorded by the light from an air spark flash with a duration of 1/1,000,000 second. (Photo courtesy of Ted Kinsman, Kinsman Physics Productions, Rochester, New York.)

common for domestic lighting in that time. Such was the brightness of this light that full surface detail and color could be seen in moving objects where previously little more than a

silhouette had been recorded. A further strength of Edgerton's work was the variety of different types of circuitry employed for triggering the flash exposure, including his use of microphones to initiate the picture-taking process.

This in turn highlights a difference in use between technical flash photography and flash pictures that were taken by the general public. Whereas the former could be undertaken in blacked-out rooms if necessary to record stroboscopic effects, the latter had to be compatible with everyday picture taking. Advances in chemical flash photography had already introduced automatic synchronization of the flashbulb with the lens aperture; the same had to be true for electronic flash if it were to be accepted for everyday use. The problem was that flashbulbs have a significant burn time (and also a significant delay before maximum brightness is achieved), whereas electronic flash is almost instantaneous in both respects. The result was a need for a new synchronization setting, which was marked X on camera bodies to distinguish it from the M that denoted flashbulb synchronization. Failure to use the correct setting in either case would result in a failed exposure.

Despite the change from single circuit to separately ionized flash tubes a remaining problem was the need for cameras to carry the full ionizing current through their synchronization contacts. Because of this cameras could be subjected to voltages in the range of 150 to 400 V making electronic flash equipment potentially hazardous to use. This problem was solved first by using electronic valves and later by employing miniaturized semi-conductor circuitry, which dropped triggering voltages to as little as 5 V in modern flash guns.

Modern Flash Units

The term "modern" applies here to any equipment that might reasonably be found in general use today. It therefore includes some items that may be considered old-fashioned together with others that are considered "cutting edge."

The least portable modern flash systems are generator packs that are usually powered by a mains electricity supply but may feature integral rechargeable batteries for use on location. The packs contain substantial banks of capacitors and are fitted with control panels that allow users to vary their light output. Separate flash heads are attached to the pack by cables. An operational limitation is imposed by the maximum cable length that connects different heads to the same power pack. Triggering can be effected either via a cable that joins the camera to the power pack or using various types of wireless connection (short-range radio or infrared triggers). Maximum output is typically 3000 J from one head and around 5000 J from a single pack. Such units tend to be used only by professional photographers and as such a variety of different heads are offered to suit different demands. Generator flash systems, examples of which are made by the likes of Hensel, Balcar, Strobex, and especially the leading Swiss manufacturer Broncolor, are therefore similar to continuous light sources because their manufacturers respond to users' needs by designing lights that are custom-made for specific applications.

FIG. 92 Circular light sources, both continuous and flash-based, have proved popular as a way of creating shadowless illumination for close-up and fashion/beauty photography. (Photograph © Jon Tarrant.)

An alternative, and more economical, approach to heavy-duty flash is provided by the monobloc design, which combines a control panel and flash head in a single unit that is plugged directly into the mains supply. In this case there is no cable between the power pack and the head because both components are contained within the same housing. Major manufacturers of these units include Elinchrom and Bowens: typical ratings are around 600 J per unit but energies up to 1500 Ws are common (there is no current agreement about whether flash heads should be rated in joules, which seem more elegant, or in watt-seconds). A variety of different light modifiers is provided by each manufacturer to adapt their standard flash heads for particular uses. Large softboxes, which provide almost shadowless illumination, are particularly popular.

Truly portable flash systems are always battery-based and are frequently mounted on the camera itself. Often there is no opportunity to modify the light output other than to focus it to match the angle of view of the lens fitted to the camera. Originally this operation was done manually but dedicated flash guns that exchange data with the camera to which they are connected can now do this automatically. There are still some battery-powered flash systems that have a power supply that is worn as a shoulder or belt pack, but most draw their energy from either rechargeable cells or disposable batteries that are housed within the flash gun itself. Among the sophisticated features that are offered by modern battery flash guns are stroboscopic flash, automatic exposure (see below), anti-redeye measures, balanced multiple-flash lighting, and modeling-lamp mode.

Exposure Control

The problem that affects flash photography the most is the difficulty of seeing and measuring the effect of the light. Experienced photographers can judge the effect of daylight and continuous artificial light by eye to make a good estimate of the exposure conditions needed to achieve a good image. The same thing is impossible with flash lighting, so manufacturers adopted the Guide Number System, wherein each flash head is given a number that can be used to determine the correct aperture to use for different flash-to-subject distances. The stated Guide Number is equal to the product of the lens aperture (f-stop) multiplied by the distance: Metric Guide Numbers are based on distances measured in meters for ISO 100 sensitivity. Thus a flash unit with a metric Guide Number of 40 requires a lens setting of f/8 when used at a distance of 5 m to capture an image on ISO 100 film, and would require the lens aperture to be changed to f/10 if the distance were decreased to 4 m.

A subsequent development turned this idea on its head and allowed the photographer to choose a predetermined aperture. The flash gun then measured the amount of light reflected back from the subject and used a thyristor to either prolong or curtail its output (within limits) so that the best possible exposure could be obtained. This system worked well for common situations but was fooled by large objects either nearer or more distant than the main subject, as these things would significantly distort the flash gun's interpretation of the amount of light that was reflected by the subject itself. When long-focus lenses were used this problem became particularly significant because there could be many objects closer to the camera that were excluded from the field of view, and to have an exposure based on these features would risk serious underexposure of the final image.

The solution was provided by Nikon, who introduced "distance technology" into its lenses. This allowed information about the range of the object on which the lens had focused to be passed to the flash gun via the camera so that an initial estimate of the correct aperture and flash power combination could be made prior to exposure. This is complemented by the amount of reflected light measured from the area of the film that coincides with the position of the autofocus sensor that was used to focus the lens. Additional measurements are taken from the rest of the image and all of these data are compared against patterns of brightnesses stored in the camera's memory so that the very best exposure is recorded with minimal effort.

Digital cameras complicate this process because the reflection characteristics of their sensors do not match those of photographic film. For this reason automatic flash exposure quality suffered a setback during the early days of digital photography. Although this is no longer a serious problem, it does illustrate the difference in behavior between film and digital capture. This difference has also driven changes in lighting techniques and previously both threatened to make flash obsolete and, by the end of the 20th century, restored it as the dominant technology of choice for photographic use.

Lighting Chronology

Prehistoric times	Oil lamps and flame torches
Roman times	Candles are developed
1780s	Work starts on developing gas lighting in England and Germany
1792	Englishman William Murdoch invents a gas lighting system to illuminate his own home
1798	William Murdoch demonstrates gas lighting for factory premises in London
1799	Frenchman Phillipe Lebon patents the Thermo-lampe for gas lighting
1807	London streets begin to be illuminated using William Murdoch's coal-gas lighting
1808	Englishman Sir Humphrey Davy invents the electric arc lamp and deduces the existence of magnesium (though the metal is not discovered until 1829)
1810	Frenchman Austin Fresnel invents a lightweight lens design for use in lighthouses; the same design was subsequently adopted for focusing photographic lights and remains in use to this day
1825	Englishmen Thomas Drummond and Goldsworth Gurney invent limelight lamps
1829	Frenchman Alexandre Bussy isolates pure magnesium metal
1832	Belgians Joseph Plateau and Austrian Simon von Stampfer independently build the first stroboscopic viewing systems using a series of naked sparks
1836	Englishman William Staite improves the electric arc lamp by devising a clockwork mechanism to regulating the movement of the carbon rods to prolong the light's burning time
1839	Michael Faraday publishes his work on electrical discharge phenomena in *Experimental Researches in Electricity*

(*continued*)

Lighting Chronology

1840	Englishman Joseph Swan demonstrates that light is emitted when electricity is passed through a carbonized filament. The open-air filament burns away in just a few seconds
1851	On Saturday, June 14, Englishman William Henry Fox Talbot freezes the motion of a printed page mounted on a revolving wheel using an electric spark to take the world's first flash photograph before an audience at the Royal Society in London
1856	Dutch brothers Friedrich and Heinrich Geissler combine glass-blowing and engineering skills to manufacture low-pressure gas discharge tubes (subsequently known as Geissler tubes)
1859	Englishman Sir Henry Roscoe and German Robert Bunsen separately undertake trials for burning magnesium as a photographic light source
1862	The first commercial burner for magnesium lighting is introduced by the Magnesium Metal Company
1864	Englishman Alfred Brothers is credited with taking the first portrait using magnesium lighting
1865	Englishman William White suggests using powdered rather than solid magnesium as a way of achieving shorter exposure times; in the same year J. Traill Taylor shows that an oxidizing agent combined with powdered magnesium produces an increased effect
1867	Belgian Zenobe Gramme builds the first commercially viable AC electricity generator
1869	Zenobe Gramme builds the first commercially viable DC electricity generator
1873	Andre Crova uses sparks in a low-pressure gas atmosphere to freeze repetitive motion
1876	While working in France the Russian engineer Paul Jablochkoff (Yablochkhov) develops an improved electric arc lamp that needs no adjustment as it burns; it is marketed by the Société Générale d'Électricité to light streets, public buildings, and docks
1879	Englishman Joseph Swan and American Thomas Edison independently demonstrate the electric filament lamp; Edison obtains both British and American patents
1880	Thomas Edison opens his first electricity generating station, which is used to provide electric street lighting in London
1882	Thomas Edison patents the three-wire electricity cabling system; New York's Pearl Street electricity generating station brings electric street lighting to America
1883	Swan and Edison join forces to manufacture carbonized-filament lightbulbs
1884	German Ernst Mach uses spark discharges to photograph bullets in flight
1887	Prussian Ottomar Anschutz builds the first photographic stroboscope, which he names the electrotachyscope and uses to view pictures as a sequence of flash-projected images; the same year Adolf Mieche and Johannes Gaedicke formulate a flash powder using manganese peroxide as the oxidizing agent
1893	Frenchman Monsieur Chauffour seals magnesium wire inside a jar that is filled with oxygen to produce the first flashbulb; the same year Serbian-American Nikola Tesla illuminates the word "LIGHT" using phosphor-coated gas discharge tubes
1898	American Daniel McFarlan Moore illuminates a chapel at Madison Square Garden in New York using cold-cathode tubes that employed a mixture of carbon dioxide and nitrogen gases in lamps that became known as Moore's tubes
1901	Englishman Peter Hewitt invents the mercury-vapor arc lamp
1902	Electric filament lamps using osmium wire are introduced
1904	UV lamps are developed
1906	Evacuated tungsten-filament lightbulbs are introduced
1908	Englishman Professor A. M. Worthington draws on several decades of his own spark-illuminated photographs to publish a collection of images in *The Study of Splashes*
1910	Frenchman Georges Claude unveils neon tube lighting in Paris

Lighting Chronology

1913	American Irving Langmuir improves tungsten lamps by filling the envelope with an inert gas to reduce evaporation from the filament
1917	Frenchman Etienne Oehmichen develops an electrical stroboscope to allow the inspection of engines while they are running
1925	Augustin and Laurent Seguin patent (and in the following year start manufacturing) an electronic flash system that has separate triggering and light-emitting electrical circuits and also employs capacitors to store the electrical energy that will be used to generate light; the same year Paul Vierkotter patents an evacuated magnesium flashbulb that is back-filled with low-pressure oxygen
1929	The world's first commercial flashbulb is manufactured in England by General Electric under the Sashalite name and in Germany by the Hauser Company under the Vacublitz name
1931	Augustin and Laurent Seguin achieve a flash duration that is just 1/1,000,000 of a second
1932	Philips introduces wire-based flashbulbs using an alloy of aluminum and 7 percent magnesium, which Philips calls hydronalium
1935	The first camera to incorporate automatic flash synchronization with the shutter mechanism, the Ihagee Exacta Model B, is announced
1936	Fluorescent lighting is introduced; the same year Frenchman Marcel Laporte publishes his work detailing the white-light characteristics of xenon discharge lamps
1937	Flashbulb failures are reduced by a chemically active Blue Dot that indicates there has been no gas leakage and the oxygen level inside a flashbulb is correct
1938	A tough lacquer coating is applied to flashbulbs to prevent shattering
1939	General Electric launches its very successful Midget #5 flashbulb; the same year Harold Edgerton's book *Flash!: Seeing the Unseen* is published
1941	Otto Reeb defines the actinic value of photographic light sources; the same year Edgerton's battery-powered portable flash system is acquired by Kodak, which markets the 55J units under the name Portable Kodatron
1945	Edgerton and his partners split from Kodak and release all rights to the electronic flash system that they previously patented for the benefit of all manufacturers
1953	General Electric launches its M2 miniature flashbulb
1957	General Electric develops the quartz-halogen lamp, which subsequently goes into production in 1960
1963	General Electric introduces the four-in-one Flashcube
1964	Colortran receives a Technical Achievement Award from the Academy of Motion Picture Arts and Sciences for the development of its tungsten-halogen fixture that subsequently evolves into the parabolic aluminum reflector (PAR) lamp
1969	Osram introduces the hydrargyrum metal iodide (HMI) lamp; although the term HMI is often used generically for high-intensity discharge lighting it is an Osram trademark
1972	Braun and Metz introduce hand-held flash guns featuring thyristor circuitry for automatic exposure control with reduced battery consumption
1987	While working on the film *Barfly* gaffer Frieder Hochheim has the idea for Kino Flo color-calibrated fluorescent tubes; his efforts are recognized by a Technical Achievement Award from the Academy of Motion Picture Arts and Sciences in 1995
1988	Broncolor unveils the Pulso A system—a generator flash pack that features both adjustable flash duration and automatic color temperature control
1990	Dedo Weigert receives a Technical Achievement Award from the Academy of Motion Picture Arts and Sciences for his Dedolight design
1992	Nikon introduces a "distance technology" system based on the F90 35mm SLR camera, the SB25 electronic flash gun, and a new series of lenses that pass their focusing data back via the camera to enable the flash gun to determine an appropriate power level before the exposure commences

FURTHER READING

Bron, P. and Condax, P. (1998). *The Photographic Flash: A Concise Illustrated History*. Switzerland: Bron Elektronik AG.

Doering, W. H. (1938). *Lifelike Portraiture*. (Trans. L. A. Leigh). London: Focal Press.

Edgerton, H. and Killian, J. (1954). *Flash!: Seeing the Unseen by Ultra-High Speed Photography*. Boston: Charles T. Branford.

Fitt, B. and Thornley, J. (1992). *Lighting by Design: A Technical Guide*. Oxford: Focal Press.

Gilbert, G. (1954). *Photo-Flash, 4th edition*. London: Focal Press.

Mortensen, W. (1941). *Flash in Modern Photography*. San Francisco: Camera Craft Publishing.

Rieck, G. D. and Verbeek, L. H. (1952). *Artificial Light and Photography: A Treatise on Artificial Light Sources and Their Application in Photography*. (Trans. by G. Ducloux). London: Cleaver Hume Press.

Tarrant, J. (2001). *The Practical Guide to Photographic Lighting for Film and Digital Photography*. Oxford: Focal Press.

Tinsley, J. (1994). *Studio Flash Technique*. Hertfordshire, UK: Paterson Photax Group.

Wakefield, G. L. and Smith, N. W. (1947). *Synchronised Flashlight Photography, 2nd edition*. London: Fountain Press. ◉

The Camera Defined

BOB ROSE
VMI, Inc.

The camera is a tool that controls the transmission of light or other energy that is required to create a visual record using light-sensitive materials or digital sensors. The energy from a scene is transmitted into a dark chamber by an opening in one end, which allows light from the scene within the angle of coverage of the lens to enter the camera. The light going through the opening will form an inverted image on the opposite side of the unit where a film or other receptor will record the image. The amount of the light is controlled by the size of the opening in the camera or lens and the length of time the opening is left uncovered.

Since its invention, there have been great improvements to the camera's features but in reality little has changed in its fundamental role and function. In contemporary cameras, the light is focused using sophisticated lenses made from high-quality optical glass and captured using superb film emulsions or sophisticated electronic CCD or CMOS sensors. Using extremely accurate electronic shuttering systems, contemporary cameras have almost unlimited freedom to capture and record images. At no time in photographic history has the camera been more versatile. It is easiest to understand the operation of a camera by tracing the light's path from an object to the recording at the film plane.

Focus and Viewing

A simple camera with a fixed focal length lens will often have a separate viewfinder that approximates what will be recorded by the camera. This type of viewfinder originated in the first box cameras. It continued to be used for many years and is now common in single-use cameras.

With cameras that have lenses capable of critically focusing at different distances, a camera needs a method to observe if the lens is focused at the correct place. This can be achieved with single lens reflex (SLR) type cameras. Autofocus technology found in many modern cameras all but eliminates this requirement for the photographer.

If a camera has a back that can be removed then often a focusing screen made of ground glass can be inserted where the projected image would be visible. This is the case for large format cameras. After critically focusing using a dark cloth to control ambient light on the focusing screen, the film, which is kept in a light-tight film holder or a large format digital back, is inserted into the plane of focus and the exposure is made.

A twin lens reflex (TLR) camera uses a viewing system that incorporates two identical lenses mounted in two separate paths in the camera. One lens is located above the other and both are controlled using a common focusing movement. One lens is projected to the viewfinder and is used for composing and focusing while the other has a shutter and the camera's diaphragm and controls the camera's exposure. A TLR uses a film size that is smaller than a view camera but larger than roll film and has been defined as medium format. The light path to the viewfinder uses the lens, which is located on the top, and uses a 45 degree mirror so that the photographer can peer down into the camera and see what the scene includes, while the bottom lens with the shutter and aperture leads directly to the imaging plane. This type of viewfinder may have a very small error field of view that is described as parallax error.

SLR cameras basically use the idea of the TLR with the exception that it has only one light pathway that is active at any one time. There is a mirror in this camera type, which is located in the light path and is movable. Just prior to exposure, the mirror is lifted out of the imaging path by the camera's mechanics allowing light to reach the imaging system and exposing the film or digital sensor. When the exposure is made, there is no image traveling to the viewfinder.

A modification to the SLR type viewfinder is a rangefinder focusing system. This system splits the image into two images superimposed into the camera's viewfinder. When the lens is focused the images move. When the lens is focused at the correct location, the images are observed to be on top of one another.

Other camera viewfinders might be found in subminiature cameras originally designed for spying, stereo cameras, underwater cameras, and other specialized camera types that also exist to support special applications of photography. These viewfinders might have a framing area or a plastic structure

that is attached to the front of the camera defining the field of view. In some of these applications it may be challenging if not impossible to look through the system.

The simplest of camera types is by far the point-and-shoot design. This type of camera became popular when technology made fully automated film handling and exposure easy. Point-and-shoot cameras evolved quickly and now have completed integrated imaging sensors and command the largest market share of all cameras sold. This type of camera was the first mass-produced digital camera type. Although some cameras use very small viewfinders, the availability and use of electronic viewfinders on the back of these cameras allows for real-time viewing and relatively "instant" playback. This feature for many makes the optical viewfinder almost obsolete. Now it is no longer common to see a camera pressed up against a photographer's face (using an optical viewfinder), but rather at arm's length where the electronic viewfinder is most easily seen except in bright light.

Exposure
Light enters the lens and passes through an adjustable opening called a diaphragm. This determines how much light will enter into the camera through the lens. A camera also has a shutter, which is often placed between the lens elements and behind the lens assembly, or at the back of the camera directly in front of the film or imaging sensor. The shutter is controlled by a timing mechanism that can be mechanical, electronic, or electromechanical (a combination of both), which opens the shutter for a specific duration of time. The shutter and the lens diaphragm together control the amount of light that causes the exposure of the film or the light-sensitive receptors in the CCD or CMOS chip. Once equipment became more prevalent, hand-held light meters became common and were the only way to determine the amount of light falling on the subject. Cameras did not have built in meters to guide proper exposure determination. Now many cameras have built-in meters and sophisticated fully automated exposure systems.

Image Handling
At this moment in the evolution of photography and its equipment, there is still a wide range of film-based photographic products available. Film still is available in common sizes for each of the different camera types: sheet or cut film used in large format view cameras, roll film for medium format cameras, and sprocketed 35 mm roll film used for this format camera. Self-processing film for "instant" cameras and film backs can also be found. Film, of course, requires no extraneous light exposure and must be kept in a dark container before and after exposure. The camera itself is the dark container and controls the lack of ambient exposure. Similarly digital cameras enclose the sensor so only the light traveling to the sensor from the scene is recorded.

Cameras with digital sensors produce electronic data, which may be ready for direct use or further digital processing. Because the amount of data they produce will vary based on the size of the sensor and its related characteristics, the media required to store this data comes in a variety of sizes and data capacities. Rather than film, products such as compact flash, memory sticks, SD (secure digital) card, and other types of removable storage products are available. Some cameras also offer one or more compartments to hold removable storage media. Less sophisticated cameras require that these data be moved from the camera using a physical hard wire while direct wireless transmission of image data during a shoot is possible and gives the greatest mobility and flexibility to more professional users. ◎

The History of the Twentieth Century Camera

BOB ROSE
VMI, Inc.

With contributions from:

TODD GUSTAVSON
George Eastman House International Museum of Photography and Film

HIROSHI YANO
Japan Camera Industry Institute

Editor's note about the George Eastman House Technology Collection:
Numbering over 16,000 objects, the George Eastman House technology collection is one of the world's largest collections of photographic and cinematographic equipment. It contains nineteenth- and twentieth-century objects of photographic technology, including cameras, processing equipment, motion picture devices, and a broad range of early historical accessories. Many of the objects are unique, representing distinguished historical ownership and significant scientific achievement.

This collection is the most comprehensive held by any institution in North America and equaled in overall quality by only three other major holdings worldwide. From devices that pre-date the formal invention of photography in 1839 to the most modern state-of-the-art instruments used by both amateurs and professionals, the collection offers visitors an unparalleled opportunity to examine and learn about photographic technology.

The history of cameras is presented as a chronology of the events and times in the photographic industry. It is a series of "firsts" and is limited both by this concept as well as the space allowed. Therefore it can only list specific details and regrettably cannot include every company that has made a contribution to photography, most of whom no longer exist. It is, however, an accurate accounting of the facts and history itself.

At the start of the 20th century, photography had officially existed for more than 60 years. Even though George Eastman had introduced the simplicity of the Kodak camera about ten years earlier, "You press the button, we do the rest" was not

an affordable concept for potential photographers of all ages. With that thought in mind, Eastman started to deliver the Brownie camera. Priced at $1 the Brownie appealed to youngsters giving them six 2-1/4 × 2-1/4″ shots for only 40¢ on a 15¢ roll of 117 film. This concept was so good that this camera lasted in one form or another for 80 years.

Eastman also set the standard at the higher end with the Kodak Model 3 Folding Pocket camera which shot 3-1/4 × 4-1/4″ images on 118 film and incorporated a fold-down front with bellows and pull out lens. In the meantime, in Germany, A. Hch. Rietzschel GmbH (later to become Agfa-Gevaert) introduced their first camera, the Clack.

Cameras of new proportions like the Kodak No. 1 and No. 4 Panoramic came to the market and photography was considered so exciting that for the Paris Exposition of 1900 the Chicago & Alton Railway created the Mammoth. Shooting 8 × 4-1/2 ft. isochromatic plates and weighing in at 900 pounds (plus 500 pounds for the plate holder), the Mammoth was the largest camera ever built.

The year 1901 brought new technology in the form of the first transatlantic radio transmission, instant coffee, and the creation by Kodak of a foil wrapper package, which effectively kept moisture and humidity away from roll film. This allowed roll film to be used for the first time in countries with tropical climates like Japan. It was also the year that two competitors, E. & H. T. Anthony & Company along with the Scovill & Adams Company, formerly known for selling photographic products, merged to become the distributor and camera manufacturer Ansco.

Air conditioning was invented in 1902 making it possible for photographic materials to be better stored. The world was given its first taste of digitized imaging in the form of Dr. Arthur Korn's demonstration of an electronic scanning, transmission, and reproduction system — the forerunner to the fax.

Kodak marched on with the No. 2 Brownie Box Camera and the No. 3A Folding Pocket camera that were introduced to the public with a 3-1/2 × 5-1/4″ postcard format on 122 film. George Eastman purchased the rights to the developing machine, which was first used and publicized in the 1905 Russo-Japanese War.

Looking for recognition as artists, photographers banded together for the first time in 1902 when Alfred Stieglitz organized the Photo Secessionist show in New York City. The quality of photography improved dramatically as Dr. Paul Rudolph finished calculating the design of the Tessar lens in Germany, producing levels of sharpness and contrast that helped make the name of his employer Carl Zeiss legendary.

The first major motion picture film (*The Great Train Robbery*) was produced by Edison labs in 1903. Photography was used to document the historic few seconds of the first flight of the Wright brother's airplane in North Carolina. Across the ocean Agfa started to compete with Kodak by introducing its first film to the German market.

In 1904 Konishi-Hoten (Konica) stepped up to the challenge and introduced their first camera, one that would start the photographic industry in Japan. The Cherry portable hand camera was affordable and used readily available 2-1/4 × 3-1/4″ plates. Back in the United States Kodak introduced the No. 2 Folding Brownie, and the New York City subway introduced rapid transit to the masses. Meanwhile, Alfred Gauthier GmbH in Germany considered a different kind of rapid movement when he discontinued camera production but announced the new Koilos shutter design. The shutter name changed to Prontor (a play on the Italian word "pronto" to emphasize its quick activation) and the basic design is still in use in cameras today.

In addition, large format panoramic photography was introduced in the form of the Cirkut camera. Rotating on its special geared tripod head and shooting 10″ wide film (on 240 cm long rolls) the Cirkut camera reproduced a full 360 degree field of view. Like many cameras of the time that were available for an extended number of years, the path of ownership and production can be traced through an interesting journey. This was especially so in the case of the Cirkut, which was first introduced by the Rochester Panoramic Company in 1904, and continued production at the Century Camera Company in 1905, the Century Camera Division of Eastman Kodak Company in 1907, the Folmer & Schwing Division of Eastman Kodak Company in 1915, the Folmer & Schwing Department of Eastman Kodak Company in 1917, Folmer Graflex Incorporated in 1926 and Graflex Incorporated in 1945, and finally ending its 45-year run in 1949.

Einstein presented his Theory of Relativity in 1905 while Eastman purchased the Folmer & Schwing Manufacturing Company and moved it to Rochester. He added the Graflex large format single lens reflex (SLR) with its focal-plane shutter to the product line a few years later.

By 1906 technology helped us wake up to Cornflakes in the morning, and general availability of panchromatic black and white film enabled high-quality color separation color photography to become a reality. But the greatest technology to be realized was the fact that new and better lens designs made it practical to experience images sharp enough to incorporate focusing into the box camera, so the Kodak 3B Quick Focus box camera was born.

Image transmission over wires was commercialized with the first fax network connection between Berlin, London, and Paris in 1907. It was also the same year that Ernst Leitz (later of Leica fame) started in business as a manufacturer of binoculars in Germany, and Ansco Photoproducts in the United States introduced its first camera, the No. 1 Ansco. But the Lumiere brothers in France really made the news with the announcement that one-shot simple color photography was possible using their Autochrome plates.

The next year Kodak fully integrated the Press Graflex 5 × 7″ SLR into the product lineup and would later find that the Graflex design was the choice of press photographers who appreciated the option of two shutters — focal-plane and lens — as well as three viewfinders — optical, wire frame, and ground glass. About the same time the first Japanese SLR was introduced. Equally talented but with fewer user options, the Sakura Flex Prano only came with a focal-plane shutter.

Henry Ford opened the nation to travelers wanting to photograph and record the wonders of the great United States when he introduced personal transportation in the form of the Model T in 1908. In the meantime, demand for photography was so great in Europe that Agfa built the largest film production facility and F. W. Hasselblad & Company spun off a separate division, Hasselblad's Fotografiska AB.

Around 1909 a variety of different manufacturers started to make roll film backs for plate cameras. It was also the year that Laben F. Deardorff left for Chicago to open up his own camera repair shop after having designed the Scovill Trial camera, which was sold to the Rochester Camera Company and produced as the Primo View. The Compound shutter, the first sealed shutter for view camera lenses was introduced.

By 1910, Stieglitz' Photo Secession movement was no longer concerned about how to make photography an acceptable art — it was more concerned about "abuse" of the art by the rapidly growing numbers of amateurs. Photographic technology broke new ground in the United States when Bausch & Lomb produced the first optical quality glass made in America. At the same time in Germany, Ernemann had its own lens design and manufacturing divisions, which relied heavily on the leading lens designers of C. P. Goertz and Carl Zeiss Jena. It was also the year that Ernemann's top lens designer, Ludwig Bertele, revolutionized the industry with his formulas for high-speed lenses. Although some of these lenses did not start to appear in production for a number of years, Ernemann was responsible for the Ernostar of the 1920s as well as the Zeiss Sonnar and Biogon designs introduced in the 1930s.

As most camera manufacturers started moving away from all wood to wood/leather or leather-covered metal, the Premo camera was introduced by Rochester Optical Company. More news from Rochester was made when Rudolph Klein and Theodor Brueck left Bausch & Lomb to form the XL Manufacturing Company and produced lens shutters (and later, to avoid confusion with a similarly named Goertz shutter, they changed the name to the Ilex Manufacturing Company).

This was also a time when the use of bellows was becoming more common along with scientifically computed lenses and an increasing number of complex moving parts. Valentin Linhof, who years earlier produced the first shutter to be incorporated into a lens, stopped making shutters and sold this business to his partner Fredrich Deckel who eventually introduced the Compur clockwork timed shutter and the Compound pneumatic shutter.

1912 was a sweet year as both LifeSavers candy and Oreo cookies were introduced to the public. X-rays were also discovered and would soon be harnessed as a life-saving tool as well as one of the biggest uses for film around the world. Germany was still busy expanding the photo industry and Agfa built its first dedicated camera factory. New camera designs started to appear too as Plaubel & Co. announced the Baby Makina with its folding struts and interchangeable roll film holder backs for mainly a 6×9cm format. It was also a time for another company to come on the scene as Industrie-u. Handelsgesellschaft mbH was founded (becoming Ihagee Kamerawerk

GmbH in 1913 and ultimately Exacta). The Speed Graphic was announced in the United States, but perhaps no camera introduced that year was as successful as the Kodak Vest Pocket. This camera for the middle class made 1-5/8 \times 2-1/2″ images on 127 film and would inspire camera designs around the world for many years to come.

In 1913 dressing up became slightly more convenient and comfortable with the creation of the bra and the zipper. The use of film was more convenient too as Eastman Portrait Film started the transition away from the use of glass plates. Optische Anstalt Jos. Schneider & Company was founded in Germany.

The next year was costly for Kodak when Eastman paid Ansco $5 million to settle the Goodwin flexible film patent — to this day nobody knows for sure who was first. However, once Kodak resolved the flexible film battle, a new strategy for identifying film was adopted. Originally Kodak numbered film by camera model, now films would be numbered sequentially in the order they were introduced.

After only six years in production, the Model T was so popular that to reduce the number of accidents on the fledgling road system, the traffic light was born in 1914. To help all these new motorized photographers remember where their photographs had been taken, the Autographic Kodak was announced. It included a stylus that was used to scratch a message through a small door on the back of the camera. Inside, carbon paper acted as a stencil through which light could expose a frame of film with the written information — almost 20 models appeared through the mid-1930s ranging from the 1A for $23 to the 3A for $109.50.

Because cameras were portable and fast working, photographers started shooting fashion for magazines. Oscar Barnack was inspired to start using the scrap ends of 35 mm motion picture film in Germany to build his first Leica Prototype, but it was not the first 35 mm still camera. That honor goes to the Tourist Multiple which took 750 18 \times 24 mm exposures (or frames half the size of the ultimate 35 mm camera film format).

Unfortunately WWI started and had a big impact on the German camera industry. Even though there were more uses of photography for reporting purposes, Japan became less reliant on Germany for supplies and started to call on the United States for roll film and England for plates.

In 1915 the Technicolor two-color process (followed by the three-color process in 1932) started to pave the way for expectations of incredibly vivid color photography, although it was used exclusively for motion pictures. The Speed Graphic became the standard press camera as newspapers started to regularly include halftone reproductions. Kodak tried its first hand at color photography with the introduction of two-color Kodachrome.

Civilian options grew as a benefit of expanding military technology such as the introduction of the tunable radio in 1916. Kodak continued to expand the product line with the No. 3A Autographic Special Model B, which featured the first coupled rangefinder to assist with focusing.

Military needs continued and Kodak's most prolific scientist, Dr. C. E. Kenneth Mees, predicted wars would be supported by photography for tactical and documentary reasons. That prediction was followed up in 1917 when the Folmer division of Kodak developed an aerial camera and Japan Optical Co. (later Nippon Kogaku, K.K., and eventually Nikon) made their first lenses for aerial plate cameras.

The Bolshevik Revolution in 1917 was a period of experiment and general social upheaval that spawned the emergence of the Soviet camera industry during the late 1920s and early 1930s.

The Treaty of Versailles in 1919 ended WWI and started Prohibition. German companies attempted to revive their camera industry, and began working together in new ways, i.e., Nettel and Contessa who merged to form Contessa-Nettel. Their first product, the Contessa-Nettle Piccolette 127 Vest Pocket camera with its 75 mm f/4.5 fixed focus lens was introduced and became widely used as a press camera because of its portability and simple viewfinder. But some industry members resisted the idea of merging, such as entrepreneur Dr. August Nagel who laid the groundwork to create the basic camera that evolved into the Super Ikonta family of rangefinder cameras. He left to form his own company, Nagel Camera Werke, after Zeiss integrated some of the other German camera manufacturers.

One good by-product of the war was the introduction of personal first aid in the form of the Band-Aid in 1920. The first radio station KDKA went live, and women won the right to vote (in the United States). Kodak released the Brownie in six colors as well as Boy Scout and Camp Fire Girl models. This was also the era of the automobile. With more than six million vehicles on the American roads, and growing rapidly (up to more than 23 million in the decade to follow), Eastman sent professional photographers around the country to identify the first Kodak Picture Spots, which were marked with signs announcing "Picture Ahead."

The German photographic industry continued with its rapid attempt to recover by flooding Japan with post-war camera deliveries, but market resistance caused the final step in German company consolidations. The Carl Zeiss Foundation continued pursuit of a unified group of companies in 1920 by merging Ica, Contessa-Nettle, Goertz, and Ernemann ultimately forming Zeiss Ikon AG in 1926.

After seeing so many images of World War I, the public started to consider photography to be normal and the rotogravure process made the pictorial section of the Sunday papers more practical. In addition, it caused the birth of a number of illustrated magazines. It was in these printed pages that wartime photographers were given a chance to become the first major wave of news, sports, and documentary photographers.

Reinhold Heidecke and Paul Franke founded Franke und Heidecke Werkstatt für Feinmechanik und Optik (F & H workshop for fine mechanics and optics, which ultimately became Rollei) in Braunschweig, Germany, and a year later announced the Heidoscope, a three lens 6 × 13 cm format stereo plate camera, which produced a pair of 45 × 10 mm images making three-dimensional photography a possibility. The Rolleidoscope or roll film version appeared about three years later.

The years to follow were a bit slow for the industry and an anti-trust ruling required Kodak to sell six companies (two camera, one paper, three plate). The public was entertained both by the photography in the form of the first 3D movie and also when the discovery of King Tut was documented and publicized. As if that was not enough, the peanut butter and jelly sandwich was introduced making a perfect portable snack for photographers on the go.

Although Deardorff had been approached in 1920 by some photographers and architects in Chicago and asked to make an 8 × 10″ view camera with movements for their work, it was not until his eighth version in 1923 that he had a winner. Based on English folding designs of the 1880s, the Deardorff view camera with its extreme flexibility beat the competition for years to come.

In 1924 the first low-level light photography became available when the Ernemann Camera Factory introduced the Ermanox, which utilized the phenomenally fast f/2 Ernostar lens. It allowed documentary photographers to show events that could never have been photographed in the past, and was most famously used by Erich Salomon who, more than anyone else, can claim to have invented photojournalism.

Japan's economy was suffering, so the government implemented high tariffs on many photographic products. This forced more domestic development like the Pearlette, the Japanese imitation of the Vest Pocket (from Konica) and the acceptance of Voigtländer/Zeiss cameras using 120 film to get 8 or 16 shots versus 8 shots on 127 film.

Advancements in 1925 came from Ansco who offered semi-auto spring wind advance and the AutoAnsco wind, which advanced film each time after the shutter fired. But it was the E. Leitz Company who created a worldwide sensation with the introduction of the Leica 35 mm camera. The Model A, the first production Leica, featured a relatively fast f/3.5 lens and a range of shutter speeds from 1/5 to 1/500 second. Although 35 mm film was considered too small by some, this was the start of something really big. But it would take time for 35 mm to become accepted, which was evidenced by the fact that Ihagee was producing more than 1000 roll film cameras per day.

Ansco made big news when it announced the Memo camera in 1926. The first mass produced 35 mm was introduced to the United States along with the Ansco Photo Vanity, which included makeup in the camera's case lid. 1926 was also the year that the former Rietzschel cameras (opal, bag Clack, Kosmo Clack, special Clack) finally started to carry the Agfa rhombus to identify the new brand name.

In 1927 the first talkie motion picture and the television debuted. Lindberg crossed the Atlantic and we were introduced to PEZ candy. A new weapon was brought into the war against disease when penicillin was introduced, and the world found a new form of entertainer when Mickey Mouse appeared in his first cartoon.

The photo industry crossed continents when Agfa merged with Ansco. Their first introduction was the Billy 120 roll film camera which shot 6 × 9 cm images and stayed in production up until the 1960s. Kodak responded to the Ansco Photo Vanity with their own line of Vanity cameras in five colors — Bluebird, Cockatoo, Jenny Wren, Redbreast, and Sea Gull — and later as a Vanity ensemble with camera, lipstick holder, compact, mirror, and change purse. In Japan Nichi-Doku Shashinki Shoten (Japan-Germany Camera Company ultimately to become Minolta) was started, and in Germany the Rolleiflex twin lens camera, the first camera to really influence the professional photographer to shift from sheet to roll film, was introduced.

Lots of innovations were to be found in 1929. They included the car radio, frozen food, the Yo-Yo, bubble gum, and the first commercially available flashbulb, the Vacublitz. First introduced by Johannes Ostermeier in Germany, it was later manufactured by GE and sold in the United States as the GE20, and private labeled for Sashalite in England. Despite its innovations, the U.S. Stock Market crash is the most memorable event of that year.

Even so, the photo industry overseas was on a roll. The first EFTE plate cameras were produced in limited numbers by the Foto-Trud cooperative in Moscow, the first Nifcalette (Minolta) 127 fixed focus folding Vest Pocket camera came out of Japan, and Zeiss Ikon started a series of folding roll film cameras, which brought prominence back to Germany.

Who could not like 1930? Sliced bread hit the market, and to celebrate 50 years of business, Gold-colored anniversary Kodak cameras were advertised as free for 12 year olds. Over half a million were given away in the first two to three days.

The Fotokor-1, a 9 × 12 cm folding plate camera was produced by the State Optical Mechanical Works (Gosudarstvennyi Optiko-Mekhanicheskii Zavod, GOMZ) and almost one million were made before the next war. Seiko Precision, formerly Seikosha, founded in 1892 as the clock-manufacturing arm of Seiko Corporation, started to produce lens shutters. The Speed Graphic with both rangefinder and flash gun sync were introduced in the United States, while the 6 × 9 cm Voigtländer Bessa roll camera became a German classic.

However, the world market was captivated with the Leica I: the first Leica camera with threaded lens flange and a high-speed interchangeable Hektor 50 mm f/2.5 lens. This new lens mount with an M39 × 1 mm thread continued in the Leica line up until the M3 appeared in 1954. It is still in use today on many enlarging lenses.

America was proud of the new Empire State Building in 1931 and Kodak brought precision engineering to America from Kodak AG (Glanz Film Factory and Nagel Camera Works) by starting production of the Nagel Vollenda and the lightweight Brownie 620.

The first Japanese lenses for conventional photography came out in 1931 (Hexar by Konica, using Zeiss glass), and in Germany, the Baby Rollei 44 was born. The Baby Rollei, which used 127 film to make superslides (4 × 4 cm) was popular until around 1938. In the meantime, Voigtländer introduced the Brillant 6 × 9 cm roll film reflex camera, along with the scale focusing Bessa I.

Ansel Adams, Imogen Cunningham, Willard Van Dyke, Edward Weston, et al., formed Group f/64 dedicated to "straight photographic thought and production" in 1932. In unique contrast, in the F. E. Dzerzhinsky Labour Commune (named after Felix Edmundovich Dzerzhinsky, founder of the Soviet secret police), the FED Camera, a copy of the Leica A, was built.

Ihagee Kamerawerk and Steenbergeen & Company introduced the VP Model — a waist level SLR named after the Vest Pocket 645 format. The Leica II with a built-in, coupled rangefinder was also announced. Twin lens reflex (TLR) users were delighted to hear about the new Rolleiflex. Its mechanical system could finally place twelve 6 × 6 cm shots on 120 film that was originally intended for 6 × 9 cm spacing. Weston introduced the Universal 617, the first light meter with a photoelectric cell bringing with it levels of exposure accuracy previously unknown.

The Zeiss Contax I was introduced to compete with Leica and offered faster lenses and a faster top shutter speed. Japan had not yet accepted 35 mm as a quality format like the United States, so Kodak bought Nagel Camera Werke and started to design a more affordable quality camera. But the year ended sadly for Kodak when George Eastman, aged 77, wrote a suicide note — "To my friends: My work is done. Why wait?" — and then shot himself.

Post-war times had their better moments, even during a depression. Prohibition ended and music was heard for the first time over FM radio and in the form of stereo records. Exacta came out with the first roll film SLR and the first Minolta brand camera appeared in 1933. Minolta's Plaubel-type camera featured a side-strut folding design, a 105 mm f/4.5 lens made by Asahi, 1-1/1200 second shutter speeds, a built-in rangefinder, and it used sheet film or plates.

Coincidentally Plaubel Makina introduced their Model 2 body with a coupled rangefinder, which stayed in production with only small variations for the next 27 years. Not to be outdone, the Zeiss Super Ikonta folding spring-out design camera with rangefinder appeared as did the Voigtländer Superb roll film TLR.

The cheeseburger and the board game Monopoly were introduced in 1934. It was also the year that the modern 35 mm cassette (officially called the Kodak film magazine) was introduced by Eastman Kodak. Prior to this date, manufacturers of 35 mm cameras provided proprietary cassettes for their cameras. The FED (Leica II copy) became the first Soviet small-format camera to be mass-produced and only the second major Soviet camera of any type. And out in a small Japanese village located at the foot of Mt. Fuji, Fuji Photo Film Company, Ltd. was founded.

Zeiss introduced the art-deco styled Ikoflex TLR, but Kodak finally produced the Retina. The new Kodak "People's Camera" brought German engineering to the United States for $54 at a time when a Leica sold for $300. Even though the No. 2 Brownie only cost $2.50, the Jiffy Six-20 cost $6.75 and

PICTORIAL REVIEW May 1930

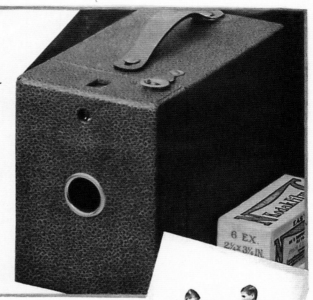

Mothers — this Camera FREE to any Child Born in 1918 !

(Any Child whose 12th Birthday falls in 1930)

Go to a Kodak dealer and accept one... complete with Roll of Kodak Film, FREE!

PAY NOTHING, BUY NOTHING

A Gift of 500,000 Cameras
to the Children of America
in Commemoration of the 50th Anniversary of Kodak

with the compliments of
George Eastman, Chairman of the Board of the Eastman Kodak Company

MOTHERS!

Beginning on the first day of May, 500,000 cameras, as illustrated, are to be given to American Children whose twelfth birthdays fall in any month of the calendar year 1930.

If you have a child who reaches the age of twelve this year, take your child to a Kodak dealer's and accept one of these cameras, complete with roll of Kodak Film—free. Buy nothing; pay nothing

The gift is made with the compliments of George Eastman, Chairman of the Board of the Eastman Kodak Company, to the Children of America to commemorate the 50th Anniversary of Kodak.

There are no reservations to the gift, except that no cameras will be given *before* May 1, or *after* May 31, 1930, and *none* after the original supply of 500,000 is exhausted. *To be sure of getting one, act early.*

The Gift's True Object

This gift is made to benefit both the giver and the children who receive it. Many eminent people hold that its

GEORGE EASTMAN
Creator of Kodak, which celebrates its 50th Anniversary by giving away 500,000 Cameras to American Children

acceptance is a duty every mother owes her child.

One leading educator declares that in developing *character, observation, appreciation of beauty and a depth of human understanding,* amateur picture-making is probably second to no other factor as an educational adjunct.

Another says that it brings a child in touch with every phase of life and nature, and implants *a clean interest* in the formative mind, during the dangerously impressionable years, when a wholesome pastime is

A GIFT of 500,000 Cameras

The camera—complete with one roll of Kodak Film—is to be given absolutely WITHOUT COST to any child whose twelfth birthday falls in any month of 1930.

500,000 cameras, as illustrated, are to be given to children who reach the age of twelve this year.

The gift is from the Eastman Kodak Company, with the compliments of George Eastman, Chairman of the Board, in commemoration of Kodak's 50th Anniversary.

Gift Cameras will be distributed May 1, 1930, by authorized Kodak dealers, and continued until the supply of 500,000 is exhausted. None after May 31, 1930.

To get a camera, simply take your child to an authorized Kodak dealer's. Pay nothing. Child must be accompanied by either parent or guardian.

most needed to safeguard the future of the growing child.

More and more, every day, thinking parents are regarding amateur picture-taking in that light.

* * * *

THIS GIFT IS MADE WITH TWO ENDS IN VIEW:

Sentiment: In appreciation of the grand-parents and parents of today, who, as the picture-taking children of yesterday, played so important a part in the development of amateur photography and of the Eastman Kodak Company.

To place in the hands of their children and grandchildren an admittedly important character-building force.

Business: To interest hundreds of thousands more children in picture-taking. And thus to raise amateur photography among the coming generation to even greater heights than its present remarkable peak. For as amateur photography increases in popularity, the use of Kodak products will naturally increase with it.

Beginning on May 1

The Anniversary Cameras will be at Kodak dealers' everywhere on May 1

Typical pictures, actual size, 2¼ x 3¼ inches, taken with the Anniversary Camera and Kodak Film.

—ready for distribution. None before that date. Take your child to one of these stores. Get the camera. No red tape, no delay, no cost.

The gift-giving period begins on May 1, 1930, and will extend into the month of May as long as the supply of 500,000 cameras holds out. Be sure of getting a camera for your child.

* * * *

EASTMAN KODAK COMPANY
Rochester, N. Y.

For a Noteworthy Expression from Mrs. Calvin Coolidge, as to the Significance of the Eastman Gift, See Page 63 of this Magazine.

FIG. 93 The ad as it looked for the 1930 marketing campaign. (Image courtesy of Eastman Kodak Company, Rochester, New York.)

the Vest Pocket Special cost $25, there were more than 60,000 Retinas sold to "serious amateurs" during its first two years of production.

Who could forget 1935; the year canned beer was introduced? The Soviet Union came out with the 6 × 9 cm Turist, 645 Reporter, and large-format (13 × 18 cm and 18 × 24 cm) film cameras. After the invention of a universal swing-and-tilt frame mechanism, engineer Nikolaus Karpf perfected Linhof's camera with the introduction of the first Technika (named from Technische Kamera).

Photography was first used for political means when the Farm Security Administration (FSA) brought Roy Stryker in to publicize the effects of the Depression and the forces of nature in the America. His photography got legislative support for recovery. Some of the most memorable photographs of all time were produced over the six years that Walker Evans, Dorothea Lange, Arthur Rothstein, et al., photographed rural hardships.

Color became a reality for amateur motion picture photographers when the first full color version of Kodachrome was introduced in a 16 mm format. Leica continued to evolve with the Leica IIIa, which offered a 1/1000 second top shutter speed. Rollei introduced the Rolleicord, which featured the Triotar lens and came in at half the price of the Rolleiflex. Zeiss announced the Contaflex 35 mm TLR with a built-in meter.

The first regular TV broadcast was made in 1936 on NBC-TV NY, and the first color negative film was announced by Agfa. Agfacolor-Neu color film had no less than 278 patented features in its design. Even though the Depression was not over, Leica sold more than 25,000 cameras that year at an average price of $300 each. This was quite remarkable considering a new Plymouth automobile cost only about $400.

But International Research Corporation appealed more to the masses with the Argus Model A priced at $12.50. The first low-cost, easy-to-use 35 mm film camera made out of Bakelite sold 30,000 units in the first couple of days. Pretty good considering the average weekly U.S. salary was only $25.

By 1936 the Contax II began producing the world's first camera with a combined viewfinder and rangefinder. The Hansa, built by Seiki Kogaku Kenkyusho (Canon) Precision Optical Instruments Laboratory, appeared as a Leica copy design concept with a Nikkor 50 mm f/3.5. The Reflex-Korell, 6 × 6 cm SLR was introduced as was the Ihagee Kine Exacta — the first 35 mm SLR. The Exacta incorporated an amazing array of features including a 20 speed shutter covering a range from 12 seconds to 1/1000 second.

Kodak finally came to market with the 35 mm Kodachrome, and *LIFE* magazine was first published opening the door for other photo feature magazines.

Some found the construction of the Golden Gate Bridge in 1937 to be an amazing engineering accomplishment and some were equally impressed with the production of the 2,000,000th Voigtländer lens. The LeCoultre Compass, one of the most complex and rare cameras of all time, was produced in very limited quantities.

A more commercially successful camera, the Argus C 35 mm camera (or the "Brick") appeared and two million were

sold during its initial year. The Minolta Flex was the first TLR manufactured in Japan and spy cameras were first seen in the form of the Riga Minox. This 130 g marvel was built by Valsts Electro-Techniska Fabrika Latvia, and used a 15 mm lens, with a fixed aperture of f/3.5, to make 8 × 11 mm images on 9.5 mm film. Exposure was controlled by varying the shutter speed from 1/2 to 1/1000 second. This basic design worked successfully in different models over the next 50 years.

More would be heard from the great grandson of Arvid Viktor Hasselblad, but after years of privileged exposure to the photo industry and travels, he opened his own photo shop, aptly named Victor Foto.

Freeze-dried coffee came on the scene in 1938 and the first practical commercial strobe was invented by Dr. (Doc) Harold Edgerton. Kodak introduced the first photoelectric exposure control (Electric Eye) 620 camera, aptly named the Super Kodak Six-20, Voigtländer came out with the Brilliant TLR, and the Russian FED-S (Cyrillic letter C, which corresponds to the English letter S), now included an additional top speed of 1/1000 second along with a faster f/2 lens.

Although the invention of the helicopter was exciting in 1939, its first use was for WWII which started that same year. This meant a change in the relationship between Agfa and Ansco, ultimately causing General Analine & Film Corp (GAF) to be formed many years later. German camera supplies dried up so the UK and the United States started making more of their own products. The first of many of these new products for Kodak were 2 × 2 Ready Mounts and the Kodaslide Projector. The Soviets managed to produce the 100,000th FED camera and Argus announced the extremely popular Argus C3 selling more than two million units over the next 28 years.

The year 1940 marked the end of production of German cameras as all facilities were shifted over to war-time requirements. Japan was caught up too as the first Minolta-made lens with the Rokkor name appeared on a portable aerial camera (it was a 200 mm f4.5 Rokkor copy of the Zeiss Tessar design). And the Swedish government approached Victor Hasselblad asking him to produce a camera identical to a recovered German 7 × 9 cm aerial camera. He built a better version called the HK7 a year later.

However, all cameras were not built for war. The Anniversary Speed Graphic integrated bed and body track rails allowing compression and focus for wide angle lenses, the Falcon-Abbey Electricamera, was the first camera with a flashbulb holder; in Japan, Mamiya Camera Co. built the Mamiya 6, a 120 roll film camera that moved the film plane to focus.

Back in the United States, the Office of the Alien Property Custodian (APC) instructed the U.S. government to sever all relationships with Agfa in Germany, and as a result took over Ansco during the war.

Over the following four years the world was amazed by the completion of Mount Rushmore and shocked by the attack on Pearl Harbor. In 1943 Kodak introduced its first true color negative film (in response to Agfacolor) just in time to photograph the first holiday season featuring Silly Putty, the Slinky, and the T-shirt.

By 1944 Ansco introduced Anscochrome, the first user processable color film. America and the world were captivated by the images shot by Margaret Bourke-White, Robert Capa, Carl Mydans, and W. Eugene Smith who covered the war for *LIFE* magazine. But, in 1945, nobody was ready to see the unbelievable photos of the atomic bomb. Fortunately, it marked the end of WWII.

The war had a disastrous effect on the people and the economy of two of the largest contributors to the photographic world. Allied Forces ruled that Japanese-made cameras could not be sold to the Japanese public until the company's overseas volumes were large enough for them to be considered a top camera exporter.

The treaty at Yalta positioned the American lines in Germany west, so Jena and Dresden fell under Soviet occupation, taking almost the entire Carl Zeiss Foundation with it. The Soviets claimed reparations and removed 94 percent of the Carl Zeiss tooling and factories, relocating them to the USSR as Kiev camera works began producing low-quality copies of the Contax and other Zeiss Ikon products.

But some of Zeiss survived and moved to Oberkochen where the German camera industry restarted. American GIs were anxious to use the Contax II and the Leica IIIc. In the newly founded firm Optische Werke Oberkochen—subsequently becoming Carl Zeiss Stiftung—126 of the former management and staff resumed operations.

Although the Japanese photo industry was basically destroyed, they were encouraged to rebuild and formed a coalition of companies. Copal began production of lens shutters and Kashio Sisakojo (Casio Computer Company Ltd.) was started.

From the USSR, Krasnogorsk Mechanical Works (Krasnogorskii Mekhanicheskii Zavod; KMZ) brought out the Zorkii (referred to in English as Zorki), a Russian word meaning "sharp-sighted," and the FED 35 mm camera was reintroduced (both were Leica II copies). In addition, Moskva (Russian for Moscow) introduced copies of the Zeiss Ikonta and Super Ikonta line.

In the meantime, the baby boom was going strong in the United States. Families were expanding and everyone wanted to use photography to share their special moments. So Kodak introduced Ektachrome, the first color film that photographers could process themselves with special chemical kits.

Japan still struggled with the photographic economy and for a time had to stop camera film production so that X-ray film could be made, but great progress was made in the rest of the world. Cambo BV was founded in The Netherlands and became the first European studio camera manufacturer to produce an all-metal large format camera. Third generation Swiss photographer Carl Koch wanted a camera for universal use and to satisfy the quick precise changing needs of the photographer, so he developed and patented the Sinar camera system. The Pacemaker Speed Graphic post-war model added new features to a design that continued for four more camera generations.

Perhaps one of the most remarkable events in 1947 was Dr. Edwin Land's announcement of the Polaroid Land Model 95, the first instant camera. Another group of photo enthusiasts became infatuated for the next 25 years with the Stereo Realist Camera from the David White Company. A glimpse of things to come popped up on the radar when Bell Labs announced the invention of the transistor.

After spending the war building sensitive clock movements, Victor Hasselblad introduced the Hasselblad 1600F, the first 6×6 cm consumer SLR with interchangeable Kodak lenses, film magazines, and viewfinders. Equally ambitious but totally unsuccessful was Bell & Howell's Foton. This was a first attempt by an American camera manufacturer to create a world-class 35 mm still camera with a 6 fps spring motor and T-stops. Its career was short-lived even when the initial price of $700 dropped to $500.

The first 35 mm cameras started to appear in Japan, reflecting the beginning of post-war industry. Pentax introduced the automatic diaphragm in a lens and Mamiya announced the Mamiyaflex, the first TLR with flash sync. Minox became available to the general public and started selling the Model II (A) while Nikon's first camera, the Nikon (later called model I) featured a 24×32 mm format and was described as some to have a Contax exterior and Leica interior.

Carl Zeiss Dresden (East Germany) introduced the world's first 35 mm SLR camera body with a built-in pentaprism viewfinder for unreversed image viewing. The Contax S (Spiegelflex or mirror reflex) featured a horizontal shutter and $M42 \times 1$ mm screw lens mount. This lens mount was quite remarkable as it became a "universal" lens mount for many and was most notably adopted by Asahi in 1957 when they changed from their original 1952 version $M37 \times 1$ mm screw mount. The universal or Pentax screw mount is still in use today. Due to the Zeiss post-war split some Contax cameras were also sold under the Pentagon brand, which later changed to Practica under the KW Company.

In 1949 Nikon moved closer to adopting the now standard 35 mm format with the Nikon M. Its 24×34 mm image allowed it to work with modern slide mounting equipment. This was also the year the Graflex Graflok back was introduced. With a metal focusing hood and removable ground glass in a frame, it became the standard for all $4 \times 5''$ view cameras.

In addition, Ilford Ltd.—the British manufacturer of monochrome plates, films, and papers—introduced a unique 35 mm ivory color enameled camera called the Advocate. Manufactured by Kennedy Instruments and utilizing a semi-wide angle 35 mm f/4.5 Dallmeyer lens, the body, with the exception of the viewfinder housing and the back, was a single piece die-cast aluminum pressing that gave the camera exceptional strength and durability.

In 1950 the credit card was born. *LIFE* magazine photographers discovered Japanese lenses (Nikon), which they used later in the Korean War. While Germany and Japan continued to recover from the war, this decade marked the Golden years of American (mostly Kodak) 35 mm cameras. Stereo cameras became especially popular, but a survey showed that overall only 16 percent of photos were taken in color at the time.

Hasselblad introduced more robust engineering into the newly designed 1600F but kept the focal-plane shutter. Leica

added variable flash sync to the model IIIf, while in Japan Ricoh announced the Ricohflex III TLR, the first truly inexpensive Japanese camera priced at ¥5800 (compared to most others costing ¥20,000).

The introduction of color television and Superglue occurred in 1951. The first video tape recorder was demonstrated at Bing Crosby Labs, and the world became aware of Univac—the first commercial computer, which weighed in at eight tons. The Nikon finally conformed to the 24 × 36mm full frame 35mm format standard when introducing the Nikon S. But the big news for photographers was that the slow transition away from flammable cellulose nitrate base, which had started many years earlier, was complete and all film was now Safety Film.

Although Victor Hasselblad had spent time at Zeiss Jena in 1930, he finally was able to adopt Zeiss lenses for his cameras in 1952. Meanwhile in Japan the Canon IVSb appeared as the first 35mm rangefinder with X-sync for use with strobes (strobos in Japan). The Asahiflex Model I, the first Japanese 35mm SLR built for mass production, featured a 50mm f/3.5 lens, 1/25 to 1/500 second shutter speeds, and a waist level finder.

The transistor radio was announced in 1953. The photo industry in Japan still lagged a bit as some components were in short supply. So Citizen Watch Company picked up the slack and began production of shutters. Rapid film transport was first demonstrated in the 35mm compact Voigtländer Vanessa and the West German part of Carl Zeiss finally got back in business with their first 35mm SLR, the Contaflex, which was a leaf shutter model and the first 35mm SLR to incorporate a behind-the-lens light meter.

The Asahiflex II was the world's first SLR with an instant return mirror. That same year, 1954, Japan Camera and Optical Instruments Inspection and Testing Institute (later called the Japan Camera Industry Institute; JCII) was formed to set standards and eliminate the image of poor Japanese quality. At this time the TLR became the most popular camera design in Japan.

It was also the year Leica announced the Leica M3 with its quick-change bayonet mount and bright-line frame viewfinder for 50, 90, and 135mm lenses.

Surveys in the United States showed a new level of prosperity. The 53 million American families who owned 38 million cameras were on track to take over 2 billion photographs a year. The shift from 4 × 5″ cameras to 35mm was accelerated by the introduction of Tri-X film.

Photographers lined up for the opening day of Disneyland in 1955. Velcro was introduced but did not quite interest the public as much as the Kodak Stereo Camera, which debuted at half the price of the Realist (signaling the beginning of its end). New camera brand names began to appear as Japanese companies were encouraged by the size of the market and the confidence that consumers were starting to develop photographs with Japanese products. The Miranda T (Orion Camera) was the first Japanese 35mm SLR with a pentaprism which, as a bonus, also happened to be interchangeable. The Olympus Wide with the first fixed 35mm lens gave ideas about future point-and-shoot (P&S) cameras.

Elvis gyrated on Ed Sullivan's TV show in 1956, but fortunately the TV remote control had just been invented so nobody needed to move from the couch to adjust the volume. Kodak introduced an amazingly tolerant Verichrome Pan film, which made taking quality pictures truly a snap. And at the same time Type C (color negative) and Type R (color reversal) print material standards were established so labs across the United States could produce better color prints more reliably.

The world entered the space age in 1957 when Sputnik orbited the globe. Asahi introduced the Pentax, the world's first 35mm SLR with right-hand rapid-wind lever, the world's first 35mm SLR with microprisms on a focusing screen, and the first Japanese SLR with a fixed pentaprism. Big camera news was Hasselblad's complete redesign of the system and utilization of a Compur shutter in the Hasselblad 500C, which was followed by the supreme wide angle (SWA) in 1954 and the 500EL motorized camera in 1965. In the meantime, Mamiya announced the Mamiyaflex C, the first interchangeable lens TLR and the Mamiya Magazine, a 35mm camera with an interchangeable back, moving film plane, and auto shutter cock actuated while winding film. With the Nikon SP Nikon found a way to make a single shutter speed dial handle the entire range of settings, where previously it required everyone else to use two dials.

The Integrated Circuit (IC) showed up in 1958 and the world was in for some big changes. Rangefinder cameras were the standard now, but many pros discovered that their exotic high-speed lenses could focus the light from the sun and burn holes in the camera's cloth focal-plane shutter. Manufacturers responded with alternate materials in new models like the Canon VL (stainless steel) and the Nikon SP (titanium).

Leica took the next step with a new bright-line frame viewfinder for 35, 50, and 90mm lenses in the M2. The Mamiya Elca became the first 35mm camera with match-needle metering, the Minolta SR-2 became the first 35mm SLR with auto diaphragm, and Yashica hit the market with the Yashica 44 while the Primo Jr. came from Tokyo Kogaku Kikai K.K. (Topcon) and Zenza Bronica introduced the first Japanese 6 × 6cm SLR.

By 1959 Nikon decided to discontinue the rangefinder camera, but response from press and magazine photographers kept them in production with Nikon SPs for another five years. Fortunately that did not stop them from introducing the Nikon F, the first system SLR, which lasted for fourteen years and is currently in its sixth generation. Canon attempted to introduce a 35mm SLR but the Canonflex only lasted about three months. In Germany Agfa announced the Agfa Optima, the first fully automatic 35mm camera, and Voigtländer delivered the Zoomar, the first production zoom lens (36–82 mm f/2.8) for 35 mm still cameras (first in Bessamatic and Exakta mounts but later in 42M × 1 mm screw).

The swing lens panoramic Widelux 140 was brought to market by the Panon Camera Company. But the Japanese industry was delivering products at a haphazard pace so in an unprecedented alliance, the Japan Camera Industry Association was formed with 44 member companies. They all agreed

to limit new product introductions to only twice per year and launched the first Japan Camera Show, which was attended by 130,000 people during its 6-day run.

In 1960 Konica and Mamiya, together with Copal, developed the vertical Hi Synchro shutter, which was capable of running at speeds as fast as 1/2000 second. Its initial use was in the Konica F, the first 35 mm SLR with a built-in, external selenium cell meter. That was the same year as the Lord Martian (Okaya Kogaku), which had a selenium meter around the front of the lens designed to compensate for filters. Miranda came on the scene with the Sensorex, the first 35 mm SLR to provide full-aperture metering, and Olympus showed the AutoEye, the first compact 35 mm Japanese camera with automatic exposure. Around the same time Voigtländer's Dynamatic became the first 35 mm compact camera in the world with a fully automatic programmed shutter.

The Asahi Pentax S2 of 1961 featured a detachable CdS meter. For its 35 mm rangefinder series, Canon introduced the fastest lens in the world, the 50 mm f/0.95 lens. The Contax IIa and IIIa were discontinued bringing to a close the era of rangefinder Contax cameras. At the same time the first mass production camera line was built in Japan. It was a great year for film with the introduction of Fujichrome 100, Fujicolor 50, and Kodachrome II.

When John Glenn became the first American astronaut to go into orbit in 1962, bringing a camera was an afterthought. An Ansco Autoset (Minolta Hi-Matic) 35 mm camera was purchased in a local drug store and hastily modified so it could be more easily operated while he was working in space in his pressure suit. While other cameras have been used in space, the Hasselblad 500C was the first to be properly integrated into the program (in total, six special different models were built for NASA). Back in Japan, the Taron Marquis was the first camera with a built-in CdS meter shortly followed by the Minolta SR-7.

In 1963 The Kodak Instamatic 100 introduced the world to the first successful drop-in loading 126 cartridge camera — all for only $15.95. After a 10-year run the records show that more than 70 million cameras were sold, so it is not surprising that the Instamatic-type camera signaled the start of the end for German viewfinder cameras. That year, Voigtländer introduced the Vitrona as the first 35 mm compact camera with built-in electronic flash. The Topcon RE Super became the first 35 mm SLR with a focal-plane shutter and through the lens (TTL) meter, and Olympus announced the PenF, the first half-frame 35 mm SLR. Also, underwater photographers were relieved to see that Nikon had purchased the Calypso camera from La Spirotechnique and refined it for reintroduction as the Nikonos I. The other big news was Polaroid's introduction of the first auto exposure instant camera, the Automatic 100, along with the first instant color print film, Polacolor.

The public was glued to their television sets in 1964 not only to watch The Beatles first appearance but also to see the results of the first high-quality electronic still photo transmission from Ranger 7 in orbit around the moon. At this time 220 film came on to the scene and cut down on the number

of rolls of 120 film that photographers had to carry. Germany continued to lose its share of consumer cameras, which mostly featured lens shutters. As a result Zeiss merged the two shutter manufacturers it owned — namely Prontor and Compur — at the location of the Prontor Werk.

The CD was born back in 1965 but it would be a few more years before user recording could be a reality. Konica introduced the Auto-Reflex, the first shutter priority auto exposure SLR and the Koni-Omega Rapid, its 6 × 7 cm rangefinder with 120 and 220 backs. Minolta was the first to make it easy to use 220 film by featuring a 120/220 switchable pressure plate in the Autocord CDs TLR. Both Olympus with the 35EM and Yashica with the Electro Half announced the first Japanese electronic shuttered cameras. Leica brought its precision to the first Leica 35 mm SLR, the Leicaflex, and Sylvania announced the Flashcube. But the most memorable camera of the year was Polaroid's instantly successful $20 Swinger instant camera.

The first time anyone saw a hand-held calculator was in 1966. It was also the first time a lens with aspherical elements was produced in commercial quantities; the Leica M-mount Noctilux had a high-speed 50 mm f/1.2 lens. In Japan, Canon delivered the Pellix, a 35 mm SLR with a fixed position semi-silvered pellicle mirror that did not move during exposure thus eliminating mirror noise and vibration. It also reduced the light that reached the film because it had to be transmitted through the mirror. While pellicle mirrors work well, the Pellix was not a great commercial success (and neither have any other cameras that followed using this same technology).

In Germany, Rollei came out with two cameras: their first 6 × 6 cm SLR system camera, the Rolleiflex SL 66, and the smallest 35 mm camera at the time, the Rollei 35. Despite its relatively high price, the Rollei 35 started the P&S revolution and sold more than 1 million cameras.

Technology permitted the first heart transplant, made the floppy disk drive a reality, and delivered the world's fastest film, Anscochrome 500, in 1967. It was also the year that marked the last Zeiss Ikon SLR, the Contarex Super Electronic (SE). Advanced for its time with behind-the-lens light metering, an electronically actuated shutter, and an accessory motor drive, it also was designed to accept an optional Tele Sensor that converted it into possibly the first aperture preferred automatic SLR. At the same time, in Japan, in spite of a reasonably positive track record, the Japanese camera industry (JCII) raised the standards bar just a bit higher to assure even higher levels of performance. These standards were used to convince everybody once and for all that "Made in Japan" meant high-quality.

By 1968 the first independent lens companies started to deliver lenses that could fit on different camera mounts via a method of interchangeable lens adapter systems. Soligor (Mirax Shoji) and Sun Optical were the first, but others soon followed. Konica delivered the AutoreflexT, the first TTL shutter priority automatic exposure 35 mm SLR. Leica improved their SLR and became the first to have selective light metering through the lens in the Leicaflex SL. It was also a big year for medium format roll film cameras in Japan with the introduction of the

Kowa Six, Fujica G690 RF, and Rittreck, among others. At this time Yashica started selling the TL electro-X, the first 35 mm SLR with an electronically timed shutter.

ARPANET appeared in 1969. It was the first practical computer networking system and the precursor to today's Internet. Although nobody could imagine what the Internet would become, our thoughts were out in space as we watched Neil Armstrong walk on the moon and marveled at the photographs he and his team brought back using their highly modified motorized Hasselblad Electronic Data Cameras (HEDC). The HEDC was equipped with a specially designed 60 mm Biogon lens with polarizer and a glass (Reseau) plate in contact with the film providing reference crosses that could be used to calculate various dimensions of parts of the scene. All twelve HEDCs taken to the moon are still there, only the film magazines were carried home. Back home on earth, Asahi continued to follow the medium format roll camera trend by introducing their scaled up version of a 35 mm SLR, the Pentax 67.

Although Nikon was the professional's choice in 35 mm SLR cameras, Canon took their first successful step into the high end of the market introducing the all black Canon F-1 camera with its extensive system of lenses and accessories. Light metering improved dramatically with the introduction of the silicon photocell, and the Fujica ST701 was the first 35 mm SLR to utilize it. Like Asahi the year before, Mamiya followed on the path of medium format roll cameras by introducing the Mamiya RB67, a 120/220 camera with revolving back.

The first e-mail was sent in 1971, and the Japanese government lifted a long-standing restriction on importation of color film, which opened the door for Kodak to expand into Asia. Asahi delivered the Pentax Electro Spotmatic (ES), the first aperture priority auto exposure and electronic focal-plane shuttered 35 mm SLR. Leica announced its first rangefinder camera with a built-in, selective area exposure meter, the M5. But the big news for consumers was Kodak's attempt to improve on the Instamatic concept by scaling down cameras and film to a 110 size cartridge. The new Pocket Instamatic format with its 13 × 17 mm image was well received, but never as successful as the full-size 126.

Polaroid took the next bold step in instant photography in 1972. The SX70 SLR camera could fold conveniently flat yet it delivered high-quality instant prints on a revolutionary new film. No more peel-apart packets. With the new system you could actually watch the self-contained print process in daylight. But all was not good for the German industry as Zeiss closed its Braunschweig plant and finally ended camera production.

Although most people did not know it, high-quality digital imaging systems were used regularly in 1973. The first commercial charge-coupled device (CCD) based digital cameras from Fairchild Imaging were fit into orbiting satellites and became the new "eye in the sky." Although the light-emitting diode (LED) had been invented two years earlier, the Fujica ST801 became the first 35 mm SLR to take advantage of the LED's bright illumination and low power consumption. Large format mass production ended in the United States when Graflex sold its tooling to Toyo Camera Company of Japan where they still continue to make 4 × 5″ and 8 × 10″ cameras.

A year after the oil crisis of 1973 the United States was affected by an increase in prices across the board in all markets. With higher prices, sales of camera bodies and lenses slowed down, so manufacturers looked to other ways to sell more and discovered there were great opportunities in providing new accessories. It was a good year for technology as Rollei delivered the Rolleiflex SLX, the first medium format electronic camera system. As a way to compete with Japanese pricing, Zeiss, Yashica, and Porsche Groupe teamed up to introduce the incredibly sophisticated Contax RTS 35 mm SLR camera system.

The first apochromatically corrected production lens, the Leitz Apo-Telyt-R 180 mm f/3.4, came out in 1975 as did the revival of the 6 × 4.5 cm format with the introduction of the Mamiya M645. Olympus delivered the OM-2, the first camera to measure light off-the-film (OTF) plane during exposure, and in 1976 Fujifilm introduced Fujicolor 400 the world's first ISO 400 color print film.

We saw the future in 1977. The Apple I computer was born and the first Star Wars movie (which turned out to be the fourth in the series) hit the big screen. Konica showed the world that autofocus (AF) was possible and delivered the C35 AF camera. Canon managed to fit a basic computer CPU chip into the very successful Canon AE-1 35 mm auto SLR.

A year later in 1978 Canon stepped up to announce the next generation and delivered the A-1. The A-1 had more automatic features than had ever been seen before, and they were all controlled from the first camera-based microprocessor system. This year also marked the end of 40 years of the universal screw mount (M42 × 1 mm) when Pentax converted their camera lenses to the K-mount bayonet (although Cosina would revive the mount about 25 years later).

The Sony Walkman first appeared in 1979 and Canon showed the AF35M (also called SureShot and AutoBoy). It was the first auto everything (expose, focus, wind, and rewind) camera that also incorporated an infrared (IR) system to allow it to focus in the dark.

Personal computers started to appear everywhere by 1981. IBM had its first desktop PC running on Microsoft DOS, and the floppy disk drive started to shrink down to 3.5″. The magnetic disc took another form as Sony used it as a recording medium in their first CCD-based digital camera, the Mavica. Pentax showed the ME-F, the first 35 mm SLR with AF (which only worked that way with their special 35–70 mm lens). Although it was a limited success, other manufacturers followed with similar designs.

The Instamatic concept took another twist in 1982 when the disc format was announced. The idea of providing 15 8 × 10 mm shots in a flat cartridge was clever but image quality was only good on small prints and the system only lasted about 8 years. More successful was the introduction of the DX encoding system, which provided electronic settings so each roll of film could tell the camera important information (eliminating the need to set film speed, for example) and

provide bar code details for labs to read. While Kodak was teaching film to speak, Fujifilm delivered speaking cameras. The Fujifilm Fotorama F55-V could actually tell the photographer what to do in several different languages ("Please use flash").

Big Brother was watching in 1984 when Apple introduced the Macintosh Computer. Electronic imaging made more of an appearance when Canon and Sony used prototype electronic cameras to record events at the Los Angeles Olympic Games. The first standard for electronic film camera recording media was set on a 47 mm magnetic disc, and CD-ROMs also became a reality. Fujifilm completely dropped the name Fujica and also announced the Fuji DL-200, the first modern 35 mm camera with pre-wind (which completely winds the roll out upon loading and rewinds frame by frame during use to protect the exposed shots).

The world first heard about Windows from Microsoft in 1985. Canon introduced the T80 35 mm SLR, which was the first to use pictographic settings, and Minolta shook up the camera industry with the announcement of the Minolta Maxum 7000 (or Alpha α outside of the United States). Initially called Maxxum, it was the world's first AF SLR system and was years ahead of everyone else.

By 1986 it became apparent that electronic imaging was challenging the computer with much larger image files than were originally imagined. To help minimize this effect, the Joint Photographic Experts Group was formed and the JPEG standard was established. It was also the year that the first commercial still video camera came to market when Canon announced the RC-701. A year later the first electronic still (not video) camera, the Casio VS-101, was delivered. And on the other end of imaging technology, Fujifilm revived the one-time-use camera (first popularized in the 1950s) with their QuickSnap.

In 1989 the first true-color photography editing system, PhotoMac, came to market. It was also the year Fujifilm introduced the world's first digital camera with removable media—Fujix Memory Card Camera DS-X.

The world had changed by 1990. Computers and digital imaging were no longer science fiction. The "standard" software for digital photographers, Photoshop V1.07, was on the market and Kodak announced the Photo CD. But the Contax RTS III arrived too and incorporated the most incredible array of technical features in a 35 mm SLR, which included for the first time both a real time vacuum back and a ceramic pressure plate that assured the ultimate in film flatness (the Leica M3 used a ceramic pressure plate and other cameras used vacuum backs, but both had never been used together). Another first was the pre-flash spot meter capability. But Zeiss had more good news. The German Democratic Republic allowed East and West German companies to merge and become one Zeiss Germany.

By 1991 consumer digital still cameras broke the 1 Megapixel barrier, and on the high end Kodak announced the DCS100 Digital, the first Kodak Pro-Digital SLR (with a CCD imager built into a Nikon F3). But the biggest event was when Tim Berners-Lee effectively created the World Wide Web and posted the first code demonstrating the ability to combine text, images, and sound on a Web page.

Apple was still the dominant computer in the graphics and photographic community in 1994, so it only seemed natural that they would introduce the first affordable camera for that market, the Apple QuickTake 100. Limited to a 640 × 480 resolution, the Kodak-built camera was superseded by the model 150 in 1996 and the model 200 (made by Fujifilm) in 1997. The rangefinder camera made a comeback with the introduction of the titanium-bodied Contax G1—the first new model since 1961.

The DVD was introduced in 1995 and Casio shipped the first "low cost" (¥65,000) digital camera with built-in LCD, the QV-10. In 1996 the world had the first look at a format that was destined to become a digital standard. The Advanced Photo System (APS) was announced by Canon, Fujifilm, Kodak, Minolta, and Nikon as the next generation Instamatic that utilized a new compact film cartridge with variable format imaging. It required the design of new cameras and lenses optimized for its relatively small imaging area. This was greeted with only modest success by the public. But the basic dimensions of the APS-C format (25 × 16 mm) were adapted as a standard by CCD manufacturers for digital cameras.

In the final years before the end of the century, professional cameras reached toward new performance levels with the Pentax 645N, which was the world's first medium format camera with a high-precision AF system. Digital camera backs were available for these pro-grade cameras providing performance and quality levels approaching and, in some cases, equaling films. By the year 2000, the consumer electronic industry started to drive camera development in a direction away from the imaging trends of the traditional camera companies. The market adapted and continues to adapt readily to the conveniences of smaller, more compact cameras and leaves the highest quality and more unusual applications to the limited number of specialized cameras and a unique niche of photographers.

FURTHER READING

Auer, M. (1975). *The Illustrated History of the Camera*. Boston, MA: New York Graphic Society.

Collins, D. (1990). *The Story of Kodak*. New York: Harry N. Abrams, Inc.

Fujimura, A. and Fujimara, W. (1991). *The History of the Japanese Camera*. Rochester, NY: International Museum of Photography.

Japanese Historical Cameras Screening Committee (2004). *The Japanese Historical Camera*. Tokyo, Japan: Japan Camera Industry Institute.

Gilbert, G. (1976). *Collecting Photographica*. New York: Hawthorn Books, Inc.

Wade, J. (1979). *A Short History of the Camera*. Hertfordshire, England: Fountain Press.

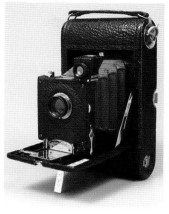

Figure (1)

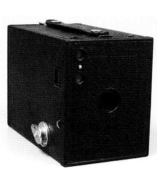

Figure (2)

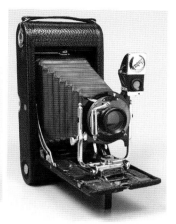

Figure (3)

Figure (4)

Figure (5)

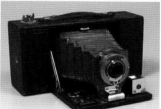

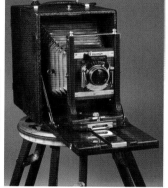

Figure (6)

Figure (7)

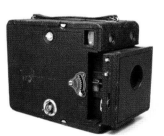

Figure (8)

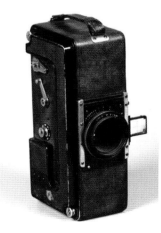

Figure (9)

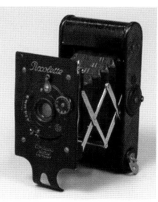

Figure (10)

Figure (11)

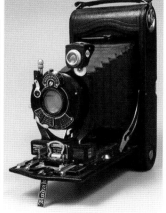

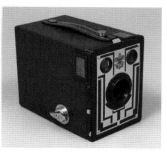

Figure (12)

[1] See the table following the photographs of the cameras.
[2] All images courtesy of the George Eastman House Technology Collection.

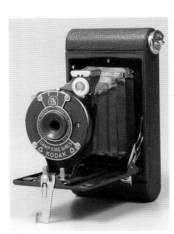

Figure (13a)

Figure (13b)

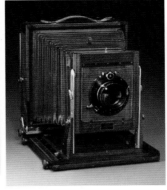

Figure (14)

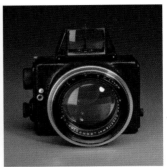

Figure (15)

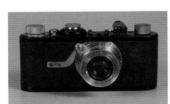

Figure (16)

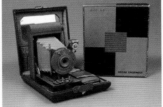

Figure (17)

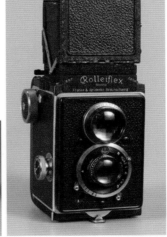

Figure (18)

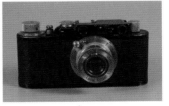

Figure (19)

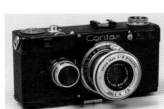

Figure (20)

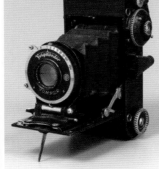

Figure (21)

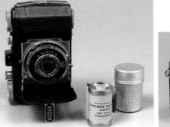

Figure (22)

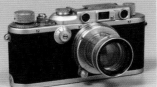

Figure (23)

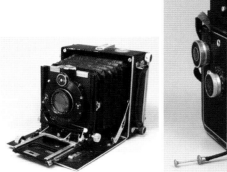

Figure (24)

Figure (25)

Figure (26)

Figure (27)

Figure (28)

Figure (29)

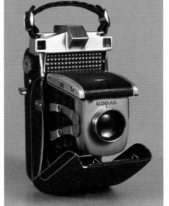

Figure (30)

Figure (31)

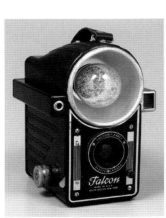

Figure (32)

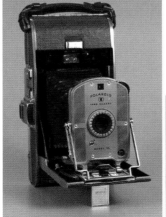

Figure (33)

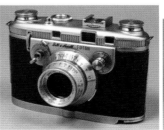

Figure (34)

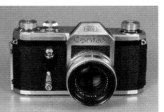

Figure (35)

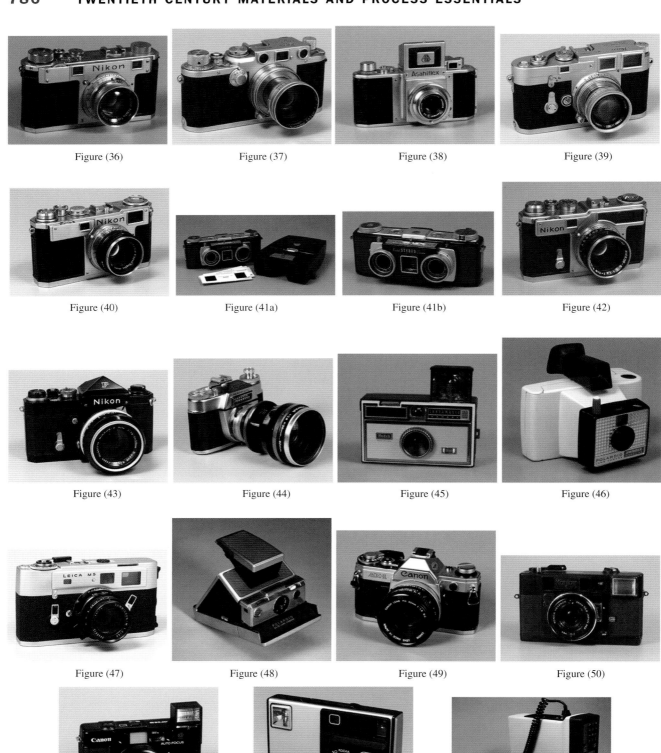

Figure (36) Figure (37) Figure (38) Figure (39)

Figure (40) Figure (41a) Figure (41b) Figure (42)

Figure (43) Figure (44) Figure (45) Figure (46)

Figure (47) Figure (48) Figure (49) Figure (50)

Figure (51) Figure (52) Figure (53)

Date	Maker	Camera[a]
1900	Eastman Kodak Company	Brownie (1)
1900	Eastman Kodak Company	No. 3 Folding Pocket Kodak (2)
1901	Eastman Kodak Company	No. 2 Brownie (3)
1902	Eastman Kodak Company	No. 3A Folding Pocket Kodak (4)
1903	Konishi-Hoten	Cherry Portable Hand (5)
1904	Eastman Kodak Company	No. 2 Folding Brownie (6)
1906	Century Camera Company	Cirkut camera (7)
1906	Eastman Kodak Company	No. 3B Quick Focus Kodak (8)
1914	New Ideas Manufacturing Co.	Tourist Multiple 35 mm (9)
1915	Contessa-Nettle	Piccolette Vest Pocket (10)
1916	Eastman Kodak Company	3A Autographic Kodak Special Model B (11)
1920	Eastman Kodak Company	Boy Scout Brownie (12)
1920	Eastman Kodak Company	Camp Fire Girls Kodak (13a and 13b)
1923	L. F. Deardorff & Sons	Deardorff (14)
1924	Heinrich Ernemann AG	Ermanox with f/2 Ernostar (15)
1925	E. Leitz GmbH	Leica 1 Model A (16)
1928	Eastman Kodak Company	Kodak Ensemble (17)
1928	Franke & Heidecke	Rolleiflex I (18)
1932	E. Leitz GmbH	Leica II (19)
1932	Zeiss Ikon AG	Zeiss Contax I (20)
1933	Voigtländer & Sohn AG	Voigtländer Prominent (21)
1934	Kodak AG	Kodak Retina 1 type 117 (22)
1935	E. Leitz GmbH	Leica IIIa (23)
1935	Linhof Präzisions Kamerawerk GmbH	Linhof Technika (24)
1935	Franke & Heidecke	Rolleicord (25)
1936	International Research Corp.	Argus Model A (26)
1936	Ihagee Kamerawerk	Ihagee Kine Exacta (27)
1937	Jaeger LeCoultre & Cie	LeCoultre Compass (28)
1937	Valsts Electro-Techniska Fabrica	Minox (29)
1938	Eastman Kodak Company	Super Kodak Six-20 (30)
1939	International Research Corp.	Argus C3 (31)
1940	Utility Mfg. Co.	Falcon-Abbey Electricamera (32)
1947	Polaroid Corp.	Polaroid Land Model 95 (33)
1948	Bell & Howell	Bell & Howell Foton (34)
1948	Pentacon	Contax S (35)
1948	Nippon Kogaku	Nikon I (36)
1950	E. Leitz GmbH	Leica IIIf (37)
1954	Asahi Optical Co.	Asahiflex II (38)
1954	E. Leitz GmbH	Leica M3 (39)
1954	Nippon Kogaku	Nikon S2 (40)

[a] The numbers in parentheses refer to the figure numbers of the cameras on the preceding pages.

(continued)

Date	Maker	Camera
1955	Eastman Kodak Company	Kodak Stereo Camera (41a and 41b)
1957	Nippon Kogaku	Nikon SP (42)
1959	Nippon Kogaku	Nikon F (43)
1959	Voigtländer & Sohn AG	Voigtländer Zoomar (44)
1963	Eastman Kodak Company	Kodak Instamatic 100 (45)
1965	Polaroid Corp.	Polaroid Swinger (46)
1971	E. Leitz GmbH	Leica M5 (47)
1972	Polaroid Corp.	Polaroid SX70 (48)
1977	Canon Camera Co.	Canon AE-1 (49)
1977	Konishiroku Photo Ind. Co., Ltd.	Konica C35 AF (50)
1979	Canon Camera Co.	Canon AF35M (51)
1982	Eastman Kodak Company	Kodak Disc (52)
1991	Eastman Kodak Company	Kodak DCS100 Digital (53)

Enlargers

BOB ROSE
VMI, Inc.

An enlarger is a precision optical device designed to project the image of a transparent medium at variable magnifications onto light-sensitive paper or film.

Early photographers did not need an enlarger. The only processes available produced the final image directly on whatever material was in the camera. Final image size was dependent on the format size of the camera.

As photographic technology improved, it became possible to make glass plate negatives. An exposed and processed glass negative was placed in contact with photosensitive paper to make each print (contact printing). The final image size was still limited by the camera format, but negatives were capable of producing multiple prints.

The desire for more convenient and portable camera systems, plus the introduction of film base in the late 1800s led to the development of smaller cameras. Unfortunately, fine details in the smaller negatives were not readily visible in a contact print. The solution was to project the smaller negative image onto photosensitive paper. Now, not only could all the details be enlarged, but the degree of magnification and final print size could be controlled.

Today, projection printing is standard practice and easily handled by the wide range of modern enlargers designed for conventional film and digital input. The following information primarily deals with conventional systems.

Basics

In its simplest form, an enlarger consists of a light source, a film carrier, and a lens. During operation, the light illuminates a negative or transparency in the holder so that the lens can project an image. Because standard laws of optics apply, increasing the distance between the enlarger and the projected image increases the magnification.

The similarity between enlargers and cameras is not surprising. A camera typically records a miniaturized view of a subject on film and an enlarger works in reverse to project and enlarge this reduced image to a size that is suitable for direct viewing.

Just like a camera, the exposure time required is dependent on the illuminance of the light image and the sensitivity of the photosensitive material. Exposure control can be as sophisticated as integrated electronic timing circuitry or as simple as a hand covering the lens.

We typically refer to the enlarged image as the negative. In actuality, this can be either a negative or positive image. Although the material exposed is most commonly negative-working paper, it can also be reversal, or positive-working paper. If required, one can also enlarge onto film.

In addition, enlargers do not always enlarge. Most systems also have the capability to provide image reduction.

Design

Two important considerations in the design of enlargers are the maximum film size that needs to be accommodated and the maximum magnification required. These factors are directly related to both the physical size of the enlarger and the space that must be provided for operation.

Today, more than a dozen film formats are used ranging from smaller than 8 × 10 mm to larger than 8 × 10 inches (203 × 254 mm). To maximize the performance of an enlarger, it is usually best to limit the range of film formats that it will accept. It would not be practical to expect one enlarger designed for 8 × 10 inch film to work efficiently with 8 × 10 mm film, which has an area 645 times smaller. The differences between the two are like comparing an image the size of

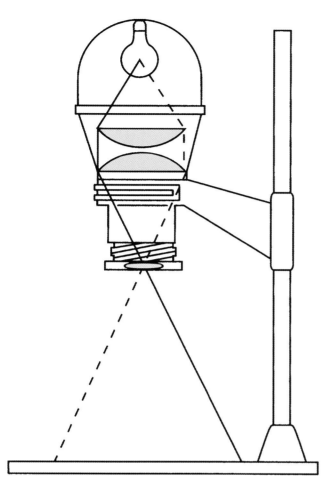

FIG. 94 Vertical enlarger. The optical system of the conventional vertical enlarger consists of a frosted lamp and condensers that spread the illumination evenly over the negative in the negative carrier. The negative is projected on the baseboard by the lens. Raising or lowering this entire unit alters the degree of enlargement; movement of the lens controls sharpness.

your small fingernail to one almost as large as a sheet of copier paper.

The magnification requirements of different formats can also be quite demanding if one enlarger is used for all applications. Most enlargers are designed to operate in a vertical orientation, but ceiling height can limit the extension and restrict the maximum print size. For occasional use, some enlargers can be rotated to project a large image onto the wall. For professional labs, however, there are enlargers specifically designed for horizontal projection. These enlargers ride on tracks mounted on the floor and are capable of projecting 8 × 10 inch films up to wall-sized or mural prints.

Construction

There are many differences in the way enlargers are constructed and operate, but most share the same basic components. We can organize the components into three subassemblies:

1. Column. The backbone of the enlarger, which links together all of the parts;
2. Base. Functions as the main support for the column as well as a place to position the holder for the photosensitive material;
3. Projection assembly. By far the most complex group of components, consisting of a lens and focusing unit, a film carrier, and an illumination system.

Column

It is the job of the column to act as the backbone of the enlarger and provide a smooth track upon which the movable components can ride. The demands placed on the column vary mainly in terms of strength. Vertical enlargers range in height from approximately 2 to 7 feet and in weight from a few pounds to several hundred pounds.

A small enlarger can have a simple column consisting of no more than a cylindrical or square tube. The weight and size of a big enlarger requires the column to be of heavy construction, often consisting of multiple complex metal extrusions bolted or welded together.

European and Asian enlargers have their columns in a straight upright vertical position. The logic to this design is that as components ride up and down the track, the optical centerline of the system is maintained. The image only changes size, not position. This means that the optical center must be located far away from the column; the column must be heavier to offset and support the extra leveraged weight.

American enlargers in general have taken a different angle, both figuratively and literally. A 5- to 15-degree slope is incorporated in the orientation of the column. The resulting enlarger can be lighter and less costly. When the magnification changes, so does the position of the projected image. The enlarging paper holder must be repositioned with each magnification change, following the image as it moves backward for small prints and forward for large prints.

A third approach to this construction is the use of two pairs of pivoting parallel arms. This parallelogram arrangement usually provides minimal movement of the projected image with changes in print size. By design this type of enlarger is limited in its range of magnification. Today this approach is only used in one enlarger model, primarily for the ability to provide direct linkage to a mechanical auto focus system.

Horizontal enlargers do not have a column in the strictest definition of the word. A column as long as a room would be costly to build and difficult to work with, so floor-mounted tracks or rails serve the same purpose.

Base

The base of the vertical enlarger can be thought of as providing two functions: (1) the main support of the enlarger column, and (2) a place to position the enlarging paper holder.

The most common configuration for an enlarger is with a half-height column mounted directly to a wooden board. This free-standing system is short enough to sit on a countertop yet permits an extensive range of magnifications. Because the

FIG. 95 Horizontal 8 × 10 inch enlarger. For selection, enlargers can be grouped into different size categories as shown in the table.

board provides the base for support of the system, it is called a baseboard.

Typically the image is projected down toward the base-board when enlarging. Photosensitive enlarging paper is held flat and in position in an accessory-enlarging easel or printing frame, which sits on the baseboard.

Full-height enlargers stand taller than most people. Their long, heavy columns could not be attached securely to a normal wooden baseboard, so a large metal U-shaped foot provides the base for this system. The need to support an enlarging easel still exists. A separate baseboard is incorporated either at one or two fixed points near the bottom of the column, or as part of an assembly that can be positioned at any point along the length of the column.

For some applications it is preferable to mount the enlarger on the wall. In this case, a special base combined with a top bracket attaches the column securely to a wall. The easel support function is provided either by a table or a custom-built counter with a baseboard that can be positioned at various levels.

Because conventional enlarging easels work best when sitting flat, they are not the proper choice for horizontal enlargers. For this purpose, it is preferable to work with a special vacuum frame or magnetic easel mounted directly on the wall.

Projection Assembly

The entire group of components that consists of the lens and focusing unit, film carrier, and illumination system is referred to as the projection assembly. On most enlargers the projection assembly is a complete module that is attached to the column by a component known as the carriage. The carriage moves along the length of the column (or on the rails of a horizontal enlarger) to whatever position or elevation is required for a desired print size.

Very small, lightweight enlargers require the operator to physically slide the projection assembly up or down to the proper elevation. Most enlargers, however, incorporate springs or weights that counterbalance the weight of the projection

Enlarger Size Categories

	Maximum Film Size[a]	**Acceptable Smaller Film Formats**[b]
Small format	35 mm (24 × 36 mm)	Subminiature (8 × 11 mm), 110 (13 × 17 mm), half frame 35 (18 × 24 mm), APS-C (16.7 × 25.1 mm), 126 (26.5 × 26.5 mm)
Medium format	6 × 9 (2¼ × 3¼ inch)	Full frame 35 (24 × 36 mm), 127 (4 × 4 cm), 645 (1⅝ × 2¼ inches), 6 × 6 (2¼ × 2¼ inches), 6 × 7 (2¼ × 2¾ inch)
Large format	4 × 5 inch (10 × 13 cm)	All in medium format plus 6 × 12 (2¼ × 4¼ inch), 9 × 12 cm (3½ × 4½ inch)
Extra large format	8 × 10 inch (20 × 25 cm)	4 × 5 inch (10 × 13 cm), 6 × 17 cm (2¼ × 6⅝ inch), 5 × 5 inch (13 × 13 cm), 5 × 7 inch (13 × 18 cm), 9 × 9 inch (23 × 23 cm)

[a] All sizes listed by most common designation followed by closest alternative dimensions in parentheses.
[b] Other formats may be accommodated with accessories or with restrictions on system performance.

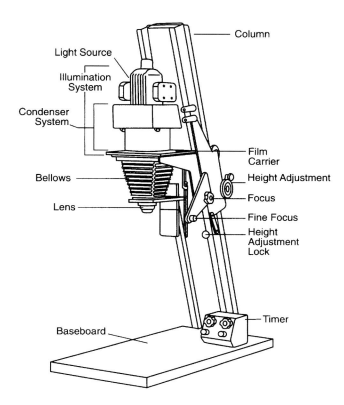

Column

Light Source

Illumination System

Condenser System

Bellows

Lens

Film Carrier

Height Adjustment

Focus

Fine Focus

Height Adjustment Lock

Timer

Baseboard

FIG. 96 Primary enlarger components and controls.

assembly to simplify movement. The actual mechanisms for movement vary and include friction drive, rack-and-pinion gearing, threaded-shaft drive, and electric motors. Some mechanisms automatically lock into position, while others require a manual operation.

Regardless of the method used, it is important that controls for this movement be easily accessible and operable at all elevations. Both coarse and fine elevation control is desirable, as is the inclusion of some scale of reference marker to indicate and permit precise repositioning of the carriage.

Lens

The proper selection of an enlarging lens is a key factor in the total performance of the enlarging system. This selection is often made difficult because the lens is an accessory not usually supplied by the enlarger manufacturer.

As with cameras, each specific film format has an ideal normal lens. The focal length of choice is considered to be one that is approximately equal to the length of the diagonal of the film. Unlike a camera lens, the lens of an enlarger is not changed to give different perspective effects. The purpose of the lens is only to project an undistorted, flat-field view of the film at various magnifications. A long focal-length lens may result in insufficient print size, and a short focal-length lens may not have sufficient covering power. Different film formats require different normal focal-length lenses. A lens selection chart for different film formats can be used. There are some exceptions to the guidelines given in the table below. When making very small prints (reduction), a longer than normal lens may be used. When making extreme enlargements shorter than normal lenses are chosen.

Lens manufacturers may also stretch the capabilities of their lenses by recommending a shorter than normal focal length in anticipation of a limited range of enlargement. Wide angle (WA) lenses are designed to offer greater magnifications for particular film formats. Specifically, these WA focal lengths of 40, 60, 80, 120, and 240 mm are intended to substitute for 50, 80, 100, 150, and 300 mm normal focal-length lenses, respectively. A slight loss in image quality may be the trade-off for this benefit.

Most enlarging lenses today offer certain operating controls which, although not essential, definitely are a convenience for darkroom work. These mechanical features include illuminated f-numbers, aperture adjustments with or without click-stops, and pre-set f-stop control.

The final criteria for lens selection are based on intended usage. One enlarging lens manufacturer lists five different 50 mm f/2.8 lenses, all designed to enlarge full-frame 35 mm film. Although price may seem to be a determining factor to measure some performance difference, upon closer examination specifications reveal more. One lens is designed to work best at 4x to make small prints (4 × 6 inch) while another is intended for 25x to make large prints (24 × 36 inch). The other three lenses are all optimized for a more typical print size at x10 (8 × 10 to 11 × 14 inch) but with varying degrees of optical quality. Of these three lenses, one needs to operate with the aperture closed down two stops and the other three stops to approximate the maximum aperture (wide open) performance of the most sophisticated lens in this group.

All enlarging lenses are equipped with a mounting thread so they can be attached easily to most enlargers. The universal or Leica thread M39 × 1/26 inch originated with the 35 mm Leica screw mount camera system and is the most common size mount today. Other sizes are used on long focal-length lenses, which have larger diameters and may be fitted with thread mounts up to M90 × 1. Enlargers often have some provision for holding filters for special effects, black and white, and color printing. One of the locations for a filter holder is directly below the lens. Because any filters used in the focused image path of the lens can affect image sharpness, it is preferable to reserve this position for optical effects filters. To change the color of the light, filtration should be inserted into the illumination system, where it will not influence image definition.

Focusing

To permit image focusing with different lenses and degrees of magnification, enlargers, like cameras, must provide the ability to vary the lens-to-film spacing. A light-tight sleeve should prevent any non-image-forming light from escaping or interfering with the projection path between the lens and the film. In specialty-model enlargers or those with limited capabilities,

this can be accomplished by a sliding or a rotating tube-within-a-tube arrangement similar to focusing systems on modern 35 mm camera lenses. Enlargers that accept multiple film formats, however, must provide more extensive adjustments.

It is not unreasonable to expect a 4 × 5 inch enlarger to have a lens-to-film spacing range from 1 to 12 inches, so the most convenient and common way to bridge this gap is to use a flexible bellows. Although bellows are quite simple and relatively inexpensive, they lack the rigidity of a telescoping tube. Therefore, standard practice is to attach the lens to a platform or lens stage and connect it to the enlarger carriage with a sliding post or rail. In this way the lens position can be varied relative to the film, which is held at a fixed location on the carriage.

Lens Selection Chart

Lens	Maximum Film Size[a]	Acceptable Smaller Film Formats[b]
28 mm	Half frame 35 mm	Subminiature, 110, APS
50 mm	Full frame 35 mm	126
80 mm	6 × 6 cm	645, 127
100 mm	6 × 9 cm	6 × 7 cm
135 mm	6 × 12 cm	6 × 9 cm
150 mm	4 × 5 inch	9 × 12 cm
180 mm	5 × 5 inch	6 × 17 cm
240 mm	5 × 7 inch	5 × 5 inch
300 mm	8 × 10 inch	9 × 9 inch

[a]Specific lens manufacturer's recommendations may vary.
[b]Other formats may be accommodated with magnification restrictions.

The way in which the lens attaches to the lens stage depends on the complexity of the enlarger. On a simple single-format enlarger, the lens may just screw in, as it will not have to be changed. Multiple-format enlargers are often designed to accept a lens board or lens plate that has the lens mounted on it. These lens boards usually snap in place or are held with a thumb screw and permit lenses to be changed easily. As an alternative, some enlargers offer an optional lens turret. Once installed, the turret provides the convenience of having any one of three lenses available simply by rotating the lens plate. The mechanisms for focusing are as varied as those used for elevation control, although they must operate on a smaller scale. In addition, the same requirements apply. Controls should be easily accessible and operable at all elevations, and coarse and fine focus controls are desirable.

Film Carrier

The image to be enlarged is generally a film original that needs careful treatment and handling. To facilitate this, the film is usually placed in a frame with a handle, which is commonly

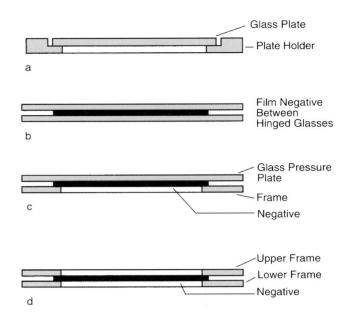

FIG. 97 Film holders: (a) glass plate holder, (b) full glass film carrier, (c) half glass film carrier, and (d) glassless film carrier.

referred to as a negative carrier or film carrier. Because the enlargement is made on a piece of flat enlarging paper, it follows that the film or plate original needs to be held flat and parallel to the paper during projection. This helps to assure an image that is sharp from corner to corner and true in shape.

The dimensional stability of glass makes this an easy task, and glass plates are the preferred choice of sensitized material for some precise scientific applications. A carrier for plates is usually a simple frame with a recessed groove that holds the plate in position.

The task of holding film flat is much more demanding, as films can vary in thickness from 0.003 to 0.007 inches and have a tendency to curl. Most glassless film carriers are of a two part design and sandwich the film between upper and lower frames that hold the film around the edges of the picture area. Small formats have less area to hold flat and can often be accommodated by the simple sandwich design. Each glass less carrier has an opening that precisely matches the dimensions of a single frame of the film format being enlarged. Any light not blocked or masked off by the carrier would mix with the image-forming light to reduce image contrast.

With larger formats, clear glass plates are commonly used on both sides of the sandwich to hold the film flat. While glass is preferred from the standpoint of flatness, it introduces additional problems. Each side of glass is an extra surface to keep clean, and any dust or scratches will certainly be visible in the enlargement. In addition, when the smooth base side of the film comes in contact with the glass pressure plate, microscopic discrepancies between the flatness of the two show up. This phenomenon is known as Newton's rings and has the

FIG. 98 Masking blades. Adjustable masking blades can be incorporated in (a) the film stage of the enlarger or (b) a removable film carrier.

appearance of irregularly shaped concentric rainbow patterns. To minimize this effect, the glass surface that will be in contact with the film base should not have a high gloss. Glass is available that has been lightly etched with acid or otherwise treated in a way to break up the smooth surface without interfering with the imaging requirements (anti-Newton-ring glass).

Glass carriers are usually sized to match the maximum film format of the enlarger. To accommodate smaller formats, either separate masks snap into the carrier or sliding masking blades within the carrier can be positioned to eliminate non-image-forming light. Some enlargers also have masking blades built into the support stage just below the carrier.

For certain cases where Newton's rings cannot be eliminated or the film original is damaged, a fluid immersion carrier offers the best solution. This special carrier has a glass pocket where the film is held flat in an optically clear oily fluid that suppresses surface scratches. Other specialty film carriers are available to provide rapid film transport of roll films. Some have unique film stretchers to flatten the film without a glass sandwich. Pin registration carriers are useful when printing with photographic masks or for complex multiple exposures.

All carriers are positioned over an opening in the projection assembly known as the film stage. Certain carriers slide directly into place, while others require the stage first to be opened or unlocked with a lever. Some systems insert a base/adaptor assembly in place for carriers to slide through. For greatest convenience an enlarger should allow easy insertion of the carrier and a way to release pressure on the film while in place on the film stage for final positioning and changing images.

Illumination Systems

The illumination system sits above the film carrier and provides light of appropriate intensity, color quality, and uniformity. There are two major components of the illumination system:

1. Light source—the lamp itself, a power supply or power converter, and some method of cooling the lamp.
2. Light source optics—the elements that spread and distribute the light across the entire dimension of the films to be enlarged.

An ideal illumination system should provide even, uniform lighting across the image plane. It should be bright enough to permit convenient exposure times, and the quality of the light should be compatible with color enlarging papers.

Light Source

The most basic light source for enlarging consists of a frosted or white lightbulb. The ones specifically designed for enlarging burn at a slightly higher color temperature (2900 K) than standard household bulbs (2600 K) and are more uniform in the way their frosting is applied. They often are powered directly on household line voltage and, depending on their size, can fit into a housing that will dissipate heat with the normal flow of air currents.

More power can be packaged into a smaller area with the use of a tungsten-halogen type bulb. These bulbs or lamps are clear glass with a special small filament that is designed to glow more brightly (3400 K) and burn more consistently than a standard enlarging bulb. Power requirements are often at voltages lower than that supplied from electrical outlets, so power converters or transformers are a necessary part of the system. In addition, voltage regulators or stabilizers are typically incorporated to guarantee accuracy and repeatability of exposures in more critical applications. The energy in this system is so concentrated that fans are often used to provide cooling. In some cases so much cooling has to be provided that the fans are remotely mounted and attached by a hose to prevent vibrations from affecting the enlarger.

Both types of lamps provide a continuous spectrum output. This means that they emit light over the entire visible range and can provide energy from ultraviolet to infrared. Although photographic papers can be sensitive to all of these energies, the invisible radiation is normally filtered out.

Another type of light source used in enlargers is the fluorescent tube. Its radiation is composed of output at a number of narrow bands of wavelengths combined with a continuous spectrum from fluorescence, which, to human vision, averages out to give the appearance of a white (or slightly colored) light. Some photographic papers have high sensitivity to this quality of light. Other photographic papers, however, especially color papers, require unusual filtration to compensate for the missing colors of the spectrum. The fluorescent tube does not generate as much heat as a standard bulb and is often referred to as a cold light. This fluorescent tube fits in a small housing, and although there are no cooling requirements, a heater is normally integrated to regulate the light and assure more consistent exposures. Special high-voltage transformers are necessary to power these systems.

Another non-continuous spectrum light source is the pulsed-xenon flash tube. Flash tubes are sometimes used in high-output systems matched to the printing requirements of specific papers. One computerized automatic light source incorporates a series of filtered tubes sequentially flashing at high rates. This effectively breaks up a single exposure into hundreds of small steps for precise manipulation and control.

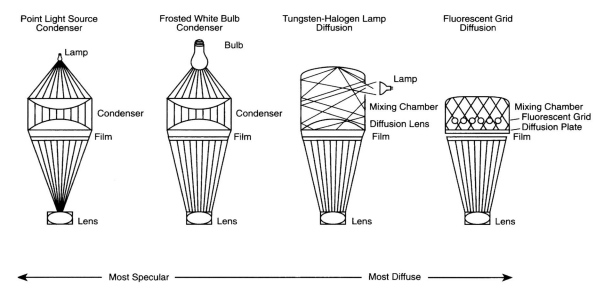

FIG. 99 Four typical illumination systems: point light source, frosted white bulb, tungsten halogen bulb, and fluorescent grid.

Customized power supplies and cooling configurations are required for these light sources.

Light Source Optics
All things considered, illumination systems incorporate optics that gives the best compromise of efficiency and performance for the most common working conditions. It is not an easy task to illuminate the negative or transparency evenly. The need to do this for a variety of film format dimensions makes the job much tougher. Further compounding the problem are the numerous possible operating magnifications. There are primarily two methods of optical construction used that offer quite different solutions to the problem:

1. Condenser—lens elements that provide concentrated, focused illumination;
2. Diffuser—translucent optical elements that provide scattered, non-directional illumination.

Differences in the projected images with these two lighting systems can be dramatic.

Four different illumination systems that vary from most specular to most diffuse are

1. Small filament clear bulb with condensers
2. Frosted white bulb with condensers
3. Frosted white bulb with diffuser
4. Fluorescent tube grid positioned next to diffuser

The major differences are in image sharpness and contrast. The effect on contrast is based on the amount of silver in a film image and is therefore mostly relative to black and white printing. Areas of opaque image silver block (and scatter)

direct light from condensers more than indirect light from a diffusion system. Low-density areas of film have little silver to block light and therefore transmit both types equally. Thus, the difference (or contrast) between high and low film densities is greater when illuminated by condensers than when illuminated with a diffusion system. This effect (Callier effect) was named after the man who discovered it (André Callier) and can be expressed in mathematical terms as the Q factor, or Callier coefficient, which is the ratio of specular to diffuse density for a given sample.

Because of the nature of the illumination, diffusion systems tend to minimize image defects and dust better than condenser systems. When contrast differences are eliminated through printing techniques, however, sharpness differences are not as obvious. Proper film handling and cleaning techniques are the preferred route to good image quality.

Condenser Systems
Condenser systems are composed of one or more lens elements that focus the light through the film and to a point near the enlarging lens, which in turn focuses the film image on the paper. In theoretically perfect systems, the point of condenser focus is precisely coincident with the center of the enlarging lens. Because of format changes, lens changes, and magnification changes, an exact match is seldom achieved. Some systems adjust condenser spacing or actually change condenser elements to shift focus and help compensate for some of these differences. In practice, for a given format, the point of condenser focus is usually designed to be slightly below the focus range of the format's corresponding enlarging lens. The converging rays from the condenser form a cone

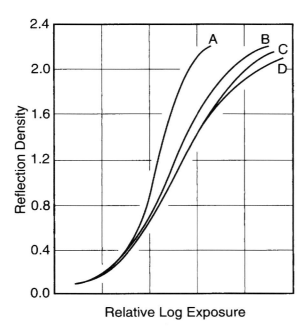

FIG. 100 Contrast differences for different enlarger systems: (A) point light source condenser enlarger, (B) frosted white light-bulb condenser enlarger, (C) tungsten-halogen diffusion enlarger, and (D) fluorescent grid (cold-light) diffusion enlarger.

non-image-forming light path will not affect the sharpness of the projected image.

Diffusion Systems

Diffusion systems can be of the simplest configuration, consisting of no more than a lightbulb, a housing with reflective white walls, and a single translucent plastic or glass plate on the output end. Much of the light in this system bounces around without reaching the enlarger lens, so it is not as efficient as condenser systems. If light power can be sacrificed, however, relatively large areas can be illuminated easily, and, unlike the focusing requirements of condenser systems, the diffusion system remains in a fixed position with output directly above the film stage. Because of the extreme scattering of light the enlarging lens focuses on a uniformly illuminated film at all magnifications and with all formats. The only adjustment that can be made to optimize illumination with format change is to modify the shape or size of the reflective walls of the internal diffusion chamber. In this way the same size lamp can concentrate its energy into more precise areas corresponding to smaller film formats.

Cold-light systems have a fluorescent grid in close proximity to the output diffusion plate. Because of this spacing and the design of the grid, the cold-light source is both highly efficient and the most diffuse of all illumination systems.

The most common diffusion configuration today is a system that deflects light projected at right angles to the optical output with either reflectors or mirrors. This light enters the diffusion, or mixing, chamber, where it blends into one consistency and is output through a molded or machined plastic diffusion lens that assures uniformity of illumination across the image plane.

One exception to the standard diffusion configuration uses a fiber-optic light transfer system. A fiber-optic cable transmits light from an external source to an expanded fiber-optic bundle that corresponds in size to the maximum film format. A diffusion panel at the output end of the bundle is used to eliminate any imaging of the ends of the fiber optics and provide a final blending of light. By design, this is a relatively efficient system and is more specular in output than traditional diffusion illumination.

Because of the low efficiency of most diffusion sources, two or more lamps are sometimes used for greater brightness. In addition, the optical mixing of diffusion systems is ideal for integrating various colors from filters or filtered lamps as well as neutral-density control. Virtually all illumination systems with built-in filters operate on the diffusion principle.

Integrating color filters requires one of two types of control systems. Either the controls are on the illumination system or they are attached to a console that is connected by a power cord. The units with controls on the illumination system generally have a series of knobs directly connected to filters. By varying the position of a calibrated knob, one can insert the specified density filter in the light path. On external control units this movement can be accomplished by small motors directly linked to the filters. An alternative system exists where two or more lamps are used, each one either colored

of light through which the enlarging lens travels. Therefore, regardless of the position the lens must be at for image focus, there is always light available within the cone to illuminate the entire image.

Improperly configured systems will have uneven illumination, most likely with a hot spot in the center. In the worst case situation the lens will project a circular vignetted (partial) view of the film image.

The size of the light source also influences this illumination condition. Large diameter bulbs project a larger area than small bulbs and are easier to work with. Conversely, some systems designed for specialized high-resolution imaging only use the lamp filament of a clear glass lamp for illumination. Because the filament is extremely small, it seems like a point to the condenser system and is referred to as a point light source. To accommodate the extremely small point source, it is necessary to provide precise three-axis positioning control for the lamp filament relative to the condensers. In this way all ideal conditions of condenser and enlarging lens focus can be met. This system needs constant refocusing and realignment of all optical components, but it provides the most specular type of illumination system for the most demanding applications.

Most condenser systems have a filter drawer or some other provision that allows for the insertion of colored filters into the light path. This location, as opposed to below the lens, is the preferred position for filtration. Filtration in the

or completely covered by a colored filter. In this case, the intensity of the lamps is varied and the resulting relationship between them gives the desired color balance. These systems are equally applicable in variable contrast black and white and color printing.

System Alignment

For optimum image quality, an enlarger needs to provide a strong rigid structure and maintain alignment among all the optical elements. The lens, film carrier, and illumination system components must be centered on the optical axis to assure uniform image illumination. For image sharpness the planes of the film carrier, lens board, and easel must be parallel. These requirements are very much the same as for process cameras.

Sometimes it is desirable to vary the relationship of the subject, lens, and film planes, as, for example, in an architectural setting where a conventional photograph shows converging vertical lines. A view camera offers image shape and sharpness control with tilt and swing adjustments. Some enlargers have similar adjustments.

As long as the enlarger lens plane and either the film plane or the easel plane can be tilted, it will be possible to correct converging lines on a negative or transparency and also obtain a sharp image on the print. The optical concept that permits this is named after Theodor Schiempflug, who first discussed the concept. The Schiempflug principal states that overall image focus will be achieved if the image plane, the lens plane, and the object plane are arranged so that they converge at a common point.

Equally important to the ability to provide this image control is the ability to return the enlarger, negative holder, and lens to zero settings precisely for normal operation.

Color Enlargers

Considerable confusion exists concerning the differences between black and white and color enlargers. In truth, there is no such thing as either. By its simplest definition, an enlarger projects an image that exposes photographic materials. That is all a black and white system has to do. If you can modify the color of the light with filters, you can use it to expose color materials properly as well.

The reason for the nomenclature is simple. When enlargers first came into existence, there was no color photography, so there could only be black and white enlargers. As color materials became available, these black and white enlargers were modified to accept color filters and therefore were capable of color enlarging. Further refinements in design included actually building the filters into a diffusion illumination system, which became known as a colorhead.

Eventually, it was easier to refer to an enlarger with a traditional frosted bulb and condenser system as a black and white enlarger. Those that had the colorhead illumination system were called color enlargers. This is still a common practice, although it does nothing to indicate to the user that either system is capable of both color and black and white enlarging.

Black and White Exposure Requirements

Standard black and white printing is possible with a variety of light sources. Graded paper is sensitive to wavelengths from long wavelength ultraviolet radiation to green light, with peak sensitivity in the blue. Most illumination system optics, enlarger lenses, and inexpensive filters absorb ultraviolet radiation so that all exposures are made with radiation in the visible spectrum.

Cold-light fluorescent systems have strong blue output, although they have almost no output in the green to red, so they appear visually dim. Because cold lights have strong output in the spectral regions where photographic emulsions have high sensitivity, such light sources are referred to as having a high actinic value. By comparison, tungsten light has a relatively low blue output but significantly higher output for the rest of the spectrum. It is visually much brighter but not relative to the sensitivity of the paper.

Panchromatic and variable contrast papers have spectral sensitivities that extend into the green and red regions and are not normally exposed well by the standard fluorescent light source, which is deficient in these colors. To provide the variable aspect of variable contrast black and white papers, the color of the light must be controlled. There are typically two color-sensitive emulsions that work together to form the basic shape (or contrast) of the variable contrast paper curve. One emulsion is basically blue sensitive and the other is blue-green sensitive. These are selectively and proportionately exposed either by yellow-magenta filtration or green/blue filtration to yield the desired contrast.

The simplest variable contrast filtration consists of a set of a dozen or more filters providing steps of contrast ranging from low contrast #00 (dark yellow) to high contrast #5 (dark magenta). As a convenience, a degree of neutral density is generally built into each filter to maintain a constant exposure value. This eliminates or minimizes exposure calculation when switching filters.

Illumination systems that have yellow and magenta filtration incorporated for color printing can also be used to control contrast with black and white variable contrast papers. Although there is a benefit of continuously variable filtration in this system, the particular filters used for color printing are often not optimum for the highest contrast black and white values.

Certain illumination systems designed for variable contrast have more specifically selected filtration. One system uses a sliding composite filter arrangement consisting of a yellow filter, exposure balanced with neutral density, and assembled next to a magenta filter. This pair of filters can be dialed into the light path to produce yellow light, magenta light, or a combination of the two. Contrast control is continuously variable over the whole range, and exposure is constant.

For higher output systems, two lamps are used, one for each color. A control system varies the intensity of the lamps to adjust the relationship of the two colors for contrast and exposure. Although magenta and yellow filters were once used for this purpose, it is more common now to use green and

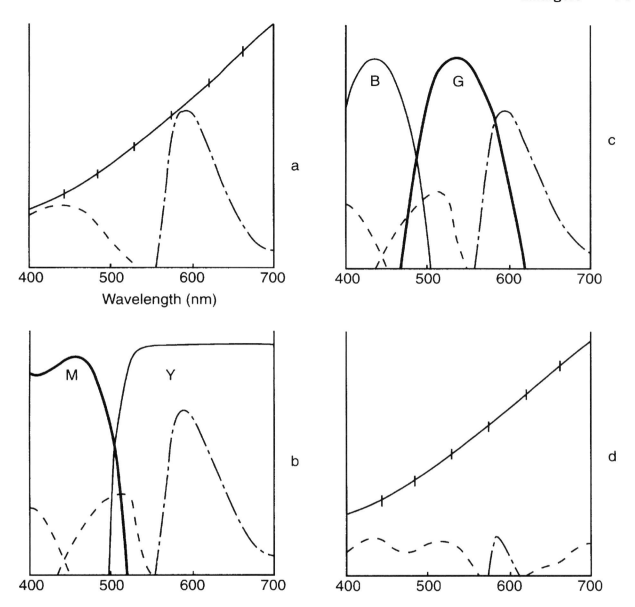

FIG. 101 Four curves illustrating the relationships of a light source, paper sensitivity and safelights. The vertical axis is relative, representing the relative energy of the light source, relative sensitivity of the paper, and relative transmittance of the safelight filter. (a) Graded black and white paper spectral sensitivity with white light exposure. Dashed line, photographic papers; solid line, 3200K lamp; broken line, amber safelight. (b) Variable contrast black and white paper spectral sensitivity with subtractive filters. Dashed line, variable contrast paper; broken line, light amber safelight filter; M, magenta filter (minus green light); Y, yellow filter (minus blue light). (c) Variable contrast black and white paper spectral sensitivity with additive filter exposures. Dashed line, variable contrast paper; broken line, light amber safelight; B, blue filter; G, green filter. (d) Panchromatic black and white paper spectral sensitivity with white light exposure. Dashed line, panchromatic paper; solid line, light source; broken line, dark amber safelight.

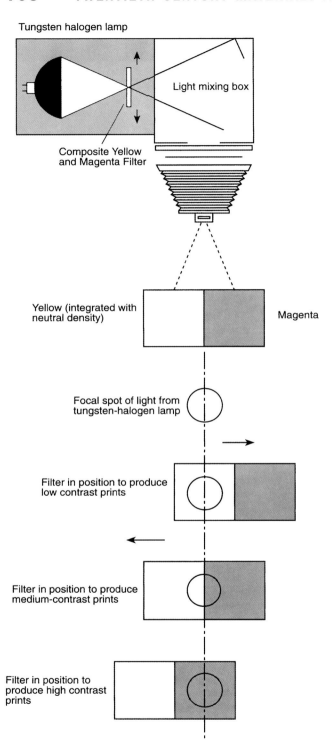

Tungsten halogen lamp

Light mixing box

Composite Yellow
and Magenta Filter

Yellow (integrated with
neutral density)

Magenta

Focal spot of light from
tungsten-halogen lamp

Filter in position to produce
low contrast prints

Filter in position to produce
medium-contrast prints

Filter in position to
produce high contrast
prints

FIG. 102 A composite yellow and magenta filter provides variable contrast control.

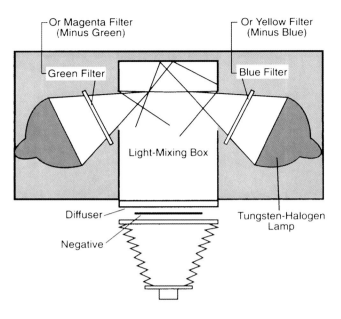

Or Magenta Filter
(Minus Green)

Or Yellow Filter
(Minus Blue)

Green Filter

Blue Filter

Light-Mixing Box

Diffuser

Tungsten-Halogen
Lamp

Negative

FIG. 103 Illumination system with yellow and magenta filtration for color printing can also be used for printing variable contrast paper.

blue. These filters are very selective in the way they expose the specific emulsions. In addition, they are selective in what they do not expose. There is no output in the red region where unwanted heat is generated and must often be additionally filtered with heat-absorbing glass and expensive infrared filters.

Color Exposure Requirements

Full color photography requires a complex assembly of emulsions with sensitivity to the three primary wavelengths of light—red, green, and blue. All color films and papers have at least one emulsion layer dedicated to each of these colors. The actual dyes that form the final image are almost always the complement of these colors × cyan, magenta, and yellow. When the proper relationship and density of the three dyes exist, the print is color balanced. This balance is accomplished using filters to vary the relative levels of red, green, and blue light output by the illumination system.

The original method of exposing color was with the additive system of red, green, and blue filters. These primary color filters each absorb two-thirds of the visible spectrum and transmit their own color of light. If red, green, and blue light beams are overlapped, the three colors can be added together to re-create the original white light as well as virtually any other color. When making color prints, however, three separate filtered exposures may be made (tricolor exposure). By varying the time of each primary color exposure, the photographs can achieve the proper density and color balance. Still in use in automated machine printers, tricolor exposure is an

Because of the relatively slow speed of color materials, high-efficiency systems have always been desirable. The most efficient single-exposure color enlarging systems use subtractive primary color filters × cyan, magenta, and yellow. Each of these three filters absorbs or subtracts an additive primary color of light and transmits the remaining two-thirds of the white light. Related to their additive counterparts, these filters are cyan (minus red), magenta (minus green), and yellow (minus blue).

Originally, separate cyan, magenta, and yellow filters of various densities were inserted manually into the enlarger. Later, color enlargers incorporated graduated dichroic color filters. These filters are made by vacuum depositing specific compounds onto clear glass. The resulting filter is fade and heat resistant. In use, the desired color density is dialed in with a calibrated control to a specified point in the light path of a diffusion illumination system.

Separate cyan, magenta, and yellow filters are still in use and are the most cost-efficient way to provide color control for enlarging with black and white enlargers. The relative sensitivities of the three emulsion layers of color printing papers are controlled during manufacture so that it is seldom necessary to use the less efficient cyan filter. Subtractive filtration systems will always be twice as efficient as additive systems. Theoretically, however, additive filters offer some benefits when speed is not an issue.

Comparing transmission curves and spectral-sensitivity data of printing papers, it is easy to see that additive filters selectively expose each individual color layer, while subtractive filters simultaneously expose two layers. Therefore, a color change is more directly implemented with the additive system. A subtractive filter adjustment results in some interaction between two colors (crosstalk) and often requires a second more minor adjustment to compensate.

In addition, the few additive enlarging systems that exist all have intelligent controllers. These computerized interfaces between the user and the illumination system offer more intuitive control and make learning color theory easier. Internal programming can eliminate calculations and make operation simpler. Most subtractive-based systems are mechanical and require a somewhat backward logic to operate. Although intelligent controllers are available in more sophisticated electronic subtractive systems, they require more levels of programming to compensate for the different degrees of crosstalk and spectral sensitivities of various color print materials.

Many people claim better color accuracy for additive systems. Although this is logical, it will only be realized when color dyes improve. However, all color exposure systems benefit from continuous developments in emulsion technology which provide fine-tuning of color sensitivity and more discrete color separation.

Specialized Application Enlarging Systems

Special imaging techniques often require an extremely complex operation or unique equipment. Some commercially available enlarging systems were created for specific tasks. Two of these systems are described here.

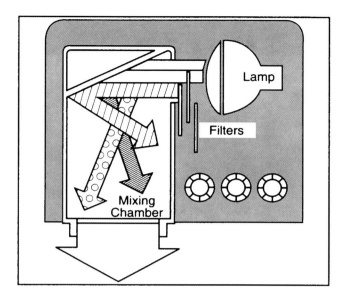

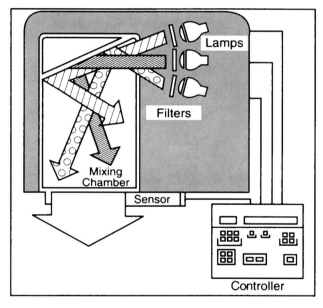

FIG. 104. Diffuse illumination colorheads. (Top) with mechanical filter control; (bottom) with electronic filter control.

appropriate practical process. In a manual enlarging system, however, it does not permit selective area exposure control (dodging and burning).

However, some additive systems have incorporated three separate filtered lamps in a diffusion integrating illumination system. A control unit varies the intensity of the lamps to adjust the relationship of the three colors for balance and exposure. Although the efficiency of these systems is very poor (each filter absorbs two-thirds of the light), the output is integrated into a single exposure.

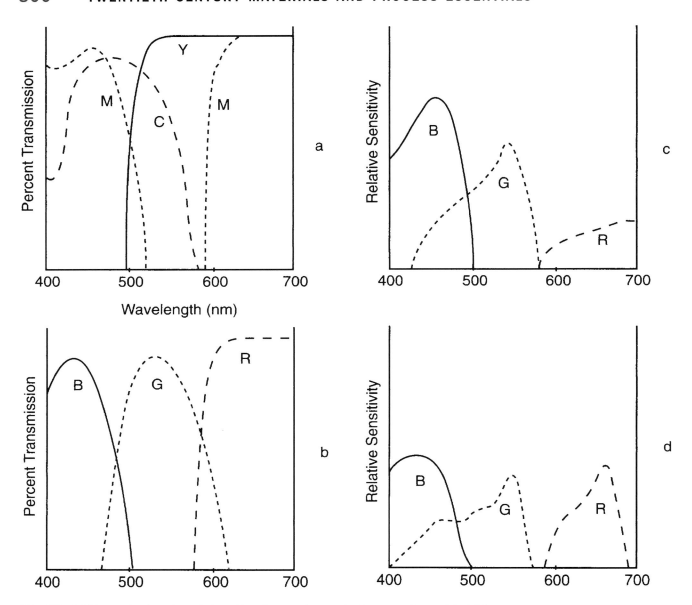

FIG. 105 Additive and subtractive printing with color negatives and color reversal materials (slides and transparencies). (a) Transmission curves for a set of subtractive filters. Dashed line, cyan filter (minus red); dotted line, magenta filter (minus green); solid line yellow (minus blue). (b) Transmission curves for a set of additive filters. Dashed line, red filter; dotted line, green filter; solid line, blue filter. (c) Spectral sensitivity curves for color negative print materials. Dashed line, red sensitivity; dotted line, green sensitivity; solid line, blue sensitivity. (d) Spectral sensitivity for color reversal print material. Dashed line, red sensitivity; dotted line, green sensitivity; solid line, blue sensitivity.

Photomontages and multiple exposures are relatively easy to accomplish with normal enlarging systems. A series of enlargers exist, however, that makes this a standard operation. When two complete projection assemblies are joined together at right angles, two images can be projected simultaneously. The inclusion of a semi-silvered mirror acting as a beam splitter allows the two individual images to be blended together and projected in the register as one.

When detailed subject matter needs precise tonal modification in select areas of the image, pinpoint illumination control is essential. Photographic masks can be created through a number of steps and may, combined with the film original,

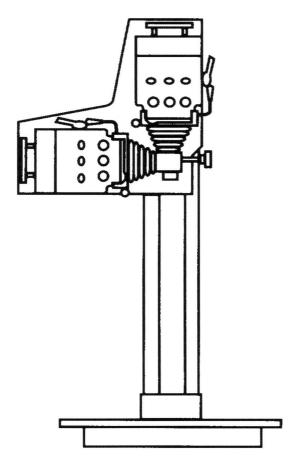

FIG. 106 Photomontage enlarging system.

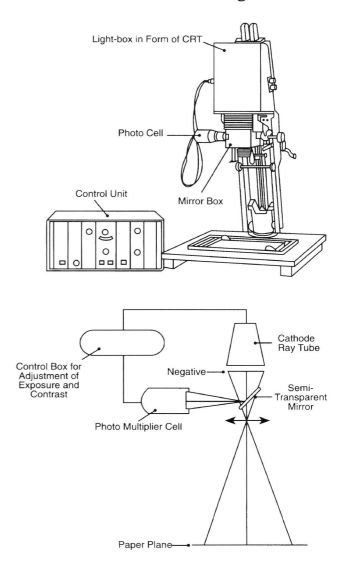

FIG. 107 CRT projection and schematic diagram.

produce the desired result. Fortunately, there is an easier and faster way through cathode-ray tube (CRT) exposure systems. A CRT is essentially the picture tube found in a high-resolution television set. The image is formed by an electron beam exposing phosphors spot by spot, rapidly across the width, and down the height of the CRT. The human visual system integrates these spots into a single image that is changed so rapidly that we perceive complete images and smooth motion in the television picture. As opposed to a conventional light source, which exposes the entire image in one shot, the CRT system uses its electron beam as the exposure source and allows us to have precise spot control of film illumination.

CRT exposure must be combined with a photomultiplier tube (PMT) measuring system that can follow the speedy little electron beam around the image and feed back the effect of the beam to a control system. On a spot-by-spot basis, the electron beam varies its intensity and the length of exposure time to produce the desired effect. The effect is regulated by pre-set (but adjustable) parameters input into the electronic

feedback system. Dark areas of a negative will receive correspondingly more illumination and exposure than light areas of a negative. This dodging and burning system can automatically print the most complex low- and high-contrast images on conventionally graded paper.

Automatic Enlarging Systems

As technology evolves various levels of automatic operation have been integrated into different components of enlarging systems. Automatic focus has been available for many years, mostly operating on a mechanical system. Lenses are calibrated to a special track attached to the enlarger column (or parallel arms). A roller riding on this track is directly linked

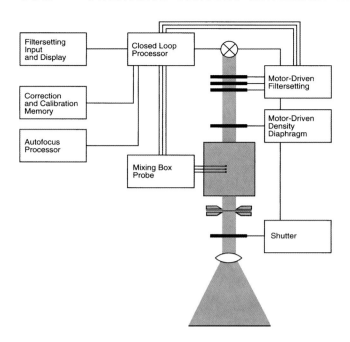

FIG. 108 Schematic diagram of a fully automatic enlarging system.

FIG. 109 Automatic enlarger network.

to the focus mechanism. As the enlarger elevation changes, the roller follows and adjusts the focus for the corresponding new print size. This system performs well but offers limited magnification control and lens selection. More common today are electronic systems that provide motorized lens positioning at any magnification and with any lens, once they are calibrated at the highest and lowest points on the enlarger column.

There are a variety of different levels of automation of illumination systems. For black-and-white printing on graded papers, a simple exposure control device can read the light from the projected image and set a timer or shutter accordingly. Black and white printing on variable contrast paper can be automated as well. Some systems measure the shadow and highlight density of the projected image and calculate the density range. Then they determine the proper contrast for printing and automatically expose the appropriate different contrast emulsions of variable contrast photographic paper.

Similar levels of sophistication have been added to color exposure systems. Reading the red, green, and blue components of a projected image, some metering systems will compare the values to previously memorized correct printing values. Once compared, the light source will automatically adjust itself to compensate for the difference between the two sets of values. The resulting print will be correct in both color and density.

Some professional lab enlargers provide complete computer-controlled, hands-off operation. Films can be electronically analyzed, and then this data, plus printing size

FIG. 110 Lambda digital RGB laser enlarger automatically exposes digital color images directly on to one of five rolls of photographic material stored on internal turret. Prints up to 50 inch wide with continuous feed up to any user programmed length. (Image courtesy of Durst Image Technology U.S., LLC Rochester, New York.)

and quantity information, can be fed directly through to the enlarger. If required, the data can also be output in a bar code format and attached to the film for reading at the enlarger station. When the film reaches the enlarger for printing, all sizing, focusing, color balance, and exposure control are

automatically set. In high-volume labs such a system can be cost justified when the time (and money) savings are considered.

Digital Enlarging Systems

Once it became apparent that high-speed scanners could adequately digitize film, and digital cameras would achieve quality levels great enough to provide original source data, the first all-digital enlarging systems were developed. Initially this was accomplished by inserting an LCD panel (which essentially represented a transparent digital film image) in the film stage of enlargers, but this proved to be very resolution limited and found its best application in small-sized mini-lab printers. However, by 1994 a number of devices were introduced incorporating optical systems utilizing discreet red, green, and blue light sources that converted electronic image data into millions of visible pixels and imprinted directly onto photosensitive materials. Light intensity must be high so either large arrays of LEDs are used in contact imaging systems, or three individual lasers create the pixels on very large format imagers. In laser enlargers a series of lenses and mirrors precisely move the imaging point across media as wide as 50 inches with resolutions up to 400 ppi. The media is fed from large rolls at speeds allowing output up to 270 square feet per hour for truly unmatched performance.

The Future

Once considered a necessity, for many, the conventional enlarger has essentially been superseded by the inkjet printer. While the convenience of operating in a room with lights on and virtually eliminating wet processing is undeniable, the quality of photosensitive printing media is preferred by many photographers and labs. As long as print media remain available, the craft and art of enlarging will endure.

FURTHER READING

Coote, J. H. (1998). *Ilford Monochrome Darkroom Practice: A Manual of Black-and-White Processing and Printing.* Boston: Focal Press.

Current, I. (1987). *Photographic Color Printing: Theory and Technique.* Boston: Focal Press.

Jacobson, R. E., Ray, S. F., and Attridge, G. G. (1988). *The Manual of Photography, 9th edition.* London: Focal Press.

Eastman Kodak (1985). *Quality Enlarging with Kodak Black-and-White Papers.* Rochester, NY: Eastman Kodak. ◎

Projection

BOB ROSE
VMI, Inc.

Ever since humans first looked at and recognized shadows, we have been interested in projected images. Early in the prehistory of moving-image photography, there was a fascination with the process of image projection. The magic lantern was invented by Athanasius Kircher in about 1640. In his book *Ars Magna Lucis et Umbrae*, first published in 1645, Kircher outlines the principles of the magic lantern. His magic lantern was a rear-screen projection show with images projected against translucent fabrics. The projected images were transparent figures that were hand-painted on glass strips. The areas around the transparent figures were heavily painted and appeared opaque. By changing the glass strips, Kircher's figures appeared and disappeared. When the lanternist moved the lantern closer to and farther from the projection screen, the images seemed to change their size and form, and when the lantern was dimmed or partially covered, the figures would seem to fade away. The exhibition/performance of magic lantern shows was considered entertainment, not much different than the motion picture today.

The phantasmagoria evolved from the magic lantern show. It too was a rear-screen projection entertainment event with sound effects, fade-ins, and dissolves. There were even X-rated striptease phantasmagoria. The use of concave mirrors and projected aerial images added to the idea of the fantastic and magical adventure. Peepshows, panoramas, and dioramas were extensions of the phantasmagoria and a fascination with perspective, lenses, light, and projection. Some of the dioramas were elaborate room-sized camera obscuras displaying painted canvases manipulated with light projected on the canvas or through translucent painted images on translucent fabric. Unfortunately, the light effects were not always manageable or consistent because of natural ambient light. The attempt to mirror reality turned some of the exhibitions into "performance art." In Daguerre's View of Mont Blanc a real chalet and barn were introduced into the diorama, and for an added touch of reality a goat eating hay was included. This innovation was not an overwhelming success; it was perhaps a bit too soon for audience participation.

The magic lantern slide show evolved into a form of traveling entertainment, where an itinerant magic lanternist carried a hand organ and a magic lantern with slides and went door to door soliciting for places to arrange a private magic lantern show. In the early 1800s the Galantee show became a popular form of entertainment, an amusement similar to hiring a performer for a private party. The entertainment was provided by a team of two; one playing music on an organ while the other projected slides.

Long strips of hand-painted slides were passed slowly in front of the magic lantern lens and gave the viewer a sense of motion. Panoramic comic strip slides added to the levity of the entertainment, while slipping slides and lever slides continued the progress toward the development of a moving image. Rack-work slide projection could simulate movement and rotation and even simulate continuous movement, such as smoke rising from a chimney.

The magic lantern slide images were not always hand-drawn and hand-painted images. By the late 1850s magic lantern slides were also photographically produced and then often, but not always, hand-colored. The photographic process was

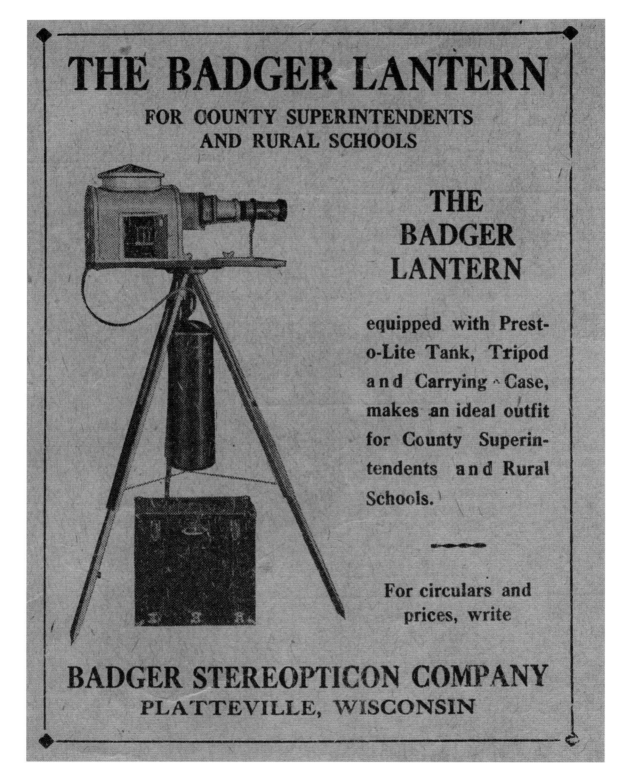

FIG. 111 A reproduction of an advertisement for The Badger Lantern that was featured in the *School News and Practical Educator*, Vol. XXVI, Taylorville and Chicago, Illinois, January 1913, No. 5.

becoming increasingly popular as a means of producing images for the magic lanterns. Drawings and engravings were also photographically reproduced as slides for the magic lanterns. The amateur photographers were encouraged to make their own photographic slides. So popular was the interest and production of slides and slide shows that the Crystal Palace presented slide shows daily throughout the 1880s and 1890s.

Two major slide publishers in London ran exhibition galleries where thousands of slides were available for viewing. Most slide publishers manufactured and sold hand viewers, usually constructed of mahogany with adjustable eyepieces, for looking at the transparencies so that they could be evaluated without the need to project them. The dealers sold the magic lantern slides either plain or colored, and if the customer wanted to personally paint the slides, a set of transparent slide painting pigments could also be purchased.

The original, single-candle japanned tin lanterns gave way to more ornate models. The drawing-room version was made of mahogany with brass fittings on the highly polished lacquered doors. Some magic lanterns had multiple chimney arrangements. The single candle was replaced by oil lanterns, then by gas, and finally by electricity.

There were a variety of slide-changing mechanisms. The Metamorphoser allowed one slide to be withdrawn as another slide replaced it. Another device had a descending curtain-like object lower between the changing slides and an endless loop device projected rapidly changing panoramas. Stacked or multiple lens magic lantern projectors provided an early multimedia-style slide show. This was possible by turning up the flame of one lantern (brightness control) while lowering the flame of another; the images appeared to fade in and out from one to the other. A day scene turned into a night scene was the most common change. Second in frequency of occurrence was a black and white image dissolving into a full color version of the same image. Live models were photographed in the real world or against a painted background scene, not unlike a Hollywood movie today. The use of photographic superimposition created a new visual vocabulary for the slide show, showing the audience a thought or an idea either by projecting one image onto another or producing a multiple combination print and then converting it into a slide for projection.

The motion-picture projector came about through the evolution of image-projecting toys coupled with the magic lantern. The Projecting Phenakistoscope used a disc of images that revolved across a shutter-like device in front of a magic lantern, projecting a smooth moving sequence. This shutter-like device was key to the smoothing of action in projected imagery and led to the development of contemporary motion-picture projectors. The Thaumatrope used a disc containing two or more images placed around the center that was twirled by two attached strings. The result is a single image that combines the separate images into one. By adjusting the tension on the string while the discs are spinning, the speed of rotation and the visual effect can be changed. The Zoetrope was another persistence-of-vision toy capable of depicting the illusion of motion. A large, thin-walled metal drum with slits in the sides, capable of revolving easily around a pivot point at its base axis, is spun around very quickly. Inside the drum is mounted a long, narrow strip of photographic images or drawings that simulate a sequence of some simple action. The viewer, looking through one of the slits in the revolving drum, sees a moving image.

Other devices somewhat similar to the Zoetrope added to the number of toys that projected or displayed moving images. The Praxinoscope Theatre is a toy with two concentric rotating drums and a strip of images rotating on the inside of the outer drum. These rotating images were reflected on pieces of glass in the center drum, which also contained a stationary section that held little pieces of scenery. To the eye, the stationary scenery became the background over which the reflected moving images of the large drum danced. The Viviscope and the Tachyscope were also based upon the Zoetrope. The use of instantaneous photography, when combined with the principles learned from the magic lantern projection devices and coupled with the persistence-of-vision toys, led to the development of the motion picture.

The projected image is a performance activity that is intended to communicate with and involve the audience. Unlike the single photograph, slide shows and motion pictures provide, if viewing conditions are ideal, an intense, fully saturated color image far superior to that of a photographic print. Coupled with sound, scale, and a visually captured audience (since there is nothing else to look at), projected images are an especially effective communication medium. But all projected images are not equal, nor are they necessarily works of art. An overhead projected image may assist in lectures and demonstrations, but it is not as compelling as a slide show or film. Projection in this instance is for presenting information in visual form; the sole purpose of the projected image is to reach a larger audience with less effort and at the least possible cost for the desired effect.

With the introduction of Kodachrome transparency film in 1935, it was only natural that Kodak make a system specifically for what would become one of the most popular forms of image presentation. In 1940 the Kodaslide Projector was introduced and the modern "slide projector" was born. Technology marched slowly until the introduction of the Kodak Carousel system in 1960. No longer at the mercy of low-capacity straight slide trays, or even single slide feed mechanisms, the circular Carousel tray provided the capacity to store and automatically show 80 slides at a time (later expanded to 140 slides in slim mounts).

The sequential still image slide show and filmstrip became the industrial and educational standard for many years, and although the multimedia slide show had been around in one form or another since before the turn of the century, it was not until the development of the sound tape/slide synchronizer that the multi-image slide show became popular. The early 1970s saw the introduction of the slide programmer, which had the ability to do quick cuts and varied dissolves. The late 1970s produced the electronic programmer, which permitted

FIG. 112 A 1935 Argus Model B Projector. (Image courtesy of the Technology Collection, George Eastman House Collection, Rochester, New York.)

FIG. 113 A 1961 EKC Carousel Projector. (Image courtesy of the Technology Collection, George Eastman House Collection, Rochester, New York.)

more sophisticated effects, with easier and faster programming and with the ability to control several projectors at once with a single control.

As the programming became easier to control, the photographic and projection techniques became more complex. The electronic programmer gave way to the microcomputer, which made it possible to control several banks of slide projectors, motion-picture projectors, lighting, and sound effects. These new more sophisticated multi-image shows with multiscreen projection began to take advantage of varied perspectives and close-up and panoramic vistas of the same subject side by side; essentially a multiviewpoint show.

However, as microcomputer technology advanced, so did the ability to capture and manage images digitally. By 1986 the first commercial projectors employing LCD imaging engines started to appear. This made it possible to connect a computer signal and project a digital image directly from the LCD, thus eliminating the need for slide film. Of course these early systems were unwieldy, relatively low quality, and expensive, which meant they were used primarily for industrial applications. But by 1991 the concept of getting photographs easily digitized and viewing them on a television was a reality with the introduction of the Photo CD. Digital imaging evolved and with improvements in technology, digital resolution became acceptable for the masses. Viewing and sharing images on a computer display became so common that Kodak discontinued the slide projector in 1994. While slide film and transparencies are still used for professional applications, the ability to project digitally is not only a standard for industrial purposes, it is also found in many commercial and consumer applications. New technology like digital light projection (DLP) expands the versatility of digital projectors to not only handle still images, but movie theater projection as well.

Regardless of the technology employed, some practical issues must be considered to ensure an ideal presentation. The projection equipment should be set up before the audience arrives, the sound tested, and the projectors focused and aligned, especially if more than one projector is to be used. Extra projection lamps, extension cords, flashlight, and gaffer tape should be part of the equipment carried to any projection location. If possible, the projectors should be isolated from the audience with a soundproof booth. If that is not possible, then the projectors should be as far behind the audience as is physically possible. With noisy equipment in the room with the audience, sound-absorbing partitions or screens should surround the equipment. For informational presentations that contain text and numbers, the audience should be no farther away than 8 times the screen height. If the text is larger than standard size or the program content is entirely pictorial, the screen-to-audience distance can be increased to 14 times the screen height.

Index